0067201

THE LOVES OF THE GODS

MYTHOLOGICAL PAINTING FROM WATTEAU TO DAVID

COLIN B. BAILEY

with the assistance of
Carrie A. Hamilton

INTRODUCTION BY
Pierre Rosenberg

WITH ESSAYS BY

Philippe Le Leyzour
Steven Z. Levine
Donald Posner
Katie Scott

Kimbell Art Museum, Fort Worth

RIZZOLI
NEW YORK

First published in the United States of America
by Rizzoli International Publications, Inc.
300 Park Avenue South, New York, NY 10010

This book has been published in conjunction with the
exhibition *The Loves of the Gods: Mythological Painting from
Watteau to David*, held at Galeries Nationales du Grand
Palais, Paris, 15 October 1991–6 January 1992;
Philadelphia Museum of Art, 23 February–26 April 1992;
Kimbell Art Museum, Fort Worth, 23 May–2 August 1992.

The exhibition has been organized by:

RÉUNION DES MUSÉES NATIONAUX, PARIS
PHILADELPHIA MUSEUM OF ART
KIMBELL ART MUSEUM, FORT WORTH

The American tour of the exhibition has received generous planning
and implementation grants from the National Endowment for the Arts.
An indemnity has been granted by the Federal Council on the Arts and
the Humanities.
In Philadelphia, the exhibition has been supported by a generous grant
from The Pew Charitable Trusts.

Edited at the Kimbell Art Museum by Wendy P. Gottlieb,
with the assistance of Katherine M. Whann and Julie K. Mayes
and at Rizzoli International Publications, Inc., New York,
by Charles Miers, with the assistance of Michael Bertrand,
Elizabeth White, and Gregory Smith.
Design consultant: Tom Dawson, DUO Design Group.
Copyright © 1992 by Kimbell Art Museum, Fort Worth, and
Réunion des Musées Nationaux, Paris. All rights reserved.

LIBRARY OF CONGRESS CATALOGING-IN-PUBLICATION DATA

Bailey, Colin B.
 The loves of the gods, mythological painting from Watteau to David /
 Colin B. Bailey with the assistance of Carrie A. Hamilton ;
 introduction by Pierre Rosenberg ; with essays by Philippe Le
 Leyzour ...[et al.].
 p. cm.
 "Published in conjunction with the exhibition The loves of the gods
 ... held at Galeries Nationales du Grand Palais, Paris, 15 October
 1991–6 January 1992; Philadelphia Museum of Art, 23 February–26
 April 1992; Kimbell Art Museum, Fort Worth, 23 May–2 August 1992."
 Includes bibliographical references and index.
 ISBN 0-8478-1521-8 clothbound edition
 ISBN 0-912804-26-2 paperback edition
 1. Mythology, Classical, in art—Exhibitions. 2. Painting,
 French—Exhibitions. 3. Painting, Modern—17th–18th centuries—
 France—Exhibitions. I. Hamilton, Carrie A. II. Galeries
 nationales du Grand Palais (France) III. Philadelphia Museum of
 Art. IV. Kimbell Art Museum. V. Title. 91-40371
 ND1422.F84B35 1992 CIP

No part of this publication may be reproduced in any manner
whatsoever without prior permission from Rizzoli International
Publications, Inc.

COVER:
François Boucher, *Hercules and Omphale* (detail),
Pushkin Museum, Moscow (cat. no. 42)

LENDERS TO THE EXHIBITION

PRIVATE COLLECTIONS
 Mrs. Ruth Blumka, New York
 Mr. and Mrs. Stewart Resnick, Philadelphia
 Martha and Ed Snider
 Alex Wengraf, Esq., London
 Anonymous Private Collectors

FRANCE
 Angers Musée des Beaux-Arts
 Besançon Musée des Beaux-Arts et d'Archéologie
 Cholet Musée des Arts
 Dijon Musée des Beaux-Arts
 Épinal Musée Départemental des Vosges
 Lille Musée des Beaux-Arts
 Montpellier Musée Fabre
 Nancy Musée des Beaux-Arts
 Nantes Musée des Beaux-Arts
 Paris Musée des Arts Décoratifs
 Paris Musée du Louvre
 Paris Musée Rodin
 Quimper Musée des Beaux-Arts
 Saint-Étienne Musée d'Art et d'Industrie
 Saint-Quentin Musée Antoine Lécuyer
 Strasbourg Musée des Arts Décoratifs
 Tours Musée des Beaux-Arts
 Troyes Musée des Beaux-Arts et d'Archéologie
 Versailles Musée National des Châteaux de Versailles
 et de Trianon

FEDERAL REPUBLIC OF GERMANY
 Berlin Staatliche Museen Preussischer Kulturbesitz
 Gemäldegalerie
 Munich Bayerische Staatsgemäldesammlungen, Alte
 Pinakothek

SWEDEN
 Stockholm Nationalmuseum

SWITZERLAND
 Basel Kunstmuseum Basel
 Geneva Musée d'Art et d'Histoire

UNION OF SOVIET SOCIALIST REPUBLICS
 Saint Petersburg The Hermitage Museum
 Moscow Pushkin Museum

UNITED KINGDOM
 London The Trustees of The National Gallery

UNITED STATES OF AMERICA
 Columbus Columbus Museum of Art
 Dallas Dallas Museum of Art
 Detroit The Detroit Institute of Arts
 Houston Museum of Fine Arts
 Houston Sarah Campbell Blaffer Foundation
 Kansas City The Nelson-Atkins Museum of Art
 Malibu The J. Paul Getty Museum
 New Orleans New Orleans Museum of Art
 Philadelphia Philadelphia Museum of Art
 Washington, D.C. National Gallery of Art

CONTENTS

FOREWORD

Until the end of the eighteenth century, the fine arts in France were ordered by genre, and paintings of sacred and profane narratives—"history paintings"—were considered the grandest and the most demanding of artistic talent. Within this category, the preeminence of mythology was undisputed, and the training offered by the French Academy of Painting and Sculpture reflected this esteem. Accordingly, the Academy prepared the most talented artists to execute narrative paintings in which the human figure was convincingly represented in dramas of great passion and pathos. The amorous content of many of the classical myths was suited, furthermore, to the tastes of a growing number of wealthy Parisian patrons, thus ensuring that there was a continuing demand for such works: as decoration; as models for tapestries; or, most importantly, as freestanding easel paintings for the picture cabinet.

Nearly every artist of talent and importance trained by the Academy—as all artists were—painted subjects from mythology. In fact, the reputation and standing of the officers of the Academy were determined by their success in this very genre. Yet despite the recent expansion of interest in eighteenth-century French painting and the groundbreaking research of French scholars in extending knowledge of a number of lesser-known masters of this age, mythological painting remains little loved and poorly understood. In part this is due to widespread unfamiliarity with the myths and legends themselves—stories that were background knowledge for an eighteenth-century audience. But it also reflects a modern preference for the formal and purely painterly, for abstract qualities in works of the past, where the artist's imagination is seen as liberated from the constraints of a given narrative program. Just as contemporary artists are rediscovering the potency of mythology, so the state of research into eighteenth-century French painting has reached a point where a survey such as The Loves of the Gods: Mythological Painting from Watteau to David is both timely and welcome.

As well as reacquainting the public with a selection of works by Watteau, Boucher, and Fragonard, the exhibition proposes to introduce a number of artists whose work is not well known in America and whose reputations, in France as well as abroad, are yet to be reestablished. While the importance and vigor of many of these artists are unquestioned by specialists in the field, the names of Antoine Coypel, Charles de La Fosse, François Lemoyne, Jean-François de Troy, and Charles-Joseph Natoire—to mention just five of the twenty-seven artists in the exhibition—are still unfamiliar to the general public. The Loves of the Gods will be the first opportunity to see and to study some of the finest examples of their work as it survives today.

The organizers of the exhibition are pleased to acknowledge their profound gratitude to the institutions and private collections throughout Europe and North America whose generous loans have been indispensable in assembling a nucleus of works of the highest quality and achievement. A special debt is owed to the Musée du Louvre for its exceptional loan of ten critical works. Colin B. Bailey, Senior Curator at the Kimbell Art Museum and formerly Assistant Curator of European Paintings at the Philadelphia Museum of Art, served as the curator in charge of the exhibition, selecting and cataloguing the works and editing the essays in this book by Philippe Le Leyzour, Steven Z. Levine, Donald Posner, Pierre Rosenberg, and Katie Scott. Our thanks go to him as well as to these distinguished scholars. Through their contributions to the catalogue and their expertise, they have placed our knowledge of French mythological painting in the eighteenth century on a more factual basis and have established a context for a more profound understanding of the achievement of French art during the reigns of Louis XV and Louis XVI.

Jacques Sallois
Président, Réunion des Musées Nationaux

Anne d'Harnoncourt
Director, Philadelphia Museum of Art

Edmund P. Pillsbury
Director, Kimbell Art Museum

PREFACE AND ACKNOWLEDGMENTS

"The study of Mythology is indispensable for painters, sculptors, poets, and all those whose task is to embellish Nature and to appeal to the Imagination. Mythology provides the foundation of their Art; it is the source from which Art's principal ornaments are derived. Mythology decorates our palaces, our galleries, our ceilings, and our gardens. Fable is Art's patrimony, an inexhaustible wellspring of ingenious ideas, joyous images, interesting subjects, allegories, and emblems." *Encyclopédie* 1751–65, X, 925.

Mythology was central to artistic practice during the *ancien régime*. The portrayal of the human figure, naked and draped, in noble and expressive narratives, was the highest calling of the history painter and the keystone of academic pedagogy. The stories recounted by Homer, Virgil, and Ovid continued to provide artists with a repertory of subjects which had engaged the imagination of the greatest painters of the past, from Correggio to Titian, Veronese to Rubens. The preeminence of history painting drawn from classical mythology was unquestioned in France throughout the eighteenth century, and it is this fundamental topos that *The Loves of the Gods: Mythological Painting from Watteau to David*, the first thematic exhibition devoted to eighteenth-century French painting to be held at the Grand Palais, seeks to reaffirm. By assembling sixty-seven of the finest mythological paintings of the period, it is possible to trace the development of a genre that ranked at the summit of the arts until the end of the eighteenth century, but one which has since fallen from favor. Not the least important aim of this exhibition is to acquaint museum visitors with stories that were immediately familiar and accessible to audiences two hundred years ago. Only then will the learning and inventiveness of eighteenth-century French painters—whose works are still too readily dismissed as trivial, frivolous, or decorative—be given their proper due. Furthermore, this survey of narrative painting introduces to a wider public some of the outstanding painters of the *ancien régime*—Charles de La Fosse, François Lemoyne, Jean-François de Troy, Noël-Nicolas Coypel, Charles-Joseph Natoire, and

Noël Hallé. By situating their work in a more familiar context—alongside the mythological paintings of Watteau, Boucher, Fragonard, and David—a richer and more generous conspectus of eighteenth-century art emerges. The changing roles of classical mythology in the culture of eighteenth-century France are widely, and variously, interpreted in the introductory essays in this catalogue, yet the purpose of the exhibition, and the success of the undertaking, depends above all on the persuasiveness of the paintings assembled—many of them masterpieces of the genre—whose potency, conviction, and eroticism fully reflect the eighteenth century's veneration for antiquity.

The Loves of the Gods: Mythological Painting from Watteau to David is quietly revisionist. For once, the emphasis shifts from developments in history painting at the end of the *ancien régime*—the splendid mythologies by Greuze and David are valedictions—to concentrate rather on the flowering of high art during the regency and the early reign of Louis XV. It is hoped that this approach will encourage a more exacting and sympathetic appraisal of the most prominent artistic personalities of the period 1720–50, one in which the methods, aims, and values of the *Académie royale de Peinture et de Sculpture* receive a more even-handed treatment than heretofore has been customary.

In the five years that have passed since this exhibition was first proposed, I have incurred so many debts that it seems almost churlish to reduce my thanks to the list included here. Above all, it is a pleasure to thank the private collectors and institutions, mentioned by name at the beginning of this book, who graciously agreed to part with their paintings for the duration of the exhibition. I am much indebted to Philippe Le Leyzour, Steven Levine, Donald Posner, Pierre Rosenberg, and Katie Scott for their elegant, thought-provoking, and occasionally controversial essays in this catalogue. *The Loves of the Gods: Mythological Painting from Watteau to David* was conceived during my tenure at the Philadelphia Museum of Art and supported by Anne d'Harnoncourt and Joseph Rishel, the latter a most receptive, if probing, mentor.

Practically every department of that institution has contributed to the realization of this project, and I should like to thank in particular Mark Tucker, Suzanne Penn, and Joe Mikuliak of the Conservation Department; Christopher Riopelle and Jen Otte of European Paintings before 1900; Lawrence Nichols of the John G. Johnson Collection; Gina Erdreich and Lilah Mittelstaedt of the Library; Irene Taurins and Martha Small of the Registrar's Department.

It is at the Kimbell Art Museum that the organization of the exhibition, in conjunction with the Réunion des Musées Nationaux, and the writing and editing of the catalogue have taken place. I owe a special debt of thanks to Director Edmund P. Pillsbury for his steadfast and effective support of the entire project. It is no exaggeration to say that the catalogue would not have been written without the sterling effort of Carrie A. Hamilton, Research Assistant, who, first in New York and then in Fort Worth, worked on every aspect of the manuscript. She was responsible for organizing the very thorough documentation that accompanies each entry, as well as for writing the lion's share of the artists' biographies.

There would have been no book at all without the extraordinary dedication and hard work of a number of people at the Kimbell Art Museum. The editing of the manuscript was carefully supervised by Wendy P. Gottlieb, Assistant Director for Public Affairs and Museum Editor, whose meticulous reading saved the author from many errors. In this she was ably assisted by Julie K. Mayes, Executive Assistant, who proved the most reliable of copy editors and a redoubtable grammarian. Katherine M. Whann, Curatorial Assistant, has immersed herself in this project with an enthusiasm and attention to detail that have never faltered. She ably assisted in the organization of almost every aspect of both the exhibition and its accompanying catalogue; my debt to her is enormous. During the year in which the catalogue was written, I imposed the eighteenth century mercilessly on Chia-Chun Shih, Librarian, and Patricia Oestricher, Library Assistant. Their efforts ensured that any work available in American libraries would find its way to my desk, and the scholarship of this catalogue is in no small way indebted to their perseverance. The book's elegant and distinctive design is due to Tom Dawson of Duo Design Group; Michael Bodycomb, Museum Photographer, is to be thanked for all his efforts. Anne C. Adams, Registrar, was unfailingly efficient in coordinating loans and arranging transportation and insurance.

At Rizzoli International Publications, Inc., I should like to thank Charles Miers for his energetic support in the preparation of the English edition of the catalogue. Michael Bertrand, production editor, Elizabeth White, Isabelle Bleecker, and Gregory Smith are warmly thanked for their indispensable contributions.

Above all, *The Loves of the Gods: Mythological Painting from Watteau to David* has been a Franco-American collaboration, and it is a pleasure to thank our colleagues in Paris. This project would never have seen the light of day without Pierre Rosenberg, conservateur général du Patrimoine, chargé du département des Peintures, who supported our request to borrow ten paintings from the Louvre and who has been relentless in securing loans for the exhibition. Philippe Le Leyzour, conservateur du Musée National des Granges de Port-Royal, has been the ideal collaborator. He has coordinated the restoration of fourteen paintings from French provincial museums and has attended to the translation of the catalogue with a sensitivity worthy of the keeper of Racine's first resting place. The elegant hang of the exhibition at the Grand Palais is also due to him, working in collaboration with Claude Pecquet.

At the Réunion des Musées Nationaux, Irène Bizot, administrateur-général, proved a tireless advocate for this exhibition, as did Claire Filhos-Petit, chef du service des expositions. For more than a year, I have been in weekly contact with Pierrette Turlais, in the service des expositions, who has brought the various stages of this exhibition to a successful conclusion with characteristic grace and good humor. We are also grateful to Francine Robinson, Registrar, and her staff for their masterly coordination of transportation and insurance. In the preparation of the catalogue, we are indebted to Anne de Margerie, responsable du département du livre et de l'image, and Marie Lionnard, who has handled a daunting amount of material and supervised the translation of the catalogue with great care. The layout of this book and color separations were the responsibility of Philippe Gentil assisted by Valerie Micots and François Brécard.

In writing on a relatively small number of paintings by twenty-seven different artists, I have relied upon the scholarship, published and unpublished, of many specialists in the field. While I have tried to acknowledge particular instances of assistance in the catalogue, I must mention here the fundamental research of Nicole Garnier, Alastair Laing, Thierry Lefrançois, Pierre Rosenberg, Antoine Schnapper, and Margret Stuffmann. Pontus Grate was exceedingly generous with archival material relating to paintings by Lemoyne and Coypel in Stockholm, and I am also grateful to Edgar Munhall and Nicole Willk-Brocard for giving me access to their unpublished doctoral theses. As always, the Service de documentation du

département des Peintures at the Louvre, an invaluable repository, was most welcoming, and I am also grateful to the Galerie Cailleux for access to their rich documentation. For help with photographs, it is a pleasure to thank Joseph Baillio, Alan Salz, Eric Turquin, Gerhard Gruitrooy, and the staff of the Service Photographique de la Réunion des Musées Nationaux. I should also like to thank the following for their help in many ways: Irina Antonova, Jean-Pierre Babelon, Thierry Bajou, Susan J. Barnes, Sylvie Béguin, Sylvain Bellanger, Richard Beresford, Per Bjurström, Ruth Blumka, Henning Bock, Paul Boerlin, Jean-Luc Bordeaux, Emmanuelle Bougerolles, Jean-Claude Boyer, Arnauld Brejon de Lavergnée, Richard R. Brettell, Brigitte de la Broise, Marjorie Bronfman, Beverly L. Brown, Christopher Brown, Yvonne Brunhammer, John Bullard, André Cariou, Görel Cavalli-Björkman, Jean-Loup Champion, Michael Clarke, Candace Clements, Claire Constans, Patrick Cooney, Odile Cortet, Henry-Claude Cousseau, Jean-Pierre Cuzin, Michel David-Weill, Christine Debrie, France Dijoud, Francis Dowley, Rosamund Downing, Elizabeth Easton, Bernard Fanchille, François Fossier, Elisabeth Foucart-Walter, Mr. and Mrs. George Frangos, Burton Fredericksen, Christian Geelhaar, Anna Gorczyca, Margaret Morgan Grasselli, Diane de Grazia, Marguerite Guillaume, Joanne Hedley, Martha Hepworth, Viviane Huchard, Bernard Huin, John Ingamells, Anthony Janson, William B. Jordan, Aleth Jourdan, Bunty King, Nancy Krieg, Claude Lapaire, Donald La Rocca, Ellen Leibowitz, John Lenaghan, Lydia Lenaghan, Patrick Lenaghan, Christophe Leribaut, Louise Lippencott, Irvin Lippman, Renée Loche, John Loud, Jean-Daniel Ludmann, Juan Luna, Gerard Mabille, Neil MacGregor, Bronwyn Maloney, J. Patrice Marandel, Ghislaine Marteaux, Gerard McCarthy, Andrew McClellan, Suzanne Folds McCullagh, Alain Mérot, Rodney

Merrington, Christian Michel, Régis Michel, Charles Moffett, Jennifer Montagu, Jacques Nicourt, Margaret Oppenheimer, James Parker, Kate Parks, Iain Pears, Ann Percy, Claude Pétry, Paula Phipps, Madeleine Pinault, Matthieu Pinette, Bruno Pons, Peggy Quigley, M.F. Ramspacher, Roland Recht, Lynda and Stewart Resnick, Marian Richmond, Margaret Richter, Marianne Roland-Michel, Betsy Rosasco, Belinda Ross, Chantal Rouquet, Marie-Catherine Sahut, Guy Stair Sainty, Anne van de Sandt, Marie-Madeleine Saphire, William Schaab, Erich Schleier, George T. M. Shackelford, Innis Shoemaker, Helge Siefert, Laura Slatkin, Martha and Ed Snider, Edith A. Standen, Gary Tinterow, Collette Vasselin, Germain Viatte, Dominique Vila, Jacques Vilain, Roger Ward, Alex and Pat Wengraf, Barbara White, Daniel Wildenstein, Rachel Wilfert, and Gillian Wilson.

In the preparation of this catalogue, I have been assisted by three people who, if they will accept it, deserve to be considered as collaborators on the project. Carol Togneri Dowd, Associate Archivist at the Provenance Index, Getty Art History Information Program, placed that institution's remarkable resources at my disposal, verifying sales records, checking prices, and furnishing me with a vast amount of material related to the previous owners of the paintings in the exhibition. In Paris, Udolpho van de Sandt proved the most indefatigable and persistent *chercheur*, ever ready to track down references at various archives and libraries and to resolve questions that would otherwise have been left in abeyance. His brilliant detective work is responsible for many of the *trouvailles* in this catalogue. Finally, my greatest debt is to Alan Wintermute, whose encouragement of this project has been unwavering and unwaning, and who has improved each entry by his scrupulous and exacting reading. Without his practical and moral support, the entire undertaking would have been a lesser one.

Colin B. Bailey
Fort Worth, July 1991

IN DEFENSE OF MYTHOLOGICAL PAINTING

PIERRE ROSENBERG

Edmond (1822–1896) and Jules (1830–1870) de Goncourt were exemplary art historians, prolific novelists, passionate collectors, and inveterate gossipmongers. In addition to their appalling *Journal*, recently reprinted to great acclaim, we have started to reread their novels. A study on their collection of drawings has just been published. And, while they are not responsible for the entire eighteenth century as is sometimes claimed, no one today questions the Goncourts' role in rediscovering Watteau, Chardin, Boucher, and Fragonard. Yet, on closer inspection, the situation is less clear-cut. Very few of the paintings included in this exhibition—graceful, charming mythologies of the loves of the gods, admired by the most discriminating collectors in the eighteenth century—would have appealed to the Goncourts. Why is this so?

One caveat before attempting to answer this question: the eighteenth century is fashionable nowadays, or at least it seems to be. In terms of the history of painting alone, a number of monographs devoted not only to leading artists, but also to those of the second rank, are now in preparation. It is quite astonishing that figures as important as Jean-François de Troy, Charles-Antoine Coypel, Noël Hallé, and Jean-Baptiste-Marie Pierre had remained without their historian for so long. Yet, regarding French art of the eighteenth century as a whole, the situation is improving, although it still lags far behind Italy, where even the most modest artist—especially if he is Venetian—can boast a monographic exhibition and at least one catalogue raisonné! It is comforting to know that each of the great figures cited above is finally being studied seriously and that work is being done on all aspects of eighteenth-century art. The study of artistic institutions flourishes—the Academy and the Salon (and its public) are very much *à la mode* at the moment; our understanding of artistic centers outside of Paris, long neglected, has increased considerably, if not at an altogether uniform rate. *Surintendants*, collectors, sales, dealers; royal, aristocratic, and bourgeois patronage; commissions from the Church—research is underway on each of these topics. The ramifications of the "expansion of French art" are at last being considered with a rigor that goes beyond a chauvinist enumeration of the more famous names. Art criticism, Salon reviews, artists' letters, travel literature—each of these subjects can now lay claim to its own specialist. If the study of iconography is less advanced, there exists a growing body of excellent theoretical material which extends much further than the writings of Diderot.

But nothing can change the fact that the eighteenth century fails, in the end, either to tempt or to seduce us. As proof of this, one has only to turn the pages of the *Art Bulletin*: articles on French painting of the eighteenth century—one might almost say the *grand siècle*—rarely appear in this important American publication. One thinks, for example, of the enormous number of paintings commissioned at considerable expense by the Church and the Crown which have remained inaccessible for more than a century. Are they not worthy of being exhibited? Do they not deserve to be restored, reframed, properly lit, and adequately labeled? And there are many other cases of this sort. The eighteenth century no longer excites; it seems unable to surprise us any more; it has become excessively familiar—or so we think. We no longer see the eighteenth century because we have lost the capacity to see it. *The Loves of the Gods: Mythological Painting from Watteau to David*—both the exhibition and its catalogue—invites us to reconsider the eighteenth century and aims at nothing less than a reinterpretation of this gilded age, a century at once daring and liberal, which conceals intellectual rigor behind a smile and reveals itself to us far less willingly than is at first apparent.

In approaching the period, "the hierarchy of the genres" is still the essential point of departure. Is it true, as was once claimed, that this "ridiculous heresy" invalidates the art of an entire century? What exactly does the term mean? It is worth pointing out that, during the eighteenth century, this concept was universally accepted: by painters, critics, *amateurs*, and theorists of both a conservative and radical bent—although this distinction, as it is understood today, is meaningless when applied to the eighteenth century.

Painting was classified by subject matter. What the painter saw with his eyes and could copy faithfully—an apple, part of a landscape, a bunch of flowers—required little more than technical expertise. The *artist*, on the

other hand, aimed at something higher than mere virtuosity. From his imagination he painted that which could not be seen—an episode from the Bible, an act of heroism, a fable from antiquity, "*les grandes actions*." Invention was his greatest gift. A second principle followed naturally from this fundamental belief: namely, that the painter's most noble calling was the representation of man. To portray man in his daily round—the province of the genre painter—was a relatively simple affair; more complex was the task of the portraitist, for whom a straightforward likeness was not sufficient and who aspired to "paint the soul." More elevated than either of these, the history painter sought to portray mankind at its most sublime, engaged in exemplary or legendary acts, and to give visual representation to certain fundamental ideas: "Inasmuch as artists are engaged upon more difficult and more noble tasks, so do they rise above the mediocre and the commonplace and become more noble themselves by virtue of their illustrious work. . . . Since the figure of Man is the most perfect of God's creations on earth, it must follow that he who imitates God by painting the human figure is far more excellent than all the others."[1]

There are two qualifying remarks to be made here. First, these universally respected rules in no way compromised Chardin's reputation as one of the greatest painters of the age—even though the artist himself always regretted that he had not been trained as a history painter and attempted to remedy this, unsuccessfully, through his son. Similarly, if after the death of Carle Van Loo—"the foremost painter in Europe"[2]—and the young Deshays in 1765, Fragonard, author of *Coresus and Callirhöe* (Paris, Musée du Louvre), was widely acclaimed as the most promising history painter in France, the artist did not go without work when he repudiated the *grand genre* shortly thereafter. As for Greuze, an artist who, more than any other, aspired to the rank of the history painter, he failed to achieve his ambitions in *The Emperor Septimius Severus Reproaching His Son, Caracalla, for Having Attempted to Assassinate Him* (Paris, Musée du Louvre), but he succeeded fully in raising genre to the level of history in *The Father's Curse: The Ungrateful Son* and *The Punished Son* (both Paris, Musée du Louvre).

My second observation is more speculative and brings us back to the twentieth century. One of the heroines in Jules Romains's *Les Hommes de bonne volonté* exclaims in indignation, "Modern artists simply do not try to paint what they see."[3] To paint what cannot be seen, to paint from the imagination, to display one's powers of invention—are these not familiar terms in the modernist's vocabulary? Indeed, after temporarily abandoning subject matter, does not the art of our time now give due honor to invention and imagination? It might be objected that this comparison misses the essential point—the nature of the subject itself. To this we shall return in our conclusion.

The eighteenth century set great store by the training of prospective artists. The part played by the Academy and the *École royale des élèves protégés* is fairly well known. Students spent long hours copying line engravings of *académies* after the most famous old masters, drawing from the live model, and copying plaster casts of the most famous antiquities; we are also well informed on the Academy's system of prizes and competitions, which culminated in the students' sojourn at the Palazzo Mancini in Rome. Chardin's poignant testimony to this apprenticeship is worth quoting in full:

At the age of seven or eight we were given a pencil and from a pattern book we began to draw eyes, mouths, noses, and ears, and then feet and hands. Only after we had spent many hours bent over our portfolios were we placed in front of the *Hercules* or the *Belvedere Torso*, and none of you could have witnessed the tears that were shed in front of the *Satyr*, the *Gladiator*, the *Venus de' Medici*, or the *Antinous*. You can be sure that, had we been able to vent our frustration on these masterpieces of ancient Greek art, they would no longer have excited the admiration of our teachers. Having spent days and nights studying these immobile and inanimate models, we were suddenly presented with living nature itself; and in a moment all the work of the preceding years was reduced to nought—we were no more prepared than the first time we ever handled a pencil. For now the eye had to be trained to look at nature, and there were many students who had never seen nature and never would. It is the torment of our profession. We work from the model for five or six years before we are allowed to use our own genius, if we have any. Talent is not formed overnight, and, happily, it is not after the first attempt that we must admit our incapacity; yet how many attempts are required, both successful and unsuccessful![4]

However, although the less talented were quickly dispatched, manual dexterity alone was not considered sufficient; efforts were also made to educate the minds of the young students. The excellent engraver Bernard Lépicié, responsible for teaching "history, mythology, geography, and the other disciplines which relate to painting," had this to say of the *École royale des élèves protégés*, the institution responsible after midcentury for forming the new French school:

At half past seven each morning, the pupils are to assemble in the study room; their history les-

son will last until nine o'clock. In accordance with the proposal submitted to M. le Directeur Général and approved by him, I can think of no better way to begin these lessons than with a passage from Bossuet's *Histoire universelle*. The aforementioned extract, which constitutes a survey of all that has happened in the past, will enable us to understand more easily père Calmet's *Histoire des juifs* and M. Rollin's *Histoire ancienne*, which we are reading in alternate classes. Once we have finished with these authors, we will turn to the sources themselves and read Herodotus, Thucydides, Xenophon, Tacitus, and Titus-Livy. . . . After supper, the students turn to classical poetry, and read, successively, Homer, Virgil, Ovid, and the other authors who have written on mythology.[5]

Lépicié expressed himself with even greater clarity in his *Leçon d'ouverture*, published by Locquin as early as 1909:

Not only is it my intention to provide you with an historical outline, but also to instruct you on the various countries and peoples you are to represent. Regarding the former, you will receive information about climate, trees, animals, rivers, and streams; then I shall explain each nation's system of government, its religion, customs, dress, and armaments. In this manner, gentlemen, without distracting you from your principal area of study, you will learn the requisite amount of history and geography necessary to satisfy both artists and scholars. . . . We shall also study iconology, read *mythology* (my emphasis), and become acquainted with the authors who will enable you to decipher what remains of the costumes of the ancients on antique bas reliefs and engraved gems.[6]

According to a contemporary wit, this amounted to little more than "supplying intellect to [prospective painters] six times a week"; in other words, providing them with culture.[7]

The attitude of our own century to this notion of culture is worth considering for a moment. Have modern artists always rejected it? For all those who claimed to be making a *tabula rasa* with their art—how honest were they?—there are many others whose work has displayed an exceptional knowledge of this literary and visual heritage. Their paintings are proof of a link with the past that is reaffirmed every day. And, if modern artists have often received this education in the course of visits to museums or through their own efforts, are we to condemn a century which attempted to provide

artistic instruction of the highest quality to its most promising students and to furnish the best among them with the instruments of their craft?

But to return to *The Loves of the Gods*—a subject from which we had not, in fact, strayed so far—at the summit of the hierarchy of the genres, history painting was divided into two distinct, if closely related, categories, whose fortunes differed quite radically as the eighteenth century progressed: history and fable, or, more properly, History and Fable. While the former consisted primarily of religious history, both the Old and the New Testament, and the Lives of the Saints, it also included ancient history—Plutarch, antiquity—and, of increasing significance, the history of France. It is the second category—Fable—that concerns us here, where Ovid conspicuously triumphed over Homer, much to Winckelmann's regret. However, the distinctions between History and Fable were not always clearcut; they were even less so since a third category of history painting, Allegory, depended equally upon the two genres and appropriated its symbols and imagery from History or Fable according to its needs.

Certain subjects, for example those which Colin Bailey has chosen to emphasize in this exhibition—*The Bath of Diana, Venus Requesting Vulcan to Make Arms for Aeneas, The Rape of Europa, Perseus Freeing Andromeda, Jupiter and Antiope, Diana and Callisto, Vertumnus and Pomona*—are unquestionably mythological. We have only to turn to the entries on "Fable" and "Mythology" in the *Encyclopédie*: "Fable is Art's patrimony, an inexhaustible wellspring of ingenious ideas, joyous images, interesting subjects, allegories, and emblems. . . . In myth, everything is alive, everything breathes the breath of an enchanted world, one in which symbols have bodily form, where matter takes on life, where the countryside, forests, rivers, and elements have their particular divinities."[8] The chevalier de Jaucourt further noted that "the study of mythology is indispensable to painters, sculptors, poets especially, and generally to all those whose task is to embellish nature and appeal to the imagination."[9] And, as one final example, the terse summary offered by Michel-François Dandré-Bardon, an excellent painter and great draftsman, but a mediocre poet and uninspired theoretician: "In the same manner as Poetry, Painting is sustained by Mythology and draws its life from fictions."[10]

But mythology was of even greater importance than this, as Jaucourt had previously implied in his entry on "fable" in the *Encyclopédie*:

It is for the following reason that the most superficial knowledge of mythology is so widespread . . . since the prints, paintings, and statues which decorate our picture cabinets and picture galleries, as well as those on our ceilings and in our

gardens, are nearly always taken from mythology, to remain entirely ignorant of this subject would be sufficient reason to spend a lifetime blushing at one's lack of education.[11]

Jaucourt added, however, that "to attempt to penetrate Fable's various meanings and mysteries is to trespass into a realm reserved for but a small number of scholars."[12]

It is passages such as these that inspired the masterful analysis of Jean Starobinski, the historian who, with Jean Seznec and Yves Bonnefoy, has so brilliantly elucidated the role of mythology in eighteenth-century thought:

> It can be argued that, during the eighteenth century, knowledge of mythology was a condition of cultural literacy, essential if one wanted to enter into those conversations in which every educated man would sooner or later be invited to participate. Rollin claimed that mythology was indispensable for all those who wished to comprehend their aesthetic milieu and win acceptance in elite society. Thus, myth performed a dual function: it was a pictorial language providing access to a specific discourse, the consequence of which was to facilitate social recognition among individuals who interpreted a universe of mythic fictions in the same way.[13]

Mythology was, above all, an indispensable tool for the use of the *honnête homme*, and one which could act at times as an instrument of society's approval. But if it constituted a repertory, "code," or dictionary—witness the enormous success of Chompré's *Dictionnaire abrégé de la fable*, first published in 1727—mythology also offered something of even greater import. And here the painters had their part to play.

As an example, let us take the story of Narcissus, told by Ovid in the third book of the *Metamorphoses*:

> Once as he was driving the frightened deer into his nets, a certain nymph of strange speech beheld him, resounding Echo, who could neither hold her peace when others spoke, nor yet begin to speak till others had addressed her. Up to this time Echo had form and was not a voice alone; and yet, though talkative, she had no other use of speech than now—only the power out of many words to repeat the last she heard. . . . Now when she saw Narcissus wandering through the fields, she was inflamed with love and followed him by stealth; and the more she followed, the more she burned by a nearer flame, as when quick-burning sulphur, smeared round the tops of torches, catches fire from another fire brought near. . . . By chance the boy, separated from his faithful companions had cried: "Is anyone here?" and "Here!" cried Echo back. Amazed, he looks around in all directions and with loud voice cries "Come!"; and "Come!" she calls him calling. He looks behind him and, seeing no one coming, calls again "Why do you run from me?" and hears in answer his own words again. He stands still, deceived by the answering voice, and "Here let us meet," he cries. Echo, never to answer other sound more gladly, cries: "Let us meet"; and to help her own words she comes forth from the woods that she may throw her arms around the neck she longs to clasp. But he flees at her approach and, fleeing, says: "Hands off! Embrace me not! May I die before I give you power o'er me!" . . . Thus had Narcissus mocked her, thus had he mocked other nymphs of the waves or mountains; thus had he mocked the companies of men. At last one of these scorned youth, lifting up his hands to heaven prayed: "So may he himself love, and not gain the thing he loves!" The goddess, Nemesis, heard his righteous prayer. There was a clear pool with silvery bright water, to which no shepherds ever came, or she-goats feeding on the mountainside, or any other cattle; whose smooth surface neither bird nor beast nor falling bough ever ruffled. Grass grew all around its edge, fed by the water near, and a coppice that would never suffer the sun to warm the spot. Here the youth, worn by the chase and the heat, lies down, attracted thither by the appearance of the place and by the spring. While he seeks to slake his thirst another thirst springs up, and while he drinks he is smitten by the beautiful form he sees. He loves an unsubstantial hope and thinks that substance which is only shadow. He looks in speechless wonder at himself and hangs there motionless in the same expression, like a statue carved from Parian marble. Prone on the ground, he gazes at his eyes, twin stars, and his locks, worthy of Bacchus, worthy of Apollo; on his smooth cheeks, his ivory neck, the glorious beauty of his face, the blush mingled with snowy white: all things, in short, he admires for which he is himself admired. Unwittingly he desires himself; he praises, and is himself what he praises; and while he seeks, he is sought; equally he kindles love and burns with love . . . but stretched on the shaded grass, he gazes on that false image with eyes that cannot look their fill and through his own eyes perishes. . . . While he thus grieves, he plucks away his tunic at its upper fold and beats his bare breast with pallid hands.

His breast when it is struck takes on a delicate glow; just as apples sometimes, though white in part, flush red in other part, or as grapes hanging in clusters take on a purple hue when not yet ripe. . . . He drooped his weary head on the green grass and death sealed the eyes that marveled at their master's beauty. And even when he had been received into the infernal abodes, he kept on gazing on his image in the Stygian pool. His naiad-sisters beat their breasts and shore their locks in sign of grief for their dear brother; the dryads, too, lamented, and Echo gave back their sounds of woe. And now they were preparing the funeral pile, the brandished torches and the bier; but his body was nowhere to be found. In place of his body they find a flower, its yellow center girt with white petals.[14]

The exceptional beauty of this lengthy passage justifies its quotation in full. If we now turn to the artists who were inspired by this myth—Lemoyne (cat. no. 25), Lépicié (cat. no. 61), and Valenciennes (cat. no. 67)—while not of Poussin's profundity, their approach can be analyzed as follows. The painter's first task was to portray a young man of ideal beauty, seduced by his own features, contemplating his reflection. Next he had to include the water (Narcissus's mirror), the instruments of the hunt, and the forest. But he had also to evoke the presence—or rather, the absence—of the pitiful nymph Echo, whom Narcissus had abandoned. This last requirement, by far the most difficult, was accomplished with varying degrees of success, but in the attempt the artists may be said to have transformed poetry into painting.

The story of *Clytia Changed into a Sunflower* (cat. no. 3) is far less familiar today. The daughter of Oceanus and Thetis, Clytia was seduced by Apollo, for whom she had developed an overwhelming passion. Abandoned by the Sun god, she resolved to starve herself to death, but Apollo transformed her into a sunflower, and thus, from dawn to dusk, her eyes never again left her lover's face.

The painter's task—to turn these magnificent legends into "eloquent images"—was not an easy one. The genre of mythological painting was not only fashionable, it was bursting with vitality; hence the constant demand for such paintings, both as overdoors and cabinet pictures. And throughout Europe, where mythological painting, disseminated through engravings, was jealously fought over, there was a consensus that the genre of mythological painting was something of a French specialty. Boucher became its champion, but others before him—artists such as Lemoyne, de Troy, and Noël-Nicolas Coypel—and a certain number after him—lesser figures who remain to be adequately studied—excelled in this manner of painting. The genre could not fail to please: it provided artists with a perfect opportunity to paint the female nude, to create seductive, erotic images, far less vapid and anodyne than is commonly assumed, as the most cursory inspection of this exhibition bears out. Admittedly, a primary objective was sexual arousal, a point to which Marmontel alluded when he reproached Boucher with painting "Venus and the Virgin Mary after the nymphs of the backstage theatre . . . having seen the Three Graces in the inappropriate setting, his paintings could not but convey the morality of his models."[15] Here Marmontel touched upon one of the primary difficulties inherent in the genre of mythological painting, a danger that would eventually cause its downfall. Before Boucher, mythological painting enjoyed fame and glory without excessive official support; in Boucher's time the genre emerged triumphant, imposing itself without difficulty, even if the artist himself had occasionally made the mistake of confusing mythology with gallantry; but thereafter, mythological painting was less and less able to satisfy the demands of a new age—official support notwithstanding, and in spite of both the intervention of the *surintendant des Bâtiments* during Louis XVI's reign and favorable reforms in artistic education.

Fable had always been attacked by those who encouraged "the perfect imitation of Nature" in the arts—an expression so widely used during the eighteenth century that it became little more than a cliché. Now fable was assailed by Rousseau and Diderot, whose objections to it were more similar than is often claimed. The former condemned "those aberrations of the heart and the mind, painstakingly culled from the mythology of the ancients."[16] Diderot simply could not abide Boucher, an artist of an earlier generation whom he considered outdated and whom he felt compelled to attack in the name of a new aesthetic, that of "progress in the arts." Although Diderot could not remain unmoved for long by "Venus's rump, neck, and beautiful arms,"[17] he nonetheless promoted a manner of painting that was more moral and sentimental—and, at the very least, more literary. Unquestionably, fable's demise was brought about by the combined assault of the antiquarians and the *philosophes*. The former reproached mythology for its historical inaccuracy, its lack of precision, and the casualness with which it evoked the very past that they were intent upon rehabilitating. The antiquarians sought rarer subjects, new and obscure—subjects that not only repelled the public, who no longer recognized them—but also infuriated the artists, who were at a loss as to how to represent them. The ambitions of the *philosophes* were of an entirely different order. For them, painting was to become a model: pleasurable, certainly, it had also to provide instruction,

and this was to become its principal function. If painting was to ennoble the soul, Brutus would soon be preferred to Venus, and the Horatii and the Sabines chosen over Diana, Psyche, Aeneas, and Mars. However, it was not David who rejected mythology. On the contrary, *Paris and Helen* (cat. no. 64) is a consummate triumph, the last attempt by a great artist to renew the genre which had inspired some of the eighteenth century's most seductive and persuasive images and its most poetic inventions, all far removed from the bombast of history.

One last comparison with the *The Loves of the Gods* that touches upon the role of myth in art: I am thinking here of Wagner's Ring cycle. Is it possible to appreciate Wagner without being able to read German, without knowing the various episodes of this splendid musical poem and understanding their symbolism and deeper implications? We are of the belief that Wagner can be enjoyed for his music alone, but we are also convinced that, in order to arrive at a deeper understanding of his operas, one should make the effort to read the libretti—and the commentaries they have inspired—before making the journey to Bayreuth. Should one not do as much for mythological painting? Resistance to this sort of approach has a long history; it helps explain the Goncourts' repudiation of eighteenth-century narrative painting. Yet today this attitude is all the more incomprehensible since it flies in the face of a tendency that can be discerned, in France at least, in the realm of opera. Not a single opera by Mozart or Verdi, Saint-Saens or Bizet, has escaped the director's scrutiny. Practically every sentence of the libretto—no matter how modest or insignificant—has produced the boldest interpretation, and at times the most preposterous over-interpretation. Barely a single allusion—the famous *"non-dit"*—slips past unnoticed, unless it comes from the director himself. And often to the impoverishment of the music. For now it is almost impossible to listen; the spectacle has become an end in itself, with each scene relating either to the Revolution—past, present, or future—or to the class struggle, the revolt of the third world, or women's liberation.

We would not wish this fate upon mythological painting, rest assured. The genre can be perfectly well appreciated on its own terms: for the sheer beauty of the paintings, the elegance of their rhythms, the refinement of their coloring, the subtlety of their execution and technique. But the greatest pleasure is reserved for those who take the trouble to return to the reading of their schooldays and to delve into their copies of Homer and Ovid once again, a task which the Goncourts, for all their enthusiasm, never set themselves.

In Poussin's *Arcadian Shepherds* (Paris, Musée du Louvre), a painting dear to Panofsky (myth or history? allegory certainly), one figure is shown laboriously deciphering the fateful inscription, while a second turns to share the terrible message with his companion. A third ponders the meaning of the event. Only he is capable of truly appreciating beauty; only he will face death with his eyes open wide.

Notes

1. Félibien 1725, V, 310.

2. Grimm's encomium is cited by Rosenberg in exh. Nice, Clermont-Ferrand, and Nancy 1977, 16.

3. Jules Romain, *Les Hommes de bonne volonté*, Paris, 1958, II, 482.

4. Cited by Diderot in the Salon of 1765, see Diderot 1957–67, II, 58.

5. Courajod 1874, 33–34.

6. Locquin 1909, 95–96.

7. Courajod 1874, 51.

8. *Encyclopédie* 1751–65, X, 924, the chevalier de Jaucourt's entry on "Mythologie."

9. Ibid.

10. Dandré-Bardon 1765 (A), 133.

11. *Encyclopédie* 1751–65, VI, 344.

12. Ibid.

13. Starobinski 1977, 977.

14. Ovid, *Metamorphoses*, III, 356–510.

15. Marmontel 1972, I, 168.

16. Jean-Jacques Rousseau, *Discours sur les sciences et les arts*, Paris, 1963, 222. This work was first published in 1750.

17. Diderot 1975–[1983], I, 214.

MYTH AND ENLIGHTENMENT

ON MYTHOLOGY IN THE EIGHTEENTH CENTURY

PHILIPPE LE LEYZOUR

Glory

To say that Louis XIV used classical mythology for his own glorification is to state the obvious. It has often been noted that, with its many flattering associations, mythology had already seduced his predecessors: Henri IV and, above all, Louis XIII had deliberately linked the French monarchy to the brilliant image of the Apollonian Sun, an image which, during the *grand siècle*, would assume obsessive proportions. Thus, in the residence of Chancellor Séguier, Simon Vouet was to have depicted the monarch's defeat of the duchy of Lorraine by the story of Apollo and Marsyas. However, these fragmentary projects cannot compare with the conscious and systematic evolution of an official political mythology, ubiquitous during the decade in which Versailles was transformed into Ovid's palace of the Sun. As noted by J-P. Néraudau, Louis XIV had wanted, from the outset, "to give Apollonian significance to the apartments of the Louvre and the Tuileries."[1] The monarch's privileged public and private space—his bedchamber—was decorated with figures of a mythic retinue: Marsyas, a ridiculous, and pitiful rival; Hyacinth, the tenderly loved favorite; Clytia, a touching and disturbing illustration of "*Respice, florebo.*"[2] Moreover, both the antechamber and the *grande galerie* celebrated the glory of Apollo himself. This iconography would be much developed in the elaboration of Versailles—both the center and the mirror image of the universe, revolving around the absolute celestial light. Inhabited by statues symbolizing the Four Elements, the Four Times of the Day, the Four Seasons, the Four Continents, and the Four Temperaments, the park extended from the foot of the palace and was given life at its center by the statues of Diana and Apollo, the children of Latona whose famous pool castigated the rebellious frogs. In the distance, the horses of the Sun leapt from a glistening mist of liquid gold. Versailles, this new Olympus, was the residence of a multiple god. Thus did the historiographer Guyonnet de Vertron write in 1685: "Sire, I should all but call your Majesty the new Pantheon, since your sacred person encompasses the perfection of all the divinities

of antiquity."[3] It should be noted, however, that this rich repertory of images served as something more than the embodiment of vaulting ambition. It was primarily the culmination of a program, elaborated both hesitantly but with great determination, by which the king became the primary spectator of the universe as well as its principal actor. Louis's complete immersion in this supreme role was to be crucial, but the dual intensity of his presence—both as spectator and as actor—was no less so. Of the motto he had asked the Academy of Inscriptions to devise for him, the king wrote in his *Mémoires historiques* that it "was meant to represent the duties of a prince, so to speak, and forever incite me to fulfill them."[4] Similarly, the mythological decoration of his palaces was intended perpetually to inspire him as the deified hero of an unchanging ritual. The genre of lyric tragedy, created by Lully and Quinault, perpetuated the seductive powers of myth on the stage of a "real" theater, yet at a level that was more often elegiac than heroic. Only then did the unmoving muses of Versailles come to life to pay homage to the god who had created them.

However, the king ascended to his apotheosis masked—"deified *à blanc*," in Jean Starobinski's evocative phrase[5]—since the process took place in a profane realm, officially discredited by the Church. Louis XIV may have borrowed his prestigious ceremonial from Apollo or Hercules, displaying it at Versailles and on triumphal arches in Paris—Louis XIV as Hercules on the Porte Saint-Martin[6]—but, in time, these divine attributes would soon become little more than seductive baubles. Did not Godeau write in the Royal Catechism that Louis XIV was the "visible image of God"?[7] And, for the second edition of his book in 1686, did not Guyonnet de Vertron choose the title *Le Nouveau Panthéon, ou le rapport des divinités du paganisme, des héros de l'Antiquité et des princes surnommés grands, aux vertus et aux actions de Louis-le-Grand?* Indeed, it is clear that the fictive realm created by the king's artists cannot be separated from a Euhemerist conception of mythology. Euhemerus, who lived in the third century B.C., is said to have discovered a gold

column commemorating the three ancient kings Uranus, Cronus, and Zeus during the course of a voyage to the island of Panchaia, which he located off the eastern coast of Arabia. According to him, the gods were kings who were deified after their death and whose memory was perpetuated through this divine mask. Thus, it seemed reasonable to claim that Louis le Grand, like those mythical heroes, was worthy of Olympus, and that, just as the writers of his century outshone the ancient poets, so did Louis's majesty consign the dazed gods to limbo. Offended by such radiance, they found themselves dispatched to the peripheries of the universe and the corners of paintings. The significance of Louis's refusal to be represented in the tired mask of Apollo on the ceiling of the Hall of Mirrors and his decision to be shown instead as the sovereign imperator have been often commented upon.[8] Only at the beginning of his reign was the language of mythology the privileged instrument by which the king and his court were glorified. Once mythology came to be completely subjugated by the Crown, the king could claim to be the equal of the gods, indeed, *primus inter pares*, since he alone was capable of restoring a golden age. Yet the mythic world was not merely conquered by the Sun King; it was irrevocably weakened. If Louis le Grand was now the equal of Jupiter—it is he who holds the thunderbolt in Le Brun's *The Crossing of the Rhine* and *The Capture of Ghent* (both Musée National des Châteaux de Versailles et de Trianon)—then mythology had lost all claim to legitimacy, since its superiority was no longer acknowledged, even in the realm of fiction. The identification of the monarch with the most powerful of the gods no longer enhanced his standing as it once had; indeed, by presenting the ferocious reality of Louis's conquests as operatic fictions, this association even risked undermining the absolute power of the monarchy itself. No longer was it suitable, as it had been in 1668, to appear as Apollo in the Ballet of the Hours nor, at Clagny, to muse upon the parallel destinies of Aeneas/Louis XIV and of Dido/Montespan.[9] The Sun had shed his mask; the allegorical discourse had ceased to function. Thus in 1677, Boileau and Racine were "rescued" from dangerous fictions, known as *historiographes du roi*, and given the mission of transmitting to posterity the heroic deeds of the most powerful monarch in the universe. How can one avoid commenting upon this appalling fiasco? From the silence of the burnt or lost texts emerge only the briefest recollections of a dreadful waste. For, if myth was to be driven offstage, what was to take its place? Royal historiography might disdain the faded prestige of ancient mythology and take nourishment in the

scholarly diet of the writings of Mabillon, but its structure remained unchanged, and it became merely the pretext for a royal epiphany, forever repeated.[10] We are still within the logic of a universe subjugated to the will of one man, and the speech delivered by Racine to Bergeret, secretary of the king's cabinet, at his reception to the French Academy in 1685, is an admirable example of such idolatrous logorrhea. "Fortunate are those who, like you, Monsieur, have the honor of approaching this great Prince and contemplating him with the rest of the world on those important occasions when he determines the fate of the entire universe."[11] Sainte-Beuve relates that "having expressed the desire to hear this speech from Racine himself, even Louis XIV seems to have been somewhat embarrassed."[12]

In the eighteenth century there are but few examples of large-scale mythological decorations which depend upon carefully organized political programs. In addition to Coypel's gallery of Aeneas, commissioned by the duc d'Orléans in 1702, should be mentioned the extraordinary ceiling of the *Salon d'Hercule* at Versailles, presented to Louis XV in 1736. Originally, Lemoyne had planned to celebrate the glory of the French monarchy, "founded and sustained by the heroic deeds of our great kings." The central section was to show "Clovis, Charlemagne, Saint Louis, and Henri le Grand inhabiting the dwelling place of the immortals."[13] It is significant that such a project, although in keeping with Louis XIV's dynastic ambitions, was eventually abandoned for an immense Apotheosis of Hercules—the traditional metaphor for monarchy—now imbued with a gloss that was more individualistic than dynastic. The official description given to the king and members of the court might dwell upon the triumphs of the hero whose own deeds assured him immortality, but it is as a result of his own efforts and due to his love of truth that Hercules is rewarded by Jupiter, for once in full possession of his majesty. A dazzling achievement, but one that was without succession, Lemoyne's decoration was doubly anachronistic in theme, if not technique. Although he appeared to revive the already outmoded iconography of a "Gallic Hercules" as a metaphor for royalty, Lemoyne, in fact, introduced a theme that would be fundamental in the later development of eighteenth-century painting— the glorification of the hero-citizen.

The Play and the Players

The confident promulgation of a mythology *d'état*, followed by its gradual demise—even if royal historiography was more than ever governed by the logic of

myth—was accompanied by a growing current of satire fed by irony, mockery, and burlesque. Criticism in its subtlest form was provided by Fénelon's *Télémaque*, published in 1699. Written for his pupil, the duc de Bourgogne, *Télémaque* is a pedagogical novel of exceptional quality, intended to form the young duke's judgment and taste. Through recourse to traditional myths, the author maps out the contours of an ideal government. In the guise of Mentor, Minerva enunciates the principles which should guide the philosopher king, whom she also cautions against the temptations of tyranny. "Bear in mind, oh Telemachus, that in the government of nations are to be found two evil practices, for which there is almost never any remedy. First, an unjust and excessively violent royal power; secondly, luxury which corrupts morality."[14] Handmaiden to utopia, temporarily relieved of its identification with the monarchy—and therefore with power and luxury, ambition and voluptuousness—mythology recovers the purity of primeval poetry in this "narrative in the form of a heroic poem."[15] But Fénelon's undertaking remains an exception, both in quality and purpose—it was written, after all, for the education of a prince. Among satirical writing, parodies of the lyric tragedies created for the Opéra enjoyed pride of place.[16] At the Saint-Germain fair between February and March and at the Saint-Laurent fair in July and August, certain directors of theatrical companies, with the support of talented authors such as Lesage and Fuzelier, created plays of a new kind—vaudevilles, pantomimes, or *opéra-comique*—in reaction to the jealously guarded monopolies of the Comédie-Française and the Opéra. Gods and goddesses became the most visible victims of this subversive repertory, and it would be tempting to argue that the proliferation of comic mythological scenes bears witness to the gradual collapse of monarchical values. Indeed, the audience of the fairs, composed largely of the lower middle classes, did not share the aristocracy's commitment to lyric tragedy, the monarchical spectacle *par excellence*. It is true that Momus, god of Mockery, had been a familiar of both the court and capital for centuries; as early as 1653, in the *Promenades de Richelieu*, Desmarets de Saint-Sorlin had satirized mythology. There is no doubt, however, that during the regency the rule of Momus grew significantly, and that mythological and literary discourses were both vigorously and variously mocked. It comes as no surprise that, in 1718, the following conversation between Mercury and Io, taken from Charpentier's *Les Amours de Jupiter et Io*, should appear on the boards of the Fair:

> . . . Were you looking for me, Madame?
> Could I hope for so charming a possibility?
> —I was going to the place where dandelions
> grow,
> So that I could gather a delicate salad. . . .[17]

It may be even more significant that, in 1716, at the beginning of his career, Marivaux published a mediocre *Homère travesti* in the style of Paul Scarron's far more entertaining *Virgile travesti* (1648);[18] and that, in 1717, in the preface to his *Momus au cercle des dieux*, René de Bonneval wrote: "Ever since man, convinced of his impotence, ceased to propitiate the gods with victims' blood, it is said that their divine Majesties sometimes fall prey to moments of boredom."[19] Discredited less by their amorous adventures than by their subservience to the cause of a detested monarch, the gods remain in heaven, waiting impatiently for their mocking messenger to regale them with the latest events in Paris. In like vein, one can cite the astonishing decoration commissioned by the regent from Antoine Coypel, his *premier peintre*, for the ceiling of the *grand salon* of the hôtel d'Argenson, Cardinal Dubois's residence. This *Assembly of the Gods*, in which various *putti* strip the protagonists of their traditional attributes, is yet another instance of such iconoclasm. One further example of the degradation of myth is Jean-Philippe Rameau's extraordinary opera *Platée*, which heaps scorn on the unfortunate Boeotian nymph and provides an unflattering portrayal of Jupiter, king of the gods. A paradoxical work, which even Rousseau, who hated Rameau, considered the composer's masterpiece, *Platée* launched a little-disguised attack upon the Royal Academy of Music—"this old shop of puppets," in Grimm's felicitous phrase.[20] As Mercury remarks in Evariste Parny's *La guerre des dieux anciens et modernes* (1799):

> Man laughs at our expense,
> And satirizes our excesses.
> We are growing old, I say this without mincing
> my words;
> Our credit diminishes from day to day.[21]

The mockery to which mythology was now exposed was all the more significant since it was responsible for the very success of the stories it inspired. The gods are now stripped bare; and it is their impotence, or rather their insignificance, which allows them to become the convenient instruments of pleasure. The regent himself organized some of his orgies in mythological fancy dress to add to their piquancy. Venus was everywhere triumphant, the only goddess to increase

her dominion. And here, as François Moureau has observed, it was the goddess of profane Love that flourished, not the celestial Aphrodite, goddess of pure Love, honored by Pausanias in Plato's *Symposium*.[22]

The weakening of the power of the court and of a *versaillais* aesthetic led to a distortion of mythology, which, during the rococo, functioned as little more than one possible mode for the expression of pleasure. According to Crébillon the younger, the libertine made use of love as an instrument of power to ensure the triumph of his selfish infatuations. One was subject to the sport of conquest and to an obsessive concern for propriety, rules which inhibited the players and necessitated the most ingenious disguises. Seen in this light, Ovid's amorous metamorphoses can be understood as so many metaphors of surprise and abduction: they are no longer proof of the monarch's omniscience, but of the libertine's successes. One of the characteristics of libertine conquest was precisely the multiplicity of cultural rules by which the game was played. Thus, amorous mythology and Racinian discourse stand as fundamental, and opposing, paradigms. The libertine's discourse is not a deliberate parody, but a delicate perversion which conflates the subtleties of language with the mechanisms of passion:

> Are you fully aware of the horror of my situation? I love you, but what is it to love? How feeble is this word compared to my feelings! And yet I must leave you forever! But what brings my despair to a climax, alas! is that you love me too! How can we live apart, we, who lament a single moment's separation and knew of no greater pleasure? I am leaving you forever. Forever! Good God! How can I write these words without dying? Do we deserve such unhappiness? I am destroying the tranquility of your life; I! who would gladly sacrifice my own to bring happiness to yours. The decision is taken, we shall never see each other again! Separated forever! Is it possible that the farewells made so recently are to be our last? The very thought overwhelms me, destroys me. What! Will every hour, every moment separate us still further! Forever missing each another, shall we ever be together again? Will each of my remaining days be a day of misery? Shall I live only for death? I shall watch them go by, those dreadful days, without enjoying your company for a single moment! I shall never see you again.[23]

This long and appealing paraphrase of one of the most famous passages in Racine's *Bérénice*[24] is the attempt of a predator to possess the one he hopes to ensnare in the net of a coded language. The following discourse uses mythological allusions to the same ends:

> Oh! what sort of dream was this, do you think? I thought I was in a delightful garden; I was Flora; if I am not mistaken, Zephyr did not much resemble you, but I found him to be the most charming god in the world. He had behaved very badly towards me, and was begging my forgiveness; but since you have accustomed me to that sort of thing, I had no trouble forgiving him. He was just about to thank me when I was handed your letter, and Zephyr's thanks were suddenly interrupted. . . .[25]

Like many other passages in Crébillon, these two excerpts from the *Lettres de la Marquise de M*** au Comte de R****, border on pastiche; such an epistolary exchange is a good example of what Jean Dagen has called "literature as performance."[26] The heroine, an accomplished actress, interprets a great role of which she considers herself worthy. Her assumed sincerity is hidden beneath a mask of rhetoric and myth; even love itself is but a product of the passionate discourse of her inner theater.

It may seem presumptuous to compare the correspondence of Crébillon's imaginary characters with Julie de Lespinasse's actual letters. However, while the origins of the two texts could scarcely be more different, it is noteworthy that Mademoiselle de Lespinasse's writing is replete with allusions to the mythological repertory of the theater of her time. Racine (*Phaedra*), Gluck (*Orpheus*), Le Franc de Pompignan (*Dido*) rise up as so many landmarks in an overabundant and contradictory text. If it is a characteristic of the libertine that he "illuminates the least impulse (of his desire) by perceptions upon which he deliberately acts,"[27] then nothing is more fascinating than Mademoiselle de Lespinasse's letters, in which the will for order and control confronts a destructive and inflammatory passion. References to mythology, while lapidary and inflected through literature and music, suddenly assume new intensity. "I cannot tell you the nature of my feelings, but they concern you, and there are times when I am quite ready to exclaim, 'Aeneas is in my heart, from which all remorse has fled'. . . . Alas! To pronounce these words, I dare not: one's conscience must not be deceived, I know. How distressed am I suddenly! How unhappy I am!"[28] However strong the feelings expressed, the references to mythology operate here in the same way as in the Marquise de M***'s text; they constrain the discourse in both.

However, the poetic value of these amorous myths should not be underestimated. In his *Temple de Gnide*—a sensuous, delicate text—Montesquieu castigates the Sybarites, "slaves ready for the first master who comes along"[29] who are incapable of experiencing pleasure, while praising the joyful love personified by Bacchus: "The god smiled upon Ariadne. He led her into the sanctuary; joy filled our hearts. We experienced a divine emotion, and, caught up in Silenus's wantonness and the Bacchantes' rapture, we took hold of a thyrsus and went to join the dancers and the musicians."[30] Hostile towards libertinage, which he considered a little-disguised form of despotism, Montesquieu was equally suspicious of unbridled sensual pleasure. Praised by La Mettrie in *L'École de la volupté* (1774), *Le Temple de Gnide* celebrates both the enlightened reign of Venus and the art of judiciously satisfying one's pleasure. Montesquieu's charming hedonism is thus quite different from Crébillon's libertinage, and even more so from the pornographic literature recently analyzed by Robert Darnton, which makes reference on rare occasions to mythology.[31] How can we characterize *Vénus dans le cloître ou la religieuse en chemise*, one of the great successes of the eighteenth-century clandestine book trade? And what of those "*livres philosophiques*" published in Cythera throughout the century, and distributed widely by booksellers in spite of the dangers involved? This is the culmination of a process by which mythology was devitalized, reduced to a name devoid of either resonance or mystery.

As far as painting is concerned, the same observation could be made of the countless mythological portraits which enjoyed such success in the eighteenth century despite their rather lowly status in the Academy's hierarchy. It is true that the libertines were not responsible for this fashion: one of the earliest examples of mythological portraiture is Coysevox's statue of the duchesse de Bourgogne as Diana, executed in 1710 for the duc d'Antin's gardens at Petit-Bourg. Twenty years later, Guillaume and Nicolas Coustou were commissioned to sculpt effigies of Louis XV and Marie Leczinska as Jupiter and Juno. By this time, however, the monarchs, far from being innovators, were merely following a trend that has been convincingly linked by Marianne Roland-Michel and Daniel Rabreau to a widespread passion for the theater.[32] If the mythic world of Louis XIV had been so persuasive that, even under duress, the elite had been moved to enthusiasm—one of the fundamental premises of myth was that it be accepted by all—mythological portraiture, by contrast, even of the king, willfully rejected narrativity, resisting any attempt at immersion within a coherent political discourse. Mythology was thus reduced to the charming and dangerous portrait of a lie: *Marie Leczinska as Juno* has no greater symbolic meaning than Nattier's *Madame de Chaulnes as Hebe*, 1744, or *Madame de Sombreval as Erato*, 1746 (both Paris, Musée du Louvre). Emphasis is now placed upon an impossible ambivalence and the reality of disguise. The most significant element of the mythological portrait is the preposition "as" in the title. It is neither the queen nor Juno who is represented, but a role, invariably seductive, yet essentially spurious. The representations of the Sun King as Apollo or Jupiter fall into quite a different category. Whereas images of Louis XIV were part of a carefully considered iconography, the mythological portrait aspired towards a false intimacy, one which might unveil, but which revealed nothing. The classical theory which held that truth could be attained by mastery of artifice was shattered during the century of the Enlightenment and replaced by a sensualist approach to the world.[33] Mythology, no longer expected to reveal hidden verities, was reduced to the status of a theatrical accessory, with no greater social dimension than the simple pleasure of the game. This was the case of the enfeebled images of improbable goddesses, who at times succeeded in spoiling great paintings: was it not reported that Antoine Coypel had used the most beautiful ladies of the court as models for the goddesses in his *Assembly of the Gods* at the Palais-Royal?[34] They are the most telling proof of the corruption of taste which Diderot denounced so vehemently. They are equally seductive, deceptive, and trivial: the human being is indeed reduced to becoming the "wearer of faces"[35] anatomized by Marivaux, an actor in a play that lacks either truth or purpose. A convenient instrument for the use of libertines, philosophers, pornographers, or *mondains*, and devoid of any transcendence, mythology seems to have retained just enough power to furnish artists and writers of the Academy of Painting, the Opéra, and the Comédie-Française with merely the joyous pleasures of an innocuous transgression.

Apprenticeship

Among the many books on the subject of education published in France during the eighteenth century, most make reference to Charles Rollin's *Traité des études*. Born in 1661, rector of the University of Paris in 1694, director of the collège de Beauvais, Rollin published his seminal work in 1726; it met with immediate and considerable success. In Book VI, entitled "On History," Rollin devotes an entire chapter to mythology: "There is hardly any subject of relevance to the study of *belles lettres* that is more useful, more in

need of profound scholarship, or more beset with problems and difficulties than the one which concerns me here."[36] Rollin's introductory sentence neatly sets forth what Baudelaire would later call the "dual, contradictory assertion" that would serve as the basis for nearly every insight on the status of mythology found in pedagogical writing: its usefulness and its dangers.

A knowledge of mythology was obviously crucial to an understanding not only of the Greek and Latin authors but also of numerous French writers; it was indispensable for paintings, engravings, tapestries, and sculpture. "The latter are no more than enigmas for those who are ignorant of mythology, which alone provides an adequate explanation."[37] It was the need to understand the literal meaning of the myths themselves that lay behind the author's desire for a history of mythology "written especially for young people."[38] It was no longer possible for a figure of the Enlightenment to accept Commander de Jars's indignant response, as related by Saint-Evremond: "Latin, in my day, Latin! It would have disgraced a gentleman!"[39] The visual arts, theater, and literature assailed the eye and the mind with a thousand-and-one references to Greek and Latin mythology; anyone unfamiliar with this repertory would have been condemned to boorish solitude. Thus, mythology was not only a symbol of culture, it was an invaluable element of sociability. The manner in which it was taught was, therefore, of paramount importance.

The Jesuits' predilection for the theater is well known. From their earliest days, the performances for which the order was responsible—notoriously extravagant by the eighteenth century—were based upon the Bible and the lives of the saints as well as classical mythology, Hercules an obvious example.[40] The teaching of mythology and allegory assumed great importance as a conduit through which it was possible to subject students to lessons in iconology. In 1756, Lacombe de Prezel published a *Dictionnaire iconologique ou introduction à la connaissance des peintures, sculpture, médailles, estampes, etc.*, but as early as 1692, père Jouvency, in his *De ratione discendi et docendi*, had asserted that "interpretations of written or painted enigmas are not merely games for one's amusement; they are exercises which enable the mind to make sense of the literary algebra by which cultivated people understand the allegories of painters and poets."[41] These exercises could be ideally practiced in the privacy of the classroom, in performances which, by their very spirit of competition, prepared young men for the rigors of public discourse. Thus did mythology become one of the most powerful, if high-minded and artificial, instruments of an apprenticeship carried out

in Latin and eminently suited for a world which was itself quite deliberately artificial. Whether interpreting the lamentations of Niobe over her dead children, or the presumably more realistic emotions inspired by a simple walk, the gods functioned as so many rhetorical devices, capable of endowing discourse with false grandeur. Georges Snyders quotes père Cerruti's extraordinary phrase in *L'Apologie de l'Institut des Jésuites*, 1762: "to set the pretense of glory before the illusions of pleasure."[42] The unnaturalness of Jesuit pedagogy—exemplified both by Rollin and the Oratorians—is confirmed by their surprisingly limited interest in subjects which were too closely related to the real world. The closed system of Jesuit education barely tolerated either history—to which Jouvency devoted only one page—geography, or the natural sciences. It might therefore be argued that it was precisely the deliberately artificial character of mythology which was responsible for its preeminence within the Jesuits' jealously confined universe, where it served to initiate the child into the mastery of cultivated and thoughtful speech.

Although all educators were agreed that a knowledge of mythology—this "poetic history" in père Gautruche's term[43]—was indispensable to the education of a well-born young man, they remained suspicious of its insinuating charms. A subtle dialectic allowed most of these authors—but, above all, Rollin—to maintain that the apparent danger of these overtly sensual stories was the very proof of their utility: they reminded the young of their debt to Christianity for having freed humanity from a morally degrading paganism, since even the most famous ancients "were not ashamed to adore an adulterous Mars, a prostituted Venus, an incestuous Juno, and a Jupiter defiled by every crime, thereby worthy of being considered the most powerful of the gods."[44] After comparing those pitiful models with the purity of the Gospels, the young could not fail to reaffirm their faith. This argument, which soon became little more than a cliché, was restated in 1748 by père Rigord in *Connaissance de la mythologie par demandes et par réponses* and in 1749 by André Joseph Panckoucke in *Les études convenables aux demoiselles, ouvrage destiné aux jeunes pensionnaires des communautés et maisons religieuses*. This unlikely syllogism barely concealed the educators' profound concern, as they extolled the Greco-Roman world and its literature while dealing with texts which were not always susceptible to a Christian interpretation. Although a morality consistent with the precepts of religion could be found easily enough in the tales of Narcissus, Phaëton, or Icarus, it was far more difficult to explain the erotic impulses in Ovid or to expunge the overwhelming currents of

desire in his poetry. Nevertheless, in 1705, Jouvency published an edition of the *Metamorphoses*, "cleansed of all obscenity, with explanations, notes, and a supplement on the gods and heroes of mythology."[45] The texts studied in the classroom had also been subjected to rigorous editing, and passages in Virgil or Horace, judged to be too licentious, were rewritten without the slightest hesitation. The love of *belles lettres* notwithstanding, one was still aware that the child, in Rollin's terrible definition, was essentially "a wretched and fertile ground for evil."[46] Such processes were primarily intended to satisfy objections first articulated by Saint Augustine: "Is it not true that we had no need of the shameful texts to learn those words more easily; but that, on the contrary, those very words are quite enough to make men commit hateful infamy openly and without remorse?"[47] Père Jouvency had wished to subject the Latin texts studied in the classroom to a systematic moral interpretation, proposing, for instance, that Cadmus's fight with the serpent should be seen as the triumph of reason over passion and that the fourth book of Virgil's *Eclogues* announces the future birth of Christ. Moralizing ancient literature in this way was soon condemned, for once embarked upon, the parallels made between Christianity and mythology, even in the realm of allegory, could easily lead the scholar astray. In eighteenth-century pedagogical literature, nearly every page devoted to mythology aims at reconciling Christian ethics with the pleasures to be derived from reading the pagan authors. This *rapprochement*, fraught with difficulties, was the subject of the Oratorian père Thomassin's *Méthode d'étudier et d'enseigner chrétiennement et solidement les lettres humaines par rapport aux lettres divines et aux écritures*, published in 1681 and reedited several times during the eighteenth century. In this treatise, Thomassin argued that one should distinguish between poetry and indulgence and that the masterpieces of pagan literature should be considered an important training ground for the student, preparing him for the battle ahead. The teacher's vigilance would ensure that the student, "when reading these poets, approached them with the mind of a judge and of a critic, approving or disapproving the deeds, words, and characters as reason and justice required."[48]

However, this paradoxical concept of mythology, shared by all Christian educators—that it was a seductive, if capricious, foundation course in the study of Christianity—was quite foreign to the thinking of Louis-René de La Chalotais, *procureur-général* of the Parlement de Bretagne. In 1763, following the expulsion of the Jesuits, La Chalotais published a remarkable work, the *Essai d'éducation nationale*, in

which he set out to formulate a new system of education, based on the notion of developing the student's critical faculties according to his daily experience. Strongly opposed both to the study of rhetoric championed by Jouvency and to an exclusive dependence on Latin, La Chalotais seems to have returned to the central precepts of the pedagogy of Port-Royal: a respect for the child, and a determination to develop his intelligence gradually. La Chalotais makes no mention of mythology, but places a great importance on history, a shift of emphasis that was quite radical at the time. In this innovative project, still in print in the nineteenth century, the demotion of rhetoric inevitably carried with it mythology's downfall. Diderot's views, expressed in his *Plan d'une Université pour le gouvernement de Russie ou d'une éducation publique dans toutes les sciences*, written at Catherine II's request in 1775, are considerably more nuanced; he allows mythology merely a subsidiary role—mainly to satisfy the scruples of religious educators. By contrast, Diderot argues that knowledge of history is essential and that mythology should thereafter be analyzed from a lay perspective and taken for what it is—an aberration. Some familiarity with mythology remains necessary in order to understand the ancient and modern authors who "insist upon portraying the vices of pagan gods, instead of showing us the virtues of great men."[49] Its ties with religion severed—and having been diminished in the process—mythology emerges as at best a historical curiosity whose very origins are now placed in doubt: in the end, did even the ancients really believe in it? "While celebrating Jupiter's debauchery, they admired Xenocrates's continency; the chaste Lucretia adored the immodest Venus. . . . The holy voice of Nature, stronger than that of the gods, came to command respect on earth, and banished the crime and the criminals to the heavens."[50] The fortunes of mythology were thus clearly linked to the evolution of educational theory; once the closed world of the university broke down, the subsequent reorientation of the colleges would undermine the authority of the ancient texts still further by ceasing to present them as venerable models. Thus, as literary history slowly superseded the study of *belles lettres*, mythology gave way to history.

Analysis

All eighteenth-century philosophers had a passion for mythology, and this is borne out by the abundant literature on the subject. The chevalier de Jaucourt, writing in the *Encyclopédie*, went so far as to make a careful distinction between *"la fable"*—an imaginary

body of fables and legends—and *"mythologie"*—the science by which the varied, complex, and interwoven origins of these poetic fictions could be analyzed. While, as we have argued, the poetic sap of the myths themselves seems to have run dry during the eighteenth century, the "passion for origins" evoked by Pierre Albouy led numerous authors to reflect upon the true nature of mythology.[51] This approach was not new: Cicero, in the *De natura deorum*, had proposed a list of possible sources, many of which reappear in the works discussed in this essay.[52] However, the age of Enlightenment was attended throughout by an impassioned quest for truth. The successive editions of Huet's *Demonstratio Evangelica* (1679, 1687, 1690) gave wide circulation to the idea that mythology was but a corrupted form of the word of God, probably dating back to some time after the flood—a notion subsequently elaborated upon by Thomassin, Rigord, and Tournemine. This interpretation had a distinguished history; it is first found in the work of Clement of Alexandria in the second century A.D. Almost at the same time as Huet's text, Fontenelle's *Histoire des oracles* sought to lay responsibility for mythology with the false priests themselves. While the Benedictine Bernard de Montfaucon did not take sides in this quarrel, his enormous work *L'Antiquité expliquée en figures*—published in five volumes between 1719 and 1724—revealed an encyclopedic intention to reduce the gods to the status of archaeological symbols of religious faith. In the same way as Fontenelle's more engaging, but more caustic, volume, Montfaucon's work can be understood, at one level, as an attempt to keep mythology at bay. A suspicion of mythology, already implicit in the definition of the *Dictionnaire de l'Académie* in 1694—fable is "something feigned and invented in order to instruct and to entertain"[53]—would be found, *grosso modo*, in almost every commentary produced during the eighteenth century. The failure of the admittedly impossible attempt to reconcile *belles lettres* with the Bible—and the classics with Christianity—would lead to universal censure by the *philosophes*. Although there was no universal consensus among the writers of the Enlightenment, the best authors, the abbé Banier for example, presented a bewildering array of explanations of mythology in all their diversity. As explained by Diderot in his article on "the mythological philosophy of the Greeks" in the *Encyclopédie*, "the multiplicity of explanations serves only to show how little we know. This poetic embroidery is so tightly woven within the material itself, that it is impossible to separate one from the other without destroying the fabric."[54]

The numerous explanations of the myths of antiquity can be considered under three headings: fear, allegory, and Euhemerism—leaving aside the interpretation that they were debased versions of the Law of Moses. Fiercely opposed to any allegorical explanation, Pierre Bayle returned to the arguments of the Epicureans and considered mythology as mankind's aberrant response to the violence of nature. By equating the Greek gods with their less prestigious counterparts in so-called "primitive" civilizations, Bayle denied the Greek religion any transcendental authority, presenting it as a set of restrictive and superstitious rituals, devoid of morality. As a disciple of Thomas Hobbes, Bayle faithfully applied the Englishman's mechanistic theories: religion, like the sovereign ruler, must impose an artificial, but necessary, law in order to create political community and thereby escape destruction and death.[55] However, this elaborate concept of a social and religious contract could not mask the fact that religion came into being through fear. In 1725, the Italian writer Giambattista Vico, a great figure in the philosophy of history, argued that men, terrified by thunder, had created Jupiter.[56] Rousseau implicitly propounded the same theory in *Émile* (1762), when he wrote that "in the beginning, man imparted life to all active forms: ignorant of their limitations, he supposed their power to be boundless, and so made them into gods. Thus was the universe inhabited by visible gods: the planets, winds, mountains, rivers, trees, all works of Nature were man's first deities."[57] Rousseau here touched upon man's essential anxiety before the living forces of the world and his effort to neutralize them by giving them names.

Much more common was the hypothesis that the entire body of mythology constituted a vast allegorical discourse, in which man contrived to personify each force of nature, regardless of its capacity for harm. An allegorical interpretation successfully reconciled quite diverse variants, the most important of which emphasized a purely physical interpretation of mythology. Thus, in his monumental *Monde primitif analysé et comparé avec le monde moderne* (1773–82), Court de Gébelin observed that the story of Hercules was an allegorical account of the clearing of the forests in Greece and the invention of agriculture.[58] Charles Dupuis, in *L'Origine de tous les cultes* (1795), considered myth as the idealization of the creative powers of the universe; Apollo, Orpheus, and Hercules are allegorical descriptions of the sun, and the whole body of mythology is a poetic physiology of nature, impenetrable, under the cover of allegory, to the uninitiated.[59] In like vein, one should mention Dom Pernetty's remarkable work, published in 1758, *Les Fables égyptiennes et grecques dévoilées et réduites au*

même principe, avec une explication des hiéroglyphes et de la guerre de Troie. Indulging his passion for chemistry, the author explains that Venus and Mars surprised by Vulcan "signifies the lemon yellow and saffron color called Venus, which combines with iron, called Mars, and, as rust, is discolored by the blacksmith, Vulcan." The rest of the book is a lengthy and similar exposition of "such inept and impertinent thought."[60]

More seriously, moral allegory offered another approach to mythology, one that had been current in French thought for some time. In his *Enarationes allegoricae fabularum*, Fulgentius (468–573) had already proposed that the three goddesses judged by Paris represented the embodiment of active life, contemplative life, and amorous life respectively. Similarly, the monstrous union of Leda (Injustice) and the swan (Power) could only give birth to scandal and dishonor (Helen). This humanist tradition, often indistinguishable from the deliberate "Christianization" of ancient texts—one need think only of the numerous *Ovides moralisés* published since the fourteenth century—had found its most eloquent advocate in Erasmus, who had written that "it is perhaps more profitable to read Mythology for its allegorical meaning than the Holy Scriptures their literal meaning."[61] Here, however, it was less a question of imposing an arbitrary Christian reading on the ancient texts than of discovering, through careful study, the text's moral truth, obscured by centuries of ignorance. It has already been noted that père Jouvency was forced to abandon the pedagogical consequences of such an approach, since it might have led to a similar investigation of the Bible.

Although the Euhemerist interpretation of mythology is but one of the methods analyzed by the abbé Banier in *La Mythologie et les Fables expliquées par l'Histoire*, it is, as the title itself suggests, unquestionably the most important.[62] Published several times during the eighteenth century—the first edition dates from 1710—this text is referred to by all mythographers of the Enlightenment. "In this work, I intend to show that, in spite of all its embellishments, Mythology encompasses part of the History of the earliest times, and that Allegory and Morality were not the original reasons for its invention."[63] Explicit and lucid, expounded with remarkable precision, Banier's arguments avoid oversimplification and attempt to explain both the complexity and the heterogeneity of an incoherent corpus of myths and legends. "It is certainly true that Mythology is an inharmonious assemblage and not a carefully planned work, created not in one country, nor at one time, nor by the same persons."[64] For these reasons, Banier does not reject automatically an allegorical interpretation of certain myths; for example, Pluto and Proserpina may be understood as symbols of the changing seasons, the cold season and the harvest. Nor does he dismiss the other possible sources of this imaginary compendium: a Phoenician word, misunderstood by a Greek poet, may well have transformed the vessel in which Europa was carried into Jupiter's bull. Similarly, Nicolas Fréret, imprisoned by Louis XIV for his impertinent *Histoire des Francs*, had explained that Pegasus referred to a boat, that the fountain of Pyrena was a port, and that the entire episode designated a battle between the Greeks and the Phoenicians.[65] However, Banier was alone in attempting a rigorous and systematic synthesis of this difficult and amorphous subject, one that avoided both tedious classification and wholesale condemnation. Mythology, he concluded in his introduction to Ovid's *Metamorphoses*, might well be considered the history of the earliest times, and, even if facts were altered, it remained the "repository of the annals of the world in its infancy."[66]

While the emphasis now placed on the historical content of the myths and legends of antiquity endowed mythology with renewed importance, it also marked the end of its potency. For what universal truths could be expressed by these falsehoods? Furthermore, this development could serve as an obstacle to certain fundamental inquiries; if the Euhemerist doctrine was valid, equally so was the thesis that the origins of the Greek gods were to be found in Phoenicia and Egypt. Banier himself asserted that "the people of the East, and above all the Egyptians, had instructed the Greeks in the history of the gods who had lived in what Varron called 'the Unknown Times.'"[67] Thus, though they later deified their own heroes, the Greeks also inherited Egyptian gods whose origins are unknown to us. The undoing of mythology in this way may have prompted the President de Brosses's *Du culte des dieux fétiches*, a work which both introduced the word "fetishism" into the French language, and reduced Egyptian religion to an animal cult. Neither Greece nor Egypt were spared in this process of demystification, which furthermore encouraged unwelcome speculation on the connections with African and American-Indian religions; after all, it could be argued that the Egyptians and the Greeks had also been savages.[68] Entire continents became subject to such scholarly analysis, China in particular, confirming once and for all the relativity of the formerly unimpeachable Greek and Christian models. And, at the same time, the enthusiastic, if occasionally inconsistent, research into the chronology of ancient times by thinkers such as Newton or Fréret aspired to nothing less than a vast historical panorama of early civilization. Undoubtedly, Western man was no longer alone.

However, it would be excessively simplistic to argue solely in terms of reason's apparent triumph over deception, propaganda, and intellectual complacency. For these notions of cultural relativism and universal consciousness were accompanied by the thrilling rediscovery of the oldest national mythologies, eclipsed by the study of the classics. In 1756, Pierre-Henri Mallet published his *Monuments de la mythologie et de la poésie des Celtes*; in 1777, Le Tourneur introduced the French public to Ossian's poetry, "invented" by Macpherson. While these were events of secondary significance at the time, in retrospect they would assume major importance as landmarks in an extraordinary renewal of interest in primitivism and the origins of national identity. From now on, each people would have its own genius—Herder's famous "Urvolk." Rejecting the philosophy of progress, in which man and the artist are citizens of the world, Herder studied myths as so many imaginary landscapes faithfully depicting the truth of each nation. Few societies, he argued, had been able to preserve their own mythologies from moral and intellectual alienation. The very role of the poet—and of the providential hero—was to allow disaffected mankind to renew its bonds with a primitive purity and authenticity, notwithstanding reason's impoverished compromises.[69] And at the same time, albeit with a symbolism appropriated from the most traditional classical mythology, images of resistance surged to the fore in music, literature, and painting—concealed, as in Psyche, or avowed, as in Prometheus.[70] Ravaged by the mythographer's penetrating analysis, mythology, in its death throes, sought revenge. Once charming, it became sublime, placing man on the throne of a diminished god, man who dreams and frets, and who, in the confusion of his immense conquests, searches for headlong flight: the Parthian shot capable of opening the wound into which night plunges.

NOTES

1. Néraudau 1986, 186, "donner aux appartements du Louvre et des Tuileries une signification apollinienne."

2. Ibid., 29; this motto may be translated as, "Look at me and I will flourish."

3. Ibid., 65, and Barthélemy 1990, 15, "Peu s'en faut, Sire, que je n'appelle votre Majesté le nouveau Panthéon puisque sa personne sacrée renferme les perfections des divinités du paganisme."

4. Louis XIV 1803, 196, "devait représenter en quelque sorte les devoirs d'un prince, et m'exciter éternellement moi-même à les remplir."

5. Starobinski 1977, 983, "divinisation à blanc." Republished and expanded as "Myth and Mythology in the Seventeenth and Eighteenth Centuries" in Bonnefoy 1981, and again in Starobinski 1989.

6. Of the Porte Saint-Martin the abbé Pluche noted: "On n'est point touché d'admiration mais de pitié et de dépit, lorsque dans une sculpture publique on expose un roi, dont la mémoire nous est chère, tout nu au milieu de son peuple, maniant une lourde massue, et portant une perruque carrée." Pluche 1739, II, 392.

7. Godeau 1650, 6.

8. See, among others, Pommier 1986, 212 ff.

9. Néraudau 1986, 60.

10. See Barret-Kriegel 1988, 62, "Les souverains donnent à leurs savants la tâche de ramasser et rassembler les titres qui justifient leurs desseins et leurs droits."

11. Sainte-Beuve 1953-55, III, 578, "Heureux ceux qui, comme vous, Monsieur, ont l'honneur d'approcher de près ce grand Prince, et qui après l'avoir contemplé avec le reste du monde dans ces importantes occasions où il fait le destin de toute la terre."

12. Ibid., "Louis XIV ayant voulu entendre ce discours de la bouche de Racine, parait lui-même avoir rougi un peu."

13. Bordeaux 1984 (A), 62, "établie et soutenue par les belles actions de nos grands rois"; "Clovis, Charlemagne, Saint Louis et Henry le Grand, jouissant du séjour de l'immortalité."

14. Fénelon 1927, II, 464, "Souvenez-vous, ô Télémaque, qu'il y a deux choses pernicieuses dans le gouvernement des peuples, auxquelles on n'apporte presque jamais aucun remède: la première est une autorité injuste et trop violente dans les Rois, la seconde est le luxe qui corrompt les moeurs."

15. Fénelon 1843, IV, 172, "narration en forme de poème héroique."

16. See, among others, Fabre 1987, 179–92.

17. Fabre 1987, 182, "... Me cherchiez-vous, Madame? / Un espoir si charmant me serait-il permis? / — Je passais en ces lieux où sont les pissenlits / J'en veux cueillir moi-même une fine salade," a parody of the famous lines spoken by Pyrrhus and Andromache in Racine's tragedy (act 1, scene 4): "... Me cherchiez-vous, Madame? / Un espoir si charmant me serait-il permis? /—Je passais jusqu'aux lieux où l'on garde mon fils. ..."

18. One could quote, for example, Marivaux 1716, 54, "Maugrébleu! Tout irait mieux, / Sans ce nombre infini de Dieux. / Chaque salope de déesse, / Nous en enfante encore sans cesse, / Et les hommes sont assez sots, / Pour honorer tant de magots." The poem contains five thousand lines.

19. Bonneval 1717, 4, "Depuis que les hommes, persuadés de leur impuissance ne les réjouissent plus par le sang des victimes, on dit que leur Majesté divine ne laisse pas de s'ennuyer quelquefois."

20. Tourneux 1877–82, VI (November 1765), 396.

21. Parny 1799, "A nos dépens l'homme commence à rire / Et nos excès prêtent à la satire. / Nous vieillissons, je le dis sans détour; / Notre crédit baisse de jour en jour."

22. Exh. Paris 1984–85 (A), 502.

23. Crébillon 1990, Letter LXV, 209, "Sentez-vous bien toute l'horreur de ma situation? Je vous aime, mais, que dis-je, aimer? Ah! que ce terme est faible pour ce que je sens! Et je vous quitte pour jamais! Et ce qui achève de me désespérer, hélas! vous m'aimez aussi! Comment pourrons-nous vivre éloignés l'un de l'autre, nous qui nous plaignions d'un seul moment passé sans nous voir, qui ne connaissions pas d'autres plaisirs. Je vous quitte pour jamais. Pour jamais! Grand Dieu! Puis-je écrire ce mot sans mourir? Avons-nous pu mériter d'être si malheureux? C'est donc moi qui trouble tout le repos de votre vie; moi! qui pour la rendre heureuse voudrais sacrifier la mienne. C'en est donc fait, nous ne nous reverrons plus! Nous serons pour jamais séparés! Serait-il possible que les adieux que nous nous fîmes, il y a si peu de temps, fussent pour nous les derniers? Cette idée m'accable, me tue. Quoi! toutes les heures, tous les moments vont nous éloigner l'un de l'autre! Occupés sans cesse à nous regretter, ne nous retrouverons-nous jamais? Chacun de mes jours ne sera donc pour moi qu'un jour malheureux? Je ne vivrai donc que pour souhaiter la mort! Je les verrai s'écouler ces jours affreux, sans jouir un seul moment de votre présence! Je ne vous verrai plus."

24. Jean-Baptiste Racine, *Bérénice*. One might recall act IV, scene V, lines 1111–14, "Pour jamais! Ah! Seigneur, songez-vous en vous-même / Combien ce mot cruel est affreux quand on aime? / Dans un mois, dans un an, comment souffrirons-nous, / Seigneur, que tant de mers me séparent de vous?"

25. Crébillon 1990, Letter LXIV, 207, "Oh! qu'est-ce donc que ce rêve, direz-vous? Je croyais être dans des jardins charmants; si je ne me trompe, j'étais Flore, Zéphire ne vous ressemblait pas, et pourtant je le trouvais le plus aimable dieu du monde. Il m'avait fait quelque méchanceté, et me priait de la lui pardonner: comme vous m'avez mise dans cette habitude-là, je la faisais sans peine, et il était à m'en remercier, lorsqu'on m'a rendu votre lettre, et troublé les remerciements de Zéphire. ..."

26. Ibid., introduction by Jean Dagen, 8, "de la littérature en représentation."

27. Foucault 1966, 222, "éclairer le moindre mouvement (de ses désirs) par une représentation lucide et volontairement mise en oeuvre."

28. Lespinasse 1971, 131, letter of October 16, 1774, "Je ne sais de quelle nature est mon sentiment: mais c'est vous qui en êtes l'objet, et il y a des instants où je suis toute prête à m'écrier: 'Enée est dans mon coeur, les remords n'y sont plus.' Hélas! Je n'ose prononcer ces mots: je le sens, on ne saurait tromper sa conscience: quel trouble s'élève en moi! Que je suis malheureuse!" The reference to Aeneas comes from Le Franc de Pompignan, *Didon* (1734).

29. Montesquieu 1758, III, 588, "esclaves tout prêts pour le premier maître."

30. Ibid., 599, "Le dieu sourit à Ariane. Il l'amena dans le sanctuaire; la joie s'empara de nos coeurs. Nous sentîmes une émotion divine, saisis des égarements de Silène et des transports des Bacchantes, nous prîmes un thyrse et nous nous mêlâmes dans les danses et dans les concerts."

31. Darnton 1991.

32. Exh. Bordeaux 1980, 31.

33. See, in particular, Kintzler 1988, chap. 2, "Le Paradoxe du jardin français," 41–63.

34. See Lépicié 1752, II, 19–20.

35. Third sheet of the *Spectateur français* (January 1722), quoted by François Moureau in exh. Paris 1984–85 (A), 497, "porteur de visages."

36. Rollin 1819, bk. 6 ("On History"), pt. 4 ("On Myth and Antiquity"), chap. 1 ("On Mythology"), 447, "Il n'y a guère de matière dans ce qui regarde l'étude des belles-lettres qui soit ni d'un plus grand usage que celle dont je vous parle ici, ni plus susceptible d'une profonde érudition, ni plus embarrassante d'épines et de difficultés."

37. Ibid., 455–56, "Ce sont autant d'énigmes pour ceux qui ignorent la fable, qui souvent en est l'explication et le dénouement."

38. Ibid., 456, "qui fût faite exprés pour les jeunes gens."

39. Anecdote related by Snyders 1965, 57, "Du latin, de mon temps, du latin! Un gentilhomme en eût été déshonoré!

40. See, among others, Dainville 1978, 476–517.

41. Jouvency 1892, 67, "les explications d'énigmes écrites ou peintes n'étaient pas de simples badinages de l'esprit, mais des exercices qui l'accoutumaient à manier avec finesse cette algèbre littéraire qu'étaient pour les gens cultivés les allégories des artistes et des poètes."

42. Snyders 1965, 53.

43. Père Gautruche, *Histoire poétique pour l'intelligence des poètes et des auteurs anciens*, Caen, 1671.

44. Rollin 1819, 453, "ne rougissaient pas d'adorer un Mars adultère, une Vénus prostituée, une Junon incestueuse, un Jupiter souillé de tous les crimes, et digne par cette raison de tenir le premier rang parmi les dieux."

45. Jouvency 1705. After this publication, Jouvency was praised as "the purifier of Latin sources" by the *Journal de Trévoux* (May 1705, art. LXXVIII).

46. Snyders 1965, 43, "une malheureuse fécondité pour le mal." This sober definition of childhood appears to have been shared by all seventeenth- and eighteenth-century Christian educators; it is the basis of the system of the Petites Écoles de Port-Royal, which, through Charles Rollin's agency, exerted an enormous influence on eighteenth-century education.

47. Arnauld d'Andilly 1727, 35, "N'est-il pas très vrai de dire que cette honteuse description n'était nullement nécessaire pour nous faire apprendre ces paroles avec plus de facilité: mais que ces paroles au contraire sont très propres pour faire commettre aux hommes cette infamie détestable avec plus de hardiesse?"

48. Thomassin 1681, I, chap. 22, "dans la lecture des poètes . . . un esprit de juge et de censeur, pour approuver et désapprouver les actions, les paroles et les personnes selon les règles de la raison et de la justice."

49. Diderot 1875, III, 411–534, "se sont épuisés à remettre sous nos yeux les vices des dieux du paganisme, au lieu de nous représenter les vertus des grands hommes."

50. Rousseau 1762, bk. 4, 351–52, "En célébrant les débauches de Jupiter, on admirait la continence de Xénocrate; la chaste Lucrèce adorait l'impudique Vénus. . . . La sainte voix de la nature plus forte que celle des dieux, se faisait respecter sur la terre, et semblait reléguer dans le ciel le crime avec les coupables."

51. Albouy 1969, 57, "passion des origines."

52. The abbé d'Olivet, of the French Academy, published a translation of Cicero's text under the title *Entretiens sur la nature des dieux*, which achieved such success that its fourth edition was mentioned in Tourneux 1877–82, VI (November 1765), 419, "L'ouvrage de Cicéron sur la nature des dieux est un des plus beaux et des plus intéressants qui nous soient restés de l'antiquité; mais il est plaisant qu'il soit orthodoxe de la traduire en français dans un temps où l'on crie sans cesse à l'impiété."

53. Académie Française 1694, I, 421, "chose feinte et inventée pour instruire et pour divertir."

54. *Encyclopédie* 1751–65, VII, 906, "La multitude des explications montre seulement combien elles sont incertaines. Il y a une broderie poétique tellement unie avec le fond, qu'il est impossible de l'en séparer sans déchirer l'étoffe."

55. *Le Dictionnaire historique et critique* was published in 1696; a second edition was published in 1702.

56. Giambattista Vico (1668–1744) published his most famous work, *Scienza nuova*, in 1725.

57. Rousseau 1762, bk. 4, 308, "L'homme a commencé par animer tous les êtres dont il sentait l'action; faute de connaitre les bornes de leur puissance, il l'a supposée illimitée, et en a fait des dieux; ainsi l'univers s'est trouvé rempli de dieux sensibles: les astres, les vents, les montagnes, les fleuves, les arbres, tous les ouvrages de la Nature ont été les premières divinités des mortels?"

58. Court de Gébelin 1773–82, I, bk. 2, passim.

59. Dupuis 1795, I, bk. 2, passim.

60. Tourneux 1877–82, III, 515, "signifient la couleur citrine et safranée appelée Venus qui s'unit avec le fer appelé Mars et c'est le forgeron (Vulcain) qui découvre cette rouille"; "cette manière inepte et impertinente."

61. Seznec 1953, 98–99, quoting from Erasmus, *Enchiridion militis christiani*, Basel, 1518, 63, "Peut-être trouvera-t-on plus de profit à lire la Fable en y cherchant le sens allégorique, que la Sainte Ecriture, si l'on s'en tient au sens littéral."

62. The abbé Antoine Banier (1673–1741) continuously revised his magnum opus, first entitled *Explication historique des Fables*. His very fine translation of Ovid's *Metamorphoses* has been famous since it was first published in 1732.

63. Banier 1738–40, x, preface, "Mon dessein dans cet ouvrage est de prouver que malgré tous les ornements qui accompagnent les Fables, il n'est pas difficile de voir qu'elles renferment une partie de l'Histoire des premiers temps, et que l'Allégorie et la Morale n'ont pas été le premier sujet de ceux qui les ont inventées."

64. Ibid., 25, "Il faut bien se convaincre que les Fables sont un tout mal assorti, qui ne fut jamais un ouvrage médité, inventé dans un même pays ni dans un même temps, ni par les mêmes personnes."

65. On Nicholas Fréret (1688–1749), his imprisonment in the Bastille, and his argument with Newton over the chronology of ancient times, see Barret-Kriegel 1988, 161–211.

66. Banier 1732, x, preface (unpaged), "les dépositaires des événements du monde naissant."

67. Banier 1738–40, xvi, preface, "Les Grecs ont été instruits par les peuples de l'Orient, et en particulier par les Egyptiens, de l'histoire des dieux qui avaient vécu dans l'espace de temps que Varron nommait les Temps inconnus."

68. These similarities were noted as early as 1724 by père Joseph-François Lafitau in his analysis of the *Moeurs des sauvages américains comparés aux moeurs des premiers temps*; Detienne 1981, 19ff.

69. Herder 1784–91.

70. Of interest here is Voltaire's high regard for his libretto for the opera *Pandore* (1740), which shows Prometheus taking sides with mankind against the implacable gods; compare his letter to d'Argental, October 13, 1769, and Michèle Mat-Hasquin's article "Voltaire et l'opéra, théorie et pratique" in *L'Opéra au XVIIIe siècle*, University of Provence, 1982.

D'UN SIECLE A L'AUTRE

HISTORY, MYTHOLOGY, AND DECORATION IN EARLY EIGHTEENTH-CENTURY PARIS

KATIE SCOTT

Edmond and Jules de Goncourt made much in *L'Art du dix-huitième siècle* (1881) of the already well-exercised contrast between the *grand siècle* and the gilded youth of the eighteenth century. In their biography of François Boucher, for instance, they evocatively juxtaposed the "artificial grandeur," the "conventional nobility," the "pomp," "dignity," and "fictitious majesty" of Louis XIV's absolute aesthetic ideals with the apparently no less "artificial," "conventional," but diminutive charms of Louis XV's dream of prettiness.[1] Later, perhaps with greater originality, the Goncourt brothers proceeded loosely to link this transformation to a revolution on Olympus; the heroic gods and goddesses of Homer and Virgil were, according to them, soundly routed by the winsome sensuality of Ovid's invading divinities.[2] The function of the new Olympiad had therefore changed. No longer did it consist in the instruction of mortals to public virtue but rather in the stimulation of polite society to never-ending sensual delight. For instance, the brothers may well have had in mind works such as Boucher's *Venus and Mars Surprised by Vulcan* (fig. 1) when they indiscreetly claimed that "whenever she deemed it necessary to reawaken the King's sensuality," Madame de Pompadour "turned to Boucher, who would throw off a series of panels illustrating a story which began in the idyllic and ended in the pornographic vein."[3] Not only does the picture depict the faithless Venus *in flagrante delictu* appropriately offered up to the spectator's voyeuristic enjoyment, but it was also long thought to be one of several paintings which decorated a boudoir belonging to the king's most celebrated mistress.[4] Such anecdotes, however historically inaccurate, nevertheless highlight the different response elicited by epic and lyric myths. The action of the former ideally inspired emulation, while empathy was stirred by the emotion of the latter, conjuring up memories of the passionate moments in life. It is the narrative and pictorial range of those moments made compelling by the passions of the gods which this exhibition seeks to celebrate, and it is the metamorphoses of these passions from historic actions which

this essay sets out to explain. The eclipse of the heroic by the sensual, of the exploits of Mars by the conquests of Venus, finds its explanation not in the abrupt waning of French military successes after the Peace of Nijmegen (1678), as is sometimes suggested,[5] nor, indeed, in the prescriptive laws of a civilizing process of infinitely longer duration,[6] but rather, as I hope to show, in the crisis of absolutist ideology at the end of the reign of Louis le Grand.[7]

Opposition to Louis XIV and Absolutist Notions of History

The eighteenth century inherited, more or less intact, a literary conception of history[8] which variously combined chronology, hagiography, legend, and myth not in an effort to recover the past, but for the purpose of edifying those with a preordained place in present and future heroic discourse, namely the princes of the church and state and the peers and nobles of the realm.[9] The exemplary mold of seventeenth- and early eighteenth-century historical genres tended to re-create the past as a place to be visited selectively rather than a continuous process to which the present was irrevocably connected. Thus, in Jean Desmarets de Saint-Sorlin's well-read epic poem *Clovis*, republished five times between 1657 and 1673, the sorcerer Auberon invited the king to his enchanted palace and introduced him into a historic gallery where the heroic deeds of their ancestors from the Trojan War to the conquest of Childeric were displayed about the walls. Moreover, spatial metaphors operated at more than one level; at the same time that a depicted Clovis was admitted to the past across the threshold of a gallery, an actual Louis XIV, to whom the poem was dedicated, was presented with a "book gallery" which he was invited to enter in order to see the *tableaux* of the royal past illustrated in the images and text of Clovis's life.[10] By the same token, a further parallel operated between the magician's acknowledgment, in book two, of the incompleteness of his scheme and his prophecy that "*Dans ces cadres restans,*

encor vuides d'histoires,/ Magnanime Clovis, se peindront tes victoires" and the intervention of the authorial voice, in the dedicatory epistle, to predict that Louis likewise would win his epithet *"le grand."*[11]

The pedagogic substance of the past was clearly not focused indiscriminately; it acted as guardian to the values of monarchy, and to that end it circumscribed the options of legitimate political action for future incumbents. History was a privileged narrative, and one, moreover, traditionally active as both council and tribunal to kings "as she [Clio] has her Theatres and her Thrones . . . she also has her scaffolds and her wheels. . . ."[12] warned the historian Pierre Le Moyne.[13] Yet if, during the first half of the seventeenth century, Desmarets's patron Richelieu had commissioned histories with which to win polemical struggles against competing power bases both at home and abroad, the inauguration of Louis's personal rule heralded the dispatch of history-as-judge in favor of a less critical assenter.[14] The Sun King's unprecedented drive to consolidate and expand central authority in any case logically ruled out the possibility of historical legitimation. Indeed, Jean Chapelain's discussions with Colbert in 1663 spelled out the perils of history for an absolutist state, because "if it [history] does not explain the causes of the things narrated, if it is not accompanied by reflections and documentary evidence, it is no more than a simple description, devoid of force and dignity," and yet if it did explain motives and hazard judgments, it not only jeopardized national security but demystified the sacred processes of rule.[15] Thus, under the joint stewardship of Chapelain and Colbert the state was increasingly guided away from history and toward glorifying, proleptic fictions, in the form of literary panegyrics and their visual equivalents—medals, monuments, pictures, and tapestries.[16] To this end, the revision of the statutes of the *Académie royale de Peinture et de Sculpture* in 1665 expressly included an article which bound students forthwith to submit annually for competition drawings of "a general subject on the heroic actions of the King,"[17] while Charles Perrault urged the *premier peintre*, Charles Le Brun, always to remember:

> . . . qu'à jamais ta main laborieuse
> Poursuive de Louis l'histoire glorieuse,
> Sans qu'un autre labeur, ni de moindres tableaux
> Profanent désormais tes illustres pinceaux.[18]

The result was a visible and visual detachment of the cult of kingship from the history of the nation, to the extent that monarchy appeared to occupy a remote temporal and spatial reality qualitatively different from the commonplace actuality of society.[19]

Fig. 1
François Boucher, *Venus and Mars Surprised by Vulcan*, 1754, oil on canvas, London, Wallace Collection

Louis, the state incarnate, its sacred center and its universal principle,[20] defied both time and place, because in him all past and future kings and kingdoms were forever present.

On 22 December 1667, a decree issued by the king's council outlined a project for multiplying, by engraving, exterior views of the royal monuments and palaces, representations of the paintings, sculpture, and tapestries made to furnish them, and records of the antiquities and works of art gathered in the *cabinet*

du roi.[21] These prints were destined to be bound together in splendid folio editions for distribution among fellow sovereigns, to foreign ambassadors, and other important visitors to the French court. In this manner French propaganda entered an international court economy as a political commodity to be circulated and exchanged. It was, initially, perhaps the nature of the European response which partially eclipsed the glory of France and endangered the national stock of heroic imagery. Starting with the Dutch war (1672–78), caricatures, pamphlets, and articles in the periodical press overtly hostile to the means as well as the ends of Louis's foreign policy flooded out of Holland into neighboring regions. Likewise, some thirty years later, the beginning of the War of the Spanish Succession (1701–13) witnessed the publication in Amsterdam of a series of satires directed at opponents of William III, collectively titled *Aesopus in Europa* and accompanied by etchings by Romeyn de Hooghe.[22] One of them in particular, *Ptolemy, Copernicus, and Mercury in Parnassus, Speaking about the Sun and the World* (fig. 2), invited sustained intellectual amusement at the deflation of Louis's cosmological disguise. The etching represents a shrunk and halting

FIG. 2
Romeyn de Hooghe, *Ptolemy, Copernicus, and Mercury in Parnassus, Speaking about the Sun and the World*, 1700–1702, etching, London, The British Museum, Stevens George 1364

king, his youthful, Apollonian mask uselessly slipped about his neck, riding a chariot, which on closer inspection turns out to be a closed stool driven across the heavens at a hysterical pace by Madame de Maintenon. Visually, the print exploited the gap between Ludovican poetics and politics by demonstrating that when Apollo came into contact with reality, instead of landing on allegorized territories located, for instance, at the four corners of Charles de La Fosse's ceiling in the *salon d'Apollon* at Versailles, the wheels of his chariot shattered on impact with England (the unicorn), and the reins fell ultimately into the hands of Germany (the eagle) and Holland (the lion). The text, meanwhile, opened with a heated discussion between Ptolemy and Copernicus about the dynamics of the cosmos, with the former citing as proof of his theory that the earth was stationary while the sun moved, that "the French Sun has shown his beams on the Alps, the Po, the whole of Italy, the Mediterranean, and has gone round the world in one day, over the South Sea and back again."[23] With Copernicus understandably unmoved, Mercury was brought in to arbitrate. He promptly agreed with both sides, on the one hand acknowledging Louis's solar ambitions and on the other predicting the end to his revolutions when other stars in their courses fought to fix him and set the Earth once more in motion.[24] What the text adds to the ridicule of ornamental mythology, well enough accomplished by de Hooghe, is a satire of the willful false consciousness of a heliolithic nation adrift in an otherwise modern, scientific world which had demoted the sun to the rank of a common star: in other words, *Nunc* and not *Nec pluribus impar.*[25]

There was, of course, as much a conflict of medium as of interest between such cheap and secretly distributed caricatures[26] and the vast, public decorative schemes triumphantly elaborated during the 1670s and 1680s by Le Brun and his school in the *grand appartement* and the *galerie des glaces* at Versailles. The vulgar medium of print moved to compromise the overwrought verisimiltude of high culture as well as to score particular political points. More worrying to the French, however, were those more limited propaganda wars fought on shared cultural territory, notably in medallic history.[27] Medals, because of their material incorruptibility, were traditionally regarded as constitutive as well as merely reflective of history, that is to say that because the evidence they provided about the past was judged primary and incontrovertible, medals were credited with an actual historicity quite different from the merely discursive validity of literary texts.[28] Satire in this field was therefore particularly to be feared. However, instead of using excoriative strategies to expose the corrupt mechanics of myth in the

manner of de Hooghe,[29] Dutch, German, and English
medalists chose to match the flushed confidence of
the *Médailles sur les principaux événements du règne de
Louis le Grand* (1702) with conceits played upon the
iconographic similitude between different myths.
Thus, in the case of charioteering, Jan Smeltzing was
one among many to enjoy the obvious and natural
confusion of Apollo with Phaeton, his overweening
fan, but perhaps unique in harnessing the joke to the
moment of maximum political impact.[30] On another
occasion, Apollo had appeared to be hijacked by the
character of Paris (fig. 3), who, during the war of the
League of Augsburg (1687–97), "came and saw but
did not conquer" Namur, and was depicted thereafter
being drawn back to Versailles in immodest haste by
three court Graces, very possibly the king's mistresses,
Mesdames de La Vallière, de Montespan, and de
Maintenon, who made frequent and similar interven-
tions in caricatures of the period.[31] Like caricatures
and subversive pamphlets, these sorts of medals were
smuggled into France, but the fact that they were
minted in gold and silver as well as baser metals sug-
gests that they functioned as expensive and enduring
jokes offered for safekeeping to a comparatively nar-
row market of highly cultured court elites. Indeed, by
1690 two had quite inappropriately made their way
into the Royal Collection.[32] With unbounded wit and
no loss of aesthetic decorum, royal mythology was
thus turned on its head, and although it is impossible
to gauge exactly the effect the counterfeited myths

had on the currency of fable, there can be little doubt
that they were designed further to encourage indige-
nous resistance to the symbolism of divine right.

Almost from the outset, the War of the Spanish
Succession had raised legitimate doubts in France
about the motivation of Louis's foreign policy.[33] The
exorbitant financial cost of the campaigns to a deplet-
ed taxpaying population and the unprecedented car-
nage of Malplaquet (1709) seemed all the more inde-
fensible in light of Louis's apparent pursuit of dynastic
rather than national interests.[34] However, unlike for-
eign critics and satirists, French *donneurs d'avis* held
back from mocking Louis's peacock pride, preferring
to hold up for quieter political reflection pictures of
the miseries and neglect of France in the hope of forc-
ing recognition of the disjunction in fortunes between
the actual and formal kingdoms. The most searching
revision of that complacent tautology—that by right
divine the king could never govern wrong—sprang
from the circle around Madame de Maintenon, with-
in which conspired members of the Le Tellier clan,
and was penned most cogently by the great military
engineer Sebastien Le Prestre de Vauban.[35] A con-
spicuous theme of Vauban's *Projet d'une dîme royale*
(1707) was that the "greatness of kings" was to be
measured by the number and prosperity of their sub-
jects, an argument which necessarily and unusually
attached *"gloire"* to the promotion and preservation of
peace.[36] The very morality of heroism was thereby
placed in jeopardy. Indeed, fueled by Jansenist theol-
ogy, which for over half a century had rallied a power-
ful current of opposition to absolutism—and to
which, incidentally, a number of the Le Tellier faction
were overtly sympathetic—criticism rained down on
he who resolved to make himself an instrument of
royal might and delivered to the eighteenth century
the parody of war as a lasting pictorial genre.[37] Thus,
Claude Gillot's *La Passion de la guerre exprimée par de
satires guerriers*, though published well after the Peace
of Utrecht (1713–15), was nevertheless accompanied
by the following verses:

> Guerriers, si vous courez défendre vos murailles,
> Partez, et s'il le faut briller dans cent Batailles;
> Mais, si vous ne voulez qu'errer en Conquérans,
> Ne portez pas plus loin vos projects éffraîans.
>
> Qu'attendez-vous du sang que vous allez répandre?
> De nos Champs désolez, de vos Villes en cendres?
> Fléaux de l'univers, Héros, êtes vous nez,
> Pour ne faire icy-bas que des infortunez?[38]

However, the image itself revealed none of the
distress alluded to in the verses and only "satirized"
the would-be tyrant by presenting him as a pun got up

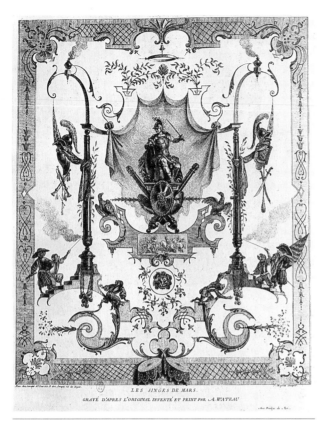

FIG. 4
Jean Moyreau after Jean-Antoine Watteau, *Les Singes de Mars*, 1729, etching, Paris, Bibliothèque Nationale, Cabinet des Estampes

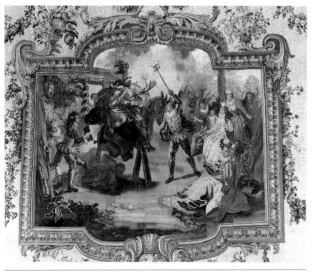

FIG. 5
Charles-Antoine Coypel, *Don Quixote and Sancho, Mounted on a Wooden Horse, Imagine They are Traveling through the Air to Avenge Doloris*, 1755, Gobelins Factory, woven by Pierre-François Cozette, Richmond, Virginia Museum of Fine Arts, The Adolph D. and Wilkins C. Williams Fund

in imperial Roman armor. Likewise, in *Les Singes de Mars* (fig. 4), Watteau, Gillot's one-time pupil, resorted to the familiar tactics of the grotesque to rattle the sublime confidence of the god of War.[39]

Significantly, in view of the recent conflict over Spain, the literary text which inspired the most sustained visual ridicule of military valor in the early eighteenth century was Cervantes's *Don Quixote*, translated by Filleau de Saint-Martin at the end of the previous century and woven from 1714 in *haute-lisse* from cartoons by Charles-Antoine Coypel.[40] Coypel's Manchagan knight was not the monstrously insane Louis of political satire[41] but a picaresque antihero whose actions, despite the purity of his intention and its valorous execution aboard a wooden horse (fig. 5), provoked spectacular catastrophe, to public delight. Inasmuch as Quixote's errors were clearly the consequence of delusions caused by his incapacity to distinguish the ideal projection of chivalry in literature from the real world of violence, they were not moral transgressions and, therefore, neither were they exemplary or historical acts.[42] Indeed, the unalloyed pleasure apparently garnered at the prospect of the knight-errant floundering in earnest tilt towards windmills and servant girls above the wainscot in the *appartements de parade* at the hôtels d'Antin or de Charost[43] stemmed from his position, narratively and visually, at the indecorous border separating an epic world of classically enclosed forms from a comic plain of grotesques as yet unscored by rational definition.[44] The conflictual dialogue between official and anti-academic cultural idioms, or put more specifically, between history painting and the grotesque, was thereby internalized. Moreover, the neutralizing result was upheld by the chivalric commitment of a hero whose satire of the bellicose playacting of a Mars or Alexander was not of his own intending and served merely to ridicule the ideal of heroism from within instead of laying siege to it from abroad.

Quixote's cruel betrayal by analogy must have struck home with a generation regularly assaulted by the rhetoric of grandeur and yet from the 1680s also increasingly conscious of the coercive tactics of a pseudo or *trompe l'oeil* history which preempted criticism.[45] Against the Crown's continued deployment to strategies of apotheosis which stressed the unquestioning duty of subjects to their king,[46] the new criticism presented an account of the past which emphasized the obligations of the sovereign to his people.[47] Morever, the yardstick for measuring the contractual sufficiency of the king's actions wielded by reformed historical discourse, hot off Dutch presses,[48] was empirical truth. Historians like Henri Philippe de Limiers and Pierre Bayle identified two important precondi-

tions of historical writing: first, the elimination of religious, national, and political bias,[49] and secondly, the repudiation of the maxims, harangues, and reflections of Renaissance exegesis which had formerly knitted the past together in an unbroken web of commentary cut loose from the events themselves.[50] Historians should henceforth adopt a plain language of such transparency that the author was metaphorically swallowed up by its words and indiscernible behind it.[51] Such views found ready acceptance in France, and Fénelon understood perhaps better than many that for history to continue to offer "the most solid moral truth" without appearing to preach,[52] its signs must, more successfully than Quixote's, reach out beyond the realm of analogy and resemblance and directly touch the world of things and events.[53] The engendered modification of the structure and terms of historical thinking profoundly challenged the viability of epic forms from the end of Louis XIV's reign.

From the point of view of the visual arts, the Dutch war, for instance, had been as much a battle of genres as a conflict in arms. In 1672 Adam-François Van der Meulen received a royal commission to paint the *The Crossing of the Rhine* (fig. 6), in which the king was depicted astride a high and prancing horse directing events above the thunder of cannon, with a view of Tolhuis, a place of one of Louis's greatest victories, in the distance.[54] Meanwhile, the following year saw publication in the Hague of a book attributed to Abraham van Wicquefort, one of de Hooghe's engravings (fig. 7) for which he illustrated a once

comfortable Dutch interior in the village of Bodegrave or Swammerdam overrun by French berserkers.[55] Corpses, some of them dismembered, abound in the foreground, while the eloquently passive feet of the menfolk, felled at the knees by fire, protrude innocently from the chimney. While the cottage is being put to the torch, a woman in the left background is savagely raped across the carcass of a heifer.[56] This, according to van Wicquefort and de Hooghe, was the unvarnished truth of the Dutch campaigns, told in the minute record of the genre painter's witnessing eye and not sung in the censored forms conjured by the history painter's universalizing mind. It was, in fact, a history of unbridled passions unleashed in the private spaces of the common people and not the story of rational actions unfolding upon the public stage. Truth abided, therefore, not just in the character of the medium which carried it but also in the kind of places in which it was spoken. It was a secret history to be ferreted out from the hidden places behind the scenes in order to expose that which officially sanctioned representations before the curtain willfully obscured. It was doubly secret, morever, because it purported to reveal those motives behind historical events, knowledge of which Chapelain and Colbert had judged so prejudicial to public order. Just as lust, anger, and pride visibly activated Louis's troops in de Hooghe's print, the popular and scandalous *nouvelles* of Courtilz de Sandras and his imitators invariably and repeatedly demonstrated that lust, not virtue, motivated princes and oiled the machinery of state.[57]

FIG. 6
Adam-François Van der Meulen, *The Crossing of the Rhine*, 1672, oil on canvas, Paris, Musée du Louvre

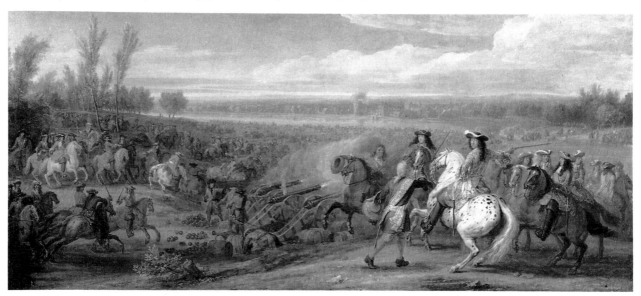

FIG. 7
Romeyn de Hooghe, *The Sacking of a Dutch Town*, 1673, etching, from
Advis fidelle aux veritables Hollandois, New Haven, Yale University,
Beinecke Rare Book Library

The immediate and vulgar history of the passions[58] played out in intimate boudoirs and *cabinets* thus came forward to demystify and challenge the remote, petrified story of mimetic actions hung about a heroic gallery.[59]

It was in the context of this varied and international demonstration that the arsenal of state propaganda contained nothing more than glosses to deceit,[60] that even defenders of absolutism such as the abbé Banier argued for the repeal of such mythic history, readily acknowledging that "that which is fabulous does not increase the glory of great men [but] serves at the most to diminish the credibility of certain facts."[61] Of the same mind, Dubos rejected the allegorical and mythological admixtures to history painting[62] in Rubens's Medici cycle, for instance, and called instead for a painted history that would follow the same critical exigences as the new Clio and that was therefore truthful and plausible for a secular and critical public.[63] It remains to be seen whether during the first half of the eighteenth century his voice was ever heard.

The Decline of Heroic Themes During the Regency

No sooner had his father *Monsieur* died in 1701 than the future regent, Philippe d'Orléans, embarked on a thorough refurbishment and redecoration of the Palais-Royal.[64] Within little more than a year of his father's death, Philippe d'Orléans had summoned Antoine Coypel to the *grand appartement* to decorate with scenes from *The Aeneid* first the ceiling and then the walls of the "new" gallery, erected parallel to the rue de Richelieu sometime between 1698 and 1701 by

Hardouin-Mansart.[65] The vault was completed in 1705, while the seven wall pictures commissioned in 1715 to decorate the blind elevation backing onto the street were finished within three years.[66] Meanwhile, starting in 1714, Oppenord, Mansart's successor as Orléans's first architect, turned his hand to replacing his predecessor's probably modest decorative works with his own much more lavish schemes of gilded ornament, most strikingly at the far end of the gallery (fig. 8) where he designed into a shallow ellipse a chimney mantel, set above with a mirror of prodigious size.[67] Flanked on either side by pairs of Corinthian pilasters between which rose impressive military trophies, the design culminated at frieze level with two winged Victories supporting a cartouche inscribed with the arms of Orléans, above which the ducal coronet broke through the cornice to lodge itself in a shell.

At the same time, Orléans's two legitimated cousins, the duc du Maine and the comte de Toulouse, were committing themselves to similarly ambitious decorative programs. Germain Boffrand had been at work at the Arsenal on modifications to the lodgings of the Grand Master of the Artillery[68] since 1712, and the surviving drawings[69] for the projected decoration of the *salon* probably date no later than 1715–17. The elevation of the window side (fig. 9) clearly indicates that, if more modestly proportioned and different in function than the *galerie d'Énée*, this room was nevertheless conceived on the same heroic scale. Indeed, above the central window two winged figures, not unrelated to Oppenord's Victories but here personifications of History and Fame, accompanied a roundel sporting the interlaced A and L of Louis-Auguste de Bourbon, duc du Maine. At the opposite end of Paris, meanwhile, the comte de Toulouse had in 1713 bought François Mansart's famous hôtel de la Vrillière. Five years later, Robert de Cotte and François-Antoine Vassé had finished transforming the gallery into a celebration in ornament of Toulouse's public functions as First Admiral of the Fleet and *Grand Veneur* and, by default, into an illustration in pictures of the count's apparently exquisite taste.[70] Echoes of the Palais-Royal abounded, most conspicuously in Vassé's third project for the chimneypiece, set once more within coved paneling, flanked by pilasters and trophies on either side and crowned by a coat of arms—although in this instance the figure of Fame is conspicuously smaller in proportion to the device she heralds. In a climate notably suspicious of grandiloquence, each of these three schemes attempted variously to reconstruct or rehabilitate the great tradition according to their several capacities and purposes. Inasmuch as all three were substantially executed

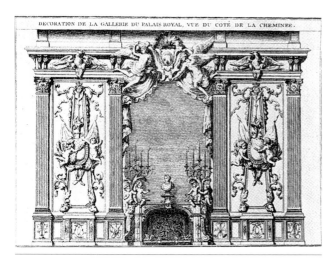

FIG. 8
Jacques-François Blondel, *Décoration de la gallerie* [sic] *du Palais-Royal, vue du côté de la cheminée,* c. 1771, etching by Le Roi, *Cours d'Architecture,* Paris, Musée Carnavalet

FIG. 9
Germain Boffrand, *Design for a salon, Arsenal,* c. 1715–17, pen and ink drawing, Berlin, Kunstbibliothek, Staatliche Museen Preussischer Kulturbesitz

and/or conceived in the heat of the *affaire des princes* (1716–17), a dispute which effectively pitted the constitutional pretensions of the royal bastards, du Maine and Toulouse, against the established authority of the regent,[71] it may be appropriate to consider them, moreover, as cultural statements unleashed across each other's bows.

Of the three, the Arsenal appears in many ways to have been iconographically and stylistically the most conservative. Its insistent bellicosity, though clearly encouraged by the nature of the building and the identity of the patron, nevertheless seems to recall certain features of Versailles and Marly. Boffrand, like Mansart at the *pavillon royal,* reserved a special place for personifications of princely virtues.[72] At the far end of the *salon,* above a chimneypiece and mirror,

Boffrand planned to station Bellona, perched upon the cornice, sword raised to quell her prisoners, and surrounded by standards yielded on the field of battle,[73] while above an adjacent doorway a projected Mars would have leant upon his shield in contemplation of the martial trophies, including a cannon, likewise ringed about him. The six arcades composed of doors, windows, and mirrors were to be linked by a broad frieze, apparently depicting the battles of Alexander;[74] below them, Boffrand anticipated a series of four paintings encased in comparatively austere rectangular frames and accompanied by explanatory cartouches seemingly fashioned from the hide of the Nemean lion. There is no evidence here of a retreat before an iconography devalued by a father's encomiastic exploitation. Indeed, the arrangement of the figurative components within paneling divided into simple rectilinear or circular shapes with plain moldings, and punctuated only by anonymous pilasters decorated with smoking votive burners and diminutive trophies, further conspired to attach the scheme to the official idiom of Louis XIV.

The remodeling of the Arsenal was planned when the duc du Maine was in the ascendency—both domestically, in his father's affections, and politically, by his father's patronage. Starting with a declaration on 5 May 1694, Louis XIV had proclaimed for du Maine and the other royal bastards[75] a rank midmost between the princes of the blood and the dukes and peers.[76] With the loss of so many of his direct descendants, he had then proceeded by edict of July 1714 to arrogate for them the right to royal succession should all legitimate blood fail, and lastly, by declaration of 23 May 1715, he had conferred upon them the rank of prince. It was the legality of these rights and titles that the legitimate house of Condé contested in an opening petition presented to the regent in 1716 which constituted the matter of the *affaire des princes.* While the duc de Bourbon-Condé, his brother the comte de Charolais, and his cousin the prince de Conti maintained that Louis XIV had violated the fundamental law of the kingdom forcibly to admit his bastards to the royal succession and that the regent should therefore immediately repeal the legislation of 1714–15, du Maine, Toulouse, and their pamphleteers sought to prove, by recourse to historical precedent, the admissibility of bastardy to the throne and therefore the legitimacy of Louis's laws. There can be little doubt that the projected decoration of the Arsenal also bespoke a consciousness of successorial rights, though the visual evidence is insufficient to establish whether it would have done so with pre-1715 complacency or post-1716 tenacity—assuming indeed that such fine distinctions might appropriately be made. As already

noted, the duc du Maine's participation in the history of the nation was to be repeatedly alluded to by initials and the symbols of war; moreover, if the paintings intended for the room were to have been of a battling kind, it seems likely that they would ideally have recorded the duke's military campaigns.[77] Moreover, the frieze, though it was to illustrate a Roman *exemplum* and not the episodes from the Frankish past deployed in the pamphlets,[78] and though it placed its edifying pattern in an upper register rather than in a literally supportive role as a precedent, would nevertheless have functioned to provide du Maine with tangible proof of his descent from the same mythical genealogy as his father, extending back to the patriarchs of antiquity.[79]

By comparison, the *galerie dorée* at the hôtel de Toulouse (fig. 10) was less programmatically explicit and iconographically reductive. Aside from Louis-Alexandre's monogram discreetly tucked into scallop-edged cartouches on the inside of the pairs of niches at either end of the gallery, perhaps only the selection of "royal" artists to design and execute the scheme betrayed a conspicuous Bourbon inheritance. The *premier architecte* de Cotte, along with the *dessinateur général de la Marine* Vassé, devised for the hôtel de Toulouse an articulation of the gallery elevation, distinctive above all for the contours of the frames which served to dispatch into paneling the *seicento* La Vrillière pictures acquired by Toulouse along with the house.[80] If in the eyes of contemporary Parisians the design did not obviously derive from royal prototypes,[81] it became, however, a signature arrangement, variations upon which were used in the king's works during the following reign.[82] Notwithstanding the fact that three of the original collection of twelve canvases were withdrawn from the gallery and the remaining canvases substantially altered in response to the new setting,[83] neither thought nor resolution seems to

FIG. 10
La Galerie dorée de l'hôtel de Toulouse, 1713–18, Paris, Banque de France

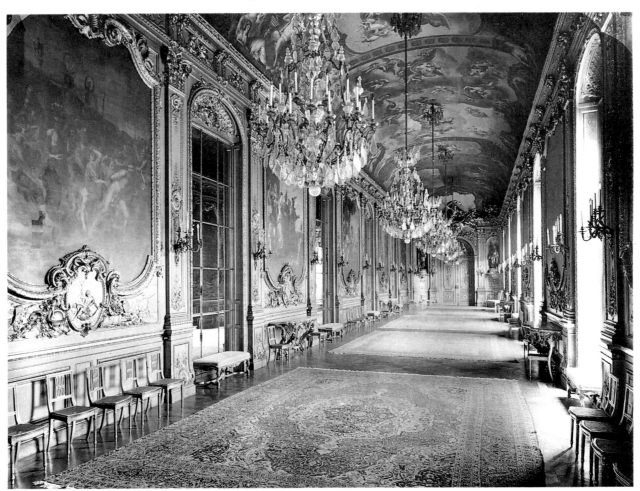

have been given to commissioning contemporary or allegorical history pictures which might have been more in keeping with Vassé's projected ornament. The new scheme therefore arose out of the constituents of the old. According to Sabine Cotté's reconstruction, it seems that originally the paintings had been arranged at regular intervals above a *lambris à hauteur*.[84] Surrounded by painted and gilded stucco alternately fashioned by Gérard Van Obstal into smoking votive burners, putti with ensigns spread, triumphal trophies, and imperial eagles, these pictures had thus been stilled beneath a mythological sky, frescoed by François Perrier, and immediately above a relentless row of Roman busts poised along a cornice. Although these disparate painted and sculpted elements never advanced a coherent narrative, an odor of grandeur stole over the entire scheme, bringing into felicitous conjunction Apollo's gilded realm with the golden age of ancient Rome and linking by the thread of heroic ornament the different times and hours of antique glory.

De Cotte's and Vassé's substitutive scheme all but snuffed out the former power and authority of these Roman *exempla* by breaking down the ornamental syntax of fame and building from it an abstract rhythm of composite pilasters, arcades, and frames which drew the physical surfaces of the scheme into satisfying tension but left images isolated one from another. Moreover, the proliferation of maritime and hunting emblems (one project for the trophies also envisaged pictorial scenes of a harbor and a chase) only added to the obfuscation of the original program. Though Vassé attempted simultaneously to fulfill the patron's emblematic needs to relate wall and vault by bringing some of the gods off Olympus and distributing them along the cornice, devices such as the ship's prow breaking through above the chimneypiece, notwithstanding its fellowship of tritons, was iconographically incongruous. Most disturbing of all were the cartouches which Vassé designed to accompany the pictures. Such cartouches, if not supporting descriptions of the pictures above, as at the Arsenal or indeed in the engravings of the *galerie dorée*, generally repeated, in a lower case, the subjects of their painted companions;[85] but here the cartouches alternately represented maritime and hunting myths—Orion surrounded by exquisitely fashioned treasures of the sea or Hercules with the head of the Erymanthian boar— and were completely at odds with the pictorial themes they appeared to complement.[86] The absence of thematic reinforcement between the various figurative elements in the room diminished the iconographic impact of Vassé's ornament and denied it the heroic leverage latent in the Arsenal solution.

However, the *galerie dorée* perhaps owed its long-term success and survival to this very lack of congruity. The collection of seventeenth-century masterpieces by Guercino, Guido Reni, Nicolas Poussin, and others created an atmosphere markedly different from what we know, for example, of the comte de Seignelay's *grand cabinet*, which otherwise deployed— to Boffrand's design—maritime motifs in commemoration of the Colberts' devoted service to the royal navy, analogous to those at the hôtel de Toulouse.[87] Setting aside for an instant the types of rooms concerned, the distinction between the two schemes seems to have amounted above all to the difference between geographical charts and old masters. The twenty maps which hung in Seignelay's "temple of memory" must have lent a professional and learned edge to the poetic fancy of tritons and dolphins disporting along the cornice; by contrast, the marginalized ornament in the *galerie dorée* was never a decorative sediment deposited by the main objects of attention but a symbolic reminder of the rank and means by which the hôtel de Toulouse had become an exemplary center of polite civilization (summarized in the pictures displayed) to rival the Palais-Royal. The *galerie dorée* being closer, then, in generative principal to the decoration of Louis XIV's *grand appartement* at Versailles, where the rooms were hung with a collection of predominantly *seicento* works until the end of the *ancien régime*,[88] it might be argued that the possession of the trophies of a princely culture was being advanced as nine points of a judicial and moral entitlement to that rank.

Of the bastards' schemes, it was undoubtedly the hôtel de Toulouse which proved representative of the heroic schemes erected in the *hôtels* of the early eighteenth-century nobility. *Habitués* of the *vieille cour*, like the duc de Villars, loyal to du Maine and Toulouse, proved belated devotees of the disintegrative structure and periphrastic logic of an ornamental epic genre, circulated discreetly about the edges of things. In 1730 Villars, a French marshal, decided to add a gallery to his *hôtel* in the rue de Grenelle, for which Pineau provided the paneling in the following years.[89] Here the spaces between the arcades were filled with pier glasses, and the contribution of painting to the overall appointment of the room was both less substantial and less high-minded than at the *galerie dorée*. History painting was displaced by copies of seventeenth-century half-length female figures[90] (fig. 11), encased in florid triangular frames above the mirrors, and if the double doors at the west end supported representations of the marshal's batons, only one of the four elaborate cartouches which traversed the cornice made any further allusion to the patron's military

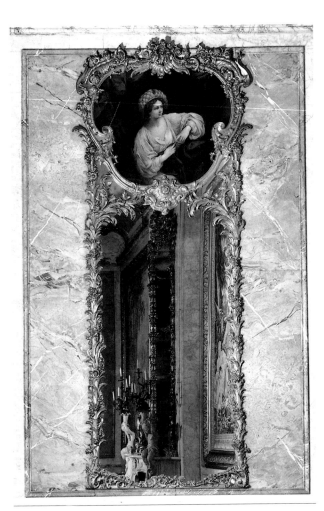

career.[91] The "representational" function of the gallery, compromised at the hôtel de Toulouse by the room's other role as a *cabinet de tableaux*, had in this instance all but disappeared. Indeed, the delicate balance effected at the hôtel de Toulouse between, on the one hand, the need to seize the tradition of the *grand siècle* in order to articulate an entitlement to power and, on the other, the caution to distance the ridiculed and despoiled forms of its language, had finally collapsed into a playful display of martial rhetoric in all its garrulous but impotent variety. Appropriately, therefore, it was in the *salon* of the petit hôtel de Villars, built shortly after the Treaty of Rastadt (1713), which was negotiated by Villars, that the duke most fulsomely acknowledged his professional accomplishments by means of military trophies and crossed marshal's batons.[92] However, trophies alone—no matter how impressive—could scarcely compensate for the lack of exemplary narrative customarily afforded by figurative sculpture and painting, particu-

larly when they were suspended, as they were at the hôtel de Villars, from delicate, fluttering ribbons and when the laurel of Fame tended to become entangled with garlands and shells of a decidedly pastoral nature. Furthermore, valorous trophies rarely enjoyed complete mastery of a space; paneling at The Metropolitan Museum of Art, thought originally to have come from the hôtel de Varengeville, was indiscriminately sculpted with trophies of Fame and Glory and others invoking the Seasons, Music, Poetry, Gardening, and Commerce.[93] The discourse of violence intrinsic to heroic action had been domesticated and transformed into a polite conceit of the spoils of conquest;[94] moreover, the transfer of such trophies from the gallery to the *salon* implies that allusions to the nobility's preferred profession were perhaps best kept for its *semblables* and not paraded in the more public spaces of the residence where they might risk mockery from a less self-deceiving public.

It would be quite inaccurate, however, to suggest that this unpicked and ornamental epic genre circulated predominately within a closely sutured faction. Villars's *salon* was very likely inspired by the earlier, mid-1720s decoration of a drawing room at the hôtel d'Evreux for which Michel Lange had sculpted magnificent trophies (fig. 12) of antique instruments of battle.[95] Given his lineage, Henri Louis de La Tour d'Auvergne, third son of the duc de Bouillon, would probably have identified with the legitimate princes, who effortlessly rallied the support of a peerage still smarting at the insult of their abrupt demotion to a rank below Louis's illegitimate sons.[96] Moreover, though not actually listed among the duc de Bourbon's so-called regiment, "encamped" from 1720 at the place Vendôme, the better to speculate in government stocks and bonds, Evreux certainly profited no less than Bourbon's vassals by loyal investment in the regent's financial experiments.[97] At the same time, Louis-Charles-Auguste Fouquet de Belle-Isle, hero of the siege of Lille and later duke and field marshal, had himself built a *hôtel* on the rue de Bourbon, yet so noble and heroic a life as his marked the decoration of his house only upon its ornament—the familiar vocabulary of palms, laurel, and trophies.[98] Since Belle-Isle was a leading figure in the duc de Chaulnes's cabal, which from 1722 worked for the downfall of the first minister, the cardinal Dubois, it should be evident that, during the regency, nobles of a wide political and cultural cast[99] indulged a common taste for gilded glory, its exemplary force cut away by satire and strife.

Ironically, whereas the bastards had been led by physiological necessity to couch their "radical" political claims in an often suspiciously orthodox cultural

style,[100] the regent, whose personal and constitutional legitimacy was much less obviously in doubt, was theoretically at liberty to mobilize greater originality in the decoration of the Palais-Royal. However, the apparently novel decision, taken at a time when no one entertained thoughts of a regency—but fully endorsed by the later campaign of 1715–17—to enliven the gallery with episodes from the decoratively unexploited *Aeneid* seems on reflection more conservative than innovative inasmuch as the choice settled on was an epic classic tale. Indeed, though Virgil's poem had never furnished the subject of a royal program, dedicatory epistles to French editions of the text reveal that the tale was thought particularly fitting for princes. For instance, in 1655 Michel de Marolles dedicated his princely folio translation of *The Aeneid*,[101] which he described as "a most beautiful *peincture*," to the young Louis XIV, first because he believed that the semidivine hero perfectly represented "the greatness of his [Louis's] extraction, which draws its origin from the most glorious bloodlines of the universe," and secondly because in Aeneas was to be found the portrait of the consummate prince, at once valorous and civilized.[102]

Later translations, such as the poet Segrais's of 1686, steadily reprinted in cheaper, octavo editions well into the eighteenth century, continued to propound flattering analogies between the Virgilian past and the Ludovican present. However, where Marolles had glorified the Trojan Aeneas so that his movements might serve as arguments and ideas to a young king at the inauguration of his reign, Segrais, writing at a time when the nation's hopes had largely been fulfilled, emphasized instead the comparison between contemporary French society and the civilization which gave *The Aeneid* life. Indeed, Segrais argued that a reincarnated Virgil would have recognized in Louis XIV a prince superior to Augustus because, "whilst Augustus's victories ended only in establishing an illegitimate authority, V. M. has no more than amplified the glory of the most just and the foremost Monarchy on earth."[103] The link between this particular brand of literary encomium and the theories of royalist *modernes* has recently been recognized, particularly in the case of Du Plaisir, who expressly rejected the view that the perfection of Western culture had been reached in antiquity and argued on the contrary that the greatness of Louis XIV's reign so surpassed the achievements of an Alexander or an Augustus that it could not be meaningfully enhanced by analogy with theirs.[104]

In the same way, but not necessarily for the same reasons, there can be little doubt that at the Palais-Royal Aeneas was not intended as a cipher for

Fig. 12
Michel Lange, *Trophies from the hôtel d'Evreux*, 1720–22, Paris, Palais de l'Elysée

Philippe d'Orléans and that, for example, the Trojan prince's single-handed victory over the Rutulians was innocent of analogy with Philippe's daring campaigns on the Iberian peninsula. Women of the court may well have volunteered as models for Coypel's ceiling, but they were not assigned roles in an allegorized narrative.[105] In the absence of such coded resemblances, Coypel's paintings have tended to be approached as illustrations—in other words, as a measured and academic translation of Virgil's text into appropriate visual forms which together comprehensively animated the tale, from the sacking of Troy, a prelude to *The Aeneid* recounted by the hero at Dido's feast in book two, to the combat between Aeneas and fierce Turnus in Latium, narrated in book twelve. And yet, the arrangement of the pictures in the gallery alone mitigated against a straightforward "reading" of the poem and spelled confusion which the circumstances of the commission can only partly explain.[106] Acknowledging in the first instance that the wall paintings may

not have been planned from the outset and that the vault was therefore conceived as an autonomous and coherent unit, it is nevertheless apparent that Coypel's disposition of events does not follow Virgil's. A crib translation would have meant locating the lost canvases, *Mercury Urging Aeneas to Abandon Carthage* and *Juno Arousing Allecto from the Underworld*, side by side to the right of the central opening, while instead they enjoyed a slipped position at either end of the gallery. Though scant visual evidence survives to justify these compositional liberties, it seems possible that Coypel settled on opening with *Mercury Urging Aeneas* because of the opportunity it gave him to introduce the hero at the very threshold of the room,[107] while Allecto perhaps naturally found her place above the chimneypiece because her mission to set peace pacts ablaze and whip up discord with her firebrands made fire an element to which she was conspicuously attached, though her purpose was arson, not a cheerful hearth.

Coypel's *galerie d'Énée* was clearly not a literal illustration of the text because the painter so obviously exceeded that commission. Not only did he rearrange events, but he omitted completely certain episodes while elaborating others in a visual paraphrase of the poem, noted for its distinctive focus and handling.[108] Through variation in the dimensions of the scenes, for instance, Coypel provided emphasis to the tale as well as affording rhythm to the program. At the center of the vault and at the midpoint of the gallery wall, Coypel stationed his two largest compositions, *Venus Appealing to Jupiter on Aeneas's Behalf* and *Aeneas in the Underworld*, works which in a number of ways brought these separate architectural planes into conjuction, thereby providing some much-needed unity to an often incoherent scheme. We learn from the 1719 edition of the *Curiositez de Paris* that the frame of *Aeneas in the Underworld* was particularly elaborate.[109] Instead of the modest references to Aeneas's famous armor crowning the other wall paintings, the frame of the centerpiece offered a "carpet of ornament" which two large and gilded figures, sculpted in relief and personifying Time and Fame, had just finished raising in order to reveal the realm below. On a formal level, these allegorial figures found ready analogues in the caryatids, *ignudi*, and especially the winged Victories which similarly framed the *quadri riportati* above, but more importantly, through their position on the cornice they were able to suggest that on a thematic level both compositions were concerned with prophecy. Indeed, in these two paintings Coypel balanced the offices of the mother against the services of the father with a symmetry scarcely justified by the text and gave their care a narrative importance which

ultimately undermined the personal achievement of the poet's hero.

Response to such free interpretations of the epic was mixed. Germain Brice was among those generous with praise; he found Coypel's creative interpolation of images "admirable" and the communion between the terrestial and celestial planes "ingenious."[110] On the other hand, Le Rouge, the presumed author of the *Curiositez de Paris*, regretted the absence of a stricter respect for the chronological sequence of the legendary events and felt an obligation to make good Coypel's errors by providing his readers with a route map of scenes numbered as they appeared in Virgil's original.[111] Likewise, while the first favored Coypel's sometimes daring handling of perspective and his powerful colorism, Le Rouge, apparently speaking in the name of connoisseurs, denounced the brilliant draperies, the blushed flesh, and the draughtsmanship as being inappropriately closer to Rubens than to the marbled remoteness of antiquity.[112] Though their judgments conflicted, both recognized in Coypel's gallery a "modern" imitation of Virgil's tale, one less concerned with accuracy of illustration than with capturing in a three-dimensional space the essence of the poem in an idiom with contemporary resonance. In this sense the gallery not only cleaved to the side of the *rubenistes* but lent its support to Houdart de La Motte and the *modernes* in the not unrelated quarrel about Homer which raged between 1713 and 1716.[113]

By comparison with the programs of du Maine and Toulouse, the regent's gallery seemed to break much more cleanly with the past. Not only was Coypel's painted *Aeneid* never populated with the political and eulogistic intentions usually at work in such heroic schemes, but the ornamental decoration eschewed, even in the modest spaces of the margins, extravagant references to the patron's status and credentials for power. The past, whether history or legend, was effectively depersonalized; it no longer functioned as the privileged mirror or portrait of history makers (princes, nobles, and ministers) but offered a generic and "democratic" discourse whose moral injunctions were there for society at large to heed. Insofar as spectators were therefore referred back to their own conduct and to their own experience, this scheme seems to announce a new history painting, one of a kind Dubos could have admired and one whose publicity depended not only on the space it occupied but on its ability to address an audience collectively. Thus, when in 1733 Lemoyne came to paint the ceiling of the *salon d'Hercule* at Versailles and invited spectators to recognize in his Hercules not the Gallic prince of former times but the image of the perfect citizen,[114] he was in many ways completing a restructuring of history

initiated by historians in Holland and by a painter with a Flemish touch. To take the comparison of the three princely schemes one last concluding step, the genealogical consciousness at the heart of the Arsenal and the Toulouse programs qualified their seats as particular, and public, only insofar as their claim as royal heirs was upheld. The Palais-Royal, on the other hand, appeared as a forum, a public space, indeed the only public space in which legitimate members of government could gather. Proof of the different significations of these places emerged most fully, however, only in the wake of the settlement of the *affaires des princes* when du Maine's and Toulouse's residences were exposed as spaces of conspiracy, from which their owners swiftly took their leave.

However, the *galerie d'Énée* should not be seen just in terms of the completeness of its negation of the Maecenas. Though the demise of analogy curtailed the extent to which the virtues of the patron might be directly expressed through a hero's actions, the overt concern with the poetics of history, with its formal properties, provided the spectacle by which that person's learning, taste, and *honnêteté* might be fully beheld.[115] Moreover, the erosion of dynamic moral virtues by softer, interactive social values is discernible in the internal structure and significations of Coypel's gallery as well as in its external relations as property attributed to a particular individual. To begin with, Coypel's rearrangement of the sequence of events, whether intentional or circumstantial, ultimately served to blur the sharp outline of the narrative progress and obscure the necessity of Aeneas's actions in fulfillment of his divine quest. Indeed, it might be argued that only in the first and last scenes does the protagonist clearly exhibit the physical and moral strength characteristic of a hero's high-minded interventions on the public stage. On the whole, the portrayal of emotion in response to given actions, rather than the execution of the heroic deeds themselves, seems to have preoccupied the painter more nearly. Consider, for example, the story of Dido and Aeneas, widely acknowledged at the time as one of the finest passages in *The Aeneid* and, of all the books, the one most often translated into French verse.[116] Coypel avoided depicting the moment of agonized fortitude when Aenaes takes his leave of Dido and Carthage, a subject keenly rendered during the previous century,[117] and instead chose to depict separately the two events which bracketed the farewell: Aeneas receiving his marching orders according to Jupiter's wish, and Dido finding in death (fig. 13) carrion comfort for her lover's betrayal. The isolation of the former outside the original narrative flow could not help but rob it of much of its moral vigor and justification,

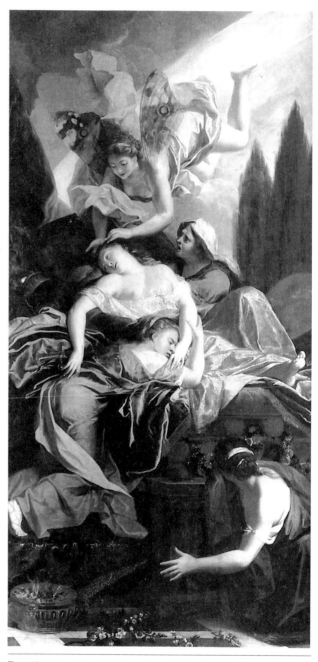

FIG. 13
Antoine Coypel, *The Death of Dido*, 1715–17, oil on canvas, Montpellier, Musée Fabre

whereas the juxtaposition of scenes of Dido's prompt and expansive welcome to Aeneas and Achate with the fatal outcome of her too-generous hospitality surely encouraged sympathy for the victim of the Trojan's uncompromising ambition. At an earlier date, Segrais had already noted a swelling tide of opinion which, fueled perhaps by admiration for Ovid's seventh *Heroides*, judged rude and perfidious Aeneas's

treatment of the siren queen.[118] Moreover, he diagnosed the pressing need to defend Aeneas's attachment to a higher, civic duty as an eloquent symptom of the yawning corruption of contemporary French mores. The queen's excess of passion was now, it seems, more willingly forgiven than the hero's absence of consideration and polish. Thus the passional theory of human personality, advanced by the satirical *nouvellistes* mentioned earlier, was supported no less by a new generation, for whom love represented not a weakness but a calling to culture.

The Triumph of Seduction in the Age of Louis XV

Politeness, unlike arms, was an ideal of "being" rather than "becoming," and the contradictions and tensions between the will to culture and the will to valor were explored more fully in the decoration of aristocratic residences in the following decades. The irrec-

oncilability of the pursuits of pleasure and fame was the *leitmotif* of another Odyssean tale, the story of Telemachus, which some twenty years after the completion of the *galerie d'Énée* inspired six of Natoire's twelve paintings for the gallery at Philibert Orry's château de La Chapelle-Godefroy.[119] Despite Mentor's civic counsel (also illustrated in an overdoor), which initially colored Telemachus's reaction to the sexual freedom, the *mollesse*, and the luxury of the island's natives, the hero gradually found himself becoming accustomed to their ways: "I felt myself weakening day by day; the sound education I had received scarcely supported me still; all my good intentions melted away. I no longer had any strength to resist the wickedness which pressed in upon me from all sides; I was even sickly ashamed of virtue. . . ."[120]

In the book, Telemachus, who like all heroes properly belonged to the fulfillment of his quest, briefly succumbed to a nearer and apparently more

FIG. 14
Charles-Joseph Natoire, *Telemachus's Ship Burned by Calypso's Nymphs*, c. 1739, oil on canvas, Leningrad, The Hermitage

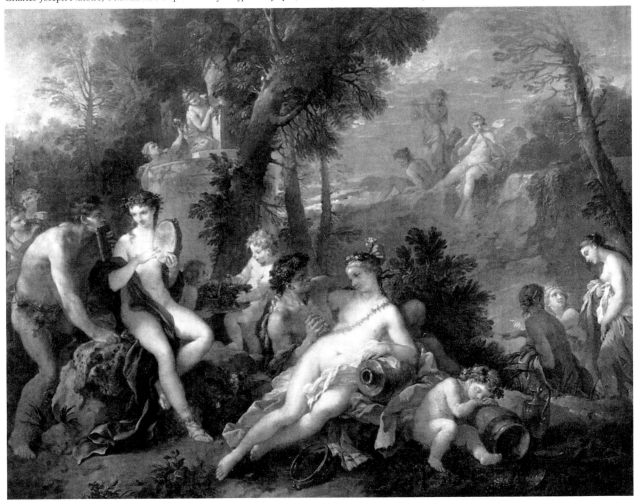

desirable goal: the conquest of pleasure, an isle presided over by Cupid and Calypso and depicted in another overdoor, pair to *Mentor and Telemachus*. However, the allegorized role Fénelon entrusted to Calypso and Mentor did not emerge so clearly in contemporary depictions of the text (and here La Chapelle-Godefroy was no exception), which generally forsook pedagogical contrast for a poetic evocation of Calypso's isle as the realm of love—a necessarily different social and moral polity to that governed by civic heroism, if not an obviously inferior one.[121]

Coupled with the ethical polarities structuring Fénelon's tale was a disparity in the dynamics and orientation of love and heroism. In the first of the two larger canvases of Orry's series, Calypso was shown having attracted and captured Telemachus, while in the second (fig. 14) nymphs inspired by Cupid's torch hastened to set ablaze the captive's ship in order to preempt further movements outward into the public sphere. Where heroism, exemplified in the gallery by a pendant series, *The History of Clovis* (1735–37), was active and demanded a hero's personal but selfless intercession in the events of the world beyond the self (Natoire significantly chose to focus Clovis's life around the battle of Tolbaic and the siege of Bordeaux), love was perceived as drawing its victims in upon themselves, precluding all movement beyond a selfish interaction with or a passive contemplation of the subject desired.[122] The implication of Telemachus's and also Aeneas's brush with eroticism ought therefore to have been that *salon galanterie*, should it become a hero's *raison d'être* instead of his occasional pleasure, would threaten the moral justification of his superiority by bringing about a "fall of public man."[123] Such a whispered warning may have echoed through the *galerie d'Énée*, where the Carthaginian episode was contained and framed within a larger epic plan, but at the *château* near Nogent-sur-Seine Telemachus's adventures on Calypso constituted the only subject of the tale, and though offset by the deeds of the noble Clovis, both sides quantitatively emerged as equally viable options. Moreover, the vanquished Telemachus, like other victims of Venus, such as those depicted by Antoine Coypel in 1708 on the *salon* ceiling at the hôtel d'Argenton,[124] showed none of the moral turpitude or spiritual anguish appropriate to such a fall. On the contrary, they exhibited a seemingly joyous and optimistic capitulation to love's authority. In the case of *The Triumph of Venus over the Gods* perhaps this was only to be expected, executed as it was in the residence of one of the regent's mistresses. However, the erotic mythology of the rococo period was no less widely known for its slack moral will—from which it must be concluded that where

the visual arts acknowledged the traditional disaccord between love and heroism, by the reign of Louis XV it invariably did so in praise of the former.

Between the opening of the *galerie d'Énée* and the completion of the gallery at La Chapelle-Godefroy, the political and economic fortunes of France had not only stabilized but improved considerably. Cardinal Fleury, bishop of Fréjus and first minister in all but name from 1726, had followed the ambitious experiments of the regency with a return to more orthodox and popular policies aimed at securing lasting *détente* both at home and abroad.[125] With subtle diplomacy he maneuvered French national interests away from the temptation of military solutions, particularly conflicts of a scale that seriously jeopardized the controller general Orry's effective but slow administrative efforts toward economic recovery.[126] So successful were Fleury and his personnel of unusually young and able ministers and secretaries of state[127] that, in the opinion of one historian, there followed in the 1730s a period in French history which "for some sections of society at least was the golden age of the *ancien régime*."[128] Though Alfred Cobban certainly had financiers, merchants, and industrialists particularly in mind, the court nobility may also be accounted among the significant beneficiaries of the ministry, although their gains were economic rather than political.[129] In fact, the political dialogue between monarchy and nobility reopened by Phillipe d'Orléans had become increasingly strained and one-sided as the regency unfolded and the dream of a power-sharing, aristocratic monarchy was finally dispelled by Louis XV's declaration on 16 June 1726 that, like Louis XIV before him, he would forthwith personally take up the mantle of government.[130] Moreover, Fleury, as befitted his conservative nature, was careful to return politics to its pre-*Polysynodie* structure, ensuring no direct link between those holding ministerial office and well-established court nobility. By this means, the cardinal won independence from competing factions at court, helped not a little by the birth of a *dauphin* in 1729, which quashed once and for all the pretensions of the "Spanish party," a label here collectively used to refer to those who had continued to rally opposition to the young king after the regent's death by looking to Philip V as a potential alternative and successor in the event that Louis XV should die without issue.[131] The court was of course never without its factions, but for a time, at least, Fleury commanded sufficient control to mute opposition within the court. It may seem appropriate during this period of virtual peace, when advancement was once again no longer to be sought through counsel or on the battlefield but entirely by way of social relations at court, that the discourse of power became deeply figured with erotic codes.

Peter Brooks has amply and richly demonstrated that, in "novels of worldliness," *libertinage* functioned as a paradigm for the search for authority through knowledge.[132] For instance, each love affair entered into by male characters in Crébillon's novels, by increasing the scope of their experience, extended the range of their control over *salon* gamesmanship. Thus, love and valor may have differed in their agencies of domination and in their interpretations of human psychology, but their objectives were invariably the same: conquest. Indeed, in Boucher's *Venus Requesting Vulcan to Make Arms for Aeneas* of 1732 (cat. no. 43), which with its pendant decorated the lawyer François Derbais's billiard room, sex and arms have become visibly so interdependent as sources of power that Aeneas's weapons appear literally forged by the flames of passion.[133] Moreover, when Méré, not unlike Boucher, suggested to *honnêtes gens* that, in order to achieve the most worthwhile superiority, "one should not wish to win at any price, but like heroes in a manner pleasing even to the vanquished,"[134] he did so acknowledging by his use of idiom the formal similarities between the spheres of pleasure and war. However, to imply similarity is of course not to judge things identical. Later, in the 1730s, Jean-Baptiste Rousseau was among those poets to explore more fully the contradictions and complexities in the relationship between these twin divinities through Venus's ultimate preference for Adonis over Mars. True to his nature, Mars was, it seems, too violent and domineering a lover, one whose jealous heart was satisfied with nothing less than possession. Before long Venus was lured away by the more subtle and amiable Adonis, from which the author drew the following lesson:

> On oublie aisément un amour qui fait peur,
> En faveur d'un amour qui flatte,
> Que le soin de charmer
> Soit votre unique affaire,
> Songez que l'art d'aimer
> N'est que celui de plaire.
>
> Voulez-vous, dans vos feux
> Trouver des biens durables?
> Soyez moins amoureux;
> Devenez plus aimables.[135]

It is perhaps worth noting that in contemporary depictions of Venus and Adonis, such as Lemoyne's version acquired by Count Tessin in 1729, the captivation of the goddess by love and her subsequent powerlessness to prevent her lover's fatal departure contrast similarly with the supreme potency of her influence when depicted with her estranged husband Vulcan or her erstwhile lover Mars.[136]

Few, meanwhile, would have argued with Boullainvilliers's claim that "there is no greater distinction among men than that between victor and vanquished,"[137] but the savagery which was said to have secured and authenticated aristocratic superiority during the Frankish conquest was, it seems, no longer sufficient to maintain it. In politics as in art, the fiction of love and *honnêteté* had become equally important instruments of domination in the post-Fronde era. In the cause of distinction, brute force had ceded to pleasing cunning as physical attrition gave way to psychological warfare, but the tactics remained the same: to divine the weaknesses and susceptibilities of others while remaining opaque to their conjectures. With this *mondain* preoccupation with the concealment of self-interest in mind, it may be possible to discern, in part, the specific historical acuity of much eighteenth-century *mythologie galante*.

Ovid's *Metamorphoses* had provided a rich compendium of subjects for the visual arts under Louis XIV,[138] and if its popularity with patrons and artists apparently waned after 1700, the more pertinent difference between seventeenth- and eighteenth-century uses of this source lies surely in the episodes favored. The subjects chosen for the decoration of the ground-floor apartments of the palais des Tuileries, for instance, were those most clearly "*allegoriques du Roi*"[139] and expressive of the speed of his vengeance against those who threatened his sovereignty and that of his descendants (*Apollo and the Cyclops*) or those determined to usurp his authority (*The Fall of Icarus*) or his grandeur (*Midas*).[140] Eighteenth-century selections from Ovid tended to avoid the more obviously didactic tales[141] and generally resisted the custom of allegorization—except perhaps where myths could be called upon to exemplify the elements or rhythms of nature. Watteau, for instance, following La Fosse's initial idea, used the budding desire of *Zephyr and Flora* to capture the rousing spirit of spring in one of a series of four overdoors painted c.1716 for Pierre Crozat's dining room in the rue de Richelieu.[142] Across the river and some ten years later, François Lemoyne decorated the *grand salon* at the hôtel Peyrenc de Moras, home to another ennobled and conspicuously cultivated financier, with stories taken from the *Metamorphoses* but fashioned this time to illustrate the Four Times of Day. The loves of *Aurora and Cephalus* and *Diana and Endymion* respectively opened and completed the cycle, while Noon had conjured a scene of *Venus Showing Cupid the Power of His Arrows* (cat. no. 27), a preparatory drawing for which is in the Louvre (fig. 15), and Evening had evoked *Diana Returning from the Hunt*.[143] In both schemes, metaphor had provided a decorous alibi for the depiction of potentially erotic adventures.

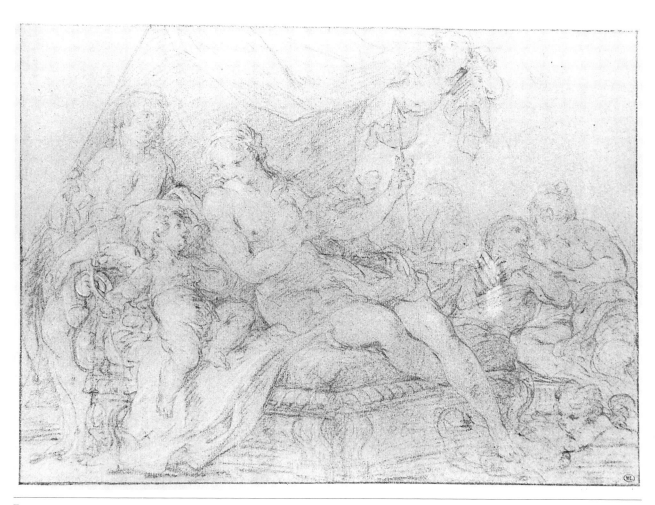

Fig. 15
François Lemoyne, *Venus Showing Cupid the Power of His Arrows*, c. 1729, drawing, Paris, Musée du Louvre

Notwithstanding the repeated and defensive declarations of eighteenth-century translators of Ovid to the effect that his poetry needed its crude sensuality polished away,[144] other patrons apparently needed no prompting to satisfy a taste for mythology without the mantle of iconographic justification, confident in the knowledge, perhaps, that the result would be couched in a stylistic code sufficiently elevated to defy outright criticism.

Regrettably, probate inventories rarely provide precise information about the treasury of themes used in decorative paintings of the period, though we know that the hôtels de Carignan, de Mazarin, de Montbazon, and de Verrue, among many others, were variously embellished with *sujets de fable*.[145] However, one exceptional example survives, the decoration of the hôtel de Soubise, remodeled and considerably enlarged initially by Pierre-Alexis Delamair and then by Boffrand for one of the foremost noble families of the realm. The sculpted decoration of the *chambre de parade*, belonging to the princesse de Soubise and situated on the first floor, included sculpted depictions of the coupled joys of *Venus and Adonis* and *Semele and Jupiter* in the medallions at the center of the wall panels, a cartouche portraying Hebe in one of the angles of the ceiling, and, seated along the cornice, stucco figures of *Bacchus and Ariadne*, *Pallas and Mercury*, and *Venus and Mars*.[146] However, more telling were the images in which surrender was assured by the disguised or veiled approach of the suitor—such as *Diana and Endymion* (fig. 16), which occupies the space above the bed (and possibly alludes to the unlikely captivation of Hector-Méridiac, a septuagenarian, by the teenage Marie-Sophie de Coucillon), the fables of Danae, Leda, and Ganymede in the remaining three ceiling cartouches, and *The Rape of Europa* in a wall medallion. All these stories exploited effects which yielded to sight (a fundamental reason, no doubt, for their pictorial success) and told of the ingenuity and guile of lovers who clothed themselves in shapes that

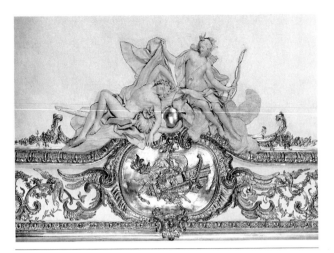

FIG. 16
Diana and Endymion, c. 1737, stucco, *chambre de parade*, hôtel de Soubise,
Paris, Archives Nationales

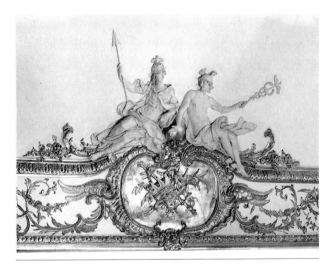

FIG. 17
Mercury and Argus, c. 1737, sculpted panel, *chambre de parade*, hôtel de
Soubise, Paris, Archives Nationales

soonest might deceive those they stooped to conquer.
Love, it seems, was the product of perception, and
Cupid ruled eyes to triumph over hearts. However,
the subject that perhaps most perfectly encapsulated
the *honnête* obsession with the form of conquest was
the fable of *Mercury and Argus* (fig. 17) told in the last
wall medallion, for there Argus invited Mercury (seen
strolling in the background) to tell the tales and play
the sleep-inducing pipes which were to bring about
his downfall, thus illustrating Méré's maxim that civ-
ilized victory secured the voluntary collaboration of
the vanquished in their own defeat. From the certain-
ty of painful retribution announced at the Tuileries
we have moved to the promise of a pleasurable and
unwitting capitulation at Soubise.

The story of Cupid and Psyche (1737–39)[147] told
by Natoire in eight canvases in the adjacent oval *sa-
lon* at the hôtel de Soubise, initially repeated the same
lesson.[148] The first two pictures portrayed the despair-
ing Psyche, who, unable to fix a suitor, was exposed by
her father on a deserted rock in fulfillment of Apollo's
prophecy that the king should abandon all hope of a
"son-in-law of mortal kind" and settle for a "cruel
monster."[149] However, Zephyr came to Psyche's aid
and conducted her to the palace of Love, which she
entered, having been seduced by the genius of the
palace and the welcome of nymphs who offered her
garlands. It was in this palace at nightfall, so the story
goes, that Cupid came under the cover of darkness
and consummated their union, extracting from Psy-
che a promise never to seek to know his identity. Inas-
much as Psyche was little more than an object of erot-
ic possession, the nature of her relationship to Cupid
was equal to those of Europa to Jupiter or Leda to Zeus
already mentioned and might be labeled a slave rela-
tionship because she blindly submits to Cupid's
despotic authority. Psyche's confinement in this kind
of harem was achieved not by force but by the fiction
spun by Cupid that her happiness depended on an ig-
norant submission. It was Cupid's knowledge of the
situation, his ability to define Psyche and gauge her
emotional vulnerability, that gave him mastery and
no doubt also pleasure in the exercise of that power.
However, as Duclos astutely surmised, infidelity was
built into the libertine's will to power,[150] for his au-
thority, like that of the military hero's, was cumulative
and guaranteed only by a succession of victories.[151] His
victim's only chance of escaping repression lay in re-
dressing the balance of knowledge by uncovering, in
turn, her partner's susceptibilities and by penetrating
his psychological motives in order to redirect them to
her own advantage, namely by securing a commit-
ment. The episode of *Psyche Showing Her Sisters the
Gifts She Has Received from Cupid* (fig. 18) marked the
moment of the heroine's grudging *prise de conscience*.
Persuaded by her more worldly and experienced sis-
ters, she determined to discover her lover's identity.
Then followed the famous and most frequently de-
picted scene of the story; Psyche lit her lamp, and the
illumination of Cupid was her own enlightenment
(fig. 19). However, her newfound knowledge initially
accomplished what her ignorance had promised;
Cupid departed, leaving her violated and suicidal.
Nymphs effected a timely rescue, and, having been
saved from drowning in the fifth scene, Psyche was
then delivered into the care of shepherds. Psyche's
sojourn in Arcadia (fig. 20) was an episode in the
Apuleian myth considerably elaborated by La
Fontaine in his highly successful version of the tale,

the likely source for Natoire's scheme. Like the poet, the painter depicted a peaceable interlude furnished with a goat, sheep, and appropriate pastoral activities (a shepherdess holds a distaff, while by her side lies evidence of basketmaking) but devoid of dramatic action to move the story along. The unwarranted attention accorded to this scene by both La Fontaine and Natoire suggests that pastoralism held a specific and more important significance for their audience, and that in Arcadia were to be found the moral codes which would ultimately lead to the successful resolution of this contest of wills. The theme of romantic love in Arcadia stood for the values of mutual trust and fidelity invested in an ideal of traditional, pre-mercantile society, where the absence of competition in human relationships secured the transparency of intentions. It was only in such a context that Psyche could apparently hope to sunder the chain reaction of conquest and inconstancy implied by Cupid's behavior.[152] Thenceforth, Psyche, insensible with fright, was in the penultimate scene brought before Venus, at which point a repentant Cupid appealed for the goddess's clemency and blessing[153] and, once they were secured, Psyche was raised up at last to Olympus in the arms of her beloved.

The vigor of the myth and the root of its outstanding popularity as a subject for decorative painting in the first half of the eighteenth century[154] perhaps stemmed most directly from its narrative and moral symmetry. Ovid's *Metamorphoses* offered tales of disguised conquest and transfigurative deliverance but no instances of resolution to the prolix sexual power games of gods and mortals. Psyche, from the moment she entered the palace of Love, relinquished all possibility of evading subjugation. Unaware of Cupid's intent, she could not in the manner of Syrinx—depicted for instance by de Troy[155]—adopt a disguise capable of defeating her suitor's advances. Arriving incognito, Cupid won the first round, and Psyche had to find other means of retrieving a measure of control, a step which exceeded the narrative scope of the Ovidian tales. A further significant factor of the myth was Psyche's aim to achieve reciprocity. Unlike the seventeenth-century *précieuse* heroine Omphale—but also memorably depicted in the eighteenth century by Lemoyne and Boucher (cat. nos. 23, 42)[156]—Psyche did not overturn the dominion of male subjectivity, thereby debasing and ridiculing the hero, but sought merely to equal Cupid's ability to fashion history. What the story of Cupid and Psyche seemed to question was not the authenticity of chauvinist perceptions of history[157] but the necessity or even desirability of authority centralized in the hands of a single individual. The political implications of such an

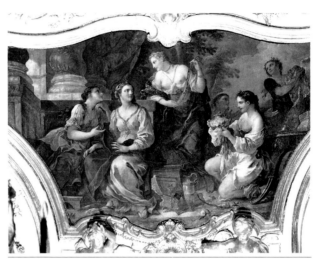

FIG. 18
Charles Natoire, *Psyche Showing Her Gifts to Her Sisters*, 1737, oil on canvas, hôtel de Soubise, Paris, Archives Nationales

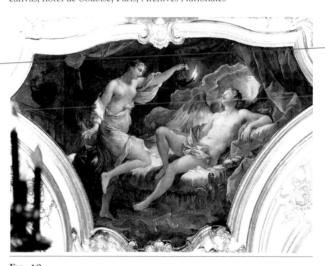

FIG. 19
Charles Natoire, *Cupid and Psyche*, 1737, hôtel de Soubise, oil on canvas, Paris, Archives Nationales

FIG. 20
Charles Natoire, *Psyche in Arcadia*, 1737, oil on canvas, hôtel de Soubise, Paris, Archives Nationales

interpretation are tantalizing indeed, particularly given the divinity of Cupid and the humanity of Psyche, perhaps a last, fading echo of a desired relationship between monarch and citizenry disallowed by divine right. In any event, the story undoubtedly implied that the pursuit of self-interest was not invariably at the cost of the prosperity of others but could, in fact, accomplish a balance of individual needs from which would emerge a superior universal interest.[158] From an obscure and dishonorable affair, Psyche, once she asserted her own interests, acceded to a heavenly marriage.

The decoration of the *salon* at the hôtel de Soubise was remarkable in a number of ways, not least for the sustained elaboration it offered of a single legend. The narrative unfolded in a measured sequence of easily intelligible forms, suggesting that, like a history, there was a lesson to be drawn. Although the decoration of drawing rooms and *cabinets* more commonly sported synoptic depictions of coupled joys, in themselves scarcely suggestive of action—never mind

instruction—the Psyche cycle seems to indicate that beneath these seemingly hackneyed and frivolous rehearsals of divine passion lies a more complex articulation of social and political concerns. The crisis of the last years of Louis XIV's reign had compromised the verisimilitude of history and cut loose mythology from its mooring at the center of royal apotheosis. Prey to the manipulations of a noble and *mondain* society determined to regain lost political ground, myth became a vehicle both for exposing the underside of the *raison d'État* and for exploring the nature of influence alive in a court society. In some senses, therefore, the Goncourts were quite right when they claimed that the new Olympus and the new mythology were "the deification of the ideals of the eighteenth century" and "the spirit of the period."

The research on which this publication is based was carried out with generous support from the Twenty-Seven Foundation.

NOTES

1. Goncourt 1981, 55.

2. Ibid., 64–65.

3. Ibid., 79.

4. For a discussion of the provenance of this picture, see Ingamells 1989, 43–44, 49–52 (P438).

5. The charge that history painting declined in the absence of victories to celebrate has often been made. See, for example, Blunt 1977, 380.

6. For the argument that European culture necessarily progressed toward greater refinement and civility, see Elias 1983, passim, though the author does not make the link between the history of manners and the history of art suggested here.

7. The most thorough discussion of the crisis facing the government from the 1680s is still Rothkrug 1965.

8. On the humanist tradition of history in France, see Huppert 1970, 3–27; Kelley 1970, 19–50, esp. 21–28. On the various genres of historical writing current in France in the seventeenth and eighteenth centuries, see Ranum 1980, 17–21; Furet 1984, 77–98. For an account of the relationship between history and fable from the sixteenth to the end of the seventeenth centuries, see Harth 1983, 129–62.

9. Even though Le Moyne allowed, in chapter VIII of *On the Art Both of Writing and Judging History* (English trans. 1695), that "private actions" might rightfully be given a place in history, it is clear that the actions he had in mind were still those performed by the nobility because they needed to exhibit "some strong and lively Character of Justice, Valor, Moderation, or Continence Extraordinary." Of the actions of "Particuliers," such as gaming, hunting, and dancing, Le Moyne claimed that "Twould be more seemly to see in a Temple or Palace, the signs of shops in the room of Hangings and Pictures" than admit them into the Temple of History (Le Moyne 1695, 104–5). In addition to being excluded from historical narrative, the commoner, according to Fleury, also had little use for history, which, as the passage below reveals, in nobiliary societies was almost indistinguishable from patrimony. "Un homme de condition médiocre," Fleury claimed, "a besoin de fort peu d'histoire; celui qui peut avoir quelque part aux affaires publiques en doit savoir beaucoup plus, et un prince n'en peut trop savoir. *L'histoire de son pays lui fait voir ses affaires et comme les titres de sa maison*" (Fleury 1686, 226 [my emphasis]). History was only of interest to those entitled to behold their part in its making. See Faret 1925, 27, 29.

10. For a discussion of the humanist tradition which construed the printed book as an object to be entered, see Fumaroli 1975, 19–34.

11. Desmarets de Saint-Sorlin 1657, "Au Roy," 32. For a recent discussion of the poet and his work, see Hall 1990, esp. 286–309.

12. Le Moyne 1670, 45–46. For other instances, see also Rapin 1725, II, 231; Rollin 1730, III, 3.

13. See Tyvaert 1974, 521–47, esp. 531–47.

14. See Ranum 1980, 157–68; Harth 1983, 153–62.

15. Chapelain 1880–83, II, 275.

16. Chapelain's letter ends, "Il y a bien, Monsieur, d'autres moyens louables de répandre et de maintenir la gloire de Sa Majesté, desquels mesures les anciens nous ont laissé d'illustres exemples qui arrestent encore avec respect les yeux des peuples, comme sont les pyramides, les colonnes, les statues colosses, les arcs de triomphes, les bustes de marbre et de bronze, les basses-tailles, tous les monumens historiques auxquels on pourroit ajouter nos riches fabriques de tapisseries, nos peintures à fresque et nos estampes au burin" (ibid., 277). See also Colbert 1861–83, V, 268–70. Moreover, Pierre Patte noted the customary advantage enjoyed by the monarch in the sphere of commemorative monuments since, "Il n'est pas d'usage d'élever en France des monumens aux grands généraux ou aux grands hommes célèbres; les Rois seuls obtiennent cette distinction" (Patte 1765, 93). As a result of the Colbert/Chapelain discussions from the following year (1663), the *Académie des Inscriptions et des Belles-Lettres* began to play an increasingly active role in the dissemination of royal propaganda. See Fabre 1890, 411–94.

17. Aucoc 1889, cxviii.

18. Perrault 1843, 308–9. This view of the role of the *premier peintre* is also clearly expressed in the preamble of Charles Le Brun's letters of ennoblement: "Ceux qui ont excellé dans la peinture ont toujours ésté, dans tous les temps, très favorablement traitez dans la cour des plus grands princes, où non seulement leurs ouvrages ont servi à l'embellissement de leurs palais, *mais encore de monuments à leur gloire, exprimant par un language muet leurs plus belles et plus héroiques actions*" (quoted from Guiffrey 1873 [B], 4–6). For a discussion of the ennoblement of artists and the changing attitude toward their role in society as expressed through these preambles, see Chaussinand-Nogaret 1985, 38.

19. See Eliade 1957, 21–98.

20. The unifying principle of monarchy found plastic expression in court ceremonies such as the "carrousel" (see Apostolidès 1981, 41–46), and although the notion of the state incarnate took on its most concrete form in the person of Louis XIV, it was still defended as one of the fundamental laws of the kingdom by his heir. In a seance of the Paris *Parlement* in March 1766, the so-called *Séance de Flagellation*, Louis XV reminded the magistrates that "Les droits et les intérêts de la nation . . . sont nécessairement unis avec les miens et ne reposent qu'en mes mains" (Flammermont 1888–98, II, 558). For the significance of the notion of the king's two bodies in literary and historical writing of the eighteenth century, see Snyders 1965, 371–73; Démoris 1978, 9–30; Kelly 1980, 4.

21. See Jammes 1965, 1–12.

22. See Stephens 1978, 119–20, no. 1364. This particular plate was the twentieth cut out of a collection of forty.

23. Ibid., 119.

24. Ibid., 120.

25. "Not unequal among many" was thus changed to "Now unequal among many."

26. On caricature in France in the late seventeenth and eighteenth centuries, see Blum 1910.

27. For an introduction to the medals of Louis XIV, see Jones 1979.

28. For an enlightening contemporary discussion of differences between medals and texts, see Limiers 1721, VII, 17–22.

29. See Jones 1982, 124–25.

30. As Mark Jones has pointed out, in 1706, when the medal was struck, the legend "he drowns in the Po" served equally to describe the fate of Louis at the hands of the duke of Savoy, as Phaeton's by the bolts of Jupiter. See Jones 1983, 204.

31. See, for example, Stephens 1978, 202–3, no. 1446.

32. See Jones 1979, 18, n. 2.

33. See Church 1975, 43–66, esp. 59. On the propaganda war that ensued and Torcy's attempts to legitimize France's claims to the Spanish throne, see Klaits 1976, passim.

34. See Church 1975, 59–60. Even after the battle of Fontenoy (1745), possibly France's only moment of unquestioned military glory in the eighteenth century, some men of letters, such as the poet Fréron, continued to speak out against the absurdity of wars that resulted from no more than the bickering of kings: "Jusqu'à quand sera-tu (Flanders) le théatre des armes, / Le culte des alarmes, / Et le triste jouet des querelles des rois" (*Mercure de France*, August 1745, 127).

35. For the circle around Madame de Maintenon, see Tellier 1987, 475–509.

36. See Keohane 1980, 327–31.

37. Saint Augustine had taught that the celebration of heroism was but a form of vanity (see Browne 1969, 109–10), a view developed in the seventeenth century by Pascal and La Rochefoucauld, who both denounced "gloire" as no more than pretentious pride (see Bénichou 1948, 155–80). For a continuation of this theme in the early eighteenth century, see Massillon 1865, I, 58–64. On Jansenism as an ideology of opposition in the seventeenth century, see Goldmann 1964, 103–41.

38. This work was one of a set of four prints entitled *Les passions des hommes exprimées par des satyres*, all engraved in 1727 by Jean Audran. See Populus 1930, 150–53, nos. 227–30.

39. See Crow 1985, 59. In 1727, Nemeitz described one of the chief attractions of the fairs, "un singe . . . en mousquetaire," who performed all the appropriate military exercises and rode a dog waving a flag (Nemeitz 1727, 177–78). Since the monkey's manager apparently earned 5,000 *livres* for staging these performances, it seems that Parisians were admirers of both the animate and inanimate forms of *singerie*.

40. First published in 1677–78, the book was extremely popular during the regency and went through no less than twenty editions between 1730 and 1780. See Bardon 1931, 97–106. For Coypel's tapestries, see Fénaille 1903–23, III, 157–282; Standen 1975, 97–106.

41. In popular broadsheets such as Romeyn de Hooghe's *'t Gednonge Huwelyk van Don Quichot de la France* (1706), Louis XIV appears as a malevolent Quixote trying to impose his ephemeral claims to the Spanish throne. On prints such as this, see Hartau 1985, 234–38.

42. In the *Réflexions critiques sur la poésie et la peinture* (1719), Dubos confirms that the humor of Cervantes's novel, like that of Charles Sorel's *Le berger extravagant* (1649), resided for eighteenth-century readers in the hero's confusion of literary metaphor with commonplace actuality. See Dubos 1755, I, 31. For a modern study of eighteenth-century interpretations of *Don Quixote*, see Close 1974, 365–78.

43. See Fénaille 1903–23, III, 157–282; Rambaud 1964–71, II, 1039.

44. The first set of borders for this series featured grotesques and were designed by Claude III Audran.

45. Dubos was among many to recognize the latent political power of images. He maintained that "ceux qui ont gouverné les peuples dans tous les tems, ont toujours fait usage des peintures et des statues pour mieux inspirer les sentimens qu'ils vouloient leur donner, soit en religion, soit en politique" (Dubos 1755, I, 34). Moreover, where preemptive methods failed, censorship took over. Amongst its many victims were Nicolas Fréret, imprisoned in the Bastille in 1715 for questioning the official view of the origins of the Franks (see Church 1975, 62). The optimism of those who believed that the regency would bring a relaxation of the laws governing political expression was rudely quashed when Lagrange de Chancel was similarly imprisoned for his attacks on Orléans in *Les Philippiques* (c. 1720). See Lagrange-Chancel 1858, 106–37; Johnson 1978, 19–20.

46. On the relationship between subject and monarch under absolutism, see Apostolidès 1981, 46–50.

47. This is what Church has described as subject-centered patriotism. See Church 1975, 64.

48. See ibid., 61–62; Leffler 1985, 1–22. Particularly important seems to have been the Dutch periodical press. See Hatin 1865, 82–134; Yardeni 1973, 208–29; Klaits 1976, 19–21. Some contemporaries, such as the marquis de La Fare, even suggested that the French invasion of the Low Countries in 1672 was prompted by a desire to silence the scandalmongering Dutch gazetteers. See Hatin 1865, 65–68.

49. Limiers 1718, "préface de la première edition"; Bayle 1715, III, 852f. See also Cassirer 1951, 208–9.

50. See Leffler 1976, 230–33.

51. An important early advocate of the plain-speaking topos was Isaac de Larrey. In his *Histoire de France sous le règne de Louis XIV*, he argued that the reign did not require "l'art de l'Historien pour l'orner et pour l'embellir" because the king's conquests could and would stand on their own merits. Instead, "il suffit de les mettre en ordre, et de leur donner cet arrangement qui fait la netteté et la clarté de la narration" (Larrey 1722, I, preface—unpaginated). See also Bruzen de La Martinière's summation of the historian's task, in which many of these themes are further developed. Bruzen de La Martinière 1740–42, II, "avertissement" (unpaginated).

52. Quoted from Leffler 1976, 233.

53. See Foucault 1982, esp. 17–77, 217–43.

54. See exh. New Orleans and Washington 1984–85, 209, no. 51.

55. See van Wicquefort 1673, plate immediately before p. 55.

56. The corresponding textual description of events is to be found ibid., 49–53.

57. In the 1680s and 1690s, Courtilz de Sandras wrote a number of semipornographic novels about the king and his court, starting with his own version of Bussy Rabutin's *Histoire amoureuse des Gaules* (1684) and culminating with *Le grand Alcandre frustré* (1696). For a discussion of these works, see Harth 1983, 190–206. Louis XIV's sexual incontinence was also parodied in popular song. See Raunié 1879, I, 8, for one entitled "La vie de Louis XIV" (1715), in which sexual immorality was directly linked to political tyranny.

58. René Démoris has persuasively argued that attention to the common and passionate body of the king offered readers the opportunity to identify with the mysteries of the embodied state. See Démoris 1978.

59. The most obvious example of such a gallery must be the *galerie des glaces*, the vault of which was decorated between 1679 and 1689 with scenes of Louis's military triumphs, starting from 1671 and including the *The Crossing of the Rhine*. The king, brandishing thunderbolts in the manner of Jupiter, was shown crossing the breach aboard his chariot, accompanied by Victories and Fame. No sign of the infantry and cavalry was included even in Van der Meulen's account. The theme also found a place on the ceiling of the *Escalier des Ambassadeurs*. Satire, it seems, had scarcely a chastening effect on the programs devised for the royal residences. On the *galerie des glaces*, see Kimball 1943, 1–6; Hautecoeur 1943–57, II, 541–46; exh. Versailles 1963, 109–19, nos. 36–40, 343, no. 150.

60. In 1739 the Jansenist abbé de Tamiers, Jacques-Joseph Duguet, launched a bitter denunciation of the analogical apparatus which sustained the king's glory: "Je sais que les noms de Mars, de Neptune, de Jupiter sont des noms vides de sens; mais ce sont des noms qui ont servi au démon pour tromper les hommes, et pour faire rendre par eux les hommes divins. C'est donc faire injure au prince que de le mettre à la place de cet usurpateur, et le prince se déshonor en consentant à cette impiété. Cependant les théâtres en retentissent; la musique s'exerce sur ces indignes fictions; les peuples s'infectent de cet espèce d'idolâtrie; les châtiments pleuvent en foule du Ciel sur une nation qui s'est fait un jeu d'un si grand mal" (Duguet 1739, 51). Several years later, the historian Bruzen de La Martinière advanced a more direct attack on the second volume of the *Médailles sur les principaux événements du règne de Louis le Grand, avec des explications historiques, par l'Académie Royale des Médailles et des Inscriptions* (Paris 1723). Bruzen more or less denounced the project as the misguided result of Colbert's passion "de flatter son maître et de contribuer à sa gloire" (Bruzen de La Martinière 1740–42, III, 92). Of the medal struck in 1663 to commemorate the foundation of the *Petite Académie*, which bore the insciption "Rerum Gestarum Fides," Bruzen remarked, "Il est pourtant certain que les membres de cette Académie avoient grandes dispositions à la flatterie, et qu'ils remplirent parfaitement les vues de leur instituteur (Colbert)" (ibid., 93). As examples of such flattery, which resulted in flagrant distortions of historical fact, Bruzen mentioned, among others, the medal struck to celebrate the "prise de Charolais" in 1693 (ibid., V, 18–19) and those that cloaked the invidious Netherlands campaigns of 1696 with the legend of *Mars in hostili sedens* (ibid., 107–8). See also Ferrier-Caverivière 1985, 52–53.

61. Banier 1715, I, 35.

62. For a general discussion of allegory, see Dubos 1755, I, 175–204; for the Medici cycle, see ibid., 180–84. See also Saisselin 1979, 121–47.

63. Ibid., 201–4.

64. On the Palais-Royal, see Champier and Sandoz 1900, esp. I, 215–21 for the gallery; Kimball 1936, 113–17; Kimball 1943, 112–17, 120–22; exh. Paris 1988, 53–115.

65. See exh. Paris 1988, 59, no. 33.

66. On the painted decoration of the gallery, see Schnapper 1969, 33–42; exh. Paris 1988, 79–94; Garnier 1989, 26–27, 34, 151–55, nos. 90–96, 170–75, nos. 127–33.

67. Blondel chose to include the engraving in his *Cours d'Architecture*, thus testifying to the long-term renown of Oppenord's design. See exh. Paris 1988, 71, no. 40.

68. On the Arsenal, see Battifol 1931, 205–55; Babelon 1970, 267–310; exh. Paris and Lunéville 1986, 41–42.

69. These drawings in the Kunstbibliothek, Berlin, are fully discussed by Bruno Pons in exh. Paris and Lunéville 1986, 207–11.

70. On the hôtel de Toulouse, see Ludmann and Pons 1979, 116–28; Kimball 1943, 117–19.

71. For the most recent and thorough discussion of the *affaire des princes*, see Ellis 1988, 169–206.

72. It is clear from surviving drawings that the doors of the *salon* and flanking vestibules were crowned with paired allegorical figures. Moreover, the exterior of the pavilion was decorated with paintings, after designs by Charles Le Brun, which once again invoked princely virtue by allusion to the divine Apollo. See the elevation and section preserved at the Nationalmuseum, Stockholm (CC 2206, THC 6690), exh. New York 1988, 42–43, nos. 24, 25. Six other drawings are preserved in the Louvre, see exh. Paris 1985–86, 63.

73. Boffrand's design for the chimneypiece wall is preserved at The Hermitage, Leningrad, and is illustrated in exh. Paris and Lunéville 1986, 210. Since this room served as an antechamber to both the male and female apartments, Boffrand used the sexes of Bellona and Mars to signal the respective entrances to the duke's and duchess's suites.

74. The suggested identification of the subject of the frieze was made by Pons, ibid., 209.

75. These included the descendants of Henri IV's bastards, notably the Vendôme.

76. For what follows, see Ellis 1988, 170–72.

77. This suggestion seems entirely plausible in view of the duke's later choice of tapestries of the *Conquêtes du Roi* for the decoration of his hôtel in the faubourg Saint-Germain. See Catheu 1945–46, 100–108; exh. Paris 1983 (B), 60.

78. See Ellis 1988, 173–75.

79. Although by the seventeenth century historians were willingly abandoning the search for a Trojan origin to the French monarchy, the popular belief that the kings of France were descendants of a heroic line stretching back to antiquity was slower to dissipate. See Tyvaert 1974, 523.

80. On the paintings of the *galerie dorée*, see Bertin 1901, 1–36; Vitzthum 1966, 24–32; exh. Paris and Milan 1989, 29–46, 184–90, nos. 53–55, 241–47, nos. 84–86, 271–74, no. 98, 305–7, no. 116, 326–29, no. 128. The widow Rouillé kept back for herself a painting of *Andromeda*, after Annibale Carracci, when she sold the *hôtel* to Toulouse. See Ludmann and Pons 1979, 122, 125, n. 42.

81. In exactly the same years, de Cotte's office was, however, elaborating very similar schemes for the elector of Cologne at the Buen Retiro and for the prince of Hesse-Kassel. See Ludmann and Pons 1979, 120–21, figs. 7, 8 (fig. 8 is reproduced upside down).

82. Most notably in the gallery at the hôtel du Grand Maître at Versailles (c. 1727), and then later in Gabriel's decorations for the *salon de la pendule* (c. 1738) and the *salon du conseil* (1755) at the château de Versailles. See ibid., fig. 9.

83. In addition to the *Andromeda* held back by Rouillé, Toulouse rejected an *Aurora and Cephalus* after Annibale Carracci's decoration in the Farnese Gallery and a *Sacrifice* by Cartouchio. For one outraged response, see Maihows 1881, 233–34.

84. See exh. Paris and Milan 1988–89, 39–46, esp. 41–43.

85. Illustrated in exh. Paris and Milan 1988–89, 42–45, figs. 8–17.

86. Much later, La Font de Saint-Yenne was still arguing in favor of using explanatory cartouches for history paintings precisely to avoid such ambiguity or confusion. See La Font de Saint-Yenne 1754, 110–15.

87. For the hôtel de Seignelay, see exh. Paris 1983 (B), 53–58.

88. For the hang of the *grand appartement* at Versailles, see Constans 1976, 157–64.

89. See Lamy-Lassale 1979, 142–48; exh. Paris 1979 (B), 10–12.

90. Some of the copies have been identified by Lamy-Lassale: a Sybil after Guido Reni; a Danae after Correggio; a Pomona after Nicolas Fouché; and a Nymph after del Sarto. See Lamy-Lassale 1979, 144.

91. Villars reserved for the garden the most blatant expression of his martial endeavours. In 1719 he commissioned from Nicolas Coustou a full-length portrait of himself, described by Dézallier d'Argenville as follows: "Il est vêtu à la Romaine, et on voit sur son front cette noble audace qui caractérise les Héros. La base de cette statue offre différens attributs qui sont autant de symboles de son goût pour les lettres et les arts, de l'abondance et de la paix qu'il a procurées à sa Patrie" (Dézallier d'Argenville 1752, 342). Though he is described as a hero, no mention is made of the battles in which he fought or the conquests he made; he is praised instead as a patron of the arts and the herald of peace. The hero is no longer the valiant soldier but the cultured diplomat, as the inscription in golden letters on the façade of the hôtel de Villars—*Mars restituor vendex pacifer / Et pacem et pacis perperit victoria fructus*—insisted, Villars's Roman armor notwithstanding. See exh. Paris 1979 (B), 34–35.

92. See exh. Paris 1979 (B), 34–35.

93. See Parker 1969, 135; exh. Paris 1984 (B), 73–77.

94. There is an analogy to be made here between the nobility's visual and textual enjoyment of history. In the preface to his *Histoire du règne de Louis XIII, roi de France et de Navarre* (1700–1711), for instance, Michel Levassor remarked upon the similarity between a nobleman's demands of history and his requirements of travel—that they should both afford pleasure and diversion. "On veut tuer le temps et se desennuer. Il suffit qu'un livre soit agréable et divertissant. On ne se met nullement en peine de profiter des examples de la vertu qui s'y recontrent, ni de refléchir sur les fautes de ceux dont il est parlé" (Levassor 1700–1711, I, preface—unpaginated). There are, of course, exceptions to every generalization, and some nobles apparently continued to favor battle paintings. Parrocel the elder, for instance, provided some such overdoors for the hôtel de Tallard (see Dézallier d'Argenville 1752, 211), and in the gallery of the hôtel de Richelieu hung two battle paintings by Martin, though they were not to compare in value to François Boucher's overdoors for the *salle des gardes* and the *salon* (see A.N., Minutier Central, II/741, "Inv. après décès" 19/viii/1788, items 882, 892, 1140).

95. See Gallet 1976–77, 84–85.

96. See Ellis 1988, 180.

97. For the duc de Bourbon's so-called "regiment," or faction, see Arsenal MS. 3892, fols. 68–70; Marais 1863–68, I, 293.

98. See exh. Paris 1983 (B), 71–74. For de Belle-Isle's taste in decorative painting, see exh. Cholet 1973, 88.

99. For a detailed discussion of the political factionalism during the regency, see Campbell 1985, 64–98.

100. The irony was particularly acute in the case of the duc du Maine, in whom a sympathetic reading of the memoirs of the Cardinal de Retz had apparently provoked a treasonable desire to play a latter-day duc de Beaufort. See Saint-Simon 1879–1930, XXIX, 86–87.

101. *The Aeneid* was in fact just the opening poem of a translation of Virgil's complete works. See Marolles 1655.

102. Ibid., "Au Roy."

103. Segrais 1700, "Au Roy."

104. See Du Plaisir 1683, 41. Meanwhile, Perrault argued in more general terms that "comme les poètes grecs et latins *n'employèrent* point dans leurs ouvrages la mythologie des Egyptiens, les poètes françois ne devoient point employer les fables des Romains et des Grecs" (Perrault 1692–97, IV, 316). For a discussion of Perrault as a *moderne*, see Picon 1989, 103–14.

105. Charles-Antoine Coypel recorded in his life of his father that the prettiest women at court vied with one another to model for a place in the *Assemblée des dieux*. See Lépicié 1752, II, 20.

106. The vault was painted between 1703 and 1705 and the wall paintings between 1714 and 1718. For a discussion of the disruptive effect of the chronology of the commission on the sequence of Coypel's Virgilian narrative, see Schnapper 1969, 33–42, esp. 39.

107. Otherwise, Aeneas makes only one further appearance on the vault, in the *Assemblée des dieux*, sheltered under an eagle's wing between Venus and Jupiter. His presence clarifies in visual terms Venus's purpose but is completely unsanctioned by the Virgilian text.

108. Thus, while Coypel elaborated the *Assemblée des dieux* (see above n. 107), he omitted entirely episodes from books 5 and 10.

109. Le Rouge 1719, I, 144–45.

110. Brice 1725, I, 242–43.

111. It should be noted, however, that Le Rouge made mistakes in the sequence he mapped out. See Le Rouge 1719, I, 144–48.

112. Ibid., 147. The brilliance of the colors was short-lived however, thanks to Coypel's ill-fated experiments in technique. See Lépicié 1752, II, 35. The paintings were probably removed from the gallery in 1783 and were then sent to Saint-Cloud. According to the architect Henri Piètre, Jean-Baptiste-Marie Pierre was behind the removal of the paintings from the Palais-Royal. Jealous of Coypel's reputation, Pierre, he had dared, "les auroient Brulés afin qu'il ne restat dans Paris que les tableaux de son tems ou de son Ecolle." However, the painter apparently contented himself with persuading the abbé de Breteuil, Orléans's chancellor, and Liébaut, the concièrge of the Palais-Royal, that the paintings should go. The day came for their removal: "L'inexorable Pierre, et l'imbécile Liébaut vainrent dans cette gallerie, avec le grand se-

cret, dans la crainte que je [Piètre] ne fís des représentations à Mgr le duc d'Orléans, et ordonnerent (non pas que l'on en deposa les dits tableaux avec leur chassis, n'y que l'on en deposa les Bordures) qu'on ce servoit de couteaux et que l'on coupa les toilles au tour des bordures afin que cela soit plus tot fait, et dans la crainte qu'il ne vaint contre ordre, ces tableaux furent portés au château de St. Cloux comme au magazin des tableaux de nule valeur de la maison d'Orléans, et dans Les Bordures restantes de ces grands tableaux de la gallerie du Palais Royal Mr Pierre fit mettre les tableaux les plus precieux du Palais Royal. Mais ces tableaux n'étoient point faits pour cette gallerie n'y la gallerie faite pour ces tableaux" (A.A.P. Ms. 51, fols. 250–52). Could this be the reason behind the delay of over a year between the removal of the pictures and the destruction of the gallery?

113. One dimension of the quarrel concerned the right of the translator to intervene in the original text, changing and rearranging those passages that seemed outmoded or even shocking to "modern" minds. See La Motte 1714, cxxxviii–clxxii; Dacier 1715, 225–60.

114. In a passage from the foreword to the iconographic description of the ceiling apparently written by Lemoyne to aid interpretation of his work, the painter makes this point particularly clearly: "The love of virtue," he announced, "raises man above himself and makes him superior to the most difficult and perilous labors: *the obstacles vanish at the sight of his king and his fatherland.* Sustained by Honor and Fidelity, he attains immortality by his own actions. *The Apotheosis of Hercules* suggests this thought" (my emphasis). See Bordeaux 1976, 309–10.

115. The accent on the regent's taste was made clearer by the inclusion of certain choice paintings from the Orléans collection hung in all likelihood between the windows. See exh. Paris 1988, 63. Included among them was a *Portrait of Charles I and His Family* after Van Dyck, currently at Goodwood House, for which Michel Lange provided a particularly elaborate frame. See Pons 1987, 46, fig. 14.

116. Best known was perhaps Boileau's translation published after his death in 1670. According to the publisher, Boileau had frequently been called upon to read it out loud, "en plusieurs réduits célèbres," and it had been much admired by those of the highest quality. See Boileau 1670, 1–67. However, more than forty years later and soon after Coypel had completed his representation of the theme, Jean Bouhier embarked upon a new translation, needed, he felt, because in Boileau's "on . . . trouve . . . une infinité d'expressions qui blesseroient sans doute la délicatesse des oreilles modernes" (Bouhier 1742, xxii).

117. One of Jean Lemaire's overdoors in the *salle des amiraux* at the hôtel de Toulouse, for instance, depicted Aeneas's departure with Dido's suicide in the background. See Piganiol de La Force 1765, III, 258.

118. Segrais 1700, 52–56.

119. On the commission for the château de La Chapelle-Godefroy, see exh. Troyes, Nîmes, and Rome 1977, 54–60, nos. 7–14. The pictures, along with "six bustes de marbre blanc représentant des empereurs romains sur leurs pilastres couverts de marbres gris et blanc," are listed in both Philibert Orry and Orry de Fulvy's inventories (A.N., Minutier Central, XXIX/477, "*Inv. après décès,*" 11/xii/1747; A.N., Minutier Central, XXIX/488, "*Inv. après décès,*" 26/v/1751). The *Telemachus* series consisted of two

overdoors, *Mentor and Telemachus* and *Cupid and Calypso* (both 1740, Troyes, Musée des Beaux-Arts et d'Archéologie), and four wall paintings: *Telemachus at the House of Calypso* (c. 1739, Leningrad, The Hermitage); *Telemachus's Ship Burned by Calypso's Nymphs* (Leningrad, The Hermitage); *Venus Presenting Cupid to Calypso* (c. 1739, Moscow, Pushkin Museum); and *Telemachus and Eucharis* (c. 1739, lost).

120. Fénelon 1968, 129.

121. Other versions of the Telemachus theme include Jean Raoux's *Telemachus Recounting His Adventures to Calypso*, presented by the duc de Vendôme to the regent in 1722 (Louvre, inv. 7362); some nine canvases by Henri de Favanne, exhibited variously in the Salons of 1737, 1746, and 1748; Louis Galloche's two works exhibited in 1743 and 1746; and Natoire's own later treatment of the text for the *Dauphin*'s apartments at Versailles.

122. It is difficult to know precisely how the paintings were hung in the gallery, whether along a single wall as at the *galerie d'Énée* or as complementary tales facing one another across the room. The Orry's inventories describe them as located between windows. See above, n. 119.

123. The phrase is borrowed from Sennett 1974.

124. On the hôtel d'Argenton, see Lépicié 1752, I, 24–26; exh. Paris and Lunéville 1986, 190–93; Garnier 1989, 161–62, no. 110.

125. See Campbell 1985, 186–217.

126. Ibid., 200–202, 215.

127. See Antoine 1989, 270.

128. Cobban 1979, 37.

129. For a general discussion of the economic fortunes of the nobility during the eighteenth century, albeit the later eighteenth century, see Chaussinand-Nogaret 1985, 43–64.

130. Antoine 1989, 265.

131. See Campbell 1985, 205–7.

132. See Brooks 1969, 40.

133. For a recent discussion of this picture and its pendant, *Aurora and Cephalus*, see exh. New York, Detroit, and Paris 1986–87, 133–38, nos. 17–18.

134. Méré 1930, I, 52. Cited in Stanton 1980, 64.

135. Rousseau 1753 (A), I, 289.

136. The picture was painted in 1729, but the provenance of the work before its acquisition by Tessin was unknown: see the discussion in cat. no. 26.

137. Quoted from Furet 1984, 130.

138. See Bardon 1957, 401–16.

139. For these pictures by Nicolas Loir, see Hautecoeur 1927, 133.

140. See Brice 1706, 81–83.

141. One exception to this general trend may have been La Fosse's ceiling for Pierre Crozat's gallery at Montmorency (see Stuffmann 1964, 16–17), which depicted *The Fall of Phaeton* (1707–9). According to Panofsky, the fate of Phaeton was a warning to every "temerarius," whose ambition tempted him to seek to rise above his allotted station in life (Panofsky 1972, 219). It is difficult to understand why Crozat should have chosen such an apparently self-reproaching theme, but he was by no means alone. In 1716, Henri de Favanne painted a version of the subject on the ceiling of the *salon* at Chanteloup for Jean d'Aubigny (see Dussieux et al. 1854, I, 241–42), and Nicolas Bertin treated the same theme between 1710 and 1720 for his patron M. de Saint-Bonnet (see Lefrançois 1981, 282–86).

142. See Levey 1964, 53–58; exh. Paris 1984–85 (A), 324–28, nos. 34, 35; Roland-Michel 1984 (B), 39–40.

143. On this series see Bordeaux 1984 (A), 116–17, nos. 80–83.

144. In May 1705 the *Journal de Trévoux* announced with approbation the publication of a new Italian edition of the *Metamorphoses*, "purgées de toute obscénité," by the Jesuit father Joseph Jouvency (May 1705, 833–37). Meanwhile, in France, the possibly more worldly abbé de Bellegarde seemed to defend the eroticism of the fables on the grounds that it would teach readers that "les désordres des passions . . . leur font en quelque manière ressembler aux bêtes." But he too felt the need to censor the text of descriptions and expressions that would seem "un peu trop libre" in the vernacular (Bellegarde 1712, "avertissement"). Finally, the abbé Banier in his 1732 translation argued that the passions of the gods "sont toujours exposez avec trop de licence," and he added that "les portraits que fait Ovid dans ses occasions sont trop vifs; la pudeur y est peu menagée" (Banier 1732, xiii–xiv). In order to ensure that such passages should not excite the reader to sexual indulgence but rather teach him or her to avoid such moral weakness, Banier felt justified in curtailing the supposed excesses of the text. See also the review in the *Journal de Trévoux*, April 1733, 649–58. Rarely does such concern arise in the reedition of the Latin original since it was believed to be linguistically and culturally inaccessible to those most prone to perversion, namely, women and the lower social orders.

145. Jean-Baptiste Van Loo, soon after returning from Italy in 1719, painted "de grands tableaux" inspired by the *Metamorphoses* for Carignan's hôtel de Soissons (Papillon de La Ferté 1887, II, 606); Charles Natoire painted four overdoors, "sujets de fables," in c. 1737 for the second *salon* at the hôtel de Mazarin (exh. Paris 1981, 46); the *salon d'assemblée* at the hôtel de Montbazon was, in 1751, decorated with overdoors depicting subjects both sacred and profane (procès-verbal d'estimation 15/vii/1751, A.N., Minutier Central, CXVII/785); and the decoration of the comtesse de Verrue's *hôtel* in the rue Cherche-Midi included a large number of mythological paintings, some of which can probably be identified with decorative works executed for her by the Boullongne (Rambaud 1964–71, II, 891).

146. See Langlois 1922, 170–72. Although this cornice was attributed to Nicolas-Sébastien Adam by eighteenth-century guidebooks, Pons convincingly argues that the ornament sculptors Lange, father and son, and Herpin were more likely executants of this scheme. See exh. Paris and Lunéville 1986, 224–25.

147. On the pictorial fortune of the story of Cupid and Psyche, see Gallet 1972, 135–36.

148. On this series, see Langlois 1922, 174; exh. Paris and Lunéville 1986, 255–67.

149. Quoted from exh. Paris and Lunéville 1986, 258–59.

150. See Brooks 1969, 11–43, esp. 22–23, 40.

151. Duclos 1965, 239–40: "C'est l'usage parmi les amants de profession d'éviter de rompre totalement avec celles qu'on cesse d'aimer. On en prend de nouvelles, et on tache de conserver les anciennes, *mais on doit surtout songer à augmenter la liste*" (my emphasis).

152. For a different interpretation of the same episode treated by Boucher in his Beauvais *Psyché*, see Hussman 1977, 45–50.

153. As Violette notes, Natoire once again takes liberties with the texts of Apuleius and La Fontaine in the depiction of this scene (exh. Paris and Lunéville 1986, 261). Natoire or Soubise seems to have favored a less violent conclusion to the story.

154. Natoire himself rendered the legend on two other occasions, first for the decoration of the former hôtel de Montmorency in the rue Saint-Honoré and second in the form of two paintings, apparently used as room dividers at the château de la Chevrette, home to the *fermier général* La Live de Bellegarde (cat. no. 39). See exh. Paris and Lunéville 1986, 260, 262–67. Moreover, Lemoyne, who may have inspired Natoire's choice of the tale for Soubise, himself treated the theme a number of times in the early 1730s (see Bordeaux 1984 [A], 121–22, nos. 92–94), at the same time that Boucher delivered an overdoor depicting *The Marriage of Cupid and Psyche* for the decoration of the *salon* at the hôtel de Mazarin (see exh. Paris 1981, 46). Lastly, for examples of the story's use by the *Bâtiments du roi*, see below, n. 158.

155. See, for example, a version acquired by The Cleveland Museum of Art, Talbot 1974, 250–59.

156. On Lemoyne's picture, exhibited at the 1725 Salon, see Bordeaux 1984 (A), 93–95, no. 47; and for a discussion of a second autograph version, see exh. New York, New Orleans, and Columbus 1985–86, 77–80, no. 8. For Omphale's place within the pantheon of *précieuses* heroines, or "femmes fortes," see Maclean 1977, 217–18. In the seventeenth century, the story of Hercules and Omphale offered an instance of role reversal where triumphant woman enslaved heroic man. Omphale claimed the lion's skin and Hercules's club, while the latter was turned into an object of mockery, dressed up in women's clothing, and wielding no more than a distaff and spindle. The iconography and antiheroic spirit of the thus-constituted myth were certainly known to Lemoyne since he owned a copy of Le Comte's *Mythologie* (1610), in which the tale was so told, and his picture was faithful to the source insofar as the costume and attributes of the figures were concerned. However, by the eighteenth century the meaning of the story had undergone a subtle change, one signaled in the picture by the prominence of Cupid. In a poem published in the *Mercure de France* in celebration of Lemoyne's canvas, the poet—M. Moraine—allows Hercules to explain that this burlesque episode of transvestism did not literally occur and that the purpose of the myth (or more accurately the fiction within the myth) was to illustrate the salutary and democratic power of love: "L'Amour seul donne un caractère / De bonne-foi, d'humanité: / Vainqueur de plus d'une chimère, / Il introduit par tout l'heureuse égalité" (*Mercure de France*, March 1725, 468–73). This "heureuse égalité" was expressed formally by Boucher when he placed his two protagonists on exactly the same footing (see cat. no. 42). The meaning of Hercules and Omphale for the eighteenth century was therefore closer to the lesson of Cupid and Psyche discussed above, but the ribaldry traditionally associated with Hercules' vacation in Lydia no doubt explains its comparatively minor success as a vehicle for polite values. By contrast, examples of the seventeenth-century theme of "women on top" were still to be found in eighteenth-century broadsheets. See, for instance, Burke 1978, pl. 18.

157. For a seventeenth-century challenge leveled at male ideology, see Harth's discussion and interpretation of Madame de Lafayette's *La princesse de Clèves* (Harth 1983, 201–3). Stanton suggests, moreover, that much of the satirical criticism ranged against the *précieuses* in the late seventeenth century was a response provoked by the feminist challenge for a cultural superiority. See Stanton 1980, 28.

158. It should be noted that the story of Cupid and Psyche was also a popular subject for the decoration of royal palaces. See, for instance, the overdoors executed in 1746 by Carle Van Loo for Marie-Thérèse d'Espagne (exh. Nice, Clermont-Ferrand, and Nancy 1977, nos. 92–93) and those executed by Jean Restout for the apartment of Marie-Joseph de Saxe at Versailles in 1748 (exh. Rouen 1970, 61–62, nos. 33–34).

BOUCHER'S BEAUTIES

DONALD POSNER

In a painting that Boucher exhibited in the Salon of 1742, two young, beautiful women are seen on the bank of a lake or stream (cat. no. 46). They seem to have retired to a hidden place in the forest, where they are sheltered by rocks and reeds and a canopy of foliage. They are shown in a moment of astonishing intimacy, both naked except for wisps of drapery, one woman reclining against her seated companion, whose left arm encircles her shoulders. Suddenly, a swan leaves the water and climbs the bank to rub his head against the thigh of the seated woman. She lifts her right arm in surprise as she and her friend gaze at the bold animal.

A spectator unfamiliar with Greek mythology might interpret the picture as a curious, but not implausible, genre scene of the experience of two bathers in a forest glade. Any informed observer will know, of course, that the seated woman, pearls in her hair and on her arm, is the princess Leda, daughter of King Thestius of Aetolia, and that the swan is, in reality, the greatest of the ancient gods, the lustful Jupiter on one of the many amorous adventures in which he seduced fair mortal maidens by appearing to them in innocent-seeming metamorphic disguises. He or she will know too that Leda will allow the bird to have his way with her (and, as a result, give birth to eggs from which were hatched Castor and Pollux, and perhaps Helen of Troy and Clytemnestra, too). But while knowing all this, the observer must still wonder why Boucher chose to depict a moment in the story when its narrative import remains unclear and the erotic drama is only hinted at.

The myth of Leda and the swan was a popular one in art since about 1500, and Boucher surely knew and admired the great illustration of it that had been made by Correggio (fig. 1). It was owned by his colleague, the painter Charles-Antoine Coypel, when Boucher was making his own picture of the subject. Correggio's depiction accords in spirit with Ovid's brief mention of the scene as it appeared woven into Arachne's tapestry, where Leda was seen "beneath the swan's wings."[1] Most representations of the story, in fact, ancient as well as modern, show the moment of the actual, or immediately impending, coition of bird and human.[2] Correggio's swan is already in Leda's lap, his left wing and right foot forcing her thighs apart, while his long neck glides up between her breasts and his beak caresses her cheek.

Surprisingly, Boucher, whom we usually think of as reveling in erotically provocative imagery, suppressed the overtly salacious aspect of the standard formula for the scene and, moreover, even dimmed the allusion to its amorous nature. That he did this intentionally is proved by X-ray photographs of the painting and also by its relationship to a hitherto unnoticed source for the design. The X rays show that originally Boucher planned to show Leda reclining with the swan close upon her (fig. 2). Evidently deciding that the arrangement did not suit his purposes, he turned the canvas upside down and began again. In redesigning the picture he had recourse to a now lost painting of 1693 by Nicolas Bertin (fig. 3).[3] The pose of Leda was taken over from Bertin's work (it is reversed in the print), as was the placement of the swan, which, not yet having mounted the girl, stands to one

FIG. 1
Correggio, *Leda and the Swan*, c. 1531–32, oil on canvas, Berlin, Staatliche Museen Preussischer Kulturbesitz, Gemäldegalerie

Fig. 2
X-ray photograph (initial idea seen when image is inverted), François Boucher, *Leda and the Swan*, 1742, Collection of Mr. and Mrs. Stewart Resnick.

side of her. But Bertin had clarified the narrative by showing the swan's beak within kissing distance of Leda's face, by introducing two cupids, one pointing at the girl, and, by way of demonstrating the mythological nature of the event, showing Jupiter's eagle in the sky. Boucher dispensed with these narrative glosses. Furthermore, he departed from customary practice by including a second woman, whom he coupled intimately with Leda. While she may have been suggested by the subsidiary figures who appear in Correggio's painting,[4] her presence here introduces an unprecedented, competing pictorial theme. This has puzzled at least one art historian, who remarked also that the pose of Leda's companion is not "in keeping with the sense of the scene."[5]

The unusual features of Boucher's representation were noted in the eighteenth century. In announcing the publication of a print after the picture in 1758,

the *Mercure de France* called attention to what still seemed, sixteen years after it was painted, "the novelty of its interpretation of the subject."[6]

The formal beauty of Boucher's *Leda and the Swan* has always been greatly admired, but its iconographic novelty has not been much appreciated in modern times. Boucher has generally been regarded as an artist little interested in the narrative or dramatic details of the stories he illustrated. The iconographic oddities of many of his pictures therefore usually go unnoticed,[7] on the assumption, it seems, that they lack purpose and are merely the result of a certain flippancy or indifference, the narrative having been on the periphery of the field of vision of an artist focused almost exclusively on the formal, decorative potential of his subject matter.[8]

It is, of course, true that Boucher was not a man given to theoretical speculation, and it would certainly

FIG. 3
Bernard Picard after Nicolas Bertin, *Leda and the Swan*, 1693, engraving, Paris, Bibliothèque Nationale, Cabinet des Estampes

missions and money mostly wanted amusing illustrations of mythological fables, not serious moralizing pictures from biblical or ancient history, which he painted only occasionally. In his day, as the abbé Pluche remarked in 1739, the Greek and Roman gods were everywhere: in songs, in the decoration of apartments, gardens, and public squares, in engravings, paintings, and poems. The learned abbé added the complaint that the gods were not presented with any instructive purpose. "Jupiter's gallantries," he said, were represented only in order "to fill our thoughts with pleasures and indulge our passions . . . in a continual series of wanton sports."[9]

Boucher, no moralist, catered to the taste of his time. He was, of course, not alone in doing so, and many of his artistic means had been prepared by the generation of his teachers and were shared by many of his contemporaries. But he understood especially well the direction eighteenth-century Parisian taste had taken, and he followed it, and contributed to it, with extraordinary originality.

It was not just mythology, but "gallant" mythology that the public wanted to see. Subjects that carried moralizing or allegorical messages, and which had been popular in the seventeenth century, such as *Hercules at the Crossroads Between Vice and Virtue* or *Hercules and Cacus*, were less frequently represented now;[10] the popularity of the ancient hero remained undiminished, but it was less the accounts of his heroic self-restraint or virtuous domination of antagonists than his willing submission to the beauteous

FIG. 4
Jacques Dumont le Romain, *Hercules and Omphale*, 1728, oil on canvas, Tours, Musée des Beaux-Arts

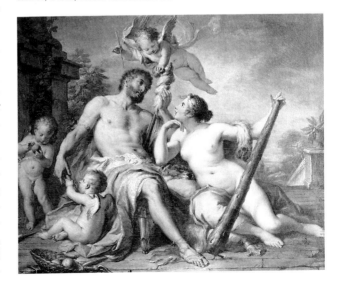

be wrong to suggest that his works were the result of any programmatic intentions. But I should like to suggest that professional intuition and artistic instinct led him to shape individual pictures in ways that cannot be explained as accidental. He must have made deliberate, conscious choices, as is indeed proved by the history of the design of *Leda and the Swan*. Some of those choices led to artistic ideas that were not fully exploited until the nineteenth century.

Boucher's career itself reflects an intelligent assessment of his own talents and of the contemporary market demand for art. He ranged widely over the genres, painting everyday scenes, exotic genre pictures, landscapes, and portraits. But he made his primary claim to professional status as a history painter, the top rung on the artistic hierachy of his time. And he recognized that the consumers readiest with com-

Queen Omphale that especially piqued the fancy of eighteenth-century spectators.

Representations of the Hercules and Omphale theme, four of them in the present exhibition, reveal the changes that were taking place in the interpretation of myth. They reveal, too, Boucher's independence and inventiveness. One way to read the story of Hercules's exchanging his club and lionskin for Omphale's distaff and draperies was as a demonstration that unbridled sensual desire is unmanly and results in humiliation and defeat. This moral reading had some currency in the sixteenth and seventeenth centuries and was not forgotten in the eighteenth century,[11] although the related but less censorious and apodictic formulation that "love makes fools of the strongest men" has always been the more usual way to understand the story.[12] Two of the pictures of the subject in the exhibition are by tradition-oriented painters who participated in the effort to revive the "*grandeur*" and didactic aims of the art of the age of Louis XIV, and who thus helped to prepare the way for the coming of neoclassicism. Not surprisingly, they retain the old emphasis on Hercules's humiliation. It is especially strong in the humorless and declamatory depiction of the story by Charles-Antoine Coypel (cat. no. 33), where the hero sits humbly on the ground at the feet of his regal mistress. In Noël Hallé's version of the subject (cat. no. 54), obviously influenced by Coypel's painting, the theme is given the same sense, but in attenuated form, and the picture, together with its pendant (cat. no. 55), seems a kind of lighthearted admonition about the dangers of immoderate indulgence in pleasure.

The remarkably sensuous version of the theme by Lemoyne (cat. no. 23), however, takes a quite different approach to the story. His Omphale does not command, but embraces Hercules, and the couple gaze with loving passion into each other's eyes.[13] Jacques Dumont, in a painting of 1728 that was surely influenced by Lemoyne, went a step farther in suppressing the suggestion of Omphale's domination of the hero. The mistress now sits beneath Hercules, at his feet, looking up lovingly at him (fig. 4). These pictures demand an "enlightened" reading of the theme, one that was readily available to spectators. In the myth, after an outburst of mad, uncontrolled passion that led him to commit a murder, Hercules cures himself by submitting to the amorous restraints of Omphale. In short, the paintings by Lemoyne and Dumont illustrate a gentle, and not very profound, truism: love can tame the savage beast in us.

But the most original "modern" version of the theme was created by Boucher (cat. no. 42). In his depiction—which intensifies the content of the

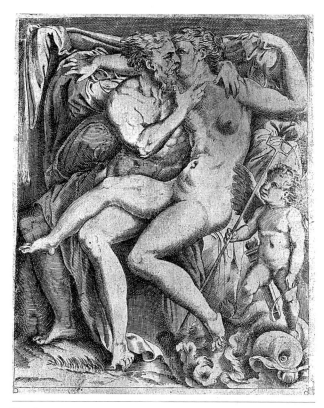

Fig. 5
Gian Giacomo Caraglio after Perino del Vaga, *Neptune and Thetis*, etching, London, The British Museum

painting by his teacher, Lemoyne—Hercules and Omphale, locked in a tight embrace, fulfill their mutual love with a deep, passionate kiss. Neither dominates. He, slightly above her, takes possession of her with grasping hand and eager mouth; but Omphale's leg is flung across his lap, indicating that while she belongs to Hercules, she also possesses him. The old theme of Hercules's submission and humiliation has in effect disappeared. Two cupids in the right foreground hold the lionskin and distaff of the story, but it is not possible to say to which of the lovers either now belongs. The attributes have become incidental details, minimal indications for identifying the fable.

Boucher's picture might be read allegorically as showing the joyous result of subduing aggressive urges and the will to dominate, of their sublimation in the passion of mutual, amorous surrender. But it is above all the daring erotic intensity of the image that grips the spectator. It was unprecedented to show Hercules and Omphale kissing, and bold enough just to represent a kiss of such passionate depth. Comparable amorous scenes are uncommon in paintings before Boucher,[14] although they are readily found in the

more private medium of prints. Boucher may, in fact, have been inspired by a print such as Caraglio's *Neptune and Thetis* (fig. 5).[15] In any event, his painting is a major precedent for such osculatory images as Fragonard's *The Happy Lovers* (fig. 6) later in the eighteenth century and Rodin's famous sculpture in the next century.[16]

The beauty of two sublime bodies locked in hot embrace—not the mythological allegory—is the true theme of Boucher's painting. If Boucher had merely omitted the symbolic attributes held by the cupids and given the setting a more modern, domestic look, the picture would have become a daringly erotic genre scene. The minimal association with ancient myth was a pretext, although a necessary one at the time if such a risqué image was to be shown in public. What must be stressed, however, is that the picture can hardly have been produced without a clear awareness on the artist's part of how, and how far, he was departing from precedent and what his innovations implied.

Boucher *chose* not to be a storyteller. He directed his pictorial energies instead to the creation of erotically exciting and aesthetically breathtaking forms, and the world of mythology, tolerant of nudity and licentious manners, became his artistic playground. Again, it is important to emphasize that Boucher had no programmatic intent. Many of his mythological paintings are fairly conventional in presentation, especially those, like *Venus Requesting Vulcan to Make Arms for Aeneas* (cat. no. 43) or *The Rape of Europa* (cat. no. 47), in which the subjects had traditionally served to

display lovely forms and surroundings. In Boucher's production there are also many nonnarrative portrayals of the ancient goddesses: the Three Graces or Venus—at her toilet, sleeping, playing with Cupid (cat. no. 48)—or, in his most famous orchestration of feminine pulchritude, the so-called *Triumph of Venus* in the Nationalmuseum in Stockholm, just enjoying, along with her companions, the pleasure of buoyant water, ocean spray, and air. Pictures like these were the easiest or, one might say, most opportunistic, response to the contemporary market demand. Their subjects had been painted since the early Renaissance, largely, if not always, for the same reason that Boucher made them, that is, to satisfy a public that wanted to admire images of beautiful bodies, but needed, by way of a justificatory pretext for its desires, that the bodies seen be "historical," cloaked with the respectability and prestige of "learning" and "high" art.[17] But Boucher's response to the taste of the age went beyond just depicting appropriate antique subjects, and as in the case of his *Hercules and Omphale*, his strategy was frequently to reconfigure or reformulate the traditional iconography of mythological narratives.

This was already true in the early 1730s, when he painted *Aurora and Cephalus* (cat. no. 44). The subject might have been expected to inspire an image of the goddess pleading with the unwilling young hunter, as Poussin had shown it a century earlier (fig. 7), or actively ravishing him, as the Carracci depicted it about 1600 on the vault of the Farnese Gallery in Rome, and as Lemoyne did in paintings of the 1720s.[18] The story is a tragic tale of love, rejection, jealousies, and death, and artists were drawn to the moments in the myth when the youth, wanting to remain faithful to his wife, Procris, attempted to repel Aurora's advances. Boucher, uniquely I believe, simply ignored the dramatic content of the story and chose to invent, even at the risk of some iconographic confusion,[19] a portrait of the couple when, for a brief time, Cephalus surrenders to "the golden goddess of the dawn, who shines with the blush of roses on her face,"[20] and reclines with her on a cushion of clouds.

In a much later painting, showing Pan and Syrinx (cat. no. 50), Boucher reshaped a mythological subject by grafting it onto a pictorial type—the Nymph and Satyr—that allowed him to emphasize the luxuriant display of the body beautiful over the action-filled moment that usually characterized illustrations of the story.[21] Poussin, in a picture now in the Gemäldegalerie, Dresden, had shown the lustful god in hot pursuit of the nymph, and the present exhibition includes two paintings, by Mignard and de Troy, that follow his authoritative example (cat. nos. 1, 17). Boucher, however, chose to represent the end of the

FIG. 6
Jean-Honoré Fragonard, *The Happy Lovers*, c. 1770, oil on canvas, Private Collection

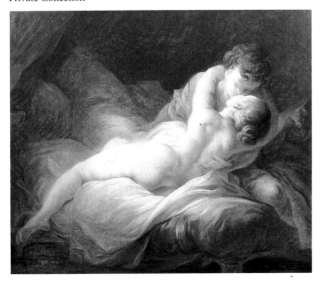

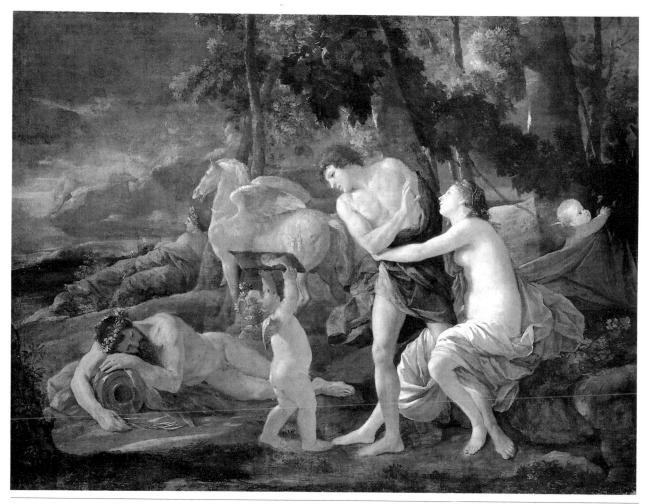

FIG. 7
Nicolas Poussin, *Cephalus and Aurora*, c. 1628, oil on canvas, London, The National Gallery

story, when Syrinx has reached the river Ladon and, as Pan finally grasps her in his arms, is transformed into a handful of reeds.[22] Pan holds her in her metamorphosed state, but at the same time, a little illogically, gazes on her nude, human form, lying close by a voluptuous water nymph. Titian's famous *Pardo Venus* in the Louvre and Watteau's *Jupiter and Antiope* (*Nymph and Satyr*) (cat. no. 14) are among the typological sources for Boucher's painting. It is worth noting that while the picture was engraved in the eighteenth century as *Pan and Syrinx*, the narrative seems to have been of no special interest to contemporary spectators, and already by 1784 it had come to be called simply "Two Nymphs Surprised by a Satyr."[23] It is additionally noteworthy that while Poussin and most other painters of the subject show Syrinx racing toward a male river-god, Boucher has her tumble into the embrace of a female figure.[24] The significance of this will be seen farther on in this essay.

In *Pan and Syrinx*, Boucher attenuated, but preserved, the narrative sense of the image. But in his exhibited painting *Diana at the Bath* (cat. no. 45), a mythological scene with no story line, Boucher left out even the standard motif that provided a semblance of action, however slight. Diana's companion, as in almost all other representations of the subject, should be helping the goddess on or off with a sandal, or else washing or drying her foot, an activity that at least indicates a scene of bathing after the chase[25] (see cat. nos. 9, 18, 21). Boucher's painting, in the absence of this motif, is a peculiar depiction of two women wholly, and unaccountably, absorbed in studying a lovely foot.

In reducing the mythological paraphernalia to a minimum and in obscuring what little narrative sense the scene might have, Boucher produced a picture that can hardly be viewed as anything more than an exquisite formal arrangement and description of

female nudes. *Diana at the Bath* thus anticipates such nineteenth-century works as Ingres's exotic odalisques with their attendants, and "bathers" by Renoir and others. It is this modernity of conception that made Boucher's *Diana at the Bath* so very appealing to later taste, and it is not surprising to discover that Renoir particularly admired it.[26] In fact, Boucher himself began the process of dissolving the distinction between pictures of beautiful divinities and of beautiful people. Georges Brunel, in his recent monograph on Boucher, has noted that a growing ambiguity of subject characterizes many of Boucher's paintings from around 1745 on, and it is often difficult to know whether they are peopled by human beings or creatures of myth. Brunel called particular attention to a set of four overdoors, two of which, when engravings after them were made in 1751, were identified as mythologies, *Erigone Conquered* and *Diana Resting*, while the other two were merely called "*pastorales.*"[27]

Especially interesting in the present context is the *Erigone* (fig. 8). The bizarre story—if story it is, since it depends on a single line in Ovid's *Metamorphoses*[28]—of the seduction of the young girl by Bacchus in the guise of a bunch of grapes had a certain currency in art in Boucher's time.[29] Carle Van Loo showed Erigone plucking a grape from a bunch while she looks knowingly toward the spectator (fig. 9).[30] Natoire, in a painting of 1747 (cat. no. 40), has her blushing with desire as she gazes longingly at the grapes she holds up in her hand, while in the background Bacchus "triumphs." In these and all other depictions of Erigone, other than Boucher's, that are known to me, the subject is unmistakable. Boucher has included cupids and has Erigone's companion draw a grape-laden vine close to the girl, which tells

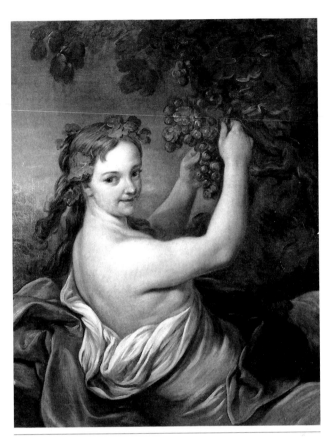

FIG. 9

Carle Van Loo, *Erigone*, c. 1747, oil on canvas, Atlanta, High Museum of Art, Gift of Harry Flackman

the story well enough, but not so well that it cannot be read just as a scene of bare-bosomed beauties enjoying a pause during the grape harvest. Indeed, until 1928 the picture was known in the Wallace Collection simply as "Shepherdesses with Sporting Loves," a title then changed to the briefer, but equally nonspecific, "Autumn."[31]

The ambiguity or vagueness of Boucher's iconography in this scene is deepened by the fact that the picture pairs with the overdoor that was engraved as *Spring (La Toilette pastorale)*, in which there is no hint of a mythological subject (fig. 10). The spectator is thus allowed—in fact, encouraged—to see in both paintings (and, indeed, in all four overdoors) nothing more than the brilliant disposition, and exquisite description, of nearly nude bodies.

It must be emphasized that pictures such as *Spring (La Toilette pastorale)* are in an important sense still history paintings. Country girls like Phyllis—as the engraving after *Spring (La Toilette pastorale)* identifies its main figure—and Nysa, and their shepherd-boy lovers, like Corydon and Mopsus, lived in the world of Virgil's *Eclogues*. They are "historical" char-

FIG. 8

François Boucher, *Erigone*, 1745, oil on canvas, London, Wallace Collection

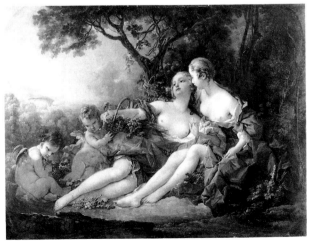

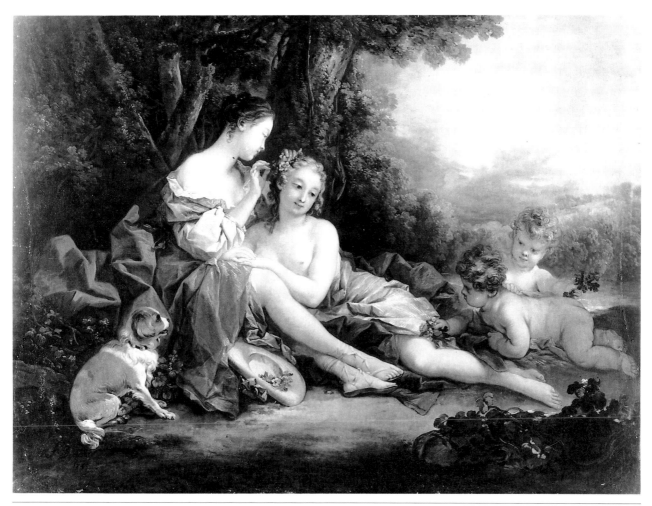

FIG. 10
François Boucher, *Spring (La Toilette pastorale)*, 1745, oil on canvas, London, Wallace Collection

acters in the same sense that the deities and humans who fill the books of Ovid's *Metamorphoses* are. Boucher always maintained the distinction between the historical pastoral and the modern rustic genre scene. Ancient shepherdesses, like the gods they served, were permitted nudity. French lasses might talk of love and their costumes might be worn revealingly, but they remain dressed and wear modern clothes (fig. 11).[32] Still, in many of his works, Boucher deliberately undermined the mythological imperative in the presentation of the nude and narrowed the line that separates history and genre. It is likely that even in the eighteenth century the ravishing creatures the artist invented were perceived neither as ancient nor modern, but merely as "Boucher's beauties."[33]

These beauties, clad in a mythological raiment of such gossamer thinness that it sometimes borders on invisibility, had important progeny. It is admittedly difficult to follow their evolutionary path uninterruptedly, for only in the work of Boucher's great pupil,

Fragonard, did their family continue meaningfully in the eighteenth century (fig. 6 and cat. no. 57). Then, for a time it seemed almost to vanish; when in the nineteenth century it reappeared, the descendants of Boucher's beauties, divested of ancient costume and altered by new historical and artistic circumstances, had branched into a new species (fig. 12).

The progressive aspects of Boucher's art have been largely ignored because we tend, looking back, to view it through the lens interposed by neoclassical critics. They, ironically, condemned Boucher as reactionary for not marching into the future armed with the heroic ideals and didactic weapons that had earlier served the age of Louis XIV.

The erotic intensity of Boucher's imagery is palpable. It seems to emanate from the artist's brushwork itself. It charges the environment, radiating from sky and clouds and from the fragments of landscape that surround and house the figures.[34] But the vital core of Boucher's eroticism is in the poses and postures of his

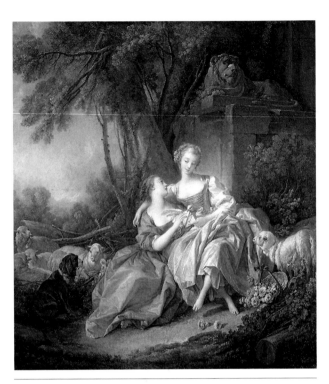

FIG. 11
François Boucher, *The Love Letter*, 1750, oil on canvas, Washington, National Gallery of Art, Timken Collection

brushing against each other. They delight in their companions' warm presence and perfect beauty. Diana's attendant kneels to admire her mistress's pretty foot (cat. no. 45).

Our response to these images is necessarily subjective, depending on personal temperament and, perhaps also, gender. Recently, a feminist critic, Eunice Lipton, noting many of the peculiarities of Boucher's pictures, has proposed that they are especially appealing to a woman's sense of selfhood and self-sufficiency. She has stressed the absence in them of "signals of [male] domination and [female] submission," and called attention to the air of comfort, security, and satisfaction that Boucher's women seem to enjoy. She believes the "*raison d'être*" of these mythological and pastoral visions to be the evocation of "the simple pleasures of bodily contact."[37]

Boucher's "texts" clearly allow for such a reading, but it is questionable whether the pleasures they communicate were intended or, more important, understood in the eighteenth century, as female oriented. Although it is possible that some women in Boucher's time were attracted to his pictures for reasons similar to those adduced by Lipton, there is, in fact, no evidence that suggests as much. Boucher himself, whose reputation as a ladies' man is well known, is hardly likely to have designed his works, even subconsciously, with a feminist audience in mind.[38] Boucher had female patrons, Madame de Pompadour being an especially devoted one, but his customers and critics were mostly men, and his "beauties" must have been conceived primarily for the delectation of the male gaze.[39] Images that often combine beauteous frontside and backside views (cat. nos. 46, 50) and that allow for the leisurely perusal of ample bosoms,

FIG. 12
Gustave Courbet, *Sleep*, 1866, oil on canvas, Paris, Musée du Petit Palais

beautiful nude bodies.[35] Bodies that present themselves with hips rotated, with arms and legs that turn and thrust with dancelike vigor or that surrender to languorous repose; bodies that are coiled and tense with the excitation of sexual arousal (cat. no. 46) or that recline and stretch in the voluptuous acceptance of erotic pleasure (cat. nos. 49, 50, and fig. 8).

Boucher's imagery exhibits an unmistakable, but in some ways problematic, eroticism. It in no way depends on overtly lascivious behavior. The swan is not seen copulating with Leda (cat. no. 46). Male figures are hardly ever sexual aggressors. Hercules's embrace is obviously invited and welcomed by Omphale (cat. no. 42). Pan, elsewhere the lust-crazed rapist, is effectively reduced in Boucher's picture to a harmless *voyeur* (cat. no. 50). Jupiter seduces Callisto—significantly, the mythological theme most often represented by Boucher[36]—but the god appears in the guise of a female, pretending to be the goddess Diana (cat. no. 49). It is mostly female bodies that Boucher paints, and then frequently in couples or in threes. Leda acquires a female companion (cat. no. 46), Erigone reposes with another shepherdess (fig. 8), and Syrinx lies alongside a river nymph (cat. no. 50). The women remain oblivious to us, the spectators, and aware only of each other. They are shown in positions of extreme intimacy, embracing, bodies intertwined,

firm bellies, and lithe legs, were surely meant to stir the libidinous instincts of a male audience. But then there is the touching, closeness, and embracing of woman with woman.

Georges Brunel has noted that in Boucher's pictures "there is a hint of a rather insistent curiosity concerning female sensuality that foreshadows Courbet's *Sommeil*" (fig. 12).[40] He is surely correct. Indeed, in the paintings we have discussed, and in many others by Boucher, there are, more than hints, strong intimations of an erotic force that draws women together in an intimacy that goes beyond companionship.

There is little need to document the fact that in the eighteenth century (as probably at all times) descriptions of erotic love between women had the power to stimulate the male libido. They are found in the lubricious writings of Voltaire, Diderot, Crébillon, and others, as well as in the century's plentiful output of crude pornographic literature and art. But if this aspect of Boucher's imagery was especially appealing to some of his admirers, it must have been little noticed by many others. The salacious allusions that enhance the erotic atmosphere of Boucher's pictures are made with great delicacy and discretion. The artist's world was far removed from the one that inspired the aggressively insistent display in Courbet's *Sleep* (fig. 12). Boucher's discretion was born of eighteenth-century manners, the period's fine sense of decorum, and its classical restraint; it allows us, if we wish, to ignore or gloss over the intimations of sapphic love in his work. It is possible to enjoy his figural groups simply in the terms with which an eighteenth-century writer described Boucher's *Jupiter in the Guise of Diana Seducing Callisto* (cat. no. 49): "This group charms by its seductive composition, and by an air that is most cheerful and most voluptuous."[41]

By their amorous attitudes and behavior, Boucher's "beauties" whisper a tale of women drawn erotically to women. But they also communicate, in full voice, something of universal appeal. In the perfection of their form and the superb grace of their postures and movements, they are the embodiment of vitality, of youthfulness, and of readiness for love. They are an affirmation of life, and the sight of them gladdens us.

Notes

1. Ovid, *Metamorphoses*, VI, 109.

2. See Knauer 1969. Boucher's contemporary Natoire followed Correggio's example closely. See exh. New York, New Orleans, and Columbus 1985–86, 105, fig. 3.

3. Lefrançois 1981, 160–62, figs. 17, 18. Versions of the theme from the 1720s by Jean-François de Troy (Bordeaux 1989, figs. 23, 24), one of which, at least, seems dependent on Bertin's work, also show the swan only approaching Leda. In one, however, Leda already embraces the bird, and in the other she caresses it. Incidentally, the idea of placing the swan to one side of Leda and not showing their copulation has its ultimate source in Leonardo's famous kneeling and standing Ledas, which were well known in France.

4. Leda also has nude companions in another painting of the subject by Bertin (Lefrançois 1981, fig. 74), which is directly dependent on Correggio's picture. In neither painting, however, unlike Boucher's representation, is there any physical contact between Leda and other women.

5. Frankl 1961, 145, who proposes that "perhaps Boucher included her in order to balance the picture and to achieve a classical triangular composition." See below, n. 35.

6. See exh. New York, New Orleans, and Columbus 1985–86, 105.

7. Levey 1982, 445, has remarked that "for many people, the subject matter [of Boucher's pictures] might seem scarcely worth pausing over." I follow his example in doing "the painter the small justice of looking at what he depicted." See also, Posner 1988.

8. Bryson 1981, Chap. 4, esp. 91ff., although he is not concerned with Boucher's interpretations of mythological subjects, has explored the aesthetic purposes of the attenuation of narrative signification in works by Boucher and some of his contemporaries. His conclusions are in many respects quite similar to mine.

9. *Histoire du ciel . . .* , cited by Manuel 1959, 5.

10. Hercules themes were frequently interpreted as glorifications of the French monarchy (see Montagu 1968, 329). It might be noted that in the early eighteenth century "officialdom" still tended to encourage bellicose themes. Lemoyne, for example, submitted a Hercules and Cacus (Paris, École Nationale Supérieure des Beaux-Arts) as his reception piece for the Academy in 1718. The original version of his *Hercules and Omphale* (cat. no. 23) was sold to a private patron.

11. Bailey in exh. New York, New Orleans, and Columbus 1985–86, 77–78, noted that Lemoyne owned a copy of a handbook on mythology, published in 1604, where the story is given such a moralizing interpretation.

12. For the history and complicated iconography of this subject, see Huemer 1979. Historically, the moral was turned in various ways, and the humorous aspect of the scene seems to have been particularly prized. The subject also sometimes served to symbolize conjugal love, a meaning that is not irrelevant to the pictures by Lemoyne and Boucher in the present exhibition.

13. Bordeaux 1984 (A), 94–95, is surely right in suggesting that Lemoyne was partly inspired by Rubens's version of the theme in the Louvre. Rubens, however, stressed Hercules's humiliation, as Omphale stands high above him and taunts him by tweaking his ear. See Huemer 1979, fig. 1 and p. 573.

14. Probably from about the same time as Boucher's painting is a Venus and Adonis by Jean-François de Troy showing the gods nude and in a passionate amorous embrace (Bordeaux 1989, fig. 21). Since both this painting and Boucher's are undated, one cannot say which picture might have influenced the other. But de Troy's work in general had a considerable impact on the younger artist, more so than is usually recognized (see Bordeaux 1989, 167, and n. 22 here), and it seems more likely, therefore, that his picture inspired Boucher. This should not, of course, lessen our appreciation of Boucher's originality in using the motif for his *Hercules and Omphale*.

15. Many examples of mythological kissing scenes exist among prints, and also some paintings, by the Netherlandish Mannerists working around 1600. Sterling 1958, 48, suggested that unspecified works by Goltzius or Spranger were a likely source for Boucher's picture.

16. Bordeaux 1975, 127–28, proposed that Rodin was inspired by Boucher's painting.

17. Paintings of nudes, when their subjects cannot be identified as historical personages, such as Venus or Bathsheba, were uncommon until the eighteenth century. They began to appear with some frequency in France around 1720. Lemoyne's large *Bather*, best known from the version in The Hermitage that was exhibited at the Salon of 1725, was a stunning novelty. See Bordeaux 1984 (A), 96 and fig. 45; and further, the discussion in Posner 1973, 31–33 and passim.

18. Bordeaux 1984 (A), figs. 46, 245.

19. Already in the eighteenth century it was recorded as *Venus and Adonis*, a title retained in Ananoff and Wildenstein 1976, I, 217–18. The accuracy of the identification as *Aurora and Cephalus* was demonstrated by Levey 1982, 442–46. See also the comments by Laing in exh. New York, Detroit, and Paris 1986–87, 136–38, who remarks that the artist "takes some liberty" in his interpretation of the subject.

20. Ovid, *Metamorphoses*, VII, 700–707.

21. See Talbot 1974.

22. The moment chosen and the general arrangement of the composition may depend on paintings by Jean-François de Troy. See Bordeaux 1989, fig. 18; Talbot 1974, figs. 14, 15.

23. Ananoff and Wildenstein 1976, II, 190.

24. There were some precedents for this, for Boucher most notably in a painting of about 1715 by Bertin (Lefrançois 1981, 134–35, fig. 49) and in one of 1723 by Noël-Nicolas Coypel (Lomax 1982, fig. 12). In both of them, however, except that Syrinx is succored by a nymph instead of a male figure, she and Pan are seen in the usual way, he in pursuit and she running.

25. The scene was derived from illustrations of the stories of Diana and Callisto and Diana and Actaeon, both occurring when the goddess was bathing. See Posner 1988, 23–24.

26. See Ananoff and Wildenstein 1976, I, 155, no. 1205; also Riopelle 1990, 32–33.

27. Brunel 1986, 202–6. Significantly, in one of the mythological pictures, *Diana Resting*, the goddess lacks the identifying crescent moon in her hair. As if by way of clarifying the subject, it was added in the engraving that Claude Duflos made after it. See also, on these pictures, exh. New York, Detroit, and Paris 1986–87, 220–24.

28. Ovid, *Metamorphoses*, VI, 125: "Liber ut Erigonen falsa deceperit uva."

29. Interest in the subject must have been stimulated by the presence of Guido Reni's painting of the subject in the Orléans collection in Paris. See exh. Frankfurt 1988–89, 188–89, with illustration.

30. Exh. Atlanta 1983, 54 and pl. 14, where other versions of the subject are noted. See also, on the subject of Erigone in art and for other French pictures of the subject, Panofsky 1960, 23–33, especially 28.

31. *Wallace Collection* 1968, 36.

32. Exceptions are when, as in Boucher's *Summer* in The Frick Collection, New York, they are shown in the privacy of the bath.

33. In the wide diffusion of Boucher's imagery through the medium of reproductive prints there was an emphasis on the formal beauty of figures, rather than on subject matter. Brunel 1986, 293, cites an instance in which a Jupiter and Danae by Boucher, in the course of three states of the print after it, lost Jupiter and the golden rain, effectively transforming Danae into an anonymous nude figure.

34. See Bryson 1981, 99 and passim.

35. Boucher created a repertory of erotic figural attitudes, which he repeated frequently in different narrative contexts. One of them, which has been dubbed the "swimming posture," is taken by Leda's companion (cat. no. 46) and by females in some of the other pictures discussed here. See Frankl 1961.

36. Exh. New York, Detroit, and Paris 1986–87, 283.

37. Lipton 1990, 72, 75.

38. Lipton 1990, 79ff., attempts to give her interpretation a historical basis by claiming that Boucher's paintings are related to a general "feminization" of the *ancien régime*, and reflect the power women exercised in his time. I believe that she has greatly overestimated the social and political potential of Boucher's female contemporaries and misunderstood the character of the period. See further, the remarks in Posner, 1990, 102–4. For Boucher's libertine style of life, see exh. New York, Detroit, and Paris 1986–87, 62ff.

39. Lipton 1990, 76, grants that Boucher's pictures "also function to satiate male desire in a fully male discourse." In a rather hostile reading of Boucher's imagery, Erica Rand argues that it operates to "disarticulate" female power "by being configured to invite erotic appropriation and to signal female enclosure," (see Rand 1990, 48–52).

40. Brunel 1986, 206.

41. "Ce groupe intéressant est présenté avec tout le charme d'une composition flatteuse, et dans l'attitude la plus riante et la plus voluptueuse." The quotation is from a sales catalogue of 1786, cited in Ananoff and Wildenstein 1976, II, 189.

To See or Not to See

The Myth of Diana and Actaeon in the Eighteenth Century

Steven Z. Levine

Diana is the name of the Roman goddess to whom were assimilated the traits and exploits of the Greek goddess Artemis. The triple goddess, or Trivia, she was called Hecate in the underworld, Phoebe or Selene or Luna in the heavens, and Artemis or Diana on earth.[1] Sixteenth-, seventeenth-, and eighteenth-century mythographers often labored to make the appropriate classical distinctions, but for most poets and painters these heterogeneous Greek and Roman personae were unproblematically subsumed under the single name Diana. As such she was commonly said to be the divine daughter of Jupiter and the Titaness Latona (Leto), the beautiful twin sister of the sun god Apollo, the virgin mistress of the nymphs, the quivered patroness of the chase, and the stern protectress of women in childbirth and of the young. Renaissance mythographers saw in the lunar divinity Diana a universal symbol of the changing of things through augmentation and diminution,[2] and it will be the task of this essay to trace some of the changes in the image of Diana in the arts and letters of eighteenth-century France.

The myths of Diana intersect with the broadest roster of mortals and divinities. She saved the nymphs Arethusa and Britomartis from lecherous attack; with her brother Apollo she killed Tityus, her mother's lustful assailant, and Niobe, her mother's proud tormenter. She also killed the boastful Chione, the unfaithful Coronis, and, inadvertently, through her brother's guile, her hunting companion Orion. She avenged Oeneus of Calydon's act of disrespect by contriving the death of his son Meleager, and she relented from exacting the same penalty on Agamemnon by aborting the impending sacrifice of his daughter Iphigenia. Like the latter, whom she immortalized, she also favored Hippolytus, who had spurned the worship of the goddess Venus on her behalf. Although many of these accounts figure in the sixteenth- and seventeenth-century iconography of Diana, the preponderance of narrative imagery focuses on the three stories of Callisto, Actaeon, and Endymion.

The stories of Callisto and Actaeon are best known from their accounts in Ovid's *Metamorphoses*, and numerous illustrated editions and independent prints provide ready pictorial prototypes for the painters of our period.[3] Each scene takes place after the hunt at the goddess's bath. The first of the stories depicts Diana's angry banishment of the pregnant nymph Callisto, who nine months earlier had been seduced by Jupiter in the bodily guise of Diana herself; after Callisto gives birth, she is transformed by Jupiter's outraged consort Juno into a bear before being transported heavenward by the god as the constellation Ursa Major (fig. 1). The second story of Diana's bath concerns the accidental intrusion of the hunter Actaeon into the naked company of the nymphs. Once more roused to fury, the goddess splashes Actaeon with water, causing horns to sprout from his forehead and transforming him into a stag; Actaeon is thereupon devoured by his own dogs (fig. 2). The twin fates of Callisto and Actaeon confirm Diana's most characteristic role as protectress of chastity, but eighteenth-century authors and artists saw no insuperable contradiction between these lethal tales of crime and punishment and the amorous story, not in the *Metamorphoses*, of Diana and Endymion. Moréri's *Grand Dictionnaire historique* (1731) indicated that the same goddess who turned the hunter Actaeon into the animal prey of his own dogs "was less severe with regard to Endymion, shepherd of Caria, for whom it is said that she left the heavens every night."[4] The noted eighteenth-century mythologist, the abbé Antoine Banier, offered a rationalist account of the apparent contradiction: "Tis well known in what manner she banished Callisto, whom Jupiter had seduced, and how dearly Actaeon paid for having seen her in the bath; but as mythology was not very consistent in its principles, it was reported that she had been in love with Endymion, and went every night to visit him in the mountains of Caria."[5] Chompré's *Dictionnaire abrégé de la fable* (1727) asserted that Diana visited Endymion at night for fear of visiting him by day; accordingly, "if she was not better behaved than the other goddesses, she at least gave the appearance of being so."[6] And during the 1750s Diderot's *Encyclopédie* confirmed the transformation of this new goddess of Love: "The pains which Latona suffered gave Diana an aversion for marriage but not for gallantry. She is accused of having loved and favored

Endymion, to have ceded to Pan metamorphosed as a white ram, and to have received Priapus in the form of an ass."[7] The two latter tales, like that of Endymion, are originally told of the lesser lunar divinity Selene rather than Artemis, but the grafting of the eager eroticism of the one ancient deity onto the self-professed chastity of the other epitomizes the eighteenth-century demythologizing project which this essay will explore.

Images of Diana abounded in the Salons of eighteenth-century France. In the forty exhibitions held between 1673 and 1799 by the *Académie royale de Peinture et de Sculpture*, some eighty-odd representations of Diana appeared with consistent regularity. Diana went off on the hunt in landscapes by Charmeton and Duperreux in 1673 and 1798, and between these dates she returned from the chase and rested or bathed in more than twenty works.[8] Diana saved the nymph Arethusa from the river-god Alpheus in paintings by Boucher (1761) and Jollain (1779); and in violation of classical, though not modern, typology she struggled playfully with Cupid in paintings by Trémolières (1737) and Jollain (1769). By far the majority of works was divided amongst the three principal themes. Diana was rarely seen to expel Callisto from her company of nymphs, but the likeness of the goddess was exhibited twelve times as Callisto's deceptive seducer Jupiter.[9] Diana was shown a further eleven times as Endymion's voyeur and ravisher,[10] and thirteen times the naked goddess was seen to confront either an accidentally or willfully intrusive Actaeon.[11] In Mignot's terra-cotta of 1757 Diana was simply said to be "surprised at the bath,"[12] and this omission of the name of Actaeon will become an iconic axiom in later single-figure works, such as the painting by Antoine-Jean

Gros (1791; cat. no. 66) that closes the chronology of this essay. Although in such works the figure of Actaeon is literally excluded from the represented scene, it is my central claim here that he allusively reappears beyond the representational frame in the person of any artist or spectator, male and female alike, who is moved to reenact the alternatively or, indeed, alternately aggressive and submissive roles of Actaeon.

The gaze and posture of the solitary surprised Diana find a sovereign counterpart in numerous single figures of the powerful huntress.[13] Many of these representations are works of portraiture, and it is crucial to underline the longstanding practice of appropriating the attributes and even the nakedness of Diana for a variety of private and political purposes. Among such works are documented or putative representations of Diane de Poitiers, mistress for more than twenty years of Henri II (fig. 3); of Gabrielle d'Estrées and Marie de Médici, the mistress as well as queen of Henri IV; of Louise de la Vallière and Françoise de Montespan, mistresses of Louis XIV; and of Marie-Adélaïde de Savoie, Marie-Adélaïde de France, and Louise de Mailly, the mother, daughter, and mistress of Louis XV, who severally embodied the maternal, virginal, and libidinal roles of the goddess in a life-size sculpture by Antoine Coysevox of 1710 and in portrait paintings of 1743 and at the Salon of 1745 by Jean-Marc Nattier (fig. 4).[14] Other allegorical portraits include Perronneau's pastel of Mademoiselle Pinchinat (1765) and Guérin's portrait of "Mademoiselle Cha***, as Diana, accompanied by her nymphs, and pursuing a stag at bay" (1769).[15] It might have been in contrast to just such a cumbersome *chasse d'amour* that the fairground poet and popular songster Charles-François Panard wrote:

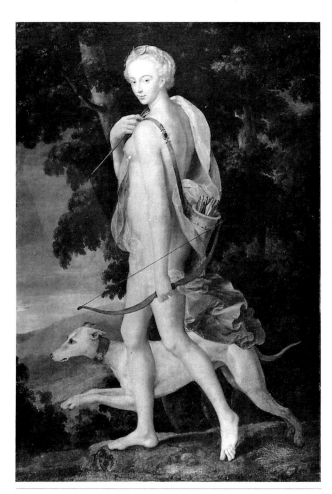

FIG. 3

School of Fontainebleau, *Diane de Poitiers (?) as Diana the Huntress,*
c. 1550, oil on canvas, Paris, Musée du Louvre

I have seen Diana exercising
Pursuing the stag with ardor;
I have seen behind the stage-flats
The game pursuing the hunter.[16]

Such oscillating avowal and disavowal of Diana's power will play a dominant role in the story ahead.

In the two centuries between the time of Diane de Poitiers and the thirteen-year-old princess Marie-Adélaïde, many women donned the guise of Diana for their own or others' ideological purposes. Two of the most powerful women of sixteenth-century politics, Diane de Poitiers and Elizabeth I of England, systematically exploited Diana's ambiguous allure in their assimilation of the traits of the goddess.[17] Seventeenth-century women and men at the *salons* of the *précieuses* cultivated the mythological device apparently as a means of fixing a distance, however mobile and traversable, between an ideal realm of feminine autonomy and the actual world of masculine domination.[18] In *Les Plaisirs des dames* of 1641, the aristocratic

pastime of the deer hunt takes on a psychological meaning as the animal quarry becomes a willing prey: "You see a poor deer who, losing its breath, seems quite content to give up its last gasp at the feet of these Nymphs, as though it believed it was turning into another Actaeon by the power of these Dianas." These women are said to be "Dianas of the towns," and for this male writer their ensnaring power stems from the fact that "we are made rather to see than to be seen, but they are made to be seen."[19] This fatal attraction for the male gaze is emblematized in a resonant line by the brother of one of the leading *précieuses*, Madeleine de Scudéry—"Would that I were Actaeon, provided I might see her"—where the mythological hunter's dismemberment is matched in the poet's self-undoing desire to observe his "*Philis dans le bain*" (1649).[20]

In the conversational ferment of the *salons* of Mademoiselle de Scudéry and her eighteenth-century followers a discourse of licit and illicit relations of gender and rank perennially came to be figured by way of the myths of Diana. In a fundamental essay on mythology in the eighteenth century, Jean Starobinski has emphasized the omnipresence of myths in society, "in the classics that one reads at school, in the tragedies that one goes to see at the theater, in history paintings, on the monuments erected on public squares, in the decoration of homes." After citing contemporary treatises on the ubiquity of mythology in daily life and the necessity for its mastery in civil intercourse, Starobinski concludes that "the knowledge of myth is the very condition of the legibility of the cultural world in its entirety. . . . It thus has a double function; it is a language of images giving access to a certain type of organization of discourse, and the function of this language is a social sign of recognition between individuals who

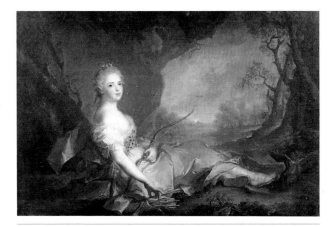

FIG. 4

Jean-Marc Nattier, *Marie-Adélaïde de France as Diana*, 1745, oil on
canvas, Musée National des Châteaux de Versailles et de Trianon

know how to decipher the universe of mythic fiction in the same way."[21] This universe of myth is coterminous with the forms of nature itself. As Voltaire put it in his *Apologie de la fable* (1765):

> These mountains, these woods which frame the
> horizon,
> Are covered with metamorphoses;
> This deer with light feet is the young Actaeon . . .
> Ovid will always charm.[22]

Much has been written about the imagery of Diana in French art prior to the eighteenth century. Françoise Bardon describes how Diane de Poitiers promoted a dual mystique of beauty and power in a series of allegorical self-representations with her lover Henri II.[23] A large cartoon-like painting of the enraged goddess and stag-headed hunter, probably from Fontainebleau, suggests the public scale of such courtly enactments (fig. 5), and her elaborately decorated château d'Anet (1547–52) is a concrete embodiment of the mingled personae of Diana/Diane.[24] André Chastel has written of Diane's reign that "a court is a mythology in action"; moreover, that "the theme of Actaeon or the punishment of the indiscreet had resonances too immediate in a society where the ritual of amorous approach and refusal was detailed each day by the poets so that a spectator could not but project familiar faces onto the personages of myth."[25] Such pictorial projections might serve to warn potential seducers or adulterers of the grave consequences of any willful or unintentional violation of feminine chastity, as in *Diana and Actaeon* from the *chambre de Diane* at the Burgundian château d'Ancy-le-Franc built for Antoine de Clermont and his wife Françoise, the younger sister of Diane de Poitiers. Based upon a much-copied print from the school of Marcantonio Raimondi, this configuration of Actaeon's mortal encounter with the goddess will reverberate down through the generations of the painters discussed here.[26]

In contrast to Henri II and Diane de Poitiers, Henri IV and Marie de Médici had themselves portrayed in 1600 in the newly constructed *galerie de la reine* at Fontainebleau not as the erotically vexed couple of Diana and Actaeon but as a sage Minerva-like Diana and a bellicose Mars. Their lost overmantel portraits by Ambroise Dubois presided over a program which illustrated the familiar as well as more obscure myths of Diana and Apollo, including the stories of Hippolytus, Oeneus, Callisto, and Endymion.[27] Later in the century, during the minority of Louis XIV, the regent queen mother, Anne d'Autriche, commissioned for her own apartments at the Louvre an elaborate decoration featuring royal allegories of the twin

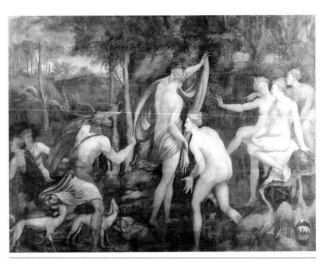

Fig. 5
School of Fontainebleau, *Diana and Actaeon*, c. 1540–50, oil on canvas, Paris, Musée du Louvre

solar and lunar divinities (1655–58). Giovanni Romanelli's circular composition of the enthroned god and goddess in the center of the vault of the *salle des saisons* may have been meant to remind the court and the twelve-year-old king of the queen's Diana-like authority (fig. 6). Romanelli's winter scene of Diana and the sleeping Endymion recalls a famous fresco by Annibale Carracci in the vault of the Farnese Gallery in Rome (1600), whereas an engraving by Jan Theodor de Bry provides the compositional basis for the scene of Diana and Actaeon which symbolizes Spring.[28]

Not long after the death of his mother, Louis XIV began to enwrap his parents' hunting *château* at Versailles with a stone envelope of grand state apartments embodying the celestial iconographies of Apollo and Diana, as well as Mars, Mercury, Jupiter, Saturn, and Venus. Between 1671 and 1680 the *salon de Diane* was decorated by Gabriel Blanchard, Claude II Audran, and Charles de La Fosse with paintings which invoked the public and private pursuits of the monarch. Diana was depicted in lunar apotheosis on Blanchard's circular ceiling, where she presides in a deer-drawn chariot over figural embodiments of navigation and the hunt. These commercial and recreational manifestations of Louis XIV's reign were further indicated in the ceiling lunettes by Audran and La Fosse which illustrate four hunting and seagoing exploits of antiquity. The lunar aspect of the room was repeated in Blanchard's large painting of Diana and Endymion opposite the chimney wall. The corresponding overmantel painting by La Fosse showed Diana substituting a deer for Agamemnon's about-to-be-sacrificed virgin daughter Iphigenia, and Blanchard's overdoor *grisailles* completed the program with further scenes in which Diana's

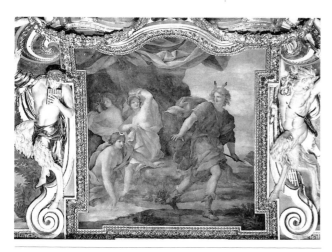

FIG. 6
Giovanni Romanelli, *Diana and Actaeon*, 1655–58, oil on canvas, Paris, Musée du Louvre

Nymphs, let us retire to this charming glade.
The crystal of its pure waters,
The sweet song of the small birds,
The cool shade beneath this green foliage
Will cause us to forget our arduous labors.
This brook, far from the noise of the world,
Offers its waves;
Let us refresh ourselves in its silvery stream;
No mortals will dare
To surprise us here,
Let us not fear to admire our beauty.

To this invitation to engage in a collective admiration of female beauty free from the scrutiny of the masculine gaze, the chorus of nymphs responds with a sigh of relief that is repeated eight times:

Ah! How one avoids [Love's] languors
When one disdains his ardors.[32]

Indeed, Diana gives safety from Cupid's tyrannical "flames" to those whom Voltaire will later call her nuns.[33]

According to this reading, Coypel poses Diana and her company at a moment of unwariness prior to, even though already mindful of, the surprise of masculine intrusion. That the seemingly distracted Diana and her absorbed attendants might do well to be wary of intrusion may be suggested here by the foreground pose of a nymph who is seated at the water's edge and who has already commenced her ablutions. Both her legs have entered the water, yet she turns her head sharply away from the bath, away from the enthroned goddess above her, toward a place beyond the paint-

dedication to chastity was displayed: a young girl offers a sacrifice to the goddess, Arethusa is saved from the clutches of Alpheus, and the horned Actaeon is driven away from Diana's bath (fig. 7).[29] Taken together with paintings of Diana and her nymphs by La Fosse and Diana and Endymion by René-Antoine Houasse commissioned for the Grand Trianon in 1688,[30] the public depictions of Diana at Versailles will constitute the classical paradigm for the representation of the gazes and postures of the goddess which the painters of the eighteenth century will variously perpetuate or overturn.

The intermixing of myth and courtly life was everywhere visible at Versailles, not only in the pictorial representations already enumerated but also quite as importantly in a steady stream of entertainments of opera and ballet. In *Le Triomphe de l'amour* of 1681, with music by Lully and words by Quinault, the wife of the *Dauphin* led the ladies of the court in a dance of Diana's nymphs. Newly married and still childless, the *Dauphine* was urged in a dedicatory verse not to emulate Diana too closely but rather to deliver herself soon of a royal heir.[31] In this context it may have seemed quite appropriate that the amorous scene in the opera between Diana and Endymion effectively annulled the standard notion of the chastity of the goddess. In contrast, in *Actéon*, the *opéra de chasse* of around 1684 by the *Dauphin*'s composer, Marc-Antoine Charpentier, the traditional axiom of Diana's chastity was gravely reasserted.

We can begin to take a bearing upon the earliest of the paintings which I will consider in this essay at some length, *The Bath of Diana* of around 1700 by Antoine Coypel (cat. no. 9), by listening to the goddess's opening recitative from Charpentier's opera:

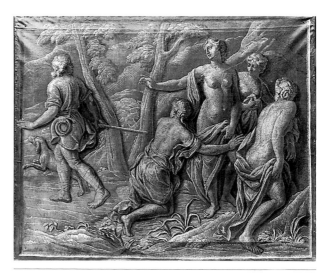

FIG. 7
Gabriel Blanchard, *Diana and Actaeon*, 1672, oil on canvas, Musée National des Châteaux de Versailles et de Trianon

ing's right-hand margin. Perhaps she does so as though in response to the sort of casual query that is posed by Diana in the opera by Charpentier: "Nymphs, what noise was that I heard from yonder bush?"; for in the opera the as yet unseen Actaeon has sought to linger by the pool in order to overhear the conversation of the goddess whose image had "struck his view" upon the instant of his chance arrival.[34] In Charpentier's version of the myth, Actaeon is at once discovered and accused of the crime of deliberately seeking to surprise the goddess and her nymphs. A splash to the head turns Actaeon into a bestial object lesson for others of similar design; and, in words very close to a verse spoken by Diana in Ovid, the nymphs taunt Actaeon to tell of what he has seen. Here too the taunt will be answered only in the mute metamorphosis of the stag-horned man.

Who is this man of horns, and what has he to do with the spectator of Coypel's *The Bath of Diana*? To restate it quite simply, Actaeon is the embodiment of the male spectator's presence before the painting; more precisely than this, he is the mythological stand-in for the male lover or husband in the face of the direct or allusive portrayal of his lover or wife. The precedent for the personal adaptation of the mythological scene of sexual confrontation extends from the *saletta di Diana* at Fontanellato (1524),[35] to the *château* of Diane de Poitiers at Anet (1547–52), to the *chambre de Diane* at Ancy (1578), to the *galerie de Diane* at Fontainebleau (1600), to the *salle des saisons* at the Louvre (1655–58), to the *salon de Diane* at Versailles (1671–80). If Coypel's scene of Diana's bath were also understood as the target and lure of its principal beholder's gaze, it would become an appropriate art-historical task to seek to identify this individual. In view of the repetition in the figure of Diana of the pose of Ariadne in Coypel's well-known painting of 1693 (cat. no. 8), it is tempting to speculate that here may be preserved some perceptual or affective trace of the painter's marriage to Marie-Jeanne Bidaud in 1689.[36] Given the courtly demeanor of Diana and her nymphs, it may however be more productive to search in the princely Orléans family of Coypel's primary patrons for the portraitlike traits of this goddess. Starting in 1688 Coypel held the position of *premier peintre* to Philippe, duc d'Orléans, the notoriously libertine brother of Louis XIV. In 1692 his son and eventual successor married the fifteen-year-old Françoise-Marie de Blois, the legitimatized daughter of Louis XIV and his mistress the marquise de Montespan, herself a once-and-former embodiment of Diana. Coypel's painting is usually dated around 1700, but a date closer to that of the Orléans marriage seems not unreasonable.[37]

What I want to stress is the extraordinary range of meanings that lies latent in the mythological theme. In the translation of the *Metamorphoses* most readily available to painters of Coypel's generation, the Royal Academician Pierre Du Ryer drew upon a broad repertory of ancient sources and Renaissance commentaries for his "new historical, moral, and political explanations of all the fables" in Ovid's book. As for Actaeon, it seems he was a prince who either had been devoured by his hunting dogs gone mad or who had ruined himself through exorbitant expenditures on the hunt. Du Ryer turned the latter interpretation into an admonition against the profligacy of princes as well as a warning against "the flatterers and the parasites" who devour the princes who nourish them. In the main, however, Actaeon functioned less as an avatar of the prince and more as a stand-in for the courtier: "This myth of Actaeon who saw Diana in the bath teaches us . . . not to be at all curious of things that do not at all concern us, and not to take pains to learn the secrets of Kings, and indeed of all the Great, because the apprehension they have that you might discover them, or the suspicion that you have discovered them, is often the cause of your destruction."[38] In contradistinction to this courtly interpretation, the popular *Ovide buffon* of 1649 reminds us that Actaeon was "the patron of all cuckolds" on account of his horns.[39]

In view of such divergent semantic possibilities, it may be intriguing to think of Coypel's painting as presenting an elaborate farce on the libertine practices of princely marriage even as it cloaks that masquerade in the learned forms of classical allusion. When Coypel was engaged between 1702 and 1706 in painting a teeming assembly of gods on the ceiling of the Palais-Royal for the newly elevated duc d'Orléans, it was reputedly an occasion for the posing of the high-born ladies of the court. According to his son, the painter Charles-Antoine Coypel, "the rumor caused by these sorts of studies gave rise to the belief in many minds that the ceiling was filled with portraits."[40] Such portraits or near-portraits may also animate *The Bath of Diana* with some vestiges of the games and faces of courtly sexuality in the waning years of the reign of Louis XIV. These were years of overt repression of sexual and other forms of representational license during the ascendancy of Louis XIV's pious second wife, the marquise de Maintenon, yet the multiple layers of significance in myth may have continued to make possible a relatively safe evasion of censorship in the name of the impious actualities of political, and particularly sexual, relations.

Earlier in the reign Louis XIV himself would appear to have sanctioned such intricate mythological impersonations. Within the confines of the court the king's sexual priority over his nobles was emblematic of his political power. In 1676 the prolific court versi-

fier Isaac de Benserade, condensed the *Metamorphoses* into a suite of moralized *rondeaux* with accompanying illustrations, and Actaeon's erotic transgression became the pretext for a scarcely veiled political warning. Though Actaeon was said to be guiltless of premeditation he was nonetheless condemned for not having "lowered his gaze." And the courtly maxim concludes, "whoever wishes to see too much is neither wise nor prudent."[41] One such courtier who may have wished to see too much was Loménie de Brienne. Recalling a painting of Mademoiselle de la Vallière as Diana made according to the instructions of Louis XIV and in which Actaeon appeared as a figure in the landscape, the lovelorn memorialist ruefully acknowledged: "And that Actaeon, it was I, an innocent trick played on me by the king, or perhaps it happened by chance."[42] In this humiliation of his love for the king's mistress, Loménie de Brienne had been "actaeonized."[43] Another aristocratic writer of the day made a similar point in 1687 in the sardonic epigraph to a book on how to choose a suitably honest woman in marriage: "Our wives are Dianas who have reduced us to the form of Actaeon."[44]

Louis de Boullongne was a painter of the same generation and much the same courtly milieu as Antoine Coypel. Boullongne's *Diana Resting* (cat. no. 10) and its pendant depiction of the boar hunt of the goddess were made in 1707 as overdoor paintings for the *grand cabinet du roi* at the château de Rambouillet, the owner of which was Louis-Alexandre, comte de Toulouse, the legitimatized younger son of Louis XIV and the marquise de Montespan and thus the brother of the duchesse d'Orléans. Boullongne's two hunting pieces may have made some sort of precise private reference to the count in his capacity as Grand Venerer of France, but what I want to focus on instead is the deviation from Coypel's narrative portrayal of Diana that is represented in Boullongne's frontal turning of the goddess's gaze. Diane de Poitiers, in her idealized role as the naked huntress, turned her eyes away from their allotted pursuit of prey in order to meet the eyes of the royal or courtly spectator in 1550; some fifty years later the portrait of Gabrielle d'Estrées again offered the spectator the subject's gaze in exchange for his or her own; and this convention of portraiture was observed in a long series of seventeenth- and eighteenth-century representations *en Diane* such as the marriage portrait of Marie-Louise de Montaigne, présidente de Riquet, painted by Antoine Rivalz in Toulouse in 1702 and unusual for this time in the bared breast of the noble subject (fig. 8).[45] Like such figures, Boullongne's Diana eschews the internalized glance of standard narrative painting and embodies instead the portrait convention of the outwardly turned gaze.

In casting outward the goddess's eyes, Boullongne may be seen to recover for narrative painting an interactive modality of viewing not readily fulfilled by that form of contemporary illusionism which failed to address the spectator's embodied presence before the work. In previous paintings of the bath by and after François Clouet the eyes of the goddess or at least one of her nymphs had similarly been turned toward the spectator;[46] but in the sixteenth century even the narrative painting of *Diana and Actaeon* at Ancy-le-Franc could feature an outward gaze on the part of the nymph who sought to veil the goddess's naked body from the view of the hunter, though not from our own.

The regal gaze of Boullongne's goddess is also found in a painting of the crowning of Diana by Peter Paul Rubens and Frans Snyders that formerly served as the central feature of the decoration of Honselaarsdijk Palace, the hunting *château* of the Netherlandish king and queen.[47] This Rubensian format of the outwardly gazing goddess might have been mediated for Boullongne by the Dutch painter Jacob Van Loo, who, as a resident of France and member of the Academy between 1663 and 1670, served as an important conduit of Netherlandish trends. One of Van Loo's several paintings of Diana's bath is comparable to Boullongne's canvas in the proportional ratio of figure to frame (c. 1645, Braunschweig, Herzog Anton Ulrich-Museum).[48] In both paintings a regally seated Diana looks straight out at the viewer, although the seminudity of Van Loo's bespangled goddess is not echoed in the chastely covered Maintenon-era huntress by Boullongne. As for Boullongne's seated nymph bathing her foot, two closely entwined nymphs by the Dutch artist together convey a composite impression of Boullongne's figure. Here, however, the notion of resemblance is indefinitely redundant, for the figure of the female bather reaching down to wash a foot slung over her knee is as much a posture of personal experience as it is an artifact of standard usage in many Northern paintings of Diana's bath.[49] This blurring of the indices of the real body and the ideal form will come to seem even more equivocal in the subsequent work of Watteau.

It seems that Watteau would have had the opportunity to meet Boullongne and to study his paintings and perhaps also his drawings during the time of their collaboration around 1708–9 with Claude III Audran, the curator of the Luxembourg Palace and a prolific designer of decorative schemes. It has long been known that the painting by Watteau that came to be engraved in 1729 as *Diana at Her Bath* (cat. no. 13) bears a compelling similarity to the figure of the foot-washing nymph in Boullongne's bathing picture of 1707. Boullongne seems to have taken great care in

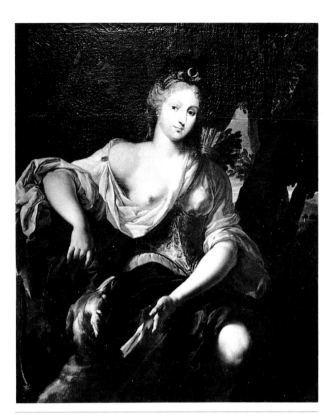

Fig. 8
Antoine Rivalz, *Marie-Louise de Montaigne, Présidente de Riquet, as Diana the Huntress*, 1702, oil on canvas, Toulouse, Musée des Augustins

the design of this and its pendant composition: gouache-touched presentation drawings on blue paper survive for both the violent scene of the hunt and its reposeful aftermath, and two large-scale figure studies, as though drawn from life, separately focus upon foot-washing and sleeping nymphs from the scene of the bath. A much smaller drawing of the bathing figure by Watteau repeats the main lines of Boullongne's drawing, especially in the shadowy area between the open thighs of the nymph, an area which in the painting by Boullongne has been obscured by drapery.[50] It is this secondary though carefully studied figure in the elder painter's composition that becomes the sole figure in Watteau's painting where the identification of Diana depends on the addition of her bow and quiver. No crescent is affixed to her head, and thus Watteau's transformation of a nymph into a goddess remains ambiguous, but what is certain is that his excerption of the bathing huntress from her standard multifigured company both goes against the grain of the Ovidian tradition and is virtually without pictorial precedent. A surprising exception is Rembrandt's etching of *Diana at the Bath* from 1631 (London, The British Museum).[51] Here the unattended goddess bears the direct outward gaze which Boullongne will later attribute,

though much less intensely, to his own figure of Diana. The irregular contouring of Rembrandt's goddess is also closer to the life-study rhythms of Boullongne's drawing than to Watteau's fluid graphic rendition, but it is the emblematic solitariness of Diana that makes an unsettling pair out of Watteau's and Rembrandt's works. Indeed, in the emblem books of the period the meaning of Actaeon's gaze is clear: "To see too much is dangerous."[52] And this danger will turn out to lurk not only at court.

In Rembrandt's print the vulnerability of the naked goddess to intrusion gives rise to thoughts of Actaeon, and also to thoughts of the painter's wife and model Saskia. For if the outward gaze of Diana-Saskia reciprocally engages the inward gaze of Actaeon-Rembrandt (and in so doing makes witting or unwitting contact with an earlier admonition by Karel van Mander that painters of the nude must heed the fate of Actaeon),[53] at the same time Rembrandt's Diana might seem to us to collude in that exchange of gazes—not so much as the outraged goddess who soon turns to taunts and revenge, but as the willing accomplice of the painter's loving yet perhaps also loathing scrutiny of the female body. If indeed Rembrandt assumes the viewing persona of Actaeon in the face of the nude of his desire, do Boullongne and Watteau also feel themselves to be Actaeons in the instant of their scopic encounter with the naked bodies of their models? If so, how so? Do they accept Actaeon's fate as the just consequence of their own desiring look, or do they assume Actaeon's visual posture but none of his moral peril? The question is especially pertinent in view of Watteau's intimate drawings and paintings of models at their toilet or at rest, who seem alternately oblivious of or quite attentive to his probing gaze.

Ovid used the myth of Diana's punishment of Actaeon in order to illuminate his own exile by the emperor Augustus: "Why did I see anything?" the courtier-poet laments.[54] The late sixteenth-century soldier-poet Agrippa d'Aubigné similarly bemoaned the political perils of inopportune looking, but for the most part Ovid's latter-day counterparts took up the erotic interpretation of the myth.[55] These authors described the beloved lady as though she were a Diana to their Actaeon. At first there is little variation in this mythic scene of desire and transgression: "I resemble the hunter who saw the naked beauty"; "I resemble him who saw the naked Nymph"; "I am that Actaeon by his hounds torn"; "I was into a deer like Actaeon changed"; "I am your Actaeon, my Diana you are"; "A new Actaeon I would gladly be."[56] In all these representations the punishment of Actaeon unerringly follows upon the naked look, but this is now conceived as a psychological punishment occasioned by the inac-

cessibility of the lady and executed by the lacerating dogs of the subject's own self-consuming thoughts. The most extended treatment of this scenario is Théophile de Viau's *L'Epître d'Actéon à Diane* (c. 1623), which has been seen as referring to the impossible passion of discrepant rank between Queen Anne d'Autriche and the comte de Montmorency. Here the letter writer's protestation of sincere love depends upon the conceit that his text is no mere artifice of representation: "Experience will make you see that here is the veritable description of the veritable state of my life, not in the least a painting made for pleasure with colors and the enhancements of poetry."[57] Contrary to this last assertion, many poets and painters do seem to take their pleasure at the expense of Diana. In Ovid the goddess deprives the transformed Actaeon of the power of speech in order that he may *not* tell of what he has seen, but telling and showing are just exactly what the painters and poets in our tradition have always continued to do.

Some may do this to disavow the goddess's power; others might wish to appropriate that power as their own. In 1545 the female poet Pernette Du Guillet sought to transform her lover–in real life the poet Maurice Scève–into an Actaeon, not to have him devoured as a stag (*cerf*) but rather transfixed as her slave (*serf*).[58] In 1578 the "new Actaeon" of Hesteau de Nuysement likewise wished to be love's slave rather than stag and not to be deprived of voice in order that he might sing the chaste goddess's praise.[59] For Tristan l'Hermite sixty years later, however, his Actaeon-like lover of a lady in her bath experienced only jealous rage that the water and not he "has kissed her in all places."[60] In this same vein the lexicographer and satirist of preciosity Antoine Furetière inverted the familiar form of the myth and asked, "Why do you trouble yourself?" of his lady whom he has surprised naked in bed.[61] In 1664 the humorist René Le Pays similarly disavowed the menacing implications of the myth: "The misfortune of Actaeon did not happen to me even though I saw something more beautiful than Diana entirely nude."[62]

If these writers could so readily enter into the varied roles of the myth—whether by way of masochistic identification with Actaeon and idealization of Diana or by way of sadistic revenge upon the goddess and jocular denial of masculine guilt—what then of the attitude of our painters Coypel, Boullongne, Watteau, and the rest? One point to note in the foregoing citations is the common literary assumption of the naked Diana's solitariness, and of the solitariness of her modern bathing surrogates as well. An intriguing interpretation of just this non-Ovidian motif is invited by the near-coincidence of date between Watteau's painting of the lone goddess and a popular satirical

comedy by Alain-René Le Sage, performed in 1714 at the Saint-Laurent fair. In this play, entitled *La Foire de Guibray*, the itinerant Italian comedians present a sample of their dramatic wares to a local judge who holds the power to grant them permission to perform before the public. The piece selected for judgment is a cantata in which Actaeon surprises Diana and "her entire court" at the bath:

> He is charmed by so much flesh.
> Instead of getting away through prompt flight,
> Pleasure arrests his steps.

The angry goddess then punishes Actaeon's rashness and the chorus echoes the familiar litany of the courtiers:

> Let us be fearful of pleasure,
> Let us take alarm,
> When it comes to offer itself
> With all its charms.
> To resist it,
> Let us think of the pain
> That it may cost us,
> When it drags us away.

Thus Diana, like Madame de Maintenon herself, would seem to continue to function as a prime enforcer of licit social relations within the rigid hierarchy of monarchical society. But this is not all that we find in the play, for indeed there is a difference between the suburban fair booth of the early eighteenth century and the royal court of 1550 or 1650 or even 1715:

> Ah! If the severe Immortal one
> Had been all alone in the bath,
> She would not have treated him
> In such a cruel way.[63]

In this simple act of fairground *lèse-majesté*, Diana's absolute sovereignty in the age of Louis XIV is undone, and, no longer the unapproachable goddess and queen, she herself is made subject to human desire. Herein lies a telling difference between all those Dianas of the court and Watteau's carnal goddess of the fair.

It is likely that Watteau was not yet a member of the Academy when he painted and drew his thoroughly modern goddess of the Moon. Perhaps it was in 1715, the year of the Sun King's death. Censorship was certainly growing lax by the end of the reign, and in any event Watteau's patronage was not at court. Yet in looking at Diana's nakedness as he does, Watteau breaks with sanctioned iconographical decorum. If Actaeon is in some sense present in Watteau's act of

visual transgression, he is neither conventionally immured within the enclosed space of theatrical illusion nor is he hidden coyly in the brush like some rustic Peeping Tom.[64] If Actaeon is present in Watteau's work, he is embodied in the spectator; emboldened by the transgressive discourse of the fair this Actaeon perhaps quivers first in awe and then with desire at the sight of the goddess brought down to earth, at the sight of a woman who might without penalty reciprocate his look. Perhaps there is a clue to his presence in the bend of her head away from the axis of her own action of washing. This motion more closely resembles the posture of the foreground nymph in the painting by Coypel than the movement of Boullongne's nymph upon which Watteau's figure is demonstrably based. In Coypel's painting the movement might seem to betoken a sudden auditory attention to an invisible Actaeon; his out-of-frame presence in the painting by Watteau would also account for Diana's acutely lowered and sharply peripheral gaze.

In Ovid's treatment of the myth, Actaeon becomes present to Diana's vengeful gaze virtually at the same instant as her unexpected appearance to him. In other ancient sources, however, it is the hunter's erotic desire and willful voyeurism which is stressed.[65] Charpentier's opera mobilizes Actaeon's desire but only in the aftermath of a chance encounter with the goddess, and in the end the mortal still pays the traditional price for his infraction. A drawing attributed to Antoine Coypel's son, Charles-Antoine, is highly unusual in intimating an alternate outcome (fig. 9). Here the mythological cast is reduced to a hornless figure of Actaeon, accompanied by a barking dog and springing out from behind a rock, and the unclothed figure of Diana, whose last wisps of drapery are pulled away from her naked body with an offering flourish by two winged cupids.

This, of course, is not the canonical form of the myth, which, by contrast, a drawing by Boullongne exemplifies (fig. 10). Here Diana rivets her eyes and her pointing hand upon the stag-horned hunter, who raises up an arm as though to fend off the goddess's gesture and gaze. Unlike the erotic implications of Charles-Antoine Coypel's composition, the postures of Boullongne's drawing reflect an *ancien-régime* hierarchy of social relations in which the unauthorized act of looking is seen as unacceptable aggression. Whether understood as willful or witless, this act is met with feminine anger and resistance, and revenge takes the form of an antlered effacement of masculine pride.

The main lines of Boullongne's composition and its residual moral gravity are still intact in a painting of the subject from the 1720s by his pupil Louis Galloche (cat. no. 12). By way of its architectural setting within the forest, Galloche's painting proclaims its fidelity to Ovid's text and perhaps also to Titian's celebrated paintings of Diana's bath in the Orléans collection, where just such hybrid structures of art and nature are depicted and described (fig. 11).[66] Galloche's painting is the epitome of academic practice just at the time when the fairground license of Watteau and other regency painters and dramatists continued to stage a subversive *mythologie galante* of daily life. In 1724 the playwright Marivaux incorporated a passing reference to Diana and Actaeon in his prose comedy *Le Dénouement imprévu*; he did so in such a way as to evacuate the emblem of its classical gravity and fill it instead with the improvisational energies of vernacular conversation. "They say he's a hunter, but does he know the story?" asks Mademoiselle Argante of a man whom she does not yet realize is the very would-be lover to whom her question refers: "He would see that the hunt is dangerous. Actaeon perished for having troubled the repose of Diana. Alas! If mine were troubled, I would know only to die."[67] In the eighteenth-century battle of the sexes, mythology continued to structure the real options at hand, however inverted and refashioned these roles may have turned out to be. With a popularized mythology so saturating the daily psychology of sex, it may have seemed to many contemporaries merely foolish to seek to sustain, as perhaps Galloche still did, the traditional apparatus of Diana's myth.

Across the gap of two decades the goddesses of Boullongne and Galloche share an artistic protocol that has no place for the burlesques and travesties of the Dianas of Watteau and Marivaux. Their transgressive insistence on the erotic potential of the goddess is echoed within academic practice, however, in the renovated mythological paintings of Jean-Francois de Troy. In his reception piece for the Academy in 1708 de Troy had dutifully accepted the burden of tradition and depicted Diana and her brother Apollo killing the children of Niobe, the nymph who had boasted of her progeny that they were more beautiful than the divine twins of Latona. In a bathing subject of around 1718, however, de Troy transformed the chaste and punitive Diana into a preening goddess of Love (fig. 12). For this composition de Troy takes over quite directly the bodily posture of Coypel's goddess, especially the distinctive spread-leg arrangement of the lower limbs. De Troy also repeats the limp-armed action of Diana in Coypel's painting, although here, instead of reaching for a fecundatory piece of fruit, she supports with her hand the top of a mirror, a venereal rather than virginal accessory that is proffered to her by an attendant nymph. As opposed to its role in representations of Venus, the mirror has no proper iconographic role in the mythology of Diana,[68] and indeed such impropriety in the symbolic construction of de Troy's painting car-

ries it well away from the academic norm. To be sure, much in 1718 is still orthodox; the tending on the part of two nymphs to the hairdressing and foot-washing of the goddess is in the main line of French descent from La Fosse, Boullongne, and Antoine Coypel, and these two actions will again be repeated with only minor changes in de Troy's later and larger representations of Diana's bath. A second bathing picture of c. 1722–24 retains the earlier gesture of adjusting the goddess's hair, but at the side it adds an unusual figural couple amidst the bullrushes and reeds (cat. no. 18). Perhaps here we have the naiad and river-god of this place, just the sort of rustic *staffage* attributed to Diana's retinue by Renaissance mythographers. The hair of the male figure is entwined with reeds, and his eyes are covered by the hand of the reed-entangled nymph; she seems to initiate this shielding gesture as though to protect the naked female goddess and her company from his intrusive Actaeonic gaze; or, contrariwise, as though to restrain him from a movement or sound that might alert the goddess to his unbidden presence. As depicted by de Troy, this swarthy river-god recalls the satyrs in paintings of Diana from Clouet to Rubens, or even the leering Faunus (or Pan) of Edmund Spenser's *Faerie Queen*, who spies upon the bathing goddess with the collusion of a nymph but only to give himself away with a foolish lustful laugh.[69] In de Troy's painting there is no attempted rape, nor does any punishment transpire. Yet the focus upon the river-god's thwarted sighting of the oblivious goddess may anticipate de Troy's subsequent stagings of Actaeon's fate.

De Troy's large canvas of *Diana Resting* shared first prize with a sober painting of *The Continence of Scipio* by his chief rival François Lemoyne at the specially convened competition for history painters in 1727 (cat. nos. 21, 30, 32, 34).[70] In his overflowing

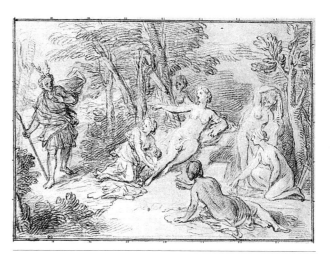

Fig. 10
Louis de Boullongne, *Diana and Actaeon*, c. 1704–07, black chalk with white highlights on blue paper, Paris, Musée du Louvre, Cabinet des Dessins

composition de Troy again would seem to have taken up the topos of the bath from its paradigmatic instance in the work of Antoine Coypel a quarter-century before. Engraved as recently as 1723, this sly norm of the genre may be seen as the immediate pretext for de Troy's witty elaborations of 1726 and 1734.[71] In his painting de Troy replaces the jewel-like lunar ornament atop the head of Coypel's similarly panther-skinned goddess with a luminous crescent which uncannily appears to float in midair. Coypel's foreground nymph seated by the water seems to be the prototype for de Troy's background river-goddess, complete with urn, who turns to look toward Diana as though with a warning, as though she too, like Coypel's nymph, has sensed Actaeon's approach. Actaeon himself is not visibly present, but in de Troy's painting of 1734 the errant hunter is incorporated into the space of narrative illusion by way of the image of the fleeing stag with hounds at his heels (cat. no. 22). The figure of Diana gestures in the direction of the stag with none of the outrage of tradition and perhaps even with a tinge of regret. Her widely splayed legs once again evoke the forbidden erotic potentialities of Coypel's courtly Diana; at the same time this pose may also recall the more overtly erotic use of the motif in a small canvas of 1728 by Antoine's much younger half brother Noël-Nicolas Coypel, who, like de Troy, had been a prominent competitor at the *concours* in 1727.[72]

The juxtaposition of de Troy's two large paintings of Diana's bath suggests an unfolding of successive moments in the Ovidian narrative. Of equal size and equivalent facture, the two pictures repeat the sequential format found in many of the illustrated editions of the *Metamorphoses*, in which the canonical scene of

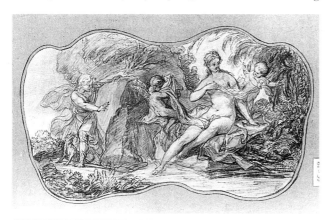

Fig. 9
Attributed to Charles-Antoine Coypel, *Diana and Actaeon*, c. 1725–30, drawing, Paris, Musée du Louvre, Cabinet des Dessins

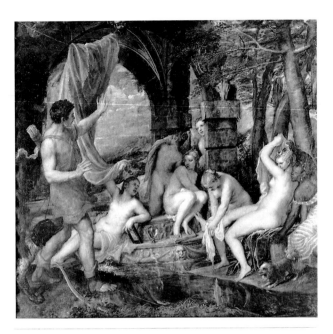

FIG. 11
Titian, *Diana and Actaeon*, 1556–59, oil on canvas, Edinburgh, National
Gallery of Scotland

Actaeon's intrusion is paired either with a scene in
which the stag-headed Actaeon comes upon his al-
tered reflection or, much more commonly, with the
scene of the fully transformed stag being torn to death
by the dogs.[73] This ostensibly nonmythological hunt-
ing scene was first illustrated in prints by Parmesan
and Fontainebleau masters of the 1540s.[74] A century
later the illustrated text of Michel de Marolles's
Tableaux du Temple des Muses (1655) explicitly played
upon the spectator's likely failure to recognize in the
familiar hunting scene the mythological theme of Ac-
taeon's death. The tiny background figures of Diana
and her companions are only allowed to be discovered
after the foreground scene of animal combat has been
initially registered as such, and additional nymphs are
even said to be hidden by the image's frame.[75] Similar
ironies are found in de Troy's own day in a 1732 draw-
ing by Jean-Baptiste Oudry for a royally commissioned
tapestry series of the *Metamorphoses*.[76] This animal-
allegorist also designed the frontispiece for a wry trea-
tise of 1734 dedicated to the king and entitled *Diane,
ou les loix de la chasse du cerf*.[77]

My sense of the humor in de Troy's *Diana Surprised
by Actaeon* stems from what I see as its refusal to adhere
to the standard options of the illustrative tradition. Ac-
cording to the axiomatic unities of preceding pictorial
practice, de Troy ought to have painted either a scene of
Diana's bath where the confrontation with the man-
headed, antlered, or stag-headed Actaeon is featured
and the scene of his death is assigned, if at all, to the
background, or a scene of Actaeon's death in the form

of a stag, in which Diana and her nymphs appear, if at
all, only as a subsidiary part. No iconographical prece-
dent exists to my knowledge for de Troy's juxtaposition
of the surprised goddess and the startled stag, but the
painter was by no means alone in the 1730s in restaging
the canonical forms of the myths of Diana. In a cantata
entitled *Diane et Actéon* of 1732, a choral work attribut-
ed to Joseph Bodin de Boismortier, there is a recurrent
refrain which underscores the vulnerability of the god-
dess and her all-female society to masculine encroach-
ment: "Flee, flee, savage faun! Flee, flee, horrid satyr!
Diana fears the homage of your amorous hearts. Assem-
ble, you naiads, second her desires! Come, young dry-
ads, join with the zephyrs. Be in this wood the sole wit-
nesses with whom her beauty shares its looks and
cares."[78] This anxious refrain recalls de Troy's faun-like
voyeur in the painting of 1720; and in the face of the
painting of 1734 the refrain asks each spectator whether
she or he is to play the role of brutal intruder or loyal ally.

In the cantata the sudden arrival of Actaeon
"strikes" the goddess with trembling and renders the
nymphs confused. In contrast, in Charpentier's somber
opera of a half-century earlier it is Actaeon who is
"struck" by the goddess's naked beauty. There his infe-
riority of rank is patent and decisive in his punishment,
whereas in Boismortier's scenario Actaeon's disempow-
erment is seen as the needless consequence of his in-
ability to exploit the "happy moment": "The timid Ac-
taeon, surprised by so much beauty, limits himself to
contemplating it." The criminal surprising of Diana in
the age of Louis XIV becomes the mocked surprising of
Actaeon under Louis XV's reign; unsplashed here, just
as in de Troy's painting, the stag in its timidity replaces
the audacity of the hunter, and so Actaeon flees, a fool
for his failure to act: "There are favorable moments
when nothing can resist you, and the less these mo-
ments endure, the more you must profit from them."[79]

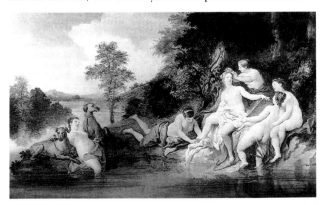

FIG. 12
Jean-François de Troy, *The Bath of Diana*, 1718, oil on canvas, Private
Collection

Le Sage had earlier suggested that such a moment might have presented itself had not Diana been encumbered by the responsibility for her virginal nymphs. Now it seems that even their presence need not have deterred a truly determined Actaeon.

In mythographic manuals the stag was a hieroglyph of timidity and also a conventional pictorial sign of a man feebly drawn into the dominating company of women. Could the self-sapping habits of aristocratic sexuality be represented and ridiculed in the cantata of 1732 and the painting of 1734? In the quite different social context of middle-class London, Hogarth makes open fun of aristocratic promiscuity by placing a stag-headed Actaeon doll in a prominent corner position in the scene of the countess's *levée* in his narrative series *Marriage à la Mode* of 1743 (London, The National Gallery).[80] There both the countess and earl pay mortally for their sexual transgressions, whereas in France the satire remains unbarbed. An example is the revisionary caption of a midcentury engraving in which Boullongne's classical composition of *Diana and Actaeon* becomes the occasion for a ribald chiding of the "unjust" and "inhuman" goddess and a lament on the errant hunter's ill-deserved fate:

> For having one moment contemplated your
> charms,
> Wouldn't it have been harsh punishment
> enough
> To have looked and not had the enjoyment of
> them?[81]

Boucher's representations of the myths of Diana constitute a midcentury summation of the trends I have tried to trace in this essay. He shows himself to be the heir of his master Lemoyne in a drawing of Diana's discovery at the bath of the pregnancy of Callisto. Boucher repeats Lemoyne's distinctive eye-shielding gesture on the part of the humiliated nymph (cat. no. 24), yet on the whole the composition seems to enact less the traditional trajectory of transgression, disgrace, and punishment than *Les Folâtres Jeux* which it is made to illustrate in a partially demythologized version engraved by Le Gros in 1791.[82] Another drawing similarly groups Diana and her nymphs in a forest glade but without indication of any particular textual episode. From this multifigured drawing Boucher excerpted the famous painting from the Salon of 1742 in which only one companion, perhaps Callisto herself, attends Diana at the bath (cat. no. 45). Here the reciprocal absorption of goddess and nymph is rendered precarious, however, by an indication of the as yet invisible Actaeon, whom Diana's two sniffing and scanning hounds may already have sensed lurking in the forest growth above the goddess's head.[83]

Boucher's transformation of the relation of Diana and her nymph into an ambiguous play of gesture is paralleled in the artist's explicit compositions on the myth of Actaeon. In an engraving by Tardieu after an early composition by Boucher, Diana's adolescent disarray stands in ineffectual contrast to a youthful Actaeon, who lunges into the rear of the scene flourishing not the horns of a stag but his own hunting horn instead (fig. 13).[84] Actaeon later acquires his conventional antlers in a drawing by Boucher dated 1766 which Augustin de Saint-Aubin etched for an elaborate new edition of the abbé Banier's translation of the *Metamorphoses* (fig. 14).[85] Diana looks and points with one hand at Actaeon, who stands his ground and pointedly looks at her. Indeed, in the line of his gaze, it would seem, there is much for him to see: in the drawing and in the unpublished first state of the print, Diana's drapery extends only to the midriff of the goddess, whereas in the book illustration of 1768 the cloth concealment is extended across her exposed genitals and down to the thigh. This public veiling of the goddess's nakedness is neither required by the Ovidian tradition nor by the private interpretation of Boucher.

In the eighteenth century the assumption of Actaeon's gaze frequently failed to bring in its train Actaeon's fate. An instructive example of this countermythological metamorphosis of the Ovidian legend may be found in a comic opera of 1755, *Les Nymphes de Diane*, written by the vaudevillian Charles-Simon Favart, with whom Boucher collaborated on a number of theatrical projects. The goal of Favart's narrative is to enact revenge upon what is held to be the lawless chastity of Diana's nymphs in the lawful name of the universal god of Love. Under such a regime the Actaeonic trespass at the bath is no crime, as the following fanfare—"And like a deer I am straightways chased off"—makes clear:

> I fall in losing breath,
> The darts are aimed at me.
> My death appears certain;
> But I receive no more than fright,
> They do not sound my capture,
> They treat me with kindness;
> Pity favors me,
> And I obtain my liberty.[86]

Not merely does this avenger of love not lose his life; he also manages to escape the detection of Diana's watchful priestess under the borrowed garb of a nymph. Here the mythological reference shifts from the story of Actaeon to that of Callisto seduced by Jupiter in the guise of Diana. The caption beneath an engraving by Fessard after de Troy's depiction of this myth points to the same transvestite ruse which Favart exploits:

The Lover who to make himself happy
Disguises his fire beneath the veil of friendship
Ought to cause you the greatest alarm.[87]

Between 1744 and 1769 Boucher painted at least six versions of the seduction of Callisto (cat. no. 49). This number of paintings on a single theme is surpassed in Boucher's work only by the seven different versions painted between 1732 and 1769 of the story of Venus who demands arms for her mortal love child Aeneas from her often-betrayed husband Vulcan (cat. no. 43).[88] In Boucher's gynocentric art the classical antithesis of Venus and Diana is made one, and the sensual female body becomes the sign of a new ideology of sexual freedom. Voltaire expressed this masculine conflation of goddesses in a series of verses written for one of the most celebrated women of the age, the ballet dancer Marie Salle:

The fires of the god her virtue condemns
Are in her eyes, in her heart unknown;
Sighing one takes her for Diana
Who has just danced beneath the traits of Venus.[89]

That Diana herself must no longer remain chaste seems to me to be a principal message of her metamorphosis in the art of Boucher and his contemporaries. *Diana at the Bath* from the Salon of 1742 was paired by Boucher with a depiction of Venus and Cupid similarly seen at rest in a waterside setting.[90] Indeed, the story I am telling here is largely about the twinning of these traditional Olympian rivals, who had more or less continuously acted out a lethal combat between chastity and love from the time of Euripides's *Hippolytus* down to that of the myth's reworking in Racine's *Phèdre* in 1677.[91] During the course of the eighteenth century Actaeon is forgiven his intrusion, Callisto is pardoned her transgression, and Diana withholds her punitive gaze. The myth of Jupiter and Callisto, largely overlooked by painters since the time of the first school of Fontainebleau, is now taken up as though ready-made for the contemporary cultural task of eroticizing Diana, of repudiating the prior system of hierarchical constraints in which her tantalizing nakedness and adamant virginity had functioned both to acknowledge the ubiquity of desire and yet also to limit its mobility across the boundaries of gender and class. In Boucher's various representations of Jupiter and Callisto, the effigy of Diana can appear as the lover rather than moral censor of the nymph, and her/his erotic posturings will thereafter migrate irrepressibly from the mythic forest of Arcady to latter-day rustic barnyards and back again. From antiquity to modernity and from female to male, the reiterated poses of the myths of Diana

endlessly circulate amid the redundant formal workings of Boucher's art,[92] and of the art of his pupil Fragonard as well (cat. no. 57). Ultimately, these gazes and postures of art are transmuted empathically back into the living, changing bodies of the spectators of these works.

Boucher's libidinous misprision of the traditional theme of the goddess's chastity was underscored in the caption to an engraving of his picture entitled *Diana's Return from the Hunt* of 1745:

Playing with Love, it is thus that a beauty
Feeds her vanity in the hurt her eyes cause;
But this god loses nothing and soon
For Endymion this rebel will forget her pride.[93]

During the eighteenth century the Moon's affair with the shepherd Endymion provided the most overt means of transforming the myth of Diana along venereal lines. In *The Art of Love* Ovid makes a brief joint reference to the myths of Endymion and the Moon and of Venus and Adonis; coincidentally perhaps, two of Boucher's earliest mythological paintings of around 1726 depicted in scarcely distinguishable poses Diana's nocturnal scrutiny of her sleeping lover as well as Venus's grieving adoration over the body of her dead lover, killed on the hunt.[94] Fragonard and other contemporaries similarly eroticized Diana in her smitten encounter with Endymion (cat. no. 60),[95] and depictions such as these point us generally in the direction of the popular literary themes of feminine initiative in love and the revolutionary traversal of hierarchies of class.[96] As the rebellious goddess says to her mortal lover who fears the patriarchal retribution of Jupiter in Le Sage's *Arlequin Endymion* of 1721, "In any case I am of full age."[97] Back in 1681, in the Lully-Quinault *Triomphe de l'amour*, a much more reluctant Diana consummates her secret desire for the sleeping youth only under the obliging allegorical cloak of Night, Silence, Mystery, and Dream.[98]

Paintings and sculptures of Diana continued to be exhibited in the last decades of the eighteenth century, during which a reformed agenda of ancient and modern civic virtue largely came to eclipse the renovated eros of the once chaste lunar deity.[99] In 1777 the critic Pidansat de Mairobert exposed the moral paradox of Diana's naked representation in connection with Allegrain's semicrouching marble figure of the goddess at the instant of being surprised by Actaeon (fig. 15): "But much as she hides her charms on one side, so does she expose them on the other."[100] The intimacy of Diana was thus acknowledged to be violated by the spectator even as this illicit view is imagined as being withheld from the implied intruder of the familiar myth.

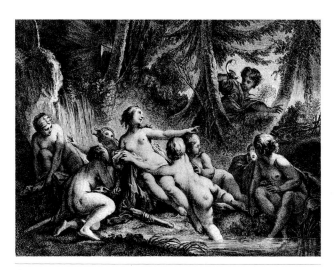

FIG. 13
Pierre-François Tardieu after François Boucher, *Diana and Actaeon*,
c. 1750, etching and engraving, Paris, Musée du Louvre, Cabinet des
Dessins, Collection Edmond de Rothschild

It is just such an ambivalent implication of the spectators of art in Actaeon's mythical drama of visual transgression that obtains still for us today, I think, in the face of the powerful but vulnerable nakedness of Diana in the painting executed in 1791 by the young Antoine-Jean Gros in the studio of David (cat. no. 66). Long misidentified in spite of her quiver as Diana's biblical counterpart, the voyeuristically violated Susanna, the painting by Gros isolates the classical goddess from amidst the accessory figures of narrative practice from Boullongne to Boucher and magnifies her to the empathic, interpersonal scale of life.[101] In 1791 another of David's students, Anne-Louis Girodet, famously transformed his life-size study of a reclining male nude into a figure of Endymion asleep, bathed in the lunar gaze of the disembodied goddess.[102] In Gros's painting it is the female who is massively embodied in the depicted figure and the Actaeonic male who may only be represented as a gazing phantasm beyond the pictorial frame.

But how is this imaginary viewing position to be occupied, and by whom, with pleasure and/or with dread? In the popular *Lettres à Emilie sur la mythologie* of 1786, C.A. Demoustier imagined Diana as reversing her traditional response to Actaeon's gaze: "He saw what no mortal should see. Today I would pardon him his involuntary crime; I punished him for it then." Between then and now Diana has come to realize, or so Demoustier says, what she had never experienced:

The charming pleasure
Of seeing oneself, in a new being,
Fused with one's lover.[103]

Of this Diana, Actaeon would have nothing to fear, but this acquiescent figure hardly seems to be the Diana of Gros. Here the ritual distance from the prohibited body of the goddess which earlier in the century had been abrogated is once again reasserted as an urgent need, though perhaps not by way of the reinstitution of the same royal gaze which had externally regulated the rule of sexuality under the patriarchal and matriarchal law of the old regime. Now, during the rapid flux of these early years of revolution, the transgressive practices of the body in Watteau, de Troy, and Boucher have yielded a newly individualized psychological standard. With Antoine-Jean Gros, as with his contemporary André Chénier, writing in 1785–87, we may approach this reempowered yet still vulnerable Diana with both longing and fear; and in awe we may address her, as we might a mother or a lover, with an ambivalent gaze:

But if the soft stream rolling with bright waves
Invites you to quit your light tunic,
Goddess, I will flee; for your chaste anger

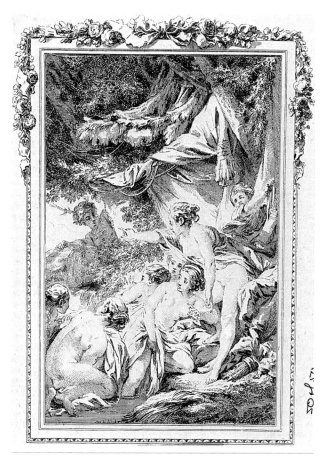

FIG. 14
Augustin de Saint-Aubin after François Boucher, *Diana and Actaeon*,
1766, etching, Paris, Musée du Louvre, Cabinet des Dessins, Collection
Edmond de Rothschild

Is terrible and mortal. I will flee far from you,
For fear lest to avenge yourself your ready pack
See an antlered branch rise up upon my head.[104]

Chénier soon lost his life in the Revolution, a political casualty, like Ovid and d'Aubigné and others before him, of having seen too much. "Why did I see anything? Why did I make my eyes guilty? Why was I so thoughtless as to harbor the knowledge of a fault? Unwitting was Actaeon when he beheld Diana unclothed; nonetheless he became the prey of his own hounds."[105] From the poets and painters of Fontainebleau and Versailles to Jean-Paul Sartre and Jacques Lacan, French authors and artists have always known that these hounds of death are Actaeon's—and our own—self-lacerating thoughts.[106] Some have sought to disavow this knowledge; others have tried to represent its precarious responsibility of possession and loss. As the dispossessed North African painter Jean-Michel Alberola has recently said: "In fact Actaeon, that is I before the painting; and I am not afraid of going blind."[107]

Fig.15
Gabriel-Christophe Allegrain, *Diana Surprised in the Bath by Actaeon*, 1777, marble, Paris, Musée du Louvre

NOTES

1. In verses of praise addressed to Louis XIII at the time of his betrothal to Anne d'Autriche (1612), the goddess Diana characterizes herself according to the classical triadic formula (Voiture 1971, I, 313–14): "I am adored in three places / Three places burn incense upon my altars, / The underworld, the azure vault / And the place tended by mortals" ("Je suis en trois lieux adorée / Trois lieux encensent mes Autels, / Les enfers, la voûte azurée / Et ce que tiennent les mortels").

2. Bolzani 1615, 791.

3. Ovid, *Metamorphoses*, II, 401–530, III, 138–259. On Ovid's influence in France, see H. Bardon 1959 and 1963, Mérot 1982, Moss 1982, Llewellyn 1988, and Standen 1988. The fullest listing of prints after Ovid is in Pigler 1956, II, 65–76, 136–37, 151–55.

4. Moréri 1731–32, III, 554, "fut moins sévère, à l'égard d'Endymion, berger de la Carie, pour lequel on dit qu'elle quittoit le ciel toutes les nuits."

5. Banier 1738–40, II, 427, "On sçait de quelle manière elle chassa Callisto, que Jupiter avoit séduite et ce qu'il en coûta à Actéon pour l'avoir vue dans le bain; mais comme la Mythologie ne se soutenoit gueres dans ses principes, on racontoit qu'elle avoit été amoureuse d'Endymion, qu'elle alloit voir toutes les nuits dans les montagnes de la Carie."

6. Chompré 1808, 140–41, "Si elle n'étoit pas plus sage que les autres déesses, elle faisoit du moins semblant de l'être."

7. *Encyclopédie*, 1751–65, X, pt. 2, 897, "Les douleurs que Latone souffrit, donnèrent à Diane de l'aversion pour le mariage, mais non pour la galanterie. On l'accuse d'avoir aimé et favorisé Endymion, d'avoir cédé à Pan, métamorphosé en belier blanc, et d'avoir reçu Priape sous la forme d'un âne."

8. The following lists are compiled from the published *livrets* of the Salon (see Salons 1673–1881): Charmeton 1673 and 1699, Boullongne the Younger and Colombel 1704, Galloche 1725, J.-B. Van Loo and Natoire 1737, Trémolières and Jeaurat 1738, La Datte 1741, Boucher and Vinache 1742, Dumont le Romain and Natoire 1743, Hallé 1753, Mignot 1759, Brenet 1771, Lagrenée the Elder and Vien 1773, Monot 1775, Lagrenée the Younger 1779, Taraval 1781, Masson 1793, Fortin 1796, Blaise and Duperreux 1798.

9. Diana and Callisto: Dupré 1804; Jupiter and Callisto: Restout 1725, Natoire 1745, Hallé 1755, Daullé after Poussin 1759, Boucher 1761 and 1765, Lagrenée the Elder 1771, 1795, and 1796, Jollain 1771, Regnault 1791, Blot after Regnault 1799.

10. Van Clève 1704, de Troy 1725, Lagrenée the Elder 1765, 1769, and 1775, Levasseur after J.-B. Van Loo 1771, Dumont le Romain 1771, Carême 1775, Delaunay 1771, Desoria 1791, Girodet 1793.

11. Jeaurat 1737, Natoire 1742, Mignot 1757, Jollain 1769, Lagrenée the Elder 1771, 1779, 1795, and 1796, Levasseur after de Troy 1775, Allegrain 1777, Monsiaux 1791, Viel after Metay 1793, Lucas 1795.

12. Salons 1673–1881, III (1757), 32, "surprise au bain."

13. The life-size Roman marble brought to France by François I and subsequently known as *Diane de Versailles* (Paris, Musée du Louvre) engendered a series of free-standing sculptures for interior and exterior display at the royal *châteaux*: Roger 1669, Collignon 1673, Desjardins 1684, Flamen 1693, Lefebvre 1703, Coustou 1710, Frémin 1717; see Favier 1970 and Souchal 1977–87, I, 109, 135, 249, 308, 335; II, 224; III, 266. Flamen exhibited a bronze Diana at the Salon of 1704, and Houdon utterly transformed the genre with his startlingly naked and striding figure of the goddess at the Salon of 1783 (San Marino, Calif., Henry H. Huntington Library and Art Gallery).

14. For sixteenth- and seventeenth-century representations *en Diane*, see F. Bardon 1963 and 1970. Notable works include School of Fontainebleau, *Diana de Poitiers (?) as Diana the Huntress*, c. 1550 (Paris, Musée du Louvre); Ambroise Dubois, *Gabrielle d'Estrées as Diana*, c. 1590–99 (château de Chenonceaux); Orazio Gentileschi, *A Woman as Diana*, c. 1624–26 (Nantes, Musée des Beaux-Arts); Claude Deruet, *The Duchesse de Chevreuse as Diana*, c. 1627–33 (Musée National des Châteaux de Versailles et de Trianon); Charles Beaubrun (?), *Anne-Marie Viguier as Diana*, c. 1640 (château d'Ancy-le-Franc); Louis Beaubrun, *Madame de Montespan as Diana* (Musée National des Châteaux de Versailles et de Trianon); Laurent de La Hyre (after), *The comtesse de Beauvais (?) as Diana* (Châlons-sur-Marne, Musée Municipal); Claude Lefebvre, *Mademoiselle de la Vallière as Diana*, 1661 (Musée National des Châteaux de Versailles et de Trianon); Pierre Mignard (school of), *An Unknown Woman as Diana*, 1680 (Musée National des Châteaux de Versailles et de Trianon); Antoine Coysevox, *Marie-Adélaïde de Savoie as Diana*, 1710 (Paris, Musée du Louvre); Nicolas de Largillière, *Portrait of a Woman as Diana*, 1714 (New York Historical Society); Jean-Marc Nattier, *The comtesse de Mailly as Diana*, 1743 (New York, Private Collection) and *Marie-Adélaïde de France as Diana*, 1745 (Musée National des Châteaux de Versailles et de Trianon); Donat Nonnotte, *Madame Jordan as Diana*, 1760 (Lyons, Musée des Beaux-Arts); J. E. Heinsius, *The baronne de Villequier as Diana*, c. 1780 (Paris, Musée du Louvre); Joseph Chinard, *Madame de Verninac as Diana*, 1808 (Paris, Musée du Louvre).

15. Salons 1673–1881, IV (1769), 17, "le portrait de Mlle Cha***, en Diane, accompagnée de ses Nymphes, et poursuivant le Cerf aux abois."

16. Panard, "Description de l'opéra" (c. 1729–54), in Finch and Joliat 1971, 322, "J'ai vu Diane en exercice / Courir le cerf avec ardeur; / J'ai vu derrière la coulisse / Le gibier courir le chasseur."

17. F. Bardon 1963 and Wilson 1939, 167–229. The Elizabethan appropriation of Diana is usefully discussed in Barkan 1980.

18. F. Bardon 1970.

19. François de Grenaille, *Les Plaisirs des dames* (1641), in F. Bardon, 1970, 202–3, "Vous voyez un pauvre Cerf qui perdant l'haleine semble estre bien aise de rendre le dernier souspir aux pieds de ces Nymphes, comme s'il croyoit devenir un autre Actéon par la puissance de ces Dianes"; "les Dianes des Villes"; "nous sommes plutost faits pour voir que pour estre veus, mais elles sont faites pour estres veues."

20. Scudéry 1983, I, 53, "Que je sois Actéon, pourveu que je la voye."

21. Starobinski 1981, I, 391, "chez les Anciens que l'on lit au collège, dans les tragédies que l'on va voir au théâtre, dans les tableaux d'histoire, dans les monuments que l'on dresse sur les places, dans les décorations des demeures." "La connaissance de la fable est la condition même de la lisibilité du monde culturel tout entier. . . . Elle a donc une double fonction; elle est un langage imagé donnant accès à un certain type d'organisation du discours, et la fonction de ce langage est signe social de reconnaissance, entre individus qui savent déchiffrer de la même manière l'univers des fictions mythiques." Other helpful works on mythology in the eighteenth century include Manuel 1959, Feldman and Richardson 1972, and Engell 1981.

22. Voltaire 1877–85, IX, 24–25, "Ces montagnes, ces bois qui bordent l'horizon, / Sont couverts de métamorphoses; / Ce cerf aux pieds légers est le jeune Actéon. . . . Toujours Ovide charmera." Strolling in the Tuileries gardens c. 1629, an earlier poet had had a similar allegorical vision to that of Voltaire (Saint-Amant 1971, I, 132): "If there I meet a deer, my sad fantasy, / With the death of Actaeon is suddenly seized" ("Si j'y rencontre un Cerf, ma triste fantaisie, / De la mort d'Actéon est tout soudain saisie").

23. F. Bardon 1963, 39–122.

24. Sylvie Béguin suggests the authorship of either Luca Penni or Jean Cousin the Elder for the anonymous *Diana and Actaeon* of c. 1540–50, see exh. Paris 1972–73, no. 233; its composition of juxtaposed naked goddess and stunned hunter follows the well-known format of an early sixteenth-century print by the Master I. B. with the Bird (Bartsch 1978– , XXV, 75). On the architecture and decoration of Anet, see Roy 1929, 285–380, and, for the tapestries, Standen 1975 (B). Cellini's bronze *Nymph of Fontainebleau*, 1543 (Paris, Musée du Louvre) was brought from Fontainebleau to Anet on Diane's behalf to reign as a new Diana above the gateway designed for her by Philibert Delorme (Vickers 1985). The most famous work expressly executed for the *château* is the massive forecourt fountain group of the naked goddess Diana embracing the royal (Actaeonic?) stag (Paris, Musée du Louvre), a sculpture variously attributed to Cellini, Goujon, Pilon, or an anonymous follower (Chastel 1966).

25. Chastel 1972–73, xxii, "une cour est une mythologie en acte"; "Le thème d'Actéon ou la punition de l'indiscret avait des résonances trop immédiates dans une société où le rituel des approches et des refus amoureux était détaillé chaque jour par les poètes, pour que l'on ne projetât, pas des visages familiers sur les personnages de la Fable."

26. For a repertory of works at Ancy-le-Franc (including bibliography), see exh. Paris 1972–73, 483. The influential print of Diana and Actaeon from the school of Raimondi (c. 1525–40; Bartsch 1978– , XXVIII, 54) was engraved in reverse by the Master IHS in 1556 (ibid., XXXI, 388); elements of its canonical composition of the splashing goddess and the antlered hunter are found repeated in numerous prints, ceramic plates, carved reliefs, and paintings down to the eighteenth century. Among them is a painting on panel of c. 1570 (Paris, Musée du Louvre), sometimes attributed to the Flemish painter Anthonie van Montfoort (called Blocklandt), in which the likenesses of Charles IX and his mistress Marie Touchet have been seen in the faces of Diana and Actaeon (F. Bardon 1963, 127–28); a much-copied painting by Giuseppe Cesari, the Cavaliere d'Arpino (Paris, Musée du Louvre), possibly executed in Paris c. 1600–1601 and later acquired in 1662 by Louis XIV, which could well have provided a compositional impetus for eighteenth-century painters such as Antoine Coypel, who refers to it in a note in 1722 (exh. Rome 1973, 107–8); and, finally, a painting attributed to Coypel (Lyons, Musée des Beaux-Arts) in which the outlines of Actaeon's posture are still quite directly taken from the sixteenth-century Italian print.

27. On the lost decoration of the *galerie de Diane* at Fontainebleau from the time of Henri IV, see Herbet 1937, 413–21, exh. Paris 1972–73, 481, and Samoyault-Verlet 1975, 243–44. The original program is recorded in part in a drawing by Claude III Audran (Stockholm, Nationalmuseum), who also restored some of the decorations in 1706 (Béguin 1971 [B], 37–38). It was around this time that Audran worked in close collaboration with Louis de Boullongne and Jean-Antoine Watteau, who thus might easily have come to have firsthand knowledge of the decorations, which ultimately were replaced during the reign of Louis XVIII (1819–22).

28. See Dunand 1980 for a discussion of de Bry's engraving of Diana and Actaeon (c. 1592) in the context of other sixteenth-, seventeenth-, and eighteenth-century representations of the successive phases of the Ovidian narrative.

29. On the *salon de Diane* and the cycles of planetary rooms at Versailles, see Marie 1968, II, 281–84, and Berger 1985, 41–50, 69–71.

30. On the decorations for the Grand Trianon, see Schnapper 1967. The influential role of the compositions by La Fosse (Rennes, Musée des Beaux-Arts et d'Archéologie) and Houasse (Narbonne, Musée d'Art et d'Histoire) is noted in Standen 1988 in a discussion of the period's popular tapestried series of Ovidian subjects (c. 1680–1730).

31. *Le Triomphe de l'amour* consists of a loosely connected suite of twenty *entrées* of music, narration, and dance; in 1681 the tenth *entrée* of the entertainment presented the story of Diana and Endymion, but at the time of its altered revival in 1705 this scene became one of only four (Pitou 1983, I, 325–26). The libretto is reproduced in Quinault 1703, I, 197–98, and the original dedicatory verses by Isaac de Benserade are reproduced in Lajarte 1878, I, 41, where the *Dauphine*, as the "charming Nymph of Diana," is implored "that you must not be too chaste" ("charmante Nymphe de Diane . . . que vous ne soyez point trop chaste"). Griselda Pollock has recently cited the unpublished work of the late Shirley Moreno on the role of Ovidian subjects such as the myth of Diana in delimiting and sustaining the aristocratic institution of marital and political alliance (Pollock 1990, 503).

32. Charpentier 1982, 8–10, "Nymphes, retirons nous dans ce charmant boccage. / Le cristal de ses pures eaux, / Le doux chant des petits oyseaux, / Le frais et l'ombrage sous ce verd feuillage / Nous ferrons oublier nos pénibles travaux. / Ce ruisseau loin du bruit du monde / Nous offre son onde, / Délassons nous dans ces flots argentés, / Nul mortel n'oserait entreprendre / De nous y surprendre, / Ne craignons point d'y mirer nos beautes"; "Ah! Qu'on évite de langueurs / Quand on mesprise ses ardeurs."

33. "Yesterday Mr. Ballot came to see me, and carried me to Mr. Lancret's, where I saw a very pretty picture which represents the most charming nun of Diana who ever trod the stage" (letter to Thieriot, in English, 14 April 1732, in Besterman 1953–77, I, 297). For Lancret's portrait of the dancer Marie Sallé as a nymph (or "nun") of Diana, see G. Wildenstein 1924 (A), no. 598.

34. Charpentier 1982, 10–12, "Nymphes, dans ce buisson quel bruit viens-je d'entendre"; "Mais quel objet a frappé ma vue?"

35. There has been no room in this essay to deal with the rich Italian tradition of the literary representation of Ovid from Dante and Petrarch to Bembo and Bruno. The painting of Correggio's *camera di San Paolo* of 1519 appropriates the iconography of Diana for the private apartment of the abbess Giovanna da Piacenza, and five years later Parmigianino's formally similar *saletta di Diana* at Fontanellato adapts the myth of Actaeon to the marital circumstances of Count Galeazzo Sanvitale and his wife Paola Gonzaga.

On an allegorical level the lacerated hunter's fatal glimpse of the chaste goddess may figure the perpetual chase after divine truth that is also embodied in the crucified Christ's transcendent access to God. Italian iconological conceptions such as these are taken to Fontainebleau in the 1540s by Primaticcio, whose *appartement des bains* featuring the myth of the goddess might still have been visible to painters such as Coypel and Boullongne prior to its destruction in 1697. The most helpful accounts of the political, economic, religious, psychological, and moral interpretations of the myth of Diana and Actaeon in the Renaissance are N. Brown 1972, Barkan 1980, and Vickers 1981. On Parmigianino at Fontanellato, see D. Brown 1984 and Asmus 1987. I would like to thank Elizabeth Honig and Maureen Pelta for sharing with me their unpublished work on various aspects of the myth of Diana in the sixteenth century.

36. On the circumstances of the painting's production, see Garnier 1989, 132–33.

37. Prior to entering into the service of the duc d'Orléans, Coypel had been employed by the duchesse de Montpensier, the daughter of the earlier duc d'Orléans, Gaston, who in 1626 had married Marie de Bourbon-Montpensier. Françoise Bardon has suggested that a painting of the goddess Diana and a subdued stag from the château d'Azay-le-Ferron may represent an allegorical marital portrait c. 1626, although an older tradition associates the painting with the first marriage of Philippe d'Orléans and Henrietta of England in 1661 (F. Bardon 1974, 59–60, and Fohr 1982, 81). Neither of these identifications may be readily sustained, yet the iconography of the seated goddess being offered a platter of fruit in sign of future fecundity finds an intriguing reflection in Coypel's painting (though the fruit is an attribute that also appears in the more recent Trianon painting by La Fosse).

38. Du Ryer 1677, 87, "les flateurs et les parasites"; "Cette Fable d'Actéon qui vit Diane dans le bain, nous apprend . . . de n'estre point curieux des choses qui ne nous concernent point, et de ne se mettre pas en peine de sçavoir les secrets des Roys, et enfin de tous les Grands, parce que l'appréhension qu'on a que vous ne les descouvriez, ou le soupçon que les ayez descouverts est souvent cause de vostre perte." Du Ryer's commentary is heavily indebted to one of the best known of the mythographical manuals of the Renaissance (Comes 1627, I, 661–65, II, 1074).

39. Richer 1665, 255, "le Patron de tous les cocus." In Richer's burlesque of the story of Callisto, it is Juno who metaphorically claims to have sprouted horns as a result of Jupiter's unfaithful seduction of the nymph (p. 165).

40. Charles-Antoine Coypel, "Vie d'Antoine Coypel . . . prononcé le 6 mars 1745," in Garnier 1989, 152, "Le bruit que firent ces sortes d'études donna lieu de croire à bien des gens que ce plafond étoit rempli de portraits."

41. Benserade 1679, 62–63, "baisse la veue"; "Qui veut trop voir n'est sage, ni prudent."

42. Louis-Henri de Loménie de Brienne, *Mémoires* (1828), in F. Bardon 1970, 213, "Et ce pauvre Actéon, c'était moi, malice innocente que le roi me fit, ou peut-être cela arriva-t-il par hasard."

43. The verbal form of the name of Actaeon had become a colloquialism for the act of cuckolding by the early years of the seventeenth century. In *Caquets de l'accouchée* [189–], 57, a "cackling," antimasculinist treatise of 1622, we find the following characterization of "a young merchant-wife from Chatelet who the day after her wedding 'enmosesed' and 'actaeonized' her husband, placing him in the zodiac at the sign of Capricorn" ("une jeune marchande d'auprès le Chastelet qui, dès le lendemain de ses nopces, a emmoysé et acteonisé son mary, le plaçant dans le zodiaque au signe du Capricorne").

44. Michel Larcher [the marquis d'Olizy], "Avertissement sur le mariage et sur le choix qu'on doit faire d'une honneste femme" (1687), in Tallemant des Réaux 1961, II, 1388, "Nos femmes sont des Dianes qui nous ont réduits à la forme d'Actéon."

45. Exh. Toulouse 1987, no. 71. Rivalz also painted a narrative scene of Diana and Actaeon around this time (Narbonne, Musée d'Art et d'Histoire). My thanks to Jean Penent of the Musée des Augustins, Toulouse.

46. Paintings of the bath of Diana by and after Clouet pose substantial difficulties of attribution and interpretation. Some writers have seen in the prototype (Rouen, Musée des Beaux-Arts) a celebration of the beauty of either Diane de Poitiers or Mary Stuart (who married François II in 1558), whereas others have seen in it a parodic, perhaps Protestant, protest against the sexual ostentation of women at court and the corresponding enfeeblement of the French Catholic king. By the time of the reuse of the composition in the 1590s for the allegorical representation of the loves of Henri IV and Gabrielle d'Estrées (Tours, Musée des Beaux-Arts), little may be left of barbed political satire other than a sly monarchical complicity in the self-masquerade (Trinquet 1968, exh. Paris 1972–73, nos. 54–55, and Jeune 1987, 66–73).

47. Snoep 1969, 278–80, figs. 6–8.

48. Exh. Washington, Detroit, and Amsterdam 1980–81, no. 51. During the 1640s Jacob Van Loo made something of a specialty of paintings on the theme of Diana and her nymphs, with or without Actaeon or Callisto. Later, in France, he became the founder of one of the eighteenth century's most illustrious families of painters. His eldest grandson Jean-Baptiste Van Loo submitted a painting of Diana and Endymion to the Academy in 1731 as his *morceau de réception* (engraved by Levasseur in 1771; exh. Paris 1982, no. 55), and he also exhibited *The Bath of Diana* at the Salon of 1737 (Toulon, Musée d'Art; exh. Toulon 1985, no. 29). Jacob's most famous grandson, Charles-André Van Loo, frescoed a vast scene of Diana's return from the hunt on the ceiling of the bedroom of the queen of Sardinia at the palace of Stupinigi near Turin in 1733, thus renewing the regal implications of the myth previously exploited by earlier monarchs and royal consorts (exh. Nice, Clermont-Ferrand, and Nancy 1977, nos. 14–15). Finally, Louis-Michel Van Loo, great-grandson of Jacob, painted an unusual portrait-like close-up view of the sleeping goddess in 1739 (exh. London 1977, no. 14).

49. On Northern representations of the myths of Diana, see Sluijter 1980–81 and 1985. My thanks to Julie McGee and Christiane Hertel for sharing with me their knowledge of mythology in Netherlandish art and art literature.

50. Boullongne's drawings for his pictures of Diana during and after the hunt (Paris, Musée du Louvre, Cabinet des Dessins) are reproduced in Schnapper and Guicharnaud 1986, nos. 32–36, and exh. Paris 1987, nos. 20–21. For Watteau's drawing after Boullongne (Vienna, Graphische Sammlung Albertina), as well as the subsequent painting and print, see exh. Paris 1984–85 (A), nos. D66, P28.

51. Bartsch 201, in Hollstein 1969, XVIII, 97–98. In addition to the etching of Diana at the bath, Rembrandt painted in 1634 a unique representation of Diana bathing with her nymphs in which the sto-

ries of Actaeon and Callisto are included in the same scene (Anholt, Museum Wasserburg Anholt). A virtuoso amalgamation of prints from the school of Marcantonio Raimondi (Bartsch 1978–, XXVIII, 54) for the stunned figure of Actaeon, from Antonio Tempesta (ibid., XXXVI, 121) for the splashing figure of Diana, and, less directly, from Cornelis Cort after Titian (ibid., LII, 181) for the wrestling group of Callisto and the nymphs, Rembrandt's comically transformed scenario was engraved minus the Callisto group in the workshop of Crispin de Passe the Elder, though it was not published until 1677 in the edition of Du Ryer's *Metamorphoses*, which is reproduced here (fig. 2). Rembrandt's influence on French seventeenth- and eighteenth-century artists need not have been mediated only through the printed illustration inasmuch as the painting itself was sold from the J.-B.-P. Lebrun collection in Paris in 1774 (Bruyn et al. 1986, II, no. A92).

52. La Feuille 1705, no. 715, "Trop voir nuit."

53. In 1604 Van Mander counseled art students to avoid giving way to visual lust with its attendant Actaeon-like scattering of the senses and ultimate devourment of the flesh (Sluijter 1985, 65–66).

54. Ovid, *Tristia*, II, 103.

55. Aubigné 1969, "Elégie" (1577), 330: "I brood over my discourse, I want to write no more, / For I am returned to my blessed village / Here where ambition does not fear ambition / Here where an Actaeon does not die when he looks" ("Je couve mon discours, je n'en veux plus escrire, / Là ou l'ambition ne craint / Là ou un Actéon ne meurt quand il regarde"). D'Aubigné writes of the desire to forestall Actaeon's fate in the context of his personal withdrawing from court to the country after a conflict with his Protestant patron, Henri IV of Navarre. Previously d'Aubigné had cast the mythological traits of Diana over the account of his vexed love affair with the Catholic Diane Salviati, in *L'Hécatombe à Diane* (c. 1570); see Mathieu-Castellani 1978 and Greenberg 1981.

56. "Je ressemble au Chasseur qui vit la beauté nue"; "Je ressemble à celui qui vit la Nymphe nue"; "Je suis cet Actéon de ses chiens déchiré"; "Je fus en cerf comme Actéon changé"; "Je suis votre Actéon, ma Diane vous êtes"; "Un nouvel Actéon je me désire bien." These verses by Amadis Jamyn (1575), Joachim Blanchon (1583), Jean de Sponde (1597), Guy de Tours (1598), Scalion de Virblueau (1599), and Marc de Papillon (1599), with additional sonnets on the theme of Diana and Actaeon by Desportes (1573), Hesteau de Nuysement (1578), Habert (1582), Durant (1588), Godard (1594), and Guy de Tours (1598), are collected in Mathieu-Castellani 1979, 261–67; extremely useful historical, semiotic, and psychoanalytic perspectives on the poems are found in Mathieu-Castellani 1981 and 1982.

57. Viau 1987, IV, 143, "L'expérience vous fera voir que c'est icy la véritable description du véritable estat de ma vie, non point une peinture faite à plaisir avec les couleurs et les rehaussements de la Poésie." For analysis of Théophile's epistle, see Saba 1988.

58. Dellaneva 1988, 50–51.

59. Mathieu-Castellani 1979, 264, "nouvel Actéon."

60. Tristan l'Hermite 1925, "La Jalousie mal fondée" (1638), "l'a baisée en tous lieux." For comparative analysis of the role of the myths of Diana in Théophile de Viau and Tristan l'Hermite, see Mathieu-Castellani 1984.

61. Furetière 1659, 57–58, "Pourquoi vous troublez-vous d'une telle surprise?"

62. Le Pays 1665, 31, "Le malheur d'Actéon ne m'est point arrivé, quoy que j'aye veu quelque chose de plus beau que Diane toute nue."

63. Le Sage 1737, I, 36, "Diane avec toute sa cour." "Il est charmé de tant d'appas. / Au lieu de s'éloigner par une prompte fuite, / Le plaisir arrête ses pas"; "Craignons le plaisir, / Ayons des alarmes, / Lorsqu'il vient s'offrir / Avec toutes ses charmes. / Pour lui résister, / Songeons à la peine / Qu'il peut nous coûter, / Quand il nous entraine"; "Ah! Si la sévère Immortelle / Au bain toute seule eut été, / Elle ne l'aurait pas traité / D'une manière si cruelle!" On the transgressive culture of the fair in the early decades of the eighteenth century, see Crow 1989 (A).

64. Domenichino's *Diana with Nymphs at Play* of 1617 (Rome, Galleria Borghese) includes two such voyeurs hidden in the bushes at the lower right who cajole the spectator in both gesture and glance not to give them away. The painting appears to have been well known to painters such as Coypel and Boullongne; quite explicit variations upon it were made earlier in the seventeenth century by Brebiette (Stockholm, Nationalmuseum) and Stella (Oldenburg, Landesmuseum), although neither of these includes the marginal spying figures.

65. Fontenrose 1981 and Leach 1981 discuss the Greek and Latin versions of the myth of Actaeon in the contexts of ancient literature and ancient painting. Whereas Ovid insists upon the chance nature of Actaeon's encounter with Diana, Statius, Arnobius, Apuleius, and Hyginus all evoke a lustful Actaeon who willfully spies upon the bathing goddess. In Nonnos (*Dionysiaca*, V, 305) Actaeon is "the insatiable viewer of the goddess not to be viewed" (Schlam 1984, 108). In the history of postclassical painting we find the voyeuristic Actaeon represented in a painting by Veronese c. 1560 (Boston, Museum of Fine Arts); in a series of painted and drawn replicas of a composition by Bernaert de Rijkere of 1566 (Boon 1977, 128); in one of Johann Rottenhammer's numerous variants of the theme dated 1602 (Munich, Alte Pinakothek); and, closer to the time of Boullongne and Watteau, in an iconographically unusual drawing of c. 1690 by Michel II Corneille (Paris, Musée du Louvre, Cabinet des Dessins). The theme of the voyeur will later become a virtual hallmark of the art of Boucher.

66. Titian's *Diana and Actaeon* and its pendant *Diana and Callisto* were delivered to Philip II of Spain in 1559. Their respective celebrity was perpetuated in more-or-less free copies by Schiavone and Rubens and especially in the Callisto print of 1566 by Cornelis Cort (Bartsch LII, 181); the latter composition became a bizarre weapon of religious politics in a Netherlandish print featuring Elizabeth I of England as Diana chastising the gravid Roman pontiff (Trinquet 1968, 16). In 1704 Titian's paintings were given by Philip V to the ambassador of France, and in 1724 they were recorded in the inventory of the duc d'Orléans (Thompson and Brigstocke 1970, 96–97) where painters such as Watteau, Galloche, and Lemoyne could easily have come to know them. Watteau's arabesque drawing of c. 1716 of *The Temple of Diana* (New York, Pierpont Morgan Library) may suggest a particularly witty adaptation of Titian's *Diana and Actaeon* in its rusticated bower crowned by the skull of a stag (exh. Paris 1984–85 [A], D71). From among the wide-ranging literature on the painting, see the opposed neo-Platonist and erotic interpretations in Tanner 1974 and Tresidder 1988.

67. Marivaux 1781, I, 215–16, "On dit qu'il est chasseur; mais sçait-il l'Histoire? Il verroit que la chasse est dangereuse. Actéon y périt pour avoir troublé le repos de Diane. Hélas! si l'on troubloit le mien, je ne sçaurois que mourir." On mythology in art and the theater as a parodic strategy of social critique, see Tomlinson 1981.

68. An exceptional earlier depiction of a mirror is found in an ornately illuminated miniature of Diana and Actaeon (1597) by Joris and Jacob Hoefnagel (Paris, Musée du Louvre, Cabinet des Dessins; Bacou 1968, no. 45).

69. Spenser 1938, VI, 162–63 (book 7, canto 6, strophes 42–49). The satyrs in Clouet's *Bath of Diana* have been seen as satirical representations of the powerful uncles of Mary Stuart, the duc de Guise and the cardinal of Lorraine (Trinquet 1968). The presence of satyrs at the goddess's bath is justified by no particular mythological story as such but rather by the satyrs' generic function as woodland gods; see Moréri 1731–32, III, 554–55, who cites the authority of the twelfth-century mythographer Albricus, in all probability on the basis of Baudouin 1627, 49, an appendix to Comes's famous *Mythologie*. Figures of satyrs leaning over the sleeping Ariadne- or Antiope-like Diana, or otherwise occupied in her waking train, are found in a School of Fontainebleau composition at Anet, in a painting by Abraham Janssens of c. 1600 (Kassel, Staatliche Kunstsammlungen), and especially in numerous works by Jordaens, Van Dyck, and Rubens (e.g., Paris, Musée de la Chasse et de la Nature; see exh. Paris 1977–78, no. 132).

70. On the *concours* of 1727, see Rosenberg 1977.

71. Garnier 1989, 132–33, lists numerous painted copies after both Coypel's painting and its engraved versions which collectively testify to its contemporary fame. Also see Babelon 1985, fig. 28, for a *chantourné* overdoor copy in the hôtel Salé, Paris.

72. Leningrad, The Hermitage; Nemilova 1986, no. 36.

73. The stories of Narcissus and Actaeon in book 3 of the *Metamorphoses* each feature an erring hunter, a chance encounter at a pool, and an ensuing dilemma of self-recognition which results in the transformation of the individual into a new, nonhuman, and terminal embodiment, a flower in the one case and an animal in the other (Barkan 1986, 37–56). In an unusual drawing of the late 1650s, Charles Le Brun juxtaposes the standard image of Narcissus bending over his reflection at the pool with the narratively unrelated image of Actaeon as an upturned stag being devoured by hounds on the far bank. Subsequent editions of Du Ryer's *Métamorphoses* (1677) as well as the later translation by Banier (1732) show a stag-headed Actaeon kneeling Narcissus-like at a spring and looking at his waiting dogs who no longer recognize him (Ovid, *Metamorphoses*, III, 200).

74. Bartsch 1978– , XXXII, 29 (Master F. P.), XXXIII, 216 (Master L. D.). Bernard Salomon (1557), Virgil Solis (1563), Antonio Tempesta (1606), Johann-Wilhelm Baur (1639), Bernard Picard (c. 1711), and many other illustrators of Ovid depict the death of Actaeon in the form of a fully transformed stag hunted down by dogs. Courbet's *Hallali of the Stag* of 1867 (Besançon, Musée des Beaux-Arts et d'Archéologie) and Gérôme's unlocated *Hallali (Diana and Actaeon)* of 1895 preserve this "real-allegorical" tradition well into the nineteenth century with masochistic or hysterical effect.

75. Marolles 1655, 146; the print is by Abraham Diepenbeeck. Tiny bathing nymphs appear in the print by L. D. and much more massive figures of Diana and her companions appear in an oil sketch by Rubens from 1639 as well as in a large-scale nonautographic replica (Nîmes, Musée des Beaux-Arts; Held 1980, I, no. 221, fig. 41).

76. Stockholm, Kungl. Akademien for de Fria Konsterna (exh. Paris 1982–83, no. 71). A painting of dogs and stag of 1718 by François Desportes (Rouen, Musée des Beaux-Arts) may similarly represent the death of Actaeon (exh. Lille 1985, no. 32).

77. Serré des Rieux 1734, frontispiece. In the dedication of the treatise Louis XV is said to have overcome youthful effeminacy by mastering the secret laws of the hunt which Diana has taught him and which thereby have equipped him to go off to wage glorious war. Since the art of martial music is at issue in the treatise as well, the dedication also invokes the king's indulgence for Apollo's gifts (p. viii): "Though Diana is for you worthy of preference, / May her brother sometimes, to the travails of his sister, / Make sweetness follow from tender sounds" ("Si Diane est pour Toy digne de préférence, / Que quelquefois le Frère aux travaux de sa Soeur, / Fasse des tendres sons succéder le douceur"). Also see *Diane, divertissement pour le Roi* (1721), in Danchet 1751, 353–58.

78. Boismortier 1900, n. pag., "Fuyez, fuyez, faune sauvage! Fuyez, fuyez, satyres affreux! Diane craint l'hommage de vos coeurs amoureux. Rassemblez-vous, naiades, secondez ses désirs! Soyez dans ce bocage les uniques témoins dont sa beauté partage les regards et les soins." Additional cantatas of the period on the theme of Diana and Actaeon are described in Vollen 1982.

79. Boismortier 1900, "Mais ce heureux moment si fertile en excuses est d'un prix qu'il ne connaît pas. Le timide Actéon surpris de tant d'appâts borne à la contempler. . . . Il est des moments favorables où rien ne peut vous résister, et moins ces moments sont durables, plus vous devez en profiter."

80. On the hieroglyphics of the stag, see Bolzani 1615, 80–89; on Hogarth, Paulson 1965, I, no. 231, and Cowley 1983. In the broken figurine of Actaeon, Hogarth draws not on learned Renaissance allusion as much as on the Falstaffian emblematics of cuckoldry (Steadman 1963 and Barkan 1980, 349–59). According to the *Oxford English Dictionary* 1933, I, 92, in the seventeenth century "there are of opinion that there is, in marriage, an inevitable destiny . . . which is either to be actaeoned, or not to be" (1615); and in a treatise on marriage of 1658 it is further said "and thou'lt Actaeon'd be."

81. The caption of Dominique Sornique's engraving (c. 1750) after Boullongne's composition is reproduced in Dunand 1980, 407, "injuste," "inhumaine," "Pour avoir, un moment, contemplé tes appas, / Ne devait-ce pas être une assez rude peine / Que de les avoir vus, et de n'en jouir pas?"

82. A dramatic parallel to the psychological turn taken by Lemoyne's Callisto, unable or unwilling to meet her mistress's gaze, is found in Fuzelier's 1727 scenario of Callisto's sexual jealousy and humiliation in the ballet *Les Amours des dieux*, with music by Mouret (Fuzelier 1734, III, 308–ll). Callisto's extremely unusual eye-shielding gesture is previously found in an austerely clothed depiction of the confrontation between the regal goddess and the trespassing nymph formerly attributed to La Hyre (La Fère, Musée Jeanne d'Aboville; exh. Grenoble, Rennes, and Bordeaux 1989–90, no. RP13). The gravity of this composition, which Lemoyne preserves, corresponds to Callisto's crucial symbolic role in affirming the unbreachable law of female chastity within the blood society of the *ancien régime* (Du Ryer 1677, 60): "Thus one wishes in my view to teach us through this myth that as chastity is the greatest treasure of a girl and the only possession which may not be recovered once one has lost it, it is not enough for a girl to resist the pursuits made against her honor, but it is necessary that she take care to flee those places where it is easy to attack her and where one may easily triumph over her weakness" ("On veut donc à mon avis nous enseigner par cette Fable que, comme la chasteté est le plus grand trésor d'une fille, et que c'est le seul bien que l'on ne recouvre pas, quand on l'a une fois perdu, ce n'est pas assez à une fille de résister aux poursuites qu'on fait contre son honneur, mais il faut qu'elle

prenne garde de fuir les lieux où il est aisé de l'attaquer, et où l'on peut facilement triompher de sa faiblesse"). For an interpretation of the myth of Callisto both as a linchpin of patriarchy and as an occasional resource in its active subversion, see Wall 1988. As for Boucher, he appears to attenuate the lachrymose encounter of nymph and mistress in a black chalk drawing c. 1740 (exh. Washington and Chicago 1973–74, no. 45) and, in the composition engraved by Le Gros in 1791 (Jean-Richard 1978, no. 1360), to convert its axiomatic outrage and despair into teasing cajolery and blushed embarrassment.

83. Exh. Washington and Chicago 1973–74, no. 49. In a lecture at Bryn Mawr College in 1988 Colin Bailey suggested this interpretation of the dogs' actions in Boucher's *Diana at the Bath*. Elsewhere we see an actual intrusion when Tasso's shepherd Amyntas secretly spies upon an intimate female pairing in *Sylvia Relieving Phyllis of a Bee Sting* of 1755 (Ananoff and Wildenstein 1976, II, no. 460; later engraved as *The Indiscreet Shepherd*) or when Pan aggressively encroaches upon Syrinx reclining in the arms of a sister river nymph in 1759 (ibid., II, no. 519). This latter nymph in a very similar rear-viewed posture is engraved with the attributes of Diana herself (Jean-Richard 1978, no. 795). The voyeuristic theme in Boucher's work may be traced back to an emblematic ornament of Summer, one of the young artist's many etchings after Watteau, whence it becomes a ubiquitous motif (ibid., nos. 160, 281, 378, 573, 739, 1158). It also appears in an engraving of a satyr spying on Diana (no. 1454), after a lost painting by Boucher c. 1722 (Ananoff and Wildenstein 1976, I, no. 6). For Boucher's drawings of the myths of Diana, see Ananoff 1966, nos. 706–24.

84. Jean-Richard 1978, nos. 1595–96. A drawing for the rearviewed figure of the nymph lunging to conceal Diana's nakedness is in Ananoff 1966, no. 500. Another drawing by Boucher shows a seemingly stunned Actaeon at the very right-hand margin of the page coming upon an extremely young Diana, who betrays her distraction of mind by pointing simultaneously in opposite directions (Robiquet 1938, between 98–99).

85. Ananoff and Wildenstein 1976, I, figs. 152–53 and Jean-Richard 1978, nos. 1558–60. Banier's translation of the *Metamorphoses* largely replaced Du Ryer's; it was published in a variety of more and less expensive formats in 1732, 1737, 1738, 1742, 1767–71, 1768, and 1787.

86. Favart 1763, IV, 6–7, "Et comme un Cerf on me chasse aussitôt." "Je tombe en perdant haleine, / Les dards sont levés sur moi. / Ma perte paroit certaine; / Mais je n'en ai que l'effroi. / On ne sonne point ma prise, / On me traite avec bonté; / La pitié me favorise,/ Et j'obtiens ma liberté." On the affinity of painters and writers at the Opéra-Comique such as Favart, see Heartz 1985.

87. Boston, Museum of Fine Arts, Department of Prints and Drawings, "L'Amant qui pour se rendre heureux / Du voile d'amitié vous déguise ses feux / Doit vous causer le plus d'allarmes."

88. Ananoff and Wildenstein 1976, I, no. 267 (1744), II, nos. 518 (1759), 533 (1760), 535 (1760), 576 (1763), 639 (1767), 668 (1769). In the 1759 version (Kansas City, Nelson-Atkins Museum of Art), the figure of the pointing Diana repeats the pose of the goddess in Tardieu's engraving of Diana and Actaeon (Jean-Richard 1978, no. 1595), whereas the naked figure of Callisto recalls the reclining posture of the newly born goddess of Love in a lost painting of 1763 (Ananoff and Wildenstein 1976, II, no. 577).

89. Besterman 1953–77, I, 305, letter to Thieriot, 13 May 1732, "Les feux du dieu que sa vertu condamne / Sont dans ses yeux, à son coeur inconnus; / En soupirant on la prend pour Diane, / Qui vient de danser sous les traits de Vénus." On the career of Marie Sallé, see Pitou 1985, II, 486–88.

90. Ananoff and Wildenstein 1976, I, no. 217.

91. On the roles of Diana and Venus in the Renaissance allegorical combat between chastity and love, see Watson 1979, 91–121. The reciprocal exchange of the traits of the previously antithetical goddesses is discussed in the context of eighteenth-century English literature in Brooks-Davies 1982.

92. Boucher's representations of Jupiter and Callisto comprise a series of repetitions and reversals of a small number of basic bodily poses of seduction, resistance, and acquiescence or consent. Callisto and the Diana-feigning Jupiter variously exchange one another's gestures and postures, and these in turn are unceasingly reembodied in other ambiguously homoerotic mythologies (*The Bath of Venus*, I, no. 198 [1742], *Diana at the Bath*, I, no. 215 [1742], *Erigone Vanquished*, I, no. 282 [1745], *Vertumnus and Pomona*, II, nos. 329, 385 [1749, 1752]) or in equally equivocal modern pastorals featuring images of female embrace (*The Fountain of Love*, II, no. 321 [1748], *The Two Confidantes*, II, no. 364 [1750]). Elsewhere the vexed embrace of Jupiter and Callisto is seen in a heterosexual context (*The Charms of Country Life*, I, no. 147 [1737], *The Pastoral Music*, I, no. 262 [1743], *Pastoral with Supplicating Shepherd*, II, no. 539 [1760]). In a drawing reproduced along with Boucher's final painting of Jupiter and Callisto (II, no. 668 [1769], fig. 1746), the active role of Diana/Jupiter is taken by a shepherd girl, while the passively receptive role of Callisto is adapted for the pose of a shepherd boy. Throughout this series of permutated poses it is sometimes the male and sometimes the female who initiates the act of love. Also worth noting relative to Boucher's final depiction of Callisto is that her pose previously served for the female personification of art in *The Drawing Lesson* of 1751, perhaps an allegorical representation of the artist himself (II, no. 378). All citations are from Ananoff and Wildenstein 1976.

93. The engraving by Duflos of 1751 is reproduced along with its well-known pictorial source (Paris, Musée Cognac-Jay), ibid., I, no. 279, fig. 826, "Se jouant de l'Amour c'est ainsi qu'une Belle/ Des maux que font ses yeux, repaît sa vanité;/ Mais ce Dieu ne perd rien; et bientôt la rebelle/ Pour un Endymion oubliera sa fierté." The word "vanité" is incorrectly transcribed as "variété" in I, 391.

94. Ovid, *The Art of Love*, III, 83–85. Ananoff and Wildenstein 1976, I, nos. 36, 39; the presumed lost early painting of *Diana and Endymion* only came to light subsequent to the publication of the catalogue raisonné (exh. St. Petersburg 1982–83, no. 25, and exh. New York, Detroit, and Paris 1986–87, fig. 77). The uncanny similarity of the postures and gestures of the dead Adonis and the sleeping Endymion, on the one hand, and the despondent Venus and the delighted Diana, on the other, is made stranger and perhaps more idiosyncratic in Boucher's utterly nonstandard painting of *Venus and Endymion* of 1769 (Ananoff and Wildenstein 1976, II, no. 670). A different sort of juxtaposition of Diana and Venus as goddesses of Love is found in François-André Vincent's paired drawings of 1778 representing Venus and Adonis and Diana and Actaeon (New York, The Metropolitan Museum of Art; Bean 1986, nos. 317–18).

95. The goddess's openhanded gesture of love at first sight in Fragonard's *Diana and Endymion* of c. 1755–56 repeats in a frankly erotic register the chaste disarray depicted in Houasse's well-known painting of 1688 in the Grand Trianon (Standen 1988, fig. 54). Apart from Boucher's painting of c. 1726 as well as J.-B. Van Loo's already mentioned *morceau de réception* of 1731, also see Dandré-

Bardon's use of the same theatrical, splayed-finger gesture of Diana in his painting of 1726 (Fine Arts Museum of San Francisco; Rosenberg and Stewart 1987, 139–41). As a young student in 1772 Jacques-Louis David later uses this stage device to characterize the goddess in his Ovidian composition *Diana and Apollo Piercing with Their Arrows the Children of Niobe* (exh. Paris and Versailles 1989–90, fig. 21).

96. This frequent theme in novels of the eighteenth century in both England and France (e.g., *La Princesse de Clèves* [1678], *Moll Flanders* [1722], *La Vie de Marianne* [1731–42], *Clarissa* [1747–48], *Julie, ou la nouvelle Héloïse* [1761], *Les Liaisons dangereuses* [1782]) is brilliantly analyzed as a social process of self-representation in Ray 1990. My point here is that mythological narratives in eighteenth-century painting similarly provide an opportunity for the trying on (and putting off) of possible selves.

97. Le Sage, Fuzelier, and d'Orneval 1737, I, 467, "En tout cas je suis fille majeur." This harlequinade set in present-day Montmartre is a fairground parody of *Diane et Endymion, ou l'amour vengé* which had been performed before the king by the Italian comedians earlier in 1721 (Riccoboni 1733, I, 155–65). The Italian comedians, banished from the Maintenon-influenced court of Louis XIV in 1697, had been officially reinstated by the regent in 1716, but their now-licit humor is made still more transgressive of traditional hierarchies of value in the parodic practices of Le Sage's troop at the *Théâtre de la Foire*.

98. Quinault 1703, I, 198: "Let sleeping Endymion be conducted / Where Diana secretly yearns. / Dreams, obey the orders of the Night" ("Qu'Endimion en dormant soit conduit / Où Diane en secret soupire. / Songes, obéissez aux ordres de la Nuit").

99. Diana's newfound civic virtue is displayed at the Salon of 1773 in Joseph-Marie Vien's royal commission for the dining room of the Petit Trianon in which "Diana, accompanied by her Nymphs, upon her return from the hunt, orders the distribution of game to the shepherds of the environs" (Salons 1673–1881, IV [1773], no. 4, "Diane, accompagnée de ses Nymphes, au retour de la Chasse, ordonne de distribuer le gibier aux Bergers des environs"). At this time the sixty-three-year-old Louis XV was in the last year of his life, but the erotic imagery of the Dianas of his youth was still visible in engravings after J.-B. Van Loo's and J.-F. de Troy's Endymion and Actaeon paintings of 1731 and 1734 exhibited by Levasseur at the Salons of 1771 and 1775. In addition, between 1765 and 1796 L.-J.-F. Lagrenée exhibited paintings of Endymion, Actaeon, and Callisto no less than twelve times (Sandoz 1983, nos. 145, 187, 194, 217–18, 248, 276, 326, 392, 419–20), characterized, however, by a shift in visual style. At the Salon of 1765 Diderot expressed sharp preference for Lagrenée's *Diana and Endymion* over Boucher's *Jupiter and Callisto* in terms of the latter's rote and repetitious *pratique* and the former's "truths of nature": "But do the personages of mythology have different hands than we?" (Diderot 1975–[1983], II, 77, "vérités de nature," "Mais est-ce que les personnages de la mythologie ont d'autres mains que nous?") The combined naturalism, rationalism, and moralism of Diderot's increasingly prevalent artistic ideology helped to undermine the psychological authority of mythological painting during the last decades of the eighteenth century and has also continued to hinder close critical attention to this work today.

100. Louis Petit de Bachaumont et al., *Mémoires secrets pour servir à l'histoire de la République des lettres en France de 1762 jusqu'à nos jours* (1777–89), in Arnason 1975, 44. Arnason discusses Allegrain's marble in relation to Houdon's plaster statue of Diana, shown in the sculptor's studio in 1777 (Gotha, Schlossmuseum), and the much more notorious bronze casting from the Salon of 1783 (San Marino, Calif., Henry E. Huntington Library and Art Gallery), with its explicit representation of the external genitalia. The baring of this traditionally unrepresentable fact of female anatomy would have been enough to "actaeonize" many contemporary spectators; in a number of extant versions of the sculpture, the apparently unacceptable facts were altered (e.g., Paris, Musée du Louvre).

101. The theme of Susanna surprised at the bath by the two elders (*Daniel*, XIII, 15–25) is axiomatic in European painting of the sixteenth through eighteenth centuries, running to almost ten pages in Pigler 1956, I, 218–27. Among the artists discussed here to paint it were Boullongne, Coypel, de Troy, Boucher, Vien, and Lagrenée (Salon of 1763).

102. On Girodet's *Endymion*, see Rubin 1978.

103. Charles-Albert Demoustier, *Lettres à Emilie sur la mythologie* 1804, I, pt. I, 83–84, "Il vit ce que nul mortel ne devoit voir. Aujourd'hui je lui pardonnerais ce crime involontaire; je l'en punis alors"; "Je l'ignorais le plaisir charmant / De se voir dans un nouvel être / Confondue avec son amant."

104. Chénier 1924, I, 69, "Mais si le doux ruisseau roulant des ondes claires / Vous invite à quitter vos tuniques légères, / Déesse, je fuirai; car ton chaste courroux / Est terrible et mortel. Je fuirai loin de vous, / De la peur qu'à te venger ta meute toute prête / Ne vois un bois rameux s'élever sur ma tête." This is a free imitation of the "Hymn to Artemis" by the Alexandrian poet Callimachus, the first to introduce into the myth of Actaeon's death the motif of accidentally sighting the naked goddess at her bath: "The laws of Cronus order thus: Whosoever shall behold any of the immortals, when the god himself chooses not, at a heavy price shall he behold" (Callimachus, "Hymn V: On the Bath of Pallas," 100–102).

105. Ovid, *Tristia*, II, 103–6.

106. Sartre 1943, 667–68, "All research always comprises the idea of a nudity which one brings into the open by parting the obstacles which cover it, as Actaeon parts the branches the better to see Diana at the bath" ("Toute recherche comprend toujours l'idée d'une nudité qu'on met à l'air en écartant les obstacles qui la couvrent, comme Actéon écarte les branches pour mieux voir Diane au bain"); Lacan 1964, 188, "The truth, in this sense, is that which runs after truth—and that is where I am running, where I am taking you, like Actaeon's hounds, after me. When I find the goddess's hiding place, I will no doubt be changed into a stag, and you can devour me, but we still have a little way to go yet" ("La vérité, en ce sens, c'est ce qui court après la vérité—et c'est là où je cours, où je vous emmène, tels les chiens d'Actéon, après moi. Quand j'aurai trouvé le gîte de la déese, je me changerais sans doute en cerf, et vous pourrez me dévorer, mais nous avons encore un peu de temps devant nous," p. 172). Also see Klossowski 1956, and Starobinski 1964, 285: "Critics, analysts, keep lit the lamp of Psyche, but think of the destiny of Actaeon" ("Critiques, analystes, gardez allumée la lampe de Psyché, mais songez au destin d'Actéon"). On Actaeon, psychoanalysis, and the disarray of theoretical and artistic vision, see Bowie 1987, 166–78.

107. Interview with the artist, in Sans 1983–84, 61, "En fait Actéon, c'est moi devant la peinture; et je n'ai pas peur de devenir aveugle." Since 1983 Alberola has signed his works "Actéon fecit"; see exh. Saint-Priest, Le Havre, and Fontevraud 1984–85. In the aftermath of modernism many other contemporaries have also turned to the exemplary allegory of Actaeon, among them Stephen McKenna in England and Paul Georges in the United States; see exh. New York and Philadelphia 1991.

CATALOGUE

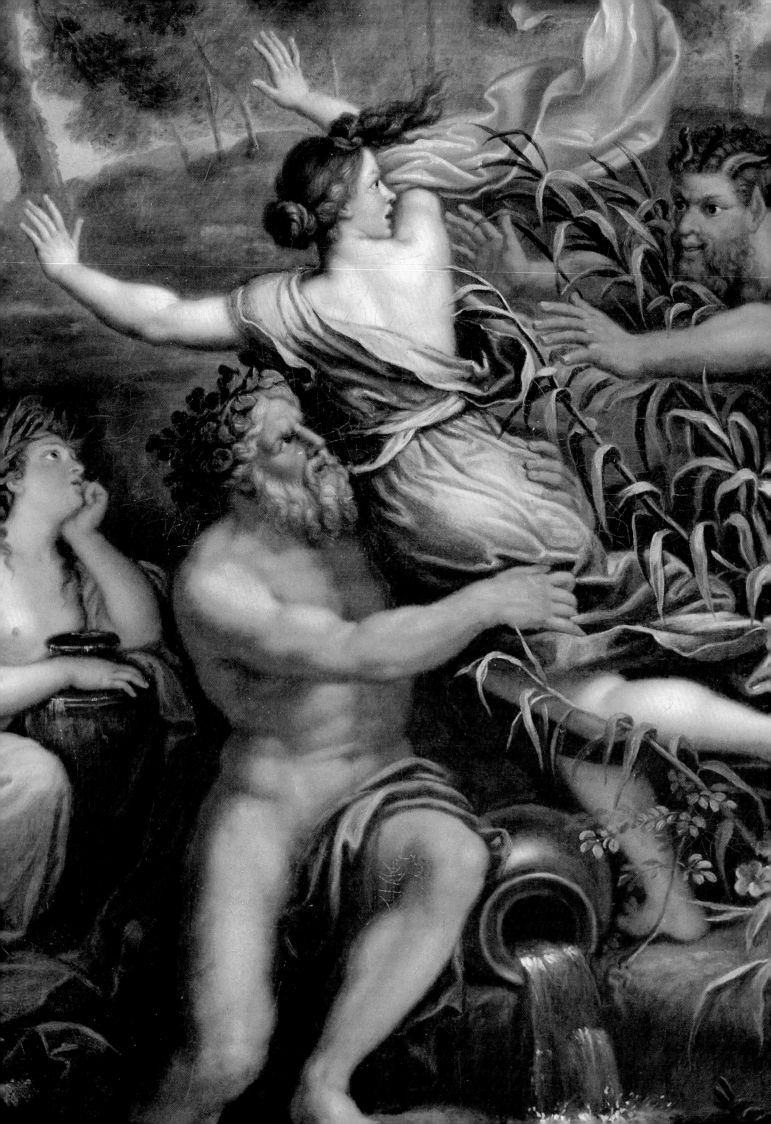

PIERRE MIGNARD
(1612–1695)

Born in Troyes in 1612, Mignard was apprenticed with Jean Boucher in Bourges at the age of twelve and then sent to Fontainebleau for two years, where he studied the Royal Collection. He returned again to Troyes, where Nicolas de l'Hôpital, maréchal de Vitry, commissioned him to decorate the chapel of the château de Courbet in Brie. Impressed, Vitry took the young artist to Paris and helped him gain admission to Vouet's studio. Mignard became so successful at copying Vouet's style that he was appointed drawing master to Anne-Marie-Louise d'Orléans, duchesse de Montpensier, the *Grande Mademoiselle*.

Mignard traveled to Italy towards the end of 1635. In Rome he lived with Charles-Alphonse Dufresnoy, a friend from Vouet's studio, with whom he studied the art of Raphael and the Bolognese school, and there established his reputation as a portraitist; during his twenty-two-year sojourn his sitters would include all three popes. Although his Italian career remains to be studied, it is known that Mignard traveled extensively only in 1654, when he visited Venice for eight months. En route, he stopped at Parma, where he saw Correggio's frescoes in the Duomo and San Giovanni Evangelista, and Bologna, where he met Francesco Albani and made drawings after the Carracci. Mignard's fame as a portraitist was so widespread in northern Italy that Francesco d'Este, Duke of Modena, called him back from Venice to paint his daughters, a commission the artist executed in ten days. Mignard was, however, mostly interested in large-scale religious and history paintings, and his few surviving Italian works reveal an artist well versed in the classical idiom.

Hugues de Lionne recalled Mignard to France, probably on behalf of Mazarin, in 1657. Mignard finally arrived at Fontainebleau in late 1658 or early 1659, where he was presented to the royal family and painted the first of his ten portraits of Louis XIV.

Mignard's Parisian career thus began in middle age. In 1662 Anne of Austria commissioned him to fresco the dome of the Val-de-Grâce, which he completed in the Correggesque manner he had learned from his trip to Parma. Mignard also decorated many Parisian *hôtels*, including the hôtel de Hérvart, for which he painted an Apotheosis of Psyche on the ceiling of one of the *cabinets* around 1663. Nevertheless, he once again established his reputation as a portraitist and revived the genre of allegorical portraiture with such masterpieces as *The Marquise de Seignelay as Thetis with Her Sons* (London, The National Gallery).

Mignard became embroiled in his famous rivalry with Le Brun in 1663 when he refused to join the Academy under Le Brun's direction. It has generally been assumed that Mignard was shut out of royal projects during Colbert's administration, but if Mignard was not employed at Versailles during this time, he did not lack for royal patronage completely. He painted two portraits of Louis XIV in 1674 (one lost, the other now known through a copy in Turin) and *Louis XIV on Horseback Crowned by Victory*, which hung in the *salon d'Abondance* by 1682 (Musée National des Châteaux de Versailles et de Trianon) and which is modeled on Rubens's equestrian portraits.

Mignard was employed by powerful members of the aristocracy during Colbert's term of office. Shortly after his return to Paris he established a long-term relationship with the *Grand Condé*, Louis II de Bourbon. Mignard painted a portrait of the Condé's son, Henri-Jules de Bourbon, duc d'Enghien, in 1660 (location unknown) and completed the monumental *Perseus and Andromeda* (Paris, Musée du Louvre) for him in 1679. More importantly, however, he worked for *Monsieur*, Philippe d'Orléans, at the château de Saint-Cloud decorating the *galerie d'Apollon* and *salon de Mars* in 1677 (destroyed). Mignard's work in these rooms has sometimes been referred to as a precedent for Le Brun's *galerie des glaces* at Versailles.

Mignard's ambitions were fully realized in 1683 when his longtime supporter, François Michel Le Tellier, marquis de Louvois, became *surintendant des Bâtiments* upon Colbert's death. Although Le Brun remained *premier peintre du roi* until his death in 1690, his importance gradually declined as Mignard received an increasing number of royal commissions (e.g., *Neptune Offering the Empire of the Sea to Louis XIV*, 1684, Musée National du Château de Compiègne, and *The Family of the Grand Dauphin*, 1688, Musée National des Châteaux de Versailles et de Trianon). In 1684 Mignard painted the ceiling of the *petite galerie* at Versailles (destroyed). As Jean-Claude Boyer has noted, it is clear from Gérard Audran's print (1686) that the simplicity of Mignard's design, the clarity of his narrative, and the delicacy of his ornamentation had evolved in an altogether different direction from Le Brun's more complex work in the *galerie des glaces*.

Ennobled in 1687, Mignard became *premier peintre du roi* and director of the Academy in March 1690. The Crown's financial difficulties and the artist's increasing age, however, prevented him from painting more grand decorations for Louis XIV. In 1691 Mignard received the commission for the dome of the Invalides and produced oil sketches for the entire project, yet he died in 1695 before the design could be executed.

PIERRE MIGNARD
Pan and Syrinx

1

PIERRE MIGNARD (1612–1695)
Pan and Syrinx, c. 1688–90
Oil on canvas
71 x 96 cm.
Sarah Campbell Blaffer Foundation, Houston, Texas

PROVENANCE
Martin Desjardins (1637–1694), estimated at 600 *livres* in his *inventaire après décès* by Hyacinthe Rigaud, 6 August 1694; Jean-François de Troy, his sale, Paris, 9–19 April, 25 May 1764, no. 95, purchased by de Langeac for 160 *livres*; Gaspard Barbier de la Bonnetière; Madame Barbier de la Bonnetière, her sale, Nantes, 16 May 1859, no. 254; Charles-Gabriel-René-Berlion, baron de la Tour du Pin Chambly de la Charce; baron de la Tour du Pin, his sale, Hôtel Drouot, Paris, 26 February 1894, no. 46; marquis de Lastic.

EXHIBITIONS
New York, New Orleans, and Columbus 1985–86, no. 3, col.

BIBLIOGRAPHY
Seelig 1972, 170, ill.; Boyer 1980 (A), 152, ill.

The tale of Pan's thwarted assault on Syrinx, who was transformed into a marsh reed to escape the satyr-god's lust, is the story with which Mercury finally lulled Argus to sleep and is one of the most celebrated and often-painted episodes in Ovid's *Metamorphoses*. As Jean-Claude Boyer has pointed out, it was practically the only mythological subject to recur in Mignard's repertory. The story of Pan and Syrinx was one that Mignard painted several times at the end of his career and which he imbued with a seriousness that is not immediately apparent on first reading.[1]

The Blaffer *Pan and Syrinx*, painted for the Flemish sculptor Martin Desjardins (1637–1694)—a close friend of Mignard's whose magnificent portrait bust of the artist is in the Louvre—was estimated by Hyacinthe Rigaud at the considerable sum of 600 *livres* in Desjardin's *inventaire après décès*, an indication of the painting's high quality.[2] Indeed, it may be considered the prototype of the group of paintings devoted to Pan and Syrinx. There is a *pentimento* visible on the right thigh of the river-god Ladon, which shows that Mignard first intended the drapery to extend all the way across Ladon's body.[3] In changing this detail, Mignard maintained the richly chromatic effect of flowing drapery alternating with exposed flesh that extends from the naiad seated by the urn in the left background to Syrinx herself, caught among the reeds.

Mignard's dignified interpretation of *Pan and Syrinx* draws upon a wide range of precedents in both French and Italian art. Among the former, he may well have been familiar with Michel Dorigny's balletic and flamboyant *Pan and Syrinx* (fig. 1), painted in 1657 for Gédéon Berbier, sieur de Metz, and engraved by Dorigny in 1666, although comparison between these two works draws attention to the greater sobriety and restraint in Mignard's composition, altogether more statuesque and impassioned.[4] Mignard certainly knew Annibale Carracci's *Pan and Syrinx* (fig. 2), one of the twelve medallions painted in imitation of bronze relief on the frieze of the ceiling of the Farnese Gallery. He had copied the entire decoration soon after his arrival in Rome for Alphonse Duplessis, cardinal of Lyons (fig. 3).[5] Yet although Mignard followed

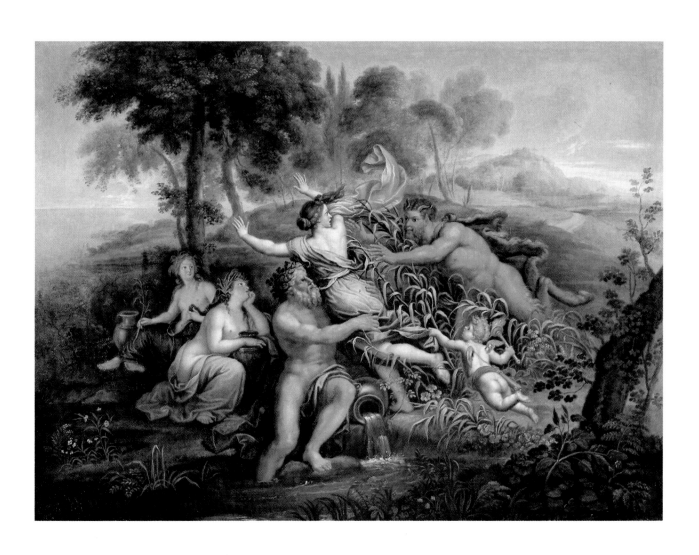

Carracci in showing Pan clutching at the enormous marsh reeds which have already begun to envelop Syrinx's robes, he portrayed this encounter with far greater drama and pathos.[6] In Carracci's decorative medallion, the scene is a secondary narrative, not intended to distract attention from the monumental ceiling paintings overhead, and is handled accordingly.

Mignard's *Pan and Syrinx* is closer in spirit to Bernini's *Apollo and Daphne* (fig. 4), a renowned composition which doubtlessly inspired Mignard's lost painting of the same subject and also provided the pose of his fleeing Syrinx. It should be recalled that Bernini's statue carried an equally austere message concerning uncontrolled desire in the form of a moralizing epigram, improvised by Cardinal Maffeo Barberini, later Pope Urban VIII, to allay concern over Daphne's nudity and inscribed by Bernini onto the pedestal itself: "He who lusts after passing beauty, will reap nothing but dry leaves or bitter fruit."[7] Such a homily, as Boyer has pertinently observed, provides the perfect commentary for Mignard's *Pan and Syrinx*.[8]

Boyer has also shown precisely how Mignard imbued this Ovidian tale of desire and deception with a sterner morality; the artist was more concerned with showing the brutality of lust and the disastrous consequences of unbridled passion than exploiting the erotic or decorative potential of the episode which so appealed to the following generation of French artists. For Mignard, the theme had personal implications. He is known to have bequeathed a painting of this subject to his elder son, Charles—and its pendant *Apollo and Daphne*, now lost, to his younger son, Rodolphe—and this has been convincingly interpreted as an injunction not to marry without paternal approval, both subjects showing, as they do, the havoc caused by the gods who pursued only their selfish passions.[9] The version of *Pan and Syrinx* that Mignard painted for his son, acquired by the Louvre in 1979, repeats our composition in a vertical format but with important differences (fig. 5). There, the two river-gods in the foreground, who do not appear in the Blaffer *Pan and Syrinx*, express their fear at the violence that is taking place above them. In the background, the naiads are replaced by a solitary Cupid, resigned

to the awful consequences of Pan's behavior, who sits and extinguishes Love's flame.

Although the Blaffer *Pan and Syrinx* is not known to have had such intimate implications for the artist, its mood of sorrow and regret remains overpowering. The naiads look upon the attempted rape with poignant but stoic dismay. Cupid's feeble attempts at restraining Syrinx are heightened by the huge reeds which dwarf him and which have already begun to engulf the nymph. Finally, the contrast of Syrinx's pure white flesh against Pan's hairy darkness, while conventional, is symbolic both of her terror—which is emphasized by her hair and robe, caught in the wind—and of his brutality.

Within two generations, Mignard's *Pan and Syrinx* would acquire yet another moral gloss, now far less profound than the artist's ruminations on the dangers of irrational desire. The verses which accompanied Edme Jeaurat's engraving of this painting, published in 1718, offered a plaint against the lax behavior of women and against adultery in general. Syrinx's terror is revealed to be little more than her disdain for the cuckold, and Pan's horns have long lost their capacity to evoke fear: "Once such horns were considered hideous. . . . But how things have changed! There is hardly a beauty today who has any difficulty in contemplating them, be they ten feet high, and she can see them on her husband and still laugh."[10] Mignard's pondered and troubled reflections on human desire and the need for control of the senses are thus reduced to illustrating a mediocre homily on infidelity.

Mignard is known to have painted at least two other versions of *Pan and Syrinx*. His powerful protector, the *surintendant des Bâtiments*, François-Michel Le Tellier, marquis de Louvois (1641–1691), owned one of these, estimated at the substantial figure of 500 *livres* in the inventory of his collection drawn up in 1691.[11] Towards the end of his career, Mignard painted *"deux grands tableaux"* representing *Pan and Syrinx* and *Apollo and Daphne* for Charles II of Spain, a prestigious commission secured through the mediation of *Monsieur*, for whom he had worked extensively at Saint-Cloud, and the last "profane" works he would paint.[12] The whereabouts of all three paintings remain unknown.

NOTES

1. Ovid, *Metamorphoses*, I, 689–712; much of this entry is based on Jean-Claude Boyer's excellent article, Boyer 1980 (A), 152–56.

2. Seelig 1972, 170, "item., un tableau de Paon et Sirinx peint par Mignard à bordure dorée prisé six cens livres."

3. Noted in Boyer 1980 (A), 156, n. 17.

4. Exh. Dublin 1985, 20–21.

5. Guiffrey and Marcel 1907–33, X, 92–95, no. 10264.

6. Thuillier 1988, 437–38, is the first to draw attention to this source.

7. Boyer 1980 (A), 156, n. 24, "Quisquis amans sequitur fugitivae gaudia formae / Fronde manus implet baccas seu carpit amaras." For Bernini's *Apollo and Daphne*, see Wittkower 1981, 183–84.

8. Boyer 1980 (A), 154.

9. Ibid., 154, 156, n. 23, and Boyer 1980 (B), 156.

10. Bibliothèque Nationale, Cabinet des Estampes, Db 27, fol. 45, "Hideux étoit jadis tel ornament de tête. Les choses changent bien! Eût-on dix pieds de crête il n'est de Belle en ce jour, qui d'un oeil aguerri, ne les vit, en riant, même sur son mari," reproduced in Seelig 1972, 171 and Boyer 1980 (A), 154.

11. Boyer 1980 (A), 156, n. 17. The painting remained in the possession of Louvois's widow and was last recorded in the inventory of Madeleine-Charlotte Le Tellier de Louvois, duchesse de La Rochefoucauld (6 December 1735), Rambaud 1964–71, I, 563.

12. Monville 1731, 130, "en effet, à la reserve *d'Apollon et de Daphne*, et de *Pan et Syrinx*, que le Roi d'Espagne avoit demandé, depuis cette époque rien de profane n'est parti de la main de Mignard."

FIG. 1
Michel Dorigny, *Pan and Syrinx*, 1657, oil on canvas, Paris, Musée du Louvre

FIG. 3
After Annibale Carracci, *Pan and Syrinx*, 1644,
black chalk drawing by Pierre Mignard, Paris,
Musée du Louvre, Cabinet des Dessins

FIG. 2
Annibale Carracci, *Pan and Syrinx*,
1597–1600, fresco, Rome, Palazzo Farnese

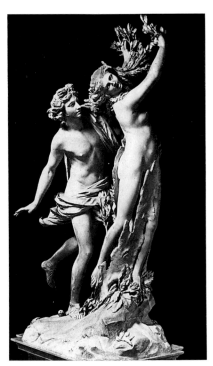

Fig. 4
Gianlorenzo Bernini, *Apollo and Daphne*,
1622–24, marble, Rome, Galleria Borghese

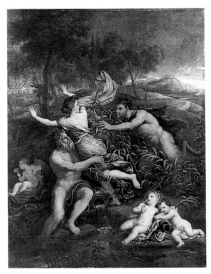

Fig. 5
Pierre Mignard, *Pan and Syrinx*, c. 1690, oil on
canvas, Paris, Musée du Louvre.

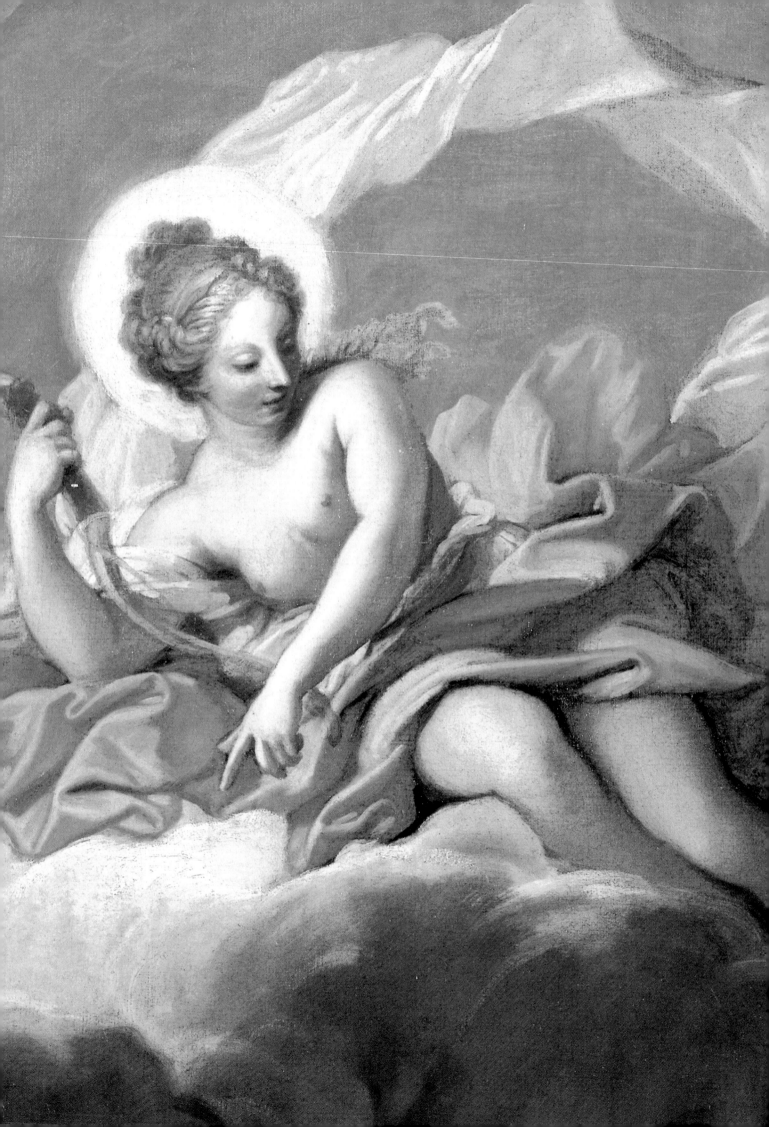

JEAN JOUVENET
(1644–1717)

Born in Rouen into a family of artists, Jean Jouvenet received his first training from his father, Laurent, a master painter-sculptor. He joined the local *corporation* at the age of fourteen but set his sights higher and moved to Paris in 1661. Unlike many aspiring artists at that time, Jouvenet was not apprenticed in a prominent Parisian atelier, such as that of Charles Le Brun, Pierre Mignard, or Philippe de Champaigne. Consequently, not much is known of his activity during this period, although Jouvenet's eighteenth-century biographers frequently described his early painting *Moses Striking the Rock* (location unknown) as "*poussiniste*" in style.

After six years in Paris, Jouvenet became a student at the Academy and received praise for his entry of *The Conquest of the Franche-Comté* in the student *concours* of 1668. The following year Jouvenet became part of Le Brun's entourage when he assisted in the decoration of the château de Saint-Germain-en-Laye. In 1671–74 Jouvenet again worked under Le Brun's supervision, this time at Versailles in the *salon de Mars*, for which he painted *Victory Sustained by Hercules* on the ceiling and two bas-reliefs in the vaults.

Impressed by Jouvenet's youthful promise and his work at Versailles, Le Brun sponsored his admission into the Academy. Jouvenet was accepted in March 1675 when he submitted *Esther before Ahasuerus* (Bourg-en-Bresse, Musée de l'Ain) as his reception piece.

By 1685 Jouvenet had established his reputation primarily through grand decorations for Parisian *hôtels*. These included such mythological paintings as *The Departure of Phaeton* (Rouen, Musée des Beaux-Arts) for Jean de Longueil at the château de Maisons in 1677, three ceiling paintings for the *hôtel* of Louis Robert,

president of the *chambre des comptes*, in 1679–80 (lost), and *Apollo and the Cumean Sibyl* (Paris, Private Collection) and *The Sacrifice of Iphigenia* (cat. no. 2) for the marquis de Saint-Pouange at the hôtel de Saint-Pouange. Although still close to Le Brun, *The Sacrifice of Iphigenia* hints at a more personal style.

After 1685 Jouvenet turned his attention increasingly to the religious paintings for which he is best known today. Following the revocation of the Edict of Nantes in 1685, art patronage by religious institutions reached a new height, and artists such as Jouvenet were in great demand. Among his best religious paintings of this period are *Christ Healing the Sick* (Paris, Musée du Louvre) for the choir of the church of the Chartreux in 1689 and *The Sacrament of the Extreme Unction* (Paris, Musée du Louvre) for the chapel of the *Agonisants* in Saint-Germain-l'Auxerrois in 1689–90, a work which reveals a mature, independent artist. Jouvenet's mastery of this genre culminated in the series of four paintings for the church of Saint-Martin-des-Champs (*Christ in the House of Simon* and *Christ Chasing the Moneylenders from the Temple* in Lyons, Musée des Beaux-Arts, and *The Resurrection of Lazarus* and *The Miracle of the Fishes* in Paris, Musée du Louvre, all signed and dated 1706). In these paintings Jouvenet used naturalistic figures with dramatic gestures organized along dynamic diagonals to present the narrative with great effect.

Although he devoted most of his time to commissions from religious institutions, Jouvenet did not lack royal support after 1685. He contributed to decorations at the Trianon in 1688 (*Zephyr and Flora*, Musée National des Châteaux de Versailles et de Trianon) and 1700 (*Apollo and Tethys*, Musée National des Châteaux de

Versailles et de Trianon), and at Meudon in 1700–1701 (*Birth of Bacchus*, Paris, Private Collection, and *Latona and the Countryfolk of Lycia*, Musée National du Château de Fontainebleau). In 1709 Jouvenet participated in the decoration of the chapelle de Versailles, where he painted *The Pentecost* on the ceiling before the royal tribune. Louis XIV so admired this work that he rewarded Jouvenet by adding 500 *livres* to his pension.

Royal support, important religious commissions, and secular projects such as the decoration of the *grand'chambre* of the Parliament of Bretagne in 1695 combined to make Jouvenet among the most prominent Parisian artists at the turn of the century. After steadily rising through the Academy's ranks after his reception in 1675, Jouvenet reached the zenith of his official career in June 1705, when he assumed the position of director.

In 1713 Jouvenet lost the use of his right arm through paralysis. Undaunted, he began painting with his left hand and completed such works as *The Triumph of Justice* for the ceiling of the *chambre des Enquêtes* of the Parliament of Rouen in 1715 (destroyed, sketches in Rennes, Musée des Beaux-Arts, and Grenoble, Musée de Peinture et de Sculpture) and *The Visitation of the Virgin* in 1716 (Paris, cathedral of Notre-Dame). Although Jouvenet never made the pilgrimage to Rome, he was not oblivious to Italian art. Both *The Triumph of Justice* and *The Pentecost* (Musée National des Châteaux de Versailles et de Trianon) reveal his awareness of the ceilings of Andrea Sacchi at the Palazzo Barberini and Baciccio at the Gesù. In spite of this development in his art, however, Jouvenet essentially remained an advocate of the grand manner until he died in 1717.

JEAN JOUVENET, *The Sacrifice of Iphigenia* (detail), c. 1685, oil on canvas, 190 x 133 cm, Musée des Beaux-Arts et d'Archéologie, Troyes

JEAN JOUVENET
The Sacrifice of Iphigenia

2

JEAN JOUVENET (1644–1717)
The Sacrifice of Iphigenia, c. 1685
Oil on canvas
190 x 133 cm.
Musée des Beaux-Arts et d'Archéologie, Troyes

PROVENANCE
Commissioned by Gilbert Colbert, marquis de Saint-Pouange (1642–1706), for a first-floor room of the hôtel de Saint-Pouange in 1682–83; François-Gilbert, marquis de Chabannais, his sale, Paris, 1776, no. 27, sold for 3,000 *livres*; prince de Conti, his sale, Paris, 8 April 1777, no. 636, sold for 1,350 *livres* [bought in], and his second sale, Paris, 15 March 1779, no. 58, purchased by Boileau for 850 *livres*; Lafrete, his sale, Paris, 27 fructidor an IX (14 September 1801), no. 20; Radix de Sainte-Foy, his sale, Paris, 16 January 1811, no. 33; Laneuville, his sale, Paris, 6 November 1811, no. 149; abbé Hubert, who donated the painting to the Musée des Beaux-Arts et d'Archéologie, Troyes, in 1848.

EXHIBITIONS
Lille 1968, no. 15, ill.

BIBLIOGRAPHY
Hébert 1756, 242; Dézallier d'Argenville 1762, IV, 215; Dézallier d'Argenville 1765, 158–59; Troyes 1850, no. 46 [as École de Jouvenet]; Leroy 1860, 15, 135, 154, 157, 281, 283, 475, 481; Lejeune 1864, 198; Troyes 1864, no. 84 [as Restout]; Blanc 1865, 8; Troyes 1907, no. 244 [as Restout]; Troyes 1911, no. 244 [as Restout]; Mireur 1901–12, IV, 86; Dacier 1909–21, pt. 10, no. 58; Montagu 1969, 97; Schnapper 1974, no. 21, ill.

The Sacrifice of Iphigenia seems to have been especially popular among artists of Le Brun's generation as a subject for chimneypieces. Until mirrors usurped this location, as they would by the end of the seventeenth century, the combination of fire, smoke, and clouds rendered this heroic myth particularly suitable for depiction in vertical format on a grand scale; Perrier, Le Brun, Bourdon, La Fosse, and Jouvenet all painted versions of the Sacrifice of Iphigenia as chimneypieces for private and princely residences.[1]

Jouvenet's *Sacrifice of Iphigenia* was commissioned to hang above the fireplace in one of the first-floor rooms of the hôtel de Saint-Pouange on the rue Neuve des Petits-Champs, acclaimed for the exceptional cleanliness of its interiors, and since 1681 the Parisian residence of Gilbert Colbert, marquis de Saint-Pouange (1642–1706).[2] It was for this influential courtier, Louvois's *premier commis*, who had been appointed *secrétaire du cabinet de la chambre du roi* in 1681, that Jouvenet painted a series of important mythological decorations in 1682–83.[3] The iconography of this commission, in which each room was dedicated to a specific divinity, recalling as it did the contemporaneous decorations at Versailles, reflected something of Saint-Pouange's ambitions and cultural aspirations. The patron also employed Jacques Rousseau, who had worked on the *salon de Vénus* at Versailles, to paint an illusionistic perspective for his gardens, which were designed by Le Nôtre. Furthermore, Jouvenet's *Sacrifice of Iphigenia* may well have been inspired by La Fosse's painting of the same subject (fig. 1), executed for the chimneypiece of the *salon de Diane* five years before.[4]

Jouvenet's *Sacrifice of Iphigenia* hung in a room devoted to Diana, for which he also painted a huge ceiling representing the Sun giving chase to the Moon, who gazes upon the sleeping Endymion, and designed panel decorations of scenes from the life of the goddess which were executed by "a less talented hand than this illustrious painter."[5] Downstairs, he painted a large oval ceiling showing Venus Visited by Zephyr and, in an adjoining room, a ceiling of Apollo and the Muses and a chimneypiece representing

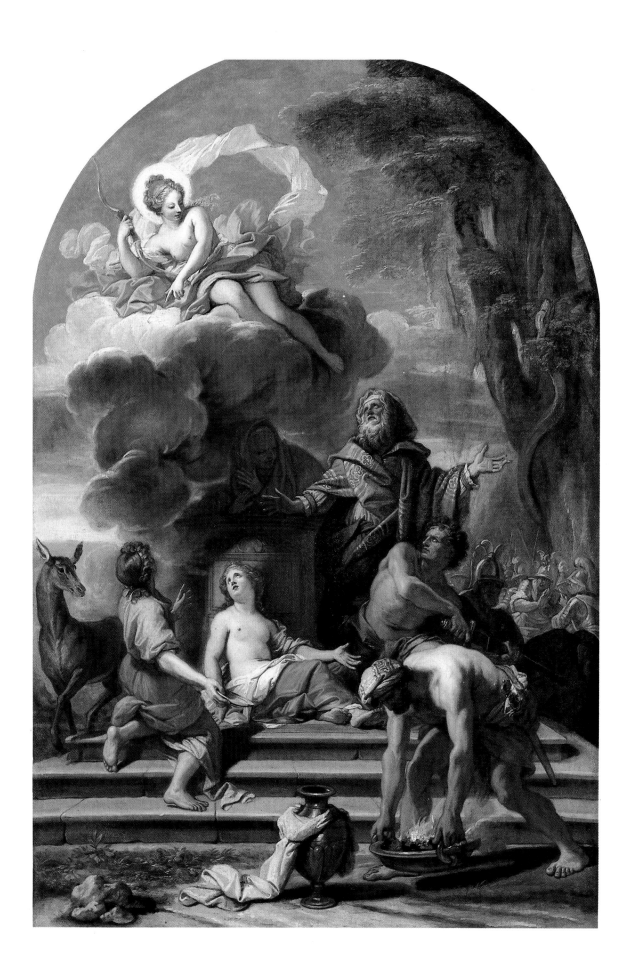

Apollo and the Sibyl of Cumae (fig. 2).[6] As Antoine Schnapper has pointed out, there is little stylistic unity among the various elements Jouvenet painted for the hôtel de Saint-Pouange; whereas the *Apollo and the Sibyl of Cumae* consists of simplified, static forms which recall Poussin, the more spirited and dramatically colored *Sacrifice of Iphigenia*, with its saturated blues and rich orange reds, is closer in handling and tonality to Mignard.[7]

Yet *The Sacrifice of Iphigenia* also announces Jouvenet's distinctive narrative style. The painting's pyramidal structure, with figures disposed in emphatically contrasting attitudes around the stone steps, is precisely that used by Jouvenet in his altarpieces (fig. 3), a compositional type that becomes habitual in his religious commissions but makes an unexpected appearance in this mythological scene. Iphigenia and the young acolyte on her immediate right are derived from figures in his slightly earlier *Family of Darius* (fig. 4), painted for the collège Louis le Grand in 1680.[8] But a more significant source for Jouvenet's composition is Pietro Testa's etching of *The Sacrifice of Iphigenia* (c. 1640–42, Paris, Bibliothèque Nationale, Cabinet des Estampes), from which the artist has taken the cloud-borne Diana pointing to the sacrificial deer as well as the long-haired acolyte who holds the cup into which Iphigenia's blood is to flow. Testa's etching would later achieve canonical status in France; it was copied by Bernard Picard to illustrate the fable of Iphigenia in the abbé Banier's enormously successful translation of Ovid's *Metamorphoses*, first published in 1732.[9]

The Sacrifice of Iphigenia forms a prelude to the Trojan War and is recounted by many classical authors, notably Ovid in the *Metamorphoses* (XII, 1–38) and Euripides in *Iphigenia at Aulis*; to both texts Jouvenet's painting makes specific reference. Having assembled one thousand ships and the leaders of the Greek army at "fish-haunted Aulis," Agamemnon was unable to set sail, deprived of the winds by Diana, whose deer he had wounded in hunting and who demanded the sacrifice of his daughter as recompense. In order to lure Iphigenia from Mycenae, Agamemnon was forced to fabricate the news of her betrothal to Achilles. On arrival, informed of her fate, the innocent daughter chose to be led "unto the goddess's altar, willingly," so that by her death the Greek cause could succeed. Just as the high priest, Calchas, was about to perform the sacrifice, however, Diana replaced Iphigenia with a hind, which was slaughtered in her place, and the brave maiden was taken off to Taulis, where she became the goddess's priestess.

As Jennifer Montagu first pointed out, Jouvenet knew his Ovid well.[10] On the tree at the far right there appears a large snake entwined around the trunk—a reference to the episode immediately before Iphigenia's sacrifice in which the Greek army, about to sacrifice to Jupiter, is astonished by the sight of a dark green serpent crawling up the tree. The serpent swallows a nest of eight young birds along with their mother and then turns to stone. This event is interpreted as a sign that the Greeks will be victorious, but only after nine years of fighting.[11]

In his depiction of the actual sacrifice, however, Jouvenet followed Euripides, who makes no mention of the serpent, and includes Achilles, the muscular young man to Iphigenia's left, "ready to suffer not, but bar [her] death," who had promised the victim that he would attend her sacrifice with his weapons "nigh the altar."[12] Achilles' angry appearance in Jouvenet's painting may derive from a third literary source: Racine's *Iphigénie en Aulide*, first performed at Versailles in August 1674 and published the following year. One of the most celebrated scenes in Racine's play was the dramatic encounter in which Achilles threatens Agamemnon with death:

> I still respect the father of Iphigenia.
> Had he not held this name, it is possible that
> the leader of so many kings
> Would have dared to approach me for the last
> time.[13]

Of course, Achilles is not shown confronting Agamemnon in Jouvenet's painting, but both his anger ("*votre impuissant courroux*") and the act of drawing his sword—neither of which is strictly required by the action taking place in the painting—suggests the influence of Racine. Jouvenet's interpretation pays discreet homage to the cause of the Moderns, all the more unexpected in an artist who is generally considered to have remained aloof from this particular debate.[14]

Initially of an arched format, as is made clear in Saint-Aubin's drawing (fig. 5), and painted rather thinly—*pentimenti* of trees show through the clouds on the upper right of the canvas—*The Sacrifice of Iphigenia* aspires to *gravitas* and drama but remains curiously inexpressive, despite the impassioned gestures of the participants.[15] The habitual disjunction between facial and corporeal expression in Jouvenet's painting, commented upon by modern historians, was first pointed out by the anonymous author of an obituary notice on Jouvenet which appeared in 1718: "As for expression, his figures adopt poses which are lively and rather true to life, but their heads do not have a great deal to say,"[16] a remark that seems especially pertinent here.

Nonetheless, the sacrifice of Iphigenia was to be Jouvenet's favored mythological subject, and he would paint the story again on at least two other occasions: for the prince de Conti in May 1688—perhaps an autograph replica of the Saint-Pouange chimneypiece—and for the Salon of 1699; both of these are lost.[17] Jouvenet's decorations were highly esteemed when Saint-Pouange's descendant, the marquis de Chabannais, put his collection up for sale in 1776 after the *hôtel* itself, which had become the offices of the *receveur général du clergé*, was demolished. *The Sacrifice of Iphigenia* fetched the considerable sum of 3,000 *livres*, and d'Angivillers, who had attempted to purchase one of the downstairs ceilings the previous year, praised Jouvenet as "one of the greatest painters of the French school."[18] Yet by the end of the eighteenth century, Jouvenet's reputation had suffered a seemingly irreversible decline. Entering the Musée des Beaux-Arts, Troyes, in 1843 as "school of Jouvenet," *The Sacrifice of Iphigenia* would soon lose its authorship altogether; until Antoine Schnapper rediscovered the painting in 1967, it languished under an attribution to Jean Restout.[19]

NOTES

1. For Le Brun's lost chimneypiece for the hôtel des Premiers Présidents, see Jouin 1889 (A), 454–55; Bourdon's painting is catalogued in O'Neill 1981, 38–40. The fullest discussion of the depiction of Iphigenia in French painting of the seventeenth and eighteenth centuries remains Dowley 1968, 466–75.

2. Brice 1752, 448, "les dedans en sont d'une grande propreté et très bien disposez."

3. Schnapper 1974, 186–88. This entry is much indebted to Schnapper's excellent monograph on Jouvenet.

4. Hautecoeur 1943–57, II, 359; Stuffmann 1964, 100–101.

5. Dézallier d'Argenville 1765, 159, "une main moins habile que celle de cet illustre peintre."

6. Schnapper 1974, 187.

7. Ibid., 42.

8. Ibid., 43, 186.

9. Exh. Philadelphia and Cambridge 1988–89, 122–24, 283.

10. Montagu 1969, 97.

11. Ovid, *Metamorphoses*, XII, 21–23.

12. Euripides, *Iphigenia at Aulis*, 1427–30, "Thou mayst, even thou, unto mine offer turn / When thou beholdst at thy throat the knife."

13. Racine 1950, I, 721, "D'Iphigénie encor je respecte le Père./ Peut-être, sans ce nom, le chef de tant de rois/m'auroit osé braver pour la dernière fois."

14. For a general discussion of Racine's interpretation of Iphigenia in a broad cultural context, see Gliksohn 1985, 90–118 passim.

15. Dowley 1968, 472, makes the point that none of the French painters who treated this subject "seemed really concerned with what concerned Timanthes most—a cumulative effect of different reactions among the individuals present at the sacrifice."

16. *Collection Deloynes*, LXII, 61, *Abrégé de la vie de M. Jouvenet*, "Ses expressions sont vives et assez vraies dans les attitudes de ses figures; mais elles ne disent pas grande chose dans ses têtes."

17. Schnapper 1974, 71, 89, 141, 181, 188. A small copy of the painting in Troyes is on deposit in the Ministry of Agriculture in Copenhagen from the Statens Museum for Kunst.

18. Lejeune 1864, 198; Hébert 1756, 241; Furcy-Raynaud 1905, 37, "un des plus grands peintres de l'école françoise."

19. Exh. Lille 1968, 32–33.

FIG. 1
Charles de La Fosse, *The Sacrifice of Iphigenia*, 1680, oil on canvas, Musée National des Châteaux de Versailles et de Trianon

FIG. 2
Jean Jouvenet, *Apollo and the Sybil of Cumae*, 1682–83, oil on canvas, Paris, Private Collection

FIG. 3
Jean Jouvenet, *Saint Peter Healing the Sick*,
c. 1675, crayon, pen and ink with wash on gray
paper, Frankfurt, Städelsches Kunstinstitut

FIG. 5
After Jean Jouvenet, *The Sacrifice of Iphigenia*,
drawing by Gabriel de Saint-Aubin in his copy
of the second Conti sale catalogue, March
1779, Private Collection

FIG. 4
Jean Jouvenet, *The Family of Darius* (detail),
c. 1680, oil on canvas, Paris, Collège Louis le
Grand

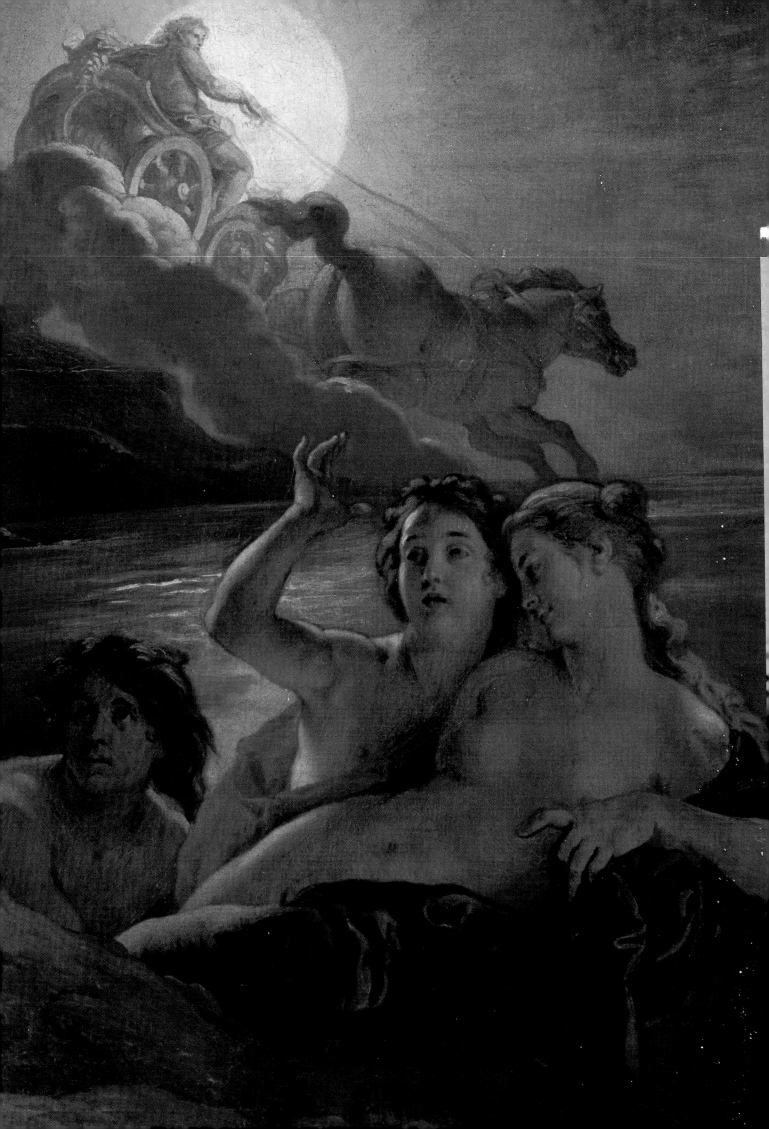

CHARLES DE LA FOSSE
(1636–1716)

Although no artist of his generation broke so thoroughly with Le Brun's hard-edged, declamatory classicism, Charles de La Fosse was the artist's most talented and most promoted pupil. After training briefly with the engraver François Chauveau, La Fosse entered Le Brun's studio (where his youthful collaboration on the ceiling of the seminary of Saint-Sulpice and at the hôtel Lambert was recorded by contemporary biographers) before leaving to study in Italy for five years (1658–63) at the Crown's expense, three of which he spent in Venice. La Fosse's early familiarity with the art of Titian and Veronese marked him indelibly and would set him apart from the gifted practitioners who, like him, later assumed prominence in the *Académie royale de Peinture et de Sculpture*.

On his return to Paris, La Fosse was again indebted to Le Brun, who secured for him the commission to decorate the marriage chapel of the church of Saint-Eustache (1665; sketch for *The Marriage of the Virgin* in Paris, Musée du Louvre), for which La Fosse contributed three paintings in fresco, a medium in which he would work thoughout his career and in which, as Dandré-Bardon pointed out, he excelled above all other French artists. He continued to work under Le Brun's patronage, collaborating on the royal *chantiers* at the Louvre and the Tuileries, and participated in the decoration of the *grands appartements* at Versailles, where he painted the lunettes and chimneypiece in the *salon de Diane* (*The Embarkation of Jason at Colchis; Alexander at the Lion Hunt*, 1671; *The Sacrifice of Iphigenia*, c. 1680) and the ceiling of the *salon d'Apollon* (*Apollo in a Chariot Pulled by Horses*, 1671).

His reception at the Academy came two years later in June 1673 with the eminently classical, even somewhat Poussinesque, *Rape of Persephone* (Paris, École Nationale Supérieure des Beaux-Arts), painted for the duc de Richelieu, whose collection of masterpieces by Rubens would later inspire in both de Piles and La Fosse a great appreciation of that artist. By

the mid-1670s La Fosse's reputation as a painter of monumental decorative cycles was firmly established.

In the summer of 1687 Nicodemus Tessin the Younger recorded that, along with Pierre Mignard, La Fosse was the artist most in demand: "He is held in great esteem and has the most pleasing color of any artist." Indeed, following his work on the *chambre du Couchant* of the Trianon de Marbre in 1688—for which he painted three of his finest mythologies (see cat. no. 3)—La Fosse was invited to London by Ralph, duke of Montagu (the former English ambassador to France) and was given charge of the monumental decoration of Montagu House (destroyed in 1850; since 1759 the site of The British Museum), an immense undertaking in which La Fosse painted ceilings of mythological subjects for the staircase, vestibule, and *salon*. He was lured back to Paris in 1692 by the possibility of taking over the decoration of the church of the Invalides—initially entrusted to Mignard—and by the prospect of being appointed *premier peintre du roi* after the aging Mignard's death. La Fosse was to be disappointed on both counts. He would be made director of the Academy in April 1699, a post he held for two years. Although he made sketches for the Invalides in its entirety, this monumental commission was eventually shared among the most prominent academicians, and La Fosse was given the decoration of the cupola (*Saint Louis Presenting Christ with His Weapons and Coat of Arms*) and four pendentives (*The Four Evangelists*). It was with the same *équipe* (Jouvenet, Louis and Bon Boullongne, and Antoine Coypel) that La Fosse worked on the decoration of the royal palaces of Marly (1699) and Meudon (1700–1702; see cat. nos. 6 and 7).

Thanks to Mansart's protection, La Fosse alone was given the entire commission to decorate the chapelle de Versailles, Mansart's last great royal building project. The latter's death in 1708 (a year before the chapel was completed) ensured that this decoration too would be shared among

the senior history painters; La Fosse contributed a *Resurrection* for the apse, which he completed in a record four months and in which his veneration for Rubens and Correggio found "eloquent expression."

Handsomely pensioned by the Crown, La Fosse, like Jouvenet, continued to undertake monumental commissions in old age. He decorated the gallery of Pierre Crozat's townhouse on the rue de Richelieu with an enormous ceiling representing *The Birth of Minerva*, and for Crozat's new *château* at Montmorency he painted a ceiling of *Phaeton Requesting the Chariot from His Father*. In 1711 he undertook four monumental religious paintings for the choir of the cathedral of Notre-Dame, but finished only two: the immense *Adoration of the Magi* and *Birth of Christ* (both Paris, Musée du Louvre) in 1715, his last works.

A prolific, esteemed, and well-patronized academician, La Fosse was the most "baroque" of French seventeenth-century painters, and his painterly and robust figural style, so well suited to ceiling decoration, is somewhat removed from the more orthodox, linear classicism of his fellow academicians. Indebted to Rubens and Van Dyck, but above all to Titian, Veronese, and Correggio, La Fosse's example suggests a more open Academy, one that, in the wake of Le Brun, encouraged such colorism and dynamism, even if the artist's "incorrection" in drawing was frequently pointed out. La Fosse's abbreviated handling, warm coloring, impassioned attitudes, and flowing draperies—qualities characterized by Blunt as the artist's "lightness"—are routinely explained as the forerunners of a more fully developed "rococo" style. While it is unquestionable that La Fosse's art has more in common with Lemoyne and Boucher than has the work of any of his contemporaries, his mature oeuvre represents an alternative orthodoxy that was fully in place as early as 1680, one that might be characterized as the private as opposed to public face of the *style Louis XIV*.

CHARLES DE LA FOSSE, *Clytia Changed into a Sunflower* (detail), 1688, oil on canvas, 131 x 159 cm, Musée National des Châteaux de Versailles et de Trianon

CHARLES DE LA FOSSE
Clytia Changed into a Sunflower, 1688

3

CHARLES DE LA FOSSE (1636–1716)
Clytia Changed into a Sunflower, 1688
Oil on canvas
131 x 159 cm.
Musée National des Châteaux de Versailles et de Trianon

PROVENANCE
Commissioned in 1688 as an overdoor for the *cabinet du Couchant* in the Trianon de Marbre; between 1699 and 1712 the room served as the duchesse de Bourgogne's bedroom.

EXHIBITIONS
Lille 1968, no. 24.

BIBLIOGRAPHY
Piganiol de La Force 1701, 343–44; Hébert 1756, 96; Dézallier d'Argenville 1762, IV, 197; Papillon de La Ferté 1776, II, 518; Thiéry 1788, 427; Soulié 1852, no. 70; Guiffrey 1881–1901, III, clmn. 89, 287, IV, clmn. 12–13; Engerand 1899, 400; Stuffmann 1964, no. 32, ill.; Thuillier and Châtelet 1964, 119; Schnapper 1967, 44, 45, 62–63, 124, 132, no. I 13, ill.; Van der Kemp 1967, 185, ill.; Schnapper 1968 (B), 342, ill.; Montagu 1969, 97; Constans 1980, 79; Scott 1988, 173.

Among classical authors, Ovid alone relates the story of Clytia, the beautiful maiden scorned by Apollo, for whom she nonetheless nurtured an overwhelming passion. Apollo fell in love instead with her rival, Leucothoe, the daughter of King Orchamus of Persia, whose bedchamber he entered by assuming the guise of her mother. In a fit of jealous rage, Clytia informed Orchamus of his daughter's defilement, and the king ordered that Leucothoe be buried alive under a heavy mound of sand. Unable to save her, Apollo sprinkled the ground under which she lay with fragrant nectar and created the sweet-smelling herb frankincense. Now spurned even further by Apollo, Clytia pined away and lost her reason. Refusing to eat or drink, she sat on the bare ground and for nine days followed Apollo's course until her body was transformed into a sunflower, whose face is always turned toward the sun.[1]

This obscure myth provided La Fosse with the subject of his masterpiece.[2] Clytia, "bare-headed and unkempt," is seated on a rock and dabs at her tears in a pose of utter dejection, not unlike a penitent Magdalene. Ignored by Apollo—seen in the background riding his chariot at full speed into the ocean—Clytia is portrayed at the very moment of her metamorphosis: the huge sunflower is watered by the compassionate river-god above her. Her "sister-nymphs," bathed in the shadows of the setting sun, express both their sadness and amazement, while the landscape, with its overarching clouds and light-stained water, distills a golden light appropriate for the mood of melancholy and regret so powerfully evoked by the figures themselves. Such exquisite harmony between figures and setting would have met with Roger de Piles's complete approval.[3]

Clytia Changed into a Sunflower was painted as an overdoor for the *cabinet du Couchant* (fig. 1), one of the suite of rooms comprising the king's apartments in the very recently completed Trianon de Marbre.[4] For the *cabinet du Couchant* La Fosse also provided a chimneypiece, *Apollo and Thetis* (fig. 2), and a second overdoor, *Diana Resting*, known today only from a good

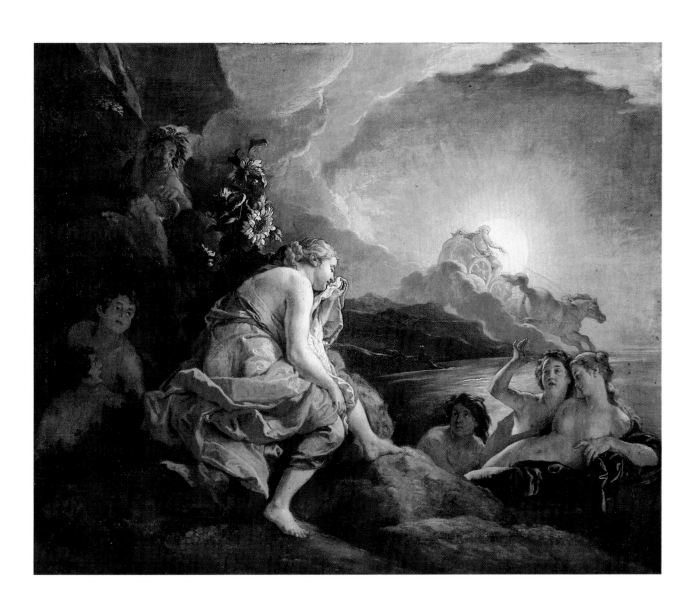

contemporary copy (fig. 3), which shows Diana and her maidens grouped in a sinuous diagonal similar to the disposition of the figures in the *Clytia Changed into a Sunflower.*[5]

La Fosse must have been given the commission for this room—whose function as a royal bedchamber determined both the Apollonine and nocturnal iconography of his paintings—at some point in December 1687. Work on the building itself, which had started in July 1687 and had proceeded at the break-neck pace later associated with Bagatelle, seems to have reached completion by early December.[6] Dangeau reported in his diary for 5 December 1687 that "the King took a long walk through the buildings he has constructed and with which he is now most pleased."[7]

By the end of the following month (January 1688), La Fosse had submitted designs for all three paintings, and these had met with Louis's approval. In a letter to the administrator of the Gobelins, La Chapelle, on 24 January 1688, Louvois, the beleaguered *surintendant des Bâtiments,* noted: "I am returning to you the plans which Sr. de la Fosse gave me and which the King has approved. He should put them to use straightaway."[8] La Fosse must have worked quickly—the first payment he received is dated 9 May 1688—and Dangeau reported on 12 July 1688 that the Trianon was finally furnished: "All the beds are in place and the King may sleep there when he wishes," which provides a *terminus post quem* for the first round of mythological decorations.[9] La Fosse was supposed to receive 1,800 *livres* for the three paintings—curiously, the *Diana Resting* was valued more highly than the others—but due to an administrative oversight he was paid 2,000 *livres,* although he had to wait until November 1696 for the account to be settled in full.[10]

La Fosse was one of several senior academicians employed to furnish the Trianon de Marbre with seventy-five mythologies appropriate for this "*palais de Flore,*" a project that absorbed ten of the most prominent history painters of the day.[11] Whereas it is now known that Louis XIV had been personally responsible for the architecture of the Trianon—and had dictated his demands to Mansart and de Cotte with supreme indifference to their artistic individualities—it is less clear that he was much involved with the program of interior decoration. As we have seen, however, artists were obliged to present their preparatory drawings for his inspection, and royal approval was not automatic: Louvois reported that the king had rejected Noël Coypel's initial design for *Apollo Crowned by Victory* for the *cabinet de Repos* as "*trop chargé de figures.*"[12]

It has been generally accepted that the academicians employed at the Trianon were left to choose the subjects of their paintings themselves, and documentary evidence, in the form of proposals submitted in 1689 for the decorations of the Trianon sous Bois, would seem to support such an astonishing lapse of administrative control.[13] On closer reading, however, it would appear that the artists were instructed—by Louvois's second-in-command, the marquis de Villacerf, perhaps—to pick their subjects from Ovid's *Metamorphoses,* a repertory capable of celebrating royal authority and the delights of nature in equal measure.[14] Until further information relating to the decoration of the Trianon de Marbre comes to light, the notion of artistic independence in matters of royal decoration should be treated very cautiously.

La Fosse's choice of subjects for the *cabinet du Couchant,* however arrived at, showed him to possess a courtier's instinct worthy of his teacher Le Brun. The related episodes of Clytia Changed into a Sunflower and Apollo and Thetis had been painted in 1668 by Nicolas Loyr for the antechamber of the *appartements du Roi* at the Tuileries palace, a *chantier* upon which the young La Fosse had been employed between 1666 and 1671.[15] Loyr's four "colored bas-reliefs" painted on gold ground represented the Times of the Day in "subjects taken from the *Metamorphoses* that can instruct courtiers in their chief duties."[16] *Apollo Returning to Thetis,* symbolizing Night, served to remind members of the court "that they must always be ready to entertain the Prince when he returns to his Palace in the evening."[17] And the story of Clytia was intended to impress upon them the need "to be ready at all times to follow the Prince, wherever he may go."[18]

It is impossible to know with what degree of pictorial success, if any, such heavy-handed interpretations were translated onto the canvas, since Loyr's paintings are lost and were not engraved.[19] Yet the source for these monarchical readings was impeccable: the recently established *Petite Académie,* forerunner of the *Académie des Inscriptions et Belles Lettres,* assembled by Colbert in 1663—its erudition and orthodoxy were unequaled.[20] La Fosse was surely aware of the resonance of these subjects, and it is likely that, on one level, he intended his decorations to convey similarly austere injunctions on the nature of fealty to the Crown. In *Apollo and Thetis* (fig. 2), Apollo not only wears the crown of laurel, which by the 1680s had become a commonplace allusion to Louis's military victories, but Thetis, as Margret Stuffmann first pointed out, is draped in robes embossed with the *fleurs de lys,* making her identification with the kingdom of France unavoidable.[21] Whether *Clytia Changed*

into a Sunflower can be similarly read as a "political parable" is less certain.[22] While Loyr's precedent had established a strong connection between this myth and the unquestioning loyalty demanded of the courtier, La Fosse pared his sensuous and richly colored overdoor of overtly moralizing references. The flattering resonance of this subject could hardly have been lost on the king and his familiars, yet it was La Fosse's great achievement in *Clytia Changed into a Sunflower* to resist sufficiently the presence of the Sun King and thereby create one of the most fluent and moving mythologies painted in the *ancien régime*. It was precisely the burden of maintaining both languages, painterly and political, that compromised *Apollo and Thetis*, generally agreed to be one of La Fosse's least successful decorations.[23]

Although La Fosse submitted preparatory drawings to the Crown, no such studies have come to light, and it is hoped that Joanne Hedley's research will locate drawings for the Trianon commission.[24] Nor is it possible to suggest a source for *Clytia Changed into a Sunflower*, a subject that had been treated only occasionally in Flemish and Italian painting of the sixteenth and seventeenth centuries.[25] For the subsidiary group of Apollo and his horses, La Fosse may have had recourse to Bloemart's engraving after Diepenbeeck's drawing (fig. 4), used to illustrate the myth in the abbé de Marolles's influential *Tableaux du Temple des Muses* of 1655—after Ovid, the fullest account of the story of Clytia available.[26] La Fosse reversed the relation of the figures in Bloemart's engraving, and his full-breasted, slightly leaden figure of Clytia, while generally indebted to Veronese's unimpeachable young matrons, may have been inspired by the dark-haired Fate who holds the spindle in Rubens's *The Fates Spinning the Destiny of the Future Queen* (fig. 5) in the Medici cycle, a repository for figures in so many of La Fosse's decorative compositions.[27]

Immediately acclaimed as one of La Fosse's most beautiful paintings—in 1701 Piganiol de la Force noted that *Clytia Changed into a Sunflower* and *Diana Resting* "have great beauty and are the finest works by La Fosse"[28]—*Clytia Changed into a Sunflower* inspired versions of the myth by Bertin and Jean-François de Troy, La Fosse's true heir, who painted the subject on at least three occasions (fig. 6).[29] An intriguing, but unattributed, canvas, given variously to Watteau, Lemoyne, and Boucher, reaffirms the appeal of La Fosse's overdoor for a later generation of history painters.[30] After midcentury, however, the subject was represented infrequently in the Salon, and *Clytia Changed into a Sunflower* ceased to represent a vital tradition in French painting.[31] Such was the disrepair into which La Fosse's reputation had fallen that, in Victor-Louis Picot's engraving, the authorship of this magnificent overdoor was given to Lemoyne.[32]

Notes

1. Ovid, *Metamorphoses*, IV, 235–70.

2. Among the subjects proposed by Antoine Coypel for the Trianon sous Bois was *Apollo and Leucothoe*, but it was never executed, Guiffrey 1892, 83.

3. Piles 1708, 229–30, "Le meilleur moyen de faire valoir les figures est de les accorder tellement au caractère du paysage qu'il semble que le paysage n'ait été fait que pour les figures."

4. Schnapper 1967, 78–79.

5. Although two larger versions of *Diana Resting* are accepted as fully autograph, neither of these may be related to the Trianon overdoor, since it is only in the Toronto copy that the female figures respond in scale and number to those in *Clytia Changed into a Sunflower*; Stuffmann 1964, 104, for the Hermitage *Diana*. A smaller version of the Leningrad composition was acquired in 1971 by the Musée des Beaux-Arts, Rennes.

6. For much of the following I am indebted to Bertrand Jestaz's pioneering article, Jestaz 1969.

7. Dangeau cited in Jestaz 1969, 278, "Il se promène fort dans les bâtiments qu'il y fait faire et dont il est très content à cette heure."

8. A.N., *Archives de la Guerre*, A¹ 800, fol. 423, cited in Jestaz 1969, 286, "Je vous renvoye les desseins que le Sr. de la Fosse m'a remis lesquelz le Roy ayant trouvé bien, il peut les mettre en mesure de travailler incessamment."

9. Dangeau cited in Magnien 1908, 6, "Trianon est présentement meublé: tous les lits y sont posés, ainsi le Roi peut y coucher quand il voudra."

10. Engerand 1899, 400–401.

11. Marcel 1906, 188–95; and for the definitive study, Schnapper 1967, 23–65 passim.

12. Louvois's letter of 17 February 1688 is cited in Jestaz 1969, 286.

13. Guiffrey 1892, 77–89.

14. Ibid., 84, "Monsieur, pour satisfaire *à l'ordre que vous m'avez donné de choisir dans les métamorphoses trois sujets* pour faire trois tableaux dans l'un des apartemens de Trianon sous bois. . . ." (emphasis mine); Jouvenet's letter to an unspecified correspondent confirms that the authority for the commission was not left entirely to the artists themselves.

15. Sainte-Fare-Garnot 1988, 95, 96, 98.

16. Brice 1706, 83, "qui marquent aux courtisans leurs principaux devoirs."

17. Ibid., 84, "qu'ils doivent travailler à divertir le Prince lorsqu'il est de retour, le soir, dans son Palais."

18. Ibid., "que les courtisans doivent toujours être prêts à suivre le Prince en quelque endroit qu'il veuille aller."

19. Sainte-Fare-Garnot 1988, 118, for J.-B.-P. Lebrun's inventory of the paintings at the Tuileries.

20. Ibid., 53–54.

21. Schnapper 1967, 44; Stuffmann 1964, 42–43.

22. Scott 1988, 173–74.

23. Schnapper 1967, 60.

24. Mariette owned drawings by La Fosse of both *Diana Resting* and *Clytia*, presumably connected with the Trianon decoration, last recorded in the sale of the abbé Gevigney, 1–29 December 1779, no. 884, "Deux très beaux dessins . . . lavés au bistre: l'un représentant un *Repos de Diane au retour de la chasse*, l'autre *Clitie changée en tournesol*. Ils viennent de la collection de Monseigneur le Prince de Conti."

25. To the brief list supplied by Pigler 1956, II, 58, should be added Rubens's decoration for the Torre de la Parada, a sketch for which is published in Held 1980, I, 265–66.

26. Marolles 1655, 107–8. For an analysis of these engravings, Johnson 1968, 171–90.

27. Stuffmann 1964, 40–43.

28. Piganiol de La Force 1701, 344, "Ces deux tableaux ont de grandes beautés et sont des meilleurs de La Fosse."

29. Bertin's *Clytia* is known today from Gaspard Duchange's engraving, Lefrançois 1981, 158; the three versions of de Troy's *Clytia* are: *Nymph in the Sun* (Alençon, Musée de Peinture de l'Hôtel de Ville); *Clytia Transformed into a Sunflower*, s.d. 1717 (Meaux, Musée Bossuet); and *Clytia* (Private Collection; fig. 6).

30. Bordeaux 1984 (A), 137, where the attribution to early Boucher is tentatively proposed.

31. Lagrenée and Jollain submitted works of this subject to the Salon of 1769, Renou to the Salon of 1773.

32. Picot's engraving is reproduced in Bordeaux 1971, 70.

FIG. 1
Detail of a project for the *cabinet du Couchant*
at the Trianon de Marbre, dated September
1687, Paris, Bibliothèque Nationale, Cabinet
des Estampes

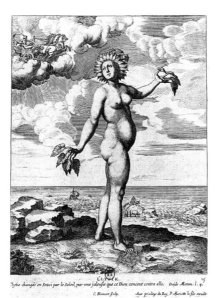

FIG. 4
After Abraham van Diepenbeeck, *Clytia*,
c. 1655, engraved by C. Bloemart, from
Tableaux du Temple des Muses, Paris,
Bibliothèque Nationale, Cabinet des Estampes

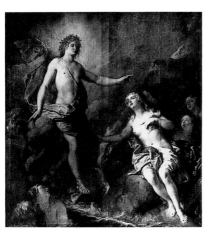

FIG. 2
Charles de La Fosse, *Apollo and Thetis*, 1688,
oil on canvas, Musée National des Châteaux
de Versailles et de Trianon

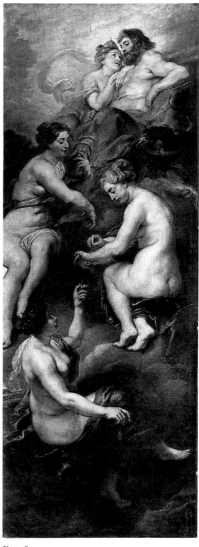

FIG. 5
Peter Paul Rubens, *The Fates Spinning the Destiny
of the Future Queen*, c. 1621–25, oil on canvas,
Paris, Musée du Louvre

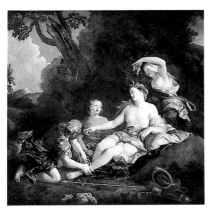

FIG. 3
After Charles de La Fosse,
Diana Resting, artist unknown, oil on canvas,
Art Gallery of Ontario, Toronto

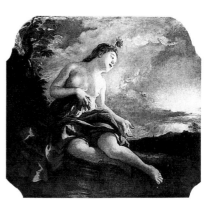

FIG. 6
Jean-François de Troy, *Clytia*, c. 1720–25, oil
on canvas, Paris, Private Collection

CHARLES DE LA FOSSE
Venus Requesting Vulcan to Make Arms for Aeneas

The Deification of Aeneas

4 & 5

CHARLES DE LA FOSSE (1636–1716)
Venus Requesting Vulcan to Make Arms for Aeneas, c. 1690–1700
The Deification of Aeneas, c. 1690–1700
Oil on canvas
179 x 152 cm. each
Musée des Beaux-Arts, Nantes

PROVENANCE
Included in the second consignment of the forty-five paintings dispatched by baron Vivant Denon to the Musée de Nantes in 1809.

EXHIBITIONS
Lille 1968, no. 26, ill.; Nantes 1975, no. 28, ill.; Nantes 1983, nos. 21–22, ill.

BIBLIOGRAPHY
Nantes 1833, nos. 95–96; Nantes 1834, nos. 95–96; Nantes 1846, nos. 139–40; Nantes 1854, nos. 483–84; Saint-Georges 1858, nos. 13–14; Clément de Ris 1859–61, I, 230, 339; Nantes 1859, nos. 119–20; Clément de Ris 1872, 494–95; Nantes 1876, nos. 783–84; Merson 1887, 38; Nantes 1903, nos. 47–48; Nicolle and Dacier 1913, nos. 629–30; Benoist 1953, nos. 629–30; Stuffmann 1964, nos. 40–41, ill.; Join-Lambert 1986, 421, ill.

Although nothing is known of the seventeenth- and eighteenth-century provenance of *Venus Requesting Vulcan to Make Arms for Aeneas* and *The Deification of Aeneas,* they are the finest examples of La Fosse's work for the private market—for it is presumably as decorative panels that these richly colored and swiftly executed paintings were commissioned. Catalogued repeatedly, and erroneously, as from the "*ancienne collection du Roi*," these monumental mythologies are first documented only in 1809, when they appear in the second consignment of the forty-five paintings dispatched by baron Vivant Denon to the newly created museum at Nantes.[1] Margret Stuffmann has plausibly suggested that they were probably impounded as *émigré* property, although no trace of their passage has yet come to light in the meticulous inventories of confiscated collections made by successive Republican and Napoleonic administrations.[2] The obscurity of their origins and early history—understandably described as "irritating" by their most recent cataloguer—renders much of what follows subject to caution and possible revision.[3]

To compound the problem, the paintings are less than successful as pendants. Although they share identical dimensions and have suffered similar damage—a seam running the entire length of the canvas at about one foot from the left is visible on both paintings—the compositions do not respond formally to each other as would be expected in a pair of pendants. Absent here are certain characteristics fundamental to the pairing of such images—for example, compositional balance and similarities in figural groupings—features that unify La Fosse's *Rape of Europa* and *Rinaldo and Armida* (figs. 1 and 2), decorations of comparable scale and ambition painted for the Duke of Montagu some years earlier.

Venus Requesting Vulcan to Make Arms for Aeneas is organized around a strong diagonal axis, which runs from Venus's swirling draperies at upper left to

Vulcan's resplendent golden robes at lower right, and in which the intensity of the couple's gaze provides the focal point. The putti who respectively carry Venus's train, grab at her knee, and try on Vulcan's handiwork infuse the composition with movement and energy, while the shadowy Cyclopes at right balance Venus's rambunctious attendants and add weight to Vulcan's domain. Although Venus's face and left arm were damaged by recent restoration, the purity of her body—her nacreous skin splendid against pink and white robes—contrasts impressively with the swarthy masculinity of Vulcan, whose expressive gestures of hand and adoring gaze leave no doubt that he has now "caught the wonted flame."[4]

Such dynamism and formal cohesion is lacking in *The Deification of Aeneas*, a resolutely static and statuesque composition in which Venus floats uncomfortably on a cloud and administers divine libation to Troy's chieftain. The insistent verticals of this painting and the difference in scale of the figures themselves—less monumental than in the pendant, more securely situated within the landscape—question the relationship between the two compositions. Are they pendants, or is it possible that they are part of a series in which a third composition would mirror more faithfully *Venus Requesting Vulcan to Make Arms for Aeneas*, its figures forming a complementary diagonal to the right? In such a configuration, the less dynamic and more earthbound *Deification of Aeneas* might serve as a centerpiece, possibly functioning as a chimneypiece flanked on either side by the two pendants. This is pure speculation.[5] For the present, the pictures illustrate rather well La Fosse's avowed willingness to bend the rules in the interests of pictorial effect. *Venus Requesting Vulcan to Make Arms for Aeneas* might be seen as an example of his commitment to what Dézallier d'Argenville called "enthusiasm, whose faults are often preferable to work of greater correction [*The Deification of Aeneas*], which lack energy and bear the mark of effort."[6]

La Fosse turned to two separate classical sources for these pendants, which depict related episodes in the culmination of Aeneas's epic struggle against the Greeks. The story of Venus's seduction of Vulcan, in which she convinces him to forge weapons fit for the "mortal warrior of high spirit," is recounted by Virgil in the eighth book of *The Aeneid*. Unlike his contemporaries Louis de Boullongne and Jean Jouvenet, who both treated this subject, La Fosse does not follow Virgil in having the meeting take place in Vulcan's "golden marriage room": the forge of Lemnos is indistinctly suggested by the cave at right.[7] Yet he captures both the goddess's impassioned bargaining—"her mother's heart dismayed by no idle fear"—as well as the self-

confidence her great beauty inspires. Vulcan is unable to resist her entreaties—"the familiar warmth passed into his marrow and ran through his melting frame"—and La Fosse depicts him acting out Virgil's recriminations as he responds to Venus: "Why seekest thou so far for pleasure? Whither, goddess, has fled thy faith in me?"[8] It should be noted that the concluding episode of this chapter, in which Venus presents Vulcan's weapons to her son, was painted by La Fosse on several occasions, although never on the scale of the Nantes pendants.[9]

The account of Aeneas's deification appears in the fourteenth book of Ovid's *Metamorphoses*—his reward for having defeated Turnus, king of the Rutuli. The gods finally agree to lay aside their "ancient anger" and are united in their accord that Venus's son is "ripe for heaven." Having secured the approval of Juno and Jupiter, Venus is transported by her "dove-born carriage" to the Laurentian coast, where she bids the river-god Numicius to cleanse Aeneas of his mortality in preparation for his ascent to Olympus: "The horned god obeyed Venus's command and in his waters cleansed and washed quite away whatever was mortal in Aeneas. . . . His mother sprinkled his body and anointed it with divine perfume, touched his lips with ambrosia and sweet nectar mixed and so made him a god."[10]

La Fosse has followed Ovid selectively. In *The Deification of Aeneas* Venus's chariot is drawn by eager swans rather than by doves, and the hero's invincible armor is overshadowed by the resplendent vase of oriental porcelain that commands a prominent position in the left foreground. Yet, just as the mood of *Venus Requesting Vulcan to Make Arms for Aeneas* is sensuous and carnal, so La Fosse achieves a solemnity in *The Deification of Aeneas* that is equally well suited to the event depicted. The oversize vessel held aloft by the admiring putto and the river-god's tender act of cleansing carry strong baptismal associations and infuse La Fosse's composition with a spirituality that would not seem out of place in a religious painting.

In the handling, color, and figural types, La Fosse's *Venus Requesting Vulcan to Make Arms for Aeneas* and *The Deification of Aeneas* share certain similarities with the artist's decorations for Marly and Meudon (cat. nos. 6 and 7) and accordingly have been dated to the late 1690s.[11] In both canvases Venus embodies La Fosse's characteristic feminine ideal, whose features recur in several of his later mythologies. According to Dézallier d'Argenville, the model was one of La Fosse's nieces, "who was extremely beautiful and who provided the artist with those fine heads that appear in several of his paintings, especially those in Monsieur Crozat's gallery."[12]

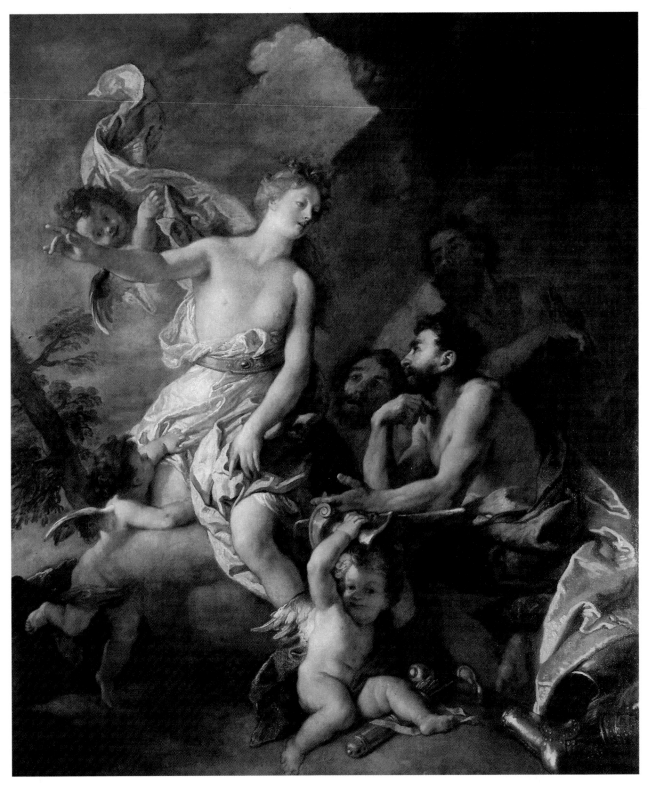

CAT. 4

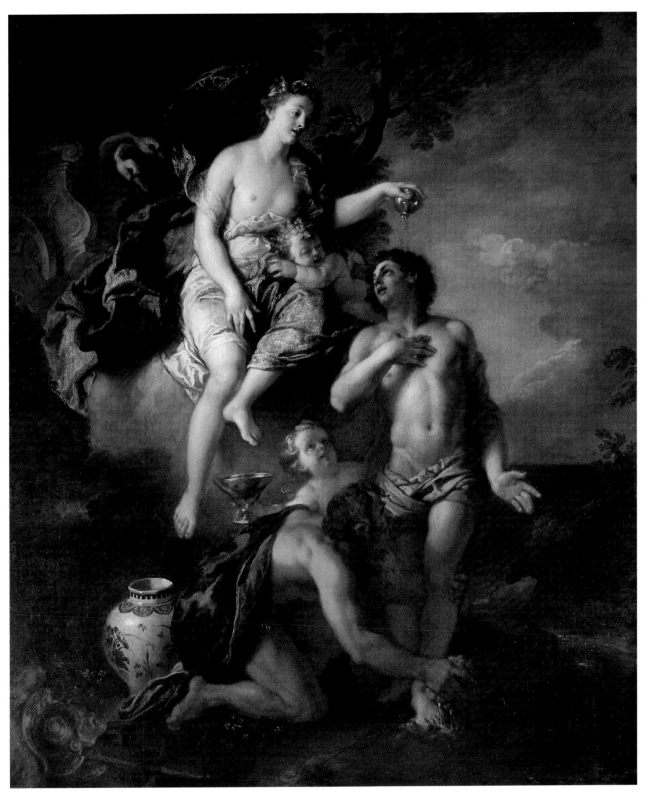

CAT. 5

A dating of c. 1690–1700 for La Fosse's pendants is also of interest because they would then appear as precocious examples of a subject that would proliferate in French painting and sculpture at the beginning of the eighteenth century—of which Antoine Coypel's grandiose decorative cycle for the gallery of Philippe d'Orléans at the Palais-Royal (1702–5 to 1714–17) is but the best documented example.[13] While this theme may have had special significance in the last decades of Louis XIV's long reign—affirming as it did both monarchical succession and the transmission of tradition through the male line—it is difficult to assign any specific political meanings to La Fosse's pendants until the circumstances of their commission are discovered.[14]

La Fosse turned to both French and Flemish models as pictorial sources in the elaboration of his pair of paintings. In *Venus Requesting Vulcan to Make Arms for Aeneas*, the goddess's pose—her arm outstretched in a gesture of pure theatricality—recalls Venus's gesture in *Venus Giving Arms to Aeneas* of c. 1650 (Carpentras, Musée Comtadin et Musée Duplessis), one of the mythological decorations in the *cabinet de l'Amour* of the hôtel Lambert—an anonymous work, now tentatively attributed to Louis Testelin.[15] This composition certainly provided the model for La Fosse's other versions of *Venus Giving Arms to Aeneas* (Brest, Musée des Beaux-Arts and Potsdam-Sanssouci; Staatliche Schlösser und Garten), and the series further included an anonymous *Deification of Aeneas* which La Fosse could also have studied.[16] The artist's familiarity with this celebrated suite of paintings is documented by one of his earliest biographers. Dubois de Saint-Gelais noted that, before leaving for Italy, La Fosse had worked with his teacher, Le Brun, "on the ceilings of the beautiful home of Monsieur Lambert."[17]

Venus Requesting Vulcan to Make Arms for Aeneas also depends on Van Dyck's *Venus in the Forge of Vulcan* (fig. 3), which entered Louis XIV's collection between 1684 and 1709, and in which the charged relationship between an imperious Venus and besotted Vulcan is exploited for the fullest pictorial effect. Not only did La Fosse develop this erotic exchange, he appropriated the putto clutching at Venus's robe in the lower left of Van Dyck's composition, transforming him into the dark-haired attendant half hidden by clouds in the far left of his own painting.[18]

Despite lacunae in almost every area of investigation, related drawings exist for the Nantes pendants which throw considerable light on La Fosse's working method. A fine *académie* (fig. 4), in which La Fosse has worked out the standing figure of Aeneas from a live model, is to be found in a private collection in Le Havre. With very slight adjustments to the profile, the painting follows the drawing exactly.[19] Spirited compositional studies for *The Deification of Aeneas* (figs. 5 and 6) are to be found on both the recto and verso of a sheet which recently appeared on the market.[20] The drawing shows that La Fosse initially conceived of *The Deification of Aeneas* as a more dynamic composition before arriving at the more solemn, if not ponderous, placement of the three protagonists in the painting itself. If the poses of Venus, Aeneas, and the river-god are carried over from the drawing with little change, La Fosse's first ideas contained considerable energy and movement; for example, the putto struggling with Aeneas's armor is more in the spirit of Virgil's epic than the Ming vase that would eventually take its place. On the verso, the putto grabbing at Aeneas's thigh would reappear as Venus's attendant in *Venus Requesting Vulcan to Make Arms for Aeneas*. Joanne Hedley has kindly brought to my attention La Fosse's fine drawing in *trois crayons*, *Nude Man Seated at a Table to the Left* (fig. 7), which is a preliminary study for the figure of Vulcan.[21]

La Fosse treated these subjects in several other canvases of smaller dimensions and lesser quality. A reduced replica of *Venus Requesting Vulcan to Make Arms for Aeneas* (Bourg-en-Bresse, Musée de l'Ain) may be identified as the "*Vénus, Vulcan, et Enée*" formerly in François Boucher's collection.[22] A version of *The Deification of Aeneas* was recorded in the collection of a Monsieur Ador;[23] a studio variant of *Venus Requesting Vulcan to Make Arms for Aeneas*, in which the figures are somewhat differently arranged, appeared on the market as from the studio of Antoine Coypel.[24]

Venus Requesting Vulcan to Make Arms for Aeneas and *The Deification of Aeneas*—robust, sensuous, painterly—display the qualities associated with La Fosse at his finest: absolute mastery of *chiaroscuro* and the heroic yet convincing portrayal of the human form. Nineteenth-century commentators were less sensitive to the artist's persuasive colorism, and no less a connoisseur than Clément de Ris could dismiss these paintings as "immediately recognizable by their russet tonality and commonplace draughtsmanship."[25] Indeed, the anonymous author of the catalogue of the Musée de Nantes had affirmed categorically that La Fosse's style "lacks elevation, his drawing is full of errors and his draperies are mannered."[26] Such criticism of an artist who, more than any of his contemporaries, announced so presciently the eighteenth century appears incomprehensible today.

NOTES

1. Clément de Ris 1872, 312–13, 493–95.

2. Exh. Lille 1968, 37–38.

3. Exh. Nantes 1983, 75.

4. Virgil, *The Aeneid*, VIII, 389.

5. The possibility of a series was first suggested by Margret Stuffmann, who tentatively connected Simonneau's engraving after La Fosse's lost *Aeneas Healed by Venus* with the Nantes pendants, Stuffmann 1964, 160, no. 42.

6. Dézallier d'Argenville 1762, IV, 192, "pour suivre l'enthousiasme, dont les fautes même sont souvent préférables à des choses plus correctes, mais languissantes et faites avec peine."

7. Jouvenet's painting, exhibited at the Salon of 1704, is known today from Desplace's engraving, see Schnapper 1974, 207, and fig. 98; Louis de Boullongne's overdoor for the *appartement d'hiver* of the château de la Ménagerie is discussed in exh. New York, New Orleans, and Columbus 1985–86, 69–70.

8. Virgil, *The Aeneid*, VIII, 395–96.

9. Stuffmann 1964, 111, no. 66, and *Venus Presenting Arms to Aeneas*, Brest, Musée des Beaux-Arts, no. 73-7-1.

10. Ovid, *Metamorphoses*, XIV, 602–6.

11. Exh. Lille 1968, 37.

12. Dézallier d'Argenville 1762, IV, 193, "Une de ses nièces, qui étoit très belle, lui a fourni de beaux airs de têtes dans plusieurs tableaux, particulièrement dans la galerie de M. Crozat."

13. Schnapper 1969, 33–42, with full bibliography. For the theme in French sculpture of the period, see Rosasco 1986 (B), 3–15, and Draper 1989, 223–37.

14. Draper 1989, 234, where the discussion relates more narrowly to the theme of *Aeneas Carrying Anchises*.

15. Rosenberg 1971, 162.

16. Babelon 1972, 140–41.

17. Dubois de Saint-Gelais 1885, 54, "Il travailla quelque tems sous ce dernier aux plafonds de la belle maison de M. Lambert."

18. Larsen 1988, I, 274–75; II, 296.

19. First published by Claude Souviron in exh. Nantes 1983, 73–74. The drawing of Venus's head in the Cabinet des Dessins, Inv. 34343, cited in Stuffmann 1964, no. 41, is a weak copy of little quality, not preparatory for this composition.

20. Christie's, London, 2 July 1985, no. 93. I am grateful to John Morris for photographs of this drawing.

21. Edinburgh, National Gallery of Scotland, Department of Prints and Drawings, *Nude Man Seated at a Table to the Left* (D3217), black and red chalks heightened with a little white on coarse buff paper, 289 x 234 mm.

22. *Catalogue raisonné des tableaux . . . de feu* M. *Boucher*, Paris, 18 February 1771, no. 56, "Vénus, Vulcan et Enée [sic] et trois Amours dont un tient un casque . . . 3 pieds 5 pouces de haut sur 2 pieds 10 pouces 6 lignes de large." This painting presumably reappears in an anonymous sale of 15 May 1786, no. 50, as "Vénus commandant des armes à Vulcain," where the width is given as "2 pieds, 2 pouces," and again in the collection of M. Collet, "Chevalier de l'ordre de Saint-Michel," 14 May 1787, no. 290.

23. Vente Ador, Paris, 12 February 1787, no. 39.

24. Versailles, Trianon Palace, 21 May 1967, no. 14, studio of Antoine Coypel, *Mars Captured by Venus*.

25. Clément de Ris 1859–61, I, 230, "Les deux compositions de La Fosse . . . sont bien reconnaissables à leur teinte rousse et à leur dessin commun."

26. Nantes 1854, 115, "son style manque d'élévation, son dessin est incorrect et ses draperies maniérées."

FIG. 1
Charles de La Fosse, *The Rape of Europa*,
c. 1689–92, oil on canvas, Iliffe Collection,
Basildon House

FIG. 3
Anthony Van Dyck, *Venus in the Forge of
Vulcan*, c. 1626–32, oil on canvas, Paris, Musée
du Louvre

FIG. 2
Charles de La Fosse, *Rinaldo and Armida*,
c. 1689–92, oil on canvas, Iliffe Collection,
Basildon House

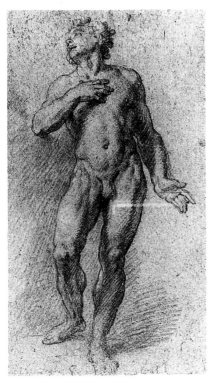

Fɪɢ. 6
Charles de La Fosse, *The Deification of Aeneas*
(verso), c. 1690, red and black chalk, and
brown ink drawing, Canada, Private
Collection

Fɪɢ. 4
Charles de La Fosse, *Aeneas*, c. 1690–1700,
red chalk drawing, Le Havre, Private
Collection

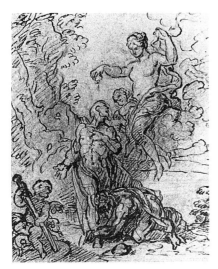

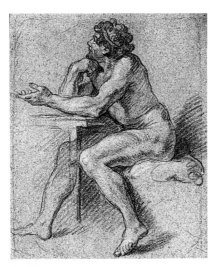

Fɪɢ. 7
Charles de La Fosse, *Nude Man Seated at a
Table to the Left*, c. 1690, red and black chalk
drawing, Edinburgh, National Galleries of
Scotland, Department of Prints and Drawings

Fɪɢ. 5
Charles de La Fosse, *The Deification of Aeneas*
(recto), c. 1690–1700, red and black chalk,
and brown ink drawing, Canada, Private
Collection

CHARLES DE LA FOSSE
Bacchus and Ariadne

6

CHARLES DE LA FOSSE (1636–1716)
Bacchus and Ariadne, 1699
Oil on canvas
242 x 185 cm.
Musée des Beaux-Arts, Dijon

PROVENANCE
Painted for the *grand salon* at the château de Marly in the autumn of 1699; removed to the Musée Spécial de l' École Française at Versailles in 1793; deposited at the Musée des Beaux-Arts, Dijon, in 1812.

EXHIBITIONS
Paris 1937, no. 85; London 1958, no. 250; Paris 1958, no. 55; Lille 1968, no. 27, ill.

BIBLIOGRAPHY
Piganiol de La Force 1701, 367; L(e) R(ouge) 1733, II, 236; Hébert 1756, 72; Dézallier d'Argenville 1762, IV, 197; Papillon de La Ferté 1776, II, 517; L(e) R(ouge) 1778, 250; Thiéry 1788, 446; Dijon 1818, no. 36; Luynes 1861, VII, 210; Guillaumot 1865, 19; Clément de Ris 1872, 467; Dijon 1883, no. 344; Guiffrey 1881–1901, IV, clmn. 478; Engerand 1899, 401; Tuetey 1902, 162; Piton 1904, 444; Marcel 1906, 188; Magnin 1914, no. 344, ill.; Caix de Saint-Aymour 1919, 263; Magnin 1929, no. 344, ill.; Magnin 1933, no. 344, ill.; Magne 1934, 91; Marie and Marie 1947, 9; Stuffmann 1964, no. 45, ill; Thuillier and Châtelet 1964, 119; Vergnet-Ruiz and Laclotte 1965, 60, 241; Rosenberg 1966, 36; Quarré and Geiger 1968, no. 64, ill.; Schnapper 1974, 139, 201; Roy 1980, 52–53, ill.; Conisbee 1981, 74–75, ill.; Rosasco 1986 (A), 127; Standen 1988, 155, ill.

In this luminous and monumental canvas, La Fosse depicts the meeting of Bacchus and Ariadne on the island of Naxos in the Aegean sea, the site of Ariadne's abandonment by Theseus. Greeted by the barking of an unlikely lap dog, Bacchus looks down solicitously as the seated Ariadne, her eyes still swollen from crying, recounts the story of her betrayal. La Fosse's broad yet fluent handling and his sensuous coloring, resonant with the warmth of the Venetians, are deployed with the utmost virtuosity in the painting of the two figures—beautiful adolescents with the innocence of Adam and Eve—who impose their massive, solidly modeled forms upon a background of sky and sea rendered with the greatest brevity.[1] La Fosse makes no attempt to open up the pictorial space as he had done so effectively in *Clytia Changed into a Sunflower* (cat. no. 3); the gilded thyrsus at lower left functions as a halfhearted *repoussoir*, and so compressed are the panthers who draw the god's chariot that they resemble a beast with two heads. If these details of place and setting are rendered summarily, so are the references to the myth itself. The crown of vine leaves in Bacchus's hair is easily overlooked, as is the panther's head which seems to be eating at the god's right hip—part of the animal skin draped around his waist. More prominent, however, is the ethereal figure seen from behind in the top left of the canvas who holds a pair of scales; he is Libra, a symbol from the zodiac representing Autumn.

It was the placement of La Fosse's canvas that accounted for this rigorous simplification and concentration of forms, since the painting was to be seen at a height of more than thirty feet in the upper story of the *grand salon* at the king's pleasure villa of Marly (fig. 1). Nor were the origins of its commission especially auspicious: the need to provide heating in the *grand salon* so that gaming and card playing could continue throughout the winter.[2]

In June 1699 the decision was made to replace the marble floor of the octagonal *grand salon* with parquet, to install four fireplaces with large mirrors above them, and to block the attic windows on the upper story in order to accommodate the flues of these new

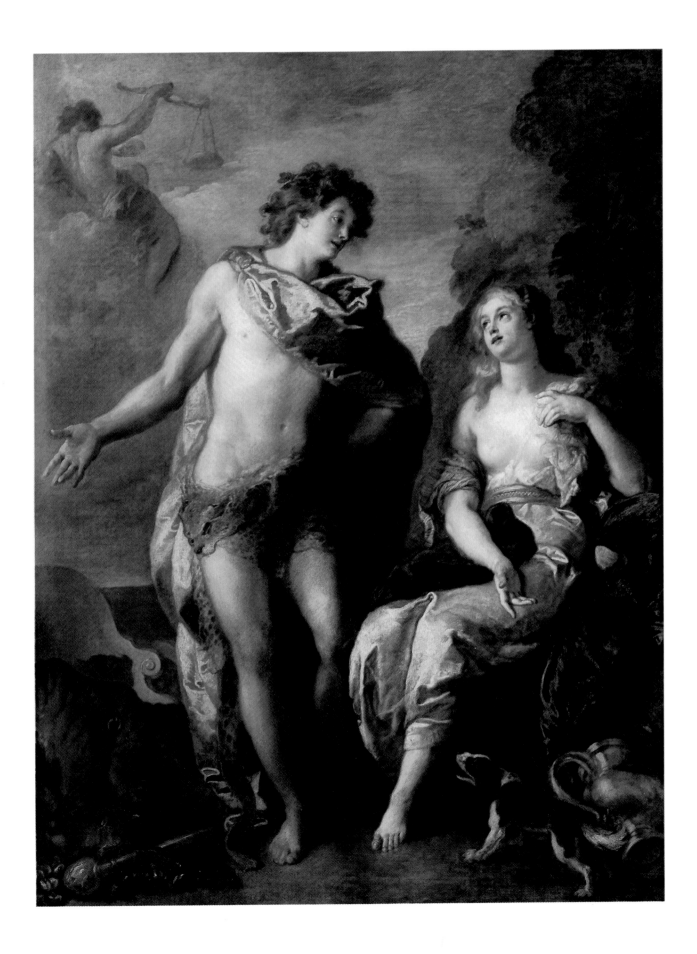

chimneypieces.[3] Pierre Lepautre, who had provided the designs for *cheminées* with mirrors "*toute en hauteur*" for several other rooms in the king's apartments at Marly, was commissioned to do so again on 20 August 1699.[4] With refurbishment under way, it would appear that Mansart initially intended to use paintings from the Royal Collection to decorate the upper story. Towards the end of the month he proposed to find "four paintings by the best masters, of sound but pleasing subjects, to place inside the window frames once they have been filled in."[5]

As late as 12 September, Mansart had prepared a list of eight such paintings from which the king would choose four, but the crucial decision to employ living artists on this project instead must have been taken at about this very time.[6] On 14 September Louis wrote to Mansart: "I am entirely of your opinion, work should begin on four paintings as you propose, only choose your painters carefully and do not press them too hard, so that they produce beautiful things."[7]

From this it emerges that it was Mansart's idea to decorate the *grand salon* with mythological paintings by prominent academicians and that he was given full control of the project. It is unlikely that he followed Louis's injunction for restraint, however, since the king visited Marly on 23 October and "had the great pleasure of seeing that all the work that he had commanded had been done."[8] Payment of 1,000 *livres* to all four artists was made in the last quarter of the year, perhaps as early as 11 October, and thus it is possible that the paintings were executed in less than a month.[9] On 29 October Louis led a party of the royal family through the palace, and Dangeau noted that "they admired the *salon* very much."[10]

Apart from his protégé La Fosse, Mansart commissioned Jouvenet, Antoine Coypel, and Louis de Boullongne to provide large-scale figure paintings representing the Seasons. Had the decision to decorate the upper story with modern painting been taken earlier, it is possible that he would have consigned the entire project to La Fosse.[11] Although Coypel's *Zephyr and Flora* (Spring) and Jouvenet's *Winter* are ruined, it is clear from Boullongne's damaged *Ceres* (Summer; fig. 2) and from Jouvenet's spirited preparatory drawing for *Winter* (fig. 3) that the artists made some effort to unify their compositions, although the formula of large, sedentary figures in abbreviated landscapes was obviously determined by the need for visibility from a great distance.[12] It is worth noting that the reference to the zodiac in *Bacchus and Ariadne* is repeated in Boullongne's *Ceres* (fig. 2), in which Leo, the symbol of Summer, looks down on the goddess from a cloud in the upper right of the canvas.

The *grand salon* at Marly would impress visitors well after Louis XIV's death, although it was "the mirrors of an extraordinary size and height" rather than the oversize mythologies "enthroned above the cornice" that seem to have commanded the most attention.[13] Madame de Pompadour found the sudden change of temperature on leaving the well-heated *salon* intolerable: "[the *salon*] is diabolical for colds, since it is so hot there and so cold outside, with the result that there is more coughing than at Christmas."[14] The duc de Luynes, a frequent visitor at Marly, was aware both of the history of the four paintings—he noted correctly that they had been commissioned to replace blocked windows—and of their authorship but commented that such knowledge was not widely shared among members of Louis XV's court: "One looks at these four paintings every day without knowing whom they are by."[15] Finally, Diderot, visiting Marly in September 1762, was overwhelmed by the opulence of the *grand salon*: "At the center of the building is one of the most beautiful *salons* it is possible to imagine. I entered and when I had reached the middle of the room I realized that it was here, once a year, that the Monarch, with the turn of a card, could change the fortunes of two or three seigneurs of his court."[16] Diderot's imagination was a little wide of the mark; it is clear that the *grand salon* served primarily for lasquenet and reversi, fashionable card games to which the inner circle of Louis XIV's court, no less than his grandson's, was addicted.[17]

If the large mythologies received scant attention—when they were impounded in August 1793, only La Fosse's and Jouvenet's canvases retained their correct attributions—their iconography was not a random or arbitrary matter.[18] In his description of Apollo's palace, "high on lofty columns," Ovid portrayed the Four Seasons in attendance around the Sun, "whose eyes beheld all things," and much of Marly's decoration, both sculpted and painted, depended on this analogy.[19] It was Lucretius, however, who, in *De rerum natura*, formulated the association of certain deities with the Seasons, and who personified Winter, the least desirable of the four, as "cold with chattering teeth," exactly as he appears in Jouvenet's painting.[20]

Mansart's decision to decorate the attic windows of the *grand salon* with mythologies representing the Four Seasons simply reinforced an iconography that was omnipresent at Marly, one that would have been interrupted by the intrusion of paintings from the Royal Collection. The four ground-floor apartments adjacent to the *grand salon* symbolized the Four Seasons, and it is by this name that they were known.[21] The façades of four of the small pavilions were decorated with medallions depicting the Four Seasons; Spring was represented by *Zephyr and Flora*, while Winter was portrayed as an old man cowering from

the Wind, not unlike Jouvenet's representation.[22] Four large sculptures, commissioned for the *grande pièce d'eau* at the same time as the mythological paintings for the *grand salon*, "gave three-dimensional form to this privileged theme."[23] And such was the ubiquity of seasonal imagery at Marly that it even infiltrated the elaborate *divertissements* with which the royal family amused itself. To celebrate the marriage of the prince de Bourbon-Condé to the king's illegitimate daughter, Mademoiselle de Nantes, in July 1685, four *boutiques* displaying the finest luxury goods and jewelry from Paris were assembled in the *grand salon* and decorated in a manner which evoked the Four Seasons. Members of the court, tending the respective stalls, assumed the characters of the Seasons; not surprisingly, the bride, who was only twelve years old, personified Spring.[24] In this perspective, Mansart's choice of subject for La Fosse, Coypel, Boullongne, and Jouvenet now appears as the inevitable extension of a predetermined program.[25]

The speed with which his canvas was to be executed and the necessary simplicity of its composition may have deterred La Fosse from making preparatory studies, since none are known for this painting. The artist may also have turned to earlier models for inspiration; Ariadne is almost identical in form and features to Thetis in *Apollo and Thetis* (Musée National des Châteaux de Versailles et de Trianon), painted a decade before for the *cabinet du Couchant* at the Trianon de Marbre.[26] La Fosse may have taken the pose of Bacchus from a discarded first idea for this composition—formerly entitled *Apollo and the Muses* (fig. 4)—although he clearly altered the position of Bacchus's head. *Bacchus and Ariadne*'s debt to works by Titian and Palma Giovane has been thoroughly discussed by Margret Stuffmann.[27]

Towards the end of his life, La Fosse would be indirectly involved with yet another decorative commission of the Seasons: Watteau's ovals for the dining room of Crozat's Parisian townhouse, executed about 1716 and, as Caylus pointed out, based on La Fosse's designs. Here Watteau followed the Lucretian model upon which the Marly decorations had been based: his *Ceres*, like Louis de Boullongne's, is a full-bodied maiden; his *Winter*, like Jouvenet's, shows an old man huddled over a fire. And Watteau's beautiful painting of *Spring* (fig. 5), destroyed by fire in 1966, may be indebted to La Fosse for more than simply its general composition; the ardent yet hesitant candor of Watteau's lovers is an informal reprise of the tender but passionate exchange of regards that lies at the heart of La Fosse's *Bacchus and Ariadne*.[28]

Notes

NOTES

1. Stuffmann 1964, 45–48, 107.

2. Kimball 1943, 67–68 and Schnapper 1974, 137–39 provide very full discussions of the commission. It should be noted that the former *salon* was absorbed into the living quarters of Adelaide of Savoy, duchesse de Bourgogne, who had so captivated the monarch since her arrival at Versailles in 1697. The need to establish an apartment for her at Marly precipitated many of these refurbishments.

3. Schnapper 1974, 138.

4. Kimball 1943, 67.

5. Cited in Schnapper 1974, 138, "quatre tableaux des meilleurs maîtres, de sujets sages et agréables pour mettre dans les cadres des dites croisées quand elles seront bouchées."

6. A.N., O¹ 1473, "Estat où sont les Ouvrages de Marly, le 12 Septembre," cited in Schnapper 1974, 139.

7. Letter from Louis to Mansart first cited in Piton 1904, 117, "Je suis de votre avis, il faut faire travailler à quatre tableaux comme vous le proposez, il faut bien choisir les peintres et ne pas les presser pour qu'ils soient beaux."

8. Dangeau 1854–60, VII, 174.

9. Guiffrey 1881–1901, IV, 478.

10. Dangeau 1854–60, IV, 178.

11. As he would do the chapelle de Versailles in 1707, a commission that was only shared among Jouvenet, Coypel, and the brothers Boullongne because of Mansart's death in 1708.

12. Antoine Coypel's *Zephyr and Flora* is catalogued in Garnier 1989, 138–39; Louis de Boullongne's *Ceres* in Rosenberg 1966, 36; Jouvenet's *Winter* in Schnapper 1974, 139, 201–2.

13. L(e) R(ouge) 1778, 250, "les glaces d'un volume et d'une hauteur extraordinaire . . . regnant sur la corniche"; Garnier 1989, 139, citing Bailly's inventory of 1733 in A.N., O¹ 1965.

14. Malassis 1878, 85, "Je descend au Salon ce soir, qui par parenthèse est diabolique pour les rhumes; il y fait un chaud énorme, et froid en sortant, aussi entend-on plus tousser qu'à Noël."

15. Luynes 1861, VII, 210, 1 February 1746, "on voit tous les jours ces quatres tableaux sans savoir de qui ils sont."

16. Diderot 1955–70, IV, 164, "le milieu de l'édifice est occupé par un des plus beaux Salons qu'il soit possible d'imaginer. J'y entrai et quand je fus au centre, je pensai que c'était là que tous les ans le monarque se rendait une fois pour renverser avec une carte la fortune de deux ou trois Seigneurs de sa Cour."

17. Dangeau 1854–60, VII, 180, "on ne joue plus que dans le Salon où l'on a fait quatre cheminées magnifiques," 183.

18. "Procès-verbal des operations à Marly . . . le 30 Aout 1793," in Tuetey 1902, 162, "l'autre par Mignard, et l'autre par Bon Boullongne."

19. Ovid, *Metamorphoses*, II, 1–32, and see the excellent account in Rosasco 1986 (A), 1–67 passim.

20. Lucretius, *De rerum natura*, V, 736–47. See also the interesting discussion in Hanfmann 1951, I, 156, 254, 277–79. It would appear that the portrayal of the Seasons as antique gods was "an iconographic device practically unknown to antiquity."

21. *Mercure Galant*, November 1683, cited in Rosasco 1986 (A), 46, "par quatre endroits de ce Sallon, qui représente l'Année, on entre dans quatre Appartemens, qui sont les quatres Saisons."

22. Rosasco 1986 (A), 127.

23. Ibid.

24. Piton 1904, 105, citing Voltaire's *Anecdotes du Règne de Louis XIV*.

25. Louis XIV did not exert a monopoly on the Four Seasons; between 1677 and 1679 Mignard decorated *Monsieur*'s gallery at Saint-Cloud with a central panel of Apollo surrounded by large paintings devoted to the Seasons, see exh. Lille 1968, 76–77.

26. Stuffmann 1964, 42–45.

27. Ibid., 47–48.

28. Levey 1964, 54.

FIG. 1
After Jules Hardouin Mansart, *Plan du Rez-de-Chaussé et du Premier Étage du Pavillon Royal*, date not known, engraved by F. Blondel, Paris, Bibliothèque Nationale, Cabinet des Estampes

FIG. 4
Charles de La Fosse, *Apollo and Thetis*, c. 1688, black, red, and white chalk drawing, Caen, Musée des Beaux-Arts

FIG. 2
Louis de Boullongne, *Ceres*, 1699, oil on canvas, Rouen, Musée des Beaux-Arts

FIG. 3
Jean Jouvenet, *Winter*, 1699, pen and ink drawing with gouache on gray paper, Paris, Bibliothèque Nationale, Cabinet des Estampes

FIG. 5
Antoine Watteau, *Zephyr and Flora (Spring)*, c. 1716, oil on canvas, destroyed 1966

CHARLES DE LA FOSSE
The Triumph of Bacchus

7

CHARLES DE LA FOSSE (1636–1716)
The Triumph of Bacchus, 1700
Oil on canvas
157 x 135 cm.
Musée du Louvre, Paris

PROVENANCE
Painted in 1700 as one of four rectangular overdoors for the *antichambre* of the *Dauphin* Louis's new apartments at the château de Meudon; removed in 1794 and placed in the Louvre.

EXHIBITIONS
Copenhagen 1935, no. 105; Paris 1960, no. 302; Rennes 1964, no. 21, ill.; Lille 1968, no. 68; New Orleans and Washington 1984–85, no. 139, ill.

BIBLIOGRAPHY
Vielcastel 1853–55, 47; Blanc 1865, 8; Grouchy 1893, 124; Engerand 1899, 402; Guiffrey 1881–1901, V, clmn. 38, 448; Marcel 1906, 188–89, 199; Biver 1923, 149, 450, 460, 472, 485, 503; Gillet 1935, 118; Stuffmann 1964, no. 54, ill.; Schnapper 1968 (A), 60, 63, no. 11, ill.; Garnier 1989, 142.

La Fosse's *Triumph of Bacchus* was one of four rectangular overdoors painted in 1700 for the antechamber of the *Dauphin* Louis's new apartments at Meudon. Four of the most prominent history painters of the day, three of whom had contributed mythological decorations for the *grand salon* of Marly the year before, were commissioned to provide paintings of Bacchic subjects appropriate for a room that functioned as a *salle à manger*. The suite was completed by Antoine Coypel's *Silenus Smeared with Mulberries by the Nymph Eglea* (fig. 1), Bon Boullongne's *Venus, Bacchus, and Ceres* (fig. 2), and Jouvenet's *Birth of Bacchus* (fig. 3), which has recently reappeared on the market. The artists each received 700 *livres* for their overdoors, although they had to wait until December 1710 for payment to be acquitted in full. The four paintings remained *in situ* at Meudon until the Revolution, when the palace was sequestered for artillery exercises and the overdoors impounded for the new Museum.[1]

The four overdoors together create an ensemble of very little artistic coherence. The paintings are not related by the scale or number of their figures, nor do the compositions correspond to one another in any formal sense. In part this may be explained by the rather low priority accorded such painted decoration in the *Dauphin*'s overall refurbishment of Meudon, a point that has been somewhat obscured by recent attempts to show that the *Dauphin*'s taste in modern painting was neither more, nor less, gallant or progressive than his father's.[2]

Despite his celebrated protection of Antoine Coypel, the *Dauphin* Louis showed little interest in employing senior academicians to decorate his new apartments; he extended his patronage far more willingly to artists such as Jean Berain and Claude III Audran, whose designs of arabesques and grotesques came to usurp mythological painting at Meudon and to set the prevailing tone there.[3]

Towards the end of 1698, at an early stage in the renovation of the palace, Audran was commissioned to decorate the ceilings of the *Dauphin*'s *chambre* and *garderobe* with grotesque designs, for which he was paid the considerable sum of 6,900 *livres* between

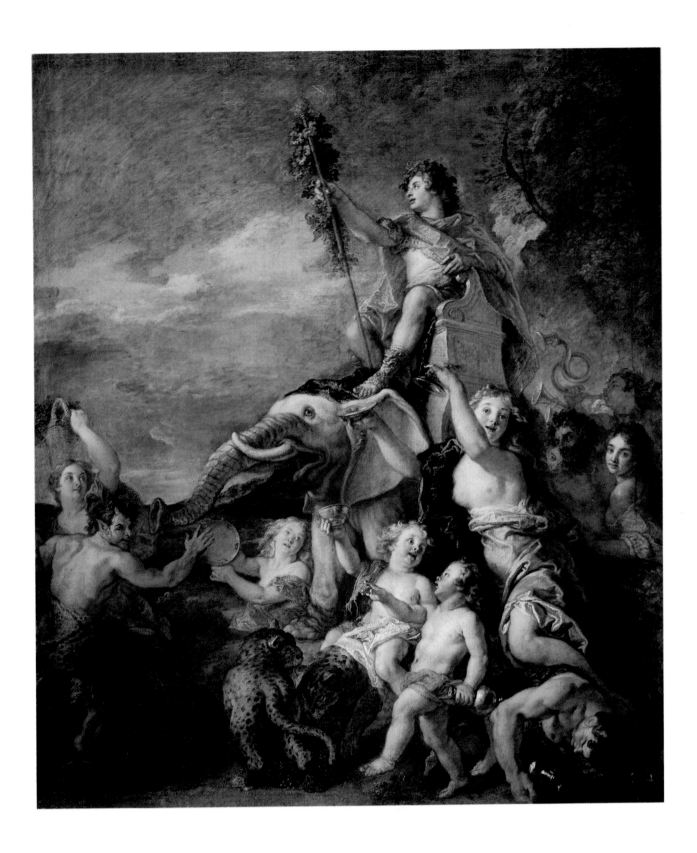

February and March 1699. So successful were these that Mansart was ordered on 25 April 1699 to have Audran paint a similar ceiling in the *cabinet d'angle*.[4] This must have been particularly galling for the *surintendant*, since it entailed painting over La Fosse's ceiling of *Pandora*, executed under Mansart's supervision for Louvois, the previous occupant of Meudon, and praised by Tessin in 1687 as "the most remarkable in the entire house."[5]

At the same time, Jean Berain's *cheminée*—an elaborate, serpentine structure with an arched mirror and bronze plaques, characterized by Fiske Kimball as "fantastic to a degree very unusual in the *grand siècle*"—was being constructed for the *grand cabinet* at a cost of over 7,000 *livres*.[6] Although both Audran's ceilings and Berain's chimneypiece are now known only through preparatory drawings and engravings, their unconventional and daring design led Kimball to describe the Meudon decorations as "the decisive creative act of the period."[7] It is noteworthy that when Louis XIV requested new metal grills in the walls of the *Petit Parc* at Versailles, he urged that they be of the "delicacy of those of Meudon."[8]

Thus, in the proto-rococo interiors of the *Dauphin's* apartments, the rectangular overdoors by Coypel, La Fosse, Jouvenet, and Bon Boullongne must have seemed distinctly old-fashioned, hanging as they did in a newly gilded room decorated with Audran's grotesques.[9] For reasons altogether different from those he proposed, Pierre Marcel's perception that the origins of a more modern aesthetic lie in the Meudon commissions remains substantially correct.[10]

La Fosse's asymmetrical composition, very thinly painted and somewhat airless—the cymbal held by the beautiful bacchante in the foreground practically touches the elephant's ear—is still by far the most successful of the series. The pink and golden sky and the blazing blues, purples, and greens of the attendants' robes make this one of La Fosse's most brilliantly colored compositions, just as the ecstatic rhythms of the dancing bacchantes and children convey a joyous musicality little encountered in French painting of this period.

La Fosse seems to have triumphed in adversity. As Mansart's protégé, he must have been acutely aware of the *Dauphin's* preference for Antoine Coypel, who, as is well known, had Madame Dacier translate passages from Virgil and Euripides to provide novel subjects for his mythological decorations at Meudon.[11] For *The Triumph of Bacchus* La Fosse seems to have employed a comparable stratagem, since this subject too rarely had been treated in seventeenth-century French art, but the sources to which he turned were considerably more diverse.

The fullest account of Bacchus's assault on the "straight-haired Indians" is to be found in Lucian's *Dionysus*, which describes how the "beardless general" and his army of crazy women and satyrs conquered the incredulous Hindus by setting their kingdom on fire.[12] Bacchus's triumphant return from India is not discussed by Lucian, but a particularly evocative account of his frenzied entourage as it accompanies him to the island of Naxos—admittedly, a separate, if related, episode—is to be found in Catullus: "Some of them . . . were bearing in solemn procession dark mysteries enclosed in caskets. . . . Others beat timbrels with uplifted hands, or raised clear clashings with cymbals of rounded bronze: many blew horns with harsh-sounding drone."[13] Reading La Fosse's painting from left to right, we see the bacchante at the far left carrying a casket on her head; the satyr next to her beats the tambourine; the bare-breasted bacchante in the right foreground holds aloft cymbals of "rounded bronze"; and, tightly compressed in the right background, several followers blow horns.

While Catullus's poem finds vivid echoes in La Fosse's painting, its subject is the meeting of Bacchus and Ariadne. For the depiction of the central element of his composition—the god himself—La Fosse had recourse to a venerable and popular compendium of mythology, Vicenzo Cartari's *Immagini con la spositione de i dei gli antichi*, which he may have known in du Verdier's translation (which went through at least three editions) or in a more recent Italian edition of 1647.[14] The account of Bacchus as a "valorous and courageous captain" includes a passage which is of great interest: "He would commonly wear for his upper garments the skins of Panthers and such like beasts. He . . . also subjugated and reduced unto his command all the hether India, returning from thence with mighty triumph and victory, *carried on the back of a huge elephant*, with all his whole army celebrating and extolling the praise and worthy exploits of their lord and commander."[15] Cartari would appear to be the source not only for the jubilant elephant—in Lucian's text Bacchus rides "a car behind a team of panthers"[16]—but also for the panther skin under Bacchus's velvet cape; the animal's head is shown engorging the god's upper arm. Finally, La Fosse may have taken the motif of Bacchus bearing the oversize thyrsus from the schematic engraving (fig. 4) that illustrated the passage in Cartari.

Quite apart from its impressive literary references, La Fosse's composition is indebted to Titian and Rubens, and, here again the artist may have been consciously emulating Coypel, whose *Silenus Smeared with Mulberries by the Nymph Eglea* deliberately echoed the composition of another admired Renaissance master-

piece, Correggio's *Allegory of Vice*.[17] *The Triumph of Bacchus* recalls Titian's *Bacchus and Ariadne* (fig. 5), which was housed in the Aldobrandini Palace in Rome throughout the seventeenth century and several copies of which were recorded.[18] Although Titian's painting treats a different theme, La Fosse's Venetian coloring and figural types derive directly from the *Bacchus and Ariadne*. The massing of figures on the right of his composition and their frenetic music making are unthinkable without Titian's example.[19]

For the detail of the two infants in the foreground of *The Triumph of Bacchus*, La Fosse looked to Rubens. The older child riding the panther is a direct reprise of the putto, seated on a lion, who holds the hymeneal torch in Rubens's *The Meeting of the King and Marie de' Medici at Lyons* (fig. 6)—part of the Medici cycle to which so many of La Fosse's paintings make reference.[20]

Only one preparatory drawing for La Fosse's ambitious composition is known. A study for the drunken satyr (fig. 7) who falls to the ground in the lower right, incorrectly identified as Silenus in eighteenth-century inventories, was formerly in the Aymonnier collection, Paris.[21]

NOTES

1. By far the fullest and most carefully documented account is found in Schnapper 1968 (A), 57–64.

2. Schnapper 1968 (A), 57–58 correcting Marcel 1906, 188–89, 199.

3. Walton 1986, 185, "fantasy, charm, delicacy and arabesque curves . . . are the vocabulary of Meudon."

4. Kimball 1943, 106–7.

5. Weigert 1932, 227, "la plus remarquable dans la maison était le plafond peint directement à l'huile sur la voûte par M. de La Fosse"; mentioned also in Stuffmann 1964, 28.

6. Kimball 1943, 64–66, "d'une fantaisie très inhabituelle."

7. Ibid., 64, "l'acte créateur décisif de cette période."

8. Walton 1986, 185.

9. Hautecoeur 1943–57, II, 627.

10. Marcel 1906, 198, "dès lors le goût du duc de Chartres et du Dauphin triomphe définitivement du goût de Louis XIV." For an extended and sophisticated discussion of this issue, see Scott 1988, 185–92.

11. Garnier 1989, 26.

12. Lucian, *Dionysus*, 1–2.

13. Catullus, *Poems*, LXIV, 256–64.

14. Cartari's *Immagini con la spositione de i dei gli antichi*, first published in 1556 and described by Seznec as "a provider of pictorial subjects," was translated by Antoine du Verdier in 1606 as *Les Images des dieux des anciens, contenant les idoles, coustumes, cérémonies et autres choses appartenans à la religion des payens*. Subsequent editions of the French translation appeared in 1610 and 1623–24. On Cartari's sourcebook, see Seznec 1953, 229–56 passim.

15. Cartari 1623–24, 538, "Bacchus s'armoit aux guerres, et avoit autrefois accoustumé de vestir les peaux de Panthères . . . [il] subiugué toute l'Inde d'où retournant victorieux, il triompha dessus un Eléphant." I have used the sixteenth-century English translation, Lynche's *The Fountaine of Ancient Fiction*, a truncated version of Cartari, published in 1599.

16. Lucian, *Dionysus*, I.

17. Exh. Lille 1985, 71–72.

18. Wethey 1969–75, III, 148–51.

19. The satyr on the far left of *The Triumph of Bacchus* assumes a contrapostal pose that is a variant of Ariadne's sweeping gesture, just as the putto in the foreground recalls Titian's child satyr who drags the ass's head. The bacchante who holds the cymbals in the foreground of La Fosse's painting repeats the pose of the follower who carries a tambourine in the background of *Bacchus and Ariadne*.

20. The pairing of Titian and Rubens as models exemplifies what Pierre Rosenberg has aptly described as "l'esprit à la fois rubénien et vénitien . . . de La Fosse," in exh. Toronto, Ottawa, San Francisco, and New York 1972–73, 169.

21. The anonymous inventory of 1733, A.N. O¹ 1966, reproduced in Biver 1923, 472, describes the figure as "sylène renversé."

FIG. 1
Antoine Coypel, *Silenus Smeared with Mulberries by the Nymph Eglea*, 1700, oil on canvas, Reims, Musée Saint-Denis

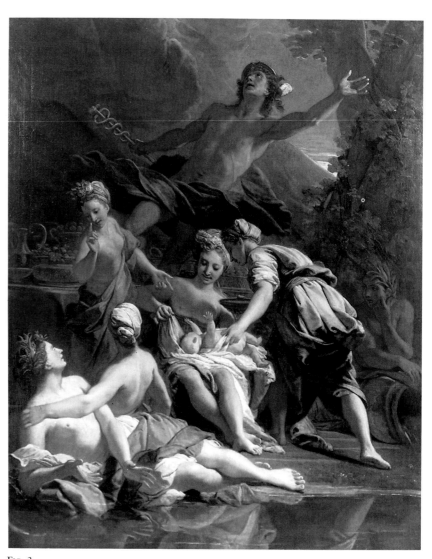

FIG. 3
Jean Jouvenet, *The Birth of Bacchus*, 1700, oil on canvas, Paris, Private Collection

FIG. 2
Bon Boullongne, *Venus, Bacchus, and Ceres*, 1700, oil on canvas, Paris, Musée du Louvre

FIG. 4
Anonymous, *The Triumph of Bacchus*, 1647,
woodcut engraving from Cartari, *Imagini delli
dei de gl'antichi*, Venice, 1647

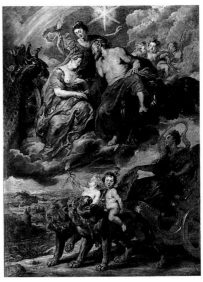

FIG. 6
Peter Paul Rubens, *The Meeting of the King and
Marie de'Medici at Lyons*, c. 1621–25, oil on
canvas, Paris, Musée du Louvre

FIG. 7
Charles de La Fosse, *Figure of a Satyr*, c. 1700,
drawing, formerly Aymonnier Collection,
photograph courtesy of the Witt Library,
London, Courtauld Institute Galleries

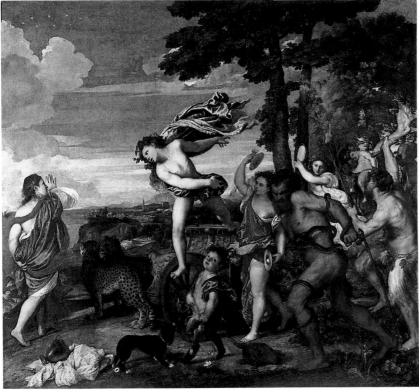

FIG. 5
Titian, *Bacchus and Ariadne*, 1522–23, oil on canvas, London, The National Gallery

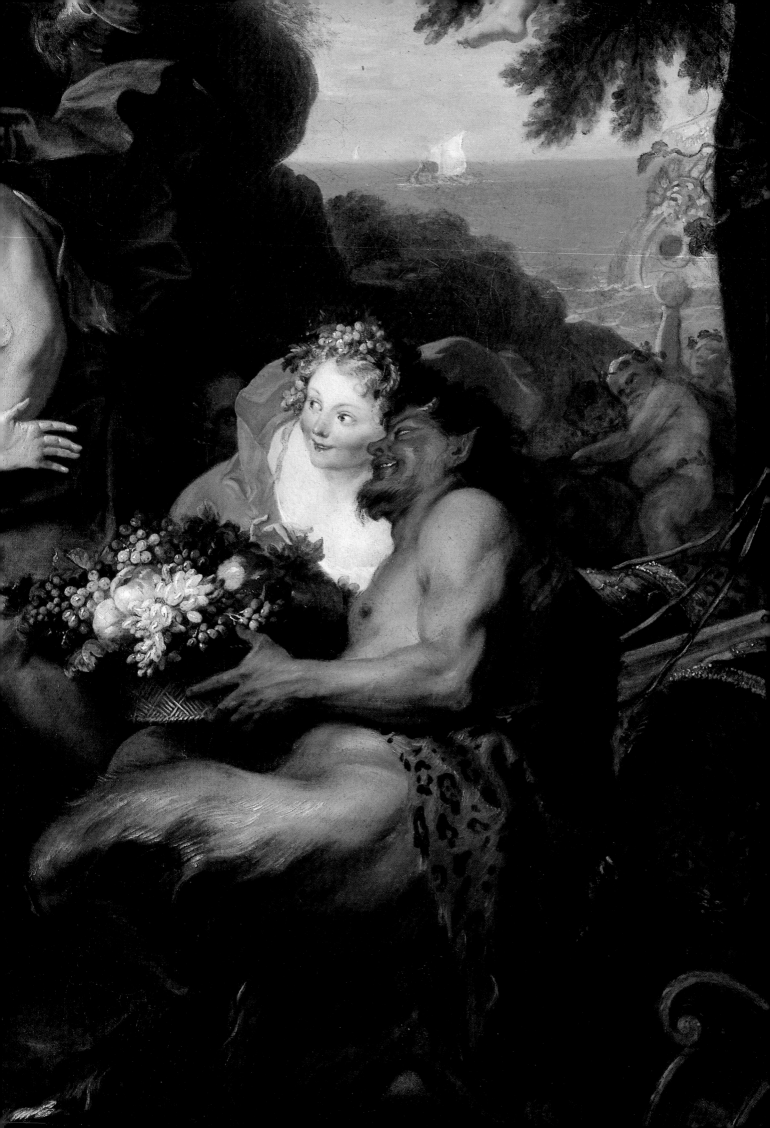

ANTOINE COYPEL
(1661–1722)

Son of Noël Coypel (1628–1707), the important court painter, Antoine Coypel began his career with many advantages, yet it was ultimately his ability to harmonize the styles of Correggio, Poussin, Rubens, and the Bolognese masters of the seventeenth century that made him one of the most successful artists of his generation. Coypel was trained in his father's studio while he became well versed in the classics at the collège d'Harcourt. In 1672 he left Paris for Rome in the company of his father, who had been named director of the French Academy in Rome. There he began to draw after antique statues as well as sixteenth- and seventeenth-century models, and was, furthermore, introduced to contemporary artists, notably Carlo Maratta, who influenced his style. As the Coypel family journeyed through northern Italy in 1675, Antoine saw the works of Correggio, Titian, and Veronese, whose impact may well account for the young artist's Venetian colorism in the 1690s. Shortly upon his return to Paris, Coypel was called on to paint the *Mai* for Notre-Dame in 1680 (*The Assumption of the Virgin*, location unknown). Thanks to the publicity of his neighbor, Donneau de Visé, founder of the *Mercure Galant*, Coypel received more attention from the Parisian press than any artist of his generation. As a result, the painting was a huge success and Coypel became fashionable almost overnight.

Coypel was elected to the Academy in October 1681 at the early age of twenty, submitting *Louis XIV after the Peace of Nijmegen* (Montpellier, Musée Fabre) as his reception piece. Two years later he received his first royal commission, *The Moroccan Ambassadors at the Italian Comedy* (Musée National des Châteaux de Versailles et de Trianon) and *Black Youth Carrying a Basket of Fruit* (Paris, Musée du Louvre). In 1685–86 the *Grande Mademoiselle* entrusted him with the decoration of the *pavillon de l'Aurore* in the gardens at Choisy. Protected by the new *surintendant des Bâtiments*, Louvois, Coypel was called on to design tapestry cartoons after Raphael's *Triumph of the Gods* series for the Gobelins. His official career continued to prosper when *Monsieur* appointed Coypel as his *peintre ordinaire* in 1685 and *premier peintre* in 1689. Although most of his paintings from the 1680s have been lost or destroyed, prints and drawings of his works from this period reveal Coypel's preference for ambitious compositions filled with gracefully orchestrated figures, spatially and theatrically distanced from the viewer.

Coypel's style became more coherent in the 1690s, due in part to changes in patterns of patronage. Royal commissions virtually vanished because of the expense of the War of the League of Augsburg, and artists were forced to pursue careers abroad or rely on private clients among the sophisticated Parisian public. For these new clients, Coypel turned away from large religious works and complex allegories and instead specialized in cabinet paintings imbued with Venetian color and Rubensian luminosity. Many of Coypel's mythological works, such as *Bacchus and Ariadne* (cat. no. 8) and *The Bath of Diana* (cat. no. 9), are in this Rubensian style; his famed *Crucifixion* (Toronto, Private Collection), painted in 1692 for the duc de Richelieu, was once attributed to Rubens himself.

While interested in Rubens, Coypel did not engage in the Rubens/Poussin debate that raged in the 1680s and 1690s, and by the middle of the 1690s he was able to synthesize the grand manner of Le Brun and Poussin with his new Rubensian style. The seven paintings in his Old Testament series of 1695–97 best illustrate this successful eclecticism. Indeed, the much admired *Susanna and the Elders* (Madrid, Museo del Prado), painted for Charles-Maurice Colbert, abbé de Villacerf, was considered to be "the most perfect picture to come from his hand."

In 1699 Coypel gained the support of the *Grand Dauphin*, Louis, who, throughout the coming years, secured his participation in many decorative ensembles for royal residences. Coypel painted *Zephyr and Flora* (Paris, Musée du Louvre) for Marly in 1699, *The Triumph of Venus* (Paris, Musée du Louvre) for the Ménagerie at Versailles in 1701, and seven mythological works from Virgil, Anacreon, and Euripides for Meudon in 1701–2.

Soon afterwards, Coypel received the most prestigious commissions of his career, grand decorations for Philippe, duc d'Orléans, and Louis XIV. For the duc d'Orléans, Coypel executed the ceiling of the *galerie d'Énée* at the Palais-Royal between 1702 and 1705 (destroyed) and seven wall paintings between 1715 and 1717 (Montpellier, Musée Fabre). In 1708, after the death of Mansart, Coypel painted the ceiling of the chapelle de Versailles—a royal commission which, with its dramatic vault opening to the heavens, recalls the ceilings of Pietro da Cortona at the Palazzo Barberini and Baciccio at the Gesù.

Coypel was appointed *directeur des dessins et tableaux du roi* in 1710, and director of the Academy in July 1714. Named *premier peintre du roi* in October 1715, his official career culminated with his ennoblement in April 1717. In the last decade of his life, Coypel painted somber, dramatic subjects in an effort to represent more traditional values, concentrating on the already outdated grand manner best embodied by Le Brun at Versailles.

ANTOINE COYPEL, *Bacchus and Ariadne* (detail), 1693, oil on canvas, 73 x 85.5 cm, Philadelphia Museum of Art

ANTOINE COYPEL
Bacchus and Ariadne

8

ANTOINE COYPEL (1661–1722)
Bacchus and Ariadne, 1693
Oil on canvas
73 x 85.5 cm.
Philadelphia Museum of Art. Purchased: Funds from the Sale of
Deaccessioned Works of Art

PROVENANCE
Painted in 1693 for Philippe I d'Orléans (1640–1701), *Monsieur*,
and placed in his picture cabinet at the château de Saint–Cloud;
by 1925 with the Dutch art dealer Dr. Nicholaas Beets; Private
Collection, Basel, 1952; Christie's, Monaco, 15 June 1990, no. 50.

EXHIBITIONS
Never before exhibited.

BIBLIOGRAPHY
Marcel 1906, 188; Dimier 1928–30, I, 106, 133, no. 75; Rosenberg
1966, 43; Schnapper 1979–80, 62; Foucart–Walter 1982, 69; Ne-
milova 1986, 72; Standen 1988, 178; Garnier 1989, no. 49.

Until it reappeared at public auction in June 1990, Coypel's most celebrated easel painting, *Bacchus and Ariadne*—painted in 1693 for Philippe d'Orléans (1640–1701), Louis XIV's younger brother—was known only from the engraving the artist had made in collaboration with Gérard Audran (fig. 1) and from a host of mediocre eighteenth-century copies which numbered no fewer than nineteen at the latest count.[1] Vibrantly colored and exquisitely finished, displaying supreme control of anatomy, drapery, and expression, Coypel's *Bacchus and Ariadne* is a *tour de force* of history painting—*in petto*—as taught by the fledgling *Académie royale de Peinture et de Sculpture*.

Seated on a rock, her right elbow conveniently resting on a velvet cushion, Ariadne, daughter of King Minos of Crete, laments her abandonment by the Athenian hero Theseus, whose ship can be seen setting sail in the distance. She is regaled by Bacchus and his band of followers, who bedeck her lonely grotto on the island of Naxos with swags of grapes in preparation for her forthcoming marriage to the god of Wine. Hymen bears aloft his flaming torch as Bacchus proposes earnestly to the disheveled Ariadne. To their left a satyr and his companion offer up a basket overflowing with seasonal fruits; on the far left two infant satyrs cavort astride a goat while an adolescent satyr drains his flask of wine, the red liquid dribbling down his chin. On the far right a wide-eyed putto takes the reins of Bacchus's sumptuously caparisoned panthers, one of whom ingests a bunch of grapes. The dancing rhythms of the putti overhead, the flowing drapery of Bacchus, who has just jumped from his chariot, and the eager, insinuating expressions of the splendidly painted satyr and his companion combine to create a mood that is at once joyous, carnal, and celebratory.

Surprisingly, no preparatory drawings are known for this ambitious and carefully orchestrated work; the only related study, a magnificent drawing in *trois crayons* for the satyr's head (fig. 2), is in reverse of the painting, and may have served for other compositions as well.[2] However, examination of *Bacchus and Ariadne* by means of infrared reflectography reveals sev-

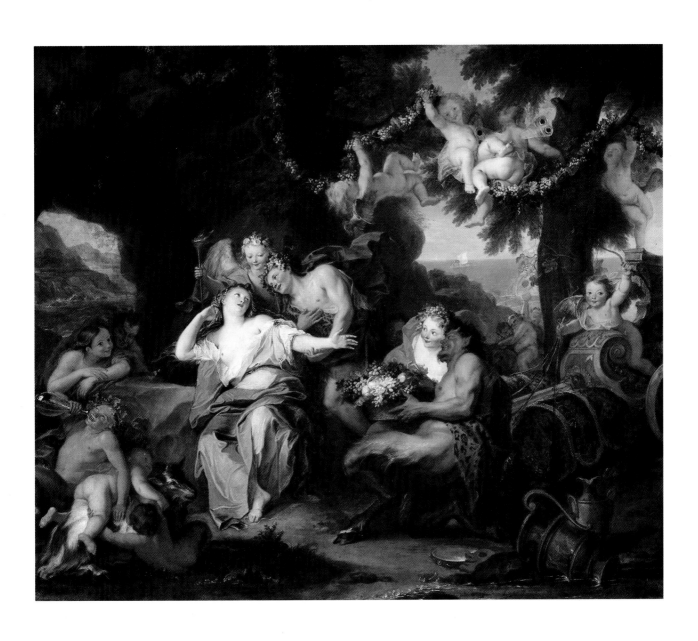

eral changes made *alla prima* on the canvas itself, the most notable of which is the suppression of a large wine cooler which initially occupied the lower right-hand corner of the painting and acted as a *repoussoir* for the scene played out in the middle ground. Directly above this, the putto who rides Bacchus's chariot was initially portrayed with his left hand resting for support on the prow of that carriage; the decision to show him brandishing an unstrung bow was a witty afterthought. Coypel also made radical adjustments to the inebriated satyr guzzling wine at lower left. Originally posed in the opposite direction, his face, as it was first painted, is clearly visible under technical examination at a position just above the satyr's stomach. Changes also occurred in the painting of the far background. Initially, the horizon line on the right extended all the way across the vista which is glimpsed through the grotto at the far left; the mountainous landscape and rocky coastline that appear in the distance are later additions.[3]

If Coypel labored hard to achieve such refinements of detail, he incorporated the literary sources for this celebrated episode with apparent ease. Eighteenth-century commentators agreed that "no artist was better acquainted with the poetics of his art than Coypel and none was better instructed in history, poetry, and mythology."[4] Although Coypel's engraving listed Ovid's *Metamorphoses* as the source for the meeting of Bacchus and Ariadne and the painting does indeed illustrate Ovid's line, "to her, deserted and bewailing bitterly, Bacchus brought love and help,"[5] it was Ovid's far more detailed account of their union in *The Art of Love* that provided Coypel with the narrative for his composition.[6] In this poem, Ariadne is described as "clad in an ungirt tunic, barefoot, with yellow hair unbound," her tender cheeks "bedewed" by tears; except for her unlaced sandals, this is exactly how Coypel portrays her.[7] Coypel's hero reenacts the proposal of marriage as recounted by Ovid, who has Bacchus leap from his chariot and proclaim: "Lo, here am I . . . a more faithful lover; have no fear, Cretan maid, thou shalt be the spouse of Bacchus."[8] Coypel also followed Ovid quite closely in his depiction of the drunken Silenus, seen in the distance behind the satyr on Bacchus's left, who "scarce sits his crookbacked ass and leaning clings to the mane before him."[9] Finally, the prominence in Coypel's painting of Hymen, god of Marriage—rarely portrayed so literally—may have been inspired by the passage in which Bacchus's followers chant "Hail Hymenaeus" at the happy conclusion of their lord's encounter with Ariadne.[10]

Coypel was also indebted to a venerable pictorial tradition, and it is impossible to consider this exquisite mythology without the precedent of Titian's *Bacchus and Ariadne* (cat. no. 7, fig. 5), a painting Coypel would have seen in Rome and one which provided the model for his imploring Bacchus, hair entwined with grapes and garments fluttering in the wind. Coypel's leering satyr and insinuating nymphs indicate the extent of his debt to Rubens, as does the robust and warm coloring of his composition as a whole.[11] Charles-Antoine Coypel noted that his father was criticized at the time for his "excessive admiration of Rubens's color which overwhelmed his paintings and made them seem less natural;"[12] it was in 1692, the year before *Bacchus and Ariadne* was painted, that Coypel executed his celebrated *Crucifixion* (Toronto, Private Collection)—described as a "veritable manifesto of Rubenism"—for Armand-Jean de Vignerod-Duplessis, duc de Richelieu (1629–1715), whose taste had recently undergone a spectacular conversion to the art of the Flemish master.[13] Yet if Richelieu's collection of works by Rubens was a potent source for Coypel, equally significant were the masterpieces by Poussin that he had inherited from his great-uncle the cardinal, to which the young artist would also have had access. Both the frenzied and balletic celebration played out in *Bacchus and Ariadne* as well as the careful delineation of draperies and accessories recall Poussin's *Triumph of Pan* (fig. 3), one of the Bacchanals in Vignerod-Duplessis's collection. Indeed, the mask and tambourine in the foreground of Coypel's painting are direct quotations from this work.[14] Coypel's ability to respond equally to Rubens and Poussin suggests his indifference to the theoretical debates waged by the pedagogues during the 1680s as well as a healthy pragmatism with regard to sources, fully in keeping with academic doctrine.

One final source for Coypel's *Bacchus and Ariadne* may be mentioned, since it situates this cabinet picture in a rather less weighty tradition and is indicative of the influence exerted by Bolognese seventeenth-century history painting on the work of a later generation of French academicians. Coypel's tendency to miniaturize both figures and landscape as well as his careful delineation of individual forms owes much to Francesco Albani, an artist to whom Coypel was often compared and to whom at least one of the copies of *Bacchus and Ariadne* was previously attributed.[15] Coypel's grouping of the three major protagonists —Ariadne gesturing theatrically, Bacchus inclining his head at an angle, Hymen emerging from behind (a compositional tic that would recur in several of his canvases of the 1690s)—may derive from Albani's *Actaeon Changed into a Stag*, a refined work on copper that entered the Royal Collection in 1693 and with which Coypel may have already been familiar.[16]

Comparison with the preparatory drawing for this work (fig. 4) shows clearly the similarities between Albani and Coypel's compositions.

Thanks to the inscription on the engraving after *Bacchus and Ariadne*, it is known that Coypel's canvas hung in *Monsieur*'s picture cabinet at Saint-Cloud, "a house of pure delight with much grandeur and magnificence," and the primary residence of the Orléans family before 1693.[17] Coypel's earliest and most sophisticated cabinet picture, *Bacchus and Ariadne* would not have been out of place in one of the three rooms adjoining *Monsieur*'s bedroom, in which were housed his incomparable collection of precious objects, porcelains, gems, and old master paintings.[18] The English zoologist Martin Lister, visiting Saint-Cloud in 1698, noted of *Monsieur*'s picture cabinet:

> [They] are a fine set of closets. The first you enter is furnished with great variety of Rock Crystals, Cups, Agats upon small Stands and the sides of the Rooms are lined with large Panes of Looking-glass from top to the bottom with Japanese varnish and Paintings of equal breadth intermixt; which had a marvellous pretty effect. The other room had in it a vast quantity of Bijou, and many of very great price; but the Siam Pagods, and other things from thence, were very odd.[19]

It was for such select company that Coypel's jewel-like mythology may have been intended.

If Philippe II, duc d'Orléans (1674–1723), the future regent, is well known as Coypel's most enthusiastic sponsor, the patronage offered by his father, *Monsieur*, is less easy to characterize. Although he certainly appreciated Coypel's talents early on—the artist was his *peintre ordinaire* by 1685 and his *premier peintre* by 1689[20]—*Monsieur* was far less prompt in employing Coypel than had been his cousin, Anne-Marie-Louise d'Orléans, duchesse de Montpensier (the *Grande Mademoiselle*), whose *pavillon de l'Aurore* at the château de Choisy had been decorated by Coypel in 1685–86, and with whom he was on unusually intimate terms.[21] By contrast, *Monsieur* had consigned the major commissions at Saint-Cloud to Pierre Mignard, who between 1677 and 1682 decorated the *galerie d'Apollon* and *cabinet de Diane* with a

series of monumental mythologies, and to his *premier peintre* Jean Nocret, who produced mythological portraits of the royal family as well as the designs for a tapestry series on the chivalric tale of *Amadis de Gaule*.[22] And whereas his son was an assiduous collector of Coypel's cabinet painting during the 1690s, *Monsieur* seems to have shown far less interest in acquiring the work of modern artists for his celebrated picture collection. Charles-Antoine Coypel noted that "some time before his death, *Monsieur* wished to have a work by his *premier peintre* in his *petit cabinet*: the form he prescribed was not the most felicitous, since the painting had to fit into a panel above a narrow door."[23] The implication of this passage is that Coypel's work was not represented in any great number in *Monsieur*'s collection.

What, then, is the status of *Bacchus and Ariadne*? Despite its abundant references to autumn, it was certainly not meant as part of a series depicting the Four Seasons, since its only possible companion, *The Triumph of Galatea* (fig. 5), painted two years later for the duc de Chartres, *Monsieur*'s son, would suggest instead the Four Elements as a possible unifying theme.[24] As the first work by Coypel to enter *Monsieur*'s collection, and one crafted with the utmost delicacy and sophistication, *Bacchus and Ariadne* was clearly intended as a statement of this ambitious artist's talents, taking on, as it did, not only Rubens and Poussin, but also Mignard, whose *Bacchus and Ariadne* from the *galerie d'Apollon* at Saint-Cloud had recently provided one of the models for a much acclaimed suite of Gobelins tapestries woven for Louvois.[25] But in its passionate celebration of the nuptials of Bacchus and Ariadne, a ceremony over which Hymen officiates and in which the putti who festoon the trees with grapes invite the spectator to participate, Coypel's cabinet picture may have communicated a message of more local significance. In February 1692 Philippe II, duc de Chartres, had married Mademoiselle de Blois, Louis XIV's illegitimate fifteen-year-old daughter by Madame de Montespan. The exceedingly favorable financial settlement that accompanied the union included the addition of the Palais-Royal to *Monsieur*'s appanage.[26] Coypel's mythology, painted the year following the marriage of *Monsieur*'s only son, celebrated these nuptials with the deftness and aplomb of a seasoned courtier.

NOTES

1. Garnier 1989, no. 49, 116–18; see also Foucart-Walter 1982, no. 44, 69–70. For the Gobelins tapestry after this composition, Standen 1988, 177–80.

2. Garnier 1989, no. 224, 194–95; Bjurström 1976, no. 350. The satyr reappears in Coypel's *Cupid and Pan Playing the Flute*, engraved by Jean Audran.

3. I am indebted to Mark Tucker, Suzanne Penn, and Joe Mikuliak of the Conservation Department at the Philadelphia Museum of Art for examining the work with me.

4. Papillon de La Ferté 1776, II, 581, "Personne n'a mieux connu la poétique de son art qu'Antoine Coypel, et n'a été plus instruit dans l'histoire, la poésie et la fable."

5. Ovid, *Metamorphoses*, VIII, 176–77.

6. Ovid, *The Art of Love*, I, 525–64. For a good discussion of the various classical sources of this episode, Thompson 1956, 259–64.

7. Ovid, *The Art of Love*, I, 529–30. Ovid's text had appeared in the following translations: Michel de Marolles's *Les Livres d'Ovide et de l'art d'aimer*, Paris 1660; Dufour La Crespilière's *L'Art d'aimer d'Ovide . . . nouvellement traduits en vers*, Paris 1666; and Claude Nicole's *L'Art d'aimer d'Ovide traduit en vers françois*, Paris 1668—to which Coypel surely had access.

8. Ovid, *The Art of Love*, I, 555–56.

9. Ibid., 543–44.

10. Ibid., 563.

11. Schnapper 1979–80, 61; Garnier 1989, 19–20.

12. *Vie d'Antoine Coypel* in Lépicié 1752, II, 10, "en attendant ils lui reprochèrent que son admiration pour le coloris de Rubens se faisoit trop connoître dans le sien, et l'éloignoit de la nature."

13. Garnier 1989, 20; on the duc de Richelieu, see Bonnaffé 1884, 274–76. Coypel's student, the Lorraine painter Charles-Louis Chéron, also observed that at this time his master "colorioit fraîchement, et sa couleur étoit dans le goût de celle de Rubens," Jacquot 1887, 347.

14. For the fullest discussion of Poussin's *Triumph of Pan*, see exh. Edinburgh 1981, 44–45. I am indebted to Joseph Rishel for this observation.

15. Garnier 1989, 79–80; Foucart-Walter 1982, 69, for the large copy after *Bacchus and Ariadne* in Le Mans, Musée Tessé, which was given to Albani in the early nineteenth century.

16. Albani's *Actaeon Changed into a Stag*, Musée du Louvre, inv. 15, was acquired by Louis XIV from Le Nôtre in September 1693, Engerand 1899, 185.

17. Saint-Simon quoted in Barker 1989, 173.

18. Mariette's plan of Saint-Cloud that shows *Monsieur*'s adjoining *cabinet des bijoux, cabinet de la Chine*, and *cabinet* is published in Berger 1969, fig. 85.

19. Lister 1698, 200-201. Christopher Riopelle kindly provided me with this reference. It has been impossible to verify the location of Coypel's *Bacchus and Ariadne* at Saint-Cloud, given the lapidary references to paintings in *Monsieur*'s *inventaire après décès* (A.N., *Minutier Central*, CXIII/189, 17 June 1701, effects at Saint-Cloud inventoried on 27 June 1701) in which neither artist nor subject are described. I am extremely grateful to Udolpho van de Sandt for consulting this inventory for me.

20. Garnier 1989, 14, was the first to establish the approximate dates of Coypel's appointments.

21. Ibid., 14–15, 101–2, for Coypel's relations with the *Grande Mademoiselle*.

22. For Mignard at Saint-Cloud, see Schnapper 1974, 84; Nocret's work on the north wing of the palace is discussed in Magne 1932, 142, 153–54.

23. *Vie d'Antoine Coypel* in Lepicié 1752, II, 14–15, "Feu *Monsieur*, quelques tems avant sa mort, voulut avoir dans son petit cabinet un tableau de son premier peintre: la forme prescrite étoit peu favorable. Ce tableau devoit remplir le panneau d'un porte étroite." The work in question, *Self-Portrait with Son Charles* (Besançon, Musée des Beaux-Arts), was probably painted c. 1698 and is first inventoried in the collection of *Monsieur*'s son, the regent, in his picture cabinet at the Palais-Royal, Garnier 1989, 129.

24. The suggestion of the Four Seasons is made by Garnier 1989, 117.

25. Exh. Lille 1968, no. 157, 76–77, exh. Paris 1990, for two other tapestries in this series.

26. Barker 1989, 214–17, who shows how little the marriage pleased the duc de Chartre's parents, but how profitable it was for all members of the Orléans family.

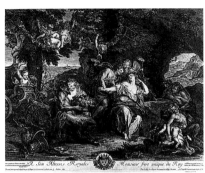

FIG. 1
After Antoine Coypel, *Bacchus and Ariadne*, 1693, engraved by Antoine Coypel and Gérard Audran, Philadelphia Museum of Art, the Muriel and Philip Berman Gift. Acquired from the John S. Phillips Bequest of 1876 to the Pennsylvania Academy of the Fine Arts

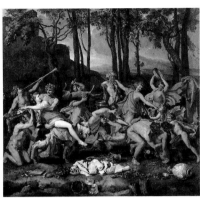

FIG. 3
Nicolas Poussin, *The Triumph of Pan*, 1636, oil on canvas, London, The National Gallery

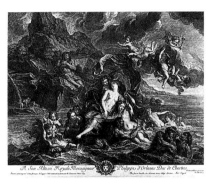

FIG. 5
After Antoine Coypel, *The Triumph of Galatea*, 1695, engraved by Antoine Coypel and Charles Simonneau, Philadelphia Museum of Art, the Muriel and Philip Berman Gift. Acquired from the John S. Phillips Bequest of 1876 to the Pennsylvania Academy of the Fine Arts

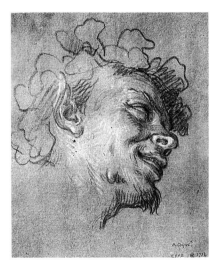

FIG. 2
Antoine Coypel, *Satyr's Head*, 1693, black, red, and white chalk drawing on brown paper, Stockholm, Nationalmuseum

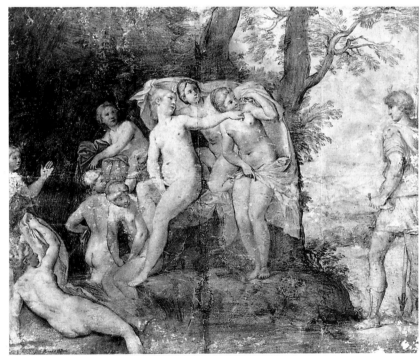

FIG. 4
Francesco Albani, *Diana and Actaeon*, c. 1615–17, black and red chalk drawing, Private Collection

ANTOINE COYPEL
The Bath of Diana

9

ANTOINE COYPEL (1661–1722)
The Bath of Diana, c. 1695
Oil on canvas
90 x 122 cm.
Musée Départemental des Vosges, Épinal

PROVENANCE
Collection of Laurent Rondé (d. 1733), *garde des pierreries de la couronne*, estimated at 800 *livres* in his *inventaire après décès*, 16 December 1733; collection of prince de Salm-Salm at Senones by 1778; confiscated in 1793 (no. 78 of *Catalogue des tableaux qui existent en la maison du ci-devant prince de Salm-Salm*, A.N., F¹⁷ 1269, no. 5); entered the Musée d'Épinal between 1827 and 1829.

EXHIBITIONS
London 1958, no. 249; Paris 1958, no. 31; Washington, Toledo, and New York 1960–61, no. 146, ill.

BIBLIOGRAPHY
Chargeoit 1778, no. 139; Lejeune 1864, 343; Dimier 1928–30, I, no. 40; Philippe 1929, no. 112; Rambaud 1964–71, I, 578; Vergnet-Ruiz and Laclotte 1965, 60, 230; Huin [c. 1980s], col.; Lomax 1982, 29–30, ill.; Garnier 1989, no. 65, col.

The *Bath of Diana*, probably Antoine Coypel's best-known work, loosely interprets Ovid's account of the "goddess of the wild woods" in repose.[1] On her return from the chase Diana was "wont to bathe her maiden limbs in the crystal water," but before doing so she engaged in an elaborate toilette in which each of her handmaidens was assigned a specific task. The "armor bearer" was responsible for Diana's hunting equipment; another relieved the goddess of her discarded robe; two nymphs "unbind the sandals from her feet."[2] Only then would the ritual cleansing take place, and it is, of course, this sacred ceremony that the hapless Actaeon had the misfortune to interrupt.

Coypel's vivid, sumptuously colored mythology re-creates the sanctuary of Gargaphie as Diana's chattering, eager nymphs perform their duties for the imperious goddess. That the hunt has just ended is indicated by the little dog at lower right who sniffs at the dead game; Diana's quiver is born aloft and her "unstrung bow" placed to rest by her feet; the dark-haired nymph at left, her back burnished by the rays of the setting sun, bends to unlace Diana's bejeweled sandal. The animated chorus from which Diana remains somewhat aloof is soon to be shattered, however, and Coypel suggests the tragic denouement by the subtlest of means: the bare-breasted attendant, seated at the edge of the pool, whose attention is suddenly caught by the sound, or sight, of something beyond the painting's edge.

Although learned, Coypel's *Bath of Diana* does not follow Ovid's text in all its details. The maiden who hands Diana a basket of fruit, an invention of the artist's, is not a particularly felicitous addition, since the gods, whose appetites are carnal, do not experience hunger.[3] Much more evocative is Coypel's handling of the protected grove. Diana and her companions are sheltered from the world by a bower of arching trees reminiscent of the background in Correggio's *Leda and the Swan*. The trees have all but disappeared in Coypel's painting—they are more easily read in Duchange's engraving (fig. 1)—yet their presence was intended to reinforce the fragile integrity of Diana's domain.

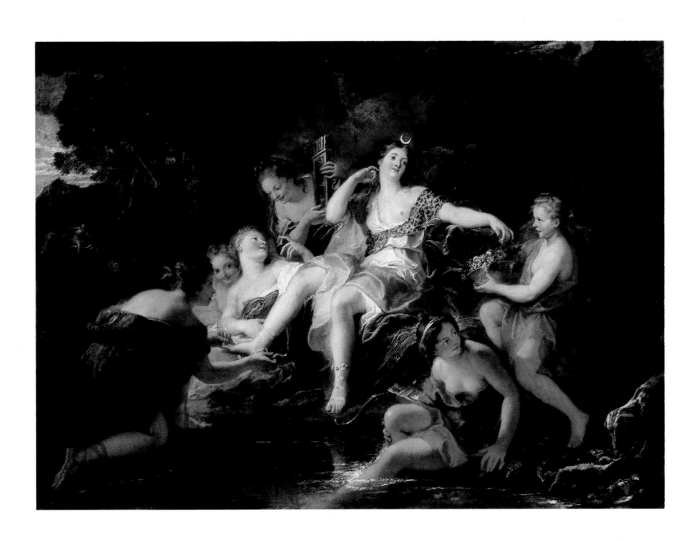

In its imaginative re-creation of Ovid's account, *The Bath of Diana* is an example of Coypel's injunction to temper erudition with grace, a point made repeatedly in his *Épître à mon fils*: "If the greatest learning is not sweetened by a pleasing manner it will soon become dry and tedious."[4] One of his most Correggesque works, *The Bath of Diana* exemplifies many of the arguments laid out in this academic treatise, written around 1707. It achieves "this lovely truthfulness," which is nevertheless based on a study of nature and the old masters;[5] it manifests the "broad knowledge of the humanities" that distinguishes the history painter;[6] the poses of Diana and her companions are suitably balletic, and their draperies sufficiently variegated to offer "an infinite charm" to the painting.[7] Most important of all, "gracefulness" is "apparent in every part of the painting."[8]

This unexpected insistence on "grace" reflected Coypel's experience of the 1690s, a critical decade for history painters, who were suddenly deprived of Crown patronage and who were forced to find a market for their narrative painting elsewhere.[9] By 1695 Coypel's reputation had come to rest almost entirely on the small-scale mythologies he produced for a private clientele, and, if his son is to be believed, it was to remedy this state of affairs that he painted the dramatic *Susanna and the Elders* (Madrid, Museo del Prado), completed towards the end of 1695: "not unaware that people were saying that he depicted only subjects which were *galants* or *pathétiques*, or of *grand mouvement*, because of his fear to fail in serious subjects, he painted a Susanna accused."[10]

Charles-Antoine's reminiscence, half a century after the event, is confirmed with extraordinary precision by eyewitness report. Daniel Cronstrom's correspondence with Nicodemus Tessin between 1695 and 1696 refers repeatedly to Coypel's frustration at the lack of *grandes commandes* in Paris and his eagerness to work in this mode for the king of Sweden.[11] Writing on 5 April 1696, Cronstrom noted, "Monsieur Coypel *fils* has worked more on cabinet paintings, but he insists that he is even better at pictures in the grand manner. Perhaps this stems from his desire to appear universal, but it remains true that he excels on the small scale."[12]

It is in the context of this "crisis" that *The Bath of Diana* should be considered, and it seems reasonable to include the painting, normally dated around 1700 on rather slim stylistic evidence, among the cabinet paintings of gallant subjects produced between 1688 and 1695.[13] As has been noted, Diana's pose is an exact reprise of Ariadne's disconsolate gesture in the *Bacchus and Ariadne* (cat. no. 8), securely dated to 1693, yet the two paintings share further similarities, even if the great difference in their respective states of preservation makes formal comparison difficult.[14] Both paintings are set against a background of arching trees through which distant vistas are visible, and both share tight brushwork—the draperies have folds of quicksilver—and warm coloring. The basket of fruit handed Diana by her androgynous maiden—described as a boy in an earlier entry on this painting[15]—is a smaller version of the splendid offering held by the satyr in *Bacchus and Ariadne*, whose pose is also repeated, with some modification, by Diana's attendant. Since neither of the engravings made after Coypel's *Bath of Diana* is of any help in establishing a date for the painting—Duchange's engraving is undated, Dupuis's is recorded as having been made in 1707—the juxtaposition of both works in the exhibition itself may help to determine whether an earlier dating to c. 1695 for *The Bath of Diana* can be sustained.[16]

The greater amplitude of the figures in *The Bath of Diana*—more painterly, less finished—and the absence of meticulously rendered details, so abundant in *Bacchus and Ariadne*, might also reflect the difference in stature of the patrons for whom the paintings were intended, as well as the differences in their cost, since it is known that Coypel's cabinet paintings were priced according to whether they were "*plus ou moins chargés*."[17] *The Bath of Diana* is first recorded in the collection of Laurent Rondé (d. 1733), one of a dynasty of jewelers, described in 1710 as *metteur en oeuvres des ouvrages de pierreries et autres*.[18] This obscure craftsman, who rose to become *écuyer, secrétaire du roi* by the time of his death, had been housed in artists' lodgings at the Louvre between 1704 and 1722, where he was a neighbor of Coypel's.[19] His small picture collection was dominated by Antoine Coypel's paintings: three original works, three copies "retouched by the artist," and a version of his *Self-Portrait*, possibly the autograph replica in the Uffizi.[20] Next to the regent, Rondé was Coypel's most fervent collector, yet the socioeconomic distance separating these two patrons finds expression less in the sort of subjects Coypel painted for them than in the degree of finish and detail he gave to their respective commissions.

Coypel's mythologies are invariably compared to the grandest of forebears—Correggio for figure types and facial expression, the Carracci, Guido Reni, and Albani for composition and handling, Rubens for color and "Flemish naturalism"—yet such weighty exemplars tend to overwhelm the artist's very real, if more modest, achievements. His *Bath of Diana*, indebted to some degree to all of these artists, is based, in fact, on Girardon and Regnaudin's *Apollo Tended by the Nymphs of Thetis* (fig. 2), the sculptural group executed between 1666 and 1674 for the Grotto of Thetis at Versailles.[21] Diana's outstretched gesture mirrors Apollo's almost exactly, and her nymphs effortlessly adopt the poses of their sculpted counterparts. Taking this

much-heralded monument as his point of departure, Coypel imbued his figures with a verve and energy that would have been indecorous in sculpture, but was appropriate for a cabinet painting of gallant subject matter. This was perfectly in keeping with academic practice, as Coypel himself explained in *L'Épître à mon fils*. Artists, he argued, should incorporate antique statuary as models for their history paintings, yet take great pains to disguise the source, an area in which Poussin had been deficient: "At all costs, our paintings should avoid giving the impression of marble or bronze which are the material of the most admirable sculptors. Let our brush achieve an effect whereby the figures in our paintings seem the very models for antique statuary itself, instead of bringing to mind the original statues from which they are modeled."[22] *The Bath of Diana* is a working illustration of such discreet empiricism.

NOTES

1. Ovid, *Metamorphoses*, III, 163–68.

2. Ibid., 168.

3. Klossowski 1972, 27–29.

4. Jouin 1883, 261, "si le savoir le plus profond n'est assaisonné d'un certain art de plaire, il devient sec et ennuyeux."

5. Ibid., 242, "cette aimable vérité."

6. Ibid., 277, "[une] grande teinture des humanités."

7. Ibid., 278, "les peintures doivent avoir quelque connoissance de l'art des ballets, non seulement pour le choix noble et gracieux des attitudes . . ."; ibid., 319, "un agrément infini."

8. Ibid., 290, "les grâces doivent généralement se répandre dans toutes les parties de la peinture."

9. Schnapper 1979–80, 59–63; Garnier 1989, 19–24.

10. Charles-Antoine Coypel, "Vie d'Antoine Coypel . . . prononcé le 6 Mars 1745" in Lépicié 1752, II, 9, "et n'ignorant pas qu'on publioit que la crainte d'échouer dans les ordonnances graves l'avoit porté à ne traiter jusqu'alors que des sujets, ou galants, ou pathétiques, ou de grand mouvement, il fit le tableau de Suzanne accusée."

11. Weigert and Hernmarck 1964, 79, 83, 85–87, 89, 90–93, 98–99.

12. Ibid., 115, "Mr. Coepel fils a quasy plus travaillé en pièces de cabinets, mais il soutient qu'il fait encore mieux le grand: peut-estre est-ce une envie de parestre universel? Il est très seur qu'il fait bien le petit."

13. For the most complete entry, see Garnier 1989, 132–33, no. 65. The author compares the nymph holding Diana's quiver to Eglea in *Silenus Smeared with Mulberries by the Nymph Eglea* (cat. no. 7, fig. 1), painted in 1700 for Meudon. While I do not dispute the resemblance, Coypel's nymphs are generally variants on the same Correggesque model, and any number of earlier examples could be used for such comparison.

14. Garnier 1989, 116–17, no. 49, for Coypel's *Bacchus and Ariadne* (cat. no. 8), which reappeared on the market in 1990 and was unknown to Madame Garnier during the preparation of her excellent monograph.

15. Philippe 1929, 50, no. 112.

16. Gaspard Duchange's engraving is erroneously dated to 1723 in Garnier 1989, 132; the engraving by his pupil, Charles Dupuis (1685–1742), is dated to 1707 in Portalis and Béraldi 1880–82, II, 93. Antoine Coypel owned the copper plate for *The Bath of Diana* as well as plates for several other engravings, yet is not known to have engraved this painting himself, Garnier 1989, 254.

17. Garnier 1989, 22–23, citing Cronstrom, provides an interesting discussion of Coypel's marketing method.

18. Guiffrey 1873 (B), 83, "Brevet de logement, 8 Mai 1710"; Garnier 1980–82, 133–34.

19. Guiffrey 1873 (B), 87, 129, 134–35; Brice 1752, I, 165–66, where Rondet [sic] is listed as "Garde des pierreries de la Couronne."

20. Rambaud 1964–71, I, 577–78; Garnier 1989, 58–59, 63, 160.

21. Souchal 1977–87, II, no. 17.

22. Jouin 1883, 312, "Evitons surtout dans la peinture de donner l'idée du marbre et du bronze. . . . Faisons, s'il se peut, par la force du pinceau, que les figures de nos tableaux paroissent plutôt les modèles vivants des statues antiques, que les statues, les originaux des figures que nous peignons."

FIG. 1
After Antoine Coypel, *The Bath of Diana*, 1723, engraved by Gaspard Duchange, Paris, Bibliothèque Nationale, Cabinet des Estampes

FIG. 2
François Girardon and Thomas Regnaudin, *Apollo Tended by the Nymphs of Thetis*, 1666–75, marble, Musée National des Châteaux de Versailles et de Trianon

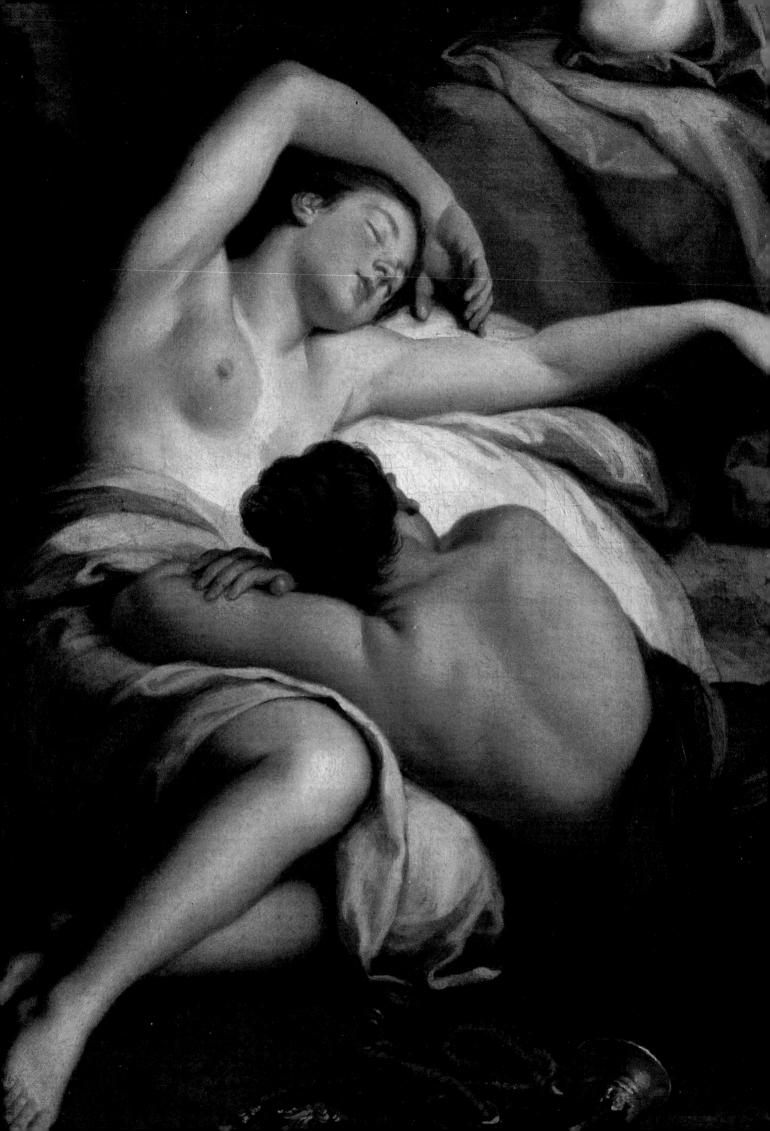

LOUIS DE BOULLONGNE
(1654–1733)

Second son of Louis de Boullongne (1604–1674), one of the founding members of the Academy, and younger brother of the history painter Bon Boullongne, alongside whom he would work until 1687, Louis de Boullongne was trained, reluctantly, by his father and immediately embarked upon an exemplary career as a history painter, winning the *Grand Prix* in May 1673 with the lost *Crossing of the Rhine* and leaving for the French Academy in Rome in April 1675. He would remain at the Palazzo Cafarelli for over four years, returning to Paris late in 1679, where he found immediate employment at Versailles, although by this date the major monumental commissions for the *grands appartements* had been completed. In August 1681 Boullongne submitted his *morceau de réception*, *Augustus Closing the Temple of Janus after the Battle of Actium* (Amiens, Musée de Picardie, sketch in Providence, Museum of Art, Rhode Island School of Design), a discreet reference to the recently concluded Peace of Nijmegen.

His first major public commission, *Christ and the Centurion* (Arras, Musée des Beaux-Arts), the *Mai* of 1686, which borrowed heavily from Jouvenet, was followed in 1688 by two mythological paintings for the Trianon de Marbre, *Venus and Adonis* and *Venus, Hymen, and Cupids* (Musée National des Châteaux de Versailles et de Trianon), in which his debt to the Bolognese Academy, notably Reni and Albani, was little disguised. Louis de Boullongne, as an exemplary academician, did not hesitate to plunder venerated examples for his public works; religious paintings by Barocci and Poussin provided the source for two of his altarpieces, *The Visitation*, 1688 (Greenville, South Carolina, Bob Jones University), and *The Adora-*

tion of the Shepherds, 1692 (church of Chantilly), respectively. His principal patron of the 1690s was Henri-Jules de Bourbon, son of the *Grand Condé*, for whom he painted both secular and religious paintings, three subjects from Virgil's *Bucolics* (now lost), which Watelet considered equal to the verses that inspired them, and a series of paintings devoted to the life of Saint Hubert for the parish church at Chantilly, which are still *in situ*. A second *Mai*, *Christ and the Samarian Woman* (Wiltshire, Wardour Castle), was commissioned by the *orfèvres* for Notre-Dame in 1695, and Boullongne was also employed on the second round of decorations at Trianon sous Bois, where he painted in 1697.

The most active period of his career began in 1699. During the four years that followed, Boullongne participated in the decoration of the royal *châteaux* of Marly (*Ceres*, Rouen, Musée des Beaux-Arts), Meudon (*David and Abigail*, Paris, Musée du Louvre; *The Queen of Sheba*, lost), and the Ménagerie (*Venus Requesting Vulcan to Make Arms for Aeneas*; *Venus Giving Arms to Vulcan*, both lost, copy of the former at the Musée National du Château de Fontainebleau). In 1703 he contributed *Baptism of Saint Augustine* (Bordeaux, Musée des Beaux-Arts) to the refectory of the couvent des Petits-Pères and frescoed the chapelle de Saint-Augustin in the Invalides, which Dézallier d'Argenville considered as fine as anything painted in Paris during the reign of Louis XIV.

Among his last works are the companion paintings of Diana for Rambouillet (1707) and the decoration of the chapelle de la Vierge at the chapelle de Versailles (1709). For the choir of Notre-Dame, Boullongne painted in 1715 two monumental religious works, *The Purification*

(Paris, Musée du Louvre) and *The Rest on the Flight into Egypt* (Arras, Musée des Beaux-Arts), a joyous and luminous composition which may have inspired Boucher's painting of the same subject for Catherine the Great some forty years later.

The commissions for Notre-Dame are Boullongne's last documented works. Thereafter he seems to have stopped painting altogether, although he made designs of medallions celebrating the reign of Louis XV for the *Académie des Inscriptions et des Belles Lettres* in 1722. He continued to participate in the Academy's meetings, however, and was appointed rector in 1717 and director in 1722. Ennobled in 1724, he was made *premier peintre du roi* in May 1725, and it was due to his initiative that a Salon was held in August of that year. As Antoine Schnapper has observed, Boullongne was probably the first French painter to gain social prominence and great material wealth through the exercise of his art. The sources of his fortune remain to be clarified, but it is likely that Boullongne's cabinet paintings for the private market, renowned for their "*caractère gracieux*" (*Mercure de France*, December 1733), were in large part responsible. He exhibited in the Salons of 1699 and 1704 in greater number than any of his contemporaries.

An exemplary draughtsman, whose preparatory drawings in black-and-white chalks on blue paper are among the most exquisite produced during Louis XIV's reign, Boullongne's rather frigid coloring and even, polished *facture* mark his work as unrepentantly "academic," although no less a connoisseur than Watelet would praise his coloring as "*fondue et caressée.*" Equally, the elegance and charm of his wide-eyed and eternally adolescent figures were prized by his contemporaries.

LOUIS DE BOULLONGNE, *Diana Resting* (detail), 1707, oil on canvas, 105 x 163 cm, Musée des Beaux-Arts, Tours

LOUIS DE BOULLONGNE
Diana Resting

10

LOUIS DE BOULLONGNE (1654–1733)
Diana Resting, 1707
Oil on canvas
105 x 163 cm.
Musée des Beaux-Arts, Tours

PROVENANCE
Commissioned by the comte de Toulouse in 1707 for the *cabinet du roi* at the château de Rambouillet; at Rambouillet until 1783; château de Châteauneuf-sur-Loire; transported in 1794 to the château de Chanteloup, where it hung in the *cabinet de Choiseul*; impounded for the Musée des Beaux-Arts, Tours, on 29 *ventôse an II* (19 March 1794).

EXHIBITIONS
Geneva 1949, no. 16; London 1958, no. 235; Paris 1958, no. 9; Bern 1959, no. 6 ill.; Lille 1968, no. 60; Toledo, Chicago, and Ottawa 1975–76, no. 11, ill.; Cholet 1980–81, 36–37, ill.; Frankfurt 1982, no. Ca 3, ill.; Fukuoka 1989, no. 9.

BIBLIOGRAPHY
Lejeune 1864, 340; Clément de Ris 1872, 429; Grandmaison 1879, 189; Grandmaison 1897, 578, no. 71; Lorin 1903, 14, 41; Maugras 1903, 112; Vitry 1911, no. 23; Caix de Saint-Aymour 1919, no. 403; Longnon 1919, 43–44; Michel 1925, 97, ill.; Hallays, André, and Engerand 1928, 53; Orliac 1930, 116; Nicolle 1931, 105–6; Vallery-Radot 1953, 206–7; Lossky 1962, no. 17, ill.; Thuillier and Châtelet 1964, 126, col.; Vergnet-Ruiz and Laclotte 1965, 60, 228; Bottineau 1980, 71; Conisbee 1981, 75, ill.; Schnapper and Guicharnaud 1986, n.p.; Mathieu 1987, 351–78; exh. Paris 1987, 21–22; Bordeaux 1989, 149, 156.

Although not a single eighteenth-century source mentions Louis de Boullongne's *Diana Resting*, this work is by far the most accomplished mythology he produced during his long and distinguished career. *Diana Resting* and its larger companion piece, *Diana at the Hunt* (fig. 1), were painted in 1707 to decorate the *cabinet du roi* at the château de Rambouillet, the country seat which Louis-Alexandre de Bourbon, comte de Toulouse (1678–1737)—the third of Louis XIV's illegitimate children by Madame de Montespan—had acquired from Fleurian d'Armenonville, *directeur des Finances*, in October 1705.[1] *Grand amiral de France* since the age of five, the comte de Toulouse had displayed great bravery in the siege of Malaga (June-August 1704), and his victory over the English and Dutch navies on behalf of Philip V made him into something of a national hero, as well as securing for him a considerable pension from the claimant to the Spanish throne. Toulouse's early remodeling of Rambouillet, carried out under the general supervision of Robert de Cotte and initially confined to decoration of the royal enfilade, was presumably completed by the summer of 1707, in time for the first state visit of Louis XIV and members of his court in August of that year.[2] Bon Boullongne, briefly *premier peintre* to the king of Spain,[3] furnished for the *chambre du roi* four overdoors of mythological subjects;[4] Louis de Boullongne's pair of paintings hung as overdoors in the nearby *cabinet du roi*.[5] *Diana at the Hunt* and *Diana Resting*, depictions of "before" and "after" in the goddess's favored pastime, were apposite subjects for a residence that functioned chiefly as a hunting lodge.

The story of Diana's repose after a day of hunting is recounted in Ovid's *Metamorphoses*:

> There was a vale in that region, thick grown
> with pine and cypress. . . . 'Twas called
> Gargaphie, the sacred haunt of high-girt Diana.
> In its most secret nook there was a well-shaded
> grotto, wrought by no artist's hand. But Nature
> by her own cunning had imitated art: for she
> had shaped a native arch of the living rock and

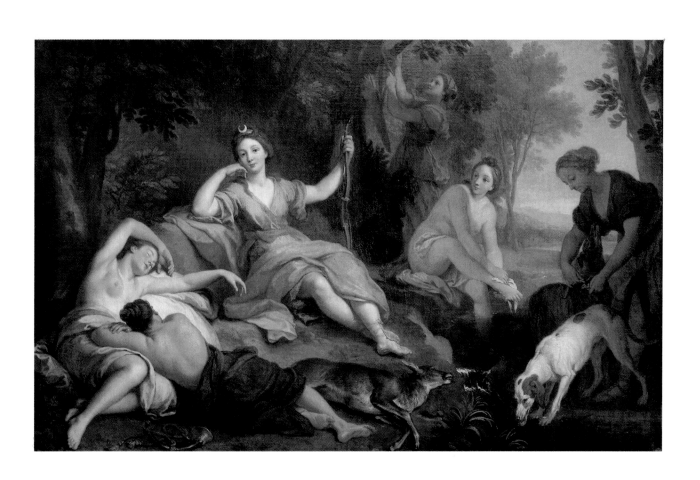

the soft tufa. A sparkling stream babbled on one side and widened into a pool girt with grassy banks. Here the goddess of the wild woods, when weary of the chase, was wont to bathe her maiden limbs in the crystal water.[6]

Boullongne has followed Ovid quite closely in creating a lyrical setting for the chaste goddess, resplendent in robes of blue and gold in a perfectly balanced composition.[7] Decorously draped—in contrast to her attendants, whose flagrant nudity is sanctioned in the sacred grove—Diana is portrayed on her return from the hunt; a doe lies at her feet, food for the Cyclopes who fashion her bow and arrows, and her dappled hunting dog drinks furiously in the stream while his companion strains to be unleashed. Diana's maidens are variously occupied: one hangs the goddess's quiver on the far tree, another bathes, and two have fallen asleep, exhausted. Diana is the last to prepare; although her hair has fallen around her shoulders, she still wears her buskins.

The sensuous abandon of the coupled nymphs, the dead doe who seems to share their sleep, and the golden sunset which casts its shadows on the bathing nymph and illumines her upper body combine powerfully to convey the protected tranquillity of Gargaphie. Yet Diana's gaze—unsmiling, silently challenging—is sufficient reminder that this idyll may soon be shattered; or is she already stirred to attention by the arrival of an unwitting Actaeon?

Although Boullongne's commission is scantily documented, his working process is revealed with unusual clarity through the series of preparatory drawings for both paintings which show how carefully and deliberately he elaborated each composition. Once the general configuration of *Diana Resting* was established,[8] Boullongne produced a carefully rendered, somewhat schematic model (fig. 2), squared for transfer, with the precise dimensions indicated in his own hand, in which he worked up both figures and landscape. Here he also took great care to denote areas of light and shade which would be followed, more or less exactly, in the finished work.[9] Certain modifications did occur, however. In the painting, Diana's quiver is replaced by the dead doe, which the late Georges de Lastic attributed to Desportes, an artist much employed at Rambouillet.[10] Drapery discreetly covers the thigh of the bathing nymph; in the drawing she is completely naked. Finally, in the painting, Boullongne's slight but significant adjustments to the poses of the reclining nymphs in the left foreground produce a more sinuous contour as well as allowing him to linger on such details as the nape of the neck and right ear of the darker maiden.

The squared compositional drawing, which may have served to obtain the patron's approval, became the basis for more detailed figure studies, two of which survive, *Young Woman Washing Her Foot* (fig. 3) and *Two Female Companions of Diana* (fig. 4), of a vigor and immediacy rarely encountered in Boullongne's graphic work.[11] These were presumably executed after live models in the artist's studio, since the Academy, which had repeatedly proscribed drawing from the female model in its assembly rooms, had granted this privilege to academicians "*chez eux.*"[12] In *Two Female Companions of Diana*, Boullongne not only refined the poses of the two nymphs as they would appear in the finished painting, he also used chalk highlights to map out the areas of light and shade—something that extends even to the highlight on the fingers of the nymph with her back to us—and then translated these solutions faithfully onto the canvas. For the celebrated *Young Woman Washing Her Foot*, Boullongne followed Le Brun's method of creating volume through parallel hatching and reinforced the model's ample contours in black chalk. However, in this drawing he portrayed the nymph in an even light, an effect quite different from the dramatic contrast in the squared drawing, and one he finally abandoned in the finished work in favor of his preliminary idea, which so well evokes the shades of Gargaphie.

In *Diana Resting*, Boullongne achieved a compelling eroticism that would have been unlikely in royal commissions by this date; the artist would be employed, rather, to "paint over nudities" in a work that had offended Madame de Maintenon.[13] Yet his decoration displays "that nobility of expression which is fundamental to the painter of subjects from history and mythology" and which, as Dézallier d'Argenville noted, characterized his output as a senior academician.[14] His sources were impeccable: both *Diana Resting* and its companion are indebted to Domenichino's celebrated *Diana with Nymphs at Play* (Rome, Galleria Borghese), a painting which the artist would have studied during his five-year *pensionnat* in Rome (1675–79).[15] Domenichino's *Rinaldo and Armida*, which entered the Royal Collection in 1685, was the source of Boullongne's painting of that subject exhibited in the Salon of 1704, and his first biographer noted that he had also "borrowed the hand of the famous Domenichino" in his fresco decorations for the Invalides, which were completed c. 1703.[16] Yet the device of pairing Diana's hunt with her bath, while traditional, had a precedent nearer home: Mignard's decorations of *Diana at the Hunt* and *The Bath of Diana* for the *cabinet de Diane* in *Monsieur's château* at Saint-Cloud, painted c. 1680–81 and now known only through carefully rendered preparatory drawings. This

suite may well have been the basis for the comte de Toulouse's commission.[17] However, through the singularly effective motif of the two reclining nymphs, Boullongne introduced an element of carnality foreign to both Domenichino and Mignard and which is Flemish in inspiration; several versions of the sleeping Diana and her maidens by Rubens and his school are recorded, and although a specific prototype remains to be established, it is to this tradition that Boullongne's *Diana Resting* also pays a discreet homage.[18]

The theme of *Diana Resting* would be treated by Louis de Boullongne on numerous occasions; he had submitted a painting entitled *Diana Resting from the Hunt* to the Salon of 1704, and at least five other versions of the subject are recorded in eighteenth-century collections, notably a large picture representing "*Diane au retour de la chasse*" valued at 400 *livres* in the estate of his second son, Jean de Boullongne (1690–1769), *conseiller au Parlement de Metz* and *honoraire amateur de l'Académie royale de Peinture et de Sculpture*.[19] Since none of these versions survives, it is not possible to comment on their relationship to the Rambouillet decoration.[20]

However, so successful was the Rambouillet *Diana Resting* that either the comte de Toulouse or his son, the duc de Penthièvre (1725–1793), seems to

have acquired a copy for the hôtel de Toulouse, the family's Parisian residence. An anonymous *Diana and Her Companions Resting after the Hunt* was recorded hanging next to the fireplace in the dining room by 1742,[21] but it was not until Jean-Baptiste-Pierre Lebrun came to make an inventory of Penthièvre's confiscated collection in November 1793 that the painting was identified as a copy of Louis de Boullongne's *Diana Resting*.[22]

By then, the original *Diana Resting* had changed locations several times. After Penthièvre had sold Rambouillet to Louis XVI in December 1783, many of the family paintings found their way to his *château* at Châteauneuf-sur-Loire, and it is there that Louis de Boullongne's *Diana Resting* and *Diana at the Hunt* are recorded in 1786.[23] They would remain at Châteauneuf-sur-Loire until the Revolution dispossessed Penthièvre of his enormous estates; early in 1794 they joined a consignment of paintings sent to the château de Chanteloup, Choiseul's home of exile, acquired by Penthièvre in 1786.[24] Here they were placed in the *cabinet de Choiseul* and inventoried by Charles-Antoine Rouget on 29 *ventôse an II* (19 March 1794) as among the objects "which may be considered useful for the arts and sciences." They immediately entered the recently created Musée des Beaux-Arts, Tours.[25]

NOTES

1. For the most accurate listing, see Schnapper's entry in exh. Lille 1968, 49–50, and for the history of Rambouillet, most recently, Bottineau 1980, 69–71.

2. This visit provides a *terminus post quem* for Boullongne's paintings which are signed and dated 1707, see Lenotre 1930, 35–36, Kimball 1943, 181, and Bottineau 1980, 70.

3. Montaiglon 1875–92, III, 408, Bon Boullongne had left Paris by 31 December 1704, "pour un voyage qu'il doit faire en Espagne au premier jour," though how long he worked for Philip V is unknown.

4. *Acis and Galatea on the Waters*, *Neptune Taking Amphitrite to His Palace in a Chariot*, *The Rape of Proserpine*, and *The Nymph Io Transformed into a Heifer by Jupiter*; all four overdoors are in Tours, Musée des Beaux-Arts, see Lossky 1962, nos. 11–14.

5. Lorin 1903, 41, for the earliest inventory of the new rooms.

6. Ovid, *Metamorphoses*, III, 155–64.

7. The figures are organized around an arch which rises to the tip of Diana's bow at the center of the composition and falls gently to the hind legs of the dog at lower right.

8. Presumably in the spirited compositional drawing formerly in the Galerie Fleurville and whose pendant, a preparatory drawing for *Diana at the Hunt*, is reproduced in Schnapper and Guicharnaud 1986, no. 33.

9. Exh. Paris 1987, 21–22.

10. Although dismissed by Schnapper in exh. Lille 1968, 49, de Lastic's notion of collaboration deserves some consideration; Desportes apparently decorated the principal stables at Rambouillet with 204 sculpted and painted deer heads, see Larousse 1865–90, XIII, 667.

11. Exh. Paris 1987, 22, for *Young Woman Washing Her Foot*, and exh. Lille 1968, 75, for *Two Female Companions of Diana*.

12. Fontaine 1910 (A), 11, citing the Academy's regulation of 1 August 1665, repeated 2 June 1703 and 28 February 1711.

13. Caix de Saint-Aymour 1919, 49, citing payments received by Louis de Boullongne in November 1710 and January 1711 for "des nudités qu'il a couvertes à un tableau de l'antichambre du Roi à Fontainebleau."

14. Dézallier d'Argenville 1762, IV, 266, "cette noblesse d'expression qui caractérise les sujets de l'histoire et de la fable."

15. For a thorough discussion of Domenichino's *Diana with Nymphs at Play*, which had been in the Borghese collection since 1617, see Spear 1982, 192–94.

16. Exh. New York, New Orleans, and Columbus 1985–86, 73; Dézallier d'Argenville 1762, IV, 268.

17. Mignard's oval drawings of *Diana at the Hunt* and *The Bath of Diana*, in the Albertina (11602, 11603), are discussed and reproduced in Boyer 1980 (B), 151, 159.

18. There is a remarkable similarity of poses between the barebreasted nymph at the far left of Boullongne's composition and her counterpart in a painting attributed to Rubens, *The Nymphs of Diana*, in the Haufstängel collection, Munich, known through a photograph in the Witt collection (fiche 13004).

19. A.N., *Minutier Central*, LIII, 446, "*Inventaire après décès*," Jean de Boullongne . . . 7 Mars 1769, "un grand tableau représentant Diane au retour de la chasse." A "*Bain de Diane*" valued at 300 *livres* is recorded in the *inventaire après décès* of Henriette-Marie de Pons (17 Sept. 1705), Rambaud 1964–71, II, 790; *Catalogue des tableaux de Madame la Comtesse de Verrue*, Paris, 27 March 1737, no. 47, "le bain de Diane," as a pendant to *Diana and Callisto*; *Catalogue raisonné des tableaux . . . qui composent les cabinets de Monsieur Dupille*, Paris, 1780, no. 261, "Diane au bain avec ses nymphes . . . toile de forme ovale, deux pieds, neuf pouces de haut, sur deux pieds cinq pouces de large," as a pendant to *Diana and Endymion*; *Catalogue des tableaux capitaux . . . le tout provenant du cabinet de M. le Chevalier Lambert*, Paris, 27 March 1787, no. 180; "Le repos de Diane . . . environée de neuf de ses Muses [sic] . . . hauteur 38 pouces, largeur 45 pouces," as a pendant to *The Death of Adonis*.

20. Boullongne is known to have made exact replicas of his mythological compositions, such as *Rinaldo and Armida*, exhibited in the Salon of 1704, of which two autograph versions have appeared on the market in recent years, exh. New York, New Orleans, and Columbus 1985–86, 72–75.

21. Piganiol de la Force 1742, III, 81.

22. A.N., F[17] 1266–7, no. 7, *État des Tableaux du ci-devant hôtel Penthièvre* (3 frimaire an II / 23 November 1793), no. 18, "un grand tableau, copié après Boulogne, représentant un Repos de Diane."

23. *Tableaux de la Galerie du château de Châteauneuf-sur-Loire*, Paris 1786, 12.

24. Fohr 1982, 15, for full archival references.

25. Grandmaison 1879, 186–91; idem, 1897, 577.

FIG. 1
Louis de Boullongne, *Diana at the Hunt*, 1707, oil on canvas, Tours, Musée des Beaux-Arts

FIG. 2
Louis de Boullongne, *Diana Resting*, 1707,
black chalk drawing with white highlights
and gray wash on blue paper, Paris, Musée du
Louvre, Cabinet des Dessins

FIG. 3
Louis de Boullongne, *Young Woman Washing
Her Foot*, 1707, black chalk drawing with
white highlights on blue paper, Paris, Musée du
Louvre, Cabinet des Dessins

FIG. 4
Louis de Boullongne, *Two Female Companions of Diana*, 1707, black chalk drawing with white
highlights on blue paper, Paris, Musée du Louvre, Cabinet des Dessins

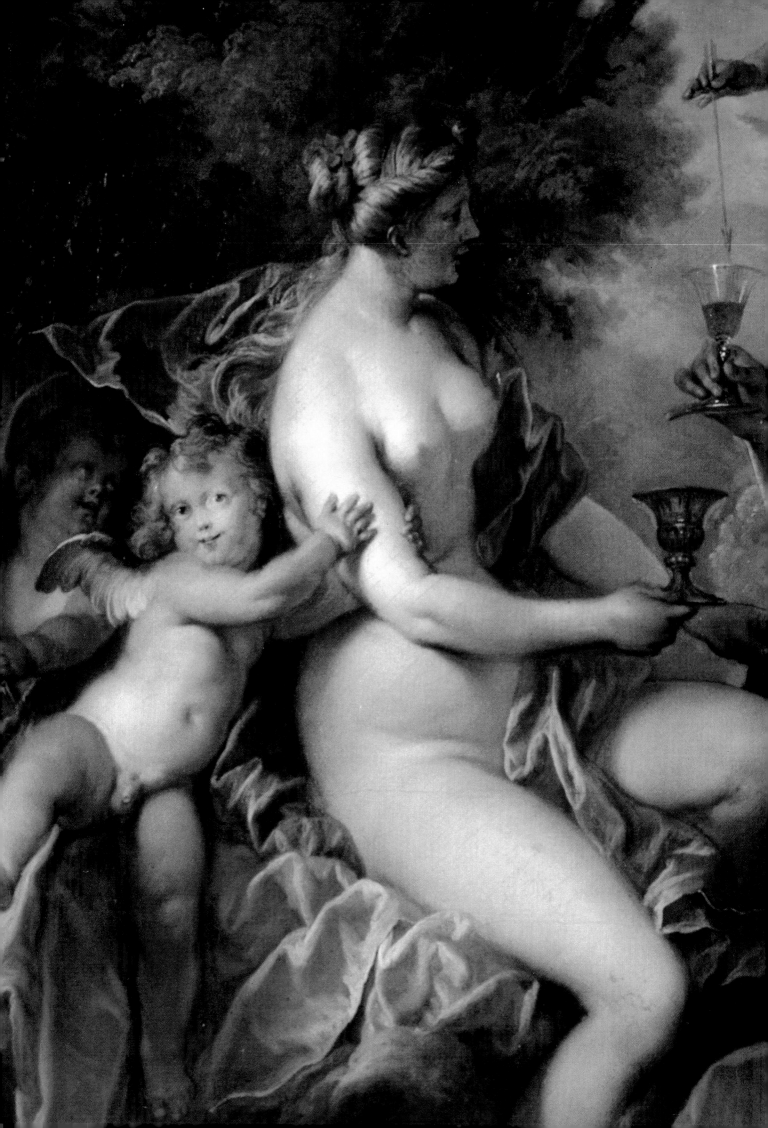

NICOLAS BERTIN
(1668–1736)

A painter who excelled in small-scale, refined mythologies of an erotic charge and artful coloring worthy of the Dutch Mannerists, Nicolas Bertin seems an unlikely pillar of the French Academy. After entering Guy-Louis Vernansal's studio at the age of ten, he worked under Jouvenet's direction before moving to the popular atelier of Bon Boullongne, in which several history painters who would achieve prominence in the first decades of the eighteenth century were trained. Protected by the marquis de Louvois, the *surintendant des Bâtiments* and sponsor of his brother, the sculptor Claude Bertin (c. 1650–1705), he was awarded a monthly stipend by the Academy, won prizes for life drawing, and was sent to Rome for four years in 1685 at the age of seventeen. During the lean decade of the 1690s Bertin was employed by the *Bâtiments du roi* to make drawings after the statuary at Versailles (Windsor Castle and Paris, Bibliothèque Nationale, Cabinet des Estampes) and also executed tapestry designs for the Gobelins Manufactory. He participated in the decoration of the royal residences—in 1698, an overdoor for the bedroom in the *appartement d'été* in the Ménagerie (lost; copy at the Musée National du Château de Fontainebleau); *Vertumnus and Pomona* (1706) for the *salon frais* at the Grand Trianon; *Boreas and Oreithyia* and *Zephyr and Flora* for the *Grand Dauphin's garde meuble* at Meudon (1709), both lost—and designed stained glass windows for the chapelle de Versailles in 1708–9. As Déza-

llier d'Argenville astutely commented, "Bertin was much more successful with small paintings than on the grand scale," and thus his involvement in the major royal commissions undertaken during Mansart's ministry was limited.

Drawing his subject matter from an elevated (and sometimes obscure) classical repertory, Bertin's miniaturizing style and delicate finish were well-suited to the burgeoning taste for Dutch seventeenth-century masters, and his work was represented in private collections as far afield as Cardinal Ottoboni's in Rome. Between 1716 and 1725 he was also called upon to decorate the newly built residence of Maximilien II Emmanuel, Elector of Bavaria, who commissioned overdoors and ceiling paintings for his palace at Nymphenburg (four of these Munich, Bayerischen Staatsgemäldesammlungen) and who tried repeatedly, though without success, to lure Bertin to Munich as court painter. Although Bertin's career in this period would be characterized by an abundance of easel painting, his decorations for Maximilien "*dans le goût grotesque*" and "*dans le goût de Chine*" suggest the ease with which history painters could turn their hands to a manner normally associated with Watteau and Audran.

Bertin also painted altarpieces, notably *Saint Philip Baptizing Queen Candace's Eunuch* (Paris, church of Saint-Germain-des-Prés), one of the two *Mai* for 1718, as well as a large number of private devotional pictures. Strident and declam-

atory on both the large and small scale, these densely packed compositions bear very clearly the stamp of Bertin's second master, Jean Jouvenet, although they lack the compelling realism and grandeur of the latter's best work.

Bertin was appointed adjunct director of the French Academy in Rome in February 1724, but the necessity of working with the aged and irascible Charles Poerson (1653–1725), who retained the directorship until September 1725, deterred him from accepting the post. It went instead to Nicolas Vleughels, whom Pierre Crozat described as "a most worthy man, a good painter, and in every way superior to M. Bertin." Bertin's relations with the administration were now at an end, but this did not prevent him from rising steadily in the Academy's ranks. He was an assiduous participant in its weekly sessions and was made adjunct rector in 1733.

Bertin's ecstatic and theatrical deities, with little hands that are svelte and tapered, pay homage both to Albani and Antoine Coypel, and his conservative academic manner coexisted with the more painterly and progressive styles of de Troy and Lemoyne well into the 1730s. Repetitive and at times pedantic, Bertin was at his most fluent outside the public arena. His attempts to render Lebrunian expression and action *in petto* are nearly always disappointing, although his graceful, erotic, and somewhat histrionic mythological paintings are sophisticated and often beautifully crafted.

NICOLAS BERTIN, *Bacchus and Ariadne* (detail), 1710–15, oil on canvas, 75 x 50 cm, Musée d'Art et d'Industrie, Saint-Étienne

NICOLAS BERTIN
Bacchus and Ariadne

11

NICOLAS BERTIN (1668–1736)
Bacchus and Ariadne, c. 1710–15
Oil on canvas
75 x 50 cm.
Musée d'Art et d'Industrie, Saint-Étienne

PROVENANCE
[?] Collection Lax, Vendôme by 1872; acquired by the Musée d'Art et d'Industrie, Saint-Étienne, in 1971.

EXHIBITIONS
Moscow and Leningrad 1978, no. 6.

BIBLIOGRAPHY
Darcel 1872, 179; Schnapper 1972, 357–60, ill.; Lefrançois 1981, no. 47, ill.

Abandoned on the island of Naxos by the Athenian hero Theseus—for whose victory over the minotaur she had been largely responsible—Ariadne was found in a disconsolate state by the god Bacchus, who immediately married her. As recounted by Ovid in *The Art of Love*, Bacchus offered his new bride immortality as a wedding gift: "as a star in the sky thou shalt be gazed at; as the Cretan crown thou shalt oft guide the doubtful bark."[1] Ariadne would be abandoned a second time, however, when Bacchus set off to conquer India, and in the *Fasti* Ovid described their meeting on his triumphant return. Bacchus was so moved by her pitiable condition that he transformed the nine jewels in Ariadne's crown into stars: the constellation known as Corona, or the "Cnossian Crown."[2]

Bertin's exquisite cabinet picture represents a specific incident in this story: the marriage of Bacchus and Ariadne. The god, languorously reclining against an enormous thyrsus, holds aloft a glass of red wine into which a smiling cupid dips the point of his arrow—an allusion to the consummation of their union—while at left two putti provide the necessary encouragement to Ariadne, seated on a cloud, who is portrayed as a more passive participant in the wedding ceremony. The putto on the extreme left, cropped by the picture frame, bears a flaming hymeneal torch, a celebratory symbol of the impending marriage.

Bertin has selectively followed both literary and pictorial sources for this frequently treated subject. Most accounts of their meeting mention Bacchus's noisy entourage of nymphs and satyrs, reduced to respectful silence on seeing the exhausted Ariadne asleep, but who then participated in the nuptials with their customary enthusiasm.[3] The inebriated putti at lower left, the carefully painted, ornate wine vessels, and the bunches of grapes liberally disposed in the foreground are the only references to the bacchanals that frequently accompanied the wedding scene. Similarly, the act of toasting the marriage is rarely found in depictions of this episode; more commonly Bacchus is shown crowning Ariadne with a celestial

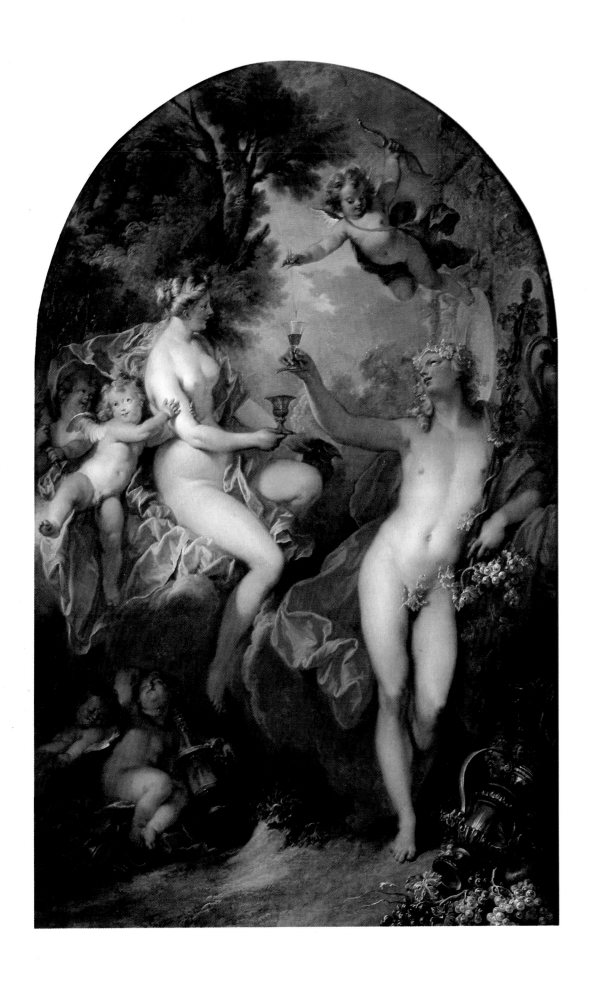

diadem.[4] Nonetheless, Bertin's Bacchus, sinuous and effeminate, characterizes well the young god as he had been described by writers from Euripides on. Even Ariadne's nudity can be accounted for. Catullus noted that, at the height of her grief, the distraught princess had torn off all her clothing: "Nor does she still keep the delicate headband on her golden head, nor has her breast veiled by the covering of her light raiment, nor her milk-white bosom bound with the smooth girdle."[5] The full-breasted Ariadne and the svelte Bacchus are familiar figures in Bertin's repertory, as is the still life of grapes and *orfèvrerie*, "rendered in meticulous detail."[6] Bertin's contemporaries agreed that he excelled above all on the small scale, that his best work displayed "a graceful, finished style,"[7] and that his coloring was "both agreeable and vigorous."[8] The delicate play of light over Ariadne's breasts and thighs, the complementary accents of Bacchus and Ariadne's flowing robes, and the acrobatic posture of the putto who grabs Ariadne's right arm are examples of Bertin's refined, proto-Flemish style at its best.

Although it is almost impossible to establish a firm chronology for Bertin's mythological painting, *Bacchus and Ariadne* has been dated to between 1710 and 1720 by Thierry Lefrançois.[9] It is to this decade that Bertin's mythological decorations for the château de Bercy (1712–14) and the *grand appartement* of the Elector of Bavaria at Nymphenburg (1716) can be securely documented.[10] Lefrançois has suggested that the artist abandoned such subjects completely in the later part of his career and devoted himself almost exclusively to religious commissions.[11]

Nonetheless, the subject of Bacchus and Ariadne recurs frequently in Bertin's oeuvre, and at least eight other compositions by him are recorded.[12] Closest to the painting in Saint-Étienne is the oval *Bacchus and Ariadne* in a Parisian private collection (fig. 1). While the figures are arranged differently, the putto overhead who dips his arrow into Bacchus's wine glass is practically identical in both paintings. Bertin, not averse to repeating himself, would adapt the poses of the Saint-Étienne *Bacchus and Ariadne* for his drawing of *Adam and Eve* (fig. 2), an example of his easy transition from the profane to the sacred.[13]

The recent discovery of Louis-François Mariage's engraving after Bertin's *Bacchus and Ariadne* (Saint-Étienne, Musée d'Art et d'Industrie) led Thierry Lefrançois to conclude, not unreasonably, that the painting in Saint-Étienne was a fragment of a larger, rectangular composition. This assumption was further supported by eighteenth-century references to at least two full-scale paintings by Bertin of the subject.[14] While it is possible that some cropping of the Saint-Étienne *Bacchus and Ariadne* has taken place, it is hard to accept this harmonious and carefully balanced composition as a fragment. Mariage's engraving, almost a century later than the painting, is in the same direction as Bertin's composition and may well have been made after yet another version of the subject, in which the central group was repeated. Given the imbalance of Mariage's composition and the irrelevance of the additional female figures on the left, it is possible that the engraving is only distantly related to Bertin's *Bacchus and Ariadne*. Bertin's paintings, of whatever scale, are firmly anchored by a strong central axis which contains the flamboyant and dynamic postures his figures often strike; such equilibrium is absent from Mariage's engraving of *Bacchus and Ariadne*. Furthermore, the arched format of the Saint-Étienne canvas is not unique in Bertin's oeuvre; his *Venus Poisoning Cupid's Arrows* (Arras, Musée des Beaux-Arts) is of almost identical shape and dimensions.[15]

If Bertin's quaffing couple enacts the marriage of Bacchus and Ariadne somewhat irreverently, the composition nonetheless depends on more venerable prototypes, which the artist, as an exemplary academician, was able to assimilate effortlessly. In his languid and effeminate posture, Bacchus recalls the antique *Apollino* (fig. 3), known in Bertin's day as the *Medici Apollo*, a plaster cast of which was recorded in the collection of the French Academy in Rome in December 1684.[16] Bertin, who took up his *pension* at the Villa Capranica some time after October 1685, may well have known and copied this statue both from the original and the reproduction. Bacchus is also indebted to a model nearer home. Of the four plaster groups commissioned to decorate the *grande pièce d'eau* at Marly in 1699, Jacques Prou's *Bacchus and Ariadne*, known today only from a contemporary line drawing (fig. 4), portrayed the god's marriage with reference to a more traditional iconography.[17] Bertin has repeated the gesture of Bacchus's raised arm—although his Bacchus holds a wine glass instead of a crown—and has also followed Prou in having the god's curly hair fall from one side of his head only, thus enhancing his girlish appearance. Dézallier d'Argenville noted that Bertin's figures often look as if their hair is still wet.[18]

Bertin's dependence on contemporary sculpture need not surprise us. The son and younger brother of sculptors, he earned his living during the 1690s by copying the sculpture at Versailles for the *Bâtiments du roi*; indeed, it was this activity alone that Mariette deemed worthy of note in his brief entry on the painter.[19] Bertin's familiarity with Louis XIV's great sculptural commissions was profound. Indeed, a group of unattributed drawings after sculpture at Versailles in the Nationalmuseum, Stockholm, which includes

a copy of Slodtz's *Vertumnus and Pomona*, another of the mythological commissions for Marly, may be tentatively attributed to Bertin himself, thus confirming with absolute precision his intimate knowledge of these classicizing figural groups.[20]

If Bertin's *Bacchus and Ariadne* conceals its debt to public statuary, it pays unabashed homage to Dutch and Flemish masters of the later seventeenth century, such as Van Meiris, Van der Werff, and Lairesse,

whose cabinet pictures were beginning to command the attention of French collectors at the time. In one of the earliest and most astute commentaries on Bertin's *Bacchus and Ariadne*, then in the collection of a Monsieur Lax from Vendôme, Alfred Darcel, recently appointed director of the Gobelins, noted: "It has the drawing of a chevalier Van der Werff, but with longer, more mannered figures, and with a coloring that aspires to Rubens."[21]

NOTES

1. Ovid, *The Art of Love*, 567–68.

2. Ovid, *Fasti*, III, 507–16. The story is recounted briefly in Ovid's *Metamorphoses*, VIII, 176–82.

3. Philostratus, *Imagines*, I, 16; Ovid, *Fasti*, I, 564–65.

4. For a contemporary Italian example, Ricci's *Bacchus and Ariadne* at Chiswick House, London, see Knox 1985, 605–7, and Hamdorf 1986, for a general account of Bacchus in Western art.

5. Catullus, *Poems*, LXIV, 65–68.

6. Schnapper 1972, 358.

7. Orlandi 1731, 335, "una maniera graziosa e finita."

8. Dézallier d'Argenville 1762, IV, 348, "aussi aimable que vigoureuse."

9. Lefrançois 1981, 45–47, 127–28.

10. Pons 1986, 207; Lefrançois 1981, 139–40. As noted by Dézallier d'Argenville 1762, IV, 351, Bertin painted a set of decorative panels of subjects from Ovid's *Metamorphoses* for the hôtel de Mortemart, rue Saint-Guillaume; Pons has dated the paneling for this building to c. 1700, but makes no reference to Bertin's commission, Pons 1986, 191.

11. Lefrançois 1981, 59–64.

12. Ibid., nos. 48, 49, 61, 152, 165–68.

13. Ibid., 181.

14. Ibid., 127–28.

15. Ibid., 140–41. Louis-François Mariage, active between 1785 and 1811, is known to have illustrated Villenave's 1802 edition of Ovid, Portalis and Béraldi 1880–82, III, 12.

16. Haskell and Penny 1981, 146–47. The *Apollino* is listed by Errard as among the most famous antique sculptures "que les Eslèves copient," Montaiglon and Guiffrey 1887–1912, I, 129.

17. Rosasco 1986 (A), 123–24; Souchal 1977–87, III, 184.

18. Dézallier d'Argenville 1762, IV, 350, "ses têtes coeffées de cheveux, pendans comme s'ils étoient mouillés."

19. Mariette 1851–60, I, 127–28; Lefrançois 1981, 191–96.

20. Stockholm, Nationalmuseum, THC 5126–29; see Rosasco 1975, 82–84.

21. Darcel 1872, 179, "C'est presque le dessin du chevalier Van der Werff, avec des figures plus longues et plus maniérées, avec un coloris qui cherche celui de Rubens."

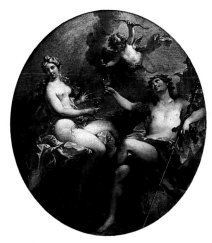

FIG. 1
Nicolas Bertin, *Bacchus and Ariadne*, c. 1710,
oil on canvas, Paris, Private Collection

FIG. 2
Nicolas Bertin, *Adam and Eve*, 1700–1710, pen and brown ink drawing, Paris, École Nationale
Supérieure des Beaux-Arts

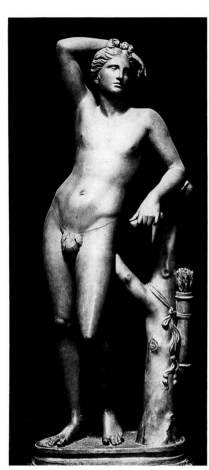

FIG. 4
After Jacques Prou, *Bacchus and Ariadne*,
c. 1700, drawing, Berlin, Staatliche Museen
Preussischer Kulturbesitz, Kunstbibliothek

FIG. 3
Apollino, marble, Florence, Uffizi (Tribuna)

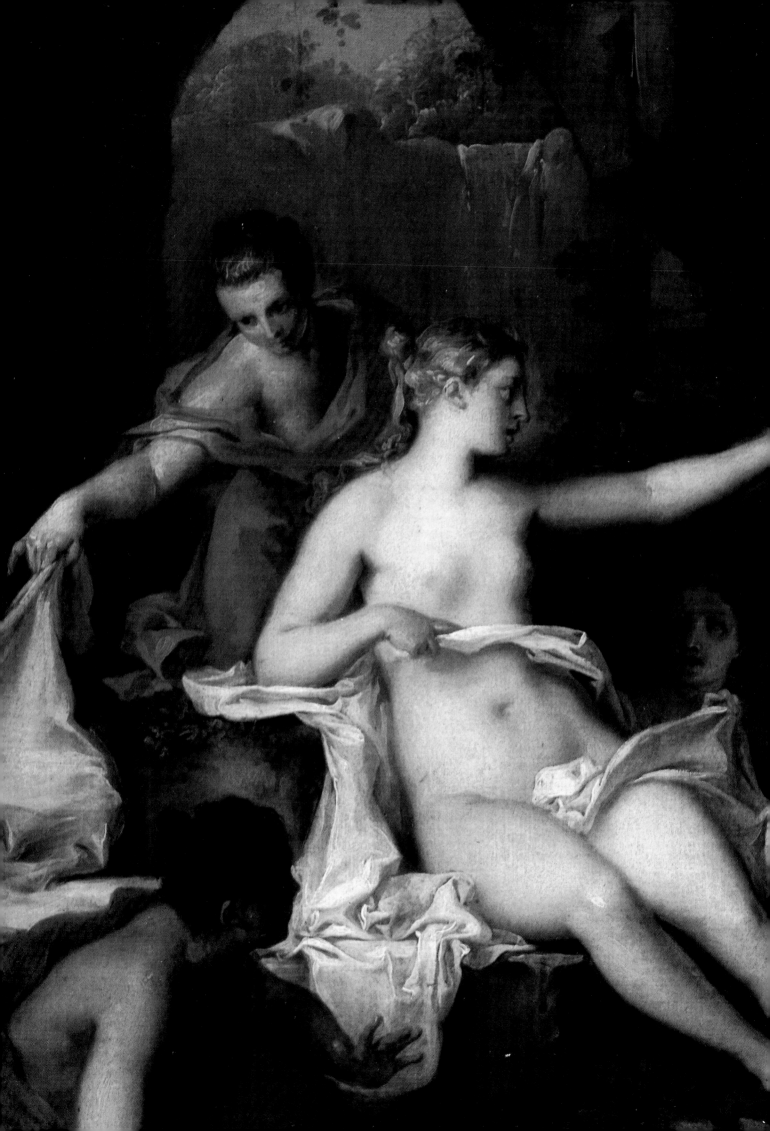

LOUIS GALLOCHE
(1670–1761)

Remembered more for the caliber of his students than for the quality of his art, Galloche, the last custodian of an academic tradition articulated by Le Brun, continued to produce public paintings in this mode well into Louis XV's reign. Born in Paris, the son of a woodcarver, Galloche was originally destined for religious orders; he entered the collège Louis le Grand and received his tonsure at the age of thirteen. By the age of eighteen, however, he had decided against a religious vocation and began to pursue an artistic career. After studying with an unknown master for six months, Galloche entered the prestigious studio of Louis de Boullongne around 1691. After four years of study with Boullongne, Galloche won the *Prix de Rome* competition of 1695 with *Jacob's Sons Showing Joseph's Robe to Their Father* (Paris, École Nationale Supérieure des Beaux-Arts), but, due to lack of funds in the royal treasury, he did not become a *pensionnaire* at the French Academy in Rome. Galloche was obliged to finance the Italian journey himself, and he remained in Italy for only two years.

Shortly after returning to Paris, Galloche opened his own studio and received his first major commission, two paintings on the life of Saint Benedict for the refectory of Saint-Martin-des-Champs, executed in 1703 (Brussels, Musée d'Art Ancien). With these works he became *agréé* at the Academy in March of that year, and he was finally received as a full member in January 1711 with the submission of *Hercules Rescuing Alceste from the Depths* (Paris, École Nationale Supérieure des Beaux-Arts).

Due to the paucity of royal projects, Galloche, like many artists of his generation, was forced to rely on commissions from religious institutions. Works such as *Saint Paul Taking Leave of the Ephesian Priests* (Paris, Musée du Louvre), the *Mai* of Notre-Dame in 1705, and the commission for Saint-Martin-des-Champs cited above helped to establish his reputation. His most famous religious painting, *The Translation of Saint Augustine's Relics to Pavia* for the couvent des Petits-Pères (location unknown), was universally admired by Galloche's eighteenth-century biographers; Papillon de La Ferté considered it "one of the best works of the French school."

Galloche also produced a number of secular paintings. From 1737 to 1751 he contributed regularly to the Salon, exhibiting *Aeneas and Dido* (Paris, Musée du Louvre) in 1737 and *Spring* (Saint-Denis, Maison de la Légion d'Honneur), a landscape executed for the Trianon de Marbre, in 1751. He was one of the few academicians to enter both the *concours* of 1727 and 1747, submitting *Hippomenes and Atalanta* (location unknown) to the former and *Coriolanus in the Volscian Camp* (Orléans, Musée des Beaux-Arts) to the latter. Galloche participated in large-scale projects, including the famed decoration of the hôtel du Grand Maître at Versailles (1724, *Adonis Leaving for the Hunt*, Versailles, Hôtel de Ville), and contributed two ceiling paintings, *Venus and Diana* and *Justice Crowned by Minerva* (location unknown), for the home of Monsieur de La Bulnaye, *premier président de la chambre des comptes* in Nantes.

While Galloche was by no means among the first rank of eighteenth century French artists, he was certainly admired and respected by his peers, who elected him chancellor of the Academy in July 1754. He was also one of the most esteemed teachers of his generation, instructing François Lemoyne, Charles-Joseph Natoire, and possibly François Boucher for a brief time. Galloche's most innovative pedagogical method—visits to the countryside to examine the effects of nature—is reflected in his own work by the use of realistic figure types, fresh colors, and harmonious lighting. At the ripe age of eighty, Galloche was invited by the Academy to present five lectures on his artistic theories, in which he emphasized the need to draw both after the antique and the live model. In another lecture, he outlined an artist's tour of Italy, recommending Rome for Raphael and the Carracci, Venice for Titian, and Parma for Correggio. While Galloche himself had absorbed these influences, he was no less sensitive to the art of Rubens and Van Dyck; in his lecture series he admitted having copied, at the age of seventy, a painting by Van Dyck in the Palais du Luxembourg. Galloche's death in 1761 was lamented by Louis Gougenot, who described him as one of the most modest and studious artists of his generation. Gougenot, however, was writing at the time of Boucher's ascendancy, and by then Galloche must have appeared a marginal, if venerable, relic, whose painting had long ceased to represent the vitality of the academic tradition.

LOUIS GALLOCHE, *Diana and Actaeon* (detail), c. 1725, 81 x 121 cm, The Hermitage, Leningrad

LOUIS GALLOCHE
Diana and Actaeon

12

LOUIS GALLOCHE (1670–1761)
Diana and Actaeon, c. 1725
81 x 121 cm.
The Hermitage, Leningrad

PROVENANCE
Louis-Antoine Crozat, baron de Thiers (1699–1770), after 1755; recorded in his *inventaire après décès*, 22 December 1770, no. 288, and valued with Greuze's *Buste d'un jeune homme* at 372 *livres* (A.N., *Minutier Central*, LXXXIII/925); inventoried in his collection by François Tronchin in 1771, no. 134; sold by Crozat de Thiers's heirs to Empress Catherine II (with the rest of the collection) on 4 January 1772; removed to Leningrad by July 1772; placed in the Imperial collection in The Hermitage, where it remains today.

EXHIBITIONS
Petrograd 1922–25 [as unknown artist]; Leningrad 1972, no. 12 [as "Diana Resting"].

BIBLIOGRAPHY
[Munich] 1774, no. 1151; Georgi 1794, 477; Leningrad 1797, no. 1710 [as unknown artist]; [Labensky] 1838, 284; Leningrad 1859, no. 2815 [as unknown eighteenth-century artist]; Lacroix 1861, 219, no. 1151; Dacier 1909–21, pt. 1, 51, 62; Ernst 1928, 176–77; Dimier 1928–30, I, no. 12; Réau 1929, no. 28 [as Chalon], no. 104 [as Galloche]; Ernst 1935, 136; Stuffmann 1968, 129, no. 134; Nemilova 1973, 311–18, col.; Sahut 1973, no. 27; Leningrad 1976, 196; Nemilova 1982, no. 115; Nemilova 1986, no. 50, ill.

"The Ancients called Diana the goddess of the Hunt and claimed that she held the forests and woods in particular esteem, spending her time hunting all manner of animals there, shunning the company of men, the better to protect her virginity."[1] It is a cruel accident that brings the youthful hunter Actaeon stumbling into the goddess's sacred bower as she bathes with her handmaidens. In fury, Diana throws water onto his face, thereby transforming him into a stag, after which he is mauled to death by his own hounds.[2]

In *Diana and Actaeon*, Galloche is attentive to both the drama and eroticism of Ovid's tale—a student at the prestigious collège Louis le Grand, he was doubtless familiar with Cartari's description[3]—and he approaches this "profane subject" with a fluency and delicacy unexpected from an artist for whom large-scale, poorly remunerated ecclesiastical commissions constituted a more customary stock-in-trade.[4]

Enthroned in her sacred grotto and attended by six nymphs—one of whom, at far left, has just dropped the vessel in which she was gathering the "crystal water" to cleanse Diana's "maiden limbs"—the goddess turns to face a startled Actaeon, hunting spear in hand, who has trespassed into her sanctuary. His eyes wide open in fear, the youth has already begun to sprout the tiny antlers of the "long-lived stag."[5] Hastening to clothe themselves and in a state of genuine alarm, the attendants retreat into the grotto's protective shade as Diana, her beautiful naked body in full light, issues her curse on Actaeon. In the foreground at right, an androgynous nymph, whose features curiously resemble those of Actaeon, raises her right hand commandingly in imitation of her mistress. Her gaze and gesture, however, are clearly directed towards an intruder beyond the canvas's edge; they seem to identify this less mythic Actaeon as the spectator himself.

Galloche is known to have painted three versions of this subject—catalogued by his eighteenth-century biographer as representing "The Bath of Diana"—each of which was said to be "different in tone."[6] Presumably, he exhibited the primary version

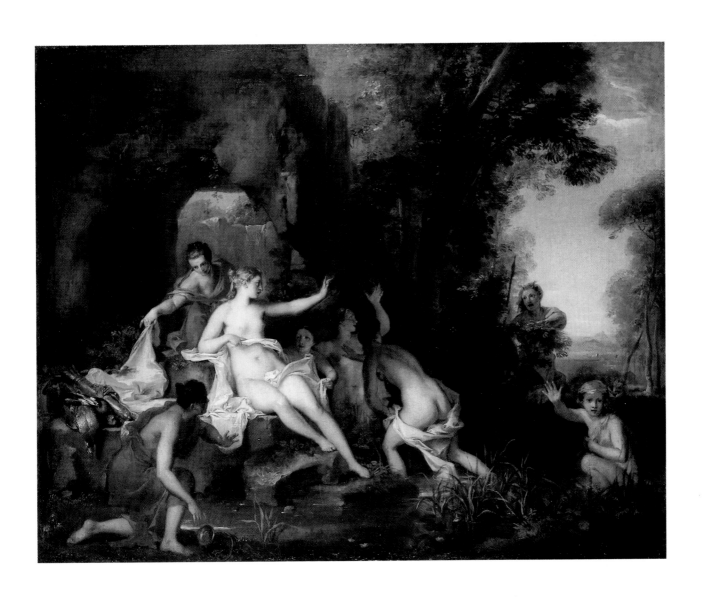

at the Salon of 1725, and it is tempting to associate the painting from Leningrad with this apparently well-received mythology.[7] If it is agreed that *Diana and Actaeon* is one of the thrice-painted "Baths of Diana," it may now be possible to identify a second version. A replica of high quality and of slightly smaller dimensions, in which the nymph at lower right is differently posed, appeared recently at auction with an attribution to Noël-Nicolas Coypel (fig. 1). Furthermore, a drawing inscribed "de Troy" (fig. 2) and published as preparatory to *Ariadne on the Island of Naxos* (cat. no. 19), can be tentatively attributed to Galloche himself and may represent a first thought for *Diana and Actaeon*.[8]

These mistaken attributions are not without interest. Both the subtle *chiaroscuro* and silvery handling of draperies in *Diana and Actaeon*, as well as the Grecian profiles and pointed fingers of Galloche's svelte maidens, do indeed recall the manner of Noël-Nicolas Coypel, an artist some twenty years Galloche's junior. Writing perceptively about the painting in 1928, Serge Ernst observed that "it is in the work of Louis Galloche that one should seek the origins of eighteenth-century style."[9] *Diana and Actaeon* bridges two generations—one might even say two schools—of French painting. And it is worth emphasizing that the pupil of Louis de Boullongne, whose debt to Antoine Coypel is more than apparent, was also the master of Lemoyne, Natoire, and, if one source is to be believed, briefly of Boucher himself.[10]

If, in *Diana and Actaeon*, Galloche attempts to keep up with a generation of history painters in whose training he had played a significant role, he does so without compromising the academic doctrine he would continue to expound well into his eightieth year. Galloche's respect for the old masters was well known: "In the private school he maintained, not only did he teach his pupils the general principles of art, he put these principles into practice in front of the work of the great masters themselves."[11] Galloche seems to have responded to a wide range of "great masters." The copies he made after Titian, Reni, and Rembrandt were listed by Gougenot as having entered the collection of his son; he turned to the portraits of Van Dyck for guidance in his early religious commissions; and Correggio was the master he venerated before all others.[12] However, Galloche was not above plagiarizing the work of lesser artists; his *Venus and Adonis* (Versailles, Hôtel de Ville), painted in 1724 for the hôtel du Grand Maître, is a little-disguised variant after Nicolas Mignard's monumental painting of the same subject, recently acquired by the Minneapolis Institute of Arts.[13]

By contrast, in *Diana and Actaeon* Galloche integrates his sources with greater art. If his miniaturizing figures are indebted to Albani and Coypel, the composition in general and Diana's imperious gesture in particular derive from Titian's *Diana and Callisto* (fig. 3). Not only the particulars of Diana's visage but the play of light and shadow which veils her expression are almost exact quotations from Titian. This celebrated *poesia* had entered the Orléans collection in 1706–7 and is a model that Galloche is likely to have recommended to his pupils.[14]

Yet, fully in keeping with Academic doctrine, Galloche is also at pains to show his skill in recording the human figure in a variety of poses. The animated gestures of Diana and her nymphs, modeled by a caressing light, derive from a study of the live model as well as from art of the past. A central tenet of Galloche's teaching, diligently recorded by Greuze's great patron and benefactor Louis Gougenot, was the complete mastery of anatomy, which the artist could not acquire by working from "the skeleton and corpse" alone: "It is living anatomy, the understanding of the movement of each muscle in action, and principally of the most active, that is of the greatest use [to painters]."[15] From Diana reclining against her ledge of stone to the long-legged nymph who rushes from the pool, head bent and drapery around her knees, Galloche's *Diana and Actaeon* is a *tour de force* of such "living anatomy."

Despite the importance accorded this subject both by Galloche and his biographer, it is not known for whom any of the three versions were painted. *Diana and Actaeon* is first recorded in the collection of Louis-Antoine Crozat, baron de Thiers (1699–1770) —the nephew and principal beneficiary of Pierre Crozat, who inherited the celebrated group of old master paintings via his older brothers in 1751.[16] The baron de Thiers extended his uncle's picture cabinet considerably—principally in the direction of Dutch cabinet painting and French painting of the eighteenth century—and in 1755 published a guide to his collection, "open to all who wish to study the great masters in order to form their taste and perfect their talent."[17] From La Curne de Sainte-Palaye's catalogue it is clear that the French paintings hung separately in the *cabinet à la suite de la bibliothèque* and that Galloche's *Diana and Actaeon* was not among them.[18] Crozat de Thiers must have acquired this painting after 1755; it does not appear in the printed guide but was sketched by that indefatigable *flâneur* Gabriel de Saint-Aubin, who visited the hôtel Crozat in 1771— at some point after the death of the baron de Thiers in December 1770 and before the entire collection was removed to Leningrad in July 1772.[19] *Diana and*

Actaeon was listed by Rémy in the appraisal of Crozat de Thiers's estate as *"Diane avec ses nymphes"*; it hung next to genre paintings by de Troy and Greuze in the *cabinet à la suite de la bibliothèque* devoted to the French school.[20] The following year, *Diana and Actaeon* appeared in the inventory of the collection made by the Genevan banker and collector, François Tronchin, on Diderot's initiative, when its dimensions were recorded accurately for the first and last time.[21] It was correctly attributed in the first catalogue of Catherine II's collection, compiled in 1774, where it was accurately described as *The Metamorphosis of Actaeon*.[22] For much of the nineteenth century, however, *Diana and Actaeon* was listed as the work of the obscure Dutch artist Louis Chalon (1687–1741), and it was not until the publication of Inna Nemilova's fully illustrated catalogue of The Hermitage's eighteenth-century French paintings that it was possible to appreciate the elegance and refinement of the work itself.[23]

Borrowing from various artistic traditions, from Poelenburgh to Albani; sensitive to landscape as well as to the female nude; composed with conviction and full understanding of Ovid's tale, but without pedantry: Galloche's *Diana and Actaeon* is above all the poignant attempt of a talented artist of the second rank to renew his art in light of the achievements of his more gifted pupils. Paraphrasing Mariette, it could be said that had all his paintings resembled *Diana and Actaeon*, Galloche would have loomed large in the history of French painting of the early eighteenth century.[24]

NOTES

1. Cartari 1623–24, 114, "les Anciens appellerent Diane la déesse de la chasse et dirent qu'elle avoit en recommandation les forests et les bois, d'autant qu'elle s'y exerçoit souvent à chasser à toutes sortes de bêtes, fuyant la conversation des hommes, pour mieux garder la virginité."

2. Ovid, *Metamorphoses*, III, 170–251.

3. Gougenot in Dussieux et al. 1854, II, 289–90, who notes that Galloche continued his studies "jusqu'à la philosophie inclusivement."

4. Ibid., 293, 296, "ces sortes d'ouvrages sont toujours payés à vil prix, en comparaison des tableaux dont les sujets sont profanes."

5. Ovid, *Metamorphoses*, III, 164, 195.

6. Gougenot in Dussieux et al. 1854, II, 305, "Trois tableaux représentant le bain de Diane. (Ils sont chacun d'un ton de couleur différent.)"

7. Wildenstein 1924 (B), 49, "un bai n de Diane"; the lapidary reference of the Salon *livret* makes the connection hypothetical at best.

8. Sotheby's, Monte Carlo, 8 December 1984, no. 370. A copy after *Diana and Actaeon*, sold as "studio of Le Brun" in the collection of L.A. Gaboriaud, Paris, Hôtel Drouot, 25 June 1929, no. 42, was recorded by Ernst 1935, 136. As the catalogue does not include a photograph of this painting, it is difficult to comment upon its relationship to Galloche's primary version. The drawing in red chalk is published in Galerie Perrin, *De Le Sueur à Carpeaux*, Paris 1989, 9. I am grateful to Pierre Rosenberg for his help with the attribution of this drawing.

9. Ernst 1928, 176, "c'est dans les oeuvres de Louis Galloche qu'il faut chercher la source du style du XVIIIe siècle."

10. The crouching figure in the left foreground of *Diana and Actaeon* is a reprise of the figure at left in Coypel's *Bath of Diana* (cat. no. 9). Natoire's *Diana and Actaeon*, engraved by Desplaces in 1735, of which a mediocre replica appeared at Sotheby's, Monaco, 7 December 1990, no. 41, may have been inspired by Galloche's composition. For Boucher as one of his pupils, see the comment made by the author of the *Description Historique des Tableaux de l'Église de Paris* (1781), cited by Laing in exh. New York, Detroit, and Paris 1986–87, 15.

11. Gougenot in Dussieux et al. 1854, II, 300, "dans l'école particulière qu'il tenoit chez lui, il ne se bornoit pas à donner à ses élèves les principes généraux de son art, il leur en faisoit l'application sur les ouvrages des grands maîtres."

12. Ibid., 292, 299, 305. Since no inventory was made at the time of Galloche's death, it is impossible to know the extent of his collection. I am grateful to Marie-Catherine Sahut for the reference to the "acte de notoriété" drawn up by Galloche's heirs in which this information is given (A.N., *Minutier Central*, XXXV/710).

13. Bordeaux 1984 (B), 119; exh. London 1986 (A), 91–96.

14. Wethey 1969–75, III, 140, for details of the celebrated gift from the duc de Gramont to Philippe d'Orléans. For Galloche's familiarity with the Orléans collection before the acquisition of Queen Christina's paintings, see Caylus in Lépicié 1752, II, 82.

15. Gougenot in Dussieux et al. 1854, II, 298, "c'est l'anatomie vivante, c'est la connoissance du mouvement des muscles dans toutes les actions, et principalement dans celles qui sont très-animées, dont nous avons le plus de besoin."

16. Stuffmann 1968, 33–35; see also Nemilova 1975, 436.

17. *Mercure de France*, 1751, cited in Stuffmann 1968, 35, "sa maison sera ouverte à tous ceux qui voudraient étudier les grands modèles pour former leur goût et perfectionner leurs talents."

18. Sahut 1973, no. 27, for the most complete summary of the provenance of this painting.

19. Dacier 1929–31, II, 190; also idem, 1909–21, pt. 1, 51, 62, for the reproduction of Saint-Aubin's illustration and the author's accompanying explanation. Saint-Aubin's illustrated copy of the *Catalogue de la Collection Crozat* is in the Musée du Petit Palais, Paris.

20. A.N., *Minutier Central*, LXXXIII/925, "*Inventaire après décès*," Crozat de Thiers, 22 December 1770, "no. 287 et 288 item., le Buste d'un jeune homme par Jean-Baptiste Greuze, une femme donnant à têter à son enfant par de Troy fils, et Diane avec ses nimphes par Galloche les dits trois tableaux . . . prisés ensemble la somme de trois cents soixante douze livres."

21. Stuffmann 1968, 129, "no. 354, *Le Bain de Diane*, toile, hauteur deux pieds, sept pouces, largeur trois pieds, neuf pouces."

22. Lacroix 1861, 219, no. 1151.

23. Nemilova 1986, 98–99.

24. Mariette 1851–60, 281, who makes this statement with regard to Galloche's *The Translation of Saint Augustine's Relics to Pavia*, painted for the refectory of the couvent des Petits-Pères.

FIG. 1
Louis Galloche, *The Bath of Diana*, oil on
canvas, Private Collection

FIG. 2
Attributed to Louis Galloche, *Diana and
Actaeon*, sanguine drawing, Paris, Private
Collection

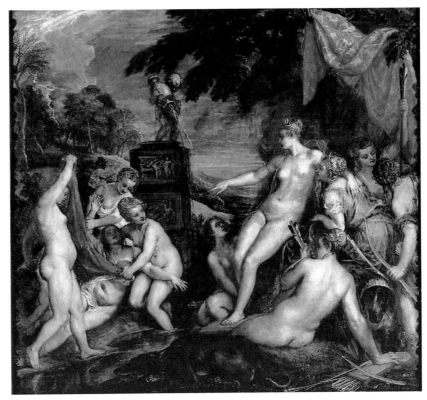

FIG. 3
Titian, *Diana and Callisto*, c. 1556–59, oil on canvas, Edinburgh, National Gallery of Scotland, on
loan from the Duke of Sutherland

JEAN-ANTOINE WATTEAU
(1684–1721)

Watteau was born in 1684 in Valenciennes, then part of French Flanders, but traveled to Paris at the age of eighteen to seek his fortune. Although little is known of his early career, he probably spent his first years in the capital in the society of transplanted Flemish artists, during which time he became good friends with Nicolas Vleughels, among others. Watteau learned his craft by working briefly as a set designer for the Paris *Opéra*, producing devotional panels in large quantities in a copy shop on the Pont Notre-Dame, where he also created shopsigns, and laboring in the book and print trade. Between 1706 and 1708 he lived and studied with Claude Gillot, who introduced him to the painting of theater scenes and ornamental imagery. Through Gillot, Watteau became Claude III Audran's shop assistant around 1708, contributing figures for Audran's ornamental designs. Audran's brother, Jean, probably provided Watteau's *entrée* to the school of the Academy, where he won second prize in the *Prix de Rome* of 1709. Watteau became a proficient ornamentalist and received commissions to decorate the *cabinet du roi* of the château de la Muette and, around 1710, a room in the *hôtel particulier* of the marquis de Nointel (two of the Nointel panels, *The Cajoler* and *The Faun*, still survive in a Parisian private collection). Watteau also began to produce easel paintings in the Flemish manner, among them country life vignettes such as *The Country Dance* (Indianapolis Museum of Art) and scenes of military life, including *The Return from the Campaign* (lost) and its pendant, *The Bivouac* (Leningrad, The Hermitage), the latter commissioned by Watteau's first dealer, Pierre Sirois.

For the next five years Watteau worked in a variety of genres. In addition to arabesques, scenes of country life, and military paintings, he produced theater scenes in the style of Gillot (*Harlequin,*

Emperor of the Moon, Nantes, Musée des Beaux-Arts), occasional landscapes (*The Waterfall*, Private Collection), rare mythological works (*Diana at Her Bath*, cat. no. 13), and early forays into a genre of his own creation, the *fête galante* (*The Island of Cythera*, Frankfurt, Städelsches Kunstinstitut). An introduction in 1712 to Charles de La Fosse proved to be critical for Watteau's career. La Fosse supported Watteau's candidacy for admission to the Academy in July of that year and introduced him to the collector Pierre Crozat. Encouraged by the work of La Fosse as well as by the study of Crozat's famous collection of old master drawings, Watteau came to an understanding of the art of Rubens and the sixteenth-century Venetian masters. His brushwork became more fluent and luminous, as seen in *Jupiter and Antiope* (cat. no. 14) and in his decorative series of the Seasons for Crozat's dining room, of which *Summer* alone survives (c. 1715, Washington, National Gallery of Art).

Around 1715 Watteau began to devote himself almost exclusively to *fêtes galantes*; they proved so popular that he was overwhelmed by admirers and clients. These patrons represented a wide range of society, from the minor nobility to affluent merchants, and included such connoisseurs as the comte de Caylus and Jean de Jullienne. The *fête galante* unites the different figural traditions of theater scenes, northern genre, and the French *tableau de mode* in verdant, often fanciful landscapes, creating a seemingly real world that is actually a fantasy image. Perhaps as an alternative to the grandiose, morally elevating art of the reign of Louis XIV, Watteau's clients appreciated this intimate, ideal world where people played at games of love. Watteau's *Embarkation to the Island of Cythera* (Paris, Musée du Louvre), painted as his reception piece for the Academy in January 1717, is his most renowned and

perhaps greatest essay in this genre. It demonstrates Watteau's unrivaled command of Rubensian rhythms of form and a sixteenth-century Venetian palette, which characterize the genre as a whole.

Having exhausted the possibilities of the *fête galante*, Watteau returned in the last three years of his life to the theater subjects he had favored in his youth, transforming them into monumental syntheses of his experience with the *théâtre de la foire* (e.g., *Love in the Italian Theater*, Berlin, Staatliche Museen Preussischer Kulturbesitz) while continuing to paint variations of earlier *fêtes galantes* (e.g., *Fête in a Park*, London, Wallace Collection). In these late paintings he worked on a grander scale, employing a more naturalistic manner. His final masterpiece, the great *Shopsign*, painted on his return from England for his friend, the art dealer Edme Gersaint (c. 1720, Berlin, Schloss Charlottenburg, Staatliche Schlösser und Gärten), exhibits a new amplitude and fluency of brushwork characteristic of his last years.

"Restless and moody" according to Gersaint, Watteau was unsettled and changed residences frequently. He did not, however, travel extensively, and his trip to London in the autumn of 1719 is the only journey abroad he is known to have undertaken. He was probably already ill with tuberculosis when he departed, and he returned to France by August 1720 in worse health than ever. He died in Gersaint's arms on 18 July 1721, not quite thirty-seven years of age. Although Watteau's art was not renewed in the work of his followers, his ideas were disseminated in paintings by Jean-Baptiste Pater, Watteau's only student, and Nicolas Lancret, as well as in prints after his work made for the *Recueil Jullienne*; François Boucher's participation in this latter endeavor ensured that Watteau's contribution would remain influential throughout the eighteenth century.

JEAN-ANTOINE WATTEAU, *Jupiter and Antiope* (also called *Nymph and Satyr*), detail, c. 1715–16, oil on canvas, 73.5 x 107.5 cm (oval), Musée du Louvre, Paris

JEAN-ANTOINE WATTEAU
Diana at Her Bath

13

JEAN-ANTOINE WATTEAU (1684–1721)
Diana at Her Bath, c. 1715–16
Oil on canvas
80 x 101 cm.
Musée du Louvre, Paris

PROVENANCE
Probably in England by 1737; Sir Thomas Seabright and Thomas Sclater Bacon, their sale, London, 17–19 May 1737, twelfth day of sale, no. 74; E. Thanet, his sale, London, 30 May 1797, no. 47; Philipp sale, London, 13 June 1806; Collection of "Willmot, Esq. and a person of Rank," no. 16; possibly offered at the Thomas Green sale, Christie's, London, 20 March 1874, no. 96; Stéphane Bourgeois, 1890; sale, Hôtel Drouot, Paris, 11 May 1896, ill.; Christina Nilsson, comtesse de Miranda; Camille Groult; J. Groult; Pierre Bordeaux-Groult; acquired by the Musée du Louvre in 1977.

EXHIBITIONS
Paris 1956, no. 97, ill.; Paris 1980–81, no. 39, ill.; Paris 1984–85 (A), no. 28, col.

BIBLIOGRAPHY
Hédouin 1845, no. 129; Hédouin 1856, no. 131; Goncourt 1875, no. 36; Mollett 1883, 61; Mantz 1890, 226–27; Dargenty 1891, 67; Mantz 1892, 178–79, 184; Larroumet 1895, 72–73; Phillips 1895, 62, n. 2; Dilke 1899 (A), 86, n. 4; Fourcaud 1901, 256; Staley 1902, 29, 65; Josz 1903, 399; Guiffrey and Marcel 1907–33, II, under no. 1451; Zimmermann 1912, 134, 191, ill.; Dacier, Hérold, and Vuaflart 1921–29, I, 28–30, II, 29, 61, 93, 133, 161, III, under no. 149; Séailles 1927, 70–71; Dimier 1928–30, I, 30, no. 8; Eisenstadt 1930, 69, n. 145, 183–84; Adhémar and Huyghe 1950, no. 137, ill.; Gauffin 1953, 10–11, ill.; *Arts* (16–22 May 1956), ill.; Parker and Mathey 1957, under no. 854; Mathey 1959, 68; Lossky 1962, under no. 17; Mirimonde 1962, 16, n. 17; Nemilova 1964, 90; Cailleux 1967, 59; Camesasca and Rosenberg 1970, no. 113, ill.; Ferré 1972, I, 214, III, 785, 1040, 1107; Nemilova 1973, 57, ill.; Posner 1973, 31, 33; exh. Toledo, Chicago, and Ottawa 1975–76, under no. 11; Eidelberg 1977, 20–22, 51, 66, ill.; Mirimonde 1977, 84, n. 16; *Connaissance des Arts* (April 1978), 35–36, ill.; *La Revue du Louvre et des Musées de France* (1978), no. 2, 135, ill.; *Gazette des Beaux-Arts* (*Chronique*) (April 1979), 6, no. 29, ill.; Nordenfalk 1979, 136–37; Hagstrum 1980, 288, n. 18, ill.; Roland-Michel 1982, no. 207, ill.; Posner 1984, 107; Roland-Michel 1984 (B), 151, 269; Grasselli 1987, II, 370–72.

"D*iana in balneo* . . . Diana leaving the bath, engraved by Pierre Aveline, showing a single figure of a woman washing her feet in a fountain. The subject is particularly enticing and the vague manner in which it is handled corresponds perfectly to the original, whose beautiful light is also reproduced." Gersaint's advertisement of Aveline's engraving (fig. 1), published in the *Mercure de France* of April 1729, is both the earliest and most succinct description of Watteau's *Diana at Her Bath*, emphasizing, as it does, the painting's strong erotic appeal and its complete disregard for literary and pictorial convention.[1]

Under a wide summer's sky filled with rolling clouds, a young woman dries her right foot on the bank of a pond. Completely naked, she sits upon the rose and white robes she has just cast off, an elaborate quiver with tips of colored feathers placed to her side. At the pond's edge is an enormous tree that has been bent in two, its upper branches falling into the water. In the background beyond the fallen oak and far to the left are sapling trees which bend in the wind. And in the far distance, a cluster of buildings suggests rustic habitation; from the chimney of one of these issues a thick plume of gray smoke, filling the sky in a line that perfectly follows the contours of the woman's ample back.

Watteau's *Diana at Her Bath* departs from pictorial and literary convention at almost every turn. Ovid described Diana and her maidens bathing, after a day at the hunt, in a "well-shaded grotto" hidden deep in the vale of Gargaphie, the goddess's "sacred haunt."[2] Watteau's Diana sits in the middle of an open clearing, where the only tree capable of providing shade and protection looks as if it has just been struck by lightning. In traditional depictions, Diana is always attended by several nymphs, all of whom perform certain tasks in her toilette; Watteau's goddess, lacking even the attribute of a crescent moon, appears quite alone, her imperious demeanor transformed into the face of a "sweet little *parisienne*."[3] The "unfamiliar woods" through which Actaeon would wander with "unsure footsteps" are nowhere in sight;[4] instead, the expansive, somewhat desolate setting, which evoked

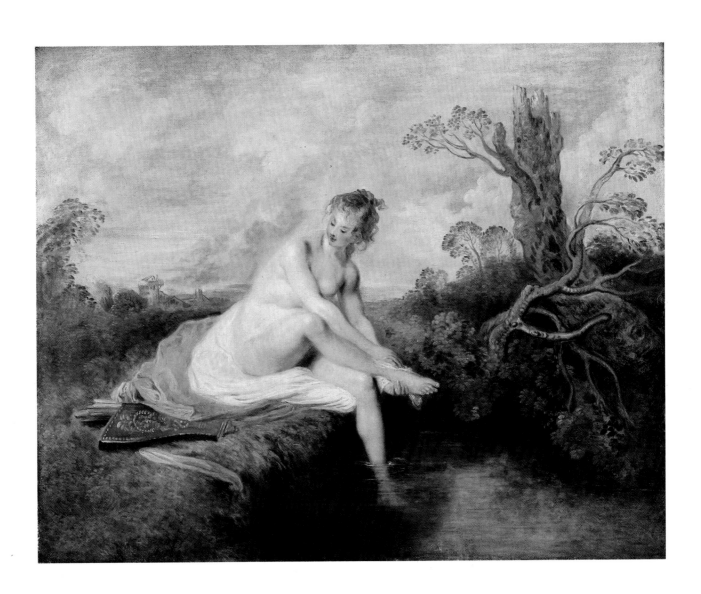

Corot's landscapes of the *"pays de France"* to at least one commentator,[5] is enlivened only by a group of buildings, modest dwellings of indeterminate character and hardly appropriate for Diana's domain. Even more startling is the smoking chimney which bellows forth and stains the summer sky.

The painting's many idiosyncracies have often been explained as Watteau's attempts to ennoble a profane depiction of the female nude by the addition of mythological attributes, however slight their presence.[6] However, the classical context was present from the beginning in Watteau's preparatory drawing (fig. 2), which shows quite clearly the goddess's quiver hanging on the tree behind her—its elongated shaft extending the diagonal of Diana's back—and the Venetian-inspired mountain range in the background, a landscape more in keeping with the mythological subject.[7]

If Watteau's interpretation of Diana is unconventional, the genesis of the composition further reveals Watteau's ambivalence towards history painting. The remarkable similarity of pose between Diana and the nymph who dries her foot in Louis de Boullongne's *Diana Resting* (cat. no. 10), first noted by Louis Réau in 1928, has been discussed in all recent commentaries on the painting.[8] Furthermore, it is generally agreed that Watteau might have known Boullongne's preparatory drawings for *Diana Resting*: either his squared and carefully finished compositional study (cat. no. 10, fig. 2) or the monumental drawing he made of the attendant drying her foot (cat. no. 10, fig. 3). Since Boullongne's *Diana Resting* had hung as an overdoor in the *cabinet du roi* at Rambouillet since the summer of 1707—and it is difficult to imagine Watteau gaining access to this room—Watteau's source is more likely to have been one of Boullongne's drawings, and there is ample precedent for his borrowing compositional ideas from the drawings of senior academicians.[9] Yet it is impossible to know at what point in his career Watteau would have infiltrated Boullongne's studio. Before his reception by the Academy in July 1712, Watteau was instructed by La Fosse to visit members of the Academy: Gersaint noted that he "withdrew, made his visits, and was *agréé* immediately," and thus a meeting with Boullongne in his studio could have taken place on this occasion.[10] However, Watteau's invitation to join the Academy dates from at least four years before *Diana at Her Bath* was painted, and in the intervening period there is little evidence to connect the two artists. Indeed, given Watteau's reputation as a painter of *fêtes galantes*, it is not clear whether he would have received a particularly warm welcome from the older artist. Dézallier d'Argenville noted how strongly

Boullongne disapproved of the genre on which Watteau's reputation rested: "He would say, in front of the entire Academy, that nothing was more dangerous for the student than the current taste for grotesques and *bambochades* since it prevented him from treating subjects of sacred and profane history with the required nobility."[11] Might *Diana at Her Bath*, with its flagrant quotation from Boullongne's *Diana Resting*, have been intended to show that Watteau could work in both modes with equal fluency?

With Diana's pose established, significant changes now intervened in the elaboration of the painting of *Diana at Her Bath*. Watteau abandoned the vertical format of the drawing and extended the composition to include a wider vista, separating Diana from the tree and replacing the mountains in the distance with buildings.[12] Although the figure of Diana herself gained in stature—Paul Mantz described her "supple and glowing flesh tones" as "painted by an admirer of Rubens"[13]—the immediacy of her expression was greatly attenuated. In the preliminary drawing, Diana turns quickly, her eyes, hidden under enormous lashes, suddenly on the alert: in the painting, her pretty face, with its red cheeks and hair in disarray, seems too small for her voluptuous body and conveys no emotion whatsoever.

Watteau's treatment of the landscape, in which he seems to have had recourse to a number of drawings, both after nature and the old masters, is also less straightforward than might be supposed. The gnarled tree with its amputated branches, a disturbing *vanitas* reference which has no place in Diana's territory, appears in less threatening form in the left foreground of Watteau's beautiful sanguine drawing after an unknown sixteenth-century Venetian artist (fig. 3).[14] Yet the cluster of buildings in the background of *Diana at Her Bath*, normally described as Venetian, is similar to the simple rustic buildings that appear in innumerable sheets; for example, the magisterial *Landscape* (Bayonne, Musée Bonnat) which Parker and Mathey considered to be a drawing from nature.[15] The smoking chimney and the shabby appearance of the buildings further recall Watteau's earlier drawings after nature made at Porcherons, a suburb of old Paris and one of the artist's many brief places of residence.[16]

However diverse Watteau's sources, the landscape in *Diana at Her Bath* conforms to de Piles's model of the *style champêtre* as articulated in the *Cours de Peinture* of 1708. Paintings in the pastoral, as opposed to the heroic, mode could be set in "much less cultivated terrain, abandoned to Nature's eccentricities."[17] As for *fabriques*, architecture which ennobled the landscape, "this term can hardly be applied to the peasants' houses and shepherds' cottages which may

be introduced in pastoral subjects: it designates the spacious and well-proportioned buildings that are always included in heroic subjects."[18] Watteau's *Diana at Her Bath* is thus "*une Diane champêtre*," compounding the artist's ambivalent approach to the genre of history painting still further.

It has recently been argued that *Diana at Her Bath* was one of the small group of mythological paintings executed around 1715–16 with which Watteau hoped to reenter, however briefly, the "mainstream of French painting."[19] Watteau's commission to paint four seasonal mythologies for Crozat's *hôtel* on the rue de Richelieu is the central body of work here, and, with *Summer* (Washington, National Gallery of Art) and *Diana at Her Bath* in mind, it seems reasonable to ask whether Watteau was really capable of working within the traditions of French history painting at all. Most eighteenth-century commentators agreed that he was unable to draw "in the grand manner," even though there was also a consensus that "his vision of art was more elevated than his practice of it."[20] Discussing Crozat's *Seasons*, Caylus wrote that Watteau's "incapacity" as a draughtsman "rendered him incapable of painting or composing anything heroic or allegorical, let alone of creating figures of a certain size."[21]

Diana at Her Bath might be seen as Watteau's second variation, also ultimately unsatisfying, on the theme of "mainstream" history painting. Despite the difficulties of dating Watteau's work, this painting has always been associated with Crozat's *Seasons*; most historians, but not all, agree that it was painted either at the same time or a little later than this commission.[22] In a radical reinterpretation of the chronology of Watteau's drawings, Margaret Morgan Grasselli has recently connected the preparatory drawing for *Diana at Her Bath* with the series of reclining nudes Watteau painted in preparation for *A Lady at Her Toilette* (fig. 4). While she does not claim that the Albertina drawing was made at the same session, Grasselli is surely right to draw attention to the similarities in handling and style of anatomy between this sheet and those in Lille and London in which models very similar to Diana are studied in distinctly awkward, unflattering poses.[23] Nor is Grasselli the first to comment on the relationship between *Nude Woman Seated on a Chaise Longue* (fig. 5) and the *Diana at Her Bath*; Lady Dilke and Émile Dacier both noted stylistic affinities between these two works.[24]

Even if Grasselli's very late dating of both drawing and painting, which she places around 1718–19—almost the eve of Watteau's departure for England—is impossible to document, her careful analysis of the drawings has the great virtue of establishing a closer link between *Diana at Her Bath* and the Wallace Collection's *A Lady at Her Toilette*, one of Watteau's supreme achievements, most recently described as "the latest and most perfect of Watteau's surviving erotic pictures."[25] *Diana at Her Bath* would then stand midway between the *Seasons*, which employ mythological iconography in the tradition of the French Academy, and *A Lady at Her Toilette*, a candid celebration of the female body in which classical references are so slight as to be frequently overlooked.[26] In the Louvre *Diana at Her Bath*, Watteau has yet to break with mythology altogether; the painting is his single surviving attempt to imbue *la fable* with a more personal vocabulary, to "bound the past to the most immediate present."[27]

How is one to explain Watteau's mixing of languages and indifference to classical precedent, so uncharacteristic of an artist generally considered well read? Was it part of a Herculean effort to revitalize the highest category of art, or does it reflect something of the "impatience and inconstancy" that Gersaint saw as the essence of Watteau's character?[28] *Diana at Her Bath*, instead of renewing the genre of mythological painting, operated, in the end, on the same level as the *fête galante*, in which, as La Roque pointed out as early as 1721, "one sees a delightful mixture of the serious, the grotesque, and the caprice of French fashion, both past and present."[29]

Thus, Walpole's stinging criticism of Watteau's figure painting—"his nymphs are as much below the forbidding majesty of goddesses as they are above the hoyden awkwardness of country girls"—was perhaps more appropriate than he realized, since this intermediary status characterizes well the pleasant but vacant Diana and her useless attributes.[30] However, if Watteau abandoned mythological painting after *Diana at Her Bath*, his veneration for the genre is expressed with typical elegance and poignancy in the great *Shopsign* (fig. 6), in which the couple with their backs to us examine at close quarters a splendid oval which can only be a Bath of Diana.[31] Although the goddess herself cannot be identified in the portion of the canvas that is visible, such carnal and uninhibited display of female nudity is inconceivable in any other subject. Sensuous and harmonious, with landscape and subject in perfect accord, this glorious mythology, like the many others that line the walls of Gersaint's shop, is painted with a conviction and fluency that had eluded Watteau in his few attempts at the grand manner. *The Shopsign* confirmed once and for all that history painting lay beyond Watteau's grasp, attainable only as the reminiscence of a great tradition from which his practice was irrevocably severed.

NOTES

1. Dacier, Hérold, and Vuaflart 1921–29, III, 74, "Diane sortant du bain, gravé par Pierre Aveline; c'est une femme seule qui se lave les pieds à une fontaine, le sujet en est fort piquant et la manière vague dont il est traité donne parfaitement l'idée de l'original et rend une belle lumière." For the most complete survey of the enormous bibliography on this painting, see exh. Paris 1984–85 (A), no. 28, 308–10.

2. Ovid, *Metamorphoses*, III, 156.

3. Rosenberg citing Mirimonde in exh. Paris 1984–85 (A), 309.

4. Ovid, *Metamorphoses*, III, 175–76.

5. Fourcaud 1901, 256.

6. Grasselli and Rosenberg in exh. Paris 1984–85 (A), 137, 310; Posner 1973, 33, n. 29.

7. Grasselli 1987, II, 371. Grasselli notes the presence of the quiver in her doctoral dissertation, which refines many of the conclusions she had reached in the catalogue of the exhibition.

8. Full bibliography in exh. Paris 1984–85 (A), 310. Rosenberg rightly pointed out that this pose is conventional, and to the corpus of possible sources he listed can be added a detail from Rottenhammer's preparatory drawing of *Diana and Actaeon* (fig. 7) which appeared in Christie's, New York, 31 May 1990, no. 117.

9. See my discussion of Boullongne's *Diana Resting* (cat. no. 10). Caylus noted that La Fosse had provided Watteau with designs for Crozat's *Seasons*, Levey 1964, 54; Eidelberg 1986, 98–103, notes that the artist's earlier cycle, known as the *Jullienne Seasons*, had been inspired by the drawings of Antoine Dieu.

10. Gersaint's *Abrégé de la vie d'Antoine Watteau*, 1744, in Rosenberg 1984 (A), 36, "Faites les démarches nécessaires, nous vous regardons comme un des nôtres. Il se retira, fit ses visites et fut agréé aussitôt." As Rosenberg pointed out, Louis de Boullongne was present when Watteau was formally admitted to the Academy on 30 July 1712, exh. Paris 1984–85 (A), 310.

11. Dézallier d'Argenville 1762, IV, 266, "Il disoit en pleine Académie, que rien n'étoit plus dangereux pour les étudians que le goût des grotesques et bambochades qui les éloignoit de pouvoir traiter noblement l'histoire sacrée et la profane."

12. The vertical format of the drawing may have been maintained in another version of the subject, now lost, and described as "une femme assise en sortant du bain; du paysage, des fabriques et un jet d'eau servent de fond à ce tableau . . . 20 pouces de haut sur 16 de large," recorded in the sale of the prince de Conti, 8 April 1777, no. 667, and that of the abbé Renouard, 10 February 1780, no. 141, see exh. Paris 1984–85 (A), 310.

13. Mantz 1892, 178.

14. Parker and Mathey 1957, 441, "d'après un maître vénetien dans le style de Campagnola."

15. Ibid., 473. For the most careful discussion of the landscape in *Diana at Her Bath*, see Eidelberg 1977, 20–22.

16. For example, *Landscape with Cottages and Figures*, reproduced and discussed in exh. London 1980, no. 7.

17. Piles 1708, 202, "des pays . . . bien moins cultivés qu'abandonnés à la bizarrerie de la seule nature."

18. Ibid., 221–22, "Ainsi ce terme convient bien moins aux maisons de paisans et aux chaumières des Bergers, lesquelles on introduit dans le goût champêtre qu'aux bâtiments réguliers et spacieux que l'on fait toujours entrer dans le goût héroïque."

19. Posner 1984, 97.

20. Mariette's response of c. 1745 to Père Orlandi's entry in *L'Abecedario Pittorico*, in Rosenberg 1984 (A), 4, "sans avoir jamais pu dessiner de grand manière"; Caylus, *La Vie d'Antoine Watteau*, read at the Academy, 3 February 1748, in Rosenberg 1984 (A), 67, "il voyait l'art beaucoup au dessus de ce qu'il le pratiquait."

21. Caylus 1748, in Rosenberg 1984 (A), 73, "Cette insuffisance . . . le mettait hors de portée de peindre ni de composer rien d'héroïque ni d'allégorique, encore moins de rendre les figures d'une certaine grandeur."

22. Posner 1984, 79; Roland-Michel 1984 (B), 151; but see Rosenberg's equivocal argument in favor of "une date relativement précoce pour le tableau du Louvre," exh. Paris 1984–85 (A), 308.

23. Grasselli 1987, II, 364–72.

24. Dilke 1899 (A), 86; Dacier, Hérold, and Vuaflart 1921–29, I, 30.

25. Posner 1984, 106, and idem, 1973, chap. 2.

26. For Watteau's discreet references to Venus in *A Lady at Her Toilette*, see Posner 1973, 71–73.

27. The quotation, Jacques-Émile Blanche's summation of Degas's art, applies particularly well to Watteau's purpose in *Diana at Her Bath*.

28. Gersaint *Abrégé . . .* , in Rosenberg 1984 (A), 39, "Ses tableaux se ressentent un peu de l'impatience et de l'inconstance qui formait son caractère."

29. La Roque in *Mercure de France*, August 1721, reprinted in Rosenberg 1984 (A), 6, "On y voit toujours un agréable mélange du sérieux, du grotesque et des caprices de la mode française ancienne et moderne."

30. Ibid., 101, quoting from Walpole's *Anecdotes of Painting in England*. Walpole may have had *Diana at Her Bath* in mind, since the work is recorded in England as early as 1737 and would not return to France until 1890. See the provenance established by Pierre Rosenberg in exh. Paris 1984-85 (A).

31. We are not proposing to connect this oval to a known composition; see the cautionary remarks in exh. Paris 1984–85 (A), 452.

Fig. 1
After Jean-Antoine Watteau, *Diana at Her Bath*, 1729, engraved by Pierre Aveline, Paris, Bibliothèque Nationale, Cabinet des Estampes

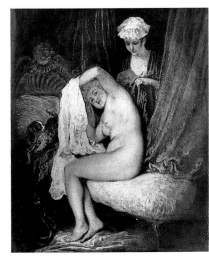

Fig. 4
Jean-Antoine Watteau, *A Lady at Her Toilette*, c. 1716–17, oil on canvas, London, Wallace Collection

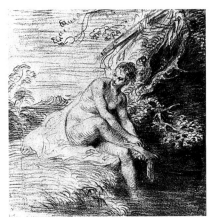

Fig. 2
Jean-Antoine Watteau, *Diana Bathing*, c. 1715–17, red chalk drawing, Vienna, Graphische Sammlung Albertina

Fig. 6
Detail from Jean-Antoine Watteau, *The Shopsign*, 1721, oil on canvas, Berlin, Schloss Charlottenburg, Staatliche Schlösser und Gärten

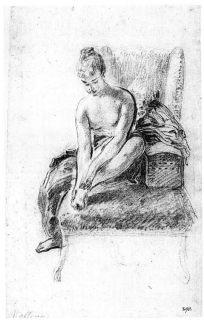

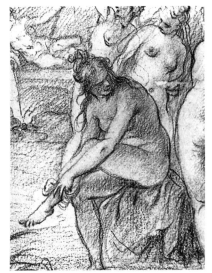

Fig. 3
Jean-Antoine Watteau, *Château Fort in a Mountainous Setting*, c. 1715, red chalk drawing, Oxford, Ashmolean Museum

Fig. 5
Jean-Antoine Watteau,
A Half-Nude Woman Seated on a Chaise Longue, c. 1715–17, red and black chalk drawing, London, The British Museum

Fig. 7
Johann Rottenhammer, *Diana and Actaeon*, 1595, red and black chalk drawing, Private Collection

JEAN-ANTOINE WATTEAU
Jupiter and Antiope

14

JEAN-ANTOINE WATTEAU (1684–1721)
Jupiter and Antiope (Nymph and Satyr), c. 1715–16
Oil on canvas
73.5 x 107.5 cm. (oval)
Musée du Louvre, Paris

PROVENANCE
Possibly executed c. 1715–16 and paid for in May 1717 by
Léopold-Philippe-Charles-Joseph, duc d'Arenberg (1690–1754);
acquired in Brussels by "M. Simonet de Paris" in 1847; Théodore
Patureau, his sale, Paris, 20–21 April 1857, no. 63; acquired by
Bourlon de Sarty, his sales, Paris, 4–5 May 1865, no. 202 [unsold]
and Paris, 9–11 March 1868, no. 44; acquired by Horsin for 600 ff;
Dr. Louis La Caze, who gave the painting to the Louvre in 1869.

EXHIBITIONS
Copenhagen 1935, no. 258, ill.; New York 1935–36, no. 4, ill.;
Vienna 1966, no. 75, ill.; Moscow and Leningrad 1978, no. 21;
Paris 1984–85 (A), no. 36, col.; Lille 1985, no. 120, col.

BIBLIOGRAPHY
Le Roy 1859, 19; Mantz 1859, 350; Lejeune 1864, 215; cat. La
Caze 1870, no. 268; Mantz 1870, 12–13; Goncourt 1875, 52;
Goncourt 1881, 77; Dohme 1883, 100; Mollett 1883, 62; Han-
nover 1889, 81, ill.; Mantz 1892, 89, 148, 176; Phillips 1895, 41;
Rosenberg 1896, 51, ill.; Besnus 1898, 74; Fourcaud 1901, 255;
Legrand 1902, 13; Staley 1902, 129; Josz 1903, 398–99; Pilon
1912, 60–61, 75, 109–110, 112, ill.; Zimmermann 1912, 187, ill.;
Dacier, Hérold, and Vuaflart 1921–29, I, 77, 154, 286, III, 24;
Dacier 1923, 4–6, ill.; Hourticq 1927, 203; Dimier 1928–30, I, 30,
no. 6; Gillet 1929, 33–34, ill.; Parker 1931, 43; Alvin-Beaumont
1932, 30–34; *L'Amour de l'Art* (December 1938), col. detail, cov-
er; Brinckmann 1943, 22, ill.; Adhémar and Huyghe 1950, 189,
196, no. 180 bis, col.; Parker and Mathey 1957, under nos. 515,
517; Gauthier 1959, col.; Mathey 1959, 35–36, 68–69, ill.; Levey
1964, 58, n. 1; Nemilova 1964, 90; Thuillier and Châtelet 1964,
165; Brookner 1967, 15, ill.; Cailleux 1967, 59; Pignatti 1969, 4,
ill.; Camesasca and Rosenberg 1970, no. 104, col.; Ferré 1972, no.
B56; Boerlin-Brodbeck 1973, 120, 231; Posner 1973, 23, 29; Bazin
1974, 61; Cailleux 1975, 87 (Eng. ed., 248); Adhémar 1977, 171;
Eidelberg 1977, 35–36, ill.; Bauer 1980, 42; Loche 1980, 190, un-
der no. 15; Mirimonde 1980, 115, ill.; Tomlinson 1981, 48–49;
Roland-Michel 1982, no. 160, col.; Posner 1984, 79–80, 97, 208,
col.; Roland-Michel 1984 (B), 71, 152, 204, 221, 257, 269, 309,
ill.; Moureau and Grasselli 1987, 61, 131–32, 134, 135, 146, 161,
165, 183, col.; exh. Paris 1989, 25–26.

"Knowing nothing about anatomy, and
hardly ever having drawn the naked figure, Watteau
neither understood the nude, nor was he capable of
expressing it; such was his discomfort that even the
painting of an *académie* caused him great effort and
gave him little pleasure."[1] *Jupiter and Antiope*, Wat-
teau's most powerful and compelling history painting,
whose violent eroticism so disturbed his nineteenth-
century champion[2]—and has so intrigued commenta-
tors a century later[3]—gives the lie to Caylus's asser-
tion, which is explicable only as academic rhetoric.
Caylus may well have had *Jupiter and Antiope* in mind
when he delivered this stinging critique and, if so, his
attack was double-edged, for he was disparaging a
work that he himself had etched some thirty years ear-
lier (fig. 1).

Asleep by the edge of a river—although there is
no water in sight—a beautiful young woman is about
to be ravished by the satyr who clambers to the top of
the bank, the weight of his entire body concentrated
in the brutish knee that pushes him towards the ob-
ject of his passion. He removes the silken drapery
from the sleeping figure with his right hand while lift-
ing the blue damask from her legs with his left. The
urgency of his lust is betrayed only by the glint in his
faun's eyes—"*la pulsion scopique*"[4]—and by his tongue,
with which he literally licks his lips in anticipation.
The woman's vulnerability is rendered all the more
poignant by the strand of golden hair which has fall-
en across her right arm, the single disruption of an el-
egant coiffure. Shrouded by trees and branches, with
rustic dwellings and a smoking chimney far in the
background, there can be no doubt as to the dreadful
outcome of the satyr's attack.

Yet while the action taking place needs little
clarification, the precise subject of Watteau's mythol-
ogy has been a matter for lengthy, if inconclusive, de-
bate, one that is hampered by the silence of the eigh-
teenth-century sources, none of which mentions this
painting. The earliest reference to Watteau's *Jupiter
and Antiope*, Karl-Heinrich van Heinecken's classifi-
cation of Caylus's etching in his unfinished *Diction-
naire des Artistes*, identified the subject as *Venus with a*

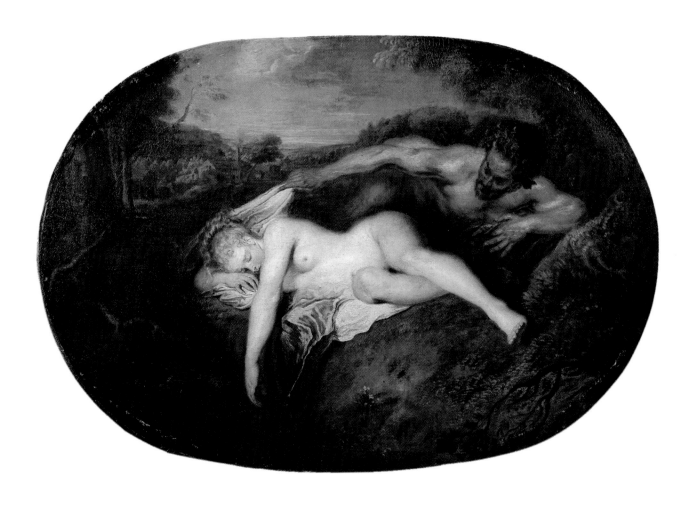

Satyr, a reasonable suggestion that seems to have escaped the notice of later commentators.[5]

It was Louis La Caze (1798–1869), the great *amateur* and *donateur* of eighteenth-century French paintings, who identified the subject as Jupiter and Antiope, and although this attribution was soon challenged by several scholars, it is not without merit, given Watteau's cavalier approach to mythology.[6] Jupiter's seduction of the beautiful maiden Antiope, who bore him twin sons, Amphion and Zethos, is recounted briefly in several classical sources. As daughter of the river-god Asopos, "the swift, deep-eddying water,"[7] Antiope is described as a nymph in *The Odyssey*, yet no details of Jupiter's seduction are to be found in this account.[8] Apollodorus, by contrast, noted that Antiope was the mortal daughter of Nycteus, King of Thebes.[9] Ovid, the only author to describe Jupiter's metamorphosis—"in a satyr's image hidden, Jupiter filled lovely Antiope with twin offspring"—says nothing of Antiope's paternity and does not specify whether she was mortal or nymph.[10] A conflation of Homer and Ovid was made in Isaac Benserade's popular rhyming translation of Ovid's *Metamorphoses*, first published in 1676, in which Antiope is described as a proud nymph. In Chauveau's accompanying illustration, Jupiter, in the guise of a satyr, is shown assaulting Antiope, who sleeps under a canopy by the bank of a river.[11]

Missing from Watteau's painting, and yet included in all previous depictions of this myth, is Jupiter's eagle—the essential attribute associated with the supreme deity of the ancient world. For many scholars, the absence of this symbol alone has sufficed to invalidate La Caze's identification, even though both Correggio's *Venus, Cupid, and a Satyr* and Titian's *Pardo Venus* (both Paris, Musée du Louvre) were thought to represent Jupiter and Antiope in Watteau's lifetime—and in neither of these canvases does an eagle appear.[12] Although we cannot know with certainty what Watteau or his contemporaries considered the subject of this painting—Caylus's etching, which might have provided some clue, is untitled—it does not seem implausible that Watteau conceived this work as representing Jupiter and Antiope. He painted that subject on at least one other occasion—a lost panel, smaller than *The Judgment of Paris* (Paris, Musée du Louvre)—which was described as having "the coloring of a Titian."[13] And he executed the so-called *Jupiter and Antiope* at a time when his immersion in Venetian sixteenth-century art was at its most intense. For the Goncourts, the picture represented a "complete appropriation" of the work of Titian, and the figure of the supposed Antiope evoked Titian's sleeping Venus to other commentators as well.[14]

Moreover, it was to actual paintings of the story of Jupiter and Antiope that Watteau turned in the elaboration of his composition. Although it remains unclear how he would have known Van Dyck's robust, youthful *Jupiter and Antiope* (fig. 2), there can be little doubt that this work served as a source for Watteau's painting of the subject: the grotesque detail of the satyr's tongue caught between his lips was employed with greater subtlety by the French artist.[15] Through La Fosse, Watteau may have come to know an engraving after Primaticcio's *Jupiter and Antiope* (fig. 3), the aging academician having developed an interest in French Mannerist art towards the end of his life.[16] The elegant braids of Watteau's Antiope, as well as the detail of her head cradled in her arm, seem to derive from Primaticcio's composition. Yet if Primaticcio's recumbent Antiope may have suggested sleep to Watteau, her expression is actually one of anguish, not rest; eyes wide open, the nymph is cowering in fear.[17]

Watteau's Antiope, justly renowned as one of his "finest creations,"[18] is indebted also to antique sculpture—the *Sleeping Eros* first noted by Donald Posner[19]—and to one of the sleeping cupids in Albani's *Diana's Nymphs Disarming Sleeping Cupids* (fig. 4),[20] part of the series of allegorical paintings which had entered the Royal Collection in November 1683 and which were well known through Benoît Audran's engravings.[21] Watteau's familiarity with this popular series is unusually well documented. One of his earliest biographers, the abbé Leclerc, noted that during his apprenticeship with Gillot, Watteau had copied "the four prints by Albani, which he painted and colored as he saw fit" to be sold by picture dealers on the Pont Notre-Dame.[22]

Distilling a diverse and impressive pictorial tradition, *Jupiter and Antiope* nonetheless displays a brazen sexuality inspired as much by contemporary libertine literature as by the mythographers' glosses.[23] Yet the painting remained far removed from the brittle eroticism of such *oeuvres badines*—its mood is more serious; its investigation of passion more authentic—and these qualities were inherent in the work from its conception. Jupiter's violent animality is established in the *Kneeling Nude Man* (fig. 5), a preparatory drawing in *trois crayons* of explosive realism, which shows a figure kneeling on a ledge, at some height from an invisible woman whose covering he removes by stealth. To steady himself, the man rests all his weight on his left hand which holds fast to the ground. This attitude—taut and nervous, poised between "the pleasures of vision and exigencies of flight"[24]—differs radically from the squat and undignified pose the satyr assumes in the finished painting, a position more

suited to the oval contours of the painting and one Watteau worked out in a second preparatory study (fig. 6), in which the chalks are applied more evenly.[25] Yet from the more vigorous drawing Watteau retained the intensity of expression, the faun's eyes, the articulated fingers. In neither drawing, however, is the aggressor shown in mythological guise; Watteau includes neither the satyr's polished horns nor his cloven hoofs, attributes that are clearly legible in the painting itself.[26] Thus Watteau's *Jupiter and Antiope* operates a metamorphosis of its own, from the profane to the classical, without compromising the artist's portrayal of man's frightening aspect which lies at the heart of this composition.[27]

Although impossible to document, it is likely that Watteau painted *Jupiter and Antiope* for Léopold-Philippe-Charles-Joseph, fourth duc d'Arenberg (1690–1754), the young war hero and favorite of Prince Eugene of Savoy who fought between 1709 and 1713 for Charles III (the future Emperor Charles VI) against the French in the later War of the Spanish Succession.[28] A receipt for 200 *livres*, signed by Watteau in May 1717, acknowledges payment for "two paintings made for His Highness the duc d'Arenberg."[29] While there is no doubt as to the authenticity of this document—one of the rare glimpses of Watteau's clientele during his lifetime—it mentions neither painting by name. D'Arenberg is known to have resided in Paris after the conclusion of war, a sojourn which should be dated to late 1715, following the death of Louis XIV in September of that year and the signing of the Third Barrier Treaty in November 1715. Recalled to military action in Hungary in May 1716, he was named *lieutenant général des armées impériales* and fought with great bravery at the battle of Peterwaradin (August 1716).[30] Although d'Arenberg and his wife were intermittently in Paris again in 1718,[31] it seems likely that he commissioned his paintings from Watteau in the winter of 1715–spring of 1716, a period that accords particularly well with the chronology that has been established for *Jupiter and Antiope*.[32]

Pierre Rosenberg's suggestion that *Jupiter and Antiope* may have been painted as an overdoor is particularly intriguing in light of d'Arenberg's receipt for *two* paintings—since overdoors were rarely commissioned as single items—and raises the possibility of a lost companion to *Jupiter and Antiope*, a work that would have been immediately recognizable by its distinctive oval format.[33] Alas, no such painting is known to have existed, and Rosenberg's hypothesis is also brought into question by the exquisite and meticulous handling of the face and body of Antiope, a

supreme example of what the Goncourts described as "*une peinture dessinée*."[34] Such careful description would have been unlikely in a work of decoration, however exalted the patron.

D'Arenberg's second Watteau, companion to *Jupiter and Antiope* or not, remains unknown. The *Signature du Contrat*, also owned by him and engraved in the 1760s as "by Watteau," was formerly considered the best possible candidate for this painting until it was convincingly removed from Watteau's oeuvre; it has since been reattributed variously to Bonaventure de Bar and Pater.[35] The d'Arenberg provenance remains clouded despite the authenticity of Watteau's receipt, and only evidence from eighteenth-century inventories will prove conclusively that Watteau's *Jupiter and Antiope* was indeed commissioned by the fourth duke. In the absence of such documentation, it is worth considering a piece of information from the nineteenth-century literature which helps sustain the connection. Duc Léopold died at his country residence, the château d'Héverlé, near Louvain, on 4 March 1754; the first published reference to Watteau's *Jupiter and Antiope* in the catalogue of Théodore Patureau (20–21 April 1857) noted that the *Nymphe Endormie* came from the château d'Héverlé, and from the collection of Prince Paul d'Arenberg.[36] The likelihood that Watteau's *Jupiter and Antiope* remained in Belgium until it was acquired on the Brussels art market in 1847[37] would also explain two further anomalies: the absence of an engraving after the work in the *Recueil Jullienne*—Jullienne rarely recorded paintings that were unavailable for sale or which were inaccessible to him—and the questionable inclusion of the painting in an interior drawn by Gabriel de Saint-Aubin (fig. 7). Given that Saint-Aubin could not possibly have seen either Watteau's *Jupiter and Antiope* or Chardin's *Woman Cleaning Vegetables*, it is more likely that he based his rather schematic reproduction of *Jupiter and Antiope* on Caylus's etching, a work which was certainly available to him in the early 1760s.[38]

Watteau returned to the subject of *Jupiter and Antiope* twice more, although in entirely different contexts. In *The Bower* (fig. 8), most recently dated to c. 1716 and one of the few decorative designs securely attributed to the artist, Watteau portrayed the satyr in full attack. The nymph, whose status is defined by the urn of water to her right, defiantly resists the onslaught, and her pose recalls the figure of Venus in Watteau's *Cupid Disarmed* (Chantilly, Musée Condé).[39] The sleeping Antiope reappeared as a fountain ornament in the civilized and urbane *Champs-Elysées* (London, Wallace Collection), a nice reversal

of Galatea's fate.[40] But the true successor to *Jupiter and Antiope* was Watteau's *Faux Pas* (fig. 9), also in the La Caze bequest. Here, in "a little canvas heightened with the coloring of a satyr's face," the violent delights of antiquity were translated into contemporary dress with no diminishment.[41]

NOTES

1. Caylus, "La vie d'Antoine Watteau . . . lue à l'Académie le 3 février 1748" in Rosenberg 1984 (A), 72, "En effet, n'ayant aucune connaissance de l'anatomie, et n'ayant presque jamais dessiné le nu, il ne savait ni le lire, ni l'exprimer; au point même que l'ensemble d'une académie lui coûtait et lui déplaisait par conséquent."

2. Paul Mantz was especially critical of Antiope when he wrote "d'une galbe pauvre, son corps est sans ampleur et sans beauté," Mantz 1870, 13; and, of the composition as a whole, "ici, le sujet seul fait penser aux peintres de la grande école, car la forme est tout à fait insuffisante," Mantz 1892, 89.

3. Démoris 1987, 160–61, and see Regis Michel's excellent analysis in exh. Paris 1989, 25–26.

4. Démoris's phrase, literally "propulsion of the eyes," is impossible to translate.

5. Heinecken 1778–90, III, 745, "Vénus avec un Satyre, petite tabatière."

6. Notably Dacier 1923, 4–6. It was in this article that Caylus's etching after *Jupiter and Antiope* was published for the first time.

7. Pausanias, *Description of Greece*, VI, 4.

8. Homer, *The Odyssey*, XI, 260–61.

9. Apollodorus, *The Library*, III, V.

10. Ovid, *Metamorphoses*, VI, 110–12.

11. Benserade's *Métamorphose d'Ovide en rondeau* is discussed in Hourticq 1927, 201, and Mirimonde 1980, 110, 114.

12. The best discussion is Mirimonde 1980, 107–19; for Titian and Correggio's *Jupiter and Antiope*, see also Engerand 1899, 70–72, 129.

13. First recorded in the Nogaret collection, sold 18 March 1782, no. 93. J.-B.-P. Lebrun's description, "coloriés d'après le Titien," is found in the *Catalogue d'une très-belle collection de Tableaux d'Italie, de Flandres, de Hollande, et de France . . . provenans du cabinet de M. [Calonne]*, Paris, 21–30 April 1788, no. 142.

14. Goncourt 1880–82, I, 50, "ce tableau de Jupiter et d'Antiope vous met sous les yeux une des plus étonnantes conquêtes d'un peintre par un autre." Fourcaud 1901, 255; Josz 1903, 398–99; Dacier 1923, 6. The landscape and rustic habitation in the background of *Jupiter and Antiope* further recall the drawings of Campagnola which Watteau had studied and copied *chez* Crozat.

15. Larsen 1988, II, 122–23; Rosenberg in exh. Paris 1984–85 (A), 332; Posner 1984, 80, 283, n. 42. I agree with Posner's conclusion that any relationship between the satyr and a figure in Van Dyck's *Christ Carrying the Cross* (Antwerp, Saint Paulskerk) is "only coincidental."

16. "Vie de Charles de La Fosse" in Dussieux et al. 1854, II, 6; Zerner 1969, L.D. 49.

17. In High Renaissance and Mannerist descriptions of this story, Antiope was rarely portrayed sleeping, Mirimonde 1980, 116.

18. Rosenberg in exh. Paris 1984–85 (A), 332, "une des plus belles créations de Watteau."

19. Posner 1984, 77, 80.

20. Watteau may have also taken the satyr's overarching pose from the nymph who clips the wings of the cupid in the right foreground of Albani's painting.

21. Engerand 1899, 177–78; Puglisi 1983, 247.

22. Leclerc's biographical notice, which appeared in the *Grand dictionnaire historique de Moreri*, Paris 1725, is published in Rosenberg 1984 (A), 8, ". . . passant une partie de son temps à copier pour les marchands du Pont Notre-Dame, les quatre estampes de l'Albane, qu'il peignait et coloriait à sa fantaisie."

23. For example, *L'Apothéose du Beau-Sexe*, London 1712, 84, "Jupiter n'a-t-il pas pris toutes sortes de figures pour s'introduire dans le sanctuaire de la volupté, et ce changement de Paradis n'a-t-il pas été fort de son goût." The connection was first made in Adhémar 1977, 171.

24. Michel in exh. Paris 1989, 26, "entre la jouissance du regard et l'exigence de la fuite."

25. Rosenberg in exh. Paris 1984–85 (A), 135–36.

26. This is somewhat unexpected, since in several drawings of satyrs made around this time Watteau indicated the horns and ears, if not the animal legs, quite distinctly; for example, two studies of a satyr holding a bottle in New York, The Metropolitan Museum of Art, and London, Courtauld Institute Galleries, and two studies of a satyr in a Parisian private collection, Parker and Mathey 1957, 510, 516.

27. This accords with Rosenberg's sensitive conclusion, "oeuvre profane ou oeuvre mythologique, oeuvre profane et oeuvre mythologique," Rosenberg in exh. Paris 1984–85 (A), 332.

28. For the best biographical notice see Gachard 1866, 412–21, and Descheemaeker 1969, 177–201, which corrects certain details in Dacier, Hérold, and Vuaflart 1921–29, I, 77–79.

29. Although noted as in the d'Arenberg family archives as early as 1859, Watteau's receipt was first published in Laloire 1922, 116–18, and is reproduced in Dacier, Hérold, and Vuaflart 1921–29, I, 77.

30. Descheemaeker 1969, 181.

31. Dangeau 1854–60, XVII, 17, 11 May 1718, "Le Duc . . . est parti aujourd'hui pour aller servir dans l'armée de l'empereur."

32. All recent authorities agree that *Jupiter and Antiope* was painted at the time that Watteau was employed on the Four Seasons for Crozat's dining room, see Rosenberg in exh. Paris 1984–85 (A), 330; Posner 1984, 80; Roland-Michel 1984 (B), 221.

33. Rosenberg in exh. Paris 1984–85 (A), 330, an idea taken up by Marianne Roland-Michel in exh. Lille 1985, 159.

34. Goncourt 1989, I, 451, in an account of their visit to La Caze's collection on 8 May 1859.

35. For this rather complicated issue see Dacier, Hérold, and Vuaflart 1921–29, III, 123; Alvin-Beaumont 1932, 31–34. The attribution to Pater is in Camesasca and Rosenberg 1983, no. 62. The *Signature du Contrat* may have been acquired by d'Arenberg during his second stay in Paris in 1727.

36. Laloire 1940, 23; *Catalogue de la belle et riche collection de Tableaux . . . formant la Galerie de M. Théodore Patureau, membre Honoraire de l'Académie Royale d'Anvers*, Paris, 20–21 April 1857, no. 63.

37. Le Roy 1859, 19.

38. Rosenberg in exh. Paris 1979 (A), 257–58. All three primary versions of Chardin's *Woman Cleaning Vegetables* were in princely collections outside France by midcentury, and no copy of Watteau's *Jupiter and Antiope* is recorded. At the time Saint-Aubin was at work on the Chicago sketchbook, 1761–64, he was particularly interested in techniques of engraving and etching, and the pages are peppered with references to prints, printmakers, and print dealers. I am most grateful to Suzanne Folds McCullagh for her help with the Saint-Aubin sketchbook.

39. Rosenberg in exh. Paris 1984–85 (A), 140–42, and Grasselli 1987, II, 304, where she notes of the sheet that "the nymphs and satyrs do suggest a possible connection to the Louvre's *Jupiter and Antiope*."

40. Rosenberg in exh. Paris 1984–85 (A), 330.

41. Ibid., 388, quoting Théophile Gautier, "cette petite toile allumée de ton comme le visage d'un satyre."

FIG. 1
After Jean-Antoine Watteau, *Jupiter and Antiope*, c. 1715–16, engraved by the comte de Caylus, Paris, Bibliothèque Nationale, Cabinet des Estampes

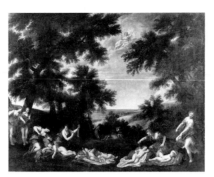

FIG. 4
Francesco Albani, *Diana's Nymphs Disarming Sleeping Cupids*, 1621, oil on canvas, Paris, Musée du Louvre

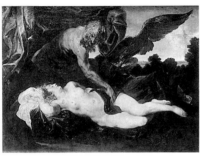

FIG. 2
Anthony Van Dyck, *Jupiter and Antiope*, c. 1615–16, oil on canvas, Ghent, Museum voor Schone Kunsten

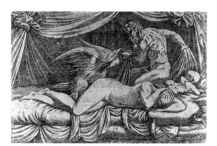

FIG. 5
Jean-Antoine Watteau, *Kneeling Nude Man*, c. 1715, black, red, and white chalk drawing, Paris, Musée du Louvre, Cabinet des Dessins

FIG. 3
After Primaticcio, *Jupiter and Antiope*, c. 1545, engraved by Master L.D., Paris, Bibliothèque Nationale, Cabinet des Estampes

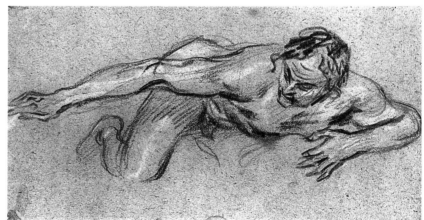

FIG. 6
Jean-Antoine Watteau, *Crouching Nude Man*, c. 1715, black, red, and white chalk drawing, Paris, Institut Néerlandais

FIG. 7
Gabriel de Saint-Aubin, Sketchbook, Folio 22: *Interior of a Private House with Watteau's "Jupiter and Antiope"*, c. 1760–64, Art Institute of Chicago, Mrs. Potter Palmer Sundry Account, Hermann Waldeck Fund, 1946.383

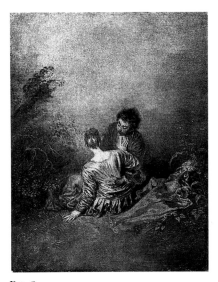

FIG. 9
Jean-Antoine Watteau, *Faux Pas*, c. 1716–18, oil on canvas, Paris, Musée du Louvre

FIG. 8
Jean-Antoine Watteau, *The Bower*, c. 1716, red chalk drawing, Washington, National Gallery of Art, Ailsa Mellon Bruce Fund

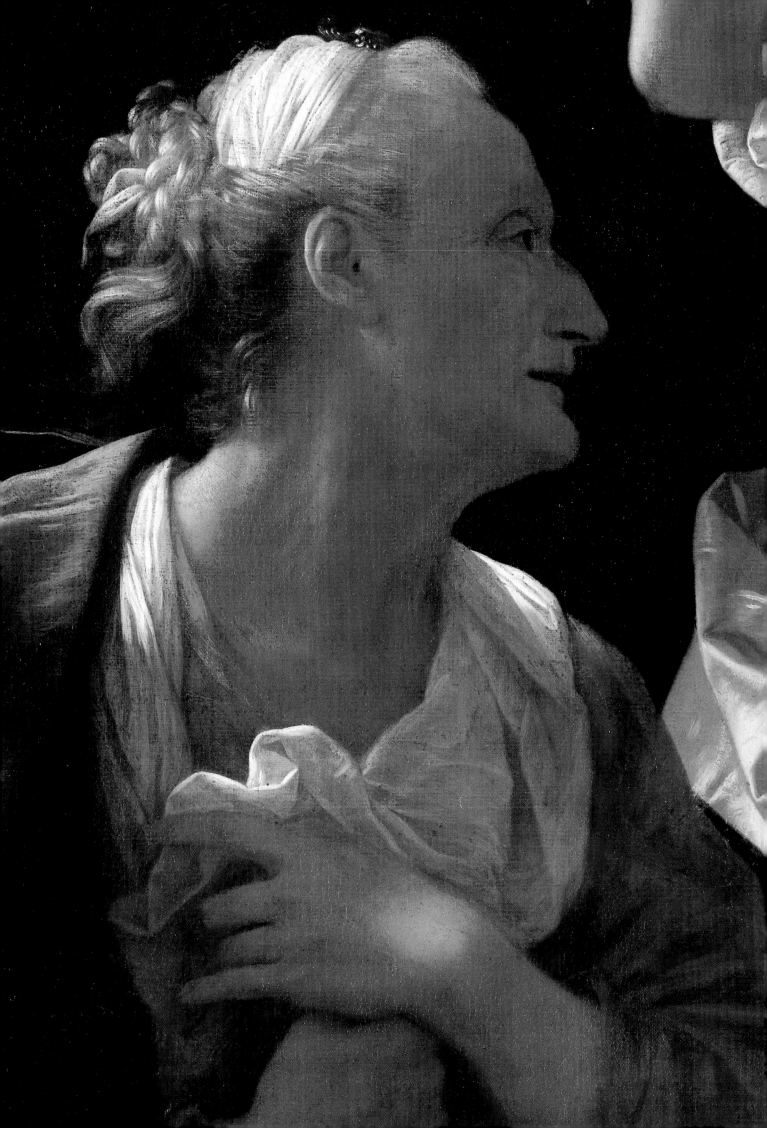

JEAN RANC
(1674–1735)

One of a number of French artists to work at the court of Philip V (1683–1746), Ranc introduced Rigaud's style of portraiture to Spain in the third decade of the eighteenth century. Born in 1674 in Montpellier, where he was trained by his father, Antoine Ranc (1634–1716), a prominent local artist, Ranc moved to Paris in 1697 to continue his studies in the studio of Hyacinthe Rigaud. He is recorded as having participated in the Prix de Rome competition in March of that year.

Formally presented by Rigaud to the Academy in December 1700, Ranc was directed to paint as his morceau de réception the portraits of the academicians Nicolas de La Platte-Montagne (1631–1706) and François Verdier (1651–1730; Musée National des Châteaux de Versailles et de Trianon) and was accepted as a portraitist upon submission of these works in July 1703. At the same time, the Academy conditionally received Ranc as a history painter after he presented Christ Carrying the Cross (location unknown). In order to determine Ranc's worthiness as a history painter, the Academy directed him to paint within a period of six months a subject chosen by Antoine Coysevox. As with the earlier portraits, Ranc was late in submitting this history painting, and in August 1704 he was remonstrated for his slowness. The Academy withdrew his conditional membership as a history painter in November 1707.

Although Ranc's relationship with the Academy may have been turbulent, he was nonetheless patronized by the court. There he was probably aided by his teacher, Rigaud, whose niece Ranc had married in 1715 and who was the favored court

portraitist at the time. Ranc painted portraits of both Louis XIV (Montpellier, Musée Fabre) and Louis XV (1718, Musée National des Châteaux de Versailles et de Trianon), both of which exhibit an excessive dependence on Rigaud. Although Ranc labored to master the brilliant reflections of light that Rigaud produced so effortlessly, his results were stiff and wooden by comparison. Probably painted in France, Ranc's Vertumnus and Pomona (cat. no. 15) is distinguished from these royal portraits by its exceptional sensitivity in the handling of paint as well as by its subject matter.

In October 1721, Jean-Baptise-Louis Andrault, marquis de Maulévrier, wrote to Cardinal Dubois on behalf of the king and queen of Spain to request a portraitist for the Spanish court, proposing Rigaud, Nicolas de Largillière, and François de Troy as possible candidates. Philip V specifically wanted a portraitist of Rigaud's caliber—the latter had painted two portraits of the king just before his departure for Spain (Musée National des Châteaux de Versailles et de Trianon and Madrid, Museo del Prado)—since he was dissatisfied with his current court portraitist, Michel-Ange Houasse (1680–1730), another Frenchman who was more successful as a genre painter. Dubois replied that the artists Philip desired were too old to make the journey but that he would provide a satisfactory replacement. After approaching Jean Raoux, who declined the offer, Dubois, with Rigaud's assistance, convinced Ranc to take the post, citing as incentives the opportunity to make more money and gain greater status than was possible in France.

In September 1722, the Mercure de France announced Ranc's departure for Spain, stating that the artist was to paint portraits of the royal family and receive the astonishing salary of 10,000 livres. Ranc arrived in Madrid by March 1723 and was soon named pintor de cámara and then First Court Painter to Philip V. As the Mercure de France predicted, Ranc primarily painted portraits of the royal family, for example, the Equestrian Portrait of Philip V (Madrid, Museo del Prado), the Portrait of Ferdinand, Prince of Asturias (c. 1723, Madrid, Museo del Prado), and The Family of Philip V (c. 1727, oil sketch, Madrid, Museo del Prado). He is also known to have painted one fresco in the old Alcázar, which was destroyed in the fire of 1734. Ranc traveled to Portugal with Philip V in 1729 to paint the Portuguese royal family, accompanied the royal entourage to Seville, and acquired lodgings at the royal residences of the old Alcázar and the palace at La Granja.

While Ranc obtained prestigious positions at the Spanish court and even directed decorative projects at the Alcázar, he was poorly paid despite his initial expectations and, according to rumor, received mediocre housing. Frustrated in his desire for greater prominence and wealth, Ranc's unhappiness increased dramatically when he was accused of starting the fire that destroyed the old Alcázar on Christmas Day 1734. The vicious rumors that circulated about Ranc's involvement in this disaster—many claimed the fire had originated in his quarters—probably contributed to a dramatic decline in his health, and he died soon after in July 1735.

JEAN RANC, Vertumnus and Pomona (detail), c. 1710–20, oil on canvas, 170 x 120 cm, Musée Fabre, Montpellier

JEAN RANC
Vertumnus and Pomona

15

JEAN RANC (1674–1735)
Vertumnus and Pomona, c. 1710–20
Oil on canvas
170 x 120 cm.
Musée Fabre, Montpellier

PROVENANCE
Sale, Paris, Hôtel Drouot, 30 January 1933, no. 18; acquired by
the Musée Fabre in Montpellier from the Galerie Marcus, Paris,
1964.

EXHIBITIONS
Montpellier 1965, no. 28, ill.; Toledo, Chicago, and Ottawa
1975–76, no. 83, ill.; Bordeaux, Paris, and Madrid 1979–80,
no. 76, ill.

BIBLIOGRAPHY
Gault de Saint-Germain 1808, 156; Baré 1884–85, 39; *Revue de
l'Art Ancien et Moderne* (January 1933), 148; Claparède 1964,
265–66, ill.; Claparède 1968, no. 64–3–1; exh. Toledo, Chicago,
and Ottawa 1975–76, 63; Luna 1987, 234, ill.; Bajou and Bajou
1988, 98, col.; Tomlinson 1989, 3.

One of the most beguiling mythological paintings produced in eighteenth-century France, Ranc's *Vertumnus and Pomona* is also among the most eccentric and the most resistant to scholarly investigation. There is little agreement as to when or where it was executed, and so much finer is this dazzling work than anything else from Ranc's hand that even his authorship has been questioned.[1] Certainly, the shimmering silks, tender expressions, and beautiful still life are little expected from an artist whose work was characterized as "hard in truthfulness, dry in imitation, cold in execution, and somber in color."[2] Yet Nicolas-Étienne Edelinck's engraving (fig. 1)—the basis for the attribution to Ranc, and a document as precious as it is rare—presents evidence that cannot be gainsaid; it is practically the only instance when discussion of *Vertumnus and Pomona* rests on such solid ground.[3]

The story of Vertumnus and Pomona, recounted in the fourteenth book of Ovid's *Metamorphoses*, is one of the more frequently depicted subjects from mythology in French painting of the eighteenth century; artists from Watteau to Boucher delighted in the erotic possibilities of juxtaposing beauty and old age and showing virtue assailed.[4] So devoted was the Roman wood nymph Pomona to her plants and fruit-bearing trees that, "guarding herself against all approach of man," she made her orchard into a sanctuary. Vertumnus, endowed with the ability to take on any shape he wished, began courting Pomona in a variety of guises—"vine-reaper," "leaf-gatherer," "vine-pruner," "apple-gatherer," "soldier with a sword," and "fisherman with a rod."[5] After assuming the appearance of an old woman and thereby winning Pomona's confidence, Vertumnus related the cautionary tale of Anaxarete, a Cypriot noblewoman who, in scorning Iphis, a youth of humble birth, had driven him to take his life. Anaxarete, coming to the window as Iphis's funeral procession passed her house, was riveted to the spot at the sight of her dead suitor and transformed by Venus into a stone statue: "That stony nature took possession of her body which had been in her heart all along."[6] Exhorting Pomona to avoid such

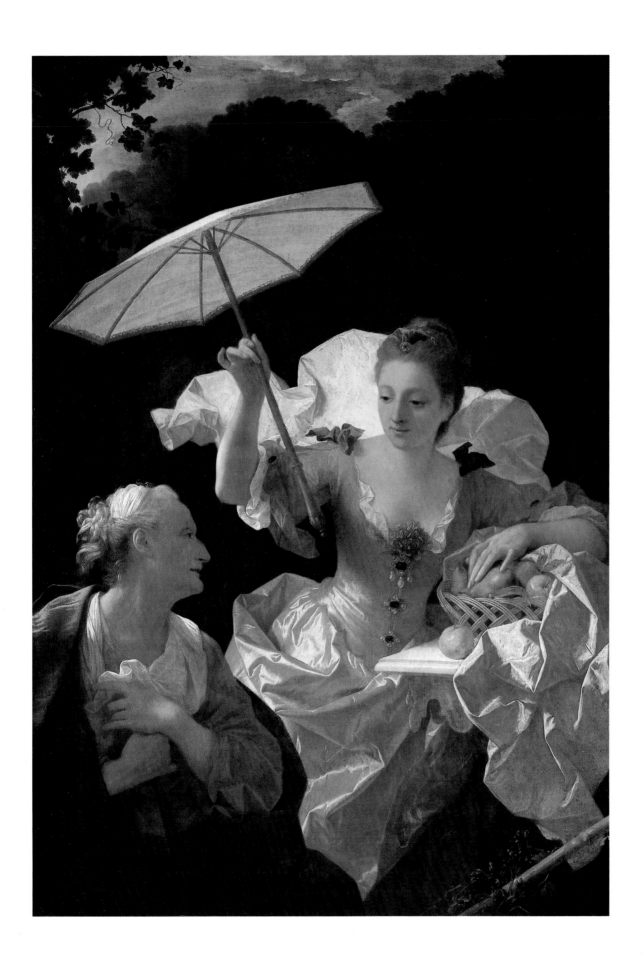

a fate and look more kindly upon Vertumnus, the hero finally relinquished his disguise and revealed himself to the maiden, ready to force himself upon her if necessary. By now, Pomona no longer needed to be coerced: "The nymph, smitten by the beauty of the god, felt an answering passion."[7]

Ranc's colorful and sophisticated painting—the chic of Pomona's day wear!—is also surprisingly attentive to the detail of Ovid's narrative. Not only does Pomona's basket of freshly picked fruit contain the "curved pruning-hook" used to "repress the luxuriant growth"—which one writer considered a harvesting implement peculiar to the Languedoc[8]—but Ranc follows Ovid almost to the letter in his portrayal of Vertumnus, who, we are told, "put on a wig of gray hair, bound his temples with a gaudy head cloth and, leaning on a staff, came in the disguise of an old woman."[9] The darkening of Ranc's canvas makes such accessories difficult to read, but it is clear that the seated woman clutches a walking stick in her right hand.

Vertumnus and Pomona can hardly be characterized as orthodox in its approach to this subject, however. Whereas the story normally provided history painters with an opportunity to treat the female nude, Ranc's skills as a figure painter are not engaged here, and his caparisoned heroine stands at the opposite extreme from Jean-François de Troy's Pomona (fig. 2), who is immodest and almost vulgar by comparison.[10] The emphasis Ranc places on dress—Pomona's billowing train, the carnation tucked into her bodice, her buttons of sapphires, and her pear-shaped pearls—betrays his status as a portraitist of considerable pretension, and such willful anachronism contributes in no small measure to the painting's charm.

Is *Vertumnus and Pomona* a history painting or a portrait? First documented only in 1933, the absence of any provenance before this date encourages caution in attempting to answer the question. Edelinck's engraving—which reproduces accessories not visible in the painting and is of an arched format that suggests that Ranc's painting may well have been cut down—was described by Gault de Saint-Germain as the "*portrait* of a young lady as Pomona in conversation with Vertumnus."[11] The convention of portraying aristocratic sitters in the guise of the Roman wood-nymph was well established in Ranc's day; the artist's teacher, protector, and uncle by marriage, Hyacinthe Rigaud (1659–1743), had painted Anne Varice de Vallière as Pomona, although it was noted at the time that Vertumnus, "simply an accompanying figure," was not intended to represent her husband.[12] Ranc, too, followed this precedent in his *Portrait of a Young Woman as Pomona* (fig. 3), in which Pomona is resplendent in a dress of blue and orange silks, her curved pruning knife in hand, the youthful Vertumnus turning to look at her in the background.[13] Indeed, there are considerable similarities between the paintings from Stockholm and Montpellier; in both cases Pomona wears a flower in her bodice and her dress, while not identical, is equally fashionable and bejeweled. Even Pomona's features—high forehead, delicate chin, lozenge-shaped eyes, a facial type characteristic also of Santerre—suggest a shared model. If there is no doubt that the Stockholm Pomona is intended as a fancy portrait, is it possible that Ranc turned to his wife Marguerite-Elisabeth Rigaud, twenty-three years his junior, as both sitter and muse?[14]

Should one, therefore, attempt to assign personalities to *Vertumnus and Pomona*? First, as Thierry Bajou has pointed out, "the extreme sophistication and the idealization of the young woman's face" argue against a commissioned portrait.[15] It might also be added that if, in the genre of mythological portraiture, the figure of Vertumnus appears as a conceit, in Ranc's *Vertumnus and Pomona* the old woman occupies such prominence and is painted with such care that she cannot be considered merely adjunct. Secondly, while *Vertumnus and Pomona* raises questions that might usefully be asked of a portrait, the search for sitters obscures Ranc's aspirations as a history painter here. The ambiguities inherent in his single known mythological painting reflect upon a debate of some importance: the competing claims for status between the two genres and Ranc's own mortifying reception into the Academy as "academician for portraiture."[16] Viewed in this light, *Vertumnus and Pomona* becomes a spectacular instance of cross-dressing within the academic hierarchy.

The story of Ranc's clouded progression through the ranks of the Academy has been told several times.[17] When, in July 1703, Ranc delivered the two portraits of Verdier and Platte-Montagne (both Musée National des Châteaux de Versailles et de Trianon), commissioned as his *morceau de réception* over two and a half years earlier, he also showed the assembled officers a painting of *Christ Carrying the Cross* which so impressed them that he was given the opportunity to reapply for admission as a history painter. Noting in the minutes that "Sieur" Ranc had "much talent for history painting," the Academy permitted the twenty-nine-year-old artist to receive the subject of his new *morceau de réception*, to be executed and submitted within six months, from the director, Antoine Coysevox.[18] More than four years later, and with the requisite history painting still not forthcoming, the question of Ranc's status within the Academy was quickly resolved; he was given two months to pay a

présent pécunaire of 150 *livres* and informed that he would now enjoy "only the quality of academician for portraiture."[19] Although neither the precise subject of Ranc's second *morceau de réception* nor the reasons preventing him from executing it are known, one thing is certain: Coysevox would have directed the artist to produce a painting of a mythological subject, as was the custom for aspiring history painters.[20] While we are not proposing Ranc's *Vertumnus and Pomona* as a candidate for this work—it is virtually impossible to establish a chronology for this artist— Ranc's *débâcle* at the Academy nonetheless provides an insight into his difficulties with the exalted genre of history and helps situate the indeterminacy of *Vertumnus and Pomona*, apparent to all who have written on the painting, within the context of his own experience of that institution's codes and regulations.[21]

If Ranc's *Vertumnus and Pomona* is the work of a history painter *manqué*, it also reveals the influence of Hyacinthe Rigaud, with whom he worked closely throughout his Parisian career.[22] Ranc's virtuosity in painting drapery never quite compensates for the vacuity of expression and repetition of gesture his sitters customarily display, yet in *Vertumnus and Pomona* the figure of the old woman is painted with such tenderness and refinement that it bespeaks a more profound response to the model. From the light gracing the nape of her neck and the back of her hand to her silvery hair pulled tightly beneath the chalk white headband, the hook-nosed Vertumnus, gazing at Pomona in adoration, is indebted to Rigaud at his most private and intimate. She is a fitting companion to *Madame Rigaud* (Paris, Musée du Louvre)—Ranc's grandmother by marriage—a painting the artist must have known very well and from which he may have derived guidance.[23]

For his rare incursion into history painting, Ranc also followed his uncle in seeking inspiration from Dutch painting of the seventeenth century. Although it is impossible to assign a specific source for *Vertumnus and Pomona*—a ubiquitous subject in Northern art—the affinities between Ranc's would-be lovers and Aert de Gelder's heavily costumed couple (fig. 4), dated c. 1700, are too striking to be entirely fortu-

itous.[24] Both canvases delight in fabric and modern dress; in each, Pomona's apparel is similarly ornate; and the "gypsy hat" that she wears in de Gelder's cabinet painting returns as the parasol in the Frenchman's more elegant version of the subject. While it is unlikely that Ranc would knowingly have sought inspiration in the work of a little-known Dutch artist, de Gelder's *Vertumnus and Pomona* enjoyed an exalted attribution to Rembrandt for most of the eighteenth century; it was as a Rembrandt that Sir Joshua Reynolds would purchase the painting in 1776.[25]

Circumstantial evidence alone would place *Vertumnus and Pomona* more comfortably within the artist's Parisian career, since the influences that bore upon its production would not have been available in Philip V's court. The painting is indebted to Rigaud and to "Rembrandt"; it reflects status claims thrown into relief by Ranc's uneasy relations with the Academy; and it was furthermore reproduced by Nicolas-Étienne Edelinck (1681–1767), who engraved several other works by Ranc in the first and second decades of the eighteenth century.[26] Since Ranc left Paris shortly after September 1722, when the *Mercure de France* announced his departure to Madrid as *pintor de cámara* to Philip V of Spain, it seems unlikely that Edelinck, whom Mariette accused of "unpardonable indolence," would have engraved *Vertumnus and Pomona* had it been painted in Madrid.[27] Ranc's Spanish career was dominated by commissions of royal portraiture of a singularly depressing nature; with the exception of a fresco decoration for the Alcázar, destroyed by fire in 1735, not a single subject painting by him is recorded.[28] Furthermore, the argument that Ranc painted *Vertumnus and Pomona* in Spain is based on the flimsiest of reasoning: the "reappearance" of Pomona's parasol in Goya's tapestry cartoon of the same title (Madrid, Museo del Prado), executed in 1777.[29] As has been noted, Goya might have taken this motif from Edelinck's engraving, from any number of French eighteenth-century paintings, or from life.[30] By contrast, the influences that conspired to produce Ranc's masterpiece are so firmly rooted in the Parisian art world of the regency that his exquisite Pomona might stand as the perfect symbol for that gilded age.

Notes

1. Bajou and Bajou 1988, 98.

2. Gault de Saint-Germain 1808, 156, "vérité dure, imitation sèche, exécution froide, coloris sombre."

3. Baré 1884–85, 39, no. 33; Bibliothèque Nationale 1930–[1977], VIII, 453, no. 31.

4. Pigler 1956, II, 253–54; Watteau's *Vertumnus and Pomona* (New York, Private Collection), painted in all possibility as a pendant to *The Judgment of Paris* (Paris, Musée du Louvre), is discussed by Rosenberg in exh. Paris 1984–85 (A), 418; for Boucher's painting of the subject in the Columbus Museum of Art, see Laing in exh. New York, Detroit, and Paris 1986–87, 243–44, who also suggests the possible source of Roy's ballet *Les Éléments*, first performed at the Tuileries in 1721 and revived on five occasions between 1725 and 1754, in which the story of Vertumnus and Pomona was used to symbolize the element of Earth.

5. Ovid, *Metamorphoses*, XIV, 635–36, 644–51.

6. Ibid., 757–58.

7. Ibid., 771.

8. Ibid., 626; Claparède 1968, X, "modèle utilisé par les vendangeurs en Languedoc."

9. Ovid, *Metamorphoses*, XIV, 654–56.

10. Even though de Troy's *Vertumnus and Pomona*, signed "de Troy filius pinxit," is probably roughly contemporaneous with Ranc's version; de Troy's *Vertumnus and Pomona* was sold at Sotheby's, New York, 12 January 1989, no. 158.

11. Gault de Saint-Germain 1808, 156 (emphasis mine).

12. Bibliothèque Nationale 1930–[1977], VII, 301–2, "groupée avec une autre qui représente Vertumne, mais qui n'est que de simple accompagnement, n'étant pas portrait," citing Hulst's catalogue in the *Mémoires inédits*.

13. This painting, formerly entitled *The Wine Harvest* and attributed to Santerre, was donated to the Nationalmuseum in 1930; its early history is unknown.

14. For Ranc's marriage to Marguerite-Elisabeth, who was also his goddaughter, Jouin 1887 (A), 140–43.

15. Bajou and Bajou 1988, 98.

16. Montaiglon 1875–92, IV, 52, "la qualité d'Académicien sur le talent des portraicts."

17. Notably by Ponsonailhe 1887, 187–88; Bottinneau 1960, 444 (the most accurate account); Luna 1980, 452.

18. Montaiglon 1875–92, III, 306, 369, "comme elle a reconnu qu'il avoit aussy beaucoup de talent pour l'Histoire par un grand tableau de Portement de Croix qu'il a faict voir. . . ."

19. Ibid., IV, 52, "et qu'il n'aura que la qualité d'Académicien sur le talent des portraicts."

20. Ponsonailhe 1887, 188, is incorrect in suggesting that Ranc submitted *Christ Carrying the Cross* for his *morceau de réception*. For a complete listing of artists' *morceaux de réception*, see Duvivier 1852–53, 353–91.

21. Bottineau 1960, 444, n. 273, points out that Ranc never entirely severed connections with the Academy.

22. The artists were still working closely together in 1720 when Rosalba visited them during her stay in Paris, Sani 1985, II, 763, 27 July 1720; Mariette 1851–60, IV, 258, called Ranc Rigaud's "disciple"; see also Dézallier d'Argenville 1762, IV, 324.

23. Rigaud's portrait was exhibited at the Salon of 1704 and later bequeathed by him to the Academy, Rosenberg, Reynaud, and Compin 1974, II, 215.

24. Pigler 1956, II, 250–53; Prague 1984, 192–93. It is interesting that Rigaud's *Presentation in the Temple*, 1743 (Paris, Musée du Louvre), would also be based on Rembrandt's composition.

25. Sumowski 1983, II, 1167, no. 755, where the painting is catalogued as having been attributed to Rembrandt in the collections of the marquis de Lassay and the comtesse de Verrue.

26. Bibliothèque Nationale 1933–[1977], VIII, 446–54; Edelinck engraved two portraits by Ranc as well as the latter's illustrations for La Motte's *Fables nouvelles*, published in 1719.

27. Mariette 1851–60, II, 221, "indolence impardonnable"; Luna 1975, 22–23, for Ranc's departure to Madrid.

28. Bottineau 1960, 449; Aznar, Morales y Marín, and González 1984, 91.

29. Exh. Bordeaux, Paris, and Madrid 1979–80, 63, 138.

30. Luna 1987, 234; Tomlinson 1989, 3.

Fɪɢ. 1
After Jean Ranc, *Vertumnus and Pomona*, c. 1710–20, engraved by Nicolas-Étienne Edelinck, location unknown

Fɪɢ. 2
Jean-François de Troy, *Vertumnus and Pomona*, c. 1720–25, oil on canvas, Private Collection

Fɪɢ. 3
Jean Ranc, *Portrait of a Young Woman as Pomona*, oil on canvas, Stockholm, Nationalmuseum

Fɪɢ. 4
Aert de Gelder, *Vertumnus and Pomona*, c. 1700, oil on canvas, Prague, National Gallery

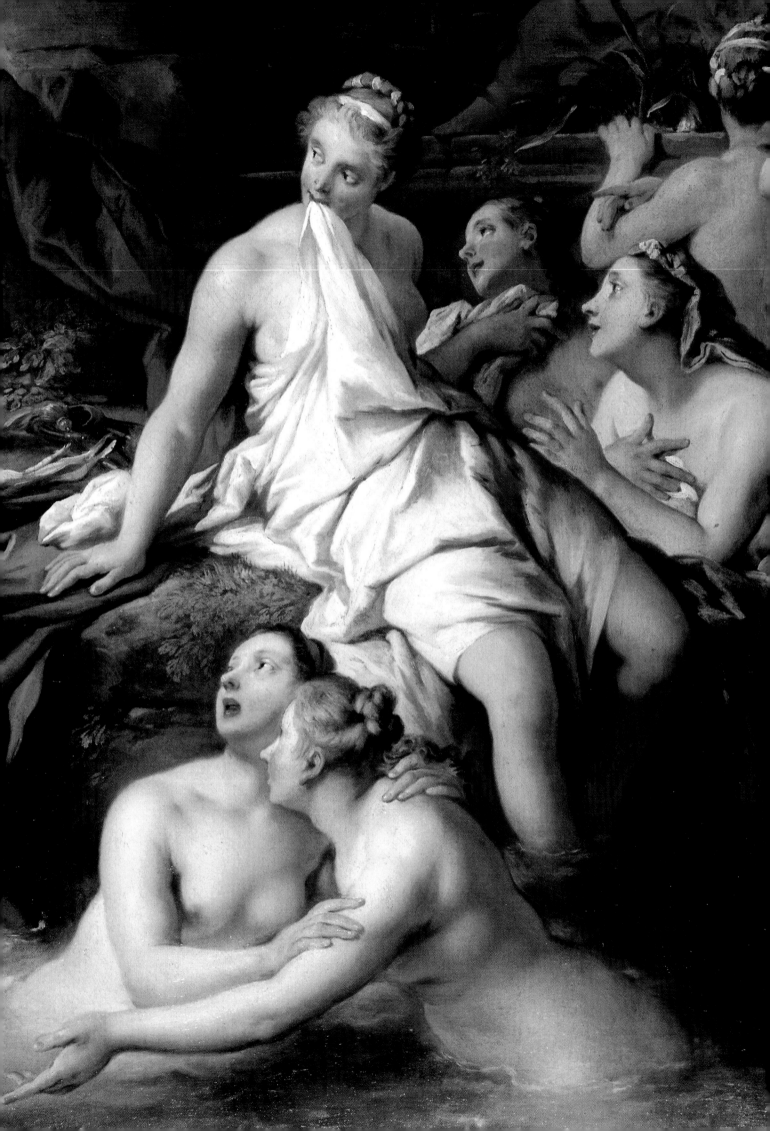

JEAN-FRANÇOIS DE TROY
(1679–1752)

Born into the third generation of a dynasty of painters originally from Toulouse, Jean-François de Troy was trained in Paris by his father, the portraitist and academician François de Troy (1645–1730). He was sent to Rome at his family's expense in the winter of 1698, where he briefly attended the French Academy and went on to Venice and Pisa. De Troy would remain in Italy for seven years—the longest Italian apprenticeship of any eighteenth-century French painter—yet the immediate consequences for his art were negligible. He initially adhered to the principles established by Antoine Coypel, whose declamatory and highly colored manner influenced the younger artist well into the 1720s.

Within two years of his return to Paris in 1706, de Troy submitted *Niobe and Her Children Pierced by Apollo's Arrows* (Montpellier, Musée Fabre) to the Academy as his *morceau d'agrément*. He was made both an associate and full member of the Academy on the same day (28 July 1708), but this may have owed more to his father's recent election to the post of director than to the qualities of the reception piece itself. Almost immediately, de Troy received a commission to decorate the Senate House in Genoa (sketch of *Christopher Columbus Setting Forth to the New World* in Paris, Musée des Arts Décoratifs) but was persuaded to remain in Paris by his father.

Rising quickly within the Academy's ranks, between 1710 and 1720 de Troy seems to have painted mostly small-scale cabinet pictures of religious and mythological subjects, distinctly erotic in character (*Susanna and the Elders*, 1715, Leningrad, The Hermitage; *Bacchus and Ariadne*, cat. no. 16; and *Mercury Confiding the Infant Bacchus to the Nymphs of Nysa*, Berlin, Staatliche Museen Preussischer Kulturbesitz, both signed and dated 1717). Here he worked in a "careful, finished manner" (de Valory) which derived from the previous generation of academicians, notably his father and Antoine Coypel. It was only in 1724 that de Troy received his

first royal commission, two overdoors representing *Zephyr and Flora* and *Acis and Galatea* (Versailles, Hôtel de Ville) for the bedroom of the hôtel du Grand Maître at Versailles, the residence of his protector, Henri, duc de Bourbon, *premier ministre*.

The seven paintings de Troy presented at the Salon of 1725 gave the most complete survey to date of his wide repertory: mythologies and genre paintings on both the large and small scale, including two of his most refined *tableaux de modes*, *The Declaration of Love* and *The Garter* (both New York, Private Collection). Between 1724 and 1735 he produced a small number of such exquisite interiors (for example, *The Reading from Molière*, 1728, England, Private Collection, and *Preparations for the Ball*, 1735, Malibu, J. Paul Getty Museum) which chronicle an urbane society at leisure and which have proven his most admired works, despite Mariette's unexpected disdain for the genre.

However, it was as a history painter that de Troy strove to establish himself; he shared first prize in the *concours de 1727* with his *Diana Resting* (cat. no. 21), a somewhat lackluster mythology that was nonetheless acquired for the Royal Collection. Between 1730 and 1732 he painted a cycle of altarpieces on the life of Saint Vincent de Paul for the Mission of Saint-Lazare in Paris. Yet it was the private sector that offered him more constant and lucrative employment: thirty-five overdoors and decorative panels for François-Christophe de La Live's recently completed *hôtel particulier* on the rue Neuve-du-Luxembourg (see cat. no. 20); four imposing history paintings for the gallery of the town house of financier Samuel Bernard (*Romulus and Remus*, *The Rape of the Sabines*, *The Continence of Scipio*, *Coriolanus*, 1729, Neuchâtel, Musée d'Art et d'Histoire); and mythological suites for the duc de Mortemart, Monsieur de Senozan, and the duc de Lorraine. By contrast, de Troy's aspirations to work for the Crown were frustrated after d'Antin awarded the decoration of the *sa-*

lon d'Hercule at Versailles (1728–36) to François Lemoyne, his bitter rival among the leading history painters of the Academy. However, for a brief time, and much to the anger of his fellow academicians, de Troy succeeded in monopolizing commissions for Gobelins tapestry cartoons by establishing a rate substantially lower than the administration's customary scale of pay. From 1737 to 1740 he submitted seven enormous cartoons for the *History of Esther* (Paris, Musée du Louvre), his masterpieces in the genre and the only works which can begin to affirm the artist's grandiose claim, reported by the Président de Brosses, that he knew of no painter greater than Veronese other than himself.

Disappointed in his ambitions for the post of *premier peintre du roi*, de Troy accepted the directorship of the French Academy in Rome, which he took up in 1738. He would remain for the rest of his life in Rome, where he continued to paint on the grand scale for patrons in both Rome and Paris and where he died in January 1752.

One of the most gifted artists of his generation, whose facility was considered to be little short of prodigious—he was said to design his compositions in his head, to work without the use of drawings and studies, and to refrain from any repainting once his canvases had appeared—de Troy's immense output and tendency to repeat himself brought charges of laxness and superficiality. "Had de Troy added serious study to his natural talent and genius," noted Dézallier d'Argenville, "he might have been remembered as one of the greatest French painters who had ever lived." With his archrival Lemoyne, de Troy introduced a sensuousness and warmth into the language of high art that was well suited to the decorative function that history painting was now being called upon to fulfill. His robust coloring, animated groupings of figures, and, at its best, highly charged painting of the female nude would be equaled in the following generation only by François Boucher.

JEAN-FRANÇOIS DE TROY, *Diana Surprised by Actaeon* (detail), 1734, oil on canvas, 129 x 193 cm, Oeffentliche Kunstsammlung, Basel, Depositum der Gottfried Keller-Stiftung

JEAN-FRANÇOIS DE TROY
Bacchus and Ariadne

16

JEAN-FRANÇOIS DE TROY (1679–1752)*
Bacchus and Ariadne, 1717
Oil on canvas
140 x 165 cm.
Staatliche Museen Preussischer Kulturbesitz, Gemäldegalerie, Berlin, property of the Kaiser-Friedrich-Museums-Verein

PROVENANCE
X. Pittet, sold to C. Soultzener on 5 August 1875; marquise d'Escayrac-Lauture, daughter of C. Soultzener, Paris; acquired by the Staatliche Museen Preussischer Kulturbesitz in 1961.

EXHIBITIONS
.Braunschweig 1983–84, no. 29, ill.

BIBLIOGRAPHY
Dimier 1928–30, II, 36, no. 37, ill.; exh. Toledo, Chicago, and Ottawa 1975–76, under no. 102; Berlin 1978, 449, ill.; Berlin 1985, 402–3, ill.; Bordeaux 1989, 148–49, ill.

Painted in 1717 with its pendant, *Mercury Confiding the Infant Bacchus to the Nymphs of Nysa* (fig. 1), *Bacchus and Ariadne* is the most accomplished and ambitious mythology of de Troy's early maturity. In an appropriately autumnal landscape, and under a clear blue sky, Bacchus and his followers arrive on the island of Naxos where Theseus, Athenian hero and slayer of the Minotaur, has cruelly abandoned Ariadne. The god of Wine, thyrsus in hand, has leaped from his chariot to propose marriage to the tearful princess, who gestures with her right hand to Theseus's ship departing in the distance. As she turns to look lovingly into Bacchus's eyes, Hymen, god of Marriage, his flaming torch in hand, swoops down to sanctify their union.

In contrast to this earnest exchange of vows, Bacchus's attendants disport themselves noisily across the island. Drunken Silenus, seen at left seated on a scowling donkey and propped up by a satyr, is being led to the dance by a bacchante. In the foreground, a baby satyr forces a grape upon a little amor, while on the far right, a fully grown satyr engages in immodest foreplay with a complaisant bacchante, licking his lips in excitement and stroking her neck with his right hand. Behind them, the two panthers who pull Bacchus's chariot look on in obvious delight.

All is sound and fury in de Troy's *Bacchus and Ariadne*, from the tambourine played by the dancing bacchante at left to the triangle held by her similarly attired companion who reclines against the lovers at right. Panpipes (carried by the satyrs at far left and far right), cymbals (played by the bacchante behind Bacchus's chariot), and little bells (attached to the satyrs' waists) add to the cacophony. As if to affirm Bacchus's new dominion, a vine takes possession of the tree in the center of the composition and sprouts grapes, visible on the trunk, at some distance above Hymen's head.

The classical source for de Troy's raucous mythology is to be found not in the *Metamorphoses*, as is sometimes claimed, but in Ovid's *Art of Love*.[1] There, Ariadne is described as having been roused from her weeping by the noisy arrival of Bacchus's

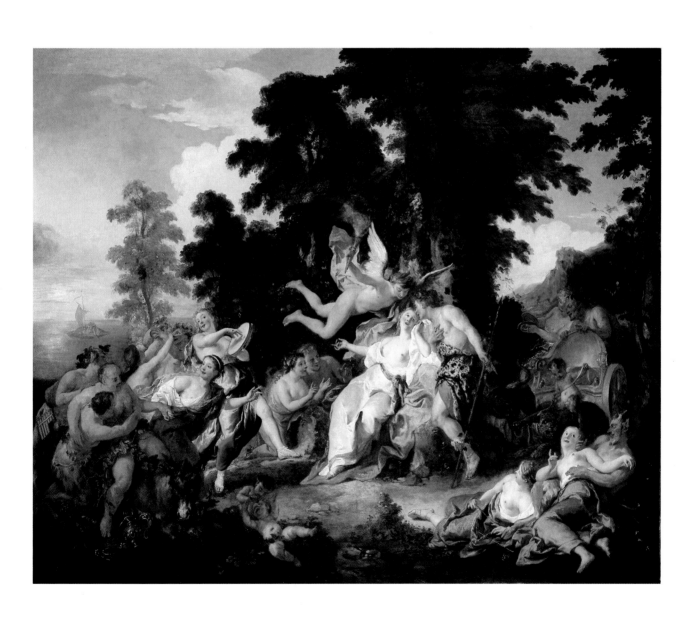

entourage on the island of Naxos: "O'er all the shore cymbals resounded and drums beaten by frenzied hand . . . Lo! Bacchanals with tresses streaming behind them. Lo! wanton satyrs, the god's forerunning band . . ."[2] So frail is Ariadne that she faints at the sight of them—"no blood was there in her lifeless frame"—and is revived only by the arrival of the god himself. Not only does de Troy evoke the carnal musicality of Ovid's description, but he captures the spirit of Ovid's text in his depiction of Ariadne, whose pale skin and white robes are set off by the ruddy flesh tones of the figures around her.[3]

Bacchus and Ariadne displays many of the characteristics of de Troy's "early" style: a complex interlocking of forms; the use of agitated, foreshortened poses; and attention to detail, both in anatomy and drapery. Claiming that it was on such *"ouvrages de jeunesse"* that de Troy's reputation would ultimately rest, the chevalier de Valory described this early style as "a careful, studied manner," a phrase that applies well to the shimmering costumes, alert expressions, and meticulous handling of classical props in *Bacchus and Ariadne*.[4] In a similar vein, Dézallier d'Argenville—critical of the facility and *fa presto* of de Troy's work as it had developed during the 1730s—noted that the young artist had possessed "a pleasing, piquant color, a magnificent sense of composition, the ability to express new thoughts well, great art in capturing the passions of the soul, and backgrounds of majestic simplicity," all of which are in evidence in *Bacchus and Ariadne*.[5]

This early style was, furthermore, impeccably academic. The source for *Bacchus and Ariadne*, whose dancing and reclining bacchantes recall figures by both Titian and Poussin, was, in fact, Antoine Coypel's celebrated cabinet picture of the same subject, painted some thirty years earlier (cat. no. 8).[6] Not only are de Troy's Bacchus, Ariadne, and Hymen modeled on the central group in Coypel's *Bacchus and Ariadne*, but figures such as the satyr and bacchante, who witness the marriage in wonderment, as well as the cavorting couple at right also depend on Coypel's prototypes. Nor was this the first time that de Troy had aped the manner of the *premier peintre du roi*; his recently discovered *Esther and Ahasuerus* (Paris, Private Collection), signed and dated 1714, is little more than a pastiche of Coypel's famous painting, which had entered the Royal Collection in 1697.[7]

Indeed, de Troy imbued his mythology with the silvery line and balletic grace recommended by Coypel as appropriate for this mode of painting: "In gracious subjects, laughter and pleasure should be conveyed throughout by the choice of objects depicted, by a certain lightness of composition, by elegant

draughtsmanship, by a soft, bright coloring and by a gentle, tempered *chiaroscuro*."[8]

Appointed *professeur-adjoint* at the Academy in July 1716, de Troy adhered to the tenets of mainstream history painting as articulated by Coypel, even in this ribald mythology. Comparison with Watteau's reception piece, *The Embarkation to the Island of Cythera* (fig. 2), painted the same year as *Bacchus and Ariadne* and far more probing in its treatment of love and passion, further serves to emphasize the older artist's conservatism and attachment to tradition.[9]

Contrary to his normal practice, de Troy did not repeat this composition, although he did not hesitate to incorporate certain elements from *Bacchus and Ariadne* in subsequent mythologies. He reversed the figure of Bacchus, holding a spearlike thyrsus, in his later treatment of the myth (see cat. no. 19) and used the Venetian landscape and monumental trees as a setting for several paintings, notably *Clytia* (fig. 3), also signed and dated 1717, and *Apollo and Daphne* (Leningrad, The Hermitage).[10] In *The Judgment of Midas* (fig. 4), a painting on panel possibly intended as furniture decoration, the figure of Pan with his monstrous horns and the nymph with a flageolet reclining in the left foreground resemble their counterparts in *Bacchus and Ariadne*. Both works also share a similar autumnal setting, and even the large oak in *The Judgment of Midas* bears a bunch of grapes that more properly belongs in the Berlin mythology. Finally, although it dates from a decade later, de Troy's *Rape of Proserpine* (fig. 5) repeats the figure of flying Hymen, but in a context which does not warrant his benevolent participation.[11]

Neither *Bacchus and Ariadne* nor its more earthbound companion painting is mentioned in any eighteenth-century source that has come to light, a surprising lacuna given the care with which these multifigured compositions were elaborated. According to a tradition that originated with Xavier Pittet, a dealer "specializing in decorative painting" who sold the pendants in 1875, *Bacchus and Ariadne* and *Mercury Confiding the Infant Bacchus to the Nymphs of Nysa* were commissioned by the regent as a gift to his mistress, the marquise de Prie.[12] It is a little disconcerting that such unfounded speculation, of obvious appeal in the age of the Goncourts, should have acquired the status of fact in recent scholarship.[13] At the time de Troy painted *Bacchus and Ariadne*, the scheming and ruthless Jeanne Agnès de Berthelot de Pléneuf, marquise de Prie (1698–1727), whose tenure as the regent's mistress was short-lived, was firmly entrenched in Turin as wife of the French ambassador there. Her return to Paris is documented to 1719.[14]

Although there is equally no evidence to connect de Troy's pendants to Philippe, duc d'Orléans, Pittet's anecdote draws attention to a link between painter and patron that has hitherto gone unnoticed. In a brief autobiographical sketch written in May 1738, prior to his receiving the order of Saint-Michel, de Troy noted with some pride that, soon after his reception into the Academy (28 July 1708), he had "attracted the benevolent attention of the regent, *Monseigneur* duc d'Orléans, who, after examining the competition, honored the artist with a pension."[15] The competition to which de Troy refers is not known, nor does he provide further details of the pension he received from the duc d'Orléans. Nonetheless, de Troy's hopes for advancement in the regent's circle suggest yet another reason for his conscious emulation of Antoine Coypel, the regent's *premier peintre* and the recipient of his most lavish commissions. Ironically, if de Troy was attempting to curry favor with compositions such as *Bacchus and Ariadne*, it was not until well into the following decade, after the regency had ended, that such lusty mythologies would gain ready acceptance among Parisian collectors.[16]

NOTES

1. Ovid, *The Art of Love*, I, 525–65. The connection with Ovid's *Metamorphoses* is made most recently by Henning Bock in Berlin 1985, 402.

2. Ovid, *The Art of Love*, I, 538, 541–42.

3. Ibid., 540. Bock in Berlin 1985, 402, mentions the "alcoholic and erotic transports on all sides."

4. De Valory in Dussieux et al. 1854, II, 259, "la manière soignée et étudiée," which, in his opinion, derived from the artist's early training with his father, the court portraitist François de Troy.

5. Dézallier d'Argenville 1762, IV, 367, "ce jeune artiste avoit un coloris suave et piquant, une magnifique ordonnance, des pensées neuves heureusement exprimées, beaucoup d'art à rendre les passions de l'âme, des fonds d'une simplicité majestueuse."

6. De Troy could have known Titian's *Andrians* (Madrid, Museo del Prado) from either a seventeenth-century copy or Podesta's engraving; Poussin's *Triumph of Flora* (Paris, Musée du Louvre) was acquired by Louis XIV in 1684–85. For the influence of Coypel's *Bacchus and Ariadne* on a younger generation of history painters, see Garnier 1989, 117, who curiously fails to mention the connection with de Troy's *Bacchus and Ariadne* from Berlin.

7. Bordeaux 1989, 145, 148.

8. "Dans les sujets gracieux, tout doit rire et plaire par le choix des objets inventés, par un certain air de légèreté dans la composition, par l'élégance du dessin, par le coloris vague et brillant, par le clair-obscur doux et tempéré, et par le pinceau moelleux, léger et fondu," Coypel in Jouin 1883, 328. Coypel's *Epître à mon fils*, while published in 1721, had been written between 1697 and 1699, and his ideas presumably circulated during de Troy's training at the Academy.

9. Montaiglon 1875–92, IV, 252–53, 28 August 1717. De Troy did not attend the session at which Watteau presented his "feste galante," but he undoubtedly knew the painting. With regard to de Troy's *Bacchus and Ariadne* it is also worth noting that Lagrange-Chancel's lyric opera *Ariane et Thésée* was performed in April 1717, Chouquet 1873, 334.

10. Ruiz 1983, 393; Nemilova 1986, 348–49.

11. Nemilova 1986, 347.

12. Pittet's invoice of 5 August 1875 is preserved in the files of the Department of European Painting at the Gemäldegalerie, Berlin; I would like to thank Erich Schleier for making it available to me.

13. As in Bock in Berlin 1985, 402, and Bordeaux 1989, 148, who is a little more cautious.

14. Thirion 1905, 23.

15. Grandmaison 1904, 623, "il s'attira la bienveillance particulière de Monseigneur le duc d'Orléans, régent, qui sur un examen de concours l'honora d'une pension."

16. Antoine Coypel's *Bacchus and Ariadne*, commissioned by the regent's father, may well have been in the regent's collection at the time de Troy painted his version of the subject.

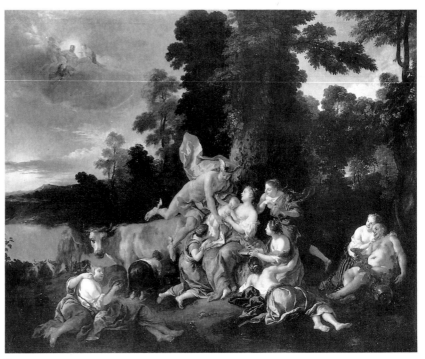

FIG. 1
Jean-François de Troy, *Mercury Confiding the Infant Bacchus to the Nymphs of Nysa*, 1717, oil on canvas, Berlin, Staatliche Museen Preussischer Kulturbesitz, Gemäldegalerie

FIG. 3
Jean-François de Troy, *Clytia*, 1717, oil on canvas, Meaux, Musée Bossuet

FIG. 2
Jean-Antoine Watteau, The *Embarkation to the Island of Cythera*, 1717, oil on canvas, Paris, Musée du Louvre

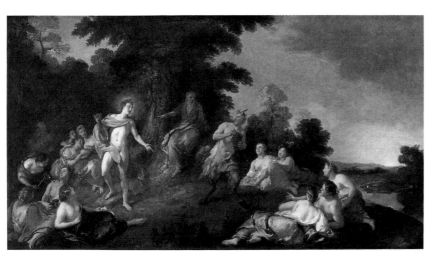

FIG. 4
Jean-François de Troy, *The Judgment of Midas*, c. 1717, oil on panel, Private Collection

FIG. 5
Jean-François de Troy, *The Rape of Proserpine*,
c. 1727, oil on canvas, Leningrad, The
Hermitage

JEAN-FRANÇOIS DE TROY
Pan and Syrinx

Diana and Her Nymphs Bathing

17 & 18

JEAN-FRANÇOIS DE TROY (1679–1752)
Pan and Syrinx, c. 1722–24
Diana and Her Nymphs Bathing, c. 1722–24
Oil on canvas
74.3 x 92 cm. each
The J. Paul Getty Museum, Malibu

PROVENANCE
? Alfred Beurdeley, his sale, Paris, Hôtel Drouot, 25 May 1883, lot 56 [as *Paysage avec baigneuses* and *Pan et Syrinx*]; Gustave Mühlbacher, his sale, Paris, Galerie Georges Petit, 15 May 1899, nos. 38–39 [as François Lemoyne]; sale, Paris, Hôtel Drouot, 15 June 1983, nos. 9–10; Galerie Pardo, Paris, 1983–84.

EXHIBITIONS
Never before exhibited.

BIBLIOGRAPHY
J. Paul Getty Museum Journal, XIII (1985), 210, ill.; Fredericksen 1985, 266; exh. New York, New Orleans, and Columbus 1985–86, 58; Bordeaux 1989, 143, 149–53, ill.

Neither signed, dated, nor engraved, *Pan and Syrinx* and *Diana and Her Nymphs Bathing* rank among de Troy's most seductive and sophisticated mythological paintings and are of a refinement of coloring and handling that the artist normally reserved for his *tableaux de modes*. Much remains to be discovered about these pendants—they are not mentioned in the eighteenth-century literature, it is not known for whom they were painted, and during the nineteenth century they were attributed to Lemoyne— yet it is unlikely that they were originally intended to serve a decorative function as overdoors, since the compositions do not relate symmetrically and de Troy's handling is meticulous and descriptive throughout. Aptly called "mythological landscapes" by a recent scholar,[1] the pendants fall within the category of cabinet paintings whose decorous but undisguised eroticism was praised somewhat disingenuously by the chevalier de Valory: "All those nude figures painted by M. de Troy retained a certain modesty which was the product of an honest soul; in looking at them one was less aware of those licentious ideas which certain subjects regularly bring to mind, than of the artist's talents."[2]

The story of Pan's assault on the nymph Syrinx is recounted in several classical texts, most memorably in Ovid's *Metamorphoses*.[3] Son of Mercury and the nymph Dryope, Pan was born half man, half goat, and his bestial features were mocked by the nymphs who resisted his lustful advances. Pan developed a passion for Syrinx, one of Diana's chaste attendants who was accustomed to hunting alone in the woods, and pursued her as she returned one afternoon from Mount Lycaeus. Upon reaching the water's edge and unable to go any further, Syrinx begged her father, the river-god Ladon, and her sister nymphs to rescue her, and she was transformed into a marsh reed at the very moment of Pan's embrace. The sweet tone produced by the air whistling through the reeds he now held in

his hands so charmed the god that he joined them together to make an instrument of seven pipes. Pan-pipes would henceforward carry his name and be used by his fellow satyrs in their revels.[4]

This popular tale of unrequited love was treated by de Troy on at least six different occasions, the last of which, a decorative panel signed and dated 1751, was painted in Rome the year before his death.[5] The *Pan and Syrinx* exhibited here, which dates from the 1720s, is related to a more expansive composition by the artist (fig. 1), signed and dated 1720, yet it is an altogether more poignant and sensuous interpretation of the subject.[6] The virginal Syrinx is shown wedged between a muscular Ladon, reclining against a massive urn, and the impassioned Pan, who clutches a bunch of marsh reeds in his right hand. The sister nymphs at left, their voluptuous bodies half in shadow and marsh reeds entwined in their hair, look on helplessly as Syrinx utters a last cry for help. The figure of Pan himself is de Troy's most poetic invention; "sighing in disappointment," he is portrayed as a handsome, lightly bearded youth, a significant departure from convention since the god was more usually shown as an older man with a broadened nose and coarse features. De Troy was certainly familiar with this tradition; as a student in Rome he had copied the marble sculpture of *Pan and Apollo* in the Ludovisi collection, and in every other version of the myth he presented Pan as a lusty, adult attacker.[7] Yet here he endows the god with a pleasant demeanor and an expression of genuine despair, both of which enable us to look beyond his grotesque body and consider Syrinx's transformation as a loss rather than a release. It is this subtle change of emphasis that accounts for the pervasive mood of melancholy in *Pan and Syrinx*.

Although de Troy's gentlemanly Pan is an affecting, if idiosyncratic, symbol of frustrated desire, the artist also drew upon far more orthodox sources for this composition. Both the pose of Syrinx, frozen in flight, as well as the highly charged juxtaposition of naked male and female flesh, derive from Poussin's *Pan and Syrinx* (fig. 2), a painting de Troy possibly knew since it had passed through several prominent Parisian collections before its acquisition by Augustus III of Saxony in 1742.[8] For the figure of Ladon, de Troy had recourse to a stock *académie*; the reclining river-god—arms outstretched, musculature carefully observed—was one of the standard poses studied by generations of academicians, recorded in drawings by artists as different as Louis de Boullongne and Jean-Baptiste Greuze.[9]

Comparison of de Troy's *Pan and Syrinx* and an overdoor of the same subject by his contemporary Noël-Nicolas Coypel, signed and dated 1723 (fig. 3),

gives a better sense of de Troy's unusual refinement and sensitivity in this often-treated theme. While at first glance the elements of the two paintings are practically the same—indeed, Coypel proves himself the more erudite history painter in showing Syrinx with her "horned bow" and quiver of arrows—de Troy, unrestricted by the confines of decoration, creates a drama of real conviction in which landscape and figures fuse to re-create the ardent passions of antiquity.

In pairing *Pan and Syrinx* with *Diana and Her Nymphs Bathing*, de Troy was not following an established iconographic tradition. In 1724 Jean-Baptiste Nattier, the portraitist's older brother, painted *The Triumph of Galatea* as a pendant to de Troy's earlier version of *Pan and Syrinx*, now in Cleveland.[10] In 1741 de Troy himself paired *Pan and Syrinx* with *Apollo and Daphne* in the pendants he painted for Christian VI of Denmark.[11] However, despite the tenuous connection in subject matter, de Troy's *Diana and Her Nymphs Bathing* not only retained the delicate touch and refined palette of its pendant, it also provided the artist with yet another opportunity to re-create an Ovidian theme with both imagination and sensitivity.

Specificity of reference in *Diana and Her Nymphs Bathing*, as in much of de Troy's profane oeuvre, is unexpected and easily overlooked: even his most appreciative critics tended to dismiss de Troy's interest in classical literature, Mariette going so far as to call him a mere "workman."[12] His former pupil, the history painter and theoretician Michel-François Dandré-Bardon, gave greater credit to de Troy's learning in recalling the advantages he derived both from his connections in high society and from "his reading of the Authors and his naturally cultivated mind."[13] For, in *Diana and Her Nymphs Bathing*, de Troy represents the moment in which Diana disrobes almost exactly as Ovid had described it: "On this day, having come to the grotto, she gives to the keeping of her armor bearer among her nymphs her hunting spear, her quiver, and her unstrung bow; another takes on her arm the robe she has laid by; two unbind her sandals from her feet. But Theban Crocale, defter than the rest, binds into a knot the locks which have fallen down her mistress's neck."[14] Clearly de Troy is not a slavish copyist; Diana's bow, which hangs on the trunk of the entwined trees in the center, is shown fully strung; one nymph, not two, has taken off her sandal and is now occupied in drying her foot. Yet with apparent ease de Troy has translated onto canvas the activity of each maiden as punctiliously described by Ovid, and thus his grouping of beautiful naked women is neither random nor arbitrary. The fourth nymph, who covers the eyes of the lascivious river-god at left—both of whom seem to have wandered in from the stream in *Pan and*

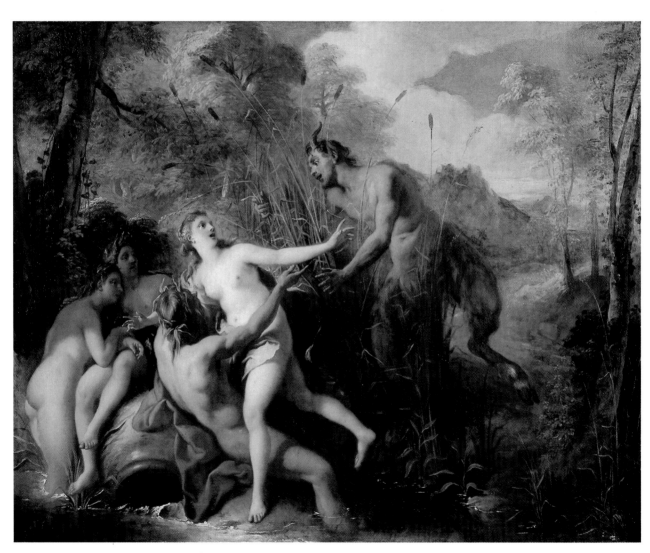

Cat. 17

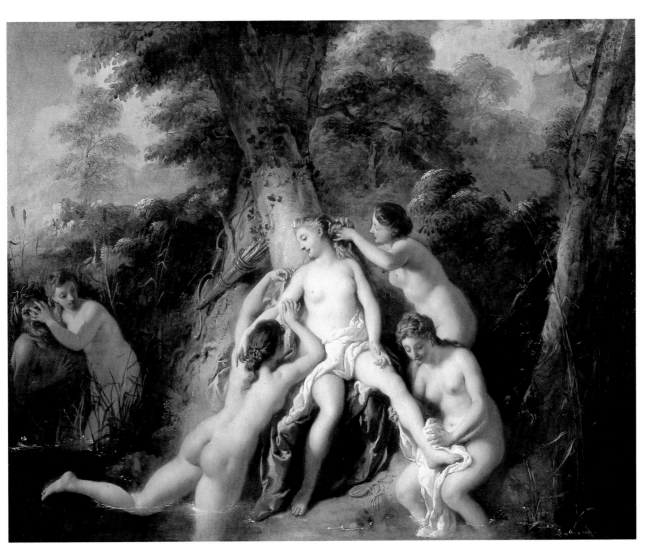

Cat. 18

Syrinx—is a clever allusion to the sequel to this episode in which Actaeon, having stumbled unwittingly across Diana in repose, is transformed into a stag and mauled to death by his own hunting dogs.

In *Diana and Her Nymphs Bathing*, de Troy's touch is at its most delicate and his coloring at its most elegant, from the pale lavender of Diana's robe to the pink ribbons of her sandals which trail into the limpid pool below. The fleshy tints of Diana and her attendants are beautifully modulated, their buttocks, breasts, and knees picked out in touches of the softest pink. Diana, with her little crescent moon pinned like a jewel to her hair, has the pearly whiteness befitting the virgin goddess, although her gesture of gently caressing the neck of the nymph who earnestly unpins her robe conveys a powerful eroticism. De Troy's learning is well disguised, but it is his easy intimacy with Ovid's account that allows him to invent these exquisite details.

Curiously, it is from an earlier depiction of *Pan and Syrinx* that de Troy has borrowed certain poses for *Diana and Her Nymphs Bathing*. For example, the nymph seen from behind unpinning Diana's gown is a quotation from Bertin's *Pan and Syrinx* (fig. 4), dated c. 1710–15, and is another example of how de Troy adapted for his own use elements from the more finished, declamatory manner of an earlier generation of history painters.[15]

Although the story of Diana would provide the artist with the subjects of his most prestigious mythologies (see cat. nos. 21, 22), de Troy is not known to have repeated this particular episode, despite its obvious appeal. However, he painted a variant of this composition, *Zephyr and Flora* (fig. 5), a work probably executed in the mid-1720s and previously attributed to Charles-Antoine Coypel.[16] The nymph seen from behind, which had become de Troy's sig-

nature, also repeats exactly the pose of the river-god in the *Pan and Syrinx* from Cleveland. Natoire, director of the French Academy in Rome, included a reminiscence of his predecessor's *Diana and Her Nymphs Bathing* in a charming landscape drawing (fig. 6), dated October 1757, in which the central group of figures, clearly intended to represent Diana and her attendants, derives from de Troy's cabinet picture.[17]

If the early provenance of these exquisite cabinet paintings remains obscure, their dating is an equally unresolved issue, since a reliable chronology for de Troy's early and middle career remains to be established. Jean-Luc Bordeaux, who has written of the "luxuriant landscape settings" and "marvelous autumnal tonalities" of the Getty pendants, has dated them to c. 1717, which seems too early for these fluent and painterly mythologies.[18] It would seem more likely that these pendants were made after, rather than before, the more orthodox *Pan and Syrinx* from Cleveland, dated 1720. In both handling and modeling the figure of Diana compares well to *Danae* (fig. 7), which in turn has been related to the signed and dated *Lot and His Daughters* (Orléans, Musée des Beaux-Arts), painted in 1727.[19] If a date of c. 1722–24 for the Getty pendants can be advanced, it is tempting to see in de Troy's careful finish and refined tonalities a response to Lemoyne, whose small-scale mythologies were beginning to attract the attention of Parisian collectors at this time. De Troy rarely reached a comparable level of fluency and finish in his mythological paintings—even his most devoted supporters were critical of his inconsistency and lack of application— yet it may be said of *Pan and Syrinx* and *Diana and Her Nymphs Bathing*, as of few other of de Troy's cabinet paintings in this genre, that they were painted "with love and tenderness, as the subject requires."[20]

NOTES

1. Fredericksen 1985, 266.

2. De Valory in Dussieux et al. 1854, II, 260, "toutes les nudités peintes par M. de Troy conservoient cette sorte de retenue qu'inspire une âme honnête, et l'on étoit moins occupé en les regardant des idées licencieuses dont certains sujets sont toujours susceptibles que du talent de l'artiste."

3. Ovid, *Metamorphoses*, I, 698-712; see also Longus, *Daphnis and Chloe*, II, 34; Ménard 1874, 84-92 passim, for a good introduction to Pan.

4. In de Troy's *Bacchus and Ariadne* from Berlin (cat. no. 16), two satyrs are shown with panpipes attached to their waists, which in both instances have the instrument's requisite seven pipes.

5. The versions are *Pan and Syrinx*, signed and dated 1720, The Cleveland Museum of Art; *Pan and Syrinx*, signed and dated 1733, reproduced in Bordeaux 1989, 156; *Pan and Syrinx*, painted in 1741 for Christian VI of Denmark and destroyed by fire in 1794; an almost identical version of the latter, installed by the Danish foreign minister Schuling in the garden of Frederiksdal Slot, reproduced in Krohn 1922, plate 3; a similar composition, signed and dated 1751 (according to Talbot 1974, 258) and engraved by François Hutin, formerly in the collection of Paul Wallraf, London; finally, "un tableau touché savamment et de bonne couleur; il représente Sirinx [sic] dans les bras du fleuve Ladon, que regarde Pan embarassé dans des roseaux," *Catalogue d'une Collection de Très Beaux Tableaux, Dessins et Estampes de Maîtres des Trois Ecoles . . . partie de ces effets viennent de la succession de feu M. J.B. [sic] de Troy*, 2–5 May 1764, no. 107.

6. For the Cleveland *Pan and Syrinx*, see the extremely well documented articles by Talbot 1974, 250–59, and Lurie in Cleveland 1982, 143–45.

7. Montaiglon and Guiffrey 1887–1912, III, 89, letter of 12 September 1702, in which Houasse writes that he had encouraged de Troy to paint after this marble group "pour l'assujetir à la correction du dessin, qu'il négligeoit pour se donner entièrement à la couleur"; for the history of *Pan and Apollo*, see Haskell and Penny 1981, 286–88.

8. Blunt 1966, 122–23. Syrinx's pose is also repeated, in reverse, in de Troy's monumental *Allegory*, which passed through Couturier & Nicolay, Paris, Nouveau Drouot, 16 December 1981, no. 22.

9. Bean 1986, 47, 122.

10. Lurie in Cleveland 1982, 143; the painting is reproduced in Grasselli 1988, 356.

11. Watson 1950, 53; Krohn 1922, plates 3, 4.

12. Mariette 1851–60, II, 101, "mais l'on dira toujours de luy que c'est un practicien"; de Valory in Dussieux et al. 1854, II, 260, noted that de Troy had "un esprit fort ordinaire" and that he was not at all cultivated.

13. Dandré-Bardon 1765 (A), II, 170, "les avantages qu'il retira de la fréquentation des bonnes compagnies, la lecture des Auteurs et son esprit naturellement élevé communiquoient à toutes ses productions et à la plupart de ses figures cette dignité de maintien."

14. Ovid, *Metamorphoses*, III, 164–70.

15. Lefrançois 1981, 134–35; the nymph was also the model for the figure of Ladon in de Troy's *Pan and Syrinx* in Cleveland. De Troy never hesitated to repeat and reverse figures in this way.

16. This painting, once attributed to Lemoyne and called *The Glorification of Venus*, Grimaldi de Cadiz sale, Amsterdam, 4–5 December 1912, last appeared at Sotheby's, New York, 18 June 1974, no. 157, as *Diana Adorned with a Garland of Flowers* by Charles-Antoine Coypel.

17. Exh. Paris 1974–75, no. 33, plate XIV. There is a weak and later copy of the painting, with some variants, incorrectly ascribed to Lagrenée, in the Musée des Beaux-Arts, Besançon. Another "Bain de Diane," of almost identical dimensions to the Getty *Diana and Her Nymphs Bathing*, was sold by Gersaint, *Catalogue d'une grande collection de tableaux des meilleurs maistres, d'Italie, de Flandres et de France . . .* , Paris, 26 March 1749, no. 47, "trente-trois pouces de large sur vingt-sept pouces de haut." No accompanying Pan and Syrinx appeared in this sale.

18. Bordeaux 1989, 49–50, 53.

19. Sotheby's, Monaco, 29 November 1986, no. 352; O'Neill 1981, I, 140–41.

20. The phrase is Poussin's: "Je l'ay peint avec amour et tendresse; le sujet le vouloit ainsi," and is his comment on the *Pan and Syrinx* he painted in 1637 for Nicolas Guillaume La Fleur, Blunt 1966, 23.

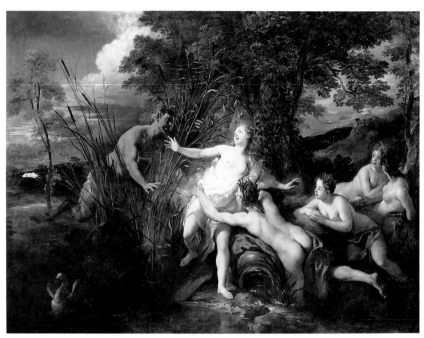

FIG. 1
Jean-François de Troy, *Pan and Syrinx*, 1720, oil on canvas, The Cleveland Museum of Art

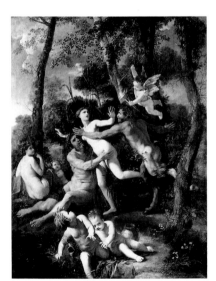

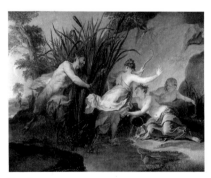

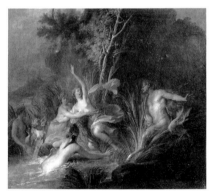

FIG. 3
Noël-Nicolas Coypel, *Pan and Syrinx*, 1723, oil on canvas, Private Collection

FIG. 4
Nicolas Bertin, *Pan and Syrinx*, c. 1710–15, oil on canvas, Paris, Musée du Louvre

FIG. 2
Nicolas Poussin, *Pan and Syrinx*, c. 1637, oil on canvas, Dresden, Gemäldegalerie Alte Meister

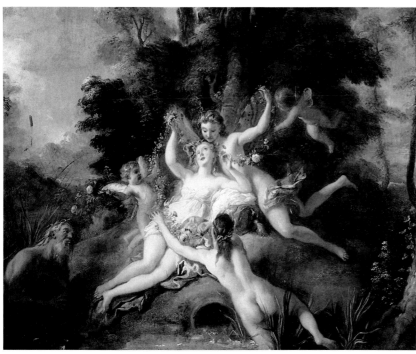

FIG. 5
Jean-François de Troy, *Zephyr and Flora*, c. 1725, oil on canvas, Private Collection

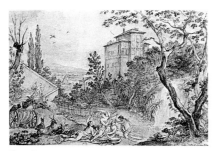

FIG. 6
Charles-Joseph Natoire, *The Villa Spada Seen from the Botanical Garden in Rome*, 1757, pen and brown ink, brown wash, and watercolor with white highlights on a black chalk drawing, Montpellier, Musée Atger

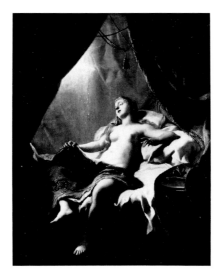

FIG. 7
Jean-François de Troy, *Danae*, c. 1721, oil on canvas, Private Collection

JEAN-FRANÇOIS DE TROY
Ariadne on the Island of Naxos

19

JEAN-FRANÇOIS DE TROY (1679–1752)
Ariadne on the Island of Naxos, 1725
Oil on canvas
161 x 128 cm.
Musée Fabre, Montpellier

PROVENANCE
Marie-Joseph de Guignard, vicomte de Saint-Priest (1732–1794), who gave the painting to the Montpellier Société des Beaux-Arts in c. 1779; École des Arts et des Ponts et Chaussées, 1787; École Centrale de Montpellier, by November 1797; given to the Muséum de la ville de Montpellier, by 1806.

EXHIBITIONS
Montpellier 1779, no. 34.

BIBLIOGRAPHY
Montpellier 1850, no. 446 [as François de Troy]; Montpellier 1859, no. 489 [as François de Troy]; Blanc 1865, 9; Lafenestre and Michel 1878, 231; Michel 1879, no. 696 [as François de Troy]; Bellier de La Chavignerie and Auvray 1882–87, IV, 597 [as François de Troy]; Michel 1890, no. 414 [as François de Troy]; Montpellier 1904, no. 537 [as François de Troy]; Montpellier 1910, no. 537; Stein 1913, 376, 392; Montpellier 1914, no. 537; Joubin 1926, no. 783; Dimier 1928–30, II, 46; Vergnet-Ruiz and Laclotte 1965, 253; Claparède 1968, X, no. 806–II; Bajou 1989, 4, ill.; Bordeaux 1989, 154, ill.

De Troy's *Ariadne on the Island of Naxos*, the first painting to enter the collection of the *Société des Beaux-Arts* of Montpellier, forerunner of the Musée Fabre, has endured both the vicissitudes of connoisseurship and the perils of overzealous restoration. Exhibited in 1779 under its correct attribution, by the middle of the following century the painting was assigned to François de Troy (1645–1730), the artist's father, despite the legibility of the date and signature, "*Par J.F. de Troy, 1725*," prominently inscribed in the lower right-hand corner.[1] Catalogued as by Jean-François de Troy in 1878, but as by François de Troy the following year, *Ariadne on the Island of Naxos* returned again to the younger de Troy in 1910, only to be rejected by Gaston Brière in 1928.[2] Brière, whose monograph on the artist has still to be revised and expanded, discounted the first initial of the signature and affirmed that the painting had been executed by François de Troy, who would have thus completed it in his eightieth year![3] The ingenious, if unlikely, suggestion that *Ariadne on the Island of Naxos* was a collaborative effort between father and son—de Troy *père* painting the figures of Bacchus and Ariadne and de Troy *fils* responsible for the putti and satyrs—was later put forward by Robert Mesuret, but failed to win acceptance.[4] Most recently, *Ariadne on the Island of Naxos* has been published as by Jean-François de Troy without discussion, the earlier battles over authorship consigned to references in the cataloguer's bibliography.[5]

Confronted with de Troy's *Ariadne on the Island of Naxos*, which has undergone a sensitive restoration for this exhibition, such confusion becomes a little easier to understand and is of more than merely academic interest. For in its glacial coloring, carefully drawn figures, and painstakingly described draperies, *Ariadne on the Island of Naxos* is one of de Troy's most old-fashioned compositions. It betrays an excessive dependence on the history painters of his father's generation and perpetuates, in the painting of the satyr who crushes the bunch of grapes between his hands and the putti who strain to drink the liquid, a *rubenisme* that had become distinctly outmoded by the 1720s.

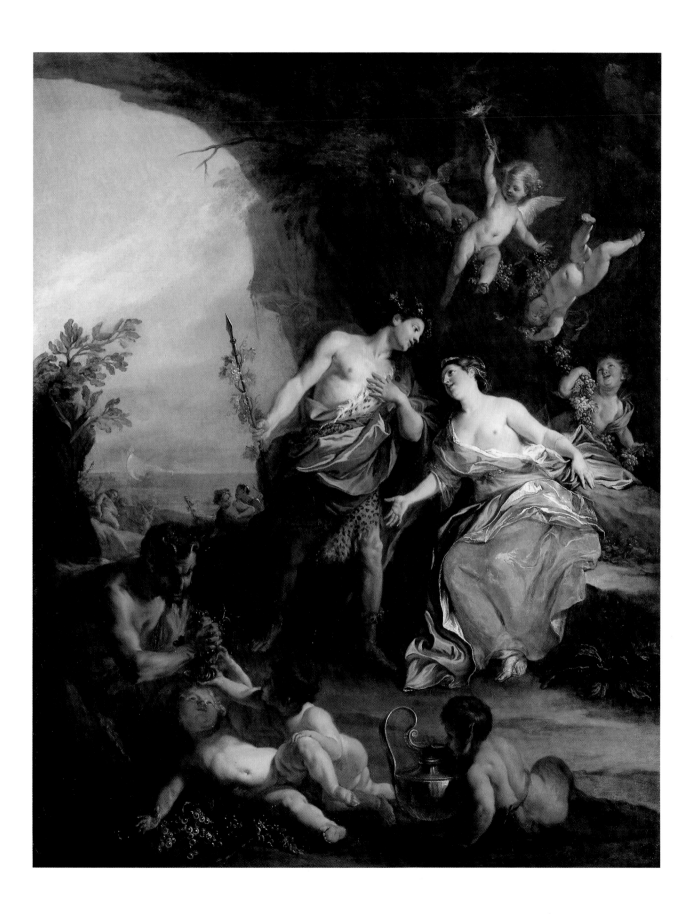

The composition in general derives from Antoine Coypel's *Bacchus and Ariadne*, painted in 1693 (cat. no. 8). From this, de Troy has taken the motif of the enormous vine, heavy with grapes, which is borne aloft by the flying putti—one of them bearing the hymeneal torch—who celebrate the impending marriage of Bacchus and Ariadne. The god of Wine and the Cretan princess strike theatrical poses reminiscent of the protagonists in La Fosse's *Bacchus and Ariadne* (cat. no. 6); indeed, one writer has gone so far as to characterize de Troy's canvas as a "clever parody" of the latter work.[6] The meticulously rendered grapes and ewer, as well as the red-cheeked and inebriated infants in the foreground, are painted with a degree of finish and Flemish naturalism that evoke Bertin (see, for example, his *Bacchus and Ariadne*, cat. no. 11), but *en grand*.

That de Troy, at the height of his Parisian career, should have painted in such an archaizing mode is almost inexplicable. While the artist's deference to his father was well documented—de Valory claimed that his early work "bore too distinctly the stamp of the artist from whom he had first received his training"— by the 1720s it would be hard to accuse Jean-François de Troy of "excessive servility" towards the precepts of his father's generation.[7] In August of the year that he signed *Ariadne on the Island of Naxos*, de Troy had amply displayed the virtuosity and originality of his art in the seven paintings he exhibited at the Salon of 1725. Among these were the monumental and freely brushed *Country Lunch* (fig. 1); the exquisitely rendered *Declaration of Love* (fig. 2), de Troy's masterpiece in the genre; and the moving and concentrated *Sacrifice of Iphigenia* (fig. 3), one of the artist's most fluent mythologies. Even if it is accepted that de Troy routinely worked in different modes at the same time,

it still remains difficult to reconcile the declamatory and somewhat simplified composition of *Ariadne on the Island of Naxos* with the sophisticated *tableaux de modes* and gracious, spirited history paintings by which de Troy was represented at the Salon of 1725.[8]

De Troy treated the story of Bacchus and Ariadne several times. In addition to the Berlin *Bacchus and Ariadne* (cat. no. 16), another version of the subject was paired with *Zephyr and Flora*, both recorded in the collection of the chevalier Lambert and sold by Lebrun on 27 March 1787.[9] Unfortunately, it is not known for whom the Montpellier *Ariadne on the Island of Naxos* was painted, for the circumstances of its commission might, in fact, help explain the reasons for de Troy's conservative manner and in turn set to rest the earlier confusion over the painting's authorship.

The subsequent history of *Ariadne on the Island of Naxos* is better known. By 1779 it had entered the prestigious collection of French paintings and drawings assembled by Marie-Joseph de Guignard, vicomte de Saint-Priest (1732–1794), *intendant du Languedoc*, *associé-fondateur* and president of the *Société des Beaux-Arts*, and that institution's greatest benefactor.[10] Saint-Priest may have had a particular affection for the de Troy dynasty; he lent François de Troy's *Self-Portrait* and *Portrait of Jeanne Cotelle* to the Montpellier exhibition of 1779, as well as a *Self-Portrait* and another unidentified history painting by Jean-François de Troy.[11] Along with a plaster cast of Houdon's *Écorché*, purchased in 1779, de Troy's mythology was one of two works donated to the *Société des Beaux-Arts* for use in its art school. As a model for aspiring figure painters, the rhetorical, almost frozen attitudes of Bacchus and Ariadne must have provided excellent material for study.[12]

NOTES

1. Montpellier 1850, 115.

2. Lefenestre and Michel 1878, 231; Michel 1879, 173; Montpellier 1910, 154; Brière in Dimier 1928–30, II, 46.

3. Brière in Dimier 1928–30, II, 46, "par l'exécution nous voyons que le tableau est du père, et non du fils."

4. Cited in Claparède 1968, X, no. 806–II.

5. Ibid.; Bajou 1989, 3–4; Bordeaux 1989, 154.

6. Bordeaux 1989, 154.

7. De Valory in Dussieux et al. 1854, II, 258, "ses premiers ouvrages portoient à cet égard le cachet de celui dont il avoit reçu les premiers principes."

8. Wildenstein 1924 (B), 39–40.

9. *Catalogue de tableaux capitaux et d'objets rares et curieux . . . le tout provenant des cabinets de M. le Chevalier Lambert et de M. Du . . .*, Paris, 27 March 1787, no. 193, "Ariane dans l'isle de Naxos . . . hauteur 27 pouces, largeur 34 pouces." The painting with which this was paired, de Troy's *Zephyr and Flora*, reappeared as by Charles-Antoine Coypel, incorrectly identified as *Diana Adorned with a Garland of Flowers* (cat. nos. 17 and 18, Fig. 5).

10. Lainé 1828–50, IX, 21; Bajou 1989, 3–4, who confuses the vicomte de Saint-Priest with his father, Jean-Emmanuel (1714–1787), also *intendant du Languedoc* and equally a benefactor of the *Société des Beaux-Arts* of Montpellier. Abraham Fontanel, the book dealer who organized the exhibition at Montpellier and purchased works of art for Saint-Priest—he acquired Fragonard's bister drawing, *The Apotheosis of Prince Frederick Henry* (Paris, Musée du Louvre, Cabinet des Dessins), also exhibited at Montpellier in 1779—later noted on the verso of this drawing that it had passed from the collection of his "respectable protecteur, M. le Vicomte de St. Priest" to the latter's son-in-law, M. Masclary. The baron de Masclary married Marie-Joseph's youngest daughter, Marie-Thérèse-Antoinette-Charlotte de Guignard de Saint-Priest, which helps confirm the identity of the president of the *Société des Beaux-Arts* as vicomte Marie-Joseph and not Jean-Emmanuel, see Stein 1913, 367; exh. Paris and New York 1987–88, 180.

11. Stein 1913, 392, nos. 32–36; François de Troy's *Self-Portrait* and *Portrait of Jeanne Cotelle* recently reappeared at Sotheby's, Monaco, 6–7 December 1990, nos. 43 and 44, although it is impossible to confirm that these were the versions owned by Saint-Priest.

12. Bajou 1989, 4.

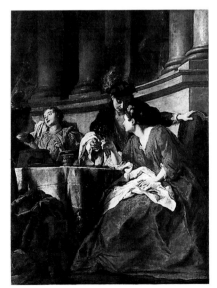

FIG. 1
Jean-François de Troy, *The Country Lunch*, 1725, oil on canvas, The Detroit Institute of Arts

FIG. 2
Jean-François de Troy, *The Declaration of Love*, 1725, oil on canvas, New York, Private Collection

FIG. 3
Jean-François de Troy, *The Sacrifice of Iphigenia*, 1725, oil on canvas, Potsdam-Sanssouci, Staatliche Schlösser und Gärten

JEAN-FRANÇOIS DE TROY
Zephyr and Flora

20

JEAN-FRANÇOIS DE TROY (1679–1752)
Zephyr and Flora, c. 1725–26
Oil on canvas
85 x 153 cm.
Collection of Martha and Ed Snider

PROVENANCE
Sale, Sotheby's, Monaco, 16–17 June 1989, no. 366, ill.

EXHIBITIONS
Never before exhibited.

BIBLIOGRAPHY
No previous bibliography.

Flora's abduction by, and subsequent marriage to, Zephyr, god of the West Wind, is recounted in the fifth book of the *Fasti*, Ovid's unfinished poetical treatise on the Roman calendar. Here, "Flora Mater" tells the poet how, as the beautiful nymph Chloris, she was ravished by Zephyr in emulation of his brother, the North Wind Boreas. Flora's fate was happier than Oreithyia's, however, since Zephyr married her and made her queen of Flowers; her kingdom now included such mortals as Narcissus, Crocus, and Adonis. Flora made it possible for Juno to conceive Mars without Jupiter's intervention; the god of War was thus named in memory of the season of his birth. And the Romans honored her divinity in the games known as the Floralia, which were frequented by prostitutes and notorious for their ribald audiences.[1] "A rakish stage fits Flora well," concludes the poet; "she is not, believe me she is not, to be counted among your buskined goddesses."[2]

Since the Renaissance, the story of Zephyr and Flora had provided artists with a metaphor for Spring and had appeared routinely in cycles representing the Four Seasons.[3] It found particular favor in France at the end of the seventeenth century in the decorative schemes, dominated by seasonal iconography, that were commissioned by the *maison du roi* during Louis XIV's later reign. Antoine Coypel painted the subject for the *grand salon* at Marly and for Madame de Maintenon's apartments at the Trianon; Louis de Boullongne's oval *Zephyr and Flora* (Musée National du Château de Fontainebleau) decorated the *galerie François Premier* at Fontainebleau.[4] The myth also furnished Watteau with the subject of his masterpiece in the genre of grand decoration, the *Zephyr and Flora* painted for Crozat, tragically destroyed by fire in 1966.[5]

De Troy painted the subject at least four times, most notably in 1724 (fig. 1) for the bedroom of the *pavillon du Grand Maître* at Versailles, the residence of his protector, Louis-Henri, duc de Bourbon (1692–1740).[6] Yet despite Pierre Marcel's assertion that "the story of Zephyr and Flora was one of the eighteenth century's favorite themes," its popularity seems to have waned as the century progressed.[7] Between 1737 and 1790 the subject appeared only eleven times in

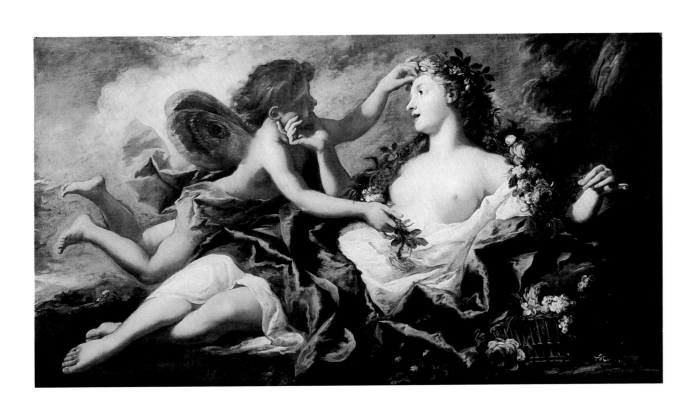

the Paris Salon—admittedly an unreliable index of the incidence of the theme in decorative cycles—and later examples, such as Lagrenée's *Zephyr and Flora* (fig. 2), signed and dated 1779, suggest how little the story had renewed itself by the end of the *ancien régime*.

By contrast, de Troy's *Zephyr and Flora* is one of the artist's more carnal mythologies. Painted as an overdoor, the canvas has recently been restored to its original curvilinear form, visible above the frame's lower edge. A recumbent Flora, breasts bared, red lips parted in pleasure—Ovid describes her as "breathing vernal roses"[8]—is being crowned by a prepubescent Zephyr, whose fat cheeks she grabs with her right hand. Both the Wind god's extreme youth and the goddess's provocative attitude had been established by the previous generation of history painters, notably Antoine Coypel and Charles de La Fosse; the latter's drawing of *Zephyr and Flora* (fig. 3) may well have been the source for Flora's singularly direct gesture in de Troy's overdoor.[9] Yet in handling and coloring, de Troy's *Zephyr and Flora* could not be more modern: in its dramatic *chiaroscuro*, electric draperies, and richly impastoed flowers, it looks to the work of Italian contemporaries such as Piazzetta and Solimena. A "dainty garland" of roses trailing across her head, her basket, at lower right, overflowing with flowers in full bloom, de Troy's Flora communicates a dark voluptuousness befitting the courtesan-goddess.

Despite the bravura of de Troy's handling—abbreviated and brushy, as would be appropriate in an overdoor—the figure of Flora is modeled with great care, and her flesh rendered with a degree of finish that contrasts with the swifter execution of flowers and drapery. That de Troy, in a work of decoration intended to be viewed from a considerable distance, crafted his goddess with such deliberation suggests something of the importance he attached to this commission. And, although it cannot be documented with absolute certainty, it has been suggested that *Zephyr and Flora* was part of the extensive suite of decorative paintings de Troy executed in 1727 for François-Christophe de La Live (1675–1753), the wealthy *receveur général des finances de la generalité de Poitiers* and uncle of the famous art lover and collector Ange-Laurent de La Live de Jully.[10] On 15 November 1727, de Troy acknowledged full payment for thirty-five paintings "which I have made for his house on the rue du Luxembourg."[11] La Live's recently built *hôtel particulier* on the rue Neuve-du-Luxembourg had been designed by the obscure architect Pierre III Le Maistre (d. 1734), with a chapel in the form of a ro-

tunda by Servandoni.[12] The overdoors and paintings "inserted in the *boiseries*" treated such generic subjects as the Four Continents, the Four Elements, the Five Senses, and the Four Seasons.[13] Despite several contemporary references to de Troy's participation in this project—for Brice the paintings were the most notable feature in the *hôtel*—the evidence of La Live's unpublished *inventaire après décès* is disappointing.[14] Characteristically, the inventory, drawn up three weeks after La Live's death on 28 December 1753, lists several overdoors "representing subjects from history in their curved frames," but with no further description, no valuation—since the paintings were considered "part of the decoration of the house"—and no mention of the artist's name.[15] Such brevity in the enumeration of decorative paintings in these notarial appraisals is by no means uncommon.

In size and subject, *Zephyr and Flora* would certainly accord with the set of Seasons that de Troy is known to have painted for La Live; in handling, it also conforms to his anonymous biographer's description of these paintings as having been "painted in one go."[16] A number of overdoors, comparable in size and facture and of equally simplified compositions, may be grouped with the Snider *Zephyr and Flora*. *Bacchus and Ariadne* (fig. 4) may well have represented Autumn in the series of the Four Seasons; *Two Muses* (fig. 5), once attributed to Fragonard, may be related to the group of paintings illustrating the Arts and Sciences; and *Orpheus* (location unknown), with his prominent lyre, might represent Hearing in the suite of overdoors devoted to the Five Senses, or Music in the series devoted to the Arts and Sciences.[17] Yet while a family resemblance among these paintings cannot be denied, their connection with La Live's commission remains tenuous on the basis of the available documents.

Undoubtedly, *Zephyr and Flora* is the most striking of this group of broadly brushed mythologies. Furthermore, it is a composition for which de Troy must have held special affection since he incorporated it, in reverse, as the fictive overdoor of the "magnificently decorated" interior in his *Oyster Dinner* (fig. 6), commissioned in 1735 for the dining room of Louis XV's *petits appartements* at Versailles.[18] Dominating the lavishly ornamented cornice, above caryatids and sculptures that might have been designed by de Troy himself, Mother Flora nicely presides over the uninhibited indulgence of the courtiers below, while at the same time allowing the artist to engage in clandestine self-promotion that seems to have gone unnoticed until this day.

NOTES

1. Ovid, *Fasti*, V, 183–379; Zephyr and Flora are also discussed in Lucretius, *De rerum natura*, V, 736–39.

2. Ovid, *Fasti*, V, 345.

3. Held 1961, 201–18.

4. Garnier 1989, 147; Engerand 1899, 446; see also Standen 1988, 170–73, for the Gobelins tapestries in the *Metamorphoses* series.

5. Levey 1964, 54; exh. Paris 1984–85 (A), 325–28.

6. Bordeaux 1984 (B), 122–23; Engerand 1901, 459–60; de Troy requested the sum of 800 *livres* for *Zephyr and Flora* and was paid half. Two other versions of the subject by de Troy are recorded in eighteenth-century collections, *Zephyr and Flora*, formerly in the collection of the chevalier Lambert (sale, Paris, 27 March 1787, no. 193), which appeared in Sotheby's, New York, 18 June 1974, no. 157 as by Charles-Antoine Coypel, and "Un tableau de J.B. de Troys [sic], représentant Zéphyr et Flore, hauteur 54 pouces, largeur 40 pouces" in *Catalogue de tableaux, dessins, gouaches . . . provenans en partie du cabinet d'un Artiste*, Paris, 22 January 1787, no. 236.

7. Marcel 1906, 193, "la gracieuse légende de *Zéphyre et Flore*, qui va devenir un des thèmes favoris du XVIIIe siècle."

8. Ovid, *Fasti*, V, 194.

9. Garnier 1989, 131, fig. 120, for Coypel's decoration for the *cabinet* of President Lambert, engraved by Benoît Audran; Levey 1964, 54, suggests that La Fosse's drawing was one of two designs that Watteau may have followed in his *Zephyr and Flora*.

10. The suggestion was first made by Dominique Brême; for François-Christophe de La Live, see Bailey 1985, 303–4.

11. Chennevières 1851–52, 161, "Je reconnais que M. Delalive m'a payé le prix de trente-cinq tableaux que j'ai fait pour sa maison rue de Luxembourg"; Brière in Dimier 1928–30, II, 7.

12. Brice 1752, I, 456; Hautcoeur 1943–57, III, 268; on Le Maître, see Rambaud 1964–71, II, 110.

13. Dussieux et al. 1854, II, 275, for the fullest description of La Live's commission in the *Extrait de la vie de M. de Troy*.

14. Brice 1752, 456, "les appartemens en sont très bien distribués et encore plus richement décorés; l'on y voit de beaux tableaux de Jean-Baptiste [sic] de Troy."

15. A.N., *Minutier Central*, CVIII / 507, "*Inventaire après décès*," François-Christophe La Live, 22 January 1754, "Dans la Salle de Compagnie . . . cinq tableaux dessus de porte représentant différens sujets d'histoire dans leur bordures contournées le tout encastré dans la boiserie du Salon" is a typical entry.

16. Dussieux et al. 1854, II, 275, "Ces tableaux sont tous faits au premier coup."

17. For the various paintings that relate to *Zephyr and Flora*, see Vilain 1972, 350, *Bacchus and Ariadne*, H. 99, L. 117 (Musée de Brest); Rosenberg 1971–73, 59, *Two Muses*, H. 91.4, L. 101.6 (New Orleans Museum of Art); Paris, Palais d'Orsay, 23 June 1978, no. 42, attributed to Jean-François de Troy, *Orpheus*, H. 92, L. 130 (location unknown).

18. Engerand 1901, 461, "Un tableau représentant une salle magnifiquement décorée, où l'on voit plusieurs personnes qui déjeunent avec les huîtres"; Gruyer 1898, 248, where the overdoor is aptly, if incorrectly, described as "*L'Amour et Psyché* conversant dans un amoureux tête-à-tête."

FIG. 1
Jean-François de Troy, *Zephyr and Flora*, 1724, oil on canvas, Versailles, Hôtel de Ville

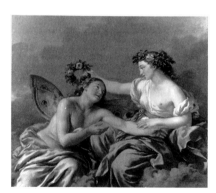

FIG. 2
Jean-Jacques Lagrenée, *Zephyr and Flora*, 1779,
oil on canvas, Zurich, Galerie Bruno Meissner

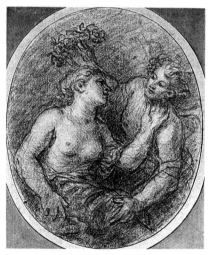

FIG. 3
Charles de La Fosse, *Zephyr and Flora*, c. 1715,
red, black, and white chalk drawing, Paris,
Musée du Louvre, Cabinet des Dessins

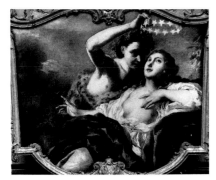

FIG. 4
Jean-François de Troy, *Bacchus and Ariadne*,
c. 1727, oil on canvas, Musée de Brest

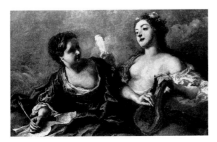

FIG. 5
Jean-François de Troy, *Two Muses*, c. 1727, oil
on canvas, New Orleans Museum of Art

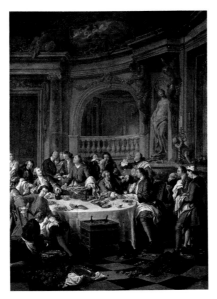

FIG. 6
Jean-François de Troy, *The Oyster Dinner*,
1735, oil on canvas, Chantilly, Musée Condé

JEAN-FRANÇOIS DE TROY
Diana Resting

21

JEAN-FRANÇOIS DE TROY (1679–1752)
Diana Resting, 1726
Oil on canvas
130 x 196 cm.
Musée des Beaux-Arts, Nancy

PROVENANCE
Awarded 2,500 *livres* in July 1727 as one of the two prizewinning entries to the *concours de 1727*; acquired by the Crown for an additional 2,000 *livres* in August 1727; located in the Throne Room of the Luxembourg Palace by 1762; Musée de Versailles; sent from Versailles in October 1800 to decorate the Palais de Lunéville during the Congress of Lunéville; given to the Musée de Nancy by the government after the Congress of Lunéville in April 1801.

EXHIBITIONS
Paris, *concours de 1727*, "à la première croisée en entrant," 1; Geneva 1949, no. 119; Nancy 1955, no. 23; Brussels 1975, no. 25, ill.

BIBLIOGRAPHY
Anonymous 1727, 1; *Mercure de France* July 1727, 1563–64, August 1727, 1847; Dézallier d'Argenville 1762, IV, 367–68; Fontenay 1776, II, 654; Papillon de La Ferté 1776, II, 599; Dussieux et al. 1854, II, 265, 275; Nancy 1854, no. 127; Clément de Ris 1859–61, I, 26–27; Nancy 1866, no. 270; Clément de Ris 1872, 306–7; Montaiglon 1875–92, V, 28; Mantz 1880, 22–23; Nancy 1883, no. 417; Nancy 1897, no. 513; Dilke 1899 (B), 284–85; Gonse 1900, 227, ill.; Engerand 1901, 462; Nancy 1909, no. 564, ill.; Fontaine 1910 (B), 35; Brière 1912, 348–49, ill.; Michel 1925, 139–40; Réau 1925, I, 29; Dimier 1928–30, I, 73–74, II, 11, 36, no. 39, ill.; Florisoone 1948, 43; Schnapper 1962, 122; Rosenberg 1977, 30–32, 35, ill.; Conisbee 1981, 78–80, ill.; Bordeaux 1984 (A), 42, 109, ill.; Crow 1985, 80, ill.; Bordeaux 1989, 154; Pétry 1989, 59, ill.

D
iana Resting, de Troy's entry to the *concours de 1727*, which shared first prize with Lemoyne's *Continence of Scipio* (fig. 1), was the artist's most handsomely rewarded commission to date and his most universally derided. De Troy received 2,500 *livres*, his half of the prize money, early in July 1727, and, since the two winning entries were then acquired for the Royal Collection, payment of a further 2,000 *livres* was made at the end of the following month.[1] Yet the artist may not have been altogether satisfied with the Crown's *largesse*; he had initially requested 4,000 *livres* for *Diana Resting*, indicative both of his avidity and of his pique at having failed to win the competition outright.[2]

But was *Diana Resting* worthy of these laurels? The connoisseurs, almost to a man, were critical of the painting. Despite its prominent display at the *galerie d'Apollon*—*Diana Resting* was the first painting to be seen upon entering the competition[3]—Crozat failed to mention the work in his correspondence with Rosalba Carriera, and it seems to have made no impression on the general public.[4] Caylus and Mariette passed over the painting in silence, and even de Troy's most fervent apologist, the chevalier de Valory, found nothing to say in its favor but noted that if Lemoyne's *Continence of Scipio* seemed feebly drawn, de Troy's *Diana Resting* was even more so.[5] The most strident criticism came from Dézallier d'Argenville, who dismissed the work as "mediocre" and who commented upon the "harshness of its coloring" and the "banality of its composition."[6] More recent scholarship, where it has considered the work in any depth at all, has been scarcely more enthusiastic.[7]

Yet if the artist's confidence was misplaced, the critics' hostility is equally difficult to explain and cannot be accounted for simply as a reaction to the work's aesthetic deficiencies. Their harshness expressed a more general disappointment: with the quality of the history paintings as a group, certainly, but also with the intrigue and nepotism that had pervaded the competition from its inception.[8] For if it is difficult to claim that de Troy's *Diana Resting* ranks among his more inspired mythological paintings, the grandeur of

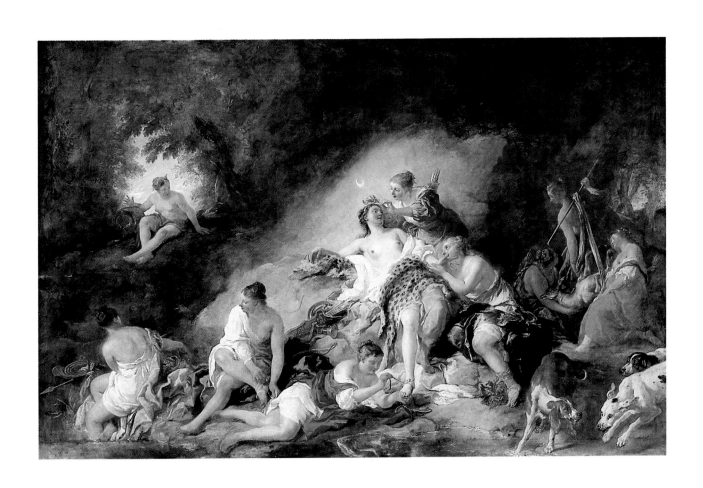

its figures and the monumentality of its conception announce a new direction in his art and would provide the model and format for such masterpieces as *Diana Surprised by Actaeon* (cat. no. 22) and *The Birth of Venus* (Potsdam-Sanssouci, Staatliche Schlösser und Gärten), painted early in the following decade.[9]

The best description of *Diana Resting*, sensitive to its pictorial qualities as well as to its literary source (Ovid, *Metamorphoses*, III, 155–70), is the elegant account that appeared in the *Mercure de France* in July 1727:

> In the outskirts of Thebes, next to a beautiful valley covered in Cypress trees, there was a charming natural grotto, with a spring that flowed along a gravel path separated by two banks which were dotted here and there with flowers. It was to this delightful spot that Diana retired after a day at the hunt. The artist has portrayed this goddess attended by her nymphs. One holds her javelin; another, her favorite, kisses her hand; the dexterous Crocale, daughter of the river-god Ismenius, unbinds her hair, while a fourth removes her buskins. . . .[10]

De Troy masterfully creates a sense of the grotto's sanctified enclosure by painting two openings at left and right, through which can be glimpsed the blue sky and white clouds of the distant landscape. Within, Diana and her maidens cleanse themselves from contact with the earthly world and repose langorously in "serene inutility."[11] Their dogs, by contrast, race to the water's edge to quench their thirst. At right, three maidens set down the dead doe they have carried in on a stretcher—food for the Cyclopes—while Diana's preferred followers relieve her of her unstrung bow, hunting horn, and elaborately ornamented quiver, which lie to her right. The goddess—bare-breasted yet with her lower body curiously swathed in drapery—reclines majestically as each attendant dutifully concentrates on her appointed task. Set in a dramatic yet evenly modulated light, the gently rhythmical grouping of figures, in which bare flesh alternates with robes of varying hue, reaches a climax in the arched body of the goddess herself. De Troy's protagonists are completely absorbed, secure in the protective sanctity of Diana's domain, and quite oblivious to the beholder's presence. Only the nymph at upper left, who is shown at the source of the spring, displays the slightest sign of emotion. Her expression is less one of surprise than an attempt to alert the goddess of an impending intrusion.[12]

Despite the graceful poses and pretty coloring, *Diana Resting* is not an entirely satisfying history painting. The accretion of tenderly observed female figures placed laterally across the picture plane—one viewed from the back, another untying her sandal, a third reclining on her side—creates an additive composition lacking general harmony. Similarly, while earlier restorations make it difficult to pass judgment on de Troy's handling of paint—*Diana Resting* is far from retaining the "perfect state of conservation" that so impressed Clément de Ris—it is clear that de Troy's touch was never meant to be consistent throughout.[13] There is a disparity in finish between the broad, sketchy handling of the tufa grotto and the careful delineation of figures and accoutrements below. While the three maidens on the right of the composition have suffered the most, it is unlikely that they were ever more than summarily sketched in; *pentimenti* visible on two of their profiles confirm de Troy's practice of making changes *alla prima*. Indeed, this triad of figures, huddled together at the entrance to the grotto and quite different in scale and handling from the other participants, may have been painted as something of an afterthought. Intended, perhaps, to suggest the cavernous depth of Diana's grotto and to enliven the void at right, this little group interrupts the fluent, pyramidal structure upon which *Diana Resting* is based.

Some of these inconsistencies may be explained by the ambiguous nature of the competition itself. Although artists were free to choose their own subjects, after consultation to ensure that episodes were not repeated, the format was to be the same in each case: four and one-half feet in height, six feet in width—dimensions which, while too large for a cabinet picture, were closer to those of an overdoor or a decorative panel.[14] The office of the *surintendant des Bâtiments* failed, however, to give any indication of the possible use to which the competition pieces might be put; nothing seems to have been decided about their eventual destination. Without knowing the distance from which their work was to be seen or the context in which it would be installed, participants could not easily assess the degree of finish and detail that would be appropriate. In an age before the public Salon had become an established institution, history painters rarely embarked upon such elaborate commissions—the participants in the *concours* had just under a year to complete their paintings—without such issues being settled well in advance.[15]

Diana Resting reflects something of the strain that resulted from the administration's naïveté. On one level, it is an extended cabinet picture, with quotations from several of de Troy's earlier works. The central group of Diana and her attendants derives from his *Bath of Diana* (fig. 2), signed and dated 1718;

Diana's rather uncomfortable pose recalls his painting of the reclining Bathsheba in *Bathsheba at the Bath* of 1727 (Angers, Musée des Beaux-Arts), where the figure is in reverse; and the nymph who gazes adoringly at Diana is similar to the figure of *Clytia Changed into a Sunflower* (cat. no. 16, fig. 3), painted in 1717.[16] Yet the freely brushed landscape and the more abbreviated handling of the ancillary figures, quite acceptable in a work of decoration, prevent *Diana Resting* from achieving the integrity and balance that characterize de Troy's best mythologies.

Both the ambiguity of function and destination were in part responsible for de Troy's discomfort in *Diana Resting*; Lemoyne, in consciously evoking Le Brun's *Franche-Comté Conquered for a Second Time: 1674* in the *galerie des glaces* at Versailles, clearly had a more public resting place in mind for his *Continence of Scipio*.[17] Not that de Troy had any difficulty in working either on the large scale or for public display. In the months before he painted *Diana Resting*—which is signed and dated 1726 and therefore must have been executed between June and December of that year—de Troy had been commissioned by the city of Paris to paint two enormous political allegories, *The Prévot des Marchands and the Échevins of Paris Imploring Saint Genevieve for Rain* (Paris, church of Saint Étienne-du-Mont) and *The Officers of the City of Paris Complimenting the King on the Occasion of His Marriage* (location unknown; sketch in Paris, Musée Carnavalet); the latter was installed at the Hôtel de Ville on 10 August 1726.[18] Although the speed at which he was capable of working was prodigious and widely remarked upon, it is possible that this abrupt transition from public allegory to private mythology was made at some cost to de Troy's powers of invention.

Finally, de Troy must have been fully aware of the powerful coteries ranged in support of his rival Lemoyne—a factor that might have inspired him to create his consummate mythology but that seems, in fact, to have inhibited him. All discussions of the *concours* evoked the jealousy and intrigue that escalated as the event drew nearer; indeed, for one knowledgeable observer, the enmity it introduced into the Academy's ranks was the competition's most abiding legacy.[19] It was even argued at the time that the exercise was little more than a put-up job to ratify d'Antin's selection of Lemoyne as continuator of the *grands travaux* at Versailles. After Lemoyne's victory at the *concours*, this argument runs, d'Antin felt confident to offer him the commission to decorate the *salon d'Hercule* in its entirety, without involving any of his fellow academicians.[20] While this implies a sense of accountability quite foreign to the spirit of post-regency politics, it focuses attention on the hidden agenda to which the *concours* was attached.[21]

Lemoyne was indeed the recipient of powerful sponsorship. His principal promoters included the artist François Stiémart, a mediocre copyist much employed at Versailles who enjoyed the *surintendant*'s complete confidence, and his "*ami chaud*," the tax collector François Berger, regarded by d'Antin as a veritable "oracle" in matters of taste.[22] De Troy, by contrast, did not hesitate to make known his resentment of d'Antin's legendary condescension towards artists[23] and had recently lost his great protector, the *premier ministre*, Louis-Henri, duc de Bourbon (1692–1740), who was removed from office and exiled to Chantilly in June 1726, at the very moment the *concours* was announced.[24] Against such odds, de Troy might have felt defeated from the outset, yet Cochin, a generally impartial observer, could write: "It was less to the beauty of his painting than to the brilliance of his reputation that de Troy owed the glory of having counterbalanced d'Antin's affections for Lemoyne."[25] Had Lemoyne's painting been any better, he continued, the decision to share the prize with de Troy would have been an injustice. If *Diana Resting* is a testament to de Troy's standing, both in court and capital, and to his adroit manipulation of patronage, it also suggests that such direct political involvement was less than favorable to the creation of the most fluent history painting.

NOTES

1. A.N., O¹ 2226, fol. 197v, 8 July 1727, "Aud Sr. 2500# par gratification, en considération du prix qu'il a remporté sur les tableaux que Sa Majesté a ordonné de faire aux peintres de son Académie de peinture pour les soutenir et les perfectionner dans leur art . . . 2500"; ibid., 30 August 1727, "Au Sr. de Troy autre 2000# pour un tableau représentant un retour de chasse de Diane . . . 2000."

2. A.N., O¹ 1921A (1) cited in Engerand 1901, 462. The best summary of the *concours de 1727* is Rosenberg 1977, 29–42.

3. "A la première croisée en entrant . . . un retour de chasse de Diane," *Explication des Tableaux exposez dans la Gallerie d'Apollon*, Paris 1727, 1; the order of presentation is also given in the extensive account of the exhibition which appeared in the *Mercure de France*, July 1727, 1562–73.

4. Sani 1985, II, 389, Crozat to Rosalba, 15 May 1727, "Il semble que M. Lemoine emportera le premier prix et M. Noël Coypel, oncle de celuy que vous connoissez, aura le second."

5. De Valory in Dussieux et al. 1854, 264–65.

6. Dézallier d'Argenville 1762, II, 367, "de Troy . . . prit pour sujet les bains de Diane qu'il peignit d'un ton de couleur un peu dur et d'une composition fort commune."

7. Dilke 1899 (B), 284, "Le de Troy est d'un coloris plein de grâce, mais le dessin est négligé, et l'ensemble d'une exécution sans intérêt"; Brière in Dimier 1928–30, II, 11, "les nymphes dévêtues de de Troy ont de l'éclat, mais quelque vulgarité; le sujet rebattu n'est pas relevé par une conception originale, c'est de l'excellent travail, mais ce n'est pas oeuvre de créateur."

8. See de Valory's perceptive analysis in Dussieux et al. 1854, II, 264; see also Rosenberg 1977, 32, "un sentiment de déception l'emporte."

9. Brière 1912, 348–49, was the first to draw attention to the connection between the paintings of Diana in Basel (cat. no. 22) and Nancy.

10. *Mercure de France*, July 1727, 1563–64, "Aux environs de Thèbes, proche d'une belle vallée couverte de Cyprès, il y avoit un antre agréable, formé par la seule nature, avec une fontaine qui couloit sur le gravier entre les rives fermées de fleurs. C'est dans ce lieu charmant que Diane venoit se reposer au retour de la chasse. Le peintre a représenté cette Déesse, servie par ses nymphes. Une tient son Javelot, une autre, qui est sa favorite, lui baise la main, l'adroite Crotale [sic], fille du fleuve Ismène, la décoëfe, et une quatrième lui ôte ses Brodequins. . . ."

11. Klossowski 1972, 28.

12. Nancy 1897, 176.

13. Clément de Ris 1859–61, I, 27, "il est dans un état de conservation parfaite."

14. *Mercure de France*, July 1727, 1563, "Chacun eut la liberté de choisir le sujet qu'il devoit traiter, en sorte cependant que deux peintres ne prissent pas le même sujet. Les grandeurs furent déterminées à 6 pieds de large sur 4 pieds et demi de haut."

15. The *concours* had first been announced in the Academy's assembly room on 14 May 1726; the artists' entries were to be finished by April 1727, Montaiglon 1875–92, V, 7; *Mercure de France*, July 1727, 1563.

16. Bordeaux 1989, 152–53. De Troy would later repeat the poses of Diana and Crocale unbinding her hair in *Preparation for the Ball*, 1735 (Malibu, The J. Paul Getty Museum), a nice instance of mythology modernized.

17. The parallel was made by Candace Clements in a lecture given at the College Art Association, New York, February 1989. Her doctoral dissertation on the *concours de 1727* is eagerly awaited.

18. Brière in Dimier 1928–30, II, 10; *Mercure de France* 1726, 1863.

19. De Valory in Dussieux et al. 1854, II, "le résultat de cette intrigue fut d'introduire la désunion parmi les artistes de l'Académie."

20. First articulated by Donat Nonnotte in Gauthier 1902, 527–28.

21. The web of intrigue is well summarized in Rosenberg 1977, 30–32.

22. De Valory in Dussieux et al. 1854, II, 264; Lemoyne would marry the copyist's sister, Marie-Josèphe Stiémart, in 1730.

23. Cochin 1880, 84, "M. d'Antin trattoit les académiciens avec assez de hauteur. . . . Il les tutoyoit, comme je l'ay dit. Cela ne plaisoit pas à M. de Troy le fils. Les artistes appeloient ordinairement M. d'Antin Monseigneur; M. de Troy ne la lui refusait pas; mais lorsqu'il en étoit tutoyé, il ne l'appeloit plus que Monsieur. . . ."

24. For de Troy's earlier participation in the decoration of the duc de Bourbons's hôtel du Grand Maître at Versailles, see Bordeaux 1984 (B), 113–26; Louis-Henri de Bourbon had appeared prominently in de Troy's painting celebrating the wedding of Louis XV and Marie Leczinska (as in n. 18).

25. Cochin in Dussieux et al. 1854, II, 412, "M. de Troy dut moins à la beauté de son tableau qu'à sa réputation éclatante la gloire de balancer l'affection que M. le duc d'Antin portoit à M. le Moine."

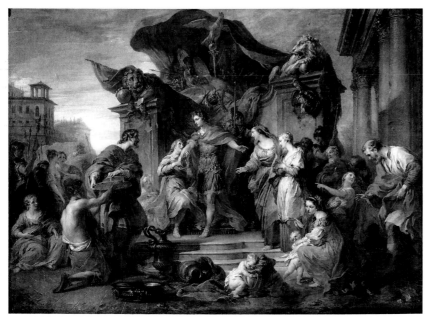

Fig. 1
François Lemoyne, *The Continence of Scipio*, 1727, oil on canvas, Nancy, Musée des Beaux-Arts

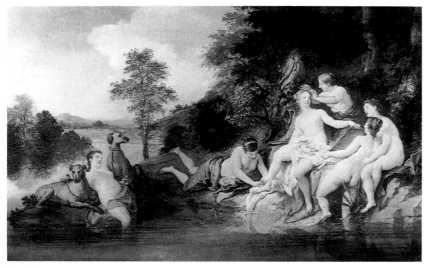

Fig. 2
Jean-François de Troy, *The Bath of Diana*, 1718, oil on canvas, Private Collection

JEAN-FRANÇOIS DE TROY
Diana Surprised by Actaeon

22

JEAN-FRANÇOIS DE TROY (1679–1752)
Diana Surprised by Actaeon, 1734
Oil on canvas
129 x 193 cm.
Oeffentliche Kunstsammlung Basel, Kunstmuseum, Depositum der Gottfried Keller-Stiftung

PROVENANCE
Recorded in the inventory of the artist, 12 July 1752 (A.N., *Minutier Central*, XXXV/67, fol. 6), and his sale, Paris, 9–19 April, 25 May 1764, no. 280, purchased by Châteauthierry for 290 *livres*; François Boucher, his sale, Paris, 18 February 1771, no. 45, sold for 480 *livres*; Louis-Jean-François Collet by 1775; Jean-Baptiste Guillaume de Gevigney, his sale, Paris, 1–29 December 1779, no. 519, purchased by Silvestre for 603 *livres*; Marie Drouet, Madame Basan, her sale, Paris, 4 April 1791, no. 28, sold for 199 *livres*, 19 *sols*; Nicolas Reber, his sale, Basel, 15 October 1810, no. 265; Herrn Imhof, Basel, by 1825; Johann Jakob Imhof-Rüsch, Basel, by 1830; J.J. Imhof-Rüsch, Basel, until his death in 1900; acquired by the Gottfried Keller-Stiftung, which donated the painting to the Kunstsammlung Basel in 1901.

EXHIBITIONS
Bern 1942, no. 174; London 1968, no. 679.

BIBLIOGRAPHY
Dussieux et al. 1854, II, 276; Lejeune 1864, 351; Delignières 1867, no. 22; Gottfried Keller-Stiftung 1901, 18; Basel 1910, no. 618; Brière 1912, 347–50, ill.; Ganz 1924, 187, ill.; Michel 1925, 140; Réau 1925, I, 29; Dimier 1928–30, II, 36, no. 40, ill.; Talbot 1974, 256, ill.; Basel 1980, 46; Damisch 1983, 122; Bordeaux 1984 (A), 42; Bordeaux 1989, 154.

Inexplicably, *Diana Surprised by Actaeon*—de Troy's masterpiece of the genre and the most thoroughly documented of all his private commissions—failed to find a buyer during the artist's lifetime. It may well have been among the thirty or more finished canvases the artist showed to Dézallier d'Argenville: "Unable to sell them, this finally drove him to seek a post in Rome, since, as he put it, 'he could no longer live honorably in Paris.'"[1]

Although the public's indifference, upon which the chevalier de Valory also commented,[2] is hard to account for, it is documented in this instance by the artist's unpublished *inventaire après décès*, drawn up in Paris on 12 July 1752—within the statutory six months following his death in Rome—in which are listed "five large paintings, on canvas, unframed, the first representing *The Death of Hippolytus*, the second *Diana at Her Bath*, the third *The Rape of Proserpine.* . . ."[3] When these paintings were sold by de Troy's heirs in April 1764, following protracted litigation over the validity of his testament, the accompanying descriptions in the sales catalogue were considerably more complete; *Diana at Her Bath* was noted as "being composed of fourteen figures, each between 18 and 20 inches in scale," which allows us to identify the unframed mythology in de Troy's inventory with the *Diana Surprised by Actaeon* from Basel.[4] Though lost, the other two history paintings recorded in the inventory and sold in 1764, dating from 1727 and 1735, respectively, are known today from engravings (figs. 1, 2), as well as replicas and preparatory drawings, and would seem to be works of equally high quality.[5]

Diana Surprised by Actaeon, signed and dated 1734, and its pendant, *The Rape of Proserpine*, painted the following year, may have been commissioned by a collector in Dijon for whom, in 1733, de Troy is supposed to have painted two compositions of these subjects with figures "more than a foot in size." Either de Troy painted two almost identical sets of pendants, which is unlikely, or his client underwent a change of heart.[6] Since the evidence of the inventory is incontrovertible and makes clear that the paintings remained, unsold, in de Troy's possession, the unnamed

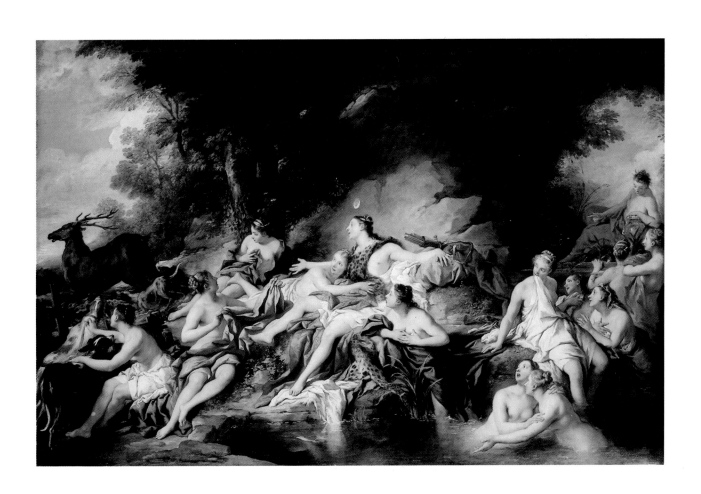

dijonnais may have been disenchanted by the artist's high prices. It was to the exorbitant cost of his private, as opposed to public, commissions that Dézallier d'Argenville imputed the lack of demand for de Troy's work.[7]

The other reason Dézallier d'Argenville advanced for de Troy's difficulties with the private market, "the unevenness of his paintings, which were often found to be carelessly finished," is not applicable here, for *Diana Surprised by Actaeon* is one of the artist's most balanced and well-integrated narrative paintings.[8] Each figure is executed with a refinement and finish that are unusual in a work of this scale, and de Troy's lively brushwork, elegant coloring, and ambitious grouping of figures create a harmonious composition unified by a golden light. De Troy maintains a masterful equilibrium between a more fluid, painterly manner—his *manière negligée*—and "the beautiful, precious finish, appropriate to easel painting, which flatters the eye of the connoisseur."[9] In thus expanding the possibilities of cabinet painting, he may also have placed excessive demands, both aesthetic and pecuniary, on his clientele.

In *Diana Surprised by Actaeon*, de Troy represents the story, told by Ovid in the *Metamorphoses*, of Diana's vengeance on the ill-fated Actaeon, whom she transforms into a stag for having dared to gaze upon her and her maidens. The grandson of Cadmus, whose sister Europa was ravished by Jupiter, Actaeon had been raised by the centaur Chiron, who taught him the art of hunting. At the end of a particularly successful morning's hunt, the youth ordered his companions to end their sport at midday and took his leave to wander alone "through the unfamiliar woods with unsure footsteps."[10] By accident he came upon Diana's sacred grotto while she and her nymphs were still bathing. Horrified at this intrusion, the nymphs rushed to Diana's side and "smote upon their breasts . . . filling the grove with their shrill sudden cries."[11] The goddess flung water in Actaeon's face, the "avenging drops" causing "the horns of the long-lived stag" to grow upon his head. Taking the form of a fully grown stag, "fear planted within his heart and tears coursing down his changeling cheeks," the hapless Actaeon now fell prey to his own pack of hunting dogs who, despite his entreaties, mauled him to death. Only then was "the wrath of the quiver-bearing goddess" appeased.[12]

In *Diana Surprised by Actaeon*, de Troy, who returned to this subject on more than one occasion, does not depict the confrontation between the two principals; rather, he conflates successive episodes in this dramatic narrative.[13] Twelve of Diana's attendants are shown clutching robes to their bodies in at-

titudes of fear and dismay; since Ovid had mentioned eleven nymphs as being present at the event, de Troy's crowded grotto is more faithful to the classical text than is immediately apparent.[14] Although Diana's troubled attendants react vigorously to the violation of their sanctuary, it is the aftermath of their encounter with Actaeon that is represented here; the fully formed stag at left, antlers pinned back by the wind, hastens to depart as the hunting dogs begin to bite at his feet. Furthermore, de Troy's portrayal of Diana is unusually poetic; her expression betrays sadness and regret rather than outrage. Diana's outstretched arms and plaintive demeanor suggest that she is fully aware of the tragedy of Actaeon's unseemly and unnecessary death.[15]

Equally striking is the pose and bearing of the fair-haired nymph seated at the edge of the pool at the right of the composition. Resting all her weight on her hands, her large frame covered by drapery of the purest white—the edge of which she holds between her teeth—the nymph turns to gaze upon the departing stag, not in fear, as do her companions, but with detached interest. The astonishing informality of her pose—de Troy could only have observed this motif from life—introduces an unexpected naturalism into this mythic assembly. But de Troy's inventiveness is double-edged. This wide-eyed maiden, whose casual attitude, no less than her arch expression, stands out among the twisting movements and heightened physiognomies of her companions, is also the most fully clothed of Diana's troupe. Whereas the other nymphs are shown naked or half-draped, her entire lower body is swathed in drapery. Is it possible that de Troy intended this figure to represent Callisto, the nymph who is ejected from Diana's company and transformed into a bear in the second book of Ovid's *Metamorphoses*? Although Callisto does not appear in the story of Diana and Actaeon, her presence in de Troy's mythology serves to emphasize the untainted maidenhood of her companions and is suggestive of a familiarity with Ovidian mythology that ran deep indeed.[16]

If de Troy's use of narrative is subtle and imaginative, his sense of *ordonnance* and his handling of the brush are no less so. Through the elegant contortions of the nymphs and the almost endless flow of their drapery, he creates a finely wrought composition that is both vital and rhythmic. Unlike *Diana Resting* (cat. no. 21), which adopted a stately, if occasionally ponderous, *mise en page*, *Diana Surprised by Actaeon* is an example of de Troy's figure painting at its most virtuosic. He effortlessly exploits the erotic possibilities of the myth in the various groupings of women who turn to one another for protection, embrace in the water,

or, in their attempt to cover themselves, reveal as much flesh as possible. His use of drapery is equally dynamic; the free-flowing silks help move the eye across the canvas more swiftly, yet, in their arbitrary configurations, they create effects that are theatrical, if not "faintly absurd."[17] Diana's impossibly long leopard skin trails languidly in the water; she reclines against a bolster of cool gray silk, conveniently placed under her left arm; robes of pure white, salmon pink, and slate blue fall into folds of delicious complexity, their function as clothing little more than an afterthought. Yet despite this battery of pleasing and decorative devices, de Troy never loses sight of the dramatic narrative; it is the telling of the myth that activates each of the protagonists and determines Diana's gesture.

Despite his generally fluid handling of paint, de Troy's brush is also capable of exquisite detail: tiny dots of impasto appear on the dogs' collars to show the brilliance of the afternoon sun as it bears down upon them; Diana's pearls, only partly hidden by the leopard skin, are immaculately described; de Troy outlines certain areas of the female body in red—Diana's underarm, the upper arm of the attendant who clutches her—an erotic mannerism that Boucher would use often in the following decade. And the painting of flesh and draperies as they dissolve in the limpid pool below is a *tour de force* rarely equaled in de Troy's history painting.

De Troy's complex arrangement of figures and accessories is painted without hesitation and with an assurance that never falters. Only one change is visible to the naked eye. The folds of Diana's bright red drapery have been adjusted to fall directly behind Callisto; *pentimenti* of the drapery as it first appeared are visible on the rock behind. This is a minor revision and seems to accord with the argument, routinely put forward by de Troy's contemporaries, that the artist painted spontaneously, eliminating the process of working through preparatory drawings and studies which lay at the heart of academic training. "It was enough for him to have the composition in his head," noted the comte de Caylus; "he would put it directly onto canvas and adjust nature accordingly."[18] That a complex composition such as *Diana Surprised by Actaeon* appeared, Minerva-like, from de Troy's head strains credibility; indeed, although no visual record of it exists, a preparatory drawing for *Diana Surprised by Actaeon*, in black-and-white chalks on gray paper, was last recorded in the collection of J.P. Heseltine.[19] Furthermore, although it has been reasonably connected with another mythological painting, de Troy's drawing in colored chalks for the head of a young woman in lost profile (fig. 3) may also have served as

a model for the nymph tending the dog at far left in *Diana Surprised by Actaeon*.[20] The myth of artist rushing to put his thoughts to canvas—"*que cela paraît*"—remains subject to serious revision.[21]

De Troy's use of drawings is not the only aspect of his working method that remains elusive. Caylus repeatedly praised the artist for painting everything from life, and, indeed, *Diana Surprised by Actaeon* gains immeasurably from such naturalistic details as the hunting dog that licks the upper arm of its pretty attendant, at left, and Callisto's striking pose in which her pregnancy is equally well observed, at right. If contemporary report is to be believed, even the artist's dark-eyed goddess could claim a source nearer home, for the model may well have been de Troy's twenty-three-year-old bride, Marie-Anne le Trouyt Deslandes, whom he married, without her parents' approval, on 2 December 1732, when he was age fifty-two.[22] Dézallier d'Argenville noted that de Troy was so captivated by his new wife "that her face appeared in all his gallant paintings; and because she had a cast in one eye, he depicted her only in profile."[23] Of course, Diana's aquiline nose, like the crescent moon that hovers above her, is an attribute of her noble divinity; it is not suggested that de Troy's goddess is intended as a portrait of his wife. Yet something of the tenderness with which her profile is painted—repeating, as it does, the wide-eyed Saint Cecilia in de Troy's *Allegory of Music* (fig. 4), dated 1733—may derive from de Troy's particular affection for the model upon whom it was based.

The repetition of faces, like gestures, is not uncommon in de Troy's oeuvre; Caylus considered it the worst abuse of his prodigious facility.[24] Not only does the nymph at upper left, clutching her dark blue robe to her breast, recall the chaste Susanna in *Susanna and the Elders*, 1721 (Leningrad, The Hermitage), but the nymph who cowers in fear against Diana's waist repeats, with some variation, the pose of the recumbent attendant who washes the goddess's feet in *The Bath of Diana* (cat. no. 21, fig. 2).[25] The pose Diana herself adopts in *Diana Surprised by Actaeon*—arms outstretched, legs splayed—repeats exactly that of Venus in the exceedingly immodest *Venus and Adonis* (fig. 5). Venus and Diana share the same gestures, but their "body language" could not be more different, and it is interesting to note how completely de Troy has removed any suggestion of sexual abandon from his depiction of Diana.

Without a buyer during de Troy's lifetime, *Diana Surprised by Actaeon* passed through a succession of prominent Parisian collections after his death. Initially separated from *The Rape of Proserpine* upon entering Boucher's collection, the painting was briefly reunited

with its pendant by the former diplomat, playwright, and royal censor Louis-Jean-François Collet (1722–1787), from whose cabinet they were engraved by Jean-Charles Levasseur.[26] By 1779 *Diana Surprised by Actaeon* reappeared, alone, in the collection of the abbé Jean-Baptiste Guillaume de Gevigney (1729–1802), recently appointed *garde des titres et généalogies de la bibliothèque du roi*. He sold it at auction and fetched the relatively modest sum of 603 *livres*, still the highest price it would make at auction during the eighteenth century.[27] The painting is next recorded in April 1791 in the posthumous sale of Marie Drouet, wife of Pierre Basan, the leading Parisian print dealer.[28] It was one of the many old master paintings acquired on the Paris market during the Revolution by Nicolas

Reber (1735–1821), a banker and entrepreneur from Basel and a major partner in the Dye Works established at Pfungstadt in the principality of Hesse Darmstadt. In 1809 Reber would buy out the Land-grave's remaining interest in this manufacture through an exchange of fifty-two paintings, which, in turn, became the foundation of the Hessisches Landes-museum.[29] *Diana Surprised by Actaeon* was not among the paintings bartered with Ludwig I but appeared in the enormous sale of Reber's own collection, auctioned in Basel to offset losses from the beleaguered Dye Works on 15 October 1810.[30] The painting remained in Basel thereafter and was deposited at the Kunstsammlung by the Gottfried Keller-Stiftung in 1901.[31]

NOTES

1. Dézallier d'Argenville 1762, IV, 368, "il me montra un jour plus de trente morceaux finis dont il n'avait pu se defaire; ce qui le détermine à demander de l'emploi à Rome *ne pouvant*, à ce qu'il disoit, *vivre avec honneur* à Paris." That de Troy was again passed over for the post of *premier peintre du roi*, left vacant by Lemoyne's suicide of 4 June 1737, may equally have influenced his decision to leave for Rome. He took up the directorship there in January 1738.

2. De Valory in Dussieux et al. 1854, II, 263, mentions "le peu d'empressement qu'il voyoit dans les amateurs à se procurer de ses ouvrages."

3. A.N., *Minutier Central*, XXXV/67, "*Inventaire après décès*," J-F de Troy, 12 July 1752, fol. 6, "item cinq grands tableaux peints sur toile et sans bordure l'un représentant la mort d'hipolyte, le second les bains de Diane, le troisième l'enlèvement de proserpine. . . ."

4. *Catalogue d'une Collection des Très Beaux Tableaux, Dessins et Estampes . . . partie de ces effets viennent de la succession de feu M. J.B. [sic] de Troy, Directeur de l'Académie de Rome*, Paris, 9 April 1764, no. 280, "un autre beau tableau composé de 14 figures, chacune de 18 à 20 pouces de proportion: il représente les Bains de Diane: peint sur toile de 4 pieds de haut sur 6 de large."

5. Cochin's engraving of *The Death of Hippolytus*, no. 279 in the de Troy sale, was announced in the *Mercure de France* in May 1735; a superb preparatory drawing for the composition is in the Hessisches Landesmuseum, Darmstadt. *The Rape of Proserpine*, no. 28 in the de Troy sale, where it is catalogued as having been painted in 1735, was engraved by J.-C. Levasseur in March 1773; a slightly smaller version, which does not include all the figures shown in Levasseur's print, is in The Hermitage, Leningrad (inv. 7526).

6. Dussieux et al. 1854, II, 276, "En 1733, il a peint pour M . . . de Dijon, l'enlèvement de Proserpine, Actéon changé en cerf, figures d'un pied ou environ de grandeur. . . ." This evidence is to be treated with some caution; the author is in error regarding the date of the pendants (painted in 1734 and 1735), and the dimensions he gives are considerably smaller. Either de Troy painted the subject first in 1733—and The Hermitage *Rape of Proserpine* is the extant first version—and again in the following years, or the mysterious collector from Dijon failed to claim his commission, leaving the paintings unframed in the possession of the artist. The precise status of the Leningrad *Rape of Proserpine* remains to be established.

7. Dézallier d'Argenville 1762, IV, 368, "le haut prix où il les avoit fait monter y contribuoit encore."

8. Ibid., 368, "l'inégalité de ses ouvrages qu'on trouvoit souvent négligés."

9. De Valory in Dussieux et al. 1854, II, 273, "ce beau fini et précieux qui leur sont propres et qui flattent agréablement l'oeil connoisseur."

10. Ovid, *Metamorphoses*, III, 177–78.

11. Ibid., 180.

12. Ibid., 202, 250.

13. De Troy's *Diana and Actaeon* (location unknown), painted as a pendant to Noël-Nicolas Coypel's *Bacchus and Venus* (cat. no. 29), showed the goddess with five of her nymphs, see *Catalogue de Tableaux des Maîtres très renommés des différentes écoles . . . [de Vigny]*, Paris, 1 April 1773, no. 95.

14. Ovid, *Metamorphoses*, III, 155–73; seven of Diana's nymphs are mentioned by name, the other four, who attend her as she undresses, are listed only in conjunction with their specific duties.

15. Ibid., III, 140–43, "But if you seek the truth, you will find the cause of this in fortune's fault and not in any crime of his. For what crime had mere mischance?"

16. De Valory in Dussieux et al. 1854, II, 272, pointed out that even if de Troy's learning was superficial, the circles in which he moved provided him with a thorough acquaintance of *les belles lettres*; "son éloignement pour les lectures instructives fut remplacé par une mémoire très heureuse; la conversation des savants et des gens instruits faisoit le fond de ses connoissances."

17. Paraphrasing Levey in Kalnein and Levey 1972, 9. As noted by Levey 1987, 200, such devices would be used to spectacular effect by Boucher in *Diana at the Bath* (cat. no. 45).

18. Caylus in Fontaine 1910 (B), 34, "il lui suffisait d'avoir une composition dans sa tête; il la mettait sur sa toile, il arrangeait ensuite la nature pour cette même composition."

19. *Dessins de l'École Française du dix-huitième siècle provenant de la collection H. [Heseltine]*, Paris 1913, no. 52, attributed to Natoire, formerly in the collection of Louis Gallichon; cited by Brière in Dimier 1928–30, II, 41; I have been unable to trace a reproduction of this drawing.

20. Galerie Perrin, *De Callot à Tiepolo*, Paris 1990, no. 8.

21. Caylus in Fontaine 1910 (B), 33; the words are supposedly de Troy's.

22. A.N., *Minutier Central*, XLVI / 320, "*Transaction*, Nicolas Rouland, Jean-François de Troy," 17 April 1749, where it is noted of de Troy's marriage that "la célébration a été faite en la paroisse de St. Eustache le 2 Decembre 1732." This document also confirms that Marie-Anne le Trouyt Deslandes died in Rome on 6 March 1742.

23. Dézallier d'Argenville 1762, IV, 368, "il en étoit épris, au point qu'il peignoit sa tête dans tous les morceaux galans qu'il a faits. Comme elle avoit un dragon dans l'oeil, il la représentoit toujours de profil. . . ."

24. Caylus in Fontaine 1910 (B), 33.

25. Bordeaux 1989, 145–46, 152–53.

26. Delignières 1867, 26, Levasseur's engravings of de Troy's pendants, published in 1773 and 1775 respectively, are the only source to mention Collet's ownership; the pendants do not appear in the sale that took place after his death, organized by J.-B.-P. Lebrun, *Catalogue de tableaux des écoles d'Italie, de Flandres et de France*, Paris, 14 May 1787. I am most grateful to Martha Hepworth of the Provenance Index, Getty Art History Information Program, and Alan Wintermute for their help with the Collet sale.

27. *Catalogue d'une riche collection de tableaux des peintres les plus célèbres des différentes écoles . . . qui composent le cabinet de M. [l'abbé de Gevigney]*, Paris, 1 December 1779, no. 519, purchased by Silvestre for 603 *livres*.

28. *Catalogue de tableaux précieux de divers grand maîtres des trois écoles . . . trouvés après le décès de Madame B. [Basan]*, Paris, 4 April 1791, no. 28, where it sold for 199 *livres*, 19 *sols*.

29. This information was kindly provided by Dr. E. G. Franz, director of the Hessisches Staatsarchiv, Darmstadt.

30. *Catalogue d'une riche collection qui composoient le cabinet de Mr. Nicolas Reber, Négotiant à Basle*, Basel, 15 October 1810, no. 265.

31. Gottfried Keller-Stiftung 1901, 17–19.

La mort d'Hippolyte

FIG. 1
After Jean-François de Troy, *The Death of Hippolytus*, 1735, engraved by C.-N. Cochin, Paris,
Bibliothèque Nationale, Cabinet des Estampes

FIG. 2
After Jean-François de Troy, *The Rape of Proserpine*, 1773, engraved by J.-C. Levasseur, Paris,
Bibliothèque Nationale, Cabinet des Estampes

FIG. 3
Jean-François de Troy, *Head of a Woman Seen from Behind*, c. 1734, colored chalk drawing, Paris, Galerie Perrin

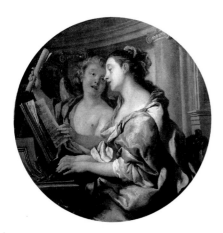

FIG. 4
Jean-François de Troy, *Allegory of Music*, 1733, oil on canvas, Oregon, Portland Museum of Art

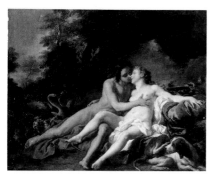

FIG. 5
Jean-François de Troy, *Venus and Adonis*, c. 1730, oil on canvas, Private Collection

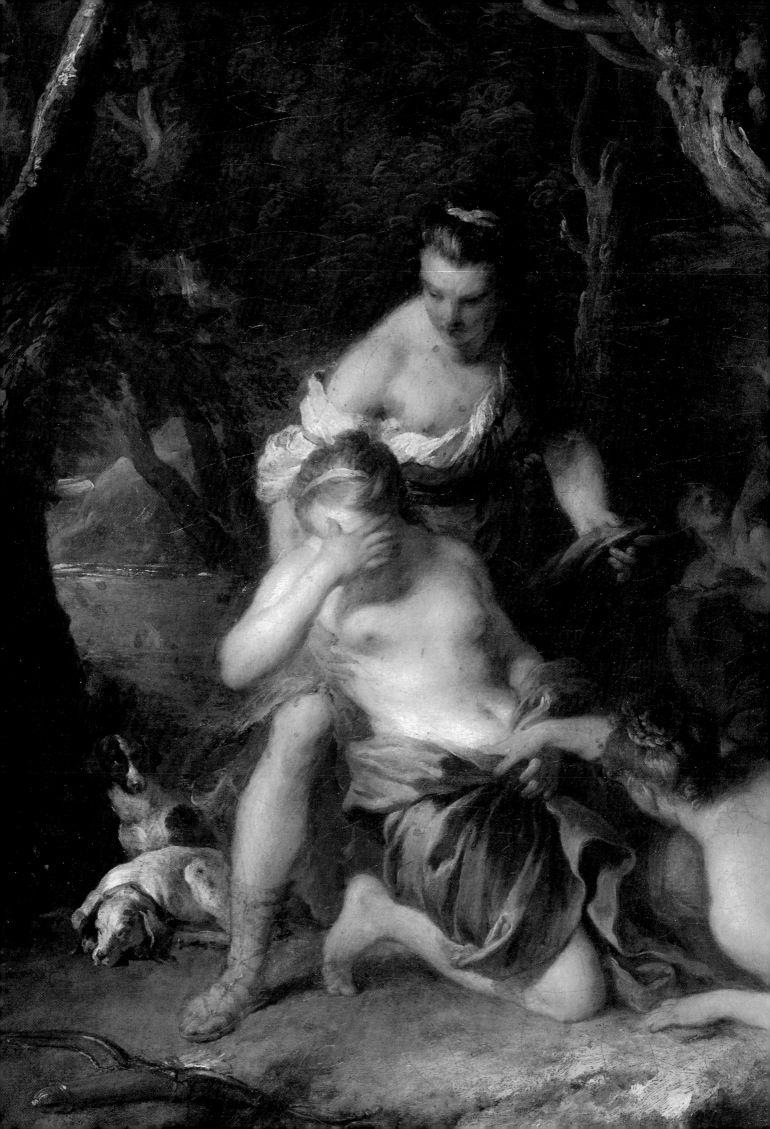

FRANÇOIS LEMOYNE
(1688–1737)

The most tortured and tragic of all French artists of the eighteenth century, whose hatred of his colleagues and little-disguised ambition were much commented upon, François Lemoyne was also the most fluent and graceful history painter of his generation and the artist whose painterly manner and luminous coloring thoroughly renewed the language of academic art in the second and third decades of the century. Of modest origins—his father was a postilion in the royal service—Lemoyne was taught briefly by his stepfather, the portraitist Robert Levrac-Tournières, and, from 1701 to 1712, by the history painter Louis Galloche, in whose studio he received an exemplary academic training. Lemoyne may also have spent a brief period in Cazes's studio.

A prizewinner for drawing at the Academy in 1706 and 1707, Lemoyne was awarded the *Grand Prix*—his second attempt—for *Ruth and Boaz* in August 1711, but, as funds were not available for his studentship in Rome, he remained in Paris. *Agréé* in December 1716 with *The Adoration of the Magi* (Houston, Sarah Campbell Blaffer Foundation) and elevated to a full member of the Academy two years later with *Hercules Slaying Cacus* (Paris, École Nationale Supérieure des Beaux-Arts), which Caylus considered the most "correct" of all his paintings, Lemoyne soon received commissions for large-scale, poorly remunerated religious compositions.

If the Crown was slow to employ Lemoyne, he found ready support in the private sector and was taken up by the wealthy and cultivated *receveur général des finances*, François Berger, who commissioned a suite of imposing history paintings from the artist and paid him a monthly stipend which removed the need to seek work elsewhere. It was in Berger's company, and at his expense, that Lemoyne traveled to Italy between November 1723 and July 1724, where he visited Venice, Rome, and Naples and where he painted a pair of pendants, *Hercules and Omphale* (Paris, Musée du Louvre) and *The Bather* (version in Leningrad, The Hermitage), which were much acclaimed and secured his reputation as a figure painter of great virtuosity.

Back in Paris, Lemoyne displayed the range of his talent at the Salon of 1725, exhibiting eight paintings, including Berger's pendants and cabinet pictures of exquisite refinement, such as *The Abduction of Europa* (Moscow, Pushkin Museum). Lemoyne's preeminence in the genre of religious decoration was also confirmed by successive commissions from the Crown: an altarpiece for the church of the Filles de l'Assomption (*The Flight into Egypt*, 1725–26, lost) and *The Vow of Saint Louis*, 1727, for the principal altar at the recently completed cathedral of Saint-Louis, Versailles.

Lemoyne was being groomed to take on the remaining decorative commissions at Versailles. With *The Continence of Scipio*, 1727 (Nancy, Musée des Beaux-Arts), he shared first prize in the *concours de 1727* with his rival Jean-François de Troy and may have begun planning the design for the ceiling of the *salon d'Hercule* as early as 1728.

At the height of his career, Lemoyne was practically overwhelmed with commissions of the highest order. He painted a heroic *dessus de cheminée*, *Louis XV Giving Peace to Europe* (Musée National des Châteaux de Versailles et de Trianon), for the *salon de la Paix* at Versailles in the summer of 1729, and was the only academician employed on the decoration of the hôtel Peyrenc de Moras (now the Musée Rodin, Paris), for which he produced eighteen overdoors (see cat. nos. 27 and 28). Lemoyne's small-scale, carefully worked cabinet pictures were also much in demand at this time (see cat. nos. 24, 25, and 26), yet their fluency and delicacy belied the effort and careful preparation they demanded from the artist.

In November 1732 Lemoyne began work in earnest on the decoration of the *salon d'Hercule* at Versailles. His radical solution depicted Hercules' ascension to Olympus and his marriage to Hebe witnessed by all the deities of antiquity in an enormous narrative, uninterrupted by architectural elements, real or fictive. This monumental mythology, comprising 142 figures of more than lifesize proportion, consumed the artist for four years and was unveiled to Louis XV in September 1736.

Lemoyne was made *premier peintre du roi* later that month, yet this long-awaited official recognition was won at great cost to his mental and physical well-being. He seems to have suffered a nervous breakdown at this time and was increasingly prone to paranoid delusions. Caylus claimed that Lemoyne would have been incapable of producing anything of merit again, yet this observation is brought into question by the preparatory drawings for *The Defeat of Porus* (Stockholm, Nationalmuseum; New York, The Metropolitan Museum of Art), Lemoyne's first ideas for a large history painting commissioned in October 1736 by the king of Spain, and by *Time Saving Truth from Falsehood and Envy* (London, Wallace Collection), his last painting, completed in 1737. None of these works displays the slightest sign of debilitation. Ever more reclusive, however, Lemoyne committed suicide on 4 June 1737 by stabbing himself nine times with his sword. The duc de Luynes heartlessly remarked that Lemoyne had killed himself because his stipend as *premier peintre du roi* was well below the sum given to Le Brun.

A draughtsman of elegance and fluency, whose rhythmic, sinuous line and eternally youthful physiognomies laid him open to the charge of "incorrection," Lemoyne imbued French history painting with a luminosity and sensuousness derived from the Venetian school, both old and new, but which were ultimately subordinated to the principles of expressive clarity and rational design inculcated by his long training at the Academy. The lightening of his palette, the warmth of his modeling, and the dynamism of his compositions were signal innovations that would be built upon by the succeeding generation of history painters, most notably his pupils Boucher and Natoire.

FRANÇOIS LEMOYNE, *Diana and Callisto* (detail), c. 1725–28, oil on canvas, 76 x 95 cm, Collection of Alex Wengraf, London

FRANÇOIS LEMOYNE
Hercules and Omphale

23

François Lemoyne (1688–1737)
Hercules and Omphale, c. 1730–35
Oil on canvas
136 x 95 cm.
Private Collection

PROVENANCE
Possibly coll. Josef Himmelsbach, Bad Schönborn, West Germany; Sotheby's, London, 4 April 1984, no. 29; New York, Stair Sainty Matthiesen.

EXHIBITIONS
New York, New Orleans, and Columbus 1985–86, no. 8, col.

BIBLIOGRAPHY
Bordeaux 1984 (A), 95, ill.

Resting from his twelve labors after returning to Thebes, Hercules became embroiled with the family of Eurytus, whose daughter, Iole, he had won unfairly in an archery contest. Hercules brutally murdered Iphitus, one of Eurytus's sons, who had consented to be his guest, and the god was then forced to seek absolution for having violated the sacred rites of hospitality. Finally, the pythoness, Xenoclea, consented to grant Hercules peace on the condition that he sell himself into slavery for one year and give the sum fetched by his enslavement to Iphitus's children. Hercules was purchased by Omphale, queen of Lydia, whom he served largely in the capacity of a willing lover, although he also found time to rid Lydia of a man-eating serpent and a murderous farmer. Omphale so subjugated Hercules that rumor reached Greece that he had taken to dressing in female attire and would weave and spin in the company of the queen's attendants.

This story, told by Apollodorus and Ovid but known also in France through Noël Lecomte's *Mythologie*—a copy of which was listed in Lemoyne's library—provided the artist with the subject of his masterpiece.[1] The primary version of Lemoyne's *Hercules and Omphale* (fig. 1), painted between May and July 1724 for his protector François Berger while they were traveling together in Rome, won the artist immediate acclaim.[2] Charles Poerson, director of the French Academy in Rome, informed d'Antin that Lemoyne had shown this work to both the cardinals de Rohan and de Polignac and that the former had commissioned a version of the painting to be executed as soon as the artist returned to France.[3] One of the eight paintings that Lemoyne exhibited at the Salon in August 1725, *Hercules and Omphale* had already inspired a celebratory epic poem that appeared in the *Mercure de France* in March of that year.[4] Laurent Cars's engraving after *Hercules and Omphale* (fig. 2) with a dedication to Berger, advertised in the *Mercure* in April 1728, was included in the gift of three prints which Lemoyne presented to the Academy that same month.[5] The painting was known on both sides of the Channel—Dubosc's engraving circulated in London—and was replicated in "countless copies and

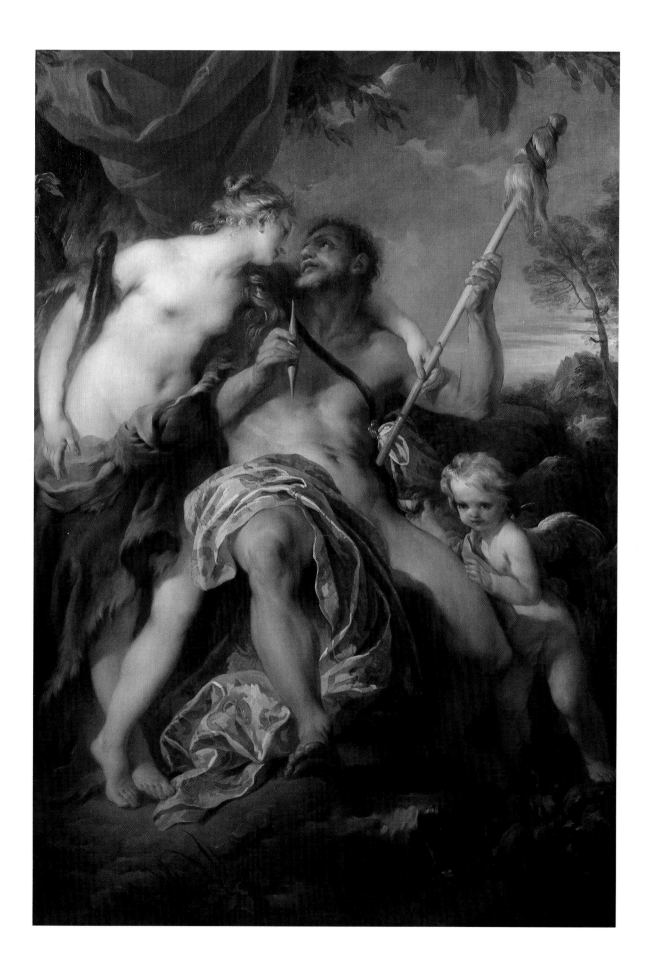

pastiches."[6] The composition was used even in the decoration of pocket watches.[7]

Both the Louvre *Hercules and Omphale* and the autograph replica exhibited here—described by Jean-Luc Bordeaux as "absolutely authentic and brilliantly executed"[8]—show Hercules seated on a rock, a distaff in his left hand, a spindle in his right. Omphale, arching her pearly white body against Hercules's massive, ruddy frame, lets fall her golden tresses upon his right shoulder as she lowers her head towards his. She is draped in the lion's pelt he has discarded and holds his huge club suggestively at her side. A winged cupid, in attendance, hands Hercules a bowl of sweets; the setting sun in the background indicates that night is about to fall.

Despite differences in scale and handling between the two versions—the replica is considerably smaller and is painted more broadly—the second version is a *répétition* of the Louvre's painting and falls into a different category than the other copies of *Hercules and Omphale* that are known. Dézallier d'Argenville, a friend of Lemoyne's, reserved a place apart for "repeated subjects" which were not mere copies, "and which are no less original as works of art."[9] "Rarely," he wrote, "does a fine artist repeat himself without adding something new. This can take the form of a change in the background, a figure added or taken away, a drapery painted in a different color, anything, in a word, that shows that his picture, even though it repeats the subject, is as original as the first version."[10] Several such changes are apparent in the smaller version of *Hercules and Omphale*. Cupid looks straight out at us, whereas his head is at an angle in the Louvre's painting, and his golden locks have been replaced by waves of hair. In the left foreground, directly beneath Hercules's gold and satin brocade, are creamy, thickly painted plants which do not appear in the Louvre version. Finally, the spatial relationship between the ball of wool and the drapery in the upper right corner of the canvas—which was probably cut down on the top as well as on the left- and right-hand sides—is quite different from that in the primary version, where the edge of the curtain glances against the newly spun wool.

In its smoothness of handling and more even modeling of flesh, Lemoyne's second *Hercules and Omphale* may be compared to *Time Saving Truth from Falsehood and Envy* (fig. 3), finished on the eve of the artist's suicide.[11] Similarities in technique suggest that the replica of *Hercules and Omphale* may have been painted several years after the original version. The weaker passages in this painting point to studio assistance—the patterned brocade is literal and perfunctory, Cupid's anatomy compressed and ungain-

ly—yet the beautiful figure of Omphale is executed with Lemoyne's characteristic fluency of touch, as are the makeshift canopy of red drapery and the glorious Venetian sunset in the background. If it is impossible to document the commission of this replica with any precision, a case can be made for dating the work late in the artist's career. Cupid's somewhat flattened expression, a facial type reminiscent of Lemoyne's pupil Natoire, might even suggest that the master was here responding to the style of a younger generation that he himself had trained. It is known that Lemoyne did not begin work on the version of *Hercules and Omphale* commissioned by the Cardinal de Rohan in 1724 until almost a decade after his return from Rome. Donat Nonnotte, Lemoyne's assistant at Versailles, recorded that it was only after the first campaign on the *salon d'Hercule* came to an end in the winter of 1732 that Lemoyne turned to Rohan's commission, which was carried out with Nonnotte's assistance.[12] Even if there is insufficient evidence to connect Rohan's *Hercules and Omphale*, painted for his château de Saverne, with the painting exhibited here, the stylistic differences between the primary and secondary versions may be accounted for by the intervening decade which saw a broadening of Lemoyne's technique, doubtless influenced by his work on decorative commissions of the grandest scale.

Discussing the influence of Italian art on the artist during his long-awaited visit to Rome in 1723–24, Mariette noted Lemoyne's debt to Veronese and Parmigianino; the sinuous Omphale does bear some resemblance to the latter's long-necked Madonnas.[13] Caylus, on the other hand, mentioned the impact on the mature Lemoyne of ceiling decorations by Michelangelo and Pietro da Cortona, and their influence is felt in the massive bulk of the figure of Hercules, which recalls, in the most general way, the *ignudi* of the Sistine Chapel.[14] Yet, despite antecedents in Italian and Flemish art, Lemoyne's *Hercules and Omphale* is shockingly new in its almost overpowering sensuality. Whereas the story of Hercules's seduction had been related with some contempt in Lecomte's anthology—"thus, the formerly invincible hero was reduced to doing things that were unworthy of him, and all for the love of a whore," was the author's terse conclusion—Lemoyne produced an image where carnality and expectation are finely balanced.[15] Here he was also responding to the latest development in contemporary Italian painting, and it is to the work of the Venetians Sebastiano Ricci and Pellegrini (fig. 4) that one must look for any comparable treatment of the theme at this time. Renewing the tradition of history painting as practiced by the *Académie royale de*

Peinture et de Sculpture, Lemoyne's *Hercules and Omphale* also provided a model for the succeeding generation of academicians; Boucher's intensely erotic *Hercules and Omphale* (cat. no. 42) is inconceivable without his master's example.[16]

Nor was Lemoyne's achievement underestimated by those nineteenth-century historians responsible for the revival of interest in French art of the reign of Louis XV. For Paul Mantz, *Hercules and Omphale* was the first "truly eighteenth-century" painting. Praising Lemoyne's palette for its "new system of color"—"the appearance of pink in the history of French eighteenth-century painting is an event of the first order"—Mantz nonetheless concluded that *Hercules and Omphale* carried the "seeds of decadence" that would gradually overwhelm the French school.[17] The Goncourts, who first saw the Louvre *Hercules and Omphale* at the home of Doctor La Caze in May 1859—"beautiful passages, an elegant female torso, youthful, fine flesh tones, Correggesque moistness"[18]—reacted far more positively, devoting one of their finest pages to the painting: "The body of Omphale is a miracle of execution: the wonderful luminosity of flesh, its moistness, its satin radiance, its pulpy whiteness, all that is downy, tender, and delicate in the naked glory of the female form as modeled by daylight, has been admirably rendered in this most polished *académie*."[19]

NOTES

1. Apollodorus, *The Library*, II, VI, 1–4; Ovid, *Fasti*, II, 303–30; Le Comte 1604, II, 695.

2. Bordeaux 1984 (A), 93–95.

3. Montaiglon and Guiffrey 1887–1912, VII, 33, letter of 4 July 1724.

4. Moraine's poem, commemorating the arrival of *Hercules and Omphale* in Berger's picture cabinet, is discussed in Scott 1988, 425, n. 377.

5. Bibliothèque Nationale 1930–[1977], III, 463–64.

6. Bordeaux 1984 (A), 37, 95 for a listing of some of these, to which should be added copies listed in the Tronchain sale, 10 February 1785, no. 45, and the de Courval sale, 11 May 1789, no. 48.

7. Cardinal 1984, 119.

8. Bordeaux 1984 (A), 95.

9. Dézallier d'Argenville 1762, I, lxxviii, "les sujets répétés, qui . . . ne laissent pas d'être original."

10. Ibid., I, lxxix, ". . . rarement un habile homme se répète, sans y mettre du nouveau. Ce sera un fond changé, une figure de plus ou de moins, une draperie d'une autre couleur; enfin, quelque chose qui constate que ce morceau, quoique répété, est aussi original que le premier. . . ."

11. Ingamells 1989, 243–48.

12. Nonnotte in Gauthier 1902, 533. Another autograph replica of *Hercules and Omphale*, framed and of smaller dimensions than the version exhibited here, was listed among Lemoyne's effects and was presumably also painted in the 1730s for an unknown client, see Bordeaux 1984 (A), 95.

13. Mariette 1851–60, III, 132.

14. Caylus in Lépicié 1752, II, 99.

15. Le Comte 1604, II, 695, "voilà donc ce jadis invincible champion faisant pour l'amour d'une putain beaucoup de choses indignes de sa qualité."

16. Lemoyne's modernity needs to be set in context, however. It is interesting to note that Giambattista Vico's *New Science*, published in 1725, offered a radical reinterpretation of the ancient myth as a "symbolical representation of historical forces and movements." Thus, the story of Hercules sewing with Omphale illustrated that "the heroic right to the fields falls to the plebian clan," cited in Galinsky 1972, 251–52. Such sociological exegesis is completely foreign to Lemoyne's traditional approach to mythology.

17. Mantz 1870, 15, "l'apparition du rose est dans l'histoire de la peinture du XVIIIe siècle un véritable événement"; see also Mantz 1880, 18–21.

18. Goncourt 1989, I, 451, "de belles parties, un torse de femme élégant, juvénile, une chair fraîche, des moiteurs corrégiennes."

19. Goncourt 1880–82, I, 137, "le corps d'Omphale est une merveille: le lumineux divin de la peau, sa moiteur, son rayonnement satiné, sa blancheur pulpeuse, tout ce qu'il y a de douillet, de délicat et de tendre dans la gloire d'un corps de femme nue, que le jour modèle, est admirablement rendu dans cette suave académie."

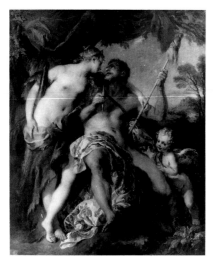

FIG. 1
François Lemoyne, *Hercules and Omphale*,
1724, oil on canvas, Paris, Musée du Louvre

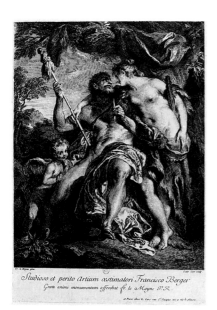

FIG. 2
After François Lemoyne, *Hercules and
Omphale*, 1728, engraved by Laurent Cars,
Paris, Bibliothèque Nationale, Cabinet des
Estampes

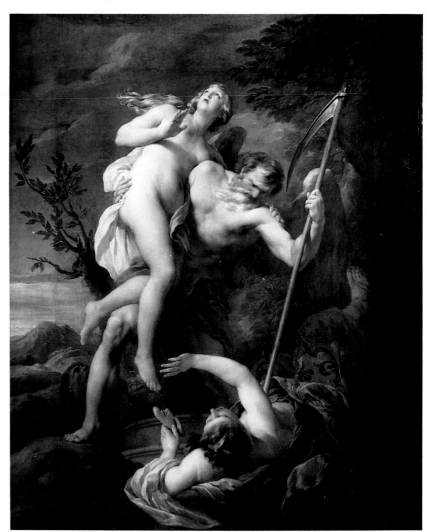

FIG. 3
François Lemoyne, *Time Saving Truth from Falsehood and Envy*, 1737, oil on canvas, London,
Wallace Collection

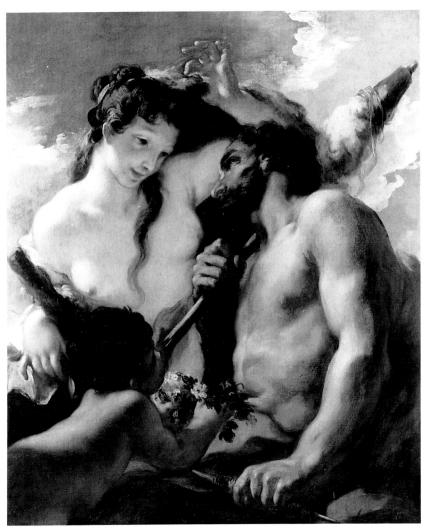

FIG. 4
Giovanni Antonio Pellegrini, *Hercules and Omphale*, oil on canvas, Private Collection

FRANÇOIS LEMOYNE
Diana and Callisto

24

FRANÇOIS LEMOYNE (1688–1737)
Diana and Callisto, c. 1725–28
Oil on canvas
76 x 95 cm.
Alex Wengraf, Esq., London

PROVENANCE
In England c. 1748; Nathaniel Webb, 1767; Richard Hulse (c. 1725–1805), his sale, Christie's, London, 21 March 1806, no. 23, acquired by Colonel Thornton for £28.7s.0d.; Mrs. Campbell Johnston, her sale, Sotheby's, London, 21 February 1945, no. 135; Mrs. M.G. Wengraf.

EXHIBITIONS
London 1954–55, no. 467.

BIBLIOGRAPHY
Dacier 1909–21, pt. 10, 29, no. 82; Fontaine 1910 (B), 65; Dimier 1928–30, II, 90, no. 4; Bordeaux 1984 (A), no. 60, ill.; Fredericksen 1988–90, II, pt. 1, 536.

One hundred fifty years before Lady Wallace bequeathed *Perseus and Andromeda* and *Time Saving Truth from Falsehood and Envy* to the nation, Lemoyne's *Diana and Callisto*, the prime version of his most copied cabinet picture, had entered England with much less fanfare.[1] Although both the identity of its first owner and the date of its departure from France remain obscure, *Diana and Callisto* had "gone over to England" before July 1748, when Caylus included this surprising provenance in a lecture given at the *Académie royale de Peinture et de Sculpture*.[2] One of four old master paintings engraved by William Walker for the London impresario and entrepreneur John Boydell—who published Walker's engraving in March 1767—*Diana and Callisto* was then recorded as in the collection of a "Nathaniel Webb, Esq.," who has so far eluded scholarly investigation.[3] Thereafter, its fame in England declined rapidly, and the painting was not heard of again until it was acquired at auction by the family of the present owner in 1945. So little known was Lemoyne's *Diana and Callisto* that when two eighteenth-century copies recently appeared on the London market (in 1967 and 1979 respectively), they would both be sold with an attribution to Louis de Boullongne.[4]

Even if the better of the two copies (fig. 1) gives but the faintest idea of Lemoyne's delicate handling and feathery brushwork, the attribution to Louis de Boullongne, an academician active during the late reign of Louis XIV, now seems astonishing. The elegance and sensuousness of this composition, full of Venetian *colore*, in which six women in varying states of undress are disposed around a pool in an airy, verdant landscape, are Lemoyne's stock-in-trade.

The artist relates the story of Diana and Callisto with characteristic economy and grace. Callisto, the daughter of King Lycaon of Arcadia and one of Diana's most devoted companions, had been ravished by Jupiter, who had assumed the "features and dress of Diana" in order to win over this virtuous maiden.[5] Deeply ashamed, and with child, it became increasingly difficult for Callisto to conceal her defilement, and in the ninth month her pregnancy was

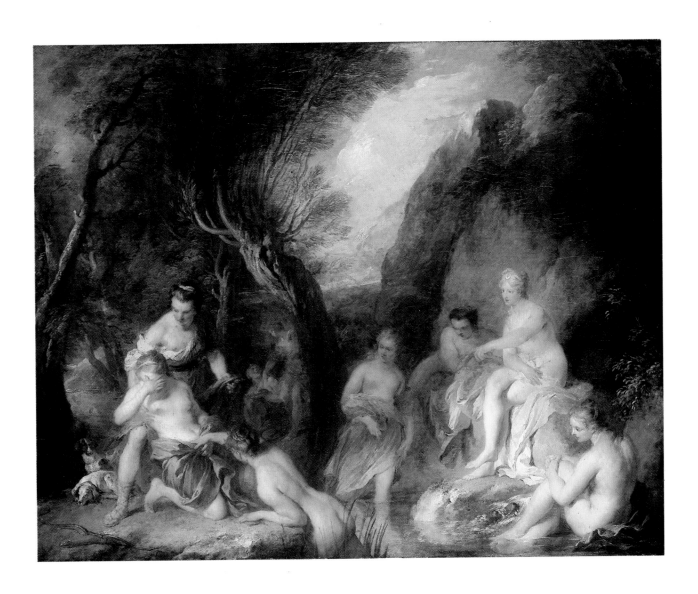

finally revealed to Diana when the goddess, after a day's hunting, instructed her followers to bathe with her "in the gently murmuring stream."[6] Reluctant to disrobe, Callisto had her garments torn from her, and at the sight of her swollen body, Diana, in fury, expelled her from the company. Now destitute, Callisto fell prey to the vengeful Juno, who transformed her into a bear. Callisto took to roaming the forests in fear, hiding not only from hunting dogs but also from other wild animals, forgetful that she was now a bear. Some years later Arcas, Callisto's son by Jupiter, unwittingly came upon his mother while hunting. As she approached him, he moved to kill her with a spear, at which point Jupiter finally took pity on the bear-maiden and transformed both mother and son into constellations of stars, the Great and Little Bear.[7]

Lemoyne exploited the moment at which Diana confronts Callisto for all its dramatic and erotic appeal. Seated on a rock, her white and golden robes arrayed beside her and a little crescent moon in her hair, Diana accuses the pitiful Callisto, whose robes have been removed by force to reveal her distended stomach. Two of Diana's attendants look on in outrage, while a third—the beautiful reclining figure at far right—witnesses the scene in quiet contemplation and expresses little emotion. Callisto raises her right hand to cover her eyes, a gesture of exquisite refinement that transforms her momentarily into a weeping Magdalene. Even the little hunting dogs at left participate in the drama: as one glares with indignation, his companion closes his eyes, shuddering at the violence of Callisto's ordeal.

Lemoyne's mastery of figure painting and his rendering of expression—the distinguishing talents of the history painter—are deployed at a very high level in *Diana and Callisto*. The lovely attendants, whose burnished bodies glow in the afternoon sun, are of a palpable eroticism that would be equaled in the following generation only by Boucher. The nymph who grabs Callisto's copper-colored robes from the bank of the pool is a figural type frequently employed by de Troy, yet only in his *tableaux de modes* would Lemoyne's great rival approach the delicacy and fluency of handling that is achieved throughout this composition. Lemoyne's landscape is equally impressive, his sinuous oak tree and limpid vista recalling the setting of the Hamburg *Narcissus*, a painting of similar facture to *Diana and Callisto*.[8] Protected by massive rocks and arching trees, with mountains and clouds receding far into the distance under a sky of pure blue, Lemoyne evokes the protected grove on the slopes of Maenalus with a poetry very much in the spirit of Ovid's narration.

Despite the virtuosity of his brushwork and the harmonious grouping of his figures, there is an imbalance in the degree to which Lemoyne finished the various protagonists in *Diana and Callisto*. The two companions to Diana's right are painted very thinly, their expressions are simplified, and their bodies and draperies are only sketched in. By contrast, the nymphs in the foreground and the figures of Diana and Callisto themselves are fine examples of Lemoyne's "smoothness of brush," which Caylus considered the artist's "greatest means of seduction."[9] This unexpected inconsistency does not impede our reading of the work and may well have been intentional: an attempt by Lemoyne to maintain the variety of touch possible in large-scale commissions in a work of considerably smaller dimensions. An autograph replica of *Diana and Callisto*—recorded by Saint-Aubin (fig. 2), now lost—was described in the catalogue of the second Conti sale (March 1779) as "*précieux et largement fait*," an unexpected conjunction of modes in a carefully painted cabinet picture, but one that also summarizes quite well the dual manner of the prime version.[10]

Although there is no reference in Lemoyne's inventory to a preparatory sketch for *Diana and Callisto*—a curious absence—the degree of calculation with which Lemoyne elaborated his compositions, of whatever scale, was legendary.[11] A compositional drawing in black and white chalks on blue paper, now lost, was recorded in three eighteenth-century collections.[12] A drawing in *trois crayons* for the figure of Diana (fig. 3) has recently reappeared and confirms Dézallier d'Argenville's observation that Lemoyne "usually drew his figures from life and draped them afterwards."[13] Lemoyne's voluptuous *académie de femme*, eerily faceless, is posed exactly as she will appear in the finished painting, with white chalk employed to map out the areas of light as it falls on Diana's body. In painting the goddess, Lemoyne made two significant changes. Diana's rather large hands are confidently drawn in the preparatory sheet, yet in the painting itself Lemoyne seems to have had difficulty here, and the goddess's accusatory gesture is somewhat obscured by *pentimenti*. Secondly, whereas the model is naked in the drawing and the piece of drapery she holds in her left hand serves no obvious function, this white cloth extends to cover far more of Diana's thighs and stomach in the painting itself. Even in the frankly erotic *Diana and Callisto*, Lemoyne did not fail to indicate the *pudeur* for which the virgin goddess was renowned.

The lost replica of *Diana and Callisto*, which, if Saint-Aubin's sketch is accurate, differed from the prime version only in the placement of the central nymph, was described as showing "*nine figures* in a

charming landscape."[14] This draws attention to the two ancillary figures who are seen at some distance behind the tree in the background and whose presence in the painting is easily overlooked. The standing woman, her hair in a chignon, gestures imperiously to a crouching figure, who clutches her garments to her breast and looks up in fear. Although the expressions and postures of both women are difficult to read, it is quite possible that Lemoyne intended to indicate the aftermath of the myth by their inclusion. Ovid recounted that Juno descended upon the hapless Callisto, flung her "face-foremost to the ground," and exacted vengeance for her liaison with Jupiter. Callisto then "stretched out her arms in prayer for mercy," but received none, for she had already begun to assume the shape of a bear.[15] In the vista beyond the tree and the rocks can be seen the remnants of two other figures, one hunting, the other running—more distinct in the copy of the painting reproduced here than in the prime version—and this, too, might allude to Callisto's sad fate, "driven over the rocky ways by the baying of hounds."[16]

Ambitious in its configuration of expressive figures and extended narrative, Lemoyne's *Diana and Callisto* was heir to an equally weighty tradition. No artist of his generation could have approached this subject without Titian's magnificent *poesia* in mind, a painting that had entered the Orléans collection in 1706 and was recommended by Antoine Coypel to students of the *Académie royale de Peinture et de Sculpture*.[17] However, Lemoyne's maidens lack the monumentality of Titian's figures, and the drama of his cabinet painting is not so thoroughly concentrated around the two protagonists as in Titian's *Diana and Callisto*. A more likely model for Lemoyne's *Diana and Callisto* is Annibale Carracci's painting of the same subject (fig. 4), acquired by Philippe d'Orléans in 1707 and another work with which Lemoyne would have been familiar since his student days.[18] Caylus noted with approval that Galloche, Lemoyne's second master, had assiduously taken his pupils to the picture cabinet of the Palais-Royal, "highly estimable even before the duc d'Orléans had acquired his fine paintings from the queen of Sweden."[19] Although Lemoyne did not model his figures after Annibale's languorous nymphs, he seems to have turned to this composition for the general disposition of figures of modest proportions in a landscape of quiet lyricism.

Lemoyne's *Diana and Callisto*, while indebted to the past, also had a distinctly contemporary resonance.[20] In its brazen eroticism it could be compared to Sebastiano Ricci's *Diana and Callisto* (fig. 5), but its modernity lay above all in its ability to make real once again the comportment of the gods, to compel our attention and involvement by bridging the distance of antiquity without compromising its nobility and grace. The immediacy and accessibility of Lemoyne's deities are his greatest achievement; like the seated nymph in the foreground of *Diana and Callisto*, we gaze in wonderment at *Arcadia redivivus*.

NOTES

1. For the copies and variants see Bordeaux 1984 (A), 105–6. Not mentioned by Bordeaux is Natoire's full-scale copy ("hauteur 2 pieds 6 pouces, largeur 3 pieds 1 pouce") recorded in the *Catalogue de Tableaux, Gouaches, Dessins et Estampes . . . provenans du cabinet du feu M. Barbier, Peintre de l'Académie de Saint-Luc*, Paris, 19 July 1779, no. 4.

2. Caylus in Lépicié 1752, II, 118, "un bain de Diane avec Callisto: tableau qui a passé en Angleterre."

3. Bordeaux 1984 (A), 105. I am grateful to Louise Lippincott, Charles Seebag-Montefiore, and Iain Pears for their help in trying to identify Nathaniel Webb.

4. Sotheby's, London, 22 February 1967, no. 62 (formerly Robinson collection); 11 July 1979, no. 73 (formerly Van den Eynde collection).

5. Ovid, *Metamorphoses*, II, 425.

6. Ibid., 455–56.

7. Ibid., 496–507. See also Graves 1955, 84–85. A summary of the classical sources is to be found in Wall 1988, 185–91.

8. Bordeaux 1984 (A), 112–13. The similarities in handling between these two paintings would further support a reading of 1727 for the date which appears on the rock in *Diana and Callisto* under Lemoyne's signature.

9. Caylus in Lépicié 1752, 11, "son pinceau étoit suave, et sans contredit, il étoit son plus grand moyen de séduction."

10. Reproduced in Dacier 1909–21, pt. 10, 29.

11. The chevalier de Valory noted that Lemoyne was "fort long dans l'exécution de ses ouvrages," in Dussieux et al. 1854, II, 265; Caylus was of like mind: "Ses ouvrages lui ont toujours infiniment coûté; il est vrai que personne n'a su mieux cacher sa peine, recouvrir, séduire enfin par les grâces du pinceau," Caylus in Lépicié 1752, II, 84.

12. In addition to the Boileau (1782) and Silvestre (1811) collections cited in Bordeaux 1984 (A), 106, the drawing is also recorded in the *Catalogue d'une collection de tableaux, dessins, gouaches . . . provenans en partie du cabinet d'un Artiste*, Paris, 22 January 1787, no. 302.

13. Dézallier d'Argenville 1762, IV, 426, "il dessinoit ordinairement ses figures d'après le modèle et les drappoit ensuite."

14. *Catalogue d'une collection précieux de tableaux et dessins de meilleurs maîtres. . . .* [prince de Conti], Paris, 15 March 1779, no. 82, "composition de *neuf figures* dans un paysage agréable" (my emphasis). In Saint-Aubin's illustration the nymph is shown standing closer to the tree.

15. Ovid, *Metamorphoses*, II, 476–80.

16. Ibid., 491.

17. Wethey 1969–75, III, 140; Coypel in Jouin 1883, 263.

18. Posner 1971, II, 50.

19. Caylus in Lépicié 1752, II, 82, "déjà recommandable, avant l'acquisition que feu M. le Duc d'Orléans fit des beaux tableaux de la reine de Suède."

20. It may also be compared to Lancret's lost *Diana and Callisto*, a work that Lancret showed only to his most intimate companions (among whom Lemoyne ranked very high), and through which he aspired "jusqu'au plus grand genre de la peinture, on veut dire l'Histoire," Ballot de Sovot, cited in Wildenstein 1924 (A), 119, and fig. 173.

FIG. 1
After François Lemoyne, *Diana and Callisto*, oil on canvas, London, Private Collection

FIG. 2
After François Lemoyne, *Diana and Callisto*, drawing by Gabriel de Saint-Aubin in his copy of the second Conti sale catalogue, March 1779, Private Collection

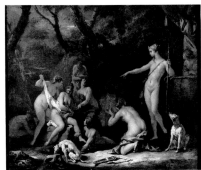

FIG. 3
François Lemoyne, *Diana*, c. 1727, black, red, and white chalk drawing, London, Private Collection

FIG. 4
Annibale Carracci, *Diana and Callisto*, c. 1598, oil on canvas, Mertoun, St. Boswell's, Duke of Sutherland

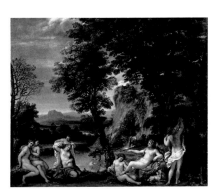

FIG. 5
Sebastiano Ricci, *Diana and Callisto*, c. 1712–16, oil on canvas, Venice, Galleria dell'Accademia

FRANÇOIS LEMOYNE
Narcissus

25

FRANÇOIS LEMOYNE (1688–1737)
Narcissus, c. 1725–28
Oil on canvas
56.5 x 105.5 cm.
Musée du Louvre, Paris

PROVENANCE
Thiébault-Sisson, c. 1932–37; Private Collection, France; Heim-Gairac Gallery, 1974; Othon Kaufmann and François Schlageter, who acquired the work in 1974 and bequeathed it to the Louvre in 1983.

EXHIBITIONS
London 1932, no. 597 (no. 197 of the commemorative catalogue); Paris 1950, no. 38; Paris 1974, no. 23, ill.; Toledo, Chicago, and Ottawa 1975–76, no. 63, ill.; Paris 1984 (A), no. 9, ill.

BIBLIOGRAPHY
Guiffrey 1877, 201; exh. Paris 1937, 94; *Burlington Magazine*, May 1974, lxii, ill.; Bordeaux 1984 (A), no. 72, ill.

In the five years after his return from Italy in August 1724, before beginning work on the *salon d'Hercule*, Lemoyne painted a number of easel paintings for private clients, of which neither Caylus nor Nonnotte deigned to give particulars.[1] *Narcissus* figured prominently in this group, and several canvases of this subject by Lemoyne are recorded.[2] His best-known version, the signed and dated *Narcissus* of 1728 (fig. 1)—copied to scale by the young Boucher—fetched the astonishing sum of 4,200 *livres* in the Conti sale of April 1777, an indication of the esteem in which Lemoyne's art continued to be held forty years after his death.[3]

The horizontal *Narcissus* exhibited here, neither signed nor dated, is distinguished by its elongated format and glorious sunset. It may have served the altogether more private purpose of decorating Lemoyne's bedroom—Michel de Marolles had equated Narcissus with *"endormissement"*[4]—and can be identified as the *"tableau quarré long représentant Narcisse"* hanging there in the company of a large devotional picture and framed prints after three of Lemoyne's most celebrated history paintings.[5] Lemoyne's choice of this subject for his bedroom also reflected something of his keen social aspirations: in 1729 he had painted an overdoor representing *Echo and Narcissus* for the bedroom of the enormously wealthy and prominent financier Abraham Peyrenc de Moras.[6]

The tragic tale of Narcissus is one of the most lyrical myths recounted by Ovid in the *Metamorphoses*. Son of the nymph Leiriope, who had been ravished by the river-god Cephisus, Narcissus grew to be a youth of extraordinary beauty, beloved by man and woman alike. Having scorned both Echo—condemned to "return the words she hears" for having aided Jupiter in his love affairs—and Ameinius—who committed suicide in response—Narcissus was finally punished by Nemesis, goddess of retributive justice, and made to fall fatally in love with his own reflection.[7] Transfixed by the image of the beautiful youth at which he gazed "in speechless wonder," Narcissus remained for days at the water's edge, refusing food and drink, fully conscious of the hopelessness of his

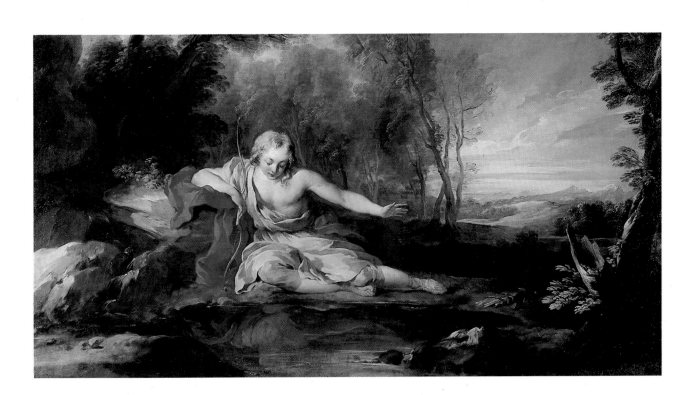

new love. Determined to die rather than abandon his reflection, he wasted away until "death sealed the eyes that marveled at their master's beauty."[8] On his funeral pyre, Narcissus was transformed into the flower of the same name, "its yellow center girt with white petals," whose balm would be used for the cure of earache and frostbite.[9]

In the Louvre's *Narcissus*, as in the Hamburg version, Lemoyne has interpreted this story of self-love with great sensitivity. Alone in a clearing, at the edge of a pool fed by the spring that flows between the rocks at left, Narcissus is portrayed enraptured by his own reflection, which we perceive only dimly on the surface of the water. His quiver and arrows cast to one side and his bow unstrung, he has abandoned the hunt and sits "like a statue carved from Parian marble."[10] Following Ovid quite closely in his depiction of Narcissus—a sixteen-year-old "who might seem boy or man," with golden curls "worthy of Apollo"— Lemoyne is at pains to show "his ivory neck, the glorious beauty of his face, the blush mingled with snowy white." Narcissus's little hands and feet, outlined in red, are fully in the spirit of Ovid's description, as is his pose—"arms outstretched to the trees"—a gesture which suggests that he is on the point of finally comprehending the nature of his infatuation.[11] The russets and greens of Lemoyne's autumnal landscape imbue the canvas with a melancholy and sadness that are overwhelming, and the distant sunset serves to echo Narcissus's loneliness and isolation.

While the figure of Narcissus is presented similarly in the Louvre and Hamburg versions—both of which share the same poignancy—there are significant differences between the two paintings, and these have been summarized by Pierre Rosenberg.[12] In the Louvre's *Narcissus*, the youth's pose is adjusted to match the distinctive rectangular format of the canvas, and he dominates the landscape without becoming engulfed by it. Resting his right elbow on a rock almost parallel to the picture plane, the angle of his outstretched arm is less pronounced and his head sits more squarely on his stocky torso. In the painting from Hamburg, Narcissus is enframed by a deeply recessive arch of trees and, with his hunting dog, forms an equilateral triangle whose sides are mirrored by the leaning tree trunks to left and right. Not only is this a composition of greater constriction, but Lemoyne's handling in the Hamburg *Narcissus* is far more literal: blades of grass, leaves, and branches are described in meticulous detail, as are the folds of Narcissus's drapery and the highlights of his silken tunic. We see Narcissus's reflection as clearly as he does, and the foliage, the bark of the trees, and the mountains in the distance are all painted with the same careful attention

as are the figures of Narcissus and his faithful hunting dog.

In the Louvre's *Narcissus*, Lemoyne paints with equal fluency but is simply less concerned with detail. The setting is now cleared of leaves and branches, the figure of Narcissus has gained in stature, and the landscape opens to reveal distant hills and mountains caught under a sky streaked with white clouds and an orange sunset. As if to emphasize his independence, Narcissus wears a costume of high-pitched, almost strident, hue. Whereas in the painting from Hamburg his cadmium cloak and blue and yellow tunic integrate effortlessly with the silvery foliage and fauna, the Louvre Narcissus wears garments of a much colder cast; his cloak is practically scarlet, his breeches lavender gray, and his magnificent tunic almost the color of the setting sun.

It is very difficult to establish an order of precedence for the two paintings.[13] The Hamburg *Narcissus*, with its richly impastoed landscape and sinuous, interlocking forms, has suffered from overzealous cleaning but may have been brought to greater finish in accordance with the expectations of Lemoyne's private clientele.[14] By contrast, the paring down of details in the Louvre *Narcissus*, with its liquid handling, expansive landscape, and yearning vista, suggests that Lemoyne allowed himself greater freedom of expression in varying a theme already depicted, where he was less concerned with precise description than with creating an atmosphere of affecting loneliness.

Although Lemoyne's *Narcissus* has been compared to Poussin's celebrated painting of the same subject, which hung in the *cabinet de tableaux* at Versailles during Lemoyne's lifetime, neither the Louvre nor Hamburg version makes the slightest reference to Narcissus's earlier encounter with Echo.[15] Poussin's deeply introspective interpretation would find distant resonance in Bertin's small *Narcissus* (fig. 2), painted a decade prior to Lemoyne's, in which several strains of the myth are brought together.[16] Lemoyne, by contrast, looked to the illustrations of Narcissus which accompanied seventeenth-century translations of Ovid, and his paintings share such details as the commanding landscape, Narcissus's reflection, and his discarded quiver with an engraving in the abbé de Bellegarde's *Les Métamorphoses d'Ovide* (fig. 3), a copy of which Lemoyne may well have owned.[17]

Lemoyne may also have been familiar with two other versions of *Narcissus*, both of which functioned as palace decorations. The Louvre *Narcissus* shares the pronounced rectangularity and open landscape of Domenichino's *Narcissus*, a large fresco painted for the *loggia del giardino* of the Palazzo Farnese around 1603–4 that Lemoyne may have seen on his earlier

visit to Italy.[18] And, an example nearer home, Houasse's *Narcissus* (fig. 4), painted in 1691 for the *salon des Sources* at the Trianon de Marbre, clearly provided the model for Lemoyne's third painting of this subject, a sketch of *Narcissus* (fig. 5), whose precise relationship to the Louvre and Hamburg paintings remains to be established.[19] Although Lemoyne's *Narcissus* has been related to Claude's celebrated *Landscape with Narcissus and Echo* (London, The National Gallery), it is extremely unlikely that Lemoyne would have known this work—one of the two Claudes actually painted for England—since it was first engraved only six years after his death.[20]

With the exception of Bertin's little standing Narcissus, most earlier portrayals of Narcissus had depicted the youth kneeling, with one or both of his hands flat on the ground.[21] Lemoyne broke with precedent in showing Narcissus seated, a pose that was presumably easier for his model to sustain, a considerable advantage given the slowness with which the artist worked.[22] Yet *Narcissus* has its roots firmly entrenched in the French academic tradition, since, on one level, the painting is a very sophisticated *académie*, a study from the living male model that formed the basis of the history painter's training.[23] Lemoyne's preparatory drawing for the figure of Narcissus, last recorded in the Boileau sale of 4 March 1782 as "*une académie*," reinstates this mythology within the mainstream of academic pedagogy.[24]

But is *Narcissus* a history painting? Despite Lemoyne's familiarity with Ovid's tale and his effortless recreation of the mythological setting, his two paintings of Narcissus contain landscapes that rank among the finest produced in France in the early eighteenth century. Clearly, Lemoyne had little interest in exploring the subject's moral or emblematic ramifications. For two centuries the story of Narcissus had exemplified the dangers of self-love and the folly of claiming greater wisdom than the ancients, yet there is no such lesson to be learned from either of Lemoyne's canvases.[25] Instead, it is the landscape which the artist has imbued with the greatest poetry, treating it, as had Poussin, as "an emotional extension of the main subject."[26] In this shifting of priorities, Lemoyne may well have been guided by a passage in de Marolles's influential *Tableaux du Temple des Muses* (1655), another book whose presence in Lemoyne's library is securely documented.[27] De Marolles's chapter on Narcissus opens, somewhat unexpectedly, with a description of the setting: "This landscape is particularly charming: and this pool, the clearest in the world, is fed by an abundant spring which flows from the rock . . . and if the perspective does not deceive us, it would seem that this knoll, where so many trees cast such sweet shade, is surrounded by water. . . . The young hunter, who is so well depicted on the river's edge, could not have chosen a more agreeable place to take his rest."[28]

NOTES

1. Caylus in Lépicié 1752, II, 100, "il fit pour des particuliers plusieurs tableaux dont le détail seroit inutile"; Nonnotte in Gauthier 1902, 527, "il fit encore quelques tableaux de cabinet."

2. Rosenberg in exh. Paris 1984 (A), 50; the Hamburg version was engraved by Jean Pelletier in 1757, Bordeaux 1984 (A), 111–13, 118. A copy on glass by Pierre Jouffrey, signed and dated 1762, is recorded in the files of the Service de Documentation, Musée du Louvre. A small autograph copy following the format of the Hamburg *Narcissus* was sold in the Dubarry sale of 11 March 1776 for 240 *livres*. It was illustrated by Saint-Aubin in the annotated sale catalogue (unpublished), now in the John G. Johnson Collection, Philadelphia Museum of Art. Copies after the Hamburg *Narcissus* are to be found in museums in Munich, Autun, and Dôle; a copy recently reappeared in the Libert-Castor sale, Hôtel Drouot, Paris 26 June 1989, no. 30.

3. *Catalogue d'une riche collection de tableaux des maîtres les plus célèbres des trois écoles . . . qui composent le cabinet de feu S.A.S. Monseigneur le Prince de Conti*, Paris, 8 April 1777, no. 689, annotated catalogue in the Frick Art Reference Library. For Boucher's copy after the Hamburg *Narcissus*, see *Catalogue d'une belle collection des tableaux des trois écoles . . . venant en partie du pays étranger*, Paris, 9–12 April 1781, no. 99, where Boucher's copy is described as "faite dans le meilleur tems."

4. Marolles 1655, 285.

5. Guiffrey 1877, 201.

6. Bordeaux 1984 (A), 116–18.

7. Ovid, *Metamorphoses*, III, 379, 405–12.

8. Ibid., 418, 503.

9. Ibid., 510; Graves 1955, 288.

10. Ovid, *Metamorphoses*, III, 419.

11. Ibid., 420–22, 441.

12. In exh. Paris 1984 (A), 50.

13. Rosenberg and Bordeaux date the Louvre *Narcissus* slightly earlier than the Hamburg version of 1728. An alternative chronology is tentatively proposed here, but such a matter, in the absence of firm documentation, remains open to revision.

14. Although it is not known for whom this painting was made, Bordeaux 1984 (A), 112.

15. Rosenberg in exh. Paris 1984–85 (A), 50; Engerand 1899, 315.

16. Bertin's *Narcissus* appeared at Sotheby's, Monte Carlo, 6 December 1987, no. 75, with an attribution to Noël-Nicolas Coypel.

17. Bellegarde 1701, 169. Another example, in which Narcissus is shown by a fountain rather than at the edge of a pond, is Diepenbeeck's engraving in Du Ryer 1702, 96. The inventory of Lemoyne's library mentions "[les] Métamorphoses d'Ovide," but without further details, Guiffrey 1877, 210.

18. Spear 1982, I, 132. Lemoyne's library included "trois livres d'estampes dont l'un représente la gallerie pharnoise," Guiffrey 1877, 209.

19. Schnapper 1967, 80; Bordeaux 1984 (A), 113.

20. Röthlisberger 1961, I, 222.

21. Panofsky 1949, 112–14; Blunt 1967, 79.

22. Dézallier d'Argenville 1762, IV, 426, noted of Lemoyne's working method, "il dessinoit ordinairement les figures d'après le modèle, et les drappoit ensuite."

23. Rubin in exh. Princeton 1977, 17–20.

24. *Catalogue d'une collection précieuse de dessins des trois écoles, tant montés qu'en feuilles . . . le tout provenant du cabinet de M. [Boileau]*, Paris, 4 March 1782, no. 140, "deux Académies, par le même, à la pierre noire, rehaussées de blanc, dont l'une est l'étude de Narcisse."

25. From Alciati's *Emblemata* (1536) to Benserade's *Les Métamorphoses d'Ovide en roudeaux* (1676), the figure of Narcissus was interpreted as a symbol of *amour propre*. Bellegarde and Du Ryer's translations include commentaries to this effect.

26. Blunt 1944, 154.

27. Guiffrey 1877, 210.

28. Marolles 1655, 283, "ce païsage est fort délicieux; et cette eau plus claire du monde, découle d'une source abondante qui tombe de ce rocher . . . et si la perspective ne nous trompe point, il s'en faut bien peu que ce tertre où tant de beaux arbres sont un ombrage si doux, n'en soit environné. Le jeune chasseur qui se voit si bien dépeint sur ce bord, ne pouvoit choisir un plus agréable lieu pour se reposer."

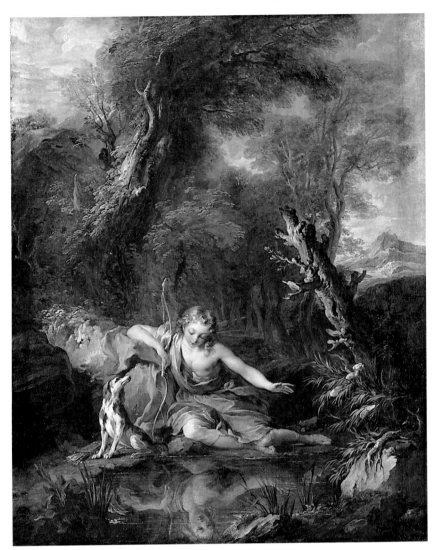

FIG. 1
François Lemoyne, *Narcissus*, 1728, oil on canvas, Hamburg, Kunsthalle

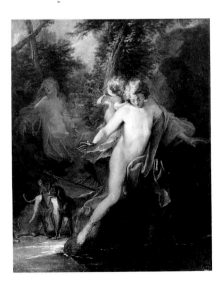

FIG. 2
Nicolas Bertin,
Narcissus, c. 1715,
oil on canvas,
Private Collection

FIG. 3
Anonymous engraving, *Narcissus*, 1701, from
the abbé de Bellegarde's *Les métamorphoses
d'Ovide*

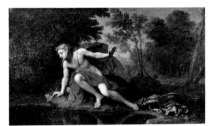

FIG. 4
René-Antoine Houasse, *Narcissus*, 1691, oil on
canvas, Musée National des Châteaux de
Versailles et de Trianon

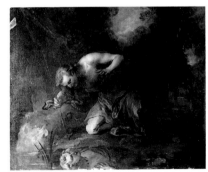

FIG. 5
François Lemoyne, *Narcissus*, c. 1728–30, oil
on canvas, Lyons, Musée des Beaux-Arts

FRANÇOIS LEMOYNE
Venus and Adonis

26

FRANÇOIS LEMOYNE (1688–1737)
Venus and Adonis, 1729
Oil on canvas
92 x 73 cm.
Nationalmuseum, Stockholm

PROVENANCE
Commissioned by Carl Gustav Tessin (1690–1754) from the artist in January 1729 for 600 *livres*; sold by Tessin in 1749 to Fredrik I, King of Sweden; at Fredrikshof until 1774; transferred to Drottningholm by Louisa-Ulrika, where it remained until 1782; brought back to the Royal Palace, Stockholm, by Gustavus III; at Drottningholm from 1793–1865, at which point it entered the collections of the new Nationalmuseum.

EXHIBITIONS
Östersund 1920, no. 18; Copenhagen 1935, no. 125; Stockholm 1945, no. 63.

BIBLIOGRAPHY
Stockholm 1867, 61; Clément de Ris 1874, 494; Mantz 1880, 24; Göthe 1887, no. 854; Göthe 1900, no. 854; Lespinasse 1911, 117; Legran and Wrangel 1912, 37; Lespinasse 1912, 212, no. 67; Stockholm 1920, no. 18; Michel 1925, 142; Réau, 1925, I, 34; Stockholm 1928, no. 854; Dimier 1928–30, I, 75, no. 38; Goldschmidt 1930, 23; Granberg 1930–31, II, 164, III, 13, 17; Moselius 1939, 82; Stockholm 1948, no. 10; Strömbom 1951, no. 59; Hoppe 1953, 45; Nordenfalk 1953 (A), 67; Nordenfalk 1953 (B), 123, 129, ill.; Stockholm 1958, no. 854; Bordeaux 1971, 68; Bordeaux 1984 (A), no. 78, col.; Nichols 1990, 3, ill.; Stockholm 1990, 198, ill.

The story of Venus and Adonis, one of the most celebrated encounters in Greek mythology, is told by Orpheus to an audience of birds and animals at the conclusion of the tenth book of Ovid's *Metamorphoses*.[1] Adonis was the offspring of the incestuous relationship between Myrrha and her father, King Cinyras of Paphos. When Cinyras discovered that the passionate maiden who illicitly attended his tent during the festival of Ceres was his own daughter, he attempted to kill her before committing suicide, but she fled the land. For nine months Myrrha roamed in agony, carrying Cinyras's child and begging the gods to deliver her from her shame. Moved to pity, the gods transformed her into a myrrh tree, from whose bark Lucina, goddess of Birth, then delivered her baby son. Despite such inauspicious beginnings, Myrrha's son Adonis grew to be a youth of great beauty who spent his days hunting.

Venus developed an overwhelming passion for this young man, so great, we are told, that it kept her even from the company of the gods of Olympus. In order to spend more time with Adonis, she took to hunting, forsaking the shade of bowers, and wearing "her garments girt up to her knees, after the manner of Diana."[2] To warn Adonis against dangerous animals such as wild boar and lions, Venus told him the story of Hippomenes and Atalanta, who were transformed into lions for having desecrated one of her holy shrines with their lovemaking. Adonis ignored these warnings and chose instead to follow his hounds, which roused a wild boar from its lair. The boar mortally wounded Adonis, and Venus, returning to Cyprus in her swan-drawn carriage to tend the dying youth, sprinkled nectar over his blood, which brought forth sweet-smelling anemones, the flower so fragile that its petals are shaken off by the wind, and whose beauty, like Adonis's, is of brief duration.

Lemoyne's *Venus and Adonis*, among the artist's most beautiful, but least known, easel paintings, shows Venus entreating the ardent hunter, who gently rebuffs her as he prepares to take his leave.[3] This moment is not recounted in Ovid—in the *Metamorphoses* Venus departs immediately after telling her cautionary

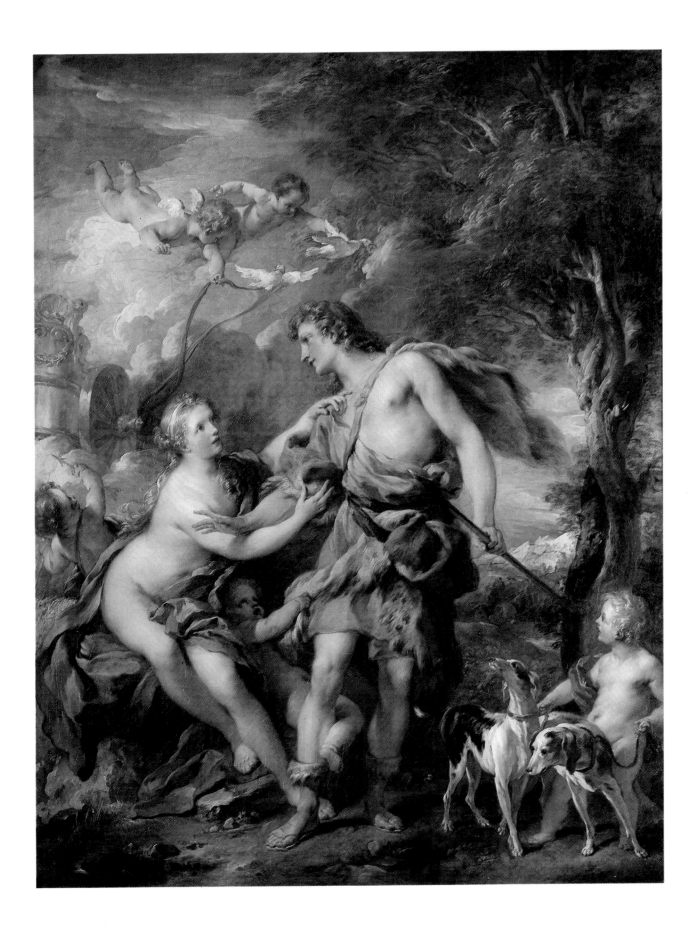

tale—but it had been immortalized in paintings by both Titian and Rubens and soon became the significant episode represented by successive generations of French painters, from Nicolas Mignard (fig. 1) to Louis de Boullongne (fig. 2).[4] Yet rarely before had the scene been treated with such chaste and tender poetry. In a radiant landscape, whose distant mountains and limpid waters evoke the terrain of Cythera, Venus implores her lover with the greatest discretion. The urgency of her admonition is conveyed less by touch than by sight; it is her imploring gaze, rather than any physical gesture, that foretells the hunter's tragic end. Adonis, statuesque and resolute, clutches his javelin purposefully but does not seem to notice the putto who tugs at his lion's skin, wrapping his chubby leg around the young man's calf in order to hold him back. Even Adonis's hunting dogs—elegant and patient, their leashes slack and their little attendant unhappy—seem in no hurry to be gone.

Although Lemoyne took license with Ovid's tale—Venus and Adonis are gilded adolescents, hardly distinguishable in age; the goddess's chariot is drawn not by swans but by white doves, prey to the playful putti—his painting went to the very heart of the story. And he carried his learning discreetly. For the cupid at far left, who hastens to depart, golden arrow in hand, alludes to the origins of the love between Venus and Adonis as described in Ovid. While embracing his mother, Cupid had "unwittingly grazed her breast with a projecting arrow."[5] Dismissing her son in irritation, Venus little realized that this wound would cause her to be "smitten with the beauty of a mortal."[6]

In this dynamic and immaculately crafted composition, Lemoyne's touch is insistent in the delineation of the central characters, and silvery, almost feathery, in the depiction of fabrics, verdant foliage, and billowing clouds. The golden bodies of Venus and Adonis, their cheeks, knees, and hands modeled in red, resonate against the colder hues of their apparel. Lemoyne's handling is of the utmost delicacy in his treatment of Venus's long tresses, the paired hunting dogs at right (which seem to have stepped out of a canvas by Oudry), and Adonis's animal pelt blowing in the wind. Dézallier d'Argenville's analysis of the exceptional fluency and sensuousness of Lemoyne's brush could apply word for word to the Stockholm mythology: "The artist has no equal for freshness and delicacy of touch. His line is fluent, his heads graceful and expressive, his handling light and lively, and his color extremely vivid."[7] Further, this exquisite cabinet painting—for which not a single drawing is known—was elaborated with great concentration and decisiveness over a period of three months.[8] Although it was

noted at the time that Lemoyne worked slowly and often painfully, there is no sign of effort or lack of facility in this work.[9] Two *pentimenti*, visible to the naked eye, indicate changes of mind worked out on the canvas itself: Venus's blue drapery initially extended further down her left thigh, and Adonis's left hand, which clutches the javelin, was moved slightly closer to the animal skin across his waist.

Given Lemoyne's obsessive preparations—he was quite capable of studying the same figure in slightly adjusted poses several times—it is inconceivable that he made no figure drawings for *Venus and Adonis*; these remain to be identified. However, both protagonists in *Venus and Adonis* are based on models in art; the artist was, after all, an exemplary academician. Adonis shares both the pose and profile of the matron immediately to the right of Scipio in Lemoyne's *Continence of Scipio* (fig. 3), his entry to the *concours de 1727*.[10] Venus, by contrast, comes from a completely unexpected source. Her pliant and rounded posture, arms outstretched, head tilted gently to the left, is based on the figure of Potiphar's wife in Cignani's *Joseph and Potiphar's Wife* (fig. 4), the prime version of which had been painted for Count Alphonso di Novellara, chamberlain to Grand Duke Ferdinando II de' Medici.[11] Although Lemoyne is not known to have visited Florence during his trip to Italy in 1723–24, it is nonetheless possible that he saw a version of Cignani's painting at this time. That Lemoyne should have remembered the figure so well is not surprising; his eager appetite for Italian painting was widely remarked upon.[12]

Despite the demand for his cabinet paintings, Lemoyne seems to have taken little pleasure in such commissions. Dézallier d'Argenville noted perceptively, "His genius was ill-suited to the constrictions of easel painting. He preferred to work on a grand scale, to which he was also drawn by his ambition."[13] In 1729, the year in which *Venus and Adonis* was painted, Lemoyne was assured "commissions on the grand scale" and of the greatest prestige. He was engaged to provide the monumental *dessus de cheminée* representing *Louis XV Giving Peace to Europe* for the *salon de la Paix* at Versailles, and following his "victory" at the *concours de 1727*, it is probable that he had also started planning the ceiling decoration of the *salon d'Hercule*, an enormous undertaking that would occupy him almost exclusively between 1729 and 1736.[14]

Under these circumstances, it is all the more surprising that Lemoyne should have been so inspired in a work whose scale and requisite degree of finish may have displeased him. This may be explained, in part, by the distinction of the patron who commissioned

this cabinet painting from Lemoyne in January 1729 and who insisted that it be finished by March of that year. Carl Gustav Tessin (1690–1754), the Swedish *surintendant des Bâtiments*, in Paris with his new wife on an official mission to study recent developments in French decorative arts and architecture, must have appeared the ideal Maecenas.[15] A connoisseur of great sophistication who had known Watteau, Tessin renewed his interest in French painting and drawing with the help of Mariette, whom he frequented during his visit to Paris in 1728–29.[16] Having recently inherited a substantial estate from his father—the court architect Nicodemus Tessin, who had died in April 1728—as well as having made a successful marriage in August 1727 to the daughter of the wealthy and cultivated comte de Sparre, formerly Swedish Ambassador to France, Tessin was exceptionally well placed to collect the finest work available on the Parisian market.[17] Arriving in Paris on 12 December 1728, in the next three months Tessin went on to purchase furniture, silver, crystal, and paintings of the highest quality, forming the nucleus of his picture collection at this time with works by the most prominent and fashionable artists of the day.[18] It was during this visit (12 December 1728–1 April 1729) that he acquired fine genre paintings by Lancret, Pater, and Desportes, as well as mythologies by Lemoyne and Noël-Nicolas Coypel (cat. no. 31).[19] Tessin seems to have shown particular determination in his purchase of Lemoyne's *Venus and Adonis*. The artist's autograph receipt, which has been graciously brought to my attention by Pontus Grate, reveals that on 15 January 1729 Tessin contracted with Lemoyne for a "cabinet painting" to be delivered in March, for which he paid the artist 300 *livres* on account. Tessin received the painting two days before he was due to return to Stockholm and made a second payment to Lemoyne of 300 *livres* on 29 March 1729. He acquired the elegant gilded frame, in which the painting still hangs today, on 21 March 1729 for the sum of 150 *livres*.[20] It is not difficult to imagine Tessin's anxiety as he awaited the arrival of his cabinet picture. Doubtless informed of the slowness with which Lemoyne worked, he was well advised to defer full payment of the commission until the painting was safely in his hands.[21]

The seven French paintings acquired by Tessin in 1728–29 are all recorded as hanging in the picture gallery of his palace in 1735.[22] The collection would grow substantially when Tessin resided in Paris as Swedish ambassador between 1739 and 1742, at which time he commissioned Boucher's masterpiece, *The Triumph of Venus* (Stockholm, Nationalmuseum).[23] However, Tessin never doubted the importance of his earlier visit to Paris, and in November 1758, nine years after his collection had been sold to the Swedish Crown, he looked back on the sojourn of 1728–29 with considerable nostalgia:

> In the year 1728, when I accepted responsibility for the Royal Palace, I found it necessary to refresh my eye and refine my taste by taking a trip abroad. Money was of no concern at the time. My inclination, my fortune, and perhaps a somewhat excusable pride in being known as a promoter of the arts in my fatherland, allowed me to make several purchases. Furthermore, I believed, and still believe, that purchases made with discrimination by connoisseurs do not decline, but rather increase, in value.[24]

Ironically, Tessin's efficiency in ensuring that Lemoyne produce his cabinet picture by a specified time prevented the artist both from making replicas of *Venus and Adonis* and from having the work engraved.[25] Lemoyne painted slowly, and it was his practice to produce autograph versions of his most successful compositions, often in varying formats, for which there was a burgeoning Parisian market.[26] Thanks to Tessin, *Venus and Adonis* disappeared completely from France. The single other documented version, in all probability a preparatory *ébauche* for Tessin's painting, was inventoried, unframed, among Lemoyne's effects as representing "*Vénus qui arrête Adonis*"; of this *ébauche* there has been no further trace.[27]

The absence of commentary by Lemoyne's contemporaries, the lack of engravings and copies, the relative obscurity of the painting itself—the first historian of Lemoyne's oeuvre compared *Venus and Adonis* to the Louvre's *Hercules and Omphale* in size[28]—all can be explained by its immediate departure for Stockholm. Had the work remained in Paris until Lemoyne's death, as was formerly supposed, it is inconceivable that it would not have been reproduced.[29] For in its limpid, gentle interpretation of the most impassioned of myths, *Venus and Adonis* bears witness to the flowering of a truly painterly academic language, no less learned for being sensuous, and no less modern for being officially sanctioned. It is a work of exquisite harmony and refinement, a poignant Arcady replete with youthful ardor: "*cospetto, che bella cosa!*"[30]

NOTES

1. Ovid, *Metamorphoses*, X, 503–739.

2. Ibid., 536.

3. Bordeaux 1984 (A), 43, 115.

4. For Mignard's *Venus and Adonis*, recently acquired by the Minneapolis Institute of Arts, see exh. London 1986 (A), 91–96; Louis de Boullongne's *Venus and Adonis*, painted for the *chambre des jeux* at the Trianon de Marbre in 1688, may well have been known by Lemoyne.

5. Ovid, *Metamorphoses*, X, 526.

6. Ibid., 528. It is worth noting that a new edition of Du Ryer's 1676 translation of Ovid's *Metamorphoses* appeared in 1728 and was announced in the *Mercure de France*, July 1728, 1646.

7. Dézallier d'Argenville 1762, IV, 426. "Personne n'a plus approché de ce maître pour la fraîcheur du pinceau et la finessse de la touche: ses contours sont coulans, ses têtes gracieuses et expressives, sa touche légère et spirituelle, et ses teintes extrêmement vives."

8. See my discussion in n. 20 of Lemoyne's autograph receipt of 15 January 1729 in which Tessin binds the artist to produce this "cabinet painting" within three months.

9. Caylus in Lépicié 1752, 84, "ses ouvrages lui ont toujours infiniment coûté."

10. Bordeaux 1984 (A), 108–10, but the position of the feet differs.

11. Roli 1977, 96, 241; Brejon de Lavergnée and Volle 1988, 110. Alan Wintermute pointed out this connection to me, and I am grateful to him for permitting me to publish his discovery here.

12. Dézallier d'Argenville 1762, IV, 420, "son amour pour son art étoit extrême: aucun morceau considérable ne lui échappoit. . . ."

13. Ibid., 417, "son génie ne s'accommodoit point d'être gêné dans un tableau de chevalet: il cherchoit les grands ouvrages; l'ambition l'y conduisoit naturellement."

14. Bordeaux 1984 (A), 114; *Louis XV Giving Peace to Europe* was installed in July 1729. Nonnotte, who assisted Lemoyne on the *salon d'Hercule*, noted that d'Antin gave orders for Lemoyne to begin working on this project as soon as the results of the *concours* were made public, Bordeaux 1984 (A), 123.

15. Bjurström 1967, 103, for the most concise summary in English. Tessin's early visit to Paris is exhaustively treated in Moselius 1939, 93–96.

16. Of Mariette's influence at this time Tessin was later to write, "je lui dois le peu que je sai [sic], et je fais cet aveu avec plaisir" cited in Bjurström 1967, 106.

17. Proschwitz 1983, 18–20.

18. Moselius 1939, 94.

19. Lancret's pendants *The Swing* and *Blind Man's Bluff* (NM 843, 844) may thus be dated 1728–29, as can Pater's *Company Bathing in a Park* (NM 874); Desportes's *Breakfast Piece with Oysters* and its pendant *Breakfast Piece with Ham* (NM 798, 799) are signed and dated 1729; Noël-Nicolas Coypel's *Judgment of Paris* (NM 793, cat. no. 31) is dated 1728. All of these paintings are now in the Nationalmuseum, Stockholm.

20. Lemoyne's receipts, dated 15 January 1729 and 29 March 1729, are in the Kunglin Biblioteket, Stockholm, Akeröarkivet, VII, 734, 739, 743; the receipt for framing is in ibid., 743. I am extremely grateful to Pontus Grate for these references.

21. It is worth noting that French cabinet paintings of such quality and finish seem to have decreased in price in the following generation; some thirteen years later Tessin paid 372 *livres* for Boucher's *Leda and the Swan* (Stockholm, Nationalmuseum), Sander 1872, 60.

22. Moselius 1939, 95, for the "General Inventarium" of 1735.

23. On Tessin's patronage of Boucher, see Grate 1987, 69–80.

24. Tessin's journal entry for 29 November 1758 is published in Moselius 1939, 95. I am grateful to Dr. Kjell Johansen of the University of North Texas for his translation.

25. I have been unable to trace any references to the engraving by Louis Jacob cited in Bordeaux 1984 (A), 115.

26. See, for example, the versions and variants of *Hercules and Omphale* and *Narcissus*, Bordeaux 1984 (A), 93–95, 111–13.

27. Guiffrey 1877, 206, "deux autres tableaux quarrés, peints sur toille, sans bordure, représentans Andromède, et l'autre Vénus qui arrête Adonis, prisés 12 *livres*. . . . "

28. Saunier in Dimier 1928–30, I, 75. Paul Mantz, the first historian to reconsider Lemoyne's oeuvre, had clearly never set eyes on the painting: "on nous assure que ce tableau . . . est remarquable par la clarté des colorations," Mantz 1880, 24.

29. Lespinasse 1912, 117, where it is stated that Tessin purchased Lemoyne's *Venus and Adonis* for Queen Louisa-Ulrika, who came to Sweden as the bride of Adolph Fredrik in 1744. Although Bordeaux correctly rejected the provenance of the Fronspertuis sale (4 March 1748) as erroneous, his proposed dating of Tessin's acquisition of *Venus and Adonis* to "around 1740" cannot be sustained, Bordeaux 1984 (A), 115.

30. Tessin's celebrated epiphany of Boucher's *Triumph of Venus*, made in a letter of July 1740 to Carl Hårleman, applies equally well to Lemoyne's *Venus and Adonis*.

FIG. 1
Nicolas Mignard, *Venus and Adonis*, c. 1650,
oil on canvas, Minneapolis Institute of Arts

FIG. 3
François Lemoyne, *The Continence of Scipio*, 1727, oil on canvas, Nancy, Musée des Beaux-Arts

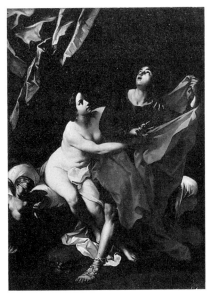

FIG. 2
Louis de Boullongne, *Venus and Adonis*, 1688,
oil on canvas, Musée National des Châteaux
de Versailles et de Trianon

FIG. 4
Carlo Cignani, *Joseph and Potiphar's Wife*,
1671, oil on canvas, Copenhagen, Statens
Museum for Kunst

FRANÇOIS LEMOYNE
Venus Showing Cupid the Power of His Arrows

The Work of Penelope

27 & 28

FRANÇOIS LEMOYNE (1688–1737)
Venus Showing Cupid the Power of His Arrows, c. 1729–30
Oil on canvas
109 x 164 cm.
Musée Rodin, Paris

PROVENANCE
Commissioned by Abraham Peyrenc de Moras (1686–1732) as one of four overdoors for the *grand salon central* of the hôtel Peyrenc de Moras, where it remained until the elements of interior decoration were dismantled and sold off by the Order of the Sacred Heart, c. 1890; sale, Paris, Nouveau Drouot, 13 December 1983, no. 107 [as attributed to François Lemoyne]; Colnaghi, New York.

EXHIBITIONS
London 1986 (B), no. 6, ill.

BIBLIOGRAPHY
Lavedan, Charageat, and Catheu 1947, 76–78; Bordeaux 1971, 67, 71; Bordeaux 1984 (A), nos. 81, 88.

FRANÇOIS LEMOYNE (1688–1737)
The Work of Penelope, c. 1729–30
Oil on canvas
87.5 x 130.5 cm. (before restoration)
Musée Rodin, Paris

PROVENANCE
Commissioned by Abraham Peyrenc de Moras (1686–1732) as one of two overdoors for the *salon ovale* of the hôtel Peyrenc de Moras, where it remained until the elements of interior decoration were dismantled and sold off by the Order of the Sacred Heart, c. 1890; sale, Paris, Ader Picard Tajan, 29 June 1989, no. 7.

EXHIBITIONS
Never before exhibited.

BIBLIOGRAPHY
No previous bibliography.

Between 1729 and 1730 Lemoyne painted eighteen overdoors for the hôtel Peyrenc de Moras on the rue de Varenne, "the most superb house in Paris."[1] This was his most important commission to date and one that would be eclipsed only by the project to decorate the *salon d'Hercule* at Versailles.[2] Designed by Jean Aubert, architect to the Bourbon-Condé—for whom he built the stables at Chantilly and the Palais-Bourbon—the hôtel Peyrenc de Moras was erected between 1727 and 1730 at impressive speed.[3] In order to bring the project to a timely conclusion, the lavish interior decoration, consisting of paneling and stucco work—and recognized then, as now, as a superb example of early rococo design—was consigned to *sculpteurs-ornemanistes* from several different ateliers.[4] Somewhat surprisingly, Lemoyne, one of the slowest of painters, was given the lion's share of the painted decoration: overdoors for the *grand salon central* and for the suite of rooms to its right, which comprised Madame Peyrenc de Moras's *appartement* (fig. 1).[5] Whether Lemoyne would have eventually decorated *Monsieur's appartement* in the north wing in like fashion is open to speculation. In the event, allegories by Nicolas Foucher (1653–1733) and Noël Coypel (1628–1707), and copies after celebrated mythologies by Antoine Coypel and Louis de Boullongne were acquired to be placed in these rooms—a curious ensemble of paintings which lacked coherence and must have seemed distinctly old-fashioned.[6] It is difficult to account for this contrast of styles, but, given the proprietor's impatience to take possession of his house and Lemoyne's difficulties in finishing his commissions on time, the architect's decision to use "ready-made" overdoors may well have been prompted by expediency rather than taste.[7]

Son of a wigmaker from the Languedoc who rose to become *chef de conseil* to the dowager duchesse de Bourbon, Abraham Peyrenc de Moras, *conseiller du roi, maître des requêtes, inspecteur de la Compagnie des*

Indes, was the self-made man *par excellence*. After serving an apprenticeship as *valet de chambre-barbier* to François-Marie Farges, the immensely wealthy contractor whose fortune had been made during Louis XIV's late wars, Peyrenc de Moras seduced his master's young daughter, married her in 1717, and armed with a substantial income of his own, set about consolidating the profit he had made on Law's stock exchange by investing in property. He acquired noble office, purchased the requisite country estates, and became part of the inner circle of financial advisers to Louis XV during his minority. Promoted to *chef de la Compagnie des Indes* in 1719, it was subsequently rumored that Peyrenc de Moras aspired to the office of *contrôleur général*, the most powerful ministerial position in the kingdom.[8]

Peyrenc de Moras's *train de vie* was no less extravagant. Following Law's disgrace, in March 1723 he acquired part of the newly developed place Vendôme, where he commissioned Jacques V Gabriel and Jean Aubert to build a magnificent town house, whose richly ornamented interiors included a paneled room decorated by Claude III Audran and Nicolas Lancret.[9] By the time of its completion in June 1725, the first hôtel Peyrenc de Moras no longer satisfied its proprietor. Aping his protectress, the doughty Louise-Françoise, duchesse de Bourbon—whose palace in the undeveloped Faubourg Saint-Germain was being constructed under Aubert's supervision—in June 1727 Peyrenc de Moras purchased a large terrain in this aristocratic neighborhood, adjacent to the Invalides. In the same year Mariette published designs for the second hôtel Peyrenc de Moras. Although the exterior plan, with its isolated *corps de logis* and oval *salons en rotule*, resembled a scaled-down version of the Palais-Bourbon, the interior decoration of the second hôtel Peyrenc de Moras surpassed anything yet created under Aubert's direction, and such competition was little appreciated by the dowager duchess.[10] Germain Brice would compare the hôtel Peyrenc de Moras to the "palaces of the greatest Seigneurs"; Blondel was struck above all by the contrast between the sobriety of the exterior façade and the "luxury that has been introduced into the interior."[11]

Yet Abraham Peyrenc de Moras would inhabit his second home for even less time than he had lived on the place Vendôme. Taking up residence in 1731, he endured the splendid surroundings for barely a year, dying in November 1732 and leaving a fortune estimated at over fifteen million *livres*, which included "a beautiful palace . . . that did not last well."[12] Less than four years later, his widow, Marie-Anne-Josèphe Farges, "a foolish, impertinent creature who had attempted to marry off her daughter to the king of Naples," leased the hôtel Peyrenc de Moras to Louise-Bénédictine de Bourbon, duchesse de Maine, for an annual rent of 100,000 *livres*.[13] Before moving into this house—which she would occupy between 1737 and 1753 and to which she would make only minor changes—the duchesse de Maine had Aubert draw up a complete inventory of its contents. This document, dated 15 January 1737, records Lemoyne's canvases in the hôtel Peyrenc de Moras with uncustomary precision, and it is all the more valuable since attached decorative paintings were rarely listed in any detail in *inventaires après décès*.[14]

From Aubert's "*Etat des lieux, décorations et meubles . . .*" the following emerges. Lemoyne painted four overdoors "representing the Times of the Day" for the "*grand salon* separating the two main apartments on the ground floor"; two overdoors, *Alpheus and Arethusa* and *Hercules Freeing Hesione*, and a *dessus de trumeaux, Mercury and Argus*, for the "*grande chambre ensuite*"; two overdoors, *The Work of Penelope* and *The Return of Ulysses and Telemachus*, and "eight *camaïeux* above the pilasters . . . representing children's games painted blue against a gold background" for the *salon ovale*; and finally, an overdoor, *Narcissus and the Nymph Echo*, for the adjoining bedroom.[15]

Until very recently, the decorations for the hôtel Peyrenc de Moras were known chiefly from a partial publication of Aubert's inventory and from preparatory drawings; the rather lackluster *Hercules Freeing Hesione* (fig. 2), painted for the *grande chambre* (or *salle d'assemblée*, as it became known during the duchesse de Maine's stewardship) and acquired by the Musée de Nancy in 1898, gave a rather dim view of this opulent commission.[16] The reappearance and acquisition by the Musée Rodin of two overdoors, for the *grand salon* and the *salon ovale*, make possible a fairer assessment of Lemoyne's skills as a decorative painter and constitute one of the more important rediscoveries of French art of the eighteenth century in recent years.

Yet certain issues remain clouded. It is not known precisely when or from whom Lemoyne received this commission. The artist was under considerable pressure in 1729—Tessin's cabinet picture had to be finished by March; the large *dessus de cheminée, Louis XV Giving Peace to Europe*, was installed at Versailles in July; the monumental *Pygmalion and Galatea* (Tours, Musée des Beaux-Arts), possibly painted for Berger, was also signed in this year.[17] By November 1730 the artist would be under contract to decorate the ceiling of Saint-Sulpice, and his pupil Nonnotte recorded that Lemoyne was already hard at work on preparatory sketches for both Saint-Sulpice and Versailles when he entered his studio at the beginning

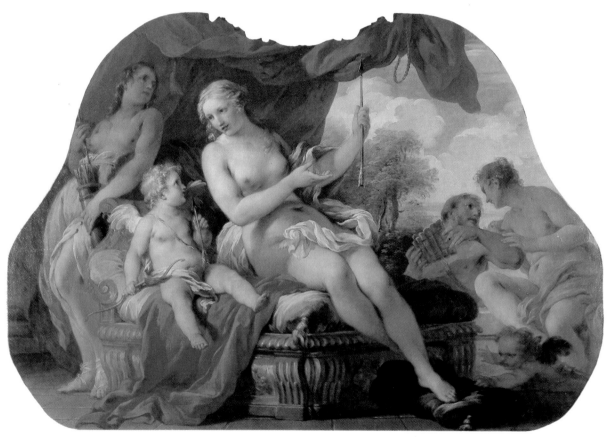

Cat. 27

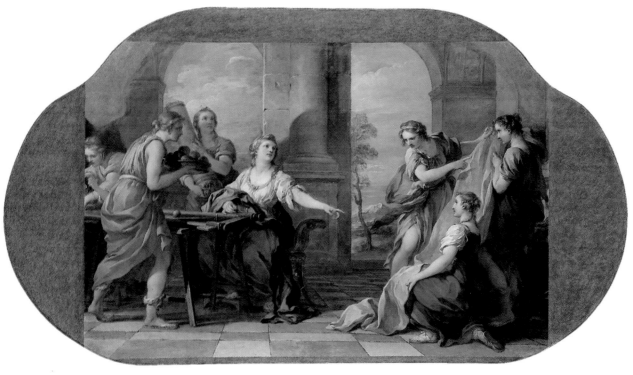

Cat. 28

of 1731.[18] It seems likely, therefore, that Lemoyne worked on Peyrenc de Moras's overdoors between late 1729 and the autumn of 1730.

The origins of Lemoyne's commissions are also obscure. Although Aubert, in a petition to Peyrenc de Moras's widow for payment of outstanding fees, listed the decoration of the *hôtel* as among the "embellishments" made "under his orders," it would seem more likely that the choice of subject came from the patron himself.[19] During construction of his first *hôtel*, Peyrenc de Moras had contracted independently with Lancret for the *turqueries* in the *cabinet de l'encoignure*; bearing in mind Lemoyne's notorious *amour-propre*, it is difficult to imagine any lesser involvement from the patron in this project.[20] The distinctive, and possibly self-serving, iconography of the *cabinet ovale*, which will be discussed in detail later on, further reinforces the argument for Peyrenc de Moras's active involvement.

Venus Showing Cupid the Power of His Arrows, the grandest in scale of the extant overdoors, was painted for the *salon central* and formed part of a series representing the Times of the Day.[21] Of the entire commission, this was the only set to be mentioned by Lemoyne's contemporaries—Caylus and Dézallier d'Argenville described the pictures with some inaccuracy as representing "four subjects taken from the *Metamorphoses*"—and it is more likely that they were familiar with the artist's studio replicas rather than with the paintings *in situ*.[22] Morning was represented by *Aurora and Cephalus* (fig. 3), known today from a preparatory drawing whose scalloped edges are identical to the drawing for *Venus Showing Cupid the Power of His Arrows* (fig. 4).[23] Evening and Night, *The Return of Diana from the Hunt* and *Diana and Endymion* respectively, are known only from the description in Aubert's inventory.[24] *Venus Showing Cupid the Power of His Arrows*, whose blond tonality and bright hues well evoke midday—as does the insistent vertical of Venus's arrow—is the best documented of the series. Comparison between this painting and the carefully finished preparatory drawing in black and white chalks on blue paper—Lemoyne's medium of choice—offers interesting clues to his working process.

Seated on a couch and protected from the sun by a glorious bright red canopy, Venus clasps an arrow which has been drawn from the quiver held by her languid attendant. The goddess is instructing Cupid in the power of Love. Her little son sits on the edge of the couch, a bow in his right hand, an arrow in his left, and listens intently while imitating Venus's gesture. On the right, a young couple is locked in passionate conversation, the bearded man holding a set of panpipes prominently between his hands. In the distance, a sky of deep blue and trees in full leaf provide the perfect summer's setting. Lemoyne's coloring is bright and radiant: orange red in the drapery, ultramarine in the quiver and cushion, amber in the ornamented couch. Venus is both elegant and sensuous, as is her attendant, who has appropriated the goddess's girdle but who is almost crushed by the encroaching picture frame at left.

The painting follows Lemoyne's preparatory drawing closely, but with notable changes. In the drawing the figures are more animated, their gestures and expressions mobile, their poses less stiff; Cupid, for example, bends his legs to anchor his body more securely on the couch. Venus engages her son in lively discussion, and the attendant behind them strains eagerly to catch her words. The drawing also includes a second putto who holds the canopy aloft; in the painting this figure is replaced by the circular cord which hangs suggestively next to the tip of Venus's arrow. Somewhat constrained by the articulation of the overdoor's frame—although it is not known who was responsible for the design, nor at what point it was passed to Lemoyne—the artist has simplified his composition, achieving greater legibility, but at a certain cost.

The subject of Lemoyne's overdoor is clear, yet the theme of Venus instructing her son in the power of his arrows does not derive from a well-known classical prototype, nor, pace Caylus, is it to be found in Ovid's *Metamorphoses*. While Love's potency is the obvious message of Venus's indoctrination, traditionally the education of Cupid was carried out by the goddess of Love in association with Mercury, messenger of the gods. The amorous couple at right, while reinforcing the general theme, also makes specific reference to Pan (here suggested by his attribute), over whom Cupid traditionally prevailed (fig. 5).[25] No struggle is suggested in Lemoyne's overdoor, however; here all is "*luxe, calme, et volupté*"; *amor vincit omnia* is a message conveyed with the complicity of all the players.

Along with its pendant *The Return of Ulysses and Telemachus*, *The Work of Penelope*, one of the two overdoors painted for the *salon ovale*, marked the first representation of this Homeric epic in French painting since the decorations commissioned by François Premier for Fontainebleau. Elongated in format, and of a more complicated *chantournement* than the overdoors for both the *salon central* and the *grande chambre*, the delicately painted figures in *The Work of Penelope* are also smaller in scale and more dynamic in pose than their counterparts in the other rooms. The painting itself has been cut down on all sides and reduced to a rectangle, with the scalloped corner on the upper right having been painted in. In the process,

two figures on the left were lost. The attendants seated at Penelope's work table—one of whose feet can be discerned at the edge of the canvas under the trellis' table—are seen quite clearly at the far left in Lemoyne's preparatory drawing (fig. 6). The overdoor originally extended further to the right as well, with the cloth laid out for Penelope's inspection draped over the standing maiden and falling behind her. A nude figure study for this attendant (fig. 7), from which Lemoyne deviated only slightly in the finished painting—where her left arm is held closer to her breast and her posture is more erect—attests to the care and premeditation with which Lemoyne elaborated these decorative panels.[26]

The story of Penelope's heroic virtue and chastity during Ulysses's twenty-year absence in the Trojan War is recounted primarily in the concluding chapters of Homer's *Odyssey*.[27] As mistress of his fortune and sole occupant of his palace, this "grave housewife" had kept at bay the most prominent of the Achaeans, who relentlessly pressed her with proposals of marriage. At first, Penelope declared that she would only consider remarrying after she had completed a shroud for her father-in-law Laertes, "against the time when the fell fate of grievous death shall strike him down." For three years she wove this cloth by day and unraveled it by night, until her subterfuge was discovered by one of her "shameless maidens" and she was compelled to finish.[28]

By the time Ulysses has returned to Ithaca, in the guise of a beggar, and infiltrated his former palace, Penelope is unable to delay her "hateful marriage" any longer. The Achaeans bring her glorious presents; Penelope retires to her upper chamber in order that "her handmaidens could bear for her the beautiful gifts"; and Ulysses consigns the remaining maidens to attend their mistress while she weaves, "twisting the yarn by her side and carding the wool" with their hands.[29] This is the scene that Lemoyne paints.

The pendant to *The Work of Penelope*, known only from Lemoyne's preparatory drawing (fig. 8) and described by Aubert as showing "the arrival of Ulysses and Telemachus," represents the *dénouement* of Penelope's ordeal. Having announced that she would accept any suitor who could shoot an arrow through twelve ax-rings with Ulysses's "back-bent bow," the "proud wooers" line up to participate in this momentous archery contest. None are able even to string the bow until Ulysses, still dressed as a beggar, does so without effort, "and tried the string, which sang sweetly beneath his touch, like to a swallow in tone."[30] His true identity now revealed, Ulysses proceeds to slaughter the arrogant suitors with his bow and arrows. With small changes in detail—Ulysses is shown in regal attire, not in the rags of a "miserable swineherd"—Lemoyne faithfully depicts Homer's dramatic conclusion. The suitors, seated around the table in angry poses, look on as Ulysses, with Telemachus holding the quiver at his side, ties the string and prepares to aim his arrow through the ax-rings, lined up at bottom right.

These rarely painted subjects were doubtless intended to proclaim the virtues of fidelity and the strength of the matrimonial bonds. In Marolles's *Tableaux du Temple des Muses*, the chapter on Penelope asks how this matron could have lived twenty years "without compromising her modesty." If all women had been like her, it continues, "the State would boast only legitimate children."[31] Peyrenc de Moras thus honors his wife and pays homage to the power of conjugal love—the *salon ovale* was, after all, part of the *appartement de Madame*—and effectively obliterates the scandalous origins of their liaison in this seemly and respectable pairing of feminine constancy and manly heroism.[32] That Lemoyne was able to encode these messages in narratives of such grace and charm attests not only to his ingenuity, but also to his unequaled familiarity with the myths and legends of antiquity, whose syntax he mastered in a language at once lyrical and sensuous.

NOTES

1. *Journal de Barbier* cited in Vacquier 1909, 12, "la plus superbe maison qu'il y eut à Paris."

2. Lemoyne would begin work on the *salon d'Hercule* in earnest after November 1732. For a summary of the decorations at the hôtel Peyrenc de Moras, which became the Musée Rodin in 1916, see Bordeaux 1971, 65–76, and Bordeaux 1984 (A), 116–19, in which the earlier article is revised.

3. On the architect Jean Aubert, Souchal 1969, 29–38, and on Aubert's sole responsibility for the hôtel Peyrenc de Moras, Gallet and Bottineau 1982, 126–29.

4. Pons 1986, 138.

5. Lavedan, Charageat, and Catheu 1947, 75–79.

6. *A.N., Minutier Central*, LXV, 263, *Délaisement à vie*, 1 August 1736, "Etat des lieux, décorations et meubles," "Grand cabinet à main gauche du grand salon, un tableau de Mr. Foucher représentant une muse qui tient trois livres d'une main et trois couronnes de l'autre . . . trois dessus de porte par Mr. Coypel le grand père qui sont ovals et qui ont été agrandis pour les placer où ils sont représentant l'Histoire qui écrit sur les ailes du Tems, un autre la Peinture et la Sculpture et l'autre la Musique . . . cabinet oval ensuite, deux dessus de porte d'après Mr. Coypel et retouchés par luy représentant l'un un repos de Diane et l'autre Bacchus et Ariane dans leurs cadres chantournés . . . chambre à coucher ensuite, un dessus de porte d'après M. Boulogne le jeune représentant Zéphire et Flore. . . ." Aubert's inventory was first discovered by Françoise de Catheu and published partially without complete references by her (as in n. 5). I am extremely grateful to Udolpho van de Sandt for tracking down this inventory for me.

7. Lemoyne was notoriously slow in completing such commissions. *Time Saving Truth from Falsehood and Envy* (London, Wallace Collection) was still in the artist's studio at the time of his death (1737), although it was part of a series commissioned by Berger a full decade before.

8. Vacquier 1909, 6–8, for the best summary of this interesting character. "On dit que le roi crée une cinquième charge d'Intendant du commerce pour M. de Moras, qui aura le département de cette compagnie, et c'est un chemin pour le mener plus haut au C.G.," Mathieu Marais to président Bouhier, 2 February 1731, in Lescure 1863–68, III, 204.

9. Thiry 1979, 52–84; Pons 1986, 122–28, for the first hôtel Peyrenc de Moras.

10. Hautecoeur 1943–57, III, 142–43; Souchal 1969, 36; Pérouse de Montclos 1989, 342–43.

11. Brice 1752, IV, 31, "la distribution des Appartements, . . . la richesse de ses décorations intérieures . . . le pourroient mettre *en parallelle* avec les palais de plus grand seigneurs"; Blondel 1752–56, II, 208, "le bâtiment a été décoré dans les dehors avec autant de simplicité qu'on avait introduit de faste dans le dedans."

12. Vacquier 1909, 14, "ce beau palais, élevé auprès de celui de Madame la Duchesse et presque son rival, n'a guère duré," citing the *Journal de Barbier*.

13. Ibid., 18–19, citing the *Journal de Barbier*, in which Madame Peyrenc de Moras is described as "sotte et impertinente créature qui aurait donné sa fille au Roi de Naples."

14. Aubert's inventory, as cited in n. 6. In Peyrenc de Moras's *inventaire après décès*, A.N., *Minutier Central*, XCV, 119, drawn up on 25 November 1732, Lemoyne is not mentioned by name in the terse description of the painted decorations.

15. Aubert, "Etat des lieux" (as in n. 6), "huit camaïeux au-dessus des pilastres dans leurs cadres ovales sculptés représentant des Jeux d'enfants peints en bleu sur fond d'or."

16. Lavedan, Charageat, and Catheu 1947, 75–79; Bordeaux 1984 (A), 117.

17. Bordeaux 1984 (A), 113–14; for Tessin's deadline, see Lemoyne's *Venus and Adonis* (cat. no. 26).

18. Nonnotte in Gauthier 1902, 529.

19. Lavedan, Charageat, and Catheu 1947, 71; Aubert finally received payment in September 1736.

20. Thiry 1979, 78, notes that Lancret's decorative commissions were contracted by Peyrenc de Moras "sous seing privé."

21. The painting has been returned to its original curvilinear shape; the *boiseries* for the *salon central* are now at Waddesdon Manor, Buckinghamshire, Pons 1986, 242.

22. Caylus in Lépicié 1752, II, 120; Dézallier d'Argenville 1762, IV, 428.

23. Bordeaux 1984 (A), 165.

24. Aubert, "Etat des lieux, décorations et meubles" (as in n. 6). "Le Soir, représenté par un Retour de Chasse de Diane; . . . la Nuit, représenté par Diane et Endimion."

25. Cartari 1647, 251. Cupid's domination over Pan appears in the mythological and emblematic literature as signifying the power of love over universal nature, see Martin 1965, 95–96.

26. For the preparatory drawings see exh. Paris 1983 (A), 108–9; Bordeaux 1984 (A), 165–66.

27. These related episodes are recounted in books XVII–XXI of *The Odyssey*, a copy of which was inventoried in Lemoyne's library, Guiffrey 1877, 210, "item, l'Odisée d'Hommère et l'Iliade d'Hommère en deux volumes."

28. Homer, *The Odyssey*, XIX, 129–56.

29. Ibid., XVIII, 296–321.

30. Ibid., XXI, 408–10.

31. Marolles 1655, 379, "Penelope, si digne des recherches de tant d'amoureux, a donc pû vivre vingt années, sans faire tort à sa pudicité . . . certes si toutes les femmes estoient de l'humeur de celle-cy, l'Estat se pourroit bien vanter de n'avoir que des enfans légitimes."

32. Peyrenc de Moras's seduction of the sixteen-year-old heiress was not forgotten by the Parisian gossipmongers, however. Barbier also noted that after Peyrenc de Moras's death in November 1732, his *hôtel* was "garni de seigneurs" who courted his widow assiduously, *Journal de Barbier* in Vacquier 1909, 19.

FIG. 1
Hôtel Peyrenc de Moras, Plan of the *rez-de-chaussée*, from Blondel's *Architecture française*, Paris, 1752–56

FIG. 4
François Lemoyne, *Venus Showing Cupid the Power of His Arrows*, c. 1729–30, black chalk drawing heightened with white, Paris, Musée du Louvre, Cabinet des Dessins

FIG. 2
François Lemoyne, *Hercules Freeing Hesione*, c. 1729–30, oil on canvas, Nancy, Musée des Beaux-Arts

FIG. 3
François Lemoyne, *Aurora and Cephalus*, c. 1729–30, preparatory drawing, Montpellier, Musée Fabre

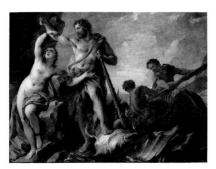

FIG. 5
Anonymous engraving, *Pan and Cupid*, 1647, from Vicenzo Cartari's *Imagini delli dei de gl'antichi*, Venice, 1647.

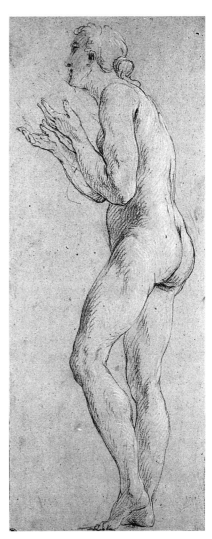

FIG. 7
François Lemoyne, *Study for a Standing Female Nude, in Profile to the Left*, c. 1729–30, black chalk drawing heightened with white, Paris, Musée du Louvre, Cabinet des Dessins

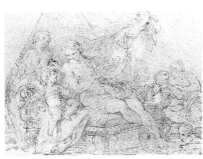

FIG. 6
François Lemoyne, *The Work of Penelope*, c. 1729–30, black chalk drawing heightened with white, Paris, Musée du Louvre, Cabinet des Dessins

FIG. 8
François Lemoyne, *Ulysses Bending His Bow*, c. 1729–30, black chalk drawing heightened with white, Paris, Musée du Louvre, Cabinet des Dessins

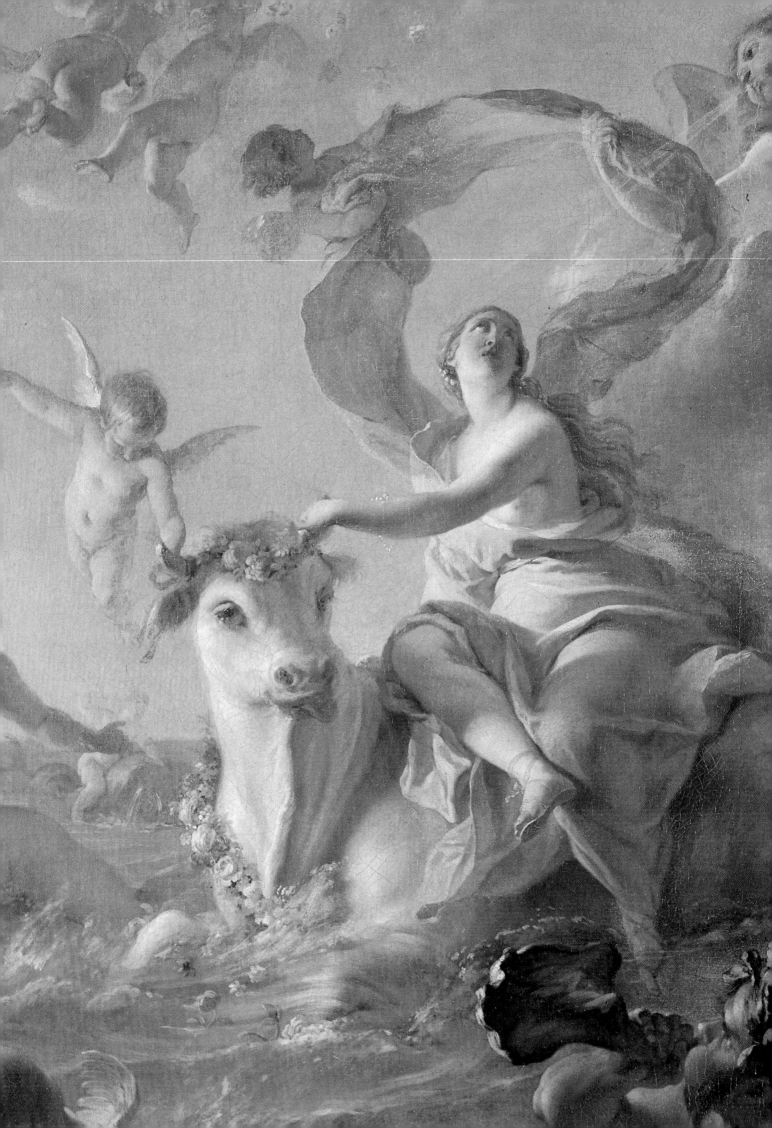

Noël-Nicolas Coypel
(1690–1734)

Characterized by graceful, yet naturalistically posed figures bathed in light, Noël-Nicolas Coypel's paintings placed him in the vanguard of the rococo movement. Noël-Nicolas was Noël Coypel's son from his second marriage and, therefore, half brother of Antoine Coypel and uncle of Charles-Antoine Coypel. Trained by his father until his death in 1707, Noël-Nicolas also took classes at the Academy. Although a successful student there, and winner of the *petit prix* in 1705, Coypel did not go on to study at the Academy's school in Rome—Dézallier d'Argenville mentioned a jealous cabal against him—and would never make the pilgrimage to Italy.

Determined to succeed without the help of his half brother, Coypel received the commission for the chapel of the Communion in the church of Saint-Nicolas de Chardonnet. There he painted *The Sacrifice of Melchisedech* and *The Manna* in 1713 (still *in situ*), which reveal his youthful tendency to follow, albeit awkwardly, the French grand manner as taught by his father. *Jacob Demanding Rachel in Marriage* (Nancy, Musée des Beaux-Arts), painted a few years later, however, exhibits more confidence, with accomplished draughtsmanship, well-defined drapery, and carefully orchestrated figures. This work signals the beginning of Coypel's rejection of the theatrical, grandiose tradition of his father and brother for the more graceful, intimate style espoused by such artists as Louis de Boullongne and the younger paint-ers of his own generation, Lemoyne and de Troy.

In December 1716 Coypel was made *agréé* at the Academy with *The Transfiguration* (location unknown) on the same day as Lemoyne and was received as a full member in November 1720 with *Amymone Carried Off by Neptune* (Valen-ciennes, Musée des Beaux-Arts). The 1720s were busy years for Coypel as he secured an increasing number of commissions and further developed his personal style. In 1720–21 he painted *The Resurrection* for the duc de Bourbon's new chapel at Chantilly (location unknown). The success of this work led to many other religious projects, including *The Sacrifice of Isaac* (1721, Tourcoing, Musée des Beaux-Arts), *Saint Anthony* and *Saint Hilaire* for the church of the Sorbonne (c. 1724, location unknown), and *The Dance of Salome* for the choir of Saint-Jean-en-Grève (1724, location unknown).

While Coypel's religious paintings exhibit a lighter, more delicate style, his mythological paintings of this decade best exemplify his modernity. In 1724 he painted the only securely documented commission from the *Bâtiments du roi*, *Arion Carried by a Dolphin* (Versailles, Hôtel de Ville), one of four overdoors for the bedroom of Louis-Henri, duc de Bourbon, in the *pavillon du Grand Maître* at Versailles. Along with *Bacchus and Venus* (cat. no. 29) and *The Triumph of Galatea* (1723, Private Collection), this decorative panel contains figures of grace and eroticism, charmingly yet naturalistically posed.

As David Lomax has noted, Coypel frequently took his compositional sources from painters of the previous generation; *Arion Carried by a Dolphin*, depends on Louis de Silvestre's painting of the same subject completed twenty-three years earlier for the *Ménagerie* at Versailles, and *Venus, Bacchus, and Cupid* (1727, Paris, Musée du Louvre) relies on Antoine Coypel's *Alliance of Bacchus and Cupid* (Dallas Museum of Art), exhibited at the Salon of 1704. Noël-Nicolas's paintings, however, are more immediate than their prototypes and avoid the stagelike settings adopted by his forebears. Furthermore, Coypel posed his figures in ways that are less dramatic and rigid. Dézallier d'Argenville noted that such works had "an air of verisimilitude which reconciled them with the Truth."

Coypel displayed his artistry as a history painter to the best effect in *The Rape of Europa*, painted for the *concours de 1727* (cat. no. 30). Filled with brilliant light and ecstatic figures that tease Jupiter and his precious cargo, this painting was Coypel's most ambitious and most widely admired composition—the public judged it the best work of the competition.

Although the public's admiration for his entry did not lead to royal patronage, Coypel was thereafter kept busy with decorative commissions for the *hôtels* and *châteaux* of his Parisian clientele. Most of these works have been destroyed, but a surviving example is *Juno and Mercury* (Ponce, Puerto Rico, Museo de Arte), painted as one of three overdoors for Samuel Bernard's *château* in Passy around 1729. Coypel was also occupied with two last great religious commissions: *Saint François de Paule* for the sacristy of the couvent des Frères Minimes in the place Royale (1730, location unknown) and the ceiling and altarpiece for the chapel of the Virgin in the church of Saint-Sauveur, Paris (1731–32, both destroyed; ceiling sketch, *The Assumption of the Virgin*, Nancy, Musée Lorrain; altarpiece drawing, *The Assumption of the Virgin*, Paris, Musée du Louvre). Coypel's painting for the chapel's altarpiece in Saint-Sauveur, placed within a retable designed by Jean-François Blondel and decorated with painted sculpture by Jean-Baptiste Lemoyne, functioned as part of an illusionistic, baroque ensemble rarely seen in France during this period. Coypel's premature death in December 1734 deprived the French school of an artist whose "uncommon talents" were extolled by every eighteenth-century commentator.

Noël-Nicolas Coypel, *The Rape of Europa* (detail), 1726–27, oil on canvas, 127 x 193 cm, Philadelphia Museum of Art : Gift of John Cadwalader

NOËL-NICOLAS COYPEL
Bacchus and Venus

29

NOËL-NICOLAS COYPEL (1690–1734)
Bacchus and Venus, 1726
Oil on canvas
101 x 82 cm.
Musée d'Art et d'Histoire, Geneva

PROVENANCE
Pierre Vigné de Vigny (1690–1772), his sale, Paris, 1 April 1773, no. 94, purchased by Donjeux for 946 *livres* [with Jean-François de Troy's *Diana and Actaeon*]; prince de Conti, his sales, Paris, 8 April 1777, no. 604 [as Nattier, *Bacchus et Ariane à table*], purchased by Brisson for 1,001 *livres* [with Jean-François de Troy's *Diana and Actaeon*], and Paris, 15 March 1779, no. 69 bis [as *Bacchus et Ariane à table*], purchased by Dubois for 830 *livres* [with Jean-François de Troy's *Diana and Actaeon*]; Madame Marchard-Roux, who presented the painting to the museum in 1840.

EXHIBITIONS
London 1968, no. 170, ill.

BIBLIOGRAPHY
Mercure de France, January 1740, 111–12; Lacombe 1755, 205; Dézallier d'Argenville 1962, IV, 448; Gault de Saint-Germain 1808, 201; Geneva 1878, no. 32 [as Noël Coypel, *Bacchus et Ariane*]; Geneva 1882, no. 38; Beaumont 1894, 645–46, no. 94; Dacier 1909–21, pt. 10, no. 69 bis; Stryienski 1912, 10, ill.; Gielly 1928, no. 1840–1; Lavallée 1928, 32; Dimier 1928–30, II, 219, 224, no. 20; Hautecoeur 1948, 20; Geneva 1954, 36; Geneva 1968, 37; Kalnein and Levey 1972, 30, ill.; Kocks 1979, 128; Lomax 1982, 34–35, ill.; exh. Paris, Malibu, and Hamburg 1981–82, 198, ill.

Crowned by vine leaves, a leopard skin barely covering his muscular torso, red-faced Bacchus leans forward as the goddess of Love, reclining against a velvet pillow placed conveniently under her left elbow, dramatically pours red wine into his silver goblet. On the ground between Bacchus's legs, a leopard chews grapes contentedly, his long tail curled around the god's pine-tipped thyrsus. Using his back as a footstool, Venus asserts Love's dominion in the subtlest of ways, and her doves bill and coo without regard for the wild beast. Two putti—one carrying a tray of grapes, the other, his little penis erect, struggling with a flagon of wine—attend the deities. Under an arched trellis at some distance in the background, Venus's attendants, the Three Graces, are variously occupied; two standing women strain to pick the grapes from the vine, while the third, seated on a rock, is embraced manfully by a putto.

Graceful, bright, pleasing in tone, Coypel's cabinet picture is also a tour de force of figure painting, with something of the genre painter's attention to details of costume and jewelry; note the care with which Coypel describes Venus's pretty headwear of pink ribbon and pearls, the fine stripes in her brocade, and the white tablecloth and elegant silverware that transform the arbor into a private dining room. The fall of light on Venus's and Bacchus's youthful bodies is masterfully handled, with delicate yellow glazes modeling Venus's breasts and Bacchus's chest, hands, and fingers. The Three Graces are Rubensian creatures painted with a miniaturist's touch: the seated figure is radiant, her enormous thigh glowing in the afternoon sunlight. The idyllic landscape and ubiquitous verdure complement the amorous activity below, just as the improbably sinuous oak in the center echoes Venus's exaggerated pose. Coypel's painting takes pleasure and carnal appetite as its subject, yet remains impeccably decorous; what has been criticized as a "faint erotic spark" is more properly the language of allusion and restraint.[1]

Once again, it is the unusual conflation of naturalism and idealization that gives such charm to this

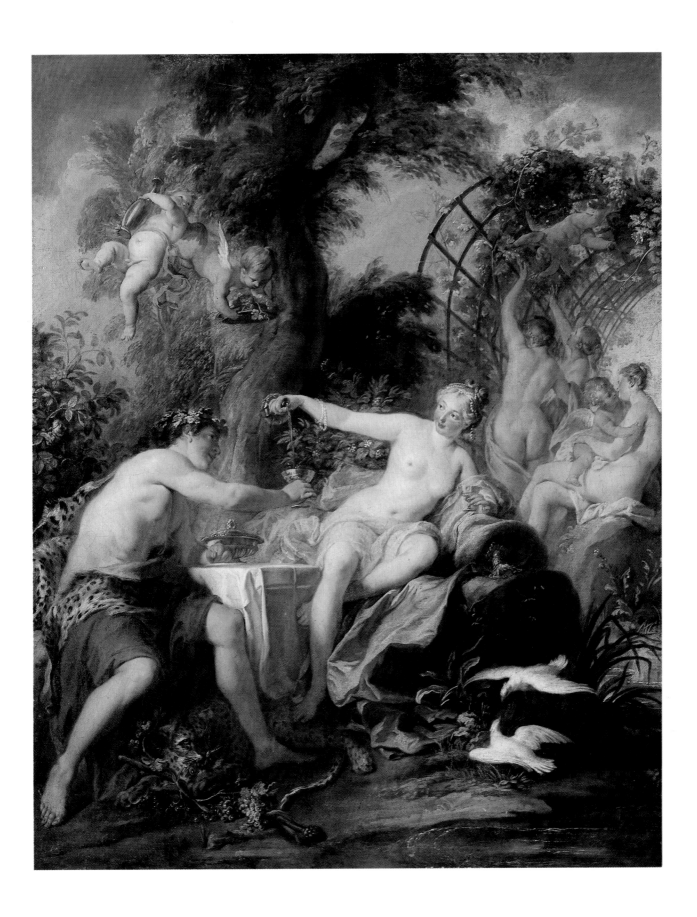

mythology. Even though only one preparatory drawing has been identified for the composition, it is likely that Coypel studied each of his figures from life.[2] *Standing Female Nude* (fig. 1)—a drawing in *trois crayons* used for the background figure seen from behind, who reaches to take the putto's offering—is a good example of Coypel's draughtsmanship, characterized by Dézallier d'Argenville as "exemplary in its tender and soft handling of the chalk."[3] In this drawing, Coypel had his model adopt a rather uncomfortable pose, while permitting her to rest her right arm on a ledge for support, and went on to describe the voluptuous folds of her back and buttocks with great care. Yet he had some difficulty in resolving the placement of her left leg, for which he tried several solutions. On the canvas itself he overcame such hesitation by covering the figure's left thigh with gray brown drapery, thus masking the contours of her left leg. Such swirling, arbitrary drapery abounds in *Bacchus and Venus*, but in this instance it serves a practical purpose.[4]

Described in the eighteenth century as representing the "Feast of Bacchus and Venus" and "Bacchus and Ariadne [*sic*] at table,"[5] *Bacchus and Venus* is, in fact, a variant on a subject that had appealed to the Northern Mannerists but which appears much less frequently in French art of the sixteenth to eighteenth centuries. Terence's proverb, "Without Bacchus and Ceres, Venus freezes," had provided artists with an opportunity to show the union of the three gods who bring pleasure—love drawing nourishment, as it does, from an abundance of food and wine.[6] Bon Boullongne's overdoor for the dining room at Meudon (fig. 2), painted in 1700, was the most recent reworking of this theme in French art, although Watteau may also have alluded to the epigram in his *Love at the Théâtre François* (Berlin, Staatliche Museen Preussischer Kulturbesitz).[7] The related subject of Bacchus and Venus, symbolizing the power of wine and love, had been painted by Rosso for the east wall of the *galerie François Premier* at Fontainebleau, where it remained until 1701 when it was deemed improper and replaced by Louis de Boullongne's *Zephyr and Flora*.[8] The god of Wine and the goddess of Love also appeared in Louis de Boullongne's ceiling decoration for the marquis de Luillier, a decoration that also incorporated the Three Graces.[9] Another variation on Terence's text, in which Bacchus is paired with Cupid, was painted by Antoine Coypel in 1704 and Noël-Nicolas in 1727; the appearance of this subject in early eighteenth-century French painting may also have owed something to Lully's successful *pastorale, Les Festes de l'Amour et de Bacchus*.[10]

Exhibited at the Salon of 1704 and engraved by Benoît Audran, Antoine Coypel's recently rediscovered *Bacchus and Cupid* (fig. 3) provided the source for Noël-Nicolas's equally refined, but considerably more fluent, cabinet painting.[11] As David Lomax first pointed out, Noël-Nicolas's Bacchus, leaning across the table, strikes a pose similar to Antoine's Cupid, and his Venus is a reprise of the cloud-borne goddess.[12] The appearance of the Three Graces in Noël-Nicolas's *Bacchus and Venus* also derives from Antoine's mythology. Noël-Nicolas Coypel was not alone in "vigorously reinventing the work of an earlier generation"—de Troy's history paintings are replete with such references—but his dependence upon his half brother's celebrated compositions was never entirely innocent.[13] Rather, it was through such quotation that Noël-Nicolas sought to assert the distinctive artistic personality that Antoine had effectively stifled in the later years of his life. The most acerbic indictment of Antoine's tutelage is to be found in the anonymous and unpublished "life" of Noël-Nicolas, inscribed as by "Perin"—doubtless a relative of the artist through his mother, Anne-Françoise Perrin—and given to Lépicié, who was preparing biographies of the members of the Academy in the 1740s: "He was brother of the First Painter of the King, who, through his jealousy, was in no small way responsible for maintaining Noël-Nicolas in a condition of mediocrity. It was only after his brother's death that Noël-Nicolas's talent suddenly burst into flower. . . . "[14]

Coypel's *Bacchus and Venus*, packed with attributes and symbols, is also a straightforward celebration of physical pleasure. There is little doubt of the outcome of Bacchus' and Venus's encounter; Pausanias recorded that, after yielding to Bacchus's entreaties, Venus gave birth to Priapus, an ugly child with enormous genitals who became the protector of vineyards, gardens, and orchards.[15] Yet Coypel is little concerned to show learning—his *Bacchus and Venus* is but distantly related to Terence's proverb—and even less to pass judgment. The mood of his painting is unrepentantly joyous and reflects the association, implicit for an eighteenth-century audience, of Bacchus and Venus with license and unbridled carnality. In the second edition of Furetière's *Dictionnaire Universel*, which appeared the year after *Bacchus and Venus* was painted, the subject of Coypel's mythology was thus defined, albeit in more ribald terms: "One says that Bacchus and Venus go together in the same way that debauchery in wine leads to debauchery in love."[16]

Well-mannered and "correct," Coypel's painting nevertheless proclaims this same message in more gentle terms. Yet, by the time Le Bas's engraving after Coypel's *Bacchus and Venus* appeared—the print was announced in the *Mercure de France* in January 1740, six years after the artist's death—such hedon-

ism would be much diluted.[17] The accompanying qua-train encouraged moderation and restraint; "the god-dess of Cythera" was to calm Bacchus's excesses, and he in turn would use the "nectar of the vine" to soothe lovers' passionate hearts. That Coypel's cabi-net painting should now proclaim the virtues of tem-perance is an unexpected transformation, but one which was facilitated by the abiding innocence and decorousness of his gilded deities.[18]

Is Coypel's *Bacchus and Venus* a celebration of debauchery or a hymn to a golden age? Neither inter-pretation seems entirely satisfactory. Had Coypel intended his cabinet picture to convey a more per-suasive moralizing or allegorical component, some indication might be given by its pendant, Jean-François de Troy's *Diana and Actaeon* (fig. 4), known through Saint-Aubin's illustration in the catalogue of the second Conti sale (15 March 1779).[19] Clearly, the pairing of these unrelated subjects reveals no unifying theme but rather attests to the pervasive demand for companion paintings, regardless of any narrative relationship. Judging from Saint-Aubin's thumbnail sketch, it is likely that de Troy and Coypel painted in concert, or at the very least were aware of each other's work; the figures would appear to occupy a similar re-lationship to the landscape and to be of comparable scale. Jean-François de Troy and Noël-Nicolas Coypel had both provided overdoors for the hôtel du Grand Maître at Versailles in 1724; they would later be em-ployed by Samuel Bernard to decorate his *château* at Passy. But the pairing of *Bacchus and Venus* and *Diana and Actaeon* is the only known record of their collab-oration for the open market.[20]

The collector probably responsible for this col-laboration was the architect Pierre Vigné de Vigny (1690–1772), who has been described as one of the most "brilliant personalities" of his profession.[21] As a young man de Vigny had worked under Robert de Cotte, upon whose recommendation he had been sent to Constantinople in 1722 to assess the possibil-ities of rebuilding the French embassy in Pera. On his return from the Orient, de Vigny spent nearly six months in Italy, lodged at the French Academy in Rome as a guest of its aging director, Charles Poerson. Back in France by December 1722, he benefited again from de Cotte's patronage, and it is most likely that, since the *inspecteur des Bâtiments* was responsible for refurbishing the hôtel du Grand Maître at Versailles

in 1723–24, de Vigny would have made the acquain-tance of Coypel and de Troy at this time through the good offices of his protector.[22]

This point is worth laboring, because so little is known of how de Vigny formed his collection of paint-ings, which consisted largely of Italian and Northern old masters but also included a substantial group of French eighteenth-century paintings.[23] Among the lat-ter, Lancret's celebrated *Four Seasons* (*Spring* and *Sum-mer*, Leningrad, The Hermitage) and Lemoyne's *model-lo* for *The Transfiguration* (destroyed during the Second World War) are works by his contemporaries that de Vigny is known to have purchased at public sale, even though his participation in the enlightened *Société des Arts* would almost certainly have given him personal access to these artists.[24] By contrast, his acquisition of a pair of mythologies from Boucher and Natoire in 1744—Boucher's *Diana and Callisto* (Moscow, Pushkin Museum) and Natoire's *Jupiter and Io* (last recorded, R. Sibilat collection)—suggests an arrangement with the artists themselves, comparable to his commission to de Troy and Coypel a generation earlier.[25]

However, there is reason to believe that Coypel did not part with his *Bacchus and Venus* immediately. A receipt in the artist's hand, dated 8 March 1728, in the Institut d'Art et d'Archéologie, Paris, records a transaction between Noël-Nicolas Coypel, his sister Anne-Françoise Dumont, and the engraver Jacques-Philippe Le Bas. Coypel acknowledges having re-ceived from his sister seventy-two francs, which he promised to give to "M. Le Bas towards the plate of the sketch of Bacchus and Venus which he is engrav-ing for her in Paris." In a different hand, underneath, Le Bas confirms having received the sum of eleven *livres*.[26] Since Le Bas's print would not be published until January 1740, it seems reasonable to assume that Coypel, like de Troy and Lemoyne, initially hoped to exploit the growing Parisian market for contemporary art by publicizing his narrative compositions through engravings. In contrast to his more successful col-leagues, Noël-Nicolas failed in this endeavor; not a single history painting by him was engraved during his lifetime.[27] The reasons for Le Bas's twelve-year de-lay in publishing his print after Coypel's *Bacchus and Venus*, and the point at which de Vigny took posses-sion of the painting itself—the architect's name is nowhere indicated on Le Bas's engraving of 1740—are issues that remain to be clarified.

Notes

1. Kalnein and Levey 1972, 30.

2. Lomax 1982, 34, "le naturel et l'aisance de chacune des figures nous conduisent à penser que Coypel a préparé sa composition à partir des dessins d'après nature et sans recourir aux poncifs académiques."

3. Dézallier d'Argenville 1762, IV, 445, "des académies parfaites pour le goût et pour le maniement tendre et moëlleux du crayon."

4. Exh. Paris, Malibu, and Hamburg 1981–82, 198–99.

5. *Catalogue de Tableaux de maîtres très renommés des différentes écoles . . .* [de Vigny], Paris, 1 April 1773, no. 94, "le Festin de Bacchus et de Vénus"; *Catalogue d'une riche Collection de tableaux des Maîtres les plus célèbres des trois Écoles . . . de feu S.A.S. Monseigneur le Prince de Conti*, Paris, 8 April 1777, no. 604, "Bacchus et Ariane à table"; in this sale the painting is given to Nattier.

6. "Sine Cerere et Baccho friget Venus"; for the most thorough discussion of this *bildthema*, Kocks 1979, 113–32, DaCosta Kaufmann 1988, 265, 268–69, and Pigler 1956, II, 48–51.

7. Schnapper 1968 (A), 63; idem, 1978, 131; Mirimonde 1961, 271–72; but see also Rosenberg in exh. Paris 1984–85 (A), 336–39, for a summary of the various interpretations of this painting.

8. Béguin 1989, 831.

9. Watelet in Lépicié 1752, II, 59.

10. For Lully's *pastorale*, Chouquet 1873, 317; Mirimonde 1961, 287, n. 41.

11. Garnier 1989, 157–58, Lomax 1982, 35, 47, no. 26. As Lomax noted, Coypel's theatrical mythology would also inspire Noël-Nicolas's *Venus, Bacchus, and Cupid*, 1727 (Paris, Musée du Louvre), a decorative panel representing Autumn in a series devoted to the Four Seasons, from which the only other known canvas depicts Winter (Musée National des Châteaux de Versailles et de Trianon).

12. Lomax 1982, 35.

13. Ibid., "les peintures du Louvre et de Genève sont un témoignage supplémentaire sur la façon dont Coypel réinvente vigoureusement les compositions des artistes de la génération antérieure. . . ."

14. École Nationale Supérieure des Beaux-Arts, Ms. 129, "Il étoit frère du premier peintre du Roy qui n'avoit pas peu contribué par sa jalousie à le tenir dans un état de médiocrité. Il a paru à la mort de son frère en s'élevant tout à coup." I am grateful to Udolpho van de Sandt and Christian Michel for their help with this document.

15. Cited in Graves 1955, 69.

16. Furetière 1727, II, 117, "On dit aussi que Bacchus et Vénus vont de compagnie pour dire que la débauche du vin mène à celle de l'amour."

17. *Mercure de France*, January 1740, 111; Bibliothèque Nationale 1930–[1977], XIII, 150.

18. *Mercure de France*, January 1740, 111, "Joignez-vous à Bacchus, Déesse de Cithere / Modérez ses excès par vos doux sentimens / Qu'il employe à son tour son Nectar salutaire / A calmer l'ardeur des Amans / Bien-tôt de l'âge d'or revivra l'innocence / On ne blâmera plus ni le vin ni vos feux / Et l'on sera charmé de voir que de vous deux / Puisse naître la tempérance."

19. Dacier 1909–21, pt. 10, 25. Coypel and de Troy's pendants were sold together in the de Vigny and Conti sales (see provenance); I have not been able to determine at what point thereafter the paintings became separated.

20. Bordeaux 1984 (B), 113–26, for the hôtel du Grand Maître; Dézallier d'Argenville 1762, IV, 367, 447–48, and Lomax 1982, 40, 47, n. 36, for Samuel Bernard's commission.

21. Gallet 1973, 263–86, for an excellent survey; see also Beaumont 1894, 610–52, in which Rémy's catalogue of his collection is reproduced. For Jean Restout's sympathetic portrait of the architect (Private Collection), dated to 1727, see Rosenberg in exh. Toledo, Chicago, and Ottawa, 1975–76, 65–66.

22. Gallet 1973, 264–68.

23. Beaumont 1894, 644–47.

24. Wildenstein 1924 (A), 70–71. Bordeaux 1984 (B), 93, and Roland-Michel 1984 (A), 30–33, for the comte de Clermont and the *Société des Arts*.

25. Ananoff and Wildenstein 1976, I, 382; Boyer 1949, 39–40.

26. Paris, Institut d'Art et d'Archéologie, carton X, fol. 3480, "Je reconnois avoir reçu de Madame Dumont la somme de soixante et douze pour donner à M. Le Bas à compte de sa planche de la débauche de *Bacchus et Vénus* qu'il grave par elle à Paris . . . le 8 Mars 1728, N. Coypel." And, in a different hand, "Reçu onze livres à conte sur le Bacus de Monsieur Coypel . . . Lebas"; Madame Dumont is presumably Anne-Françoise Coypel (1686–1755), who married the sculptor François Dumont on 16 November 1712, Dumont and Lavigne 1877, 229, 237.

27. There is some confusion regarding Le Bas's engraving of *The Alliance of Bacchus and Venus*; Bénard 1810, 286, and Robert-Dumesnil 1835–71, II, 221, followed by Messelet in Dimier 1928–30, II, 226, "Gravures originales," no. 5, claim that Noël-Nicolas Coypel etched the composition, which was then completed by Le Bas. Dézallier d'Argenville 1762, IV, 448, makes no mention of this collaboration, nor does the most recent catalogue on Le Bas's oeuvre, Bibliothèque Nationale, 1930–[1977], XIII, 150. Le Bas's print is inscribed "N. N. Coypel pinxit . . . Le Bas sculp."

FIG. 1
Noël-Nicolas Coypel, *Standing Female Nude*,
1726, black, red, and white chalk drawing,
Paris, École Nationale Supérieure des Beaux-Arts

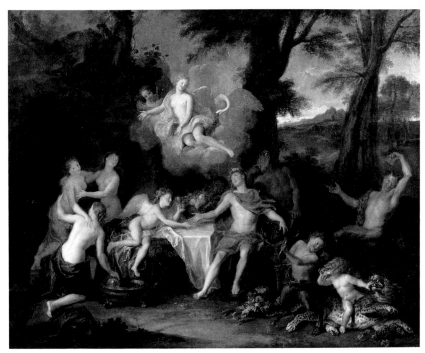

FIG. 3
Antoine Coypel, *Bacchus and Cupid*, 1704, oil on canvas, Dallas Museum of Art

FIG. 2
Bon Boullongne, *Bacchus, Venus, and Ceres*,
1700, oil on canvas, Paris, Musée du Louvre

FIG. 4
After Jean-François de Troy's *Diana and
Actaeon* and Noël-Nicolas Coypel's *Bacchus
and Venus*, drawing by Gabriel de Saint-Aubin
in his copy of the second Conti sale catalogue,
March 1779, Private Collection

Noël-Nicolas Coypel
The Rape of Europa

30

Noël-Nicolas Coypel (1690–1734)
The Rape of Europa, 1726–27
Oil on canvas
127 x 193 cm.
Philadelphia Museum of Art: Gift of John Cadwalader

PROVENANCE
Probably purchased by Charles-Jean-Baptiste Fleuriau, comte de Morville (1686–1732), for 1,500 *livres* after the *concours de 1727*; Augustin Blondel de Gagny, his sale, Paris, 10–24 December 1776, no. 230, purchased by Lenglier for 2,021 *livres*; sale, Paris, Lebrun, 10 December 1778, no. 105 [as *Le Triomphe de Neptune et d'Amphitrite . . . l'enlèvement d'Europe*], sold for 1,500 *livres*; sale, Le P***, Paris, 3 March 1785, no. 56; marquis de Chamgrand, de Proth, Saint-Maurice, Bouillac, sale, Paris, 20 March 1787, no. 196, purchased by Lebrun for 600 *livres*; Charles-Alexandre de Calonne, his sale, Paris, 21–30 April 1788, no. 140, purchased by Lerouge for 751 *livres*; Madame Goman, her sale, Paris, 6 February 1792, no. 90, purchased by Saubert for 1,450 *livres*; Vincent Donjeux, his sale, Paris, 29 April 1793, no. 341, purchased by Lebrun for 603 *livres*; Joseph Bonaparte by 1815, who gave the painting to General Thomas Cadwalader in October 1839; by descent to John Cadwalader.

EXHIBITIONS
Paris, *concours de 1727*, "à la quatrième croisée," 3; Philadelphia 1950, no. 17, as by Charles-Antoine Coypel; Pittsburgh 1951, no. 82, ill.; San Francisco 1964, no. 162, ill.; Toledo, Chicago, and Ottawa 1975–76, no. 22, col.; New York 1977, no. 4, ill.

BIBLIOGRAPHY
Anonymous 1727, 3; *Mercure de France*, July 1727, 1568; Caresme 1740, 399; Marsy 1746, I, 168; Pernety 1757, 284; Dézallier d'Argenville 1762, IV, 443 [as "Triomphe d'Amphytrite"]; Dandré-Bardon 1765 (A), II, 156 [as "Triomphe d'Amphytrite"]; Fontenay 1776, I, 443 [as "Triomphe d'Amphytrite"]; Papillon de La Ferté 1776, II, 636–37 [as "Triomphe d'Amphytrite"]; Pahin de La Blancherie 1783, 234 [as "Triomphe d'Amphytrite"; not exhibited]; Mariette 1851–60, II, 29 [as "Triomphe de Galathée ou d'Amphithrite ou la Naissance de Vénus"]; Dussieux et al. 1854, II, 265; Blanc 1865, 2–3 [as "Triomphe de Galatée"]; Sensier 1865, 327; Mantz 1880, 22–23; Bertin 1893, 172, 416; Dimier 1928–30, I, 74, II, 11, 219; Philadelphia 1950–51, 93, 95, ill.; Benisovich 1956, 298, ill.; Bardon 1957, 407; Rosenberg 1977, 32, 37, ill.; Conisbee 1981, 78–80, ill.; Lomax 1982, 35, 39–40, ill.; exh. Atlanta 1983, 16–17, ill.; Bordeaux 1984 (A), 42, 109, ill.; Crow 1985, 80, ill.; Sani 1985, II, 468.

T he *Rape of Europa*—Noël-Nicolas Coypel's masterpiece and, with Natoire's *Toilet of Psyche* (cat. no. 39), the first eighteenth-century French painting of importance to enter America—was universally recognized as the outstanding entry to the *concours de 1727*. Practically the centerpiece of the exhibition, *The Rape of Europa* hung in the fourth bay of the Louvre's *galerie d'Apollon*, next to Collin de Vermont's *Antiochus and Stratonice* (location unknown),[1] and was greatly admired by Parisians and foreigners alike, since, as Caylus noted, the competition had become an "object of curiosity" for those visitors who swelled the capital after the recently concluded Peace of Aix-la-Chapelle.[2]

Writing to Rosalba Carriera on 15 May 1727, the day the *concours* opened, Pierre Crozat was confident that Lemoyne would take first prize, and "uncle Coypel," as Noël-Nicolas was called in order to distinguish him from his younger nephew, Charles-Antoine, the second: "The truth is that Noël Coypel, who was a perfectly mediocre painter three years ago, can now be said to take precedence over all the others."[3]

Crozat's encomium was echoed in every other contemporary account of the *concours de 1727*. Mariette, noting bitterly that the public alone had appreciated Coypel as he deserved, commented that "everyone, to a man, regarded his picture with an admiration that bordered on astonishment."[4] Although he favored Jean-François de Troy, the chevalier de Valory admitted that the most popular paintings by far at the *concours* were Coypel's *Rape of Europa* and Cazes's *Triumph of Venus* (fig. 1).[5] Dézallier d'Argenville, whose discussion of Coypel's *Rape of Europa* was later followed in countless eighteenth-century lives of the artist, wrote that the painting was "found to be so beautiful, and its coloring so fresh and sophisticated, that the public had no difficulty in crowning it triumphant."[6]

It came as something of a disappointment, then, that Coypel's *Rape of Europa* received no such recognition from the organizers of the competition themselves; the duc d'Antin recommended that Lemoyne

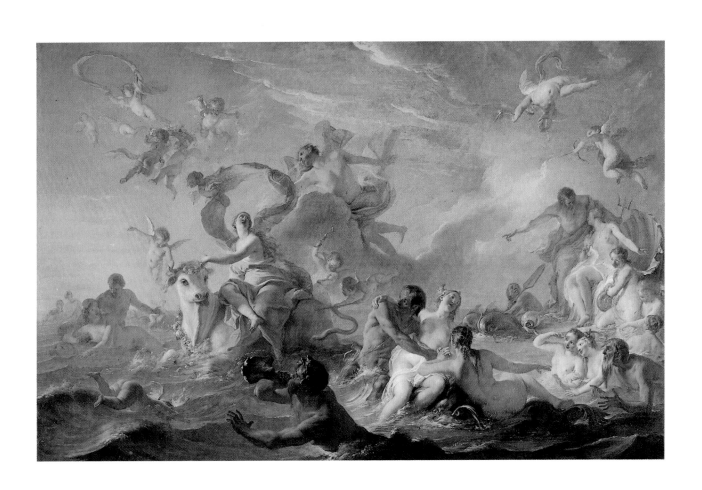

and de Troy share the first prize of 5,000 *livres* and that, in addition to acquiring the winning entries for the Royal Collection, the Crown also purchase Charles-Antoine Coypel's *Perseus Freeing Andromeda* (cat. no. 32) for 2,000 *livres*.[7] Without an advocate at court, the connoisseurs agreed, Noël-Nicolas Coypel's victory in the public arena was of little value.[8] However, according to Dézallier d'Argenville, an unexpected Maecenas did appear in the person of Charles-Jean-Baptiste Fleuriau, comte de Morville (1686–1732), Secretary of State for Foreign Affairs: "Sensitive to the injustice that Noël-Nicolas had suffered in the distribution of prizes, [he] gave him the sum of 1,500 [*sic*] *livres*, the amount that the Crown had promised the victor. This act of generosity was widely acknowledged, and the Minister's love of the arts was considered to be equal to his taste."[9]

The chronology of de Morville's beneficence is of some interest, since his "act of generosity" may have been double-edged. The count would be stripped of his considerable diplomatic and ministerial powers on 19 August 1727—the same day that his father, Joseph-Jean-Baptiste Fleuriau d'Armenonville, Keeper of the Seals, was requested to hand his portfolio to the reinstated Chancellor d'Aguesseau. The public disgrace of both father and son marked the beginning of Cardinal Fleury's ascendancy and the "reversal of ministers" in Louis XV's cabinet.[10] It is unclear whether de Morville was still in office when he awarded his prize to Noël-Nicolas Coypel—the results of the competition were announced at the Academy on 30 June 1727 and the prizewinning paintings presented to the king at Versailles on 20 July—but Dézallier d'Argenville's use of the term "Minister" would suggest that he was.[11] De Morville's decision to crown Coypel independently and in accordance with the *vox populi*, while it doubtless reflected the opinions of Crozat's circle, served also to reinforce the distance separating him from the inner sanctum of ministers who enjoyed Fleury's favor.[12] Although it is impossible to date de Morville's magnanimous gesture with any greater precision, it is clear that his patronage would thereafter be of limited value to the hapless Coypel, who remained without an official protector and whose career, it was noted, had been plagued with such instances of bad timing.[13]

But did de Morville ever take possession of the prize painting? While there is no reason to doubt Dézallier d'Argenville's account, *The Rape of Europa* does not appear among the paintings inventoried in the hôtel d'Épernon, de Morville's family home on the rue Platrière, following his death on 3 February 1732.[14] With the exception of works by Rosalba Carriera and Charles-Antoine Coypel, de Morville, like Pierre Crozat, did not collect contemporary painting. Nor was his acquisition of *The Rape of Europa* alluded to in any of the letters between Crozat and Rosalba Carriera that have survived, letters in which de Morville—an enthusiastic collector of the latter's pastels—is frequently mentioned.[15]

Although the possibility of *The Rape of Europa* having remained with its author cannot be ruled out—the loss of Coypel's own *inventaire après décès* prevents us from establishing this point—it is unlikely that the artist retained possession, since, in all probability, he would have otherwise had such an important painting engraved.[16] The subsequent history of *The Rape of Europa* is better documented. It reappears in the formidable collection formed by the *receveur général des finances*, Augustin Blondel de Gagny (1695–1776)—"a fairy palace where nothing was counted curious but in proportion to its being expensive"—and was seen there by Gabriel de Saint-Aubin, who commemorated his visit in a drawing dated 28 April 1771.[17] Saint-Aubin went on to include *The Rape of Europa*, which he prominently signed and dated 1727, as an imaginary *dessus de cheminée* in the wash drawing *Seated Girl with a Cat on Her Lap* (fig. 2).[18] *The Rape of Europa* then passed quickly through a succession of Parisian collections (see provenance), the most notable of which, formed by Lebrun for Charles-Alexandre de Calonne, also included the version of Restout's *Hector Taking Leave of Andromache* (cat. no. 34) exhibited here.[19] Last recorded in the estate sale of the art dealer "*citoyen*" Vincent Donjeux (29 April 1793), *The Rape of Europa* finally entered the superb collection of old master paintings assembled by Napoleon's eldest surviving brother, Joseph Bonaparte (1768–1844), king of Spain between 1808 and 1814. These paintings were shipped *en bloc* in 1815 to Point Breeze, Bordentown, New Jersey, Bonaparte's residence of exile until 1839.[20] Unharmed by the fire that destroyed part of his collection in 1830, *The Rape of Europa* was offered as a token of affection to the Philadelphian general Thomas Cadwalader (1795–1873) on the eve of Bonaparte's departure for England. "I hope you will accept with pleasure this souvenir of my warm feelings for you and your family," Bonaparte wrote in a letter dated 25 October 1839. "*The Rape of Europa* is one of the finest works by Coypel, from the French school of the previous century."[21] The painting remained in the Cadwalader family until 1951.

It is not difficult to understand the enthusiasm that *The Rape of Europa* inspired in successive generations of eighteenth-century connoisseurs, collectors, and art dealers. In its sumptuous coloring, lively and dynamic groupings of beautiful figures, and masterful

handling of light, it is one of the most joyous and celebratory mythologies painted in Europe during the eighteenth century.

Coypel, whom Dézallier d'Argenville noted to have reflected long and hard on his art, represents the moment in which Europa, princess of Tyre, recognizes the full consequences of her abduction by Jupiter, who had won her by taking the form of a friendly bull. The artist masterfully renders the conclusion of Ovid's cautionary tale: "The god was . . . soon in full flight with his prize on the open ocean. She trembles with fear and looks back at the receding shore, holding fast a horn with one hand, and resting the other on the creature's back. And her fluttering garments stream behind her in the wind."[22]

Coypel is faithful to the particulars in Ovid's description as well as to its general mood of apprehension and regret. The bull's body is as white "as the untrodden snow"; his tiny horns are polished "cleaner and more clear than pearls";[23] even the folds of skin hanging below the bull's neck—"the long dewlap down in front"—are meticulously rendered.[24] Coypel summarizes his seventeenth-century sources quite easily: Europa, her eyes cast heavenward, is based on Guido Reni's heroines; the central motif of Europa astride a bull, pricked by Cupid's arrows, is taken from Albani; the aged and bearded river-god at far right is a quotation from Rubens.[25]

However, Coypel's signal achievement here is the invention of several subsidiary groups, which not only demonstrate his consummate skill as a figure painter but also infuse the stately, lonely progress of Jupiter and Europa with unprecedented energy and movement, thereby breaking radically with the established iconography for this much-painted myth.[26] Thus, Zephyr, god of the West Wind, aided by an infant Wind god, spurs Jupiter forward across the ocean; tritons and nereids, Neptune's male and female attendants, frolic in the bull's wake, the nereids' hair braided with strands of pearl and coral, as befits these lesser divinities of the sea. In the foreground, a dark-skinned triton blows hard upon his conch, the better to conceal Jupiter's excited bellowing, according to the ingenious explanation offered in the *Mercure de France*.[27] On the right, Neptune, god of the sea, explains Jupiter's conquest to his consort, Amphitrite. The various groups are painted with unusual delicacy of touch and refinement of color: Europa's flesh is modeled in yellow and pink glazes, a bracelet of tiny pearls is visible on her left arm, the folds of her dress are described in almost liquid strokes of salmon pink. Moreover, this virtuosity is sustained throughout the densely populated mythology, in which the art dealer Lebrun counted no fewer than twenty-eight figures.[28]

Alone among the participants of the *concours de 1727*, Coypel seems to have conceived his entry not as an official painting but as a much-extended cabinet picture and to have finished his figures appropriately. He rejected the more conventional pyramidal structure of Cazes's *Birth of Venus* and Lemoyne's *Continence of Scipio* and instead punctuated his canvas with flying and swimming figures in a sea of motion, at no cost to the composition's general harmony. It is the golden rays of the late afternoon sun, cast across a cloud-streaked sky, that succeed in unifying *The Rape of Europa* and preventing the inhabitants of sea and air from dissolving into separate groups. The rhythms produced by this strong sunlight as it models the various participants—from the tawny conch-blowing triton in the center to the lily-skinned attendants of Amphitrite at right—contribute further to the sensuous delight that Coypel's canvas so unremittingly celebrates.

Most compelling in this "rich and ingenious composition" is Coypel's naturalism:[29] the unlikely combination of effects observed from life in a narrative of noble and mythic subject matter; the late afternoon sky, whose racing clouds are streaked with orange; the putto at left, diving into the water, and his companion at upper right, swinging through the sky from the silken drapery, attitudes Coypel might well have observed in children at play; the two white-skinned maidens at lower right, who shield their eyes from the sun's oppressive glare—it is to details such as these that Dézallier d'Argenville referred when he noted that "because of the manner in which Coypel approached mythology, his work took on an air of verisimilitude which reconciled it with the Truth."[30]

Coypel's ambitious and complicated mythology seems to have been painted quickly and with little apparent effort; no preparatory drawings or studies are known. The artist may well have embarked upon *The Rape of Europa* shortly after the competition was first announced on 14 May 1726. The catalogues of the Champgrand and Calonne sales indicate that the painting was dated 1726, the year in which de Troy signed his *Diana Resting* (cat. no. 21).[31] While the signature is still visible under the figure of the bearded triton at lower right, the date itself is now indecipherable.

However, the results of a recent technical examination show that Coypel crafted his competition piece with remarkable care and deliberation, and reveal an exacting intelligence that paid scrupulous attention to every motif, further confirming that Coypel conceived *The Rape of Europa* as a cabinet painting of the highest order. It is evident that the placement of several figures was revised once the

composition was completed. The heads of both the triton blowing the conch and the dark-skinned nereid with her back to the viewer were moved substantially to the left; the bull's tail, which initially intersected the muscular triton's back, was reconfigured in a curl; the bull's right hoof, of which only the upper half is now visible above the foam, was first shown fully modeled rising out of the water, almost colliding with the wings of the diving putto (fig. 3). Zephyr's butterfly wings initially extended well into the clouds at almost twice their present size, and the tiny oculus, neatly inscribed within the web of the wing, was reduced in the truncation to a semicircle. The most dramatic change occurred in the group of marine attendants at far right who observe Europa's abduction from the safety of Amphitrite's chariot. Coypel had initially painted a second nereid, reclining between the thighs of the dark-haired maiden whose arms are folded on the edge of Amphitrite's chariot (fig. 4). Holding her right breast between the thumb and forefinger of her right hand, this ecstatic attendant, in an attitude of extreme abandon, may have been painted out for reasons of propriety.[32]

Coypel labored hard on such details, yet without compromising the extraordinary harmony he was able to achieve in this complex and ambitious cabinet painting. His attempt to revitalize *The Rape of Europa* by the inclusion of an extensive supporting cast and by attending to precise meteorological conditions seems, at first, to have met with general approval and perfect understanding. The two strictly contemporaneous descriptions of Coypel's *Rape of Europa*—in the little catalogue that accompanied the exhibition and in the account that appeared in the *Mercure de France* in August 1727—situated the mythology in the chronology of Ovid's narrative and went on to explain the presence of the subsidiary deities without hesitation.[33] Within a generation, however, the subject of Coypel's mythology had become impossibly confused—despite the genuine admiration with which it was discussed—and the painting would be routinely misidentified in almost every eighteenth-century account, including the opinions of the most eminent connoisseurs of the day. With few exceptions, the authors followed Dézallier d'Argenville in cataloguing Coypel's entry as *The Triumph of Amphitrite*, even though they would have known perfectly well that Neptune's consort was returned to him on the back of a dolphin and that she betrayed none of the fear of Coypel's heroine.[34] Mariette, whose enthusiasm has already been mentioned, noted that Coypel had painted a "Triumph of Galatea or Amphitrite or The Birth of Venus," thus raising every possibility save the actual subject of Coypel's mythology.[35]

These mistakes—which Pierre Rosenberg has dismissed too readily as "an easily understandable lapsus"[36]—focus attention on Coypel's stratagem at the *concours de 1727*: the innovative reworking of a much-painted myth in order to display, in a prestigious public arena, his creative powers as a history painter. There can be no doubt that Coypel himself was fully aware of the differences in these myths; his handling of the central group in *The Rape of Europa* follows Ovid's account too closely for any confusion, and on other occasions he painted orthodox versions of both *The Birth of Venus* and *The Triumph of Amphitrite*.[37] At the *concours de 1727* Coypel's ambitions were more complex. In consciously evoking these related maritime mythologies and in casting a usually desolate subject in a sea brimming with ecstatic inhabitants, Coypel was taking on the two French artists whose primacy in this genre was undisputed. The drawing to which several historians have pointed as an immediate source for Noël-Nicolas's *Rape of Europa*, Antoine Coypel's similarly entitled compositional study (fig. 5), provides the first model.[38] On closer inspection, it is clear that this drawing represents a composite scene, showing, from left to right, Venus triumphant, born aloft by tritons; Europa abducted by Jupiter in the guise of a bull, in a pose remarkably similar to Noël-Nicolas's heroine; and, on the far right, Neptune and Amphitrite racing their horses across the waters. The profusion of zephyrs and putti in the sky—one is seated in a chariot drawn by a pair of doves—evokes the dual presence of Venus and Jupiter in this busy scene. It also suggests the second prototype, to which both Antoine and his half brother were indebted, namely Poussin's great *Triumph of Venus* (fig. 6), commissioned by Cardinal Richelieu in c. 1635, engraved by Jean Pesne in 1700, and recorded as hanging in the hôtel de Bretonvilliers in Paris until at least 1719.[39]

It is not possible to prove that Noël-Nicolas had access either to Antoine Coypel's drawing or to Poussin's mythology, although it is likely that he knew them both. His relationship with his half brother had been embittered and uneasy, for Antoine Coypel seems to have done nothing to promote Noël-Nicolas's career. Dézallier d'Argenville noted that "Coypel the uncle's" timidity and fear had prevented him from realizing his "uncommon talent" until Antoine Coypel's death in 1722. Crozat had made a similar observation, though in a somewhat different context, in his letter to Rosalba Carriera cited earlier.[40] Thus, Noël-Nicolas's reliance on Antoine's drawing would not have been a straightforward matter of studio practice. In turning to this complex *Rape of Europa/Birth of Venus* and following its aggregated iconography, he

was showing himself the equal of his venerated half brother and claiming, beyond him, kinship with Poussin's iconic Bacchanal. Such an ambitious undertaking was acknowledged, but ambiguously: public recognition, certainly, but lack of official validation at the *concours* itself and a complete misunderstanding of the subject on the part of later commentators. Yet Coypel's aspirations in *The Rape of Europa* may have ultimately succeeded in quite a different way. His painting seems to have inspired the young François Boucher—winner of the Academy's *Grand Prix* in 1723 and no doubt a visitor to the *galerie d'Apollon* in the summer of 1727—who, in *The Triumph of Venus* (fig. 7) commissioned for Louisa-Ulrika of Sweden in 1742, would go on to complete the tradition that Coypel had so brilliantly renewed.

NOTES

1. Anonymous 1727, 3; *Mercure de France*, July 1727, 1567–68.

2. Caylus in Lépicié 1752, II, 100, "le concours fut un grand objet de curiosité pour la ville, et pour les étrangers que la paix attiroit alors dans le Royaume." The Treaty of Aix-la-Chapelle, signed on 30 May 1727, is discussed by Barbier 1857, II, 5–6.

3. Sani 1985, I, 468, "La verité [c'est] que Noël Coypel qui n'estoit il y a trois ans qu'un très médiocre peintre, semble aujourd'hui l'emporter sur tous les autres." Professor Sani's definitive edition corrects Sensier 1865, 327.

4. Mariette 1851–60, II, 29, "tout le monde le regardoit avec une admiration mêlée d'étonnement."

5. De Valory in Dussieux et al. 1854, II, 265, "l'équité du public parvint à se faire jouer et força les gens les plus prévenus en faveur de MM. Lemoine et de Troy à convenir que les deux meilleurs tableaux du concours étoient ceux de M. Cazes et M. Noël Coypel."

6. Dézallier d'Argenville 1762, IV, 442, "celui de Noël-Nicolas Coypel . . . fut trouvé si beau, le coloris en parut si frais, si suave, que le public lui adjugea la palme."

7. Rosenberg 1977, 30.

8. Mariette 1851–60, II, 29, "l'on plaignit l'auteur en secret de n'avoir personne auprès du ministre qui fît sentir la force de ses talents."

9. Dézallier d'Argenville 1762, IV, 443, "Un sécretaire d'Etat, connoissant l'injustice qu'on faisoit à Noël-Nicolas dans la distribution du prix, lui donna la somme de quinze cens livres, qui étoit celle que le Roi avoit promise pour le tableau gagnant. Ce trait de générosité est sçu de tout le monde: l'amour que ce Ministre avoit pour les beaux arts, égaloit sa connoissance"; see also Rosenberg 1977, 32, 37, 141, n. 23; Lomax 1982, 39, 47, n. 31.

10. Barbier 1857, II, 13–17 (August 1727); Lescure 1863–68, II, 230–31, "On dit que M. de Morville n'étoit pas au gré du Cardinal."

11. For the dates of the results of the *concours*, Montaiglon 1875–92, V, 27, and for the presentation at court, *Mercure de France*, July 1727, 1847.

12. Had de Morville's "act of generosity" taken place after 19 August 1727, it might have been a somewhat desperate measure to embarrass the Crown's much publicized *largesse* towards the history painters of the Academy.

13. Dézallier d'Argenville 1762, IV, 442–43, noted that, although laureate of the *Grand Prix*, "un cabale de jaloux" prevented Noël-Nicolas from studying in Rome at the Crown's expense; his late career was marred by a lawsuit against the Wardens of the Church of Saint-Sauveur, who had refused to pay him for the chapelle de la Vierge which he had decorated at cost. Coypel also lost the commission to decorate the gallery of the hôtel du Grand Prieur to the portraitist Jean-Marc Nattier, Dussieux et al. 1854, II, 356.

14. A.N., *Minutier Central*, CXV, 476, "*Inventaire après décès*," 3 March 1732, in which de Morville's choice collection of old master paintings is inventoried in some detail. For a published description of de Morville's *hôtel*, with its ceiling decorations by Pierre Mignard, see Brice 1752, I, 473–75; Coypel's *Rape of Europa* is not mentioned in this account.

15. Sani 1985, II, 460–62, 468–69, 481–83, 568–70. To complicate matters further, an unpublished and anonymous life of Noël-Nicolas dating from c. 1740 among the papers of the Academy asserts that "un *financier* voyant l'injustice qui lui fut faite . . . prit son tableau, lui donna la même somme que le Roy avoit promis de donner au Peintre victorieux," Paris, École Nationale Supérieure des Beaux-Arts, MS. *129* (my emphasis). Might the "financier" here be Blondel de Gagny?

16. Guiffrey 1883, 309, for the *Procès-verbal d'apposition de scellés après le décès de Noël-Nicolas Coypel, peintre ordinaire du Roi* (14 December 1734). The *inventaire après décès*, drawn up by maître Dutartre on 23 December 1734 and recorded in his register for this day, has not survived in the much damaged *étude* LVI of the *Minutier Central*.

17. Pozzi 1932, 112–13; Dacier 1929–31, II, 145; Bailey 1987, 438–39. The drawing was not known by Dacier, who includes a related gouache, no. 339, in his catalogue.

18. Dacier 1929–31, II, 54; Suzanne Folds McCullagh kindly informs me that the drawing should be dated c. 1773–75.

19. *Catalogue d'une très belle collection de Tableaux d'Italie, de Flandres, de Hollande, et de France . . . provenans du Cabinet de M. [Calonne]*, Paris, 21–30 April 1788, nos. 140, 153.

20. Bertin 1893, 416, "Liste des Tableaux de la Galerie de Joseph Bonaparte"; Benisovich 1956, 296–98.

21. Bertin 1893, 172, "J'espère que vous accepterez avec plaisir le souvenir que je vous envoie des sentiments qui m'ont uni à votre famille, depuis le long séjour que j'ai fait parmi vous. . . . P.S. le *Rapt d'Europe* est un des meilleurs tableaux de Coypel, de l'école française du siècle dernier."

22. Ovid, *Metamorphoses*, II, 870–75.

23. Ibid., 852, 856.

24. Ibid., 854.

25. Dézallier d'Argenville 1762, IV, 442, noted the relationship between Coypel and Reni's heroines ("la fraîcheur de ses carnations nous rappelle celles du fameux Guide"); for the various versions of Albani's *Rape of Europa*, Puglisi 1983, 333–40; the bearded river-god at right derives from Rubens's *Disembarkation at Marseilles* (Paris, Musée du Louvre) from the Medici cycle, which Coypel would have seen at the Palais du Luxembourg.

26. The subject has been exhaustively treated by Barbara Mundt in exh. Berlin 1988.

27. *Mercure de France*, July 1727, 1568, "sur le devant on voit un Triton qui contrefait avec sa conque le mugissement du Taureau."

28. *Catalogue d'une belle collection de Tableaux Originaux de Trois Écoles . . . par J.P.B. Lebrun, Peintre* ["et lui appartenant," according to the annotated copy in the RKD], Paris, 10 December 1778, 47, "un superbe tableau, composé de vingt-huit figures."

29. *Catalogue de Tableaux de bons maîtres des écoles d'Italie, des Pays-Bas et de France du Cabinet de M. Le P.*, Paris, 3 March 1785, no. 56, "Europe au milieu des eaux, composition ingénieuse et riche, dont le coloris est frais et brillant."

30. Dézallier d'Argenville 1762, IV, 446, "de la manière dont il traitoit la fable, elle recevoit dans son ouvrage un air de vraisemblance qui la réconcilioit avec la verité."

31. *Catalogue d'une Collection précieuse de Tableaux des Trois Écoles et autres objets curieux du Cabinet de M. [marquis de Chamgrand, de Proth, Saint-Maurice, Bouillac]*, Paris, 20 March 1787, 100, "Noël Coypel, 1726"; Paillet's entry is repeated word for word in Lebrun's catalogue for the Calonne sale the following year (as in n. 19).

32. Coypel also effaced the head of a youthful bearded triton who appeared at the very edge of the canvas, just above the cluster of nereids by Amphitrite's chariot, a severe case of overcrowding. It is a pleasure to thank Mark Tucker and Joe Mikuliak at the Philadelphia Museum of Art, who examined this picture with me.

33. Anonymous 1727, 3, "les Divinitez de la Mer le regarde avec curiosité; Zephir et les Amours favorisent son entreprise"; *Mercure de France*, July 1727, 1568, "Neptune et Amphitrite sont à droite, qui admirent ce prodige."

34. Dézallier d'Argenville 1762, IV, 443; of the earlier sources, Caresme 1740, 399, Marsy 1746, 168, and de Valory in Dussieux et al. 1854, II, 265, are the only authors to identify the subject correctly; see the full listing in "Bibliography."

35. Mariette 1851–60, II, 29, "Un des premiers morceaux qui servit à le faire connoître fut un tableau représentant le Triomphe de Galathée ou d'Amphitrite ou la Naissance de Vénus qu'il exposa dans la galerie du Louvre en 1727. . . ."

36. Exh. Toledo, Chicago, and Ottawa 1975–76, 31.

37. Lomax 1982, 34, for Coypel's *Triumph of Amphitrite*, pendant to *Pan and Syrinx*, signed and dated 1723, appeared at Sotheby's, Monaco, 13 June 1982, and is now in a private collection in New Jersey; his *Birth of Venus*, signed and dated 1732, entered Catherine the Great's collection between 1766 and 1768, Nemilova 1986, 80; the drawing in the Cabinet des Dessins, formerly in the collection of the comte d'Orsay (ORS.483) and attributed to Coypel by Jean-François Mejanès, should be related to the Leningrad mythology, exh. Paris 1983 (A), 170.

38. Lomax 1982, 38; Garnier 1989, 161, 217.

39. Blunt 1966, 120; Rosenberg in exh. Paris, New York, and Chicago 1982, 308, provides a complete bibliography and notes, following Margret Stuffmann, showing that the painting was not recorded in Pierre Crozat's collection but belonged to his nephew Louis-Antoine, baron de Thiers. The provenance of Poussin's *Triumph of Venus* between 1719 and 1755 remains to be established.

40. Dézallier d'Argenville 1762, IV, 442; for Crozat's letter of 15 May 1727, see n. 1.

FIG. 1
Pierre-Jacques Cazes, *The Triumph of Venus*,
1727, oil on canvas, County Durham, Bowes
Museum, Barnard Castle

FIG. 4
Noël-Nicolas Coypel, detail of *The Rape of
Europa*, 1727, infrared reflectography,
Philadelphia Museum of Art

FIG. 2
Gabriel de Saint-Aubin, *Seated Girl with a Cat
on Her Lap*, 1771, pencil and sepia wash
drawing, location unknown

FIG. 5
Antoine Coypel, *The Rape of Europa*, c. 1705, black, red, and white chalk drawing, Paris, Musée du
Louvre, Cabinet des Dessins

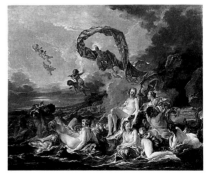

FIG. 3
Noël-Nicolas Coypel, detail of *The Rape of
Europa*, 1727, infrared reflectography,
Philadelphia Museum of Art

FIG. 6
Nicolas Poussin, *The Triumph of Venus*,
c. 1635, oil on canvas, Philadelphia Museum of
Art, Purchased: The George W. Elkins
Collection

FIG. 7
François Boucher, *The Triumph of Venus*, 1742,
oil on canvas, Stockholm, Nationalmuseum

NOËL-NICOLAS COYPEL
The Judgment of Paris

31

NOËL-NICOLAS COYPEL (1690–1734)
The Judgment of Paris, 1728
Oil on canvas
101 x 82 cm.
Nationalmuseum, Stockholm

PROVENANCE
Acquired by Carl Gustav Tessin (1690–1754) from the artist for
600 *livres* on 29 January 1729; sold by Tessin in 1749 to Fredrik I,
king of Sweden; at Fredrikshof until 1774; transferred by Louisa-
Ulrika to Drottningholm, where it remained until 1782; brought
back to the Royal Palace in Stockholm by Gustavus III; at Drott-
ningholm from 1793 until 1865, when it entered the collection of
the new Nationalmuseum.

EXHIBITIONS
Östersund 1920, no. 8; Copenhagen 1935, no. 39; Paris 1937,
no. 146; Stockholm 1945; Stockholm 1979–80, no. 503, ill.

BIBLIOGRAPHY
Stockholm 1867, 57; Clément de Ris 1874, 494; Göthe 1887, no.
793; Göthe 1900, no. 793; Lespinasse 1911, 117; Legran and
Wrangel 1912, 37; Lespinasse 1912, 213–14, no. 68; Stockholm
1920, no. 8; Stockholm 1928, no. 793; Dimier 1928–30, II, 219,
224, no. 23, ill.; Granberg 1930–31, II, 155, 157, 158, III, 13, 17;
Moselius 1939, 95; Nordenfalk 1953 (A), 67–68; Nordenfalk
1953 (B), 123, 129, ill.; Stockholm 1958, no. 793; exh. Toledo,
Chicago, and Ottawa 1975–76, 31; Tomobe 1981, no. 75, col.;
Lomax 1982, 39–40, 42, ill.; Stockholm 1990, 94, ill.

Because she had not been invited to the mar-
riage of Peleus and Thetis, Eris, goddess of Discord,
interrupted the wedding celebrations by casting be-
fore the assembled gods a golden apple inscribed "to
the Fairest." Juno, Minerva, and Venus each claimed
the apple as rightfully hers, and the goddesses ap-
pealed to Jupiter for a decision. Unwilling to assume
responsibility in this delicate matter, Jupiter instruct-
ed Mercury, the winged messenger of the gods, to take
the golden apple to Paris, son of King Priam of Troy,
who was living at the time as a shepherd on Mount
Ida. "Young and handsome and in every way suscepti-
ble to love," Paris was commanded to bestow the ap-
ple on the most beautiful goddess, a daunting prospect
which he accepted with extreme reluctance.[1] Encour-
aged by Mercury, however, Paris rose to the task and
requested that the three goddesses disrobe in turn so
that he could judge them with their attributes re-
moved. All three bribed him: Juno offered to make
him lord of all Asia; Minerva guaranteed invincibility
in battle; but Venus, in promising him Helen of
Troy—"beautiful Leda's daughter, more beautiful than
her mother"—ensured that the apple would be hers
and "retraced her way victorious to the sky."[2]

The story of this momentous beauty contest, the
consequences of which would set into motion the
Trojan War, was recounted with a good deal of wit
and cynicism by Lucian, Apuleius, and Ovid, and was
one of the most frequently depicted episodes from
classical mythology in European painting of the sev-
enteenth and eighteenth centuries.[3] Noël-Nicolas
Coypel's treatment of the subject, signed and dated
just below the tip of Minerva's javelin, was one of a
number of small-scale mythologies he would paint in
the 1720s, at a time when public commissions *en
grand* were lacking.[4] Arguably the finest of Coypel's
exquisite cabinet pictures, *The Judgment of Paris* con-
flates successive episodes of this well-known tale.
Paris, seated by his sheep—which are restrained from
walking out of the canvas by a black she-goat—holds
the golden apple in his left hand, but seems in no hur-
ry to part with it. He sits back in some trepidation—
"I was mute and chill tremors had raised my hair on

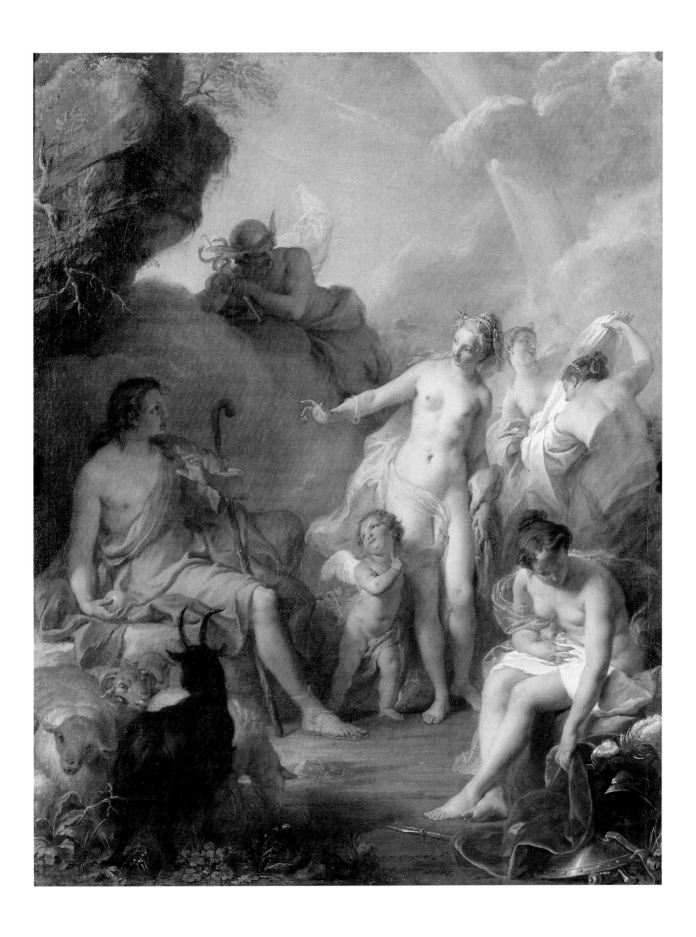

end"—as Venus bares her plump little body for his inspection.[5] Cupid's arch expression and eagerness to cover Venus with her flimsy yellow shift leave no doubt that Paris has reached a decision. The action of the other goddesses also suggests that the competition has come to an end; Minerva, at right, seated on a rock, attempts to cover her naked body while bending down to retrieve her velvet cloak and plumed helmet. Behind her, Juno puts on her white robes with unseemly haste, unable to attire herself quickly enough. Such is her confidence of victory, however, that Venus's nudity is all the more flagrant. In the background, Mercury, reclining against a cloud with his golden caduceus in shadow, witnesses the scene with amused detachment.

In its "lightness," "elegant drawing," "soft and bright coloring," and "gentle, restrained *chiaroscuro*," Coypel's cabinet painting adheres very closely to the recipe for "*les sujets gracieux*" in Antoine Coypel's *Épître à mon fils*, first published in 1708, reprinted in 1720, and a veritable blueprint for history painting as it would develop in the 1720s and 1730s.[6] Academic orthodoxy notwithstanding, Noël-Nicolas's *Judgment of Paris* is also a frank celebration of the female nude, treated sensuously and with unusual candor in the strong afternoon light that filters into this protected grove. Coypel's painting of flesh is at its most seductive; touches of pink, gray, and yellow describe the ample contours of Venus's naked form, while Minerva's left arm and thigh are modeled by strokes of blue gray, with pink highlights deftly describing the folds of flesh under her left arm. Juno's broad back, half in shadow, is almost sculptural. The acuity of Coypel's observation and the informality of the poses his figures adopt—Minerva, clutching her garments to her breast with one hand, picking up her affairs with the other; Juno, slipping her dress over her head as one might a nightgown—give this mythology its strong erotic power. (By contrast, Coypel's handling of Paris and Mercury is almost perfunctory.) Such is the overwhelming presence in this painting of the female model studied from life that it is surprising that no preparatory drawings have yet been identified. A female *académie* (fig. 1) attributed to Noël-Nicolas stands in oblique relationship to the composition; viewed from the back, her weight resting on her left leg, the voluptuous nude clasps an apple to her breast. Is it possible that this study represents a preliminary idea, discarded early on, for the figure of Venus?

Coypel's *Judgment of Paris* occupies a position midway between Watteau's ironic, almost humorous, interpretation of the myth (fig. 2) and de Troy's sensuous but more straightforward depiction (fig. 3) in which a besotted Paris, urged on by Hymen's flame and Cupid's arrows, is about to hand the apple to

a smiling and conspicuously more beautiful Venus.[7] If Coypel, like Watteau, recovers something of the irreverence of Lucian's narration—his goddesses assume distinctly unceremonious postures in their eagerness to cover up—he attends to the issue of their nudity with greater concentration than does de Troy, whose painting of flesh is formulaic by comparison. Like Watteau, Coypel summarizes a range of pictorial sources before breaking with tradition in his treatment of this theme; unlike Watteau, his intention is renewal, not parody.

Coypel surely knew Rubens's *Judgment of Paris* (London, The National Gallery), then in the Orléans collection,[8] and may also have been familiar with Albani's *Actaeon Changed into a Stag* (fig. 4), which had entered the Royal Collection by 1683 and from which he seems to have appropriated the distinctive pose of Diana's seated attendant at right for his figure of Minerva.[9] Yet his composition is indebted to a more obvious prototype which has been generally overlooked in discussions of the subject. Although Coypel's Venus—her right arm outstretched, her pearl bracelet hanging loosely from it—is a stock figure from his repertory of the 1720s,[10] she is based here on the figure of Juno in Marcantonio Raimondi's celebrated engraving after Raphael's *Judgment of Paris* (fig. 5), just as the figure of Cupid in Coypel's mythology derives from Raphael's winged attendant.[11] It was to this engraving that Watteau also had turned for the striking pose of Venus in his *Judgment of Paris*—seen from behind, draping herself in white—which, with some variation, depends upon the figure of Minerva in the center of Raphael's composition.[12]

Coypel's *Judgment of Paris* may share yet another source with Watteau's more celebrated panel. It has been pointed out that Watteau may have been influenced by a *pastorale héroïque* of *The Judgment of Paris* written by the abbé Simon-Joseph Pellerin and Marie-Anne Barbier, with music by Bertin de la Doué, performed in June 1718 and parodied by d'Orneval at the *Foire Saint-Laurent* the following month.[13] This undistinguished opera was revived in Paris nine years later and performed at the *Académie royale de Musique* on 15 July 1727, when its libretto was published for a second time. It is quite plausible, though impossible to document, that the reappearance of Pellerin and Barbier's opera may have been of some inspiration to Coypel; Paris and Venus, in contrast to the other figures, adopt distinctly "theatrical" poses, although at no moment in Pellerin's play do the three goddesses appear together on the stage for Paris's inspection.[14]

It is characteristic of Coypel's best work, however, that such diverse sources—Raphael, Albani, the *pastorale héroïque*, and the living model—are

fused. Such assimilation, a cornerstone of academic pedagogy, was alluded to in the earliest life of Noël-Nicolas Coypel, written by his brother-in-law Claude-François Caresme in 1740: "It would appear that he made a careful study of Correggio's graces and Parmigianino's pleasing attitudes, but without neglecting Nature, which must always provide the artist with his primary and most reliable model."[15] Furthermore, Coypel's understanding of mythology and his capacity to pictorialize it naturalistically allow him to indulge a certain imaginative license, exemplified in *The Judgment of Paris* by the intrusion of a fourth female figure. The identity of the white-skinned maiden in the background at right who helps Juno with her robes is revealed by her diaphanous butterfly wings and by the rainbow that falls to earth through the clouds behind her. Iris, messenger of the gods, slips into Coypel's mythology almost unnoticed, yet her role is "in character"—she customarily dances attendance upon Juno—and her attributes are punctiliously, if discreetly, included without in the least disturbing the harmony of Coypel's radiant painting.[16]

Coypel's erudite and sensuous cabinet picture did not remain in his possession for very long. It was the first painting acquired by Carl Gustav Tessin (1690–1754), the Swedish *surintendant des Bâtiments* whose visit to Paris in 1728–29 is more thoroughly discussed in the entry on Lemoyne's *Venus and Adonis* (cat. no. 26). On 29 January 1729 Tessin paid Coypel the substantial sum of 600 *livres* for *The Judgment of Paris* (fig. 6); eleven days later he acquired a frame for this painting.[17] The care with which Tessin recorded his expenditure in Paris also throws light on Coypel's method of production and his relationship to the market, issues of general interest for which little concrete evidence exists in the decades before the biennial Salon was introduced. Unless Tessin went to Coypel's studio immediately upon arriving in Paris (12 December 1728) to commission this painting—which Coypel, who dated the work "1728," would thus have had less than three weeks to complete—it seems likely that the artist painted *The Judgment of Paris* without a particular patron in mind and that it remained in his studio awaiting a prospective buyer. It is unlikely that the painting would have remained there for very long. With its diminutive figures, immaculate finish, and elegant coloring, it would have easily found a place alongside the seventeenth-century Dutch and Flemish cabinet paintings that were entering the Parisian market in some number at this time.[18] That *The Judgment of Paris* had yet to find an owner was Tessin's gain, and it is fitting testimony to his deeply felt appreciation of French contemporary art that the alacrity with which he visited Coypel's studio should have paid off so handsomely.

NOTES

1. Lucian, *The Judgment of the Goddesses*, III.

2. Ovid, *Heroides*, XVI, 85, 88.

3. Lucian, *The Judgment of the Goddesses*, III–XVI; Ovid, *Heroides*, V, 33–41; XVI, 51–88; Apuleius, *The Golden Ass*, X; Pigler 1956, II, 195–201.

4. This group includes *Bacchus and Venus* (cat. no. 29) and *Diana Bathing*, signed and dated 1728 (Leningrad, The Hermitage).

5. Ovid, *Heroides*, XVI, 67.

6. Coypel in Jouin 1883, 328, "un certain air de légèreté . . . l'élégance du dessin . . . le coloris vague et brillant . . . le clair-obscur doux et tempéré."

7. For Watteau's *Judgment of Paris*, Rosenberg in exh. Paris 1984–85 (A), 417–18; de Troy's recently discovered *Judgment of Paris*, sold in Paris, Drouot-Richelieu, 6 April 1990, no. 18, as by Noël-Nicolas Coypel, is catalogued in *A Collector's Miscellany: European Painting, 1600–1800*, Colnaghi, London and New York, 1990, 31. Another version of the subject by de Troy was engraved by Jean Daullé as *Le Prix de la Beauté*, see Bibliothèque Nationale 1930–[1977], VI, 132–33.

8. Dubois de Saint-Gelais 1727, 415–17; Rooses 1977, III, 141–42.

9. Puglisi 1983, I, 330; Lomax 1982, 47, n. 35, referring to an observation made by Donald Posner.

10. This gesture appears for the first time in Coypel's overdoor, *Venus and Cupid* (sold Paris, Ader Picard Tajan, 5 December 1990, no. 75). The figures of Venus in *Bacchus and Venus* (cat. no. 29) and Europa in *The Rape of Europa* (cat. no. 30) are based on the same model.

11. Exh. Lawrence, Chapel Hill, and Wellesley 1981–82, 146–47, for the most complete discussion of the engraving, which has been much cited in discussions of Manet's *Déjeuner sur l'herbe* but generally overlooked as a source for eighteenth-century painters.

12. Rosenberg in exh. Paris 1984–85 (A), 417–18, for the other pictorial sources Watteau may have used.

13. Rosenberg in exh. Paris 1984–85 (A), 418, citing the research of Boerlin-Brodbeck 1973.

14. *Mercure de France*, July 1727, 1665; Chouquet 1873, 334. I am grateful to Udolfo van de Sandt for help with Pellerin's libretto.

15. Caresme 1740, 399, "il paroît qu'il avoit fait une étude particulière des grâces du Corrège, et du tour aimable du Parmesan, sans négliger la belle nature qu'un peintre doit toujours regarder comme son premier et plus assuré modèle"; Lomax 1982, 40, has pertinently noted of the figure of Minerva, "il y a là une intelligence de la forme féminine qu'on ne trouvait guère avant Watteau et qu'on ne retrouvera ensuite que chez Boucher."

16. For another depiction of Juno and Iris, in which Iris is similarly identified by her butterfly wings and a rainbow, see Lemoyne's *Juno, Iris, and Flora* (Paris, Musée du Louvre), an overdoor dated to c. 1720–24, Bordeaux 1984 (A), pl. 1, 87.

17. I am most grateful to Pontus Grate, who is finishing a catalogue on the eighteenth-century French paintings in the Nationalmuseum, Stockholm, for providing me with this information, which is to be found in the Kunglin Biblioteket, Åkeröarkivet, VII, fol. 734.

18. Banks 1977, 60–106 passim, for the best general introduction to this important topic.

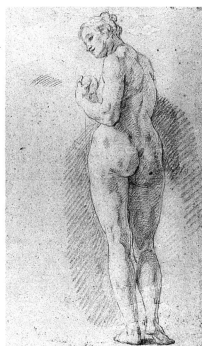

FIG. 1
Attributed to Noël-Nicolas Coypel, *Standing Female Nude*, c. 1728, black chalk drawing, Paris, Private Collection

FIG. 3
Jean-François de Troy, *The Judgment of Paris*, c. 1725–30, oil on canvas, Private Collection

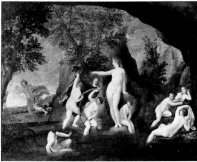

FIG. 4
Francesco Albani, *Actaeon Changed into a Stag*, c. 1640, oil on canvas, Paris, Musée du Louvre

FIG. 6
Tessin's receipt to Noël-Nicolas Coypel, dated 31 January 1729, for 600 *livres*, from Kunglin Biblioteket, Åkeröarkivet, VII, 741 (L 82:2:7)

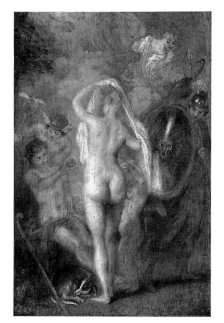

FIG. 2
Jean-Antoine Watteau, *The Judgment of Paris*, c. 1728, oil on canvas, Paris, Musée du Louvre

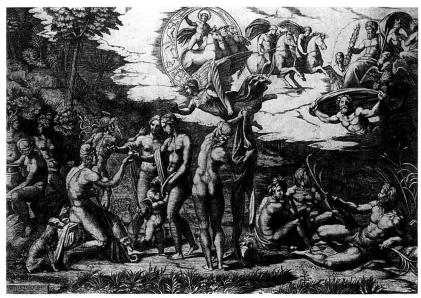

FIG. 5
After Raphael, *The Judgment of Paris*, c. 1517–20, engraved by Marcantonio Raimondi, Washington, National Gallery of Art

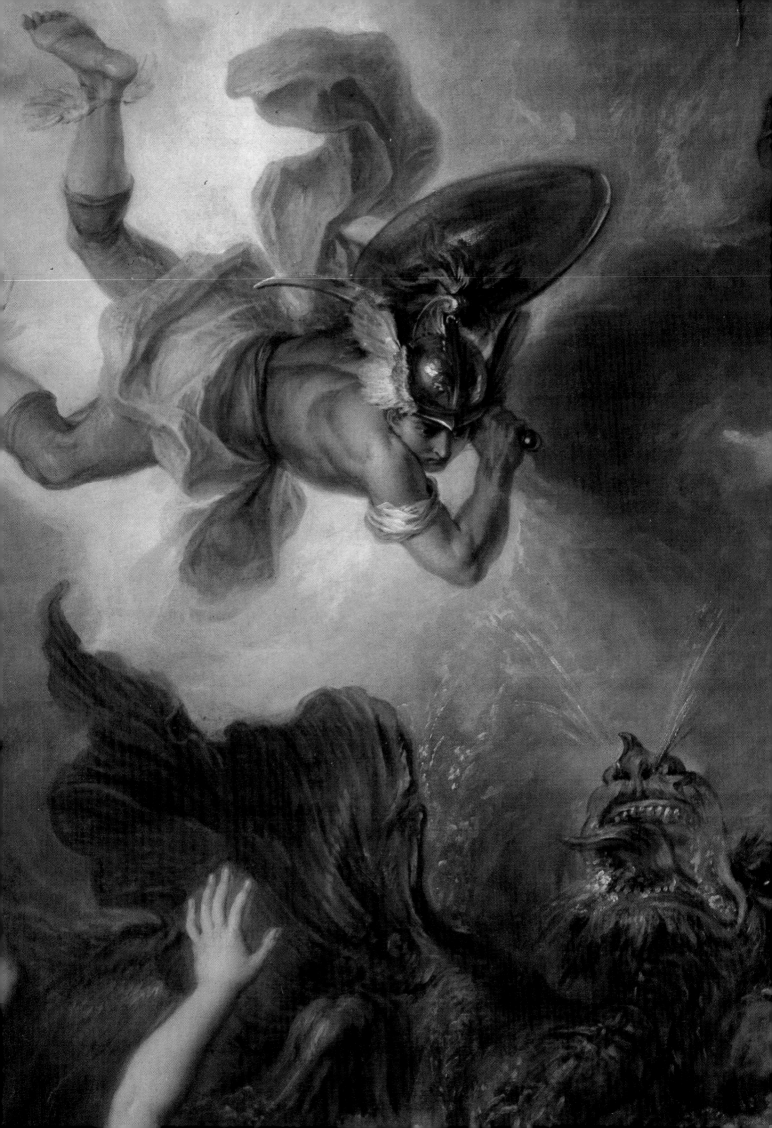

CHARLES-ANTOINE COYPEL
(1694–1752)

Son and grandson of prominent academicians, Charles-Antoine Coypel was trained by his father, Antoine Coypel, and during his early career benefited from the latter's experience, wealth, and connections. At Antoine's encouragement, he copied drawings after the Carracci and Raphael, examined works in the Orléans collection at the Palais-Royal—Antoine was *premier peintre* to the Orléans family—and studied at the Academy, where he won prizes for life drawing in October 1705 and April 1707. Considered something of a prodigy by his contemporaries, Coypel completed his first painting, *The Fortune Teller* (location unknown), in 1704 and a self-portrait in 1709 (location unknown, print by N. Tardieu).

In view of such precocity, it came as little surprise that Coypel was made an associate and full member of the Academy on 13 August 1715 upon submission of *Jason and Medea* (Berlin, Schloss Charlottenburg, Staatliche Schlösser und Gärten), a painting he withdrew in 1746, thirty years later, and replaced with *The Sacrifice of Abraham* (location unknown). At the same time, Coypel received his first major commission, a tapestry series for the Gobelins depicting episodes from the tale of Don Quixote. He would be engaged on this celebrated series for the remainder of his life.

Upon his father's death in 1722, Coypel inherited much of his wealth and also received many of his most prestigious appointments, including that of *premier peintre* of the Orléans family and *directeur des dessins et tableaux du roi*. Financially secure, Coypel actively pursued a literary career as both playwright and theoretician. Adverse criticism, however, eventually led Coypel to abandon his theatrical career in 1732.

Coypel's experience in the theater influenced his paintings, which exhibit a desire to capture effectively a diverse range of emotional moods. For example, *Jupiter and Isse* (Versailles, Hôtel de Ville), painted in 1724 as part of the decoration of the bedroom of Louis-Henri, duc de Bourbon, at the *pavillon du Grand Maître* at Versailles, and *Perseus Freeing Andromeda* (cat. no. 32), his entry for the 1727 *concours*, employ dramatically posed figures to convey narrative through exaggerated gestures and expressions. However, it was Coypel's tapestry cartoons, such as the *Tenture des Fragments d'Opéra*, executed between 1733 and 1741 for Queen Marie Leczinska, that best revealed his efforts to unify these sister arts.

Although Coypel's commitment to this theatrical manner was not original—he was following the teachings of his father and the theories of Le Brun—no other artist of his generation attempted to implement these precepts with such literal-minded perseverance. Coypel also distinguished himself stylistically through an almost Flemish attention to detail and use of a brittle, silvery light to illuminate pearly flesh and create sharp contours. His paintings were so obviously constructed that Mariette was moved to comment that Coypel "was incapable of introducing either the unaffected or the natural into his art."

While Coypel was admitted into the Academy as a history painter, he also worked in other genres. As a sympathetic portraitist, his sitters included members of the royal family, associates from the theater, and relatives. He was also proficient at mildly satirical genre paintings such as *Children Playing at Their Toilette* (1728, Paris, Private Collection), which gently mocks adult vanity and manners. Coypel even took an interest in sculpture and the unification of the visual arts. When he painted *The Entombment* for the choir of the college church Saint-Nicolas-du-Louvre in 1734 (location unknown, print by F. Joullain), he also designed the accompanying sculptural elements.

Although Coypel did not need a protector and was able to devote much of his time to writing, he became the favorite painter of Queen Marie Leczinska, for whom he painted fifteen works over a period of twenty-five years. These consisted of decorations for her rooms at Versailles, most of which were religious or allegorical in subject matter. Among such unpromising commissions were *The Apotheosis of Monseigneur le duc d'Anjou*, painted in 1734 (lost), and *France Pleading for the Cure of Louis XV* (church of Clairvaux), painted in 1744 for the queen's *grand cabinet*.

Coypel's financial independence may have been responsible for his somewhat turbulent relationship with the Academy, and he abstained from attending sessions at the Academy between 1715 and 1725 and again from 1737 to 1747. His friendship with Charles Le Normant de Tournehem, *directeur général des Bâtiments*, and subsequent appointment as *premier peintre du roi* in January 1747, however, led to Coypel's election as director of the Academy in June 1747. From this point on, Coypel acted as a liaison between the Academy and the *Bâtiments*. In his new position, Coypel was also able to institute academic reforms, including the foundation of the *École royale des élèves protégés*.

Coypel painted very little after 1747, confining his work to commissions from the royal family. His late works reveal a softer, warmer style with a subdued palette, more fluid handling, and lighter tonality, yet his death in 1752 signaled the passing of the most outspoken supporter of the grand manner.

CHARLES-ANTOINE COYPEL
Perseus Freeing Andromeda

32

CHARLES-ANTOINE COYPEL (1694–1752)
Perseus Freeing Andromeda, c. 1726–27
Oil on canvas
131 x 196 cm.
Musée du Louvre, Paris

PROVENANCE
Purchased by the Crown for 2,000 *livres* on 30 August 1727 after the *concours de 1727*; located in the *cabinet des tableaux du roi* at Versailles by 1732 until around 1760.

EXHIBITIONS
Paris, *concours de 1727*, "à la deuxième croisée," 2; Copenhagen 1935, no. 37; Paris 1960, no. 581; Toledo, Chicago, and Ottawa 1975–76, no. 20, ill.; Stockholm 1983, 174, ill.

BIBLIOGRAPHY
Anonymous 1727, 2; *Mercure de France*, July 1727, 1564–65, August 1727, 1847–48; Mariette 1851–60, II, 29; Sensier 1865, 226; Montaiglon 1875–92, V, 28; Both de Tauzia 1878, no. 745; Mantz 1880, 22–23; Lafenestre and Richtenberger 1893, no. 180; Engerand 1896, 300–301; Engerand 1901, 126–27; Benois 1910, 110; Brière 1913, 34–35; Ingersoll-Smouse 1920, 150, ill.; Michel 1925, 144, ill.; Réau 1925, I, 36, ill.; Schneider 1926, 59–60, ill.; Dimier 1928–30, I, 73–74; Gillet 1929, 26; Jamieson 1930, 9, 68–69; Grappe, Huyghe, and Boucher 1935, 237, ill.; Hourticq 1939, 51, ill.; Dorival 1942, II, 21; Hautecoeur 1959, 570; Thuillier and Châtelet 1964, 186; Kalnein and Levey 1972, 28, 31; Rosenberg 1977, 30–31, 40–41, ill.; Conisbee 1981, 78–80, ill.; Lefrançois 1983, no. 72, ill.; Bordeaux 1984 (A), 42, 109, ill.; Sani 1985, II, 769; exh. Paris 1990, 81–83, ill.

The success that greeted *Perseus Freeing Andromeda*, Charles-Antoine Coypel's histrionic entry for the *concours de 1727*, seems to have affirmed the thirty-three-year-old academician's sense of artistic purpose. On the duc d'Antin's orders, Louis de Boullongne retained the painting for the Royal Collection after the competition ended;[1] three weeks later, on 20 July 1727, it was presented to Louis XV at Versailles with Lemoyne and de Troy's prizewinning entries;[2] Charles-Antoine received payment of 2,000 *livres* on 30 August 1727;[3] and Nicolas Tardieu's engraving of the work was announced in the *Mercure de France* that same month.[4] Such an enthusiastic reception served to dispel any doubts Coypel may have entertained about the status of his art. In his *Dialogue sur la connoissance de la peinture*, read at the Academy on 6 July 1726, two months after the *concours* was first announced, he had railed against the connoisseurs' disdain for "the works of our time" and their prejudice in favor of the old masters, "which are falling into ruin."[5] Coypel's victory in the public arena may also have inspired a celebrated drawing, *Painting Ejecting Thalia from the Cabinet of Monsieur Coypel* (fig. 1), executed on 14 December 1727, in which the artist, a prolific but undistinguished playwright, confidently restated his allegiance to the art which had brought fame to his dynasty.[6]

The most succinct description of *Perseus Freeing Andromeda* appeared in the little pamphlet printed on 15 May 1727 to coincide with the opening of the competition: "Perseus, as he returned from having cut off Medusa's head, caught sight of Andromeda, daughter of Cepheus, chained to a rock to atone for the crime of her mother, Cassiope, who had claimed to be more beautiful than the nereids. Perseus fights the sea monster who has been sent to devour the maiden, kills him, and marries Andromeda."[7]

This much-illustrated myth, dramatically recounted in Ovid's *Metamorphoses* but told also by Apollodorus and Hyginus—it was to the latter's sixty-fourth fable that the *Mercure de France* alluded[8]—provided Coypel with the subject of his *chef d'oeuvre*. Under a stormy sky darkened by thunder and lightning,

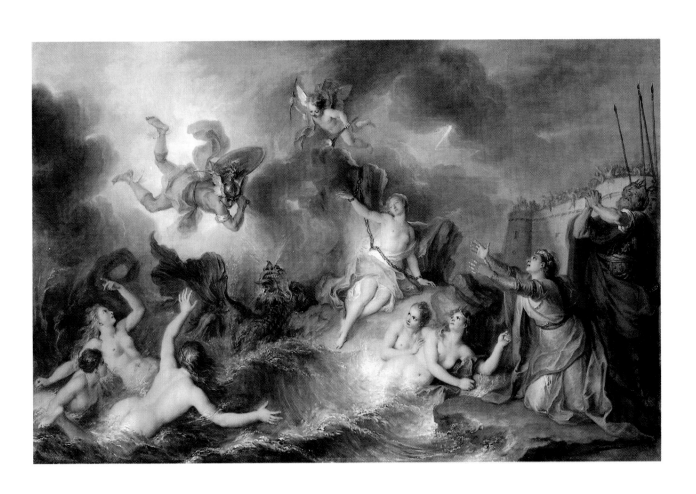

Perseus, the son of Jupiter and Danae, "flying on Mercury's winged sandals," plunges headlong through the "empty air" and attacks the monster with the hooked sword Minerva had given him for use against the Gorgon Medusa.[9] Andromeda, chained to a rock in the center of the composition, "the warm tears trickling down her cheek," is on the point of losing consciousness.[10] At right, Cepheus and Cassiope, King and Queen of Ethiopia—"the grieving father and the mother . . . both wretched, but she more justly so"[11]—urge Perseus to victory, as do their subjects, who have gathered on the battlements of a castle in the distance. Five nereids—the beautiful, long-haired sea deities offended by Cassiope's outburst—witness Perseus's unexpected arrival with undisguised fury. The monster himself, his "greedy fangs" wide open, has already been wounded and "belches forth water mixed with purple blood."[12] Finally, the happy aftermath of this encounter is alluded to by the untroubled figure of Cupid—his bow in one hand, a hymeneal torch in the other—who presides at equal distance over Perseus and Andromeda.

Executed in an ambitious, impassioned, and strident manner, *Perseus Freeing Andromeda* seems to have been painted quickly and with relatively few changes of mind. Louis Surugue's engraving, published in 1732, recorded that the work was executed in 1726, presumably in the latter part of the year, since the *concours* was announced in May.[13] A finished design for the composition in gouache appeared in the collection of Philippe Coypel, the artist's brother, and this, rather than the painting itself, may have served for Surugue's engraving.[14] And, although Mariette reproached Coypel for failing to draw from life, it is possible that the artist made figure studies for the various protagonists in *Perseus Freeing Andromeda*, since this was standard practice for the history painter. Such drawings, however, remain to be identified.[15]

Muted in color—the silvery gray and brown tonality is punctuated only by the nacreous flesh tones of the nereids and the cold hues of Cassiope and Cepheus's draperies—*Perseus Freeing Andromeda* is impeccably crafted; the figures, draperies, and landscape are executed with a care and finish that are unexpected from an artist whose work in the grand manner had heretofore been confined to tapestry cartoons. Details such as the glint of Perseus's helmet, the light reflecting from the hilt of his sword, the foam of the enormous waves in the foreground, and the pearls entwined in the nereids' hair are of a refinement that Coypel would achieve again only in cabinet paintings of much smaller scale. His drawing is assured, if mannered. The nereids, of Rubensian proportions, betray too readily their origins as academic studies; their exaggerated expressions derive directly from the pedagogic manuals that had circulated since the Academy's foundation.[16] Yet Coypel's canvas is a worthy testimony to that institution's values, and if it is no surprise that the administration was eager to encourage such unquestioning orthodoxy, it is worth noting that Pierre Crozat, an altogether more objective observer, praised Coypel as "a young man who is extremely intelligent and who takes enormous pains and infinite trouble in the search for his art."[17]

Coypel's "enormous pains and infinite trouble" are not immediately apparent to modern eyes; even the most sympathetic commentators have found the theatricality of his compositions unpalatable or, at worst, repellent.[18] Such a charge was leveled at the artist in his own day by no less a connoisseur than Mariette, who was both a good friend and a genuine admirer of Coypel's art. Claiming that Coypel's literary and artistic production suffered equally from exaggeration, Mariette noted perceptively that he had

> inherited this fault from his father, who himself had exaggerated the expressions of his figures. The son went one better and turned to the theater as a model for both gestures and expressions. There, even in the performances of the finest actors, he found only grimaces, forced attitudes, and expressions so artificial that true feeling played no part. It thus came to pass that our painter was incapable of introducing either the unaffected or the natural into his art.[19]

Mariette's indictment of excessive theatricality could readily be applied to *Perseus Freeing Andromeda*. After all, Coypel was already a playwright of some renown, and the theater had already furnished him with subjects for his mythological paintings.[20] He was engaged at this time in illustrating Riccoboni's *Histoire du Théâtre Italien*,[21] and he owned several miniature theaters whose purpose, Mariette explained, was to provide the backgrounds and light effects for his paintings.[22] Coypel may have even appeared on the stage. Rosalba Carriera, Crozat's guest in Paris, noted in her diary on 14 January 1721: "attended an opera by Coypel *fils*, whom I also heard sing."[23] Given that *Persée*, Quinault and Lully's extremely popular *tragédie lyrique*, was performed again in Paris in 1722 and 1723, the case for the theater as a potent influence on Coypel's entry to the *concours de 1727* seems incontrovertible.[24]

Without denying the strength of the bonds that tied Coypel to the theater, the relationship between history painting and the stage was rarely as transparent as

these arguments would imply.[25] Coypel's *Perseus Freeing Andromeda* does not faithfully reproduce Quinault and Lully's staging of the deliverance of Andromeda, in which tritons join the nereids to berate Perseus for interfering with divine justice ("*Téméraire Persée . . . respectez la vengeance divine*").[26] In fact, it is more fruitful to consider the competition piece in light of academic pedagogy, albeit of a slightly old-fashioned kind. From this it emerges that the painting's debt to both art theory and to the art of the past is of greater importance than its obvious, if unspecific, kinship with the theater.

First, it should be remembered that the theater had long been recommended as a source of instruction for aspiring academicians. Antoine Coypel had encouraged history painters to study gesture, posture, and attitude there, since, for the artist, such devices had to replace the spoken word in communicating narrative.[27] The abbé Dubos, in advocating greater authenticity in the representation of the passions, also urged the artist to consider the theater as a useful repository.[28] Moreover, the painter's difficulties in conveying sequential narrative had preoccupied writers on art since Félibien, and the care with which Charles-Antoine Coypel indicated the various stages of the myth of Andromeda—from the nereids' jealousy at the origins of the event to Perseus's victory and subsequent marriage, the happy conclusion—suggests that he had taken to heart Le Brun's well-known reading of Poussin's *Gathering of the Manna*.[29]

Not only did Coypel follow theoretical injunction to the letter in *Perseus Freeing Andromeda*, he also attempted to combine two distinct iconographic traditions in his treatment of the subject. As Jean-Claude Boyer has pertinently remarked, the story of Andromeda provided artists with an excellent opportunity to treat the female nude, even though Ovid had not described the heroic maiden as naked.[30] At its most exalted, this tradition, exemplified by Titian's *Perseus and Andromeda* (London, Wallace Collection)—a painting Coypel would have known both in the original and from a seventeenth-century copy—led to "an almost complete effacement of the story."[31] Alternatively, the artist could favor erudition—"a care for archeological precision"—in which the various details of the story were meticulously recorded, as in the celebrated mural decoration at the Farnese Gallery.[32] If Coypel seized the opportunity to display learning, he was not insensitive to the erotic potential of the myth; his Andromeda, while diminutive, is compensated for by a bevy of fleshy nereids, yet the accumulation of these naked forms, seen from all angles, has none of the power of Lemoyne's more concentrated painting of the same subject (fig. 2), executed three years earlier.[33]

It is Coypel's dependence on both literary and artistic sources—the distinctive armory of the history painter—that lies at the heart of *Perseus Freeing Andromeda* and is consistent with his wish to see modern painting, bright and highly colored, accorded the veneration routinely given to old masters. Unrepentantly eclectic in his dependence on the art of the past, Coypel was the exemplary academician, but the literalness with which he followed his sources was already a quarter of a century out of date. As was first pointed out by Florence Ingersoll-Smouse, Coypel took his composition from the famous overdoor in the Farnese Gallery, executed in 1604–5 by Annibale Carracci with the young Domenichino's assistance and disseminated throughout Europe in engravings by Carlo Cesio and Jacques Belly (fig. 3).[34] Although Coypel had not been to Italy, he was undoubtedly familiar with this celebrated composition, of which no less than two full-scale copies were to be found in Paris at the beginning of the eighteenth century.[35] By his own admission, Coypel had been brought up on the works of the Carracci.[36] Even if the scale of Annibale's commanding Andromeda is quite different from that of Coypel's heroine, and even though the figures of Cepheus and Cassiope are paraphrases and not copies of Domenichino's grieving couple, the relationship between the two works is undeniable. As a model, however, this Bolognese composition was considered conventional, if not *retardataire*, by 1726. Mignard had owned a drawing by Annibale Carracci for the figure of Andromeda and had based the heroine in his own *Perseus and Andromeda*, 1679 (Paris, Musée du Louvre) on the Farnese fresco; Antoine Coypel had copied Carracci's heroine in a pen and ink drawing, which his son may well have known.[37] Thus, Charles-Antoine's dependence on a source that had enjoyed canonical status with the artists of his father's and grandfather's generations fully betrayed his aesthetic conservatism.

Coypel was also sensitive to the Venetian masters who exerted such a profound influence on the work of his contemporaries, but whose impact on his own declamatory manner was more limited. The figure of Perseus recalls the flying warrior in Veronese's late mythology (fig. 4), housed at Meudon between 1700 and 1737, the source for Lemoyne's *Perseus and Andromeda* already cited.[38] If Coypel's nereids at lower left bear only a distant relationship to Rubens's intertwined sea deities in *The Disembarkation at Marseilles* (Paris, Musée du Louvre), part of the Medici cycle with which every artist of his generation was familiar, a more convincing model for the figure of Andromeda

is to be found in a source nearer home.[39] In scale and posture Coypel's princess is very close to Le Lorrain's exquisite bronze (fig. 5), executed around 1695–96, which Coypel may have studied in Crozat's collection.[40] Le Lorrain's figure had already provided the model for Jean-Baptiste Lemoyne's lost *morceau de réception* of 1710,[41] known today from an anonymous engraving, and Coypel's reliance on this sculpture may not have been entirely fortuitous since Ovid had likened the inert Andromeda to a marble statue.[42]

The range of models to which *Perseus Freeing Andromeda* is indebted reflects the care and deliberation with which Coypel elaborated his competition piece, a point which is easily lost in the habitual and generalized comparisons with the theater. Yet there is one last source that should be considered, for, more than any of the partial borrowings mentioned here, it draws attention to Coypel's principal objective in 1726–27, that of perpetuating the example of his father, both in theory and in practice. If King Cepheus at right bears a family resemblance to the patriarchs in Antoine's Old Testament subjects (one thinks, for example, of Haman in *The Fainting of Esther*, 1697, Paris, Musée du Louvre), the composition as a whole depends on the lost *Bellerophon Slaying the Chimera*, an ambitious history painting unfinished at the time of Antoine's death which had passed into Charles-

Antoine's possession.[43] This related subject seems to have provided Charles-Antoine with the model that enabled him to integrate harmoniously the various elements of his prolix *Perseus Freeing Andromeda*. Antoine Coypel's vigorous preparatory study in black and red chalks (fig. 6) gives the general configuration of the lost work. From this drawing it is clear that Coypel *fils* was indebted to his father not only for the pyramidal structure and tumultuous setting of his composition, but also for such elements as the large rock at center and the distinctive pose of the nereid seen from the back in the lower left corner.[44] Indeed, Antoine Coypel's painting may well have been understood at the time to have represented Perseus and Andromeda; Rosalba Carriera, visiting his studio on 9 November 1720, noted in her diary that she had seen a painting of Andromeda, which probably refers to the unfinished *Bellerophon Slaying the Chimera*.[45] No less than in his writings and in his commissions for the Gobelins manufactory, Charles-Antoine's first independent artistic statement paid homage to the artist whose example had touched every aspiring history painter reaching maturity in the first two decades of the eighteenth century. Ironically, this earnest and heartfelt vindication of his father's art served largely to proclaim its complete desuetude in the post-regency era.

NOTES

1. *Mercure de France*, July 1727, 1573; Montaiglon 1875–92, V, 28.

2. *Mercure de France*, August 1727, 1847.

3. A.N., O¹ 2226, fol. 197; Engerand 1901, 127.

4. *Mercure de France*, August 1727, 1848, "le tableau de l'Andromède de M. Charles Coypel paroîtra bientôt en estampe, gravée par M. Tardieu." An engraving after the painting did not appear until 1732.

5. Coypel 1732, 24–25, "ceux qui menacent ruine"; for Coypel's lecture, Montaiglon 1875–92, V, 12.

6. Zafran 1980, 280–81, where the author speculates that the drawing was "possibly occasioned by thoughts on the death of his respected father," which had occurred some five years earlier.

7. Anonymous 1727, 2, "Persée revenant de couper la tête à Méduse, apperçut Andromède, fille de Cephée, attachée à un rocher, pour expier la ruine de sa mère Cassiope, qui s'étoit vantée de passer en beauté les naïades [*sic*]. Il combat le Monstre qui venoit pour la dévorer, le tue et épouse Andromède."

8. *Mercure de France*, July 1727, 1564–65, "Hipgin [*sic*], ch. 64."

9. Hyginus, *Fabulae*, 64; Ovid, *Metamorphoses*, IV, 718–20.

10. Ovid, *Metamorphoses*, IV, 674–75.

11. Ibid., 691–92.

12. Ibid., 727–28.

13. Wildenstein 1964, 268.

14. *Catalogue de tableaux, dessins, estampes, bronzes . . . provenant de la succession de feu* M. *Coypel, Ecuyer*, Paris, 11 June 1777, 7, in which drawings for both *Perseus Freeing Andromeda* and *The Sacrifice of Iphigenia* are recorded, and it is noted "le premier a été gravé par Surugue."

15. Mariette 1851–60, II, 31, "il n'avoit pas assez connu la nécessité d'étudier d'après nature." For Coypel's studies for *Achilles Pursuing the Trojans into the River Scamandros*, 1737 (Leningrad, The Hermitage), and *Allegory of Painting Appearing to a Winged Youth*, c. 1730 (Texas, Private Collection), Bean 1986, 80–82.

16. For example, Testelin 1696, the plates of expressive heads in the manner of Le Brun at the back of this volume.

17. Sani 1985, II, 481, "Ce jeune homme qui est plein d'esprit se donne des soins et des peines infinies en faveur de la peinture."

18. Rosenberg in exh. Toledo, Chicago, and Ottawa 1975–76, 30; Rosenberg 1977, 40, and Conisbee 1981, 78–80, for the most sensitive appraisals.

19. Mariette 1851–60, II, 31, "il le tenoit de son père, qui lui-même avoit outré les caractères qu'il avoit jugé à propos de donner à ses figures. Son fils renchérit sur lui; il alla chercher des modèles d'attitude et d'expression sur le théâtre, et il n'y trouva, même dans le jeu des meilleurs acteurs, que des grimaces, des attitudes forcées, des traits d'expression arrangés avec art et où les sentiments de l'âme n'ont jamais aucune part. Il en arriva que notre peintre ne put jamais mettre de naïveté ni de naturel dans ses tableaux."

20. Schnapper 1968 (C), 256, for *Rinaldo Abandoning Armida* (Paris, Private Collection), exhibited at the Salon of 1725 and inspired by Quinault and Lully's *Armide* (1686).

21. L. Riccoboni, *Histoire du théâtre italien, depuis la décadence de la comédie latine . . . avec des figures qui représentent leurs différens habillemens*, 2 vols., Paris 1730–31; the first volume was originally published in Paris by Pierre Delorme in 1728.

22. *Catalogue des tableaux, desseins, marbres, bronzes . . . du Cabinet de feu* M. *Coypel*, Paris 1753, 90–91; on Mariette's involvement, Dacier 1932, 61–72, 131–44 passim.

23. Sani 1985, II, 774, "sentito un'opera di Mr. Coypel il figlio ed ancora a cantare lo stesso."

24. Chouquet 1873, 320; Rosenberg in exh. Toledo, Chicago, and Ottawa 1975–76, 30, "the whole scene somehow resembles the final scene of a spectacular opera performance, with the sudden appearance of a winged Perseus falling from the sky."

25. Schnapper 1968 (C), 259–64, remains the best discussion of the issue, which will doubtless be developed in Thierry Lefrançois's forthcoming monograph on the artist.

26. *Recueil général* 1703, II, 351, Act IV, Scene VI of *Persée*.

27. Coypel in Jouin 1883, 348–49, in which he notes that painters and sculptors in antiquity "alloient toujours étudier dans les spectacles publics et y dessinoient les attitudes et les gestes qui représentoient le plus vivement les mouvements de la nature soit par les acteurs, les danseurs ou les pantomimes."

28. Dubos 1770, 197, "les peintres sont poètes, mais leur poésie ne consiste pas tant à inventer des chimères . . . qu'à bien imaginer quelles passions et quels sentiments l'on doit donner aux personnages . . . comme à trouver les expressions propres à rendre ces passions sensibles."

29. Puttfarken 1985, 1–8; Le Brun's lecture is reprinted in Jouin 1883, 41–48. The prominence of the nereids, whose wounded pride is to be assuaged by Andromeda's sacrifice, is also brought out in the verses accompanying Surugue's print, "Fuyez jalouses Nereides, etc."; Coypel's faithfulness to the narrative in this regard distinguishes *Perseus Freeing Andromeda* from all previous interpretations of the subject, including those in classical art, Phillips 1968, 1–23.

30. Boyer in exh. Paris 1990, 73–75.

31. Ibid., 81, "cet effacement à peu près complet du sujet." For Titian's *Perseus and Andromeda*, which seems to have exerted little influence on eighteenth-century French painters, Ingamells 1982, 397, and Bréjon de Lavergnée 1987, 249.

32. Boyer in exh. Paris 1990, 83, 97–99, for an excellent summary.

33. Ingamells 1989, 248–49.

34. Ingersoll-Smouse 1920, 150; Spear 1982, 134; Boyer in exh. Paris 1990, 98–99.

35. Boyer in exh. Paris 1990, 99, and bibliography there cited; Cotté in exh. Paris and Milan 1988–89, 40–41; Thuillier 1988, 421–48, for a general survey of Carracci's influence on French art in the seventeenth and eighteenth centuries.

36. C.-A. Coypel in Lépicié 1752, 39, "son fils même [here he refers to himself] apprit à manier le crayon, en copiant sous ses yeux des ouvrages du Carrache . . ."

37. Boyer in exh. Paris 1990, 100; Garnier 1989, 236, where the relationship to Carracci's *Andromeda* is not mentioned.

38. Engerand 1899, 89–90; Ingamells 1989, 248–49; Boyer in exh. Paris 1990, 74–75, in which Natoire's copy of the painting is also catalogued.

39. Schneider 1926, 59, was the first author to point to this connection. He was followed by Gillet 1929, 26, and Rosenberg in exh. Toledo, Chicago, and Ottawa 1975–76, 30.

40. Beaulieu 1982, 115.

41. Beaulieu 1979, 291–92.

42. Ovid, *Metamorphoses*, IV, 675.

43. Garnier 1989, 180; *Catalogue des tableaux, desseins . . .* (as in n. 22), 25, no. 106, "Trois tableaux en désordre . . . et un très-grand tableau représentant Bellérophon combattant la Chimère."

44. Garnier 1989, 233, no. 548.

45. Sani 1985, II, 769, "vidi con le sorelle e cognato l'Andromeda del sopradetto Co[ypel]."

FIG. 1
Charles-Antoine Coypel, *Painting Ejecting Thalia from the Cabinet of Monsieur Coypel*, 1727, gouache drawing, Paris, Bibliothèque Nationale

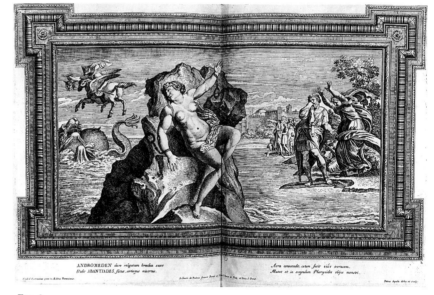

FIG. 3
After Annibale Carracci and Domenichino, *Perseus and Andromeda*, 1641, engraved by Jacques Belly, Paris, Bibliothèque Nationale, Cabinet des Estampes

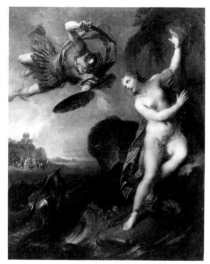

FIG. 2
François Lemoyne, *Perseus and Andromeda*, 1723, oil on canvas, London, Wallace Collection

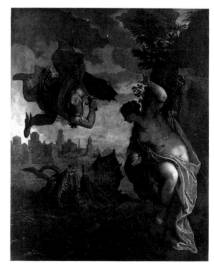

FIG. 4
Paolo Veronese, *Perseus and Andromeda*, 1584, oil on canvas, Rennes, Musée des Beaux-Arts

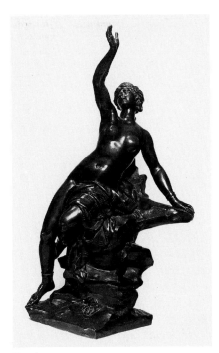

FIG. 5
Robert Le Lorrain, *Perseus and Andromeda*,
c. 1695–96, bronze, Paris, Musée du Louvre

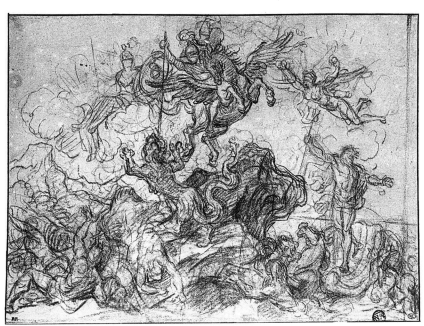

FIG. 6
Antoine Coypel, *Bellerophon Slaying the Chimera*, c. 1720, black and red chalk drawing, Paris,
Musée du Louvre, Cabinet des Dessins

CHARLES-ANTOINE COYPEL
Hercules and Omphale

33

CHARLES-ANTOINE COYPEL (1694–1752)
Hercules and Omphale, 1731
Oil on canvas
180 x 133 cm.
Bayerische Staatsgemäldesammlungen, Alte Pinakothek, Munich

PROVENANCE
Acquired by Paul-Hippolyte de Beauvillier, duc de Saint-Aignan (1684–1776), and inventoried in his estate by Jean-Baptiste-Pierre Lebrun, 6–7 February 1776 (A.N., *Minutier Central*, LI, 1117); Saint-Aignan sale, Paris, 17 June 1776, no. 37, purchased by Lebrun for 250 *livres*; acquired by Herzog Carl II August von Zweibrüken-Birkenfeld (1746–1795) from Johann Christian von Mannlich (1741–1822) in 1778; collection transferred to Kaiserslautern in 1793, then to Mannheim by 1799, and finally to the Churpfalzbaierische Gemälde-Sammlungen in 1805; located in the Hofgartengalerie from 1805 until 1836; Schloss Schleissheim until 1925, when it entered the Alte Pinakothek.

EXHIBITIONS
Straubing 1952, 15.

BIBLIOGRAPHY
Mannlich 1805–10, I, 123–24, II, 40, no. 191; Munich 1818, no. 191; Munich 1822, no. 89; Munich 1825, no. 79; Thienesonn 1825, no. 88; Schottky 1833, 78; Munich 1850, no. 915; Parthey 1863, 302, no. 3; Munich 1870, no. 625; Teichlein 1875, no. 1083; Bayersdorfer 1885, no. 1202; Bever 1905, no. 753; Bassermann-Jordan 1910, no. 753; Van Oertzen 1924, 42; Munich 1928, 30; Dimier 1928–30, I, 131, no. 42 [as Antoine Coypel]; Munich 1936, no. 1168; Dube 1969, 283, ill.; Le Moël and Rosenberg 1969, 57, 61; Lefrançois 1983, no. 126, ill.; Munich 1983, no. 1168, ill.; Bordeaux 1984 (A), 37, 95, ill.

"Hercules lying at Omphale's feet. Omphale rests her right hand on Hercules's club, and her left on Cupid's shoulder. A second amor is occupied in dressing Hercules, who is sewing."[1] Jean-Baptiste-Pierre Lebrun's concise description of Coypel's stately *Hercules and Omphale* is of interest for two reasons: the painting is rarely cited again by French authors, and German commentators of the eighteenth and nineteenth centuries proved singularly insensitive to this well-mannered, but unorthodox, interpretation of a much-treated theme. For Johann Christian von Mannlich (1741–1822)—the future general-direktor of the Bavarian Picture Gallery who, in all likelihood, acquired the work from Lebrun himself for Herzog Carl II August's collection—the real subject of Coypel's mythology was Louis XV and Madame de Pompadour, even though the *maîtresse en titre* was no more than ten years old at the time *Hercules and Omphale* was painted.[2] Writing some thirty years later, Julius Schottky described the work as representing Hercules and Omphale "in the guise of Louis XV and the Pompadour . . . the *non plus ultra* of tasteless French *galanterie* in spirit and execution."[3] Finally, although the painting is clearly signed and dated "C. Coypel, 1731" on the first step of the podium leading to Omphale's throne, no less a scholar than Louis Dimier published *Hercules and Omphale* as by Antoine Coypel.[4]

Charles-Antoine's interpretation is an idiosyncratic but elevated treatment of a subject that exerted a particular appeal on history painters of the *Académie royale de Peinture et de Sculpture* in the first decade of Louis XV's personal reign. Enthroned on a podium and practically enveloped by swags of gray green velvet, Omphale, queen of Lydia, wears the pelt of the Nemean lion like a cloak—the animal's head itself rests on her right thigh—and holds erect Hercules's massive club as she looks imperiously on the supine and hopelessly infatuated god whose services she has purchased for one year. Hercules, here portrayed as a red-cheeked young man, wears a bracelet studded with jewels on his upper arm—a sign of his enslavement—and pulls yarn languidly from an oversize distaff, unable to avert his gaze from the beautiful queen.

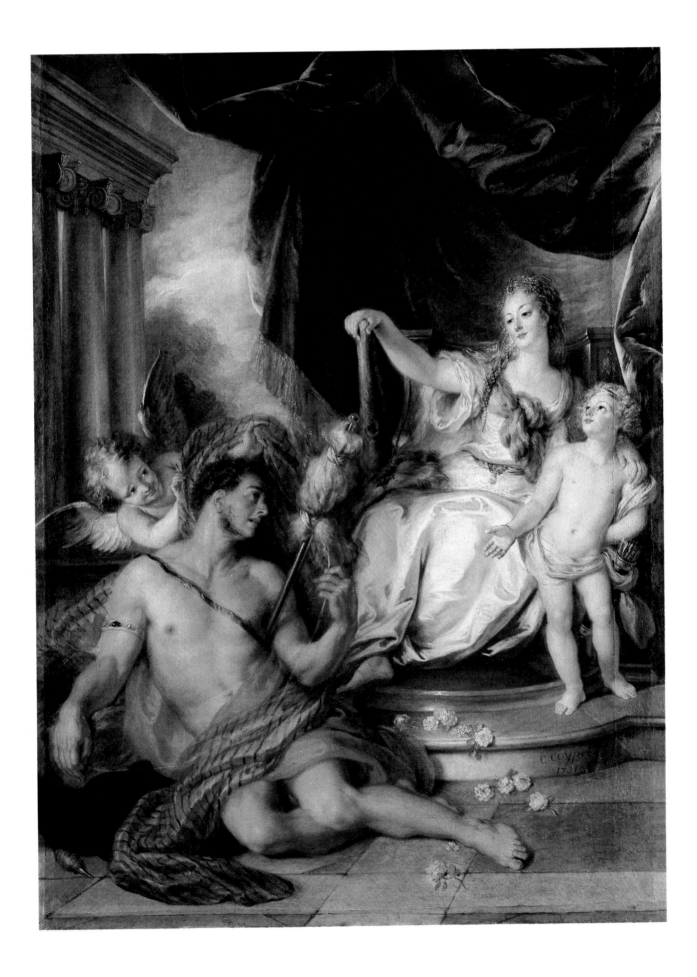

Although Omphale assumes the pose of a *"femme forte"* worthy of Pierre Lemoyne's gallery, Coypel's painting is almost completely bereft of the sexuality that made this subject so compelling to other artists of his generation; it was for good reason that Charles-Antoine was Marie Leczinska's preferred painter.[5] Fully draped and resplendent in robes of pure white, Omphale appears more matronly than seductive. In no earlier version of the subject is Hercules presented as an ephebe, and Coypel's portrayal of the god as a youth who is hardly able to support a full beard is willfully aberrant, flaunting tradition in a way that anticipates Boucher; Hercules is the unlikely ancestor of Boucher's boyish Mars in the Wallace Collection's *Mars and Venus* (fig. 1).[6] Yet Coypel's reasons for inverting the conventional presentation of Hercules are mysterious. He was certainly familiar with the appropriate manner in which to represent the god, even in such shameful guise; indeed, the massive *Hercules Farnese* was the single statue of antiquity venerated in the artist's pictorial testament, *Painting Ejecting Thalia* (fig. 2), painted within a year of *Hercules and Omphale*.[7] Nor did this radical break with a well-established iconography contribute in any way to the painting's eroticism; Coypel's *Hercules and Omphale* has little of the hothouse sensuality that pervades both Lemoyne and Boucher's famous examples (see cat. nos. 23 and 42). Instead, Coypel sought to bring a certain degree of decorousness and ingenuity to his interpretation of the myth, the very qualities that had distinguished his father's narrative painting.[8]

One piece of evidence that throws indirect light on Coypel's practice at the time he painted *Hercules and Omphale* is his *Discours sur la nécessité de recevoir des avis*, a lecture read at the Academy on 4 November 1730, which appeared in print at the beginning of 1732.[9] Although the text gives little insight into his working method and reiterates standard academic theory, it is possible to apply Coypel's priorities as articulated here to *Hercules and Omphale*. Of great interest is the parity given in this lecture to drawing and color; Coypel urges the artist to seek advice from partisans on both.[10] And, while Coypel's handling may strike us as dry and linear—*Hercules and Omphale* was executed only two years before Boucher's *fa presto* treatment of the subject—his painting of drapery and flesh is generally fluent and vigorous. For example, Cupid's body is enlivened with touches of pinks and yellows, and Hercules's muscular and ruddy torso is bound by a sash of cold blue in a juxtaposition of unexpected eloquence.

Of equal concern to Coypel is the "scrupulous observation" of costume, a precept he takes to heart in the elaboration of Omphale's lavishly ornamented crown, the pearls in her braided hair, and the ruby and pearl decorations at her waist.[11] But the central argument in Coypel's lecture is the need to learn from the work of others—the art of the past and the present—a fundamental topos of academic pedagogy. In reminiscing about his own career, Coypel recalls his debt to the portraitists of his father's generation, François de Troy, Largillière, and Rigaud, artists whose manner of painting could not be further from his own.[12] Yet in *Hercules and Omphale* Coypel incorporates a standard device from Baroque portraiture. The curtain that hangs, miraculously suspended, from the upper edge of the canvas and the landscape and architecture used as staffage in the background are elements that more properly belong in the work of Coypel's aforementioned mentors and that seem slightly discordant in this subject picture.

Coypel accorded a special place in his lecture to the work of "the gifted practitioners with whom we live" and encouraged artists to consult the work of their contemporaries.[13] Although he was familiar with Lemoyne's celebrated *Hercules and Omphale*, the prime version of which had been exhibited at the Salon of 1725, in which Coypel was also a participant, his painting has very little in common with this full-blooded interpretation and seems deliberately prudish by comparison. An even more recent example of the subject, Dumont Le Romain's faintly ridiculous *morceau de réception* (fig. 3), submitted to the Academy on 23 September 1728, is a painting that Coypel would also have known; his presence at that meeting is firmly documented.[14] Although it is unlikely that an academician of fifteen years' standing would seek inspiration in the work of a *débutant*—work in which numerous *gaucheries* in execution are apparent—Coypel's and Dumont's canvases do, in fact, share certain motifs: the presence of several cupids, the oversize *massue* precariously balanced, and the head of the Nemean lion "feeding" on the thigh of its owner.

Finally, Coypel's unusual interpretation may also have been indebted to examples from the past. In the *Discours sur la nécessité de recevoir des avis*, he repeated the need to consult the work of "the great masters who have preceded us," a dependency that Mariette considered an article of faith for Coypel: "they were his oracles; he turned to them at every stage."[15] Two seventeenth-century models would have been available to the artist: Vouet's *Hercules and Omphale* (location unknown), housed at the Palais du Luxembourg in Coypel's lifetime, a model with which, judging from Dorigny's engraving, Coypel's canvas has little in common;[16] and Rubens's splendidly irreverent, but profoundly learned, painting of the subject (fig. 4), which had entered the Orléans collection in 1721,

where it languished under an attribution to Thomas Willebiorts (1614–1654), a follower of the master.[17] Rubens's early masterpiece celebrates the carnality of the myth in a way that was abhorrent to Coypel, but it may have been the inspiration for the motif of Omphale enthroned, a literal and striking visual metaphor for the "woman on top."[18]

Coypel's unprecedented portrayal of Hercules as an adolescent may be the most extreme instance in the visual arts of a process that has been analyzed in some detail by literary historians, namely the "demystification and demythification characteristic of the Enlightenment." In losing his privileged status and being shown as a "victor overwhelmed by passion, no longer possessing either physical or moral superiority," Hercules was transformed into a "figure more romantic than epic."[19] Such a commentary provides an eloquent gloss on Coypel's languorous hero.

Iconographically unorthodox, *Hercules and Omphale* remains formally conventional and adheres to a format Coypel established early on for relatively small-scale history paintings. The composition in general recalls *The Fainting of Armida* (fig. 5), exhibited at the Salon of 1725, and the figure of Hercules repeats almost exactly the pose of the blond adolescent who symbolizes Genius in *Painting Inspired by Genius* (fig. 6), dated c. 1730, a work that remained in Coypel's possession during his lifetime.[20] Although *Hercules and Omphale* would appear at first glance to have little in common with Coypel's more grandiose narrative paintings—for example, the *Fragments d'Opéra* series painted for Marie Leczinska between 1733 and 1741, which placed unreasonable demands upon his talents as a history painter—it includes motifs that would be repeated in canvases of the 1730s and 1740s. The standing figure of blond Cupid reappears in *The Sleep of Rinaldo*, 1739–41 (Nantes, Musée des Beaux-Arts), and "theatrical" devices such as the parquet floor, curved platform, and flowers tossed at the hero's feet recur in *Joseph and Potiphar's Wife*, 1737 (location unknown) and *Cupid and Psyche*, 1748 (Lille, Musée des Beaux-Arts), to give but two examples.[21] Yet even on the relatively modest scale of *Hercules and Omphale*, Coypel's skills were placed under a certain amount of strain. The billowing curtains and flowing draperies are not without a certain heaviness, and, with the formulaic handling of Omphale's virginal dress, they confirm Papillon de La Ferté's criticism that "the execution of [Coypel's] draperies was not always felicitous; the folds are often heavy and they are rarely natural."[22] Furthermore, neither the ambitious foreshortening of Hercules's right arm nor the modeling of Omphale's outstretched hand is entirely successful; respectively, they are limp and

lacking in muscle. However, one fault of which the artist was regularly accused—the excessive adornment of his figures' faces—does not apply here.[23] Given Coypel's tendency to exaggeration, Hercules and Omphale gaze upon one another with sincere and understated passion.

Much about Coypel's *Hercules and Omphale* remains elusive: no drawings or preparatory studies are known; no single source, pictorial or literary, provides a clue to the unusual presentation of his *dramatis personae*; and the early history of the canvas is poorly documented.[24] The painting is first recorded as in the collection of Paul-Hippolyte de Beauvillier, duc de Saint-Aignan (1684–1776), the cultivated and blue-blooded French ambassador in Rome between 1732 and 1740, remembered today as Subleyras's most discriminating and enthusiastic patron.[25] Inventoried in Saint-Aignan's estate by Lebrun and sketched by Gabriel de Saint-Aubin in his copy of the sales catalogue (fig. 7), *Hercules and Omphale* must have seemed strikingly old-fashioned in the company of the other works by French artists in Saint-Aignan's collection.[26] For the most part, these had been acquired during his tenure as ambassador and included fine examples of the early work of Subleyras, above all, but also of Blanchet, Trémolières, Pierre, and Vernet, all of which had been painted in the same decade as Coypel's exercise in the grand manner.[27]

There is one reason to believe that Saint-Aignan may have acquired *Hercules and Omphale* from Coypel himself before he left Paris for Rome at the end of September 1731. Among the paintings he later commissioned from the *pensionnaires* in Rome, Pierre's *Aurora and Tithonus* is of exactly the same dimensions as Coypel's *Hercules and Omphale*: "*hauteur cinq pieds, largeur quatre pieds.*"[28] Pierre's painting itself is lost, but from Saint-Aubin's thumbnail sketch it would appear to respond to Coypel's *Hercules and Omphale*. The two paintings are linked thematically as well; both show mature heroines who indulge a taste for younger men, although here Pierre, unlike Coypel, was simply being faithful to Ovid's narration.[29] Is it possible that Saint-Aignan had the young history painter, of whose aspirations he was probably aware, execute a pendant to hang with his earliest acquisition of contemporary French painting? In Lebrun's catalogue there is no indication that these paintings were in any way related, but four months earlier, when called to the hôtel Sainte-Avoye to estimate Saint-Aignan's collection, the dealer had listed these paintings together; they appear as the first and second items in his appraisal.[30] Whether this was fortuitous, or whether Lebrun had recognized their unlikely

kinship but saw no reason to maintain the connection once the paintings appeared on the open market, is hard to say. That *Hercules and Omphale* may have been reduced in size to serve a decorative purpose— possibly to be inserted into paneling—can be advanced with greater certainty; a seam, some four inches from the edge of the painting, is visible along the vertical edge at the right.[31]

Neither Coypel's *Hercules and Omphale* nor Pierre's *Aurora and Tithonus* did well at the Saint-Aignan sale. While works by artists such as Vernet and Subleyras far exceeded Lebrun's estimations, Coypel's mythological painting was purchased by Lebrun for only 250 *livres*, little more than its appraised value.[32] *Hercules and Omphale* then entered the collection being formed for Herzog Carl II August von Zweibrüken-Birkenfeld (1746–1795), who succeeded to the title on the death of his uncle, Christian IV (1722–1775), an avid collector of French

painting and one of Boucher's keenest patrons in the 1760s.[33] Ironically, upon the death of Christian IV, the dowager duchess, in disposing of the paintings formerly housed in the gallery of Christian's *petit château*, had sold Coypel's *chef d'oeuvre*, *The Sacrifice of Iphigenia* (location unknown), painted in 1730 and given pride of place on the walls of Coypel's *cabinet* in *Painting Ejecting Thalia*.[34] While the collection formed by Christian IV's nephew included such masterpieces as Chardin's *Woman Cleaning Vegetables* and Boucher's *Blond Odalisque* (both Munich, Alte Pinakothek), Coypel's *Hercules and Omphale* must have appeared, even at the time, as something of a curiosity. One wonders if Mannlich, Boucher's former pupil and Carl II August's "eyes," was impelled to acquire the painting for reasons that had as much to do with the fanciful but mistaken identity of its protagonists as with the painting's considerable, though less immediately apparent, aesthetic qualities.

NOTES

1. *Catalogue d'une belle collection de tableaux originaux de bons maîtres . . . qui composent le cabinet de feu M. le duc de Saint-Aignan*, Paris, 17 June 1776, no. 37, "Hercule aux pieds d'Omphale, sa main droite appuyée sur la massue d'Hercule et la gauche sur l'Amour. Un autre Amour est occupé à parer Hercule qui file."

2. Mannlich 1805–10, II, 40, no. 191. Boucher's former pupil (see n. 33) had harsh words for such mythological painting: "Seitdem die Coypels, Le Moine und Boucher die erste Stelle in der Königlichen Akademie begleiteten, verlohr die französische Schule nach und nach ihre Grösse, Reinheit, Adel und Wahrheit," ibid., I, 123–24.

3. Schottky 1833, 78, "A. Coypel [sic] Herkules und Omphale, unter der Gestalt Ludwigs XV und der Pompadour, das *non plus ultra* abgeschmackter französischer Galanterie in Giest und Werk."

4. Dimier 1928–30, I, 131, no. 42.

5. Maclean 1977, 79–87, for Lemoyne's *Gallerie des femmes fortes*; for a provocative assessment of the changing iconography of Omphale, Scott 1988, 425, n. 377.

6. Ingamells 1989, 49–52.

7. Zafran 1980, 281, 287, n. 26, for the prevalence of this sculpture in paintings of artists in their studios.

8. Coypel in Lépicié 1752, II, 5–6, "la manière noble et délicate dont il exprimoit les passions de l'âme et sa scrupuleuse exactitude dans ce qui regarde le costume firent juger qu'il partegeoit son loisir entre la lecture et la bonne compagnie."

9. Montaiglon 1875–92, V, 79; Coypel 1732, 1–20; the censor's approval was given on 3 December 1731.

10. Coypel 1732, 2–3.

11. Ibid., 3, "l'homme d'érudition sera satisfait si le costume est scrupuleusement observé dans un tableau."

12. Ibid., 9–10.

13. Ibid., 6, "j'ajoute ici que nous devrions faire la même chose à la vue de ceux des habiles gens avec qui nous vivons."

14. Montaiglon 1875–92, V, 47–48; Dumont Le Romain's *Hercules and Omphale* is catalogued in Lossky 1962, no. 35.

15. Coypel 1732, 6, "J'ai dit ailleurs, que c'étoit dans l'idée de critiquer nos propres ouvrages, qu'il falloit consulter ceux des grands maîtres qui nous ont précédez"; Mariette 1851–60, II, 35, "c'étoient là ses oracles; il les consultoit à chaque instant."

16. Engerand 1899, 296–97; Thuillier in exh. Paris 1990–91, 111.

17. Dubois de Saint-Gelais 1727, 457–58; for two excellent articles on this painting, Huemer 1979, 562–74, and Foucart 1985, 387–96. Coypel's familiarity with the Orléans collection was profound; he was the regent's godson and boasted of having instructed Louis, duc d'Orléans (1703–1752)—who mutilated Correggio's *Leda*—in the "connoissance de la peinture," Coypel 1732, 18.

18. Scott 1988, 425.

19. Tobin 1981, 90, "au XVIIIe siècle, Hercule, en tant que figure littéraire sérieuse, perd complètement son statut privilégié. Le mythe d'Hercule est emporté par le mouvement de démystification et donc de démythification qui caractérise le Siècle des Lumières."

20. *Catalogue des tableaux, desseins, marbres, bronzes . . . et autres Curiosités de Prix du Cabinet de feu* M. *Coypel*, Paris 1753, no. 110, "la peinture réveillant le Génie endormi"; the painting is reproduced and fully catalogued in Serre and Leegenhoek 1988, 51–53.

21. Schnapper 1968 (C), 255, 259.

22. Papillon de La Ferté 1776, II, 641, "le goût de ses draperies n'est pas aussi heureux: les plis en sont pesans, et l'imitation des étoffes est souvent peu fidele à la nature."

23. Ibid., 64, "on lui a reproché quelque fois d'avoir un peu trop fardé ses figures."

24. One source from the theater, La Motte's *Omphale*, first performed in November 1701 and again in Paris in March 1721 and January 1733, may be discounted; it is even more unorthodox in its interpretation of the myth than Coypel's painting, Chouquet 1873, 328.

25. Le Moël and Rosenberg 1969, 51–56.

26. A.N., *Minutier Central*, LI, 1117, "*Inventaire après décès*," 6–7 February 1776, cited in Le Moël and Rosenberg 1969, 54; Saint-Aubin's sketchbook, "tout plein de charmants croquis," is in the Bibliothèque de l'Institut, MS. *1874*, Le Moël and Rosenberg 1969, 60–61.

27. For Saint-Aignan's remarkable collection of works by Subleyras, see exh. Paris and Rome 1987, 71–73, 124, 155–57, 182–83, 186, 189, 211–13; Vernet's magnificent *Mediterranean Harbor Scene with a Fountain of Neptune*, signed and dated 1743, previously in his collection, recently appeared at auction, Sotheby's, London, 19 April 1989, no. 60.

28. *Catalogue d'une belle Collection . . .* (as in n. 1), no. 56, "Titon et l'Aurore . . . ce tableau, composé de cinq figures a été peint en Italie par ce célèbre Artiste, haut. 5 pieds, larg. 4 pieds."

29. Pierre would repeat the subject on a horizontal format for the *concours de 1747*, Locquin 1912, 6. This version is in the Musée de Poitiers.

30. Le Moël and Rosenberg 1969, 60, 63, citing the entries in Lebrun's inventory.

31. Exh. Straubing 1952, 15, where it is noted that the painting "war früher rings etwas verkleinert." The strip of one inch on the left of the composition, however, appears to be a later addition.

32. Le Moël and Rosenberg 1969, 60, 63. Both Coypel's and Pierre's paintings were estimated at 200 *livres*; *Hercules and Omphale* was purchased for 250 *livres* by Lebrun (according to the annotated sales catalogue in the Rijksbureau voor Kunsthistorische Documentatie, information kindly provided by Burton Frederiksen); *Aurora and Tithonus* fetched 300 *livres*.

33. Laing in exh. New York, Detroit, and Paris 1986–87, 258, 289, provides the clearest summary of this dynasty's collecting. Christian IV, "duc de Deux Ponts," had sent Mannlich to Paris in 1763 and introduced him to Boucher, in whose atelier he would study between 1765 and 1766, ibid., 41.

34. *Catalogue des Tableaux originaux des Grands Maîtres des Trois Écoles, qui ornoient un des Palais de feu son Altesse Monseigneur Christient, duc des Deux Ponts*, Paris, 6 April 1778, no. 68; Zafran 1980, 282, 287, n. 33.

FIG. 1
François Boucher, *Mars and Venus (detail)*,
c. 1754, oil on canvas, London, Wallace
Collection

FIG. 2
Charles-Antoine Coypel, *Painting Ejecting Thalia*, 1732, oil on canvas, Private Collection

FIG. 3
Jacques Dumont Le Romain, *Hercules and
Omphale*, 1728, oil on canvas, Tours, Musée
des Beaux-Arts

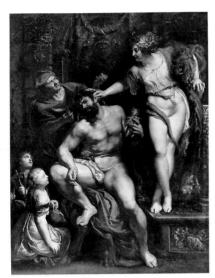

FIG. 4
Peter Paul Rubens, *Hercules and Omphale*,
1606, oil on canvas, Paris, Musée du Louvre

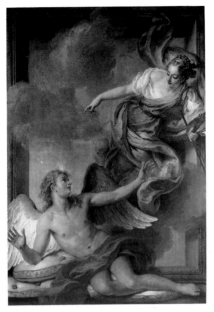

FIG. 6
Charles-Antoine Coypel, *Painting Inspired by
Genius*, c. 1730, oil on canvas, Texas, Private
Collection

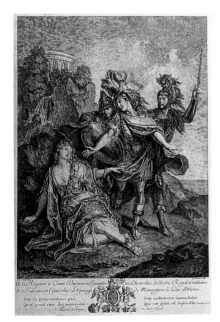

FIG. 5
After Charles-Antoine Coypel, *The Fainting of
Armida*, 1725, engraved by François Joullain,
Paris, Bibliothèque Nationale, Cabinet des
Estampes

FIG. 7
After Charles-Antoine Coypel, *Hercules and
Omphale*, drawing by Gabriel de Saint-Aubin
in his copy of the duc de Saint-Aignan's sale
catalogue, June 1776

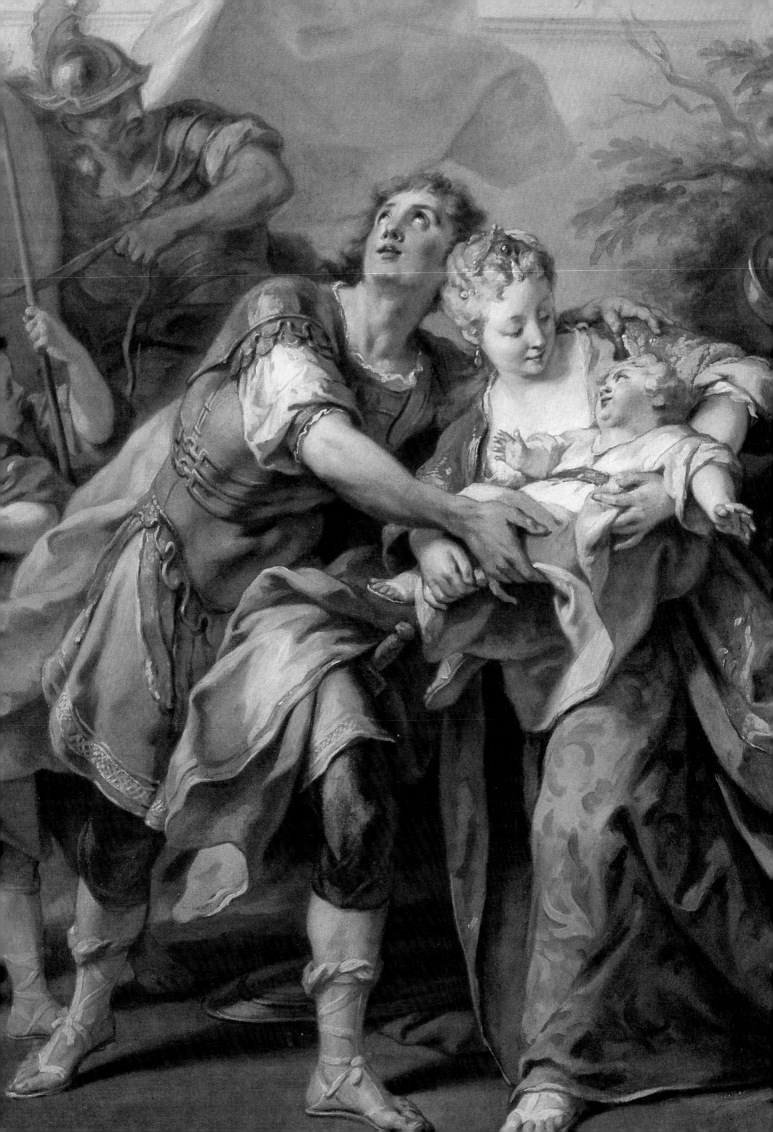

JEAN RESTOUT
(1692–1768)

Preeminent as a painter of large-scale religious works, Restout nonetheless developed a repertory of graceful, elongated figures, choreographed in a balletic manner, which reflected a renewed sensitivity to the grand manner. Restout's *oeuvre* thus represents yet another example of the stylistic diversity within the upper reaches of the Academy in mid-eighteenth-century France. Born in Rouen and orphaned at an early age, Restout was raised by his uncles, Jacques and Eustache Restout, both of whom were artists. Taken to Paris before 1707 to complete his apprenticeship in the studio of his already-famous maternal uncle, Jean Jouvenet, Restout soon became his most valued assistant and collaborator. Following Jouvenet's death in 1717, Restout even completed the New Testament tapestry cartoon series begun by his uncle in 1711 (e.g., *The Last Supper*, 1723, destroyed, and *Jesus Curing the Sick*, 1725, Lille, Musée des Beaux-Arts).

Jouvenet sponsored Restout's reception into the Academy, where he was admitted in May 1717 with *Venus and Vulcan* (Private Collection) and received as a full member in June 1720 with *Alpheus and Arethusa* (Rouen, Musée des Beaux-Arts). *Venus and Vulcan* reveals Restout's debt to Jouvenet's own *Venus and Vulcan*, exhibited at the Salon of 1704 (location unknown, print by L. Desplaces), and it was such excessive dependence on Jouvenet's style that compelled Mariette to remark, "Not only was he a follower of his [Jouvenet's] manner, one could say that he was almost a copyist."

Like his uncle, Restout established himself as a religious painter early in his career, producing *Ananias and Saint Paul* (Paris, Musée du Louvre) for the church of Saint-Germain-des-Prés in 1719. With the scarcity of royal commissions between 1710 and 1730, church decoration provided artists the rare opportunity to exhibit publicly before the institution of a regular Salon in 1737. The most prestigious of

Restout's religious commissions include *The Death of Saint Scholastica* for the convent of Bourgueil (1730, Tours, Musée des Beaux-Arts), *The Apotheosis of Saint Augustine* in fresco on the ceiling of the library of the abbey of Sainte-Geneviève (1730), two paintings on the life of Saint Vincent de Paul for the Maison de Saint-Lazare in 1732 (one lost, the other in Paris, church of Sainte-Marguerite), and *The Nativity* for the Cathedral of Saint-Louis in Versailles (1760–61, *in situ*). These compositions recall Jouvenet both in the use of crossing diagonals and carefully balanced figure groups and in the contemplative mood that they achieve. Yet Restout's figure types are more elongated than Jouvenet's, with piquant oval faces and beautifully tapered fingers, while his execution is more painterly and energetic.

It has been suggested that the austere realism of Restout's religious works and his illustrations for L.B. Carré de Montgeron's *La Vérité des miracles opérés à l'intercession de M. de Pâris* (1737)—a Jansenist rejection of the Papal Bull *Unigenitus* (1713)—as well as portraits of such Jansenist figures as the abbé Firmin Tournus (c. 1730, Vire, Musée des Beaux-Arts) and François de Pâris (location unknown) are evidence of Restout's Jansenist leanings. While Restout maintained his anonymity as illustrator of the de Montgeron text, the risk he took in participating in such a project suggests that he had a personal commitment to the movement. As Philip Conisbee has pointed out, however, Restout and others like him were professionals first and foremost and did not reject important commissions from non-Jansenist institutions. For example, Restout painted four works for the seminary chapel of the Jesuit church of Saint-Sulpice in 1744 (e.g., *The Birth of the Virgin*, Paris, church of Saint-Honoré-d'Eylau).

While Restout acquired fame painting large-scale religious works, he was also involved in a number of secular projects. Although he rarely received direct royal

patronage, he completed commissions from the *Bâtiments du roi*, including the Gobelins tapestry series of The Arts (e.g., *Apelles Painting the Portrait of Campaspe*, 1739, representing Painting, Lyons, Hôtel de la Préfecture, and *Pygmalion and Galatea*, 1745, representing Sculpture, Paris, Musée du Louvre), overdoors for Fontainebleau (location unknown), and two works for the *grand cabinet* of the apartments of the *Dauphine*, Marie-Josèphe de Saxe, at Versailles (*Psyche Fleeing from Venus's Anger* and *Psyche Seeking Venus's Pardon*, 1747, both Paris, Musée du Louvre). Restout also participated in the decoration of the hôtel de Soubise, where he contributed, among other works, *Phoebus and Boreas* for the *chambre de la princesse* in the *appartement des enfants du prince* and *Neptune and Minerva* for the *salle d'assemblée* preceding the *chambre de parade de la princesse* (both 1738, Paris, Archives Nationales). Restout's most prestigious secular commission, however, was for Frederick II, king of Prussia, for whom he painted *The Triumph of Bacchus and Ariadne* in 1757 (Potsdam-Sanssouci, Staatliche Schlösser und Gärten), one of a cycle of four mythological paintings in which Carle Van Loo, Jean-Baptiste-Marie Pierre, and Antoine Pesne also participated. Friedrich Melchior Grimm commented that Frederick considered Restout one of the three best French painters of the day.

Well respected by his contemporaries, Restout was one of only four artists to have participated in both *concours*; in 1727 he submitted *Hector Taking Leave of Andromache* (Private Collection) and in 1747, *Alexander Attended by His Doctor Philip* (Amiens, Musée des Beaux-Arts). Restout also rose steadily through the Academy's ranks, and by the time of his death in 1768 he had held the posts of chancellor as well as director. He died in the Louvre in lodgings he had been awarded in 1756 by the marquis de Marigny.

JEAN RESTOUT, *Hector Taking Leave of Andromache* (detail), 1728, oil on canvas, 128 x 194 cm, Mrs. Ruth Blumka, New York

JEAN RESTOUT
Hector Taking Leave of Andromache

34

JEAN RESTOUT (1692–1768)
Hector Taking Leave of Andromache, 1728
Oil on canvas
128 x 194 cm.
Mrs. Ruth Blumka, New York

PROVENANCE
Étienne-Michel Bouret (1709–1777); Charles-Alexandre de Calonne (1734–1802), his sale, Paris, 21–30 April 1788, no. 153, purchased back by Lebrun for 600 *livres* [with Restout's *Continence of Scipio*, no. 154]; Calonne's second sale, London, 23 March 1795, no. 43 [with Restout's *Continence of Scipio*, no. 44]; Vienna, Palais Reitzes; purchased by the present owner directly from the Baroness Reitzes in New York.

EXHIBITIONS
[1727 version]: Paris, *concours de 1727*, "à la troisième croisée," 2; probably in the *Salon de la Correspondance*, Paris 1783, no. 73. [1728 version]: Never before exhibited.

BIBLIOGRAPHY
Anonymous 1727, 2 [1727 version]; *Mercure de France*, July 1727, 1567 [1727 version]; Poinsinet de Sivry et al. 1767–82, IV, 59 [both versions]; *Galerie françoise* 1771, 5 [1727 version]; Papillon de La Ferté 1776, II, 634 [1727 version]; Pahin de La Blancherie 1783, 234 [1727 version]; Chennevières-Pointel 1847–62, III, 322 [1727 version]; Formigny de La Londe 1863, 56 [1727 version]; Guiffrey 1873 (A), lix, no. 6 [1727 version]; Mantz 1880, 22 [1727 version]; Engerand 1901, 423–24 [1727 version]; Dimier 1928–30, I, 74 [1727 version]; Brière 1931, 210; Messelet 1935–36, 114, 165, no. 141 [1727 version]; exh. Rouen 1970 (A), 209; Rosenberg 1977, 32, 39; O'Neill 1981, I, 122–23 [1727 version]; Rosenberg and Schnapper 1982–83, 50; Bordeaux 1984 (A), 42, 109 [1727 version]; Berlin 1985, 404; Siefert 1988, no. 162 [1727 version]; sale, Paris, Ader Picard Tajan, 5 December 1990, no. 73 [1727 version].

The most copied of the thirteen entries to the *concours de 1727*—and the only competition piece to be used in the decoration of pocket watches and snuff boxes—Restout's painterly *Hector Taking Leave of Andromache* was little acknowledged at the time.[1] Crozat, predicting Lemoyne's and Noël-Nicolas Coypel's victories, seems hardly to have heard of Restout at all: "I leave it to you to imagine the mortification of the artists who have entered the fray, of whom the principals are MM de Troy, Coypel, Tetou [*sic*], Galoche [*sic*] and Casses [*sic*]."[2] Yet Restout's treatment of a theme that had much engaged history painters of his uncle's generation—and would again those of his son's—was not only dramatic, colorful, and skillfully, if conventionally, ordered, it was also a most intelligent interpretation of the poignant episode that forms the climax to the sixth book of Homer's *Iliad*.[3]

In this epic account of the tenth year of the Trojan War, Hector is roused to leave the protective walls of Troy to do battle with the Greeks, who are slaughtering his people. Returning home to bid farewell to his wife, Andromache, and infant son, Astayanax, he is told that they are to be found by the great wall of Ilios, whither they have gone to watch the battle that is being waged outside. When they meet at the Scaean Gate, Andromache implores her husband to remain within: "This prowess of thine will be thy doom, neither has thou any pity for thine infant son nor hapless me that shall soon be thy widow."[4] Resolute in the performance of his duty, Hector moves to embrace the baby Astayanax, who, frightened by the crest of horse hair trailing from his father's helmet, shrinks back, crying, into his nurse's arms. The almost unbearable tension is broken by the child's fear, and Hector, laughing aloud, removes his helmet before holding his son in his arms. He is then seized with pity for his wife, "smiling through her tears," as he returns the baby to her and quickly takes his leave.[5]

The commentary on *Hector Taking Leave of Andromache* that appeared in the *livret* accompanying the exhibition was more concerned with Hector's

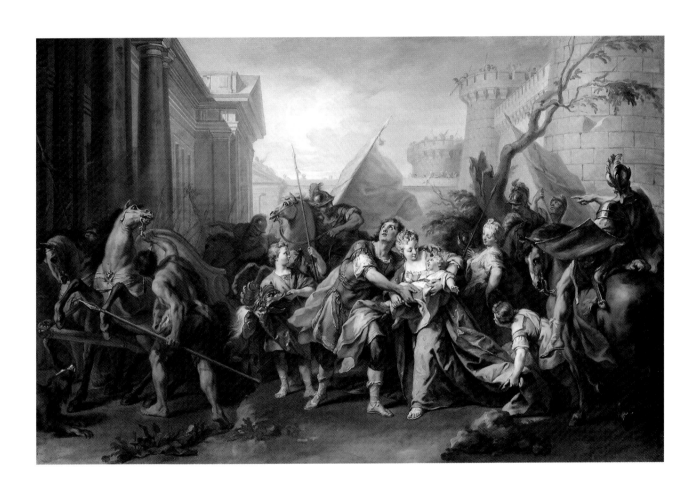

impending battle against Achilles than with Restout's delicacy in conveying the actual leave-taking.[6] The critic of the *Mercure de France* did much better, however, in identifying the "significant moment" that Restout had chosen to represent: "The baby, frightened by his father's arms, and above all by his plumed helmet, threw himself into his nurse's arms. At which, Hector removed his helmet, raised his son to the gods, and, after a short prayer, gave him back to Andromache, who held him with a smile mixed with tears."[7] It is the visor of the golden helmet held by the page to Hector's right—a dragon's head with its tongue sticking out—that so skillfully provides the key to the narrative. Although Restout also includes the tuft of horsehair indicated in the text, it is his invention of the anthropomorphic helmet that makes Astayanax's fright immediately comprehensible and gives the *denouement* of this tragic scene its blessed relief—hence, also, the kindly expression of the nursemaid and Andromache's solicitous, maternal expression. By contrast, Charles-Antoine Coypel's version of the same subject (fig. 1), signed and dated 1732, while remaining faithful to the details of Homer's account, is far less successful in communicating its pathos.[8]

As both Mary O'Neill and Nicole Garnier have pointed out, Restout based his competition piece on Antoine Coypel's *Hector Taking Leave of Andromache* (fig. 2), painted c. 1711 for the duc d'Orléans, repeated on a far larger scale in 1717–18 as a tapestry cartoon for the Gobelins, and engraved by Nicolas Tardieu.[9] Restout, in whom the regent had begun to show interest just before he died—a fact noted by all the artist's biographers—could have known Coypel's painting in any, or all, of these incarnations; he had taken over Jouvenet's commissions for the Gobelins after the latter's death in 1717.[10] Although Restout's *Hector Taking Leave of Andromache* is more fluent in handling and less strident in expression—and his sky blues, salmon pinks, and apple greens are colors that would have been foreign to the older painter—he has done little more than rearrange Coypel's composition. The classical architecture in the background, the pair of horses harnessed to Hector's chariot, the young page who carries the helmet—even the little dog—have all been shamelessly appropriated. Restout's most significant contributions to the subject—the infusion of greater energy and movement through the figures at far left and right who plunge into the composition and the more emphasized recessive perspective—are, in fact, devices he learned from his uncle and master, Jean Jouvenet, in whose studio he had trained for ten years.[11]

If Restout's vocabulary in *Hector Taking Leave of Andromache* is primarily that of Coypel, plagiarism of this sort was practically an article of faith for this artist, who regularly sought inspiration from the academicians of his uncle's generation and fully admitted as much. Mariette, who had little taste for Restout's paintings, called him a "copyist": one who, "however excellent he might be, and whatever modifications he brings to his art, can never be a great artist."[12] Yet looking back on his career, Restout did not hesitate to encourage students to copy from their masters in order to acquire "a method of working."[13] Not bound to a single model, as Mariette suggested, Restout recalled with some pleasure how, even after being admitted as a full member of the Academy, he continued to seek advice: "The necessity I have always felt of doing nothing without approval led me to consult these gentlemen on every painting I undertook."[14]

Nor was this mere rhetoric. If *Hector Taking Leave of Andromache* takes no pains to conceal its debt to Antoine Coypel, Restout's *Juno Visiting Aeolus* (Leningrad, The Hermitage), also executed in 1727, is a reprise of Louis de Boullongne's painting of the same subject, shown at the Salon of 1699 and engraved by Dupuis in 1718.[15] No artist of his generation was a more earnest apprentice than Jean Restout.

Yet *Hector Taking Leave of Andromache* is more than a mere pastiche. Restout takes academic methodology very seriously and seeks to implement the principles offered the aspiring history painter with an eagerness that occasionally borders on the simpleminded. Restout follows the exhortation to read "the good authors," who "ennoble the mind": "It is indispensable for the artist that he become thoroughly familiar with such things so that they can provide the seed of enthusiasm once he begins to compose."[16] His immersion in Homer's text is suggested by the motif of the young page holding the helmet, as well as by the contrast between Hector's glance heavenward and Andromache's affection for the infant, which represents the conflict between duty to the state and the bonds of family.

The history painter is also expected to display a knowledge of "the manners and customs of the Ancients, their feats, games, sacrifices, and funerals . . . their architecture, furnishings, weapons and defenses, their civil and military dress."[17] From Hector's chariot at left to the flags, standards, helmets, and battlements of the Trojan host, Restout fully demonstrates such "erudition." Moreover, not only is the painter's narrative and archaeological vocabulary codified, but the means by which he conveys expression

and psychology is also handed down to him. In his lecture, Restout points out that "M. Jouvenet taught me a principle, which he had learned from M. Le Brun, that the head of a figure must always face the same direction as his raised shoulder, and that his eyes must follow the same direction as the head."[18] This formula is precisely followed in *Hector Taking Leave of Andromache* (fig. 3).

Paradoxically, although Restout's sincere commitment to academic practice in the "*genre agréable*" did not guarantee official recognition, it seems to have prompted interest in the private sector; he was the only participant to repeat his competition entry to scale the following year. The primary version, shown at the *concours de 1727* (fig. 4)—signed and dated 1727 and discussed by all of Restout's eighteenth-century biographers—remained with the artist during his lifetime and was probably lent by his son, Jean-Bernard Restout (1732–1797), to Pahin de La Blancherie's *Salon de la Correspondance* in 1783.[20] It has only very recently reappeared at public auction.[21] The second version, exhibited here and published by Pierre Rosenberg in 1979 as "an autograph replica dating from the following year," has undergone a successful restoration.[22] Clearly signed and dated "1728" (fig. 5), it is almost identical to the *concours* painting, and the differences between the two canvases are very slight; they occur in the placing of rocks and foliage in the foreground, in the gnarled tree at right—more leafy in the replica—and in the figures on the first turret of the castle at upper right. However, Restout changed one detail at the last minute, it would seem, to distinguish between the primary and secondary versions. In the *concours* entry, the soldier on horseback at right, viewed from behind, carries an oval shield. Originally painted as such in the replica— its curved outlines are still visible to the naked eye —Restout modified the shape of the shield into an oblong.

It is not known why or for whom Restout painted the second version of *Hector Taking Leave of Andromache*. The painting is first recorded in the collection of Voltaire's "*belle âme*," Étienne-Michel Bouret (1709–1777)—*fermier général, directeur des postes, secrétaire du cabinet du roi*—whose extravagance would undo him towards the end of his life.[23] It was Bouret who, by 1757, had assembled eight of François Lemoyne's greatest mythological paintings for the decoration of his new *hôtel* on the rue Grange-Batelière. To complete this suite, Louis XV lent him Lemoyne's *Continence of Scipio* (Nancy, Musée des Beaux-Arts), promptly reclaiming it four years later when Bouret's financial difficulties were made known.[24] Although we do not know in which of

Bouret's several residences Restout's *Hector Taking Leave of Andromache* was seen, it is a pleasant notion that at some point, long before the present exhibition, two of the *concours* paintings were temporarily reunited.

By the time it entered Bouret's collection, however, *Hector Taking Leave of Andromache* was probably paired with the artist's own *Continence of Scipio* (fig. 6), painted the same year and of almost identical dimensions; both paintings are recorded as successive lots in the Calonne sale of 21–30 April 1788.[25] Lebrun, the dealer responsible for forming and dispersing Calonne's collection, noted that *The Continence of Scipio* "could serve as a pendant" to *Hector Taking Leave of Andromache*. Such hesitation was not simply conventional marketing—it was often more profitable, in the eighteenth century as today, to sell pendants separately—but, as has been noted, may allude to the less than obvious relationship between the two canvases.[26] Linked thematically—both stress the "importance of virtue and selfless heroism"[27]—the compositions are not unified pictorially. The pyramidal structure of *Hector Taking Leave of Andromache*, with its strong central axis, finds little resonance in *The Continence of Scipio*, where the emphasis falls on the figure of the African general and endows the composition with a dramatic imbalance. Yet the *concours de 1727* may have influenced Restout in another way; his *Continence of Scipio* is based on Lemoyne's prize-winning entry of the same subject. True to form, Restout had again "taken advice," but this time from an artist only four years his senior.[28]

There is good reason to believe that Restout's *Hector Taking Leave of Andromache* and *The Continence of Scipio* remained united for a while. In the catalogue of the Calonne sale in the library of The National Gallery, London, are to be found intriguing annotations in an elegant eighteenth-century hand that are probably those of the collector himself.[29] Next to Lebrun's careless entry for "*les Adieux d'Hector et d'Andromaque*"—the width of the painting is incorrectly given as "47 inches" (an inversion of 74), and the work is listed as having been engraved by Cochin (it was engraved by Levasseur and submitted by him to the Salon of 1769)[30]—appears the comment: "[the paintings] were given to me; withdraw them for use, as overdoors."[31] Calonne peppered his copy of the catalogue with similar instructions intended for Lebrun's use, since, by the time the sale took place, the former *contrôleur général* no longer lived in Paris. Stripped of office in April 1787, he had left France for London and would remain there until the outbreak of the Revolution.[32] Lebrun followed his orders by acquiring both works for 600 *livres*, and they would

reappear when the remnants of Calonne's collection were auctioned in London in March 1795. It is not known in which of his residences—St. James's or Wimbledon—Calonne had placed Restout's heroic paintings.[33]

Calonne's decision to use these pendants as overdoors fixes attention on the decorative quality of Restout's *Hector Taking Leave of Andromache*: its elegant coloring, sweetened expressions, and balletic poses. Ultimately unsuccessful in reconciling the grand manner with the more sensuous, painterly style that was gaining ground in the 1720s, Restout's competition piece has been described as marking the definitive closure of the age of Le Brun.[34] Another formulation is possible: the youthful work of an avatar of Jouvenet's, graced by the shadow of Pittoni.

NOTES

1. Apart from the two autograph versions discussed here, there is a full-scale copy in the Staatliche Galerie, Halle; a copy of the central group in the Musée des Beaux-Arts, Orléans (inv. 749a); and a copy sold in Paris, 18 March 1981, no. 113. The pocket watch, made by Veigneur Frères in Geneva, is illustrated in Jaquet and Chapuis 1945, plate XIV; the snuff box, which was sold at Sotheby's, London, 18 June 1979, is listed in Rosenberg and Schnapper 1982–83, 50. The decorations of the watch and snuff box are after Levasseur's engraving.

2. Sani 1985, II, 468, Crozat's letter to Rosalba Carriera, 15 May 1727, "Je vous laisse à penser de la mortification des autres qui sont entrés en lisse, dont les principaux sont Mss. De Troy, Coypel, Tetou, Galoche et Casses."

3. For the fullest treatment of Homeric themes in French painting of the eighteenth century, Siefert 1988, 113–21, 296–97; earlier versions of this subject, which fall outside Dr. Siefert's dissertation, include La Fosse's *Hector and Andromache*, painted for Leverrier and exhibited at the Salon of 1699 (last recorded as with Glen Trayer Scott Ltd., Toronto, in *Apollo*, October 1977, 8), and Bon Boullongne's *Hector and Andromache*, c. 1699 (Troyes, Musée des Beaux-Arts), engraved by Moyreau in 1726, thus another model available to Restout, Schnapper 1978, 129.

4. Homer, *The Iliad*, VI, 407–9. Three editions of Madame Dacier's translation were published between 1711 and 1719.

5. Ibid., 485–94.

6. Anonymous 1727, 2, "Hector, fils de Priam Roy de Troyes et Frère de Paris, allant au combat contre le vaillant Achilles, Capitaine Grec, dit adieu à Andromaque son épouse et à sa famille, recommandant son fils Astaniaque aux Dieux; Andromaque pleure prévoyant le malheur d'Hector qui y fut tué par Achilles."

7. *Mercure de France*, July 1727, 1567, "mais cet enfant éfraïé des armes de son père, et surtout du panache de son Casque, se jetta entre les bras de sa nourrice: ce que voyant Hector, il ôta son Casque, prit son fils, l'éleva vers le Ciel; et après une courte Prière aux Dieux, il le remit à Andromaque, qui le reçut avec un sourire mêlé de larmes."

8. Charles-Antoine Coypel's *Hector Taking Leave of Andromache* recently appeared at Sotheby's, Monte Carlo, 29 November 1986, no. 351.

9. O'Neill 1981, I, 122–23; Garnier 1989, 178–79; Wildenstein 1964, 149, no. 48.

10. Messelet 1935–36, 113, for Restout's participation in the *Tenture du Nouveau Testament*.

11. Mariette 1851–60, IV, 382, "Il a fait d'assez belles choses, mais qui ressembloient trop à celles qu'il avoit vu faire à son oncle."

12. Ibid., "Or, un copiste, quelqu'excellent qu'il soit, et quelque modification qu'il y mette, ne fera jamais un grand homme."

13. Restout in Formigny de La Londe 1863, 62, "Il faut par nécessité se former un pratique de travail."

14. Ibid., 63, "la nécessité, que j'ai toujours ressentie de ne rien faire sans avis, me faisait consulter ces Messieurs à chaque tableau que je faisais."

15. Nemilova 1986, 263; exh. Rouen 1970 (A), 189, no. 14.

16. Restout in Formigny de La Londe 1863, 64, "la lecture des bons auteurs, les actions et les sentiments des héros . . . tout cela donne de la noblesse à l'esprit, il est comme indispensable qu'il se rende ces choses familières et qu'elles soient le germe de son enthousiasme quand il compose."

17. Ibid., 65, "qu'il connaisse . . . les moeurs et coutumes de tous les anciens peuples, leurs fêtes, jeux, sacrifices, funérailles etc. . . . qu'il ait connaissance de leur architecture, de leurs ameublements, de leurs armes défensives, de leurs habits de guerre et civils . . ."

18. Ibid., 69, "Je tiens un principe de M. Jouvenet, lequel il avait reçu de M. Le Brun, qui est que la tête doit être tournée du côté que l'épaule lève, et que le regard suive le mouvement de la tête."

19. It should also be noted that Restout, by his own admission, took empirical advice as well, turning to the actor Michel Boyron, called Baron (1653–1724), who also advised Antoine Coypel on gesture and expression, Restout in Formigny de La Londe 1863, 69–70.

20. Poinsinet de Sivry et al. 1767–82, IV, 59; *Galerie françoise* 1771, 5; Rousselin in Chennevières-Pointel 1847–62, III, 322; Pahin de La Blancherie 1783, 234, no. 70, "*Les Adieux d'Hector à Andromaque*, à M. Restout, son fils, *Peintre du Roi.*"

21. Ader Picard Tajan, Paris, 5 December 1990, no. 73.

22. Rosenberg 1977, "une répétition originale d'une année postérieure." The painting has been restored by Mark Tucker, Conservator of Paintings at the Philadelphia Museum of Art.

23. Poinsinet de Sivry et al. 1767–82, 59, "une très bonne copie chez M. Bouret et dont l'originale est resté au fils de M. Restout." Balteau, Barroux, and Prévost 1933–[1989], VI, 1462–63; Voltaire's praises of Bouret are sung in a letter of November 1761, Besterman 1953–77, XLVII, 210–11, letter 9372.

24. Ingamells 1989, 245–48; Bouret's activities as a Maecenas would repay closer investigation.

25. *Catalogue d'une très-belle collection de Tableaux d'Italie, de Flandres, de Hollande, et de France . . . provenans du Cabinet de M. [Calonne]*, Paris, 21 April 1788, no. 153 (*Hector Taking Leave of Andromache*), no. 154 (*The Continence of Scipio*). It is interesting that Calonne also owned Noël-Nicolas Coypel's entry to the *concours de 1727*, *The Rape of Europa* (cat. no. 30).

26. Ibid., no. 154, "la Continence de Scipion, riche composition de vingt-deux figures de même grandeur que le précédent, auquel il peut servir de pendant"; Rosenberg and Schnapper 1982–83, 51.

27. Bock in Berlin 1986, 404.

28. Gaehtgens 1983, 179–91, for a general discussion of the painting.

29. I am extremely grateful to Carol Dowd for obtaining a copy of this catalogue for me.

30. *Catalogue d'une très-belle collection* (as in n. 25), no. 153; Rosenberg and Schnapper 1982–83, 51, point out the possible inversion of the figure; Levasseur's engraving was announced in the *Mercure de France*, October 1769, 175, "elle peut servir de pendant à la Continence de Scipio [after Lemoyne], publiée précédemment."

31. *Catalogue d'une très-belle collection* (as in n. 25), no. 153, "m'ont été donné; les retirer pour servir de dessus des portes" (MS. annotations).

32. Balteau, Barroux, and Prévost 1933–[1989], VII, 922–23.

33. The price is taken from the annotated copy of the Calonne sales catalogue in the Frick Art Reference Library, New York; *A Catalogue of all that Noble and Superlatively Capital Assemblage of Valuable Pictures . . . the Property of the Right Hon. Charles Alexander de Calonne*, London, 23 March 1795, no. 43, *The Parting of Hector and Andromache*; no. 44, the companion, *The Continence of Scipio*. The auctioneer further claimed that *The Parting of Hector and Andromache*, "a very capital picture," had "cost M. de Calonne a very considerable sum," which is quite untrue in light of Calonne's comments cited above (as in n. 31).

34. Garnier 1989, 179.

FIG. 1
Charles-Antoine Coypel, *Hector Taking Leave of Andromache*, 1732, oil on canvas, Private Collection

FIG. 2
Antoine Coypel, *Hector Taking Leave of Andromache*, c. 1711, oil on canvas, Tours, Musée des Beaux-Arts

FIG. 3
Jean Restout, detail of *Hector Taking Leave of Andromache*, 1728, oil on canvas, New York, Mrs. Ruth Blumka

FIG. 4
Jean Restout, *Hector Taking Leave of Andromache*, 1727, oil on canvas, Private Collection

FIG. 5
Jean Restout, detail of *Hector Taking Leave of Andromache*, 1728, oil on canvas, New York, Mrs. Ruth Blumka

FIG. 6
Jean Restout, *The Continence of Scipio*, 1728, oil on canvas, Berlin, Staatliche Museen Preussischer Kulturbesitz, Gemäldegalerie

JEAN RESTOUT
The Deification of Aeneas

35

JEAN RESTOUT (1692–1768)
The Deification of Aeneas, 1749
Oil on canvas
136 x 107 cm.
Musée des Arts Décoratifs, Strasbourg

PROVENANCE
Mèwes Collection, château de Scharrachbergheim; acquired by the Musée des Arts Décoratifs, Strasbourg, in 1977.

EXHIBITIONS
Rouen 1970 (A), no. 36, ill.

BIBLIOGRAPHY
Messelet 1935–36, 164, no. 140; Ludmann 1979, 451–52, ill.; Rosenberg and Schnapper 1982–83, 48–49; Vilain 1983, 384; Join-Lambert 1986, 421, ill.

While profane subjects appeared infrequently in the "austere Restout's" *oeuvre*—a fact acknowledged by all eighteenth-century commentators[1]—episodes from the life of Aeneas dominated the artist's rare incursions into the "*genre agréable*," from his *morceau d'agrément* (New York, Private Collection), submitted on 29 May 1717, to the enormous *Dido Showing Aeneas the Buildings of Carthage* (Lyons, Hôtel de la Préfecture), painted in 1751 for the series *La Tenture des Arts*.[2] Predictably, the most erotic encounter associated with the Trojan hero, in which Venus seduces Vulcan into making arms for her son—a subject favored by his contemporaries—was treated by Restout only once, in the ambitious but uneven *morceau d'agrément* cited above, a youthful pastiche of Jouvenet and Louis de Boullongne.[3] "Do not look for his work on the sides of our carriages or in the gilded alcoves of our houses, where the arts pander to luxury," warned the *Galerie françoise*.[4] And, fully in character, *The Deification of Aeneas*, signed and dated 1749, is a fine example of Restout's gentle and reserved approach to subjects from mythology.

Seated on a rock and supported by the river-god at left, whose ruddy, muscular torso contrasts so strikingly with his own, Aeneas is being anointed by Venus, who has gained the gods' approval to elevate her son to their assembly. Ethereal in flowing robes of icy blue, Venus pours "divine perfume" onto Aeneas's head, while holding in her left hand a small tray on which a second ewer contains "the ambrosia and sweetened nectar" with which she will later touch his lips. On Venus's orders, Aeneas himself has been "washed clean" of "whatever was mortal in him"—his warrior's garb lies in a pile on the right—and the whiteness of his body, reinforced by the pale green robes in which he is shrouded, symbolizes this purification.[5]

Painterly and fluent in execution, soft and subtle in coloring—something rarely possible in Restout's public commissions—*The Deification of Aeneas* is nevertheless a curious cabinet picture, since, as was repeatedly pointed out, "Restout's manner of painting was broad, and little suited to details; yet, from the

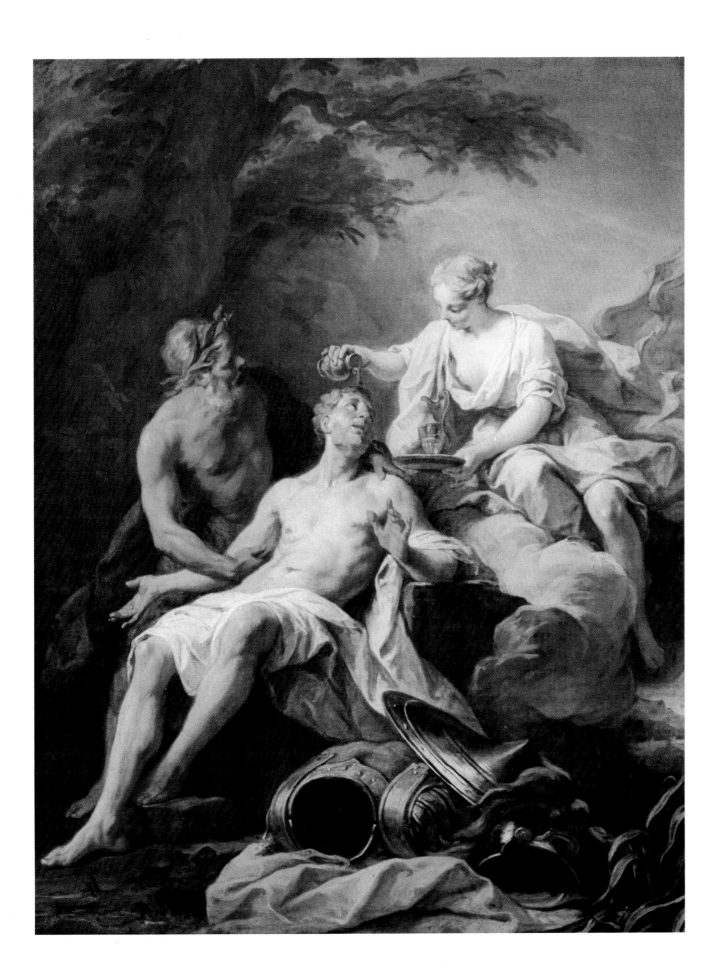

spectator's point of view, these did not appear to have been neglected.["]6

The artist prepared his canvas with great care. Following a procedure discussed in some detail in his lecture to the Academy,[7] Restout made a relatively finished drawing of the composition, squared for transfer (fig. 1), in which he indicated not only the gestures and expressions of the three figures but also laid in the areas of light and shade. Not satisfied with Venus's head and upper body, he reworked her profile and right arm on a separate piece of paper which he affixed to the sheet as a flap (fig. 2).[8] The finished painting introduces further refinements. For example, the Venus of the drawing is shown with both breasts exposed; in the painting she is more modestly draped. In the drawing she holds a small vial, the size and shape of an apple; in the painting, this has been replaced by a tray with two vessels. By far the most significant changes occur in the portrayal of Aeneas himself. In the drawing he leans against the river-god and faces the goddess, whereas in the painting he is shown seated in the opposite direction, his right elbow resting on a stone that emerges from under Venus's cloud. Finally, Vulcan's handiwork, so prominent in the foreground of the painting, is barely visible in the drawing.

For the composition as a whole, Restout turned to one of his earliest mythological paintings, the frequently copied *Diana and Endymion* (fig. 3), painted in 1724 as part of the suite of overdoors for the duc de Bourbon's apartments at Versailles.[9] The tender relationship between the goddess of the hunt and her sleeping shepherd is transposed a quarter of a century later with little modification. Though beautifully integrated, the individual figures in *The Deification of Aeneas* are also stock types from the artist's repertory. For example, the pose of Aeneas is based on a male *académie* and would be used again a decade later for the figure of Minerva in *Minerva Presenting the Portrait of Louis XV* (Caen, Académie).[10]

Incorrectly identified as *Mars and Venus* until 1970,[11] it is a little surprising that the subject of Restout's graceful and unrhetorical mythological painting should have given rise to further discussion.[12] Infrequently painted in the eighteenth century—Bardon noted its appearance in the Salon but once[13]—the story of Aeneas's deification could nonetheless claim an iconography which distinguished it quite clearly from the episode in which Venus presents her son with arms. In all depictions of this latter event, Aeneas is portrayed clad in armor; Restout himself had painted the subject early in his career (fig. 4).[14] By contrast, in *The Deification of Aeneas*, the hero is shown naked. Furthermore, in other examples of *The Deification of Aeneas* with which Restout might have been familiar—La Fosse's decorative panel (cat. no. 5) and Sebastien Le Clerc's *morceau de réception* of 1704 (Tours, Musée des Beaux-Arts)—the hero's arms are included, if only surreptitiously, as they were in Restout's preparatory drawing.[15]

Comparison between Restout's modest cabinet painting and the most famous example of this subject, Le Brun's early *Deification of Aeneas* (fig. 5)—which boasted an attribution to Poussin in the eighteenth century—lends further support to the identification of the subject.[16] It also brings out the beguiling reticence of Restout's art. Jansenist in spirit, if not in fact, he suppresses all emblems of eroticism in his interpretation of *The Deification of Aeneas*; Venus's chariot in the upper right of the canvas is barely visible, and neither doves nor putti are anywhere in sight. Furthermore, his red-cheeked Venus, swathed in robes and ministering in rapt concentration to her grateful son, is far removed from Le Brun's elegant dominatrix. It cannot be entirely fortuitous that she adopts the same pose as the figure of Mary Magdalene in Restout's *Christ in the House of Simon* (Chevreuse, parish church), painted in 1741 and exhibited at the Salon of 1747.[17] In this artist's world, sacred and profane love are to be treated with delicacy and decorum.

NOTES

1. Poinsinet de Sivry et al. 1767–82, IV, 58; *Galerie françoise* 1771, 5, "l'austère Restout ne s'abaissa jamais à des tons moins élevés"; Mariette 1851–60, IV, 382, who "dares not" pass judgment on Restout's treatment of the "sujets de la fable."

2. Rosenberg and Schnapper 1982–83, 42–45; Messelet 1935–36, 166; Ludmann 1979, 452; a sketch for this tapestry cartoon, which represents Architecture and was never woven, is in the Musée des Arts Décoratifs, Strasbourg.

3. The painting is fully catalogued in *From Watteau to David: A Century of French Art*, Maurice Segoura Ltd., New York 1982, 22–24. The figure of Venus is taken from Louis de Boullongne's *Juno Requesting Aeolus to Release the Winds* (engraved by Dupuis in 1718).

4. *Galerie françoise* 1771, 5, "qu'on ne le cherche pas sur les panneaux de nos chars, ni dans ces alcoves dorées où les arts encensent la mollesse."

5. Ovid, *Metamorphoses*, XIV, 595–608.

6. Poinsinet de Sivry et al. 1767–82, IV, 60, "La manière de M. Restout était large, et ne s'asservissant guères aux détails, qui, néanmoins, à l'oeil du spectateur, ne semblaient pas avoir été négligés"; the point is repeated almost word for word in Papillon de La Ferté 1776, II, 634.

7. Restout in Formigny de La Londe 1863, 66, "ensuite toutes les figures d'après son esquisse, chacune sur son plan, par rapport à l'échelle de perspective, ce qui formerait une seconde esquisse."

8. Rosenberg and Schnapper 1982–83, 49, figs. 8 and 9.

9. Ibid., 48; Bordeaux 1984 (B), 122, 125.

10. Exh. Rouen 1970 (A), 66, no. 40, 143, plate XLIX.

11. Messelet 1935–36, 164; exh. Rouen 1970 (A), 63, no. 36, pl. XLVIII.

12. Ludmann 1979, 451–52; Rosenberg and Schnapper 1982–83, 48–49. Ludmann's arguments for the subject as *Venus Presenting Arms to Aeneas*—following Virgil, *The Aeneid*, VIII, 608–25, and based on one phrase in Perrin's translation of 1650—are ingenious but untenable.

13. H. Bardon 1963, 229, citing Antoine Boizot's entry to the Salon of 1747. For representations of Aeneas in eighteenth-century French art, see Bardon 1950, 77–98, and Tervarent 1967, 1–14.

14. Rosenberg and Schnapper 1982–83, 42–45, 48–49.

15. Restout in Formigny de La Londe 1863, 68, claimed La Fosse as one of his earliest mentors; for Sebastien Le Clerc's *Venus Bringing Nectar and Ambrosia for the Deification of Aeneas Who Has Been Purified by the River Numicius*, Lossky 1962, no. 66. On the representation of this particular episode in French painting of the eighteenth century, Join-Lambert 1986, 419–22.

16. Rosenberg and Schnapper 1982–83, 49, cite this as the canonical image; Thuillier's excellent entry in exh. Versailles 1963, 12–13, traces the painting no further than 1925. Le Brun's *Deification of Aeneas* appears in the *Catalogue des Tableaux et autres effets du Cabinet de M. Thélusson*, Paris, 1 December 1777, no. 30, as by Poussin, and Saint-Aubin's illustrated copy of this catalogue, in the John G. Johnson Collection, Philadelphia Museum of Art, confirms that Le Brun's *Deification of Aeneas* and Thélusson's "Poussin" are one and the same. I am grateful to Carrie Hamilton for bringing Saint-Aubin's illustration to my attention.

17. Exh. Rouen 1970 (A), 55–56; Ludmann 1979, 452, was the first to make this connection.

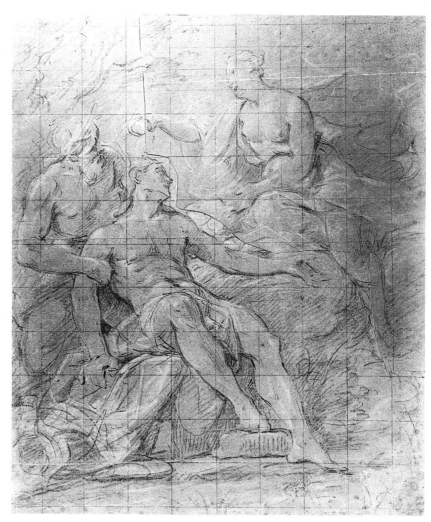

FIG. 1
Jean Restout,
The Deification of Aeneas, 1749,
black chalk drawing with white highlights,
Caen, Musée des Beaux-Arts

FIG. 2
Jean Restout,
Profile of Venus, from a sheet
affixed to *The Deification of Aeneas*, 1749,
black chalk drawing with white highlights,
Caen, Musée des Beaux-Arts

FIG. 3
Jean Restout, *Diana and Endymion*, 1724, oil on
canvas, Versailles, Hôtel de Ville

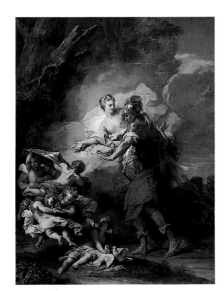

FIG. 4
Jean Restout, *Venus Presenting Arms to Aeneas*,
1717, oil on canvas, Ottawa, National Gallery
of Canada

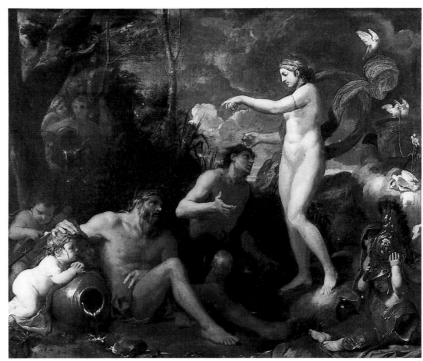

FIG. 5
Charles Le Brun, *The Deification of Aeneas*, c. 1642, oil on canvas, Montreal, Museum of Fine Arts

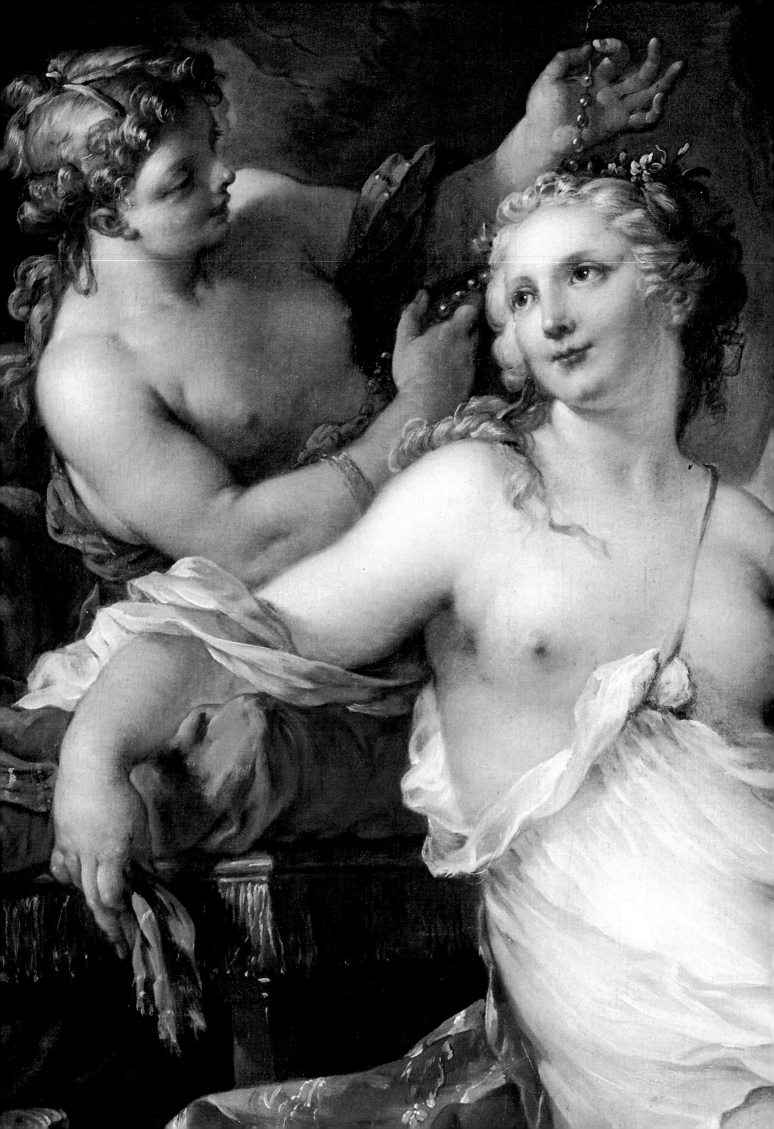

CHARLES-JOSEPH NATOIRE
(1700–1777)

Charles-Joseph Natoire, born in Nîmes in March 1700, probably first trained with his father, the architect and sculptor Florent (c. 1667–1751). In 1717 he traveled to Paris, where he studied with Louis Galloche and then François Lemoyne. Natoire was an outstanding student, winning the *Prix de Rome* in August 1721 with *Manoah Offering a Sacrifice to God* (Paris, École Nationale Supérieure des Beaux-Arts) and becoming a *pensionnaire* in Rome in September 1723. In Rome he completed such student tasks as copying old master paintings—for example, Pietro da Cortona's *Rape of the Sabines*—but in 1727 he also participated in the decoration of the Academy's new residence, the Palazzo Mancini, receiving in the same year a commission to paint *Christ Chasing the Moneylenders from the Temple* for the Cardinal de Polignac (1727–28, Paris, church of Saint-Médard).

Natoire was back in Paris by September 1730, when he was *agréé* at the Academy. News of his talent had spread, and he received prestigious commissions well before his full acceptance into the Academy, by far the most important of which were a series of paintings for the château de La Chapelle-Godefroy (see cat. nos. 36, 37), three overdoors of Old Testament subjects for the Parisian *hôtel* of the duc d'Antin in 1732 (*Jacob and Rachel Leaving the House of Laban*, Atlanta, High Museum of Art; *The Meeting of Jacob and Rachel at the Well*, Private Collection; and *Hagar and Ishmael in the Desert*, Paris, Musée du Louvre), and a painting for the queen's chamber at Versailles, *Youth and Virtue Presenting Two Princesses to France* (1734, Musée National des Châteaux de Versailles et de Trianon). Although preoccupied with these projects, Natoire eventually completed his *morceau de réception* and was received

into the Academy in December 1734 with *Venus Requesting Vulcan to Make Arms for Aeneas* (cat. no. 38), a variation of Boucher's earlier interpretation of the same subject (cat. no. 43).

Natoire continued to work for the Crown and court members after his reception into the Academy. His series of tapestry cartoons devoted to the tale of Don Quixote was commissioned for Beauvais by Pierre Grimod du Fort between 1735 and 1743. He contributed four paintings for the château de Marly in 1743 (e.g., *Bacchus and Ariadne*, Paris, Présidence de l'Assemblée Nationale), and he even painted a portrait of the *Dauphin* Louis in 1747 (Musée National des Châteaux de Versailles et de Trianon), one of his rare essays in this genre. Natoire's best-known and most impressive secular commission, however, was his series of decorative panels illustrating the story of Psyche for the *salon ovale de la princesse* at the hôtel de Soubise, executed between 1736 and 1739. These elegant and highly colored compositions, set into Germain Boffrand's elaborate *boiseries*, are filled with graceful, long-limbed women who twist and curve to exhibit more fully their supple flesh and sumptuous attire.

While Natoire excelled at such secular projects, he also performed splendidly in religious commissions such as *Saint Stephen before the Doctors who Produce False Evidence Against Him* for the chapel of Saint-Symphorien in the church of Saint-Germain-des-Prés (1745, Rennes, Musée des Beaux-Arts). His participation in the illusionistic decoration of the chapelle des Enfants-Trouvés (1746–50), designed by Germain Boffrand, produced one of the most acclaimed religious works of the day. Integrated within the chapel's architecture, Natoire's paintings were surrounded by architectural *trompe l'oeil* set-

tings by Gaetano and Paolo Antonio Brunetti. Covering the walls and ceiling, such an ensemble was without precedent in France, and in Europe was paralleled only by the works of Giambattista Tiepolo. Destroyed in the nineteenth century, the chapel's decoration is now known only through Étienne Fessard's prints, which were extremely popular in their own day; Madame de Pompadour, Madame Geoffrin, Jean de Jullienne, and the comte de Caylus were among those who subscribed to Fessard's edition.

In May 1751, shortly after completing this project, Natoire received the post of director of the French Academy in Rome. While honored by this appointment, the move to Rome essentially signaled the end of Natoire's career, and he was eventually passed over for the post of *premier peintre du roi* in favor of his rivals Carle Van Loo and François Boucher. Natoire's principal work in Rome was the fresco (1754–56) representing the Apotheosis of Saint Louis for the ceiling of the French national church in Rome, San Luigi dei Francesi. Generally reliant on the ceiling designs of Carlo Maratta and more specifically on Sebastiano Conca's ceiling in Santa Cecilia of 1721–24, Natoire's balanced system of crossing diagonals now appeared old-fashioned. Anton Raphael Mengs, the preeminent representative of the more progressive, neoclassical style in Rome at the time, condemned the work for its lack of imagination and poor design. Little troubled by such criticism, Natoire produced numerous drawings inspired by the Roman landscape and became increasingly devout during his remaining years as director of the French Academy in Rome. Due to accusations of mismanagement, Natoire resigned his position in August 1775 and retired to Castel Gandolfo, where he died two years later.

CHARLES-JOSEPH NATOIRE, *The Toilet of Psyche* (detail), c. 1735, oil on canvas, 198 x 169 cm, New Orleans Museum of Art, bequest of Judge Charles F. Claiborne

CHARLES-JOSEPH NATOIRE
Jupiter Abducting Ganymede

Danae Receiving Jupiter as a Shower of Gold

36 & 37

CHARLES-JOSEPH NATOIRE (1700–1777)
Jupiter Abducting Ganymede, c. 1731
Oil on canvas
123 x 108 cm.
Musée des Beaux-Arts et d'Archéologie, Troyes

PROVENANCE
Commissioned by Philbert Orry, comte de Vignory (1689–1747), as overdoors for the second ground-floor bedroom of the château de La Chapelle-Godefroy around 1731; inherited by Orry's brother, Jean-Henri-Louis Orry de Fulvy (1703–1751); by descent to his son, Philbert-Louis Orry de Fulvy, who sold the *château* with its decoration to Bouret de Valroche in 1760; acquired by Jean de Boullongne (1690–1769), who purchased the *château* in 1761; inherited by his son, Jean-Nicolas de Boullongne (1726–1787); by descent to Paul-Esprit-Charles de Boullongne (b. 1758); the *château* was seized in 1793 and the paintings deposited at the abbey of Notre-Dame-aux-Nonnains de Troyes; relocated to the Musée de Troyes in 1835.

EXHIBITIONS
Bordeaux 1958, no. 242; Troyes, Nîmes, and Rome 1977, no. 9, ill.

BIBLIOGRAPHY
Lassertey 1793, 83; Anonymous 1835, 102; Troyes 1850, no. 103; Troyes 1864, xxi, no. 71; Babeau 1876, 15; Troyes 1879, no. 91; Troyes 1886, no. 111; Troyes 1897, no. 160; Morel-Payen 1929 (A), 9; Morel-Payen 1929 (B), 32; Troyes 1911, no. 204; Boyer 1949, no. 36; Vergnet-Ruiz and Laclotte 1965, 246; Sainte-Marie 1977, 16; Nemilova 1986, 218.

CHARLES-JOSEPH NATOIRE (1700–1777)
Danae Receiving Jupiter as a Shower of Gold, c. 1731
Oil on canvas
122 x 106 cm.
Musée des Beaux-Arts et d'Archéologie, Troyes

PROVENANCE
As for *Jupiter Abducting Ganymede*.

EXHIBITIONS
Brussels 1953, no. 96; Bordeaux 1958, no. 243; Tokyo, Yamaguchi, Nagoya, and Kamakura 1986–87, no. 23, col.; Fukuoka 1989, no. 14, ill.

BIBLIOGRAPHY
Lassertey 1793, 83; Anonymous 1835, 102; Troyes 1850, no. 102; Troyes 1864, xxi, no. 72; Babeau 1876, 15; Troyes 1879, no. 92; Troyes 1886, no. 113; Troyes 1897, no. 162; Babeau 1899, 507, ill.; Troyes 1911, no. 206; Morel-Payen 1929 (A), 9, ill.; Morel-Payen 1929 (B), 32; Boyer 1949, no. 38; Vergnet-Ruiz and Laclotte 1965, 246; Sainte-Marie 1977, 16; exh. Troyes, Nîmes, and Rome 1977, 56; Nemilova 1986, 218.

Natoire's *Jupiter Abducting Ganymede* and *Danae Receiving Jupiter as a Shower of Gold* were painted around 1731 as overdoors for the second ground-floor bedroom of the château de La Chapelle-Godefroy, the Orry's country seat at Nogent-sur-Seine since 1706.[1] They hung in a room devoted to the Loves of Jupiter whose principal decoration was Natoire's large *Rape of Europa* (fig. 1), signed and dated 1731, and were part of the series of nine paintings devoted more generally to the Loves of the Gods which Orry commissioned from Natoire for the private rooms at La Chapelle-Godefroy between 1731 and 1734.[2] Natoire would go on to contribute four overdoors representing the Seasons for the *salle à manger* and two further sets of history paintings for the *galerie* of the *château*: six canvases treating the heroic feats of the Frankish king, Clovis, and six more of scenes from Fénelon's uplifting history of Telemachus.[3] The entire suite was completed by 1740, when the king is said to have paid his first visit to the *château*.[4] With the exception of the Four Seasons—engraved by Natoire and Aveline and announced in the *Mercure de France* in July 1735—all the paintings from the château de La Chapelle-Godefroy can be accounted for; thirteen of the twenty-one entered the Musée de Troyes between 1834 and 1864, and a fourteenth, *Leda and the Swan*, said to have been sold to the Marquess of Hertford for five francs, was restored to its companions in 1983.[5]

The commission to decorate the château de La Chapelle-Godefroy was inspired by its proprietor's sudden and unexpected rise to ministerial office. In March 1730 Philbert Orry, comte de Vignory (1689–1747)—*maître des requêtes* since 1715, *intendant* of Soissons, Perpignan, and Lille respectively thereafter—was given the post of *contrôleur général des finances*, which he held for fifteen years, until his disgrace in December 1745.[6] Protected by the *premier ministre* Cardinal de Fleury, whose passion for order and economy he shared, Orry also succeeded the imperious duc d'Antin as *directeur général des Bâtiments* in November 1736. His most important artistic reform was to reinstate the biennial Salon, and for this Orry was elected vice-protector of the Academy in April 1737.[7]

The fifth child of Jean Orry—a *gentilhomme verrier* from Rouen who had made his fortune supplying Louis XIV's army with horses and munitions during the War of the Spanish Succession[8]—Philbert Orry was harshly treated by his better-born peers and has been viewed no more sympathetically by modern historians. Alluding to his modest origins, the embittered marquis d'Argenson commented that he had "bourgeois bad taste"; Jean Locquin, and Fiske Kimball after him, claimed, without evidence, that Orry was "notoriously incompetent in matters of art."[9] Yet his embellishment of La Chapelle-Godefroy should caution against such invective. Orry's decision to decorate the *château* exclusively with contemporary history painting placed him at the vanguard of taste, and his choice of Natoire as the principal executant showed considerable discernment.[10] In 1730 Natoire was, quite simply, the most promising young history painter available; Boucher was yet to return from his personally financed sojourn in Italy, and Van Loo would remain abroad until 1734.[11] Natoire had already come to the attention of the *directeur général des Bâtiments* after winning the prestigious painting competition organized by the *Accademia di San Luca* in Rome in December 1725.[12] "The young man draws well," Vleughels had reported to the duc d'Antin on 22 May 1727, "he has been noticed here and should gain esteem in France," sentiments echoed by Pierre Crozat, who recommended Natoire to Rosalba Carriera in January 1729.[13] Orry seems to have employed Natoire as soon as he could do so without contravening the strict guild regulations that still governed the practice of painting; apart from the members of the *Académie de Saint-Luc*, only those attached to the *Académie royale de Peinture et de Sculpture* could handle the brush.[14] Natoire was made an associate member at the Academy in September 1730, and it is probable that he started work on the decorations for La Chapelle-Godefroy immediately thereafter; two of his largest and most ambitious compositions for this series are dated 1731.[15] Indeed, work for Orry seems to have prevented Natoire from attending to his *morceau de réception*; *Venus Requesting Vulcan to Make Arms for*

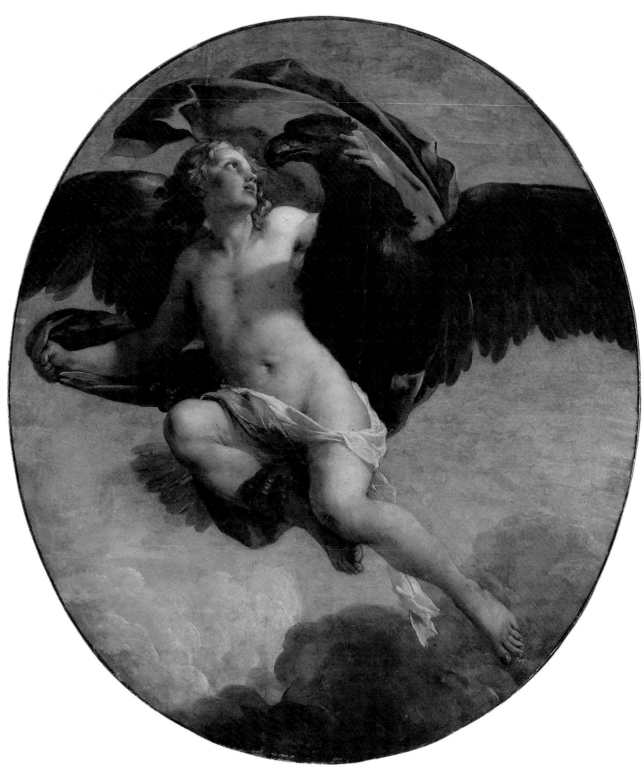

CAT. 36

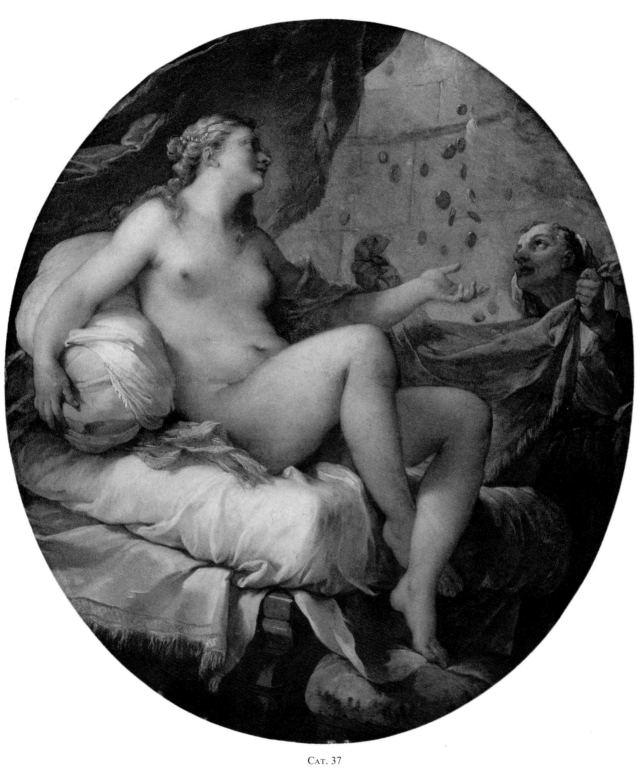

CAT. 37

Aeneas (cat. no. 38) had to wait until the first campaign at La Chapelle-Godefroy came to an end and was not submitted until 31 December 1734.[16]

Although Natoire's decorations for Orry are as thoroughly documented as any private commission awarded in the eighteenth century, certain fundamental issues remain unclear. We do not know the extent of the refurbishment of the château de La Chapelle-Godefroy—designed at considerable cost by Jacques de La Joue (the painter's father) in 1706—nor do we know who was responsible for the choice of subjects for the various rooms.[17] It is unlikely that the thirty-year-old Natoire had much of a say in this matter, and it is here that his commission differs notably from the project on which Boucher was contemporaneously engaged, the series of history paintings for François Derbais (cat. nos. 43, 44), in which the patron seems to have given the painter a relatively free hand. In other ways, however, Natoire's and Boucher's decorations are quite closely related. Not only did the two artists treat similar subjects on a comparable scale, but, more significantly, as aspiring history painters they were given the opportunity early in their careers to work *en grand*.[18] Only a generation before, younger artists would have been obliged to seek such possibilities exclusively in poorly paid religious commissions.

It is not known how Natoire gained access to the powerful *contrôleur général*, although it has been suggested that he was introduced to him by Bouchardon, a fellow student at the Academy in Rome.[19] Quite apart from whether the young sculptor was in any position to dispense patronage of this sort, Bouchardon did not leave Rome for Paris until 11 September 1732, by which date Natoire's work at La Chapelle-Godefroy was well under way.[20] On the basis of the dedication to him in Duflos's engraving after Natoire's *Bacchanal* (cat. no. 41), Ferdinand Boyer assigned responsibility for the commission to Orry's younger brother, Jean-Henri-Louis Orry de Fulvy (1703–1751), whom he considered to be the conduit by which Natoire was presented to the *contrôleur général*.[21] This too can be discounted, if only because the choice of such dedications normally rested with the engraver and not the artist. One possibility which has not been discussed is that Natoire was recommended to Orry by the duc d'Antin. In 1732 the *directeur général*, who had shown exceptional generosity towards the artist during his studentship in Rome, would commission three overdoors from Natoire for his Parisian *hôtel*. It would also have been quite natural for Orry to turn to his older and considerably more experienced fellow minister for advice in matters artistic.[22]

If Natoire's multifigured compositions at La Chapelle-Godefroy suggest his limitations as a decorator on the grand scale—Paul Mantz noted perceptively of eighteenth-century French artists that "as the size of their canvases increased, so the power of their ideas and color diminished"—his less ambitious overdoors bear none of this strain.[23] *Jupiter Abducting Ganymede* and *Danae Receiving Jupiter as a Shower of Gold* are glorified *académies*, certainly, but they are painted in rich, saturated colors and display the artist's complete mastery of the human figure.

Jupiter's abduction of the beautiful Ganymede—the youngest of the "three peerless sons" born to Tros and Callirhoë, king and queen of Troy[24]—is related briefly by Homer and Ovid, and more humorously by Lucian in *The Dialogues of the Gods*. Taking the shape of an eagle—the only bird capable of bearing his thunderbolts—Jupiter swept down to Mount Ida, where Ganymede was tending his father's flocks, and carried the boy off to Olympus to serve as cupbearer to the gods: "who, even now, though against the will of Juno, mingles the nectar and attends the cups of Jupiter."[25] It is Natoire's familiarity with this celebrated homoerotic encounter that accounts for the "somewhat effeminate Ganymede," which seems to have puzzled at least one scholar, and the artist portrays Jupiter's rape with a mixture of passion and tenderness.[26] Ganymede looks adoringly into the eagle's eyes and rests his left hand gently on its head, caressing the bird, which suddenly appears less threatening despite its size and the darkness of its plumage. In contrast, Ganymede's right hand is clenched tightly as it grasps the orange red fabric that flutters in the wind. Jupiter's intentions are clearly indicated by the way his massive claw wraps itself around the boy's right leg. Like Orpheus in the *Metamorphoses*, Natoire is eloquent on the subject of "boys beloved by gods."[27]

The pendant to this overdoor, *Danae Receiving Jupiter as a Shower of Gold*, is even more explicit, for Natoire abandons the convention of the slung-over leg in favor of a pose that is far more revealing. Informed by an oracle that he would be murdered by his grandson, Acrisius, king of Argos, imprisoned his maiden daughter Danae in a "brazen chamber underground" to prevent her from ever giving birth. Unperturbed, Jupiter seduced the princess by assuming the shape of a stream of gold "which poured through the roof into Danae's lap."[28] Not believing that Jupiter had been responsible for begetting Danae's son, Acrisius had both mother and child locked up in a wooden casket and thrown into the ocean. This coffin washed ashore on the island of Seriphos, where Danae and her son, Perseus, were given shelter. The oracle's premonition of the manner of Acrisius's death

was fulfilled when Perseus, after killing the Gorgon Medusa and rescuing Princess Andromeda, hunted down Acrisius at the funeral games at Larissa and killed him with his discus.[29]

Nowhere in the brief accounts of Jupiter's liaison with Danae is mention made of an elderly maidservant who attempts to catch the stream of gold. This figure had been introduced by Titian in his *poesia* for Philip II of Spain (fig. 2), and Natoire followed Titian's *Danae with Nursemaid* so closely that his overdoor is little more than a pastiche of the latter.[30] Since he could not have seen the primary version of Titian's painting, Natoire may have been familiar with the copy recorded in the collection of Prince Pio of Savoy in Rome, a picture cabinet "in which there are some extremely good paintings" and which had been made accessible to students at the Palazzo Mancini through Vleughels's good offices.[31] In November 1724 Vleughels had secured permission from the *principe* to copy Veronese's *Rape of Europa*, and the painting was initially assigned to Natoire before being given to Jeaurat; it would later provide Natoire with a model for his *Rape of Europa* at La Chapelle-Godefroy.[32]

Jupiter Abducting Ganymede is similarly indebted to a well-known model, although this time the source is Parisian, not Roman. Although Ganymede's pose bears some resemblance to that of the blond-haired youth snatched from Venus by Minerva in Pietro da Cortona's fresco on the vault of the *sala di Venere* in the Pitti Palace (fig. 3), Natoire's composition clearly takes its inspiration from Le Sueur's *Abduction of Ganymede* (fig. 4), originally painted as ceiling decoration and transferred around 1700 to the *cabinet de l'Amour* in the hôtel Lambert, where it was installed as an overdoor.[33] Similarities in both form and function identify it as the model for Natoire's *Jupiter Abducting Ganymede*; the shared motif of the boy clutching his cloak with his right hand is too specific to be merely coincidental.

Natoire's models betray his preferences as a colorist, and his handling and figure types are also related to the art of Lemoyne. Yet Natoire broke with his master both in the vigor and solidity of his modeling and in the warmth and robustness with which he painted flesh. In *Danae Receiving Jupiter as a Shower of Gold*, for example, the physical presence of the princess imposes itself in a manner that would become less and less frequent in Natoire's art; her enormous parted thighs dominate the pictorial space, and even the bolster upon which she reclines bursts through its cover. Here, at least, the perfume exuded is not weak, nor the *galanterie* insipid. To paraphrase Mantz, Natoire fashioned a nude full of fire and enthusiasm; for once it is he who can be called "le grand amoureux."[34]

Fluent and painterly in their execution and unrepentantly derivative in their conception—an eclecticism fully in keeping with the training dispensed by the Academy in Paris and Rome—Natoire's three paintings transformed the second bedroom at La Chapelle-Godefroy into a celebration of Jupiter's conquests.[35] By far the most sensitive appreciation of *Jupiter Abducting Ganymede* and *Danae Receiving Jupiter as a Shower of Gold*—and, for that matter, of all the paintings by Natoire at La Chapelle-Godefroy—comes from the least likely source. Citoyen Lassertey—the *administrateur du département de l'Aube* responsible, in the winter of 1792, for selecting works from émigré collections for the future Musée de Troyes—wrote with genuine admiration and impressive erudition of the contents of La Chapelle-Godefroy, which had passed to the Boullongne dynasty in 1761. Finding himself in a dwelling "worthy of the magnificent Lucullus,"[36] Lassertey confessed that Natoire's history paintings filled him with "the respect and emotion one always feels in the presence of works of exceptional beauty."[37] Before the mythological paintings, executed by a brush inspired "by all the arts of luxury and voluptuousness united," he experienced "the most delicious sensations," admiring above all the "broad, fluent, and brilliant touch of this great artist."[38] Not until the end of the following century would Natoire's art again be so enthusiastically appraised.

NOTES

1. Troyes 1864, xxi, "autre chambre," quoting from the inventory drawn up in 1793 and deposited in the Archives de l'Aube; unfortunately, Natoire's decorations at La Chapelle-Godefroy are not even mentioned "pour mémoire" in the voluminous inventory of Orry's effects, A.N., *Minutier Central*, XXIX/477, "*Inventaire après décès*," 11 December 1747.

2. Troyes 1864, xxi; Babeau 1876, 7–15; Sainte-Marie in exh. Troyes, Nîmes, and Rome 1977, 55–56.

3. Sainte-Marie in exh. Troyes, Nîmes, and Rome 1977, 57–60.

4. Babeau 1876, 19.

5. See the list completed in Sainte-Marie 1977, 16–18, and the same author's more extended entries in exh. Troyes, Nîmes, and Rome 1977, 54–60; Babeau 1876, 17, n. 1, for Hertford's purchase in 1849.

6. Marais 1863–68, IV, 114, 24 March 1730, "M. des Forts est renvoyé et M. Orry est à sa place"; on Orry, see the sympathetic biography in Michaud 1854–65, XXXI, 413–14; Ross-Orry 1977, 5–8; Antoine 1978, 195; Udolpho van de Sandt has noted that in Orry's *inventaire après décès* (as in n. 1) he is repeatedly referred to as "très puissant Seigneur *Philbert*, chevalier Seigneur de La Chapelle Saint-Gérand et autres lieux" (emphasis mine).

7. Montaiglon 1875–92, V, 200–201.

8. Ozanam 1977, 2–4.

9. D'Argenson, cited in Ross-Orry 1977, 7, "le mauvais goût bourgeois de Monsieur Orry"; Locquin 1912, 2, "notoirement incompétent en matière artistique"; Kimball 1943, 175.

10. Orry's affection for La Chapelle-Godefroy was considerable; the duc de Luynes, a less hostile observer at court, noted that Orry regretted "sans cesse de ne pouvoir vivre dans sa terre de La Chapelle, près de Nogent, et toujours prêt à y aller avec plaisir," cited in Babeau 1876, 7.

11. Laing in exh. New York, Detroit, and Paris 1986–87, 17; Sahut in exh. Nice, Clermont-Ferrand, and Nancy 1977, 20.

12. Natoire's prizewinning drawing, *Moses Descending from Mount Sinai*, is reproduced and discussed in exh. Rome, University Park, and New York 1990, 126–27.

13. Montaiglon and Guiffrey 1887–1912, VII, 348, "ce jeune homme dessine d'un goût qui le fait considérer ici et qui sera estimé en France"; Sani 1985, II, 464–65, 495.

14. Pons 1986, 13.

15. Montaiglon 1875–92, V, 78; *The Rape of Europa* (Leningrad, The Hermitage) and *Jupiter and Io* (Troyes, Musée des Beaux-Arts) are signed and dated 1731.

16. Montaiglon 1875–92, V, 149.

17. Brice 1752, II, 166–67, who gives both the architect and the cost of building La Chapelle-Godefroy, "deux cens mille écus de dépensé"; this information, which seems to have escaped the attention of Natoire's historians, is noted in Roland-Michel 1984 (A), 17–18.

18. Both artists produced seasonal allegories in the form of putti paintings, a relatively new genre in French painting, and both painted large-scale versions of *The Rape of Europa*. For the latter, Nemilova 1986, 218; Ingamells 1989, 64–67.

19. Chervet 1912, 196.

20. Montaiglon and Guiffrey 1887–1912, VIII, 370.

21. Boyer, cited in exh. Troyes, Nîmes, and Rome 1977, 55.

22. Zafran in exh. Atlanta 1983, 35; the three paintings for d'Antin, all of Old Testament themes, are *Jacob and Rachel Leaving the House of Laban* (Atlanta, High Museum of Art), *The Meeting of Jacob and Rachel at the Well* (New York, Private Collection), and *Hagar and Ishmael in the Desert* (Paris, Musée du Louvre).

23. Mantz 1880, 42, "en agrandissant leur cadre, ils ont souvent affaibli leur pensée et leur coloris."

24. Homer, *The Iliad*, XX, 230–35; Ovid, *Metamorphoses*, X, 155–61; Lucian, *The Dialogues of the Gods*, 10 (4).

25. Ovid, *Metamorphoses*, X, 160–61.

26. Sainte-Marie in exh. Troyes, Nîmes, and Rome 1977, 56, who considers Natoire's skills in painting the female nude as the reason for this Ganymede "quelque peu féminisé." For an account of Ganymede in Italian art, Saslow 1986.

27. Ovid, *Metamorphoses*, X, 153–54.

28. Apollodorus, *The Library*, II, iv.

29. Ibid.; Graves 1955, I, 237–41.

30. Wethey 1969–75, III, 133–36; Rouquet in exh. Tokyo, Yamaguchi, Nagoya, and Kamakura 1986–87, 182–83, makes the connection with Titian's *Danae with Nursemaid*.

31. Wethey 1969–75, III, 136.

32. Montaiglon and Guiffrey 1887–1912, VII, 31, Poerson to d'Antin, 27 June 1724, "le cabinet du Prince Pio dans lequel il y a de fort bons tableaux entre les autres un ravissement d'Europe de Paul Veronese qui est fort connu"; ibid., 102, 12 December 1724, for Vleughels's decision to assign Pietro da Cortona's *Rape of the Sabine Women* to Natoire instead.

33. Sainte-Marie in exh. Troyes, Nîmes, and Rome 1977, 56–57, for both suggestions; Mérot 1987, 262.

34. Mantz 1880, 47–48.

35. *Perseus and Andromeda* (Troyes, Musée des Beaux-Arts), traditionally included as among the La Chapelle-Godefroy commissions but not listed as decorating a specific room in the *château*, is an even more flagrant example of Natoire's dependence on the Venetians; it is a copy of Veronese's painting of the subject then in the Royal Collection, now in Rennes, Musée des Beaux-Arts, Boyer in exh. Paris 1990, 75.

36. Lassertey 1793, 79, "digne du fastueux Lucullus."

37. Ibid., 80, "nous y sommes entrés avec émotion, et pénétrés de ce respect qu'on éprouve à l'aspect de ce qui est singulièrement beau."

38. Ibid., 82, "tous les arts du luxe et de la volupté semblent s'être réunis au pinceau de Natoire . . . on éprouve les sensations les plus délicieuses à la vue des trois tableaux exquis"; ibid., 80, "nous avons admiré la touche large, moëlleuse, et brillante de ce grand artiste."

FIG. 1
Charles-Joseph Natoire, *The Rape of Europa*,
1731, oil on canvas, Leningrad, The Hermitage

FIG. 2
Titian, *Danae with Nursemaid*, 1553–54, oil on
canvas, Madrid, Museo del Prado

FIG. 4
Eustache Le Sueur, *The Abduction of Ganymede*, c. 1644, oil on canvas, Paris, Musée du Louvre

FIG. 3
Pietro da Cortona, *Minerva Tearing Youth
Away from Venus*, ceiling of the *sala di Venere*,
1641–42, fresco, Florence, Palazzo Pitti

CHARLES-JOSEPH NATOIRE
Venus Requesting Vulcan to Make Arms for Aeneas

38

CHARLES-JOSEPH NATOIRE (1700–1777)
Venus Requesting Vulcan to Make Arms for Aeneas, 1734
Oil on canvas
192 x 138 cm.
Musée Fabre, Montpellier

PROVENANCE
Presented to the Academy on 31 December 1734 as his *morceau de réception*; collection of the *Académie royale de Peinture et de Sculpture*; relocated to the *Muséum*; transferred to the Musée de Montpellier in 1803.

EXHIBITIONS
Brussels 1975, no. 54, ill.; Troyes, Nîmes, and Rome 1977, no. 17, ill.

BIBLIOGRAPHY
Montpellier 1850, no. 319; Duvivier 1952–53, 381 [mistakenly identified as the version in the Louvre]; Montpellier 1859, no. 351; Clément de Ris 1859–61, II, 388; Clément de Ris 1872, 489; Montaiglon 1875–92, V, 149; Lafenestre and Michel 1878, 223 [mistakenly identified as the version in the Louvre]; Michel 1879, no. 615; Mantz 1880, 38; Michel 1890, no. 321; Montpellier 1904, no. 420; Fontaine 1910 (A), 189; Montpellier 1910, no. 420; Chervet 1912, 197 [mistakenly identified as the version in the Louvre]; Montpellier 1914, no. 420; Joubin 1924, 210; Brière 1924, 325; Réau 1925, I, 31 [mistakenly identified as the version in the Louvre]; Joubin 1926, no. 696; Boyer 1949, no. 43; Claparède 1968, IX, no. D 803–I–I4; Kuznetsova and Georgievskaya 1979, under no. 44.

"My dear niece, the idea of commissioning beautiful nudes after Boucher and Natoire to cheer me up in my dotage is the act of a tenderhearted soul, and I am most grateful to you. One should be able to have copies made at little cost."[1] Voltaire's jocular letter of June 1757 sheds light on an opinion, widely held and unquestioned in his day, which cannot be sustained today—namely, that Boucher and Natoire were artists of equal merit. Until Natoire left Paris to take up the directorship of the French Academy in Rome in September 1751, the careers of these two talented, ambitious, and well-patronized history painters had followed very similar paths; indeed, until the arrival of Madame de Pompadour and her faction, it was Natoire who had seemed the more favored of the two. As early as January 1732 Mariette had identified both young artists as preeminent among a generation of gifted practitioners;[2] both participated in the decoration of the hôtel de Soubise and the *cabinet des médailles* at the *Bibliothèque du roi*;[3] it would appear that the two artists even collaborated on the decoration of *pantins*, the puppets that enjoyed such a vogue in the mid-1740s.[4] Natoire and Boucher had been made associate professors of the Academy on the same day, 2 July 1735, and shared the same address, the hôtel de Longueville, rue Saint-Thomas du Louvre, until 1743.[5] If Bachaumont considered them equally prominent, the abbé Raynal gave the palm to Natoire, whom he placed second only to Carle Van Loo.[6]

The relationship between the two artists is best understood in examining Natoire's *Venus Requesting Vulcan to Make Arms for Aeneas*, the *morceau de réception* he presented to the Academy on 31 December 1734. The subject had been given to him on 30 September 1730 by the *premier peintre*, Louis de Boullongne—it had been awarded once before, to Samuel Massé, in September 1705—and Natoire took four years and three months to produce the required painting; only Watteau had tarried longer.[7] Such was the official protection Natoire enjoyed that he was able to fulfill the Academy's principal requirement under the gentlest of conditions: no time limit was imposed, he

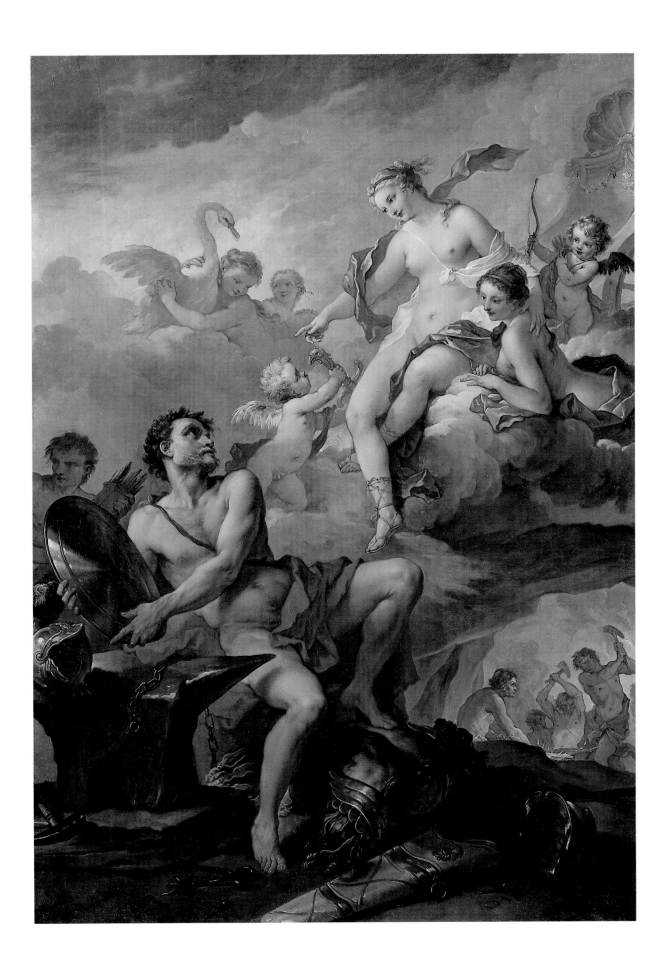

was not reprimanded for his lateness, and he was exempted from paying the *présent pécunaire*, still regularly levied on those who exercised the lesser genres.[8]

Hung thereafter in a position of some prominence in the Academy's assembly room,[9] *Venus Requesting Vulcan to Make Arms for Aeneas* was one of thirty canvases exiled in 1803 to Montpellier, where it constituted the nucleus of the museum that would bear the name of its principal donor, François-Xavier Fabre, after 1825.[10] Just as Natoire's departure from Paris to Rome in the autumn of 1751 had heralded his almost instant eclipse, so the dispatch of his *morceau de réception* to the provinces was responsible for a curious omission in the cataloguing of his *oeuvre*. During the nineteenth century the painting lost its privileged status as Natoire's presentation piece; until 1924 Natoire's overdoor of the same subject (fig. 1), painted for Grimod du Fort, was considered his *morceau de réception* and was discussed as such by Paul Mantz and Henri Chervet, Natoire's first historians.[11] Not that André Joubin's correction of this glaring error was motivated by any particular affection for the painting itself; he described *Venus Requesting Vulcan to Make Arms for Aeneas* as "a mythology of the boudoir and the operetta, which leads directly to *La Belle Hélène*."[12]

The comparison of Natoire and Offenbach does Joubin little honor, but his *boutade* is not altogether wide of the mark. As Alastair Laing has noted of Boucher's *Rinaldo and Armida* (Paris, Musée du Louvre)—his *morceau de réception* of January 1732—such presentation pieces could place a considerable strain on the aspiring academician and were "in some ways more a reflection of the Academy's expectations than of [the artist's] particular gifts."[13] Natoire sought to display his virtuosity as a figure painter and to convey Virgil's narrative as skillfully as possible, hence the piling up of Venus's attendants and the oversized armor in Vulcan's crowded forge. His youthful enthusiasm operated at some cost to his powers of invention; if not "congested to the point of confusion," *Venus Requesting Vulcan to Make Arms for Aeneas* is indeed overcrowded.[14]

Ambitious in the variety of poses and expressions it essays, if simplified and abbreviated in its handling, *Venus Requesting Vulcan to Make Arms for Aeneas* is an impressive work at any level, especially from a *débutant*. As was common in portrayals of Venus and her estranged spouse, the artist has conflated two episodes from the eighth book of Virgil's *Aeneid*: the goddess's return to their "golden nuptial chamber" in order to convince Vulcan to make weapons for her mortal son, Aeneas, and her reception of "arms fit for a brave warrior," which are presented to her hot off the anvil.[15]

Natoire's canvas is an exercise in "*la peinture claire*," with Vulcan's drapery and Aeneas's armor providing the only cold accents in the composition. Illuminated overall by a blond, caressing light, each figure is crisply delineated and carefully modeled in an effort to illustrate as much of the narrative as possible. Yet Natoire's classicism is tempered. Vulcan's handsome Cyclopes, both the figure behind him and those working furiously in the cave at right, are muscular adolescents whose hideous third eyes are not emphasized. Vulcan himself is a precarious mixture of the idealized and the natural. Based on the model Natoire would have studied at the Academy, Vulcan's bright red cheeks and unkempt hair introduce a vivid, if disconcerting, note of realism, as do the veins on his arms and legs and the tufts of hair on his chest and stomach. While more idealized, Venus and the Three Graces, their plump white bodies dusted with pink, are compressed into the upper quadrant of the composition. It is almost as if Natoire ran out of canvas; his massive Vulcan dominates in a strange reversal of priorities which lessens the painting's erotic charge.

It has long been noted that Natoire based his *morceau de réception* on Boucher's *Venus Requesting Vulcan to Make Arms for Aeneas*, painted in 1732 for François Derbais (cat. no. 43)—the first of Boucher's dated works and one with which Natoire was surely familiar.[16] Not only is his overall composition close to that of Boucher's, but Natoire appropriated certain motifs quite shamelessly; he repeats the recumbent female nude, introduced for the first time at upper left in Boucher's painting, not once, but twice, and the bearded Vulcan follows Boucher's hero in all particulars except the most provocative. Even the armor is the same. The sword that Vulcan holds in Boucher's *Venus Requesting Vulcan to Make Arms for Aeneas* is identical to that borne aloft by the blue-winged putto in Natoire's composition; in both, the distinctive gilded shaft bears the profile of a ferocious eagle. Whether Natoire simply copied Boucher or whether both painters had access to the same studio props—in this case, armor *alla romana*—is a question that would merit further investigation.[17]

As the model for a *morceau de réception* which would be on continuous display in the Academy's assembly rooms, Boucher's *Venus Requesting Vulcan to Make Arms for Aeneas* presented obvious difficulties. Natoire was obliged to do more than plagiarize; he civilized Boucher's explicit composition. Yet Natoire's mythology has a well-documented gestation of its own and can be shown to have been carefully worked out and significantly revised before being submitted to the Academy in December 1734. A preliminary compositional drawing in black and white chalks with

touches of sanguine, of the utmost delicacy (fig. 2), offers a *mise en page* that differs quite radically from the painting itself.[18] While the general groupings and pronounced diagonal axis would remain unchanged—Natoire has followed Boucher even more closely in balancing Venus with a group of attendants at upper left—the composition evolves out of a quite different tradition: religious painting of the Italian Baroque, especially the altarpieces that Natoire had studied so carefully during his travels in Emilia on his return to Paris from Rome. In his drawing for *Venus Requesting Vulcan to Make Arms for Aeneas*, the goddess has more the appearance of a Madonna enthroned, Vulcan and his attendants might be a group of supplicants, and the figure on Venus's left, who looks out at the viewer, seems more suited to a misericord than to a mythology.[19]

Accordingly, it was the figure of Venus that needed the greatest revision if a transformation from the sacred to the profane was to be made. She was studied from life in a beautiful red and white chalk drawing (fig. 3) in which Natoire took particular care with her right hand, repeating it separately at the bottom right of the sheet.[20] Through this change alone, Venus now commanded instead of offering comfort. The drawing would be followed line for line in the final painting, but with one significant difference: Natoire softened his model's tense expression into a smile. Finally, Natoire produced a quickly brushed oil sketch (fig. 4), signed at the foot of the anvil, in which he laid out the final composition in all its essentials.[21] He deviated from it only twice in the *morceau de réception* itself, suppressing the stick and rope in the upper left of the sketch and consigning the energetic Cyclops with the raised mallet at lower right to the mouth of the cave.

Highly prized in the eighteenth century, this luminous *modello* was accurately described as "a very fine finished sketch" in the sale of the abbé de Gevigney,[22] and, rather less so, as "without doubt one of Natoire's most beautiful paintings" at the d'Ennery sale of December 1786.[23] Listed by Boyer as "either a sketch or a *ricordo*," it is surely to be placed in the former category.[24] According to the Academy's statutes,

history painters and sculptors were required to produce a sketch for approval before going on to execute the finished work, which, moreover, had to be completed on the premises. By the 1720s these rules were not always rigorously imposed, despite an injunction of 28 February 1711, repeated the following year, reminding members that "both the sketch and the painting should be done in the Academy."[25] Among Natoire's contemporaries, Dumont le Romain, Jeaurat, and Carle Van Loo all followed the regulations regarding the submission of sketches for the Academy's approval.[26] Although Natoire was not required to present a sketch for approval, nor to paint *Venus Requesting Vulcan to Make Arms for Aeneas* in the Academy or in the presence of one of its officers, it would nonetheless seem that he followed this procedure informally. Whether his sketch was ever officially approved is not known, but the ease with which he went on to complete his *morceau de réception*, in which few revisions are evident, suggests the soundness of the Academy's methods.

If the process by which Natoire arrived at *Venus Requesting Vulcan to Make Arms for Aeneas* was lengthy and ponderous, his careful preparations paid off. He would return to the subject at least twice more: in an overdoor representing the element of Fire for Grimod du Fort and in a composition for the duc de Chevreuse engraved by Jean-Jacques Flipart in 1762.[27] Thereafter, the rosy-cheeked figure of Venus assumed canonical status in Natoire's *oeuvre*; pert, blond, and long-legged, she would reappear in many mythologies and is the pliant and coaxing goddess in the recently discovered *Venus and Adonis* (fig. 5).[28]

Yet, in the end one is compelled to judge Natoire's *Venus Requesting Vulcan to Make Arms for Aeneas* on the terms he himself had established—that is, by comparison with Boucher's prototype. And here Mantz's conclusions remain valid. Natoire, he argued, was overwhelmed by Boucher's "silver brush" and the "radiance of his bright painting . . . [He] was never more than a sweetened and diminished version of Lemoyne: and among his faded whites touched occasionally by yellow he scattered the rose petals gathered in his master's garden."[29]

NOTES

1. Besterman 1953–77, XXXI, 203, "Votre idée, ma chère nièce, de faire peindre de belles nudités d'après Natoire et Boucher pour ragaillardir ma vieillesse est d'une âme compatissante, et je suis reconnaissant de cette belle invention. On peut aisément en effet faire copier à peu de frais," Voltaire to Marie-Elisabeth de Dompierre de Fontaine, June 1757.

2. Bottari 1822–25, II, 331, Mariette to Gabourri, 28 January 1732, "Monsu Natoire et Monsu Boucher m'hanno ciascun promesso uno de loro disegni. Io ho già parlato al primo per aver il suo ritratto ma egli no vuol sentir parlare. Monsu Boucher sarà piu facile a convertire." In a previous letter, undated, Mariette had referred to Natoire as "un bravissimo intagliatore," ibid., 291.

3. Pons in exh. Paris and Lunéville 1986, 221–35; Ananoff and Wildenstein 1976, I, 364–65, no. 246, for Boucher's overdoors at the Bibliothèque Nationale, painted in 1746; Violette in exh. Troyes, Nîmes, and Rome 1977, 43, for Natoire's contribution to that series.

4. Ananoff and Wildenstein 1976, I, 32.

5. Montaiglon 1875–92, V, 160; Laing in exh. New York, Detroit, and Paris 1986–87, 23, and Violette in exh. Troyes, Nîmes, and Rome 1977, 42, both citing the *Almanach Royal*.

6. Lacroix 1857, V, 419; Raynal in Tourneux 1877–82, I, 462, "Nouvelles Littéraires," 24 August 1750, "Natoire qui va prendre la place de de Troy à Rome, est notre plus grand peintre après Vanloo."

7. Montaiglon 1875–92, V, 78; ibid., IV, 15; Massé's *morceau de réception* is in Paris, École Nationale Supérieure des Beaux-Arts; Watteau took five years and one month to produce *The Embarkation to the Island of Cythera*.

8. Montaiglon 1875–92, V, 149; Chardin, who was admitted and received on the same day, 28 September 1728, had to pay the "modified *présent pécunaire*" of 100 *livres*, ibid., 48.

9. Fontaine 1910 (A), 189; Natoire's *morceau de réception* hung in the *salle d'assemblée* next to Pellegrini's *Painting and Drawing Instructing Cupid* (Paris, Musée du Louvre).

10. Clément de Ris 1872, 263–64, 489.

11. Mantz 1880, 38, "Vénus est là, avec les Amours, et aussi un Vulcain ridicule"; Chervet 1912, 197, 203; Brière 1924, 325, rectified the error in the Louvre's previous catalogues.

12. Joubin 1924, 210, "mythologie de boudoir, voire d'opérette, qui conduit droit à *La Belle Hélène*."

13. Laing in exh. New York, Detroit, and Paris 1986–87, 160.

14. Ibid., Laing's apt phrase for Boucher's *Rinaldo and Armida*.

15. Virgil, *The Aeneid*, VIII, 372, 441.

16. Claparède 1968, IX, no. D 803–I–I4; Vilain in exh. Brussels 1975, 97, and in exh. Troyes, Nîmes, and Rome 1977, 61; Laing in exh. New York, Detroit, and Paris 1986–87, 135.

17. I am grateful to Donald LaRocca, Assistant Curator of Arms and Armor at The Metropolitan Museum of Art, for discussing this issue with me.

18. Vilain in exh. Troyes, Nîmes, and Rome 1977, 60, no. 16.

19. Bean 1986, 186, no. 204, for Natoire's copy after Lanfranco's *Holy Family Appearing to Saint Francis* as an example of such models.

20. As Vilain in exh. Troyes, Nîmes, and Rome 1977 pointed out, there is a copy of this drawing in Lyons, Musée des Beaux-Arts (inv. 1962–238).

21. Kuznetsova and Georgievskaya 1979, no. 44; an unpleasant copy after this sketch is to be found in The Detroit Institute of Arts (89.670). I am grateful to Patrice Marandel for allowing me to see his unpublished catalogue entry on this painting.

22. *Catalogue d'une riche Collection de tableaux des peintres le plus célèbres des différentes écoles . . . qui composent le cabinet de M. [de Gevigney]*, Paris, 1 December 1779, no. 544, "une très-belle esquisse terminée."

23. *Catalogue de tableaux des trois écoles . . . du cabinet de feu M. d'Ennery*, Paris, 11 December 1786, no. 27, "ce tableau est, sans contredit, un des plus beaux de son auteur."

24. Boyer 1949, 39, no. 45, "esquisse ou réduction."

25. Montaiglon 1875–92, IV, 152, 30 July 1712, "Qu'ils seront tenus de faire dans un lieu de l'Académie l'exquisse ou le tableau qui leur sera donné pour ouvrage de réception, s'ils sont Peintres . . ."

26. Closer in date to Natoire's own presentation, the history painter Dumont le Romain seems to have followed this procedure to the letter. *Agréé* on 28 June 1726, Dumont le Romain submitted a sketch for his *morceau de réception* on 10 January 1728 and, on the strength of this, was given six months to produce *Hercules and Omphale* (Tours, Musée des Beaux-Arts), which he painted in the Academy itself, Montaiglon 1875–92, V, 38, 140; Jeaurat and Delobel, with whom Natoire had studied in Rome, both presented sketches for their *morceaux de réception* on 28 February 1733 and were required to execute the works "under supervision," a procedure followed also by Carle Van Loo and Dandré-Bardon, ibid., 98, 115, 146.

27. Rosenberg in exh. Troyes, Nîmes, and Rome 1977, 65–66, for Natoire's commissions for Grimod du Fort; for the recently discovered *Ceres Giving Nourishment to Triptolemes*, which represented earth in this series, Pinette 1983, 397–98; Bibliothèque Nationale 1930–[1977], IX, 229, for Flipart's engraving, incorrectly related to Natoire's *morceau de réception* by Vilain in exh. Troyes, Nîmes, and Rome 1977, 61.

28. Nichols 1990, 4–6.

29. Mantz 1880, 47, "son pinceau d'argent, et le rayonnement de sa claire peinture"; ibid., 54, "Natoire n'a jamais été qu'un Lemoyne adouci et atténué: il a semé dans les blancheurs fades et mélangées parfois d'un peu de jaune les pétales des roses qu'il avait cueillies au jardin de son maître."

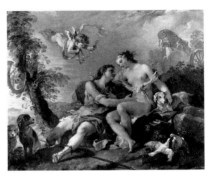

FIG. 1
Charles-Joseph Natoire, *Venus Requesting Vulcan to Make Arms for Aeneas (The Element of Fire)*, c. 1740, oil on canvas, Autun, Musée Rolin

FIG. 4
Charles-Joseph Natoire, *Venus Requesting Vulcan to Make Arms for Aeneas*, c. 1734, oil sketch, Leningrad, The Hermitage

FIG. 5
Charles-Joseph Natoire, *Venus and Adonis*, c. 1740, oil on canvas, Philadelphia Museum of Art

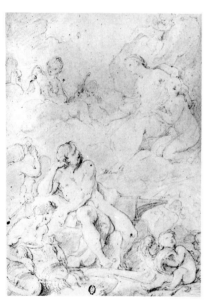

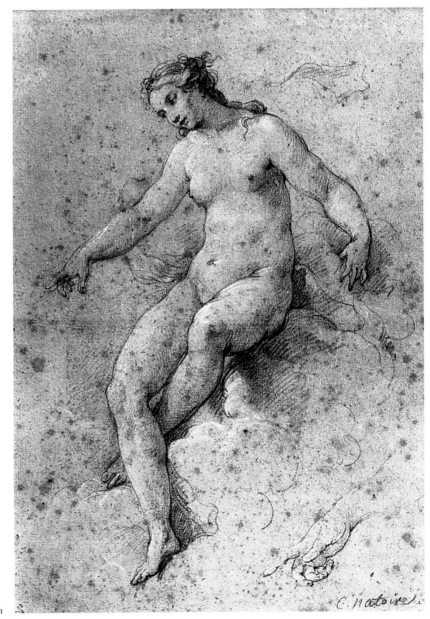

FIG. 2
Charles-Joseph Natoire, *Venus Requesting Vulcan to Make Arms for Aeneas*, c. 1734, black and white chalk drawing, Paris, Bibliothèque Nationale, Cabinet des Estampes

FIG. 3
Charles-Joseph Natoire, *Study of Venus*, c. 1734, red and white chalk drawing, Vienna, Graphische Sammlung Albertina

CHARLES-JOSEPH NATOIRE
The Toilet of Psyche

39

CHARLES-JOSEPH NATOIRE (1700–1777)*
The Toilet of Psyche, c. 1735
Oil on canvas
198 x 169 cm.
New Orleans Museum of Art: Purchased through the Bequest of
Judge Charles F. Claiborne

PROVENANCE
Commissioned c. 1734–35 by Louis-Denis de La Live de Belle-
garde (1679–1751) for the château de la Chevrette; Joseph-
Hyacinthe-François de Paule de Rigaud, comte de Vaudreuil
(1740–1817), his sale, Paris, 26 November 1787, no. 78 [sold with
Vénus qui défend à l'Amour de voir Psyché], purchased by Beauvar-
let for 1,360 *livres*; Jacques-Firmin Beauvarlet (1731–1797), his
sale, Paris, 13 March 1798, no. 26 [sold with *Vénus qui défend à
l'Amour de voir cette divinité*], sold for 201 *livres*; Joseph Bonaparte
(1768–1844), his sale, Bordentown, New Jersey, 17–18 Septem-
ber 1845, no. 17 [as *Toilet of Venus*]; James Robb, New Orleans,
between 1845 and 1859, his sale, New Orleans, 1 March 1859, no.
78; Randolph Newman, New Orleans; acquired by the New Or-
leans Museum of Art in 1940.

EXHIBITIONS
Boston 1845, no. 17; Toledo, Chicago, and Ottawa 1975–76, no.
72, ill.; St. Petersburg 1982–83, no. 48, ill.; Little Rock 1983; Mi-
ami 1984, 161, no. 87, ill.; Orléans 1984, no. 7, ill.

BIBLIOGRAPHY
The Broadway Journal, 30 August 1845, 195; Robb 1859, no. 78;
Hawkins 1892, no. 13; Bertin 1893, 416, no. 52; New Orleans
1914, no. 103; New Orleans 1932, no. 2084; Boyer 1949, no. 115
[as "Vénus à sa toilette"]; Rutledge 1955, 149 [as "Toilette of
Venus"]; Benisovich 1956, 298, ill.; Polley et al. 1967, 91, ill.;
Toledano and Fulton 1968, 789; Hiesinger 1976, 13–15, ill.;
Caldwell and McDermott 1980, 50, ill.; Perkins and Gavin 1980,
102 [as "The Toilet of Venus"]; Jordan 1984, 7, ill.; exh. Paris and
Lunéville 1986, 263, 267; Yarnall and Gerdts 1986, IV, 2562, no.
65527; Bailey 1989, 25, ill.

*Exhibited in Paris only

D
uring the 1730s Natoire depicted episodes
from the tale of Psyche's much-tested love for Cupid
—recounted by Apuleius in *The Golden Ass* and told
anew in 1669 by La Fontaine in *Les Amours de Psyché
et de Cupidon*—in no fewer than three decorative cy-
cles. Between 1736 and 1738, Psyche's travails pro-
vided the subject of eight canvases for the renovated
salon ovale at the hôtel de Soubise, Natoire's and Bof-
frand's most celebrated commission.[1] Natoire painted
overdoors with episodes from this story for the hôtel
de Montmorency, rue Saint-Honoré, whose history is
still to be told in full.[2] And he decorated the *salon* of
the château de la Chevrette at Saint-Denis, to the
north of Paris, with four large history paintings in-
spired by this myth; it is this commission, the earliest
of the three, that concerns us here.[3]

The château de la Chevrette (fig. 1) was acquired
on 24 November 1731 by the extremely wealthy *fer-
mier général*, Louis-Denis de La Live de Bellegarde
(1679–1751), "born and bred in the affairs of the
Ferme . . . of great devotion, extremely charitable and
without the slightest arrogance: *un tout honnête
homme*."[4] The most notable refurbishment undertak-
en by the new proprietor involved the creation of a
salon, "made in such a way that one was able to lower
four paintings which instantly divided the room in
two."[5] The authorship of these paintings is first men-
tioned in the *Catalogue Historique* (1764) of La Live
de Jully's collection; the pioneering collector of
French paintings was the chatelain's second son.[6] In
the brief biography of Natoire that Mariette con-
tributed to this publication, "the Psyche paintings at
the château de la Chevrette near Saint-Denis" are in-
cluded among the artist's most noteworthy achieve-
ments.[7] Luc-Vincent Thiéry recorded the subject of
two of them in 1786; his *Guide des Amateurs* listed
"two large paintings by Natoire" in the *petit salon* of
the hôtel de Vaudreuil, hanging opposite the win-
dows, "one showing Psyche at her Toilette, the other
Cupid carrying Psyche through the air."[8]

This is more or less how the pair of paintings
would be described in both the Vaudreuil and Beau-
varlet sales. In the hastily prepared catalogue of the

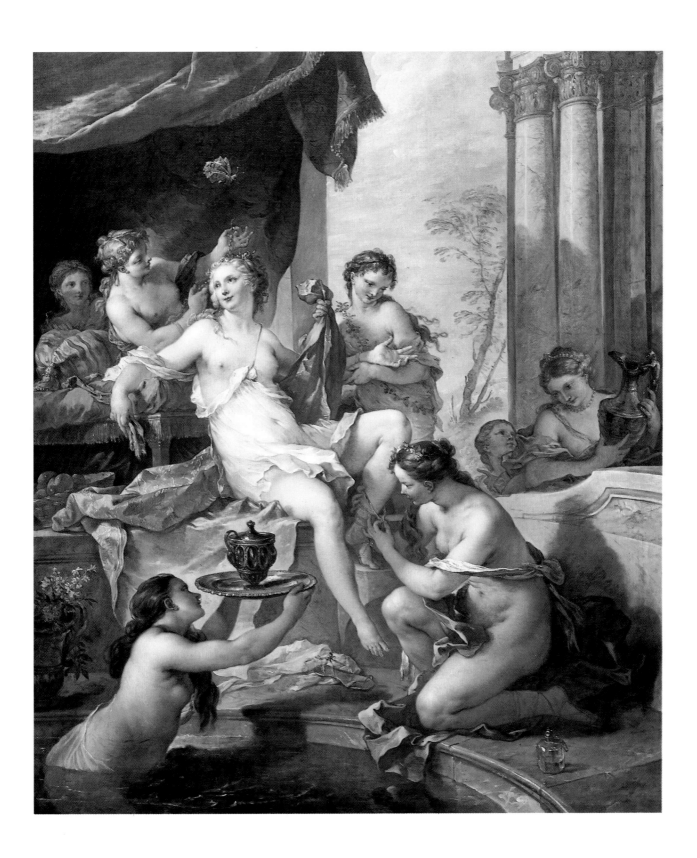

former, Lebrun listed the companion to *The Toilet of Psyche* as representing "Venus who forbids Cupid to see Psyche," and recorded the dimensions of both paintings as "27 [*sic*] inches in height by 63 inches in width."[9] In Beauvarlet's posthumous sale of March 1798, the titles remained the same, but the dimensions were given as "8 feet 3 inches [*sic*] in height, 5 feet 3 inches in width."[10] As Patrick Violette has noted, Lebrun had substituted "27" for "77"; with the dimensions corrected, they match those of *The Toilet of Psyche*, until very recently the single canvas from this series to have survived.[11]

Violette is also to be credited with identifying a preparatory drawing for *The Toilet of Psyche*'s companion. *Venus Showing Psyche to Cupid* (fig. 2), a relatively finished drawing made, perhaps, for presentation to the patron (or the architect), shows a scene that corresponds to the rather vague eighteenth-century descriptions of the painting, and its figures manifest their kinship to those in the canvas from New Orleans.[12] The precise subject of this drawing is to be found in Apuleius's text; it comes from the beginning of the fourth book of *The Golden Ass* in which Venus, angered and insulted by the adulation that Psyche's great beauty commands, importunes Cupid, her "winged son . . . rash enough and hardy," to assist her in taking vengeance on the upstart princess: "She egged him forward with words and brought him to the city, and showed him Psyche (for so the maiden was called)."[13] In Natoire's drawing, Venus, borne aloft by infant zephyrs, has left her chariot in order to point out the victim whom Cupid is to inflame with "wretched love" for "the most miserable creature living." Psyche, seated on a rock, holds court to her followers, unaware of the cruel plot that is being hatched against her.[14]

However, with regard to Natoire's remaining paintings for the *salon* at la Chevrette we are on less solid ground, despite Violette's ingenious attempt at reconstruction. Two works remain to be identified, and for these Violette has proposed Natoire's lost oval of *Cupid and Psyche* in La Live de Jully's collection and a drawing of *Psyche Obtaining the Elixir of Beauty from Proserpine* (fig. 3), formerly owned by the comte d'Orsay.[15] Only the second suggestion is tenable. If one imagines the mobile partition dividing the *salon* at la Chevrette, which Diderot recalled as being both "sad and magnificent," it is clear that two large vertical paintings would have been required for either side of this temporary wall.[16] *Venus Showing Psyche to Cupid*, paired with *The Toilet of Psyche*—both episodes occurring at the beginning of the tale—most probably hung together on one side of the partition. If we accept the d'Orsay drawing as a design for the third painting on

the basis of its handling, the scale of its figures, and the similarities in Psyche's costume, a fourth drawing—most probably representing an episode from the second half of the story—remains to be discovered to complete the series.

Despite the fragmentary visual and documentary evidence for Natoire's first Psyche series, his activities at la Chevrette can be dated quite precisely. Visiting Rome in December 1767, Alexis-Janvier de La Live de La Briche, the youngest of La Live de Bellegarde's children, paid a call on the aging director of the French Academy, by then a figure almost forgotten in Paris: "I've just met old Natoire . . . and he reminded me of the time when he was in the service of my father at la Chevrette and needed a child to model for one of the figures for his paintings. My father said to him, 'Here's one, use him'; the child was I, who had just been born!"[17] Alexis-Janvier was born 13 February 1735, and if his recollection is accurate—he may well have been used as a model for one of the zephyrs in *Venus Showing Psyche to Cupid*—it would date the series to between 1735–36, a chronology also defensible on stylistic grounds.[18] Thus, Natoire's decorations at la Chevrette would seem to anticipate his work at the hôtel de Soubise by at least a year. Is it possible that Boffrand had seen these canvases before handing Natoire the lion's share of the painted decoration for that *hôtel*?

The Toilet of Psyche was Natoire's most accomplished history painting to date. His assembly of smiling, red-cheeked nymphs—Rubensian in their proportions, Lemoinean in their blondness—represents a considerable improvement on the ill-digested, multifigured compositions for Orry at La Chapelle-Godefroy and, closer in time, his well-intentioned, but constrained, *morceau de réception* for the Academy (cat. no. 38). *The Toilet of Psyche* treats an episode that follows *Venus Showing Psyche to Cupid*. In plotting her revenge against Psyche, Venus also enlisted Apollo's aid; his oracle informed Psyche's father that she would be married to a serpent, "dire and fierce," who would come for her on a rock at the top of the highest hill. Psyche bravely prepared herself for this "funeral marriage" and was led to the designated meeting place, where she was left "weeping and trembling."[19] At this point Cupid intervened and summoned Zephyr, god of the West Wind, to deliver Psyche to his enchanted palace, where, as in Natoire's painting, she was bathed and nourished in preparation for their first encounter. Cupid visited Psyche each night thereafter, always leaving before the break of day and concealing his identity from her. Encouraged by her envious sisters, who claimed that her consort was indeed a man-eating serpent, Psyche

cast the flame of a lamp on Cupid as he slept, revealing his beauty and confirming her love for him. A drop of burning oil from the lamp caused the god to wake, and, furious at Psyche for disobeying his orders, Cupid left the enchanted palace and broke off their marriage.[20] Psyche's arduous search for her lost husband completes Apuleius's saga.

In *The Golden Ass*, Psyche is "moved with delectation" at the sight of the beautiful palace. She is invited to enter the chamber and take repose upon the bed, "and desire what bath you will have, and we, whose voices you hear, be your servants, and ready to minister unto you according to your desire."[21] According to La Fontaine, Apuleius's disembodied voices were an infelicitous device, since they rendered Psyche's solitude both "tedious and frightening."[22] He chose to improve upon the original by having Psyche served by nymphs who dress her, divert her agreeably, and provide entertainment. La Fontaine described these scenes in some detail—he owned that the taste of his century ran to the *galant*—leading Psyche through a series of magnificently attired rooms to a mirrored *cabinet*, where she is undressed and waited upon by a "troupe of nymphs."[23]

It is this moment that Natoire represents, although in his canvas Psyche's bathroom and bedroom occupy an indeterminate location, half indoors, half *al fresco*. The large butterfly with scarlet dots on its wings, hovering above Psyche's head, attests to Natoire's familiarity with the allegorical interpretation of this myth as the progress of the Soul guided by Love.[24] Yet this sumptuous mythology is hardly platonic; it is an exuberant and wholehearted celebration of the female body. The virgin princess, whose lily-white flesh is a sign both of her nobility and purity, is seated upon a dazzling orange brocade, her right arm draped casually across the daybed behind her. The nymphs remove her clothing and sandals in preparation for her bath; a vial of perfume can be seen at the pool's edge. These activities take place outdoors in the light of a perfect summer's afternoon.

In *The Toilet of Psyche* Natoire's handling is deft. His canvas is quickly painted, its herringbone weave visible to the naked eye through the thin paint surface. Psyche and the four servants who enframe her are described with considerable attention to both detail and surface—less so the ancillary figures in the background, who are little more than sketched in. Relatively few changes, all of them slight, are apparent on the canvas itself; Psyche's sandal has been moved forward, the face of the attendant carrying an ewer at right has been reworked, and Natoire seems to have hesitated over the position of the index finger of Psyche's right hand.

Yet on the whole Natoire's composition is painted with great fluency, not surprisingly, since he probably prepared each figure carefully beforehand; like Lemoyne, Natoire regularly made finished compositional drawings as well as life studies for his principal figures. Only one drawing survives for *The Toilet of Psyche*, a female *académie* for the figure of Psyche (fig. 4), which the artist has followed exactly in the finished painting.[25]

Radiant and harmonious in coloring and effortless in its grouping of naked figures thoroughly absorbed in the ritual of the toilette, Natoire's mythology brilliantly masks the composite sources upon which it is based. In fact, *The Toilet of Psyche* is an amalgam of references, attitudes, and quotations. As a model for the composition, Natoire may have looked to *The Bath of Psyche* (fig. 5) from the Gobelins tapestry series *Les Amours de Psiché*, commissioned in 1686 and based on Giulio Romano's *Bath of Venus and Mars* in the Palazzo del Té.[26] Psyche's circular marble bath and the ornate vessels carried by the nymphs suggest that Natoire was familiar with Giulio's decorations in one form or another; Félibien, it should be noted, had earlier recommended this series to aspiring history painters of the Academy.[27]

Individually, the figures in *The Toilet of Psyche* adopt poses and gestures which derive from different subjects altogether. The figure of Psyche at her bath would not be out of place as the heroine in the Old Testament subject of David and Bathsheba, and indeed there is strong resemblance between the central group in *The Toilet of Psyche* and Maratta's *Bathsheba at the Bath* (fig. 6), an oval decoration Natoire could have seen at the Pallavicini palace in Rome during his student days.[28] The kneeling nymph who unties Psyche's sandal is a figural type common in representations of Diana at the Bath; her companion, who inexplicably performs her duties up to her waist in water, is a displaced nereid who should more properly inhabit a marine mythology.

In *The Toilet of Psyche* Natoire also pillages the work of his fellow academicians. The composition is very close to that of Cazes's *Toilet of Venus* (fig. 7), although there is no way of proving that Natoire would have had access to this drawing, of which at least three versions survive.[29] Natoire's auburn-haired nymph with puffy eyes who removes Psyche's headdress is borrowed from a figure in Boucher's *Rape of Europa* (London, Wallace Collection) and is of a completely different facial type from her more refined companions.[30] Finally, the dramatic baldachino above Psyche's bed, in perilous proximity to the bath, is a late baroque device that had been used by Boucher in *Hercules and Omphale* (cat. no. 42), but which

ultimately derives from Lemoyne's masterpiece of the same subject (cat. no. 23).[31]

While *The Toilet of Psyche* relies upon various sources and integrates them masterfully—it is among the most synthetic of Natoire's large-scale compositions—it, in turn, became a model of sorts. In furnishing Boucher with a program for ten *tableaux* relating to the story of Psyche—the artist was commissioned to produce six tapestry cartoons for Beauvais in 1737[32]—Bachaumont's description of *The Toilet of Pysche* brings Natoire's canvas instantly to mind: "The Toilet of Psyche surrounded by the nymphs who serve her. What beautiful vessels of gold and crystal! What fine incense burners with their smoke and perfume! How beautiful and richly attired is Psyche's chamber: in the background one can see part of the alcove in which there is a baldachino bed that makes one's mouth water."[33] Everything about this description, from the crystal vases to the "mouth-watering bed," evokes Natoire's painting. But, if Bachaumont could encourage Boucher to reread La Fontaine, study engravings after Raphael,

and look at his beautiful wife for inspiration, he would have seriously compromised his standing as an eminent connoisseur in proposing Natoire's latest production as a venerable model.[34]

If Natoire's *Toilet of Psyche* enjoyed a celebrity of sorts in its own day, its fortunes in the following century took quite a different and unexpected turn. After passing from Joseph Bonaparte's collection at Point Breeze to that of the Louisiana banker James Robb in New Orleans, *The Toilet of Psyche* could claim to be by far the best-known example of rococo painting in America, exhibited seven times in three cities between 1845 and 1884 and copied for a Philadelphia collector.[35] Within weeks of its acquisition by Robb, and some thirty years before Boucher's great *Marches* entered the Museum of Fine Arts, Natoire's *Toilet of Psyche* was exhibited at Boston's Avery Hall.[36] Much admired in the press, the painting was described by *The Broadway Journal* in September 1845 as "mellow and of a pleasing tone . . . the figures natural and the head of Venus [sic] charmingly executed."[37]

NOTES

1. Pons and Violette in exh. Paris and Lunéville 1986, 221–35, 255–62.

2. Violette in exh. Paris and Lunéville 1986, 262; the only other reference to this commission is Champeaux 1898, 276. Violette's *thèse d'État* on Natoire is eagerly awaited.

3. Violette in exh. Paris and Lunéville 1986, 262–67, for the most thorough account.

4. Bailey 1988 (A), ix, citing the opinion expressed in the Bibliothèque Nationale, MS. f.f. 14077, *Mémoire pour servir à l'histoire de publicanisme moderne*, fol. 145, "il a pour ainsi dire été nourry dans les emplois des Fermes Générales . . . d'une grande dévotion, fort charitable, point fier et très honnête homme."

5. Dufort de Cheverny 1886, I, 86, "au milieu duquel était un salon fait de telle manière que, avec des ressorts on baissait quatre tableaux et qu'à l'instant on jouissait de deux salons."

6. Bailey 1988 (A), ix–xi. The *inventaire après décès* of both Marie-Josephe Prouveur de Preux (1697–1743) and La Live de Bellegarde, which might have shed light on the interior decoration at la Chevrette, are missing from the much-damaged *étude* LVI (Maître Dutartre) in the *Minutier Central*.

7. La Live de Jully 1764, 57, "les tableaux de Psiché au château la Chevrette près S. Denys."

8. Thiéry 1787, 543–44, "en face des croisées sont deux grands tableaux de Natoire: l'un fait voir Psyché à sa toilette, l'autre, l'Amour lui faisant traverser les airs."

9. *Catalogue d'une très-belle collection de tableaux d'Italie, de Flandres, de Hollande, et de France . . . provenans du cabinet de M. [le comte de Vaudreuil]*, Paris, 26 November 1787, no. 78, "l'un représente Vénus qui défend à l'Amour de voir Psyche . . . elles ont été peintes du bon tems de ce maître pour le château de la Chevrette, hauteur 27 pouces [sic], largeur 63 pouces."

10. *Catalogue de Tableaux, la plupart de Peintres de l'École Française . . . après le décès du C^en Beauvarlet, Graveur*, Paris, 13 March 1798, no. 26, "hauteur 8 pieds 3 pouces [sic], largeur 5 pieds 3 pouces."

11. Violette in exh. Paris and Lunéville 1986, 263; *Venus Showing Psyche to Cupid* reappeared at Christie's, London, 5 July 1991, no. 66, as this catalogue was going to press.

12. Ibid., 262; the drawing appeared most recently at Sotheby's, New York, 12 June 1982, no. 40, as *Cupid and Psyche*. The subject appears on one of the triangular paintings in Raphael's *sala di Psyche* at the Villa Farnesina, Dussler 1971, 97.

13. Apuleius, *The Golden Ass*, IV, 31.

14. Ibid.

15. Violette in exh. Paris and Lunéville 1986, 264; Méjanès in exh. Paris 1983 (A), 121–22, no. 106, was the first to make the connection between *Psyche Obtaining the Elixir of Beauty from Proserpine* and the decorative ensemble at la Chevrette.

16. Rey 1904, 82, for Diderot's letter of 15 September 1760 to Sophie Volland describing a day spent in "ce triste et magnifique salon."

17. Buffenoir 1905, 142, "J'ai retrouvé ici avec grand plaisir le vieux Natoire . . . , il m'a rappelé le temps où étant avec mon père à la Chevrette, il cherchait un enfant pour mettre dans un de ses tableaux, et mon père lui dit: En voilà un! C'était moi qui venait de naître," reproduced by Violette in exh. Paris and Lunéville 1986, 266, and cited in Bailey 1988 (A), xi.

18. This corrects a later dating of c. 1745 proposed by Rosenberg in exh. Toledo, Chicago, and Ottawa 1975–76, 59.

19. Apuleius, *The Golden Ass*, IV, 32–33.

20. Ibid., V, 1–31 passim.

21. Ibid., 2.

22. La Fontaine 1965, 404, "Apulée fait servir Psyché par des voix dans un lieu où rien ne doit manquer à ses plaisirs, c'est-à-dire qu'il lui fait goûter ces plaisirs sans que personne paraisse. Premièrement, cette solitude est ennuyeuse; outre cela elle est effroyable."

23. Ibid., 405, 411, "une troupe de Nymphes la vint recevoir jusque par-delà le perron."

24. Mirimonde 1968, 2–4.

25. Rosenberg in exh. Toledo, Chicago, and Ottawa 1975–76, 59.

26. Standen 1964, 143, 149, who further notes that the subject of Guilio's *Mars and Venus* had been confused since the Renaissance as representing *Psyche Taking Her Bath*. The *Toilet of Psyche* was not among the subjects treated by Raphael at the Villa Farnesina.

27. Félibien 1725, III, 185–86; the *Entretiens* had been republished as recently as 1725.

28. Christie's, London, 9 April 1990, no. 66A.

29. Rosenberg and Julia 1986, 356–57.

30. Ingamells 1989, 64–65.

31. Bordeaux 1984 (A), 93–95.

32. Hiesinger 1976, 7–23, remains the definitive account of Bachaumont and Boucher's "collaboration"; Laing in exh. New York, Detroit, and Paris 1986–87, 189, makes some apposite revisions to her argument.

33. *Portefeuille de Bachaumont* in Ananoff and Wildenstein 1976, I, 18, "La toilette de Psiché environnée de Nymphes qui la servent. Que de beaux vases d'or et de cristal! Que de belles cassolettes qui fument et parfument! Que la chambre de Psiché est belle et riche, on voit dans le fond une partie d'Alcôve sous laquelle il y a un lit en Baldaquin qui fait venir l'eau à la bouche."

34. Ibid., 19, "on peut voir aussi par curiosité la Psiché de Raphael gravée par Marc Antoine à ce que je crois chés M^r. Crozat, et chés Messieur Mariette. Ce qu'il y a de mieux à faire c'est de lire et re-lire la Psiché de La Fontaine et surtout bien regarder Madame Boucher." Boucher's tapestry of *The Toilet of Psyche* is indebted neither to Bachaumont nor Natoire.

35. Benisovich 1956, 296–98; Jordan 1984, 6–7; for its exhibition in Boston and New Orleans, Yarnell and Gerdts 1986, IV, 2562; for the copy in James Harrel's collection, Yarnell and Gerdts 1986, IV, 2562, no. 65529.

36. *Catalogue of Fourteen Valuable Paintings formerly the Property of the late Joseph Bonaparte*, Boston, 1845; Robb's purchases were being restored by George Howorth of Boston and were exhibited in that city "by permission for a few days."

37. *The Broadway Journal*, 30 August 1845, 195. I am grateful to Dodge Thompson for all the references to the nineteenth-century provenance of *The Toilet of Psyche*.

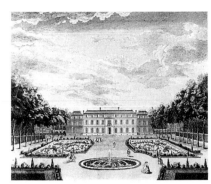

FIG. 1
After Dupin de Franqueil, *View of the château de la Chevrette*, engraved by Ange-Laurent de La Live de Jully, Paris, Bibliothèque Nationale, Cabinet des Estampes

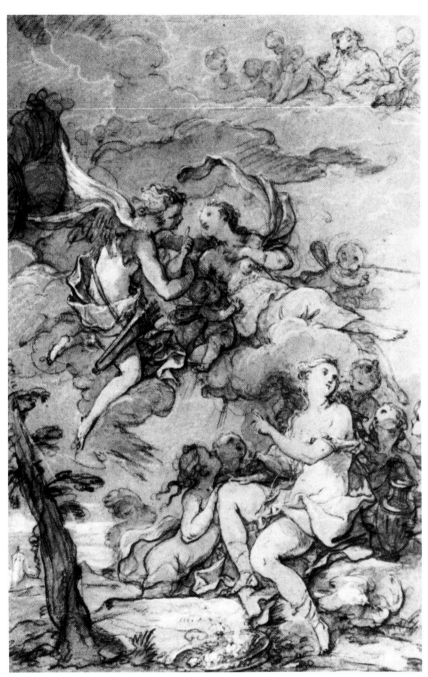

FIG. 2
Charles-Joseph Natoire, *Venus Showing Psyche to Cupid*, c. 1735, black chalk and gray wash drawing heightened with white, Private Collection

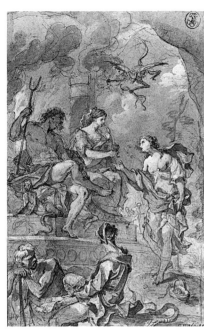

FIG. 3
Charles-Joseph Natoire, *Psyche Obtaining the Elixir of Beauty from Proserpine*, c. 1735, black chalk and brown wash drawing with white highlights, Paris, Musée du Louvre, Cabinet des Dessins

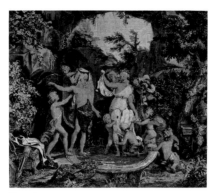

FIG. 5
After Giulio Romano, *The Bath of Psyche*, 1686, Gobelins tapestry, New York, The Metropolitan Museum of Art, gift of Julia A. Berwind, 1953

FIG. 7
Pierre-Jacques Cazes, *The Toilet of Venus*, pen and gray ink and gray wash drawing, Paris, Private Collection

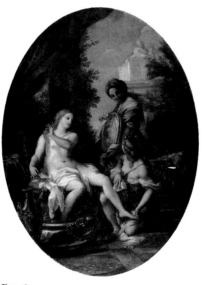

FIG. 6
Carlo Maratta, *Bathsheba at the Bath*, c. 1700, oil on canvas, Private Collection

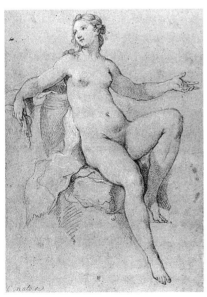

FIG. 4
Charles-Joseph Natoire, *Study of Psyche*, c. 1735, black chalk drawing with white highlights, London, The British Museum

CHARLES-JOSEPH NATOIRE
The Triumph of Bacchus

40

CHARLES-JOSEPH NATOIRE (1700–1777)
The Triumph of Bacchus, 1747
Oil on canvas
199 x 225 cm.
Musée du Louvre, Paris

PROVENANCE
Exhibited at the *concours de 1747* and purchased by the Crown on 29 September 1747 for 1,500 *livres*; château de la Muette, Paris; intended for the newly founded *Muséum* in 1793; château de Saint-Cloud by 1824, where it remained until c. 1870–72 when it was removed to the Louvre.

EXHIBITIONS
Paris, *concours de 1747*, no. 9; Munich 1958, no. 140; Paris 1960, no. 646; Troyes, Nîmes, and Rome 1977, no. 56, col.

BIBLIOGRAPHY
Leblanc 1747, 58–61; *Mercure de France*, October 1747, 127; Gougenot 1748, 59–60; Dézallier d'Argenville 1772, 19; Tourneux 1877–82, I, 93; Both de Tauzia 1878, no. 819; Mantz 1880, 43–44, 112; Engerand 1895, 277; Engerand 1901, 315; Nolhac 1907, 49; Tuetey and Guiffrey 1909, 219; Chervet 1912, 392, ill.; Locquin 1912, 6, 179, 226; Brière 1924, no. 656; Nolhac 1925, 100; Boyer 1949, no. 75; Schönberger and Soehner 1960, 372, ill.; Rosenberg 1972, 14, ill.; exh. Toronto, Ottawa, San Francisco, and New York 1972–73, 186; exh. Brussels 1975, 100; Duclaux 1975, 31, 46; Brunel 1986, 239, ill.; exh. New York, Detroit, and Paris 1986–87, 238.

Listed in the *livret* as "a Feast of Bacchus," Natoire's entry to the *concours de 1747* combines unrelated episodes from the legend of the god of Wine.[1] The upper half of the canvas shows the triumphant Bacchus, in a chariot drawn by panthers, leading a band of music-making followers, his entry announced by a scantily clad attendant who blows a horn. The god holds a bunch of grapes in his right hand, and the pine-tipped staff entwined by ivy, known as the thyrsus, in his left. In the center of the composition, a beautiful maiden with flowing tresses of golden hair raises a bunch of grapes to her mouth and squeezes the juice from them. Her ecstatic expression indicates that she is Erigone, daughter of the Athenian Icarius, whom Bacchus seduces by taking the form of a bunch of grapes.[2] She is attended by a bare-breasted woman and two satyrs, one of whom offers her a basket of fruit while the other plays upon the panpipes. She is also accompanied by three inebriated putti, one of whom has fallen asleep against her knee. Other bacchanalian accessories are liberally arrayed in the foreground: an ornamented ewer, wine cooler, and goblet; a tambourine; the ubiquitous thyrsus; and, for good measure, the goat in whose guise Mercury had delivered the infant Bacchus to the nymphs of Nysa.[3] At the left of the composition, a satyr—his grotesque hindquarters and oversized panpipes just visible at the canvas's edge—rests his hand on the thigh of a flute-playing bacchante. Although these various groupings are not part of a single narrative, each element serves to proclaim "the sweetness and pleasurableness of [Bacchus's] fruits."[4]

The Triumph of Bacchus was displayed prominently in the *galerie d'Apollon* between Boucher's *Rape of Europa* (cat. no. 47) and Pierre's *Rinaldo and Armida*, the latter soon to be replaced by *Aurora and Tithonus* (Musée de Poitiers).[5] For nearly one hundred and fifty years, Boucher's and Natoire's competition pieces remained together; they decorated the *salon* of the château de la Muette until 1792, when they were reserved as a pair for the newly created *Muséum*. In the nineteenth century, having been extended by a foot on each side (fig. 1), both canvases hung together at

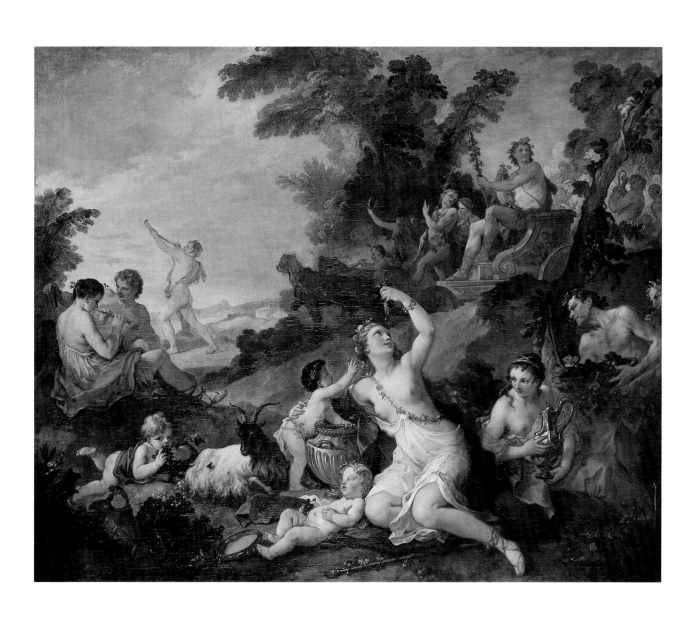

the château de Saint-Cloud until their return to the Louvre following the outbreak of the Franco-Prussian War.[6] Although Natoire's contemporaries had little difficulty in appreciating the charms of his *Triumph of Bacchus*—it was the single entry to the *concours* for which Mariette expressed unqualified praise—its reputation declined dramatically thereafter.[7] Discolored varnish and the disagreeable extensions led Paul Mantz to conclude that Natoire had painted nothing less than a "gathering of the jaundiced."[8] Even after its cleaning in 1976, when the painting was restored to its original dimensions, its most enthusiastic advocates had difficulty in responding as wholeheartedly as had their eighteenth-century forebears. To claim that the painting's chief attraction was its "surrealist appeal" was an instance of damning with faint praise.[9]

Such reticence is understandable. After Boucher's *Rape of Europa*, Natoire's *Triumph of Bacchus* was certainly the best history painting of a sadly uninspired competition, yet it lacks the grace and fluency of his best decorations (for example, cat. no. 39) and has little of the concentration and refinement of his finest cabinet pictures (for example, cat. no. 41). In part this may be explained by the circumstances of its commission, since it was unclear whether Natoire was to paint a subject to please or to instruct—a decorative painting of the sort that, he complained, had been required of him since his return to Paris in 1730, or a painting that would edify as well as give pleasure.[10] As can be seen from Natoire's correspondence with Antoine Duchesne—his friend with access to Lenormant de Tournehem's ear—the *directeur général's* exceptional patronage may have produced such miserable results precisely because of his reluctance to impose conditions; without knowing where it was to hang, or in what company, it is doubtful whether Natoire—or any academician of his generation—could have produced a fully resolved history painting.

Although only one condition was imposed upon the academicians invited to participate in the *concours de 1747*—that all the canvases be of the same dimensions—the *directeur général's* hopes for a renewed canon of historical subjects was widely known. In the end he must have been a little disappointed, since histories only outranked mythologies by six to five.[11] Duchesne was adamant about the need for history painters to move with the times and did not hesitate to provide the amiable Natoire with a succession of novel subjects, meticulously described, which betrayed a complete insensitivity to aesthetic concerns. In his first letter, written from Versailles on 1 April 1747, Duchesne proposed an episode from the life of Charlemagne—to be taken from Pierre Bayle's *Dictionnaire*—or, alternatively, the death of Leonardo da Vinci, made famous in Vasari's *Vite*.[12] Duchesne elaborated this composition to the last detail; Leonardo da Vinci, exhausted from his heroic efforts, was to be shown resting in the arms of François Premier, with only the musician who had been summoned to divert him in attendance, playing his guitar. On the painter's easel is his masterpiece, *La Belle Ferronière*; scattered around the studio are the implements he used for his experiments in oil painting. His famous treatise on the art of painting would be included, as well as his plans and inventions, since the painter was equally famous as an architect and engineer. Finally, on a table can be seen the *modello* of Leonardo's equestrian statue, the "Sforza horse," another example of his universality as an artist. "I do not presume to paint your picture for you," Duchesne concludes, "but this subject, or another like it, will enable you to succeed under the present circumstances. This advice comes from one who has his ear to the ground."[13]

Natoire's reply, written on 7 April, is equally illuminating. It shows that, in accordance with the *directeur général's* wishes, he had already solicited the *amateurs* for "a less hackeneyed subject," yet this had been to no avail since "they were unable to suggest anything better than what I already had in my head." In the end, the allure of novelty was not sufficient: "I prefer a subject which will allow me to paint the nude, so that I can present the art of drawing to its best advantage; it is so beautiful and so little appreciated."[14] Wisely, Natoire was not prepared to abandon the genre in which he had made his reputation.

Duchesne's reply, written three days later, contained an even more outrageous suggestion: the subject of Queen Marguerite of Scotland honoring the unspeakably ugly poet Alain Chartier with a kiss. To satisfy Natoire's preference for the nude, Duchesne even presented this story in mythological guise; Diana would represent the queen of Scotland, Apollo the ugly Alain Chartier, and the ladies of the *Dauphine's* retinue would be metamorphosed into the nymphs of Diana.[15] Such a proposition was too absurd to contemplate, and Natoire's reply, if he gave one, has not come down to us.

Duchesne's proposals were not, however, quite as preposterous as they might at first seem. At La Chapelle-Godefroy, Natoire had devoted six large canvases to the history of Clovis, king of the Franks, and he had also provided Beauvais with designs for a tapestry series relating the adventures of Don Quixote commissioned by Grimod du Fort.[16] Nor were troubadour subjects completely alien to artists of Natoire's generation; among Boucher's earliest commissions was a series of drawings to illustrate the third edition of Père Gabriel Daniel's *Histoire de France*.[17] Duchesne's

choice of the Death of Leonardo was prescient; it would be the subject of one of the *Histoire de France* tapestries commissioned from Menageot by the Gobelins in 1780.[18] But in 1747 the representation of the nude was still the keystone of academic language; it was not in the historical genre that professors of the Academy were trained to excel. Natoire's predictable choice of an erotic mythology acted, at one level, as a vindication of academic, and not merely *galant*, values.

However, as his correspondence reveals—and as would be borne out by the entry itself—Natoire recognized that history painters were guilty of "repeating too often the same hackneyed subjects," a charge of which he himself was hardly innocent.[19] He seems to have already considered the possibility of renewing his repertory and, citing Rubens as an example, argued that "if this great artist treated well-worn themes just as the others, this did not prevent him from imbuing the most commonplace subject with new ideas."[20] It is precisely this that Natoire attempts in *The Triumph of Bacchus*.

The central episode in this painting, Erigone seduced by a bunch of grapes—which only the abbé Leblanc and Donald Posner seem to have recognized—had been portrayed both by artists of a previous generation (Cazes) and of Natoire's own (Boucher, Carle Van Loo).[21] Traditionally, the motif consisted of a naked female figure contemplating a bunch of grapes (fig. 2); its conjunction with a second episode was unprecedented.[22] The precise subject of the scene taking place in the background of Natoire's canvas also gave rise to confusion. When the painting was purchased by the Crown in September 1747, it was listed as *The Triumph of Bacchus on His Return from India*, a slight inaccuracy since both Ovid and Catullus had noted that, after conquering the "long-haired Indians," Bacchus returned in triumph on an elephant.[23] If in Natoire's competition piece Bacchus's homecoming is portrayed generically, its association with Erigone's ravishment in the foreground remained problematic; in 1792 the subject of the painting was erroneously recorded as depicting Bacchus and Ariadne.[24]

While withholding the authorship of the competition pieces, the *livret* of the Salon of 1747 gave their subjects in some detail. Unfortunately, the entry for Natoire's "Feast of Bacchus" is uncharacteristically terse: "based on an ode by Anacreon."[25] In fact, as Udolpho van de Sandt has confirmed, Natoire's *Triumph of Bacchus* was inspired by Anacreon's *Ode XLIX*, the appropriately named *Fête de Bacchus en Tableaux*. Responding to the opening invocation—"Famous Painter, take your brush / And render faithfully my idea"—Natoire follows the poem almost line for line. Bacchus, "god of the Harvest," is surrounded by his "playful court," entering "upon a triumphant chariot drawn by tigers, thyrsus in hand, and crowned by vine." At the sound of his pipes and drums, satyrs and bacchantes begin to "dance on the grass"; the poet encourages the painter to portray their "various games," which include breast-feeding an infant wolf and riding a goat, incidents happily Natoire chose to ignore. However, a third bacchante, "squeezing a bunch of grapes in one hand with the juice running down her fingers," provides the model for Natoire's Erigone. At the conclusion of the ode the poet implores the painter, "if your art is capable," to portray "Bacchus's kind laws that serve to calm our darkest sorrows."[26]

Properly speaking, *Ode XLIX* was a work more modern than ancient. Antoine de La Fosse, the translator and editor of these verses, freely admitted that he had completed Anacreon's fragment so that the poet's reasons for composing this ode—to inspire a painting of the subject—could now be carried out.[27] Pared of its additions in Madame Dacier's edition of 1716, La Fosse's *Ode XLIX* reappeared at a propitious moment for Natoire; the translation of Anacreon was included in the two-volume edition of La Fosse's collected works published in 1747.[28]

Thus, if the two incidents portrayed in *The Triumph of Bacchus* depend on established narrative sources, the painting's celebration of "country matters"—so intense that the abbé Leblanc could hear the shepherds singing—is inspired by Anacreon's forty-ninth ode in modern verse.[29] The artist's newfound erudition, translated onto the canvas with only limited success, may also have been encouraged by a slighting remark made by La Font de Saint-Yenne in his review of the Salon of 1746. After discussing Natoire's entries, the critic had embarked upon a more general attack against history painters, whom he charged with illiteracy: "most of our painters lack invention because they are not studious and do not read enough."[30] With *The Triumph of Bacchus*, Natoire sought both to silence La Font de Saint-Yenne and to satisfy an administration eager for new subjects.

These were not his primary objectives, however. In keeping with his profession of faith to Duchesne, *The Triumph of Bacchus* paid homage to the system of *dessin*, especially life drawing, which was fundamental to the Academy's ideology and well-being. Natoire's figure studies for *The Triumph of Bacchus* are among his most beautiful and suggest the care with which he prepared the various groups of his composition, even if an overall harmony eluded him. Drawings survive for the background figure of Bacchus (fig. 3), in which Natoire reworked the god's expression as it would appear in the finished painting;[31] for the satyr who

brings Erigone a basket of grapes (fig. 4), his horns and pointed ears clearly indicated;[32] and for Erigone herself (fig. 5), shown completely naked and presumably studied from life.[33] For the female attendant carrying an ewer on her left, Natoire had recourse to *Seated Woman Feeding a Child* (fig. 6), a drawing which may have first been used for the foreground figure in *Psyche Received by the Nymphs* (Paris, hôtel de Soubise), painted in 1737.[34]

The Triumph of Bacchus is deserving of something more durable than a *succès d'estime*; Natoire's masterful figure drawing, rich, saturated coloring, and sensual groupings embody a powerful carnality whose impact was all the more immediate for a generation rediscovering the authentic values of the pastoral.[35] Although Leblanc's lavish, and at times indiscriminate, praise has been taken rather lightly, Mariette's brief encomium—"this painting does him honor"—should be given appropriate consideration.[36] Yet in

the end, *The Triumph of Bacchus* disappoints; its additive composition and displaced figures, its ambitious, but ultimately unresolved, narrative, all reflect something of the strain that the *concours de 1747* seems to have placed upon the artist. The competition was an inappropriate vehicle for state patronage—dispensed more commonly through official portraiture, the decoration of royal residences, and the fabrication of tapestries—and general dissatisfaction may be found in the movement, led by Boucher and Natoire, to share the prize money among all the participants equally, thereby to award no prizes.[37] Less oblique was Cochin's criticism, which sets the entire undertaking in context: "In truth, when artists, after long and hard work, have succeeded in acquiring extraordinary talent, they should no longer be subjected to these so-called competitions, which are fitting only for students; mature artists recognize no judge other than the public."[38]

NOTES

1. *Explication des Peintures, Sculptures, et autres ouvrages de Messieurs de l'Académie Royale . . .* , Paris 1747, no. 9, "une Fête de Bacchus."

2. Panofsky 1960, 23.

3. Apollodorus, *The Library*, III, 4.3.

4. Hyginus, *Fabulae*, CXXX.

5. *Mercure de France*, October 1747, 127, noting that "il en a depuis exposé un autre qui représentoit Titon et l'Aurore; ce tableau quoique fait en quatorze jours a mérité les suffrages des Connoisseurs."

6. Dézallier d'Argenville 1772, 18; Tuetey and Guiffrey 1909, 219; Mantz 1880, 43; Rosenberg in exh. Troyes, Nîmes, and Rome 1977, 89–90.

7. Mariette in *Collection Deloynes*, XI, no. 25, 9, "par M. Natoire et qui lui fait honneur." For Mariette's unpublished comments, see cat. no. 47, n. 46.

8. Mantz 1880, 44, "La *Fête de Bacchus* est une réunion des lymphatiques."

9. Rosenberg in exh. Troyes, Nîmes, and Rome 1977, 90, "elle s'inscrit parmi les nombreuses toiles du XVIIIe siècle à sujet mythologique dont l'irréalisme foncier devrait séduire aujourd'hui une génération avide de surréalisme et d'étrangeté."

10. Jouin 1889 (B), 144, Natoire complaining of "des sujets agréables" and also that "depuis que je suis à Paris on ne ma jamais demandé ote chose."

11. Locquin 1912, 174–77.

12. Jouin 1889 (B), 140–43.

13. Ibid., 142, "Je ne prétens pas vous tracer votre canevas . . . mais ce sujet ou un autre est capable de vous faire réussir dans les circonstances présentes, et ce conseil vient d'un ami qui a sondé le guet."

14. Ibid., 145, "Je préfère donc un sujet qui me procure des parties nues pour que je puisse faire valoir celle du dessain, qui ait si belle et que peut de personne connoisse."

15. Ibid., 146–47, letter of 10 April 1747; the painting of Queen Marguerite of Scotland and Alain Chartier was to be the pendant to the Death of Leonardo.

16. Exh. Troyes, Nîmes, and Rome 1977, 57–60; exh. Compiègne and Aix-en-Provence 1977, 11.

17. Laing in exh. New York, Detroit, and Paris 1986–87, 16; Ruch 1964, 496–500.

18. Willk-Brocard in exh. Paris 1984–85 (B), 328–30.

19. Natoire repeated the subject of *The Triumph of Bacchus* in the wedding picture for La Live de Jully (cat. no. 41) and in a painting of identical dimensions to the *concours* entry, exhibited at the Salon of 1750 (location unknown), no. 26; Boyer 1949, no. 76.

20. Jouin 1889 (B), 144, "cela na pas empêché qu'il naye donné comme les otes dans des idées usée, mais l'habille homme sait toujours donner des trais nouveaux dans les suiet les plus commun."

21. Leblanc 1747, 58, "la figure d'Erigone est parfaitement belle et bien dessinée"; see Posner's discussion of this theme in his introductory essay.

22. Panofsky 1960, 27–28; Bjurström 1982, 888, for Cazes's *Landscape with Nymphs and Fauns*, noted by Rosenberg and Julia 1986, 359, as representing *Erigone Seduced by Bacchus in the Form of a Bunch of Grapes*; Zafran in exh. Atlanta 1983, 54, for Van Loo's *Erigone* in Atlanta, High Museum of Art; Ingamells 1989, 59–61, for *Bacchus and Erigone* in the Wallace Collection.

23. Engerand 1895, 277; ibid., 1901, 315; for a discussion of the classical sources, see the entry to La Fosse's *Triumph of Bacchus* (cat. no. 7).

24. Tuetey and Guiffrey 1909, 219, "Natoire, grand tableau, *Bacchus, Ariane* [sic]."

25. *Explication des Peintures* . . . (as in n. 1), no. 9, "une Fête de Bacchus. Sujet tiré d'une Ode d'Anacréon"; this would be repeated in the *Mercure de France*, October 1747, 127, and by Leblanc 1747, 58, and Dézallier d'Argenville 1772, 18. Nowhere is a specific ode cited.

26. Anacréon 1706, 92–93, "Peintre fameux, pren ton pinceau / et fai de mon idée un fidèle tableau. / Pein-moi le Dieu de la Vendange, / sur un char triomphant par des tigres traîné, / Le thyrse en main, le front de pampres couronné, / Tel qu'en retour des bords du Gange. / Qu'il soit environné d'une folâtre Cour / De Satires et de Bacchantes / Dansans sur les herbes naissantes, / Au son du fifre et du tambour / Pein de leurs jeux divers l'agréable caprice. / Que l'une, heureuse nourrice / Allaite un jeune loup qu'elle porte en ses bras; / que l'autre sur un bouc assise, / D'un beau tissu de soie en riant le conduise, / Et du talon hâte ses pas. / Qu'un autre dans sa main tienne et presse une grape, / Dont le jus par les doits s'échappe, / Que reçoit dans sa bouche un Satire altéré. / . . . Et si ton art le peut, / fai nous y voir écrites / les douces loix qu'il a prescrites, / pour calmer nos plus noirs chagrins." I am indebted to Udolpho van de Sandt for the transcription of La Fosse's translation.

27. Ibid., 92, "l'ode où j'ai pris la liberté de mêler mes pensées à celles d'Anacréon, pour remplir un endroit vuide qui s'y trouve . . . Ce qui nous en reste m'a fait croire que le poète y demandoit à un peintre un tableau qui représentôt une Fête de Bacchus, et j'ai tâché d'en remplir l'idée dans une description un peu entendue."

28. Anacréon 1716, 149, where the ode is reduced by two-thirds, with La Fosse's details expunged; La Fosse 1747, II, 147–48, for the *Feste de Bacchus en Tableau* in the republished *Oeuvres*; the *approbation* and *privilège* for these volumes are dated 20 March 1746 and 10 May 1746 respectively, and thus the edition would certainly have been available to Natoire in early 1747.

29. Leblanc 1747, 59, "Là je crois entendre ces Bergers tranquillement assis, chanter le bonheur de la vie champêtre."

30. La Font de Saint-Yenne 1747, 77, "la plûpart de nos Peintres sont peu inventeurs, parce qu'ils sont peu studieux et rares lecteurs."

31. This drawing most recently appeared at Sotheby's, New York, 8 January 1991, no. 78.

32. Exh. Toronto, Ottawa, San Francisco, and New York 1972–73, 186, no. 97.

33. This drawing, cited by Rosenberg in exh. Troyes, Nîmes, and Rome 1977, 90, is reproduced in Rosenberg 1972, 14.

34. Duclaux 1975, 46, no. 69; Méjanès in exh. Paris 1983 (A), 122–23, no. 109.

35. Leblanc 1747, 59, "ce tableau a je ne scais quoi de pastorale qui touche l'âme, et qui ravit les sens"; for the contemporaneous development of the pastoral in Boucher's oeuvre, Laing 1986, 55–64.

36. Mantz 1880, 43, taking exception with Leblanc's comparison between Natoire ("M. Natoire a parfaitement imité le Poussin") and the painter from les Andelys; for Mariette's annotated comment, "et qui lui fait honneur," see n. 7.

37. Montaiglon 1875–92, VI, 69.

38. Cochin in Dussieux et al. 1854, II, 412–13, "En effet, lorsque des artistes, après de longs travaux, sont parvenus à acquérir des talents au dessus de l'ordinaire, ils ne doivent plus être exposés à de prétendus exercices d'émulation qui ne conviennent qu'à des élèves, et ils ne reconnoissent d'autres juges que le public"; the passage is taken from the *Essai sur la vie de M. Charles Parroce*, read before the Academy on 6 December 1760.

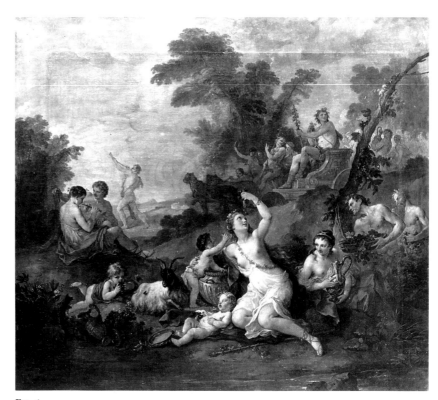

FIG. 1
Charles-Joseph Natoire, *The Triumph of Bacchus*, 1747, oil on canvas, Paris, Musée du Louvre,
showing the extensions removed in 1970

FIG. 2
Carle Van Loo, *Erigone*, c. 1747, oil on canvas,
Atlanta, High Museum of Art

FIG. 3
Charles-Joseph Natoire, *Study of Bacchus*,
c. 1747, red chalk drawing, Private Collection

FIG. 5
Charles-Joseph Natoire, *Study of Erigone*, c. 1747, red chalk drawing, Private Collection

FIG. 6
Charles-Joseph Natoire, *Seated Woman Feeding a Child*, c. 1735–40, black chalk, sanguine, and gray wash drawing with white highlights, Paris, Musée du Louvre, Cabinet des Dessins

CHARLES-JOSEPH NATOIRE
Bacchanal

41

CHARLES-JOSEPH NATOIRE (1700–1777)
Bacchanal, 1749
Oil on canvas
79.3 x 100 cm.
Museum of Fine Arts, Houston; museum purchase

PROVENANCE
Ange-Laurent de La Live de Jully (1725–1779), his sale, Paris, 5 March 1770, lot 95 [with *Triomphe d'Amphitrite*], purchased by Bourlat de Montredon for 855 *livres*, his sale, Paris, 16 March– 1 April 1778, lot 16 [with *Triomphe d'Amphitrite*], purchased by Quesnot (?) for 3,001 *livres*; Mesnard de Clesle, his sale, Paris, 4 December 1786, no. 63 [with *Triomphe d'Amphitrite*], purchased by Paillet for 2,201 *livres*; sale, Lempertz-Auktion, Cologne, 25 November 1976, no. 475 [as Noël Hallé]; sale, Christie's, London, 29 May 1981, no. 4 [as Noël Hallé]; Didier Aaron, Inc., by 1983; purchased by the Museum of Fine Arts, Houston, in 1984.

EXHIBITIONS
New York 1983, no. 14, ill.

BIBLIOGRAPHY
Mercure de France, October 1749, 161; La Live de Jully 1764, 57–58; Gault de Saint-Germain 1808, 208; Lejeune 1864, 245; Bibliothèque Nationale 1930–[1977], VIII, 71–72; Boyer 1949, 46, 60–61; exh. Rouen 1970 (B), under nos. 34 and 34 bis [as lost]; exh. Troyes, Nîmes, and Rome 1977, 55, 56 [as lost]; Bailey 1985, 304; Bailey 1988 (A), xi; Marzio 1989, 152, ill.

Hanging with its pendant, *The Triumph of Amphitrite* (fig. 1), in the "*première pièce sur le jardin*" of La Live de Jully's *hôtel* on the rue Saint-Honoré, Natoire's *Bacchanal* was described admiringly by Mariette as "possessing a softness in color and perfection of drawing worthy of Lemoyne."[1] During the eighteenth century, these radiant mythologies were among Natoire's most highly prized cabinet pictures, fetching the substantial sum of 3,000 *livres* at the Bourlat de Montredon sale of March 1778.[2] Mariette's enthusiasm, repeated by several *experts*, was of relatively short duration, however. In 1808 Gault de Saint-Germain, who included the *Bacchanal* and *The Triumph of Amphitrite* in his brief entry on Natoire, would dismiss the artist as a sterile imitator whose color was "livid and leaden" and whose brush was "mannered."[3] If the artist's rehabilitation was well underway by 1880, it lagged far behind that of Boucher's—the Goncourts seem barely to have heard of Natoire—and it was only in 1977, two hundred years after his death, that Natoire's painted and graphic *oeuvre* would be studied in any depth. One year prior to this commemorative exhibition, Natoire's *Bacchanal* had reappeared at auction, separated from its pendant and was sold with an attribution to Noël Hallé.[4]

Yet the *Bacchanal* is not only one of Natoire's more securely documented works—engraved by Claude Duflos (fig. 2) in October 1749 and carefully catalogued in at least three eighteenth-century sales —it was also a prestigious commission that probably gave the artist considerable pleasure. For it would appear that the *Bacchanal* and *The Triumph of Amphitrite* were painted to celebrate the marriage of Ange-Laurent de La Live de Jully (1725–1779) and Louise-Elisabeth Chambon (1729–1752), which took place on 26 June 1749, four months before Duflos's engravings were announced in the *Mercure de France*.[5] If this hypothesis is correct—and there is little likelihood of ever proving it conclusively—the *Bacchanal* and *The Triumph of Amphitrite* were probably commissioned by La Live de Jully's father, La Live de Bellegarde, in anticipation of his son's nuptials. Thus, Natoire's pendants, celebrating the triumphs of a male and a female

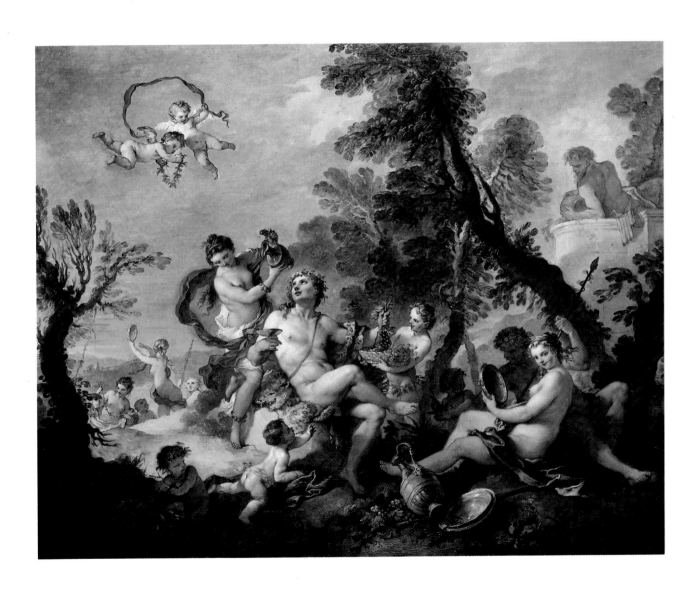

deity, do honor to the groom and to his bride in equal measure. The verses that Duflos appended to his engraving would suggest as much; Bacchus, whose conquests of India assure him immortality, is now surrounded by "a laughing troupe, who join to his own favors the flames of Love."[6]

Natoire was an obvious choice for the task, since he had previously decorated the *salon* of La Live de Bellegarde's country house (cat. no. 39) and taught drawing to his second son, a charge he acquitted with distinction.[7] Since the dating of these pendants to 1749 is reasonably secure and since it is also known that La Live de Jully did not begin collecting contemporary French painting until the mid-1750s, the status of Natoire's pendants is unlike that of most of the other works in La Live de Jully's picture collection.[8] Their presence is thus best explained by this personal association, and the *Bacchanal* certainly conveys the easy sensuality and promise of physical pleasure appropriate for an impending wedding.

In the *Bacchanal*, Natoire turned to a subject that enjoyed pride of place in his repertory; between 1738 and 1750 he painted the Triumph of Bacchus on at least five occasions.[9] Such was Natoire's fondness for the theme that his tapestry cartoon *Mark Antony Entering Ephesus*, 1741 (Arras, Musée des Beaux-Arts) could easily be mistaken for a rather heavily costumed interpretation of the god's triumphant procession.[10] Yet of all Natoire's bacchanalian paintings, the *Bacchanal* painted for La Live de Jully is by far the most satisfying: it is brilliantly colored, elegantly drawn, and unusually harmonious in its ambitious grouping of figures.

Under the late afternoon sky of a summer's day, streaked orange by the setting sun, "youthful Bacchus" is served wine by a voluptuous bacchante, her bright red drapery forming a perfect circle as it floats in the air around her. Bacchus, his golden hair falling in curls over his shoulder, gazes at the bacchante in mute adoration, hardly noticing the faun at right who hands him a basket of grapes. The god is completely naked except for the red sash attached to his habitual panther skin; the animal's head nuzzles against the attendant's right leg. In keeping with the painting's matrimonial purpose, Bacchus and the wine-serving bacchante are the center of attention, the object of the benevolent gaze of both the amoretti who hover in the sky and the sculpted satyr—distinguished by his horns, ears, and panpipes—reclining on the garden wall at right. Directly below the statue a second couple—he holding the thyrsus, she a tambourine—are interrupted from their embrace by one of the several putti who crawl about the foreground. Despite the numerous references to bacchic ritual—the tambourines that "boom if you do but touch them," the

pine-tipped thyrsus, the rank and file of "crack-brained crazy women, wreathed with ivy" dancing in the background[11]—Natoire's *Bacchanal* is a relatively mild interpretation of the frenzied celebrations that customarily accompanied Bacchus's arrival. Natoire dilutes the Attic symbolism of the bacchanal; his fauns and satyrs have shed their animal attributes, and their revels are played out before a company of naughty children. The abbé Leblanc's comparison of Natoire and Poussin was indeed misplaced; in Natoire's bacchanals, the pastoral always claims precedence over the priapic.[12]

In the Houston *Bacchanal*, Natoire's touch is at its most refined—feathery and limpid in its handling of foliage and sky, more insistent in the delineation of balletic figures, which are painted with delicate impasto and translucent glazes. The fluency of his brush may, in part, be accounted for by his familiarity with the composition, since, on one level, the *Bacchanal* is little more than an exercise in paraphrase. It has been noted that the figures of the seated Bacchus and his wine-pouring companion repeat, with only the slightest variation, those of Jupiter and Hebe in Natoire's early work *Jupiter Served by Hebe* (fig. 3).[13] The bacchante assumes the same pose as the gods' cupbearer; only the arrangement of her bright red drapery is adjusted, and, in keeping with the music making that accompanies the god of Wine, she is shown with little bells on her ankle and wrist. The bearded Jupiter in *Jupiter Served by Hebe* has been transformed into the youthful Bacchus by a change of coiffure and the adjustment of his left arm.[14] Even the secondary figures in the *Bacchanal* are based on counterparts in Natoire's earlier mythology. The infant who looks up at the seated god is in reverse of the crawling child in *Jupiter Served by Hebe*; the red-cheeked bacchante in the foreground at right, engaging the viewer in an impudent stare, is a reprise of the figure of Venus resting on a cloud before her swan-drawn carriage in the background of *Jupiter Served by Hebe*. In the *Bacchanal*, her wreath of flowers has been metamorphosed into a golden tambourine.

Natoire was not content with merely copying, however, albeit his own *oeuvre de jeunesse*. He may well have returned to the figure studies made in preparation for *Jupiter Served by Hebe*; the bacchante who pours wine in both compositions is based on the *Female Nymph Holding an Ewer* (fig. 4), one of Natoire's most splendid red chalk drawings.[15] Although the central figures in the *Bacchanal* simply repeat their counterparts in *Jupiter Served by Hebe*, it is fascinating to note that Natoire worked out this section of the composition again in a spirited preparatory drawing (fig. 5), in which the bacchante pours a

healthy draught of red wine into Bacchus's golden *coupe*.[16] For reasons of simplicity, and perhaps to avoid interrupting the god's wide-eyed gaze, this detail was suppressed in the finished painting; the juice of the grape as it leaves the lip of the gilded ewer is arrested in midair.

Natoire's working process—additive, self-referential, utterly orthodox—produces a composition which effectively masks the various stages of its conception. His figures inhabit a leafy, sunlit Arcadia and give no sense of their origins as learned models or previously used quotations. The sinuous rhythms of the windswept trees are repeated in the curves of Bacchus's glorious naked body; the pliant, but decorous, female attendants—one staring directly, the other lowering her eyes in modesty—direct our attention to a distant land replete with the promise of pleasure.

Alas, La Live de Jully's first marriage lacked the harmony of Natoire's *Bacchanal*. The young couple were to lose a son in infancy,[17] and the twenty-one-year-old Louise-Elisabeth swiftly embarked upon a series of well-publicized liaisons—most notably with the opera singer Pierre Jeylotte—for which she showed little remorse at the time of her premature death in August 1752.[18] Nor was La Live de Jully's grief particularly profound; he memorialized Louise-Elisabeth in a set of funerary monuments, and it was the opportunity to exercise patronage in this way that seems to have encouraged him to collect the work of his contemporaries.[19] Such was La Live de Jully's new-found enthusiasm for the arts, his sister-in-law Madame d'Épinay commented rather spitefully, "that in the present situation a good artist would be rather disappointed were his wife to return."[20]

NOTES

1. La Live de Jully 1764, 57, "ces tableaux sont d'une suavité de couleur et d'une perfection de dessein digne de Le Moine."

2. *Catalogue d'une belle Collection de tableaux, dessins, estampes . . . provenant du cabinet de feu M. Bourlat de Montredon*, Paris, 16 March 1778, no. 16, 3001, to Quesnot (?); price and buyer from the annotated sales catalogue at the Rijksbureau voor Kunsthistorische Documentatie, The Hague.

3. Gault de Saint-Germain 1808, 208, "petit goût de dessin, coloris livide, plombé; pinceau maniéré."

4. Lempertz-Auktion, Cologne, 25 November 1976, no. 475.

5. Bailey 1985, 304–5, 339; I owe this suggestion to Patrick Violette. For Duflos's engraving, see *Mercure de France*, October 1749, 161, and Bibliothèque Nationale 1930–[1977], VIII, 72; although the marriage contract between La Live de Jully and Chambon is lost, it is recorded as having been drawn up by Mâitre Dutartre on 26 June 1749 in the "Inventaire des Papiers" in A.N., *Minutier Central*, XLVIII/253, "*Inventaire après décès*," Ange-Laurent de La Live de Jully, 1 April 1779.

6. Bibliothèque Nationale, Cabinet des Estampes, Db 26, "mais lorsqu'environné d'une riante troupe / Joignant les feux d'Amour à tes propres faveurs / D'un jus délicieux tu couronnes ta coupe."

7. La Live de Jully 1764, 57–58; for La Live de Jully's engravings after Natoire's designs, see Bibliothèque Nationale 1930–[1977], XII, 325–26, nos. 13–16.

8. Other exceptions would be Tocqué's portraits of La Live de Jully "en chasseur" and his wife "en Diane," La Live de Jully 1764, 4.

9. The other four paintings are *Bacchus Receiving Drink from a Child, Accompanied by Two Bacchantes and Silenus*, Salon of 1738, possibly in the posthumous sale of Madame Lenglier, Paris, 10 March 1788, no. 267; *Bacchus and Ariadne*, Salon of 1743, for the apartment of Madame Adélaïde at Marly, now on deposit at the Assemblée Nationale; *The Triumph of Bacchus*, exhibited at the *concours de 1747* (cat. no. 40); and *The Triumph of Bacchus*, Salon of 1750, recorded in the collection of Duclos-Dufresnoy, Paris, 1 *fructidor an* III (18 August 1795), no. 3, last recorded at the Galerie Charpentier, Paris, 20 March 1951, no. 91.

10. Exh. Troyes, Nîmes, and Rome 1977, 70, no. 24.

11. Lucian, *Dionysus*, I.

12. Leblanc 1747, 58, "c'est un tableau d'une composition aussi heureuse que sçavante et où M. Nattoire a parfaitement imité l'un des plus grands modelles qu'il pouvoit se proposer en ce genre, je veux dire le Poussin," referring to Natoire's entry to the *concours de 1747*.

13. Didier Aaron, *French Paintings of the Eighteenth Century*, New York 1983, 38.

14. Sainte-Marie in exh. Troyes, Nîmes, and Rome 1977, 56; the model for the cross-legged deity was, of course, the *académie*; of the several such drawings Natoire made for his students' instruction, two study this distinctive pose: *Seated Nude Male Seen from the Right*, Paris, Cabinet des Dessins (inv. 31388) and *académie*, Paris, École Nationale Supérieure des Beaux-Arts (inv. 3078).

15. Rosenberg in exh. Toronto, Ottawa, San Francisco, and New York 1972–73, 185–86.

16. Rosenberg and Schnapper in exh. Rouen 1970 (B), 74–75; on the verso of this sheet is a rough sketch for the entire composition.

17. Chastellux 1875, 356, gives the date of Ange-Louis Honoré's birth as 18 June 1750; in the marriage contract between La Live de Jully and his second wife, Marie-Elisabeth Nettine, it was noted that "de son premier mariage . . . il n'a aucun enfant," A.N., *Minutier Central*, XLVIII/119, "*Mariage*," 10 July 1762.

18. Roth 1951, II, 328–30.

19. Réau 1920, 223–24, and Bailey 1988 (A), xiv–xv.

20. Roth 1951, II, 472, "Savez-vous, Monsieur, qu'un habile artiste en pareil cas serait peut-être désolé que sa femme revînt?"

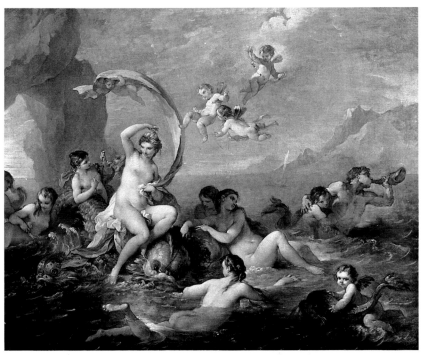

FIG. 1
Charles-Joseph Natoire, *The Triumph of Amphitrite*, 1749, oil on canvas, location unknown

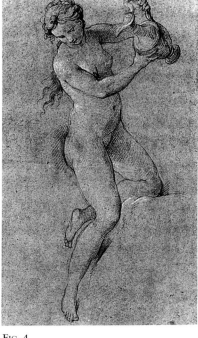

FIG. 4
Charles-Joseph Natoire, *Female Nymph Holding an Ewer*, c. 1731–34, red chalk drawing, Private Collection

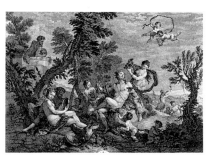

FIG. 2
After Charles-Joseph Natoire, *Bacchanal*, 1749, engraved by Claude Duflos, Paris, Bibliothèque Nationale, Cabinet des Estampes

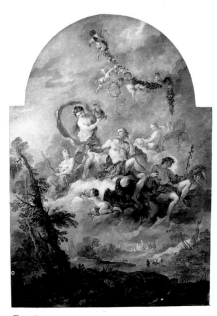

FIG. 5
Charles-Joseph Natoire, *Study for the Bacchanal*, c. 1749, red chalk drawing (recto), Rouen, Bibliothèque Municipale

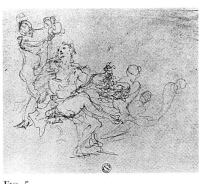

FIG. 3
Charles-Joseph Natoire, *Jupiter Served by Hebe*, c. 1731–34, oil on canvas, Troyes, Musée des Beaux-Arts

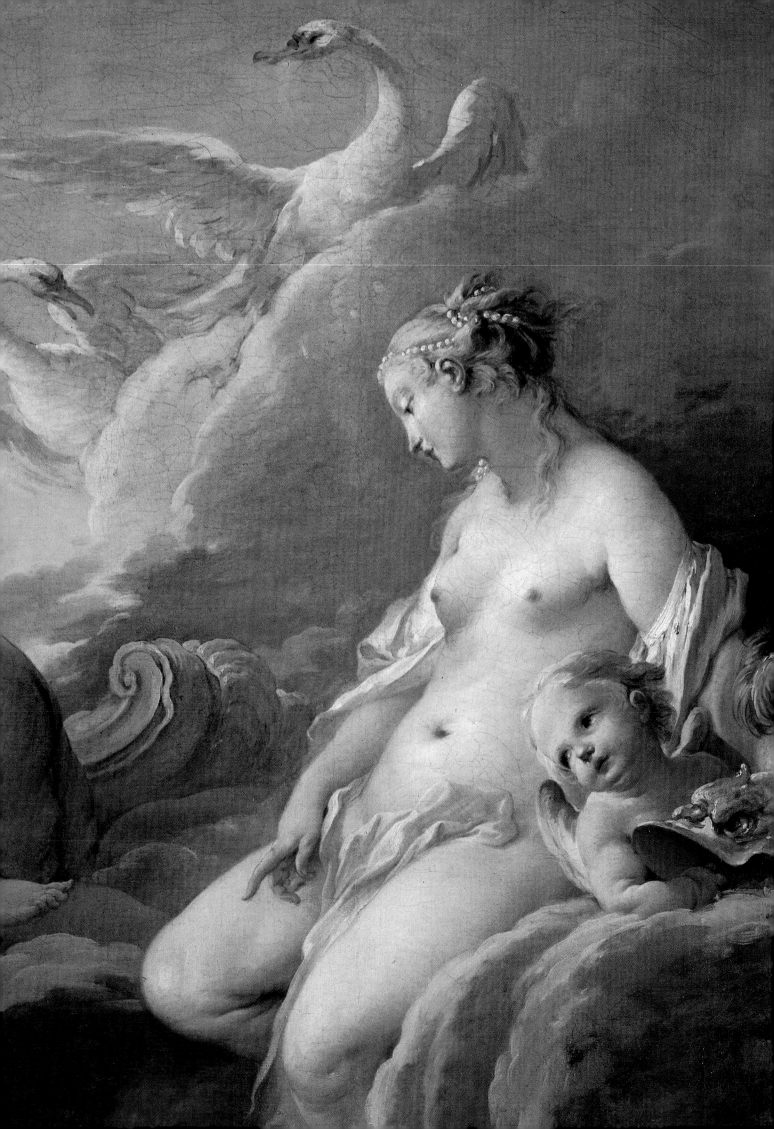

FRANÇOIS BOUCHER
(1703–1770)

Born in Paris in September 1703, Boucher probably received his earliest training from his father, Nicolas, a master painter in the Academy of Saint-Luc. In the early 1720s he attracted the attention of François Lemoyne with the recently rediscovered *Judgment of Susanna* (Paris, Private Collection) and became the artist's pupil for a brief period sometime between 1721 and 1723, after which he may have studied with Louis Galloche. In August 1723 Boucher won the *Prix de Rome* with *Evilmerodach Releasing Jehoiachin from Prison* (location unknown), although he was prevented from taking up his scholarship in Rome because there was no room for him at the French Academy. Thus, Boucher remained in Paris, making designs for engravings of thesis plates in Jean-François Cars's studio, drawing copies after old masters for the print market, and contributing well over one hundred etchings after Watteau's drawings and paintings for Jean de Jullienne's two memorials to the artist, the *Figures de différents caractères* and the *Recueil Jullienne*. In late March or early April of 1728, Boucher finally traveled to Italy at his own expense. He arrived in Rome in May, and Nicolas Vleughels, then director of the French Academy, allowed him to stay "in a little hole of a room."

It is unclear how long Boucher remained in Italy, but he returned to France by November 1731, when he became *agréé* at the Academy. Soon afterwards he received his first major commission, a series of paintings for the *hôtel* of François Derbais (e.g., *Mercury Confiding Bacchus to the Nymphs of Nysa* and *The Rape of Europa*, both London, Wallace Collection, and cat. nos. 43 and 44), and was received into the Academy shortly thereafter in January 1734 with *Rinaldo and Armida* (Paris, Musée du Louvre).

Boucher's paintings of the 1720s are stylistically diverse and have been misattributed to such artists as François Lemoyne, Giambattista Tiepolo, and Sebastiano Ricci (e.g., *The Sacrifice of Gideon*,

c. 1728, Paris, Musée du Louvre). By the 1730s, however, the emerging artist's work exhibited stylistic coherence; his figures were now painted with pearly, luminous flesh tones adopted from François Lemoyne and with fluid brushwork learned from Castiglione and the Venetians. As he began to experiment in the lesser genres, Boucher forged these diverse sources into an individual style. While Castiglione inspired him throughout his career, the work of Dutch masters, Abraham Bloemaert in particular, increasingly came to interest Boucher, who produced a series of etchings after the latter's work in 1735. The example of his elders Noël-Nicolas Coypel and Jean-François de Troy may also have encouraged Boucher to seek a more intimate manner, appropriate for cabinet pictures.

While talented contemporaries such as Carle Van Loo and Charles-Joseph Natoire provided spirited competition, Boucher managed to win a number of prestigious commissions. Although he was not the first choice for the decoration of the hôtel de Soubise—and his work there would not win him fame as did Natoire's decoration for the *salon de la princesse*— Boucher would produce more overdoors for this project than any other artist, seven in all, including *Venus and Cupid at the Bath*, 1738 (Paris, Archives Nationales). He also executed his first royal commissions at about the same time—four grisailles of the Virtues for the ceiling of Queen Marie Leczinska's *chambre* in 1735 (still *in situ*) and two hunting scenes for the *galerie des petits appartements du roi* at Versailles (*The Leopard Hunt*, 1736, and *The Crocodile Hunt*, 1739, both Amiens, Musée de Picardie).

As Boucher's fame grew, so did the demand for his work. Boucher not only produced a large number of paintings, but he created tapestry cartoons for the Beauvais and Gobelins manufactories, porcelain designs for Sèvres, and sets and costumes for the *Opéra* and *Théâtre de La Foire*. He soon established an international reputa-

tion, and was even offered the position of *premier peintre* to the king of Prussia, probably in 1748, but refused the honor.

Nevertheless, Boucher's steadiest source of income came from the Crown, and he would benefit in particular from Madame de Pompadour's installation as *maîtresse en titre* in 1745. He completed a number of works for the king's *châteaux*, including paintings for Choisy (e.g., *Venus Disarming Cupid*, Private Collection, and *Venus Viewing Cupid Asleep*, location unknown, both 1744, for the *appartement des bains*) and ceiling paintings for the *cabinet du conseil* at Fontainebleau in 1753 (*The Chariot of Apollo* with four paintings of the Seasons, *in situ*). His contributions to Madame de Pompadour's château de Bellevue, which include *The Light of the World* (1750, Paris, Musée du Louvre) for her private chapel and *The Toilet of Venus* and *Venus Playing with Cupid* (1751, New York, The Metropolitan Museum of Art, and Washington, National Gallery of Art) for the *appartement des bains*, exemplify his virtuosity as a painter of sacred and profane subjects.

Named *premier peintre du roi* in August 1765 in the final decade of his life, Boucher came to use a broader technique which helped compensate for his failing eyesight. While he most frequently painted variations of his beloved pastorals in these last years, he also completed large-scale decorative panels, notably a series of splendid mythologies representing the Elements, painted in 1769 for Bergeret de Frouville (six paintings now in the Kimbell Art Museum, Fort Worth, and the J. Paul Getty Museum, Malibu). Although less spirited in handling than are his youthful works, these late masterpieces display an acuity and inventiveness undiminished by age and unmatched by the works of any of his contemporaries. Not since Le Brun had a single French artist exercised such a monopoly over the imagery of a particular society. Boucher died in his lodgings in the Louvre on 30 May 1770.

FRANÇOIS BOUCHER, *Venus Requesting Vulcan to Make Arms for Aeneas* (detail) 1732, oil on canvas, 252 x 175 cm, Paris, Musée du Louvre

FRANÇOIS BOUCHER
Hercules and Omphale

42

FRANÇOIS BOUCHER (1703–1770)*
Hercules and Omphale, c. 1731–34
Oil on canvas
90 x 74 cm.
Pushkin Museum, Moscow

PROVENANCE
Pierre-Louis-Paul Randon de Boisset (1708–1776), his estate inventory [as *Woman and Satyr*], 18 October 1776, no. 115 (A.N., *Minutier Central*, LXXXIV/546), and his sale, Paris, 27 February 1777, no. 192, purchased by Philippe-Guillaume Boullogne de Préninville for 3,840 *livres*; Joseph-Hyacinthe-François de Paule de Rigaud, comte de Vaudreuil (1740–1817), his sale, Paris, 26 November 1787, no. 75, purchased by Donjeu[x] for 900 *livres*; sale, Paris, 7 February 1792 [actually held on 13 February 1792], no. 37, sold for 806 *livres*; Prince Galitzin, Moscow; Prince Youssoupov, Saint Petersburg, by 1839; taken from the Youssoupov collection and placed in The Hermitage in 1925; relocated to the Pushkin Museum in 1930.

EXHIBITIONS
New York, Detroit, and Paris 1986–87, no. 13, ill.; New York and Chicago 1990, no. 8, col.

BIBLIOGRAPHY
Thiéry 1787, 547; Mantz 1880, 59; Michel 1886, 10; Josz 1901, 21; Kahn 1905, 19; Michel 1906, 4, no. 167; Nolhac 1907, 5, 115; Macfall 1908, 146; Roujon, n.d., 21; Benois 1910, 116; Nolhac 1918, 18; Nolhac 1925, 13; Réau 1925, I, 41; Réau 1929, no. 13; Nolhac 1931, 25; Sterling 1958, 48, 235, ill.; Malitskaya and Antonova 1965, pl. 61; Charmet 1970, 19, ill.; Bordeaux 1975, 127–28, ill.; Ananoff and Wildenstein 1976, I, no. 107, ill.; Jean-Richard 1978, 396; Kuznetsova and Georgievskaya 1979, 17, no. 45, ill.; Ananoff and Wildenstein 1980, 6, no. 108; Bordeaux 1984 (A), 37, 94, ill.; exh. Paris and New York 1987–88, 34, ill.; Bailey 1989, 25, ill.

*Exhibited in Paris only

The most explicit and carnal of Boucher's mythological paintings—of a "hothouse intensity" never again equaled in his art[1]—*Hercules and Omphale* is also Boucher's most cavalier essay in the *grand genre*, oblivious to literary and pictorial tradition alike. It is not altogether surprising that, in the earliest known reference to this painting, its subject was recorded as simply "Woman and Satyr"; Pierre Rémy, the *expert* responsible for appraising the works of art in Randon de Boisset's estate, rectified this error by the time the paintings were catalogued for sale.[2] Yet, for all the inconsistencies of its *mise en scène*, *Hercules and Omphale* conveys the consummation of physical passion with an urgency that is without precedent in French painting; it was for good reason that the Goncourts dubbed Boucher "Ovid's painter."[3] Further, the independence with which Boucher here approached the esteemed genre of history painting had implications of greater import; it succeeded in liberating his brush. Nothing in the artist's earlier work prepares us for the accomplished figure drawing, sophisticated color harmonies, and compositional resolution of this dazzling cabinet picture.

Seated on a bed under a hastily erected canopy, in a boudoir located in the middle of a colonnaded gallery,[4] Hercules, the most powerful of the gods, and Omphale, queen of Lydia, to whom he has been indentured for one year, are locked in an embrace so ardent that we all but avert our eyes in modesty. The bedroom is in a state of disarray; crimson drapery spills around the bed, toppling the ornate rococo table of organic design whose gilded carved putto turns his gaze from the lovemaking behind him.[5] A green velvet bolster with golden tassel has fallen to the floor, providing Hercules with an elegant footstool. And at the foot of the bed, a blue-winged putto carries off Omphale's distaff and spindle, to be used now by Hercules in his sewing. His little companion, whose quiver of arrows is just visible at the canvas's edge, struggles with the mane of the Nemean lion—Hercules's apparel, temporarily appropriated by the Lydian maiden. Yet, contrary to tradition, neither lover is shown disporting his or her partner's attributes; each retains his unambiguous sexual identity.

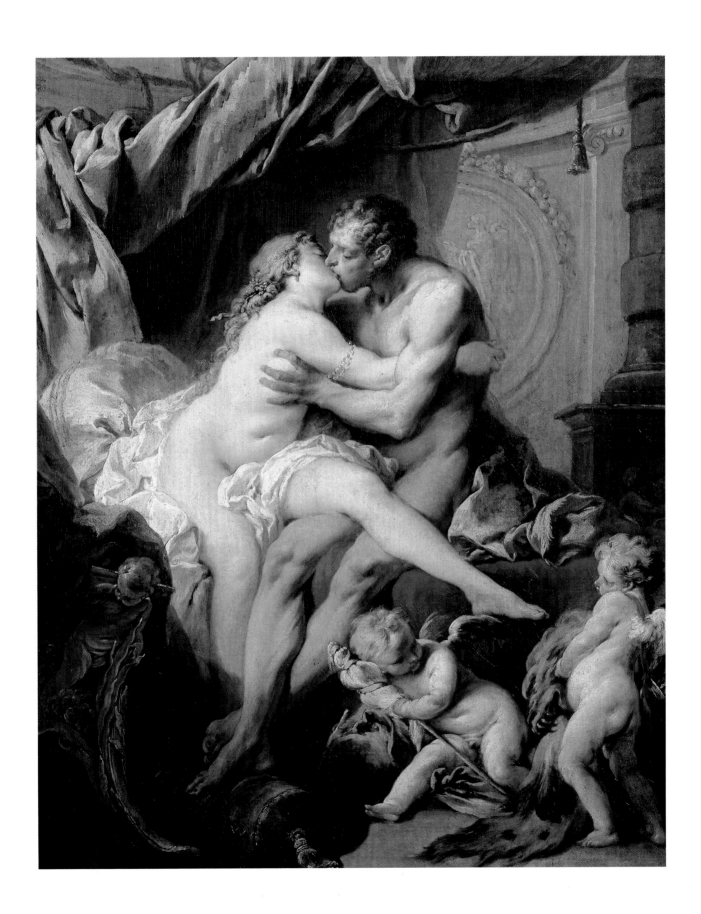

Nowhere is Boucher's redefinition of narrative syntax more radical than in his presentation of the lovers themselves, who engage in uninhibited sexual foreplay never mentioned in the classical texts.[6] Abandoning her dominion over the subservient god, red-cheeked Omphale strains to return Hercules's kiss, her body clasped tightly between his enormous hands. A further sign of *her* submission, the bracelet on her upper arm, customarily worn by the enslaved god, is now restored to its rightful owner. Despite his muscular and ruddy frame, Boucher's Hercules is hardly the colossus of nine labors who has been reduced to wearing women's attire and spinning yarn; rather, he is portrayed as a lusty youth, barely able to support his first beard.

Although the couple would not be amiss in the setting of Fragonard's *Lock* (Paris, Musée du Louvre), their lovemaking is carried out on a mock-heroic stage, an arena inhospitable to such intimacy. Decorating the circular medallion on the wall behind them, a bald man, his wares on his back, shakes his finger at the couple reprovingly.[7] Yet, none of this seems to matter; these potentially discordant elements in no way detract from the cogency of Boucher's portrayal of sexual passion. If in *Hercules and Omphale* the artist takes liberties with pictorial precedent, his painting goes straight to the heart of Ovid's message.

Boucher painted *Hercules and Omphale* with considerable spontaneity and energy—"instinct with youth throughout"—the figures seem to have emerged, Athena-like, straight onto the canvas.[8] Closer inspection also reveals that Boucher made numerous changes *alla prima; pentimenti*, visible to the naked eye, are everywhere apparent. The banded column was first placed much closer to the medallion, growing in scale only after it was moved to frame the painting at right. Boucher's decision to drape the lovers under a canopy of red velvet may also have been made fairly late; initially the undraped cord continued along the upper edge of the canvas, and more of the medallion's circular frame could be seen. Boucher adjusted the profiles of both the red-haired putto carrying the lion's mane—his forehead was higher, his little nose more pointed—and of Hercules himself, whose head initially towered over Omphale at an even more commanding angle.[9]

In fact, the verism of Boucher's mythological painting is achieved by reference to a wide range of sources, whose assimilation is disguised with characteristic artistry. Although, as Alastair Laing has observed, "nothing could be less Lemoinean" than Boucher's *Hercules and Omphale*,[10] the putti in this painting are appropriated from Lemoyne's *Putti Play-ing with the Accoutrements of Hercules* (fig. 1); it is Boucher's master who may be credited with reintroducing this genre into eighteenth-century French painting.[11] For the lovers themselves, Boucher could have turned to a variety of prototypes, the most likely of which, Caraglio's etching of *Neptune and Thetis*, is discussed by Donald Posner in his introductory essay. But the art that Boucher would have seen in Rome—if not his more intimate experiences in that city—also informs the striking poses of Hercules and Omphale. The motif of Omphale's "slung over leg," the only allusion to her subjugation of the enslaved god, derives from Carracci's *Hercules and Iole* in the Farnese Gallery ceiling (fig. 2). Another painting from this celebrated fresco, the bronze medallion of *Salmacis and Hermaphroditus*, may also have offered a model for the kiss itself.[12] As a precedent for Hercules's immodest embrace of Omphale's right breast, however, Boucher did not have to look so far; de Troy's *Mars and Venus*, etched by Caylus (fig. 3), shares both the candor and palpable eroticism of the figures in Boucher's cabinet painting, but conveys them in the more private medium of engraving.[13]

And, although it is argued here that Boucher's interpretation distances itself from textual authority, Ovid's presence pervades the scene in another way. While Boucher is inattentive to the details of Hercules and Omphale's liaison as described by the classical authors, his portrayal of their sensual abandon finds a vivid parallel in the third book of Ovid's *Amores*.[14] Of a moment of similar rapture, Ovid writes: "Indeed, she threw her ivory arms, whiter than the Thracian snow, about my neck, and thrust kisses struggling with passionate tongues, and placed lustful thigh over my thigh."[15] Could Boucher have had this passage in mind when considering the amours of Hercules and Omphale?[16]

To arrive at this depiction of passionate abandonment was a singular achievement that depended on the fusion of several factors: the confidence to stand back from venerated models and immediate forebears to interpret the spirit, if not the letter, of the classical sources and the technical facility equal to this ambition. It is more satisfactory to place *Hercules and Omphale* in the period between Boucher's return from Italy—in 1731, if not before—and his reception as *peintre d'histoire* at the Academy on 30 January 1734. It was to these years that *Hercules and Omphale* was customarily dated before Laing's ingenious, but unconvincing, attempt to locate it to Boucher's Roman sojourn, of which very little is known.[17] Without denying the links between the painting and certain works assumed to date from the later 1720s, such a precocious chronology is unwar-

ranted here.[18] Quite simply, *Hercules and Omphale* is a far more fluent and harmoniously integrated composition than any subject picture Boucher had made in the previous decade. Most telling is the comparison between this mythological painting and a charming pastoral landscape, *Peasants with a Goat and a Cow* (fig. 4), which Laing has reasonably associated with those "precious paintings in the Flemish manner" that Boucher was said to have executed in Rome.[19] Not only does the rakishly kerchiefed boy cutting bread bear a striking resemblance to Boucher's curly-haired Hercules, but the peasant girl in the background holds a distaff trimmed with ribbon which will find its way into the hands of the putto in *Hercules and Omphale*. Yet the differences between the two compositions are more important than these shared motifs. Above all, Boucher's feasting peasants, though pleasing individually, do not relate pictorially; they are painted in isolation and create an additive composition, typical of his work of the later 1720s. The painting of drapery and anatomy is uneven and at times—such as in the girl's dress and left hand and the seated peasant's red trousers—formulaic. In *Hercules and Omphale* there is a new amplitude and command in Boucher's handling of both, and a successful resolution of all elements, major and minor, in a composition which is both dynamic and, despite its modest size, monumental.

Indeed, *Hercules and Omphale* conforms in almost every detail to the manner in which Boucher was said to have worked in the years immediately following his return from Italy. Here is the anonymous author of the *Galerie françoise*, among the most perceptive of the early commentators on Boucher's art and career: "As a rule, the first paintings he made on his return from Italy reflect the time he had spent there and are replete with the masculine vigor of the old masters. Their color is both true to life and harmonious, though always brilliant; and the heads and figures in his paintings have all the qualities of expression imaginable."[20] In fact, the best discussion of Boucher's style after 1731, which might have been written with *Hercules and Omphale* in mind, is made by Laing himself: "In all of them, there is also a roughness of facture and coloring . . . underlining an overt virtuosity in the handling of paint that broke entirely with the smooth handling, warm Italianate palette, and delicate glazes of the tradition embodied by Galloche, Lemoyne, and J.-F. de Troy."[21]

If this later date is accepted, the obvious affinities between *Hercules and Omphale* and a group of history paintings, securely documented to between 1732 and 1734, need no longer be explained away. As Louis Réau was the first to point out, *Hercules and Omphale* might well be set in a distant corner of the enchanted palace that provides the background for *Rinaldo and Armida* (fig. 5); banded columns with Ionic capitals, cascading drapery, and suspended cords are to be found in both.[22] The little putti in *Hercules and Omphale* would subsequently become occupants of their own paintings. The putto holding Omphale's distaff is very close to the sleeping infant, tickled with hay, in *L'Amour Moissoneur* (Private Collection), and his companion, whose profile has been changed, initially resembled the putto at left holding a dove in *Putti Playing with Birds* (Providence, Museum of Art, Rhode Island School of Design).[23] Omphale is painted in like manner to the dark-haired girl who gazes with affection at Princess Europa in *The Rape of Europa* (fig. 6), securely dated to 1734.[24] And, if it is objected that such similarities of motif and figure type may be discounted because the paintings differ so radically in "scale and handling," it is precisely the different purposes for which these paintings were made that explain the discrepancies in their *facture*. We should not expect works of large-scale decoration, or a presentation piece to the Academy of considerable size and ambition, to be handled in the same way as a cabinet painting, with figures that appear almost miniature by comparison.[25]

This leads to one final question: why and for whom was *Hercules and Omphale* painted? If it was intended to exhibit Boucher's virtuosity in the genre of erotic history painting, *Hercules and Omphale* was a signal failure; the painting was without succession. However, given its rampant sexuality, it is reasonable to speculate whether the painting was intended to serve a more private purpose. By contrast, Boucher's drawing of *Hercules and Omphale* (fig. 7)—which shows the god and his consort in an ecstatic, but more conventional, embrace and is related to the Pushkin canvas in date but in little else—is recorded in at least two versions and was engraved and copied by younger artists.[26] The painting enjoyed no such immediate fame, and it was never reproduced in a print.

Furthermore, it seems likely that Boucher maintained possession of the painting for some years before it entered the prestigious picture cabinet formed by Pierre-Louis-Paul Randon de Boisset (1708–1776), whom Boucher would advise on the formation of his collection at a much later point in his career, and with whom he traveled to Flanders in 1766.[27] In the abbé Lebrun's obituary of this Maecenas, published in the *Almanach Historique* within weeks of his death, it was noted that Randon de Boisset had come to collecting rather late in life. A first trip to Italy in 1752 whetted his appetite, and in Florence he purchased six paintings by Joseph Vernet: "It is flattering for

M. de Vernet [*sic*] that M. de Boisset's *first acquisitions* would enrich France with paintings we would otherwise not have known. . . . This purchase inspired in the collector a taste for painting which thereafter knew no bounds."[28] From this, it follows that Boucher's *Hercules and Omphale* would not have entered Randon de Boisset's cabinet in the year—or even in the decade—in which it was painted, but at a date no earlier than 1752. Of the eighteen works by Boucher in Randon de Boisset's picture collection, no less than ten were painted in the 1760s, the decade in which the two men's friendship was formed.[29] This would also suggest that Fragonard's copy of Boucher's *Hercules and Omphale*, of exactly the same dimensions— lost since it appeared in the posthumous sale of M. de Sireul, Randon de Boisset's companion—would have been painted during the young artist's apprenticeship in Boucher's studio, a reasonable assumption given the inaccessibility of Randon de Boisset's collection during his lifetime.[30]

A splendid anomaly in Boucher's oeuvre, *Hercules and Omphale* must have caused as much of a shock when it came under the hammer in Paris in February 1777 as it did when exhibited in New York and Chicago over two hundred years later.[31] Valued in Rémy's appraisal of the collection at a mere 300 *livres*, the painting fetched the staggering sum of 3,840 *livres* at public auction, an event of sufficient importance to be noted in the daily press.[32] Its subsequent passage through the "patriotic collection" of French paintings assembled by the comte de Vaudreuil could not sustain such a price, and within a decade the market value of *Hercules and Omphale* dropped by more than 75 percent.[33]

Although Boucher returned to the subject infrequently, he treated the loves of Hercules and Omphale towards the very end of his life for Le Mire and Basan's illustrated edition of the abbé Banier's translation of Ovid's *Metamorphoses* (fig. 8), which appeared in four volumes between 1767 and 1771. Wholly, if not tediously, conventional, Boucher here restored the spindle to Hercules and the god's *massue* to the imperious Omphale.[34] Paradoxically, it was the mythological paintings of Boucher's late career that earned him Diderot's unremitting scorn and hostility; in a celebrated piece of journalism, the *philosophe* went so far as to accuse him of consorting with prostitutes of the lowest order.[35] It was less the artist's subject matter, however, than his willful distance from life and experience and his tendency to mannerism and repetition that so enraged Diderot. Of the early *Hercules and Omphale* the critic would have had nothing but praise, not because its treatment of the myth was any more seemly, but because the manner in which it was painted seemed to bespeak integrity and engagement. Writing in 1767 about Boucher on his return from Italy, Diderot noted regretfully: "His color was forthright and true; his composition was sound, yet full of verve; his handling was broad and grand."[36] Could he have been thinking of *Hercules and Omphale*?

NOTES

1. Laing in exh. New York, Detroit, and Paris 1986–87, 122. This entry owes a great deal to Alastair Laing's probing research, as do those for catalogue numbers 43–47 and 49.

2. A.N., *Minutier Central*, LXXXIV/546, "*Inventaire après décès*," M. Randon de Boisset, 18 October 1776, "no. 115, un tableau représentant une femme et un satyr par Boucher peint sur toile dans sa bordure de bois sculpté et doré prise la somme de trois cent livres." I am most grateful to Bruno Pons for giving me the reference to this document.

3. Goncourt 1880–82, I, 145, "Et quelle ressemblance entre ces deux peintres de la décadence, entre ces deux maîtres de sensualisme, Ovide et Boucher!"

4. Paillet described the setting as "une galerie d'architecture avec des draperies suspendues," *Catalogue d'une belle collection de tableaux, la plupart des premiers maîtres Flamands . . .* , Paris, 13 February 1792, 13.

5. There is no known model for this piece of furniture, whose leg comprises a sheath of corn clutched by the putto, with bunches of grapes attached. For their help in identifying this "meuble fantaisiste," I wish to thank Gillian Wilson and James Parker.

6. For a discussion of the story and for references to Ovid, Apollodorus, and Lucian, see cat. no. 23.

7. I have been unable to identify this figure in Boucher's repertory. For access to the painting while on exhibition at The Metropolitan Museum of Art, New York, I am grateful to Gary Tinterow and Anne Norton.

8. Laing in exh. New York, Detroit, and Paris 1986–87, 120, elegantly translating Alexandre Benois's enthusiastic description, which appeared in *Staryé Gody* in 1909.

9. Certain areas remained unresolved, for example, the point at which the red drapery crosses Omphale's right foot.

10. Laing in exh. New York, Detroit, and Paris 1986–87, 122.

11. Nichols 1990, 3–5; Bordeaux 1984 (A), 89, no. 41.

12. Martin 1965, 91, 97; Goltzius's *Labor and Diligence* may also have supplied an appropriate model for Boucher's couple, Bartsch 1978–, III, 110.

13. Bibliothèque Nationale 1930–[1977], IV, 123, no. 416.

14. The first three books of the *Amores* had been translated by Martignac as recently as 1697.

15. Ovid, *Amores*, III, vii, 7–10; Martignac 1697, 313–15, translating, "Elle jettoit à mon cou ses bras plus blancs que l'yvoire et que la neige, elle me baisoit avec ardeur, mettant sa langue dans ma bouche, et pour comble de volupté elle s'entrelassoit avec moy." The connection was first made in Bordeaux 1975, 128.

16. Although in the absence of a list of contents of Boucher's library it is impossible to prove that he had read the *Amores*, it was clearly Boucher's working method to familiarize himself with the literary text before rendering the subject in paint; for which, see Bachaumont's advice to him on the Psyche tapestry commission of 1737, Hiesinger 1976, 7–23.

17. Laing in exh. New York, Detroit, and Paris 1986–87, 123, who bases his argument on the similarity he perceives between Boucher's Hercules and the head of Tarquin in a black chalk counterproof after a drawing by Vleughels, formerly in the collection of the comte d'Orsay, whose attribution to Boucher is, however, open to debate, Méjanès in exh. Paris 1983 (A), 181.

18. The figures of Hercules and Omphale might usefully be compared to those in the early *Pastoral* (Leningrad, The Hermitage), dated in Nemilova 1986, 52, to the 1740s (a decade too late, in this author's opinion), but to the mid–1720s by Laing in exh. New York, Detroit, and Paris 1986–87, cat. no. 2 bis, 101–3 (French edition only).

19. Laing in exh. New York, Detroit, and Paris 1986–87, 113; Papillon de La Ferté 1776, II, 657, "il se mit à peindre, et fit plusieurs petits tableaux précieux, à la manière des Flamands," discussing Boucher's production in Rome. *Peasants with a Goat and a Cow* is reproduced in color in Sotheby's, London, 5 July 1984, no. 369.

20. *Galerie françoise* 1771, 2, "en général les premiers tableaux qu'il a peints en revenant d'Italie, se ressentent du séjour qu'il y a fait, et sont pleins des beautés mâles et vigoureuses des grands maîtres. La couleur en est vraie, locale et harmonieuse, quoique toujours brillante; les têtes et les figures ont toute l'expression dont la toile peut être animée."

21. Laing in exh. New York, Detroit, and Paris 1986–87, 58, in his introductory essay, "Boucher: The Search for an Idiom."

22. Réau 1925, I, 41; see also Ananoff and Wildenstein 1976, I, 238–39; the cogency of this juxtaposition is admitted by Laing in exh. New York, Detroit, and Paris 1986–87, 122.

23. Laing in exh. New York, Detroit, and Paris 1986–87, 129, fig. 97; 128.

24. Ingamells 1989, 65; the date was first proposed by Hermann Voss.

25. For *Rinaldo and Armida*, Boucher's *morceau de réception*— submitted to the Academy on 30 January 1734 and described as "congested to the point of confusion"—see Laing in exh. New York, Detroit, and Paris 1986–87, 160–62; for the paintings comprising Derbais's commission, see cat. nos. 43 and 44.

26. For the various versions of this drawing, see Méjanès in Paris 1983 (A), 170, Ors. 468, "attributed to Boucher," Jean-Richard 1978, 396, no. 1645. A small painting on copper, attributed to N.-R. Jollain and based on the anonymous engraving (or the drawing formerly in de Sireul's collection), appeared in Sotheby's, Monte Carlo, 14 June 1990, no. 473.

27. See de Sireul's *Avertissement* in *Catalogue des Tableaux et Desseins précieux des Maîtres célèbres des Trois Écoles . . . du Cabinet de feu M. Randon de Boisset*, viii–x.

28. Lebrun 1777, 155, "il est flatteur pour M. de Vernet que *la première acquisition* de M. Boisset ait enrichi la France de six Tableaux que nous ne connoissions pas: c'étoit multiplier ses triomphes" (my emphasis). Pidansat de Mairobert's *Approbation* is dated 12 December 1776 (Randon de Boisset died on 28 September 1776). The author is referred to as "l'abbé Lebrun" in the *Privilège du Roi* and should not be confused, as he nearly always is, with the twenty-eight-year-old art dealer Jean-Baptiste-Pierre Lebrun. The abbé Lebrun was chaplain to the *chanoinesses de Belle Chasse* of Saint-Germain. I am indebted to Andrew McClellan for this information.

29. Though Randon de Boisset's taste ran to the pornographic; he owned Boucher's prurient *Raised Skirt* and *The Intimate Toilette*, which recently reappeared on the Parisian market, Ader Picard Tajan, "Collection de Monsieur et Madame Roberto Polo," Paris, 30 May 1988, no. 8.

30. Laing in exh. New York, Detroit, and Paris 1986–87, 120, should be credited with the discovery of Fragonard's lost copy in the Varanchan collection, sold Paris, 29 December 1777, no. 32; previously the copy was cited as having been only in de Sireul's collection, whose close friendship with Randon de Boisset is alluded to by Lebrun 1777, 156, "qui depuis quinze ans étoit lié avec lui de la plus tendre amitié."

31. Metra 1787–90, III, 418, 14 November 1776, "M. Randon de Boisset est mort. C'étoit un de nos millionaires possesseur de plus riche cabinet du royaume. Le public verra du moins les tableaux *qu'il tenoit renfermés*" (my emphasis).

32. For Rémy's inventory, see n. 2; the price was published in the *Journal de Paris*, 10 March 1777.

33. Bailey 1989, 19–25; the painting hung in the same room as Ménageot's *Hercules Returning Alceste to Her Husband* (location unknown), exhibited at the Salon of 1785.

34. Ananoff and Wildenstein 1976, I, 237, fig. 422; Jean-Richard 1978, 326. I am grateful to Christopher Riopelle, Associate Curator of European Painting at the Philadelphia Museum of Art, for obtaining the photograph of Le Mire's engraving.

35. Diderot 1975–[1983], II, 75, "et que peut avoir dans l'imagination un homme qui passe sa vie avec les prostituées du plus bas étage."

36. Laing in exh. New York, Detroit, and Paris 1986–87, 122, citing Diderot's comments in the Salon of 1763: "Il avait une couleur forte et vraie; sa composition était sage, quoique pleine de chaleur; son faire large et grand."

FIG. 1
François Lemoyne, *Putti Playing with the Accoutrements of Hercules*, c. 1721–24, oil on canvas, Philadelphia Museum of Art

FIG. 3
After Jean-François de Troy, *Mars and Venus*, engraved by the comte de Caylus, Paris, Bibliothèque Nationale, Cabinet des Estampes

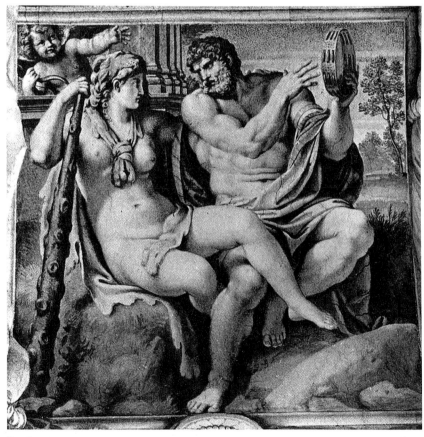

FIG. 2
Annibale Carracci, *Hercules and Iole*, 1597–1600, fresco, Rome, Palazzo Farnese

FIG. 4
François Boucher, *Peasants with a Goat and a Cow*, c. 1730, oil on canvas, Private Collection

FIG. 6
François Boucher, *The Rape of Europa* (detail), 1734, oil on canvas, London, Wallace Collection

FIG. 7
François Boucher, *Hercules and Omphale*, c. 1731, Paris, Musée du Louvre, Cabinet des Dessins

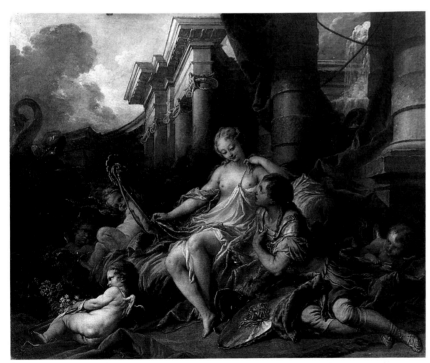

FIG. 5
François Boucher, *Rinaldo and Armida*, 1734, oil on canvas, Paris, Musée du Louvre

FIG. 8
After François Boucher, *Hercules and Omphale*, c. 1767–71, engraved by Noël Le Mire for the abbé Banier's *Métamorphoses d'Ovide*, Philadelphia Museum of Art

FRANÇOIS BOUCHER
Venus Requesting Vulcan to Make Arms for Aeneas

Aurora and Cephalus

43 & 44

FRANÇOIS BOUCHER (1703–1770)
Venus Requesting Vulcan to Make Arms for Aeneas, 1732
Oil on canvas
252 x 175 cm.
Musée du Louvre, Paris

PROVENANCE
François Derbais, inventoried in his estate by Colins, 2 March 1743, as in the *salle de billard* (A.N., *Minutier Central*, LIX/230), valued at 240 *livres* with *Aurora and Cephalus*; Claude-Henri Watelet (1718–1786), his sale, 12 June 1786, no. 11 [sold with *Aurora and Cephalus*, then called *Venus and Adonis*]; purchased by the Crown for 3,121 *livres*; placed in the Louvre in 1786.

EXHIBITIONS
New York, Detroit, and Paris 1986–87, no. 17, col.

BIBLIOGRAPHY
Villot 1857, no. 25; Paris 1867, no. 25; Mantz 1880, 66; Lafenestre and Richtenberger 1893, no. 31; Engerand 1901, 47, n. 2, 594; Kahn 1905, 27; Michel 1906, 12, no. 315; Nolhac 1907, 14–15; Kahn 1907, 7, ill.; Macfall 1908, 23, ill.; Nolhac 1925, 32–33; Michel 1925, 488; Réau 1925, I, 40–41; Dorival 1942, I, 22, ill.; Voss 1953, 82; Brunel 1971, 205, ill.; Ananoff and Wildenstein 1976, I, no. 85; exh. Nice, Clermont-Ferrand, and Nancy 1977, 36; Jean-Richard 1978, 139, 256; Ananoff and Wildenstein 1980, no. 84, ill.; Conisbee 1981, 82, ill.; Levey 1982, 442, ill.; Rosenberg 1984 (B), 224; Bordeaux 1984 (A), 98, ill.; Crow 1986, 12–13, ill.; Brunel 1986, 64–65, 84, 135, ill.; Levey 1987, 200; Pétry 1989, 59.

FRANÇOIS BOUCHER (1703–1770)
Aurora and Cephalus, 1733
Oil on canvas
250 x 175 cm.
Musée des Beaux-Arts, Nancy

PROVENANCE
François Derbais, inventoried in his estate by Colins, 2 March 1743, as in the *salle de billard* (A.N., *Minutier Central*, LIX/230), valued at 240 *livres* with *Venus Requesting Vulcan to Make Arms for Aeneas*; Claude-Henri Watelet (1718–1786), his sale, 12 June 1786, no. 11 [sold as *Venus and Adonis* with *Venus Requesting Vulcan to Make Arms for Aeneas*]; purchased by the Crown for 3,121 *livres*; placed in the Louvre in 1786; transferred to the Musée de Versailles before 1800; sent in October 1800 to decorate the palais de Lunéville during the Congress of Lunéville; given to the Musée de Nancy by the government in April 1801.

EXHIBITIONS
Geneva 1949, no. 61; Brussels 1953, no. 13, ill.; New Orleans 1953–54, no. 36, ill.; London 1954–55, no. 77; Nancy 1955, no. 2; Brussels 1975, no. 53, ill.; New York, Detroit, and Paris 1986–87, no. 18, ill.

BIBLIOGRAPHY
Nancy 1854, no. 105; Clément de Ris 1859–61, I, 27–28; Burty 1864, 165; Nancy 1866, no. 143; Mantz 1880, 88, n. 1; Nancy 1883, no. 273; Nancy 1897, no. 317; Gonse 1900, 227, ill.; Engerand 1901, 594; Kahn 1905, 92, ill.; Michel 1906, 40, no. 88; Nolhac 1907, 5, 33; Macfall 1908, 35; Nancy 1909, no. 327, ill.; Nolhac 1925, 13, 67–68; Fenaille 1925, 54; Gillet 1935, 186, ill.; Shoolman and Slatkin 1950, 60; Moskowitz and Mongan 1962, under no. 694; Schnapper 1962, 122; Vergnet-Ruiz and Laclotte 1965, 74, 227; exh. Paris 1971, 101; exh. Washington and Chicago 1973–74, 27, ill.; Ananoff and Wildenstein 1976, I, no. 86; Ananoff and Wildenstein 1980, no. 85, ill.; Levey 1982, 442–46, ill.; Bordeaux 1984 (A), 98, ill.; Brunel 1986, 64–65, ill.; Jacoby 1987, 265; Levey 1987, 200, ill.; Pétry 1989, 59–60, ill.

He returned to Paris and set about decorating a large room for a private client with subjects from Ovid's *Metamorphoses*. His ingenious compositions attracted crowds of admirers and served to make the young artist's talents better known.[1]

> It could be said that Boucher was born with a brush in his hand; to confirm this one has only to look at what he painted in his youth, in particular The Rape of Europa owned by M. Watelet, one of a set of large pictures made for a marble mason called Dorbay [*sic*], who furnished his entire house with them. These were easy for Boucher to do; so eager was he to make himself known that I believe he would have painted them for nothing, rather than let slip such an opportunity.[2]

Thanks to the archival research of Georges Brunel, Boucher's first great series of mythological paintings—which all eighteenth-century commentators recognized as absolutely critical in launching his career—can be documented with an unusual degree of precision.[3] *Venus Requesting Vulcan to Make Arms for Aeneas* and *Aurora and Cephalus*, inscribed with the dates 1732 and 1733, respectively, are the two vertical panels which, together with three large paintings of horizontal format and two overdoors, decorated the *salle de billard* in the house of François Derbais (d. February 1743) on the rue Poissonnière. They are listed without the artist's name, but with their subjects more or less correctly identified, in the *inventaire après décès* of this obscure *avocat au Parlement*—son of the naturalized Flemish "marble mason" Jérôme Derbais (d. 5 October 1712), whom Mariette had mistakenly credited with their commission.[4] By far the most important works in a collection of some 200 paintings, the large canvases in the *salle de billard*, which also included Boucher's *Mercury Confiding the Infant Bacchus to the Nymphs of Nysa* and *The Rape of Europa* (both London, Wallace Collection), were appraised as such by the dealer and restorer "Sieur" Colins; in the inventory of Derbais's paintings drawn up on 2 March 1743, *Venus Requesting Vulcan to Make Arms for Aeneas* and its pendant, *Aurora and Cephalus*, were valued together at 240 *livres*.[5] D'Angiviller would pay nearly ten times that amount when he acquired the pair of paintings for the Crown at public auction some forty years later.[6]

The set of early mythologies with which Derbais "filled" his house—of which he had gained full possession only after his mother's death in 1728—gave Boucher his first opportunity to treat grand subjects on a grand scale. The vigor of his coloring, the sureness and freedom of his technique, his flawless figure drawing—noted by every eighteenth-century commentator—resulted in a set of history paintings that set new standards for the Academy.[7] Derbais's commission performed the additional service of establishing a repertory of subjects that would sustain Boucher throughout his career. Recognized by contemporaries as an event of the first order, the later history of this series is an eloquent comment on the disrepair into which Boucher's reputation had fallen by the end of the *ancien régime*. Consigned to storage, *Aurora and Cephalus* was separated from its pendant and sent in September 1800 to decorate the palais de Lunéville in preparation for the peace negotiations between France and Austria. Since the administration saw no reason to demand its return after the Peace of Lunéville was signed on 9 February 1801, *Aurora and Cephalus* was among the first paintings to enter the newly created Musée de Nancy.[8] Its companion, *Venus Requesting Vulcan to Make Arms for Aeneas*, languished at the Gobelins until its return to the Louvre in the 1850s.[9] By this time, *Mercury Confiding the Infant Bacchus to the Nymphs of Nysa* and *The Rape of Europa* had lost their attribution to Boucher. Although Lord Hertford acquired them as by Boucher in 1843, they were exhibited in 1860 as the work of Lemoyne, and, despite their reinstatement by Philippe Burty, it was as by Lemoyne that they would be catalogued until 1920.[10]

Venus Requesting Vulcan to Make Arms for Aeneas takes as its subject the story of Venus's nocturnal visit to the forge of Lemnos, recounted by Virgil in the eighth book of *The Aeneid*, in which the goddess urges her estranged spouse to provide arms for her illegitimate son, the Trojan hero Aeneas. After pleading the justice of her cause, she resorts to a more craven form of persuasion: "She throws her snowy arms round about him, and fondles him in soft embrace," thereby assuring Vulcan's aid. Leaving the golden wedding chamber in the middle of the night, Vulcan returns to his forge at Mount Etna and orders his assistants, the three-eyed Cyclopes, to make arms immediately for a "brave warrior."[11]

In keeping with a well-established pictorial tradition, Boucher conflates these two episodes. The supplicant goddess is shown seated on a cloud with the swans who draw her carriage behind her, and in the company of the Three Graces, one of whom—in the earliest use of a recumbent pose which would assume notoriety in Boucher's oeuvre—caresses a pair of doves. Vulcan, sword in hand, his assistants at work around him, returns Venus's gaze in mute admiration, Aeneas's armor already waiting at his feet.

At the heart of Boucher's composition, as in Virgil's narration, is the impassioned exchange between the gods themselves, which is depicted with exceptional candor. As André Michel first pointed out,

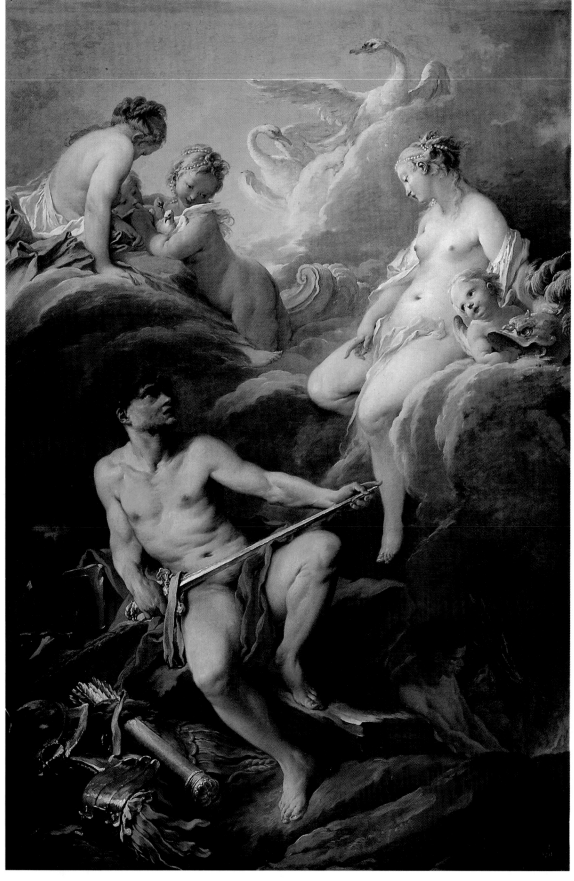

CAT. 43

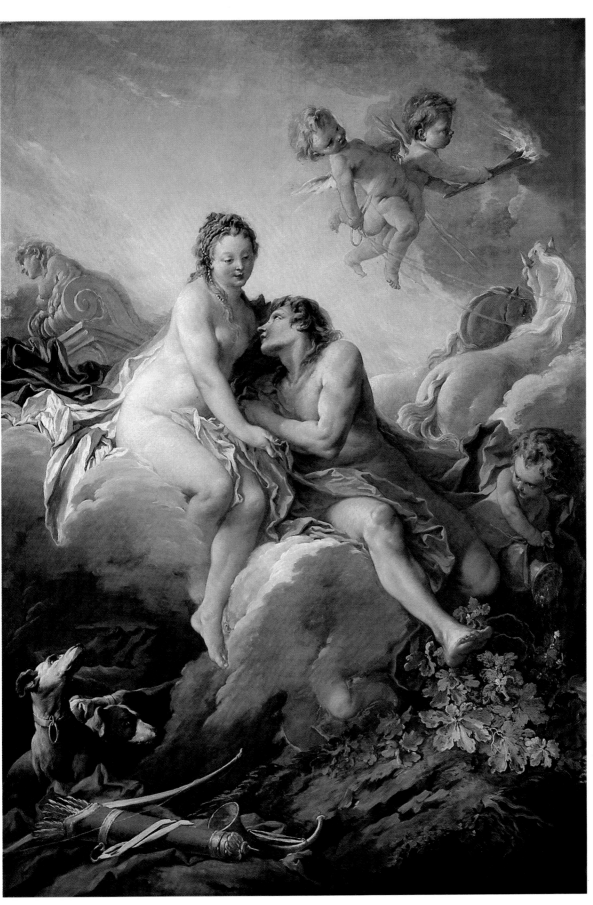

CAT. 44

there is no doubt that Venus has been granted her request; the blond putto seated on the cloud beside her holds a golden helmet, complete with resplendent powder-blue plumage and a fierce visor.[12] Vulcan appears to be in a position of some pain, however, as he reproaches Venus for her subterfuge, asking, "Why seekst so far for pleas? Whither goddess has fled thy faith in me?"[13] Similarly, the inclusion of three Cyclopes, the youngest of whom is just visible behind Vulcan's anvil, not only satisfies pictorially by balancing the triad of plump Graces above, but is another example of Boucher's attentiveness to Virgil's text, in which the attendants, "Brontes and Steropes and Pyracmon," are mentioned by name.[14]

Such learning is carried lightly, however, and in no way inhibits Boucher from painting the life-size deities with remarkable energy and assurance; in 1786 *Venus Requesting Vulcan to Make Arms for Aeneas* was noted to be distinguished "as much by the beauty of its color as by an admirable impasto and the most intelligent touch."[15] This new fluency in handling and amplitude of form were departures for the young artist; Venus is the first of "several hundred" female nudes who conform to Boucher's dictum that women should have bodies but no bones.[16] And if the eroticism of this painting recalls *Hercules and Omphale* (cat. no. 42), Boucher now communicates sexuality more allusively, although his language is still thinly veiled. Legs splayed, right hand held insinuatingly, Venus assumes the pose normally associated with a woman at her toilette; one thinks of Watteau's painting on panel, engraved between 1722 and 1723.[17] And the trailing white drapery, a convenient *cache-sexe*, serves only to fix attention on the voluptuous and snowy region it is intended to conceal. Similarly, Vulcan's tense expression and provocative handling of the sword are responses in kind; rarely could the standard *académie* have been used to such unseemly ends.[18]

The flair and control of Boucher's first dated painting have often been remarked upon; his brazen sensualism less so. So striking and so novel was his interpretation that two of Boucher's most gifted contemporaries, Charles-Joseph Natoire (1700–1777) and Carle Van Loo (1705–1765), plagiarized this painting quite shamelessly.[19] Generally overlooked in *Venus Requesting Vulcan to Make Arms for Aeneas* is Boucher's own engagement in friendly rivalry with Natoire, the most conspicuously favored history painter of their generation. On 30 September 1730 the Academy had assigned this very subject to Natoire for his *morceau de réception*, an event which Boucher, *agréé* on 24 October 1731, must have been aware of.[20] On one level, the exuberance with which he approached the first of Derbais's decorations may

have been an attempt to steal Natoire's thunder. Unwisely, perhaps, the latter played Boucher at his own game in liberally quoting from this composition in the *Venus Requesting Vulcan to Make Arms for Aeneas* (cat. no. 38) that he submitted to the Academy on 31 December 1734.[21] The juxtaposition of these two paintings in the exhibition leaves little doubt as to who could claim victory.

If Boucher had a "hidden agenda" in choosing the story of Venus and Vulcan, it did not compromise his success in bringing a new vitality to the language of mythological painting. *Venus Requesting Vulcan to Make Arms for Aeneas* is remarkable, above all, for its "many traits of nature painted with a charged brush," as Watelet was the first to point out to the ill-mannered neoclassical painter Julien de Parme.[22] Yet, in this monumental canvas—so spontaneous, so seemingly artless—Boucher nevertheless pays his dues to the masters of the past. Discussing Boucher's Italian sojourn, the author of the *Galerie françoise* singled out Pietro da Cortona as a potent influence on the nascent history painter; it was from this princely decorator that Boucher had borrowed "the beauty of his compositions, the picturesque grouping of figures, and the magisterial effects of *chiaroscuro*."[23] Cortona's frescoes for the gallery of the Pamphili Palace, a series devoted to the life of Aeneas with which Boucher may have been familiar, provide a possible source here.[24] Cortona's circular medallion of *Venus at the Forge of Vulcan* (fig. 1) bears such similarity with Boucher's *Venus Requesting Vulcan to Make Arms for Aeneas*—Vulcan's tormented expression, the helmet-bearing putto, and even the painting of armor itself are common to both compositions—that it may be considered the primary model for the painting.[25]

In *Aurora and Cephalus*, the companion to *Venus Requesting Vulcan to Make Arms for Aeneas*, Boucher has concentrated all of his attention on the lovers themselves, dispatching ancillary figures, such as the putti seen hurtling through the sky, to the peripheries of the canvas or disguising their presence completely; another putto can be found hiding in the cloud on which Cephalus is seated, his little legs running along the ground, his right ear and cheek just visible by Aurora's foot. Although accurately identified in Derbais's *inventaire après décès*, the subject of this painting, misinterpreted by Paillet in the catalogue of Watelet's posthumous sale of 12 June 1786, has since caused a certain amount of confusion.[26] As Levey and Laing have both pointed out, the misunderstanding is not due to Boucher, who renders an infrequently treated tale with admirable insight and economy.[27]

Only two months after his wedding to Procris, Cephalus, described by Ovid as an Athenian prince,

was abducted by Aurora, saffron-robed goddess of the Dawn, upon whom Venus had inflicted an insatiable longing for young mortals as punishment for having seduced Mars. Catching sight of the young hunter as he was spreading nets for the "antlered deer," Aurora swept down from the heights of "ever-blooming Hymettus," whence she bore the youth against his will. However, she soon tired of Cephalus, who could speak only of his adored Procris, and, in releasing him, spitefully cast doubt on his wife's loyalty. Determined to test Procris, Cephalus disguised himself and gained access to the princess, who ardently resisted his love-making but hesitated momentarily at his offer of a great fortune. Cephalus then revealed his true identity and condemned Procris for her treachery; "overwhelmed with shame," she fled from her husband and sought comfort in the company of Diana and her maidens. Lonely and contrite, Cephalus begged forgiveness and was pardoned; the husband and wife spent many "sweet years together in harmony."[28] The sequel to this tale, Cephalus's accidental and tragic killing of Procris, would provide the subject of one of Fragonard's rare mythological paintings (cat. no. 58).

Although Venus, in berating Vulcan for his reluctance to make arms for Aeneas, had accused him of offering his services to Aurora—"thee the spouse of Tithonus could sway with tears"[29]—there is no tradition, either allegorical or emblematic, in which Virgil's and Ovid's goddesses are thus linked. After they had entered Watelet's collection, Boucher's pendants were associated with a pair of vertical paintings, only slightly smaller in scale, representing Venus and Cupid by Pierre-Charles Trémolières (1703–1739); this may explain Paillet's confusion in cataloguing *Aurora and Cephalus* as yet another of the goddess of Love's amorous encounters.[30]

As with its pendant, scrupulous narration did not impede Boucher's brush.[31] Flames in hand, Aurora's little attendants dispel the dark of night, bringing in their wake the "faintly-rinsed lemon sky of dawn."[32] The foremost putto holds the gossamer reins of Homer Lampus and Phaeton, the two white steeds that draw the goddess's chariot, while a third putto, at right, irrigates the earth from a rustic watering can, flowers sprouting as he pours, an obvious symbol of the morning dew. Although Cephalus's nets are not in evidence—as they would be in Saint-Aubin's later interpretation of the myth—his status as a hunter is indicated by the splendid still life of bow, arrows, and horn in the foreground at left.[33] As Laing has pointed out, Boucher allowed himself one liberty with Ovid's account: although Cephalus, in contrast to the more comely and maternal Aurora, is clearly presented as a young boy, his expression conveys rapture, not dismay.[34]

Although no drawings or sketches are known for *Venus Requesting Vulcan to Make Arms for Aeneas*, we are better informed as to Boucher's working method in *Aurora and Cephalus*.[35] Two beautiful drawings for the figures of Aurora and Cephalus, in red and white chalk on brown paper, establish that Boucher worked very much in the manner prescribed by the Academy, carefully studying his models from life and making the requisite stylizations on the canvas itself. The result is far from the "labored assemblage of separately studied figures" that is supposed to have characterized this tradition.[36] Aurora (fig. 2), who is shown in the preparatory drawing with a kerchief in her hair, lips pursed, and eyes cast down, gains a more elegant pearl headdress in the painting, as well as a rather glazed look in her eyes, brought on perhaps by Cephalus's interminable singing of Procris's praises.[37] The recently discovered drawing for Cephalus (fig. 3) is even more revealing of Boucher's commitment to studying from the live model.[38] Not only is Cephalus's yearning pose fully worked out on paper, but Boucher tried three different solutions for the youth's left hand, even though this detail would eventually be placed in shadow in the painting. Furthermore, the short-haired model in Boucher's drawing would be rejuvenated on canvas by the addition of trailing curls and an exaggerated profile; might the author of the *Galerie françoise* have been thinking of this doe-eyed hunter when he spoke of the figures "in the style of Lanfranco" that Boucher painted upon his return to Paris?[39]

While the originality of *Aurora and Cephalus* has been noted—the corporeal putti and animated handling are both Boucher's inventions—Boucher also includes references both to the live model and to other paintings. Levey pointed out that the harpy who adorns the prow of Aurora's chariot also appears in Agostino Carracci's cartoon for his fresco in the Farnese Gallery (though not in the fresco itself), underscoring Aurora's predatory nature.[40] A more accessible model, and one which Boucher is almost certain to have known, is Lemoyne's overdoor for the duc de Bourbon's *chambre à coucher* in the hôtel du Grand Maître at Versailles, executed in 1724 (fig. 4), in which similar qualities of *fougue* and unbridled carnality are deployed on a much smaller scale.[41] If the acid coloring, barely concealed brushwork, and unrepentant sensuality are, admittedly, more typical of Italian painting at this time, it is useful to compare Boucher's *Aurora and Cephalus* to Sebastiano Ricci's *modello* for a ceiling decoration of the same subject (fig. 5)—also regularly misidentified as *Venus and Adonis*—which exudes a *brio* comparable to that of Boucher's monumental canvas.[42]

One last issue, the "biographical element" in Boucher's *Aurora and Cephalus*, remains to be addressed. It is no longer possible to accept the identification of Aurora as the dark-eyed beauty Marie-Jeanne Buseau (1716–after 1786), who became Madame Boucher on 21 April 1733.[43] Nor is there the slightest similarity between Boucher's callow youth and the dashing sitter of Lundberg's memorable pastel.[44] As has been justly observed, the ages of Boucher and his bride at the time of their marriage—thirty-three and seventeen, respectively—invert the distance in years separating Aurora and Cephalus, and the attempt to identify the goddess and her young lover as Boucher and his young wife misses the piquancy of Ovid's narration.[45] Yet, even though such precise identification—Boucher/Cephalus, Marie-Jeanne Buseau/Aurora—runs counter to the very manner in which eighteenth-century artists approached the genre of mythological painting, the matrimonial aspect of Boucher's canvas should not be dismissed too lightly. Since the Renaissance, the story of Cephalus and Procris had served to illustrate the related themes of fidelity and jealousy, and the subject had earlier enjoyed a certain currency in the celebration of nuptials.[46] Boucher, who executed *Aurora and Cephalus* in the year of his own marriage, may well have been sensitive to the secondary meanings of this story, particularly to Ovid's encouragement of marital trust; after all, it was presumably the artist, not the patron, who selected this subject. It may be such private associations that account for the gentle joyousness of the lovers' embrace, which is far more tenderly portrayed than in any other example of the subject Boucher may have known. It is hard not to return to Levey's conclusion that in *Aurora and Cephalus*, "under all the decorative, mythological trappings, there is a vision of real love."[47]

It was generally acknowledged that Boucher's purpose in the "large paintings" he executed for Derbais was to present himself to the Parisian art world and general public as a figure painter of astonishing virtuosity and a decorator of protean talents. Yet it is not clear what Boucher hoped to gain from this commission—an undertaking that occupied him for the better part of two years and one, if Mariette is to be believed, that he would have gladly done *gratis*. Contemporaries concurred that the artist sought, above all, to make his talents known; more recently, Alastair Laing has even suggested that Derbais's *hôtel particulier*—in an unfashionable part of Paris, it might be added—acted as a kind of gallery in which Boucher could "display his work to prospective clients."[48]

Attractive though this hypothesis may seem, it is not entirely convincing. It is beyond question that, in the years between his return from Rome and his reception as full member of the Academy, Boucher worked with a ferocious single-mindedness to create a market for his art. The mythological paintings in Derbais's *salle de billard*, though not engraved during the patron's lifetime, were indeed widely known. The *Mercure de France* announced in January 1734 that the artist was "already renowned for a quantity of works"; Natoire and Van Loo copied *Venus Requesting Vulcan to Make Arms for Aeneas*; Bachaumont referred to the series as a model of its kind.[49] Yet these are the responses of insiders and do not constitute a market; in fact, no other patron followed Derbais in commissioning paintings of this scale in such quantity, and the immediate consequences for Boucher's career were negligible. Neither the commission to decorate Marie Leczinska's bedroom at Versailles in 1735 nor the opportunity to participate, in a secondary role, in the decoration of the hôtel de Soubise between 1736 and 1738 suggests the slightest recognition of Boucher's talents as a monumental painter with a distinctive palette.[50] The suite of paintings in Derbais's house remained without parallel in Boucher's oeuvre.

But was it really Boucher's intention to put the architects and designers out of business? Had Derbais's commission caught on, the consequences would have been damaging to the practitioners of rococo decoration, in which gilded, mirrored, and delicately sculpted ornament enjoyed an unchallenged authority. Boucher, who was closely connected both privately and professionally to prominent craftsmen in the luxury trades, would surely have recognized that this sort of mythological painting could have little place in the decorative schemes designed by a Boffrand or a Gabriel.[51] Indeed, the banishment of large-scale narrative paintings from the interiors of the wealthy was a constant complaint in art criticism of the first half of the eighteenth century.[52] Can we impute such dissatisfaction with contemporary practice, distinctly radical in nature, to Boucher himself?

It seems unlikely that, in the suite of mythological paintings made for François Derbais, Boucher was attempting to challenge the hegemony of rococo decoration. Nor was it strictly necessary for him to execute such a series in order to "make himself known"; as Mariette's early letters to Gabborri make abundantly clear, the artist had already gained something of an international reputation.[53] A clue to Boucher's possible reasons for executing this series is to be found in Bachaumont's encouragement to the artist as he was about to embark upon the Psyche tapestry series in 1737—"remember well all that you did for M. Dherbais [sic]"—and by a tradition, with no basis in fact, that transforms *Venus Requesting Vulcan to*

Make Arms for Aeneas into a tapestry cartoon for Madame de Pompadour (age eleven at the time).[54] Is it possible that, in painting the suite of mythologies for Derbais, Boucher sought to present himself as a serious candidate for employment by the Tapestry Manufactories—that he was trying to sway official, rather than private, taste? If this is the case, it was not Lemoyne he was taking on,[55] but Jean-François de Troy, whose facility, inexhaustible inventiveness, and cut-price rates had made him the most attractive *fournisseur* of tapestry cartoons.[56] The clarity, legibility, and high decorative appeal of Boucher's narrative paintings, which displayed his proficiency in all the requisite formats, were the best possible advertisement of his skills in a genre still monopolized by Charles-Antoine Coypel and Jean Restout, two history painters of the old school. Boucher, of course, would more than succeed in his ambitions to provide designs for tapestries, haltingly at first—he began working for Beauvais as early as 1734—and with unquestioned preeminence as his career progressed.[57] But this would be at some cost to his early powers of invention. Both as a decorator and as a designer of tapestries and stage sets, Boucher would have to retreat from the scale and exuberance of these early works. Irrepressible in their energy, uncompromising in their erotic power, assured in every passage of their handling, these paintings are the complete articulation of a revolutionary language that would be tamed and civilized over the next three decades.

NOTES

1. Papillon de La Ferté 1776, II, 658, "Il revint à Paris en 1731, et s'occupa à peindre une grande salle pour un particulier, où il représenta des sujets tirés des *Métamorphoses*. Ses ingénieuses compositions attirèrent un concours d'admirateurs, qui publièrent les talens de ce jeune artiste."

2. Mariette 1851–60, I, 165, "On peut dire qu'il est né le pinceau à la main. Il ne faut que voir ce qu'il a peint dans sa jeunesse, et en particulier cet enlèvement d'Europe qu'a M. Watelet et qui faisoit partie du nombre de grands tableaux qu'il avoit fait pour un sculpteur marbrier nommé Dorbay qui en avoit garni toute sa maison, ce qui lui avoit été très-facile, car Boucher, ne cherchant alors qu'à se faire connoître, les auroit, je crois, faits pour rien, plus tost que d'en laisser manquer l'occasion."

3. Brunel 1986, 64; Laing in exh. New York, Detroit, and Paris 1986–87, 133–35, 157–59; Ingamells 1989, 64–67.

4. As in n. 2. The date of Jérôme Derbais's death is given in Rambaud 1964–71, I, 248–49, who publishes his *notoriété après décès*.

5. A.N., *Minutier Central*, LIX/230, "*Inventaire après décès*," M. Derbais, 2 March 1743, "Dans la Salle du Billard, item., deux tableaux peints sur toile dont un représente la naissance de Bacchus et l'autre l'enlèvement d'Europe dans leur bordure de bois doré et sculpté, prisés trois cent cinquante livres; item., deux autres grands tableaux . . . dont un représente l'Aurore et Cephale, et l'autre Vénus qui commande des armes à Vulcain pour Mars [*sic*] . . . prisés deux cent quarante livres; item., un autre grand tableau . . . représentant la naissance de Vénus . . . prisé deux cent cinquante livres." I am most grateful to Udolpho van de Sandt for a copy of this document.

6. Engerand 1901, 593–94.

7. See the excellent discussion by Laing in exh. New York, Detroit, and Paris 1986–87, 133–36.

8. Schnapper 1962, 121–22.

9. Brunel 1971, 205–6, 210; the painting first appears in Villot's catalogue published in 1857.

10. Ingamells 1989, 67, n. 8.

11. Virgil, *The Aeneid*, VIII, 370–453.

12. Michel 1906, 13.

13. Virgil, *The Aeneid*, VIII, 395–96.

14. Ibid., 424–25.

15. *Catalogue de Tableaux . . . le tout provenant du Cabinet de feu M. Watelet*, Paris, 12 June 1786, no. 11, "tant par la beauté de la couleur que par un empâtement admirable et la touche la plus savante."

16. Boucher's advice to Mannlich that "on ne doit presque pas se douter qu'on corps de femme renferme des os . . . sur plusieurs centaines que j'ai fait déshabiller . . . je n'en ai trouvé qu'une seule qui possédât ce haut degré de beauté," cited by Laing in exh. New York, Detroit, and Paris 1986–87, 272.

17. Rosenberg in exh. Paris 1984–85 (A), 333–36.

18. It has been noted that Boucher would repeat the figure of Vulcan in the frontispiece for the "Tombeau de John Churchill, duc de Marlborough," engraved by Laurent Cars, one of Owen MacSwiny's *Tombeaux des Princes*, Jean-Richard 1978, 139; Brunel 1986, 135.

19. Van Loo's *Venus Requesting Vulcan to Make Arms for Aeneas* (Private Collection) is published by Sahut in exh. Nice, Clermont-Ferrand, and Nancy 1977, 36, no. 39.

20. Montaiglon 1875–92, V, 78, "il [Natoire] ira chez M. de Boullongne . . . qui lui donnera le sujet de son ouvrage de réception."

21. Ibid., 149.

22. Rosenberg 1984 (B), 224, "il me répondit qu'il y avoit beaucoup de vérités de nature et un pinceau moëlleux"; Julien de Parme visited the celebrated amateur in his rooms in the former *Académie d'Architecture* at the Louvre on 9 May 1774.

23. *Galerie françoise* 1771, 2, "il emprunta . . . la beauté de l'ordonnance, l'arrangement pittoresque des grouppes, et les grands effets du clair obscur."

24. Briganti 1962, 250–51.

25. It might be noted that Natoire had previously copied Pietro da Cortona's *Rape of the Sabine Women* from the Sachetti collection in 1725, and this had hung in a place of honor at the French Academy in Rome, Montaiglon and Guiffrey 1887–1912, VII, 197, 240.

26. Ananoff and Wildenstein 1976, I, 219.

27. Levey 1982, 445; Laing in exh. New York, Detroit, and Paris 1986–87, 138.

28. Ovid, *Metamorphoses*, VII, 690–752.

29. Virgil, *The Aeneid*, VIII, 383–84.

30. Engerand 1901, 593–94; Paillet acquired all four paintings for the Crown. Trémolières's lost pendants, considerably more expensive than Boucher's mythologies (4,501 *livres* as opposed to 3,201 *livres*), were also dispatched to the palais de Lunéville in September 1800; all trace of them disappears after 1824, exh. Cholet 1973, 81–82.

31. Laing in exh. New York, Detroit, and Paris 1986–87, 136, writes eloquently of "the extraordinary freedom of [Boucher's] fantasy plant in the foreground . . . and the gamboling cupids in the air, who introduce a note of festivity that had almost been banished from monumental French history painting."

32. Levey 1982, 445.

33. Saint-Aubin's *Aurora and Cephalus* (Providence, Museum of Art, Rhode Island School of Design), dated c. 1752 (also called *Le Lever du Jour*), is reproduced in Dacier 1912, 13–15.

34. Laing in exh. New York, Detroit, and Paris 1986–87, 138.

35. Ibid., 133, recording a possible *modello* or reduction of *Venus Requesting Vulcan to Make Arms for Aeneas* which appeared in Chardin's posthumous sale of 6 March 1780 and which bears dimensions in proportion to those of the painting in the Louvre.

36. Ibid., 138; the assessment is unnecessarily harsh.

37. Slatkin in exh. Washington and Chicago 1973–74, 26–27; Grasselli in exh. Washington 1982, 16–17, for two sensitive discussions of the drawing.

38. The drawing is published in Thomas Le Claire, Kunsthandel VI, *Meisterzeichnungen, 1500–1900*, Hamburg 1989, 74–75.

39. *Galerie françoise* 1771, 2.

40. Levey 1982, 445–46; Carracci's cartoon is in The National Gallery, London.

41. Bordeaux 1984 (A), 97–98.

42. Rizzi in exh. Udine 1989, 104; Haskell 1980, 236; Daniels 1976, 83, in which the subject is called *Venus Bidding Farewell to Adonis*.

43. As first proposed by Slatkin in exh. Washington and Chicago 1973–74, 27.

44. Levey 1982, 446.

45. Laing in exh. New York, Detroit, and Paris 1986–87, 138. It should also be noted that the model used for the goddess Aurora served again for the attendant at right in the lost *Birth of Venus* (fig. 6), the fifth large canvas in Derbais's *salle de billard*, Ananoff and Wildenstein 1976, I, 299–300, where both dimensions and dating are inaccurate.

46. Examples come from rather elevated stations of society, however; Lavin 1954, 278–79, cites the example of Chiaberra's (the "Italian Pindar") *Rapimento di Cefalo*, written to celebrate the marriage of Marie de' Medici to Henry IV of Navarre in 1600.

47. Levey 1982, 446.

48. Laing in exh. New York, Detroit, and Paris 1986–87, 135, 157–60.

49. *Mercure de France*, January 1734, 126, "déjà connu par quantité d'ouvrages qui font honneur à la Peinture et à ses heureux talents"; for Natoire's and Vanloo's copies, n. 19; for Bachaumont's encouraging remarks, Laing in exh. New York, Detroit, and Paris 1986–87, 159.

50. For these commissions, Ananoff and Wildenstein 1976, I, nos. 115–18, four allegorical ceiling medallions in grisaille, commissioned for the *chambre de la reine* at Versailles in 1735; and nos. 158–64, the overdoors at the hôtel de Soubise. On this latter commission, which gave birth to Boucher's first fully-fledged *Pastorales*, Laing in exh. New York, Detroit, and Paris 1986–87, 173–77.

51. Pons 1986, 44, 135–45, and Scott 1988, 15–47 ("The Practice of Interior Decoration"), for the best introduction to this issue.

52. See Bailey 1987, 432–34, and Laing in exh. New York, Detroit, and Paris 1986–87, 158.

53. Bottari 1822–25, II, 331–32, letter of 28 January 1732, in which Mariette assures his correspondent that, with regard to his request for a portrait, "Monsù Boucher sara più facile a convertire."

54. Laing in exh. New York, Detroit, and Paris 1986–87, 159, "souvenés vous bien de tout ce que vous avés fait ché M. d'Herbais," citing Bachaumont's manuscript in the Bibliothèque de l'Arsenal, Paris; Lafenestre and Richtenberger 1893, 293.

55. As proposed in Brunel 1986, 71.

56. Dézallier d'Argenville 1762, IV, 368–69, "comme il cherchoit à s'occuper, il avoit proposé de faire au rabais les tableaux qui servent de modèles aux tapisseries du Roi; ce qui déplut à ses confrères."

57. Standen in exh. New York, Detroit, and Paris 1986–87, 325–31, for the best summary.

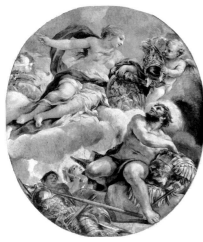

FIG. 1
Pietro da Cortona, *Venus at the Forge of Vulcan*,
1651–54, fresco, Rome, Galleria Doria-
Pamphili

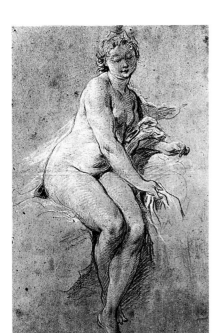

FIG. 2
François Boucher, *Aurora*, c. 1733, red chalk
drawing heightened with white, Private
Collection

FIG. 4
François Lemoyne, *Aurora and Cephalus*, 1724, oil on canvas, Versailles, Hôtel de Ville

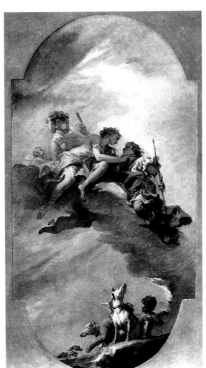

FIG. 5
Sebastiano Ricci, *Aurora and Cephalus*, c. 1707,
oil on canvas, Orléans, Musée des Beaux-Arts

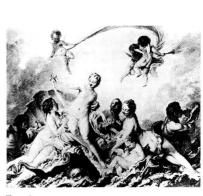

FIG. 6
François Boucher, *The Birth of Venus*, c. 1734,
oil on canvas, location unknown

FIG. 3
François Boucher, *Studies of a Male Nude*,
c. 1733, red and white chalk drawing on brown
paper, Private Collection

Fʀᴀɴçᴏɪs Bᴏᴜᴄʜᴇʀ
Diana at the Bath

45

Fʀᴀɴçᴏɪs Bᴏᴜᴄʜᴇʀ (1703–1770)
Diana at the Bath, 1742
Oil on canvas
56 x 73 cm.
Musée du Louvre, Paris

Pʀᴏᴠᴇɴᴀɴᴄᴇ
Exhibited at the Salon of 1742, no. 18; Berthélémy-Augustin Blondel d'Azincourt (1719–1794), his sale, Paris, 10 February 1783, no. 41, purchased by Hamont for 409 *livres* [paired with Boucher's *Venus and Cupid*, but sold separately]; ? Baron Thibon, his sale, Paris, 14 May 1821 or 1841 (inscribed on destroyed stretcher); comte de Narbonne, his sale, Paris, 24 March 1851, no. 6; M. Van Cuyck until 1852, when it was purchased by the Louvre.

Eхнιвιтιοɴs
Salon 1742, no. 18; Vienna 1966, no. 4, ill.; New York, Detroit, and Paris 1986–87, 22, no. 39, ill.

Bɪʙʟɪᴏɢʀᴀᴘнʏ
Villot 1857, no. 24; Burty 1865, 81; Paris 1867, no. 24; Mantz 1880, 98, ill.; Lafenestre and Richtenberger 1893, no. 30, ill.; Gonse 1900, 42; Kahn 1905, 93, ill.; Michel 1906, 46, no. 130, ill.; Nolhac 1907, 41, 133; Macfall 1908, 39, ill.; Lafenestre [1920s], n.p., ill.; Fenaille 1925, 56, ill.; Nolhac 1925, 82, ill.; Gillet 1929, 54, ill.; Gillet 1935, 186, ill.; Hourticq 1939, 64, ill.; Reff 1964, 555, 556, 558, ill.; Thuillier and Châtelet 1964, 182; Brunel 1971, 210, 212, ill.; exh. Washington and Chicago 1973–74, 61, ill.; Ananoff and Wildenstein 1976, I, no. 215, ill.; exh. Compiègne and Aix-en-Provence 1977, 28, ill.; Jean-Richard 1978, 268; Ananoff and Wildenstein 1980, no. 220, ill.; Tomobe 1981, no. 60, col.; Brunel 1986, 205–6, ill.; Gowing 1987, 534, ill.; Levey 1987, 200, ill.; Posner 1988, 23–27, ill.

Since it entered the Louvre in February 1852, *Diana at the Bath* has been one of Boucher's most universally admired paintings. The painting was copied by Manet within two weeks of its acquisition by the museum and thereafter by Fantin-Latour, Whistler, and Tissot; reproduced on porcelain by Renoir, who claimed that it was the first painting he ever truly loved; and even used in the 1950s by a leading Parisian cosmetics company to promote the sale of skin cream.[1] Its earlier history, however, is surprisingly spare; the painting is documented, with inaccuracies, only twice during the eighteenth century and seems to have elicited no particular response from Boucher's contemporaries.[2] In bringing order to these inconsistencies of record, recent scholarship has tended to lose sight of Boucher's achievement in *Diana at the Bath* and to ignore completely the artist's subtle handling of narrative, which lies at the heart of the composition.

To a protected grove, radiant with afternoon sunlight, Diana has withdrawn to "bathe her limbs in the crystal water" after the rigors of the hunt.[3] Her bright red quiver with its pretty arrows lies abandoned by the water's edge; the spoils of the chase are trussed to the bow at right, red ribbon wrapped around the bird's hind leg. A single attendant is present, and she has just removed Diana's buskins in preparation for the ritual cleansing of the goddess's feet; no sandals can be seen, but their blue ribbons trail across the attendant's arms. Seated on a bolt of blue drapery transformed into a makeshift throne—whose appearance in the vale of Gargaphie is as dramatic as it is inexplicable—the naked goddess fingers a strand of pearls. Her red-haired attendant, crouching uncomfortably at Diana's feet, gazes upon her beautiful form in mute wonderment; the adolescent goddess looks down benevolently, but without emotion. All is silent and still in this verdant grove, although the furthermost dog raises his head from the water, eyes and nose alerted to a presence we cannot yet see.

The early history of *Diana at the Bath* can be summarized quite briefly. Exhibited at the Salon of 1742,

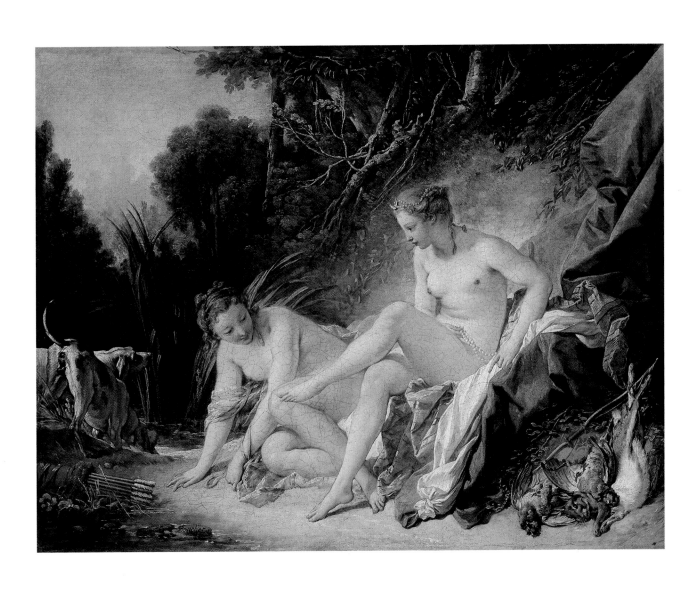

where it was described as "Diana Resting, leaving the bath with one of her companions," it next appears as part of the collection of paintings and drawings sold on 10 February 1783—for reasons that remain mysterious—by Berthélémy-Augustin Blondel d'Azincourt (1719–1794), renowned *amateur* and avid collector of Boucher's drawings.[4] In this sale it was paired with Boucher's *Venus and Cupid* (fig. 1), but was purchased separately for the relatively modest sum of 409 *livres*.[5] The date at which *Diana at the Bath* had entered Blondel d'Azincourt's collection is unknown. The collector was only twenty-three years old when it was painted and he was then renowned more for his bravery in war than for his interest in the arts. By 1749, however, Blondel d'Azincourt had begun to form a picture cabinet of his own—his father, Blondel de Gagny, had one of the finest collections of old master paintings in the capital—and had even written a small treatise on collecting. Here, he openly admitted his distaste for Italian painting as "too dark and showing only sad subjects," claiming to prefer seventeenth-century Dutch and Flemish genre painting above all others;[6] *Diana at the Bath* would certainly have appealed to this *amateur*'s preference for carefully finished cabinet pictures of pleasing subject matter. And while we have no record of Blondel d'Azincourt's collection at this date, it is perhaps noteworthy that Boucher was one of only two living French artists whom he included in his "lists."[7]

Although the pairing of *Diana at the Bath* with *Venus and Cupid* was, in all likelihood, Blondel d'Azincourt's doing—since it was generally accepted that pendants were of critical importance to a harmonious display—*Diana at the Bath* corresponds to the format that Boucher was beginning to follow for highly finished small works, regardless of genre. At the Salon of 1742 it appeared with his *Landscape in the Environs of Beauvais* (Leningrad, The Hermitage), described in the Salon *livret* as "of the same size," and practically all of Boucher's cabinet paintings of the 1740s share similar dimensions.[8]

If the format was standard, so was Diana's pose; the cross-legged female nude is ubiquitous in academic vocabulary and was used by history painters from Boullongne to Natoire.[9] The motif also appears in Boucher's oeuvre at this time in the figure of the girl removing her stocking in *The River Scamandre* (location unknown, engraved by Nicolas de Larmessin) and would be repeated in *Nymphs Reposing from the Chase* (fig. 2), for which, true to form, Boucher returned again to study the seated figure from life. It has been well said that, in *Diana at the Bath*, the "female Spinario" provides the artist with one of his "happiest inventions."[10]

The sources available to Boucher for the cross-legged Diana have received considerable scrutiny, and to the possibilities discussed by Laing might be added the figure of Venus drying her foot in Claude's serene mythological landscape, *The Judgment of Paris* (fig. 3), which is known to have been in Paris between 1720 and 1748.[11] Most recently, Donald Posner has noted the intriguing similarities between the figures in *Diana at the Bath* and the fully clothed attendants who take off their sandals in Jacob Van Loo's painting of the same subject (fig. 4), then in the collection of the prince de Carignan.[12] However, to have seen this painting prior to executing *Diana at the Bath*, Boucher would have needed to gain access to the collection itself, since the sale of Carignan's pictures, advertised for 30 July 1742, did not take place until the following year.[13] The striking resemblance between these two works may, in fact, be no more than one of Baudelaire's "astonishing geometric parallelisms."[14]

More concretely, two drawings for *Diana at the Bath*—one very well known, the other previously unpublished—document once again the deliberation and care with which Boucher prepared his composition. *Seated Female Nude* (fig. 5), an extremely delicate figure study in red and white chalks, is probably a product of Boucher's imagination rather than a drawing from life.[15] Boucher's main concern was to fix Diana's distinctive, semirecumbent position and to lay out the areas of light and shade across her body, which he did with the broadest of hatches; note the white spots on her claw-like hand, which will be translated into dimples in the painting itself. Diana's simplified expression, the sinuous contours of her delicate body, and her perfectly elongated feet endow this drawing with a timeless, almost abstract, quality. This is not the case with a second drawing (fig. 6), in which Boucher carefully recorded the features of Diana's crouching attendant from life. Although he reinforced the contours of her form and strengthened particularly the lines of her feet and hands, this drawing is of a different type from the *Seated Female Nude*. The amplitude of the crouching figure who so commands the page and her distinctive features—triangular face, pinched chin, doe-like eyes—are characteristic of Boucher's figure drawing of the 1730s and suggest that he prepared his cabinet pictures in the manner he employed for his work on a far grander scale.[16]

More than anything else, it is the extraordinary refinement of drawing and the satinate handling of paint that makes *Diana at the Bath* one of the artist's supreme achievements; the two figures themselves "might have been modeled by a caress."[17] Diana and her attendant are painted with meticulous finish, yet Boucher's brush is fluent and delicate throughout.

His touch is lively and varied: of the utmost refinement in the figures themselves, outlined in the softest rose, where each digit and fold of flesh is lovingly described; looser and feathery in the foliage and verdure in the background; creamy, almost chalky, in the painting of the hounds and still life. Boucher unites the figures of Diana and her attendant—crouching in an ungainly pose—through an exchange of astonishing informality and suggestiveness; there can be no doubt that the nymph does not fix her gaze on Diana's foot alone.[18] And to a Parisian's fascination with jewels, ribbons, and fabrics, he brings the history painter's vision of an Arcadia, both timeless and urgently present. Only Boucher could pose the drinking dog at left with such egregious disregard for propriety without disturbing the serenity of the composition as a whole.

In the quality of his drawing, facility of handling of forms, and distillation of narrative—Boucher's "intense concentration," aptly noted by Levey[19]—*Diana at the Bath* bears comparison with *The Triumph of Venus* (Stockholm, Nationalmuseum), the artist's unquestioned masterpiece, painted for Carl Gustav Tessin and exhibited at the Salon of 1740, though the painting was realized on a considerably smaller, and perhaps more marketable, scale. In *Diana at the Bath*, as with *Leda and the Swan* (cat. no. 46), Boucher seems to have been experimenting with a manner of which he would soon tire, in which meticulous description and careful finish—the stock-in-trade of the genre painter—were used for subjects of an altogether more elevated canon. This was certainly not new; "placid scenes of the huntress and her companion enjoying their repose" are something of a commonplace in history painting of the first half of the eighteenth century.[20] But Boucher had yet to treat grand subjects on this diminutive scale with any consistency.

Yet while we might assume that such radiant, polished mythologies of flagrant eroticism would have satisfied demand at every level, it seems that neither the artist nor his patrons responded as they should have done. Boucher may have fixed his prices too high, establishing a tariff of "600 *livres* for work of this scale, when there is finish."[21] The price did not deter such connoisseurs as Crozat de Thiers from seeking to acquire cabinet-size genre paintings; Scheffer reported to Tessin that the artist was literally persecuted by the baron with offers of more money for *The Milliner* (*Morning*; Stockholm, Nationalmuseum), commissioned for Louisa-Ulrika in 1745, the only painting in the series of the Times of the Day that Boucher actually completed.[22] But, by contrast, demand for history paintings on this scale seems not to have been forthcoming. And, perhaps most important, the artist himself gradually retreated from the assiduous and painstaking finish that this work required, the strain of which may have contributed to his failing eyesight, first remarked upon in the late 1740s.[23] Although Boucher continued to produce these diminutive mythologies intermittently throughout his career, *fijn-malerie* never displaced decoration on the large scale as the preeminent genre in his oeuvre.

Discussing *Diana at the Bath* with great sensitivity, Paul Mantz has commented that, in this work above all, "the enthusiasm of [Boucher's] mind worked as one with the serenity of his hand."[24] While the "serenity" of Boucher's hand has never been at issue, the intellectual content of the painting has been considered largely irrelevant. Of course, the directness, informality, and "naturalness" with which Boucher approaches this classical subject are both radical and, from a modern perspective, refreshing. But it does not follow from this that *Diana at the Bath* is bereft of narrative content, nor is there any evidence to support the contention that Boucher's contemporaries regarded the painting as "flawed by its lack of even a hint of 'story.'"[25] This is to view *Diana at the Bath* through nineteenth-century eyes. Indeed, its great beauty is only enhanced by an appreciation of Boucher's receptiveness to Ovid's drama, which he conveyed with exquisite economy of means in the simple raising of a dog's head.

NOTES

1. Reff 1964, 555–57; Lloyd 1975, 722–26, for the painting's influence on Pissarro; Brunel 1971, 212, for Renoir's enthusiasm ("la *Diane au bain* de Boucher est le premier tableau qui m'ait empoigné, et j'ai continué toute ma vie à l'aimer, comme on aime ses premiers amours"); Villot urged the Louvre's acquisition in blatantly nationalistic terms: "Le tableau que je propose d'acheter ne laisse rien à désirer et ne peut manquer d'être apprécié comme il le mérite par tous ceux qui portent un vif intérêt à notre art national," letter to Nieuwerkerke, 14 February 1852, *Archives des Musées Nationaux*, P⁶ 1852 (copy in the Service d'Étude et de Documentation des Peintures, Musée du Louvre).

2. Laing in exh. New York, Detroit, and Paris 1986–87, 197–99; Posner 1988, 23–27. It should be noted that Boucher's wife copied the painting in miniature for Blondel d'Azincourt; in the catalogue of his *first* sale, the subject is listed as "Diane sortie du bain, et qui raccommode ses brodequins," *Catalogue raisonné d'un cabinet curieux . . . [Blondel d'Azincourt]*, Paris, 18 April 1770, no. 45.

3. Ovid, *Metamorphoses*, III, 164.

4. Laing in exh. New York, Detroit, and Paris 1986–87, 198–99, for the most thorough summary.

5. Ibid., 199, who notes ruefully, "today one can only marvel at the comparative esteem in which the two pictures were once held." One can ask whether this price was really so low; Tessin had paid only 372 *livres* for Boucher's *Leda and the Swan* (cat. no. 46).

6. Bailey 1987, 434–38, 446, "ils sont souvent trops brun et n'offrent que des sujets tristes."

7. Institut d'Art et d'Archéologie, Université de Paris IV, Ms. 34, Blondel d'Azincourt, "Première idée de la curiosité," fol. 19; Van Loo is the only other contemporary artist noted.

8. Berlin 1985, 410, for *Venus and Cupid*; Laing in exh. New York, Detroit, and Paris 1986–87, 22, 195, 200; *Woman Fastening Her Garter*, 1742 (Lugano, Thyssen-Bornemisza Collection) is of similar dimensions; Nemilova 1986, 46–47, for Boucher's *Landscape in the Environs of Beauvais*, which, admittedly, is of somewhat smaller dimensions overall (49 x 58 cm.).

9. See the entries in this catalogue for Louis de Boullongne's *Diana Resting* and Watteau's *Diana at Her Bath* (cat. nos. 10 and 13). Natoire uses this pose for the figure of Dorothea in *Dorothea Surprised by the Curé, the Barber, and Cardenio* (Compiègne, Musée National de Palais), a tapestry cartoon in the Don Quixote series painted 1742–43, exh. Compiègne and Aix-en-Provence 1977, 27–29, where the relationship with Boucher's *Diana at the Bath* is noted.

10. Laing in exh. New York, Detroit, and Paris 1986–87, 199, 220–22.

11. Russell in exh. Washington 1982, 155.

12. Posner 1988, 24–25.

13. Ibid., 27, n. 11; the sale took place on 18 June 1743.

14. Tabarant 1947, 85, "Vous doutez que de si étonnants parallélismes géométriques existent dans la nature?" for Baudelaire's retort to the charge that Manet had copied Goya.

15. Laing in exh. New York, Detroit, and Paris 1986–87, 199, correcting the view previously held by Slatkin in exh. Washington and Chicago 1973–74, 61.

16. Boucher's *Head and Shoulders of a Young Woman* (Stockholm, Nationalmuseum), associated with this crouching figure in Ananoff and Wildenstein 1976, I, 328, fig. 654, may, in fact, be preparatory for the attendant standing behind the bull in *The Rape of Europa*, 1734 (London, Wallace Collection). It has also been related to one of the figures in *The Woman at the Fountain*, c. 1730 (Louisville, J.B. Speed Art Museum), Bjurström 1982, no. 827.

17. Goncourt 1880–82, I, 145, "de formes qu'on dirait modelées par une caresse."

18. Posner 1988, 26–27, rather overdoes Boucher as a foot fetishist.

19. Levey 1987, 200.

20. Posner 1988, 24.

21. Goncourt 1880–82, I, 173, citing Carl Reinhold Bersch's letter, dated 12 October 1745, to Tessin: "Le prix restera un secret entre Votre Excellence et lui, à cause de la coutume qu'il a établie de se faire donner 600 livres pour ces grandeurs, quand il y a du fini."

22. Laing in exh. New York, Detroit, and Paris 1986–87, 224–27; Scheffer's letter to Tessin, dated 7 October 1746, is published in Heidner 1982, 144; Crozat de Thiers owned Galloche's *Diana and Actaeon* (cat. no. 12).

23. Heidner 1982, 154, citing Scheffer's letter to Tessin of 27 February 1747, in which he mentions that "l'affoiblissement de sa vue le rend tous les jours moins capable d'application."

24. Mantz 1880, 98, "l'enthousiasme de l'esprit s'accommode avec la sérénité de la main."

25. Posner 1988, 26.

FIG. 1
François Boucher, *Venus and Cupid*, c. 1742, oil on canvas, Berlin, Staatliche Museen Preussischer Kulturbesitz, Gemäldegalerie

FIG. 4
Jacob Van Loo, *Diana with Her Nymphs*, oil on canvas, Berlin, Staatliche Museen Preussischer Kulturbesitz, Gemäldegalerie

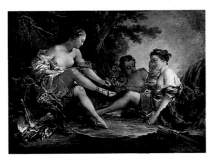

FIG. 2
François Boucher, *Nymphs Reposing from the Chase*, 1745, oil on canvas, Paris, Musée Cognac-Jay

FIG. 5
François Boucher, *Seated Female Nude*, c. 1742, red and white chalk drawing, New York, The Metropolitan Museum of Art, Bequest of Walter C. Baker, 1971 (1972.118.197)

FIG. 6
François Boucher, *Crouching Female Nude*, c. 1742, black and white chalk drawing, Le Havre, Musée des Beaux-Arts

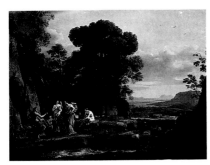

FIG. 3
Claude Lorrain, *The Judgment of Paris*, c. 1645, oil on canvas, Washington, National Gallery of Art

FRANÇOIS BOUCHER
Leda and the Swan

46

FRANÇOIS BOUCHER (1703–1770)*
Leda and the Swan, 1742
Oil on canvas
60 x 74 cm.
Mr. and Mrs. Stewart Resnick

PROVENANCE
Exhibited at the Salon of 1742, no. 21 bis; François-Michel Harenc de Presle (1710–1802) by August 1758, his sale, Paris, 16–24 April 1792, no. 59 (unsold), and his second sale, Paris, 11 *floréal an* III (30 April 1795), no. 67, purchased by Lebrun for 1,200 *livres*; ? Countess of Pembroke, Rome; Théodore Patureau, Paris, who sold it to Dr. Lombard of Liège before 1857; comte d'Hane de Steenhuyse et de Leuwerghem of Ghent, his sale, Hôtel Drouot, Paris, 27 March 1860, no. 3, sold for 3,000 francs; Carlton Gates, his sale, New York, 21 December 1876, no. 480; Professor Paolo Paolini, his sale, American Art Galleries, New York, 11 December 1924, no. 112; George F. Harding Museum, Chicago; sale, Sotheby's, New York, 6 June 1985, no. 147 [as "studio of François Boucher"]; Stair Sainty Matthiesen.

EXHIBITIONS
Salon 1742, no. 21 bis; New York, New Orleans, and Columbus 1985–86, no. 15, col.; New York 1987, no. 22, col.; New York, Detroit, and Paris 1986–87, exhibited in Detroit only, uncatalogued.

BIBLIOGRAPHY
Macfall 1908, 39 [as in Stockholm]; Michel 1906, 46 [as in Stockholm]; Nolhac 1925, 78–80 [as in Stockholm]; Frankl 1961, 144–45 [as in Stockholm]; exh. Washington and Chicago 1973–74, 61 [as in Stockholm]; Ananoff and Wildenstein 1976, I, 336, no. 4 [incorrectly listed as a copy of the Stockholm version]; Jean-Richard 1978, 371 [as in Stockholm]; Reynolds 1980, 104, 108 [as in Stockholm]; exh. Manchester 1984, 17; Owens 1986, 78, ill.; exh. New York, Detroit, and Paris 1986–87, 200.

*Exhibited in Philadelphia and Fort Worth only

Among the paintings and sketches that Boucher submitted to the Salon of 1742 were two cabinet pictures of mythological subjects—*Diana at the Bath* (cat. no. 45) and *Leda and the Swan*—both painted with great refinement and delicacy, and in a finished manner appropriate to their modest scale. *Leda and the Swan* is best known from the version commissioned by Count Carl Gustav Tessin at a cost of 372 *livres* and shipped to Sweden in June 1742, where it has remained ever since (fig. 1).[1] As it is clear that this picture could not have appeared at the Paris Salon that opened its doors on 25 August 1742 (the King's Feast Day), the Salon version, listed in the *livret* as number "*21 bis*," had been considered lost until very recently.[2]

The painting that Boucher exhibited—the "Paris" *Leda and the Swan*—was engraved in 1758 by the Englishman William Wynne Ryland (1732–1785); an advertisement for the engraving appearing in the *Mercure de France* in August of that year.[3] The engraving (fig. 2) differs from the version of *Leda and the Swan* in Stockholm in the patterning of the drapery that falls between Leda and her companion, as well as in details in the shrubbery to their right. The engraving, but not the notice in the *Mercure*, further stipulated that this version of Boucher's painting was "taken from the cabinet of Mr. de Prele [*sic*]."[4]

It is this picture—exhibited at the Salon of 1742, engraved by Ryland, and copied in miniature for Blondel d'Azincourt by Madame Boucher[5]—that is shown here, a major rediscovery since it is not only the "lost" Salon painting, but also Boucher's prime version of the subject. The freer style in which it is painted, the slightly softer contours of the faces of Leda and her companion, and the *pentimenti* visible in the drapery, Leda's left leg, and the swan's neck would already suggest that Boucher executed the Salon painting before Tessin's version. X-ray photographs (fig. 3) reveal further evidence, for when the painting is turned upside down, it becomes clear that Boucher first treated the theme more traditionally, showing Leda alone, reclining voluptuously, the long-necked swan imposing itself against her breast.[6] He would

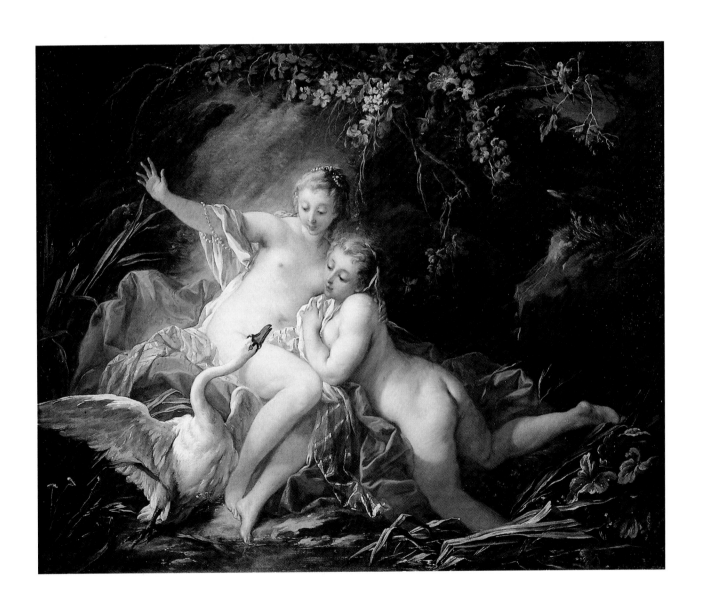

return to this more conventional design in a drawing, engraved by Demarteau (fig. 4), clearly a variation of the abandoned composition.[7]

The major differences between the Resnick and Stockholm versions of the subject are similar to those changes noted for the engraving. In the primary version in the Resnick collection, the stripes of the brocade held by Leda's companion are clearly indicated through the folds; in the painting from Stockholm, the regularity of this pattern is interrupted as the drapery falls to the ground. Furthermore, the silvery tufts of grass on the hillock at right in the Resnick painting do not appear in the *Leda and the Swan* from Stockholm.[8]

The prime version of *Leda and the Swan* was first owned by François-Michel Harenc de Presle (1710–1802), whom Marmontel remembered as being as ugly as he was cultivated and whose collection *"des trois écoles"* was ranked eighth in importance by Thiéry in 1784.[9] We know that Harenc de Presle refurbished his town house on the rue de Sentier in the late 1750s; on 2 April 1759 the *Feuille Nécessaire* commended the "masculine" decoration of his *appartements* as being "far removed from the prevailing taste for false brilliance."[10] It is possible that Harenc de Presle also began forming his small but choice picture cabinet at this time; Boucher's *Leda and the Swan* is first documented as in his collection in August 1758.[11] In 1786 the painting was recorded as hanging in the *petit cabinet* alongside works by Jan Breughel and Palamedesz; Thiéry, in his extensive description of Harenc de Presle's collection, praised *Leda and the Swan* as "from the artist's best period." That, in a footnote, the author felt compelled to insert an almost obligatory and quite gratuitous censure—"an artist who produced an infinite number of graceful but erroneous works"—is testimony to the spectacular decline in Boucher's posthumous reputation well before the onset of the French Revolution.[12]

Having come from a Protestant banking family that had converted after the Edict of Nantes, François-Michel Harenc de Presle purchased the office of *secrétaire du roi* in 1744, and, although he remained attached to financial circles in Paris—his brother-in-law was one of the directors of the East India Company—he was not an active banker as had been his forebears. Rather, he seems to have withdrawn from commerce and is simply described as *écuyer* in the documents that we have discovered, maintaining an elegant and aristocratic style of living as befitted a wealthy *anobli* who had acquired hereditary nobility with the purchase of his expensive office.[13]

Jean-Baptiste-Pierre Lebrun, who managed Harenc de Presle's first estate sale in April 1792—unsuc-cessfully, it must be presumed, since nothing was sold—wrote that he was divesting himself of his collection because of impending blindness.[14] When the paintings came onto the market a second time, exactly three years later, Joseph-Alexandre Lebrun (1755–1802), the younger brother of the more famous picture dealer, gave no reason for the sale.[15] By this time it is likely that the loss of Harenc de Presle's fortune compelled him to sell off both his paintings and his furniture. Upon his death seven years later (19 March 1802), nothing of any value was listed among his effects, which were estimated at under 20,000 *livres*.[16] Harenc de Presle's decline notwithstanding, it is interesting to note that there was a certain consistency of taste among the grandees of the *ancien régime*—the queen of Sweden and a first generation noble owned versions of the same erotic cabinet painting—especially since it was the banker's son who purchased the prime version.

Describing Ryland's print after *Leda and the Swan*, the *Mercure de France* pointed out Boucher's novel interpretation of the subject as well as the charm of his draughtsmanship.[17] Indeed, Boucher's instincts were unerringly pictorial; in *Leda and the Swan* he is less concerned with textual fidelity, as a comparison between the abandoned *première pensée* and the final composition proves. Nowhere in the various accounts of Jupiter's seduction of Leda, wife of King Tyndareus of Sparta—an amorous encounter that would produce Castor and Pollux, Helen and Clytemnestra—are there allusions to a second female of similar beauty to Leda herself.[18] In fact, the innovative and seductive poses of the two women in *Leda and the Swan* derive from Boucher's earlier *Three Graces Playing with Cupid* (fig. 5), one of four drawings inscribed *"pour l'hôtel Mazarin"*—a set of overdoors that were never executed—and among the sheets brought back to Stockholm by Tessin.[19] Leda and her companion repeat, with some slight variation, the figures of the two Graces on the right, and Boucher effected the transition from dalliance to alarm with no difficulty whatsoever.

However, in *Leda and the Swan* Boucher plays down the impending violation. Unlike the engravings after his drawings of the subject, he makes no reference to Cupid, nor does his craning swan invoke the menacing lust of the most powerful of the gods as in Natoire's painting of the same subject (fig. 6), which, in other ways, resembles Boucher's *Leda and the Swan* quite closely; the striped brocade, leafy vegetation, and Leda's foot resting on the water are elements found in both.[20] Instead, Boucher inserted a recumbent nude that appears countless times in his oeuvre: first, peripherally in *Venus Requesting Vulcan to Make*

Arms for Aeneas (cat. no. 43), then more prominently in the *Odalisque* (fig. 7) and *The Education of Love* (Berlin, Schloss Charlottenburg, Staatliche Schlösser und Gärten), the latter commissioned by Frederick the Great and painted within a year of *Leda and the Swan*.[21] With the addition of this second female figure, Boucher created a pyramid of sumptuous white flesh and luxurious raiment, tempering the overtly erotic by a pastoral intimacy midway between the river Euphrates and the *Opéra Comique*.

NOTES

1. Sander 1872, 60, no. 116, for Tessin's shipment of *Leda and the Swan* on 10 June 1742, with appraised value attached.

2. Grate in exh. Manchester 1984, 17, was the first to suggest that the version exhibited at the Salon of 1742 had "disappeared"; see also Laing in exh. New York, Detroit, and Paris 1986–87, 200.

3. *Mercure de France*, August 1758, 157.

4. Jean-Richard 1978, 371, no. 1539.

5. *Catalogue raisonné d'un cabinet curieux . . . [Blondel d'Azincourt]*, Paris, 18 April 1770, no. 41, "Vénus couchée et endormie, avec un Amour; un Léda; ces deux morceaux très agréables . . . h. 1 pouce 10 lignes, l. 1 pouce 7 lignes, sous glace, et en bordure de bronze doré."

6. Bailey in exh. New York, New Orleans, and Columbus 1985–86, 104, fig. 2.

7. Jean-Richard 1978, 208, no. 784.

8. Grate 1987, 69–70, while agreeing with the precedence of the two versions, discusses the relative differences of "spontaneity" and "finish" between the two.

9. Marmontel 1972, I, 68, "Madame Harenc avait un fils unique, aussi laid qu'elle, et aussi aimable. C'est M. de Presle . . . qui s'est longtemps distingué par son goût et par ses lumières parmi les amateurs des arts"; Thiéry 1784, 158.

10. *La Feuille Nécessaire*, 2 April 1759, 118–19, "M. Aran [sic] de Presle a fait faire dans sa maison, rue de Sentier, des morceaux de décoration bien éloignés de ce faux brillant."

11. *Mercure de France*, as in n. 3.

12. Thiéry 1788, I, 443–48, "une imagination vive et brillante qui a produit une infinité d'ouvrages gracieux, mais incorrects."

13. A.N., *Minutier Central*, V/886, "*Inventaire après décès*," Harenc de Presle, 5 *germinal an* X (26 March 1802), for a listing of Harenc de Presle's offices and fortune.

14. *Catalogue d'objets rares et précieux en tout genre formant le cabinet de M. Aranc [sic] de Presle*, Paris, 16 April 1792, iii, "sa vue, par malheur, s'affoiblissant tous les jours, et se voyant privé de la jouissance de cette riche collection, il se détermine aujourd'hui à s'en séparer."

15. *Catalogue d'objets rares et précieux en tout genre formant le cabinet du C. Aranc [sic] de Presle*, Paris, 11 *floréal an* III (30 April 1795), no. 67; *Leda and the Swan*, here described in exactly the same terms as in the earlier sale ("tableau superbe du plus beau faire et de la plus belle couleur"), was bought back by the younger Lebrun for 1,200 francs.

16. "*Inventaire après décès*," as in n. 13.

17. *Mercure de France*, August 1758, 157, "la nouveauté de la disposition du sujet, l'agrément du dessin et le talent de l'artiste rendent cette estampe digne de la curiosité des amateurs."

18. Hyginus, *Fabulae*, LXXVII, is terse; for accounts of this myth, Graves 1955, 206–7.

19. Bjurström 1982, no. 848; the putative commission has never been much investigated, although it is worth noting that Françoise de Mailly, duchesse de Mazarin and *dame d'atours de la reine*, had her *hôtel* redecorated by Pineau in the later 1730s, Pons 1986, 48.

20. Natoire's *Leda and the Swan* is part of the decoration of the château de La Chapelle-Godefroy, completed between 1731 and 1734 (see cat. nos. 36 and 37).

21. Ananoff and Wildenstein 1976, I, nos. 204, 264, 285; Frankl 1961, 138–52, for the classic but outdated article on the pose of this "swimming woman" in Boucher's oeuvre.

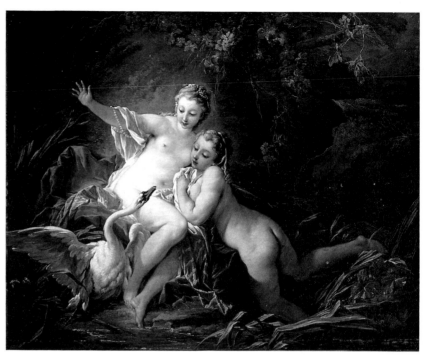

FIG. 1
François Boucher, *Leda and the Swan*, 1742, oil on canvas, Stockholm, Nationalmuseum

FIG. 2
After François Boucher, *Leda and the Swan*,
1758, engraved by William Wynne Ryland,
Paris, Musée du Louvre, Cabinet des Dessins,
Collection Edmond de Rothschild

FIG. 3
X-ray photograph (initial idea seen when image is inverted), François Boucher, *Leda and the Swan*,
1742, Collection of Mr. and Mrs. Stewart Resnick

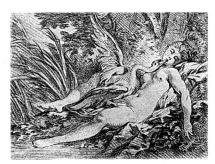

FIG. 4
After François Boucher, *Leda and the Swan*,
engraved by Gilles Demarteau, Paris, Musée du
Louvre, Cabinet des Dessins, Collection
Edmond de Rothschild

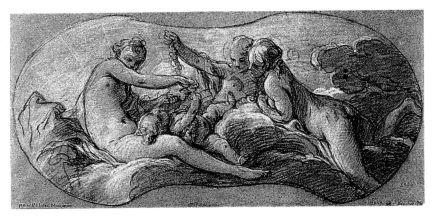

FIG. 5
François Boucher, *Three Graces Playing with Cupid*, c. 1739, black and white chalk drawing,
Stockholm, Nationalmuseum

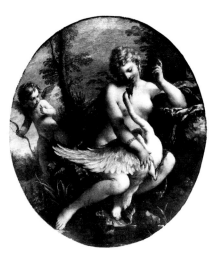

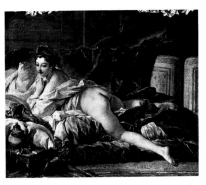

FIG. 7
François Boucher, *Odalisque*, c. 1745, oil on
canvas, Paris, Musée du Louvre

FIG. 6
Charles-Joseph Natoire, *Leda and the Swan*,
c. 1731–34, oil on canvas, Troyes, Musée des
Beaux-Arts

FRANÇOIS BOUCHER
The Rape of Europa

47

FRANÇOIS BOUCHER (1703–1770)
The Rape of Europa, 1747
Oil on canvas
160 x 193 cm.
Musée du Louvre, Paris

PROVENANCE

Exhibited at the *concours de 1747* and purchased by the Crown on 29 September 1747 for 1,500 *livres*; château de la Muette, Paris; intended for the newly founded *Muséum* in 1793; château de Saint-Cloud by 1824, where it remained until c. 1870–72 when it was removed to the Louvre.

EXHIBITIONS

Paris, *concours de 1747*, no. 8; Munich 1958, no. 17; Paris 1960, no. 553; New York, Detroit, and Paris 1986–87, no. 54, col.

BIBLIOGRAPHY

Bret 1747, 3, 6, 7; Leblanc 1747, 52–58; *Mercure de France*, October 1747, 127; Gougenot 1748, 59–60; Baillet de Saint-Julien 1749, 59–60; *Mercure de France*, December 1752, 138–39; Dézallier d'Argenville 1772, 19; Tourneux 1877–82, I, 92; Both de Tauzia 1878, no. 712; Mantz 1880, 112–13; Goncourt 1880–82, I, 189; Engerand 1901, 49; Michel 1906, 63–65, no. 142, ill.; Nolhac 1907, 49–51; Macfall 1908, 46; Tuetey and Guiffrey 1909, 219; Locquin 1912, 6; Frizzoni 1913, 31, ill.; Fenaille 1925, 64; Nolhac 1925, 99–102; Valentiner 1956, 69; Schönberger and Soehner 1960, 372, ill.; Béguin 1971 (A), 201; Brunel 1971, 206, 208, ill.; Kalnein and Levey 1972, 113; exh. Brussels 1975, 100; Ananoff and Wildenstein 1976, II, no. 350, ill.; Jean-Richard 1978, 239; Ananoff and Wildenstein 1980, no. 365, ill.; Conisbee 1981, 93, ill.; Standen 1984–85, 78, ill.; Crow 1985, 13, ill.; Brunel 1986, 236–39, ill.; Goodman-Soellner 1987, 50; Jacoby 1987, 270; exh. Berlin 1988, 156–59; Llewellyn 1988, 162, 164–66, ill.

The Rape of Europa, Boucher's entry to the *concours de 1747*, is his least appreciated mythology. Criticized at the time for its excessive prettiness—Mariette likened it to a fan—it soon fell into oblivion. Not only was *The Rape of Europa* overlooked by the most ardent of those who rediscovered Boucher at the end of the nineteenth century, but its attribution was even cast into doubt, due, in part, to the additions (fig. 1) that would continue to disfigure the painting until 1970.[1] Recently dismissed as an *"oeuvre de circonstance,"*[2] even Boucher's most sensitive historian has allowed that it bears "the showy qualities of a competition piece."[3] Yet no less a connoisseur than Dézallier d'Argenville—who saw the painting in the *salon* of the château de La Muette, where it hung alongside Natoire's *Triumph of Bacchus* (cat. no. 40) until 1793—could describe *The Rape of Europa* as one of Boucher's finest works.[4] If the truth lies somewhere between these extremes of opinion, a more considered examination of the *concours de 1747* and of Boucher's particular strategem on that occasion helps both to reinstate the painting as well as to explain its shortcomings.

The Rape of Europa was one of eleven paintings submitted to a competition organized by Charles Lenormant de Tournehem, the recently appointed *directeur général des Bâtiments du roi*, whose intention was "to encourage emulation in what was regarded as the highest branch of painting, and to provide economic support for it by guaranteeing the purchase of all the entries by the Crown for installation in the royal palaces."[5] Lenormant de Tournehem first conceived of this competition after visiting the Salon of 1746, which seems to have affected him as it did the burgeoning art critic Étienne La Font de Saint-Yenne (1688–1771); both men were now convinced that the French School was in serious decline.[6] On 3 September 1746, Lenormant de Tournehem informed the Academy of his intention to "commission several paintings for the king in order to foster emulation and determine who should thenceforth be of service to His Majesty."[7] Having secured royal approval by the end of the year, Lenormant de Tournehem announced

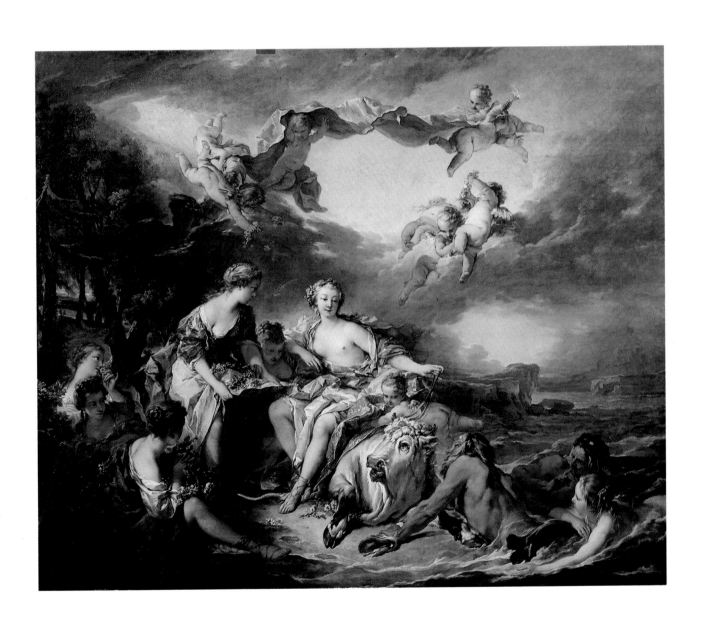

the terms of this exceptional act of official patronage in a letter written on 17 Februrary 1747 and read before the Academy eleven days later.[8] Ten history painters—whose names had been supplied by Charles-Antoine Coypel, *premier peintre du roi* as of 20 January 1747—were to treat subjects of their choice in "whichever genre they were inclined by genius and inspiration."[9] They had six months to complete their paintings, intended as "one of the principal ornaments of the next exhibition," and only one condition to follow: all of the paintings were to be of the same size, six feet in width and four feet in height.[10] At this point nothing was said about winners or prize money, but, as the Salon drew nearer, the original decision to honor six candidates was revised—after lobbying by Boucher, Natoire, and Dumont le Romain—so that each of the competitors would be rewarded.[11]

Although no effort was made to influence the choice of subject matter—towards the representation of recent French victories in the Low Countries, for example—it was quite clear what Lenormant de Tournehem had in mind. As Antoine Duchesne, an official in the Ministry of Fine Arts, pointed out to Natoire in April 1747, the *directeur général* shared the opinion of the connoisseurs "who lament that history painters, seduced by those shallow stories taken from the *Metamorphoses* or from sacred and profane history, simply repeat the themes that had so impressed them in the old masters."[12] New subjects, he implied, taken from the history of "every country and every century" and capable of transforming "the galleries of princes into charming and instructive Libraries," would gain immediate favor.[13] Yet while several of the competitors chose to depict uplifting incidents from ancient history, Boucher and Natoire remained faithful to the genre in which they had secured their reputations. Described as "instinct with voluptuousness," *The Rape of Europa* could hardly be considered novel. At best it might be credited with "bringing something new to a hackneyed subject," although such a strained argument did little honor to the abbé Leblanc's credentials as an impartial critic.[14]

Should, then, *The Rape of Europa*, which hung in a position of prominence in the *galerie d'Apollon* in August 1747, be seen as Boucher's refusal to conform to the *directeur général*'s desire for more elevated themes in contemporary history painting?[15] In fact, the choice of this "hackneyed subject" reflected the artist's opportunism rather than his stubbornness; for in painting *The Rape of Europa* he was working for two masters at once and using the same composition to satisfy quite different demands. Not only was *The Rape of Europa* Boucher's competition piece—to be remunerated at the same rate as a bust-length por-

trait—but it also provided the design for one of the first tapestries in the series *The Loves of the Gods*, commissioned by the Beauvais manufactory in the summer of 1747.[16] Boucher would not complete this set until 1752, yet his early progress encouraged Oudry to report enthusiastically to Louis Fagon on 12 August 1747: "Sieur Boucher is presently at work on paintings for a tapestry series representing *The Loves of the Gods* which shall be very beautiful. He has completed two paintings already."[17] Although Oudry is no more specific than this, it is very likely that one of the "completed paintings" to which he referred is *The Rape of Europa*, which provided the basis for the tapestry of that subject (fig. 2), woven thirteen times between 1750 and 1772.[18]

If *The Rape of Europa* had to satisfy both the reforming *directeur général* and the Beauvais manufactory, it also had to conform to yet another condition: an exceedingly unusual format, five feet in height and six feet in width. At some point between January 1747—when the dimensions for the competition paintings were set, as in the *concours de 1727*, at the standard format of four feet by six feet—and the following June—when Bailly was ordered to find frames for the finished paintings in the stores at Versailles[19]—a new and rarely used format had been introduced, for reasons that are unclear, with dismal consequences for the competitors, who had little experience with these proportions.[20] If, as Charles-Antoine Coypel argued, the administration was to be praised for allowing artists to choose their own subjects and for providing an arena for history painting more hospitable than the gloomy interiors of churches and the "detestable" walls of brightly colored *appartements*, it had failed over the crucial issue of format. Coypel congratulated Lenormant de Tournehem (and himself) for delivering artists from the caprice of the overdoor: "Our academicians will no longer be able to blame the singularity of the contours of their paintings. For it must be admitted that, for some time now, these have been shaped in such a way that even the most able composer inevitably finds himself in the middle of his canvas, surrounded by almost insuperable obstacles."[21] Although the competition paintings did not suffer the indignity of the *chantournement* to which Coypel alluded, their almost square format seems to have been created with a decorative end in mind.

This, at least, was the reasonable assumption of the abbé Raynal, who tersely noted that the suite of competition entries was intended to decorate the royal palace of Choisy.[22] Although a sudden attack of paralysis had forced the battle painter Charles Parrocel to halt work on the decoration of Choisy in June 1747—he was engaged in a series of gallery

paintings honoring the recent French military campaign in Flanders—it seems unlikely that such a heterogeneous group of history paintings was intended as a last minute replacement.[23] The ease with which Boucher's and Natoire's mythologies fitted into the *salon* of the royal hunting lodge at La Muette, however, suggests that Lenormant de Tournehem had a specific location in mind for the competition paintings as a group, and that, *pace* the *premier peintre*, they were to serve as decoration.

Given the diversity of the requirements it had to meet, it is not surprising that Boucher prepared *The Rape of Europa*, a common enough subject, with exceptional care. Several preparatory drawings are known (though none from life), the most notable of which are studies for the clusters of "flying putti," judged by Mariette to be the most successful part of the composition.[24] Boucher employed figures from earlier compositions as well. The seated girl in the foreground at left repeats the flute-playing figure in *Bacchantes* (fig. 3), painted two years earlier, and the attendant in the background smelling a flower is a *reprise* of Boucher's pastel head in the manner of Rosalba.[25]

Boucher also sought to renew his subject in turning to a less commonplace narrative source. The story of Jupiter's abduction of Europa, the virginal princess of Tyre whom he seduced by assuming the form of a friendly bull, is to be found at the end of the second book of Ovid's *Metamorphoses*. Ovid's brief account culminates with bull and maiden in midocean on their way to the island of Crete, with Europa fully aware of the bull's true intentions.[26] The bull's courtship of Europa, in which he frolics on dry land with the princess and her maidens, also greatly appealed to eighteenth-century painters and had been treated by Boucher some thirteen years earlier.[27] It is this episode that would seem to provide the source for Boucher's competition piece, although nowhere in Ovid's rather cursory discussion of the pre-nuptials is such prominence given to flowers, which practically overwhelm the lower left quadrant of *The Rape of Europa*. Such is the pleasure Europa's maidens take in the abundant flora—one carries flowers in her skirt, another holds a freshly plucked flower to her nose, a third is seated with a basket of flowers between her knees—that they seem hardly to notice the lascivious bull at all. Only one account of Europa's abduction gives such prominence to the realm of Flora: Moschus's epic poem, tranlsated from the Greek in 1697, to which Boucher may have had recourse.[28] Sadly, the Salon *livret*, which gives the classical source for several of the competition pieces and thus might have clarified this point, lists Boucher's entry simply by its title.[29]

In keeping with the bucolic tradition, Moschus devotes as much time as possible to the flower-gathering activities of Europa and her troupe. Europa's maidens, "of like age with her, born the same year and of high degree," spend most of their time dancing near streams and delighting in nature.[30] Moschus describes Europa and her entourage in a passage that Boucher seems to have transferred directly onto the canvas: "Forthwith were they before her sight, bound *flower baskets in hand* for the long-shore meadows, there to foregather as was their wont and take their pleasure with the springing roses and the sound of the waves."[31] Moschus's poem is filled with maidens playing in "blossomy meads," "waxing merry" over the flowers, plucking and smelling them, in complete innocence of the true intentions of the "lovely ox" whose "divine fragrance" is the chief of his charms.[32] The felicity of Boucher's choice of this unlikely source was double-edged; not only did it renew a well-worn theme, but the particulars of Moschus's description were especially well suited for a tapestry design, in which a profusion of flowers and verdure was *de rigueur*.

Thus, in *The Rape of Europa* Boucher's use of narrative allowed him to reconcile a variety of disparate demands: an unusual format, a duality of function, and the injunction that history painters renew the content, if not the style, of their productions.[33] The sophistication of Boucher's storytelling was perhaps more apparent to eighteenth-century eyes than to our own, and by far the most sensitive account of the painting is to be found in the description of Claude Duflos's engraving after *The Rape of Europa* which appeared in the *Mercure de France* in December 1752.[34] The anonymous author drew attention to the self-satisfied figure of Cupid in the center of the composition who settles Europa comfortably on the bull's back and even succeeds in placing a set of reins in her left hand; this is probably the first time that Jupiter is to be ridden as a horse. According to the author, the contrast drawn between innocence and experience—the credulous maidens and the scheming bull—is reinforced by the addition of the two tritons and nymph at right, who are "in Jupiter's confidence."[35] The bearded triton whispers encouragement into the bull's left ear, while his younger companion raises a finger to silence him. For the author of the *Mercure de France*, the juxtaposition of calm seas and stormy clouds indicated something more than the changeability of the weather; it was an allusion to love's inconstancy. The anonymous writer was sensitive to *The Rape of Europa*'s pictorial qualities as well; he praised the darkened clouds across a sky of pure blue as "one of the chief beauties of this painting."[36]

Indeed, it is the dynamism of the arch described by the putti racing through the sky—and repeated in the more gentle curve below in a line that connects the nymph's left arm with the leg and shoulder of the seated flower girl—that endows this static composition with considerable energy, despite the unpromising proportions of the canvas. Yet, in spite of the wealth of picturesque detail and the brilliance of Boucher's spatial solutions, *The Rape of Europa* is ultimately weakened by the "trivial expression" of the princess herself.[37] There is something unsettling in the contrast between the rosy-cheeked attendants—the very picture of innocence—and their bare-breasted princess, skirts girded around her thighs, whose immodesty is both blatant and inappropriate. The delicate balance Boucher normally achieved between *"badinage"* and *"volupté . . . le tout sans trop de liberté"* seems, for once, to have failed him.[38]

One possible explanation for the weaker passages in *The Rape of Europa* may be found in the criticism Boucher had received for his *envoi* to the Salon of the previous year and which he now sought to rebut. The most strident dissatisfaction had been voiced by La Font de Saint-Yenne, and, although this would seem tame in comparison to Diderot's scathing, but unpublished, attacks of the 1760s, we know that Boucher and his fellow academicians had been greatly afflicted by these remarks.[39] La Font de Saint-Yenne's *compte-rendu* of the Salon of 1746, published in The Hague, had appeared in Paris only the following year, and it is quite possible that certain weaknesses in Boucher's competition piece resulted from his eagerness to anticipate this critic's further objections.[40] The Academy's uproar can be dated precisely to August 1747,[41] and although the abbé Leblanc considered the appearance of La Font de Saint-Yenne's pamphlet too late to have influenced the contributions to the *concours de 1747*, this might well have been an instance of special pleading. Thus, if

Boucher's grisaille overdoors, *Eloquence* and *Astronomy* (Paris, Bibliothèque Nationale), exhibited at the Salon of 1746, had been "cold and without character," the adolescent maidens in *The Rape of Europa* are overflowing with life.[42] Whereas La Font de Saint-Yenne had wished for "stronger and more vigorous flesh tones" in the two overdoors, Boucher has gone to the opposite extreme in painting Europa's attendants with apple-red blush in their cheeks.[43] Finally, if the figures in the earlier paintings had lacked "truthfulness," Boucher here errs in the other direction in bringing together as many "truthful" attitudes as possible, but at some cost to the credibility of his mythological painting; the girl smelling a flower immediately betrays her origins as portraiture.

However hard Boucher may have tried, he could not have hoped to please all constituencies. While his *Rape of Europa* was acclaimed as the best of the group, the *concours de 1747* was a distinctly lackluster event, which, despite Lenormant de Tournehem's well-meaning intentions, was not repeated the following year.[44] Indeed, as Laing has pointed out, the public arena was henceforward dangerous territory for Boucher; only from the vantage point of the 1760s would La Font de Saint-Yenne's criticism seem reasoned, even genteel.[45] Laing also noted regretfully that if it was over *The Rape of Europa* that the earliest criticisms of Boucher's manner were voiced—hence the defensive posture of the artist's supporters—none of these disparaging comments actually survived in written or printed form. In the minuscule and hardly legible annotations Mariette made on his copy of the Salon *livret* can be found a pithy and succinct summary of the charges against Boucher. They read as follows: "*The Rape of Europa* has too much the look of a fan. The best thing about it are the flying cupids in the sky. The rest is nothing more than a scene of the imagination with actresses in their makeup. This is the product of the society in which we live."[46]

NOTES

1. Mariette's unpublished commentary, "a trop l'air d'un éventail," is found in his annotated copy of the *livret* to the Salon of 1747 in the *Collection Deloynes*, XI, no. 25 (see n. 46); for Mantz 1880, 113, *The Rape of Europa* was "d'une exécution sèche et peu spirituelle"; Michel 1906, 63–64, considered the painting a later replica or even a copy; Nolhac 1907, 50, expressed similar doubts. The extensions, which were made at some point after 1824, were removed in 1970, see Brunel 1971, 201, 206, 208.

2. Brunel 1986, 236.

3. Laing in exh. New York, Detroit, and Paris 1986–87, 237.

4. Dézallier d'Argenville 1772, 18.

5. Laing in exh. New York, Detroit, and Paris 1986–87, 237. See also the excellent summary in Locquin 1912, 1–7.

6. The fullest study of this interesting art critic is Descourtieux 1977–78.

7. Montaiglon 1875–92, VI, 35, "Il alloit ordonner plusieurs tableaux pour le Roi, afin d'exciter l'émulation et de connoître par là ceux qui sont en état d'être utiles à Sa Majesté."

8. Ibid., 45.

9. Ibid., "L'intention du Roi étant que chacun travaille dans le genre de peinture pour lequel il se sent le plus de génie et d'inclination." In addition to the ten history painters named by Coypel, Jeaurat submitted the eleventh competition piece, *Diogenes Breaking his Bowl* (Paris, Musée du Louvre).

10. Ibid., "Je me flatte, Monsieur, que ces dix tableaux seront finis à temps pour faire un des principaux ornements de l'exposition prochaine au Salon du Louvre."

11. A.N., O^1 1923A, fol. 120, Lenormant de Tournehem to Coypel, 29 September 1747, in which the rules of the competition are laid out (six prizes of "100 jetons d'argent et une médaille d'or" to be awarded by the artists themselves), reprinted in Furcy-Raynaud 1906, 331; Montaiglon 1875–92, VI, 67–69, 30 September 1747, "Sur cet exposé MM. Dumont le Romain, Boucher et Natoire ont prié que sans aller au scrutin on partageât également les six prix entre les onze concurents afin d'éviter toute jalousie."

12. Jouin 1889 (B), 140, "Qui se plaignent que les peintres d'histoire, charmés de ces vains faits pris de la métamorphose et de l'histoire sacrée et prophane, répètent ces mêmes faits qui les ont frapés dans les tableaux des grands maîtres."

13. Ibid., "Une histoire suivie des principaux événements de tous les païs et de tous les siècles. Les galleries des princes seroient des Bibliothèques amusantes et instructives."

14. Leblanc 1747, 57–58, "Tout respire la volupté . . . on doit du moins lui scavoir gré de paroître neuf dans un sujet si rebattu."

15. Ibid., 33–73 passim, who describes the paintings in the order in which they were hung in the *galerie d'Apollon* (an order not followed in the *livret*). Boucher's *Rape of Europa* hung between Dumont le Romain's *Mucius Scaevola Putting His Hand in the Fire* (Besançon, Musée des Beaux-Arts) and Natoire's *Triumph of Bacchus* (cat. no. 40).

16. Furcy-Raynaud 1906, 324–25, for the new tariffs for official portraiture, drawn up on 13 May 1747; Standen 1984–85, 63–84, for an excellent account of the tapestry series *Loves of the Gods*.

17. Standen 1984–85, 65, "Le Sr. Bouché me fait actuellement des tableaux pour une tenture qui représente les amours des dieux qui sera très belle: illya déjà deux tableaux de fait," Oudry's letter to Fagon, head of the *Conseil royal des Finances* and closely connected with the administration of Beauvais.

18. Ibid., 77–79; the cartoon for the tapestry, in five strips by 1820, was sold off in 1829.

19. A.N., O^1 1923A, fol. 112, minute to "M. Bailly, garde des tableaux du Roi," 23 June 1747.

20. The first published reference to the new dimensions is in the *livret* for the Salon of 1747, which specifies "onze tableaux en largeur, de 6 pieds sur 5 de haut, ordonnez extraordinairement pour le Roy aux principaux Officiers de son Académie . . . ," *Explication des Peintures, Sculptures, et autres ouvrages de Messieurs de l'Académie royale*, Paris 1747, 6–7.

21. Coypel 1751, 1–2, "Nos Académiciens n'auront point à se rejetter non plus sur la singularité des formes de leurs Tableaux. Car il faut en convenir encore, depuis un tems on les découpe de manière que le plus ingénieux compositeur se trouve au milieu de sa toile, environné d'obstacles presque insurmontables."

22. *Nouvelles Littéraires* 1747–55 in Tourneux 1877–82, I, 92; Raynal was critical of the undertaking: "C'est peu pour un grand roi et trop pour les artistes qui ont très-mal répondu au choix du prince et mal soutenu l'honneur de notre école."

23. Engerand 1901, 384.

24. The list of drawings is to be found in Ananoff and Wildenstein 1976, II, 51, and in Laing in exh. New York, Detroit, and Paris 1986–87, 238–39. *Two Cupids with Drapery, One Brandishing a Torch* (formerly G. Bourgarel sale, 15–16 June 1922, no. 17) was used again for the two putti at top left in *The Rising of the Sun*, 1753 (London, Wallace Collection), as noted in Ingamells 1989, 71.

25. Rosenberg and Stewart 1987, 117–19; Laing in exh. New York, Detroit, and Paris 1986–87, 239, and Stuffmann 1968, 126, for the version formerly in the collection of Crozat de Thiers.

26. Ovid, *Metamorphoses*, II, 833–75.

27. For *The Rape of Europa* painted for Derbais, see cat. nos. 43 and 44.

28. Moschus, *Europa*, 1–166; de Longepierre's translation appeared in two editions in 1686 and 1697.

29. *Explication des Peintures* (as in n. 20), II, no. 11, "L'Enlèvement d'Europe." The explanation accompanying Cazes's entry of the same subject was much more complete and cited a passage from Lucian's *Dialogues of the Gods* in which Neptune, Amphitrite, and Venus all attend the ravishment of Europa. It was the "Dialogue de Notus et de Zephire" that was incorrectly cited in the *Mercure de France*, October 1747, 127, no. 8, as the source for Boucher's painting, and is listed again in Ananoff and Wildenstein 1976, II, 49–50.

30. Moschus, *Europa*, 30–31.

31. Ibid., 33–36 (my emphasis).

32. Ibid., 89–90.

33. Brunel 1986, 237.

34. *Mercure de France*, December 1752, 138–39. The engraving was, in all likelihood, made after a studio replica of smaller dimensions "retouché par ce maître," now in the North Carolina Museum of Art (fig. 4); see Laing in exh. New York, Detroit, and Paris 1986–87, 240.

35. *Mercure de France*, December 1752, 139, "deux nymphes et un triton [sic] qui sont dans le secret de Jupiter."

36. Ibid., "l'ouverture que l'on voit dans le Ciel, dont l'éclat et la lumière produisent une des grands beautés du Tableau."

37. Laing in exh. New York, Detroit, and Paris 1986–87, 239.

38. "Playfulness and voluptuousness, always in moderation," from Alexis Piron's request that lodging in the Louvre be granted to Boucher, cited in Mantz 1880, 28.

39. Leblanc 1747, 2, "le petit ouvrage qui contient l'examen des Tableaux de l'année dernière et qui a fait tant de bruit parmi les peintres." A measure of Boucher's exasperation is the satirical frontispiece he designed for Leblanc's pamphlet, in which the figure of Painting is shown seated and gagged before her easel, mocked by a crowd of figures and animals symbolizing Envy and Stupidity; the engraving is reproduced in Ananoff and Wildenstein 1976, I, 35.

40. Montaiglon 1875–92, VI, 63, 5 August 1747; Lepicié noted that the *Dialogue de M. Coypel sur l'exposition des Tableaux dans le Sallon du Louvre* (as in n. 21) was prompted by the appearance of La Font de Saint-Yenne's *Réflexions sur quelques Causes de l'état . . .* with its "jugements peu exacts sur nos meilleurs maîtres."

41. Leblanc 1747, 58, noting of Natoire's *Triumph of Bacchus* (cat. no. 40) "que son tableau, comme tous les autres, étoit achevé longtemps avant que la Brochure aît paru, puisqu'il n'y a pas de plus d'un mois qu'elle est répandue dans le public." Leblanc's *Lettre sur l'exposition . . .* is dated 30 August 1747.

42. La Font de Saint-Yenne 1747, 75, "extrêmement froide et sans caractère."

43. Ibid., "On désireroit dans ses chairs un coloris plus fort et plus vigoureux."

44. Lenormant de Tournehem had originally intended to repeat the *concours* annually and to include "un nombre des peintures qui ne seroient pas pris du corps de l'Académie"; see the "Note de Lenormant" published in Furcy-Raynaud 1906, 332–33, which should probably be dated to 17 January 1747, as in Engerand 1901, xviii.

45. Laing in exh. New York, Detroit, and Paris 1986–87, 239.

46. *Collection Deloynes*, XI, no. 25, 11, "par M. Boucher, a trop l'air d'un éventail. Ce qui est de mieux sont les amours voltigeurs dans le ciel. Il semble du reste voir un scène d'esprit dans toutes les actrices avec leur fard. Voilà ce que produit la société où l'on se trouve." I am extremely grateful to Udolpho van de Sandt for helping me decipher Mariette's almost illegible annotations.

FIG. 1
François Boucher, *The Rape of Europa*, 1747, oil on canvas, Paris, Musée du Louvre, showing the extensions removed in 1970

FIG. 2
After François Boucher, *The Rape of Europa*, c. 1750–72, wool and silk tapestry, Los Angeles County Museum of Art, Gift of J. Paul Getty

FIG. 3
François Boucher, *Bacchantes*, 1745, oil on canvas, The Fine Arts Museums of San Francisco, Roscoe and Margaret Oakes Collection

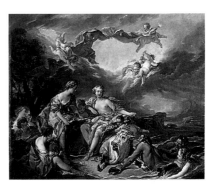

FIG. 4
After François Boucher, *The Rape of Europa*, c. 1760, oil on canvas, Raleigh, North Carolina Museum of Art

FRANÇOIS BOUCHER
Venus Disarming Cupid

48

FRANÇOIS BOUCHER (1703–1770)
Venus Disarming Cupid, 1751
Oil on canvas
142 x 114 cm.
Mr. and Mrs. Stewart Resnick

PROVENANCE
Commissioned in 1751 by Jeanne-Antoinette Poisson, Madame de Pompadour (1721–1764), and inventoried by Pierre Rémy in the "vestibule on the ground floor" of the hôtel d'Evreux on 26 July 1764, when it was valued at 450 *livres*; marquis de Ménars, his sale, Paris, 18 March 1782, no. 20, purchased by Vestris, "danseur," for 730 *livres*; Duterrage sale, Paris, 20 December 1790, no. 12; Rhone collection; comte de Pembroke, his sale, Paris, 30 June 1862, no. 4; Choupot collection; William Randolph Hearst; Private Collection, France.

EXHIBITIONS
San Francisco 1939, no. 110; San Francisco 1939–40, no. 190; Tokyo, Umeda-Osaka, Hokkaido-Hakodate, and Yokohama 1990, no. 19, ill.

BIBLIOGRAPHY
Goncourt 1880–82, I, 188–89; Cordey 1939, 87, 90, no. 1232; exh. Paris 1971, 74; Ananoff and Wildenstein 1976, II, no. 375, ill.; Jean-Richard 1978, 250; Ananoff and Wildenstein 1980, no. 397, ill.; exh. New York 1987, 49.

I n 1765, looking back on a career that had gloried in the female nude, Boucher confided his ideal to his young German pupil Johann Christian von Mannlich (1741–1822): "One should hardly be able to imagine that a woman's body contains any bones; without being fat they must be rounded, yet delicate and slim-waisted."[1] This description applies particularly well to the female deities in Boucher's Crown commissions of the 1740s and 1750s, among which may be included his paintings for Madame de Pompadour since it is reasonably clear that for these, too, the Treasury paid the bills.[2]

Venus Disarming Cupid, possibly executed for the château de Bellevue, Madame de Pompadour's residence of choice between 1750 and 1757, is among the finest of a group of decorative mythologies in which Boucher's "rounded yet delicate" ideal all but overwhelms the canvas. Seated on a cloud, the reins of her carriage draped suggestively across her thigh, Venus has just removed Cupid's quiver and holds one of his precious darts in her right hand. The red-cheeked infant, his curly hair streaked with gray, pleads with his mother as she steadies his quiver with her left hand in order to prevent any more arrows from spilling into the air. Neither narrative nor psychological drama is of the slightest interest to Boucher in this painting. Rather, he crafts the monumental figure of the goddess of Love with a softness and sensuousness that would earn him the epithet of "Venus's court painter."[3] The long-legged goddess, her silver gray hair trailing in the wind, is a *tour de force* of flesh painting; the folds of her stomach, the crook of her arms, and her ample thighs are described with the attention of a voluptuary, yet one who never loses control. Despite the freedom with which he paints clouds, sky, and drapery, Boucher's handling of both figures is seamless, his hatching strokes carefully disguised to produce a finish of flawless porcelain. When one was commissioned to work for the *marquise*, he confided to the Swiss plenipotentiary Carl Fredrick Scheffer in April 1750, "there are things one can neither refuse nor neglect."[4]

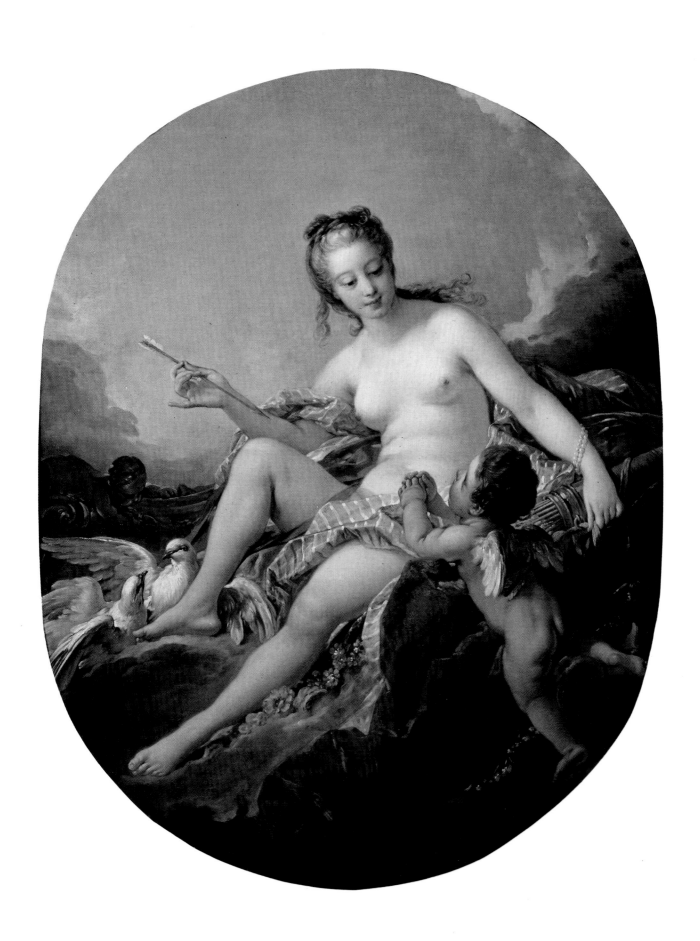

Yet such were the demands on Boucher's time that he was compelled to work efficiently.[5] For both the subject and the design of *Venus Disarming Cupid*, Boucher looked no further than *The Toilet of Venus* and *Venus Disarming Cupid* (both Paris, Musée du Louvre), a pair of overdoors he had painted in 1749.[6] Paring down his presentation of the theme, he simply transposed the central figures of *The Toilet of Venus* (fig. 1) into the subject of Madame de Pompadour's *Venus Disarming Cupid*, adjusting only the position of Venus's right arm and removing the garland of flowers from Cupid's hands. Thus, the study in black and white chalks for the figure of Cupid (fig. 2), generally associated with the present painting, is, in fact, preparatory to the earlier composition and would have been used for a second time in 1751.[7] For the imposing figure of Venus, however, Boucher returned to the live model, even though Venus's provocative pose had been established as early as 1743.[8] A fine study for this figure (fig. 3), identical to the painting and lacking only the bracelet of pearls and the obligatory *cache-sexe* of striped brocade, is signed and dated 1751.[9] This drawing also helps account for the additive quality of the final composition, in which the figures of Venus and Cupid do not altogether relate to one another. Although he based his design on *The Toilet of Venus*, it is clear that Boucher reforged his composition, conceiving Venus as a separate entity and imposing Cupid upon her. The disjuncture is slight, however, and would not have been felt at the distance from which *Venus Disarming Cupid* was intended to be viewed. Above all, the reconfiguring of Boucher's canvas seems not to have impeded the fluency of his brush.

Engraved by Fessard in April 1761—a framed copy of this print was inventoried as hanging in Madame de Pompadour's bedroom—and repeated in several drawings and engravings, *Venus Disarming Cupid* became something of a cliché in Boucher's late *oeuvre*.[10] Jean-Baptiste-Marie Pierre based his small canvas (Paris, Musée des Arts Décoratifs), hitherto unattributed, on Boucher's composition; Madame de Pompadour's picture was widely copied, and it often appeared on gold boxes and miniatures.[11] Yet despite the ubiquity of the image and the fame of the patron for whom *Venus Disarming Cupid* was painted, the early history of the work is far from clear and has been confused in recent literature.[12]

Venus Disarming Cupid is first mentioned on 26 July 1764 by Pierre Rémy, the *expert* called to appraise the works of art after Madame de Pompadour's death on 15 April 1764.[13] Along with several other paintings by Boucher, it was listed as in the "vestibule on the ground floor" of the hôtel d'Evreux, a room that acted as a *garde-meuble* for items brought in from Madame de Pompadour's various residences.[14] Lapidary though they are, Rémy's notations are unfailingly accurate; *Venus Disarming Cupid* was succinctly described as a "*tableau de forme ovale*" and valued at 450 *livres*.[15] It may also be assumed that the work was framed, since in those instances when Boucher's paintings had been detached from paneling they were scrupulously listed as "*sans bordures*."[16] One point is certain: *Venus Disarming Cupid* did not decorate Madame de Pompadour's Parisian residence.[17] Not only was its passage in the vestibule temporary, but it appears to have been commissioned no later than 1751, two years before the *marquise* acquired the hôtel d'Evreux (the present Elysée Palace), one of the grandest buildings in the Faubourg Saint-Honoré.[18] Although *Venus Disarming Cupid* is neither signed nor dated and no documents for its commission are known, a dating of 1751 has always been advanced on stylistic grounds. The painting may be compared to *The Toilet of Venus* (New York, The Metropolitan Museum of Art) and *The Bath of Venus* (Washington, National Gallery of Art), both of which are signed and dated 1751 and recorded as in the *salle de bain* at Bellevue.[19] The inscription on the preparatory drawing for *Venus Disarming Cupid*—"F. Boucher/ 1751"—while possibly by a different hand, supports this chronology.

Indeed, most of Boucher's paintings assembled in the vestibule of the hôtel d'Evreux in July 1764 had been brought in from elsewhere—including the ravishing *Sleep of Venus* (fig. 4), signed and dated 1754, which is more freely painted and of a somewhat warmer tonality than *Venus Disarming Cupid*.[20] Although the prior location of these paintings is not specified in the *marquise's* posthumous inventory, it is possible that many had been commissioned for the château de Bellevue, whose decoration had occupied several of the most prominent history painters and sculptors between 1750 and 1753, Boucher above all.[21] Madame de Pompadour would sell Bellevue to the Crown in 1757 and strip the interior of its contents; some of the paintings that had decorated the *château*, but by no means all, were installed at the hôtel d'Evreux.[22] In the absence of conclusive archival evidence, it is here proposed that *Venus Disarming Cupid*, along with *The Sleep of Venus* and its pendant, now curiously entitled *The Drawing Lesson* (fig. 5), may have decorated one of the principal rooms at Bellevue, perhaps the *chambre du roi*; in size, disposition, and handling the three works share obvious affinities.[23] Because the contents of this room are not mentioned in Dézallier d'Argenville's otherwise complete account of the *château*, this hypothesis must remain speculative, and the history of

Boucher's three paintings between 1757 and 1764 remains to be established.[24]

And what of the iconography of the sumptuous mythologies that may have adorned the "chief of the personal creations of the *Marquise?*"[25] Recently, it has been argued that the works of art commissioned by the *marquise* after 1750 reflected a distinctive personal message, intimately connected to the cessation of her carnal relations with the king.[26] Not only did the *maîtresse en titre* closely identify herself with Venus, she also effected a subtle but brilliant transformation of that goddess's venereal powers through the commission of public statuary in which Venus came to represent Friendship rather than Love.[27] Boucher's three decorative mythologies might also be seen to participate in this domesticized vision of Love; Venus and the attendant cupids are shown sleeping, painting, or, in *Venus Disarming Cupid*, renouncing the instruments of desire altogether. Despite the palpable sensuality of Venus's lily-white form, the composition may be interpreted as the dormition of passion and an end to Love's follies; it is, after all, a full quiver of arrows that Venus has removed for safekeeping.

However, one caveat needs to be made. The iconography of the paintings commissioned by Madame de Pompadour—in contradistinction to Pigalle's sculptures for Bellevue—was not her exclusive property. As has been noted, *Venus Disarming Cupid* looks back to Watteau's celebrated painting of this subject, itself a reprise of a drawing by Veronese.[28] Moreover, Watteau's delicate mythology had provided Boucher with the design of his earliest interpretation of the theme, the *Venus Disarming Cupid* (fig. 6) commissioned in 1744 as part of a set of three overdoors for Choisy, at a time when Madame d'Étioles was still a twinkle in the king's eye.[29] Thus, if little else may be advanced with any certainty of the early history of *Venus Disarming Cupid*, it may be said that, in matters of taste as in much else, Madame de Pompadour's preferences ran instinctively to the royal.[30]

NOTES

1. Mannlich 1989, I, 196, "on ne doit presque pas se doutter, qu'un corps de femmes a des os, me dit il, sans être grasses elles doivent être potelées, délicates et de fine taille sans être maigres"; the translation is Laing's in exh. New York, Detroit, and Paris 1986–87, 272.

2. Posner 1990, 77–78.

3. Fréron in *L'Année Littéraire*, 1757, "que Vénus et sa Cour ont choisi pour leur Peintre," cited in Ananoff and Wildenstein 1976, I, 79.

4. Heidner 1982, 253, "Ce sont des choses qu'on ne peut refuser ni négliger."

5. Boucher was currently engaged upon decorations for La Muette (*Vertumnus and Pomona*, Columbus Museum of Art, and *Arion Rescued by the Dolphin*, Princeton University Art Museum) and "une partie des ouvrages de Bellevue" which would include his masterpieces in the genre, *The Rising of the Sun* and *The Setting of the Sun* (London, Wallace Collection).

6. Ananoff and Wildenstein 1976, II, 28–29, nos. 330 and 331.

7. Ibid., 75–76; Jean-Richard 1978, 250; Macfall 1908, 84, was the first to make the connection between the drawing from The British Museum and the painting in the Louvre. A second drawing by Boucher, however, may be associated with the figure of Cupid in *Venus Disarming Cupid*; it appeared at Christie's, London, 25 June 1968, no. 93, as noted in Jean-Richard 1978, 250.

8. As in *The Toilet of Venus* (New York, Private Collection), signed and dated 1743, in Ananoff and Wildenstein 1976, I, 361, reproduced twice in color in that volume.

9. Hamburg Kunsthalle (inv. 23974); this drawing seems to have been entirely overlooked in the literature.

10. Cordey 1939, 87, no. 1195; for the variants of *Venus Disarming Cupid*, see the discussion by Alan Wintermute in exh. New York 1987, 48–49.

11. The attribution to Pierre of *Venus Disarming Cupid*, catalogued as anonymous in the Musée des Arts Décoratifs (inv. 11302, Don Maclet), was first suggested by Alan Wintermute; for the copy attributed to Hugues Taraval, kindly brought to my attention by Katherine Whann, see Christie's, New York, 4 April 1990, no. 218; a copy of similar dimensions to the original (yet in rectangular format) recently appeared at Sotheby's, Sussex, 20 May 1991, no. 70; for the appearance of *Venus Disarming Cupid* on gold boxes and miniatures, Nocq and Dreyfus 1930, 32, no. 90, Reynolds 1980, 96 (Charlier's *Venus Disarming Cupid* in London, Wallace Collection), and Sotheby Parke Bernet A.G., Zurich, 6 May 1980. I am grateful to Carrie Hamilton for these references.

12. Marandel in exh. Tokyo, Umeda-Osaka, Hokkaido-Hakodate, and Yokohama 1990, 167, no. 19.

13. Cordey 1939, 90, no. 1232.

14. Laing in exh. New York, Detroit, and Paris 1986–87, 256–57, for the clearest summary of the process of appraising Madame de Pompadour's paintings.

15. Cordey 1939, 90, "L'Amour désarmé, tableau de forme ovale par F. Boucher; prisé quatre cens cinquante livres."

16. Ibid. Both *The Toilet of Venus* (New York, The Metropolitan Museum of Art) and *The Bath of Venus* (Washington, National Gallery of Art) are specified as "sans bordure."

17. Contrary to Marandel's assertion, as in n. 12, 167, where he assigns this painting with "the distinguished provenance of having decorated the Parisian *hôtel* of Madame de Pompadour."

18. Kimball 1943, 195–96, who notes that Madame de Pompadour took up residence in 1753; Brice 1752, I, 316, describes the hôtel d'Evreux as "un des plus considérables qui se voient à présent à Paris, tant pour son étendue, que par la magnificence des décorations."

19. Laing in exh. New York, Detroit, and Paris 1986–87, 255–58.

20. This painting, unknown to Ananoff, is published by Marandel in exh. Tokyo, Umeda-Osaka, Hokkaido-Hakodate, and Yokohama 1990, 167–68, no. 20; it is number 1233 in Rémy's inventory, Cordey 1939, 90.

21. Among Boucher's paintings commissioned for Bellevue that appear in the "vestibule au rez-de-chaussée" are *The Interrupted Sleep*, 1750 (New York, The Metropolitan Museum of Art) and *The Two Confidantes*, 1750 (Washington, National Gallery of Art), listed as "représentants des pastoralles," Cordey 1939, 90, no. 1231; for Vanloo's work at Bellevue, see exh. Nice, Clermont-Ferrand, and Nancy 1977, 70–71, nos. 123–28.

22. Biver 1933, 13; the transaction took place on 27 June 1757.

23. The pendant to *The Sleep of Venus* must be *The Drawing Lesson* (New York, Private Collection), whose dimensions and handling would seem to correspond exactly; these appear to be the paintings listed by Rémy directly after *Venus Disarming Cupid* as "deux tableaux de forme ronde, sans bordure, l'un représente Vénus et des Amours endormis, l'autre Vénus avec des Amours," Cordey 1939, 90, no. 1233, Ananoff and Wildenstein 1976, II, 83, no. 378. It is worth noting that when, in July 1766, Marigny finally attended to the redecoration of Bellevue, *three* paintings by Lagrenée were commissioned for the *chambre du roi*, two overdoors and one "entre les croisées," Furcy-Raynaud 1904, 50–53.

24. Dézallier d'Argenville 1752, 29–36; Laing in exh. New York, Detroit, and Paris 1986–87, 257, notes of Boucher's paintings for the *salle de bains* that "Bellevue having been stripped of its pictures when she relinquished it, it is improbable that they came directly from there."

25. Kimball 1943, 195.

26. Gordon 1968, 249–62; Posner 1990, 77.

27. Goodman-Soellner 1987, 44, discusses Madame de Pompadour's performances as Venus in the various ballets written for her between 1748 and 1750; Gordon 1968, 257, quoting d'Argenson's comment of 2 February 1751, "La Marquise jure ses grands dieux qu'il n'y a plus que de l'Amitié entre le Roi et elle. Aussi se fait-elle faire pour Bellevue une statue où elle s'est représentée en déesse de l'Amitié."

28. Jean-Richard 1978, 250; Posner 1984, 75, 79, for Watteau's *Love Disarmed* (Chantilly, Musée Condé).

29. Engerand 1901, 44–46; Ananoff and Wildenstein 1976, I, 356, no. 241.

30. Posner 1990, 74–105, for an extremely thorough, but rather harsh, assessment of Madame de Pompadour's patronage of the arts.

FIG. 1
François Boucher, *The Toilet of Venus*, 1749,
oil on canvas, Paris, Musée du Louvre

FIG. 4
François Boucher, *The Sleep of Venus*, 1754, oil
on canvas, Private Collection

FIG. 2
François Boucher, *Suppliant Cupid*, c. 1749,
black and white chalk drawing, London,
British Museum

FIG. 5
François Boucher, *The Drawing Lesson*, c. 1754,
oil on canvas, Private Collection

FIG. 6
François Boucher, *Venus Disarming Cupid*,
c. 1743, oil on canvas, Private Collection

FIG. 3
François Boucher, *A Study of Venus*, 1751,
black and white chalk drawing, Hamburg,
Kunsthalle

FRANÇOIS BOUCHER
Jupiter in the Guise of Diana Seducing Callisto

49

FRANÇOIS BOUCHER (1703–1770)
Jupiter in the Guise of Diana Seducing Callisto, 1759
Oil on canvas
56 x 74 cm.
The Nelson-Atkins Museum of Art, Kansas City, Missouri
(Nelson Fund)

PROVENANCE
M. de Montblin, *conseiller au Parlement*, his sale, Paris, 25–26 February 1777, no. 4; Mesnard de Clesle, his sale, Paris, 4 December 1786, no. 65, purchased by Lebrun for 999 *livres*, 19 *sous*; M. G[outte], his sale, Paris, 29 March–3 April 1841, no. 196; Edward Timson, his sale, Christie's, London, 18 July 1930, no. 61; Howard Young Galleries, London, until 1932, when it was acquired by The Nelson-Atkins Museum of Art.

EXHIBITIONS
New York 1939, no. 15, ill.; Indianapolis 1965, no. 1, ill.; New York 1980, no. 26, ill.; New York, Detroit, and Paris 1986–87, no. 70, col.

BIBLIOGRAPHY
Michel 1906, no. 180; Nolhac 1907, 116; Frankfurter 1933, 30, ill.; Kansas City 1933, 41, ill.; *Life*, 26 September 1938, 35; Kansas City 1949, 61, ill.; Kansas City 1959, 260, ill.; Ananoff and Wildenstein 1976, II, no. 518, ill.; Jean-Richard 1978, 265; Ananoff and Wildenstein 1980, no. 547, ill.; Ward 1983, 753, ill.

Hastening to repair the ravaged earth after Phaeton's disastrous stewardship of the horses of the Sun, Jupiter took a particular interest in his beloved kingdom of Arcadia, restoring her springs and rivers and causing her "forests to grow green again."[1] During his tour of inspection, he spied the beautiful maiden Callisto, the daughter of King Lycaon and Diana's most esteemed hunting companion. Inflamed by love "to his very marrow," Jupiter assumed the guise of his daughter Diana in order to win Callisto's confidence and was thus able to enter into easy conversation with her. As she related her day's activities, Jupiter, unable to restrain himself any longer, "broke in upon her story with an embrace and by this outrage betrayed himself."[2] Vainly offering resistance, Callisto was soon overcome; she bore her shame for nine months before Jupiter's defilement could no longer be hidden from Diana and the other maidens in her entourage. Callisto's expulsion from the sacred grotto, her transformation into a bear by the vengeful Juno, and her eventual metamorphosis into a constellation of stars named after that animal are the tragic consequences of Jupiter's dalliance on the slopes of Maenalus.[3]

As Alastair Laing has noted, it was Callisto's amorous encounter with Jupiter rather than the revelation of her pregnancy to Diana that provided Boucher with one of his favorite subjects.[4] He treated the story four times between 1759 and 1769, and it was presumably by one of these paintings that he was posthumously represented in Pahin de La Blancherie's survey of three centuries of French painting, held at the *Salon de la Correspondance* in 1783.[5] Whether the story of Jupiter and Callisto enjoyed pride of place in Boucher's late *oeuvre* because it resolved his difficulties in "creating convincing male physiognomies" or whether its popularity is to be explained by a sempiternal demand for lesbian erotica remains open to discussion.[6] That Boucher delighted in the pairing of female nudes is beyond dispute (see also, for example, cat. nos. 43, 45, 46, and 50), yet in all the known versions of *Jupiter and Callisto* he tempered his presentation of the motif with due restraint; in none did he repeat the far more lascivious embrace of the two nymphs at left in *Apollo Revealing His Divinity to Isse* (fig. 1).[7]

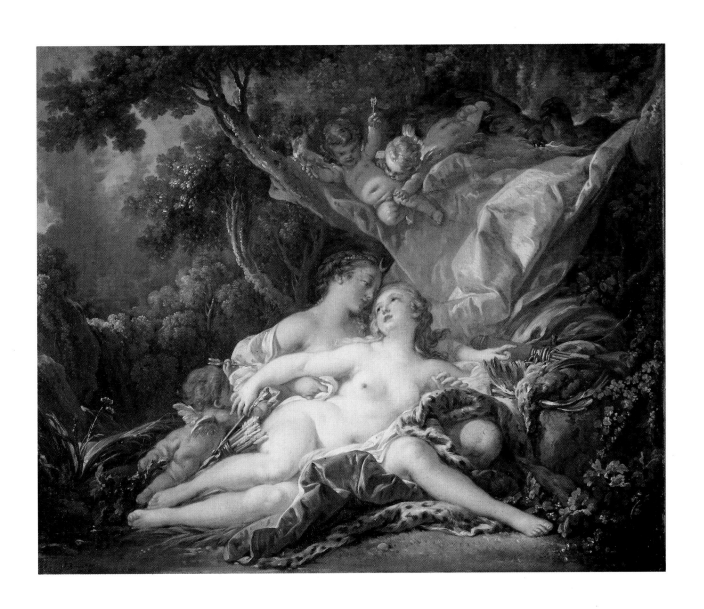

Boucher's pleasure in the coupling of naked women is not achieved at Ovid's expense, however, and the *Metamorphoses* is followed with unobtrusive fidelity. Unlike the *Jupiter and Callisto* (fig. 2) Boucher painted the following year, which established both the format and composition for subsequent versions of the theme, *Jupiter in the Guise of Diana Seducing Callisto* is set in a dense wood whose autumnal foliage threatens to overwhelm the two figures. This is perfectly in keeping with Ovid's description of the groves of Arcadia as "the forest that all years had left unfelled."[8] Although he did not describe Jupiter's ravishment of Callisto in any detail, Ovid noted that she was simply attired and that her hair was "loose flowing."[9] If, for obvious reasons, Boucher expanded on this description, he followed the Latin poet with regard to Callisto's coiffure; her fair hair trails loosely behind her, in notable contrast to the disguised Jupiter's pearl-studded braids. Finally, the scarlet quiver at right to which Jupiter points—the most strident note of color on the canvas—also accords with Ovid's account which, prior to Jupiter's arrival, has Callisto in repose, "with her head pillowed on her painted quiver."[10]

It was not merely in such particulars that Boucher declared himself "Ovid's painter." He handles Ovid's narrative both clearly and elegantly, introducing a fierce eagle at upper right to confirm that the crescent moon on "Diana's" forehead is a mere sham. Boucher also successfully conflates the two sequences in the *Metamorphoses* in which Jupiter first wins Callisto's confidence by discussing the hunt with her—hence his gesture towards the dead game laid out on the rock at right—and then interrupts her account by revealing his true intentions. Jupiter's attack is portrayed symbolically as the pair is assailed by putti who fly in from all directions, the instruments of love clutched in their chubby little hands. Callisto's realization of the inevitable rape is alluded to obliquely in the despairing expression with which she looks up at Jupiter and by the arching of her beautiful body: for, as Ovid relates, "whom could a girl o'ercome, or who could prevail against Jove?"[11]

In *Jupiter in the Guise of Diana Seducing Callisto*, drama is, of course, subordinated to display. As the dealer Alexandre-Joseph Paillet (1743–1814) noted in December 1786, "It would be hard to imagine a more seductive work, in which the composition were any richer and more complete in detail; the facility of Boucher's touch and the gracefulness of his drawing show this artist at his most brilliant."[12] Even taking into account a vendor's customary hyperbole, this is sensitive commentary. Boucher's handling is fluid and painterly, but it is also remarkably finished. His brush caresses the surfaces of pink bodies and rich fabrics; he delights in painting materials, the trophies of the hunt, and a proliferation of verdure; yet at the same time his composition is tightly constructed around two interlocking triangles in which the arrangement of flesh and fabric appears the most natural complement in the world.[13]

At this point in his career, such spatial organization and command of figure painting came easily to the artist, of whom Reynolds complained that he worked "without drawings or models of any kind."[14] While, as Laing has pointed out, Boucher was happy to return to the model and make drawings from life when the need arose, he was also able to delve into a repertory of forms and motifs that he had established during thirty years of unremitting hard work.[15] Thus, the fine drawing in *trois crayons* (fig. 3), formerly considered to be a preparatory study for *Jupiter in the Guise of Diana Seducing Callisto*, is, as Laing has shown, an independent work, probably made after the painting, which incorporates a third putto never intended as part of the composition.[16] The market for finished drawings of this quality had developed considerably since the reopening of the Salon in 1737; in this regard it should be remembered that drawings appeared for the first time at the Salon of 1741 and were exhibited regularly thereafter.[17]

Nonetheless, the extent to which Boucher paraphrased himself in *Jupiter in the Guise of Diana Seducing Callisto* has not been fully appreciated. Although not a single preparatory drawing for the composition survives, the figure of Callisto, reclining voluptuously in Jupiter's lap, derives from that of the bare-breasted Erigone in *Bacchus and Erigone* (fig. 4), painted as an overdoor in 1745.[18] The two figures differ only in the positioning of their hands and in the extent of their *déshabille*. The maniacal putto with torch and arrow in hand is ubiquitous in Boucher's mythological paintings; he is a fatter version of the torch-bearing amor in *Apollo Revealing His Divinity to Isse* (fig. 1), but he is even more closely related to the figure who presides in *Sleeping Bacchantes*, 1758 (New York, Private Collection), whose pose he repeats exactly, but in reverse.[19] Even the distinctive salmon pink drapery, incongruously hitched to the trees to create a canopy for Callisto's makeshift bed, had appeared earlier in *Diana and Callisto* (fig. 5), a compositional study in black chalks dating from the 1740s and Boucher's single treatment of the episode preferred by pictorial tradition.[20]

These disparate quotations are effortlessly integrated to produce a cabinet painting of refinement and controlled eroticism. Obviously intended for the market—the abbé Raynal commented spitefully that

Boucher was too much motivated by money[21]—*Jupiter in the Guise of Diana Seducing Callisto* is first recorded in the small collection of French paintings formed by M. de Montblin, an obscure *conseiller au Parlement* of far less elevated standing than the owners of the later versions of the subject.[22] Next to nothing is known of de Montblin's acquisition of *Jupiter in the Guise of Diana Seducing Callisto*—his name does not appear in the dedication on Gaillard's engraving after the painting, advertised in the *Mercure de France* in August 1760—yet there are no reasons to doubt his proprietorship.[23] It is most unlikely that *Jupiter in the Guise of Diana Seducing Callisto* was "inserted" into his sale by the auctioneer, an ingenious suggestion based on a misunderstanding of the date when Gaillard's engraving first appeared.[24] Gaillard's *two* prints of *Diana and*

Callisto advertised in the *Journal de Paris* in August 1777 are, in fact, after heads by Greuze and have nothing at all to do with Boucher's composition.[25]

In any event, it was probably the painting itself, rather than Gaillard's engraving or the several copies it inspired, that provided the model for a small miniature on ivory (fig. 6) painted at the end of the eighteenth century. And it is pleasant to think that *Jupiter in the Guise of Diana Seducing Callisto* was one of the paintings that Papillon de La Ferté had in mind when he commented: "No artist drew naked women with greater correction, none better conveyed the movement of their muscles and the softness of their skin, nor rendered with greater skillfulness and wit those infantile figures of love."[26]

NOTES

1. Ovid, *Metamorphoses*, II, 408.

2. Ibid., 410, 433.

3. Ibid., 440–507.

4. Laing in exh. New York, Detroit, and Paris 1986–87, 293.

5. Ananoff and Wildenstein 1976, II, nos. 533, 576, 668, for the other three versions; Pahin de La Blancherie 1783, no. 88, "*Jupiter qui prend la figure de Diane pour tromper Callysto* à M. Brichard, notaire." It has not been possible to identify to which version of the painting this refers.

6. Laing in exh. New York, Detroit, and Paris 1986–87, 283; see also the remarks in Donald Posner's introductory essay.

7. Laing in exh. New York, Detroit, and Paris 1986–87, 249–50. The modesty of Boucher's handling of the encounter between the "Lord of all Olympus" and the Arcadian maiden is touched upon in an unexpected source; *Life* magazine, writing enthusiastically in September 1934 of *Jupiter in the Guise of Diana Seducing Callisto*, aptly described the two protagonists as "Versailles cocottes at play."

8. Ovid, *Metamorphoses*, II, 418.

9. Ibid., 413.

10. Ibid., 421.

11. Ibid., 436–37; Papillon de La Ferté 1776, II, 660, mentioned specifically the extent of Boucher's "connoissances littéraires."

12. *Catalogue de Tableaux précieux des Trois Écoles . . . provenant du cabinet de M. le Chevalier de C [Mesnard de Clesle]*, Paris, 4 December 1786, no. 65, "Il seroit difficile de présenter un morceau plus séduisant, d'une composition plus riche et plus soignée dans tous ses détails, la facilité de la touche et les grâces du dessin indiquent un des momens brillans du génie de cet artiste."

13. Ward 1983, 753.

14. Cited by Laing in exh. New York, Detroit, and Paris 1986–87, 285.

15. That Boucher worked ten hours each day was noted in the *Galerie françoise* 1771, 4, "un travail de dix heures par jour depuis le moment qu'il avoit commencé à manier les crayons, jusqu'aux derniers instans de sa vie."

16. Laing in exh. New York, Detroit, and Paris 1986–87, 284–85, correcting Ward 1983, 753.

17. Jacoby 1987, 269–70, who notes that Boucher started exhibiting drawings at the Salon of 1745.

18. Ingamells 1989, 59–60.

19. Ananoff and Wildenstein 1976, II, 185–87, no. 515; Jean-Richard 1978, 262–63, no. 1037, for Gaillard's engraving in which the similarity is most apparent.

20. Slatkin in exh. Washington and Chicago 1973–74, 59, no. 45; the drawing appeared at Christie's, London, 8 December 1976, no. 110.

21. *Nouvelles Littéraires*, August 1750, in Tourneux 1877–82, I, 462, "Nous n'avons point de peintre aussi gracieux que Boucher; mais il travaille pour l'argent et par conséquent il gâte son talent."

22. *Catalogue d'une belle collection de Tableaux . . . provenant de la succession de M. de Montblin, conseiller au Parlement*, Paris, 25–26 February 1777, no. 4. Montblin also owned Leprince's *Russian Lullaby*, now in Malibu, The J. Paul Getty Museum. The first owners of the other versions of *Jupiter in the Guise of Diana Seducing Callisto* were Bergeret de Grandcourt, the duc des Deux-Ponts, and the duc de Caylus.

23. Jean-Richard 1978, 265, no. 1054, for the dedication to "Monsieur d'Arbonne, Grand Maître des Eaux et Forêts"; *Mercure de France*, August 1760, 170, for Buldet's advertisement of Gaillard's engraving, announced as a pendant to Ryland's engraving of Boucher's *Leda and the Swan* (cat. no. 46). My thanks to Alastair Laing for this reference.

24. Doubts of de Montblin's ownership are expressed by Laing in exh. New York, Detroit, and Paris 1986–87, 284, who argues that, since the sale catalogue of February 1777 made mention of an engraving that was announced only in August of that year, some sharp dealing was afoot. Laing's error is not entirely his own; both the Bibliothèque Nationale 1930–[1977], IX, 409, and Jean-Richard 1978, 265, no. 1152, assert that Gaillard's engraving is first announced in the *Journal de Paris* in August 1777.

25. *Journal de Paris*, 12 August 1777, 3, "Callisto et Diane, *deux estampes de neuf pouces de haut sur sept de large . . . d'après les tableaux de J.B. Greuze*" (my emphasis). Gaillard's two engravings after Greuze are correctly catalogued in the Bibliothèque Nationale 1930–[1977], IX, 409–10, nos. 179 and 180.

26. Papillon de La Ferté 1776, II, 660, "Aucun peintre n'a dessiné avec plus de correction les femmes nues, aucun n'a mieux exprimé la flexibilité des muscles et la mollesse de la peau, ni donné plus de finesse et d'esprit, aux caractères enfantins des amours."

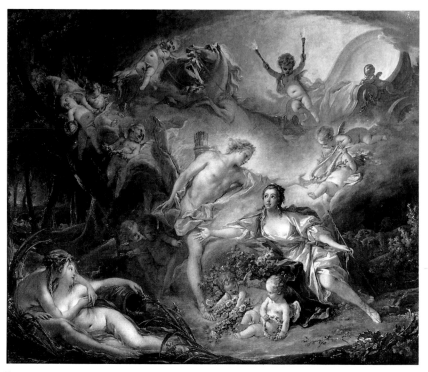

FIG. 1
François Boucher, *Apollo Revealing His Divinity to Isse*, 1750, oil on canvas, Tours, Musée des Beaux-Arts

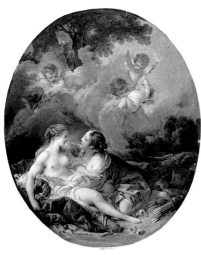

Fig. 2
François Boucher, *Jupiter and Callisto*, 1760, oil
on canvas, Collection of Mrs. D. McDonald,
on loan to The Fitzwilliam Museum,
Cambridge

Fig. 3
François Boucher, *Study of Three Putti in the
Clouds*, c. 1759, black, red, and white chalk
drawing, Kansas City, The Nelson-Atkins
Museum of Art

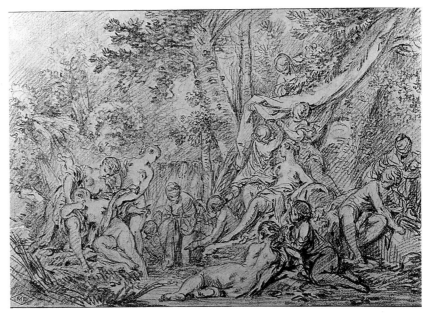

Fig. 5
François Boucher, *Diana and Callisto*, 1740s, black chalk drawing, Private Collection

Fig. 4
François Boucher, *Bacchus and Erigone*, 1745,
oil on canvas, London, Wallace Collection

Fig. 6
After François Boucher, *Jupiter in the Guise of
Diana Seducing Callisto*, miniature on ivory,
Courtesy of The New York Historical Society,
New York City

FRANÇOIS BOUCHER
Pan and Syrinx

50

FRANÇOIS BOUCHER (1703–1770)
Pan and Syrinx, 1759
Oil on canvas
32.5 x 41.5 cm.
The Trustees of The National Gallery, London

PROVENANCE
Armand-Pierre-François de Chastre de Billy, his sale, Paris, 15–19 November 1784, no. 48 [as *Deux Nymphes au bain et couchées sur des draperies, entre des roseaux . . .*], purchased by Quesnot (?) for 651 *livres*; M. Godefroy, his sale, Paris, 15 November 1785, no. 45 [as *Deux Nayades surprises par un Faune*], sold for 660 *livres*; ? Charles de Wailly (1730–1798), his sale, Paris, 24 November 1788, no. 50; ? Pau de Saint-Martin, his sale, Paris, 2 October 1820, no. 77 [as *Deux nymphes couchées dans des roseaux et surprises par un satyre*]; Robert Hollond by c. 1840; bequeathed to The National Gallery in 1880 by Mrs. Robert Hollond; entered the collection in 1885 after her death.

EXHIBITIONS
Never before exhibited.

BIBLIOGRAPHY
London 1882, no. 1090; London 1889, no. 1090; London 1901, no. 1090; Michel 1906, no. 248, ill.; Nolhac 1907, 120, ill.; London 1921, no. 1090; London 1929, no. 1090; Davies 1946, no. 1090; Shoolman and Slatkin 1950, 66; Davies 1957, no. 1090; exh. Paris, 1971, 87; exh. Washington and Chicago 1973–74, 100, 102, ill.; Talbot 1974, 256, ill.; Ananoff and Wildenstein 1976, II, no. 519, ill.; Jean-Richard 1978, 340; Ananoff and Wildenstein 1980, no. 547, col.; Reynolds 1980, 92; *National Gallery Technical Bulletin*, 1983, 68.

"There is no denying Boucher's cleverness and fertility; his light and rapid execution, and his occasionally dainty though always superficial colouring excited the admiration of Paris. He had a happy facility in grouping his figures, and taken altogether was the ablest decorative painter of his time: but that time was a bad one, and Boucher's art entirely suited to it. In the thoroughly artificial and corruptly frivolous life of the French capital under Louis XV, an art founded on nature or having any high ideal would have met with no favour, and Boucher was more than willing to pander to the general taste, restrained by no manner of scruple. . . . He ended a not very reputable life in 1770."

Thus reads the unusually emotional biographical sketch that accompanied the terse entry for *Pan and Syrinx* in the seventy-fourth edition of The National Gallery's *Descriptive and Historical Catalogue*, published in 1889.[1] Such a visceral reaction would be enough to make one grieve for the fate of eighteenth-century French art in England were it not for the bequest to the nation in 1897 by Lady Wallace of the paintings and decorative art assembled by the fourth Marquess of Hertford and added to by his illegitimate son (and her husband), Sir Richard Wallace. The creation of the Wallace Collection may have done little to reverse the prejudice against Boucher, however; The National Gallery continued to print this polemical biography until 1913.[2]

Mrs. Robert Hollond's bequest of her "little Boucher" should not be underestimated. Twice engraved in the eighteenth century and twice copied in miniature by Charlier,[3] *Pan and Syrinx* is among the most erotic mythologies Boucher ever painted—exquisitely finished and utterly candid in its exploration of physical desire. If the keepers of The National Gallery rather neglected this precious object—until 1946 it was routinely catalogued as having been painted on panel—French scholars had no doubt that *Pan and Syrinx* was "a very important canvas."[4]

Yet Boucher's painting is also the most willfully aberrant treatment of the tale of Pan and Syrinx. As

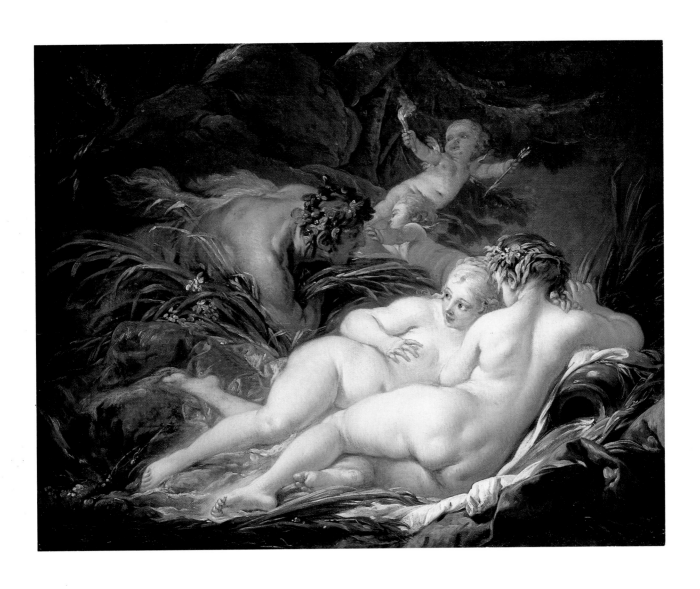

recounted by Ovid in the *Metamorphoses* and by
Longus in *Daphnis and Chloe*, the lusty Pan—"neither
perfect man nor perfect goat"[5]—developed an over-
whelming passion for the nymph Syrinx, who was
"patterned after the Delian goddess in her pursuits
and above all in her life of maidenhood."[6] Pursued by
Pan to the banks of the river Ladon, Syrinx, in des-
peration, called to her "sisters of the stream" to deliv-
er her into safety, which they did by transforming the
beautiful maiden into marsh reeds. It was the "low
and complaining sound" brought forth by the wind as
it stirred in the reeds that inspired Pan to make the
pipes used by him and his followers thereafter in all
their revels.[7]

In Boucher's *Pan and Syrinx*, the elements of this
much-painted tale are refashioned in an ingenious
and surprising manner. The tawny-skinned Pan,
gamely sporting a Van Dyck beard and moustache,
has the requisite ears and animal hindquarters, al-
though no horns are in evidence. Lunging forward at
the river's edge, he embraces the marsh reeds as Sy-
rinx, reclining comfortably, looks up in fright, her left
hand resting gently on the shoulder of her naked "sis-
ter nymph," whose headdress of reeds is her only at-
tribute. All is dark and airless in this curious riverbed
composed of water, reeds, and the most elegant of blue
and white silks which trail before the urn. Illumina-
tion is provided by the fire of Cupid's torch, for there
is no sky behind the massive rocks and sweeping
branches that enclose the protected stream. Syrinx
and her companion assume poses that are both com-
plicit and frank; the faceless nymph displays a back of
Rubensian fleshiness, and Syrinx is shown without
the almost obligatory *cache-sexe*, her claw-like hand
resting upon her right nipple. Pan is portrayed with
the outraged expression of a cuckold; the foremost
winged putto makes a futile attempt to restrain him,
and even the arrow-bearing Cupid registers alarm in-
stead of pleasure. All this suggests a license that goes
far beyond the conventional treatment of Ovid's tale,
whose erotic potential was fairly well exploited in the
eighteenth century (see cat. nos. 1 and 17).[8] Above
all, in Boucher's *Pan and Syrinx* there is no sense that
we are watching Syrinx in flight; rather than witness-
ing her escape and transformation, we seem to have
interrupted, like Pan himself, an embrace of ardent
carnality.

Thus, while many of the particulars of Ovid's ac-
count remain firmly in place—Pan is even depicted
"wreathed with a crown of sharp pine needles"[9]—they
have been rearranged almost out of recognition. Not
altogether surprisingly, the subject of Boucher's paint-
ing was lost to eighteenth-century commentators.
Paillet, in the catalogue of the de Billy sale in Novem-

ber 1784, described *Pan and Syrinx* as representing
"two nymphs bathing, lying on drapery between the
marsh reeds, who are surprised by a satyr led on by two
amors."[10] In the Godefroy sale of the following year,
the painting was described as showing "two naiads
surprised by a faun," although here, at least, the resis-
tance of one of the putti was indicated.[11] Not until
Pan and Syrinx entered The National Gallery was its
true subject reinstated, yet its disquieting iconography
was passed over in silence. *Pace* Martin Davies's
scholarly entry, the nymph with a jar is not the river-
god Ladon, whose masculinity is never in question in
earlier examples of the theme.[12]

Cavalier with regard to textual and pictorial tra-
dition, *Pan and Syrinx* is yet another example of
Boucher's seemingly inexhaustible capacity to rein-
vent himself—and at no cost to his creative vitality.
The reclining nude viewed from the back—after the
recumbent *Odalisque*, Boucher's most sensual figure—
appears for the first time in the drawing of *The Three
Graces* (fig. 1), signed and dated 1749, and again the
following year in combination with a second female
in the foreground at right in the Beauvais tapestry
Neptune and Amymone of 1753 (Private Collection).[13]
The cartoon for this tapestry also introduced the fig-
ure of the groping satyr (fig. 2), which Boucher re-
peated for the figure of Pan and would use again in the
Sleeping Bacchantes (Private Collection), painted in
1760.[14] As for the recumbent nude, she reappears at
least twice more in Boucher's oeuvre: at lower right in
the company of another naiad and triton in *The Rising
of the Sun*, 1753 (London, Wallace Collection) and as
one of the sea creatures in *Juno Requesting Aeolus to
Release the Winds* (fig. 3), painted in 1769. It should be
noted that in both of these instances Boucher once
again made preparatory drawings, even though the
distinctive pose was repeated both times with little
variation.[15]

In *Pan and Syrinx* Boucher does more than para-
phrase himself; he returns to the live model, despite
the charge that he had abandoned nature. Although
it is not possible to accept all the drawings assigned
to this painting by Ananoff and Wildenstein—by
their account *Pan and Syrinx* would seem the most
thoroughly prepared canvas, inch for inch, in Bou-
cher's entire oeuvre—two very fine sheets do, indeed,
bear upon the production of this work.[16] *The Nymph
Syrinx* (fig. 4), possibly drawn from the live model,
was intended to fix the ungainly but affecting torsion
of the nymph's body as she turns to face her aggressor,
although, as in the painting, Syrinx's almost quizzical
expression can hardly be said to betray fear.[17] Unusu-
ally for Boucher, the progression from drawing to
painting increased the flagrancy of Syrinx's nudity by

accentuating the undulating line of her body and by moving her right hand to a far more brazen position on her breast. In a second drawing (fig. 5), Boucher studied the two women together. Described as a "preliminary study for the painting," *Two Nudes* differs from the finished work in several details; the nymph viewed from the back has the beginnings of a real profile, and Syrinx's right arm and left leg are positioned in such a way that the sense of her having rushed into the river for protection is attenuated still further.[18]

Despite these discrepancies, there is such correspondence in handling between *Two Nudes* and *Pan and Syrinx* that the drawing becomes a virtual blueprint for the finished work. Boucher's dependence on this drawing goes beyond a mere transcription of forms; his brush strokes begin to match his handling of the chalks. Thus, the hatching lines that describe Pan's muscular back are almost drawn in paint, and the white highlights and roseate shadows on the bodies of Syrinx and her companion repeat, almost stroke for stroke, the web of black and white lines that model the figures on the preparatory drawing. *Pan and Syrinx* might be called *"une peinture dessinée,"* to repeat the Goncourts' memorable term for Watteau's technique.[19] For once, the categories of painting and drawing are interchangeable, a fusion rare for Boucher but commonplace in the work of his most brilliant pupil, Fragonard.

The contrast between Fragonard's youthful and ribald treatment of *Pan and Syrinx* (fig. 6), painted in 1761, and Boucher's cabinet picture—which the younger artist could not possibly have known, since he was in Rome at the time—is a telling one.[20] For all its *fougue* and exuberance, Fragonard's oval has none of the more complex and insinuating sexuality of Boucher's jewel-like *Pan and Syrinx*, whose flesh tones fairly glow with pleasure. For this reason it seems unlikely that Boucher would have chosen to exhibit *Pan and Syrinx* at the Salon. Compare, for example, his more conventional treatment of the subject in the medallion he contributed to Maurice Jacques's *Sketch for a Gobelins Tapestry* (fig. 7), painted the year before.[21] *Pan and Syrinx*, on the other hand, was for private delectation and as such accords well with what little is known of the taste of its first owner, Armand-Pierre-François de Chastre de Billy,[22] *ancien premier valet de garde-robe du roi* and an "enlightened art lover," who "frequented the artists of our school, visited them often, followed their studies and their progress, and considered their friendship an honor."[23] To Paillet's encomium might be added that de Billy lived with the artists as well, since he was granted lodgings in the Louvre in February 1761.[24] De Billy's small but choice picture collection was renowned above all for its Italian paintings—he had traveled in Italy for six months at the end of 1749[25]—and the Crown purchased no less than six Italian paintings from his posthumous sale of November 1784.[26] But de Billy had also acquired a number of very fine works by contemporary French artists, chief among whom were Boucher, Pierre, Vernet, and Robert. If it did not have the character of the marquis de Marigny's "cabinet des nudités," de Billy's collection included cabinet pictures of erotic subject matter, such as an autograph version of Boucher's *Odalisque* (location unknown) and the preliminary sketch for *Mercury Confiding the Infant Bacchus to the Nymphs of Nysa*, 1734 (Cincinnati Art Museum).[27] If, in the present state of our knowledge, it is difficult to confirm Laing's hypothesis that de Billy may have enjoyed a "private connection with Boucher"—though they were neighbors at the Louvre—it is impossible to substantiate his more fanciful notion that de Billy was engaged in procurement for Louis XV.[28] Yet de Billy's ownership of *Pan and Syrinx* does, indeed, suggest a taste that was not only sophisticated and refined but also somewhat libertine—one that could take pleasure in Boucher's felicitous renewal of the *Metamorphoses* in anticipation of the *Liaisons Dangereuses*.

NOTES

1. London 1889, 58.

2. Ingamells 1989, 9–17; London 1913, 89. I am grateful to Jacqueline McComish for her assistance.

3. Ellen Julia Hollond's letter of.19 July 1880 to F.W. Burton, director between 1874 and 1894, in the archives of The National Gallery, London; Jean-Richard 1978, 339–40, nos. 1412, 1413 (Martenasie's engraving), 390, no. 1260 (Vidal's engraving); Reynolds 1980, 92, no. 61, for Charlier's miniature on ivory in the Wallace Collection, London.

4. Michel 1906, 16, no. 248, "une toile très importante."

5. Longus, *Daphnis and Chloe*, II, 34.

6. Ovid, *Metamorphoses*, I, 694–95.

7. Ibid., 705–12.

8. Bailey in exh. New York, New Orleans, and Columbus 1985–86, 58–59.

9. Ovid, *Metamorphoses*, I, 699.

10. *Catalogue des Tableaux . . . qui composoient le Cabinet de feu M. de Billy, Écuyer, ancien Commissaire des guerres, et ancien Premier Valet de Garde-Robe du Roi*, Paris, 15 November 1784, no. 48, "deux nymphes au bain et couchées sur des draperies, entre des roseaux; un Satire, conduit par deux Amours, vient les surprendre."

11. *Catalogue de tableaux italiens, flamands, hollandois, et françois . . . provenant du cabinet de M. Godefroy*, Paris, 15 November 1785, no. 45, "deux Nayades surprises par un Faune; on y voit aussi deux amours, dont un est occupé à le repousser."

12. Davies 1957, 17; the identification of Ladon as the nymph with a jar is still made in recent catalogues, for example, London 1986, 65.

13. Ananoff and Wildenstein 1976, II, 30, possibly related to the group of the Three Graces in the Beauvais tapestry *Venus and Vulcan* (1754–56); Standen 1984–85, 72–73, for the Beauvais tapestry and tapestry cartoon in the series *The Loves of the Gods*.

14. Ananoff and Wildenstein 1976, II, 203–4; in a review of *Bacchantes and Satyrs*, exhibited at the Salon of 1761, the abbé de La Porte described the figure of Pan as "l'image de l'ardent et sombre désir, sous une vieille peau tannée," quoted in Ananoff and Wildenstein 1976, I, 95.

15. Ingamells 1989, 71; Laing in exh. New York, Detroit, and Paris 1986–87, 323.

16. Ananoff and Wildenstein 1976, II, 191–92.

17. Slatkin in exh. Washington and Chicago 1973–74, 102, no. 79.

18. Ibid., 100–101, no. 78.

19. Goncourt 1989, I, 451, "une peinture dessinée."

20. Cuzin and Rosenberg in exh. Rome 1990–91, 149–50.

21. Standen in exh. New York, Detroit, and Paris 1986–87, 343–44; Ananoff and Wildenstein 1976, II, 213, no. 548, considers that one of the "deux médallions" Boucher exhibited at the Salon of 1761 represented *Pan and Syrinx*, which is extremely unlikely since *Jupiter and Callisto*, 1760 (Cambridge, Fitzwilliam Museum) and *Bacchantes and Satyrs*, 1760 (London, Private Collection) are the "two medallions" known to have been exhibited then.

22. Davies 1957, 18, for the label on the back of the stretcher, "Ex Collectione Ar^di P^iri F^sci de Chastre de Billy," which, as Udolpho van de Sandt has noted, gives the collector's full name in Latin, as is confirmed in the various documents he has discovered.

23. Paillet as in n. 10, iii–iv, "d'un Amateur instruit . . . M. de Billy dut le goût et la préférence qu'il conserva toute sa vie pour les productions de l'École d'Italie, d'abord à la fréquentation des Artistes de notre École qu'il visitoit souvent, dont il suivoit et les études et les progrès, et de l'amitié desquels il s'honoroit."

24. A.N., O^1 105, fol. 67, for the *brevet* of 15 February 1761 authorizing him to take over the lodgings in the Louvre formerly occupied by "la dame de Niert." Lebrun 1777, 181, and Thiéry 1784, 159, both list de Billy as residing in the "cour du Louvre."

25. A.N., O^1 93, fol. 295, for the *brevet* of 15 October 1749 authorizing de Billy to travel in Italy for six months.

26. Furcy-Raynaud 1906, 82, for Pierre's letter to d'Angiviller of 13 November 1784, in which he informs the *surintendant* that the Crown's bids for the forthcoming sale have been placed with Paillet; Engerand 1901, 540, 542–45; two paintings from de Billy's collection are in the Louvre: Cortona's *Jacob and Laban* (inv. 105) and Pasquale Rossi's *Schoolmistress* (inv. 260), the latter acquired as by Crespi.

27. Laing in exh. New York, Detroit, and Paris 1986–87, 262–63.

28. Ibid., 263; A.N., O^1 113, for the *brevet* of 10 May 1768 confirming de Billy's post as "Premier Valet de Chambre du Roi ayant la clé des coffres," but such responsibility cannot be shown to have included pandering to the king's sexual needs.

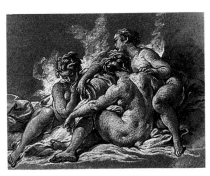

FIG. 1
François Boucher, *The Three Graces*, 1749, black, red, and white chalk drawing, San Francisco, The Fine Arts Museums of San Francisco

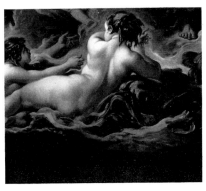

FIG. 3
François Boucher, detail from *Juno Requesting Aeolus to Release the Winds*, 1769, oil on canvas, Fort Worth, Kimbell Art Museum

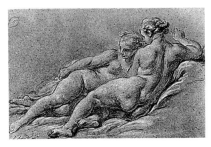

FIG. 5
François Boucher, *Two Nudes*, c. 1759, black chalk drawing heightened with white, Private Collection

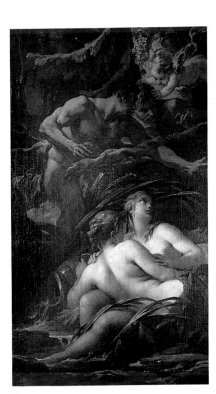

FIG. 4
François Boucher, *The Nymph Syrinx*, c. 1759, black, red, and white chalk drawing, Bloomington, Indiana University Art Museum

FIG. 6
Jean-Honoré Fragonard, *Pan and Syrinx*, 1761, oil on canvas, Private Collection

FIG. 2
Attributed to François Boucher, *Satyrs and Nymphs*, c. 1753, oil on canvas, Paris, abbaye de Chaâlis, Musée Jacquemart-André

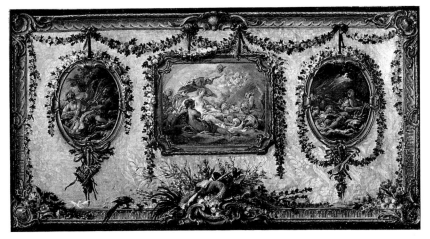

FIG. 7
Maurice Jacques and François Boucher, *Sketch for a Gobelins Tapestry*, 1758, oil on canvas, Paris, Mobilier National

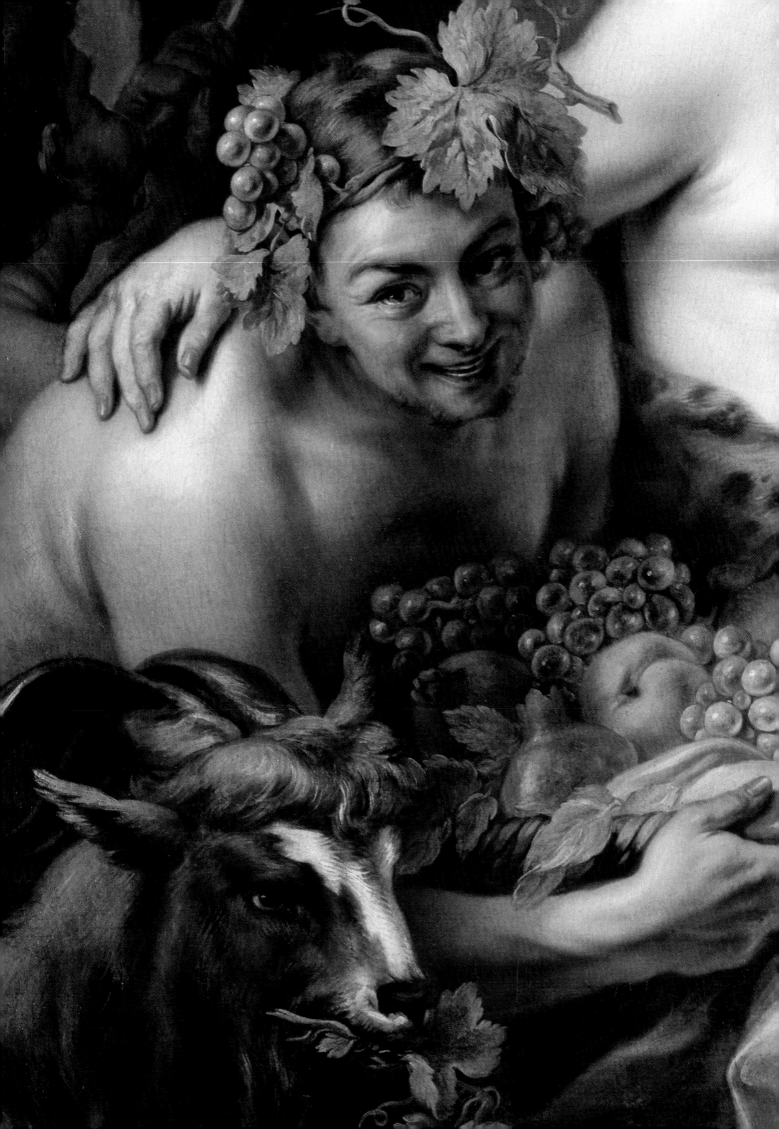

CHARLES-ANDRÉ VAN LOO
(1705–1765)

Born in Nice in July 1705 to a family of artists—his grandfather was the portraitist Jacob Van Loo (1614–1670) and his father the history painter Abraham-Louis Van Loo (c. 1641–1712)—Charles-André Van Loo, called Carle, was first trained by his older brother, Jean-Baptiste Van Loo (1684–1745), with whom he traveled to Italy on two occasions, in 1712–15 and 1716–18. During the second visit, Van Loo continued to learn from his brother but also took drawing lessons in Rome from Benedetto Luti and was given more formal instruction from the sculptor Pierre Legros.

Returning to Paris around 1720, Carle Van Loo produced his first work, *The Good Samaritan* (oil sketch, Montpellier, Musée Fabre) in 1723 and two years later received his first commission, *The Presentation of Christ in the Temple* (Lyons, cathedral of Saint-Jean) for the chapter room of Saint-Martin-des-Champs. These early works, with mannered yet gracefully elongated figures placed in luminous settings, reflect the influence of both his brother and his Roman teacher Luti.

In August 1724 Van Loo won the *Prix de Rome* with *Jacob Purifying His Home Before His Departure for Bethel* (location unknown). Due to lack of royal funds, however, he did not become a *pensionnaire* and was obliged to finance the trip to Italy independently; he arrived in Rome in May 1728. His most important Roman painting, *Aeneas Carrying Anchises* (1729, Paris, Musée du Louvre), which enjoyed a *succès d'estime* in France, was indebted to Federico Barocci both for its composition and its overall coloring. Van Loo's aspirations as a history painter were also satisfied in *The Apotheosis of Saint Isidore (in situ)*, his ceiling fresco for the church of San Isidoro, executed in 1729.

Three years later, Van Loo left Rome and traveled to Turin, where he was patronized by the king of Sardinia, for whom he painted such monumental works as *Diana and Her Nymphs Resting* for the ceiling of the queen's bedroom at Stupinigi and a series of canvases for the royal palace in Turin (Turin, Palazzo Reale). Van Loo's royal commissions were executed in a classical, almost conservative, manner, with precise definition of forms, clear compositions, and fresh colors reminiscent of Carlo Maratta.

Having returned to Paris in 1734, Van Loo was made an associate member of the Academy in August 1734 and admitted as a full member in July 1735 with *Apollo Flaying Marsyas* (Paris, École Nationale Supérieure des Beaux-Arts). Thereafter he received commissions from the upper echelons of Parisian society and respected religious institutions. For example, at the hôtel de Soubise he contributed, among other works, *Castor and Pollux* for the *salle de compagnie de la princesse* in 1737 (Paris, Archives Nationales) and painted *Asia* (c. 1747, Jerusalem, The Israel Museum) as part of the Four Continents for the *salon* of the *hôtel* of Jacques-Samuel Bernard. Although Van Loo continued to produce secular decorations, the immediacy and elegance of his style were most effective in such religious works as *Saint Charles Borromeo Giving Communion to the Plague-Stricken* (Paris, cathedral of Notre-Dame), painted in 1743 for the chapel of Saint-Marcel at Notre-Dame, and *The Adoration of the Angels* (1751, Brest, Musée des Beaux-Arts) for the chapel of the Assumption in Saint-Sulpice. His most esteemed work, however, was the series of seven paintings executed between 1746 and 1755 for the choir of the church of the Petits-Pères (now known as Notre-Dame-des-Victoires), representing scenes from the life of Saint Augustine. The grace, sincerity, and accessibility of these works assured their success.

While Van Loo's talents as a history painter of classical and religious subjects contributed to his popularity, his skill in portraiture provided a regular income, and his *turqueries* were also fashionable. Van Loo's ability to transform his style in order to suit the patron, subject, and setting led his biographer Dandré-Bardon to remark that "his style was an ingenious combination of manners from many great painters."

Never as closely attached to the court as Boucher, Van Loo nonetheless enjoyed sustained patronage from the royal family and Madame de Pompadour. He received his first royal commission in 1736, when he participated in the decoration of the *galerie des petits appartements du roi* at Versailles, contributing the exotic hunt scenes *The Bear Hunt*, 1736, and *The Ostrich Hunt*, 1738 (both Amiens, Musée de Picardie). Van Loo also painted overdoors for the *grand cabinet* of the *Dauphine*, Maria-Thérèse-Raphaëlle, at Versailles in 1744, portraits of the queen and king in 1747 and 1748 (Musée National des Châteaux de Versailles et de Trianon), and a number of works for Madame de Pompadour, who patronized Van Loo almost as enthusiastically as she did Boucher. In fact, Van Loo painted a moving tribute to his patroness shortly before her death in 1764, *The Arts Imploring Destiny to Spare Pompadour's Life* (Pittsburgh, The Frick Art Museum).

Admired by his peers as well as by the royal family, Van Loo rapidly rose through the Academy's ranks and eventually became its director in June 1763. A respected teacher, he was named governor of the recently founded *École royale des élèves protégés* in April 1749 and was made *premier peintre du roi* in June 1762. In spite of the universal respect and admiration he enjoyed during his lifetime—Grimm considered him "the first painter in Europe"—Van Loo's posthumous reputation was in disarray shortly after his death in May 1769; the verb "vanlooter" came to be used as a synonym for exaggerated sweetness. If it is difficult to accept Grimm's claim today, Van Loo surely deserves to be rescued from the oblivion into which the nineteenth century had cast him. His elegant and powdery colorism, mastery of figure drawing, and command of sincere, if somewhat vapid, expression were very real talents that are only now being appreciated with something of the enthusiasm his contemporaries expressed.

CHARLES-ANDRÉ VAN LOO *Drunken Silenus* (detail), 1747, oil on canvas, 164 x 195 cm, Musée des Beaux-Arts, Nancy

CHARLES-ANDRÉ VAN LOO
Drunken Silenus

51

CHARLES-ANDRÉ (CARLE) VAN LOO (1705–1765)
Drunken Silenus, 1747
Oil on canvas
164 x 195 cm.
Musée des Beaux-Arts, Nancy

PROVENANCE
Purchased by the Crown after the *concours de 1747* for 1,500 *livres*; hung in the *deuxième pièce* of the *appartement* of the marquis de Marigny at the hôtel de la Surintendance at Versailles and then in the *salles de la Surintendance*; sent from Versailles in October 1800 to decorate the palais de Lunéville during the Congress of Lunéville; given to the Musée de Nancy by the government after the Congress of Lunéville in April 1801.

EXHIBITIONS
Paris, *concours de 1747*, no. 10; Nancy 1955, no. 11; Nice, Clermont-Ferrand, and Nancy 1977, no. 107, ill.; Lille 1985, no. 117, ill.

BIBLIOGRAPHY
Bret 1747, 5–6; Leblanc 1747, 41–44; *Mercure de France*, October 1747, 127; Panard 1747, 6; Gougenot 1748, 55–56; Dandré-Bardon 1765 (B), 31, 60; Nancy 1854, no. 182; Clément de Ris 1859–61, I, 26; Blanc 1865, 11; Nancy 1866, no. 233; Clément de Ris 1872, 307–08; Tourneux 1877–82, I, 92; Nancy 1883, no. 376; Nancy 1897, no. 517; Gonse 1900, 227; Engerand 1901, 478; Furcy-Raynaud 1904, 184; Nolhac 1907, 49; Nancy 1909, no. 569, ill.; Locquin 1912, 6, 182–83, 226; Nolhac 1925, 100; Réau 1935–36, no. 95; Schnapper 1962, 122; H. Bardon 1963, 219; Vergnet-Ruiz and Laclotte 1965, 254; exh. Brussels 1975, 100; Brunel 1986, 238–39, ill.; exh. New York, Detroit, and Paris 1986–87, 239; Pétry 1989, 60, ill.

"The Pagans divided their Gods into several Classes; in the last Class, which Ovid names the Populace of the Gods, were the Satyrs and Silenes. The latter, as Pausanias remarks, were no other than Satyrs advanced in Age."[1] As eighteenth-century mythographers were also quick to point out, Bacchus's teacher Silenus, the son of Pan by a woodland nymph, was preeminent among the aged satyrs. Since antiquity, Silenus had been portrayed "short of stature, but fat and fleshy," supporting himself with the thyrsus and following Bacchus's triumphant procession seated on an ass, "tottering and not able to keep himself up."[2] For refusing to sing to Chromis and Mnasyllos he was fettered with his own garlands and painted with the juice of mulberries by the shameless nymph Eglea.[3] On another occasion, "stumbling with the weight and years and wine," he was captured by a group of Phrygian rustics and led off to King Midas, who was so delighted to have his company that he entertained him for ten days before returning him to Bacchus, his grateful "foster child."[4] It was as a reward for such hospitality that Bacchus granted Midas his wish of turning everything he touched to gold.

The central figure in *Drunken Silenus*, Van Loo's entry to the *concours de 1747*, follows Montfaucon's description of ancient images of the satyr: "His bald head . . . is exactly like Socrates's, excepting the Satyr's Ears . . . [and] he is so bald, that the Hair does not appear till almost the Nape of the Neck."[5] Yet it was less the artist's familiarity with classical tradition than the striking realism of his "Silenus, provider and companion of Bacchus" that aroused comment at the time and has not ceased to do so. This unedifying subject, a curious choice for a competition organized to renew the genre of history painting, shows Silenus hoisted upon a barrel and served wine by an inebriated bacchante; he is supported by two leering fauns and a repulsive infant, who proudly pushes out his stomach in imitation of his master. Even the obsequious and all-praising abbé Leblanc ventured that there were "those who would have preferred a more noble subject from the artist, an opinion that can but flatter him."[6]

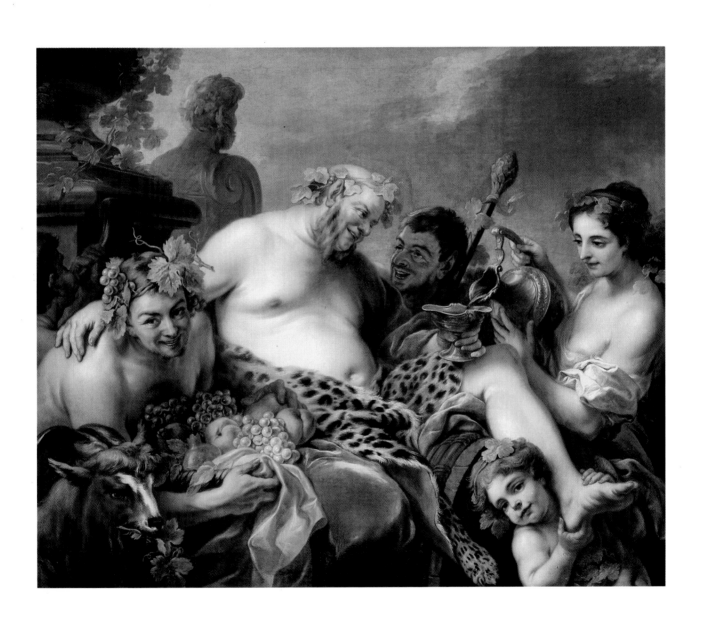

Van Loo's ribald bacchanal neither impaired his standing as the "first painter of Europe," nor was it singled out from the other entries for criticism.[7] On the contrary, Antoine Bret considered it the finest work in the competition, "painted by the Rubens of our time" and "deserving of victory."[8] Van Loo's color was the equal of Rubens's, claimed the abbé Leblanc, although his comment that *Drunken Silenus* was drawn in the manner "of the best Italian masters" hardly inspires confidence. The abbé Gougenot, while disagreeing with both these points, nonetheless admired Van Loo's "beautiful composition and brilliant coloring," concluding that *Drunken Silenus* was the work of a "great artist."[9] The playwright Charles-Antoine Panard made reference to *Drunken Silenus* in his play *Les Tableaux*, performed by the *comédiens italiens* in September 1747. Among the most admired paintings in the *concours*, claims the Pupil, in pitiable verse, are:

> Erigone, Europa, and Silenus
> Along with the cynical Diogenes,
> These are the favored paintings,
> That merit the prizes.[10]

From then on the "poetic quality" of *Drunken Silenus* would be mentioned in every eighteenth-century biography of Van Loo, although it is difficult to see exactly where the "the flame of poetry" burns in this painting.[11]

Clearly, Van Loo's entry to the *concours* in no way compromised his credentials as an exemplary academician; although he was not the first candidate for the post, he would succeed Dumont le Romain as governor of the *École royale des élèves protégés* in April 1749.[12] In fact, *Drunken Silenus* served to promote Van Loo's skills as a vigorous colorist as well as to provide him with an opportunity to paint the human figure life-size.[13] Hanging in the *galerie d'Apollon* between Restout's *Alexander Receiving Medicine from Philip* (Amiens, Musée de Picardie) and Dumont le Romain's *Mucius Scaevola Before Lars Porsena* (Besançon, Musée des Beaux-Arts et d'Archéologie), *Drunken Silenus* must have seemed unusually aggressive. To be stared at so insinuatingly by a vine-chewing goat, a fruit-bearing faun, and a foot-carrying infant cannot have failed, then as now, to have arrested the spectator's attention.[14]

Van Loo's lurid coloring and careful but spirited application of paint were well suited to the riotous behavior of the figures, who practically spill out of the picture. Papillon de La Ferté noted of Van Loo that "his compositions convey the character of the subjects they represent," an insight that is certainly valid

for *Drunken Silenus*.[15] Nor did the artist make the slightest concession to the decorative; not only is Silenus's enormous stomach articulated with loving attention—Van Loo was criticized for painting his flesh with "excessive whiteness"[16]—but the dark-eyed and intoxicated bacchante fails to impose herself on the gathering of rowdy males. "Piquant and beautiful" she might be, yet it is hard to share Leblanc's enthusiasm for her as a figure "worthy of Apelles." Her glazed expression and weak smile show that she, too, knows the charms of the liquid she pours, since "it was not long ago that she herself had sampled it."[17]

That *Drunken Silenus* was so well received, and that the generally mild Van Loo should have permitted himself this depiction of unrestrained drunkenness, bears witness both to the esteem in which Rubens continued to be held and to the Flemish master's enduring suitability as a model for history painters of the Academy. For, even if a specific painting by Rubens was never mentioned by eighteenth-century critics, there was no doubt in their minds that Van Loo's composition was indebted to him. Van Loo created through copying, explained Leblanc; "it might be said that he saw Nature only through the eyes of the old masters," wrote Dandré-Bardon approvingly.[18] The most likely source for his competition piece was *Drunken Silenus Supported by Satyrs* (fig. 1), considered to be by Rubens in the eighteenth century. The painting had been in Richelieu's collection, and two versions of it appear to have circulated in France during Van Loo's lifetime.[19] Thirty years prior to the *concours*, Watteau had copied this composition when it was in the Orléans collection (fig. 2). Yet although the regent had employed Van Loo as a young man—and thus the artist may have seen Rubens's painting in the early 1720s—he seems to have divested himself of this work early on.[20] While it remains unclear how or when Van Loo would have had access to *Drunken Silenus Supported by Satyrs*, the deportment of the revelers in his competition piece and, above all, their placement at the very edge of the picture plane make the comparison with Rubens as unquestionable as it is unprovable.[21]

If Rubens was his primary inspiration, Van Loo may have looked to other sources for the presentation of the central figures in *Drunken Silenus*. From Roman sarcophagi to illustrated mythographies (fig. 3), Silenus had been shown resting on the shoulders of two attendants in a manner that Van Loo was happy to follow.[22] For the leering faun with scrubby beard, however, he turned to a less respectable model. This wide-eyed boy, whose basket contains not merely grapes—as in Natoire's *Triumph of Bacchus* (cat. no. 40)—but also peaches and a pomegranate, evokes Caravaggio's far more sophisticated adoles-

cents, which Van Loo might have seen in the Borghese collection in Rome. But, unlike either Rubens or Caravaggio, it was beyond Van Loo's powers to create a new language of art by forging the antique with the natural; *Drunken Silenus* is ultimately pastiche rather than invention.

All eighteenth-century descriptions of Van Loo's working method noted that the artist would not touch the canvas before having thoroughly prepared his composition with drawings. On this point Dandré-Bardon was categorical: "As regards drawing, he was so disciplined that he would produce nothing, nor make the slightest change or correction, without having first traced his outlines with the pencil. He would use the brush only after having exhausted the crayon; it might be said that he translated the very marks of his chalks into color."[23] Here, at least, *Drunken Silenus* is aberrant. Not a single preparatory drawing or study is known, and yet Van Loo's handling, while abbreviated, is no less assured than in those works for which the customary studies are recorded. That *Drunken Silenus* is anomalous in more than its subject is reinforced by Leblanc's comment that Van Loo had to paint his entry in record time: "Those who are aware of how little time the artist had to paint *Drunken Silenus* will admire the facility of his genius all the more."[24] At the time the *concours* was announced in January 1747, Van Loo was occupied with a full-length portrait of Queen Marie Leczinska (Musée National des Châteaux de Versailles et de Trianon), which was unveiled at Versailles in early May; shortly afterwards, he received a commission to decorate a niche in the *Dauphine*'s oratory at Versailles.[25] It is therefore unlikely that *Drunken Silenus* was one of the five competition paintings ready to be framed by June 1747.[26] The pressures of time may have deprived Van Loo of his meticulous preparations, but they also worked to his advantage in producing a history painting that stands apart from the rather sweetened classicism his art came to represent for future generations.[27]

In its turn, *Drunken Silenus* has confounded the most sensitive of observers, eliciting a series of responses so contradictory that one sometimes wonders if it is the same work that is under discussion. Described by one historian as "possessing beauty without grace or prettiness,"[28] *Drunken Silenus* produces "a quite decorative effect" upon another.[29] What Clément de Ris viewed as a "bacchanal by moonlight"[30] —presumably because of the blooming of the varnish—has been characterized by Pierre Rosenberg as a mythology "with metallic colors, as shiny as enamel."[31] Vulgar and unexpected, certainly—innovative and experimental, possibly—the final summation of Van Loo's *Drunken Silenus* may be left to Mariette: "a much-vaunted painting, but that is about the best that can be said for it."[32]

NOTES

1. Banier 1732, II, 276, "Les Païens avoient divisé les Dieux en plusieurs classes. Dans la dernière qu'Ovide nomme la populace des Dieux, étoient les Satyres et les Silenes. Ceux-ci, suivant la remarque de Pausanias n'étoient aux-mêmes que des Satyres avancez en âge," English translation from the 1732 edition published in Amsterdam.

2. Montfaucon 1719, I, 264, "Il était de petite taille, mais gros et chauve tenant un bâton, ou le thyrse pour se soûtenir. . . . Il alloit quelquefois monté sur un âne. Nous l'avons déjà vu en cet équipage; mais chancelant et ne pouvent s'y soûtenir"; English translation from Montfaucon 1721–22, I, 167.

3. Virgil, *Eclogues*, VI, 13–26.

4. Ovid, *Metamorphoses*, XI, 89–100.

5. Montfaucon 1719, I, 265, "Sa tête chauve qui vient après, ressemble parfaitement à celle de Socrate, aux oreilles de Satyre près . . . si pelée, que les cheveux ne commencent presque qu'à la nuque du cou"; English translation from Montfaucon 1721–22, I, 168.

6. Leblanc 1747, 41, "ceux qui par un sentiment, qui ne peut être que flatteur pour l'Auteur, auroient souhaité de lui un sujet de plus grande composition."

7. For Grimm's encomium, "M. Carle Vanloo que l'on peut regarder comme le premier peintre de l'Europe," made in September 1753, see Rosenberg in exh. Nice, Clermont-Ferrand, and Nancy 1977, 16.

8. Bret 1747, 5–6, "le Rubens de notre âge"; "le dernier qui fixe nos yeux / semble mériter la victoire."

9. Gougenot 1748, 55, "Ces défauts n'empêchent pas que l'on ne reconnaisse que ce tableau est parti de la main d'un grand homme . . . soit qu'on l'admire par sa belle composition ou par le brillant de son coloris."

10. Panard 1747, 5–6, "Erigone, Europe, Silène / Et le Cynique Diogène, / Sont les morceaux les plus chéris, / Et ceux de ce rang-là qui meritent le prix."

11. Dandré-Bardon 1765 (B), 31; Fontaine-Malherbe 1767, 185; *Galerie françoise* 1771, 4, "le feu de la poésie brille dans le Silène."

12. Sahut in exh. Nice, Clermont-Ferrand, and Nancy 1977, 21; Van Loo succeeded Dumont le Romain, whose tenure as first director of the *École royale des élèves protégés*, founded in June 1748, lasted less than a year.

13. Leblanc 1747, 41, "qu'il ne faille un Art infini pour grouper aussi heureusement qu'il l'a fait cinq figures grandes comme nature dans un si petit espace."

14. *Explication des Peintures, Sculptures, et autres ouvrages de MM. de l'Académie royale*, Paris 1767, no. 10; "Silène nourricier et companion de Bacchus"; as indicated by Leblanc 1747, 41, Van Loo's painting was the second to be seen upon entering the *galerie d'Apollon*.

15. Papillon de La Ferté 1776, II, 669, "Ses compositions . . . portent le caractère des sujets qu'elles représentent."

16. Leblanc 1747, 42, "Beaucoup de gens auroient désiré que les chairs de Silène fussent moins blanches."

17. Ibid., 42, "Le plaisir qu'elle paroît prendre à verser cette liqueur semble dire qu'elle en connoît le charme, et qu'il n'y a pas long-tems qu'elle vient de le goûter."

18. Ibid., 43, "C'est ainsi que dans leurs imitations que les grands peintres sont créateurs"; Dandré-Bardon 1765 (B), 26, "On diroit qu'il ne voit la Nature qu'avec les yeux de ces grands maîtres."

19. Martin 1970–72, 217–25; Teyssèdre 1963, 262, 292; *Drunken Silenus Supported by Satyrs* is now considered a work from Rubens's studio.

20. Grasselli in exh. Paris 1984–85 (A), 212–13; Dandré-Bardon 1765 (B), 12, and Sahut in exh. Nice, Clermont-Ferrand, and Nancy 1977, 19, for Van Loo's participation in the restoration of the *galerie François Premier* at Fontainebleau during the regency; Martin 1970–72, 221, who notes of Rubens's *Drunken Silenus Supported by Satyrs* that the duc d'Orléans "gave the painting away"; it does not appear in Dubois de Saint-Gelais's *Description des Tableaux du Palais-Royal*, published in 1727, and is next recorded as part of Dutartre's collection in l'hôtel du Pin in Thiéry 1788, I, 584.

21. Van Loo, "the Rubens of our Academy," may have aspired to similar heights in *Drunken Silenus*, but his capacities were not equal to the task. Although *Drunken Silenus* (Munich, Alte Pinakothek), Rubens's masterpiece in this genre, would not have been available to him at any point in his career, Van Loo may well have been familiar with de Piles's eulogy of this work: "Je suis persuadé que dans cet ouvrage Rubens a voulu porter la Peinture au plus haut degré qu'elle puisse monter: tout y est plein de vie, d'un dessein correct, d'une suavité et d'une force tout ensemble extraordinaire," Piles 1681, 104. For Rubens's *Drunken Silenus*, which is documented after 1716 in the Düsseldorf Gallery of the Elector Johann Wilhelm, see Munich 1986, 460, 591.

22. Bober and Rubinstein 1986, 116–19, figs. 82 and 82a; for Marcantonio Raimondi's *Procession of Silenus*, see exh. Lawrence, Chapel Hill, and Wellesley 1981–82, 202–3; Cartari 1647, 331.

23. Dandré-Bardon 1765 (B), 50, "Ses procédés à l'égard du Dessein étoient si austeres qu'ils ne produisoit rien, ne changeoit, ne réformoit pas la moindre partie que le contour n'en fût décidé par un trait correct. Il ne se servoit jamais du pinceau que lorsque le crayon n'avoit plus rien à faire; encore fixoit-il avec la couleur toutes les traces de la craie."

24. Leblanc 1747, 43, "Ceux qui savent le peu de tems que le Peintre a été à le faire ne peuvent qu'admirer davantage une facilité que sert si bien son génie."

25. Sahut in exh. Nice, Clermont-Ferrand, and Nancy 1977, 66; Bailey in exh. New York, New Orleans, and Columbus 1985–86, 88, for Coypel's pair of religious paintings which were to accompany Van Loo's *Adoration of the Magi*; Furcy-Raynaud 1906, 329, for Lenormant de Tournehem's letter to Coypel concerning this commission.

26. A.N., O¹ 1923A, fol. 112; Lenormant de Tournehem's order to Bailly, *garde des tableaux du roi*, dated 23 June 1747, noted, without specifying names, that five paintings were still outstanding. Since Galloche and Cazes failed to complete their entries in time for inclusion in the Salon *livret*, it would seem that Van Loo was one of three other participants whose paintings were only "*presques finis*."

27. Sahut in exh. Paris 1984–85 (B), 369, notes that David's pupils invented the verb "vanlooter" to criticize those who sought grâce at the expense of drawing.

28. Sahut in exh. Nice, Clermont-Ferrand, and Nancy 1977, 65, "d'une beauté sans grâce ni galanterie."

29. Schnapper in exh. Lille 1985, 156, "d'effet très décoratif."

30. Clément de Ris 1859–61, I, 26, "une bacchanale vue au clair de lune."

31. Rosenberg in exh. Nice, Clermont-Ferrand, and Nancy 1977, 14, "aux couleurs métalliques, luisant comme un émail."

32. Sahut in exh. Nice, Clermont-Ferrand, and Nancy 1977, 65, "Fort prosné, mais c'est tout ce qu'on en peut dire," citing Mariette's annotated Salon *livret* in the *Collection Deloynes*, II, no. 25.

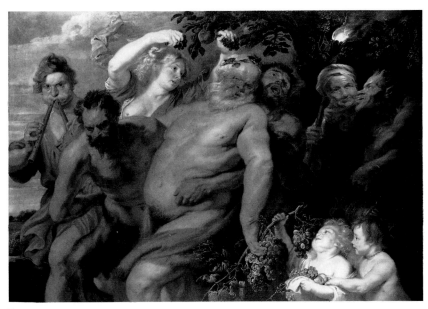

FIG. 1
School of Peter Paul Rubens, *Drunken Silenus Supported by Satyrs*, c. 1620, oil on canvas, London,
The National Gallery

FIG. 2
Jean-Antoine Watteau, *Drunken Silenus Supported by Satyrs*, c. 1717, red, black, and white chalk
drawing, Washington, National Gallery of Art, Gift of Mr. and Mrs. Paul Shepherd Morgan in
Honor of Margaret Morgan Grasselli

FIG. 3
Anonymous, *Silenus*, engraved illustration from
Vicenzo Cartari's *Imagini delli dei de gl'antichi*,
Venice, 1647

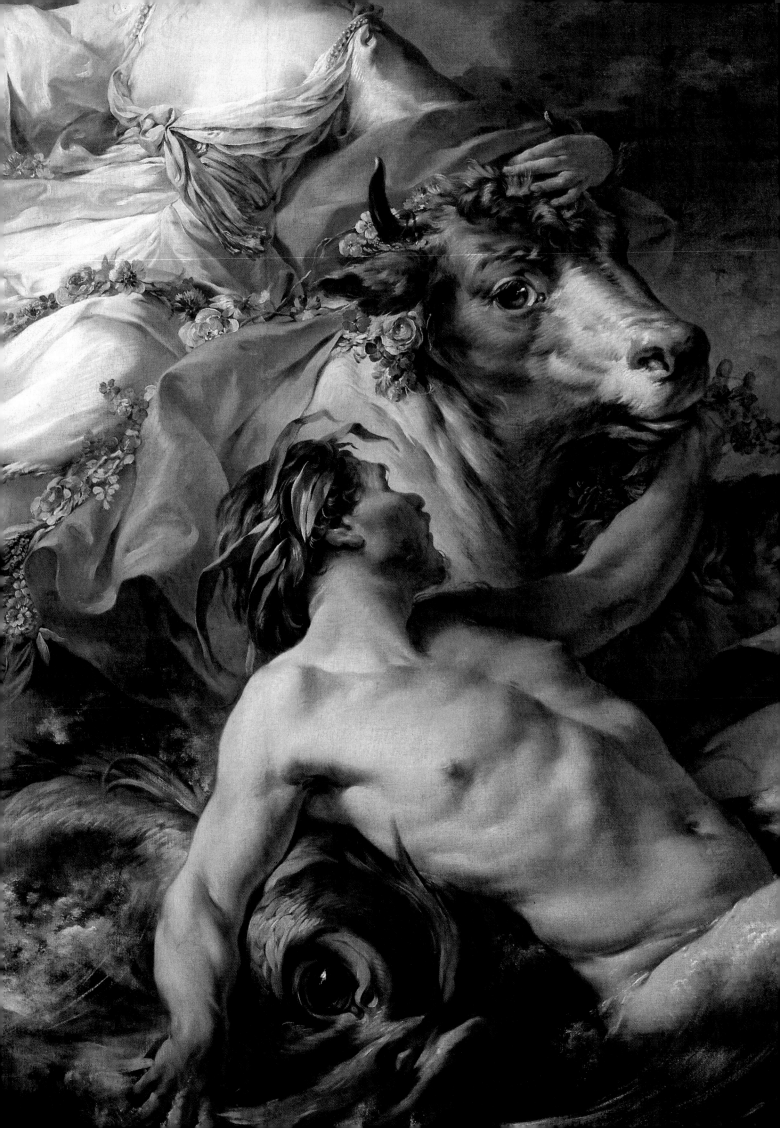

Jean-Baptiste-Marie Pierre
(1713–1789)

Born in Paris in 1713, Pierre was trained by Charles-Joseph Natoire and won the *Prix de Rome* in 1734 with *Delilah Cutting Samson's Hair* (location unknown). Pierre left the following year for Rome, where he remained until 1740, following the habitual academic curriculum under the easy directorship of Jean-François de Troy and exploring printmaking techniques in his series *The Costumes of the People of Rome* (1736). Although he also absorbed the lessons of Raphael, Veronese, the Carracci, and Guido Reni—as would be exhibited in his mature work—Pierre caused a sensation upon his return to Paris with genre paintings such as *The Schoolmistress* (1741, Auxerre, Musée d'Art et d'Histoire) and *The Return from the Market* (c. 1745, Dijon, Musée des Beaux-Arts), paintings that revealed the influence of the *bamboccianti*. However, it was as a history painter that Pierre was received into the Academy in March 1742 with *Diomedes Slain by Hercules* (Montpellier, Musée Fabre), a colorful, if bombastic, pastiche of Le Brun's celebrated painting of the same subject.

The fluid, spirited style of Pierre's early works disappeared around 1750, when he began to use a more linear, restrained technique, a stylistic change of heart possibly connected to his appointment in 1748 as a professor at the Academy and a subsequent desire to present himself as a classically trained history painter. Using this new style, Pierre painted such prestigious commissions as four overdoors for the *salon de compagnie* of the hôtel de Soubise in 1751 (e.g., *Venus Requesting Vulcan to Make Arms for Aeneas*, Paris, Archives Nationales) and the enormous *Judgment of Paris* for the marble salon of the Neue Palais, Potsdam, for Frederick II in 1757 (Potsdam-Sanssouci, Staatliche Schlösser und Gärten).

Although Pierre skillfully exhibited his decorative abilities in these projects, it was as a painter of religious works on the grand scale that his talents were best engaged. Between 1749 and 1756 he painted *The Assumption of the Virgin* on the ceiling of the chapel of the Virgin in the church of Saint-Roch in Paris. Pierre also painted a number of altarpieces, which he frequently exhibited at the Salons, including *The Flight into Egypt* for the chapelle de l'Enfance de Jésus at Saint-Sulpice in 1751 (Paris, church of Saint-Sulpice) and *The Descent from the Cross* for the cathedral of Saint-Louis at Versailles in 1761 (*in situ*). Generally admired for their dramatic and moving expression of emotion, Pierre's religious paintings were criticized by Diderot, who claimed that they were unoriginal and blatantly derivative of the seventeenth-century Bolognese school.

Vain and pompous, Pierre came under increasing attack from Diderot, who considered him "the most insipid of our artists," yet his career prospered through the continuous support of the royal family, the duc d'Orléans in particular. In 1752, after Charles-Antoine Coypel's death, Pierre became *premier peintre* to the duc d'Orléans and curator of his collection. He painted *The Apotheosis of Psyche* on the ceiling of the *salon* of the duchesse d'Orléans at the Palais-Royal around 1756 and, according to Mariette, a ceiling of one of the *chambres de parade* in a newly constructed *appartement* at the Palais-Royal. In 1769 Pierre also produced a compartmentalized illustration of *The Story of Armida* for a *salon* ceiling in the right wing at the château de Saint-Cloud, a work described by the *Mercure de France* as "a monument which glorifies the arts, honors the nation, and dignifies the august Prince who commissioned it."

Financially and socially well established—his niece married the vicomte de Vergennes in 1782—Pierre became a painter courtier of unassailable authority. In 1762 he received the order of Saint-Michel through the efforts of the duc d'Orléans, at which point, with the exception of certain commissions from the royal family, he essentially ceased to paint, concentrating instead on an official career and thus avoiding more critical reviews of his work. Pierre was rewarded for his efforts when he was named *premier peintre du roi* in June 1770, after Boucher's death, and elected director of the Academy in July of that year. In January 1778 he was appointed director of the Academy in perpetuity, a post created especially for him.

An authoritative, conservative, and unpopular director of the Academy, Pierre and his ally, Charles-Claude de Flahaut de la Billarderie, comte d'Angiviller (1730–1810), director of the *Bâtiments du roi*, dominated the cultural milieu of Paris during the reign of Louis XVI and promoted history painting in the classical manner to the exclusion of the other genres. In a letter Pierre drafted for d'Angiviller to be sent to Chardin in response to the latter's request for financial aid, Pierre stated, "You must recognize that in the same occupation your studies have never incurred such high costs, nor such a considerable loss of time, as those of your colleagues who followed the great genres."

JEAN-BAPTISTE-MARIE PIERRE, *The Rape of Europa* (detail), 1750, oil on canvas, 240.4 x 274.4 cm, Dallas Museum of Art, Foundation for the Arts Collection, Mrs. John B. O'Hara Fund.

JEAN-BAPTISTE-MARIE PIERRE
The Rape of Europa

52

JEAN-BAPTISTE-MARIE PIERRE (1713–1789)
The Rape of Europa, 1750
Oil on canvas
240.4 x 274.4 cm.
Dallas Museum of Art, Foundation for the Arts Collection, Mrs.
John B. O'Hara Fund

PROVENANCE
Claude-Henri Watelet (1718–1786), his sale, Paris, 12 June 1786,
no. 14 [sold with François Boucher's *Rape of Europa* and *Mercury
Confiding the Infant Bacchus to the Nymphs of Nysa* as one lot], pur-
chased by Saubert for 3,423 *livres*; Private Collection, England;
David Koetser until 1946; collection of Georges Wildenstein; Pri-
vate Collection, New York; acquired by the Dallas Museum of Art
in 1989.

EXHIBITIONS
Salon of 1750, no. 56; New York, New Orleans, and Columbus
1985–86, no. 18, col.

BIBLIOGRAPHY
Bordeaux 1984 (A), 101, ill.; exh. Berlin 1988, 155.

According to the dealer Alexandre-Joseph
Paillet, Pierre painted *The Rape of Europa* to complete
the decoration of the *salon* of his friend and protector,
the celebrated *amateur*, collector, and theoretician,
Claude-Henri Watelet (1718–1786), who owned
more than twenty works by the artist.[1] Exhibited at
the Salon of 1750, *The Rape of Europa* may also have
been intended, along with the other history paintings
Pierre submitted that year, to counter allegations that
he was wasting his talents in painting *bambochades*.[2]
Largely overlooked by the critics in favor of the more
obviously erotic *Leda* (location unknown)—"every-
one has felt the effect of this painting, which is not
limited to the eyes"—*The Rape of Europa* was praised
with the rest of Pierre's *envoi* for its facility, vigorous
coloring, and masterful draughtsmanship.[3] As the
critic and collector Baillet de Saint-Julien pointed
out, "his brush is easy, fluent, and voluptuous," an apt
description of Pierre's technique in this ambitious
decorative painting.[4]

The story of Jupiter's abduction of Europa, the
beautiful daughter of King Agenor of Tyre, comes
from the second book of Ovid's *Metamorphoses*, which
Pierre, though he read Latin, would most probably
have known from the abbé Banier's immensely popu-
lar translation.[5] Pierre has followed Ovid quite closely
in certain details; the bull's muscular neck, his small,
polished horns strewn with garlands, and his amiable
and placid expression are all distinctly indicated in
the text. In keeping with the decorative quality of the
work, however, Europa's fright and her anxious glance
toward the shore behind her are understated. And,
while there are passages of bravura painting—particu-
larly in Europa's swirling draperies, the head and neck
of the bull, and the triton who feeds the animal with
flowers—the ancillary figures are not depicted with
the same flair. Pierre's *Rape of Europa*, implied Baillet
de Saint-Julien, is to be admired rather than adored.[6]

For his monumental composition, Pierre looked
to Italian examples of this celebrated myth. He would
have seen Veronese's *Rape of Europa* in the Doge's
Palace in Venice, where the picture was on display
from 1733, and was doubtless familiar with the

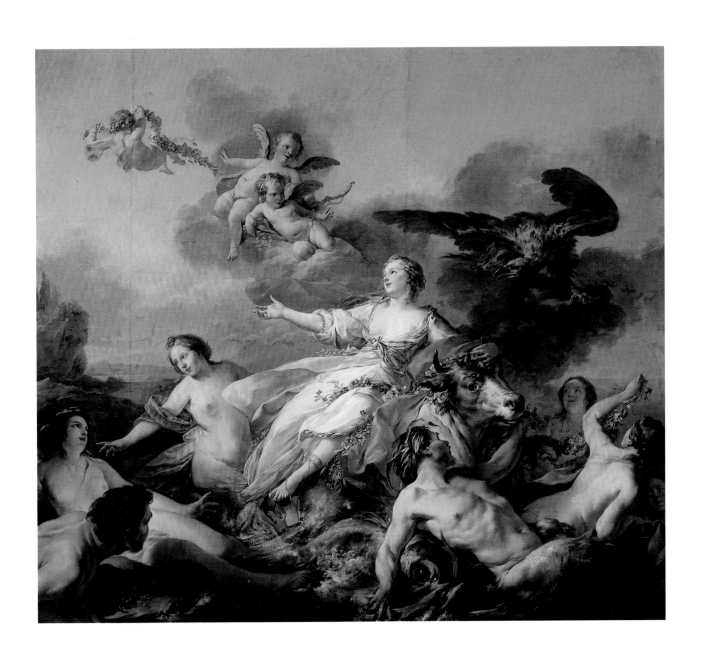

copy—then considered the *modello*—in the Orléans collection.[7] Also inventoried in Pierre's small picture collection at the time of his death was "a painting on canvas in its gilded frame representing the Rape of Europa by Benedette Castiglione."[8] For the figures of Europa and the lascivious bull surrounded by amoretti and baby zephyrs, Pierre seems to have plagiarized Simone Cantarini's etching of *The Rape of Europa* (fig. 1), a habit for which Diderot would later take him to task.[9]

Pierre also drew inspiration from examples nearer home. *The Rape of Europa* was painted for a decorative ensemble that included Boucher's *Rape of Europa* and *Mercury Confiding the Infant Bacchus to the Nymphs of Nysa* (both London, Wallace Collection), part of the series commissioned nearly twenty years earlier by François Derbais (see cat. nos. 43 and 44) with which it was noted to be "in perfect accord."[10] Pierre followed Boucher in representing Jupiter as both bull and eagle, as well as in his portrayal of the three amoretti who watch over Europa, carrying the attributes of Love. In fact, Pierre's *Rape of Europa* is a sequel to Boucher's mythology. While the latter painted the episode in which Europa is encouraged by her maidens to mount the friendly bull, Pierre depicts the abduction itself, where Europa's mood has changed from pastoral gaiety to tremulous fear.

Watelet's commission to "*suo amico*," Pierre—whom he had first met in Rome in 1736 and with whom he would remain on intimate terms throughout his life—was not merely the patronage of a talented *protégé*.[11] As with Watelet's commission of Doyen's enormous *Bacchanal* (location unknown), exhibited at the Salon of 1758,[12] the *amateur's* decision to decorate the salon of his *hôtel* on the rue Charlot with epic history painting reflected his deep-seated dissatisfaction with the prevailing taste for "*le goût léger.*"[13] In his *Life of Louis de Boullongne, premier peintre du roi*, read to the Academy on 4 April 1751, Watelet's praise of the latter's ceiling decorations contained a thinly disguised attack on the rococo ornament that proliferated in interior design. Watelet was confident that such excesses would eventually be replaced by decoration more "noble, rich, and elegant" in character.[14] Intended primarily to encourage a revival of painted, as opposed to sculpted, ceiling decoration—by midcentury, a lost cause—Watelet's polemic helps place his commissions of the 1750s in context. While having little to do with the return to the antique that so dominates our view of "progressive" history painting in the decades before the Revolution, the graceful mythologies with which Watelet surrounded himself

in the rue Charlot reflect his commitment to the lyrical-epic mode as the most elevated language of private, if not public, decoration.[15] A quarter of a century later—by which time Watelet, his finances in disarray, had been given grace and favor lodgings at the Louvre—such grand mythologies would appear characteristic of the worst excesses of *la manière française*.[16] The insufferable Julien de Parme, visiting Watelet's apartment at the Louvre in May 1774, was outraged by the picture cabinet that awaited him: "Who would have believed it! A member of the *Académie des Belles-Lettres*, admitted for his Poem on Painting; a man who passes for one of the most enlightened art lovers of the day; one who has seen the finest paintings that Italy has to offer; is it possible that such a man would have the work of Vanloo, Boucher, Pierre, Vien, and Doyen in his picture cabinet, and that he finds them very beautiful, whereas I consider them detestable!"[17] Such prejudices would enjoy extraordinary longevity.

Pierre returned to *The Rape of Europa* seven years later, in 1757, in a tapestry cartoon in the series *The Loves of the Gods*, commissioned for the Gobelins by the marquis de Marigny. Formerly in the Musée d'Arras and destroyed during the First World War, Pierre's cartoon is known today from a beautiful red chalk drawing (fig. 2). A spirited oil sketch of this subject (fig. 3), which is also indebted to Boucher's *Rape of Europa*, has recently reappeared; it may be one of the five "little pictures, recently finished," exhibited in Pierre's studio in July 1759.[18]

Although no preparatory studies or sketches for Watelet's *Rape of Europa* survive, Europa's majestic pose recalls the fine *Allegory of Victory* (fig. 4). This drawing, which may have been made at the time of the Peace of Aix-la-Chapelle (1748), may be related to *The Rape of Europa*, above all in the handling of the seated Victory's right hand, the turn of her neck, the modeling of her breast, and the folds of her drapery.[19] Pierre's happy invention of a bearded triton feeding flowers to the bull was derived from a similar figure who pulls Venus's chariot in the recently discovered *Venus on the Water* (fig. 5), a cabinet picture exhibited at the Salon of 1746 with which *The Rape of Europa* has an obvious affinity. Pierre's *Rape of Europa* was engraved by Louis-Simon Lempereur, whose print was announced in January 1762—the figure of Europa described as mounted on the bull "*en amazone*"—and exhibited in the Salon of the following year.[20] A copy of *The Rape of Europa*, painted after Lempereur's engraving, is in the Bruckenthal Museum, Sibui, Romania.[21]

NOTES

1. *Catalogue de Tableaux . . . le tout provenant du Cabinet de feu* M. *Watelet*, Paris, 12 June 1786, no. 14, "Ce magnifique morceau a été fait pour achever le salon de feu M. Watelet"; Rosenberg 1985, 270–73, for the most recent account of the relations between Pierre and Watelet.

2. The point is made in Halbout 1970, 56–64. I am most grateful to Madame Halbout for letting me consult her unpublished thesis on Pierre.

3. Baillet de Saint-Julien 1750, 20, "tout le monde en a senti l'effet et il ne s'est point arrêté aux yeux."

4. Ibid., 19, "Son pinceau est aisé, coulant, et voluptueux."

5. Banier's translation had been reprinted in 1742.

6. Baillet de Saint-Julien 1750, 19, "L'enlèvement d'Europe n'a pas été moins loué que ce dernier: mais a peut-être attiré moins de regards."

7. Gould 1959, 153.

8. A.N., *Minutier Central*, XXXI/253, *"Inventaire après décès,"* 25 May 1789, "Dans la Bibliothèque . . . item., un tableau peint sur toile dans son cadre doré représentant l'Enlèvement d'Europe par Benedette Castiglione."

9. Bartsch 1978–, XLII, 104; Seznec 1955, 67–74 passim.

10. Paillet in *Catalogue de Tableaux . . .* (as in n. 1), no. 14, "il ne semble nécessaire de ne point désunir ces trois ouvrages capitaux et si parfaitement d'accord." As Ingamells 1989, 66, has noted, Boucher's four mythologies for Derbais must have entered Watelet's collection between March 1743, the month of Derbais's death, and 1750, the year of Pierre's commission to complete the *salon.*

11. Vicq d'Azyr in Watelet and Lévesque 1792, I, xxi–xxii, notes that Watelet first visited Italy at the time of Maria-Theresa's marriage to Francis Stephen of Lorraine in February 1736, and that his friendship with Pierre, who had arrived at the French Academy in Rome the previous year, dated from this first sojourn; Ericksen 1974, 225, notes Watelet's emendation on the title page of the series of vases he engraved after Pierre's designs in 1749.

12. Sandoz 1975, 32, no. 15.

13. Watelet in Lépicié 1752, II, 59; Montaiglon 1875–92, VI, 266–67.

14. Watelet in Lépicié 1752, II, 59, "des ornamens nobles, riches, et élégans."

15. Watelet in Lépicié 1752, II, 60–61; see also his article, "Galerie," in Watelet and Lévesque 1792, II, 387, "L'ensemble d'un nombre de compositions relatives les unes aux autres . . . peuvent être regardées comme les poèmes de la peintre." It was in Watelet's home in the rue Charlot that d'Alembert was nursed back to health by Julie de Lespinasse, see Marmontel 1972, I, 222.

16. Henriet 1922, 190, and Cayeux 1965, 134, for the loss of Watelet's fortune in 1772 as a result of the malfeasance of his *caissier*, Roland.

17. Rosenberg 1984 (B), 224, "Qui l'auroit cru! Un homme qui est de l'Académie des Belles-Lettres, et qui en a obtenu l'entrée par un Poème sur la peinture; un homme qui passe pour l'amateur les plus éclairé de nos jours; un homme qui a vu tout ce que l'Italie à de plus rare en peinture, et qui a analysé pour ainsi dire les beautés de cet art; croiroit-on qu'un tel homme n'eut dans son cabinet que des Vanloo, des Bouchers, des Pierre, des Vien, des Doyen, etc. . . . qu'il trouve très beaux, et que je trouve détestables?"

18. Fenaille 1903–23, IV, 190, 193; Bean 1986, 216–17; *La Feuille Nécessaire*, 2 July 1759, 342, "le même atelier offre encore cinq petits tableaux nouvellement finis. . . ." The Blaffer *Rape of Europa* is reproduced in *La Folie d'Artois*, Paris 1988, 173.

19. Exh. Paris 1976–77, no. 12.

20. *Affiches, Annonces, et Avis divers*, II, 20 January 1762, for the announcement of Lempereur's engraving, in which Europa is described "montée en amazone sur le taureau"; Diderot 1975–[1983], II, 193, for Lempereur's engraving at the Salon of 1763.

21. Frimmel 1906, 23–24, where the copy is incorrectly listed as after Watelet's painting.

FIG. 1
Simone Cantarini, *The Rape of Europa*,
etching, Vienna, Graphische Sammlung
Albertina

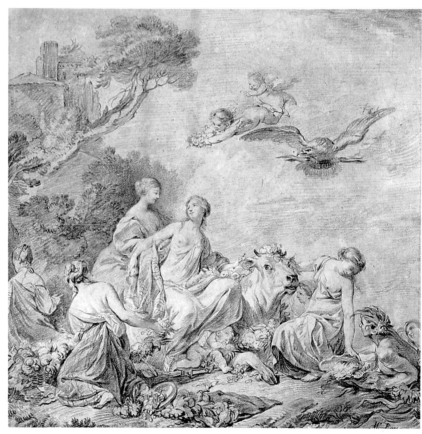

FIG. 2
Jean-Baptiste-Marie Pierre, *The Rape of Europa*, c. 1757, red chalk drawing, New York, The
Metropolitan Museum of Art, Harry G. Sperling Fund, 1981

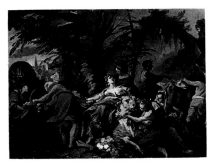

FIG. 3
Jean-Baptiste-Marie Pierre, *The Rape of Europa*,
c. 1757, oil sketch, Houston, The Sarah
Campbell Blaffer Foundation

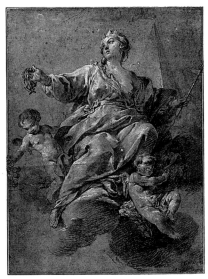

FIG. 4
Jean-Baptiste-Marie Pierre, *Allegory of Victory*,
c. 1750, black chalk drawing heightened with
white, The Art Institute of Chicago

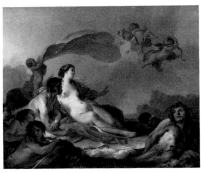

FIG. 5
Jean-Baptiste-Marie Pierre, *Venus on the Water*,
c. 1746, oil on canvas, New York, Private
Collection

JEAN-BAPTISTE-MARIE PIERRE
The Judgment of Paris

53

JEAN-BAPTISTE-MARIE PIERRE (1713–1789)
The Judgment of Paris, 1759
Oil on canvas
62.5 x 79 cm.
Private Collection

PROVENANCE
Dubois, his sale, Paris, 18 December 1788, no. 65, purchased by
Carrier for 80 *livres*; Private Collection, Switzerland; Stair Sainty
Matthiesen, New York.

EXHIBITIONS
New York, New Orleans, and Columbus 1985–86, no. 19, col.;
New York 1987, no. 59, ill.

BIBLIOGRAPHY
No previous bibliography.

In 1755, Frederick the Great of Prussia commissioned four huge history paintings for the decoration of the marble *salon* (*Marmorsaal*) in the Neues Palais, Potsdam. The artists chosen were Antoine Pesne, Frederick's *premier peintre*, who died before completing his *Abduction of Helen*, and three of the leading history painters in France, Carle Van Loo, Restout, and Pierre, who were to paint *The Sacrifice of Iphigenia*, *The Triumph of Bacchus*, and *The Judgment of Paris* (fig. 1), respectively.[1] In the notes he assembled for his obituary notice on Carle Van Loo, Dandré-Bardon recorded that the artist had agreed to have his painting ready by Easter 1757 and that he received payment of 12,000 *livres* in three installments for *The Sacrifice of Iphigenia*. It is likely that the same conditions applied to Restout and Pierre as well.[2] Yet, whereas Van Loo and Restout both exhibited their monumental commissions at the Salon of 1757—the year after hostilities with Prussia had broken out—Pierre failed to meet this deadline. Though expected at the Salon, *The Judgment of Paris* did not appear and would not be finished until July 1759, when it was shown in the artist's studio and discussed in some detail in the press.[3] It remains unclear why Pierre waited another two years to exhibit the painting publicly, since it was clearly ready in time for the Salon of 1759.[4] Shown with *The Beheading of John the Baptist* (Avignon, Musée Calvet) and *The Descent from the Cross* (Versailles, cathedral of Saint-Louis) at the Salon of 1761—where it was sketched by Saint-Aubin (fig. 2)—*The Judgment of Paris* received qualified praise from most critics, with the exception of Diderot, who detested the picture and did not hesitate to say so: "What on earth is the king of Prussia going to do with this feeble *Judgment of Paris?*"[5]

The problem with the final composition, as most critics were quick to point out, was that the enormous size of the canvas (fourteen by twenty-one feet) could not sustain a scene in which there were so few participants. Unlike Van Loo's *Sacrifice of Iphigenia* or Restout's *Triumph of Bacchus*, "paintings which require a large number of people,"[6] the story of the momentous beauty contest on Mount Gargarus—whose

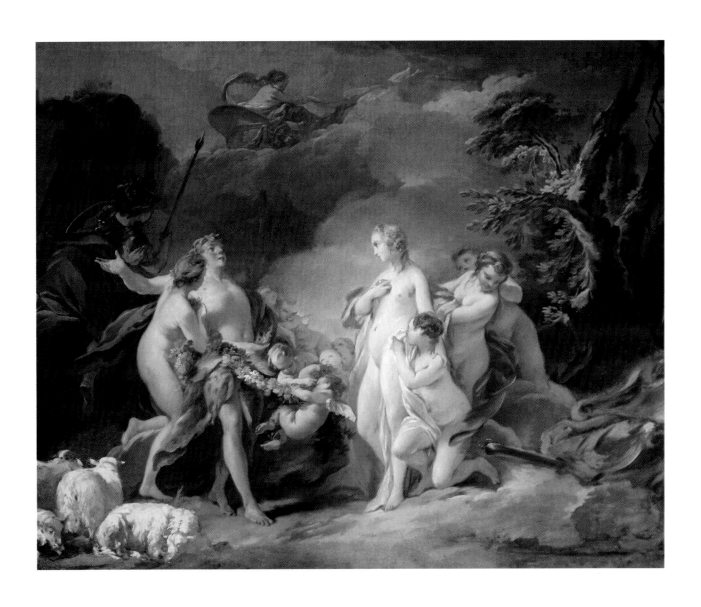

consequences would set in motion the Trojan War—required a hushed and dramatic setting, "a great silence, profound solitude, and the falling of day."[7] Diderot also criticized Pierre for introducing several putti and the Three Graces into his composition, claiming that the latter attended Venus only at her toilette. Somewhat perversely, he considered these accessories typical of Pierre's lack of imagination.[8] Here Diderot was less just than the abbé Bridard de La Garde, author of a generally critical review in the *Observateur Littéraire*; if the latter dismissed the inappropriately dressed figure of Paris as too rustic, he conceded that Pierre was faced with "a stage that is too vast for an insufficient company of players."[9]

These problems are not apparent in Pierre's preparatory sketch for the painting, a bravura exercise in pinks, creams, and blues which can be dated to the late 1750s. In the sketch, Paris has just handed the golden apple to Venus, who has won over the shepherd by her promise of Helen of Troy. There is much activity in Pierre's preliminary treatment of the subject. The Graces rush to clothe Venus, who had disrobed at Paris's insistence; he demanded that all three goddesses be judged naked. On the left, Minerva, javelin in hand, takes her leave; in the sky above her, Juno departs from the scene in a chariot drawn by peacocks. In the contrast established between the fair-skinned attendants and the more ruddy shepherd, as well as in its handling and disposition of light, Pierre's sketch may be compared to *Bacchus and Ariadne* (fig. 3), dated to around 1755.[10]

In the full-scale *Judgment of Paris*, Pierre kept the central group more or less intact, while replacing Paris's dramatic, but inexplicable, gesture with a more conventional one; the shepherd hands Venus the golden apple, and, to drive the point home, a flying putto crowns her victorious. In other ways the painting differs radically from the sketch. The landscape and the grazing animals now occupy far greater space, which has the effect of diminishing the dramatic intensity of Paris's choice, and there is an imbalance created by the group of female figures at right, pushed to the edge of the canvas. Comprising Minerva, scowling as she retrieves her garments, a second naked female who might well be Iris, the messenger of the gods—but whom contemporaries interpreted as representing Jealousy or Discord—and Juno, who hurries to depart at upper right, this trio of naked deities further detracts attention from the action that takes place on center stage.[11]

None of these constraints are visible in the sketch, however, where the play of light fixes attention on the central group and where the figure of Minerva, at left, is balanced by the majestic oak at right, thus giving greater symmetry and cohesion to the composition. Mariette may have written that Pierre's talents "shone above all in large-scale works," but in this case it is his *première pensée* that represents the traditional theme most felicitously.[12]

Pierre may have consciously attempted to introduce new elements into his interpretation of *The Judgment of Paris*. Diderot, who typically re-created the picture as he would have painted it, has Paris seated on a rock, the light of day about to fade, and the three goddesses still in the shepherd's presence.[13] This conventional reading of the story, in which Mercury also appears, ultimately derives from Marcantonio Raimondi's engraving after Raphael's *Judgment of Paris* and would be followed by several of Pierre's contemporaries, most notably Boucher.[14] At its most beguiling in Noël-Nicolas Coypel's painting from a generation earlier (cat. no. 31), the tale is similarly treated in two lesser-known works: in a drawing by Natoire (fig. 4) and in a cabinet painting of almost identical dimensions to Pierre's sketch which may be attributed to Étienne Jeaurat (fig. 5).[15] In contrast to all of these, however, Pierre has chosen to concentrate upon the amorous implications of Paris's choice, and in his assured groupings of cupids and Graces, he proves himself a master of understated eroticism.

NOTES

1. Bartoschek 1979, for reproductions of Van Loo's and Restout's paintings. Halbout 1970, no. 76, gives a full discussion of Pierre's *Judgment of Paris* and the related commissions, although the sketch was not known to her.

2. Bibliothèque Nationale, Département des Manuscrits, Fonds Français 13081, Dandré-Bardon, *Recueil des Manuscrits divers*, fol. 279, "Cent louis en commencant, autres cent louis quand le tableau sera ébauché et les sept mille deux cent livres restant lui seront payées quand il livrera le tableau, qu'il promet donner à Paque 1757."

3. Tourneux 1877–82, III, 427, 1 October 1757, "M. Pierre devait traiter le Jugement de Pâris: il n'a rien exposé"; *Feuille Nécessaire*, 2 July 1759, 340–41, for a full discussion of the painting.

4. Which opened its doors on 25 August 1759.

5. Diderot 1975–[1983], II, 114, "et que fera le roi de Prusse de ce mauvais jugement de Pâris."

6. *La Feuille Nécessaire*, 2 July 1759, 340, "Tableaux qui étoient susceptibles d'un grand nombre de figures."

7. Diderot 1975–[1983], II, 115, "que tout particulièrement annonce un grand silence, une profonde solitude et la chute du jour."

8. Ibid., "Point de Grâces, les Grâces étaient à la toilette de Vénus; mais elles n'ont point accompagné la déesse . . . c'est la pauvreté d'idées qui fait employer ces faux accessoires."

9. [Bridard de La Garde] 1761, 19–20, "il pourroit par conséquent avoir l'inconvénient d'un trop vaste Théâtre pour une scène peu nombreuse."

10. Halbout and Rosenberg 1975, 14.

11. *La Feuille Nécessaire*, 2 July 1759, 340, "la Jalousie qui est à ses côtés, lui montre Junon déjà montée dans son char"; Gabriel de Saint-Aubin, who sketched *The Judgment of Paris* in his copy of the Salon *livret*, noted "la discorde est à côté de Pallas"; Dacier 1909–21, pt. 6, 8.

12. Mariette 1851–60, IV, 154, "C'est surtout dans ces grandes compositions que brille son pinceau; il est moins fait pour des tableaux plus renfermés et où il faut établir des grâces et un travail plus précieux et plus délicat."

13. Diderot 1975–[1983], II, 115–16.

14. For example, Boucher's *Judgment of Paris*, 1754, in the Wallace Collection, London, and a later version, dated c. 1759, in the Musée des Beaux-Arts de Mulhouse.

15. Natoire's drawing is reproduced in exh. Stuttgart 1984, no. 193. The attribution to Jeaurat is based upon comparison with the signed *Laban Searching in His Daughters' Tents* (Leningrad, The Hermitage), exhibited at the Salon of 1737.

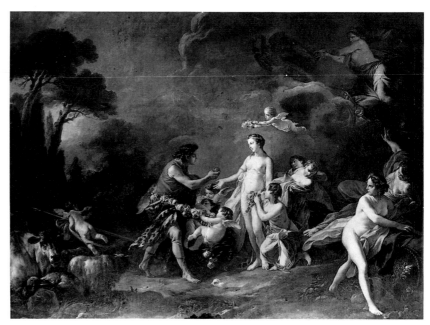

Fig. 1
Jean-Baptiste-Marie Pierre, *The Judgment of Paris*, 1759, oil on canvas, Potsdam-Sanssouci,
Staatliche Schlösser und Gärten

Fig. 2
After Jean-Baptiste-Marie Pierre, *The Judgment
of Paris*, black chalk drawing by Gabriel de
Saint-Aubin, from his copy of the *livret* of the
Salon of 1761

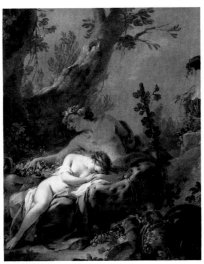

FIG. 3
Jean-Baptiste-Marie Pierre, *Bacchus and
Ariadne*, c. 1755, oil on canvas, Stanford
University Museum of Art 71.37. Gift of the
Committee for Art at Stanford

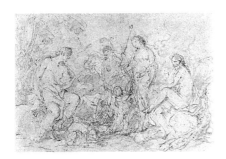

FIG. 4
Charles-Joseph Natoire, *The Judgment of Paris*,
black and white chalk drawing, Staatsgalerie
Stuttgart

FIG. 5
Attributed to Étienne Jeaurat, *The Judgment of
Paris*, c. 1730–40, oil on canvas, Private
Collection

NOËL HALLÉ
(1711–1781)

Son of Claude-Guy Hallé (1652–1736), a rector of the Academy, and grandson of Daniel Hallé (1614–1675), a Rouennais painter of religious images, Hallé was also the brother-in-law of Jean Restout. Despite the strength of these family connections with the Academy, Hallé was originally trained as an architect, but he eventually received artistic instruction from his father and Jean Restout. Hallé won the *Prix de Rome* in 1736 with *The Crossing of the Red Sea* (location unknown) and went to study in Rome in 1737. He stayed there until 1744—three years beyond the normally allotted time—in order to complete tapestry cartoons after Raphael's work in the Vatican *Stanze* (e.g., *The Punishment of Heliodorus*, location unknown) for the Gobelins. Encouraged by Jean-François de Troy, director of the French Academy in Rome, Hallé also painted independent works such as *Joseph Accused by Potiphar's Wife* (c. 1740–44, University of Chicago, David and Alfred Smart Gallery), which reveal the influence of the older history painter's sensuous colorism. Hallé returned to Paris in 1744. There he became an associate member of the Academy in June 1746, and a full member in May 1748 with *The Dispute of Minerva and Neptune over the Naming of Athens* (Paris, Musée du Louvre). Once again within Restout's orbit, Hallé drew upon his example and, as David Lomax has noted, used Restout's painting of *The Baptism of Christ* (Paris, church of Saint-Nicolas du Chardonnet) as a model for his own composition of the subject for the Carthusian church in Lyons (1746, Lyons, church of Saint-Bruno), painted shortly after his return to Paris. Hallé renewed Restout's formula, however, by imparting a new sentimentality and gentleness through a more lyrical use of gesture and pose. Other religious paintings, such as

Saint Peter Delivered from Prison, 1764, for the church of Saint-Pierre Saint-Barbe (Saint-Chamond, *in situ*), cited as "one of his most beautiful paintings" in an obituary tribute, manifest similar expressive qualities.

Although Hallé painted a number of religious works for independent institutions, such as a ceiling for Saint-Sulpice (*The Angel Appearing to the Magi with the Star That Will Guide Them*), he was primarily occupied with work for the Crown. Like his contemporaries Pierre and Vien, Hallé was called upon to provide history paintings for the decoration of royal residences, part of the resurgence of state patronage at the end of the Seven Years' War. For example, in 1765 he painted *The Emperor Trajan Aiding a Poor Woman* (Marseilles, Musée des Beaux-Arts) for the *galerie* at the château de Choisy, and in 1776 he executed *Bacchus Surrounded by His Court* (*The Wine Harvest*) for the dining room of the Petit Trianon (Musée National des Châteaux de Versailles et de Trianon). Sufficiently impressed with Hallé's abilities, in 1777 the Crown also purchased *The Liberality of Cimon the Athenian* (Paris, Musée du Louvre), a work done independently of any decorative project.

In addition to these prestigious commissions, Hallé also painted more workaday religious compositions for the *Bâtiments du roi*, for example, *Saint Vincent de Paul Preaching* for a chapel in the cathedral of Saint-Louis at Versailles (1761, *in situ*) and *Saint Louis Carrying the Crown of Thorns in Procession from Vincennes to Paris*, 1773, for the chapel of the École Royale Militaire. His carefully drawn compositions, frequently set within precisely delineated architectural backgrounds, were painted with clear, bright colors and contain dramatically, yet convincingly, posed figures with oval faces and high, broad foreheads.

While Hallé successfully employed his decorative style in these religious works, it was perhaps best suited to the requirements of tapestry cartoons for the Gobelins. Hallé produced a number of cartoons, which rank among his finest work; for example, the magisterial *Hippomenes and Atalanta* (cat. no. 56), *Achilles Discovered at the Court of Deidamia* (1769, Limoges, Musée Municipal), and *Silenus Smeared with Mulberries by the Nymph Eglea* (1771, Lille, Musée des Beaux-Arts).

In 1771 Hallé became overseer of the Gobelins, a prestigious offical appointment due in equal part to his exceptional decorative talents and his close friendship with Jean-Baptiste-Marie Pierre. In 1775 he was named *commissaire du roi* and placed in charge of reorganizing the French Academy in Rome in anticipation of Vien's arrival, following Natoire's disastrous final years. As a reward for his efforts, Hallé would receive the order of Saint-Michel in 1777.

Unlike Lépicié and his other peers at the Academy, Hallé rarely ventured outside the field of history painting. He produced a few charming genre works, such as *The Education of the Rich* and *The Education of the Poor* (both Private Collection), exhibited at the Salon of 1765, which show sweet images of childhood innocence, and rustic scenes, such as *Winter* (*Old Man Warming Himself*; 1747, Boston, Museum of Fine Arts). Hallé periodically worked as a book illustrator, making engravings for Jean-Antoine Guer's *Moeurs et usages des Turcs* (1746–47), among others. In spite of his contemporary renown, however, Hallé was quickly forgotten after his death in June 1781. Although the meticulous research of provincial *érudits* earlier in this century resurrected his work, it is only within the last decade that his reputation has been restored.

NOËL HALLÉ, *Hippomenes and Atalanta* (detail), 1765, oil on canvas, 321 x 712 cm, Musée du Louvre, Paris

NOËL HALLÉ
Hercules and Omphale

Bacchanal

54 & 55

NOËL HALLÉ (1711–1781)
Hercules and Omphale (*The Dangers of Love*), 1759
Oil on canvas
97 x 130 cm.
Musée des Arts de Cholet

PROVENANCE
Jean-Baptiste-François de Montullé (1721–1787), his sale, Paris, 22 December 1783, no. 76 [as Claude Hallé]; Duclos the younger, his sale, Paris, 2 April 1792, no. 79 [with cat. no. 55], sold for 160 *livres*; sale, Verrières-le-Buisson, 5 April 1981, ill.; sale, Nouveau Drouot, Paris, 15 June 1983, no. 70B; acquired by the Musée des Arts de Cholet in 1983.

EXHIBITIONS
Salon of 1759, no. 16 [exhibited with cat. no. 55]; Paris 1984–85 (B), no. 74, ill.; Fukuoka 1989.

BIBLIOGRAPHY
Anonymous 1759 (A), 21; Anonymous 1759 (B), 114–15; Fréron 1759, 220; Estournet 1905, 192, 206, no. 68; H. Bardon 1963, 236, 238; Diderot 1975–[1983], I, 41, 65; Bukdahl 1980, 69, 262, n. 45; Willk-Brocard 1983, 390–92, ill.; exh. Paris 1984 (A), 44, ill.

NOËL HALLÉ (1711–1781)
Bacchanal (*The Dangers of Wine*), 1759
Oil on canvas
97 x 130 cm.
Musée des Arts de Cholet

PROVENANCE
Jean-Baptiste-François de Montullé (1721–1787), his sale, Paris, 22 December 1783, no. 76 [as Claude Hallé]; Duclos the younger, his sale, Paris, 2 April 1792, no. 79 [with cat. no. 54], sold for 160 *livres*; acquired by the Musée des Arts de Cholet in 1983.

EXHIBITIONS
Salon of 1759, no. 16 [exhibited with cat. no. 54]; Paris 1984–85 (B), no. 75, ill.; Fukuoka 1989.

BIBLIOGRAPHY
Anonymous 1759 (A), 21; Anonymous 1759 (B), 114–15; Fréron 1759, 220; Estournet 1905, 192, 206, no. 69; H. Bardon 1963, 236, 238; Diderot 1975–[1983], I, 41, 65; Bukdahl 1980, 69, 262, n. 45; Willk-Brocard 1983, 390–92, ill.; exh. Paris 1984 (A), 44, ill.

allé's *envoi* to the Salon of 1759 was in-tended to demonstrate his proficiency as a painter of sacred and profane subjects on both the large and small scales. Together with the enormous *Rest on the Flight into Egypt* (Orléans, Musée des Beaux-Arts)—which Diderot maliciously claimed to be unable to find in the *salon carré*—Hallé submitted a pair of pen-dants, *Hercules and Omphale* and *Bacchanal*, listed in the *livret* as *The Dangers of Love* and *The Dangers of Wine*, respectively.[1] These moralizing titles did little justice to the character of Hallé's cabinet paintings, which were recognized, then as now, as charming, playful, and decorous. One wag noted that several ladies of society would have been happy to change places with Omphale, since Hallé's Hercules was more attractive than terrifying, and that the fate of the young satyr in *Bacchanal* inspired envy rather than caution.[2]

Hercules and Omphale is based, very loosely, on Apollodorus's tale of Hercules's yearlong enslavement to Omphale, queen of Lydia. Seated at the foot of Omphale's throne, surrounded by her attendants—the foremost wears the Nemean lion skin on her head—Hercules is suddenly overcome as the tapestry with episodes of his former heroism is unfurled by the flying putti at right. Presented with a ferocious image of himself, club in hand, Hercules drops his spindle and recoils from Omphale's touch. His enormous *mas-sue* is pulled from under the carpet by a pair of infants who point their fingers accusingly; a third implores Hercules to take note of the image on the tapestry. Shamed into enlightenment, it might be supposed that Hercules's tenure at the court of Lydia is soon to end.

In *Bacchanal*, a rather handsome satyr—recog-nizable by his enormous ears and animal hindquar-ters—is forced to drink wine by a pair of comely bac-chantes, one of whom squeezes a bunch of grapes above his head while the other holds a cup to his mouth. The group is surrounded by inebriated com-panions of all ages, from the bloated children in a drunken stupor at left to the pair of satyrs fighting over a naked bacchante at right, a passage that is now almost impossible to discern. In the middle ground Bacchus's music-making followers erupt onto the scene; the bacchante who "clashes the cymbals of rounded bronze" is about to be carried off by a lusty satyr, while behind her two satyrs set upon each other ferociously.[3] Before an imposing temple in the dis-tance, a priest officiates at the sacred rites responsible for this mayhem.

Spirited, fluid, and delicately colored, *Hercules and Omphale* and *Bacchanal* are characteristic of Hallé's "pure and chaste brush."[4] The artist's refined palette—sky blues, salmon pinks, apple greens, an ap-pealing mixture derived from Restout and Boucher—and his distinctive manner of painting figures—in-fants with oversized heads, doe-eyed nymphs with red cheeks and turned-up noses—endow this fanciful mythology with considerable charm.[5] That Hallé's diminutive figures act out their domestic drama amid a sea of drapery serves only to enhance the painting's decorative quality.

In a far poorer state of conservation—the area in shadow behind the foreground figures has become al-most illegible over time and the face of the bacchante in the center has little to do with Hallé—the *Baccha-nal* seems to have been the more acclaimed of the pair in its day. If Diderot thought the contrast between the drunken satyr and his fair-skinned temptresses over-stated—he was painted the color of "well-baked brick," the critic remarked, and "seemed to have emerged form a potter's furnace"—the sensuous juxta-position continues to make an impact.[6] The less dam-aged figures in the middle ground, swiftly painted with considerable flair, better illustrate the virtuosity for which Hallé was celebrated.

It would be an exaggeration to claim that Hallé's pendants were greatly remarked upon in a Salon that was dominated by Carle Van Loo's enormous *Made-moiselle Clairon as Medea* (Potsdam-Sanssouci, Staat-liche Schlösser und Gärten), and in which the submissions of two promising debutants, Gabriel-François Doyen and Jean-Baptiste Deshayes, caused the greatest excitement.[7] Yet, with the exception of Diderot, when critics responded at all to *Hercules and Omphale* and *Bacchanal*, they did so favorably. "Pleas-ing works" that "did honor to their author,"[8] the pen-dants were nevertheless subjected to careful scrutiny in the *Lettre critique à un ami*, which criticized the clumsy foreshortening of the dark-haired bacchante kneeling in the foreground of the *Bacchanal*; indeed, her right leg is weak.[9] Boucher's nefarious influence on Hallé, noted by other critics as well, made these mythologies unbearable for Diderot, who had little time for them.[10] His harsh and dismissive comments show that he failed to appreciate either their narra-tive content or the skill of their handling. "There is neither wit nor subtlety in them," he raged; "they are without movement and without ideas."[11] This was an opinion shared neither by other *salonniers* nor by the Swedish engraver Pierre Gustave Floding, a protégé of the aged Count Tessin, studying in Paris at the time. Asked by Tessin in December 1759 to commission an allegorical portrait from the most acclaimed history painter of the Salon—Tessin's valediction would have been of the same dimensions as Hallé's pendants—Floding approached several artists but recommended

CAT. 54

CAT. 55

Vien and Hallé as best suited to the task. The former's drawing might be more correct, he informed Tessin, "but Hallé's coloring was the more seductive."[12]

If, for Diderot, Hallé's mythologies were fit only for the hacks of the Pont Notre-Dame, a more reasoned assessment would emphasize both the artist's meticulous preparation and his efforts to imbue these mildly suggestive mythologies with a precocious, if fashionable, classicism.[13] In *Hercules and Omphale*, Hallé returned to a subject he had first treated fifteen years earlier, the life-size *Hercules and Omphale* (fig. 1), painted in Rome in 1744 and exhibited at the Salon of 1748, which remained in the artist's studio until his death.[14] From J.-A. Patour's engraving of this lost painting, it is clear that the god and his consort in our version are variants of the figures established early on.[15] In both paintings, Hallé's short-haired, bearded god is based on two celebrated antique models, the *Farnese Hercules* and the *Reclining Hercules* (the "Hercules Chiaramonti"), which he would have had ample opportunity to study during the seven years he spent in Rome.[16]

Although Hallé's son—Napoleon's future *premier médecin*—claimed that his father prepared his paintings with "a large number of drawings from life in chalk and pastel," none appear to have survived for either *Hercules and Omphale* or *Bacchanal*.[17] By contrast, two detailed and fairly finished oil sketches, which seem, at first glance, virtually identical to the Salon paintings, recently reappeared on the market.[18] The modifications Hallé would introduce into the finished works suggest a demanding intelligence and an acute visual sense. In the sketch for *Bacchanal* (fig. 2), both the priest in the background and the riotous satyrs and bacchantes in the middle ground assume such importance that they almost overwhelm the central quartet of figures. While the painting itself would remain full of incident—the dealer Lebrun counted seventeen principal figures—Hallé distinguishes much more efficiently between the primary and subsidiary groupings.[19] In the sketch for *Hercules and Omphale* (fig. 3), Hallé's modifications were even more subtle. Initially, Hercules shared something of the coarse features and melodramatic gestures of Hallé's earlier model; he is also shown, arms akimbo, literally springing from Omphale's feet. In the finished painting, Hallé ennobled the god's expression and adjusted his pose, the better to complement Omphale's astonished expression. In the transition from sketch to painting, even the tapestry was modified. In the sketch, the medallions, which show scenes from the god's former life, are garlanded with flowers, adding unnecessary *papillotage* to a part of the composition that is already full of detail. The second medallion, more legible in the sketch than in the painting, contains a voluptuous nude, possibly the Amazon whose girdle Hercules was instructed to obtain as his ninth labor. In the final composition, this female figure has been replaced by Hercules himself—the heads are different, but the pose is unaltered—and as such the contrast between the god's present *mollesse* and his former valor is even more sharply drawn.

Hallé also took great care in the architectural settings of his Salon paintings. It was noted by his first biographer, his son Jean-Noël Hallé, that "whenever he had the opportunity to include buildings in his compositions, the nobility and the purity of the architecture he painted confirmed that he would have made an excellent architect."[20] In *Hercules and Omphale*, the queen's bedchamber opens onto a courtyard enclosed by a splendid Doric colonnade with a frieze of triglyphs and metopes, its pediment surmounted by classical urns. In the *Bacchanal*, the priest performs his rites in front of an elegant temple with Corinthian capitals, reminiscent of the Temple of the Sibyl, surrounded by a balustrade.

Hallé's architectural staffage is not the only classicizing element in his "rococo" mythologies. Like other history painters of his generation (for example, Vien and Lagrenée), he was more than happy to yield to the current infatuation with *le goût grec*—the taste for ornament inspired by the antique that infiltrated all aspects of Parisian fashion and taste in the 1750s and 1760s.[21] In *Hercules and Omphale* and *Bacchanal*, Hallé's concessions to this regnant mode may seem slight, but stage props such as the severely architectonic bed upon which Omphale's attendant reclines, the massive throne on which the queen is seated, and the silver cassolette, or perfume burner, at right, with its garlands "in the shape of well ropes," all attest to the concealed erudition and unexpected modernity of Hallé's unassuming mythologies.[22]

NOTES

1. Rosenberg in exh. Paris 1984 (A), 44–45; Willk-Brocard 1983, 390–92, and idem in exh. Paris 1984–85 (B), 269–72.

2. *Journal Encyclopédique*, 15 October 1759, 114–15, "Hercule n'a pas été trouvé si effrayant que plus d'une dame n'eût volontiers désiré courir le risque de remplacer Omphale"; as regards the "jeune faune, . . . le grand malheur qui puisse lui arriver n'a pas paru fort redoutable."

3. Catullus, *Poems*, LXIV, 260–61.

4. Renou, *Éloge de M. Hallé, peintre, Collection Deloynes*, LXII, no. 1950, 26, "son pinceau chaste et pur."

5. *Lettre critique à un ami*, 1759, 22, "Les têtes de ses Enfans sont énormes"; Willk-Brocard in exh. Paris 1984–85 (B), 270, for an excellent summary of Hallé's manner.

6. Diderot 1975–[1983], I, 65, "un satire d'une belle brique, bien dure, bien jaunâtre, et bien cuite . . . qui sort du four d'un potier."

7. Willk-Brocard 1983, 391; Diderot 1975–[1983], I, 30–31.

8. Fréron 1759, 220, "Les deux petits tableaux . . . plaisent singulièrement. . . . Ils font honneur au talent de M. Hallé."

9. *Lettre critique à un ami*, 1759, 21, "Celle qui est vue par le dos n'est pas d'un tour heureux, le raccourci de la jambe est ingrat et je crains même qu'elle ne pêche par l'ensemble."

10. The point is made by Bukdahl 1980, I, 68–69.

11. Diderot 1975–[1983], I, 65, "nul esprit, nulle finesse, point de mouvement, point d'idée, mais le coloris de Boucher."

12. Lundberg 1931–32, 277, "M. Hallé demandoit de même 1,200 livres, son dessin est biens moins correct, son coloris plus séduisant, quoique moins vrai que celui de M. Vien." Tessin's commission, *The Angels Who Stand Watch over the Sleep of a Virtuous Man*, seems not to have been awarded in the end.

13. Diderot 1975–[1983], I, 65, "Je renvoye ses deux petits pendants au pont Notre-Dame."

14. Willk-Brocard 1983, 391. *Catalogue de tableaux, dessins, estampes . . . provenans du cabinet de feu M. Hallé, chevalier de l'ordre du Roi*, Paris, 2 July 1791, no. 25; the painting's dimensions are given as "haut. 7 pieds 5 pouces, largeur 5 pieds." Pahin de La Blancherie 1783, 237, no. 92, where this early version of *Hercules and Omphale* is recorded as in his widow's possession.

15. Patour's engraving is reproduced in Bukdahl 1980, I, 70, who confuses it with the Cholet painting, and in Willk-Brocard 1983, 391.

16. Haskell and Penny 1981, 229–32, for the *Farnese Hercules*; Bober and Rubinstein 1986, 168, no. 133, for the *Hercules Chiaramonti*.

17. [Hallé] 1782, 196, "Il n'est pas un de ses tableaux, qui ne lui ait coûté un grand nombre d'études d'après nature, soit au crayon, soit au pastel."

18. Willk-Brocard 1983, 390. It should be noted that Montullé, in whose collection Hallé's pendants are first recorded, also owned "une esquisse représentant le Triomphe de Bacchus, riche composition de vingt-six figures, hauteur 27 pouces, largeur 34 pouces," *Catalogue d'une belle Collection de Tableaux des Écoles d'Italie, de Flandres, de Hollande, et de France . . . venans du cabinet de M. [de Montullé]*, no. 77. In Hallé's posthumous sale are recorded *two* sketches for *Hercules and Omphale*, one of which would appear to be the sketch reproduced in Willk-Brocard's article, *Catalogue de tableaux* (as in n. 15), no. 26, "une esquisse du même sujet [Hercule et Omphale] . . . hauteur 16 pouces, largeur 21 pouces 6 lig," and no. 37, "trois esquisses peints à huile, dont Hercule et Omphale," no dimensions given.

19. *Catalogue d'une belle Collection de Tableaux* (as in n. 18), no. 76 bis, "riche composition de dix-sept figures principales."

20. [Hallé] 1782, 185, "En effet, toutes les fois qu'il a eu occasion de faire entrer des édifices dans ses compositions, la noblesse et la pureté de son Architecture ont fait voir qu'il eût été excellent Architecte."

21. Ericksen 1974, 87, notes further that the furniture in Hallé's *Education of the Rich* (Paris, Private Collection), exhibited at the Salon of 1765, is of "a heavy neoclassical character."

22. Ericksen 1974, 269, for Cochin's critique of La Live de Jully's furniture ("guirlandes en forme de cordes à puits"); Laing in exh. New York, Detroit, and Paris 1986–87, 256, for Boucher's earlier use of ornament in *le goût grec*—the cassolette in *The Toilet of Venus*, 1751 (New York, The Metropolitan Museum of Art). It should be remembered that it was in the Salon of 1759 that Greuze exhibited the *Portrait of La Live de Jully* (Washington, National Gallery of Art), in which the harp-playing *amateur* is surrounded by the aggressively neoclassical furniture designed by Le Lorrain for his *cabinet flamand*. Hallé was patronized by La Live de Jully in the 1750s.

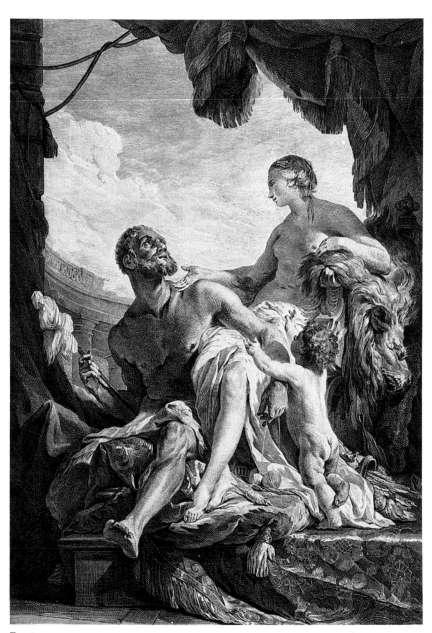

FIG. 1
After Noël Hallé, *Hercules and Omphale* (*The Dangers of Love*), c. 1770, engraved by J.-A. Patour,
Copenhagen, Statens Museum for Kunst, Kupferstitchsammlung

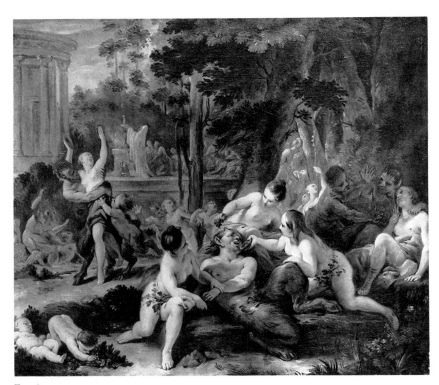

FIG. 2
Noël Hallé, *Bacchanal*, c. 1759, oil sketch, location unknown

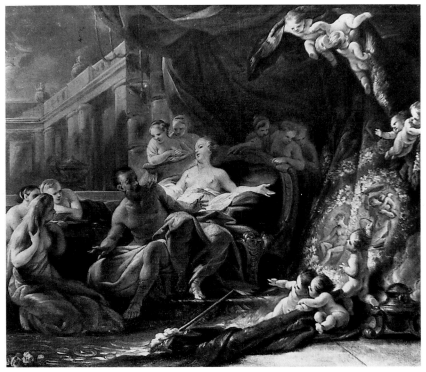

FIG. 3
Noël Hallé, *Hercules and Omphale*, c. 1759, oil
sketch, location unknown

NOËL HALLÉ
Hippomenes and Atalanta

56

NOËL HALLÉ (1711–1781)*
Hippomenes and Atalanta, 1765
Oil on canvas
321 x 712 cm.
Musée du Louvre, Paris

PROVENANCE
Commissioned by the *Bâtiments du roi* in 1762 for the sum of 5,000 *livres* as a tapestry cartoon for the Gobelins; at the Gobelins, where it was inventoried in 1794 and 1810; located in the Louvre in 1832; transferred to the Musée de Saint-Étienne in March 1965; returned to the Louvre in April 1990.

EXHIBITIONS
Salon of 1765, no. 16.

BIBLIOGRAPHY
Anonymous 1765 (A), 535–59; Anonymous 1765 (B), 147–48; Anonymous 1765 (C), 104; [Bridard de La Garde] 1765, 157–58; Fréron 1765, 151–52; [Le Paon] 1765, 12; Mathon de La Cour 1765, 13–14; [Hallé] 1782, 193; Guiffrey 1897, 375; Engerand 1901, 230–31; Stryienski 1903, 283; Fenaille 1903–23, IV, 197, 213; Estournet 1905, 159–60, 190, 209, no. 83; Locquin 1912, 189, and n. 3; Diderot 1975–[1983], II, 6, 7, 20–21, 84–86, ill.; Bukdahl 1980, 69–71; Saint-Étienne 1981, no. 18; Willk-Brocard 1983, 392; exh. Paris 1984–85 (B), 269, ill.

**Exhibited in Paris only*

Hippomenes *and* Atalanta was commissioned for the Gobelins in September 1762 as a tapestry cartoon in the series *The Loves of the Gods*.[1] Hallé had been Cochin's candidate, and the letter in which the *secrétaire perpétuel de l'Académie* explained his choice is worth considering in some detail. As Cochin informed the marquis de Marigny, Hallé was unemployed at the time and was little inclined to paint for the open market: "He has confided to me that he is unhappy about having to work without commissions and to paint without knowing where his canvases are destined."[2] Not only were Hallé's "bright, clear, pleasant colors" particularly well suited to tapestry cartoons, but his relative prosperity would also allow the *Bâtiments du roi* to spread payment for them over several years.[3] Cochin predicted that the demand for tapestries would revive upon the conclusion of present hostilities—the Seven Years' War would end in February 1763—and, while the Gobelins had never been more efficient, it was his opinion that its success depended upon the creation of "a stock of paintings more agreeable than those used in the past."[4] Thus it was important to renew the number of cartoons available so that prospective *amateurs* rich enough to decorate their houses with "such products" could be presented with an appealing choice. On Hallé's side, he was eager to start work on "something useful which would maintain his reputation at the Salon."[5]

On 28 September 1762 Marigny instructed Cochin, in concert with Soufflot, to provide Hallé with the subjects for two cartoons, a commission that would eventually expand into three. Although Marigny warned both officials that, given the economic climate, they were to favor "the genre that is most marketable with the wealthy"—namely, mythology—the commission to Hallé reflected Cochin's and Soufflot's overeagerness to renew the classical canon with less commonplace subjects.[6] *Hippomenes and Atalanta* was followed by *Achilles Discovered at the Court of Deidamia* (Limoges, Musée Municipal), exhibited at the Salon of 1769, and *Silenus Smeared with Mulberries by the Nymph Eglea* (fig. 1), exhibited at the

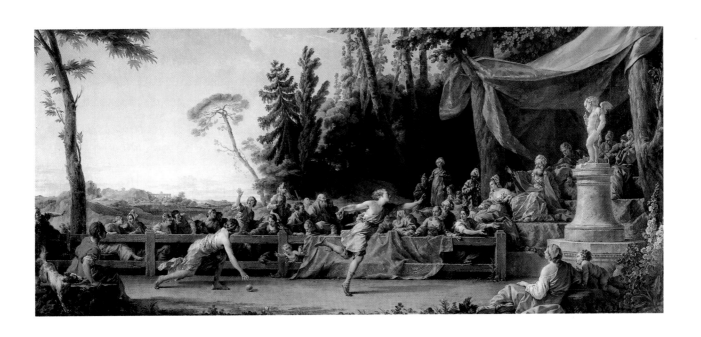

Salon of 1771, both ten feet in height, and fifteen and twelve feet in length, respectively. If Cochin had intended this group as a set, he may well have been disappointed at the limited demand for wall hangings on such a scale. *Silenus Smeared with Mulberries by the Nymph Eglea* was the only model of the three to be woven into a tapestry.[7]

Hallé's initial overtures to Cochin were somewhat disingenuous. He was not entirely "without work," since in 1761 he had received a commission from the Gobelins for *The Genius of the Arts* (Angers, Musée des Beaux-Arts), a pendant to Boucher's tapestry cartoon and part of the *tenture* ordered by Madame de Pompadour.[8] Nonetheless, an expansive format suited Hallé well, and it remained true that commissions of this size and type of subject nearly always emanated from the Crown. It is not known exactly when Hallé began work on *Hippomenes and Atalanta* or how long he took to complete this gigantic history painting. A sketch was required for Cochin's and Marigny's approval, and, although it is unclear when it was presented, by December 1763 Hallé was reported to be hard at work "on a large and magnificent painting for the king, to be shown at the next Salon."[9] Not ready in time for the Salon of 1763, *Hippomenes and Atalanta* must have been finished well before the opening of the Salon of 1765; from the winter of 1764 onward, Hallé was engaged upon yet another royal commission, *The Justice of Trajan* (Marseilles, Musée des Beaux-Arts), for the *galerie* at Choisy.[10]

Although the subjects Cochin chose for Hallé's tapestry cartoons were less recondite than those selected for the *salle des empereurs* at Choisy, the story of Hippomenes and Atalanta had never before been treated at the Gobelins.[11] Told variously by Apollodorus, Euripides, and Hyginus, the contest between Hippomenes and Atalanta, which forms the climax of the tenth book of the *Metamorphoses*, had provided Ovid with one of his most engaging narratives, of which Hallé would prove himself a worthy interpreter.[12]

In a vain attempt to curb Adonis's passion for hunting wild and dangerous animals, Venus tells him the story of the momentous race between Hippomenes, son of Megareus, great-grandson of Neptune, and Atalanta, daughter of Schoeneus, whom certain authors claimed was exposed on Mount Parthenon as an infant and reared by hunters, later developing into an athlete of outstanding strength.[13] Warned by an oracle that she should never marry, the beautiful, fleet-footed Atalanta would challenge her numerous suitors to a race, offering her hand as the prize but exacting their death if they were defeated.

Not to be a bride "until conquered first in speed," Atalanta had dispatched "a rash throng" of young men until Hippomenes, a spectator at one of these races, fell madly in love with her and resolved to stay the course.[14] Gazing upon the youth "with softening eyes," Atalanta felt "the impulse of love" for the first time and did her best to dissuade Hippomenes from competing, such was her confidence of victory.[15] The suitor wisely turned to Venus for help, and the goddess provided him with three golden apples from the fields of Tamasus, instructing him carefully in their use. During the race—in which Atalanta was clearly the swifter—Hippomenes cast the golden apples before her, causing the champion runner to pause in wonderment and retrieve them. By such means was Hippomenes able to reach the finish line first. However, in the flush of victory, "puffed up with his success," Hippomenes forgot to pay tribute to Venus; overcome by "incontinent desire," he and his young bride inadvertently defiled one of Venus's shrines with their lovemaking. As punishment, the goddess transformed Hippomenes and Atalanta into lions, "animals to whom the gods deny the intercourse of love," and the couple spent the rest of their days in the service of Cybele, mother of the gods, harnessed to her chariot.[16]

As was traditional, it is the conclusion of this momentous race that Hallé depicted. In a clearing protected by monumental firs and pines—a bay and an aqueduct are visible far in the distance—Hippomenes, one last apple in hand, makes a balletic dash for the finish line. In a gesture that resembles an invocation to Love, he propels himself toward the statue of Cupid, shown with a large gilded bow in his left hand and a full quiver of arrows at his feet. The god of Love's collusion in the outcome of this race is indicated by the finger he raises to his lips. Close behind, Atalanta crouches to pick up the second apple, and as she does so the numerous spectators who line the wooden fence spur Hippomenes to victory. Behind the statue of Cupid are seated Atalanta's father, Schoeneus, the beturbaned patriarch unmistakable in a copper red mantle, and an assorted retinue of figures colorfully dressed *à la turque*. This expansive composition, which has all the excitement and local color of a Derby Day in antiquity, is closed off by the most elegant of *répoussoirs*: at left, an excited dog, barking and wagging its tail; at right, a cluster of pink and white hollyhocks.

In this masterful panorama—populated by no fewer than forty figures—Hallé's limpid, elegant coloring, graceful figure painting, and bravura treatment of richly patterned fabrics display a virtuosity unequaled by any of his fellow academicians who

worked on this monumental scale during the 1760s and 1770s. *Hippomenes and Atalanta* is a *tour de force* of history painting that demonstrates the artist's ability to paint the human figure nobly draped and in expressive attitudes, to unify an elaborate composition through harmonious groupings, and to communicate a narrative of the greatest poetry with clarity and invention. Both the silvery tonality—gray blue in the sky and foliage, pale blue, apple green, and mustard yellow in the costumes—and the degree of finish in both the staffage and drapery are unexpected in a cartoon of this size. Indeed, despite its imposing narrative source, *Hippomenes and Atalanta* shares certain characteristics of contemporary genre painting; Hallé maintains interest and fluency by recourse to the motifs and expressions that could easily animate a *drame bourgeois*. Thus, if the aqueduct in the distance, the billowing canopy at right, and the statue of Cupid at the finish line are elements inspired by the grand manner, Hallé's mass of spectators keenly reacting to the afternoon's event more readily evoke Greuze and the novel of *sentimentalité*. From the barking dog at left, the infant who breaks free of his mother to push through the fence, and the group of women at right urging Hippomenes to victory, *Hippomenes and Atalanta* is replete with picturesque details of a sweetened, almost anecdotal, naturalism.

In addition, Hallé does not lose sight of the purposes for which his cartoon was to serve, and he pays particular attention to the elements that best translate into tapestry. Thus, lavish drapery abounds—from the gold and blue canopy edged in mauve, at right, to the diamond-patterned carpet on the dais behind the statues of Cupid, to the steel blue cloth incongruously draped over the wooden fence in the center of the composition. Yet the exotic costuming, colorful accessories, and grandiose staging of this work never overwhelm the central figures. Of Hallé's Hippomenes and Atalanta—painted life-size with exceptional grace and refinement—it may well be said that "the running gave a beauty of its own."[17]

Carefully composed—the crescendo of gestures and expressions intensifies as Hippomenes nears the finish line—*Hippomenes and Atalanta* is clearly the product of considerable preparation and study.[18] Yet few traces of the process by which this immense tapestry cartoon came into being have survived. The sketch that Hallé was required to present for official approval has yet to be discovered, and only three drawings—no more than *croquis*—have been identified, although many more must have been made. Nonetheless, from these it is apparent that Hallé followed his diminutive jottings quite faithfully in the finished painting. Studies are known for the dog at

left, his hind legs resting on the ledge (fig. 2), for the figure of Hippomenes (fig. 3)—even more androgynous than in the cartoon—and for the crouching Atalanta (fig. 4)—on a sheet sadly cut at right—above which appears a more finished drawing of Hippomenes's left arm, slightly modified in the painting itself.[19] "Few artists made more drawings than Hallé," noted his son Jean-Noël. "He filled volumes with these rapid sketches, drawn at the very moment they entered his mind's eye."[20]

But what exactly is the status of these *croquis*, described by the same source as "the artist's games?"[21] The studies for the dancing Hippomenes and the crouching Atalanta are most likely notations extracted from memory rather than studied from life, whereas the drawing of the disembodied arm is worked up with greater deliberation, possibly from the living model. Indeed, Hallé may have turned also to sculpture for the pose of the sprinting Hippomenes; his hero recalls Nicolas Coustou's *Apollo Running* (fig. 5)—an imposing prototype whose dynamism is somewhat attenuated by Hallé's more mannered athlete—one of the four *coureurs* executed between 1713 and 1714 for the *bassin des carpes* at Marly.[22]

Hallé's working process, like that of many of his contemporaries, remains little documented—it is to be assumed that he was assisted in this project—yet we are much better informed of the reaction to *Hippomenes and Atalanta* at the Salon of 1765. Equaled in size only by Lépicié's *William the Conqueror Invading England* (Caen, abbaye aux Hommes) and displayed prominently on the central wall of the *salon carré* (fig. 6)—where, in the opinion of certain critics, it was hung too high—Hallé's tapestry cartoon was discussed at some length in every review, inspiring in Diderot an eloquence and enthusiasm he normally reserved for less-established members of the Academy.[23] The artist's treatment of figures, landscape, and perspective was universally praised, as was his execution "of a color and smoothness that is most appealing."[24] Nearly all critics had difficulty with the figures of Hippomenes and Atalanta, however, complaining that their respective sexes were insufficiently characterized. If one reviewer actually confused their identities altogether—for Le Paon it was Hippomenes who is bending down to retrieve the apple[25]—most agreed that Atalanta's femininity might have been made more apparent. The dark-haired figure with a muscular back caused Mathon de La Cour to exclaim that "had Hippomenes's drapery not revealed something of his upper body, it would have been impossible to decide between them."[26] Here, Hallé's familiarity with the classical sources seems to have undone him; Atalanta, an unbeaten champion and erstwhile compan-

ion of Diana, had fallen in love with Hippomenes precisely because of his youth and his "girlish" face, an allusion seemingly lost on the *salonniers*.[27]

Such was Diderot's excitement in front of *Hippomenes and Atalanta*—he could hardly believe that Hallé was capable of such a thing—that he was inclined to allow the artist almost anything, even Hippomenes's mannered pose. "He shows off, he struts about, he is pleased with himself"; what could be more natural in one who is about to taste victory and triumph, Diderot rallied?[28] In fact, it was Hallé's naturalism that gave Diderot the greatest satisfaction—the critic was always at his best when he could "enter" a painting—and he describes the setting poetically as "a grand and vast landscape . . . fresh as a spring morning, with young trees in bud, their branches and shadows entwined to form a natural bower."[29] Diderot goes on to read each section of Hallé's panorama as part of a *drame bourgeois*, little concerned whether or not his fanciful transcriptions accurately represent the artist's intentions. Thus, the single tree at the left is the starting post of the competition, which would make it the briefest of race tracks; the gold and blue canopy at right protects the spectators alternately from the sun overhead and the coolness of the trees; the patriarch gesticulating from his throne is "without doubt" Hippomenes's joyful father, even though Megareus is never mentioned as having witnessed his son's triumph.[30] But Diderot's criticism is impressive, above all, as an example of his capacity to respond passionately to an exceptional work by an artist against whom he was deeply prejudiced. Grimm, in reaction to Diderot's newfound, if short-lived, enthusiasms, had little patience with Hallé's dancing Hippomenes; that a Greek raised in the woods and mountains should comport himself in a manner befitting the stars of the Paris Opera was "both false and in bad taste."[31]

Grimm's acerbic comments are the only discordant notes amid a chorus of praise. Thus, it is all the more curious that Hallé's *Hippomenes and Atalanta* should have ultimately failed in the purposes for which it had been commissioned. Like Fragonard's *morceau d'agrément*, *Coresus and Callirhoë* (Paris, Musée du Louvre)—purchased by the Crown to be used as a tapestry cartoon and also exhibited at the Salon of 1765—*Hippomenes and Atalanta* was never woven at the Gobelins, although a halfhearted attempt to begin fabrication may have been made as late as 1776.[32] Excessive in size and complexity, with too many figures perhaps,[33] *Hippomenes and Atalanta* remains one of the few "undiscovered masterpieces" of the *ancien régime*, and Hallé's resurrection began only with the exhibition organized at the bicentenary of Diderot's death.[34] The restoration and cleaning of this tapestry cartoon in preparation for its installation in the Grand Louvre will complete the rehabilitation of an artist who remains too little known. In front of *Hippomenes and Atalanta*, at least, it should not be hard to concur with Diderot's gasp of admiration: "*Voilà un tableau!*"[35]

NOTES

1. Engerand 1901, 230–31; Furcy-Raynaud 1903, 240; Fenaille 1903–23, IV, 197. For much of the information contained in this entry, some of it unpublished, I am extremely grateful to Nicole Willk-Brocard, who is completing a *thèse d'État* on the Hallé dynasty.

2. Furcy-Raynaud 1903, 240, "Il se trouve sans ouvrage et m'a confié l'ennuy que lui donne la position de travailler sans but et de faire des tableaux sans destination."

3. Ibid., "Sa couleur est claire, belle, agréable, et vrayment propre à réussir en ce genre d'ouvrage." Cochin's predictions regarding payment to Hallé were also accurate; of the 5,000 *livres* allocated for *Hippomenes and Atalanta*, he received 1,200 *livres* on 13 May 1766, another 1,200 *livres* on 18 September 1766, and the final payment on 13 June 1771, information supplied by Nicole Willk-Brocard quoting from MS. 33, Bibliothèque Centrale de la Réunion des Musées Nationaux; Marigny had promised Cochin that "dans les premier tems commodes je l'aideray par des accomptes," Furcy-Raynaud 1903, 241.

4. Furcy-Raynaud 1903, 241, " La base de ses succès sera toujours d'avoir un fonds de tableaux plus agréables que ceux qu'elle exécutoit par le passé."

5. Ibid., "Son but est de s'occuper à quelque chose d'utile et qui puisse être propre à soutenir sa réputation au Salon." Hallé would be one of several artists willingly conscripted into royal service; Cochin made similar approaches to Fragonard and Deshayes.

6. Ibid., "Dans des temps de détresse comme ceux-cy, il faut préférer le genre dont le débit peut estre le plus à portée des gens aisés."

7. Engerand 1901, 231; Fenaille 1903–23, IV, 198–99; Willk-Brocard 1983, 392, n. 2.

8. Engerand 1901, 229–30; Fenaille 1903–23, IV, 195–96.

9. Furcy-Raynaud 1903, 241, "M. Hallé me fera voir des esquisses. . . ," Marigny's letter to Cochin dated 28 September 1762; Ratouis de Limay 1907, 116, "ce dernier travaille à un grand et magnifique tableau pour le Roy, qui doit être placé au premier salon," Dom Maur's letter to Desfriches dated 4 December 1763.

10. Engerand 1901, 224–28.

11. Pigler 1974, II, 134; H. Bardon 1963, 228; the subject, rarely treated in the eighteenth century, had been painted by Galloche for the *concours de 1727*.

12. Ovid, *Metamorphoses*, X, 560–707.

13. Apollodorus, *The Library*, III, ix.2.

14. Ovid, *Metamorphoses*, X, 570, 574.

15. Ibid., 610, 637.

16. Montfaucon 1724, III, 120, "Enyvré de son bonheur, il oublia de rendre graces à la déesse"; Ovid, *Metamorphoses*, X, 689; Hyginus, *Fabulae*, CLXXXV.

17. Ovid, *Metamorphoses*, X, 590.

18. The execution of paintings on this scale was physically hazardous as well; Hallé suffered an accident in his studio in the winter of 1764, possibly while working on *The Justice of Trajan*; see Dom Maur's letter to Aignan-Thomas Desfriches dated 14 January 1765 in Ratouis de Limay 1907, 116–17.

19. Nicole Willk-Brocard informs me that the *Study of Atalanta* in the École Nationale Supérieure des Beaux-Arts (inv. P.M. no. 149, Donation Mathias Polakovits) is on the verso of a sheet containing a *première pensée* for *Silenus Smeared with Mulberries by the Nymph Eglea* (fig. 1).

20. [Hallé] 1782, 197, "Peu d'Artistes ont plus dessiné que lui. . . . Il a rempli des volumes de ces dessins légers, que la main du peintre trace aussi rapidement que son esprit les conçoit."

21. Ibid., "Ce sont les jeux d'un Artiste."

22. Souchal 1977–87, I, 169–70; Coustou's *Apollo Running* was paired with Guillaume Coustou's *Daphne*, and the latter's statue of *Hippomenes* with Le Pautre's *Atalanta* (the four statues are in Paris, Musée du Louvre). The ensemble may be considered a likely point of reference in Hallé's preparations.

23. Diderot 1975–[1983], II, plates 1–4, for Gabriel de Saint-Aubin's watercolor of the Salon of 1765; [Bridard de la Garde] 1765, 157–58, "Les personnages. . . perdent un peu par l'élévation où la forme et l'étendue de ce tableau ont obligé de le placer" [Le Paon]; 1765, 12, "La position trop élevée dans laquelle il est exposé ne lui est pas avantageuse."

24. [Le Paon] 1765, II, "Il est d'un coloris et d'un suave qui flatte beaucoup."

25. Ibid., "On y voit Athalante suspendue dans sa course sur un pied et Hyppomene ramassant une pomme d'or."

26. Mathon de La Cour 1765, 14, "Si la draperie d'Hyppomene ne découvroit pas une partie da sa poitrine, l'Énigme seroit impossible à deviner." The critic of the *Journal Encyclopédique* noted of the two protagonists that "on a prétendu qu'il étoit difficile à distinguer leur sexes. Il est vrai que la figure d'Athalante eût été plus agréable à voir de face que par le dos," *Collection Deloynes*, XLVII, no. 1295.

27. Ovid, *Metamorphoses*, X, 615–16, 631, "Ah, how girlish is his youthful face!"

28. Diderot 1975–[1983], II, 85, "Il s'étale, il se pavane, il se félicite."

29. Ibid., 84, "Imaginez un grand et vaste paysage, frais, mais frais comme un matin au printemps. . . . Voyez des arbres frais et verds, mariant leurs branches et leurs ombres, et formant un berceau naturel."

30. Ibid., 85.

31. Ibid., "Pas moi, ventre-saint-gris. Que le chaste et sauvage Hippomène se pavane, si vous l'exigez, je le veux bien; mais qu'un Grec élevé dans les bois et les montagnes se pavane dans la carrière comme M. Vestris ou M. Gardel à l'Opéra, cela est faux et de mauvais goût."

32. Rosenberg in exh. Paris and New York 1987–88, 210–11; Fenaille 1903–23, IV, 213, reproducing the accounts of the *tapissier* Vavoque (1776), in which the sum of four *livres* is noted as "détendre les traits de la *Course d'Atalante*," which, as Edith Standen kindly informs me, suggests that an initial tracing of the composition onto the cloth may have taken place.

33. Fréron 1765, 151, had wanted to see even more spectators represented but assumed that Hallé had restricted the number since it was, after all, a tapestry cartoon, "et qui l'aurait porté à un prix excessif." Is it possible that Hallé had already included too many figures?

34. Willk-Brocard in exh. Paris 1984–85 (B), 269.

35. Diderot 1975–[1983], II, 84.

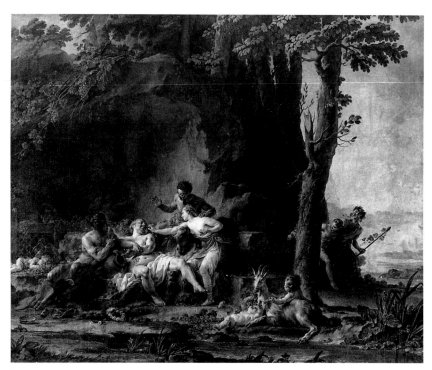

FIG. 1
Noël Hallé, *Silenus Smeared with Mulberries by the Nymph Eglea*, 1771, oil on canvas, Lille, Musée des Beaux-Arts

FIG. 2
Noël Hallé, *Study of a Dog*, c. 1765, black chalk drawing, Private Collection

FIG. 3
Noël Hallé, *Study of Hippomenes*, c. 1765, black chalk drawing, Private Collection

FIG. 4
Noël Hallé, *Study of Atalanta and Hippomenes' Left Arm*, c. 1765, black chalk drawing (verso),
Paris, École Nationale Supérieure des Beaux-Arts

FIG. 5
Nicolas Coustou, *Apollo Running*, c. 1713–14,
marble, Paris, Musée du Louvre

FIG. 6
Gabriel de Saint-Aubin, detail of *The Salon Carré During the Salon of 1765*, 1765, watercolor, Paris,
Musée du Louvre, Cabinet des Dessins

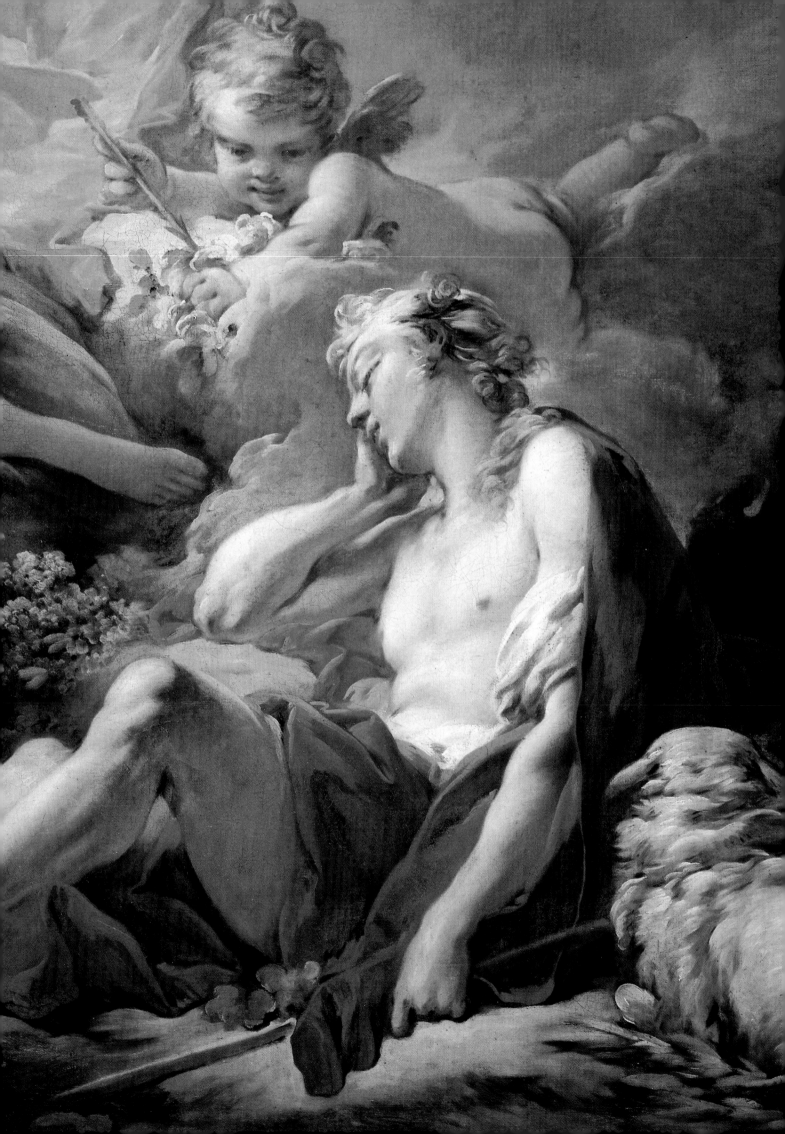

JEAN-HONORÉ FRAGONARD
(1732–1806)

Born in Grasse, the son of a glove maker, Fragonard moved to Paris when he was six years old. He was admitted into Chardin's workshop, where he learned the rudiments of painting, and then applied to study under Boucher, who, impressed by his rapid progress, admitted Fragonard as his pupil. Fragonard was never to study formally at the Academy, but Boucher's tutelage was enough to guide him to victory in the *Prix de Rome* in 1752 with *Jeroboam Sacrificing to the Idols* (Paris, École Nationale Supérieure des Beaux-Arts), an exceptionally accomplished picture in the grand manner.

During the four years that Fragonard spent at the *École royale des élèves protégés* before leaving for Rome at the end of 1754, he benefited from the instruction of its director, Carle Van Loo—by all accounts a first-rate teacher—and painted his only other documented early works, *Psyche Showing Her Sisters the Gifts She Has Received from Cupid* (1753–54, London, The National Gallery) and *The Washing of the Disciples' Feet* (1755, cathedral of Grasse). These anomalous works reveal qualities which characterize Fragonard's production of the 1750s: the distinctive palette of sharp pinks, strong reds, cold blues, and brassy yellows—deriving perhaps from Restout as much as from Boucher—and, in the case of the *Psyche Showing Her Sisters the Gifts She Has Received from Cupid*, sparkling effects of light and shimmering draperies.

Fragonard arrived in Rome in December 1756, and little is known of his five years of study at the French Academy, then directed by Natoire. Fragonard seems to have had some difficulty finding his way at the Academy, and Natoire, though encouraging, found the young painter's palette too mannered and his work uneven. Fragonard painted a number of small private works during his Roman stay, mostly pastoral landscapes and unusual genre scenes.

Of lasting importance to Fragonard were the friendships he initiated in Rome with Hubert Robert, an artist of a kindred spirit, and the abbé de Saint-Non, his first great patron. In 1760 Fragonard stayed with Saint-Non at the Villa d'Este, where his careful study of its overabundant gardens shimmering in the summer light, was immortalized in a group of large, finished red-chalk drawings (now in Besançon, Musée des Beaux-Arts); this endeavor permanently determined his vision of nature. On his return journey with Saint-Non through most of the art centers of Italy, Austria, and Germany, he made hundreds of small black-chalk sketches of masterpieces of Italian art and architecture, a repertory of images from which he drew inspiration throughout his career.

Upon his return to France, Fragonard painted sentimental genre scenes and landscapes, frequently in the Dutch manner. For his admission to the Academy, he submitted the vast *Coresus and Callirhoë* (Paris, Musée du Louvre), a work whose smoky gray palette and languid melodrama dazzled the critics at the Salon of 1765. Noble and sublime, it was purchased by the Crown, and immediately established Fragonard's reputation as a history painter in the grand manner. Although royal commissions for the Louvre, Bellevue, and Versailles soon followed, none were executed. Instead, Fragonard seems to have turned his back on official patronage and, by his own choice, was never received by the Academy as a history painter; he would exhibit in the Salon only once more, in 1767. Henceforth he worked mainly for a sophisticated private clientele, producing over the next decade small easel paintings such as *The Swing* (1767, London, Wallace Collection), a masterpiece of erotica painted for the baron de Saint-Julien, as well as comparably refined, lush landscapes, which look back to his Tivoli drawings, notably the so-called *Fête at Rambouillet* (c. 1768–70, Lisbon, Museu Calouste Gulbenkian); and the great series of seventeen "fancy dress" portraits known as the *Figures de Fantaisie* (1769), each painted with a brio and slashing brush strokes worthy of Frans Hals. Fragonard's greatest achievement as a large-scale decorative painter came in 1773 with his completion of four panels illustrating *The Progress of Love* (New York, The Frick Collection), commissioned by Madame du Barry, Louis XV's mistress, to decorate the dining rooms of Ledoux's pavilion at Louveciennes and rejected by her in favor of Vien's more fashionable histories in the Greek manner.

Late in 1773 Fragonard traveled to Italy a second time in the company of his patron, the *fermier général* Pierre-Jacques-Onesyme Bergeret de Grancourt. Fragonard acted as tour guide, memorializing the sites and people they saw in a series of pen-and-wash drawings remarkable for their translucent, painterly technique. His large decorative panel, *The Fête at Saint-Cloud* (c. 1774, Paris, Banque de France), which recalls Watteau's graceful *fêtes galantes*, seems a direct attempt to translate the amplitude and freedom of these wash drawings into paint.

In the late 1770s Fragonard modified his style in two distinct, though related, ways: he painted refined and highly finished genre scenes in the manner of the seventeenth-century Dutch *petits maîtres*, occasionally in collaboration with his sister-in-law, Marguerite Gérard, and smoky nocturnal allegories of an almost hothouse sensuality. *The Bolt* (c. 1780, Paris, Musée du Louvre) and *The Stolen Kiss* (c. 1785–88, Leningrad, The Hermitage) are supreme examples of Fragonard's "Dutch" painting, while *The Fountain of Love* (c. 1785, London, Wallace Collection) and various versions of *The Sacrifice of the Rose* are the most perfect of his proto-Romantic works, which looked forward to Girodet and Prud'hon.

Fragonard's last datable paintings are several panels which he added to *The Progress of Love* (c. 1790, New York, The Frick Collection). Fragonard was appointed a curator of the newly established National Museum in 1793, where he served in various capacities before retiring in 1800. He died, largely forgotten, in 1806.

JEAN-HONORÉ FRAGONARD
Jupiter and Callisto

Cephalus and Procris

57 & 58

JEAN-HONORÉ FRAGONARD (1732–1806)
Jupiter and Callisto, c. 1755
Oil on canvas
75 x 173.5 cm.
Musée des Beaux-Arts, Angers

PROVENANCE
Gentil de Chavagnac, her sale, Paris, 20 June 1854, no. 50 [as François Boucher]; bequeathed by Jean-Jacques-Émile Duboys to the Musée des Beaux-Arts, Angers, in 1882.

EXHIBITIONS
Never before exhibited.

BIBLIOGRAPHY
Jouin 1887 (B), no. 792 [as François Boucher, "Scène mythologique"]; Michel 1906, no. 181 [as François Boucher]; Wildenstein 1923, 120–22, ill.; Morant 1953, 10, ill.; Réau 1956, 147; Wildenstein 1960, no. 50, ill.; Vergnet-Ruiz and Laclotte 1965, 236; Morant 1968, 9–10, ill.; Wildenstein and Mandel 1972, no. 55, ill.; Cuzin 1987, 36, no. 24, ill.; Rosenberg 1989, no. 10, ill.

JEAN-HONORÉ FRAGONARD (1732–1806)
Cephalus and Procris, c. 1755
Oil on canvas
75 x 173.5 cm.
Musée des Beaux-Arts, Angers

PROVENANCE
Gentil de Chavagnac, her sale, Paris, 20 June 1854, no. 51 [as François Boucher]; bequeathed by Jean-Jacques-Émile Duboys to the Musée des Beaux-Arts, Angers, in 1882.

EXHIBITIONS
Never before exhibited.

BIBLIOGRAPHY
Jouin 1887 (B), no. 791 [as François Boucher, "Allégorie de l'Amour"]; Michel 1906, no. 104 [as François Boucher]; Wildenstein 1923, 120–22, ill.; Morant 1953, 10; Réau 1956, 147; Wildenstein 1960, no. 51, ill.; Vergnet-Ruiz and Laclotte 1965, 236; Morant 1968, 9–10; Wildenstein and Mandel 1972, no. 57, ill.; Cuzin 1987, 36–37, no. 25, ill.; Rosenberg 1989, no. 11, ill.

Like practically all of Fragonard's early mythologies, *Jupiter and Callisto* and *Cephalus and Procris* were long thought to have been painted by his master. Catalogued as by Boucher in the Gentil de Chavagnac sale of June 1854—the first recorded reference to them—they were also included in Soullié and Masson's monumental catalogue raisonné and were only restored to Fragonard in 1923.[1] For Georges Wildenstein, who made this reattribution, the issue was clear; *Jupiter and Callisto* and *Cephalus and Procris* were distinguished from Boucher's art by their "freedom and liveliness," "lighter touch," and "more transparent colors."[2] Recent scholarship has confirmed Wildenstein's intuitions while dismantling much of the chronology he established for Fragonard's early paintings.[3] Yet, if in the four years before he left for Rome in October 1756 Fragonard produced the most coherent body of work of any point in his career, our understanding of his activities at this time remains partial and obscure. Only three paintings by him are firmly documented to the period 1752–56, and there is little agreement in dating the pastorals and mythologies assigned to these years.[4]

Not surprisingly, the most rudimentary information is lacking for *Jupiter and Callisto* and *Cephalus and Procris*, the latter of which is a masterpiece of Fragonard's early career. Although no trace of the original *chantournement* is to be found on the canvases themselves, it can be assumed that they were painted as overdoors. The sketch for *Jupiter and Callisto* (Private Collection) might further suggest that the canvas has been truncated at the top, but since it is of such different proportions overall—square rather than rectangular—it should more properly be considered a *première pensée* abandoned as the painting progressed.[5] It is not known for whom these mythologies were commissioned, nor which doors or picture cabinets they subsequently adorned.

Jupiter and Callisto and *Cephalus and Procris* present fewer problems stylistically, falling comfortably within the group of mythologies and pastorals that Fragonard produced in great number in the early years in Paris. As in other paintings from this period, Fragonard employs his preferred palette of powder blue, lemon yellow, and rose. His handling is swift and varied: delicate and precise in the contours of his figures, broad and creamy in the voluminous draperies, of the greatest brevity in the foliage and staffage. The matronly goddess seen in profile in *Jupiter and Callisto*, feet crossed, skirt raised to the thigh, is a figural type much used in Fragonard's early work. She evolves from the figure of Psyche in *Psyche Showing Her Sisters the Gifts She Has Received from Cupid*, 1753–54 (fig. 1), and is the basis for both *The Shepherdess* (Milwaukee Art Museum) and the young mother in *Spring* (fig. 2), dated to c. 1755 and 1755–56, respectively, by Jean-Pierre Cuzin and somewhat earlier by Pierre Rosenberg.[6] The wide-eyed Callisto recalls the nymph who unrolls a swath of luxuriant brocade at left in *Psyche Showing Her Sisters the Gifts She Has Received from Cupid*, and her features, if not her pose, resemble those of the young mother in *Spring*. The figure of Procris in *Cephalus and Procris* is in reverse of the bare-breasted mother in *Summer* (fig. 3), whose expression she also shares. Finally, in *Cephalus and Procris* Fragonard's treatment of drapery and, above all, of hands—the cursive fingers that dance away from the wrist—is to be seen again in *Blind-Man's Bluff* (Toledo Museum of Art), dated by both Cuzin and Rosenberg to c. 1755.[7]

For the compositions of *Jupiter and Callisto* and *Cephalus and Procris*, Fragonard looked to his recent work and sought guidance from other models as well. The paintings recall Fragonard's overdoors for the *grand salon* of the hôtel Matignon—his only secular commission in these years which can be tentatively documented—and the similarities between them extend beyond the figural relationships already noted.[8] For both sets of overdoors Fragonard employed the same rectangular format; the elongated proportions of *Jupiter and Callisto* and *Cephalus and Procris* are so pronounced that one wonders if the connection with the Matignon overdoors is entirely coincidental. The placement of figures in *Jupiter and Callisto* follows that established in *Spring*, whereas the more resolutely centered structure of *Cephalus and Procris* may be likened to the *mise en page* of *Summer*. This composition also provided Fragonard with the seed of one of his happiest inventions. The crescent moon in *Jupiter and Callisto*—the symbol of Diana's divinity conveniently transformed into a garden bench—repeats the motif of the curving oak, bent over by the wind, seen at right in *Summer*.

If in conception and execution *Jupiter and Callisto* and *Cephalus and Procris* represent an advance on the single-figure Seasons, they depend nonetheless on models other than Fragonard's juvenilia. As Cuzin has noted, Fragonard drew inspiration from Boucher's most recent work; *Jupiter and Callisto* is indebted to *Sylvia Relieving Phyllis from a Bee Sting* (fig. 4), an overdoor painted in 1755 for the hôtel de Toulouse.[9] Cuzin's comparison between *Cephalus and Procris* and *Amyntas Reviving in the Arms of Sylvia* (Paris, Banque de France), a second overdoor from this series painted the following year—in which he discerns a shared dusky tonality as well as more generalized similarities in composition—is less convincing.[10] For the motif of Cephalus hastening to remove the arrow from Procris's breast, Fragonard copied the illustration he

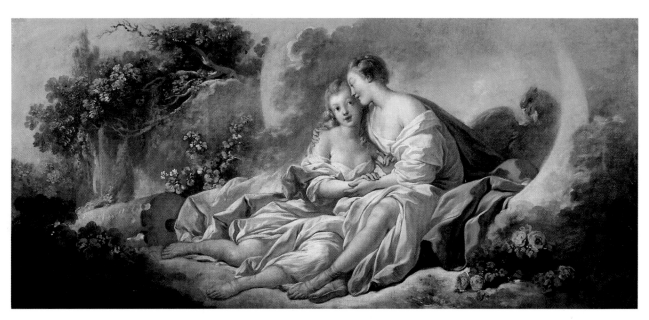

CAT. 57

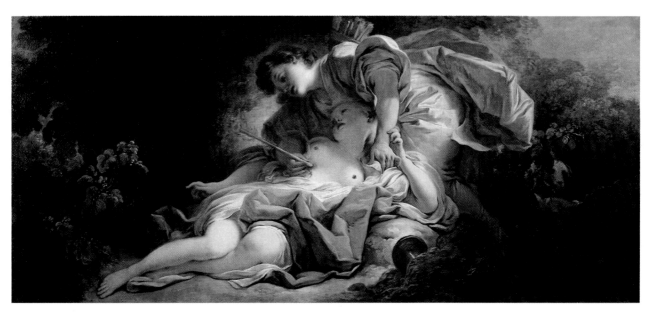

CAT. 58

found in a late sixteenth-century Dutch edition of the *Metamorphoses*; Pieter van der Borcht's engraving (fig. 5) is the unlikely source of Fragonard's affecting design.[11] If it is objected that this model is unneccessarily obscure, it is not suggested that Fragonard turned to this illustrated Ovid for anything other than the repertory of images it offered him.[12]

In both mythologies, Fragonard's treatment of narrative is refreshingly direct and lacking in pedantry; he refrains from overwhelming his canvases with the sort of classical paraphernalia that is generously arrayed in *Psyche Showing Her Sisters the Gifts She Has Received from Cupid*. In *Jupiter and Callisto*, the infatuated Jupiter and deluded nymph are seated companionably on the crescent moon, the god's identity established by the smirking eagle in the background. No other allusions to Ovid's tale are provided, and none are needed. Jupiter urges the innocent maiden to recount the day's events; her animated gestures show that she is in the middle of her narration, while the god's fond regard and tender caresses reveal nothing of his true intentions. This is as gentle an interpretation of the rape of Callisto as would be produced during the eighteenth century.

Its companion, the more inventive of the pair—"a grand, sorrowful poem, in flowing, almost breathless, rhythms"—treats the concluding episode from the benighted tale of Cephalus and Procris told by Ovid and Hyginus.[13] After their reconciliation, Cephalus continued to indulge his passion for the hunt, leaving the marriage bed early each morning accompanied by his "wonderful hound," Laelaps, and armed with a javelin that unfailingly hit its mark—two presents given to him by Procris. Exhausted from his labors, Cephalus would take rest in the open fields, calling upon the breeze, Aura, to refresh him and relieve "the heat with which [he] burned." His words were overheard and misconstrued, and news reached Procris that he had again been unfaithful to her. Although Cephalus vigorously denied any wrongdoing, Procris continued to doubt him, and she surreptitiously followed him one morning on his way to the hunt. True to form, Cephalus lay on the grass and beckoned the breeze to "come and soothe his toil."[14] Upon hearing these words, Procris swooned to the ground; at the sound of the rustling leaves, Cephalus instinctively hurled his javelin and mortally wounded her. "With loving arms I raised her body, dearer to me than my own, tore open the garment from her breast and bound up the cruel wound, and tried to staunch the blood, praying that she would not leave me stained with her death."[15]

It is this tragic scene that Fragonard renders with such poetic grace. Having cast away his horn and hunting nets—they lie in a pile by his feet—Cephalus rushes to tend his dying wife; his yellow cloak billowing in the wind, he is followed by the faithful Laelaps, more spaniel than hound, trailing close behind him. As Cephalus makes to remove the arrow, Procris, in agony, the blood draining from her body, looks up at him; still unsure of her husband's fidelity, she touches his left arm with affection. As Ovid wrote, this is a tale told with many tears.[16]

For the various stylistic reasons that have been discussed, I prefer to follow Cuzin in dating the pendants to c. 1755 rather than placing them two years earlier, as Rosenberg has done.[17] In format and composition they are variations on the Matignon overdoors, but more complex in figural arrangement and more fluent in handling, while the comparison with Boucher's overdoors also supports a later dating. The precise chronology of *Jupiter and Callisto* and *Cephalus and Procris* may never be established conclusively, but it is of interest for reasons other than those of conventional connoisseurship. For, once they are dated to around 1755, these mythologies come to represent one aspect of Fragonard's development as a *pensionnaire* of the *École royale des élèves protégés*—the recently founded finishing school intended to prepare winners of the *Grand Prix* for their sojourn at the French Academy in Rome. Fragonard's passage in this elite establishment—he was admitted on 20 May 1753 and remained until 20 October 1756—has presented some difficulties for scholars who prefer a Fragonard *hors de l'Académie* from the very start of his career.[18]

Had the statutes of the new *École royale* been followed to the letter, every moment of Fragonard's waking hours would have been accounted for. *Pensionnaires* were to spend the daylight hours drawing from the live model and copying antique statuary and old master painting—the traditonal academic diet—and to devote the hours before sunrise and after sunset to intellectual pursuits, studying history in the morning and reading Virgil and Ovid after supper.[19] It was a primary concern of the *École royale*'s earliest critic, the author of the *Réponse à la lettre de M. de *—published in 1749—that the institution would multiply the number of painters and turn them into intellectuals ("*des hommes lettrés*"). His arguments against the *École royale* have the virtue of describing the prevailing conditions that an aspiring history painter might have expected to encounter at midcentury. There was less and less demand for epic history painting, he argued, since "to paint the ceilings in our modern apartments

is now out of the question; now that everything has been reduced to the overdoor, paintings have also become furniture."[20] The sudden insistence upon book learning—students enjoyed the services of a professor hired to instruct them "in history, mythology, and geography"[21]—was also misplaced. According to our anonymous pamphleteer, "when an artist has a subject to paint, he reads or obtains instruction in all apsects of it. . . and then he begins to compose."[22] The author, who may have been affiliated with the Academy—no radical, he!—was concerned that the existing system of training would be transformed by the *École royale*; had this establishment functioned as was originally planned, his fears may have been grounded. Yet in the early years of Van Loo's governorship, at least, the *status quo ante* remained little changed. Thus, Fragonard's activities between 1753 and 1756 were, in all likelihood, those of any gifted twenty-three-year-old student "with a commendable preference for history painting" who had recently won the *Grand Prix*.[23] Taking *Jupiter and Callisto* and *Cephalus and Procris* as examples, the promising history painter might have expected to paint overdoors, to immerse himself in his subject as required, and to begin "to taste and enjoy the material profits of his work."[24] There is no reason to believe that Fragonard's studentship at the *École royale* required him to follow any other course.

For these reasons, it is hard to see Fragonard's tenure at the *École royale* as marking a definitive rupture with the training he had received in Boucher's atelier. As the most gifted of Boucher's pupils, he evidently flourished under the new regime, receiving an annual pension of 400 *livres*, free lodgings, and the privilege of exhibiting once a year at Versailles.[25] Nor is there any reason to believe that his involvement

with Boucher came to an end in the summer of 1753. Boucher had moved into spacious lodgings at the Louvre in June of the previous year, and it is likely that he maintained close relations with his protégé, who now lived a stone's throw away.[26] Fragonard surely continued to consort with Boucher, possibly assisting him on larger projects, and doubtless received some, if not all, of his earliest commissions upon the recommendation of his former master. None of this can be documented, but it is clear, as Georges Wildenstein was the first to note, that Fragonard was in no hurry to leave for Rome since he was so busy with work for the private sector, to which, *pace* Rosenberg, the *École royale* seems not to have objected.[27] One week after Fragonard's request to remain in Paris for the full term of his scholarship was granted—Lépicié having cited the quality of Vanloo's instruction as his main reason for staying—he received a commission, though poorly paid, to paint an altarpiece for the Confraternity of the Blessed Sacrament in Grasse, which he in turn exhibited at Versailles a year later, in April 1755.[28]

Thus, if Fragonard's talents were nurtured in the protected, privileged, and reasonably liberal environment of the *École royale des élèves protégés*, it comes as little surprise that his art continued to develop in emulation of Boucher's. Nor would this have been been grounds for concern in the early 1750s since Boucher, a full professor at the Academy since July 1737, was routinely cited as among the best teachers in Paris.[29] The instruction dispensed at the *École royale* did not impede Fragonard's development as a painter of decorative mythologies and pastorals; on the contrary, in extending the training he had received in Boucher's studio it served to encourage his talents in this genre.

NOTES

1. Jouin 1887 (B), 303–4; Soullié and Masson in Michel 1906, 9, 13; Wildenstein 1923, 120–22.

2. Wildenstein 1923, 120, "Elles sont plus libres, plus vivantes que celles-ci, leur touche est plus légère, leur coloris plus transparent."

3. Rosenberg in exh. Paris and New York 1987–88, 31–39; Cuzin 1987, 19–40; Fragonard's *Jupiter and Callisto* and *Cephalus and Procris* were nos. 50 and 51 in Wildenstein's catalogue raisonné; in Rosenberg 1989 they are nos. 10 and 11.

4. Rosenberg in exh. Paris and New York 1987–88, 33–34. While there is now general agreement on the early work as a whole, Cuzin and Rosenberg inevitably differ on the sequence of works painted before 1756; see Cuzin 1987, 261–68, and Rosenberg 1989, 70–76.

5. Cuzin 1987, 264, no. 26; Rosenberg 1989, 72, no. 12.

6. Cuzin 1987, 267, no. 41, 269, no. 50; Rosenberg in exh. Paris and New York 1987–88, 50–51, dates the commission at the hôtel Matignon for Honoré-Camille-Léonor Grimaldi (1720–1795), duc de Valentinois, somewhat earlier, and places it before *Psyche Showing Her Sisters the Gifts She Has Received from Cupid* (fig. 1), which is securely documented to 1753–54.

7. Cuzin 1987, 268, no. 44; Rosenberg 1989, 75, no. 41.

8. Rosenberg in exh. Paris and New York 1987–88, 50–51; exh. Paris 1981, 27–33, for the eighteenth-century history of the hôtel Matignon.

9. Cuzin 1987, 36–37; Laing in exh. New York, Detroit, and Paris 1986–87, 263–67.

10. Cuzin 1987, 37. Since *Amyntas Reviving in the Arms of Sylvia* is dated 1756, it may well have been painted after *Cephalus and Procris.*

11. Lavin 1954, 285, plate 41c.

12. Sheriff 1990, 98–104, has suggested that Fragonard turned to Dutch engravings of the seventeenth century for his early decorative series of the Seasons, now at The Detroit Institute of Arts.

13. Cuzin 1987, 37, "grand poème douloureux dans des rythmes ondoyants, presque haletants." The story of Cephalus and Procris is found in Ovid, *Metamorphoses*, VII, 661–865, and Hyginus, *Fabulae*, CLXXXIX. For an excellent discussion of the representation of the subject in Renaissance and Baroque painting, see Lavin 1954, 260–87.

14. Ovid, *Metamorphoses*, VII, 754, 815, 837.

15. Ibid., 845–50.

16. Ibid., 865.

17. Cuzin 1987, 264, nos. 24, 25; Rosenberg 1989, 72, nos. 10, 11, "datent de 1753 environ."

18. Rosenberg in exh. Paris and New York 1987–88, 33, "Il nous faut insister sur un point: Fragonard n'a pas été élève de l'Académie. . . [il] ne suivra pas l'exemplaire enseignement de l'école"; for a slightly different point of view, see Cuzin 1987, 16, who argues that Fragonard may have informally attended courses at the *Académie royale* before competing for the *Grand Prix* in August 1752.

19. Courajod 1874, 19–24.

20. Ibid., 47, "Il n'est plus question de plafonds dans les apartemens; tout se réduit aux dessus de portes, et l'on peut dire que la peinture est devenue meuble."

21. The first article of the *École royale*'s statutes had made provisions for "l'homme de lettres choisi pour leur orner l'esprit des connoissances de l'histoire, de la fable, de la géographie, et autres relatives aux arts qu'ils embrassent"; cited in Courajod 1874, 19.

22. Ibid., 51, "Si l'on a un sujet à composer, on doit lire ou se faire instruire de tout ce qui concerne son sujet et aller son train . . . et cela dans le moment même de la composition."

23. Montaiglon and Guiffrey 1887–1912, XI, 156, "des heureuses dispositions du Sr. Jean Honoré Fragonnard [*sic*] . . . dans la peinture pour l'histoire," as he would be qualified in Marigny's *brevet* for the French Academy in Rome.

24. *Réponse à la lettre de M. de ** in Courajod 1874, 52, "Ils peignent tous et ont commencé a goûter et à jouir de leur gain."

25. Ibid., 16, 34–35.

26. Laing in exh. New York, Detroit, and Paris 1986–87, 28, notes that Boucher obtained the lodgings of the recently deceased *premier peintre* Charles-Antoine Coypel. The *École royale* was housed between the rue Fromenteau and the place du Louvre, with access to the Academy's Assembly Rooms.

27. Wildenstein 1923, 121; Rosenberg in exh. Paris and New York 1987–88, 34; Courajod 1874, 22, for article XI of the statutes, which allowed sculptors to use the services of *pensionnaires* "à condition qu'ils ne les emploieront qu'à des ouvrages capables de les fortifier dans leur art." Nothing was said about painters.

28. Rosenberg in exh. Paris and New York 1987–88, 38–39; Cuzin 1987, 22–23. Fragonard was paid 700 *livres* for *The Washing of the Disciples' Feet* (cathedral of Grasse), equivalent to almost two years' stipend.

29. Courajod 1874, 49; the author of the *Réponse à la lettre de M. de ** noted that Vanloo, Natoire, Boucher, Restout, and Pierre were the "plus habiles maîtres . . . tous égaux en mérite."

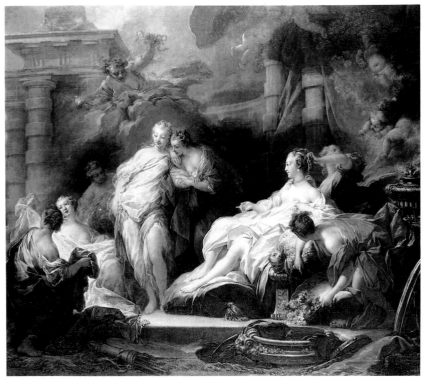

FIG. 1
Jean-Honoré Fragonard, *Psyche Showing Her Sisters the Gifts She Has Received from Cupid*, 1753–54, oil on canvas, London, The National Gallery

FIG. 4
François Boucher, *Sylvia Relieving Phyllis from a Bee Sting*, 1755, oil on canvas, Paris, Banque de France (formerly the hôtel de Toulouse)

FIG. 2
Jean-Honoré Fragonard, *Spring*, 1755–56, oil on canvas, Paris, hôtel Matignon

FIG. 3
Jean-Honoré Fragonard, *Summer*, 1755–56, oil on canvas, Paris, hôtel Matignon

FIG. 5
Pieter van der Borcht, *The Death of Procris*, 1591, engraving from the 1591 Antwerp edition of Ovid's *Metamorphoses*, Amsterdam, Rijksmuseum, Rijksprentenkabinet

JEAN-HONORÉ FRAGONARD
Aurora

Diana and Endymion

59 & 60

JEAN-HONORÉ FRAGONARD (1732–1806)
Aurora, c. 1755–56
Oil on canvas
95 x 131 cm.
Private Collection

PROVENANCE
Michel Ephrussi; Charles Sedelmeyer by 1906, his sale, Paris, Sedelmeyer Gallery, 16–18 May 1907, no. 201; Eugène Sedelmeyer; François Coty, his sale, Galerie Charpentier, Paris, 30 November–1 December 1936, no. 20; anonymous sale, Palais Galliera, Paris, 25 November 1971, no. 22.

EXHIBITIONS
Paris 1921, no. 4, ill.; Tokyo and Kyoto 1980, no. 5, ill.

BIBLIOGRAPHY
Sedelmeyer 1906, no. 63, ill.; Saint-Groux 1907, 34, ill.; Sedelmeyer 1914, no. 78, ill.; Wildenstein 1921, 357; *The Illustrated London News*, 28 April 1936, ill.; *Beaux-Arts*, 13 November 1936, 5, ill.; Grappe 1946, 63; Wildenstein 1960, no. 25, ill.; Wildenstein and Mandel 1972, no. 26, ill.; Cuzin 1987, 39, no. 55, ill.; exh. Paris and New York 1987–88, 34, ill.; Rosenberg 1989, no. 27, ill.

JEAN-HONORÉ FRAGONARD (1732–1806)
Diana and Endymion, c. 1755–56
Oil on canvas
95 x 137 cm.
National Gallery of Art, Washington, Timken Collection 1960.6.2

PROVENANCE
The fourth Marquess of Hertford (1800–1870), his *inventaire après décès*, 1871, no. 438 [as François Boucher, *The Sleep of Adonis*]; Sir Richard Wallace by 1883; by descent to Lady Wallace, from 1890 to 1897; inherited by Sir John Murray-Scott, from 1897 to 1912, his *inventaire après décès*, 1912 [as François Boucher, *Diana and Endymion*]; bequeathed to Lady Victoria Sackville in 1913; sold to Jacques Seligmann in 1913; purchased by Knoedler and Co. in 1914; sold to John McCormack in March 1922, but returned to Knoedler and Co. in October of the same year; purchased in 1924 by W.R. Timken, who bequeathed the painting to the National Gallery of Art in 1959.

EXHIBITIONS
Paris 1883–84, no. 7 [as François Boucher]; San Francisco 1920, no. 90, ill. [as François Boucher].

BIBLIOGRAPHY
Kahn 1904, 68, 99 [as François Boucher]; Michel 1906, no. 124, and verso p. 152 [as François Boucher]; Macfall 1908, 147, 150 [as François Boucher]; *The Art Quarterly*, Autumn 1960, 307, ill. [as François Boucher]; Seligman 1961, 269 [as François Boucher]; Washington 1965, no. 1554 [as François Boucher]; Washington 1968, no. 1554, ill. [as François Boucher]; *National Gallery of Art Annual Report*, 1972, 54, ill. [as François Boucher]; Washington 1975, no. 1554, ill. [as François Boucher]; Ananoff and Wildenstein 1976, I, 173 [as François Boucher]; *National Gallery of Art Annual Report*, 1977, 45, ill. [as François Boucher]; Mallett 1979, 199 [as François Boucher]; Ananoff and Wildenstein 1980, no. 36 [as François Boucher]; exh. New York, New Orleans, and Columbus 1985–86, 137, ill.; Cuzin 1986, 65–66, n. 6; Cuzin 1987, 39, no. 56, ill.; exh. Paris and New York 1987–88, 34, ill.; Ingamells 1989, 384, no. 16 [as François Boucher]; Rosenberg 1989, no. 28, ill.

"Fragonard, (Honoré) [*sic*] . . . one of Sieur Boucher's disciples. I wish him the same brush as his master, but I doubt that he will ever have one quite as fine."[1] With regard to Fragonard's early work, Mariette's predictions could not have been wider of the mark. So close were the styles of teacher and pupil in the mid-1750s that for the historians who rediscovered both artists at the end of the nineteenth century, Fragonard's *oeuvre de jeunesse* was practically indistinguishable from that of his master's maturity. *Diana and Endymion* is but the most spectacular example of this interchangeability.[2] First recorded as by Boucher in the collection of the fourth Marquess of Hertford (1800–1870)—it hung in the *grande galerie* of his home on the rue Lafitte and was inventoried in 1871 as representing *The Sleep of Adonis*[3]—*Diana and Endymion* retained this erroneous, but long-established, attribution for more than a century until it was identified as an early Fragonard by Alan Wintermute in 1985.[4] Indeed, the characteristics that distinguish Fragonard's early style from Boucher's—"the colors, the youthful models, the liveliness of the compositions, and the exuberance of nature"—are abundantly in evidence in *Diana and Endymion*.[5]

Once *Diana and Endymion* was restored to its proper author, it could also be reunited with its pendant, the variously titled *Aurora*, whose attribution to Fragonard had never been in question.[6] Even the most cursory examination of the canvases reveals that both paintings were made as overdoors with edges that were subsequently extended (fig. 1); the original curvilinear shape—rounded at the top, scalloped along the bottom—is identical in both cases. The overdoors respond to one another in terms of function as well. *Aurora* and *Diana and Endymion* represent Day (or Morning) and Night (or Evening) respectively, and as such stand at the end of a long tradition—increasingly under attack from critics who sought to reinvest history painting with greater intellectual content—in which mythology provided the emblems and symbols of interior decoration.[7]

Of the eighteenth-century history of *Aurora* and *Diana and Endymion* nothing is known. Not only are the details of their commission entirely lacking, but we cannot even be certain that the series is complete, since the Times of the Day were commonly produced in sets of two, three, or four paintings. Nonetheless, the juxtaposition of these radiant mythologies in the current exhibition is fortuitous. Seen together possibly for the first time since the eighteenth century, they are Fragonard's most passionate and exuberant mythologies, whose ethereal figures, billowing draperies, and locomotive clouds are inspired—not inhibited—by the standard format that set the artist's brush into operation.

Despite the fairly conventional iconography of these pendants, the sleeping figure in the foreground of *Aurora* has caused such confusion that the painting has generally been mistitled *The Awakening of Venus*, a subject not recounted in classical mythology.[8] In fact, "rosy-fingered" Aurora, the nymphomaniacal goddess of the Dawn, is shown with the morning star above her head, "rising from the saffron bed" and "sprinkling fresh rays upon the earth."[9] Accompanied by a bleary-eyed putto, she scatters roses as she goes and gazes fondly upon the figure of Night, whose eyes are already closed and who covers herself with a heavy blue green blanket. Although the subject of Fragonard's overdoor would normally be incorporated into depictions of the Rising of the Sun, *Aurora* evokes the passage from night to day with exquisite tenderness.[10] Above Night's mantle, all is in darkness; from the lemon-rinsed clouds of morning at left emerges the clear bright light of day, reaching its zenith in Aurora's smiling face.

In its flowing forms, which echo the contours of the overdoor, *Aurora* bears witness to the agility of Fragonard's brush. His touch is ever suited to the element it describes: broad and insistent in the heavy swags of drapery that entomb the sleeping Night; abbreviated, even electric, in the clouds of blue gray and ocher that swirl like stormy waves across the canvas; delicate and fastidious in the painting of the smiling Aurora, whose sepulchral form is articulated, most suggestively, in strokes of red.

The pendant *Diana and Endymion*, whose composition mirrors that of *Aurora*, shows Diana as goddess of the Moon, venturing upon the sleeping Endymion and his flock on Mount Latmus. It is literally love at first sight. So taken is Diana with the "unsurpassing beauty" of this well-born shepherd that she intercedes with Jupiter on his behalf to grant him the gift of eternal sleep, which ensures that Endymion will remain young forever.[11]

Fragonard's treatment of the subject is conventional, following the tradition described a century earlier in *Les Tableaux du Temple des Muses*. Here Marolles had noted that "[the goddess] cannot restrain herself from gazing upon the sleeping Endymion, head in hand, resting on his elbow"; he also noted that it was with some difficulty that she summoned the courage "to approach him in order to savor the sweet perfume of his breath and thus experience indescribable pleasure."[12] Fragonard's interpretation is considerably less carnal. Bearing down upon a scene of the utmost tranquility, cloud-borne Diana, the crescent moon behind her, is astonished at the sight she beholds. The beautiful, red-cheeked Endymion, holding his shepherd's staff in his left hand, has fallen asleep with his dog and sheep. Endymion is oblivious

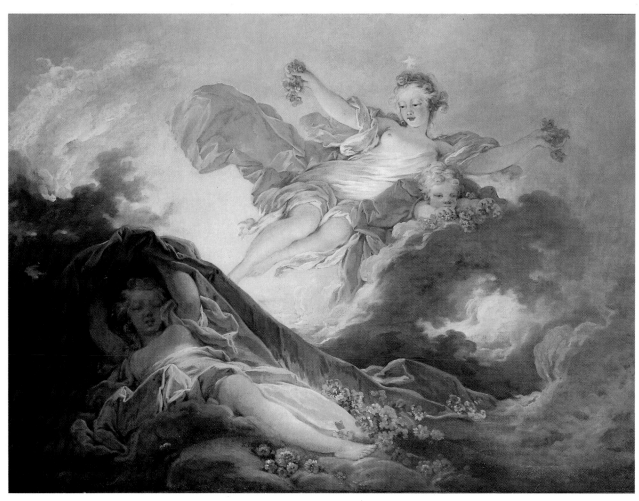

Cat. 59

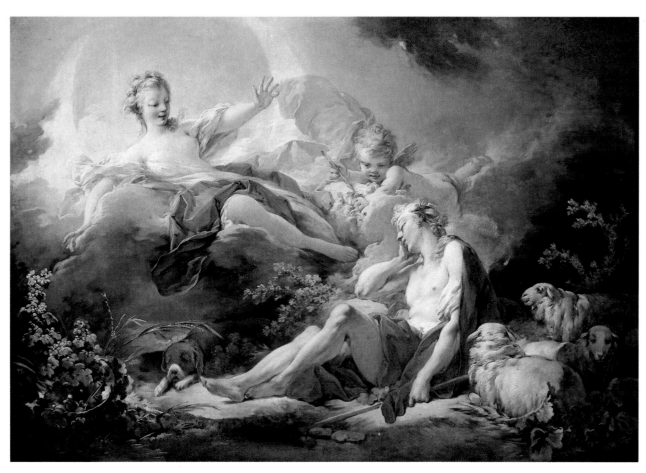

CAT. 60

to the goddess's intentions, which are clarified by the presumptuous Cupid, who prepares to hurl his dart at the sleeping boy. Only a lone sheep at right, gazing stupidly in Diana's direction, is alerted to her presence.

Diana and Endymion is a true *nocturne*. The sky is painted the inky blue of night; gray and gray black clouds hover on the peripheries, and the figures are illumined by a pale, cold light. Such is the icy tonality of Fragonard's canvas that Endymion's scarlet cloak fairly jumps off the canvas. Less schematic than its pendant,[13] *Diana and Endymion* bristles with activity, and Fragonard's touch is equal to the task. From the bravura handling of the draperies and clouds to the more finished depiction of the figures themselves—the long-legged Endymion started life as an *académie*—Fragonard arranges the various elements of his composition within a series of concentric circles that, in turn, respond to the overdoor's serpentine contours. Such is the energy and movement created in *Diana and Endymion* that one begins to wonder how the shepherd can sleep so soundly amid all the commotion.

Aurora and *Diana and Endymion* exhibit a confidence in handling and employ a high-keyed palette that set them apart from Fragonard's earlier pastorals and mythologies. In *Aurora* the paint is applied freely, almost *fouetté* (or "whipped up"), to use an eighteenth-century term. The more complex *Diana and Endymion* is executed with an astonishing sureness of touch—examination of the canvas revealing only the most minor of revisions.[14] The yellow and mauve of Night's drapery in *Aurora* and the purple of the hollyhocks at left in *Diana and Endymion* are colors that appear for the first time in Fragonard's palette. In both overdoors Fragonard's figures are at their most expansive, and his command of pictorial space, while conventional, is at its most assured.

Despite their originality, both works remain greatly indebted to Boucher. Paraphrasing the views of the Goncourts, it might be said that Fragonard's "appropriation" of Boucher serves to liberate his art;[15] his figures gain in poetry and conviction, his compositions reveal greater fluency and dynamism. Not only do *Aurora* and *Diana and Endymion* incorporate individual motifs from Boucher's most important commissions of the early 1750s, their very handling is the strongest argument for Fragonard's continued involvement with his master's studio in the years before he left for Rome.

Boucher's tapestry cartoons, *The Rising of the Sun*, 1752, and *The Setting of the Sun*, 1753 (both London, Wallace Collection), painted to decorate Madame de Pompadour's château de Bellevue, are the crucial sources for Fragonard's *Aurora* and *Diana and Endymion*.[16] The manner in which Fragonard paints the bravura clusters of trailing clouds in the background of his overdoors is identical to Boucher's handling of the sky and sea in these cartoons.[17] In *Aurora*, the figure of the goddess of the Dawn is modeled on that of her counterpart in *The Rising of the Sun* (fig. 2); arms outstretched, roses on her fingers, she repeats the pose almost exactly.[18] The figure of Night derives from the dark cloud of Night draping herself above a radiant Apollo and Tethys in *The Setting of the Sun* (fig. 3). In *Diana and Endymion*, a composition for which a pictorial tradition was well established, Fragonard's dependence on Boucher is less obvious. The expressive figure of Diana—a departure from the more contemplative attitude in which the goddess was customarily portrayed—recalls the figure of Night, blinded by the Sun, in *The Chariot of Apollo* (fig. 4), the ceiling decoration for Fontainebleau upon which Boucher was also engaged in the summer of 1753.[19] The mischievous Cupid, resting upon a cloud, assumes a pose reminiscent of Boucher's innumerable recumbent odalisques.

Fragonard also appropriated something of the baroque grandeur of Boucher's decorations—admittedly far more ambitious and complex than the overdoors they inspired—for his relatively commonplace decorations. This point is best made by comparing *Aurora* and *Diana and Endymion* with Hallé's *Diana* (fig. 5), one of a set of three overdoors of the Times of the Day shown at the Salon of 1752 with which Fragonard was surely familiar.[20] Hallé's decoration is more representative of the prevailing tradition, and the differences between these works reflect something of Fragonard's efforts to introduce movement and sentiment into what was rapidly becoming a moribund form. Hallé's *Diana*, symbolizing Evening, was noted as having incorporated its emblem "in the quite natural manner."[21] By contrast, Fragonard's pendants are bursting with vitality and incident; a decorative format could not contain his energy for long.

Indeed, *Aurora* and *Diana and Endymion*, generally dated to c. 1755–56, was among the last works Fragonard painted during his tenure at the *École royale*, and as such are his final essays *à la manière de Boucher*. Despite the charge leveled against him in later years that he chose to work exclusively for the boudoirs of the wealthy, Fragonard returned infrequently to this mode of decoration after 1756.[22] Curiously, though, the pairing of Night and Day would recur at least twice more in his mature work. In July 1766 Cochin attempted to obtain Fragonard's services for the redecoration of Bellevue by awarding him the commission of two overdoors for the *salon des jeux*.

The subjects given were "Apollo in his chariot followed by Aurora who scatters flowers (Day) and Diana in her chariot drawn by deer followed by Night who unfolds her veil of stars (Night) . . . with their poetic emblems, which will inspire his genius for the picturesque."[23] Somewhat naïvely, Cochin assured Marigny that Fragonard had promised to start work immediately, yet it is unlikely that he did. If the paintings were ever completed, there is no record of them. A sketch that may relate to the overdoor of Night, recorded in the Vieuxvillet sale of February 1788, is, perhaps, the sole trace of Fragonard's activity for the residence that once boasted his master's apotheosis.[24]

Fragonard reverted to the models of his youth in the only other suite of decorative mythologies by him that have survived. *Cupid Setting the Universe Ablaze* (fig. 6) and *Night Spreading Her Veil* (Private Collection)—two of a set of four overdoors sold by Drouais to Madame du Barry in June 1770 for the *ancien pavillon* at Louveciennes—depend entirely on *Aurora*.[25] So close, in fact, to the latter is *Night Spreading Her Veil* that it was recently published as an *oeuvre de jeunesse*.[26] As these later works show, by the 1760s an Olympian syntax no longer held the power of enchantment for Fragonard.

NOTES

1. Mariette 1851–60, II, 263, "Fragonard (Honoré) . . . il est disciple du Sieur Boucher. Je lui souhaite un aussi bon pinceau que celui de son maître. Je doute qu'il l'aît jamais."

2. Cuzin 1986, 65, n. 6, aptly describes "la perméabilité de Fragonard à la manière de Boucher au moment où il fréquentait l'École des élèves protégés."

3. Ingamells 1989, 384, no. 16; in the *inventaire après décès* of the Marquess of Hertford, *Diana and Endymion* was listed as "no. 438. Boucher, *Le Sommeil d'Adonis*" and valued at 1,000 francs. This information was kindly provided by John Ingamells.

4. Exh. New York, New Orleans, and Columbus 1985–86, 137. Wintermute's reattribution was confirmed with alacrity by Cuzin 1986, 66, and Rosenberg in exh. Paris and New York 1987–88, 34.

5. Rosenberg in exh. Paris and New York 1987–88, 34, "Déjà, la personnalité de Fragonard s'y manifeste, certaines couleurs, les modèles, de tout jeunes adolescents, l'allant des compositions, l'exubérance de la nature sont des constantes du génie fragonardien."

6. Cuzin 1987, 270, nos. 55, 56; Rosenberg 1989, 74, nos. 27, 28.

7. La Font de Saint-Yenne 1747, 16–17, "La peinture est réduite dans ces grandes pièces à des représentations froides, insipides, et nullement intéressantes: les quatres Elemens, les Saisons, les Arts, et autres lieux communs triomphes du peintre plagiare et ouvrier . . ."

8. Sedelmeyer 1906, "no. 63, *Le Réveil de Vénus*," for the earliest published reference. The subject is correctly identified as "L'Aurore" in *Collection François Coty, Tableaux Anciens*, Galerie Charpentier, Paris, 30 November 1936, no. 20.

9. Virgil, *The Aeneid*, IV, 129.584. For a good summary of the iconography of Aurora, see Judson 1966, 4–5.

10. Hébert 1756, II, 242, describes Jouvenet's lost ceiling for the hôtel de Saint-Pouange as representing "le Lever du soleil, accompagné de l'Aurore: la lune sous la figure de Diane se retire et regarde le Berger Endymion endormi." For Boucher's *Rising of the Sun*, 1753 (fig. 2), an example Fragonard would have known intimately, see n. 16.

11. Apollodorus, *The Library*, I, vii, 5. On the symbolism of Endymion in seventeenth- and eighteenth-century painting, see Colton 1967, 426–31, Dowley 1973, 305–18, and Rubin 1978, 47–84.

12. Marolles 1655, 115, "Il semble qu'elle ne se puisse lasser de le regarder dans la posture où il s'est endormy, appuyé d'une main sur le coude . . . s'approchant de luy pour sentir le doux parfum de son haleine, elle gouste des délices qui ne se peuvent exprimer."

13. Cuzin 1987, 39, mentions the organization "un peu scolairement des figures selon les diagonales de la toile."

14. X-radiography reveals that Endymion's right leg was slightly adjusted, that more drapery was initially visible behind Diana's right shoulder, and that the shepherd's staff was laid in first, with the sheep added as something of an afterthought. These are very slight changes. I am grateful to Elizabeth Walmsley, who carried out these examinations and kindly supplied me with photographs.

15. Goncourt 1880–82, I, 50, for their discussion of Watteau's "appropriation" of Titian in *Jupiter and Antiope* (cat. no. 14).

16. Cuzin 1987, 39, observes in *Aurora* "de beaux morceaux assez directement inspirés de Boucher," but without citing the Wallace Collection cartoons; Ingamells 1989, 68–78, for *The Rising of the Sun* and *The Setting of the Sun*.

17. It is on background passages such as these that Fragonard would have assisted Boucher during his apprenticeship (1749–52). Cuzin 1987, 14, following the Goncourts, notes that "Fragonard aurait beaucoup travaillé à l'exécution des grandes peintures à sujet mythologiques destinées à servir de cartons pour les Gobelins." Is it possible that he continued to assist Boucher in this way after 1753? If so, his acquaintance with the tapestry cartoons for Bellevue would have been even more intimate.

18. Fragonard's *Poetry* (New York, Private Collection), dated to c. 1752 by Rosenberg and to c. 1753 by Cuzin, is based on a similar prototype to the figure of Aurora in *Aurora*.

19. Ananoff and Wildenstein 1976, II, 105. For the traditional treatment of Diana and Endymion, as in the engraving accompanying Marolles's chapter on "La Lune et Endymion," see Restout's *Diana and Endymion*, 1724 (Versailles, Hôtel de Ville), for the hôtel du Grand Maître; Dandré-Bardon's youthful *Diana and Endymion*, 1726 (San Francisco, Palace of the Legion of Honor); and Jean-Baptiste Vanloo's *morceau de réception* of 1731 (Paris, Musée du Louvre). Cuzin 1987, 39, has compared the figure of Night in *The Chariot of Apollo* to its counterpart in *Aurora*.

20. Cuzin 1987, 251, n. 18, was the first to suggest the comparison with Hallé's series; Hallé's *Diana (The Allegory of Night)*, was very recently sold at auction, Paris, Ader Picard Tajan, 7 April 1991, no. 39.

21. [Huquier], *Lettre sur l'exposition du Louvre*, Paris 1753, 26, "Le soir est désigné par une Diane, cet emblème est tout naturel."

22. Bachaumont's criticism in the *Mémoires Secrets* of 1769, cited by Rosenberg in exh. Paris and New York 1987–88, 228, is typical: "On prétend que l'appas du gain l'a détourné de la belle carrière où il étoit entré et pour la postérité il se contente de briller aujourd'hui dans les boudoirs et dans les gardes-robes."

23. Furcy-Raynaud 1904, 51, 53, cited by Rosenberg in exh. Paris and New York 1987–88, 227.

24. Engerand 1901, 246–47, 249, who notes that Fragonard failed to produce the overdoors. Might the sketch for Night in the Vieuxvillet sale of 18 February 1788, no. 133, described as "la Nuit qui précede le lever de la lune et qui étend ses voiles sur l'horizon," be related to the aborted commission for the château de Bellevue?

25. Rosenberg in exh. Paris and New York 1987–88, 326–28; Cuzin 1987, 288, nos. 148–51; Rosenberg 1989, 89–90, nos. 165–68.

26. Rosenberg in exh. Toulon 1985, no. 12. See the most recent dating in Cuzin 1987, 288, no. 249, and Rosenberg 1989, 89, no. 166.

Fig. 1
X-ray photograph, Jean-Honoré Fragonard,
Diana and Endymion, c. 1755–56, oil on canvas,
Washington, National Gallery of Art

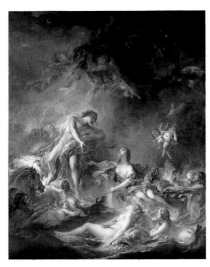

Fig. 3
François Boucher, *The Setting of the Sun*, 1752,
oil on canvas, London, Wallace Collection

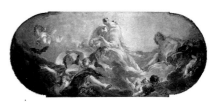

Fig. 4
François Boucher, *The Chariot of Apollo*, 1753,
oil on canvas, Musée National du Château de
Fontainebleau

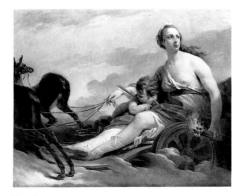

Fig. 5
Noël Hallé, *Diana*, 1752, oil on canvas, Private
Collection

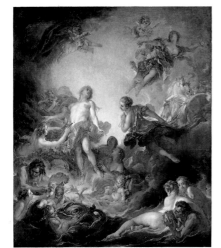

Fig. 2
François Boucher, *The Rising of the Sun*, 1753,
oil on canvas, London, Wallace Collection

Fig. 6
Jean-Honoré Fragonard, *Cupid Setting the
Universe Ablaze*, 1770, oil on canvas, Toulon,
Musée des Beaux-Arts

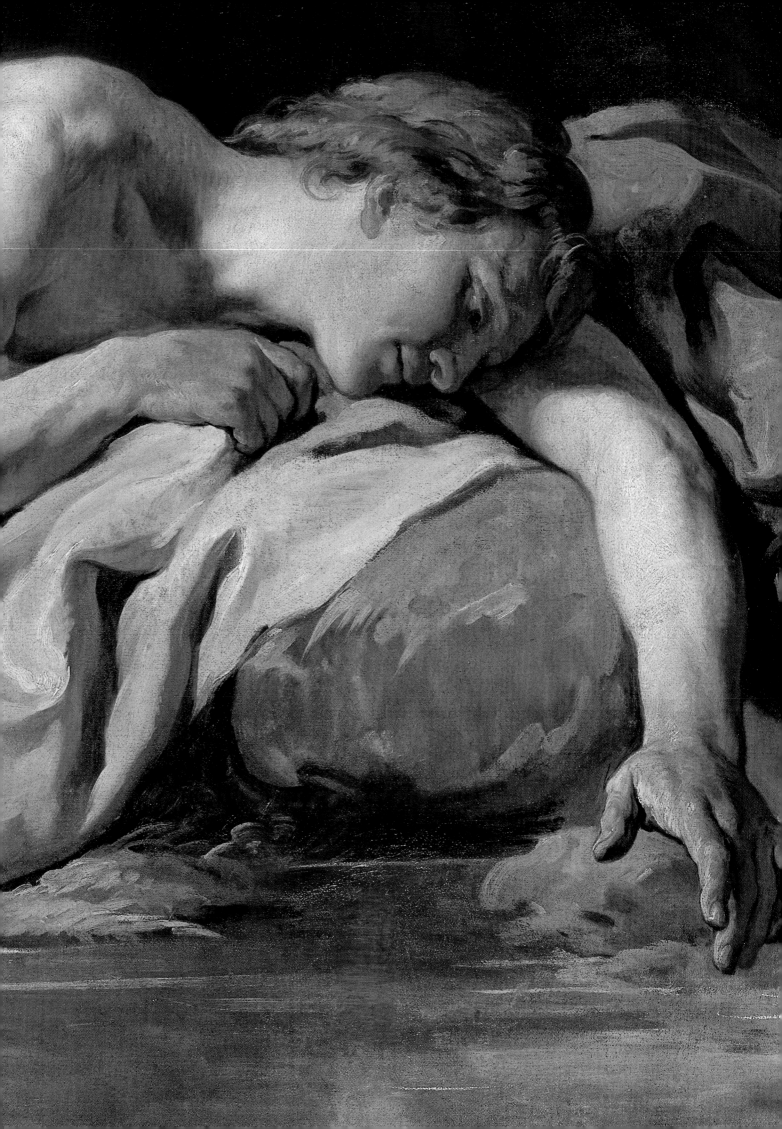

NICOLAS-BERNARD LÉPICIÉ
(1735–1784)

Son of the famed engraver and biographer François-Bernard Lépicié (1698–1755) and the artist Renée-Elisabeth Marlié (1714–1773), Nicolas-Bernard Lépicié was born in Paris in June 1735. His father trained him to be a printmaker, but, due to poor eyesight, Nicolas-Bernard turned to a career in painting. He entered the studio of Carle Van Loo around 1751 and won *petits prix* at the Academy in 1751 and 1753. In September 1759 Lépicié received second prize in the *Prix de Rome* with *The Miracle of the Prophet Elisha* (location unknown), but he never made the trip to Italy.

Taking advantage of the new taste for nationalistic subjects, Lépicié presented *William the Conquerer Invading England* (Caen, abbaye aux Hommes) as his *morceau d'agrément* in September 1764, subsequently exhibiting this painting at the Salon of 1765. Lépicié was received into the Academy as a full member in July 1769 with *Chiron Educating Achilles* (Troyes, Musée des Beaux-Arts et d'Archéologie). Probably due more to the influence of his father and his main supporter, Cochin, than to his own talent, Lépicié rapidly rose through the Academy's ranks, becoming a full professor in July 1777, only eight years after his reception.

Lépicié initially produced awkward, uninspired history paintings in a restrained and severe style, which were indebted to his contemporaries Vien and Lagrenée. His first major commission was for three works for the refectory of a Benedictine abbey in Caen, which comprised his

morceau d'agrément as well as *The Baptism of Christ* and *Christ Commanding His Disciples to Present the Young Children to Him* (1763 and 1767, Caen, abbaye aux Hommes). This project was quickly followed by commissions from the Crown, including *Adonis Transformed by Venus into an Anemone* and *Narcissus* for the *grand cabinet* of the Petit Trianon (1769 and 1771, Musée National des Châteaux de Versailles et de Trianon), works of unexpected beauty and lyricism. Lépicié also received an order from the *Bâtiments du roi* for a handful of tapestry cartoons for the Gobelins in the 1780s as part of d'Angiviller's campaign to encourage and revive history painting of a high moral tone. He painted *Regulus Leaving Rome to Save Carthage* (1779, Musée de Carcassonne), *The Piety of Fabius Dorso* (1781, Chartres, Musée des Beaux-Arts), and *Mattathias Killing a Jew Who is Sacrificing to the Idols* (1783, Tours, Musée des Beaux-Arts), but, unfortunately for the artist, they were poorly received at the Salon and were never made into tapestries.

Around 1773 Lépicié began painting genre works inspired by the vogue for seventeenth-century Dutch paintings and influenced by the neo-Dutch works of Chardin and Greuze. He was particularly attracted to Chardin's still-life and genre paintings, works he knew intimately since his father had been Chardin's favorite engraver. Lépicié's first successful, and now most famous, genre painting was *Le Lever de Fanchon* (1773, Saint-Omer, Musée de

l'hôtel Sandelin), a candid scene of everyday life painted with a silvery palette and simple color harmonies. Lépicié's gradual abandonment of history painting was greeted with relief by critics, who admired his genre scenes but condemned his talents as a public painter. Bachaumont stated that "Lépicié is at his best when he does not try to rise to the genre of history painting," and an anonymous necrologist wryly commented, "what inexplicable folly made him seek grand commissions of historical subjects?"

Working in a style similar to that of his genre paintings, Lépicié also produced charming portraits of children and, less frequently, candid images of adults. Using a gray neutral background, Lépicié focused his attention on the sitter, revealing a sense of life and personality. His *Young Draughtsman (Carle Vernet)* (1772, Paris, Musée du Louvre)—a representation of Joseph Vernet's son and a student in Lépicié's atelier—and his portrait of Carle's sister, *Emilie Vernet* (1769, Paris, Musée du Petit Palais), are fine examples of his intimate and affecting depictions of children.

Pious and modest, Lépicié gave generously to the poor and, according to rumor, took to dressing in a monk's robe. Such eccentricities, and the request for forgiveness in his last will and testament for an unusually large number of small faults, led to the general opinion that he was both nervous and impressionable. Suffering from tuberculosis and a moral crisis, the origins of which remain mysterious, Lépicié died in September 1784.

NICOLAS-BERNARD LÉPICIÉ, *Narcissus* (detail), 1771, oil on canvas, 113 x 143 cm, Musée Antoine Lécuyer, Saint-Quentin

NICOLAS-BERNARD LÉPICIÉ
Narcissus

61

NICOLAS-BERNARD LÉPICIÉ (1735–1784)
Narcissus, 1771
Oil on canvas
113 x 143 cm.
Musée Antoine Lécuyer, Saint-Quentin

PROVENANCE
Given to the Musée de Saint-Quentin by M. Huet-Jacquemin by 1856.

EXHIBITIONS
Maubeuge 1917, 22, no. 106 [dated 1775].

BIBLIOGRAPHY
Saint-Quentin 1856, 23; Gaston-Dreyfus 1922, no. 33 [dated 1775]; Ingersoll-Smouse 1923, 370 [dated 1775]; Vergnet-Ruiz and Laclotte 1965, 242 [dated 1775]; Debrie 1982, 11; Debrie 1983, 33, ill.

In March 1768 Cochin's proposals for the interior decoration of the Petit Trianon—Ange-Jacques Gabriel's masterpiece, erected in record time and at enormous expense between May 1762 and November 1764—were conveyed to ten history painters of the Academy.[1] Mindful, perhaps, of the relatively recent fiasco at Choisy, where his imperial themes had so displeased Louis XV that they would eventually be replaced by mythologies "in which many women appear," Cochin sensibly abandoned Tasso and Homer in favor of Ovid, reassuring the marquis de Marigny that the *Metamorphoses* would provide the Petit Trianon with "appropriate subjects of the required pictorial effect."[2] The painted decoration of Louis XV's *maison de plaisance* was to consist of four large allegories of Sustenance for the dining room, commissioned from the most senior academicians, and thirteen overdoors, to be painted by history painters of the second rank, for the three principal *cabinets*.[3] Cochin may have thought his choice of mythological subjects both new and ingenious. Since, he argued, "it was in this *maison de plaisance* that the king keeps his most beautiful flowers," he had commissioned episodes from the *Metamorphoses* in which due honor was paid to the realm of Flora.[4] Indeed, the Petit Trianon was enclosed by a different sort of garden—botanical, vegetable, and flower—on three of its sides, and Gabriel and Guibert had furthermore based the sculpted ornament of the interior on floral motifs.[5] Yet Cochin's program, accepted with alacrity by the administration, was entirely conventional, returning to the iconography of the Trianon de Marbre, Louis XIV's much grander *maison de plaisance,* which was decorated between 1688 and 1714.[6] Cochin's enthusiasm notwithstanding, it proved much easier to build the Petit Trianon than to decorate its relatively small number of rooms. Although Louis XV would spend his first night there on 9 September 1770, the last paintings would not be installed until July 1776, two years after his death.[7]

The decoration of the *grand cabinet "sur le fleuriste"* overlooking the flower garden (fig. 1) was shared between Nicolas-René Jollain, who painted

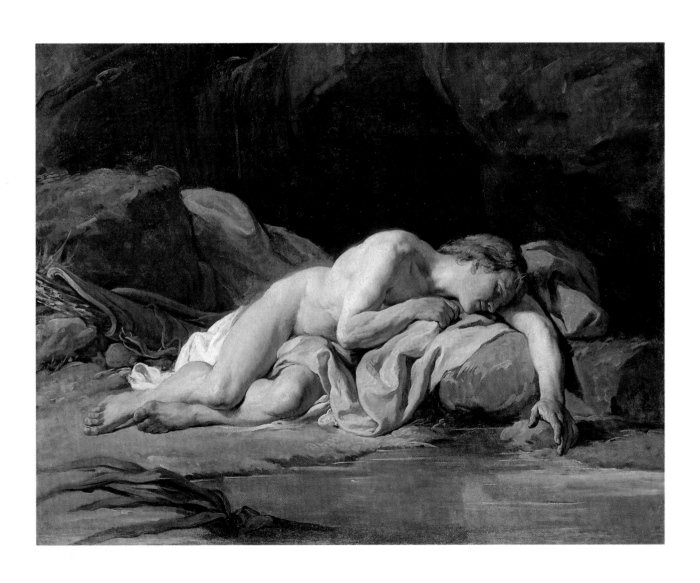

Clytia Transformed into a Sunflower and *The Death of Hyacinth* (both Musée National des Châteaux de Versailles et de Trianon), and Nicolas-Bernard Lépicié, whose overdoors of *Adonis Transformed by Venus into an Anemone* (fig. 2) and *Narcissus* (fig. 3) are the finest mythologies of the entire commission.[8] *Adonis Transformed by Venus into an Anemone* was exhibited at the Salon of 1769, installed in the *grand cabinet* soon thereafter, and retouched a decade later by the artist, who finally signed and dated this overdoor in 1782.[9] The pendant *Narcissus*, signed and dated 1771, was exhibited at the Salon of that year, although Lépicié may have begun working on it as early as 1769.[10] Despite Diderot's unfavorable reaction—he likened the painting to a "poor Magdalene"—*Narcissus* was one of Lépicié's most successful compositions, twice repeated by the artist in 1771 and engraved by Levasseur in June 1778.[11]

It is the second of these *répétitions*, the broadly painted *Narcissus*, clearly signed and dated 1771, that is exhibited here. Formerly considered a later replica—and, due to an early misreading of the last figure, generally dated 1775—this imposing figure study repeats, but radically simplifies, the overdoor in the *grand cabinet*.[12] Its relationship to the primary version, less straightforward than might be assumed, remains intriguing and problematic.

In an airless grotto, his bow and quiver of arrows cast behind him, the beautiful Narcissus, "either boy or man," reclines against a rock, staring at his reflection "in a clear pool with silvery bright water to which no shepherds ever came."[13] Smiling "in speechless wonder at himself," he tries to embrace the handsome youth who returns his gaze, as yet unaware of the impossibility of this newfound love.[14] Reduced to the most essential elements, Lépicié's *Narcissus* omits both the boy's reflection and the faithful hunting dog, motifs included in most eighteenth-century interpretations of this subject.

Instead, Lépicié concentrated on the naked figure: "smooth cheeks, his ivory neck, the glorious beauty of his face, the blush mingled with snowy white."[15] Indeed, the very presence of the live model threatens to overwhelm Lépicié's mythology; his Narcissus is ruddy and unidealized, his toes and knees reddish in coloring, his large hands and muscular torso far removed from the refinement of Ovid's hero, whose body might have been carved from Parian marble. Quite naked except for the drapery which falls in heavy and clumsy folds to cover his genitals, the figure of Narcissus dominates the composition; rocks, water, and verdure are painted summarily. The handling of Narcissus's pale skin and golden cloak, deliberate and at times heavily impastoed, is a good exam-ple of what has been described as Lépicié's "richly textured, crusty, thick laying on of paint."[16]

The differences between the overdoor for the *grand cabinet* and the *Narcissus* from Saint-Quentin go beyond details of landscape and accessories. It is not merely a question of variant compositions; rather, the two paintings should be treated as examples of distinct genres—the overdoor as history painting, the replica as *académie*. In the overdoor for the Petit Trianon, Narcissus is shown in a densely forested landscape at the moment of his metamorphosis; Cupid, whose presence alerts the little hunting dog at right, descends, torch in hand, as Narcissus's golden hair blossoms into a crown of tiny flowers.[17] The composition is brought to a delicate finish, with details such as Narcissus's reflection, his hunting apparel, and the marsh reeds at the edge of the pool at right all carefully described.

In the replica, a canvas larger on all sides than the overdoor, the naked Narcissus is portrayed without accessories, whereas in the overdoor he wears a robe of silk from which hangs a chain. As such, this single-figure study falls within a tradition that was central to academic pedagogy. Ubiquitous after midcentury, the *académie peinte*—the study after the nude model posed as a figure from mythology—was treated by artists such as Pierre (fig. 4), Brenet (fig. 5), and Berthélemy in his *Dying Gladiator* (1773, Los Angeles County Museum of Art). The most impressive example in the genre, the anonymous *Morpheus* (fig. 6), once thought to have been painted by Fragonard, suggests the grandeur and power to which this exercise might aspire.[18] Of course, these examples, and many more like them, are by young history painters at the start of their careers; after December 1773, *pensionnaires* in Rome were required to submit a painted *académie* for the Academy's approval as part of their final year's work.[19] Such student exercises might not be expected of the thirty-six-year-old Lépicié, an *adjoint à professeur* who by the 1770s was a proven recipient of royal commissions for history paintings on the grandest scale.[20] Yet in this respect, Lépicié may have been something of an anomaly; at least two painted *académies* by him were recorded in his collection, one entitled *Prometheus*, another described as "a fine nude male, lying down and seen from one side . . . intelligently executed and quite finished, the figure, painted in the light, emerges from a brown background."[21]

What, then, is the status of the *Narcissus* from Saint-Quentin? Should it be considered as part of the process through which Lépicié's more refined and inventive overdoor for the Petit Trianon came into being? Although one might not expect to find *pentimenti* in a replica—such as those visible between

Narcissus's buttocks and the rocks—the dating and scale of the Saint-Quentin *Narcissus* argue against its use as a preparatory study for the royal commission. Or should the painting be seen as an *académie*, quite independent of the Trianon commission, an exercise that was part of the history painter's continuing instruction in which Lépicié repeated a pose of his own invention? Whereas the presence of the live model is much attenuated in the overdoor, it is inescapable in this figure study. In the *Narcissus* from Saint-Quentin, Lépicié, an exemplary teacher, returns to the dual sources of his craft—nature and art—to celebrate the keystone of academic language: the human body, nude and nobly draped, in an expressive attitude. And by this time , the study from life had acquired the status of a self-sufficient work of art: "Skillfully painted, an *académie* has as great a claim as any other sort of painting to be considered a precious cabinet picture."[22]

NOTES

1. Engerand 1901, 29–30, 162–63, 285–86; Furcy-Raynaud 1904, 137–41, for the correspondence between Marigny and Cochin in the two months before the paintings were commissioned; Gallet and Bottineau 1982, 177, for the construction of the Petit Trianon, budgeted at 700,000 *livres* in 1763.

2. For Choisy, Engerand 1901, 224–29, and Furcy-Raynaud 1904, 244, "ces quatres sujets, dans lesquels il entre beaucoup de femmes," Pierre's letter of 14 November 1771 to the marquis de Marigny; Furcy-Raynaud 1904, 138, for Cochin's letter of 20 February 1768 to Marigny, in which he explains his reasons for rejecting subjects from Homer and Tasso—"j'ay craint que cela ne parût trop sérieux"—and justifies his choice of the *Metamorphoses* as providing "des sujets convenables et susceptibles de faire un bon effet de peinture."

3. Brière-Misme 1967, 219–40; Gallet and Bottineau 1982, 179; Gendre 1983, 401–2.

4. Furcy-Raynaud 1904, 138, "C'est dans cette maison de plaisance que le Roy conserve ses plus belles fleurs; j'ay cherché pour les dessus-de-porte des sujets où il puisse entrés des fleurs, pris dans *Les Métamorphoses*, parce qu'il me semble que les tableaux en seront plus agréables."

5. Gallet and Bottineau 1982, 177–79.

6. Schnapper 1967, 23–31 passim.

7. Gallet and Bottineau 1982, 180; Brière-Misme 1967, 233, for d'Angiviller's letter of 22 July 1776, in which he expresses impatience with Hallé's late delivery of *The Wine Harvest*, one of the four panels in the dining room of the Petit Trianon.

8. Engerand 1901, 237–38, for Jollain's overdoors; ibid., 285–86, for Lépicié's overdoors; Ingersoll-Smouse 1923, 368, "ce sont là peut-être, les meilleures toiles d'histoire qu'ait signés l'artiste."

9. Engerand 1901, 286, who notes that Lépicié was finally paid for this commission on 14 March 1781; Gaston-Dreyfus 1922, 157–58, no. 8.

10. Gaston-Dreyfus 1922, 162, no. 21; *Journal de Paris*, 30 June 1778, 723, for the announcement of Levasseur's engraving after *Narcissus*, "le Tableau peint par N.B. L'Épicié *en 1769*" (my emphasis).

11. Diderot 1957–67, IV, 177, "Ce Narcisse ressemble à une mauvaise Magdaleine"; Gaston-Dreyfus 1922, 162, nos. 22 and 23, for the small replicas of both overdoors painted for Cochin and exhibited at the Salon of 1771. There is no evidence to support the argument that Lépicié's paintings for the Petit Trianon were based on Cochin's designs, Ingersoll-Smouse 1923, 368.

12. Exh. Maubeuge 1917, 22, 87, no. 105, where *Narcissus* is incorrectly dated 1775; this was followed by Gaston-Dreyfus 1922, 166, no. 33, and Vergnet-Ruiz and Laclotte 1965, 242.

13. Ovid, *Metamorphoses*, III, 352, 407–8.

14. Ibid., 448.

15. Ibid., 422–23.

16. Gaston-Dreyfus 1922, 151, "sa peât est savoureuse, croustillante, épaisse aux bons endroits."

17. It was noted in the *Encyclopédie* that "on offroit aux furies des couronnes et des guirlandes de narcisse, parce que, selon le commentateur d'Homère, les furies engourdissent les scélérats"; *Encyclopédie* 1751–65, XI, 22.

18. Exh. Princeton 1977, 31; Cleveland 1982, 157–60, for the unattributed *Morpheus*, there entitled *Allegorical Figure of Sleep*.

19. Montaiglon and Guiffrey 1887–1912, VIII, 126, for Terray's order to Natoire, dated 31 December 1773.

20. Gaston-Dreyfus 1922, 144–45; Locquin 1912, 254–55; Volle in exh. Paris 1984–85 (B), 307.

21. *Vente de tableaux, dessins, estampes, et utensiles de peinture, après le décès de M. Lépicié, peintre du roi*, Paris, 10 February 1785, no. 35, "une belle figure d'homme nud, couchée et vue de face, supérieurement bien dessinée, savamment peintre et très-terminée, sur un fond brun, la figure s'y détache en clair, sur toile de 3 pieds sur 2 de haut"; these dimensions differ notably from the *Narcissus* in Saint-Quentin; ibid., no. 354, "une autre belle étude de la figure de Prométhée, de même grandeur." The sale also included no. 83, "cinquante belles Académies à la sanguine et à la pierre noire"; no. 84, "Deux portefeuilles remplis d'Académies."

22. Watelet and Lévesque 1792, I, 8, "Une académie, sçavamment peinte, a autant de droits à devenir un tableau de cabinet précieux, qu'on ouvrage de tout autre genre."

FIG. 1
Ange-Jacques Gabriel, *grand cabinet* of the Petit Trianon, 1762–64, Musée National des Châteaux
de Versailles et de Trianon

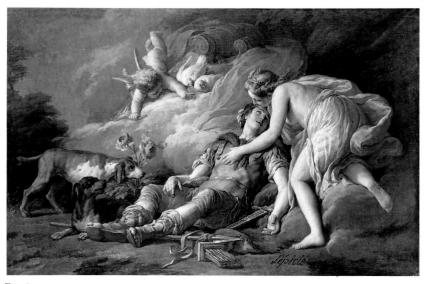

FIG. 2
Nicolas-Bernard Lépicié, *Adonis Transformed by Venus into an Anemone*, 1769 (signed and dated
1782), oil on canvas, Musée National des Châteaux de Versailles et de Trianon

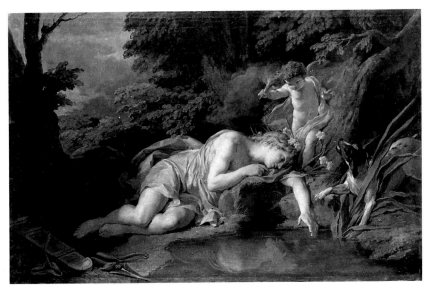

FIG. 3
Nicolas-Bernard Lépicié, *Narcissus*, 1771, oil on canvas, Musée National des Châteaux de
Versailles et de Trianon

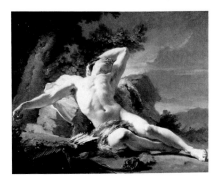

FIG. 5
Nicolas-Guy Brenet, *Sleeping Endymion*, 1756,
oil on canvas, Worcester Art Museum

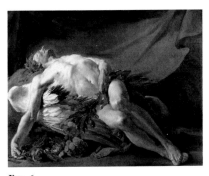

FIG. 6
Anonymous, *Morpheus (Allegorical Figure of
Sleep)*, c. 1770, oil on canvas, The Cleveland
Museum of Art

FIG. 4
Jean-Baptiste-Marie Pierre, *Seated Male Nude
as Prometheus*, 1747, oil on canvas, Karlsruhe,
Staatliche Kunsthalle

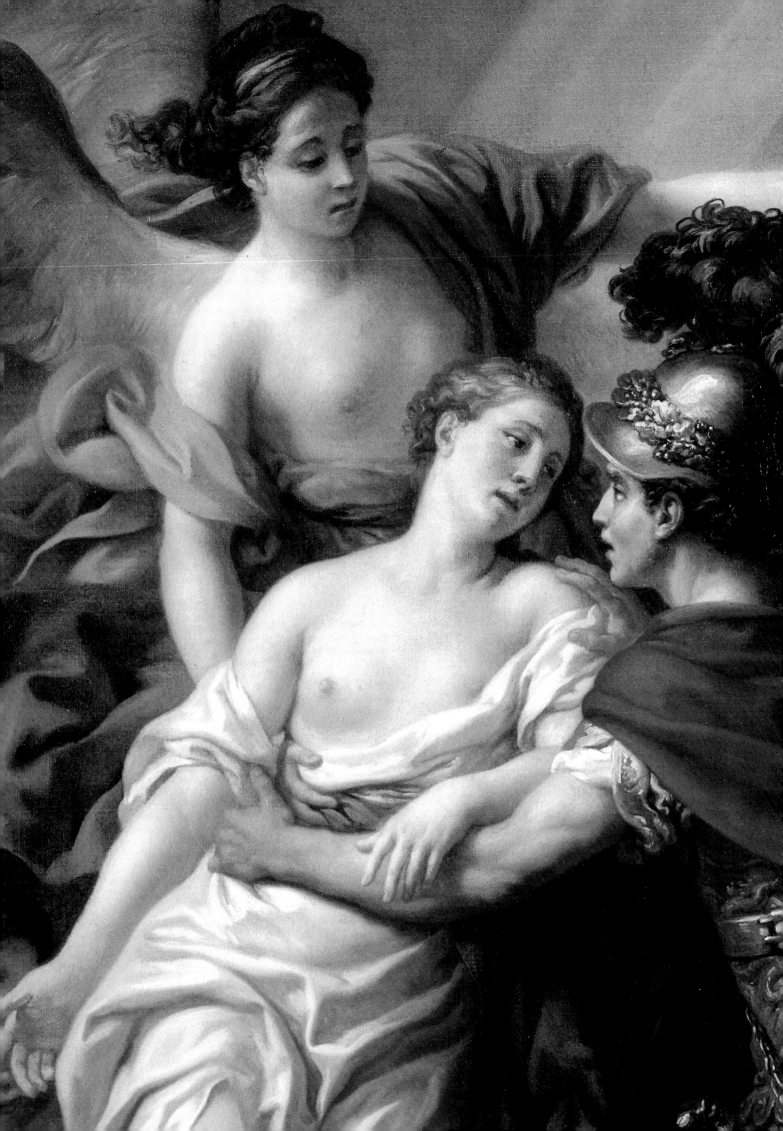

JOSEPH-MARIE VIEN
(1716–1809)

Born in Montpellier in 1716 into a family of artisans, Vien spent his youth training with local artists, most notably Jacques Giral, and left for Paris in July 1740 with letters of introduction to Natoire, Charles Parrocel, and the comte de Caylus. He entered the school of the Academy and subsequently benefited from the advice of all three men.

After moderate success as a student—he won second prize for drawing in 1741 and first prize in 1742—Vien was awarded the *Prix de Rome* in August 1743 with *David Submitting to the Will of God* (Paris, École Nationale Supérieure des Beaux-Arts). In October 1744 he left for Rome, where he remained until April 1750. There he was particularly intrigued by classical art, antiquities, and the seventeenth-century Bolognese school, although he also made numerous studies from nature. His earliest work of any importance, *The Sleeping Hermit* (1750, Paris, Musée du Louvre), which received high praise when exhibited upon his return to Paris, reflects the influence of Guercino.

At the beginning of 1747, Charles Ricard, *définiteur général de l'ordre des Capucins de France* in Rome, commissioned Vien to paint a series of six paintings on the life of Saint Martha for the church of the Capuchin monastery at Tarascon. Vien completed the series in Paris and submitted one of them, *The Departure of Saint Martha* (Tarascon, church of Sainte Marthe), to the Academy in November 1751 as his second attempt to become *agréé*. His first effort had been rejected in May 1751, and he almost failed again, since the committee examining the painting was divided over the merits of naturalism in his work. Vien was admitted to the Academy only after the comte de Caylus called upon Boucher, who judged the painting favorably. Vien was eventually received as a full member of the Academy in March 1754 with *Daedalus and Icarus* (Paris, École Nationale Supérieure des Beaux-Arts).

With the support of Caylus, Vien took advantage of the burgeoning interest in classical antiquity fostered by the recent discoveries at Herculaneum and Pompeii, and transformed his works accordingly. Employing classical motifs and sources and a more linear, austere style, he was responsible for inventing *le goût grec*. For example, the composition of Vien's famed *Seller of Loves* (Musée National du Château de Fontainebleau), exhibited at the Salon of 1763, drew upon an illustration in a publication of the recently discovered antique works at Herculaneum. In this painting, Vien's use of classical sources was accompanied by a smoother, more polished style with brilliant local color, while maintaining a high standard of draughtsmanship and attention to detail. Caylus also encouraged Vien to experiment with ancient techniques, which led to the creation of a handful of encaustic paintings in the mid–1750s (e.g., *Minerva*, 1754, Leningrad, The Hermitage) and failed attempts to produce works in sanguine on marble.

Vien's critical triumph with *le goût grec* naturally led to financial rewards as he received an increasing number of prestigious commissions, and he eventually became one of the favored artists of the royal family. Although he contributed *Marcus Aurelius Aiding the People* (1765, Amiens, Musée de Picardie) to the decoration of the *galerie* at Choisy, he is best remembered as the artist whose paintings on the Progress of Love supplanted those of Fragonard at Madame du Barry's pavillon de Louveciennes (1773–74, Paris, Musée du Louvre, and Chambéry, Préfecture).

Vien also received a number of religious commissions, for which his clear narrative style worked equally well. *Saint Germain and Saint Vincent* for the church of Saint-Germain-l'Auxerrois in Paris (1755, Castre, Musée Goya), *Saint Denis Preaching the Faith in France* for the church of Saint-Roch (1767, Paris, church of Saint-Roch), and *Saint Louis and Marguerite of Provence Visiting Saint Theobald* for the chapel of the Petit Trianon (1774, Musée National des Châteaux de Versailles et de Trianon) are among Vien's more impressive altarpieces, with their precise definition of forms, carefully articulated narratives, and monumental structures. Although his religious paintings are skillfully arranged, they lack convincing expression of emotion.

In 1775 Vien was chosen to replace Natoire as director of the French Academy in Rome, where, with the assistance of the interim director, Noël Hallé, he instigated a series of reforms to improve the education of the *pensionnaires* and the quality of their work. In November 1781 Vien returned to Paris, where he received the order of Saint-Michel in March 1782 for his efforts and became *premier peintre du roi* and director of the Academy in May 1789, after Pierre's death.

Vien survived the Revolution relatively unscathed, through the combined factors of his advanced age, close relationship with his former pupil David, and willingness to take part in the Republic's burgeoning arts administration. With Napoleon's rise to power, Vien once again attained prominence; he was named senator in December 1799, Commander of the Legion of Honor in June 1804, and Count of the Empire in April 1808. Vien's death in March 1809 was much lamented by David and his numerous followers, who mourned the passing of "the savior of the French school."

JOSEPH-MARIE VIEN, *Venus, Wounded by Diomedes, Is Saved by Iris* (detail), 1775, oil on canvas, 159 x 204 cm, Columbus Museum of Art, Ohio.

JOSEPH-MARIE VIEN

Venus, Wounded by Diomedes, Is Saved by Iris

62

JOSEPH-MARIE VIEN (1716–1809)
Venus, Wounded by Diomedes, Is Saved by Iris, 1775
Oil on canvas
159 x 204 cm.
Columbus Museum of Art, Ohio

PROVENANCE
Count Vincent Potocki, his sale, Paris (?), 1781 (?), no 253; sale, Hôtel Rameau, Versailles, 15 June 1977, no. 48 [as *Mars and Venus*]; Heim Gallery, London, 1981; Private Collection, London; Stair Sainty Matthiesen; acquired by the Columbus Museum of Art in 1986.

EXHIBITIONS
Salon of 1775, no. 4; Toledo, Chicago, and Ottawa 1975–76, no. 114, ill.; London 1981, no. 12; New York, New Orleans, and Columbus 1985–86, no. 21, col.; Columbus 1986–87, 30, 34, ill.

BIBLIOGRAPHY
Anonymous 1775 (A), 13; Anonymous 1775 (B), 11; [Cochin] 1775, 7; *Mercure de France*, October 1775, 178; Bachaumont et al 1777–89, XIII, 186; La Roque 1877, 53; Locquin 1912, 195–96; Diderot 1957–67, IV, 234, 242, 276; Soubeyran and Vilain 1975, 100; Caraco 1985, 14, ill.; Jeromack 1987, 77, ill.; Gaehtgens and Lugand 1988, no. 235, col.; Siefert 1988, no. 120, ill.

The story of Venus wounded by Diomedes forms the climax of the fifth book of *The Iliad*. Diomedes, the Greek hero and Minerva's champion, fells Aeneas with a stone and is on the point of killing him when Venus sweeps down and envelops her son in her robes, thus preventing his imminent death. In fury, Diomedes tracks down the goddess, insults her, and wounds her with his spear. Venus is forced to let go of Aeneas, and he falls from her protective cover, but Apollo arrives on the scene in time to catch him and shroud him in a cloud, thus preventing the death of the Trojan hero for a second time. Faint and in pain, Venus is rescued by Iris, the "wing-footed" Messenger of the gods, and led from the battle to Mars, who offers the goddess his chariot, which will take her back to Olympus.[1]

It is the latter incident that Vien portrays in *Venus, Wounded by Diomedes, Is Saved by Iris*, signed and dated 1775 and exhibited at the Salon of that year. It was the last secular work he would paint before leaving Paris to take up the directorship of the French Academy in Rome and the first of four Homeric history paintings he would exhibit in the Paris Salon between 1775 and 1783.[2] If Diderot was fully aware of the pictorial difficulties presented by Homer's account of the encounter between Venus and Diomedes—"sixty verses that are enough to discourage even the most avid lover of poetry"—Vien had little trouble choosing the appropriate moment to portray.[3] For, almost to the letter, the artist followed the description of the scene given by his erstwhile mentor, Anne-Claude-Philippe de Tubières, comte de Caylus (1692–1765), in the *Tableaux tirés de l'Iliade, de l'Odysée d'Homère, et de l'Enéide de Virgile*—a recipe book of Greek and Roman subjects for the use of history painters, published in 1757. Caylus described the sixth *tableau* from the fifth book of *The Iliad* in considerable detail. Mars was to be shown hurrying to assist Iris, who helps Venus into the chariot—even though the god of War had to be begged to relinquish his horses in *The Iliad*. The central group was to be surrounded by a protective cloud, its luminosity

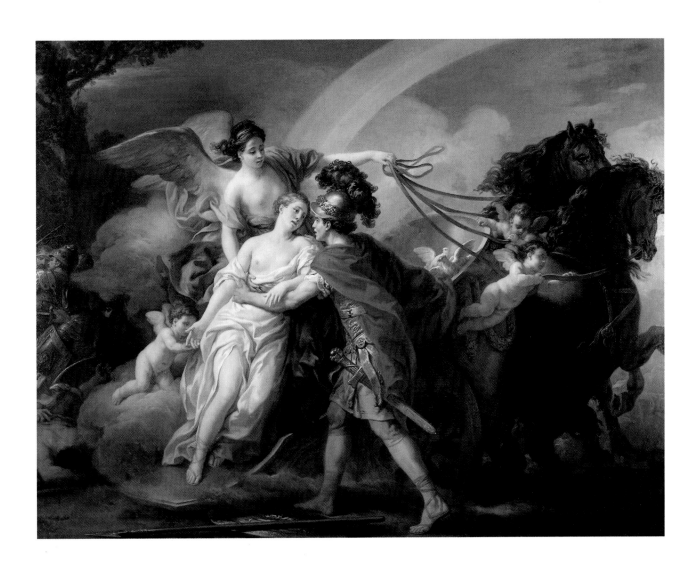

brought out by the contrast with Mars's black horses, which offered "a magnificent opposition."[4] Finally, noted Caylus, "to connect the two moments described in Homer, I would show Iris standing in the chariot, holding the horses' reins with one hand while supporting Venus with the other, assisted by Mars, as attentive as an anxious lover."[5]

As is immediately apparent, Vien looked to Caylus rather than to Homer in his interpretation of this theme. The main group is bathed in a blond light, which sets the gods apart from the carnage of battle depicted in the background. The darkness of Mars's horses does, indeed, contrast with Venus's pallor, her white robes, and the pinks and creams of Iris, who is accompanied by her traditional attribute, the rainbow. Vien also followed Caylus for the emotional register of his composition. Iris looks down on Venus solicitously while Mars, hurrying to catch her as she swoons, exhibits the concern of an eager suitor.

In his eagerness to include Venus's pair of white doves, which Caylus considered an essential adjunct, Vien seems also to have taken the antiquarian's other instructions to heart. He was punctilious in representing Mars's chariot—according to Caylus, it was "common knowledge that chariots of the gods had only two wheels"[6]—and in draping Venus in "the lightest, most voluptuous, and gently colored garment . . . in which the goddess's girdle should not be forgotten."[7] Vien's *Venus, Wounded by Diomedes, Is Saved by Iris* corresponds perfectly, then, to Caylus's presumptuous claim to have provided artists with their paintings "ready for the easel, as it were."[8] It is a mark of his influence over Vien—the last *premier peintre du roi*—that eight years after the publication of the *Tableaux tirés de l'Iliade. . .* and ten years after his death, Caylus's injunctions could still be translated into paint with such scrupulous fidelity.

However, critics at the Salon of 1775 were less than wholehearted in their enthusiasm for Vien's ambitious history painting; none bothered to identify the source of this Homeric interpretation. Although there was general praise for Vien's refined palette and his successful grouping of almost life-size figures—"there is both unity and harmony," noted Diderot—the figure

of Mars was universally criticized.[9] He reminded Diderot of a *savoyard* rather than the god of War; it could hardly be said of him that he had a warlike bearing.[10] Pidansat de Mairobert, the art critic of the *Mémoires secrets*, summed up the general consensus: "When an artist chooses to paint a subject from Homer, he must have the poet's genius and, above all, his passion, especially when he depicts the god of War."[11] Vien paid little attention to such criticism, however, and would use the same model for the figure of the bellicose Hector in *Hector Convincing Paris to Fight for the Homeland* (fig. 1), exhibited at the Salon of 1779. Here Hector is shown wearing a costume almost identical to that of Mars, and he repeats the god's pose in reverse.[12]

With its distinctive palette of cool pinks, acid greens, and light mauves, its erudite allusions, and its strong erotic charge—"a picture of beauty bleeding is always interesting," as Caylus had remarked[13]—*Venus, Wounded by Diomedes, Is Saved by Iris* was Vien's most ambitious and heroic Grecian painting to date. Furthermore, his attraction to this little-exploited theme was prescient, and a later generation of pure classicists—including Gagneraux, Ingres, and Flaxman—would turn to this episode for its refined sensuality and charged oppositions.[14]

Vien's painting must have entered the collection of the Polish noble, Count Vincent Potocki (d. 1825), almost immediately. It was one of few modern French paintings in the Grand Chamberlain's enormous collection of some three hundred pictures, catalogued in Warsaw but probably sold in Paris in 1781.[15] Potocki's interest in the French school seems to have waned shortly thereafter; his collection had included more than thirty-eight works by or after Boucher and a generous and representative sample of French seventeenth- and eighteenth-century painting from Poussin to Vernet.[16] Although by the time of the sale of his monumental print collection in 1820 there were very few French pictures listed in the catalogue, it is worth noting that Potocki also owned a *première pensée* for Vien's first monumental canvas, the celebrated *Sleeping Hermit* (Paris, Musée du Louvre), painted in 1753.[17]

NOTES

1. Homer, *The Iliad*, V, 296–365.

2. Siefert 1988, 267–68; Gaehtgens and Lugand 1988, 193.

3. Diderot 1957–67, I, 131, "Il y a là soixante vers à décourager l'homme le mieux appelé à la poésie."

4. Caylus 1757, 39, "Les chevaux noirs de Mars fournissent une magnifique opposition."

5. Ibid., "et pour accorder les deux instants que présente le Récit d'Homère, je placerois Iris dans le char, tenant déjà les rênes d'une main, soutenant Vénus de l'autre et répondant aux soins de Mars, ou plutôt d'un amant empressé."

6. Ibid., lxxviii, "Homère ne fait mention que des chars à quatre roues . . . ou de ceux que montoient les Divinités d'Olympe et personne n'ignore que le genre de ces derniers n'avoient que deux roues."

7. Ibid., xxxix, "Vénus doit avoir peu d'habillemens . . . très légers, voluptueux, et de couleurs douces: la ceinture ne doit pas être oublié."

8. Ibid., v, "Chaque sujet est, pour ainsi dire, placé sur le chevalet."

9. Diderot 1957–67, IV, 276, "Il y a de l'accord, de l'harmonie."

10. Ibid., "Son Mars ressemble à un savoyard; cela, c'est le Dieu de la guerre? Ce l'est comme j'ai l'air d'un moulin à vent."

11. *La Lanterne magique au Champs-Elysées*, Paris 1775, 11, "Il est vrai que Mars n'a pas là l'air fort martial." Bachaumont et al. 1777–89, XIII, 186, "Quand on tire un sujet d'Homère, il faudrait avoir son génie et surtout sa chaleur, si c'est pour transmettre sur la toile le Dieu de la guerre."

12. Gaehtgens and Lugand 1988, 196–97.

13. Caylus 1757, 37, "Le tableau de la beauté dont on voit couler le sang est toujours un objet intéressant."

14. See the listing of specific works in *Art as Decoration*, Heim summer exhibition, 1981, no. 12, and Siefert 1988, 260–66.

15. *Catalogue des dessins, tableaux, miniatures . . . contenus dans le cabinet de S.E. Mr. le comte Vincent Potocki*, Warsaw, 1780 (Lugt 3343).

16. Marandel in exh. New York, Detroit, and Paris 1986–87, 83, 86–88.

17. *Catalogue d'une collection nombreuse d'estampes anciennes et modernes . . . provenant du cabinet de M. le comte V.P.*, Paris, 9–28 February 1820, no. 859.

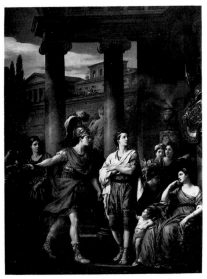

FIG. 1
Joseph-Marie Vien, *Hector Convincing Paris to Fight for the Homeland*, 1779, oil on canvas, Musée National du Château de Fontainebleau

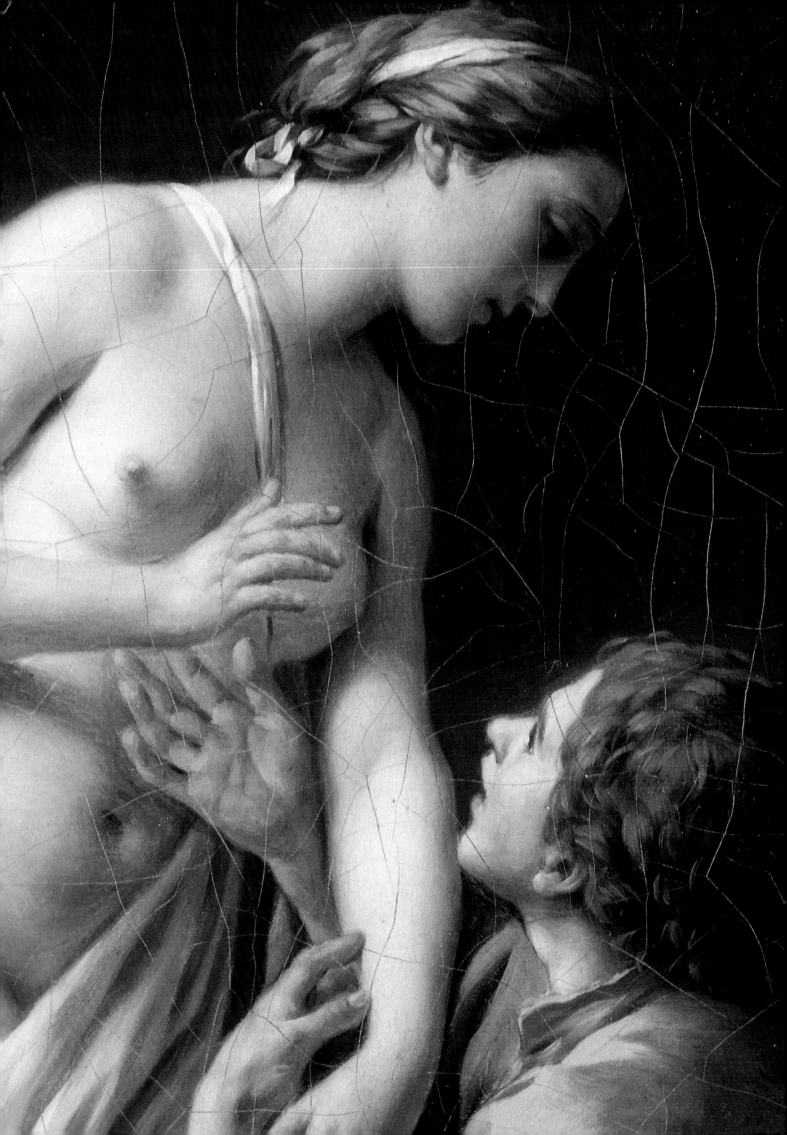

LOUIS-JEAN-FRANÇOIS LAGRENÉE
(1724–1805)

The older brother of the painter Jean-Jacques Lagrenée, Louis-Jean-François Lagrenée was born in Paris in December 1724. He studied with Carle Van Loo, won the *Prix de Rome* in March 1749 with *Joseph Explaining Pharaoh's Dreams* (location unknown), and entered the recently established *École royale des élèves protégés*. He did not remain in Paris for the requisite three years, leaving instead in September 1750 to become a *pensionniare* at the French Academy in Rome. Although Lagrenée experimented briefly with an energetic baroque manner, he essentially followed the style of his teacher, Van Loo, by studying the seventeenth-century Bolognese school. During his sojourn in Rome he copied Domenichino's *Saint Cecilia Distributing Alms to the Poor* (1753, Musée de Grenoble).

Lagrenée had returned to Paris by September 1754, when he was received as an associate member of the Academy. He became a full member in May 1755 with *The Abduction of Dejanira* (Paris, Musée du Louvre), which is indebted to such famous seventeenth-century models as Annibale Carracci's Polyphemus series on the vault of the Palazzo Farnese, which he would have seen in Rome, and Guido Reni's *Abduction of Dejanira* (Paris, Musée du Louvre), which he would have seen in the Royal Collection in Paris. After his reception, Lagrenée established his reputation among the wealthy *noblesse de finance* as a painter of decorative works; the banker Pâris de Montmartel was one of the most ardent of his early patrons.

Although Lagrenée's work was relatively unknown abroad, he was invited to Russia to become *premier peintre* to the Empress Elisabeth and director of the Academy of Painting in St. Petersburg on the basis of his burgeoning reputation. He left Paris in September 1760 and painted *The Empress of Russia Protecting the Arts* (1761, Leningrad, The Hermitage) shortly after his arrival in Russia as his reception piece for the Academy of St. Petersburg. In addition to fulfilling imperial and academic obligations, Lagrenée painted numerous portraits of members of the Russian nobility, most of which are lost today.

Due to the death of the Empress Elisabeth, Lagrenée returned prematurely to Paris in April 1762, and in October of that year he was named a full professor at the Academy—a mere seven years after his reception. He immediately began exhibiting at the Salon and came to the attention of Diderot, who responded enthusiastically to Lagrenée's entries at the Salon of 1763, but suggested, nonetheless, that the artist paint on a smaller scale. Diderot even purchased examples of Lagrenée's work, including a precious *Magdalene* (1765, Private Collection) on copper—the artist's favorite support. While such intimate images of the Magdalene and the Virgin were very popular, Lagrenée was less successful with large-scale religious works, such as *The Assumption of the Virgin* (1759, cathedral of Douai) and *The Visitation of the Virgin* for the chapel of the marquis de Serant's *château* (1781, Madrid, Museo del Prado)—strained and unconvincing exercises, fully revealing their lack of spiritual inspiration. Public recognition and a prestigious career in such a short period of time led to an increasing number of secular commissions. Lagrenée's record book reveals that he painted at least 457 works by the end of his life. He exhibited more than 150 of these at the Salon, 69 of which were mythological paintings—more than any other eighteenth-century artist. Many of these mythological works were relatively small in scale and intended as parts of decorative ensembles for Parisian *hôtels*.

Some of Lagrenée's finest decorative mythologies were painted for the Crown, from which he received his first commissions in the mid-1760s. He painted the overdoors *Justice and Clemency* and *Bounty and Generosity* (1765, Musée National du Château de Fontainebleau) to complete the decoration of the *galerie* at Choisy, *Mars and Venus Surpised by Vul-can* and *Psyche Viewing Cupid Asleep* (1768, Paris, Musée du Louvre) for the king's bedchamber at Bellevue, and *Ceres and Triptolemus* (1769, Musée National des Châteaux de Versailles et de Trianon), one of four large panels for the dining room of the Petit Trianon. The smooth, creamy surfaces, classically idealized figures, and saturated colors of these works led to his being called "the French Albani."

Lagrenée's fortunes continued to prosper when d'Angiviller became director of the *Bâtiments du roi*. His classicizing subject matter and linear style suited the renewed taste for the antique and naturally appealed to Vien's greatest supporter. Lagrenée received a number of commissions from the *Bâtiments du roi* between 1777 and 1789, particularly a series of tapestry cartoons for the Gobelins, such as *Fabricius Refusing the Presents of Pyrrhus* (1777, Libourne, Musée des Beaux-Arts et d'Archéologie), *Popilius Tracing a Circle with His Cane* (1779, Lille, Musée des Beaux-Arts), and *The Death of the Wife of Darius* (1785, Angers, Musée des Beaux-Arts)—all were part of d'Angiviller's efforts to revive history painting with noble and moral subjects. D'Angiviller's approval of such works led to Lagrenée's appointment in August 1781 as director of the French Academy in Rome, where he remained until September 1787. Although Lagrenée lived through the revolutionary decade with relatively little personal upheaval, both the public and private clientele for his art had disappeared. His late work remains largely unknown.

LOUIS-JEAN-FRANÇOIS LAGRENÉE, *Pygmalion* (detail), 1781, oil on canvas, 58. 42 x 48. 26 cm, The Detroit Institute of Arts, Founders Society Purchase, Mr. and Mrs. Benjamin Long Fund, Miscellaneous Gifts Fund and City of Detroit Insurance Recovery Fund.

LOUIS-JEAN-FRANÇOIS LAGRENÉE
Pygmalion

63

LOUIS-JEAN-FRANÇOIS LAGRENÉE (1724–1805)
Pygmalion, 1781
Oil on canvas
58.42 x 48.26 cm.
The Detroit Institute of Arts, Founders Society Purchase, Mr. and
Mrs. Benjamin Long Fund, Miscellaneous Gifts Fund, and City of
Detroit Insurance Recovery Fund

PROVENANCE
Possibly in the Dubourg sale, 1869; sale, Hôtel Drouot, Paris, 23
March 1908, no. 31; Galerie Joseph Hahn, Paris; purchased by
The Detroit Institute of Arts in 1972.

EXHIBITIONS
Paris, Detroit, and New York 1974–75, no. 115, ill.

BIBLIOGRAPHY
Goncourt 1877, no. 301; Sandoz 1961, 133; Sandoz 1963, 60; *Art
Quarterly*, Spring/Summer 1973, 115, ill.; *Burlington Magazine*,
CXV/843 (June 1973), 393; Schnapper 1975, 112–17, ill.;
Diderot 1975–[1983], I, 43, ill. [incorrect identification]; Sandoz
1983, no. 349, ill.

During his long career, Lagrenée painted the subject of Pygmalion, one of the "*sujets de la fable*" written out in his *Livre de raison*, as many as eight times.[1] The theme served a dual purpose in his oeuvre: as an allegory of Sculpture it was frequently paired with its sister art of Painting, and as an Ovidian narrative of considerable erotic appeal it perfectly suited the talents of a history painter who excelled in small-scale mythologies, simplified in presentation, and of exquisite, if bloodless, finish. Although relatively well known and thoroughly studied, *Pygmalion* is among the least securely documented of Lagrenée's extant works. Noted in the artist's account book as simply "*Pigmalion*"—with neither price nor purchaser indicated—the painting remained in Lagrenée's possession until the Revolution, when he seems to have sold it, along with a group of small paintings, at public auction.[2] Thus, it would have been during Lagrenée's lifetime, and with his knowledge, that *Pygmalion* became paired with an oval of identical dimensions, *Painting Cherished by the Graces* (fig. 1), signed and dated 1772—a false pendant, made some nine years earlier. The ovals remained together until 1908, and since the coupling of these themes is recurrent in Lagrenée's oeuvre, such confusion was understandable. However, so predictable in his pairing of images was Lagrenée that once one looks at the so-called pendants, it is immediately apparent from their dissimilar proportions that they were painted independently of one another.[3]

The story of Pygmalion bringing his sculpture to life, told by Ovid in the tenth book of the *Metamorphoses*, enjoyed particular vogue in eighteenth-century France. Pygmalion, king of Cyprus, was a virtuous citizen who shunned the "vile Propoetides"—young women driven into prostitution for having denied the divinity of Venus—and lived "unmarried . . . and long without a partner of his couch."[4] He sculpted an ivory statue of the greatest beauty, with which he fell passionately in love, and took to speaking to it, showering it with presents, and laying it in his bed at night. Finally, on Venus's feast day, Pygmalion summoned the courage to ask the goddess for a wife as beautiful as

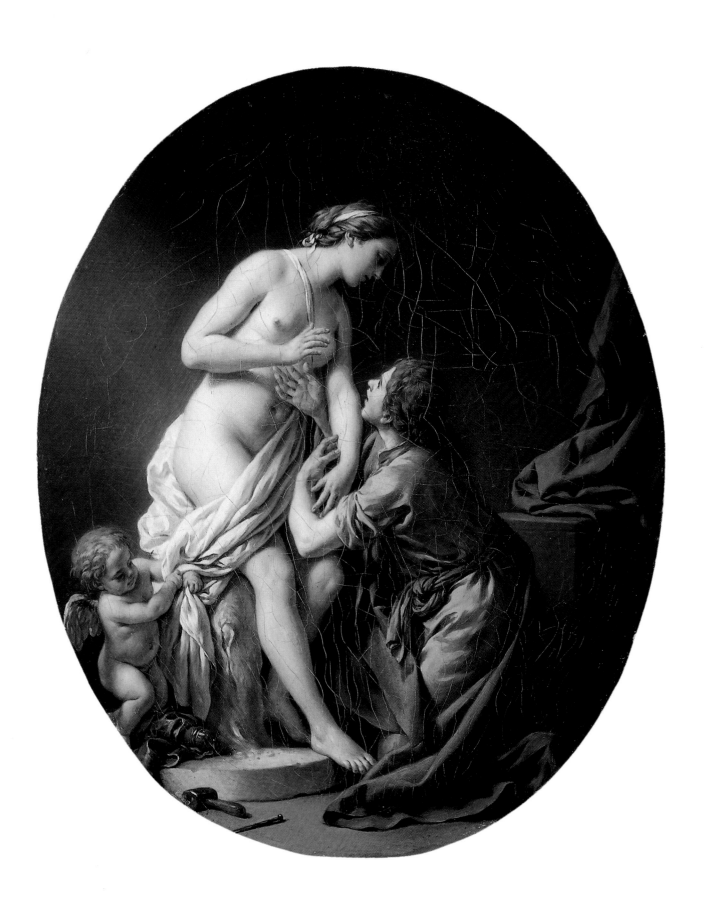

his ivory sculpture. Venus responded by endowing the statue with life, thus enabling Pygmalion to "press with his lips upon real lips at last."[5] The couple married and had two children, a daughter, Paphos, after whom the island off the coast of Cyprus was named, and a son, Cinyras, who, in an incestuous relationship with his daughter Myrrha, would beget the beautiful Adonis.

For an eighteenth-century audience, the resonance of the Pygmalion theme was double-edged.[6] It stood as a metaphor of creation, both artistic and material, and as an example "of the delight that the love of art and beauty can inspire in sensitive and passionate souls."[7] Less platonically, it served as a symbol of nascent concupiscence, of "the moment when a frigid woman softens, the moment one never forgets."[8] In the *Encyclopédie*, the chevalier de Jaucourt interpreted the climax of this tale as symbolizing Pygmalion's masculinity: "It should be understood that he found the means of exciting a beautiful person who was formerly as cold as marble."[9] For both the artist and the art lover, then, the subject was replete with favorable associations, and this may account for its contemporary popularity. Throughout the century, from Raoux (fig. 2) and Lemoyne (fig. 3) to Monnet and Gauffier (fig. 4), the moment of the statue's miraculous transformation—it was only in 1770 that Rousseau christened her Galatea—provided artists with a potent image of creativity.[10] In theater and opera, the subject was no less popular; Rameau's *Pygmalion*, cannibalized by Lancret's biographer, Ballot de Sauvot, was performed 203 times between 1748 and 1781.[11]

Lagrenée's "worldly allegory," signed and dated 1781, is among the most restrained interpretations of the myth, with accessories and attributes pared to the very minimum.[12] Whereas the "rococo" Jean Raoux and the "neoclassical" Gauffier both follow Ovid very closely in including a rich array of the "gifts pleasing to girls" with which Pygmalion courted the statue,[13] Lagrenée's cabinet picture, with its porcelain flesh tones and creamy draperies, is sober by comparison. Austere yet tender, it is also a departure from his slightly earlier treatment of the theme. In the more animated and crowded *Pygmalion*, painted around 1777 for the marquis de Véri (fig. 5), Venus and Cupid appear floating on clouds, and the scene takes place under a Doric colonnade of some severity. This more ambitious cabinet picture also testifies to Lagrenée's modernity; the dolphin resting at the base of the statue—an otherwise inexplicable ornament in a setting such as this—alludes to the statue's newfound identity as Galatea, a name she shared with the sea nymph.[14]

In Lagrenée's *Pygmalion* of 1781, Galatea repeats the pose established earlier, whereas Pygmalion, although similarly draped, assumes a more supplicant position. The central group in both canvases derives, in fact, from Falconet's marble of the same subject (fig. 6), exhibited at the Salon of 1763, in which Lagrenée had also participated after an absence of two years.[15] Falconet's triad of figures, pared of all ornament, had spurred Diderot to a paroxysm of delight: "This is the object I would choose for my collection, were I to have one!"[16] The critic feared that Falconet would meet the same end as Prometheus, punished for having stolen the fire of creation from the gods. Diderot concluded his impassioned and lengthy review of Falconet's *Pygmalion at the Foot of His Statue* with a list of improvements, of some interest with regard to Lagrenée's later interpretation. Apart from reversing the position of the protagonists, Diderot's most important innovation was that the figures be shown touching. He envisaged Pygmalion "getting up slowly from his knees until he reaches the level of her heart, upon which he gently places the back of his hand; however, at all times his eyes are fixed on those of the statue, waiting for them to open."[17] When Lagrenée came to paint his *Pygmalion*, he could not, of course, have read this passage—the first edition of Diderot's *Salons* was not published until 1798—yet it was at the Salon of 1763 that his friendship with Diderot was formed. Diderot had written approvingly of Lagrenée's cabinet paintings and had even acquired a tiny *Magdalene* on copper (Paris, Private Collection) the following year.[18] It is tempting to associate Lagrenée's interpretation of Pygmalion and Galatea with Falconet's entry revised by Diderot. In his painting, the figure of Pygmalion is shown rising to his feet, his restrained expression in keeping with "the fear of being mistaken, or ruining the miracle through any of a thousand accidents."[19] Gently touching Galatea's arm, Pygmalion extends his hand, palm outward, in a gesture that brings Diderot's directive immediately to mind.

NOTES

1. Sandoz 1983, 172, no. 37; 178–79, no. 73; 205, no. 157; 222–23, no. 205; 235, no. 244; 246, no. 287; 249, no. 292; 270, no. 349. This is the least conservative estimate, since it includes all paintings entitled *La Sculpture*; Schnapper 1975, 112, notes that the story of Pygmalion is among those written out by Lagrenée in his *Livre de raison*, MS. 50, Paris, Bibliothèque d'Art et d'Archéologie, fol. 209.

2. Sandoz 1983, 369, 372, "Six tableaux vendus à une vente dont l'un représente la Peinture encouragée par les Grâces et son pendant représente Pigmalion amoureux de sa statue . . . ces six tableaux ont été vendus en assignats"; see also Schnapper 1975, 112.

3. Mireur 1901–12, IV, 152, notes that the pendants first appeared at the "Dubourg" sale, 1869, which is not listed in Lugt and has been impossible to trace; *Painting Cherished by the Graces* appeared recently at auction, Ader Picard Tajan, Paris, 9 April 1991, no. 42.

4. Ovid, *Metamorphoses*, X, 238, 245–46.

5. Ibid., 292–93.

6. Carr 1960, 239–55, for a good introduction, although unreliable on the paintings illustrated; and Schneider 1987, 111–23, for the best summary of the theme in French art of the eighteenth and nineteenth centuries.

7. Tourneux 1877–82, XI, 140, "du délire que peut exciter dans une âme sensible et passionnée l'amour des arts et de la beauté," Grimm's enthusiastic review of Rousseau's *Pygmalion*, performed in Paris for the first time on 30 October 1775.

8. Exh. Paris 1984–85 (B), 454, "l'instant où une femme insensible s'attendrit, cet instant qu'on oublie jamais," Mathon de La Cour's comment on Falconet's *Pygmalion at the Foot of His Statue* (fig. 6), exhibited at the Salon of 1763.

9. *Encyclopédie* 1751–65, XIII, 591, "On peut croire que ce prince trouva le moyen de rendre sensible quelque belle personne qui avoit la froideur d'une statue."

10. Sandoz 1983, 44, for Charles Monnet's drawing of *Pygmalion in Love with His Statue* (Paris, Musée du Louvre, Cabinet des Dessins); Reinhold 1971, 317–18, for Rousseau's *scène lyrique*, written in 1762 and first produced in Lyons in 1770; the author notes that the statue had first been named *Galatea* in Thémiseul de Saint-Hyacinthe's novel of the 1740s, but that this appellation did not gain currency until the appearance of Rousseau's opera.

11. Carr 1960, 242, n. 5.

12. Sandoz 1967, 118; Schnapper in exh. Paris, Detroit, and New York 1974–75, 516; Schnapper 1975, 116.

13. Ovid, *Metamorphoses*, X, 259–60.

14. Sandoz 1961, 5–10; exh. Stockholm 1983, 234; Schneider 1987, 114, 122, n. 2, notes, however, that the dolphin is also Venus's symbol, appearing as it does on the base of the *Venus de' Medici*.

15. Gaborit in exh. Paris 1984–85 (B), 451–54.

16. Diderot 1975–[1983], II, 245, "Voilà le morceau que j'aurais dans mon cabinet, si je me piquais d'avoir un cabinet."

17. Ibid., 246, "Il était alors accroupi; il se relève lentement, jusqu'à ce qu'il puisse atteindre à la place du coeur. Il y pose légèrement le dos de sa main gauche, il cherche si le coeur bat; cependant ses yeux attachés sur ceux de sa statue attendent qu'ils s'entr'ouvrent."

18. Volle in exh. Paris 1984–85 (B), 286.

19. Diderot 1975–[1983], 247, "la crainte ou de se tromper, ou de mille accidents qui pourraient faire manquer le miracle."

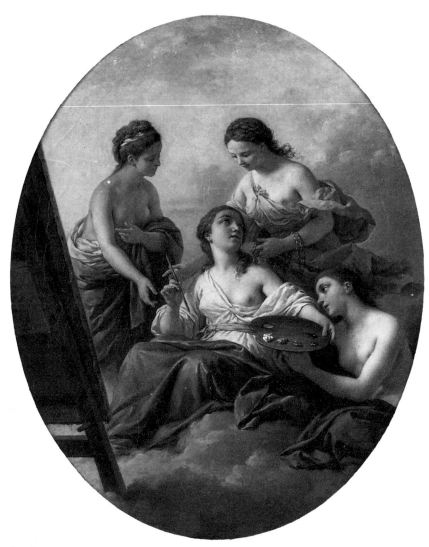

Fig. 1
Louis-Jean-François Lagrenée, *Painting Cherished by the Graces*, 1772, oil on canvas, Private
Collection

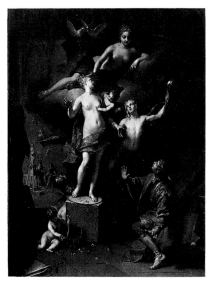

Fig. 2
Jean Raoux, *Pygmalion*, 1717, oil on canvas,
Montpellier, Musée Fabre

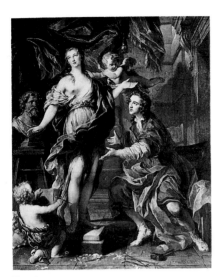

FIG. 3
François Lemoyne, *Pygmalion and Galatea*, 1729, oil on canvas, Tours, Musée des Beaux-Arts

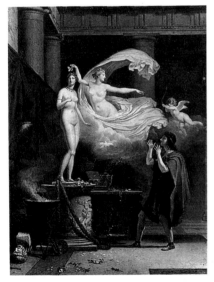

FIG. 4
Louis Gauffier, *Pygmalion and Galatea*, 1797, oil on canvas, The City Art Gallery of Manchester

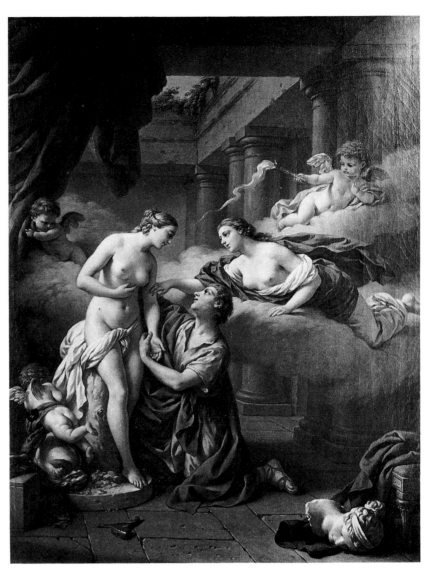

FIG. 5
Louis-Jean-François Lagrenée, *Pygmalion and Galatea*, c. 1777, oil on canvas, Helsinki, Museum of Foreign Art Sinebrychoff

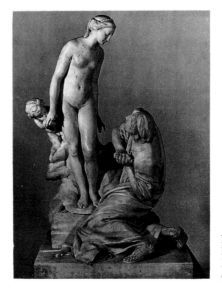

FIG. 6
Étienne-Maurice Falconet, *Pygmalion at the Foot of His Statue*, 1761, marble, Paris, Musée du Louvre

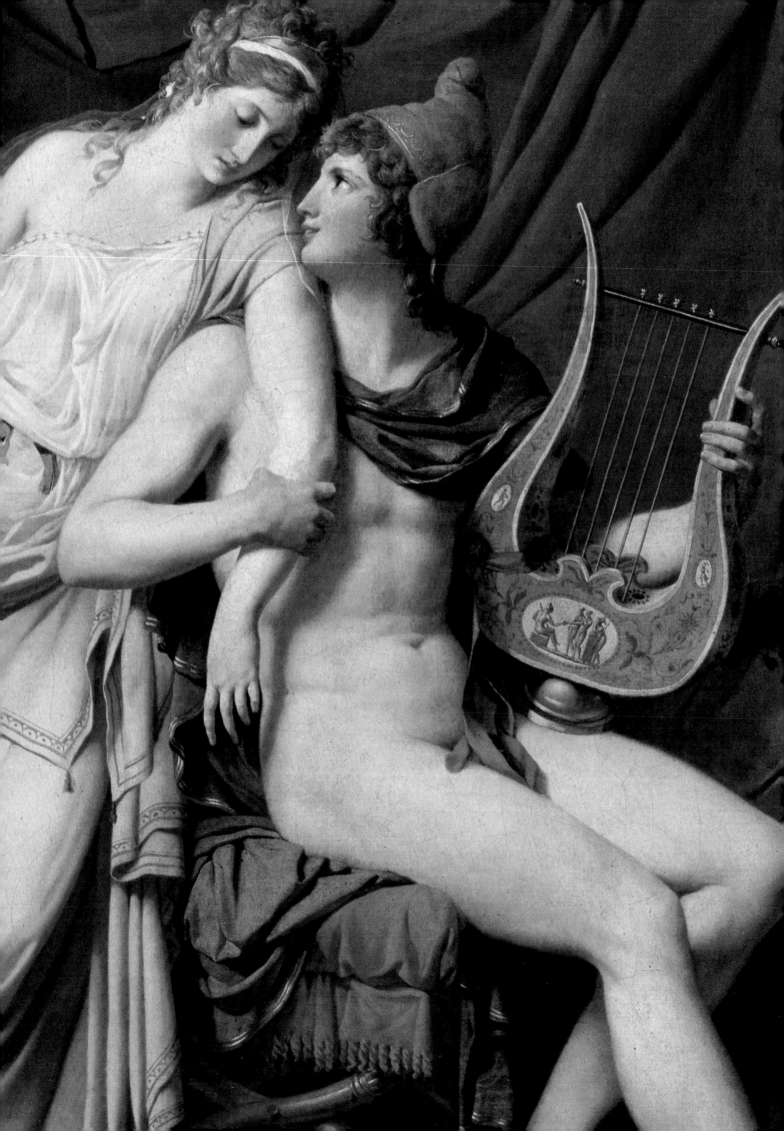

JACQUES-LOUIS DAVID
(1748–1825)

David, the son of a haberdasher, was born in Paris on August 30, 1748. He entered the studio of Joseph-Marie Vien before 1766 on the recommendation of a distant relative, François Boucher, *premier peintre du roi*. David attended classes at the Academy and competed several times for the *Prix de Rome* before finally succeeding in 1774 with *Erasistrates Discovering the Cause of Antiochus's Illness* (Paris, École Nationale Supérieure des Beaux-Arts), a grand manner history painting steeped in the rococo tradition of Lagrenée and Boucher.

It was during his first stay in Rome (1775–80) that David matured as an artist, having studied the works of Veronese, Caravaggio, Valentin, and Poussin, as well as the art of the ancients. Back in France, David painted *Belisarius* (Lille, Musée des Beaux-Arts), a work which had been planned in Rome. Arguably the first "Davidian" painting, *Belisarius* was the sensation of the Salon of 1781 and drew to David's studio his first generation of students, including Fabre, Girodet, and Drouais. In 1783 David gained full membership in the Academy with *Hector and Andromache* (Paris, École Nationale Supérieure des Beaux-Arts) and in 1784–85 made a second trip to Rome, where he painted his seminal masterpiece, *The Oath of the Horatii* (Paris, Musée du Louvre). On his return to Paris in 1785, David received private commissions from a diverse range of patrons: *The Death of Socrates* (1787, New York, The Metropolitan Museum of Art) for the liberal aristocrat Trudaine de la Sablière; *Paris and Helen* (1788, Paris, Musée du Louvre) for the comte d'Artois; and *The Portrait of Lavoisier and His Wife* (New York, The Metropolitan Museum of Art) for the enlightened financier and scientist. At the Salon of 1789 his major entry was the royal commission *The Lictors Bringing Brutus the Bodies of His Dead Sons* (1789, Paris, Musée du Louvre).

With the advent of the Revolution, David's history paintings from the 1780s were perceived, retrospectively, as calls to political change; he soon became the Re-

public's leading painter, developing into a genuinely important figure in the political life of France. Although David embodied the ideal to which academic pedagogy aspired, he led the attack on the Academy— the artistic Bastille, as he called it—which was abolished in 1793, largely due to his efforts. A member of the Jacobin club well before he was commissioned to paint a vast canvas commemorating *The Oath of the Tennis Court* (an unfinished fragment is preserved in the Musée National des Châteaux de Versailles et de Trianon), David was prevented from completing this monumental modern history painting by the shifting political climate. He was elected as a delegate from Paris to the Convention in September 1792 and in September 1793 joined the newly reorganized Committee of General Security, the policing agency that decided who should be sent before the Revolutionary Tribunal for trial.

From the early 1790s onward, David's art was enlisted in the service of propaganda for the Revolution. His crowning achievement for the revolutionary government was the series of three portraits of the "Martyrs of Liberty": *The Death of Marat* (1793, Brussels, Musées Royaux des Beaux-Arts), *The Death of Lepeletier de Saint-Fargeau* (destroyed), and the unfinished *Joseph Barra* (1794, Avignon, Musée Calvet).

Too closely allied with Robespierre, David was arrested on contrived charges and imprisoned in the Hôtel des Fermes on 15 Thermidor *an* II (27 July 1794). A month later he was transferred to the Luxembourg, remaining there until his release in late 1794.

A founding member of the *Institut* in 1795, David spent the next four years painting portraits—perhaps only Goya, among David's contemporaries, could match his genius as a portraitist—and meticulously preparing a huge history painting, *The Rape of the Sabines* (1799, Paris, Musée du Louvre), a controversial work in which David attempted to return to the stylistic purity of the Greeks.

An early supporter of Napoleon Bonaparte, whom he admired and frequently painted—from the heroic allegory *Bonaparte Crossing the Great Saint Bernard* (1801, several versions, the most famous at Malmaison) to the late *Napoleon in His Study* (1812, Washington, National Gallery of Art)—David was commissioned by the emperor to commemorate the festivals of the empire and glorify his reign. The artist responded by creating his most grandiose masterpieces: *The Coronation of Napoleon and Josephine* (known as the *Tableau du Sacre*, 1805–7, Paris, Musée du Louvre) and *The Distribution of the Eagles* (1810, Musée National des Château de Versailles et de Trianon), overwhelming *machines* in which exacting detail is subordinated to a panoramic vision.

In 1814 David completed his last great work, *Leonidas at Thermopylae* (Paris, Musée du Louvre), begun twelve years earlier as a pendant to *The Rape of the Sabines*. Having remained loyal to Napoleon, David was forced into exile after the Bourbons' return to power in 1815. In January 1816, following the passage of the law against regicides, David left for Brussels, where he would remain for the rest of his life. He moved in a circle of revolutionary exiles and produced several brilliant mythologies, such as *Cupid and Psyche* (1817, The Cleveland Museum of Art), *The Anger of Achilles* (1819, Fort Worth, Kimbell Art Museum), and *Mars Disarmed by Venus and the Graces* (1824, Brussels, Musées Royaux des Beaux-Arts), splendid, but disturbing, experiments in imbuing ideal subjects with realistic detail, which confounded his contemporaries and met with little critical success.

Although it had been made clear to David that, were he to ask for a pardon he would be allowed to return to his homeland, he refused, steadfastly maintaining his principles. He died in Brussels on December 29, 1825; ignoring the pleas of his loyal friends, the Bourbon government refused to allow his body to be interred on French soil.

JACQUES-LOUIS DAVID, *Paris and Helen* (detail), 1789, oil on canvas, 144 x 174 cm, Musée des Arts Décoratifs, Paris

JACQUES-LOUIS DAVID
Paris and Helen

64

JACQUES-LOUIS DAVID (1748–1825)*
Paris and Helen, 1789
Oil on canvas
144 x 174 cm.
Musée des Arts Décoratifs, Paris

PROVENANCE
Commissioned by Isabella Czartoryski Lubomirska, *Princesse Maréchale* (1736–1816); Prince Lubomirski, his sale, Paris, 3 May 1873, no. 3, purchased by Lefebvre de Viefville, whose descendants donated the painting to the Musée des Arts Décoratifs in 1962.

EXHIBITIONS
Paris 1913, no. 28; London 1972, no. 64, ill.; Paris 1973, n.p.

BIBLIOGRAPHY
Thomé 1826, 162; David 1880, 59, 638; Holma 1940, 126; exh. Paris 1948, 55; Ryszkiewicz 1967, 46–48; Wildenstein 1973, 209; Majewska-Maszkowska 1976, 316, ill.; Schnapper 1980, 68, 88; exh. Rome 1981–82, 151; Bordes 1983, 25, 97, n. 64; Gorczyca 1987, no. 2; Korshak 1987, 106, ill.; Dowley 1988, 505; Siefert 1988, 247; exh. Paris and Versailles 1989–90, 184, ill.

I n 1788 and 1789, David painted two versions of *Paris and Helen*—his most erudite essay in the "*genre agréable*" and the most overinterpreted work in his entire corpus.[1] The primary version of the subject (fig. 1), exhibited at the Salon of 1789 with its owner's name withheld from the *livret*,[2] may have been commissioned by the comte d'Artois as early as 1785–86. The composition was elaborated through a series of *croquis* and more carefully worked preparatory drawings—one of which is dated 1786—and the painting itself was expected at the Salon of 1787, where it would have made a fitting companion to *The Death of Socrates* (New York, The Metropolitan Museum of Art).[3] Prevented by illness—an accident in the studio, perhaps—from completing *Paris and Helen* in time for the Salon of 1787, David signed the painting the following year[4] and submitted it to the Salon of 1789—where it was generally well received—five weeks after its proprietor, Louis XVI's libertine and reactionary younger brother, had fled Paris for Brussels.[5]

David's "superb replica" of *Paris and Helen*,[6] signed and dated 1789 and of almost identical dimensions to the primary version, was painted for the flamboyant and extremely wealthy Polish aristocrat, Isabella Czartoryski Lubomirska (1736–1816)—the *Princesse Maréchale* who resided in Paris between November 1786 and the outbreak of the French Revolution.[7] Although Princess Isabella may have commissioned the replica as early as 1787–88, while the primary version remained in David's studio, it is not clear whether she took possession of the painting at that moment. More liberal in her political affiliations than the comte d'Artois—she was attached to reforming circles within the Polish Diet—Isabella proved less receptive to constitutional changes in her country of adoption and "emigrated" on 12 August 1789.[8] Like the comte d'Artois, she also seems to have abandoned her picture collection at this time. Lubomirska's recovery of *Paris and Helen* some nine years later was entirely due to David. The artist later noted that the replica had been sold in Paris in May 1793 for 3,500 francs,[9] and a letter from the princess's son-in-law, written from Vienna in October 1798, confirms

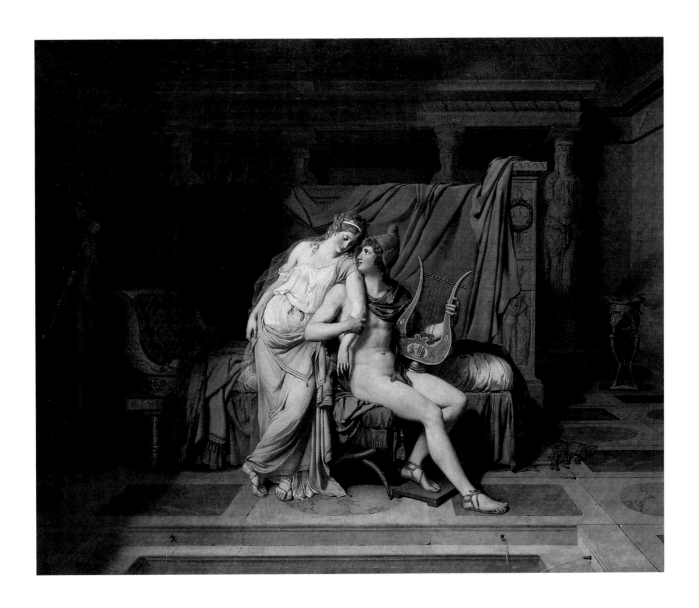

David's role in reuniting the patron with her painting. "I have just visited your mother," wrote Count Stanislaus Kostka Potocki to his wife, "who, in fact, summoned me, along with Alex, to show us her painting of *Paris* which, by a miracle, she has managed to fish up again, or which, should I say, David has fished up for her."[10]

The history of the painting between 1789 and 1798 may never be known, but David's vigilance with regard to his former client is of some interest. Before the Revolution, Princess Isabella had been a generous patron; she paid Madame Vigée Le Brun 12,000 *livres* for the *Portrait of Prince Henry Lubomirski as the Genius of Fame* (cat. no. 65, fig. 5), an unheard-of sum for a portrait of this size.[11] In the more settled period of the Directory, when David was attempting to recreate a private market for his art, his attentiveness to the *Princesse Maréchale* may not have been altogether disinterested.

For his two exalted patrons David represented a Homeric episode without precedent in French art. Although Paris, the Phrygian prince cum shepherd boy, had been variously represented in eighteenth-century painting—judging the celebrated beauty contest on Mount Ida, abducting Helen of Troy, in confrontation with Hector—the consummation of his liaison with Helen was rare in European art.[12] In fact, David's inspiration came from Italy, not France. As Antoine Schnapper has pointed out, the loves of Paris and Helen had been painted by Angelica Kauffmann in 1773 and by Gavin Hamilton ten years later. David may well have been familiar with the latter's commission for the Galleria Borghese.[13]

Above all, David returned to the narrative source; the nuptials of Paris and Helen are recounted at length by Homer in the third book of *The Iliad*. Having seduced and abducted the wife of Meneleus and thus set the Trojans against the Greeks, Paris was obliged to settle the affair in single combat. Overcome by Helen's aggrieved husband, he was rescued from battle by Venus in the form of a cloud, who shrouded Paris in mist and conveyed him to the safety of "his fragrant, vaulted chamber," there to await Helen. The goddess then assumed the guise of "an ancient dame," a wool comber "well-loved of Helen," and besought the princess, on Paris's behalf, to return home: "There he is in his chamber and on his inlaid couch, gleaming with beauty and fair raiment. Thou wouldst not deem that he had come hither from warring with a foe, but rather that he was going to the dance, or sat there as one that had but newly ceased from the dance."[14] Initially distrustful and hesitant, Helen incurred Venus's anger and had to be coerced by the goddess into returning to Paris's "beautiful

palace," where, upon seeing the prince alive, she experienced the mixed emotions of joy and guilt: "Thou hadst come back from the war; would thou hadst perished there, vanquished by a valiant man that was my former lord. . . . But, nay, I of myself bid thee refrain and war not again against fair-haired Menelaus . . . lest haply thou be vanquished anon by his spear."[15] Paris responds to these accusations by frankly declaring his passion—"come let us take our joy, couched together in love; for never yet hath desire so encompassed my soul"—quietly leading "his wife," as Homer calls her, to the nuptial couch.[16]

The elegance with which David translated Homer's account onto canvas has been little remarked upon. To suggest that David was acquainted with this passage through Horace's brief summary does little justice to the scrupulousness with which the artist customarily prepared his history paintings.[17] Set in Paris's "fragrant . . . chamber"—the perfume provided by the *athénienne* at right—*Paris and Helen* portrays Helen's submission with an understatement and discretion worthy of Homer. The urgency of Paris's passion is revealed only by his ardent profile and the pressure he applies to Helen's left arm. Helen's posture—head bowed, eyes closed in modesty, full breasts visible through the translucent chiton—perfectly captures her state of mind: regretful, yet willing.

The genesis of *Paris and Helen* has been fairly well established, and the deliberation with which David arrived at this meticulously furnished interior has been much commented upon. Initially, Helen was shown seated (fig. 2) as described in Homer, imploring, or "chiding," her lord.[18] Furthermore, the profusion of amatory ornament and archaeological reference in the finished painting—so exhaustively decoded to reveal David's "hidden agenda"—appears to have been something of an afterthought; in neither of the finished compositional studies are the furnishings *à l'antique* decorated with any specificity. Indeed, in David's first preparatory study (fig. 3), the martial is given precedence over the marital; a shield and spear, reminiscent of the arms in the background of the preparatory drawing and sketch for *The Oath of the Horatii* (Lille, Musée des Beaux-Arts; Paris, Musée du Louvre), hang on the back wall, just above the head of the bed.[19] In the dated *Study for Paris and Helen* (fig. 4), these weapons have disappeared, and David introduces the gratuitous figure of Cupid, his right leg caught up in his bow. Only after establishing the pose and proportions of his figures did David turn his attention to the setting.

Nonetheless, it is the wealth of archaeological references in *Paris and Helen* that has so intrigued commentators from David's time to our own.[20] Not

that his erudition was always favorably received. Chaussard described Paris as "a Hercules trying to play the lyre," and dismissed Goujon's tribuna in the background as a "striking anachronism."[21] More recently, David's classical quotations have been considered "pedantic" and have been interpreted as the consequence of an impoverished imagination.[22] Yet if, as Régis Michel was the first to note, these quotations are never arbitrary, their meaning and function may be a great deal less arcane and insidious than has been claimed.

The symbolism of the decor in *Paris and Helen* acts as a subtext accompanying the central narrative of David's canvas. Homer ended his account by referring to Helen as Paris's "wife," and nuptial imagery abounds in a composition whose "exemplary conjugality" has been noted.[23] Venus and Cupid are thus the deities to whom due honor is paid. Surmounting the column at left, "Venus Pudica," based on the *Venus Victrix*—her name inscribed in Greek—holds the golden apple of Discord in her left hand. She is shown again, receiving the prize, on the medallion decorating Paris's lyre. At the foot of the column, between the sphinx and the griffin, is the figure of a veiled woman, a symbol of the modest bride, derived from an antique plaque.[24] The wreath of myrtle hanging on the exposed edge of the screen behind the wedding couch is another commonplace nuptial ornament.

The motifs decorating the bed and screen otherwise refer to Paris and Helen's liaison. On the far left of the bed is a gilded relief of Jupiter seducing Leda in the form of a swan—possibly copied from Ammannati's sculpture—an obvious allusion to Helen's parentage, inspired, perhaps, by Homer's comment that she was "sprung from Zeus."[25] At Leda's feet is a giant torch similar to the freestanding candelabra included in both preparatory drawings—another hymeneal reference now incorporated as decorative motif. To the left of this group, almost impossible to discern, is a loutrophoros—a long-necked vase used for bringing water for the ceremonial bath on the eve of marriage—which had appeared quite prominently in the foreground of the preparatory oil sketch for *Paris and Helen* (Private Collection).[26] Underneath the myrtle wreath on the screen, Mercury's face appears alongside the caduceus, his herald's staff—another allusion to Paris's judgment of the three goddesses, who had been escorted to Mount Ida by this Messenger of the gods. Below Mercury is a relief of *Cupid and Psyche* based on the Capitoline statue—the figure of Psyche is shown winged in David's painting—symbolizing Love's victory.[27]

Not only have several well-known monuments of antiquity been domesticated as decoration for Paris's bedroom—the most extreme example of furnishing in *le goût grec*—but the figures of Paris and Helen themselves are consciously modeled on antique prototypes. The figure of Paris—legs crossed, sporting a Phyrgian cap—is taken from a Greek vase published in the *Recueil des Antiquités Étrusques, Grecques, et Romaines tirés du Cabinet de Mr. Hamilton*, a compendium from which David made innumerable tracings during his student days in Rome.[28] The standing figure of Helen has been related to several antique sculptures, the most appealing of which is a bas-relief of Paris (fig. 5) in the Galleria Borghese, whose pose she imitates.[29] For the grouping of the two lovers, David may have looked to an antique medallion representing *Mars and Venus*, a rather obvious borrowing that seems to have irritated Chaussard.[30] The single discordant element in this mosaic of references would appear to be the tribuna in the background, festooned with swags of myrtle. The staring caryatids, their peploses tightly knotted at the waist, are copied from Jean Goujon's Renaissance masterpiece in the *salle des Cent-Suisses* in the Louvre.[31] Schnapper considered David's quotation of this group somewhat surprising.[32] Although Goujon's reputation as the father of modern sculpture was being established at the very moment that David was at work on *Paris and Helen*, David's inclusion of this monument is less an example of cultural jingoism than a witty allusion to the tribuna's function in the Louvre.[33] In the 1780s, the *salle des Cent-Suisses* housed the Royal Collection of Greek and Roman antiquities, and David can be said to have transformed Paris's fragrant chamber—complete with Roman impluvium—into a private *salle des antiquités*.[34]

Daunting only in its accumulation, David's symbolism is neither recondite nor obscure; the monuments he incorporates are familiar enough and serve to reinforce the action of his principals. In April 1793, David might confide to his pupil Jean-Joseph Sue that *Paris and Helen* was his first attempt "in the Greek and thoroughly antique manner,"[35] but this was antiquity functioning as decoration, to be enjoyed by an aristocratic milieu in which ancient Greece was intermittently topical and fashionable.[36] It is doubtful that any of David's references in *Paris and Helen* were intended to be ironic, let alone subversive.[37] Nor is it clear whether, as early as 1788–89, David was seeking to reform his style; Delécluze's comment that the decision to paint Paris nude—or nearly so—was the first step in his master's campaign to recover a truly Attic manner was made with the benefit of hindsight.[38] Nor was David's larger purpose, if he had one, commented upon by critics of the Salon of 1789, who equally failed to mention any of his references to the antique. While admitting that the "*genre gracieux*" was something of a departure for David, they praised the grace,

elegance, and voluptuousness of *Paris and Helen*; yet, with the exception of Carmontelle, the critics devoted their more expansive comments to David's principal submission to the Salon of 1789, *The Lictors Bringing Brutus the Bodies of His Dead Sons* (Paris, Musée du Louvre).[39] It will suffice to note Cochin's enthusiastic account of the painting in a letter to his friend Descamps, a characteristically generous and concise summary which deserves to be better known: "It is a masterpiece of grace, purity, and the most precious finish. It is painted with great clarity and perhaps rather too much so. If this is a slight failing, which detracts a little from the overall effect, David's manner creates agreeable works which will outlive those paintings in which darker tones predominate. And the aim of painting is to please, after all."[40]

Paris and Helen seems to have pleased uncommonly well; it is David's only private commission of the 1780s to have been repeated. Although David, assisted by his most gifted pupils, was in the habit of producing replicas of his monumental history paintings for private collectors—a reduced *Belisarius* (Paris, Musée du Louvre) for the comte d'Angiviller, a cabinet picture of *The Oath of the Horatii* (The Toledo Museum of Art) for the comte de Vaudreuil—the replica of *Paris and Helen* is distinguished from these in two ways.[41] First, in its relationship to the original: only a few centimeters smaller on each side, the replica is not reduced in scale. Second, its quality is such that it is the single replica for which David's authorship is largely unquestioned. For once, the vexed issue of studio assistance—Girodet or Gérard—seems irrelevant.[42]

The differences between the two versions are slight, mainly a question of variant tonalities. In the replica, Helen wears a mustard yellow himation—the outer garment worn by the Greeks—over her transparent bodice (in the primary version her dress is coral). Both lovers are portrayed with darker curls; the transition from blond to brunette is at its most striking in Paris's coiffure. Finally, there are slight changes of detail in the bedding and upholstery.[43] However, the same sophisticated and frigid color harmonies remain: blue, mauve, and silvery gray, juxtaposed with red and orange. Only the emphases have shifted.

In terms of quality of execution, however, the differences between the two works are harder to describe. In the replica, the immodest blush that betrays the young lovers' passion is less competently handled; Paris's red cheeks, in particular, stand out. Indeed, his naked form has lost something of its milky white purity; the flesh tones have acquired a more ruddy, and thereby rustic, appearance. Helen's limp left arm, clutched hard by the eager suitor, is painted somewhat clumsily in the replica; the leaden modeling renders it

almost inert. Yet elsewhere, the precision and delicacy of David's touch do not falter; his attention to detail, as in the primary version, is astonishing. Note, as two of several examples, the red reflections of Paris's Phrygian bonnet on Helen's golden headband, and the scarlet of the cushion picked up by the mahogany legs of the stool below.

Nor is this any less than should be expected. David painted the second version of *Paris and Helen* for one of the most cultivated and voracious collectors of French art of her day, whose interest in classical antiquity was quite the equal of David's—and considerably more profound than that of the proprietor of the first version of *Paris and Helen*. Familiar with the very contents of Sir William Hamilton's collection, Isabella Lubomirska was accompanied on her travels in France and Italy by her son-in-law, Stanislaus Kostka Potocki—whose portrait David had painted in 1781 and who is considered the founding father of classical archaeology and art history in Poland.[44]

David's access to the *Princesse Maréchale* is documented by several contemporary sources. He corresponded with the English miniaturist Maria Cosway (1759–1838), who stayed with Isabella Lubomirska at the Palais-Royal during her second visit to Paris in 1787.[45] He developed a close friendship with the American insurgent Filippo Mazzei (1730–1816)—whose portrait he painted in the winter of 1790—employed by the king of Poland in the spring of 1788 to write a twice-weekly newsletter from Paris, in which the eccentricities of the *Princesse Maréchale* provided relief from the discussion of more weighty issues.[46] Through the *Mémoires* of Potocki's traveling companion, the writer J. U. Niemcewicz, it is known that David attended the princess's Salon at the Palais-Royal, along with Greuze, Vigée Le Brun, and Hubert Robert.[47] So widely cast was the net of David's connections to Isabella's circle that there is no reason to believe that the princess would have commissioned the replica of *Paris and Helen* only after seeing the original in the comte d'Artois's bedroom at Bagatelle in May 1789.[48] That the primary version of *Paris and Helen* is unlikely to have been painted for the *folie d'Artois* at all invalidates this argument from the outset, but even the briefest survey of their mutual acquaintances reveals that the princess would have had ample opportunity to patronize David at almost any time before her precipitous departure from Paris in August 1789.

Nor is this investigation of the overlapping circles of patron and painter merely an exercise in prosopography. It was precisely the aristocratic, cosmopolitan, and cultivated milieu in which the princess moved—connected to the court, but freed of its

stifling ceremonial—that sponsored the latest wave of the classical revival in French arts and letters. From Gluck's operas—his *Parigi ed Elena* had opened to mixed reviews in Vienna in November 1770—to the abbé Berthélemy's *Voyage du jeune Anarchasis en Grèce*, from *le goût grec* to Vigée Le Brun's *souper grec*, this Parisian *beau monde* appropriated and made fashionable the "*manière grec et tout à fait antique*" in which David claimed to have painted *Paris and Helen*.[49] Of course, David's response to antiquity was far more profound than Vigée Le Brun's *divertissements*. His careful reading of Homer and his enthusiasm for Winckelmann—whose dictum of a limpid and flavorless beauty is given felicitous expression in *Paris and Helen*—are not to be gainsaid.[50] No less than in *The Death of Socrates*, the stillness and concentration of *Paris and Helen* reflect a deep-seated reverence for the austerity and refinement of antiquity. Yet classical, one might say Davidian, purity is achieved in the *manner* of painting rather than in the *meaning* of the painting—a misunderstanding that has led to aberrant readings of *Paris and Helen* as political, sexual, and social satire.[51] Much more than a "Lagrenée with genius added,"[52] David's *Paris and Helen* nonetheless transforms the essentially sterile Greek manner practiced by Lagrenée, Vien, and (briefly) Vincent into a language of finely wrought eroticism; one critic commented that it was impossible to look at David's painting without blushing.[53] In *Paris and Helen*, David modernizes mythological painting, replacing Ovid's bravura with Homer's innuendo. As was pointed out by David's first biographer, whose information came from the aged artist himself, "never before had the amatory been painted with such elevation."[54]

NOTES

1. Schnapper in exh. Paris and Versailles 1989–90, 184–88, for the best summary of recent literature; see also Michel in exh. Rome 1981–82, 148–52, for a brilliant, if not altogether tenable, interpretation of the picture, and Siefert 1988, 247–49, for a thorough review of the Salon criticism.

2. Furcy-Raynaud 1906, 262, letter from Cuvillier to Vien, 10 August 1789, "Je pense avec vous, M^r., que son tableau de *Pâris et Hélène* peut être exposé sans laisser aucune crainte en taisant le propriétaire."

3. Schnapper in exh. Paris and Versailles 1989–90, 188–91, for the preparatory drawings; *Collection Deloynes* XV, no. 379, *L'Ami des Artistes au Sallon*, 1787, "le public apprendra avec bien de regrets qu'une longue maladie de ce grand Artiste l'a empêché de finir un autre Tableau, dont la composition gracieuse et galante auroit contrasté avec la sévérité de celui de Socrate; c'est *Pâris et Hélène*."

4. The painting is inscribed at lower left: "L. David faciebat/Parisis anno MDCCLXXXVIII."

5. Herbert 1972, 137, for the details of d'Artois's emigration.

6. Schnapper in exh. Paris and Versailles 1989–90, 184, "une superbe répétition."

7. Majewska-Mazkowska 1976, 601–17, for the best summary in English on this interesting figure. I am most grateful to Anna Gorczyca for letting me read her unpublished study, *Les Amours de Pâris et Hélène*, Mémoire inédit de D.E.A., Paris IV, 1987.

8. Majewska-Mazkowska 1976, 604; Bock 1977, 89.

9. David 1880, 638, "Notes de David—Répétition peinte en 1789 pour la princesse Lubomirska; en vente à Paris en mai 1773 [sic] adjugée 3,500 f." The date should read 1793; I have not been able to trace David's painting in any of the five sales recorded by Lugt for the month of May 1793.

10. Potocki's letter of 24 October 1798, published by Majewska-Mazkowska, is quoted by Schnapper in exh. Paris and Versailles 1989–90, 184, "Je reviens de chez ta mère qui m'a fait chercher ainsi qu'Alex pour nous faire voir son tableau de *Pâris* qu'elle a miraculeusement repêché ou plutôt que David a repêché et lui a renvoyé."

11. Bock 1977, 83–84, 89–90, who notes that Vigée Le Brun had retained the *Portrait of Prince Henry Lubomirski as the Genius of Fame* in order to exhibit it at the Salon of 1789, and that the portrait was returned to the princess in Warsaw in 1796.

12. Although Bachaumont et al. 1777-89, XXXVI, 320, considered the subject of Paris "bien rebattu," it had not been exhibited at the Salon before. *The Judgment of Paris* had been painted by Louis de Boullongne (Salon of 1699), Bon de Boullongne (Salon of 1704), Surugue (Salon of 1742), Lagrenée (Salons of 1759 and 1777), and Pierre (Salon of 1761, see cat. no. 53); Boullongne had painted *The Abduction of Helen* (Salon of 1704). Challe and Vien had both treated *Hector Reproaching Paris for Having Remained in Helen's Arms* (Salons of 1765 and 1779, respectively).

13. Schnapper in exh. Paris and Versailles 1989–90, 186.

14. Homer, *The Iliad*, III, 341–95.

15. Ibid., 428–36.

16. Ibid., 441–48.

17. Coche de La Ferté and Guey 1952, 133–34; Michel in exh. Rome 1981–82, 149.

18. Michel in exh. Rome 1981–82, 149.

19. Schnapper in exh. Paris and Versailles 1989–90, 168–71, for the preparatory studies for *The Oath of the Horatii*.

20. Polak 1948–49, 287–315, and Coche de La Ferté and Guey 1952, 129–61, remain the standard accounts. I have confined myself to the latter article, which resumes and expands Polak's more ambitious survey.

21. Chaussard 1806, 157, "C'est Hercule qui veut pincer la lyre . . . l'Architecture, par un singulier anachronisme, est empruntée de celle du Louvre."

22. Kemp 1968, 269; Coche de La Ferté and Guey 1952, 158, "Cet effort de création est si limité, que, dans l'ensemble, la fidelité archéologique l'emporte sur l'imagination."

23. By Régis Michel in exh. Rome 1981–82, 151, "Le couple turbulent de l'Iliade devient exemplairement conjugal."

24. Coche de La Ferté and Guey 1952, 148–49; Korshak 1987, 108.

25. Coche de La Ferté and Guey 1952, 79–80; Homer, *The Iliad*, III, 418.

26. Coche de La Ferté and Guey 1952, 151; Schnapper in exh. Paris and Versailles 1989–90, 184, fig. 62, for the preparatory oil sketch.

27. Michel in exh. Rome 1981–82, 149, noting the eighteenth-century fame of the Capitoline sculpture.

28. Coche de La Ferté and Guey 1952, 136–37; Picard 1952, 106; Michel in exh. Rome 1981–82, 66, 69, n. 39, for David's drawings after the antique.

29. Gorczyca (as in n. 7) made the comparison in her unpublished *Mémoire*. It should be added that the figure of Paris in David's painting wears his tunic off the shoulder, as in this sculpture. Michel in exh. Rome 1981–82, 149, proposes the *Borghese Faun* as a model for Helen's "Praxitelean posture."

30. Coche de La Ferté and Guey 1952, 139; Chaussard 1806, 157, "L'Hélène est commune; Le Pâris est dessiné d'après une médaille."

31. Coche de La Ferté and Guey 1952, 154–58; Michel in exh. Rome 1981–82, 150; Korshak 1987, 105, 107; Schnapper in exh. Paris and Versailles 1989–90, 186.

32. Schnapper 1980, 89.

33. Michel in exh. Rome 1981–82, 150, discusses the rehabilitation of Goujon's reputation in the mid-1780s by Quatramère de Quincy and suggests that David's choice of the tribuna might have been influenced by the theoretician's polemic.

34. Dézallier d'Argenville 1787, II, 112, "Au Louvre dans la salle des Cent-Suisses, qui est aujourd'hui la salle des antiques, on remarque une tribune enrichie d'ornamens très-proprement travaillés et soutenue par quatre cariatides de douze pieds de haut."

35. For the *Autobiographie de David*, dated April 1793, Bordes 1983, 174–75, "Il ne fit pas de cet agréable que l'on avait vu jusqu'alors et il le fit à la manière grecque et tout à fait antique."

36. As noted by Schnapper 1980, 88–89.

37. Korshak 1987, 102–16, for the most extreme example of this sort of interpretation, and Dowley 1988, 504–12, for a polite and considered rebuttal of her arguments.

38. Delécluze 1855, 122, "Le Pâris est même représenté nu, ce qui ne rend le sujet ni plus agréable, ni plus satisfaisant, mais indique au moins l'époque précise où David a eu les premières velléités d'adopter l'usage de peindre ses personnages sans aucun vêtement, selon l'usage des artistes grecs."

39. Siefert 1988, 248–49, for a full listing of the Salon criticism.

40. For Cochin's letter of 20 September 1789, Michel 1986, 88, "Son autre tableau est *Pâris et Hélène*. C'est un chef d'oeuvre de grâce, de pureté, et du fini du plus précieux. Il est dans un système très clair, et même peut-être un peu trop, mais si c'est en quelque manière un petit défaut qui nuit un peu à l'effet, c'est en même temps le moyen de faire des tableaux plus agréables et d'une bien plus longue durée que ceux forcés en noir, le but de la peinture est de plaire."

41. Schnapper in exh. Paris and Versailles 1989–90, 136–37, for the reduced *Belisarius*, and 162, for a brief discussion of The Toledo Museum of Art's *Oath of the Horatii*; Wintermute in exh. New York 1989, 113–19, and Crow 1989 (B), 47–51, for a study of the unfinished studio replica of *The Death of Socrates* (The Art Museum, Princeton University).

42. Girodet's legatee, P.-A. Coupin, upon whose witness Crow so depends in his recent article (as in n. 41), claimed that almost every canvas signed by David was painted with the assistance of his pupils. Regarding *Paris and Helen*, Coupin 1827, 62, notes that the caryatids were painted by Gérard, the design of the background was provided by Girodet, and Isabey was responsible for the column with Venus at left. Unfortunately, Coupin does not discuss the authorship of the *répétition* of *Paris and Helen*. I am grateful to Jean-Loup Champion for his help with Coupin's "Appendix."

43. In the replica, Paris is seated on a scarlet cushion, similar in color to his cap; in the primary version, his cap and stool are painted a more subdued shade of red. In the replica, the pillow at the head of the bed has lost both its elaborate embroidery and blue lining. The drapery that hangs across the screen, blue mauve in the primary version, is painted slate blue in the replica.

44. Zoltowska 1974, 325–33; Majewska-Mazkowska 1976, 602–5.

45. Bordes 1983, 24–25.

46. Bordes 1981, 159–62.

47. Zoltowska 1977, 331–32; Bordes 1983, 24, 97, n. 64.

48. Schnapper in exh. Paris and Versailles 1989–90, 184, following Gorczyca's thesis. For a discussion of d'Artois's patronage of living artists, see Bailey 1988 (B), 73–80.

49. Mosser 1983, 155–67; Schnapper 1980, 88–89.

50. Kemp 1968, 266–70; Michel in exh. Rome 1981–82, 149–50, for the most impassioned argument on the influence of Winckelmann's Neoplatonism.

51. Michel in exh. Rome 1981–82, 149, and, above all, Korshak 1987, 102–6.

52. Schnapper 1980, 89.

53. *Collection Deloynes*, XVI, no. 420, *Le Frondeur au Salon*, "Regardez cette pose d'Hélène: ne sentez-vous pas circuler dans vos veines une partie de ce feu qui consume Pâris."

54. Anonymous 1824, 32, "Jamais on n'avait vu la galanterie traitée avec autant d'élévation"; Schnapper in exh. Paris and Versailles 1989–90, 18–19, has established David's collaboration in the *Notice sur la vie et les ouvrages de M. J.-L. David*.

Fig. 1
Jacques-Louis David, *Paris and Helen*, 1788, oil
on canvas, Paris, Musée du Louvre

Fig. 2
Jacques-Louis David, *Paris and Helen*, c. 1788, black chalk drawing, Stockholm, Nationalmuseum

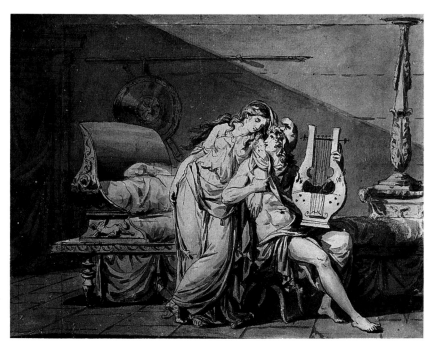

FIG. 3
Jacques-Louis David, *Paris and Helen*, c. 1788, pen and black ink
and gray wash drawing over pencil, Private Collection

FIG. 5
Paris, bas relief sculpture, Rome, Galleria
Borghese

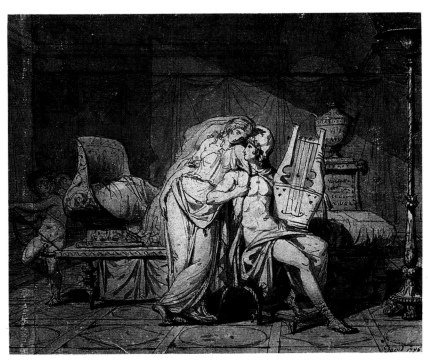

FIG. 4
Jacques-Louis David, *Study for Paris and Helen*, 1786, pen and black ink
and gray wash drawing over pencil, Malibu, The J. Paul Getty Museum

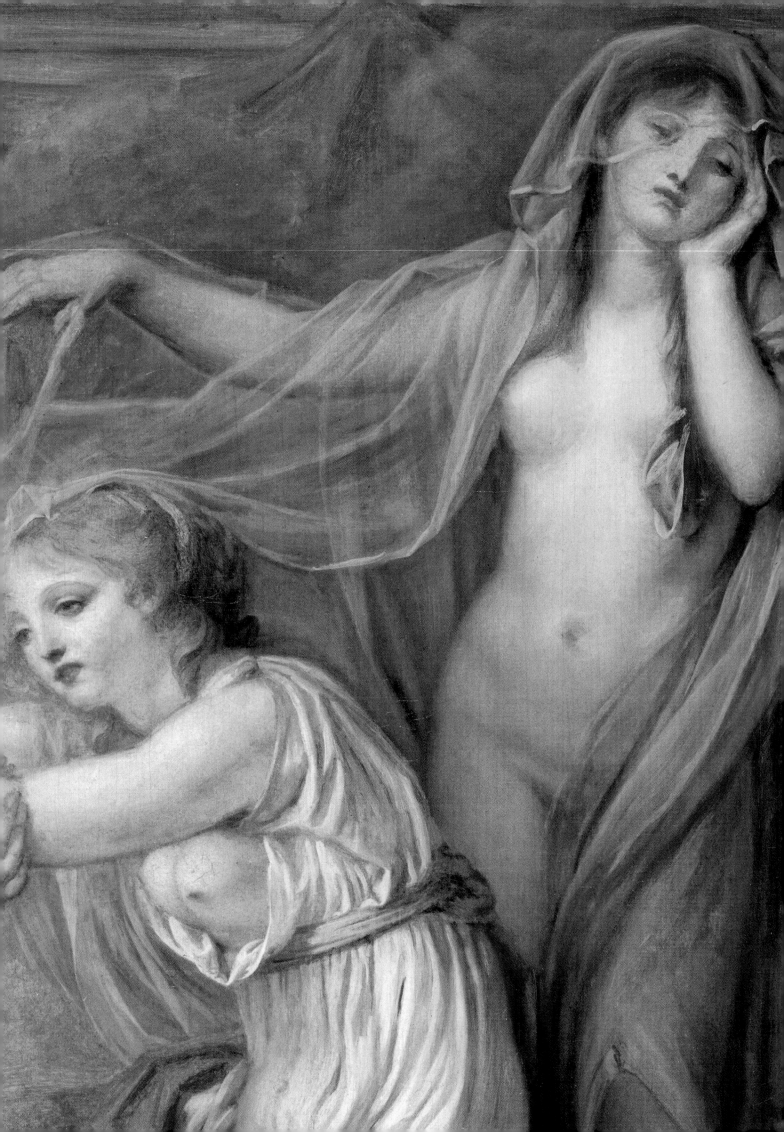

JEAN-BAPTISTE GREUZE
(1725–1805)

Born in Tournus in August 1725, Greuze was sent by his father in the late 1740s to study with the most prominent artist of the province, the obscure Charles Grandon (1691–1762) of Lyons. Around 1750 Greuze moved to Paris, where he became a student at the Academy and was befriended by the sculptor Jean-Baptiste Pigalle, who in turn brought him to the attention of Louis de Silvestre, director of the Academy and drawing master to the royal family. Greuze's splendid portrait of Silvestre (Munich, Alte Pinakothek) was one of his first Parisian works and, along with paintings such as *The Family Bible Reading* (Paris, Private Collection), was eventually exhibited at the Salon of 1755, leading to Greuze's conditional acceptance into the Academy in June of that year.

In September 1755, independent of Academy sponsorship, Greuze left for Italy in the company of Louis Gougenot, abbé de Chezal-Benoît. Based on the quality of works he sent to Paris from Italy, Greuze came to the attention of the marquis de Marigny, who commissioned two paintings from the artist for Madame de Pompadour, *Simplicity* (1759, Fort Worth, Kimbell Art Museum) and *Young Shepherd Holding a Flower* (1761, Paris, Musée du Petit Palais), both completed after Greuze's return to Paris. Greuze arrived in Paris in April 1757 and exhibited genre paintings he had executed in Italy at the Salon of that year, for example, *The Broken Eggs* (1756, New York, The Metropolitan Museum of Art) and *The Neapolitan Gesture* (1757, Worcester Art Museum). These works reveal his admiration for seventeenth-century Dutch genre painting as well as his fascination with expression, local color, and anecdotal detail.

Greuze's success at the Salon of 1757 attracted the attention of important collectors such as Ange-Laurent de La Live de Jully, whose portrait he painted around 1757 (Washington, National Gallery of Art) and who owned ten of his paintings; Jean de Jullienne, Watteau's erstwhile pa-

tron; and the marquis de Marigny. Diderot, Greuze's most famous and steadfast admirer, also contributed to his early fame by praising the sentimentality, morality, and drama of *The Marriage Contract* (Paris, Musée du Louvre), which was exhibited at the Salon of 1761. Another admirer, the abbé de La Porte, said of this painting, "His brush can ennoble the rustic genre without altering its essential truth."

Greuze continued to receive accolades at the Salon until 1767, when, after waiting twelve years, the Academy demanded that he submit his *morceau de réception*, withholding the privilege of exhibiting at the Salon until he did so. Eager to be accepted into the Academy as something more than a mere genre painter, Greuze decided to present a history painting and altered his style accordingly. His reception piece, *Septimius Severus Reproaching Caracalla* (Paris, Musée du Louvre), reflects his study of Rubens's Medici cycle in the more fluid, spontaneous handling of paint, while the emotional tenor and compositional structure are indebted to Poussin, above all the great *Death of Germanicus* (Minneapolis Institute of Arts). *Septimius Severus Reproaching Caracalla* was not well received at the Academy in July 1769; Greuze was relegated to the status of genre painter but he was informed of this decision only after he had taken his oath of membership. As both members of the Academy and perceptive critics acknowledged, this ambitious work fell below the standards required of such an austere subject. Furious with this judgment, Greuze severed his ties with the Academy and thereafter exhibited his paintings at his studio to coincide with the Academy's biennial Salon.

Greuze now returned to painting naturalistic, Dutch-inspired genre paintings, but increasingly employed the narrative devices of French history painting to engage the viewer more effectively. As a consequence, his compositions conveyed narrative through classical structure, there-

by creating a hybrid in the hierarchy of genres—a type of painting that elevated the moral tone of genre. Greuze's two great masterpieces, *The Father's Curse: The Ungrateful Son* and *The Father's Curse: The Punished Son* (1777 and 1778, both Paris, Musée du Louvre), painted almost a decade after the debacle with the Academy, are the ultimate expressions of the artist's mature style.

In spite of Greuze's success with such works and the constant patronage of an international clientele—the Russians in particular— he was always in need of money, thanks to the profligate ways of his difficult wife, Anne-Gabrielle Babuty, whom he had married in February 1759. Avaricious and vulgar, she conducted business on her husband's behalf, embezzled large sums of money, and engaged in illicit liaisons with both his clients and his students. Unwilling to tolerate her behavior any longer, Greuze had the marriage annulled in August 1793.

In order to maintain his household, Greuze formed partnerships with the printmakers who made engravings after his works, and began producing in increasing number sentimental and salacious images of young women, which reflect the darker side of his *sensibilité*. A sympathizer with the Revolution, Greuze exhibited at the *Salon de l'Encouragement des Arts* in 1790 and became a member of the *Commune des Arts* in October 1793. He painted a few early portraits of Napoleon (e.g., 1792, Musée National des Châteaux de Versailles et de Trianon) and other revolutionary figures, such as Armand Gensonné (c. 1792, Paris, Musée du Louvre), Jean-Nicolas Billaud-Varenne (c. 1793, Dallas Museum of Art), and Fabre d'Eglantine (c. 1792, Paris, Musée du Louvre). In spite of these commissions and a pension from the Royal Exchequer—paid irregularly— Greuze's fortunes declined rapidly, and in 1801 he wrote to Lucien Bonaparte that he had lost everything. He died a pauper in March 1805.

JEAN-BAPTISTE GREUZE, *Psyche Crowning Cupid* (detail), c. 1790, oil on canvas, 147 x 180 cm, Musée des Beaux-Arts, Lille.

JEAN-BAPTISTE GREUZE
Psyche Crowning Cupid

65

JEAN-BAPTISTE GREUZE (1725–1805)
Psyche Crowning Cupid, c. 1790
Oil on canvas
147 x 180 cm.
Musée des Beaux-Arts, Lille

PROVENANCE
Collection of the artist; by descent to Anne-Geneviève Greuze, called Caroline (1762–1842), her sale, Paris, 25–26 January 1843, no. 1; Meffre, his sale, Paris, 25–26 November 1845, no. 33; comte de Morny, his sale, Paris, 24 May 1852, no. 8; Alexandre Leleux, Lille, who bequeathed the painting to the Musée de Lille in 1873.

EXHIBITIONS
Valenciennes 1918, no. 145, ill.

BIBLIOGRAPHY
Lejeune 1864, 282; Lille 1875, no. 247; Lille 1893, 127; Mauclair 1906, no. 41; Benoit 1909, 392; Leblanc 1932, 19; Brookner 1956, 199; Vergnet-Ruiz and Laclotte 1965, 238; Lille 1970, no. 68, ill.; Brookner 1972, 130, ill.; exh. Hartford, San Francisco, and Dijon 1976–77, 200; Bock 1977, 85, ill.; Vilain 1980, 114; exh. Clermont-Ferrand 1984, 28; Oursel 1984, 53–54, ill.

"We often meet with Images of *Psyche* and *Cupid* in the ancient Monuments; their Marriage is represented there; but the Marbles and Gems do not agree with the History we have related just before."[1]

Nor, it might be added, does Greuze's *Psyche Crowning Cupid*—a late and unfinished masterpiece which has little to do with Apuleius's prolix, but engaging, fairy tale. Nearly everything about this history painting remains frustratingly incomplete. Although Greuze must have prepared *Psyche Crowning Cupid* with his customary thoroughness—preparatory drawings are recorded for all the figures and even for the pair of doves—not a single study has survived.[2] No trace of the painting is to be found in the inventory of the artist's possessions made at the time of his divorce in September 1793,[3] yet it is likely that *Psyche Crowning Cupid* was included in the group of "ten large- and medium-sized paintings, sketches of mythological and historical subjects," recorded in Greuze's studio at the time of his death in March 1805.[4] The argument for *Psyche Crowning Cupid*'s having remained in Greuze's family is confirmed by its appearance—along with at least four preparatory drawings—in the collection of the artist's second daughter, Anne-Geneviève Greuze, called Caroline (1762–1842).[5] According to Théodore-Michel Lejeune (c. 1817–1868), the author of one of the first documented surveys of eighteenth-century French painting, *Psyche Crowning Cupid* was "almost entirely repainted" after being sold in January 1843 "on the pretext of finishing it."[6] His claim that *Psyche Crowning Cupid* had lost its "virginal purity"—a description particularly inappropriate for this painting—must be seriously questioned after its recent cleaning, which confirms that the canvas was painted by the same hand throughout. Nonetheless, *Psyche Crowning Cupid* continues to perplex commentators.[7] Although recently characterized as "a grisaille in brown," the inventory of 1805 had taken care to describe Greuze's paintings as sketches; while the figures in *Psyche Crowning Cupid* are fully modeled, the background and accessories are little more than laid in, or sketched in the most summary of strokes. If considerably more than "one-third of the

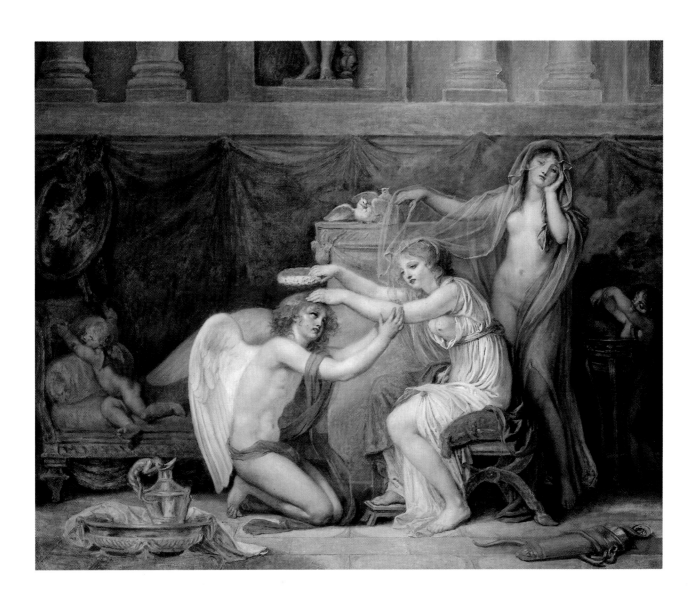

work"—as the artist termed his *ébauches*[8]—*Psyche Crowning Cupid* remains a painting in progress, as is confirmed by comparison with the finished *Innocence Carried off by Cupid* (fig. 1), a "near pendant" which left Greuze's studio in the mid–1780s.[9]

If the status of *Psyche Crowning Cupid* has been contested, so has its stature. Nothing is known of its commission—if indeed it was commissioned—nor is the painting mentioned in any contemporary source. While historians concur that it is a late work, there is little agreement as to whether it was painted before or after 1789. Edgar Munhall has tentatively dated *Psyche Crowning Cupid* to around 1785; Anita Brookner and Jacques Vilain place it later, to the 1790s.[10] Yet, whereas Vilain lamented the absence of this "magnificent painting" from the important monographic exhibition of 1976, Brookner, in her elegant summary of Greuze's late style, dismissed *Psyche Crowning Cupid* as "a dab at neoclassicism. . . a large melancholy piece overflowing with bric-a-brac."[11]

It may never be possible to answer some of the most rudimentary questions concerning this late mythology. For whom was it painted? When, precisely, was it executed? Was it abandoned, and if so, why? Languid and prurient, the painting appeals nonetheless. In representing the consummation of innocent and untarnished love, Greuze employs conventional vocabulary to evoke enervation and lassitude. The joyous union of Cupid and Psyche is rendered with a "martyr's prestige," and filtered through the lens of disaffected experience.[12]

"*Psyche Crowning Cupid*. Seated, Psyche is about to place the white crown of Purity on the kneeling Cupid's head. Behind her, the figure of Modesty veils herself. In the background, an amor places two crowns of roses on the bed while another, at right, pours incense onto a perfume burner."[13] To this succinct description should be added that the crowning takes place before an imposing but unornamented altar upon which a pair of doves are seated and that the accessories in the foreground relate to the preparations undertaken by both participants. The ewer and basin at left refer to Psyche's ritual purification before the wedding; Cupid's quiver of arrows, cast to one side, symbolizes his newfound constancy. The marriage bed at left is also blessed by the image of the Sun, gazing down from a shield attached to the swag of mauve brown drapery.

Despite the plethora of classical references, the subject of *Psyche Crowning Cupid* is not to be found in any narrative source, nor is its iconography sanctioned by pictorial tradition. Apuleius, and Lafontaine after him, had described in some detail the consummation of the marriage, in which Psyche, bathed and rested, is visited at night by Cupid, whom she is not permitted to see.[14] At the end of *The Golden Ass*, Apuleius recounts their marriage for a second time, when Psyche is finally admitted to the Assembly of the Gods and reunited with her husband in a magnificent celebration of nuptials.[15] Clearly, *Psyche Crowning Cupid* relates to neither of these episodes; it is not, strictly speaking, a marriage scene at all. Rather, Greuze employs the motif of the Lover Crowned—yet in a curious reversal of roles, for it is now Cupid who is supplicant and the virginal Psyche who anoints him. Greuze's dependence upon this commonplace theme of spurious antiquity, which had first appeared in French painting at midcentury, is altogether characteristic of the old-fashioned resonance of *Psyche Crowning Cupid*. Rooted in *le goût grec* popular in the artist's early maturity, the composition is a variant of Greuze's earlier *Votive Offering to Cupid* (fig. 2), exhibited at the Salon of 1769.[16] Though fuller in bloom, the chestnut-haired Psyche is similar to the dubious virgin who appeals to Cupid; their Grecian costumes are identical, as is the mawkish disjunction between face and body noted with some asperity by Diderot. Of the girl in the *Votive Offering to Cupid*, he commented, "her face suggests one age, and her body another," a criticism that could be applied to the bare-breasted Psyche in *Psyche Crowning Cupid*.[17]

Not only does the principal motif in *Psyche Crowning Cupid* derive from the mildly erotic hymeneal pictures popular during the Enlightenment, its classical paraphernalia can also be related to the studio props that had first infiltrated history painting in the 1750s. The *lit à l'antique* in the background, the incense-burning *athénienne* at right, the stool with its oversize *pieds de biche* upon which Psyche is seated: these are standard ornaments in *le goût grec*, fashionable some thirty years earlier but outmoded to a generation witnessing the more austere and authentic classicism of David and his pupils.[18] Greuze's attempts to go beyond the merely decorative do not altogether succeed in elevating the register of his canvas. For the figure of Modesty, whose voluminous veil covers very little of her own body but trails unceremoniously over Psyche's head, Greuze has looked to illustrations in Ripa (fig. 3), as well as to contemporary revisions of the *Iconologia*; her eyes cast down and blushing, his vestal displays the same insidiousness as the figures she attends.[19] Even more incongruously, and with complete disregard for the particulars of the myth of Psyche, Greuze has depicted Venus presiding over the marriage of her son. Between the bases of the engaged Ionic capitals in the background are seen the legs and telltale dolphin characteristic of *Venus de' Medici*, a statue that occasionally appears in other history paintings and portraits by Greuze, and of which he owned a bronze-colored plaster replica.[20]

Perhaps the most poignant aspect of this intensely mannered work is Greuze's manic eclecticism—he pillages both the ancients and the moderns—coupled with his obsessive self-referentiality. For the figure of Cupid, an adolescent with enormous wings, Greuze may have looked to examples in contemporary statuary, such as Bouchardon's *Cupid Carving His Bow from Hercules' Club* (fig. 4) or Houdon's *Morpheus* (Paris, Musée du Louvre).[21] The striking similarity in pose and features between Cupid and the sitter of Vigée Le Brun's *Portait of Prince Henri Lubomirski as the Genius of Fame* (fig. 5), painted early in 1789, presents the intriguing possibility that Greuze drew inspiration from the work of one of his most successful pupils.[22] Historians have also pointed to the Davidian influences in *Psyche Crowning Cupid*. Set in a severely classical stone basement—with draperies pinned to the wall as in David's *Andromeda Mourning* (Paris, École Nationale Supérieure des Beaux-Arts, on deposit to the Musée du Louvre) and marble tiles that recall the floor plan of *Paris and Helen* (cat. no. 64)—*Psyche Crowning Cupid* also shares the cold tonalities, enameled coloring, and rigorously planar structure of the latter work.[23]

Yet, underlying *Psyche Crowning Cupid* are reminiscences of Greuze's earlier and generally ill-fated incursions into history painting. The bed, the altar, the furnishings with their ungainly *pieds de biche*—even the little footstool—are props that had first been used in *Septimius Severus Reproaching Caracalla* (Paris, Musée du Louvre).[24] A diminutive version of the winged Cupid had earlier appeared in Greuze's drawing *Anacreon in His Old Age Crowned by Love* (New York, The Pierpont Morgan Library), and the grotesque animal drinking from the golden ewer at left is a variant on the ornamental incense burner in *The Love Letter* (New York, Private Collection), a drawing of the mid-1770s.[25]

Greuze oscillated precariously between these nostalgic and contemporary modes of classicism. If not quite "doomstruck," *Psyche Crowning Cupid* communicates a highly pitched, almost hysterical, eroticism, far removed from the certainties of David's forcefully segregated antiquity.[26] Taken together with *Innocence Carried Off by Cupid*, dated to before 1786, and the magisterial *Young Girl and Death* (fig. 6), a drawing of the 1790s, a dark vision of sexuality emerges in Greuze's late work.[27] In the supposedly chaste *Psyche Crowning Cupid*, there is little sign of rejoicing; the participants appear either exhausted or depressed, and the ceremony of matrimony produces neither pleasure nor enthusiasm. Perhaps it is not entirely fortuitous that the single study associated with this painting, the vigorous wash drawing variously entitled *Woman Crying on a Tomb* and *The Afflicted Woman* (fig. 7), employs a pose very similar to that of Psyche's, but to funereal ends.[28] In Greuze's smoke-filled wedding chamber one senses both the corruption of the spirit and a premature loss of innocence. In this regard, *Psyche Crowning Cupid* remains at an equal distance from the archaeological frigidity of Lagrenée the younger's *Psyche in the Enchanted Palace* (fig. 8) and the refinement of Gérard's Neoplatonic *Cupid and Psyche* (Paris, Musée du Louvre).[29]

In *Psyche Crowning Cupid*, Greuze's message is somber and troubling. If, as David d'Angers recollected, the artist chose to "poetize the pleasures of the senses by idealizing them," Greuze has crafted a miserable image of matrimony, yet one that was consistent with his own sorry conjugality.[30] It should be remembered that in 1785 Greuze had finally initiated divorce proceedings against his terrible wife, Anne-Gabrielle Babuty—who both cuckolded and robbed him—and that the couple legally separated in August 1793.[31] These are the very years during which Greuze was at work on *Psyche Crowning Cupid*. Thus, the story of Cupid and Psyche, traditionally understood as a "transparent allegory of the Soul,"[32] may have had more personal implications for Greuze than he was prepared to admit. On one level, perhaps, his unfinished canvas depicts a disenchanted soul in torment.

NOTES

1. Montfaucon 1721–22, I, 117, for the English text; Montfaucon 1719, I, 192, "On trouve très-souvent des images de Psyché et de Cupidon dans les anciens monumens; leur mariage y est représenté; mais les marbres et les pierres gravées ne s'accordent pas avec l'histoire que nous venons de rapporter."

2. Mauclair 1906, 85, nos. 1414, 1415, 1430, 1433. I am most grateful to Edgar Munhall for letting me consult his preliminary and unpublished catalogue entry on this painting.

3. Barroux 1896, 89; Arquié-Bruley 1981, 140–43, for the "inventaire après le divorce des Sieur et Dame Greuze," in which the only paintings by Greuze are listed as "no. 38, quatorze toiles sur lesquelles se trouvent dessinés différents portraits" and "no. 39, vingt-huit petits toiles et panneaux." Neither lot would seem to include the unfinished *Psyche Crowning Cupid*.

4. Arquié-Bruley 1981, 148, "dix grands et moyens tableaux, esquisses de sujets fabuleux et historiques." Among the few listed works in this description, the "Danae" may be connected to the *Aegina Visited by Jupiter* (New York, The Metropolitan Museum of Art). Greuze's *inventaire après décès* of 4 germinal an 13 (25 March 1805) is published for the first time in this article.

5. Arquié-Bruley 1981, 130.

6. Lejeune 1864, 282, "Ce tableau, qui n'avait été vendu que 3,000 fr. en 1843, dans sa pureté virginale, parce qu'il n'avait que peu d'apparence, a été repeint presque entièrement sous prétexte de le terminer." Lejeune is mistaken about the price fetched at Anne-Geneviève Greuze's posthumous sale; it brought 6,000 francs.

7. As in, for example, Lille 1970, 152, where the painting is described as "une grisaille brune . . . propre à l'austérité de ce style," when, in fact, the work is unfinished.

8. Réau 1922, 396, quoting Greuze's letter of 11 September 1785 to Prince Nicolai Borisovich Yusupov (1751–1831), in which he notes that "l'ébauche . . . c'est, par conséquent, le tiers de l'ouvrage."

9. Benoît 1909, 392; Munhall in exh. Hartford, San Francisco, and Dijon 1976–77, 198–99.

10. Munhall's unpublished entry dates *Psyche Crowning Cupid* to "about 1785(?)"; Brookner 1956, 199, and idem, 1972, 130, "early 1790s"; Vilain 1980, 114, "dans les années 1790"; Oursel 1984, 53, "vers 1790."

11. Vilain 1980, 114, "le magnifique tableau du Musée de Lille"; Brookner 1956, 199.

12. Brookner 1956, 195.

13. Lille 1893, 247, "*Psyche couronnant l'Amour.* Elle est assise et va déposer sur le front de Cupidon agenouillé sa couronne blanche de pureté; derrière elle, la Pudeur se voile; dans le fond, un amour place deux couronnes de roses sur le lit; à droite, un autre amour jette de l'encens sur un brûle parfums."

14. Apuleius, *The Golden Ass*, V, 3–6. It is the scene in which Psyche takes a candle to discover her husband's identity that most captivated French artists during the eighteenth century. Subleyras had painted the subject as an overdoor for the Palazzo Mancini in 1732, exh. Paris and Rome 1987, 152–53; Lemoyne had repeated the subject numerous times, notably in an oval in Frederick the Great's possession by 1752, Bordeaux 1984 (A), 122–23; Vien's overdoor of *Cupid and Psyche* (Lille, Musée des Beaux-Arts) was exhibited at the Salon of 1761; and Lagrenée's overdoor for the château de Bellevue (Paris, Musée du Louvre) was exhibited at the Salon of 1769.

15. Apuleius, *The Golden Ass*, VI, 23–24.

16. Ingamells 1989, 202–5, for a discussion of earlier versions of the subject by Carle Vanloo and Vien.

17. Diderot 1957–67, IV, 107, "Mais cette tête est d'un âge, et le reste de la figure est d'un autre."

18. Ericksen and Watson 1963, 108–12, for the history of the *athénienne*; Ericksen 1974, 29–36, 48–50, for the phenomenon of *le goût grec*.

19. Gravelot and Cochin 1791, IV, 47. The standing figure of Modesty recalls Greuze's *Meditation* (Sarasota, The John and Mable Ringling Museum of Art) and the preparatory drawing for it in the Museum of Art, Rhode Island School of Design, both dated to around 1780 and reproduced in Thompson 1990, 34–35.

20. Haskell and Penny 1981, 325–28; Munhall in exh. Hartford, San Francisco, and Dijon 1976–77, 200–201, for the reduction of the *Venus de' Medici* in Greuze's *Anacreon in his Old Age Crowned by Love* (New York, The Pierpont Morgan Library), and idem, in exh. Paris 1984–85 (B), 242, for the symbolism of the statue in Greuze's *Portrait of Claude-Henri Watelet* (Paris, Musée du Louvre); Arquié-Bruley 1981, 143, for the "buste de Vénus de Médici en plâtre bronzé" inventoried by Lebrun in Greuze's collection at the time of his divorce (as in n. 3).

21. Exh. Duisberg 1989, 134, for Bouchardon's *Cupid Carving His Bow from Hercules' Club*; ibid., 30–33, for Houdon's *Morpheus*, the sculptor's *morceau de réception*, presented to the Academy on 28 July 1777.

22. Bock 1977, 85–86.

23. Brookner 1972, 129–30.

24. Munhall in exh. Hartford, San Francisco, and Dijon 1976–77, 146–49; idem, in exh. Paris 1984–85 (B), 253–58.

25. Munhall in exh. Hartford, San Francisco, and Dijon 1976–77, 200–201, and 161, where he notes that such ornament recalls Saly's vase designs engraved in 1746, a precocious example of *le goût grec*.

26. Brookner 1956, 196; idem, 1972, 130.

27. This body of work, which would repay closer study, is an example of what Robert Rosenblum has termed "Neoclassic Erotic," Rosenblum 1967, 20.

28. *De Watteau à Prud'hon*, Galerie Cailleux, Paris, 1951, no. 64; I am grateful to Edgar Munhall for drawing this to my attention and to Marianne Roland-Michel for procuring a photograph.

29. Schneider 1912, 241–54, for a survey of the theme of Cupid and Psyche in the nineteenth century; Jean-Jacques Lagrenée's *Psyche in the Enchanted Palace* is catalogued in exh. Paris, Detroit, and New York 1974–75, 514.

30. David d'Angers's *carnets* are cited by Munhall in exh. Hartford, San Francisco, and Dijon 1976–77, 25, "Ceci pourrait indiquer qu'il sentait le besoin de poétiser le plaisir des sens, en les portant vers l'idéalisation."

31. Barroux 1896, 84–90; Brookner 1956, 195–96; Arquié-Bruley 1981, 128–29.

32. Schneider 1912, 242.

FIG. 1
Jean-Baptiste Greuze, *Innocence Carried Off by Cupid*, c. 1786, oil on canvas, Paris, Musée du Louvre

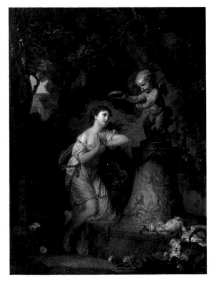

FIG. 2
Jean-Baptiste Greuze, *Votive Offering to Cupid*, 1767, oil on canvas, London, Wallace Collection

FIG. 3
Anonymous, *Modesty*, engraving from Ripa's *Iconologia*, Padua, 1630

FIG. 4
Edme Bouchardon, *Cupid Carving His Bow from Hercules' Club*, 1739, marble, Paris, Musée du Louvre

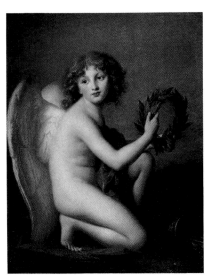

FIG. 5
Elisabeth-Louise Vigée Le Brun, *Portrait of Prince Henri Lubomirski as the Genius of Fame*, 1789, oil on canvas, Berlin, Staatliche Museen Preussischer Kulturbesitz, Gemäldegalerie

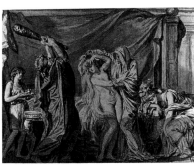

FIG. 6
Jean-Baptiste Greuze, *A Young Girl and Death*, c. 1790, black chalk, brown ink, and gray wash drawing, Rouen, Musée des Beaux-Arts

FIG. 7
Jean-Baptiste Greuze, *Woman Crying on a Tomb*, c. 1791, black chalk, india ink, and bistre wash drawing, Paris, Private Collection

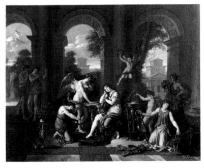

FIG. 8
Jean-Jacques Lagrenée, *Psyche in the Enchanted Palace*, 1798, oil on canvas, Paris, Private Collection

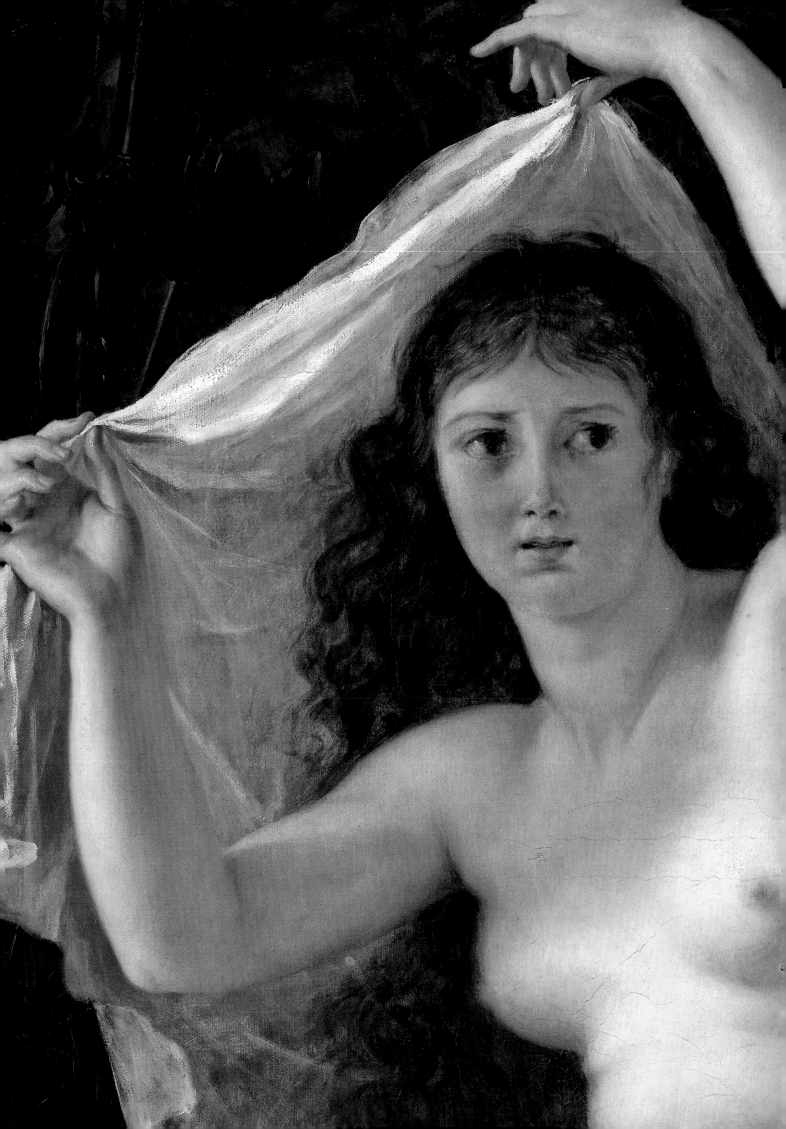

ANTOINE-JEAN GROS
(1771–1835)

Born in Paris in March 1771 to the miniaturists Jean-Antoine Gros (d. 1789) and Cécile-Madeleine, née Durand, Gros entered David's atelier at the end of 1785. In 1787 he began studying at the school of the Academy, where in 1792 he unsuccessfully competed for the *Prix de Rome*. David obtained a passport for Gros shortly thereafter, and the young artist left for Italy in January 1793. After traveling to Florence, Milan, and Venice, Gros settled in Genoa, where he responded to the color and energy of the work of Van Dyck and Rubens, although *The Bather* (cat. no. 66) suggests an even earlier interest in these artists. Gros's sketchbooks from this period, now in the Louvre, reveal that he was also experimenting with English themes and a mannered, visionary style, which might be termed proto-romantic.

Gros's career took a dramatic turn when he met Josephine Bonaparte in Genoa in December 1796. Impressed by his talent, she escorted Gros to Milan, where she presented him to Napoleon, the victor of the Battle of Arcola, who commissioned *Napoleon at Arcola* (Musée National des Châteaux de Versailles et de Trianon) from the young history painter. Gros's success in this contemporary heroic mode led to his appointment to the commission established to supervise the confiscation of art from Italy.

Gros returned to Paris in early 1801 and exhibited at the Salon both *Napoleon at Arcola* and *Sappho at Leucadia* (Bayeux, Musée Baron-Gérard), the latter a dramatic suicide scene whose haunting, moonlit setting reflects Girodet's influence. Thanks to the renewed patronage of Napoleon upon his return to Paris, however, Gros virtually ceased to paint works inspired by classical antiquity; instead he became one of Napoleon's preferred portraitists, producing between 1801 and 1810 a number of images of Napoleon as First Consul (1802, Paris, Musée National

de la Légion d'Honneur; 1804, Liège, Musée des Beaux-Arts; and a series of three works for honored cities executed in 1803, location unknown). It was at this time that Gros also painted his masterpiece, *Napoleon in the Pesthouse of Jaffa* (Paris, Musée du Louvre), exhibited at the Salon of 1804. Here the artist created a heroic and humanitarian image of the ruler, imbued with almost religious significance, by drawing upon the traditional Christian iconography of miraculous healing. Using a richly colored palette that heightened the exoticism of the scene, Gros also relied upon David's practice of situating his composition against a rigidly architectural background, as in the famed *Oath of the Horatii*.

While Gros had great success with his portraits of Napoleon, he was equally admired for his battle scenes. One of his first efforts in this genre was *The Battle of Nazareth*, commissioned in 1801. Although Napoleon halted the completion of this work, the arresting quality of the unfinished painting inspired Géricault to pay 1,000 francs to copy it and led Delacroix to enthuse over its fluid handling, rich color, and dynamic composition. Gros further developed his talent as an official painter in images of heightened action and vivid details, such as *The Battle of Aboukir* and *The Battle of the Pyramids* (1806 and 1810, both Musée National des Châteaux de Versailles et de Trianon). *Napoleon on the Battlefield of Eylau* (1806, Paris, Musée du Louvre), one of the most dramatic and moving of these works, foreshadows Géricault's *Raft of the Medusa* in its immediate and realistic portrayal of death.

Due to the success of Gros's portraits and battle scenes, Napoleon entrusted him with important religious projects as well. In 1811 Gros painted *Charles V Visiting the Abbey of Saint-Denis Where He Is Received by Francis I* (Paris, Musée du

Louvre) for the sacristy of Saint-Denis, and in the same year he received the commission to paint *The Apotheosis of Saint Genevieve* for the cupola of the Panthéon (completed in 1824).

Although often engaged upon commissions for Napoleon, Gros also established an independent career as the portraitist of the Napoleonic establishment, both military and civil, and his sitters included General Lasalle (1815, Private Collection), Count General Fournier-Sarlovèze (1812, Paris, Musée du Louvre), and Madame Récamier (c. 1825, Zagreb Museum). His work for Napoleon would not prevent Gros from also becoming the official portraitist of Louis XVIII in 1814.

When David was exiled to Brussels in January 1816, he left Gros in command of his studio, with the injunction to maintain the traditions of history painting. Inspired by his teacher's confidence, but also admonished by David's letters from Brussels, Gros came to regret his youthful manner and its impact on younger artists such as Delacroix. At Girodet's funeral in 1824, Gros went so far as to declare that he should have been more selective in his subject matter and style. In an effort to redeem himself, Gros now painted "noble" subjects in a classicizing manner as a means of purifying his style. Gros's late style, even more mannered than David's, is seen in such works as *Bacchus and Ariadne* (Salon of 1822, Ottawa, National Gallery of Canada). This newfound orthodoxy alienated the romantics, whom he had initially inspired, while his efforts at refinement were, in turn, rejected by the more classically minded students of David, such as Ingres. After the failure of *Hercules and Diomedes* (Toulouse, Musée des Augustins) at the Salon of 1835—the most extreme statement of his allegiance to Davidian ideals—Gros, in despair, threw himself into the Seine, where he drowned in June 1835.

ANTOINE-JEAN GROS, *The Bather* (detail), 1791, oil on canvas, 99 x 81cm, Musée des Beaux-Arts et d'Archéologie, Besançon.

ANTOINE-JEAN GROS
The Bather

66

BARON ANTOINE-JEAN GROS (1771–1835)
The Bather (*Diana at Her Bath*), 1791
Oil on canvas
99 x 81 cm.
Musée des Beaux-Arts et d'Archéologie, Besançon

PROVENANCE
Collection of the artist, his sale, Paris, 23 November 1835, no. 10
[as *Jeune femme au bain*], purchased by the artist's widow, Augustine Dufresne Gros, for 1,820 francs; bequeathed by her to the city of Besançon in March 1841; placed in the Musée de Besançon in 1842.

EXHIBITIONS
Paris 1913, no. 367; Paris 1936, no. 4; Brussels 1947, no. 15, ill.; Brussels 1953, no. 64, ill. [as "Baigneuse surprise"]; Paris 1954, no. 26; Paris 1957, no. 65, ill. [as "Diane au bain"].

BIBLIOGRAPHY
Lancrenon 1844, no. 91; Delestre 1845, 11; Lancrenon 1850, no. 91; Lancrenon 1853, no. 117; Lancrenon 1858, no. 117; Clément de Ris 1859–61, I, 52; Lancrenon 1865, no. 142; Delestre 1867, 16, 19; Clément de Ris 1872, 76; Lancrenon and Castan 1879, no. 259; Triper Le Franc 1880, 51; Castan 1889, 38; Rosenthal 1913, 346, ill.; Saunier 1913, 284, ill.; Magnin 1919, 120, 235, ill.; Schnapper 1991, 66, ill.

Acquired at Gros's posthumous sale by his widow for the sum of 1,820 francs,[1] *The Bather*—which had presumably remained in the artist's possession until his suicide—was bequeathed by Madame Gros to the city of Besançon in March 1841 and, with Gros's portrait of his mother-in-law, entered the municipal museum the following year.[2] The painting has been given several titles: *Susanna at the Bath*, *The Bather*, and, since 1957, *Diana at Her Bath*, yet these vagaries of nomenclature obscure its most conspicuous quality. Gros's *Bather* is, without a doubt, the most striking and unorthodox figure study produced by a student of the Academy during the eighteenth century.[3]

Seated upon white drapery that trails into the pool, a young woman—completely naked, her thick black hair falling to her waist—reacts in fright to an intruder we cannot see. Her eyes wide open, she rushes to cover herself in a gesture of studied artificiality. Behind the white veil and barely discernible among the marsh reeds, a large bow and quiver of arrows are suspended from a tree, identifying the terrified girl as a companion of Diana's, if not the goddess herself. As has been noted repeatedly, "nothing is less mythological or academic than the frank realism with which this beautiful body, fresh and robust, has been depicted."[4] With her immense *chevelure*, Rubensian figure, and indecorously exposed underarm, *The Bather* imposes herself with an immediacy more readily associated with Courbet's realism than with the training dispensed at the *Académie royale de Peinture et de Sculpture* on the eve of its abolition.

It is, however, within the academic tradition that Gros's *Bather* should be situated. Although the canvas is neither signed nor dated, Gros's earliest biographers concurred in assigning *The Bather* to 1791—the artist's sixth year in David's atelier and his fourth year in the Academy's school.[5] In Tripier Le Franc's account, Gros painted *The Bather* on a day when the female model came to pose for students of the Academy. Having first sketched this "gracious figure" in front of the model herself, Gros rushed home to his father's studio in order to complete the paint-

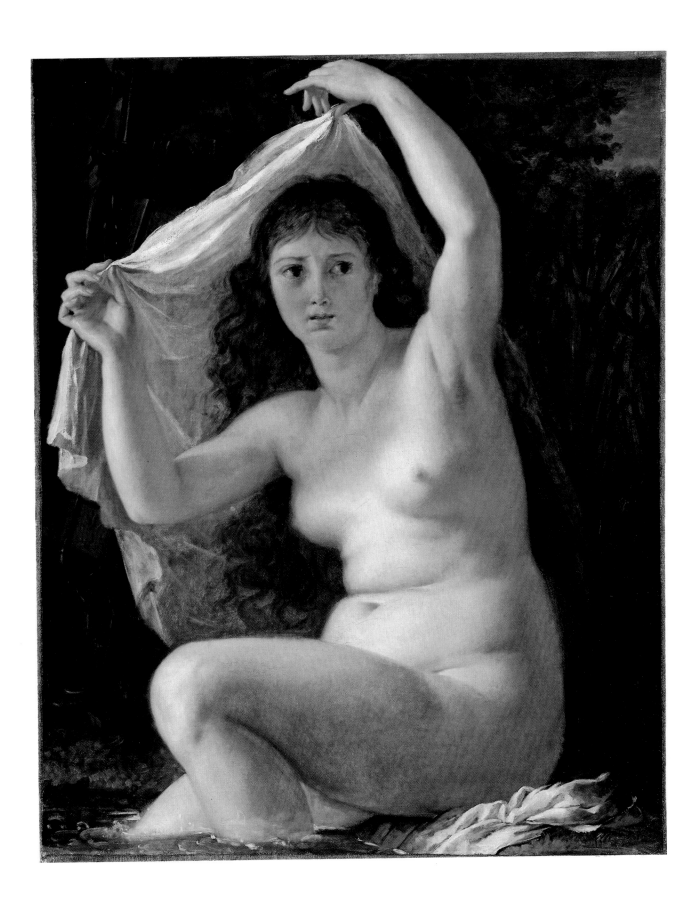

ing, which was much admired by professors and fellow students alike and helped to establish the twenty-year-old artist's reputation.[6]

As appealing and colorful as this account is, not a single line of it is true. Life study at the Academy was strictly confined to the male model, who posed for two hours each day before a class that had grown to some four hundred students by the 1760s; the very notion of a young woman disrobing before the adolescent male students in the *salles de l'Académie* is unthinkable.[7] So rigidly were the sexes segregated during the *ancien régime* that women, deprived of access to the male nude, were unable to aspire to the status of history painter. It was only with the annual drawing competition for the *tête d'expression*, founded by the comte de Caylus in 1760, that female models were introduced into the Academy; but, as is apparent from Cochin's celebrated engraving of this event, the young women were so heavily shrouded in apparel that only their faces were visible.[8]

While study of the female model from life was not permitted at the Academy, academicians enjoyed the prerogative of posing such models privately, *chez eux*.[9] Although Gros's teacher, David, must have occasionally employed such models, both written and pictorial evidence suggests that study after the female nude was not encouraged in his studio. Only one such example by David is known: the startling but unfinished *Psyche Abandoned* (fig. 1), very recently published by Antoine Schnapper and dated to c. 1787.[10] Delécluze, who describes the *dessinateurs d'après nature* in David's studio at a slightly later date, speaks only of a male model;[11] and not a single painted study comparable to Gros's *Bather* survives among the well-documented *oeuvre de jeunesse* of Drouais, Girodet, and Fabre, David's most gifted students.[12]

Nevertheless, Tripier Le Franc's account has the merit of reinstating Gros's figure study within the Academy's curriculum. *The Bather* relates in size, disposition, and handling—but not in gender—to the requirements of the *prix La Tour*, a competition inaugurated at the Academy in September 1784 in which students were to paint "a half figure in *chiaroscuro*."[13] Consisting only of "a head with two hands, life-size," the painting required for the *prix de la torse*, as it came to be called, was less demanding than an *académie peinte*, in which the entire figure was represented.[14] Professors of the Academy were to pose the model "so that one side would be illuminated, while the other was deprived of natural light by accidental shadows."[15] Students eligible to participate were allotted six sessions, each lasting seven hours, to complete their paintings on canvases of uniform size, known as "*une toile de 40*" (110 x 80 cm).[16]

Gros won the *prix de la torse* in August 1791. Although his *Painting of a Man* is lost, his earliest biographer noted the similarities between this canvas and *The Bather*, with which it is more or less contemporary.[17] While *The Bather* is painted on a canvas slightly smaller than "*une toile de 40*," the presentation of the figure is comparable to that in the *prix de la torse*. Diana's attendant is depicted life-size, flush to the picture plane, and posed in such a way that "she is about to drape herself with a cloth that has already cast its shadow over her body."[18] Thus, the conditions of the *prix La Tour* apply, informally, in this most private of exercises.

It is difficult to know under what circumstances Gros painted this voluptuous model, whom he has, perhaps, rendered with greater enthusiasm than technical skill. Yet in keeping with academic pedagogy, Gros's approach to the human form—refreshingly direct in the eyes of those historians writing at the beginning of this century—is mediated through his familiarity with classical prototypes. The pose of the subject of *The Bather* derives from antique statuary; bent forward, arms uplifted, her hair falling in wavy tresses, Gros's figure is a variant of the celebrated *Aphrodite from Rhodes* (fig. 2).[19] Furthermore, the curious gesture of her draping herself with a veil held delicately between the thumb and forefinger of both hands has iconographic significance. Modern commentators have been struck by the young woman's expression, midway between "fear and modesty";[20] indeed, the act of veiling is a well-established symbol of Modesty, personified as "a young virgin, candid in expression, who lowers her eyes and blushes."[21] While the blatant nudity of Gros's model might suggest immodesty, rather than the reverse, her act of veiling makes reference to a longstanding pictorial tradition; Gros may have also been familiar with Lebarbier's *Ulysses Returning to Ithaca with Penelope* (*La Pudeur*, fig. 3), exhibited at the Salon of 1789, in which the figure of Penelope is shown in the process of draping her face with a veil, an allusion to her exemplary chastity.[22]

Thus, in categorizing Gros's *Bather*, it can be argued that his painting occupies an intermediary position between the *prix de la torse*, which had no pretensions to narrative, and the *académie peinte*, which established the naked figure in a mythological or historical setting. Unlike Watteau's *Diana at Her Bath* (cat. no. 13), to which it bears a superficial resemblance, Gros's *Bather* does not elude mythology in order to achieve a more insistent physical presence. Rather, it is the work of a gifted debutant approaching the female nude for the first time and adapting academic formulae accordingly. Despite

certain *maladresses* in the painting of the bather's body and the mannered gesture of veiling—so much at odds with Gros's potent naturalism—the young artist breaks free of convention to achieve what Leon Rosenthal described as a "thrilling sensation of physiological life."[23] Neither Diana nor bather, goddess nor artist's model, Gros's *Bather* looks forward, beyond Delacroix's *Mademoiselle Rose* (Paris, Musée du Louvre) to the hired models painted by Courbet and Renoir.

Teleology aside, this vital figure study is also firmly rooted in the orbit of David's studio on the eve of the Revolution—a gathering of exceptionally gifted students who won the *Prix de la torse* and the *Prix de Rome* with startling regularity. Despite later claims to the contrary, David, during the period Gros studied with him, was producing a generation of history painters whose command of academic language was the most assured and complete in that institution's history. Cochin knew this well, and writing in September 1786 to his friend Jean-Baptiste Descamps, he expressed his admiration in terms that might well apply to the twenty-year-old author of *The Bather*: "By a miracle that none of us fully understands, David's school has reached a degree of perfection such that his nineteen-year-old students are already fully formed men."[24]

NOTES

1. *Catalogue des Tableaux, Esquisses, Dessins, et Croquis de M. le Baron Gros, Peintre d'Histoire*, Paris, 23 November 1835, no. 10, "Jeune femme au Bain"; Archives de la Seine, D48 E³29, no. 2005, *Procès-verbal de la vente après décès du Baron Gros*, 7 December 1835, no. 10, "Jeune femme au bain adjugée dix huit cents vingt francs . . . à Mde. Gros." This confirms Escholier's hypothesis in exh. Paris 1936, 43, which seems to have gone unnoticed.

2. Tripier Le Franc 1880, 51, notes that the baronne Gros's will was drawn up in Rome on 5 March 1841. On the back of the canvas is the transcription "légué au Musée de / la ville de Besançon . . . par . . . Madame Augustine Dufresne / veuve d'Antoine Jean Gros / décédée le 5 Janvier 1842."

3. The inscription on the reverse of the canvas identifies Gros's painting as *Suzanne au Bain*; Lancrenon 1844, 22, no. 19, cites the painting as *La Baigneuse*; the latter title is retained in all museum publications until exh. Paris 1957, 30, no. 65, when the painting was called *Diane au Bain*.

4. Magnin 1919, 120, "Mais rien n'est moins mythologique ni académique que la franche réalité de ce beau corps robuste et frais."

5. Delestre 1845, 11; idem, 1867, 16; Tripier Le Franc 1880, 51; Castan 1889, 38; the dating is followed most recently by Hubert in Tulard 1989, 844, and Schnapper 1991, 66.

6. Tripier Le Franc 1880, 51.

7. Rubin in exh. Princeton 1977, 22.

8. Ibid., 41, n. 41, and 24, fig. 5, for Cochin's engraving of the *Concours pour le Prix de l'Étude des Têtes et de l'Expression*.

9. Fontaine 1930, 11, citing the Statutes of 1665, "à la reserve du modèle de femme qu'ils pourront étudier chex eux." These regulations were repeated in the Academy's sessions of 2 June 1703 and 28 February 1711.

10. Schnapper 1991, 64–67; *Psyche Abandoned* is the pendant to the finished *Vestale* (Private Collection). Might these have been studies of the naked and draped figure to be used as examples in his growing atelier?

11. Delécluze 1855, 46.

12. Ramade in exh. Rennes 1985, 45–47, 56–58, and exh. Spoleto 1988, 41–43, for Drouais's and Fabre's impressive group of *académies*, exclusively of the heroic male nude.

13. Grunchec in exh. New York et al. 1984–85, 25; Montaiglon 1875–92, VIII, 205.

14. Montaiglon 1875–92, VIII, 209, "concours d'une figure peinte, avec deux mains, de grandeur naturelle."

15. Ibid., 209–10, "MM. les Professeurs . . . sont invités de poser le Modèle de manière à présenter une partie éclairée, et l'autre privée de la lumière directe par une ombre accidentelle."

16. Ibid., 210.

17. Montaiglon 1875–92, X, 124; 6 August 1791, "prix de M. De La Tour à Jean Gros"; Delestre 1845, 11, "Cette peinture est un chef d'oeuvre sous le rapport du naturel, de l'énergie, de la couleur, du dessin, et de l'effet."

18. As in the *Catalogue des Tableaux . . .* (as in n. 1), 8, "Elle est nue et se dispose à étendre sur elle un linge qui déjà porte une ombre sur son corps."

19. Stewart 1990, I, 224, II, 808. It should be noted that two years later in Rome, Gros would transform the statue of *A Lady Arranging Her Hair* in the Palazzo Colonna into a "Venus Anadyomene"; see the Louvre sketchbook, RF 29955, fol. 90.

20. Delestre 1845, II, "un mouvement instinctif de pudeur lui fait tenir une draperie blanche"; Tripier Le Franc 1880, 51, "un mouvement de crainte et de pudeur lui fait prendre un voile léger pour s'en couvrir."

21. Gravelot and Cochin 1791, IV, 47, "On représente La Pudeur sous les traits d'une jeune vierge; la candeur sur le front, elle baisse les yeux et rougit."

22. The preparatory sketch for this painting reappeared at Ader Picard Tajan, Paris, 12 December 1989, no. 46.

23. Rosenthal 1913, 346, "un sens palpitant de la vie physiologique."

24. Michel 1986, 80, "Ce seroit qu'il entrast chés David, dont l'École est montée, je ne scais par quel miracle, à un tel degré que les élèves dès l'âge de dix neuf ans y sont déjà des hommes."

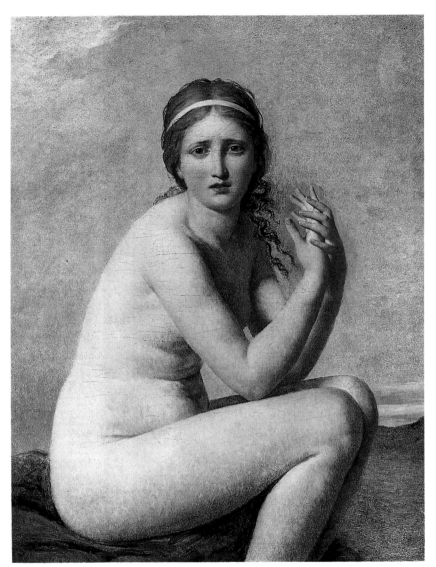

FIG. 1
Jacques-Louis David, *Psyche Abandoned*, c. 1787, oil on canvas, Private Collection

FIG. 2
Aphrodite from Rhodes, c. 100 B.C., marble, Rhodes Museum

FIG. 3
Jean-Jacques-François Le Barbier, detail of *Ulysses Returning to Ithaca with Penelope (La Pudeur)*, 1789, oil on canvas, Private Collection

PIERRE-HENRI DE VALENCIENNES
(1750–1819)

Pierre-Henri de Valenciennes was born in December 1750 in Toulouse, the son of a wigmaker. His father died when he was only four, and Valenciennes was eventually sent to the Academy of Painting in Toulouse, where he studied with the history painter Jean-Baptiste Despax (1709–1773) and the miniaturist Guillaume-Gabriel Bouton.

Valenciennes made his first trip to Italy in 1769 in the company of his protector, Mathias du Bourg, a *conseiller* of the *Parlement de Toulouse*. In 1771 Valenciennes returned to Paris, where Philippe du Bourg, Mathias's brother, introduced him to the duc and duchesse de Choiseul. Impressed by Valenciennes's talents, they gained him entry to the studio of Gabriel-François Doyen in 1773.

One of the most traveled artists of the century, Valenciennes did not remain in Paris for long and left again for Rome in September 1777. He moved about extensively during the next decade, but it is difficult to establish a precise itinerary since his drawings and writings do not specify the dates of travel and are the only evidence of the exotic sites he visited. He journeyed to Naples, Sicily, Egypt, Greece, and Turkey, among other places, but also returned in 1780 to Rome, where he took courses in perspective from a mathematics professor, and in 1781 visited Paris, where he met Claude-Joseph Vernet, who praised his work and offered him further advice on the painting of perspective.

Around 1785 Valenciennes settled in Paris. There his official career commenced in March 1787 when Pierre-Antoine de Machy presented him to the Academy. Valenciennes was granted an associate membership on the basis of three Italian views and was received as a full member shortly thereafter in July with *Ci-cero Discovering the Tomb of Archimedes* (Toulouse, Musée des Augustins) as his reception piece. He exhibited this work, as well as three other classically styled landscapes, at the Salon of 1787. At least two of these, *The Ancient City of Agrigento* (Paris, Musée du Louvre) and *Landscape of Ancient Greece* (The Detroit Institute of Arts), purchased by the marquis de Crillon, reveal Valenciennes's interest in seventeenth-century heroic landscape painting, especially the works of Poussin and Claude Lorrain. In 1789 Valenciennes came to the attention of other members of the aristocracy when the marquis de Clermont d'Amboise and baron de Montesquiou both purchased paintings he had exhibited at the Salon, and when the comte d'Artois commissioned two large landscapes for his château de la Muette (*The Cascade* and *The Stone Bridge*, both New York, Private Collection).

At the end of the eighteenth century, landscape was considered a lesser genre of largely decorative use. Valenciennes, however, was determined to claim for the historical landscape the same moral force and expressive power as the genre of history painting. He presented these views in his famed treatise, *Éléments de perspective pratique à l'usage des artistes suivis de réflexions et conseils à un élève sur la peinture et particulièrement sur le genre du paysage* (Paris, 1800). In this manifesto, he recommended that landscapists paint elevated tales from classical antiquity and follow the stylistic examples of Poussin, Annibale Carracci, Domenichino, and Claude Lorrain in order to achieve works of intellectual inspiration and ideal beauty. Furthermore, Valenciennes felt that artists should make studies from nature in order to "appreciate its [nature's] manifold variety, to understand its contrasts and harmonies, to embellish it and represent it on the canvas with all the charm and sublimity of ideal beauty." Such works as *The Two Poplars at the Villa Farnese* (c. 1783, Paris, Musée du Louvre) and *Rocca di Papa Seen Through Clouds* (1782–84, Paris, Musée du Louvre) are fine examples of his spontaneous, fresh response to nature.

Valenciennes's efforts to raise the standard of landscape painting, however, were not always successful. As Peter Galassi has noted, the artist generally produced idyllic, tranquil landscapes with generic, classical staffage—works that hardly inspired the degree of emotional response and intellectual analysis found in contemporary commentaries on history paintings by David and his school. Valenciennes's efforts to invigorate the genre of landscape, though, were much admired in his lifetime, and he had a successful official career. In 1812 he succeeded Pierre-Charles Dandrillon as Professor of Perspective at the École Impériale des Beaux-Arts and was named a member of the Legion of Honor in 1815. Furthermore, it was through his efforts that the École des Beaux-Arts established a *Prix de Rome* for landscape painting in 1816, of which one of his students, Achille-Etna Michallon, was the first laureate. Even a critic such as C.-P. Landon stated that it was through Valenciennes's example that "the art of landscape has been ennobled, one might even say regenerated."

Despite Valenciennes's contemporary fame, his reputation suffered after his death in February 1819. The bold and adventurous landscapists of the nineteenth century dismissed his formal landscapes as structured and artificial, forgetting that his brilliant, summary oil sketches had an important residual influence; it should be remembered that Corot was instructed by Michallon and Jean-Victor Bertin, two of Valenciennes's students.

PIERRE-HENRI DE VALENCIENNES, *Narcissus Admiring His Reflection* (detail), 1792, oil on canvas, 54 x 81 cm, Musée des Beaux-Arts, Quimper

PIERRE-HENRI DE VALENCIENNES
Narcissus Admiring His Reflection

67

PIERRE-HENRI DE VALENCIENNES (1750–1819)
Narcissus Admiring His Reflection, 1792
Oil on canvas
54 x 81 cm.
Musée des Beaux-Arts, Quimper

PROVENANCE
Alphonse Giroux, his sale, Paris, 24–25 February 1851, no. 124, purchased by J.-M. de Silguy, who gave the painting to the Musée des Beaux-Arts, Quimper, in 1864.

EXHIBITIONS
Salon of 1793, no. 331; Fukuoka 1989, no. 48.

BIBLIOGRAPHY
Quimper 1873, no. 591; exh. Toulouse 1956–57, 33; exh. Paris, Detroit, and New York 1974–75, 636–37; Lacambre 1976, n.p.; Quiniou 1976, 32, ill.; Cariou 1985, 26, ill.; Bordes and Michel 1988, 49, ill.; Heim, Béraud, and Heim 1989, 361, ill.

To the Salon of 1793, which opened on 10 August in commemoration of the fall of the monarchy, Valenciennes submitted an unusually modest *envoi*: a pair of pendants representing *Narcissus Admiring His Reflection* and *Byblis Changed into a Fountain* (fig. 1).[1] Lost among the 829 works on display in this second open Salon, *Narcissus Admiring His Reflection* was discussed both laconically and uncharitably: "this landscape adds little to the author's reputation."[2] Owing to the Republic's involvement in European war, the Salon was generally of little interest to the press that year—only two reviews are known—and Valenciennes's elegant conceit was overlooked.[3] With the well-known story of Narcissus he had paired the obscure tale of Byblis, an Ionian princess who developed a consuming passion for her twin brother Caunus and who, after being brutally rejected by him, wandered the land in grief until the gods transformed her into a fountain.[4] Valenciennes's pendants represent the tragic consequences of illicit and unnatural love—not merely incest, but also self-love—with a sensitivity and tenderness rarely apparent in the classical landscapes he had previously exhibited at the Salon. In this novel pairing—Narcissus admires his reflection, Byblis falls in love with a twin brother who is the reflection of her—Valenciennes touches upon an autoeroticism that found its most compelling expression in Girodet's *Endymion*, 1791 (Paris, Musée du Louvre), exhibited, incidentally, at the same Salon.

In Valenciennes's interpretation of a subject frequently treated by history painters, the emphasis shifts, almost imperceptibly and with no loss of poetry, from figures to landscape. Narcissus, "worn by the chase and the heat," takes his rest before a pool of limpid clarity under the shade of a massive oak.[5] Through the trees in the distance can be seen the ruins of an ancient city and beyond them a range of mountains washed by the afternoon sun. A pair of hunting dogs at his side, his gleaming javelin standing erect by the foot of the tree, Narcissus has already become entranced by his own reflection. In a landscape of the utmost tranquillity, permeated by a golden, roseate light, Narcissus remains alone with his dogs;

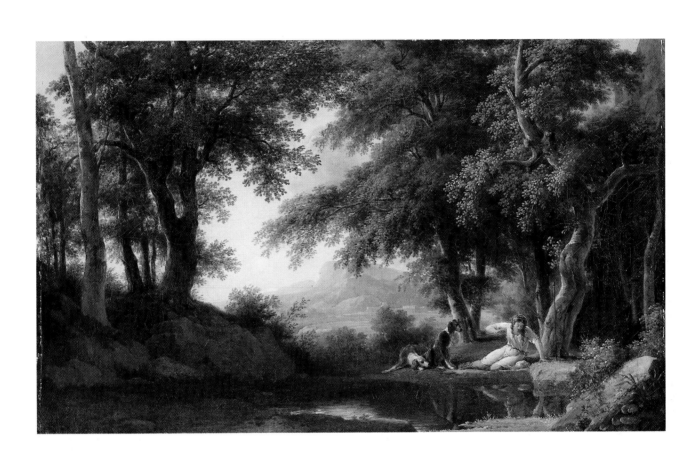

all is still and hushed. This is Nature as perceived by the ancients, Valenciennes would later write, ideal and sublime, "which excludes mortals from a habitation made for the gods."[6]

Painted in a cool, autumnal palette and of a finish that recalls Ruysdael rather than Poussin, *Narcissus Admiring His Reflection* was elaborated over a period of two years, a long maturation even for this painstaking artist. Valenciennes first conceived of the pendants as early as 1790 in a pair of carefully rendered presentation drawings quite different from the finished paintings.[7] In *Narcissus* (fig. 2), the protected bower is almost overwhelmed by the lush vegetation—plants trailing from the trees, exotic rocks and flowers lining the pool—and the kneeling adolescent is lost amid this exuberant, but uncontrolled, nature. The tree and rocks at left, while enframing the composition—a predictable *repoussoir*—tower over the figure of Narcissus and detract attention from the landscape's narrative. In the painting, Valenciennes places this tree in shadow and moves it to the middle ground, thus giving precedence to the figure and dogs around the crystal water and creating a screen of russet-colored foliage through which may be glimpsed a glorious vista, receding far into the distance. Other changes of detail in *Narcissus Admiring His Reflection*—the placement of the javelin, the addition of a pair of hunting dogs, the altered pose of Narcissus himself—also contribute to the more geometric and rigorous *mise en page* of the composition. All of these changes are recorded faithfully in a second drawing (fig. 3), dated 1792 and dedicated to a "M. Layne," which would seem to be a *ricordo* rather than a preparatory study.[8] Drawings of the latter category have yet to be identified—the artist's sketchbooks for the Revolutionary period are lost—although two of the oil sketches made in Italy in the 1780s may be related to this landscape. The grouping of trees in *Narcissus Admiring His Reflection* recalls the forest of La Fayolla, in the environs of Nemi (fig. 4), and the mountain range in the background might well be a memory of Monte Cavo at Rocca di Papa.[9]

Clearly, this carefully constructed and balanced composition was not intended to evoke memories of an observed terrain. It is an idealized landscape, "the noblest genre of landscape painting, in which the artist's genius is at its most engaged," capable of instructing, edifying, and uplifting the sensitive observer.[10] That Valenciennes sought to elevate the modest genre of landscape painting by appropriating both the language and function of history painting has long been noted.[11] His use of mythology to achieve such ends, however, has been overlooked.

Thus, while *Narcissus Admiring His Reflection* might evoke the Augustan landscapes of Claude Lorrain (fig. 5), Valenciennes's aspirations were of an even higher order. Claude was an admirable painter, he allowed, whose sunrises and sunsets were "rendered with the most exacting truthfulness and interest," yet, like Dughet, he merely copied Nature as it could be found in Italy and elsewhere and thus failed to stir the imagination.[12] "Did they cause the soul to experience anything more than admiration?" Valenciennes asks about Claude and Dughet.[13] In fact, it is Poussin, Titian, Annibale Carracci, and Domenichino whom Valenciennes venerates, artists "imbued with the writings of the sublime poets" who can, by simply closing their eyes, "envisage an ideal Nature, a Nature adorned with the riches of the Imagination, which genius alone can conceive and represent."[14] For Valenciennes, the painter of *paysages historiques* responds to Nature not merely as a sterile portraitist but as one whose knowledge of classical literature is as profound as that of the most erudite of history painters. And, for the landscapist at least, it is the "reading of the *poets* which electrifies his soul and ignites his genius."[15] Thus, in Valenciennes's search for the *beau idéal*, mythology is all pervasive; it is the soul of Nature.[16] Claude and Dughet are criticized because their trees could never have been mistaken for hamadryads, and their fountains fail to evoke the naiads who inhabit them.[17] Valenciennes then suggests how different moods and states of mind can be achieved through the canon of mythological subjects. The story of Narcissus, for example, is a metaphor of contemplation: "The artist then calms himself by showing Narcissus at the fountain's edge, its still, clear waters reflecting the image of this wretched lover, whose languorous and fading beauty announces the terrible end that will finally set his soul at rest."[18] Indeed, *Narcissus Admiring His Reflection* achieves something of this serenity; interiorized and lacking in rhetoric, it conveys a melancholy painted with all "the colors of sentiment."[19]

NOTES

1. Foucart in exh. Paris, Detroit, and New York 1974–75, 629–31, who notes that *Byblis Changed into a Fountain* is signed "Valenciennes"—without the particle—and dated 1792; Michel in Bordes and Michel 1988, 49; Cariou in exh. Fukuoka 1989, 208–9; Heim, Béraud, and Heim 1989, 361, 363.

2. *Explication par ordre des numéros et Jugement motivé des ouvrages de peinture, sculpture, architecture, et gravure, exposés au Palais national des Arts*, Paris (1793), 45, "Ce paysage est au dessous de la réputation de l'auteur."

3. Michel in Bordes and Michel 1988, 50–51.

4. Ovid, *Metamorphoses*, IX, 450–665.

5. Ibid., III, 414.

6. Valenciennes 1800, 378, "cette nature idéale et sublime telle que les anciens l'avoient conçue, qui semblent exclure les hommes du séjour de la terre pour y faire habité la Divinité."

7. Sold at Christie's, London, 25 March 1969, no. 170, as *Arethusa* and *Narcissus*; exh. William Schaab Gallery, New York, 1973–74; cited by Foucart in exh. Paris, Detroit, and New York 1974–75, 629, and Lacambre 1976.

8. "M. Layne" remains mysterious; I am grateful to Madeleine Pinault for her help with this drawing.

9. Lacambre 1978, 139–40, 144; R.F. 2995, *La Fayolla, near Nemi: View of the Forest* (fig. 4) (replica also at the Louvre, R.F. 2889); R.F. 3025 and R.F. 3037, for views of Monte Cavo.

10. Watelet in Watelet and Lévesque 1792, IV, 9, "les *représentations idéales* enfin (genre le plus noble du *Paysage*, parce que le génie s'y montre davantage)."

11. Galassi in exh. New York 1990, 233–35, for the most recent summary.

12. Valenciennes 1800, 376, "Claude Lorrain a rendu, avec la plus exacte vérité et même avec intérêt, le lever tranquille et le brulant déclin de l'astre du jour."

13. Ibid., "Mais ont-ils affecté l'imagination? Ont-ils fait éprouver à l'âme d'autre sentiment que l'admiration?"

14. Ibid., 377–78, "Ces Peintres se sont pénétrés de la lecture de ces poètes sublimes; il les ont médités; et en fermant les yeux, ils ont vu cette Nature idéale, cette Nature parée des richesses de l'imagination, et que le seul génie peut concevoir et représenter."

15. Ibid., 391, "C'est principalement la lecture des *poètes* qui doit électriser et allumer son génie" (my emphasis).

16. Galassi in exh. New York 1990, 235, for a slightly different conclusion, in which he notes that "despite Valenciennes's rhetorical invocation of ancient authors and high moral ideals, the nominal narrative theme of *paysage historique* is rarely more than a pretext for the *beau idéal*."

17. Valenciennes 1800, 377, 380.

18. Ibid., 384, "Il aime à se tranquilliser en représentant Narcisse au bord d'une fontaine, dont les eaux calmes et lympides réfléchissent avec justesse l'image de ce malheureux amant, de qui les grâces langoureuses et flétries annoncent le terme fatal qui doit rendre le repos à son âme"; Foucart in exh. Paris, Detroit, and New York 1974–75, 630, was the first to draw attention to this passage.

19. Ibid., 382, "la couleur du sentiment," Valenciennes's felicitous description of Poussin's landscapes.

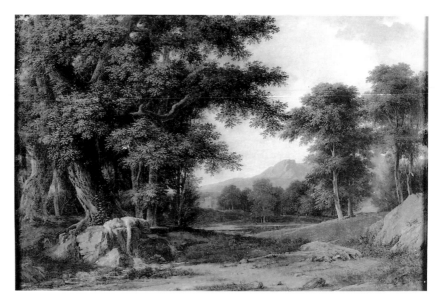

FIG. 1
Pierre-Henri de Valenciennes, *Byblis Changed into a Fountain*, 1792, oil on canvas, Quimper, Musée des Beaux-Arts

FIG. 2
Pierre-Henri de Valenciennes, *Narcissus*, c. 1790, black chalk drawing heightened with white, Private Collection

FIG. 3
Pierre-Henri de Valenciennes, *Narcissus*, 1792,
black chalk drawing heightened with white,
Paris, Musée du Louvre, Cabinet des Dessins

FIG. 4
Pierre-Henri de Valenciennes, *La Fayolla, near Nemi: View of the Forest*, c. 1785, oil on paper
mounted on cardboard, Paris, Musée du Louvre

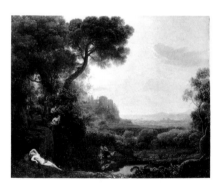

FIG. 5
Claude Lorrain, *Narcissus*, 1644, oil on canvas,
London, The National Gallery

MYTHOLOGICAL PAINTINGS
EXHIBITED AT THE SALON, 1699–1791

CARRIE A. HAMILTON AND ROSAMUND DOWNING

This appendix represents the first complete listing of mythological paintings that were exhibited in French eighteenth-century Salons between 1699 and 1791, the date of the last painting in this exhibition. By compiling this information we hope to provide the basis for future analysis of trends in the painting and collecting of mythological works.

The most difficult aspect of organizing the appendix was defining the category of "mythology." Anthony D. Smith pointed out the pitfalls and gray areas of such a definition in his study of history painting in late eighteenth-century France and England, citing as an example the problem of Cupid.[1] The god of Love's appearance in Salon paintings was so frequent and the titles so generalized that they could be regarded as simple allegories of Love rather than depictions of a particular myth. We have included these images of Cupid, as well as other generic mythological figures such as satyrs and nymphs. For the most part, however, the mythological narratives listed here derive from classical authors such as Ovid, Apollodorus, and Homer. We also list subjects from Torquato Tasso's *Jerusalem Delivered* and Ludovico Ariosto's *Orlando Furioso* because they were treated as mythological subjects in the eighteenth century.[2] We do not include the following: Greek and Roman histories; mythological allegories related to specific people, places, and events, such as Jean-Jacques Lagrenée's *Mercure, représentant le commerce, répand sous les auspices de Louis XVI, l'abondance sur le Royaume . . .* (Salon de 1781, no. 39); mythological portraits, such as those frequently painted by Jean-Marc Nattier where sitters are portrayed as gods or goddesses; and generic antique subjects, such as Pierre-Henri de Valenciennes's *Paysage, dans lequel on apperçoit l'entrée d'une village antique . . .* (Salon de 1787, no. 174).

The appendix appears as two lists, the first of which is organized chronologically by Salon and then alphabetically by artist. The artists' dates appear only once, next to the first entry for each one. The Salon number and title of the painting complete the entry. The titles of the paintings are ordered alphabetically under each artist's subsection in the early, non-numbered Salons and then numerically by Salon number in the later Salons. In the cases where the painting was an oil sketch, we indicate "(sketch)" at the end of the title. We did not include works that were listed anonymously.

The second list contains the same information reorganized by artist rather than by Salon. The artists appear alphabetically, with their paintings listed chronologically after the Salon date. Again, the earlier paintings are listed alphabetically under each Salon, and later works appear numerically by Salon number. The artists' dates come before the Salon date and appear only once.

For the sake of consistency, we have used Bellier and Auvray as our guide for spelling artists' names and as a source for their dates. On the rare occasions that an artist did not appear in Bellier and Auvray, we have turned to Bénézit and Thieme-Becker. The titles come from the *livrets*. We did not regularize or modernize the titles, so that names such as Ariadne appear in a number of different ways. In some cases the titles are somewhat lengthy descriptions, too long to include in full. We have provided the title up to a natural breaking point in the description or have indicated, by the use of ". . ." at the end of the title, that pertinent information is to be found in the *livrets*.

NOTES

1. Smith 1979, 157. For more information on mythological paintings in French eighteenth-century Salons, see Bardon 1963.

2. For example, see Fenaille 1903–23, III, 121–31, who publishes Rinaldo and Armida as part of the Gobelins tapestry series devoted to the *Metamorphoses*, which was executed 1704–14.

1699

BOULLONGNE, BON (1649–1717)
Galathée sur les eaux
Le sacrifice d'Iphigénie
Le triomphe de Neptune
L'éducation de Jupiter par les Coribantes

BOULLONGNE, LOUIS DE (1654–1733)
Galathée sur les eaux
Junon qui commande à Éole de lâcher
les vents pour disperser la flote d'Aenée
Le jugement de Pâris
Le rapt de Proserpine
Psyché et l'Amour
Zéphire et Flore

COLOMBEL, NICOLAS (1646–1717)
Atalante et Hippomène
Psyché et l'Amour
Retour de chasse de Diane

CORNEILLE, MICHEL (1642–1708)
Apollon se couchant dans le sein de Thétis
Vénus sur les eaux

COYPEL, ANTOINE (1661–1722)
La Ceinture de Vénus
Psyché et l'Amour
Vénus qui donne les armes à Énée

COYPEL, NOËL (1628–1707)
Déjanire qui envoye à Hercule par Licas
Hercule déifié, ou l'apothéose d'Hercule
Hercule domptant Achéloüs
Hercule reprochant à Junon les maux
qu'elle luy a causez par sa jalousie
Hercule sacrifiant à Jupiter après ses victoires
La chemise empoisonnée par le centaure Nesse
Le centaure Nesse et Déjanire
Zéphire et Flore

HALLÉ, CLAUDE-GUY (1652–1736)
Vulcain qui surprend Mars et Vénus

JOUVENET, JEAN (1644–1717)
Le Sacrifice d'Iphigénie
Vénus et Vulcain

LA FOSSE, CHARLES DE (1636–1716)
La naissance de Minerve du cerveau de Jupiter
L'adieu d'Hector et d'Andromaque

PAILLET, ANTOINE (1626–1701)
Renaud et Armide
Renaud et Armide

PLATTE-MONTAGNE, NICOLAS DE
(1631–1706)
Hercule, à qui Junon donne à teter

UBELESQUI, ALEXANDRE (1649–1718)
Bacchus et Ariadne
La naissance de Bacchus
La naissance de Vénus

1704

BERTIN, NICOLAS (1668–1736)
La naissance d'Adonis
Une Baccanale

BOULLONGNE, BON
Danaé
Le jugement de Pâris
Sémélé
Un petit Amour qui baise un pigeon

Vénus accompagnée de Bacchus et de Cérès
Zéphire et Flore

BOULLONGNE, LOUIS DE
Diane se reposant après avoir chassé
Galathée sur les eaux
La naissance de Bacchus
L'enlèvement de Proserpine par Pluton
Pâris qui conduit Hélène à ses vaisseaux
Regnaud et Armide dans les plaisirs
Vénus et Adonis
Vénus et Adonis
Vénus qui engage Vulcain à faire des armes pour Énée
Zéphire et Flore

CHÉRON, ELISABETH-SOPHIE (1648–1711)
Tancrède qui dans un combat singulier tué
Clorinde sans la connoître

CHRISTOPHE, JOSEPH (1662–1748)
Adonis et la nymphe Écho
Apollon et la Cibille
Le combat d'Hercule et d'Achéloüs
L'enlèvement d'Europe
Vertumne et Pommone

COLOMBEL, NICOLAS
Diane
Léda dans la bain trompée par Jupiter sous la forme d'un cigne
L'enlèvement d'Europe

COTELLE, JEAN (1645–1708)
Mars et Vénus

COYPEL, ANTOINE
L'enlèvement de Proserpine
L'union de Bacchus et de l'Amour
Regnaud et Armide dans les plaisirs

COYPEL, NOËL
Apollon se reposant après avoir tué le serpent Python
Déjanire et le centaure Nesse blessé par Hercule
Déjanire envoyant à Hercule par Licas la chemis empoisonée du centaure. L'Apothéose d'Hercule
Le combat qu'il [Hercule] eut avec Achéloüs.
Amalthée qui donne la corne d'abondance pour être envoyée à Hercule en échange de celle qu'il avoit otée à Achéloüs
Zéphyre et Flore, et de plusieurs Amours qui jouent

FAVANNE, HENRI DE (1668–1752)
Cyanne qui montre à Cérès la ceinture de sa fille
Proserpine enlevée par Pluton
Silène éveillé par la nymphe Eglé en luy frotant le visage d'une meure
Vénus sur les eaux

FRIQUET DE VAUROZE, JACQUES-ANTOINE
(1648–1716)
Triomphe de Thétis sur les eaux

JOUVENET, JEAN
Andromaque, qui tâche à sauver son fils Astyanax découvert par Ulisse dans le tombeau d'Hector, de la fureur de Grecs
Vénus qui engage Vulcain de faire des armes pour Énée

LA FOSSE, CHARLES DE
Acis et Galathée écoutant Poliphème jouant d'une flute

MAROT, FRANÇOIS (1666–1719)
Vénus qui engage Vulcain à faire des armes pour Énée

PLATTE-MONTAGNE, MATHIEU DE
(C. 1608–1760)
Apollon sur le Parnasse avec les Muses

SILVESTRE, LOUIS DE (1675–1760)
Apollon et Daphné
Mercure qui endort Argus au son de sa flûte pour luy couper la teste
Vénus et Adonis

TAVERNIER, FRANÇOIS (1659–1725)
L'enlèvement de Déjanire
Neptune sur les eaux

TROY, FRANÇOIS DE (1654–1730)
Didon et Énée dans un festin

UBELESQUI, ALEXANDRE
L'enlèvement d'Europe par Jupiter méthamorphosé en Taureau
Vénus qui sollicite Vulcain de faire des armes pour Énée
Vertumne et Pomone

VAN SCHUPPEN, JACQUES (1670–1751)
La mort d'Adonis

VERNANSAL, GUY-LOUIS (1648–1729)
La Naissance d'Adonis
La Naissance de Bacchus

1725

COYPEL, CHARLES-ANTOINE (1694–1752)
L'Amour, sous la figure d'un Ramoneur qui sort d'une cheminée
La Guerre et la Religion. La Guerre caractérisée par Mars, qui ordonne à Vulcain de forger des Armes, et la Religion par Numa Pompilius qui fait porter le feu sacré au Temple de Vesta
L'Apothéose d'Hercule (sketch)
Renaud qui abandonne Armide

LEMOYNE, FRANÇOIS (1688–1737)
Andromède sur le rocher, Persée en l'air qui vient la délivrer, et tuer le dragon qui devoit la dévorer
Apollon et Daphné
Europe qui se met sur le Taureau, accompagnée de ses Suivantes, qui cueillent des fleurs, et lui en présentent des guirlandes
Hercule et Omphale
Les Chevaliers Danois qui vont chercher Renaud dans l'Isle enchantée, ou ils rencontrent les charmes voluptueux qu'Armide avoit placez aux avenues pour les empêcher d'arriver jusqu'à son Palais

RESTOUT, JEAN (1692–1768)
La Nymphe Callisto, trompée par Jupiter, qui la vient voir sous la figure de Diane

TROY, JEAN-FRANÇOIS DE (1679–1752)
Diane et Endimion
Le Sacrifice d'Iphigénie
Léda couchée et groupée avec Jupiter en Cigne
Renaud endormi sur un lit de gazon dans un paysage, et Armide laissant tomber le poignard

1737

BOIZOT, ANTOINE (1702–1782)
Ixion foudroyé par Jupiter

CAZES, PIERRE-JACQUES (1676–1754)
La naissance de Vénus
Léda, et Jupiter transformé en Cigne

COLLIN DE VERMONT, HYACINTHE
(1693–1761)
Les adieux d'Hector et d'Andromaque
Les dieux qui coupent les ailes à l'Amour, pour
l'empêcher de remonter au Ciel
Les Noces de Thétis et Pelée, ou la Discorde jette
entre les Divinitez, une Pomme d'or
Pyrame et Thisbé
Renaud et Armide

COYPEL, CHARLES-ANTOINE
Le Sacrifice d'Iphigénie

DELOBEL, NICOLAS (1693–1763)
La Naissance de Vénus

DUMONT LE ROMAIN, JACQUES
(1701–1781)
L'éducation de l'Amour

FAVANNE, HENRI DE
Nayades
Télémaque déclare imprudemment
sa passion à Eucaris
Télémaque prend l'Amour pour
un Enfant ordinaire; il ressent son pouvoir ainsi
que Calypso et ses Nymphes
Thétis, qui après s'être changée en Lion, en Feu,
et en diverses autres Figures, pour s'échapper
du lien avec lequel Pélée la tient serrée est forcée
de consentir à l'épouser

GALLOCHE, LOUIS (1670–1761)
Énée chez Didon, Reine de Cartage, à laquelle il se
découvre. Le moment ou Didon caresse l'Amour
sous la figure d'Ascagne

JEAURAT, ETIENNE (1699–1789)
Diane surprise au bain par Actéon
La Noce de Daphnis et Cloé
Les Nymphes tutelaires du Païs présentent
Daphnis et Cloé à l'Amour . . .

LAMY, CHARLES (1689–1743)
Latone qui alaite Apollon et Diane

LE CLERC, SEBASTIEN (1676–1763)
La Reine Hécube, femme de Priam, faisant
présenter au Palladium une de ses plus belles robes,
pour obtenir sa protection pour la ville de Troyes
Vertumne et Pomone
Zéphire et Flore

MASSÉ, SAMUEL (1672–1753)
L'Enlèvement d'Europe
Vénus sur les Eaux

NATOIRE, CHARLES-JOSEPH (1700–1777)
Amphitrite sur les Eaux
Diane au Bain
Io enlevée par Jupiter

RESTOUT, JEAN
Apollon qui montre à jouer de la lyre
à l'Amour

TRÉMOLIERES, PIERRE-CHARLES
(1703–1739)
Diane disarmant l'Amour
Minerve qui enseigne une nymphe à faire de la
Tapisserie

VAN LOO, CHARLES-ANDRÉ (1705–1765)
Jupiter et Junon

VAN LOO, JEAN-BAPTISTE (1684–1745)
Un Bain de Diane

1738

BOIZOT, ANTOINE
77 *L'origine de l'Amour démontré par la beauté,*
tenant un verre ardent, qui allume le Flambeau de
l'Amour
111 *L'éducation de l'Amour par le secours de*
Mercure et de Vénus
112 *Vénus qui désarme l'Amour*
114 *L'Amour piqué par une abeille*

BOUCHER, FRANÇOIS (1703–1770)
43 *Vénus, qui descend de son Chariot soutenue*
par l'Amour, pour entrer au Bain
104 *Les trois Grâces qui enchaînent l'Amour*
106 *L'éducation de l'Amour par Mercure*

CHRISTOPHE, JOSEPH
120 *Un petit Bacchanale d'enfans . . .*

COYPEL, CHARLES-ANTOINE
2 *Armide, qui fait détruire par les Génies*
infernaux le Palais quelle leur avoit fait
élever pour s'y renfermer avec Renaud
et les Plaisirs

GALLOCHE, LOUIS
6 *Adonis qui quitte Vénus pour aller*
à la Chasse
8 *Armide, qui voulant poignarder Renaud,*
va céder à l'Amour; qui prenant ce Héros sous sa
protection, la suite de ce Dieu rit
de la colère de l'Enchantresse et célèbre d'avance le
Triomphe de son Maître

HUILLIOT, PIERRE-NICOLAS (1674–1751)
55 *Un Buste de Bacchus, ou l'Amour,*
qui prend son parti, le couronne de Myrthe, luy
ayant pendu son Carquois au col

JEAURAT, ETIENNE
115 *Repos de Diane*
146 *Le départ d'Achille, pour aller vanger*
la mort de Patrocle

LAMY, CHARLES
35 *Latone, qui allaite Apollon et Diane*
44 *Mercure amoureux d'Hersé*
45 *Apollon avec Issé*

MASSÉ, SAMUEL
119 *Une jeune Bacchante jouant avec*
des enfans

NATOIRE, CHARLES-JOSEPH
24 *Bacchanale*
57 *Bacchus reçoit à boire d'un Enfant,*
accompagné de deux Bacchantes
et de Silène
109 *Les trois Grâces qui enchaînent l'Amour*

OUDRY, JEAN-BAPTISTE (1686–1755)
16 *Silène, barbouillé de Mures par la nymphe*
Eglée

RESTOUT, JEAN
103 *La dispute de Minerve et Neptune*
au sujet de la Ville d'Athènes
105 *Neptune et Amphitrite*
134 *Gageure de Phébus et Borée pour ôter*
le manteau du Voyageur

TRÉMOLIERES, PIERRE-CHARLES
91 *Diane au Bain* (sketch)
93 *Le triomphe de Galatée sur les Eaux* (sketch)
101 *L'hymen d'Hercule et d'Hébé enchaîné par*
l'Amour . . .
110 *Vénus qui embrasse l'Amour*

VAN LOO, CHARLES-ANDRÉ
42 *Vénus à sa Toilette*

1739

BOIZOT, ANTOINE
Bacchus et Arianne
Vertumne et Pomone

BOUCHER, FRANÇOIS
Aurore et Céphale
Psyché conduite par Zéphire dans le Palais
de l'Amour

DANDRÉ-BARDON, MICHEL-FRANÇOIS
(1700–1783)
Jason au champ de Mars, en présence
de Medée, du Roy et tout le Peuple de Colchos…

MILLET, JOSEPH-FRANCISQUE (1697–1777)
L'Enlèvement d'Europe
Mars et Vénus, avec des Cyclopes,
qui forgent dans un antre

NATOIRE, CHARLES-JOSEPH
Galatée
Télémaque dans l'Isle de Calipso, parmi les
Nymphes, caressant l'Amour sous la figure d'un
Enfant
Vénus qui donne l'Amour à Calipso

1740

BOIZOT, ANTOINE
92 *Renaud qui quitte Armide, par le conseil des*
Chevaliers qui le pressent de retourner au Camp
de Godefroy . . .

BOUCHER, FRANÇOIS
9 *La naissance de Vénus, ou cette Déesse paroît*
sortir du sein des Eaux avec les Grâces,
accompagnée des Tritons, des Néréides,
et des Amours

DUMONS, JEAN-JOSEPH (1687–1779)
90 *Vénus, et l'Amour piqué par une abeille*

LA JOUE, JACQUES DE (1687–1761)
47 *Neptune avec ses attributs . . .*

LAMY, CHARLES
91 *Le mariage de Cupidon avec Psyché*

1741

BOIZOT, ANTOINE
89 *Zéphire et Flore*
90 *Aurore et Céphale*
91 *L'Éducation de l'Amour*
93 *Les Grâces qui instruisent l'Amour*

COYPEL, CHARLES-ANTOINE
1 *Armide, qui voulant poignarder Renaud, va*
céder à l'Amour prenant ce Héros sous sa
protection . . .

JEAURAT, ETIENNE
15 *Les vendanges de Daphnis et Cloée*
16 *Repos de Cérès*

PIERRE, JEAN-BAPTISTE-MARIE
(1713–1789)
125 *Psiché, abandonné par l'Amour,
accueillié et consolée par les Nymphes*
VAN LOO, CHARLES-ANDRÉ
12 *Un Fleuve*
13 *Une Nayade*

1742

BOIZOT, ANTOINE
102 *Renaud et Armide dans les plaisirs*
BOUCHER, FRANÇOIS
18 *Repos de Diane, sortant du Bain
avec une de ses Compagnes*
21 *Léda*
JEAURAT, ETIENNE
29 *Repos de Vénus*
30 *Vénus et Adonis*
LAMY, CHARLES
101 *L'Aurore . . .*
NATOIRE, CHARLES-JOSEPH
23 *Vénus à la Fontaine*
24 *Vénus à sa Toilette*
25 *Daphnis et Cloé*
26 *Zéphire et Flore*
27 *Bacchus et Arianne*
28 *Diane au Bain, surprise par Actéon*
PIERRE, JEAN-BAPTISTE-MARIE
123 *L'Enlèvement de Céphale par l'Aurore*
124 *La naissance de Vénus*

1743

BOIZOT, ANTOINE
77 *Réconciliation de Vénus et l'Amour*
78 *Vénus qui essaye les Armes de l'Amour*
BOUCHER, FRANÇOIS
17 *La naissance de Vénus*
18 *Vénus à sa toilette, sortant du bain*
19 *Muse Clio, qui préside à l'histoire
et l'éloge des grands Hommes . . .*
20 *Muse Melpomène, elle préside à la Tragédie . . .*
DUMONT LE ROMAIN, JACQUES
14 *Repos de Diane*
GALLOCHE, LOUIS
11 *Triomphe d'Amphitrite*
12 *Le récit que Télémaque fait
de ses aventures à Calipso* (sketch)
12 *Triomphe d'Amphitrite* (sketch)
NATOIRE, CHARLES-JOSEPH
24 *Repos de Diane*
25 *Bacchus et Ariane*
26 *Apollon et les Muses sur le Parnasse*
27 *Vénus qui se promene sur la mer
et Neptune qui vient la recevoir*
PIERRE, JEAN-BAPTISTE-MARIE
95 *Ganimède*

1745

BOIZOT, ANTOINE
133 *Les regrets d'Apollon, sur la mort
d'Hyacinthe*
134 *Vénus et Adonis*

COURTIN, JACQUES-FRANÇOIS
(1672–1752)
91 *Mercure qui endort Argus*
DELAISTRE, JACQUES-ANTOINE
(1690–1765)
106 *Thétis visitant le tombeau d'Achille*
JEAURAT, ETIENNE
26 *Le sommeil de Chloé*
27 *Chloé qui se baigne dans la Caverne des
Nymphes*
28 *Lycoenion caché, qui écoute Daphnis et Chloé*
29 *Chloé qui couronne Daphnis de Violettes*
MASSÉ, SAMUEL
86 *Hercule qui confie Déjanire au Centaure Nesse
pour passer le Fleuve*
87 *Une fête de Bacchus*
NATOIRE, CHARLES-JOSEPH
19 *Thalie, Muse de la Comédie*
20 *Terpsicore qui caractérise la danse*
21 *Calliope; cette muse préside à l'Histoire*
22 *L'éducation de l'Amour*
23 *L'éducation de Bacchus*
24 *Jupiter changé en Diane*
PIERRE, JEAN-BAPTISTE-MARIE
71 *Jupiter et Io*
72 *Vertumne et Pomone*
RESTOUT, JEAN
7 *Vénus qui exauce la prière de Pigmalion . . .*
VAN LOO, CHARLES-ANDRÉ
13 *Thesée, qui après avoir vaincu
le Taureau de Maraton, l'amene au Temple
d'Apollon pour le faire sacrifier*

1746

BOIZOT, ANTOINE
104 *L'Aurore*
COURTIN, JACQUES-FRANÇOIS
83 *Pan et Sirinx*
84 *Herigone et Jupiter en grape de raisin*
85 *L'Enlèvement de Déjanire par
le Centaure Nessus*
DUMONS, JEAN-JOSEPH
101 *Un Fleuve*
102 *Une Nayade*
FAVANNE, HENRI DE
8 *La séparation de Télémaque et d'Eucaris*
9 *Les nymphes excitées par l'Amour, mettent le
feu au Vaisseau pour empêcher l'évasion de
Télémaque*
10 *Le songe de Télémaque dans l'Isle de Cypre*
11 *Vénus qui met l'Amour entre les mains de
Calypso*
14 *Une Bacchanale*
GALLOCHE, LOUIS
1 *Télémaque qui raconte ses aventures à Calypso,
accompagnée de ses Nymphes*
6 *Un Amour qui menace*
HALLÉ, NOËL (1711–1781)
138 *Une Fête de Bacchus* (sketch)
NATOIRE, CHARLES-JOSEPH
34 *Le songe de Télémaque, dans le moment que
Vénus luy apparoît: Cupidon veut le percer du
trait ; Minerve le garantit de son Égide*

35 *Télémaque dans l'Isle de Calypso, entoure des
Nymphes, et badinant avec l'Amour sous la figure
d'un Enfant*
PIERRE, JEAN-BAPTISTE-MARIE
60 *Medée qui poignarde ses enfants après avoir tué
sa rivale . . .*
62 *Vénus sur les eaux*
66 *Pan et Sirinx*

1747

BOIZOT, ANTOINE
88 *La déification d'Énée*
89 *Vénus qui prie Vulcain de forger
des armes pour son fils Énée*
BOUCHER, FRANÇOIS
8 *Jupiter changé en Taureau, port sur son dos
Europe qu'il enlève par surprise*
32 *Les forges de Vulcain*
CAZES, PIERRE-JACQUES
11 *L'enlèvement d'Europe*
COLLIN DE VERMONT, HYACINTHE
5 *Pyrrhus Fils d'Eacide Roy des Molosses, n'avoit
que deux ans, lorsque ces Peuples s'étant revoltez
contre son Père, le chasserent de ses états . . .*
COURTIN, JACQUES-FRANÇOIS
65 *Zéphire et Flore*
FAVANNE, HENRI DE
12 *La sybile Déiphobe, qui demande à Apollon de
multiplier ses années au nombre des grains de sable
qu'elle tient dans sa main*
15 *Armide desarmée par l'Amour*
16 *Iris vient de la part de Junon trouver
le Sommeil . . .*
LEVRAC-TOURNIERES, ROBERT
(1668–1752)
30 *Les Grâces qui ornent la Nature*
NATOIRE, CHARLES-JOSEPH
9 *Une fête de Bacchus*
PIERRE, JEAN-BAPTISTE-MARIE
7 *Armide voyant l'armée des Sarrazins
defaite entièrement, et craignant de tomber en la
puissance de Renaud . . .*
55 *Une Bacchanale*
VAN LOO, CHARLES-ANDRÉ
10 *Silène, nourricier et Compagnon
de Bacchus*

1748

BOIZOT, ANTOINE
66 *Les Muses qui, après avoir enchaîné l'Amour,
le remettent entre les mains
de la Beauté*
FAVANNE, HENRI DE
2 *Télémaque qui raconte ses Avantures
à Calypso*
3 *Télémaque au milieu des Nymphes
qui chantent et lui cueillent des Fleurs
pour l'amuser*
4 *Télémaque arrive dans l'Isle de Chypre,
et conduit au Temple de Vénus pour faire
ses Offrandes*
HALLÉ, NOËL
48 *Dispute de Neptune et de Pallas*
50 *Hercule et Omphale*

LEVRAC-TOURNIERES, ROBERT
17 *La Déesse Flora sous un Berceau de Chevrefeuille*
18 *Hébé, Déesse de la Jeunesse*
PIERRE, JEAN-BAPTISTE-MARIE
39 *Bacchanale*
39 *Bacchanale*
41 *Junon qui demande à Vénus sa ceinture*
41 *Junon qui trompe Jupiter avec cette Ceinture*
RESTOUT, JEAN
8 *[Psyché] fuit la colère de Vénus . . .*
9 *Psyché qui se jette aux pieds de Vénus, lorsqu'elle est à sa Toilette, pour lui demander grâce d'avoir été aimée de son Fils*
TROY, JEAN-FRANÇOIS DE
1 *Medée, fille du Roy Aeates, inspirée par l'Amour, fait promettre à Jason, dans le Temple de Diane . . .*
2 *Jason dans le Champ de Mars, en présence du roy et de tous les habitans de Colchos, assujettit au joug les Taureaux consacrez à ce Dieu*
3 *Jason, après avoir femé les dents du Serpent, et se voyant attaqué par les soldats qu'elles avoient fait naître tous armez, lance au milieu d'eux une pierre, dont l'effet enchanteur leur fait tourner contr'eux leurs propres armes*
4 *Jason ayant, par la vertu des herbes, endormi le Dragon, gardien de la Toison d'or, se faisit sans obstacle de la riche dépouille du mouton de Phryxus, et fut en Thessalie accompagné de sa Maîtresse*
5 *Jason infidèle à Medée, épouse Creuse fille de Créon Roy de Corinthe*
6 *Medée, pour se vanger avec éclat de sa Rivale, luy fait présent d'une Robe empoisonnée, qui luy cause la mort ainsi qu'à Créon son père*
7 *Medée met le comble à sa vengeance, en poignardant deux Fils qu'elle avoit eu de Jason*

1750

COLLIN DE VERMONT, HYACINTHE
29 *Jupiter et Mercure chez Philémon et Baucis*
30 *Hébé, Déesse de la Jeunesse, et Femme d'Hercule, qui rajeunit à sa prière Yolas Neveu de son Mary*
32 *Anacréon, fameux Poète Grec, reçoit de nuit l'Amour chez lui . . .*
DELOBEL, NICOLAS
94 *Neptune et Amphitrite*
FAVANNE, HENRI DE
6 *Junon vient trouver l'Océan pour lui demander que la grande Ourse ne vienne jamais se plonger dans ses Eaux*
8 *Mars qui se blesse en prenant une Flèche de l'Amour*
8 *Mercure qui après avoir endormi Argus, se dispose à lui trancher la tête pour délivrer Yo, changée en Vache*
HALLÉ, NOËL
69 *L'Éducation de l'Amour*
70 *Athalante et Méléagre*

NATOIRE, CHARLES-JOSEPH
26 *Triomphe de Bacchus*
27 *Un Amour qui aiguise des Flèches*
PIERRE, JEAN-BAPTISTE-MARIE
56 *L'enlèvement d'Europe*
57 *Léda*
60 *Psyché, retirée du Fleuve par les Nymphes*
VAN LOO, CHARLES-ANDRÉ
16 *L'Amour debout qui tient négligemment son Arc . . .*
20 *Vénus dans le bain*

1751

COLLIN DE VERMONT, HYACINTHE
12 *Les Meneides refusoient de célèbrer la fête de Bacchus que toute la ville de Thèbes reconnoissoit pour fils de Jupiter. Elles voyent leurs fuseaux et leurs laines se transformer en Pampres de vigne, et sont elles-mêmes changé . . .*
13 *Une troupe de jeunes Nymphes se voyant poursuivies par un Berger insolent qui se moquoit d'elles, le changent en olivier sauvage*
DUMONT LE ROMAIN, JACQUES
7 *Athalante et Méléagre*
FAVANNE, HENRI DE
4 *Vénus qui vient trouver Neptune, pour le prier de favoriser le voyage de son Fils Énée en Italie*
5 *Adonis confié aux Nayades pour prendre soin de son éducation*
LE SUEUR, PIERRE (VERS 1739–1786)
68 *Une Nymphe des eaux*
PIERRE, JEAN-BAPTISTE-MARIE
37 *Neptune qui réprime les vents, ou le Quos ego*
RESTOUT, JEAN
6 *Didon qui fait voir à Énée les Bâtimens de Cartage*

1753

BOIZOT, ANTOINE
99 *L'Aurore qui invogue l'Amour pour obtenir rejeunissement de Titon*
CHALLES, CHARLES-MICHEL-ANGE (1718–1778)
118 *Didon sur le bûcher*
COLLIN DE VERMONT, HYACINTHE
15 *Les noces de Thétis et Pélée*
HALLÉ, NOËL
50 *Le Midy, sous l'Emblème de Vénus et l'Amour*
51 *Le Soir, désigné par une Diane*
JEAURAT, ETIENNE
17 *Achille qui laisse à Thétis sa mère se soin des funérailles de son ami Patrocle, et part pour aller venger sa mort*
LE LORRAIN, LOUIS-JOSEPH (1715–1759)
166 *Hercule qui va faire manger Diomède par chevaux*
167 *Les Grâces qui enchaînent l'Amour* (sketch)

VAN LOO, CHARLES-ANDRÉ
8 *Jupiter et Antiope*

1755

BOIZOT, ANTOINE
64 *Le Châtiment de l'Amour*
HALLÉ, NOËL
31 *La Sybille de Cumes, qui obtient d'Apollon de vivre autant d'années qu'elle a de grains de sable dans sa main*
32 *Jupiter sous la forme de Diane, et la nymphe Callisto*
LAGRENÉE, LOUIS-JEAN-FRANÇOIS (1724–1805)
124 *Le Centaure Nessus qui enlève Déjanire: Hercule lui décoche une flèche*
125 *Jupiter transformé en satyre regarde Antiope dormant avec l'Amour*
127 *L'Amour qui brise son Arc*
128 *Le Centaure Chiron instruisant Achilles*
128 *Mercure qui enseigne la Géographie à l'Amour*
129 *Hercule brisant les chaînes de Promethée sur le Mont Caucase . . .*
RESTOUT, JEAN
12 *L'Amour instruit par Mercure*
VENEVAULT, NICOLAS (1697–1775)
72 *La nymphe Io*
VIEN, JOSEPH-MARIE (1716–1809)
37 *Dédale dans le labyrinthe, attachant les ailes à Icare*
38 *Vénus sortant de la mer, portée par des Tritons, et accompagnée de Nayades et d'Amours*
41 *Une Tête de Minerve, d'après l'antique*
42 *Une nymphe de Diane occupée de l'Amour endormi, dans un paysage*
43 *Une tête d'Anacréon*
44 *Flore*
44 *Zéphire*

1757

BOUCHER, FRANÇOIS
11 *Les Forges de Vulcain*
HALLÉ, NOËL
25 *La nymphe Io changée en Vache*
JEAURAT, ETIENNE
14 *Promethée*
LAGRENÉE, LOUIS-JEAN-FRANÇOIS
81 *Pan, après avoir poursuivi la Nymphe Sirinx jusqu'au Fleuve Ladon, est retenu par plusieurs Naiades, et par ce Fleuve qui la dérobe à ses poursuites, en la changeant en Roseaux*
84 *Herminie, Amante de Tancrède*
85 *Bacchus consolant Ariane abandonnée par Thesée*
LE LORRAIN, LOUIS-JOSEPH
90 *La Nymphe Peristere changée en Colombe*
LE METTAY, PIERRE-JOSEPH (1728–1759)
126 *Bacchus naissant remis entre les mains des Nymphes*

PIERRE, JEAN-BAPTISTE-MARIE
19 *L'Enlèvement d'Europe*

VAN LOO, CHARLES-ANDRÉ
5 *Amimone et Neptune*
6 *Le Sacrifice d'Iphigénie*

VENEVAULT, NICOLAS
49 *L'Union de l'Amour et de l'Amitié*

VIEN, JOSEPH-MARIE
29 *Proserpine ornant la statue de Cérès . . .*
30 *Dédale qui attache des ailes à Icare*

1759

BOIZOT, ANTOINE
46 *Flore couronnée par le Zéphire*
47 *L'Amour qui se repos sur ses armes*

DESHAYS DE COLLEVILLE, JEAN-BAPTISTE-HENRI
(1729–1765)
92 *Hector exposé sur les rives du Scamandre*
après avoir été tué par Achilles et traîne
à son char. Vénus préserve son corps
de la corruption

HALLÉ, NOËL
16 *Le Danger de l'Amour, représenté*
par Hercule et Omphale
16 *Le Danger du Vin, représente*
par des Bacchantes et des Faunes,
assistant à une Fête de Bacchus

LAGRENÉE, LOUIS-JEAN-FRANÇOIS
25 *Vénus aux forges de Lemnos,*
accompagnée des Grâces et des plaisirs,
demande à Vulcain des armes pour
son fils Énée
26 *L'Aurore enlève Céphale . . .*
27 *Le Jugement de Pâris*
28 *Satyre se jouant du sifflet du Dieu Pan*

VENEVAULT, NICOLAS
53 *L'Amour piqué par une Abeille*

1761

BOIZOT, ANTOINE
51 *Télémaque accompagnée de Minerve*
sous la figure de Mentor, raconte ses Avantures
à la Nymphe Calypso

DOYEN, GABRIEL-FRANÇOIS (1726–1806)
90 *Vénus blessée par Diomède*
93 *Les charmes de l'harmonie, représentés par une*
Vénus ailée qui joue de la harpe
94 *L'Espérance qui nourrit l'Amour*

GREUZE, JEAN-BAPTISTE (1725–1806)
103 *Une Tête d'un nymphe de Diane*

PIERRE, JEAN-BAPTISTE-MARIE
14 *Le Jugement de Pâris*

VAN LOO, CHARLES-AMÉDÉE-PHILIPPE
(1718–1795)
38 *Satyres*
38 *Satyres*

VAN LOO, CHARLES-ANDRÉ
7 *L'Amour menaçant*

VIEN, JOSEPH-MARIE
22 *Zéphire et Flore*
24 *L'Amour et Psyché*
27 *La Déesse Hébé*

1763

BOIZOT, ANTOINE
71 *Argus discourant avec Mercure*

CHALLES, CHARLES-MICHEL-ANGE
53 *La mort d'Hercule*
55 *Vénus endormie*

DESHAYS DE COLLEVILLE, JEAN-BAPTISTE-HENRI
44 *Danaé et Jupiter en pluye d'or*

DOYEN, GABRIEL-FRANÇOIS
120 *Andromaque, ayant caché Astianax*
fils unique d'Hector, dans le tombeau
de son père . . .

HALLÉ, NOËL
22 *Le Combat d'Hercule et d'Achéloüs* (sketch)

LAGRENÉE, LOUIS-JEAN-FRANÇOIS
32 *La lever de l'Aurore; elle quitte la couche du*
vieux Triton

PIERRE, JEAN-BAPTISTE-MARIE
12 *Mercure amoureux de Hersé, changé*
en pierre Aglaure, qui vouloit l'empêcher d'entrer
chez sa soeur
15 *Une bacchante endormie*

RESTOUT, JEAN
3 *Orphée descendu aux Enfers*
pour demander Euridice

VAN LOO, CHARLES-ANDRÉ
2 *Les Grâces enchaînées par L'Amour*

VIEN, JOSEPH-MARIE
26 *Proserpine orne de Fleurs le buste*
de Cérès sa mère

1765

AMAND, JACQUES-FRANÇOIS (1730–1769)
165 *Mercure dans l'action de tuer Argus*
168 *Tancrède pansé par Herminie*
169 *Renauld et Armide*

BOIZOT, ANTOINE
56 *Les Grâces enchaînent l'Amour*
57 *Mars et l'Amour disputent sur le pouvoir de*
leurs armes . . .

BOUCHER, FRANÇOIS
8 *Jupiter transformé en Diane pour*
surprendre Callisto

BRENET, NICOLAS-GUY (1728–1792)
133 *L'Amour caressant sa mère,*
afin qu'elle lui rende ses Armes

BRIARD, GABRIEL (1725–1777)
129 *La rencontre de Psyché et du Pêcheur*
129 *Psyché abandonnée*

CHALLES, CHARLES-MICHEL-ANGE
44 *Hector entrant dans la Palais de Pâris*
qu'il trouve assis auprès d'Hélène,
lui reproche sa suite du combat qu'il venoît
d'engager contre Ménélas

DESHAYS DE COLLEVILLE, JEAN-BAPTISTE-HENRI
33 *Achille prêt d'être submergé par*
le Scamandre et le Simois, est secondé
par Junon et Vulcain . . .
34 *Jupiter et Antiope*

HALLÉ, NOËL
16 *La Course d'Hippomène et d'Atalante*

LAGRENÉE, LOUIS-JEAN-FRANÇOIS
25 *Diane et Endimion*

MONNET, CHARLES (1732–1808)
181 *L'Amour*

PARROCEL, JOSEPH-IGNACE-FRANÇOIS
(1704–1781)
108 *Céphale se reconcile avec Procris,*
que sous un déguisement il avoit éprouvée
infidèle . . .
109 *Procris, par l'erreur de Céphale, est tuée du*
même dard qu'elle lui avoit donné . . .

TARAVAL, HUGHES (1728–1785)
183 *Vénus et Adonis*

VAN LOO, CHARLES-ANDRÉ
2 *Les Grâces*

1767

BACHELIER, JEAN-JACQUES (1724–1806)
37 *Psyché enlevée du rocher par les Zéphirs*

CARESME, PHILIPPE (1754–1796)
178 *L'Amour*

JOLLAIN, NICOLAS-RENÉ (1732–1804)
152 *L'Amour enchaîné par les Grâces*

LAGRENÉE, LOUIS-JEAN-FRANÇOIS
20 *Jupiter et Junon sur le Mont Ida,*
endormis par Morphée
23 *L'Épée, par Bellone, présentant à Mars les*
rênes de ses Chevaux
26 *Mercure, Hersé, et Aglaure jalouse de sa sœur*
27 *Renaud et Armide*
28 *Persée après avoir delivré Andromède*
29 *Retour d'Ulysse et de Télémaque*
auprès de Pénélope
31 *L'Amour Remouleur*

RESTOUT, JEAN-BERNARD (1732–1797)
149 *Les plaisirs d'Anacréon . . .*

TARAVAL, HUGHES
144 *Repas de Tantale*
145 *Vénus et Adonis*
147 *Une Tête de Bacchante*
148 *Hercule, enfant, étouffant les Serpens dans*
son berceau (sketch)

1769

BOUNIEU, MICHEL-HONORÉ (1740–1814)
183 *Silène barbouillé de mures*
par la Nimphe Eglé
184 *Repos de Bacchus*

BRENET, NICOLAS-GUY
122 *Aethra, mère de Thesée, le conduit*
au lieu ou son père avoit caché son épée
et ses souliers

BRIARD, GABRIEL
116 *La Naissance de Vénus*
117 *La Mort d'Adonis*

HALLÉ, NOËL
11 *Achille reconnu à la cour de Deidamie,*
par la choix qu'il fait des armes qu'Ulisse avoit
mêlées avec des Bijoux de Femmes, à dessein
de la découvrir

JOLLAIN, NICOLAS-RENÉ
167 *Clitie changée en Tournesol*
168 *Hiacinthe changé en Hiacinte*
169 *Diane surprise par Actéon*
170 *L'Amour captif de Diane*
171 *L'Amour vainqueur de Diane*

LAGRENÉE, LOUIS-JEAN-FRANÇOIS
14 *Cérès enseigne l'Agriculture au Roi
Triptolème, dont elle nourrissoit le fils
de son propre lait*
15 *Mars et Vénus surpris par Vulcain*
16 *Psiché surprend l'Amour endormi*
17 *Télémaque dans l'Isle de Calypso, devient
amoureux de la Nymphe Eucharis,
en caressant l'Amour*
18 *Alphée poursuit Aréthuse, Diane
les métamorphose, l'un en Fleuve
et l'autre en Fontaine*
19 *Clitie abandonnée par Apollon*
20 *Bacchus et Ariane*
21 *Diane et Endymion*
26 *Hercule et Omphale*
27 *Calysto, Nymphe de Diane,
sortant du bain*
28 *Euphrosine, Thalie et Aglaié*

LÉPICIÉ, NICOLAS-BERNARD (1735–1784)
123 *Adonis changée en Anémone par Vénus*
124 *Achille instruit dans sa Musique,
par le Centaure Chiron*

TARAVAL, HUGHES
131 *Le Triomphe de Bacchus*

VAN LOO, CHARLES-AMÉDÉE-PHILIPPE
30 *L'Hymen veut allumer son Flambeau
à celui de l'Amour*

VAN LOO, LOUIS-MICHEL (1707–1771)
5 *L'Éducation de l'Amour*

1771

BELLE, CLÉMENT-LOUIS-MARIE-ANNE
(1722–1806)
23 *Psiché et l'Amour endormis*

BOUNIEU, MICHEL-HONORÉ
200 *Jupiter et Io*
201 *Neptune et Amphytrite*
202 *Pluton et Proserpine*

BRENET, NICOLAS-GUY
112 *Jupiter et Antiope*
114 *Vénus*
115 *Diane*
116 *Apollon, avec le Génie des Arts*

HALLÉ, NOËL
1 *Silène dans sa Grotte, barbouillé
de mures par Eglé*

JOLLAIN, NICOLAS-RENÉ
177 *Jupiter sous la forme de Diane séduit Calisto*

LAGRENÉE, JEAN-JACQUES (1740–1821)
216 *Un Satyre jouant avec un enfant*

LAGRENÉE, LOUIS-JEAN-FRANÇOIS
6 *Une nymphe qui se mire dans l'eau*
11 *Mars et Vénus, Allégorie sur la Paix*
12 *La Métamorphose d'Alphée et d'Aréthuse*
13 *Diane surprise au Bain par Actéon*
14 *Jupiter, sous la forme de Diane, séduit
la Nymphe Callisto*
15 *Apollon chante la gloire des grands hommes*
16 *Vénus et l'Amour endormis*
17 *Léda*
18 *La Nymphe Écho, amoureuse
de Narcisse*
19 *Eglé, jeune Nymphe*

21 *Télémaque rencontre Termosiris,
Prêtre d'Apollon, qui lui enseigne l'art
d'être heureux dans l'Esclavage,
et lui apprend la Poésie Pastorale*

LÉPICIÉ, NICOLAS-BERNARD
30 *Narcisse changé en la fleur qui porte
son nom*
31 *Narcisse changé en la fleur qui porte
son nom*
32 *Adonis changé en Anémone*
34 *La colère de Neptune*

MONNET, CHARLES
172 *L'Amour caresse une colombe*
172 *L'Amour lance ses traits*
174 *L'Aurore qui chasse la Nuit* (sketch)

PASQUIER, PIERRE (1731–1806)
125 *Armide et Renaud*

RESTOUT, JEAN-BERNARD
139 *Jupiter chez Philémon et Baucis*

VAN LOO, CHARLES-AMÉDÉE-PHILIPPE
24 *Vénus et l'Amour couronnés
par les Grâces*

1773

DOYEN, GABRIEL-FRANÇOIS
26 *Cybèle, mère des Dieux, représente
la Terre avec ses attributs*

JOLLAIN, NICOLAS-RENÉ
155 *Vénus sur les Eaux*
156 *Anacréon caressant l'Amour*

LAGRENÉE, JEAN-JACQUES
178 *Apollon accorde à la Sybille de Cumes, de
vivre autant d'années qu'elle a de grains de sable
dans les mains*

LAGRENÉE, LOUIS-JEAN-FRANÇOIS
9 *Les Trois Grâces au Bain*
14 *La Poésie; Anacréon caressé par les Muses*
16 *La Musique. Orphée; Pluton lui rend
Euridice, son Épouse*
16 *La Sculpture. Pigmalion amoureaux
de sa Statue; Vénus l'anime*
17 *Bacchus nourri par les Déesses de la Terre*
19 *Vénus noue le bandeau à l'Amour*
20 *Diane, au bain, se fait rapporter son arc
par un chien*
21 *La Nymphe Salmacis*

LÉPICIÉ, NICOLAS-BERNARD
55 *Les Grâces…*

MARTIN, GUILLAUME (1737–1800)
185 *Silène, porte par de jeunes Silvains,
et par des Bergers devant la nymphe Eglé,
qui lui presente à Boire*

MONNET, CHARLES
159 *Zéphire et Flore*
160 *Borée et Orithie*

PASQUIER, PIERRE
127 *Les Trois Grâces*

RENOU, ANTOINE (1731–1806)
166 *Clitie, changée en Tournesol*
167 *Biblis, métamorphosée en Fontaine*

TARAVAL, HUGHES
105 *Procris blessée par Céphale
son amant . . .*

108 *L'Apothéose de Psiché* (sketch)
110 *Un groupe d'Hercule, de Pan
et de Mercure* (sketch)
112 *Le lever du soleil, précédé
et accompagné des heures conduites
par l'Amour* (sketch)

VIEN, JOSEPH-MARIE
4 *Diane, accompagnée de ses Nymphes,
au retour de la Chasse . . .*

1775

BOUNIEU, MICHEL-HONORÉ
158 *Pan lié par des Nymphes*

CARESME, PHILIPPE
148 *La Nymphe Menthe métamorphosée.
Proserpine, irritée d'avoir surpris Pluton
avec Menthe, fille du Cocyte, la changea
en Menthe ou Baume, et son frère en Baume
sauvage, pour avoir favorisé les amours
de sa sœur*
151 *Diane et Endimion* (sketch)

DURAMEAU, LOUIS-JACQUES (1733–1796)
129 *L'Été: Cérès et ses Compagnes
implorent le Soleil, et attendent, pour
moissoner, qu'il ait atteint le signe
de la Vierge*

JOLLAIN, NICOLAS-RENÉ
110 *La Toilette de Psyché*

LAGRENÉE, JEAN-JACQUES
140 *Les fils et les filles de Niobé tués
par Apollon et Diane*
141 *Une Bacchanale*

LAGRENÉE, LOUIS-JEAN-FRANÇOIS
6 *Armide désespérée de n'avoir pu se venger de
Renaud, veut se tuer, Renaud lui retient le bras*
10 *Diane et Endimion*
11 *L'Amour abandonne Psyché*
12 *L'Amour console Psyché*
14 *La Sibylle obtient d'Apollon de vivre
autant d'années qu'elle tient de grains
de sable dans sa main*

MONNET, CHARLES
142 *Zéphire et Flore*
143 *Borée et Orithie*

ROBIN, JEAN-BAPTISTE-CLAUDE
(1734–1818)
181 *La Fureur d'Atys*

TARAVAL, HUGHES
81 *Télémaque dans l'Isle de Calypso,
il commence à lui raconter ses aventures*

THEAULON, ETIENNE (1739–1780)
192 *Jeunes Nymphes dansant dans une grotte,
au coucher du Soleil*

VIEN, JOSEPH-MARIE
4 *Vénus blessé par Diomède à la guerre
de Troye, Iris descend du ciel pour la tirer
du champ de bataille et Mars l'aide à monter
dans son Char pour la conduire sur l'Olympe*

1777

BERTHÉLEMY, JEAN-SIMON (1743–1811)
209 *L'Aurore qui pleure sur le tombeau
de Memnon*

BOUNIEU, MICHEL-HONORÉ
141 *La Mort d'Adonis*
142 *La Nymphe Galatée jettant des pommes à un Berger*
143 *Un Satyre, que des Femmes forcent à boire*
144 *Nymphes, portant leurs offrandes au Dieu Pan, sont rencontrées par un Satyre*
145 *Tête d'une Bacchante*

CARESME, PHILIPPE
136 *Menthe, métamorphosée par Proserpine, en menthe ou baume*

JOLLAIN, NICOLAS-RENÉ
110 *Alceste vient, avec ses enfans, implorer Apollon dans son Temple . . .*
111 *Junon emprunte la ceinture de Vénus pour séduire Jupiter*
112 *Jupiter vaincu par l'Amour et le sommeil, s'endort dans les bras de Junon*
113 *Persée délivre Andromède enchaîne au rocher: l'Amour transforme les chaines en guirlandes de fleurs*
115 *Les Chevaliers allant chercher Renaud dans le Palais d'Armide, sont arrêtés par deux nymphes, qui s'efforcent de les séduire*
116 *Renaud rompt le charme de la Forêt enchantée, malgré le prestige des Nymphes*

LAGRENÉE, JEAN-JACQUES
27 *Télémaque racontant ses aventures à Calypso*
28 *Bacchus apporté aux Corybantes par Mercure*
33 *Télémaque dans l'Isle de Calypso*

LAGRENÉE, LOUIS-JEAN-FRANÇOIS
3 *Pigmalion, dont Vénus anime la Statue*
4 *Le Jugement de Pâris*

MÉNAGEOT, FRANÇOIS-GUILLAUME (1744–1816)
202 *Les adieux de Polixène à Hécube, au moment ou cette jeune Princesse est arrachée des bras de sa mère pour être immolée aux manes d'Achille*

OLLIVIER, MICHEL-BARTHÉLEMY (1712–1784)
129 *Télémaque et Mentor sont conduits prisonniers devant Aceste, Roi de Sicile, qui, sans les connoître, les condamne à l'esclavage*

TARAVAL, HUGHES
86 *Triomphe d'Amphitrite*

VAN LOO, CHARLES-AMÉDÉE-PHILIPPE
8 *L'Aurore et Céphale*

1779

DOYEN, GABRIEL-FRANÇOIS
18 *Anacréon chante une ode à la louange de Vénus, l'Amour accorde sa lyre, la Déesse descend du ciel et courrone le Poète de mirthe et de rose*
19 *Une Nymphe enivre l'Amour*
20 *Bacchantes endormies*
24 *Hector reporté par Priam, après l'avoir retiré des mains d'Achille*
25 *Une Nymphe, qui a volé un nid d'amours*

DURAMEAU, LOUIS-JACQUES
34 *Combat d'Entelle et de Darès*
35 *Piété filiale de Cléobis et Biton*

GUÉRIN, FRANÇOIS (c. 1751–1791)
88 *Junon*

HUET, JEAN-BAPTISTE (1745–1811)
98 *Hercule chez la Reine Omphale*

JOLLAIN, NICOLAS-RENÉ
114 *Aréthuse poursuivie par le Fleuve Alphée et secourue par Diane*
116 *Renaud quittant Armide pour suivre la Gloire*
117 *Anacréon recevant sa lire de la main des Grâces*
117 *Anacréon sacrifiant aux Grâces*
118 *Vertumne et Pomone*
119 *Toilette de Vénus*
120 *Le Retour de Mars*
121 *Thétis confiant Achille, son fils, au Centaure Chiron*
122 *Apollon et la Sybille de Cumes*

LAGRENÉE, JEAN-JACQUES
38 *Diane au Bain*
41 *Mercure voulant entrer chez Hersé, en est empêché par Aglaure, qu'il change en statue*

LAGRENÉE, LOUIS-JEAN-FRANÇOIS
7 *L'Éducation de l'Amour*
8 *Les Grâces lutinées par les Amours*
9 *Les Grâces qui prennent leur revanche*
11 *Vénus et l'Amour*
12 *Diane et Actéon*
16 *Pan et Syrinx*

OLLIVIER, MICHEL-BARTHÉLEMY
135 *Télémaque et Mentor sont conduits prisonniers devant Alceste, Roi de Sicile, qui sans les connoître, les condamne à l'esclavage*

SUVÉE, JOSEPH-BENOIT (1743–1807)
187 *Herminie, sous les armes de Clorinde, rencontre un Vieillard, et s'étonne de sa tranquilité et de sa bonheur au milieu des horreurs de la guerre . . .*

VIEN, JOSEPH-MARIE
4 *Hector détermine Pâris, son frère, à prendre les armes pour la défense de la Patrie*

1781

BERTHÉLEMY, JEAN-SIMON
153 *Apollon, après avoir lavé le sang dont Sarpédon étoit tout défiguré et l'avoir parfumé d'ambroisie, ordonne au Sommeil et à la Mort de la porter promptement en Lycie, ou la famille et ses amis lui firent de Funérailles*

CALLET, ANTOINE-FRANÇOIS (1741–1823)
147 *Le Printemps: Zéphir et Flore . . .*
148 *Hercule sur le bûcher, déchirant la chemise de Nessus* (sketch)

DOYEN, GABRIEL-FRANÇOIS
19 *Mars vaincu par Minerve*

JOLLAIN, NICOLAS-RENÉ
124 *Le Réveil d'Endimion*

LAGRENÉE, JEAN-JACQUES
44 *Calipso, s'appercevant de la douleur de Télémaque au récit des aventures d'Ulisse, son père, ordonne aux Nymphes d'interrompre leurs chants*

LAGRENÉE, LOUIS-JEAN-FRANÇOIS
2 *Préparatifs du combat de Pâris et de Ménélas*
8 *Hercule et Omphale*
11 *Combat de l'Amour et de la chasteté*

MARTIN, GUILLAUME
165 *Sacrifice d'Iphigénie*

MONNET, CHARLES
158 *Vénus sortant du Bain*

PASQUIER, PIERRE
102 *L'Amour*

TARAVAL, HUGHES
50 *Triomphe d'Amphitrite*
51 *Diane au bain, surprise par Actéon*
52 *Télémaque dans l'Isle de Calipso*

VAN LOO, CHARLES-AMÉDÉE-PHILIPPE
18 *Les Amants unis par l'Hymen et couronnés par l'Amour*

VIEN, JOSEPH-MARIE
1 *Briseis emmenée de la tente d'Achille*

1783

DAVID, JACQUES-LOUIS (1748–1825)
162 *La douleur et les regrets d'Andromaque sur le corps d'Hector son mari*

DURAMEAU, LOUIS-JACQUES
13 *Herminie sous les armes de Clorinde*

JULIEN, SIMON (1735–1800)
188 *Tête d'une Bacchante*

LAGRENÉE, JEAN-JACQUES
14 *Fête à Bacchus ou l'Automne*
16 *Bacchus apporté par Mercure aux Corybantes*
19 *Mort d'Adonis*
21 *Télémaque parmi les Bergers d'Egypte*
22 *Télémaque laissé seul avec Mentor, regarde avec plaisir les beaux habits que les Nymphes de Calypso lui avoient préparés, mentor semble lui reprocher de s'occuper de pensées indignés du Fils d'Ulysse*

LE BARBIER, JEAN-JACQUES-FRANÇOIS (1738–1826)
152 *Le Sommeil de Jupiter*

MÉNAGEOT, FRANÇOIS-GUILLAUME
29 *Astyanax arraché des bras d'Andromaque par l'ordre de Ulysse*

REGNAULT, JEAN-BAPTISTE (1754–1829)
166 *Persée délivre Andromède, et la remet entre les mains de ses Parens*
167 *L'Éducation d'Achille par le Centaure Chiron*
169 *Énée ofre des présens à Latinus, et lui demande sa fille en mariage* (sketch)
170 *Pyrrhus tue Priam sur le dernier de ses fils* (sketch)
172 *Andromède délivrée par Persée*
172 *Le Mariage de Persée et Andromède*
173 *L'Aurore et Céphale*

TAILLASSON, JEAN-JOSEPH (1745–1809)
184 *Hector sur un lit funèbre, et entoure de sa Famille en pleurs* (sketch)

184 *Priam conduisant le corps d'Hector*
à Troie, arrêté par la foule du Peuple
aux portes de la Ville (sketch)
VAN LOO, CHARLES-AMÉDÉE-PHILIPPE
4 *Zéphire et Flore, ou le Printemps*
VIEN, JOSEPH-MARIE
1 *Priam partant pour supplier Achille de lui rendre*
le corps de son fils Hector
VIGÉE LE BRUN, ELISABETH-LOUISE
(1755–1842)
113 *Junon venant emprunter la ceinture*
de Vénus
VINCENT, FRANÇOIS-ANDRÉ (1746–1816)
93 *Achille secouru par Vulcain, combat*
les Fleuves du Xante et du Simoïs
94 *Enlèvement d'Orithie*
96 *Enlèvement d'Orithie*

1785

CALLET, ANTOINE-FRANÇOIS
62 *Achille trainant le corps d'Hector devant*
les murs de Troye et sous les yeux de Priam
et Hécube, qui implorent le Vainqueur
LAGRENÉE, JEAN-JACQUES
10 *Renaud abandonnant Armide, qui, ne pouvant*
le retenir, tombe évanouie de douleur
LAGRENÉE, LOUIS-JEAN-FRANÇOIS
3 *Ubalde et le Chevalier Danois*
LE BARBIER, JEAN-JACQUES-FRANÇOIS
134 *Jupiter endormi sur la Mont Ida*
MÉNAGEOT, FRANÇOIS-GUILLAUME
20 *Alceste rendue à son mari par Hercule*
PEYRON, JEAN-FRANÇOIS-PIERRE
(1744–1814)
178 *L'héroïsme de l'amour conjugal. Alceste*
s'étant dévouée volontairement à la mort,
pour sauver les jours de son epoux . . .
REGNAULT, JEAN-BAPTISTE
106 *Mort de Priam*
107 *Pigmalion amoureux de sa Statue*
108 *Psyché venant à la faveur d'une lampe,*
pour poignarder son amant qu'elle croit un
monstre: elle reconnoit l'Amour
109 *Deux Bacchantes*
SUVÉE, JOSEPH-BENOIT
22 *Énée, au milieu de la ruine de Troye, n'ayant*
pu déterminer Anchise, son père, à quitter son
Palais et sa Patrie, veut, dans son désespoir,
retourner au combat . . .
TAILLASSON, JEAN-JOSEPH
110 *Philoctète à qui Ulisse et Néoptolème*
enlèvent les flèches d'Hercule
114 *Vénus arrêtant Adonis, prêt à partir*
pour la chasse
TARAVAL, HUGHES
18 *Hercules Enfant étouffant deux serpens*
dans son berceau
VIEN, JOSEPH-MARIE
1 *Retour de Priam avec le corps d'Hector*

VIGÉE LE BRUN, ELISABETH-LOUISE
86 *Bacchante assise, de grandeur naturelle*
et vue jusqu'aux genoux
WERTMÜLLER, ADOLF ULRIK (1751–1811)
121 *Une petite tête de l'Amour*

1787

CALLET, ANTOINE-FRANÇOIS
83 *L'Automne, ou les Fêtes de Bacchus*
DOYEN, GABRIEL-FRANÇOIS
11 *Priam demandant à Achille le corps d'Hector*
LAGRENÉE, JEAN-JACQUES
13 *Ulysse arrivant le Palais de Circé*
PERRIN, JEAN-CHARLES-NICAISE
(1754–1831)
166 *Esculape reçoit des mains de Vénus les herbes*
et simples nécessaires à la guérison d'Énée
REGNAULT, JEAN-BAPTISTE
120 *La reconnoissance d'Oreste et d'Iphigénie,*
dans la Tauride
121 *Mars désarmé par Vénus*
TAILLASSON, JEAN-JOSEPH
125 *Une tête de Nymphe de Diane*
VIEN, JOSEPH-MARIE
1 *Les Adieux d'Hector et d'Andromaque*
VINCENT, FRANÇOIS-ANDRÉ
22 *Renaud et Armide*

1789

CALLET, ANTOINE-FRANÇOIS
65 *L'Été ou les Fêtes de Cérès*
DAVID, JACQUES-LOUIS
89 *Les Amours de Pâris et Hélène*
HUE, JEAN-FRANÇOIS (1751–1823)
71 *L'intérieur d'un bois, ou Vénus présente*
son fils à Calypso . . .
LAGRENÉE, JEAN-JACQUES
9 *Télémaque et Mentor jetés dans l'Isle*
de Calypso
10 *Achille sous l'habit de fille, reconnu par Ulysse*
au milieu de la cour de Lycomède
LE BARBIER, JEAN-JACQUES-FRANÇOIS
98 *Ulysse sortant de Sparte avec Pénélope*
pour retourner à Ithaque, ou la Pudeur
PERRIN, JEAN-CHARLES-NICAISE
117 *Thésée prend en horreur le crime*
de son Épouse, et déplore la perte
de son fils Hippolyte
TAILLASSON, JEAN-JOSEPH
94 *Herminie, devenue Berger, grave sur les arbres*
ses aventures malheureuses et le nom de Tancrède
VALENCIENNES, PIERRE-HENRI DE
(1750–1819)
119 *Pyrrhus appercevant Philoctète*
dans son antre, à l'Isle de Lemnos
VIEN, JOSEPH-MARIE
1 *L'Amour fuyant l'Esclavage*

1791

BALTHASAR, FRANÇOIS
(c. 1779–1800)
184 *Sacrifice d'Iphigénie* (sketch)
BONVOISIN, JEAN (1752–1837)
697 *Apollon veut ravoir un Trépied qu'Hercule*
emporte du Temple de Delphes
CHAISE, CHARLES-EDOUARD (1759–1798)
764 *Fête à Bacchus*
DESORIA, JEAN-BAPTISTE-FRANÇOIS
(1758–1832)
58 *Thesée en présence de sa Mère et de son*
Grand-Père, levant la pierre sous laquelle étoient
l'épée et les brodequins de son Père
703 *Diane et Endymion*
FORTY, JEAN-JACQUES (1744–1800)
785 *Ganimède*
GAUFFIER, LOUIS (1761–1801)
720 *Achille reconnu par Ulysse*
HUE, JEAN-FRANÇOIS
139 *Narcisse*
JOLLAIN, NICOLAS-RENÉ
278 *Énée et Didon*
LAVILLE-LEROUX BENOITS, MARIE-GUILHELMINE
(1768–1826)
164 *Les Adieux de Psyché à sa Famille*
LE BARBIER, JEAN-JACQUES-FRANÇOIS
737 *Le Pouvoir de l'Amoure*
LE SUEUR, PIERRE-ETIENNE
(c. 1791–c. 1810)
276 *Apollon dans son exil*
LEFEBVRE, [PEINTRE, RUE SAINT-HONORÉ]
(c. 1791–c. 1793)
777 *Énée, prêt à déposer son Père Anchyse sur le*
Mont Ida
LEFEVRE, ROBERT (1756–1830)
51 *Vénus embrassant l'Amour*
53 *Vénus enlèvant les armes de l'Amour*
MONSIAU, NICOLAS-ANDRÉ (1754–1837)
311 *Diane vue par Actéon*
MOREAU, JEAN MICHEL (1741–1814)
749 *Hector, arrachant Pâris d'auprès d'Hélène,*
poour le mener au combat
PARSEVAL, AUGUSTE (1745–1837)
147 *Junon, attachant les yeux d'Argus*
à la queue de son Paon
REGNAULT, JEAN-BAPTISTE
302 *Jupiter, sous la forme de Diane,*
séduisant Callisto
303 *L'Éducation d'Achille par le Centaure Chiron*
VIEN, JOSEPH-MARIE
369 *Les adieux d'Hector et d'Andromaque*

AMAND, JEAN-FRANÇOIS
(1730–1769)
1765
165 *Mercure dans l'action de tuer Argus*
168 *Tancrède pansé par Herminie*
169 *Renaud et Armide*

BACHELIER, JEAN-JACQUES
(1724–1806)
1767
37 *Psyché enlevée du rocher par les Zéphirs*

BALTHASAR, FRANÇOIS
(ACTIVE C. 1779–C. 1800)
1791
184 *Sacrifice d'Iphigénie (sketch)*

BELLE, CLÉMENT-LOUIS-MARIE-ANNE
(1722–1806)
1771
23 *Psiché et l'Amour endormis*

BERTHÉLEMY, JEAN-SIMON
(1743–1811)
1777
209 *L'Aurore qui pleure sur le tombeau
de Memnon*
1781
153 *Apollon, après avoir lavé le sang dont
Sarpédon étoit tout défiguré et l'avoir
parfumé d'ambroisie, ordonne au Sommeil
et à la Mort de la porter promptement
en Lycie, ou la famille et ses amis lui firent
de Funérailles*

BERTIN, NICOLAS
(1668–1736)
1704
La naissance d'Adonis
Une Baccanale

BOIZOT, ANTOINE
(1702–1782)
1737
Ixion foudroyé par Jupiter
1738
77 *L'origine de l'Amour démontré
par la beauté, tenant un verre ardent,
qui allume le Flambeau de l'Amour*
111 *L'éducation de l'Amour par le secours
de Mercure et de Vénus*
112 *Vénus qui désarme l'Amour*
114 *L'Amour piqué par une abeille*
1739
Bacchus et Arianne
Vertumne et Pomone
1740
92 *Renaud qui quitte Armide, par le conseil
des Chevliers qui le pressent de retourner
au Camp de Godefroy . . .*
1741
89 *Zéphire et Flore*
90 *Aurore et Céphale*

91 *L'Éducation de l'Amour*
93 *Les Grâces qui instruisent l'Amour*
1742
102 *Renaud et Armide dans les plaisirs*
1743
77 *Réconciliation de Vénus et l'Amour*
78 *Vénus qui essaye les Armes de l'Amour*
1745
133 *Les regrets d'Apollon, sur la mort
d'Hyacinthe*
134 *Vénus et Adonis*
1746
104 *L'Aurore*
1747
88 *La déification d'Énée*
89 *Vénus qui prie Vulcain de forger
des armes pour son fils Énée*
1748
66 *Les Muses qui, après avoir enchaîné l'Amour,
le remettent entre les mains de la Beauté*
1753
99 *L'Aurore qui invoque l'Amour pour obtenir
rejeunissement de Titon*
1755
64 *Le Châtiment de l'Amour*
1759
46 *Flore couronnée par le Zéphire*
47 *L'Amour qui se repos sur ses armes*
1761
51 *Télémaque accompagnée de Minerve
sous la figure de Mentor, raconte ses Avantures
à la Nymphe Calypso*
1763
71 *Argus discourant avec Mercure*
1765
56 *Les Grâces enchaînent L'Amour*
57 *Mars et l'Amour disputent sur le pouvoir
de leurs armes . . .*

BONVOISIN, JEAN
(1752–1837)
1791
697 *Apollon veut ravoir un Trépied qu'Hercule
emporte du Temple de Delphes*

BOUCHER, FRANÇOIS
(1703–1770)
1738
43 *Vénus, qui descend de son Chariot
soutenue par l'Amour, pour entrer au Bain*
104 *Les trois Grâces qui enchaînent l'Amour*
106 *L'éducation de l'Amour par Mercure*
1739
Aurore et Céphale
*Psyché conduite par Zéphire dans le Palais
de l'Amour*
1740
9 *La naissance de Vénus, ou cette Déesse
paroît sorir du sein des Eaux avec les Grâces,
accompagnée des Tritons, des Néréides,
et des Amours*

1742
18 *Repos de Diane, sortant du Bain
avec une de ses Compagnes*
21 *Léda*
1743
17 *La naissance de Vénus*
18 *Vénus à sa toilette, sortant du bain*
19 *Muse Clio, qui préside à l'histoire
et l'éloge des grands Hommes . . .*
20 *Muse Melpomène, elle préside à la Tragédie . . .*
1747
8 *Jupiter changé en Taureau, port sur son dos
Europe qu'il enlève par surprise*
32 *Les forges de Vulcain*
1757
11 *Les Forges de Vulcain*
1765
8 *Jupiter transformé en Diane pour surprendre
Callisto*

BOULLONGNE, BON
(1649–1717)
1669
Galathée sur les eaux
Le sacrifice d'Iphigénie
Le triomphe de Neptune
L'éducation de Jupiter par les Coribantes
1704
Danaé
Le jugement de Pâris
Sémélé
Un petit Amour qui baise un pigeon
Vénus accompagnée de Bacchus et de Cérès
Zéphire et Flore

BOULLONGNE, LOUIS DE
(1654–1733)
1669
Galathée sur les eaux
*Junon qui commande à Éole de lâcher
les vents pour disperser la flotte d'Aenée*
Le jugement de Pâris
Le rapt de Prosperpine
Psyché et l'Amour
Zéphire et Flore
1704
Diane se reposant après avoir chassé
Galathée sur les eaux
La naissance de Bacchus
L'enlèvement de Proserpine par Pluton
Pâris qui conduit Hélène à ses vaisseaux
Regnaud et Armide dans les plaisirs
Vénus et Adonis
Vénus et Adonis
*Vénus qui engaage Vulcain à fire des armes
pour Énée*
Zéphire et Flore

BOUNIEU, MICHEL-HONORÉ
(1740–1814)
1769
183 *Silène barbouillé de mures par la Nimphe Eglé*
184 *Repos de Bacchus*

1771
200 *Jupiter et Io*
201 *Neptune et Amphitrite*
202 *Pluton et Proserpine*
1775
158 *Pan lié par des Nymphes*
1777
141 *La Mort d'Adonis*
142 *La Nymphe Galatée jettant des pommes
à un Berger*
143 *Un Satyre, que des Femmes forcent à boire*
144 *Nymphes, portant leurs offrandes au Dieu
Pan, sont rencontrées par un Satyre*
145 *Tête d'une Bacchante*

BRENET, NICOLAS-GUY
(1728–1792)
1765
133 *L'Amour caressant sa mère,
afin qu'elle lui rende ses Armes*
1769
122 *Aethra, mère de Thesée, le conduit au lieu
ou son père avoit caché son épée et ses souliers*
1771
112 *Jupiter et Antiope*
114 *Vénus*
115 *Diane*
116 *Apollon, avec le Génie des Arts*

BRIARD, GABRIEL
(1725–1777)
1765
129 *Psyché abandonnée*
1769
116 *La Naissance de Vénus*
117 *La Mort d'Adonis*

CALLET, ANTOINE-FRANÇOIS
(1741–1823)
1781
147 *Le Printemps: Zéphir et Flore . . .*
148 *Hercule sur le bûcher, déchirant
la chemise de Nessus* (sketch)
1785
62 *Achille trainant le corps d'Hector devant
les murs de Troye et sous les yeux de Priam
et Hécube, qui implorent le Vainqueur*
1787
83 *L'Automne, ou les Fêtes de Bacchus*
1789
65 *L'Été ou les Fêtes de Cérès*

CARESME, PHILIPPE
(1754–1806)
1767
178 *L'Amour*
1775
148 *La Nymphe Menthe métamorphosée.
Proserpine, irritée d'avoir surpris Pluton
avec Menthe, fille du Cocyte, la chagea
en Menthe ou Baume, et son frère
en Bayme sauvage, pour avoir favorisé
les amours de sa soeur*
151 *Diane et Endimion* (sketch)

1777
136 *Menthe, métamorphosée par Proserpine,
en menthe ou baume*

CAZES, PIERRE-JACQUES
(1676–1754)
1737
La naissance de Vénus
Léda, et Jupiter transformé en Cigne
1747
11 *L'Enlèvement d'Europe*

CHAISE, CHARLES-EDOUARD
(1759–1798)
1791
764 *Fête à Bacchus*

CHALLES, CHARLES-MICHEL-ANGE
(1718–1778)
1753
118 *Didon sur le bûcher*
1763
53 *La mort d'Hercule*
55 *Vénus endormie*
1765
44 *Hector entrant dans la Palais de Pâris qu'il
trouve assis auprès d'Hélène, lui reproche sa suite
du combat qu'il venoît d'engager contre Ménélas*

CHÉRON, ELISABETH-SOPHIE
(1648–1711)
1704
*Tancrède qui dans un combat singulier tué
Clorinde sans la connoître*

CHRISTOPHE, JOSEPH
(1622–1748)
1704
Adonis et la nymphe Écho
Apollon et la Cibille
Le combat d'Hercule et d'Achéloüs
L'enlèvement d'Europe
Vertumne et Pommone
1738
120 *Un petit Bacchanale d'enfans . . .*

COLLIN DE VERMONT, HYACINTHE
(1693–1761)
1737
Les adieux d'Hector et d'Andromaque
*Les dieux qui coupent les ailes à l'Amour,
pour l'empêcher de remonter au ciel*
*Les Noces de Thétis et Pelée, ou la Discorde jette
entre les Divintez, une Pomme d'or*
Pyrame et Thisbé
Renaud et Armide
1747
5 *Pyrrhus Fils d'Eacide Roy des Molosses, n'avoit
que deux ans, lorsque ces Peuples s'étant revoltez
contre son Père, le chasserent de ses Etats . . .*
1750
29 *Jupiter et Mercure chez Philémon et Baucis*
30 *Hébé, Déesse de la Jeunesse, et Femme
d'Hercule, qui rajeunit à sa prière Yolas Neveu
de son Mary*

32 *Ancréon, fameux Poète Grec, reçoit de nuit
l'Amour chez lui . . .*
1751
12 *Les Meneides refusoient de célèbrer la fête de
Bacchus que toute la ville de Thèbes reconnoissoit
pour fils de Jupiter. Elles voyent leurs fuseaux et
leurs laines se transformer en Pampres de vigne,
et sont elles-mêmes changé . . .*
13 *Une troupe de jeunes Nymphes se voyant
poursuivies par un Berger insolent qui se moquoit
d'elles, le changent en olivier sauvage*
1753
15 *Les noces de Thétis et Pélée*

COLOMBEL, NICOLAS
(1646–1717)
1699
Atalante et Hippomène
Psyché et l'Amour
Retour de chasse de Diane
1704
Diane
*Léda dans la bain trompée par Jupiter
sous la forme d'un cigne*
L'enlèvement d'Europe

CORNEILLE, MICHEL
(1642–1708)
1699
Apollon se couchant dans le sein de Thétis
Vénus sur les eaux

COTELLE, JEAN
(1645–1708)
1704
Mars et Vénus

COURTIN, JACQUES-FRANÇOIS
(1672–1752)
1745
91 *Mercure qui endort Argus*
1746
83 *Pan et Sirinx*
84 *Herigone et Jupiter en grape de raisin*
85 *L'Enlèvement de Déjanire par le Centaure
Nessus*
1747
65 *Zéphire et Flore*

COYPEL, ANTOINE
(1661–1722)
1699
La Ceinture de Vénus
Psyché et l'Amour
Vénus qui donne les armes à Énée
1704
L'enlèvement de Proserpine
L'union de Bacchus et de l'Amour
Regnaud et Armide dans les plaisirs

COYPEL, CHARLES-ANTOINE
(1694–1752)
1725
*L'Amour, sous la figure d'un Ramoneur qui sort
d'une cheminée*

*La Guerre et la Religion. La Guerre caractérisée
par Mars, qui ordonne à Vulcain de forger des
Armes, et la Religion par Numa Pompilius qui fait
porter le feu sacre au Temple de Vesta*
L'Apothéose d'Hercule (sketch)
Renaud qui abandonne Armide

1737
Le Sacrifice d'Iphigénie

1738
2 *Armide, qui fait détruire par les Génies
infernaux le Palais quelle leur avoit fait élever
pour s'y enfermer avec Renaud et les Plaisirs*

1741
1 *Armide, qui voulant poignarder Renaud,
va céder à l'Amour prenant ce Héros sous
sa protection . . .*

COYPEL, NOËL
(1628–1707)

1699
*Déjanire qui envoye à Hercule par Licas
Hercule déifié ou l'apothéose d'Hercule
Hercule domptant Achéloüs
Hercule reprochant à Junon les maux qu'elle lui a
causez par sa jalousie
Hercule sacrifiant à Jupiter après ses victoires
La chemise empoisonnée par le centaure Nesse
Le centaure Nesse et Déjanire
Zéphire et Flore*

1704
*Apollon se reposant après avoir tué
le serpent Python
Déjanire et le centaure Nesse blessé par Hercule
Déjanire envoyant à Hercule par Licas la chemis
empoisonée du centaure. L'Apothéose d'Hercule
Le combat qu'il [Hercule] eut avec Achéloüs.
Amalthée qui donne la corne d'abondance pour
être envoyée à Hercule en échange de celle qu'il
avoit otée à Achéloüs
Zéphire et Flore, et de plusieurs Amours qui jouent*

DANDRÉ-BARDON, MICHEL-FRANÇOIS
(1700–1783)

1739
*Jason au champ de Mars, en présence de Medée,
du Roy et tout le Peuple de Colchos*

DAVID, JACQUES-LOUIS
(1748–1825)

1783
162 *La douleur et les regrets d'Andromaque
sur le corps d'Hector son mari*

1789
89 *Les Amours de Pâris et Hélène*

DELAISTRE, JACQUES-ANTOINE
(1690–1765)

1745
106 *Thétis visitant le tombeau d'Achille*

DELOBEL, NICOLAS
(1693–173)

1737
La Naissance de Vénus

1750
94 *Neptune et Amphitrite*

DESHAYS DE COLLEVILLE,
JEAN-BAPTISTE-HENRI
(1729–1765)

1759
92 *Hector exposé sur les rives du Scamandre après
avoir été tué par Achilles et traîné à son char.
Vénus préserve son corps de la corruption*

1763
44 *Danaé et Jupiter en pluye d'or*

1765
33 *Achille prêt d'être submergé par le Scamandre
et le Simois, est secondé par Junon et Vulacin . . .*
34 *Jupiter et Antiope*

DESORIA, JEAN-BAPTISTE-FRANÇOIS
(1758–1832)

1791
58 *Thesée en présence de sa Mère et de son
Grand-Père, levant la pierre sous laquelle
étoient l'épée et les brodequins de son Père*
703 *Diane et Endymion*

DOYEN, GABRIEL-FRANÇOIS
(1726–1806)

1761
90 *Vénus blessée par Diomède*
93 *Les charmes de l'harmonie, représentés
par une Vénus ailée qui joue de harpe*
94 *L'Espérance qui nourrit l'Amour*

1763
120 *Andromaque, ayant caché Astianax fils
unique d'Hector, dans le tombeau de son père . . .*

1773
26 *Cybèle, mère des Dieux, représente la Terre
avec ses attributs*

1779
18 *Anacréon chante une ode à la louange de
Vénus, l'Amour accorde sa lyre, la Déesse descend
du ciel et courrone le Poète de mirthe et de rose*
19 *Une Nymphe enivre l'Amour*
20 *Bacchantes endormies*
24 *Hector reporté par Priam, après l'avoir retiré
des mains d'Achille*
25 *Une Nymphe, qui a volé un nid d'amours*

1781
19 *Mars vaincu par Minerve*

1787
11 *Priam demandant à Achille le corps d'hector*

DUMONS, JEAN-JOSEPH
(1687–1779)

1740
90 *Vénus, et l'Amour piqué par une abeille*

1746
101 *Un Fleuve*
102 *Une Nayade*

DUMONT LE ROMAIN, JACQUES
(1701–1781)

1737
L'éducation de l'Amour

1743
14 *Repos de Diane*

1751
7 *Athalante et Méléagre*

DURAMEAU, LOUIS-JACQUES
(1733–1796)

1775
129 *L'Été: Cérès et ses Compagnes implorent
le Soleil, et attendent, pour moissoner, qu'il ait
atteint le signe de la Vierge*

1779
34 *Combat d'Entelle et de Darès*
35 *Piété filiale de Cléobis et Biton*

1783
13 *Herminier sous les armes de Clorinde*

FAVANNE, HENRI DE
(1668–1752)

1704
*Cyanne qui montre à Cérès la ceinture de sa fille
Proserpine enlevée par Pluton
Silène éveillé par la nymphe Eglé en luy frotant
le visage d'une meure
Vénus sur les eaux*

1737
*Nayades
Télémaque déclare imprudemment sa passion
à Eucaris
Télémaque prend l'Amour pour un Enfant
ordinaire; il ressent son pouvoir ainsi que
Calypso et ses Nymphes
Thétis, qui après s'être changée en Lion, en Feu,
et en diverses autres Figures, pour s'échapper
du lien avec lequel Pélée la tient serrée est forcée
de consentir à l'épouser*

1746
8 *La séparation de Télémaque et d'Eucaris*
9 *Les nymphes excitées par l'Amour, mettent le
feu au Vaisseau pour empêcher l'évasion de
Télémaque*
10 *Le songe de Télémaque dans l'Isle de Cypre*
11 *Vénus qui met l'Amour entre les mains de
Calypso*
14 *Une Baccanale*

1747
12 *La sybile Déiphobe, qui demande à Apollon de
multiplier ses années au nombre de sable qu'elle
tient dans sa main*
15 *Armide desarmée par l'Amour*
16 *Iris vient de la part de Junon trouver le
Sommeil . . .*

1748
2 *Télémaque qui raconte ses Avantures à Calypso*
3 *Télémaque au milieu des Nymphes qui chantent
et lui cueillent des Fleurs pour l'amuser*
4 *Télémaque arrive dans l'Isle de Chypre, et
conduit au Temple de Vénus pour faire ses
Offrandes*

1750
6 *Junon vient troucer l'océan pour lui demander
que la grande Ourse ne vienne jamais se plonger
dans ses Eaux*

8 *Mars qui se blesse en prenant une Flèche*
de l'Amour
1751
4 *Vénus qui vient trouver Neptune, pour le prier*
de favoriser le voyage de son Fils Énée en Italie
5 *Adonis confié aux Nayades pour prendre soin*
de son éducation

FORTY, JEAN-JACQUES
(1744–1800)
1791
785 *Ganimède*

FRIQUET DE VAUROZE,
JACQUES-ANTOINE
(1648–1716)
1704
Triomphe de Thétis sur les eaux

GALLOCHE, LOUIS
(1670–1761)
1737
Enée chez Didon, Reine de Cartafe, à laquelle il se
découvre. Le moment ou Didon caresse l'Amour
sous la figure d'Ascagne
1738
6 *Adonis qui quitte Vénus pour aller à la Chasse*
8 *Armide, qui voulait poignarder Renaud, va céder*
à l'Amour; qui prenant ce Héros sous sa
protection, la suite de ce Dieu rit de la colère
de l'Enchantresse et célèbre d'avance le Triomphe
de son Maître
1743
11 *Triomphe d'Amphitrite*
12 *Le récit que Télémaque fait de ses aventures*
à Calipso (sketch)
12 *Triomphe d'Amphitrite* (sketch)
1746
1 *Télémaque qui raconte ses aventures à Calypso,*
accompagnée de ses Nymphes
6 *Un Amour qui menace*

GAUFFIER, LOUIS
(1761–1801)
1791
720 *Achille reconnu par Ulysse*

GREUZE, JEAN-BAPTISTE
(1725–1806)
1761
103 *Une Tête d'un nymphe de Diane*

GUÉRIN, FRANÇOIS
(c. 1751–1791)
1779
88 *Junon*

HALLÉ, CLAUDE-GUY
(1652–1736)
1699
Vulcain qui surprend Mars et Vénus

HALLÉ, NOËL
(1711–1781)
1746
138 *Une Fête de Bacchus* (sketch)

1748
48 *Dispute de Neptune et de Pallas*
50 *Hercule et Omphale*
1750
68 *L'Éducation de l'Amour*
70 *Athalante et Méléagre*
1753
50 *Le Midy, sous l'Emblème de Vénus et l'Amour*
51 *Le Soir, désigné par une Diane*
1755
31 *La Sybille de Cummes, qui obtient d'Apollon*
de vivre autant d'années qu'elle a de grains
de sable dans sa main
32 *Jupiter sous la forme de Diane, et la nymphe*
Callisto
1757
25 *La nymphe Io changée en Vache*
1759
16 *Le Danger de l'Amour, représente par Hercule*
et Omphale
16 *Le Danger du Vin, représente par des*
Bacchantes et des Faunes, assistant à une Fête
de Bacchus
1763
22 *Le Combat d'Hercule et d'Achéloüs* (sketch)
1765
16 *La Course d'Hippomène et d'Atalante*
1769
11 *Achille reconnu à la cour de Deidamie,*
par la choix qu'il fait des armes qu'Ulisse avoit
mêlées avec des Bijoux de femmes, à dessein
de la découvrir
1771
1 *Silène dans sa Grotte, barbouillé de mures*
par Eglé

HUE, JEAN-FRANÇOIS
(1751–1823)
1789
71 *L'intérieur d'un bois, ou Vénus présente*
son fils à Calypso . . .
1791
139 *Narcisse*

HUET, JEAN-BAPTISTE
(1745–1811)
1779
98 *Hercule chez la Reine Omphale*

HUILLOT, PIERRE-NICOLAS
(1674–1751)
1738
55 *Un Buste de Bacchus, ou l'Amour, qui prend*
son parti, le couronne de Myrthe, luy ayant pendu
son Carquois au col

JEAURAT, ETIENNE
(1699–1789)
1737
Diane surprise au bain par Actéon
La Noce de Daphnis et Cloé
Les Nymphes tutélaires du Païs présenent Daphnis
et Cloé à l'Amour . . .

1738
115 *Repos de Diane*
146 *Le départ d'Achille, pour aller vanger la mort*
de Patrocle
1741
15 *Les vendanges de Daphnis et Cloée*
16 *Repos de Cérès*
1742
29 *Repos de Vénus*
30 *Vénus et Adonis*
1745
26 *Le sommeil de Chloé*
27 *Chloé qui se baigne dans la Caverne*
des Nymphes
28 *Lycoenion caché, qui écoute Daphnis et Chloé*
29 *Cloé qui couronne Daphnis de Violettes*
1753
17 *Achille qui laisse à Thétis sa mère se soin des*
funérailles de son ami Patrocle, et part pour aller
venger sa mort
1757
14 *Promethée*

JOLLAIN, NICOLAS-RENÉ
(1732–1804)
1767
152 *L'Amour enchaîné par les Grâces*
1769
167 *Clitie changée en Tournesol*
168 *Hiacinthe changé en Hiacinte*
169 *Diane surprise par Actéon*
170 *L'Amour captif de Diane*
171 *L'Amour vainqueur de Diane*
1771
177 *Jupiter sous la forme de Diane séduit Calisto*
1773
155 *Vénus sur les Eaux*
156 *Anacréon caressant l'Amour*
1775
110 *La toilette de Psyché*
1777
110 *Alceste vient, avec ses enfans, implorer*
Apollon dans son Temple . . .
111 *Junon emprunte la ceinture de Vénus pour*
séduire Jupiter
112 *Jupiter vaincu par l'Amour et le sommeil,*
s'endort dans les bras de Junon
113 *Persée délivre Andomède enchaîne au rocher :*
l'Amour transforme les chaines en guirlandes de
fleurs
115 *Les chevalliers allant chercher renud dans le*
Palais d'Armide, sont arrêtés par deux nymphes,
qui s'efforcent de les séduire
116 *Renaud rompt le charme de la Forêt*
enchantée, malgré le prestige des Nymphes
1779
114 *Aréthuse poursuivie par le Fleuve Alphée*
et secourue par Diane
116 *Renaud quittant Armide pour suivre la Gloire*
117 *Anacréon recevant sa lire de la main*
des Grâces
117 *Anacréon sacrifiant aux Grâces*

118 *Vertumne et Pomone*
119 *Toilette de Vénus*
120 *Le Retour de Mars*
121 *Thétis confiant Achille, son fils, au Centaure Chiron*
122 *Apollon et la Sybille de Cumes*
1781
124 *Le Réveil d'Endimion*
1791
278 *Enée et Didon*

JOUVENET, JEAN
(1644–1717)
1699
Le Sacrifice d'Iphigénie
Vénus et Vulcain
1704
Andromaque, qui tâche à sauver son fils Astyanax découvert par Ulisse dans le tombeau d'Hector, de la fureur de Grecs
Vénus qui engage Vulcain de faire des armes pour Énée

JULIEN, SIMON
(1735–1800)
1783
188 *Tête d'une Bacchante*

LA JOUE, JACQUES DE
(1687–1761)
1740
47 *Neptune avec ses attributs . . .*

LA FOSSE, CHARLES DE
(1636–1716)
1699
La naissance de Minerve du cerveau de Jupiter
L'adieu d'Hector et d'Andromaque
1704
Acis et Galathée écoutant Poliphème jouant d'une flute

LAGRENÉE, JEAN-JACQUES
(1740–1821)
1771
216 *Un Satyre jouant avec un enfant*
1773
178 *Apollon accorde à la Sybille de Cumes, de vivre autant d'années qu'elle a de grains de sable dans les mains*
1775
140 *Les fils et les filles de Niobé tués par Apollon et Diane*
141 *Une Bacchanale*
1777
27 *Télémaque racontant ses aventures à Calypso*
28 *Bacchus apporté aux Corybantes par Mercure*
33 *Télémaque dans l'Isle de Calypso*
1779
38 *Diane au Bain*
41 *Mercure voulant entrer chez Hersé, en est empêché par Aglaure, qu'il change en statue*

1781
44 *Calipso, s'appercevant de la douleur de Télémaque au récit des aventures d'Ulisse, son père, ordonne aux Nymphes d'interrompre leurs chants*
1783
14 *Fête à Bacchus ou l'Automne*
16 *Bacchus apporté par Mercure aux Corybantes*
19 *Mort d'Adonis*
21 *Télémaque parmi les Bergers d'Egypte*
22 *Télémaque laissé seul avec Mentor, regarde avec plaisir les beaux habits que les Nymphes de Calypso lui avoient préparés, mentor semble lui reprocher de s'occuper de pensées indignés du Fils d'Ulysse*
1785
10 *Renaud abandonnant Armide, qui, ne pouvant le retenir, tombe évanouie de douleur*
1787
13 *Ulysse arrivant le Palais de Circé*
1789
9 *Télémaque et Mentor jetés dans l'Isle de Calypso*
10 *Achille sous l'habit de sa fille, reconnu par Ulysse au milieu de la cour de Lycomède*

LAGRENÉE, LOUIS-JEAN-FRANÇOIS
(1724–1805)
1755
124 *Le Centaure Nessus qui enlève Déjanire: Hercule lui déeoche une flèche*
125 *Jupiter transformé en satyre regarde Antiope dormant avec l'Amour*
127 *L'Amour qui brise son Arc*
128 *Le Centaure Chiron instruisant Achilles*
128 *Mercure qui enseigne la Géographie à l'Amour*
129 *Hercule brisant les chaînes de Prométhée sur le Mont Caucase . . .*
1757
81 *Pan, après avoir poursuivi la Nymphe Sirinx jusqu'au Fleuve Ladon, est retenu par plusieurs Naiades, et par ce fleuve qui la dérobe à ses poursuites, en la changeant en Roseaux*
84 *Herminie, Amante de Tancrède*
85 *Bacchus consolant Ariane abandonnée par Thésée*
1759
25 *Vénus aux forges de Lemnos, accompagnée des Grâces et des plaisirs, demande à Vulcain des armes pour son fils Énée*
26 *L'Aurore enlève Céphale . . .*
27 *Le Jugement de Pâris*
28 *Satyre se jouant du sifflet du Dieu Pan*
1763
32 *La lever de l'Aurore; elle quitte la couche du vieux Triton*
1765
25 *Diane et Endimion*
1767
20 *Jupiter et Junon sur le Mont Ida, endormis par Morphée*
23 *L'Épée, par Bellone, présentant à Mars les rênes de ses Chevaux*

26 *Mercure, Hersé, et Aglaure jalouse de sa sœur*
27 *Renaud et Armide*
28 *Persée après avoir délivré Andromède*
29 *Retour d'Ulysse et de Télémaque auprès de Pénélope*
31 *L'Amour Remouleur*
1769
14 *Cérès enseigne l'Agriculture au Roi Triptolème, dont elle nourrissoit le fils de son propre lait*
15 *Mars et Vénus surpris par Vulcain*
16 *Psiché surprend l'Amour endormi*
17 *Télémaque dans l'isle de Calypso, devient amoureux de la Nymphe Eucharis, en caressant l'Amour*
18 *Alphée poursuit Aréthuse, Diane les métamorphose, l'un en Fleuve et l'autre en Fontaine*
19 *Clitie abandonnée par Apollon*
20 *Bacchus et Ariane*
21 *Diane et Endymion*
26 *Hercule et Omphale*
27 *Calysto, Nymphe de Diane, sortant du bain*
28 *Euphrosine, Thalie et Aglaié*
1771
6 *Une nymphe qui se mire dans l'eau*
11 *Mars et Vénus, Allégorie sur la Paix*
12 *La Métamorphose d'Alphée et d'Aréthuse*
13 *Diane surprise au bain par Actéon*
14 *Jupiter, sous la forme de Diane, séduit la Nymphe Callisto*
15 *Apollon chante la gloire des grands hommes*
16 *Vénus et l'Amour endormis*
17 *Léda*
18 *La Nymphe Écho, amoureuse de Narcisse*
19 *Eglé, jeune Nymphe*
21 *Télémaque rencontre Termosiris, Prêtre d'Apollon, qui lui enseigne l'art d'être heureux dans l'Esclavage, et lui apprend la Poésie Pastorale*
1773
9 *Les Trois Grâces au Bain*
14 *La Poésie; Anacréon caressé par les Muses*
16 *La Musique. Orphée; Pluton lui rend Euridice, son Épouse*
16 *La Sculpture. Pigmalion amoureux de sa Statue; Vénus l'anime*
17 *Bacchus nourrit par les Déesses de la Terre*
19 *Vénus noue le bandeau à l'Amour*
20 *Diane, au bain, se fait rapporter son arc par un chien*
21 *La Nymphe Salmacis*
1775
6 *Armide désespérée de n'avoir pu se venger de Renaud, veut se tuer, Renaud lui retient le bras*
10 *Diane et Endimion*
11 *L'Amour abandonne Psyché*
12 *L'Amour console Psyché*
14 *La Sibylle obtient d'Apollon de vivre autant d'années qu'elle tient de grains de sable dans sa main*
1777
3 *Pigmalion, dont Vénus anime la Statue*
4 *Le jugement de Pâris*

1779
7 *L'Éducation de l'Amour*
8 *Les Grâces lutinées par les Amours*
9 *Les Grâces qui prennent leur revanche*
11 *Vénus et l'Amour*
12 *Diane et Actéon*
16 *Pan et Syrinx*
1781
2 *Préparatifs du combat de Pâris et de Ménélas*
8 *Hercule et Omphale*
11 *Combat de l'Amour et de la chasteté*
1785
3 *Ubalde et le Chevalier Danois*

LAMY, CHARLES
(1689–1743)
1737
Latone qui alaite Apollon et Diane
1738
35 *Latone, qui allaite Apollon et Diane*
44 *Mercure amoureux d'Hersé*
45 *Apollon avec Issé*
1740
91 *Le mariage de Cupidon avec Psyché*
1742
101 *L'Aurore . . .*

LAVILLE-LEROUX BENOITS,
MARIE-GUILHELMINE
(1768–1826)
1791
164 *Les Adieux de Psyché à sa Famille*

LE BARBIER, JEAN-JACQUES-FRANÇOIS
(1738–1826)
1783
152 *Le Sommeil de Jupiter*
1785
134 *Jupiter endormi sur la Mont Ida*
1789
98 *Ulysse sortant de Sparte avec Pénélope pour retourner à Ithaque, ou la Pudeur*
1791
737 *Le pouvoir de l'Aurore*

LE CLERC, SEBASTIEN
(1676–1763)
1737
La Reine Hécube, femme de Priam, faisant présenter au Palladium une de ses plus belles robes, pour obtenir sa protection pour la ville de Troyes
Vertumne et Pomone
Zéphire et Flore

LE LORRAIN, LOUIS-JOSEPH
(1715–1759)
1753
166 *Hercule qui va faire manger Diomède par chevaux*
167 *Les Grâces qui enchaînent l'Amour* (sketch)

1757
90 *La Nymphe Peristere changée en Colombe*

LE METTAY, PIERRE-JOSEPH
(1728–1759)
1757
126 *Bacchus naissant remis entre les mains des Nymphes*

LE SUEUR, PIERRE
(vers 1739–1786)
1751
68 *Une Nymphe des eaux*

LE SUEUR, PIERRE-ETIENNE
(vers 1791–vers 1810)
1791
276 *Apollon dans son exil*

LEFEBVRE, [PEINTRE, RUE SAINT-HONORÉ]
(vers 1791–1793)
1791
777 *Enée, prêt à déposer son Père Anchyse sur le Mont Ida*

LEFEVRE, ROBERT
(1756–1830)
1791
51 *Vénus embrassant L'Amour*
53 *Vénus enlèvant les armes de L'Amour*

LEMOYNE, FRANÇOIS
(1688–1737)
1725
Andromède sur le rocher, Persée en l'air qui vient la délivrer, et tuer le dragon qui devoit la dévorer
Apollon et Daphné
Europe qui se met sur le Taureau, accompagnée de ses Suivantes, qui cueillent des fleurs, et lui en présentant des guirlandes
Hercule et Omphale
Les Chevaliers Danois qui vont chercher Renaud dans l'Isle enchantée, ou ils rencontrent les charmes voluptueux qu'Armide avoit placez aux avenues pour les empêcher d'arriver jusqu'à son Palais

LÉPICIÉ, NICOLAS-BERNARD
(1735–1784)
1769
123 *Adonis changée en Anémone par Vénus*
124 *Achille instruit dans sa Musique, par le Centaure Chiron*
1771
30 *Narcisse changé en la fleur qui porte son nom*
31 *Narcisse changé en la fleur qui porte son nom*
32 *Adonis changé en Anémone*
34 *La colère de Neptune*
1773
55 *Les Grâces*

LEVRAC-TOURNIERES, ROBERT
(1668–1752)
1747
30 *Les Grâces qui ornent la Nature*

1748
17 *La Déesse Flora sous un Berceau de Chevrefeuille*
18 *Hébé, Déesse de la Jeunesse*

MAROT, FRANÇOIS
(1666–1719)
1704
Vénus qui engage Vulcain à faire des armes pour Énée

MARTIN, GUILLAUME
(1737–1800)
1773
185 *Silène, porte par de jeunes Silvains, et par des Bergers devant la nymphe Eglé, qui lui présente à boire*
1781
165 *Sacrifice d'Iphigénie*

MASSÉ, SAMUEL
(1672–1753)
1737
L'Enlèvement d'Europe
Vénus sur les Eaux
1738
119 *Une jeune Bacchante jouant avec des enfans*
1745
86 *Hercule qui confie Déjanire au Centaure Nesse pour passer le Fleuve*
87 *Une fête de Bacchus*

MÉNAGEOT, FRANÇOIS-GUILLAUME
(1744–1816)
1777
202 *Les adieux de Polixène à Hécube, au moment ou cette jeune Princesse est arrachée des bras de sa mère pour être immolée aux manes d'Achille*
1783
29 *Astyanax arraché des bras d'Andromaque par l'ordre de Ulysse*
1785
20 *Alceste rendue à son mari par Hercule*

MILLET, JOSEPH-FRANCISQUE
(1697–1777)
1739
L'Enlèvement d'Europe
Mars et Vénus, avec des Cyclopes, qui forgent dans un antre

MONNET, CHARLES
(1732–1808)
1765
181 *L'Amour*
1771
172 *L'Amour caresse une colombe*
172 *L'Amour lance ses traits*
174 *L'Aurore qui chasse la Nuit* (sketch)
1773
159 *Zéphire et Flore*
160 *Borée et Orithie*
1775
142 *Zéphire et Flore*
143 *Borée et Orithie*

1781
158 *Vénus sortant du Bain*

MONSIAU, NICOLAS-ANDRÉ
(1754–1837)
1791
311 *Diane vu par Actéon*

MOREAU, JEAN-MICHEL
(1741–1814)
1791
749 *Hector, arrachant Pâris d'auprès d'Hélène,*
poour le mener au combat

NATOIRE, CHARLES-JOSEPH
(1700–1777)
1737
Amphitrite sur les Eaux
Diane au Bain
Io enlevée par Jupiter
1738
24 *Bacchanale*
57 *Bacchus reçoit à boire d'un Enfant,*
accompagné de deux Bacchanantes et de Silène
109 *Les trois Grâces qui enchaînent l'Amour*
1739
Galatée
Télémaque dans l'Isle de Calipso, parmi les
Nymphes, caressant l'Amour sous la figure
d'un Enfant
Vénus qui donne l'Amour à Calipso
1742
23 *Vénus à la Fontaine*
24 *Vénus à sa Toilette*
25 *Daphnis et Cloé*
26 *Zéphire et Flore*
27 *Bacchus et Arianne*
28 *Diane au Bain, srprise par Actéon*
1743
24 *Repos de Diane*
25 *Bacchus et Ariane*
26 *Apollon et les Muses sur le Parnasse*
27 *Vénus qui se promene sur la mer et Neptune*
qui vient la recevoir
1745
19 *Thalie, Muse de la Comédie*
20 *Terpsicore qui caractérise la danse*
21 *Calliope; cette muse préside à l'Histoire*
22 *L'éducation de l'Amour*
23 *L'éducation de Bacchus*
24 *Jupiter changé en Diane*
1746
34 *Le sonde de Télémaque, dans le moment*
que Vénus luy apparoît: Cupidon veut le percer
du trait ; Minerve le garantit de son Égide
35 *Télémaque dans l'Isle de Calypso, entoure des*
Nymphes, et badinant avec l'Amour sous la figure
d'un Enfant
1747
9 *Une fête de Bacchus*

1750
26 *Triomphe de Bacchus*
27 *Un Amour qui aiguise des Flèches*

OLLIVIER, MICHEL-BARTHÉLEMY
(1712–1784)
1777
129 *Télémaque et Mentor sont conduits*
prisonniers devant Aceste, Roi de Sicile, qui,
sans les connaître, les condamne à l'esclavage
1779
134 *Télémaque et Mentor sont conduits*
prisonniers devant Alceste, Roi de Sicile, qui
sans les Connoître, les condamne à l'esclavage

OUDRY, JEAN-BAPTISTE
(1686–1755)
1738
16 *Silène, barbouillé de Mures par la nymphe Eglée*

PAILLET, ANTOINE
(1626–1701)
1699
Renaud et Armide
Renaud et Armide

PARROCEL, JOSEPH-IGNACE-FRANÇOIS
(1704–1781)
1765
108 *Céphale se reconcilie avec Procris, que sous*
un déguisement il avoit éprouvée infidèle . . .
109 *Procris, par l'erreur de Céphale, est tuée*
du même dard qu'elle lui avoit donné . . .

PARSEVAL, AUGUSTE
(1745–1837)
1791
147 *Junon, attachant les yeux d'Argus à la queue*
de son Paon

PASQUIER, PIERRE
(1731–1806)
1771
125 *Armide et Renaud*
1773
127 *Les Trois Grâces*
1781
102 *L'Amour*

PERRIN, JEAN-CHARLES-NICAISE
(1754–1831)
1787
166 *Esculape reçoit des mains de Vénus les herbes*
et simples nécessaires à la guérison d'Énée
1789
117 *Thésée prend en horreur le crime de son*
Épouse, et déplore la perte de son fils Hippolyte

PEYRON, JEAN-FRANÇOIS-PIERRE
(1744–1814)
1785
178 *L'héroïsme de l'amour conjugal. Alceste*
s'étant dévouée volontairement à la mort, pour
sauver les jours de son epoux . . .

PIERRE, JEAN-BAPTISTE-MARIE
(1713–1789)
1741
125 *Psiché, abandonné par l'Amour, accueillié*
et consolée par les Nymphes
1742
123 *L'Enlèvement de Céphale par l'Aurore*
124 *La naissance de Vénus*
1743
95 *Ganimède*
1745
71 *Jupiter et Io*
72 *Vertumne et Pomone*
1746
60 *Medée qui poignarde ses enfants après*
avoir tué sa rivale
62 *Vénus sur les eaux*
66 *Pan et Sirinx*
1747
7 *Armide voyant l'armée des Sarrazins defaite*
entièrement, et craignant de tomber en la
puissance de Renaud . . .
55 *Une Baccanale*
1748
39 *Baccanale*
39 *Baccanale*
41 *Junon qui demande à Vénus sa ceinture*
41 *Junon qui trompe Jupiter avec cette Ceinture*
1750
56 *L'Enlèvement d'Europe*
57 *Léda*
60 *Psychée, retirée du Fleuve par des Nymphes*
1751
37 *Neptune qui réprime les vents, ou le Quos ego*
1757
19 *L'Enlèvement d'Europe*
1761
14 *Le Jugement de Pâris*
1763
12 *Mercure amoureux de Hersé, changé en pierre*
Aglaure, qui vouloit l'empêcher d'entrer chez sa
soeur
15 *Une bacchante endormie*

PLATTE-MONTAGNE, MATHIEU DE
(vers 1608–1760)
1704
Apollon sur le Parnasse avec les Muses

PLATTE-MONTAGNE, NICOLAS DE
(1631–1706))
1699
Hercule, à qui Junon donne à teter

REGNAULT, JEAN-BAPTISTE
(1754–1829)
1783
166 *Persée délivre Andromède, et la remet*
entre les mains de ses Parens
167 *L'Éducation d'Achille par le Centaure Chiron*

4 *Jason ayant, par la vertu des herbes, endormi
le Dragon, gardien de la Toison d'or, se faisit sans
obstacle de la riche dépuille du mouton de Phryxus,
et fut en Thessalie accompagné de sa Maîtresse*
5 *Jason infidèle à Medée, épouse Creuse fille
de Créon Roy de Corinthe*
6 *Medée, pour se vanger avec éclat de sa Rivale,
luy fait présent d'une Robe empoisonnée, qui luy
cause la mort ainsi qu'à Créon son père*
7 *Medéemet le comble à sa vengeance, en
poignardant deux fils qu'elle avoit eu de Jason*

UBELESQUI, ALEXANDRE
(1649–1718)
1699
Bacchus et Ariadne
La naissance de Bacchus
La naissance de Vénus
Le Sacrifice d'Iphigénie
Vénus et Vulcain
1704
*L'enlèvement d'Europe par Jupiter méthamorphosé
en Taureau*
*Vénus qui sollicite Vulcain de faire des armes
pour Énée*
Vertumne et Pomone

VALENCIENNES, PIERRE-HENRI DE
(1750–1819)
1789
119 *Pyrrhus appercevant Philoctète dans son
antre, à l'Isle de Lemnos*

VAN LOO, CHARLES-AMÉDÉE-PHILIPPE
(1718–1795)
1761
38 *Satyres*
38 *Satyres*
1769
30 *L'Hymen veut allumer son Flanbeau à celui
de l'Amour*
1771
24 *Vénus et l'Amour courpnnés par les Grâces*
1777
8 *L'Aurore et Céphale*
1781
18 *Les Amants unis par l'Hymen et couronnés
par l'Amour*
1783
4 *Zéphire et Flore, ou le Printemps*

VAN LOO, CHARLES-ANDRÉ
(1705–1765)
1737
Jupiter et Junon
1738
42 *Vénus à sa Toilette*
1741
12 *Un Fleuve*
13 *Une Nayade*

1745
13 *Thesée, qui après avoir vaincu le Taureau
de Maraton, l'amene au Temple d'Apollon pour
le faire sacrifier*
1747
10 *Silène, nourricier et Compagnon de Bacchus*
1750
16 *L'Amour debout qui tient négligemment
son Arc . . .*
20 *Vénus dans le bain*
1753
8 *Jupiter et Antiope*
1757
5 *Amimone et Neptune*
6 *Le Sacrifice d'Iphigénie*
1761
7 *L'Amour menaçant*
1763
2 *Les Grâces enchaînées par L'Amour*
1765
2 *Les Grâces*

VAN LOO, JEAN-BAPTISTE
(1684–1745)
1737
Un Bain de Diane

VAN LOO, LOUIS-MICHEL
(1707–1771)
1769
5 *L'Éducation de l'Amour*

VAN SCHUPPEN, JACQUES
(1670–1751)
1704
La mort d'Adonis

VENEVAULT, NICOLAS
(1697–1775)
1755
72 *La nymphe Io*
1757
49 *L'Union de l'Amour et de l'Amitié*
1759
53 *L'Amour îqué par une Abeille*

VERNANSAL, GUY-LOUIS
(1648–1729)
1704
La Naissance d'Adonis
La Naissance de Bacchus

VIEN, JOSEPH-MARIE
(1716–1809)
1755
37 *Dédale dans le labyrinthe, attachant les ailes
à Icare*
38 *Vénus sortant de la mer, portée par des
Tritons, et accompagnée de Nayades et d'Amours*
41 *Une Tête de Minerve, d'après l'antique*
42 *Une nymphe de Diane occupée de l'Amour
endormi, dans un paysage*

43 *Une tête d'Anacréon*
44 *Flore*
44 *Zéphire*
1757
29 *Proserpine ornant la statue de Cérès . . .*
30 *Dédale qui attache des ailes à Icare*
1761
22 *Zéphire et Flore*
24 *L'Amour et Psyché*
27 *La Déesse Hébé*
1763
26 *Proserpine orne de Fleurs le buste de Cérès
sa mère*
1773
4 *Diane, accompagnée de ses Nymphes, au retour
de la Chasse . . .*
1775
4 *Vénus blessé par Diomède à la guerre de Troye,
Iris descend du ciel pour la tirer du champ de
bataille et Mars l'aide à monter dans son Char
pour la conduire sur l'Olympe*
1779
4 *Hector détermine Pâris, son frère, à prendre
les armes pour la défense de la Patrie*
1781
1 *Briseis emmenée de la tente d'Achille*
1783
1 *Priam partant pour supplier Achille de lui rendre
le corps de son fils Hector*
1785
1 *Retour de Priam avec le corps d'Hector*
1787
1 *les Adieux d'Hector et d'Andromaque*
1789
1 *L'Amour fuyant l'Esclavage*
1791
369 *Les Adieux d'Hector et d'Andromaque*

VIGÉE LE BRUN, ELISABETH-LOUISE
(1755–1842)
1783
113 *Junon venant emprunter la ceinture de Vénus*
1785
86 *Bacchante assise, de grandeur naturelle et vue
jusqu'aux genoux*

VINCENT, FRANÇOIS-ANDRÉ
(1746–1816)
1783
93 *Achille secouru par Vulcain, combat
les Fleuves du Xante et du Simoïs*
94 *Enlèvement d'Orithie*
96 *Enlèvement d'Orithie*
1787
22 *Renaud et Armide*

WERTMÜLLER, ADOLF ULRIK
(1751–1811)
1785
121 *Une petite tête de l'Amour*

BIBLIOGRAPHY

A

ACADÉMIE FRANÇAISE 1694: Académie Française. *Dictionnaire de l'Académie Française*. 2 vols. Paris, 1694.

ADHÉMAR 1977: Hélène Adhémar. "Watteau: Les Romans et l'imagerie de son temps." *Gazette des Beaux-Arts* 90 (November 1977), 165–72.

ADHÉMAR AND HUYGHE 1950: Hélène Adhémar and René Huyghe. *Watteau: Sa vie, son oeuvre*. Paris, 1950.

ALBOUY 1969: Pierre Albouy. *Mythes et mythologie dans la littérature française*. Paris, 1969.

ALVIN-BEAUMONT 1932: V. Alvin-Beaumont. *Le Pedigree, erreurs, et vérités en art autour de Watteau*. Paris, 1932.

ANACRÉON 1706: Anacréon. *Traduction nouvelles des Odes d'Anacréon, avec de remarques par Mr. de La Fosse, sur la seconde edition faite à Paris en 1706*. Paris, 1706.

ANACRÉON 1716: Anacréon. *Les Poésies de Anacréon et de Sapho, traduits en français, avec des remarques, par Madame Dacier. Nouvelles edition, augmentée des notes latines de M. de La Fosse et de la traduction en vers français de M. de La Fosse*. Amsterdam, 1716.

ANANOFF 1966: Alexandre Ananoff. *L'Oeuvre dessiné de François Boucher (1703–1770)*. Paris, 1966.

ANANOFF AND WILDENSTEIN 1976: Alexandre Ananoff and Daniel Wildenstein. *François Boucher*. 2 vols. Lausanne and Paris, 1976.

ANANOFF AND WILDENSTEIN 1980: Alexandre Ananoff and Daniel Wildenstein. *L'Opera completa di Boucher*. Milan, 1980.

ANONYMOUS 1727: Anonymous. *Explication des tableaux exposez dans la Galerie d'Apollon*. Palais du Louvre, Paris, 1727.

ANONYMOUS 1759 (A): Anonymous. *Lettre critique à un ami, sur les ouvrages des messieurs de l'Académie, exposés au Sallon du Louvre*. Paris, 1759.

ANONYMOUS 1759 (B): Anonymous. "Lettre sur l'exposition publique des ouvrages de l'Académie Royale de Peinture et de Sculpture de France dans le Salon du Louvre à Paris." *Journal Encyclopédique* 7, pt. 2 (15 October 1759), 103–25.

ANONYMOUS 1765 (A): Anonymous. "Peinture." *L'Avant-Coureur*, no. 35 (2 September 1765), 537–39.

ANONYMOUS 1765 (B): Anonymous. "Ouvrages de peinture, sculpture, et gravure de l'Académie Royale, exposés au Sallon du Louvre depuis le 25 août dernier, fête de S. Louis." *Affiches, Annonces et Avis Divers*, no. 37 (11 September 1765), 147–48.

ANONYMOUS 1765 (C): Anonymous. "Peintures, sculptures, et gravures exposées au Salon du Louvre le 25 août 1765, jour de la St. Louis et dont l'exposition a été prorogée jusqu'au 7è octobre suivant." *Journal Encyclopédique* 7, pt. 3 (1 November 1765), 96–108.

ANONYMOUS 1775 (A): Anonymous. *Entretiens sur l'exposition des tableaux de l'année 1775*. Paris, 1775.

ANONYMOUS 1775 (B): Anonymous. *La Lanterne magique aux Champs-Élysées ou entretien des grand peintres sur le Sallon de 1775*. Paris, 1775.

ANONYMOUS 1824: Anonymous. *Notice sur la vie et les ouvrages de J.-L. David*. Paris, 1824.

ANONYMOUS 1835: Anonymous. "Supplément au catalogue du Musée Départemental, établi dans le local de Saint-Loup à Troyes." *Annuaire Administratif et Statistique du Département de l'Aube* (1835), 101–03.

ANTOINE 1978: Michel Antoine. *Le Gouvernement et l'administration sous Louis XV: Dictionnaire biographique*. Paris, 1978.

ANTOINE 1989: Michel Antoine. *Louis XV*. Paris, 1989.

APOLLODORUS 1961: Apollodorus. *The Library*. 2 vols. Trans. Sir James George Frazer. London and Cambridge, Mass., 1961.

APOSTOLIDES 1981: J.-M. Apostolidès. *Le Roi-Machine: Spectacle et politique au temps de Louis XIV*. Paris, 1981.

APULEIUS 1935: Apuleius. *The Golden Ass*. Trans. W. Adlington. London and New York, 1935.

ARNASON 1975: H. H. Arnason. *The Sculptures of Houdon*. New York, 1975.

ARNAULD D'ANDILLY 1727: Robert Arnauld d'Andilly, ed. and trans. *Les Confessions de Saint Augustin*. Paris, 1727. 1st ed. Paris, 1649.

ARQUIÉ-BRULEY 1981: Françoise Arquié-Bruley. "Documents notariés inédits sur Greuze." *Bulletin de la Société de l'Histoire de l'Art Français* (1981), 125–54.

ASMUS 1987: Ute Davitt Asmus. "Fontanellato II: La Trasformazione delli amante nell'amato, Parmigianinos Fresken in der Rocca Sanvitale." *Mitteilungen des Kunsthistorisches Institutes in Florenz* 37 (1987), 2–58.

AUBIGNÉ 1969: Agrippa d'Aubigné. *Oeuvres*. Paris, 1969.

AUCOC 1889: L. Aucoc. *L'Institut de France: Lois, statuts, et règlements concernant les anciens académies et l'Institut de 1635 à 1889*. Paris, 1889.

AZNAR, MORALES Y MARIN, AND GONZÁLEZ 1984: José Camón Aznar, José Luis Morales y Marín, and Enrique Valdivieso González. *Summa Artis*. Vol. XXVII, *Arte español del siglo XVIII*. Madrid, 1984.

B

BABEAU 1876: Albert Babeau. "Le Château de La Chapelle-Godefroy." *Mémoires de la Société Académique d'Agriculture, des Sciences, Arts, et Belles-Lettres du Département de l'Aube*, vol. 40 of the collection; vol. 13, 3rd ser. (1876), 5–33.

BABEAU 1899: Albert Babeau. "Musées de Province: Le Musée de Troyes." *Gazette des Beaux-Arts* 21 (1899), 497–511.

BABELON 1970: Jean-Pierre Babelon. "Le Palais de l'Arsenal à Paris: étude architecturale et essai de répertoire iconographique critique." *Bulletin Monumental* 128 (1970), 267–310.

BABELON 1972: Jean-Pierre Babelon. "Nouveaux documents sur la décoration intérieure de l'Hôtel Lambert." *Bulletin de la Société de l'Histoire de l'Art Français* (1972), 135–43.

BABELON 1985: Jean-Pierre Babelon. "La Maison du bourgeois gentilhomme: L'Hôtel Salé, 5, rue de Thorigny, à Paris." *Revue de l'Art*, no. 68 (1985), 7–34.

BACHAUMONT ET AL. 1777–89: Louis Petit de Bachaumont et al. *Mémoires secrets pour servir à l'histoire de la République des lettres en France depuis 1762 jusqu'à nos jours*. 36 vols. London, 1777–89.

BACOU 1968: Roseline Bacou. *Dessins du Louvre: Écoles allemande, flamande, hollandaise*. Paris, 1968.

BAILEY 1985: Colin B. Bailey. "Aspects of Patronage and Collecting of French Painting in France at the End of the *Ancien Régime*." Ph.D. diss., Oxford University, 1985.

BAILEY 1987: Colin B. Bailey. "Conventions of the Eighteenth-Century *cabinet de tableaux*: Blondel d'Azincourt's *La Première idée de la curiosité*." *Art Bulletin* LXIX/3 (September 1987), 431–47.

BAILEY 1988 (A): Colin B. Bailey. Introduction to Ange-Laurent de La Live de Jully's *Catalogue historique du cabinet de peinture et sculpture françoise de M. de Lalive*. New York, 1988.

BAILEY 1988 (B): Colin B. Bailey. "Artois, mécène, et collectionneur." In *La Folie Artois*, 73–79. Paris, 1988.

BAILEY 1989: Colin B. Bailey. "The Comte de Vaudreuil: Aristocratic Collecting on the Eve of the Revolution." *Apollo* (July 1989), 19–26.

BAILLET DE SAINT-JULIEN 1749: L.-G. Baillet de Saint-Julien. *Lettre sur la peinture, la sculpture, et l'architecture*. Amsterdam, 1749. Reprint. Geneva, 1972.

BAILLET DE SAINT-JULIEN 1750: L.-G. Baillet de Saint-Julien. *Lettres sur la peinture à un amateur*. Geneva, 1750. Reprint. Geneva, 1972.

BAJOU 1989: Thierry Bajou. "The Musée Fabre and its Collectors." *Apollo* (January 1989), 3–11.

BAJOU AND BAJOU 1988: Thierry Bajou and Valérie Bajou. *De Jean Cousin à Degas: Chefs-d'oeuvre de la peinture, Musée Fabre*. Montpellier, 1988.

BALTEAU, BARROUX, AND PRÉVOST 1933–[1989]: J. Balteau, M. Barroux, and M. Prévost, eds. *Dictionnaire de biographie française*. 17 vols. Paris, 1933–[1989].

BANIER 1715: Abbé Antoine Banier. *Explication historique des fables*. 3 vols. Paris, 1715.

BANIER 1732: Abbé Antoine Banier. *Trad. Ovide. Les Metamorphoses*. Amsterdam, 1732. English translation also published in Amsterdam, 1732.

BANIER 1738–40: Abbé Antoine Banier. *La Mythologie et les Fables expliquées par l'Histoire*. 3 vols. Paris, 1738–40. Translated as *The Mythology and Fables of the Ancients Explain'd from History*. 4 vols. London, 1739–40. Reprint. New York and London, 1976.

BANIER 1757: Abbé Antoine Banier. *Metamorphoses d'Ovide*. 3 vols. Paris, 1757.

BANKS 1977: Oliver Talcott Banks. *Watteau and the North: Studies in the Dutch and Flemish Baroque Influences on French Rococo Painting*. New York, 1977.

BARBIER 1857: Edmond-Jean-François Barbier. *Chronique de la régence et du règne de Louis XV (1718–1763)*. 4 vols. Paris, 1857.

BARDON 1963: Françoise Bardon. *Diane de Poitiers et le mythe de Diane*. Paris, 1963.

BARDON 1970: Françoise Bardon. "Le Portrait en Diane et la préciosite." *Rivista di Cultura Classica e Medioevale* 12 (1970), 181–218.

BARDON 1974: Françoise Bardon. *Le Portrait mythologique à la cour de France sous Henri IV et Louis XIII: Mythologie et politique*. Paris, 1974.

BARDON 1950: Henry Bardon. "L'Énéide et l'art XVIe–XVIIIe siècle." *Gazette des Beaux-Arts* 37 (1950), 77–98.

BARDON 1957: Henry Bardon. "Ovide et le grand roi." *Les Études Classiques* (October 1957), 401–16.

BARDON 1959: Henry Bardon. "Sur l'influence d'Ovide en France au 17ème siècle." In *Atti del Convegno Internazionale Ovidiano* 2, 69–83. Rome, 1959.

BARDON 1963: Henry Bardon. "Les Peintures à sujets antiques au XVIIIe siècle d'après les livrets de Salons." *Gazette des Beaux-Arts* 61 (April 1963), 217–50.

BARDON 1931: M. Bardon. *Don Quichotte en France au XVIIe et au XVIIIe siècles (1605–1815)*. 2 vols. Paris, 1931.

BARÉ 1884–85: Baré. "Edelinck (Nicolas-Etienne)." *Bulletin des Beaux-Arts* 1 (1884–85), 37–39.

BARKAN 1980: Leonard Barkan. "Diana and Actaeon: The Myth as Synthesis." *English Literary Renaissance* 10 (1980), 317–59.

BARKAN 1986: Leonard Barkan. *The Gods Made Flesh: Metamorphosis and the Pursuit of Paganism*. New Haven and London, 1986.

BARKER 1989: Nancy Nichols Barker. *Brother to the Sun King: Philippe, Duke of Orléans*. Baltimore, 1989.

BARRET-KRIEGEL 1988: Blandine Barret-Kriegel. *Jean Mabillon*. Paris, 1988.

BARROUX 1896: M. Barroux. "Procès-Verbal d'apposition de scellés chez Greuze d'après son divorce (1793)." *Bulletin de la Société de l'Histoire de l'Art Français*, 1896, 84–90.

BARTHÉLEMY 1990: Maurice Barthélemy. *Métamorphoses de l'opéra français*. Paris, 1990.

BARTOSCHEK 1979: Gerd Bartoschek. *Die Gemälde im Neuen Palais, Potsdam-Sanssouci, Staatliche Schlösser und Gärten*. Potsdam, 1979.

BARTSCH 1854–70: Adam von Bartsch. *Le Peintre graveur*. 21 vols. Leipzig, 1854–70. 2d ed. Wurzburg, 1920–22. Reprint (21 vols. in 4). Nieuwkoop and Hildesheim, 1970.

BARTSCH 1978–: Adam von Bartsch. *The Illustrated Bartsch*. Ed. Walter L. Strauss. New York, 1978–.

BASEL 1910: Kunstmuseum Basel. *Katalog der Oeffentlichen Kunstsammlung in Basel*. Basel, 1910.

BASEL 1980: Kunstmuseum Basel. *Museum*. Basel, 1980.

BASSERMANN-JORDAN 1910: Ernst Bassermann-Jordan. *Unveröffentlichte Gemälde Alter Meister aus dem Besitze des Bayerischen Staates*. Vol. III of *Die Gemäldegalerie im Kgl. Schlosse Schleiszheim*. Leipzig, 1910.

BATTIFOL 1931: L. Battifol. "La Construction de l'Arsenal au XVIIIe siècle et Germain Boffrand." *Revue de l'Art Ancien et Moderne* 59 (1931), 205–55.

BAUDOUIN 1627: Jean Baudouin. *Recherches touchant la mythologie divisées en IIII. traictez; recueillis des anciens autheurs*. In Natalis Comes. *Mythologie*. Vol. 2. Paris, 1627. Reprint. New York and London, 1976.

BAUER 1980: H. Bauer. *Rokoko Malerei*. Mittenwald, 1980.

BAYERSDORFER 1885: A. Bayersdorfer. *Verzeichniss in der Königlishen Gallerie zu Schleissheim Aufgestellten Gemälde*. Munich, 1885.

BAYLE 1715: P. Bayle. *Dictionnaire historique et critique*. 3 vols. Rotterdam, 1715.

BAZIN 1974: Germain Bazin. "Enquête sur Watteau." *L'Oeil*, no. 230 (September 1974), 61.

BEAN 1986: Jacob Bean. *Fifteenth–Eighteenth Century French Drawings in The Metropolitan Museum of Art*. New York, 1986.

BEAULIEU 1979: Michèle Beaulieu. "L'Andromède de Robert Le Lorrain." *La Revue du Louvre et des Musées de France*, 1979, no. 4, 291–93.

BEAULIEU 1982: Michèle Beaulieu. *Robert Le Lorrain (1666–1743)*. Neuilly-sur-Seine, 1982.

BEAUMONT 1894: C. de Beaumont. "Pierre Vigné de Vigny, architect du Roi." *Réunion des Sociétés des Beaux-Arts des Départements* (1894), 633–52.

BÉGUIN 1971 (A): Sylvie Béguin. "François Boucher, les tableaux du Louvre." *La Revue du Louvre et des Musées de France*, 1971, no. 2, 201.

BÉGUIN 1971 (B): Sylvie Béguin. "Quelques nouveaux dessins d'Ambroise Dubois." *Revue de l'Art* 14 (1971), 31–38.

BÉGUIN 1989: Sylvie Béguin. "New Evidence for Rosso in France." *Burlington Magazine* CXXXI/1041 (December 1989), 828–38.

BELLEGARDE 1701: Abbé J.-B. Morvan de Bellegarde. *Les Métamorphoses d'Ovide*. Paris, 1701.

BELLEGARDE 1712: Abbé J.-B. Morvan de Bellegarde. *Métamorphoses d'Ovide avec des explication à la fin de chaque fable*. 2d ed. Paris, 1712.

BELLIER DE LA CHAVIGNERIE AND AUVRAY 1882–87: Émile Bellier de La Chavignerie and Louis Auvray. *Dictionnaire général des artistes de l'école française depuis l'origine des arts du dessins jusqu'à nos jours*. 3 vols. Paris, 1882–87. Reprint. 5 vols. New York, 1979.

BÉNARD 1810: Piéri Bénard. *Cabinet de M. Paignon Dijonval, état détaillé et raisonné des dessins et estampes dont il est composé*. Paris, 1810.

BÉNÉZIT 1966: Emmanuel Bénézit. *Dictionnaire critique et documentaire des peintres, sculpteurs, dessinateurs, et graveurs de tous les temps et de tous les pays*. 8 vols. Paris, 1966. 2d ed. 10 vols. Paris, 1976.

BÉNICHOU 1948: P. Bénichou. *Morales du grand siècle*. Paris, 1948.

BENISOVICH 1956: Michel Benisovich. "Sales of French Collections in the United States During the First Half of the 19th Century." *Art Quarterly* XIX/3 (Autumn 1956), 288–301.

BENOIS 1908: Alexander Benois. "La Peinture des époques baroque et rococo." *Starye Gody* (October–December 1908), 720–34.

BENOIS 1910: Alexander Benois. "La Peinture française, italienne et anglaise aux XVIIe et XVIIIe siècles." In *Les Anciennes Écoles de peinture dans les palais et collections privées russes représenteés à l'exposition organisée à St. Petersbourg en 1909 par la Revue de l'Art Ancien "Starye Gody."* Brussels, 1910.

BENOIST 1953: Luc Benoist. *Ville de Nantes, Musée des Beaux-Arts. Catalogue et guide*. Nantes, 1953.

BENOIT 1909: François Benoit. *La Peinture au Musée de Lille*. Vol. 3. Paris, 1909.

BENSERADE 1679: Isaac de Benserade. *Métamorphoses d'Ovide en rondeaux imprimez et enrichis de figures par ordre de sa majesté et dediez à Monseigneur le Dauphin*. Amsterdam, 1679. 1st ed. 1676.

BERGER 1969: Robert Berger. *Antoine Le Pautre: A French Architect of the Era of Louis XIV*. New York, 1969.

BERGER 1985: Robert Berger. *Versailles: The Château of Louis XIV*. University Park, Pa., and London, 1985.

BERLIN 1978: Staatliche Museen Preussischer Kulturbesitz, Berlin. *Picture Gallery. Catalogue of Paintings, 13th–18th Century*. Trans. Linda B. Parshall. Berlin, 1978.

BERLIN 1985: Staatliche Museen Preussischer Kulturbesitz, Berlin. *Gemäldegalerie Berlin. Geschichte der Sammlung und Augewählte Meisterwerke*. Berlin, 1985. English ed. New York, 1986.

BERTIN 1893: Georges Bertin. *Joseph Bonaparte en Amérique*. Paris, 1893.

BERTIN 1901: G. E. Bertin. "Notice sur l'hôtel de La Vrillière et de Toulouse occupé depuis 1810 par la Banque de France." *Mémoire de la Société de l'Histoire de Paris et de l'Ile de France* 28 (1901), 1–36.

BESNUS 1898: A. Besnus. *Mes relations d'artiste*. Paris, 1898.

BESTERMAN 1953–77: Theodore Besterman, ed. *Voltaire: Correspondance*. 135 vols. Geneva, 1953–77.

BEVER 1905: H. Bever. *Katalog der Gemälde-Galerie im K. Schlosse zu Schleissheim*. Munich, 1905.

BIBLIOTHEQUE NATIONALE 1930–[1977]: Bibliothèque Nationale, Département des Estampes, Paris. *Inventaire du fonds français, graveurs du XVIIIe siècle*. Ed. Marcel Roux. 14 vols. Paris, 1930–[1977].

BIBLIOTHEQUE NATIONALE 1939–[1989]: Bibliothèque Nationale, Département des Estampes, Paris. *Inventaire du fonds français, graveurs du XVIIe siècle*. Ed. Roger Armand Weigert. 9 vols. Paris, 1939–[1989].

BIVER 1923: Paul Biver. *Histoire du château de Meudon*. Paris, 1923.

BIVER 1933: Paul Biver. *Histoire du château de Bellevue*. Paris, 1933.

BJURSTRÖM 1967: Per Bjurström. "Carl Gustaf Tessin as a Collector of Drawings." In *Contributions to the History and Theory of Arts, Figura*, 99–120. Stockholm, 1967.

BJURSTRÖM 1976: Per Bjurström. *French Drawings, Sixteenth and Seventeenth Centuries*. Stockholm, 1976.

BJURSTRÖM 1982: Per Bjurström. *French Drawings, Eighteenth Century*. Vol. 6 of *Drawings in Swedish Public Collections*. Stockholm, 1982.

BLANC 1865: Charles Blanc. *Histoire des peintres de toutes les écoles: École française*. Vol. 2. Paris, 1865.

BLONDEL 1752–56: Jacques-François Blondel. *L'Architecture française*. 4 vols. Paris, 1752–56.

BLUM 1910: A. Blum. "L'Estampe satirique et la caricature en France au XVIIIe siècle." *Gazette des Beaux-Arts* 1910, 379–92.

BLUNT 1944: Anthony Blunt. "The Heroic and the Ideal Landscape in the Work of Nicolas Poussin." *Journal of the Warburg and Courtauld Institutes* 7 (1944), 154–68.

BLUNT 1966: Anthony Blunt. *The Paintings of Nicolas Poussin: A Critical Catalogue*. London, 1966.

BLUNT 1967: Anthony Blunt. *Nicolas Poussin: The A.W. Mellon Lectures in the Fine Arts 1958, National Gallery of Art, Washington, D.C.* 2 vols. Washington, D.C., 1967.

BLUNT 1977: Anthony Blunt. *Art and Architecture in France, 1500–1700*. London, 1977.

BOBER AND RUBINSTEIN 1986: P. P. Bober and R. O. Rubinstein. *Renaissance Artists and Antique Sculpture: A Handbook of Sources*. London, 1986.

BOCK 1977: Henning Bock. "Ein Bildnis von Prinz Heinrich Lubomirski als Genius des Ruhms, von V. Le Brun." *Niederdeutsche Beiträge zur Kunstgeschichte* 16 (1977), 83–92.

BOERLIN-BRODBECK 1973: Y. Boerlin-Brodbeck. *Antoine Watteau und das Theater*. Basel, 1973.

BOILEAU 1670: G. Boileau. *Les Oeuvres posthumes*. Paris, 1670.

BOISMORTIER 1900: Joseph Bodin de Boismortier. *Diane et Actéon*. Paris, 1900 (originally performed in 1732).

BOLZANI 1615: G. P. V. Bolzani. *Les Hiéroglyphiques*. Trans. I. de Montlyard. Lyons, 1615. Reprint. New York and London, 1976.

BONNAFFÉ 1884: Edmond Bonnaffé. *Dictionnaire des amateurs français au XVIIe siècle*. Paris, 1884.

BONNEFOY 1981: Yves Bonnefoy, ed. *Dictionnaire des mythologies et des religions des sociétés traditionnelles et du monde antique*. Paris, 1981.

BONNEVAL 1717: René de Bonneval. *Momus au cercle des dieux*. Paris, 1717.

BOON 1977: K. G. Boon. "De Antwerpse Schilder Bernaert de Rijckere en Zijn Tekeningen-Oeuvre." *Oud Holland* 91 (1977), 109–31.

BORDEAUX 1971: Jean-Luc Bordeaux. "François Lemoyne et la décoration de l'hôtel Peyrenc de Moras (Musée Rodin)." *Gazette des Beaux-Arts* 77 (February 1971), 65–76.

BORDEAUX 1974: Jean-Luc Bordeaux. "François Le Moyne's Painted Ceiling in the Salon d'Hercule at Versailles: A Long Overdue Study." *Gazette des Beaux-Arts* 83 (May–June 1974), 301–18.

BORDEAUX 1975: Jean-Luc Bordeaux. "Some Reflexions on Rodin's *The Kiss*." *Gazette des Beaux-Arts* 86 (October 1975), 123–28.

BORDEAUX 1976: Jean-Luc Bordeaux. "The Epitome of the Pastoral Genre in Boucher's Oeuvre: *The Fountain of Love* and *The Bird Catcher* from *The Noble Pastorale*." *J. Paul Getty Museum Journal* 3 (1976), 75–101.

BORDEAUX 1984 (A): Jean-Luc Bordeaux. *François Le Moyne (1688–1737) and His Generation*. Neuilly-sur-Seine, 1984.

BORDEAUX 1984 (B): Jean-Luc Bordeaux. "La Commande royale de 1724 pour l'Hôtel du Grand Maître à Versailles." *Gazette des Beaux-Arts* 104 (October 1984), 113–26.

BORDEAUX 1989: Jean-Luc Bordeaux. "Jean-François de Troy—Still an Artistic Enigma: Some Observations on His Early Works." *Artibus et Historiae* 20/X (1989), 143–69.

BORDES 1981: Philippe Bordes. "Un Portrait de David identifié: L'Insurgé américain Filippo Mazzei." *La Revue du Louvre et des Musées de France*, 1981, no. 3, 159–62.

BORDES 1983: Philippe Bordes. *"Le Serment du Jeu de Paume" de Jacques-Louis David: Le Peintre, son milieu, et son temps, de 1789 à 1792*. Paris, 1983.

BORDES AND MICHEL 1988: Philippe Bordes and Regis Michel, eds. *Aux armes et aux arts! Les Arts de la Révolution, 1789–1799*. Paris, 1988.

BOTH DE TAUZIA 1878: Both de Tauzia. *Notice supplémentaire des tableaux exposés dans les galeries du Musée National du Louvre et non décrits dans les trois catalogues des diverses écoles de peintures*. Paris, 1878.

BOTTARI 1822–25: Giovanni Gaetano Bottari. *Raccolta di lettere sulla pittura, scultura, ed architettura scritte da più celebri personaggi dei secoli XV, XVI, e XVII*. Milan, 1822–25.

BOTTINEAU 1960: Yves Bottineau. *L'Art de cour dans l'Espagne de Philippe V, 1700–1746*. Bordeaux, 1960.

BOTTINEAU 1980: Yves Bottineau. "Le Château de Rambouillet." In *Monuments historiques de la France* 112 (1980), 65–80.

BOUHIER 1742: Jean Bouhier. *Les Amours d'Enée et Didon, poème traduit de Virgile, avec diverses autres imitations d'anciens poètes grecs et latins*. Paris, 1742.

BOWIE 1987: Malcolm Bowie. *Freud, Proust, and Lacan: Theory as Fiction*. Cambridge and New York, 1987.

BOYER 1949: Ferdinand Boyer. "Catalogue raisonné de l'oeuvre de Charles Natoire." *Archives de l'Art Français* 21 (1949), 31–107.

BOYER 1980 (A): Jean-Claude Boyer. "Un chef-d'oeuvre retrouvé de Pierre Mignard (1612–1695): *Pan et Syrinx*." *La Revue du Louvre et des Musées de France*, 1980, no. 3, 152–56.

BOYER 1980 (B): Jean-Claude Boyer. "L'Inventaire après décès de l'atelier de Pierre Mignard." *Bulletin de la Société de l'Histoire de l'Art Français* (1980), 137–65.

BOYER 1984: Jean-Claude Boyer. "Un Cas singulier: Le *Saint Charles Borromée* de Pierre Mignard pour San Carlo ai Catinari." *Revue de l'Art*, no. 64 (1984), 23–34.

BREJON DE LAVERGNÉE 1987: Arnauld Brejon de Lavergnée. *L'Inventaire Le Brun de 1683: La Collection des tableaux de Louis XIV*. Paris, 1987.

BREJON DE LAVERGNÉE AND VOLLE 1988: Arnauld Brejon de Lavergnée and Nathalie Volle. *Musées de France, repertoire des peintures italiennes du XVIIe siècle*. Paris, 1988.

BRET 1747: Antoine Bret. *Epître au roy sur quelques tableaux exposés au Louvre pour le concours proposé par M. de Tournehem, directeur général des Bâtiments*. Paris, 1747.

BRICE 1706: Germain Brice. *Description nouvelle de la ville de Paris, et recherche des singularitez les plus remarquables qui se trouvent à present dans cette grande ville.* 2 vols. Paris, 1706.

BRICE 1752: Germain Brice. *Description de la ville de Paris et de tout ce qu'elle contient de plus remarquable.* 9th ed. Paris, 1752. Reprint. Geneva and Paris, 1971. Other editions published in Paris: 1698, 1706, 1725.

[BRIDARD DE LA GARDE] 1761: [Abbé Ph. Bridard de La Garde]. *Observations d'une société d'amateurs, sur les tableaux exposés au Salon cette année 1761.* Extract of three articles written for *L'Observateur Littéraire. Collection Deloynes,* VII, no. 94, 1–72.

[BRIDARD DE LA GARDE] 1765: [Abbé Ph. Bridard de La Garde]. "Observations sur les ouvrages de peinture et de sculpture, etc., exposés au Louvre en 1765." *Mercure de France* (October 1765), 139–69.

BRIÈRE 1912: Gaston Brière. "Tableaux de J.-Fr. de Troy aux Musées de Bâle et de Neuchâtel." *Bulletin de la Société de l'Histoire de l'Art Français* (1912), 347–50.

BRIÈRE 1913: Gaston Brière. "Observations sur quelques peintures par les Coypel (III. Tableau attribué à Charles-Antoine Coypel au Musée de Neuchâtel)" and "Note complémentaire sur un tableau de Ch.-Antoine Coypel au Musée de Neuchâtel." *Bulletin de la Société de l'Histoire de l'Art Français* (1913), 33–35 and 382–85.

BRIÈRE 1924: Gaston Brière. *Musée National du Louvre. Catalogue des peintures exposées dans les galeries.* Vol. 1, *École française.* Paris, 1924.

BRIÈRE 1931: Gaston Brière. "Notes et documents. L'Exposition des chefs-d'oeuvre des musées de province: École française, XVIIe et XVIIIe siècles." *Bulletin de la Société de l'Histoire de l'Art Français* (1931), 189–217.

BRIÈRE-MISME 1967: Clotilde Brière-Misme. "La Résurrection de la salle à manger de Louis XV au Petit Trianon." *Bulletin de la Société de l'Histoire de l'Art Français* (1967), 217–40.

BRIGANTI 1962: Giuliano Briganti. *Pietro da Cortona, o della pittura barocca.* Florence, 1962.

BRINCKMANN 1943: A. E. Brinckmann. *J. A. Watteau.* Vienna, 1943.

BROOKNER 1956: Anita Brookner. "Jean-Baptiste Greuze—II." *Burlington Magazine* XCVIII/639 (June 1956), 192–99.

BROOKNER 1967: Anita Brookner. *Watteau.* London, 1967. (Paris and Verona, 1969).

BROOKNER 1972: Anita Brookner. *Greuze: The Rise and Fall of an Eighteenth-Century Phenomenon.* Greenwich, 1972.

BROOKS 1969: P. Brooks. *The Novel of Worldliness: Crébillon, Marivaux, Laclos, Stendhal.* Princeton, 1969.

BROOKS-DAVIES 1982: Douglas Brooks-Davies. "The Mythology of Love: Venerean (and Related) Iconography in Pope, Fielding, Cleland, and Sterne." In *Sexuality in Eighteenth-Century Britain,* 176–97. Manchester, 1982.

BROWN 1984: David Alan Brown. "Parmigianino at Fontanellato." *FMR,* no. 1 (June 1984), 140–47.

BROWN 1972: N. O. Brown. "Metamorphoses II: Actaeon." *The American Poetry Review,* no. 1 (November/December 1972), 38–40.

BROWNE 1969: P. Browne. *Augustine of Hippo.* Berkeley, 1969.

BRUNEL 1971: Georges Brunel. "A propos des tableaux de Boucher des collections du Louvre." *La Revue du Louvre et des Musées de France,* 1971, no. 3, 202–16.

BRUNEL 1986: Georges Brunel. *Boucher.* London and New York, 1986.

BRUYN ET AL. 1986: J. Bruyn et al. *A Corpus of Rembrandt Paintings 1631–34.* Vol. 2. Dordrecht, Boston, and Lancaster, 1986.

BRUZEN DE LA MARTINIÈRE 1740–42: A.-A. Bruzen de La Martinière. *Histoire de la vie et du règne de Louis XIV.* 5 vols. The Hague, 1740–42.

BRYSON 1981: Norman Bryson. *Word and Image: French Painting of the Ancien Régime.* Cambridge, 1981.

BUFFENOIR 1905: H. Buffenoir. *La Comtesse d'Houdetot: Sa famille, ses amis.* Paris, 1905.

BUKDAHL 1980: E.-M. Bukdahl. *Diderot critique d'art.* Vol. 1, *Théorie et pratique dans les Salons de Diderot.* 2 vols. Copenhagen, 1980.

BURKE 1978: P. Burke. *Popular Culture in Early Modern Europe.* London, 1978.

BURTY 1864: Philippe Burty. "De Paris à Bade." *Gazette des Beaux-Arts* (1864), 160–73.

BURTY 1865: Philippe Burty. "La Gravure, la lithographie, et la photographie au Salon de 1865." *Gazette des Beaux-Arts* 19 (July–December 1865), 80–95.

C

CAILLEUX 1967: Jean Cailleux. "Newly Identified Drawings by Watteau." *Burlington Magazine* CIX/766 (January 1967), 56–63.

CAILLEUX 1975: Jean Cailleux. "Un Étrange Monument et autres études sur Watteau." *Art et Curiosité* special issue (March–April 1975), 85–88. Published in English: "A Strange Monument and Other Watteau Studies." *Burlington Magazine* CXVII/865 (April 1975), 246–49.

CAIX DE SAINT-AYMOUR 1919: Comte de Caix de Saint-Aymour. *Les Boullongne.* Paris, 1919.

CALDWELL AND McDERMOTT 1980: Joan G. Caldwell and Betty N. McDermott. *New Orleans Museum of Art: Handbook of the Collection.* New Orleans, 1980.

CALLIMACHUS 1921: Callimachus. "Hymn." In *Callimachus and Lycophron.* Trans. G. R. Mair. London and New York, 1921.

CAMESASCA AND ROSENBERG 1970: Ettore Camesasca and Pierre Rosenberg. *Tout l'oeuvre peint de Watteau.* Paris, 1970. 2d ed. Paris, 1983. First published in Italian with authors Montagni and Macchia (1968); also published in English with authors Camesasca and Sunderland (1971).

CAMPBELL 1985: P. R. Campbell. "The Conduct of Politics in France in the Time of Cardinal Fleury, 1723–1743." Ph.D. diss., University of London, 1985.

CAQUETS DE L'ACCOUCHÉE [189–]: *Les Caquets de l'accouchée.* Paris, [189–]. Originally published in 1622.

CARACO 1985: Edward P. Caraco. "First Painters to the King." *Arts Quarterly* (Fall 1985), 13–16.

CARDINAL 1984: Catherine Cardinal. *Catalogue des montres du Musée du Louvre.* Vol. 1, *La Collection Olivier.* Paris, 1984.

CARESME 1740: Claude-François Caresme. "Appendice au dialogue sur le coloris. Abrégé de la vie de Noël Coypel." [1740] In *Revue Universelle des Arts.* Ed. Paul Lacroix and C. Marsuzi de Aguirre. Vol. 15. Paris and Brussels, 1862.

CARIOU 1985: A. Cariou. *Quimper, Musée des Beaux-Arts.* Quimper, 1985.

CARR 1960: J. L. Carr. "Pygmalion and the Philosophes: The Animated Statue in Eighteenth-Century France." *Journal of the Warburg and Courtauld Institutes* 23 (1960), 239–55.

CARTARI 1556: Vicenzo Cartari. *Immagini con la spositione de i dei gli antichi.* Venice, 1556. (*Imagini delli dei de gl'antichi.* Venice, 1647; Geneva, 1647; trans. by Antoine Du Verdier in 1606 as *Les Images des dieux des anciens;* other French editions in 1610 and 1623–24).

CASSIRER 1951: Ernst Cassirer. *The Philosophy of the Enlightenment.* Princeton, 1951.

CASTAN 1886: A. Castan. *Catalogue des peintures, dessins, sculptures, et antiquités du Musée de Besançon.* Besançon, 1886.

CASTAN 1889: A. Castan. *Histoire et description des musées de la ville de Besançon.* Paris, 1889.

CATHEU 1945–46: F. de Catheu. "La Décoration des hôtels du Maine au faubourg Saint-Germain." *Bulletin de la Société de l'Histoire de l'Art Français* (1945–46), 100–08.

CATULLUS 1952: Catullus. "The Poems of Garius Valerius Catullus." In *Catullus, Tibbulus, and Pervigilium Veneris.* Trans. F. W. Cornish. London and Cambridge, Mass., 1952.

CAYEUX 1965: Jean de Cayeux. "Watelet et Rembrandt." *Bulletin de la Société de l'Histoire de l'Art Français* (1965), 131–61.

CAYLUS 1757: Anne-Claude-Philippe de Tubières, comte de Caylus. *Tableaux tirés de l'Iliade, de l'Odysée d'Homère, et de l'Énéide de Virgile.* Paris, 1757.

CECIL 1950: Robert Cecil. "The Remainder of the Hertford and Wallace Collections." *Burlington Magazine* XCII/567 (June 1950), 168–72.

CHAMPEAUX 1898: Alfred de Champeaux. *L'Art décoratif dans le vieux Paris.* Paris, 1898.

CHAMPIER AND SANDOZ, 1900: V. Champier and R. Sandoz. *Le Palais Royale d'après des documents inédits, 1624–1900.* 2 vols. Paris, 1900.

CHAPELAIN 1880–83: Jean Chapelain. *Lettres de Jean Chapelain.* Ed. P. Tamizey de Larroque. 2 vols. Paris, 1880–83.

CHARGEOIT 1778: Jean-Baptiste Chargeoit. *Inventaire des collections de Salm* (MS), 1778.

CHARMET 1970: Raymond Charmet. *French Paintings in Russian Museums.* Trans. Muriel Dubois-Ferrière. New York, 1970.

CHARPENTIER 1982: Marc-Antoine Charpentier. *Actéon: Opéra de chasse.* Saint-Michel de Provence, 1982.

CHASTEL 1966: André Chastel. "Diane de Poitiers: 'L'Eros de la beauté froide.'" [1966] In *Fables, Formes, Figures.* Vol. 2, 263–72. Paris, 1978.

CHASTEL 1972–73: André Chastel. "Fontainebleau: Formes et symboles." In exh. Paris, 1972–73, xiii–xxviii.

CHASTELLUX 1875: Henri-Paul-César Chastellux. *Notes prises aux archives de l'état-civil de Paris, avenue Victoria, 4, brûlées le 24 mai 1871.* Paris, 1875.

CHAUSSARD 1806: P. Chaussard. "Notice historique et inédite sur M. Louis David." In *Le Pausanias français; état des arts du dessin en France, à l'ouverture du XIXe siècle: Salon de 1806,* 145–74. Paris, 1806. Reprinted in *Revue Universelle des Arts* 18 (1863), 114–28.

CHAUSSINAND-NOGARET 1985: G. Chaussinand-Nogaret. *The French Nobility in the Eighteenth Century: From Feudalism to Enlightenment.* Trans. W. Doyle. Cambridge, 1985.

CHÉNIER 1924: André Chénier. *Oeuvres poétiques.* Vol. 1. Paris, 1924.

CHENNEVIÈRES 1851–52: Ph. de Chennevières. "Jean-François de Troy." *Archives de l'Art Français* (1851–52), 161.

CHENNEVIÈRES-POINTEL 1847–62: Ph. de Chennevières-Pointel. *Recherches sur la vie et les ouvrages de quelques peintres provinciaux de l'ancienne France.* 4 vols. Paris, 1847–62.

CHERVET 1912: Henri Chervet. "Charles-Joseph Natoire." *La Revue de l'Art Ancien et Moderne* 31 (January–June 1912), 193–204, 383–96.

CHOMPRÉ 1808: Pierre Chompré. *Dictionnaire abrégé de la fable pour l'intelligence des poëtes, et la connaissance des tableaux et des statues.* Paris, 1808. 1st ed., 1727.

CHOUQUET 1873: Gustave Chouquet. *Histoire de la musique dramatique en France depuis ses origines jusqu'à nos jours.* Paris, 1873.

CHURCH 1975: W. F. Church. "France." In *National Consciousness: History and Political Culture in Early Modern Europe,* ed. O. Ranum. Baltimore, 1975.

CLAPARÈDE 1964: Jean Claparède. "Musée Fabre à Montpellier: Nouvelles acquisitions." *La Revue du Louvre et des Musées de France,* 1964, no. 1, 265–68.

CLAPARÈDE 1968: Jean Claparède. *Musée Fabre, Montpellier: Catalogue des peintures et sculptures du Musée Fabre à la ville de Montpellier.* Unpublished manuscript. Paris, Bibliothèque du Louvre, 1968.

CLÉMENT DE RIS 1859–61: Louis-Torterat Clément de Ris. *Les Musées de province.* 2 vols. Paris, 1859–61.

CLÉMENT DE RIS 1872: Louis-Torterat Clément de Ris. *Les Musées de province.* Paris, 1872.

CLÉMENT DE RIS 1874: Louis-Torterat Clément de Ris. "Les Musées du Nord: École française." *Gazette des Beaux-Arts* 10 (1874), 493–98.

CLEVELAND 1982: Cleveland Museum of Art. *European Paintings of the 16th, 17th, and 18th Centuries: The Cleveland Museum of Art Catalogue of Paintings, Part Three.* Cleveland, 1982.

CLOSE 1974: A. Close. "Don Quixote as a Burlesque Hero: A Reconstructed Eighteenth-Century View." *Forum of Modern Language Studies* 10 (1974), 365–78.

COBBAN 1979: A. Cobban. *History of Modern France.* Vol. 1, *1715–1799.* 3rd ed. Harmondsworth, 1979.

COCHE DE LA FERTÉ AND GUEY 1952: E. Coche de La Ferté and J. Guey. "Analyse archéologique et psychologique d'un tableau de David: *Les Amours de Pâris et d'Hélène.*" *Revue Archéologique* 45 (1952), 78–80.

[COCHIN] 1775: [Charles-Nicolas Cochin] *Observations sur les ouvrages exposés au Sallon du Louvre, ou lettre à M. le comte de ***.* Paris, 1775.

COCHIN 1880: Charles-Nicolas Cochin. *Mémoires inédits de Charles-Nicolas Cochin sur le comte de Caylus, Bouchardon, les Slodtz.* Paris, 1880.

COLBERT 1861–83: Jean-Baptiste Colbert. *Lettres et mémoires de Colbert.* Ed. P. Clément. 10 vols. Paris, 1861–83.

COLLECTION DELOYNES: *Collection de pièces sur les beaux arts imprimées et manuscrites, recueillie par Pierre-Jean Mariette, Charles-Nicolas Cochin, et M. Deloynes, dite Collection Deloynes.* 64 vols. Paris, Bibliothèque Nationale, Cabinet des Estampes.

COLTON 1967: Judith Colton. "The Endymion Myth and Poussin's Detroit Painting." *Journal of the Warburg and Courtauld Institutes* 30 (1967), 426–31.

COMES 1627: Natalis Comes [Natali Conti]. *Mythologie.* Trans. Jean Baudouin. 2 vols. Paris, 1627. Reprint. New York and London, 1976.

CONISBEE 1981: Philip Conisbee. *Painting in Eighteenth-Century France.* Ithaca, 1981.

CONSTANS 1976: Claire Constans. "Les Tableaux du grand appartement du Roi." *La Revue du Louvre et des Musées de France,* 1976, no. 3, 157–73.

CONSTANS 1980: Claire Constans. *Musée National du Château de Versailles: Catalogue des peintures.* Paris, 1980.

CORDEY 1939: Jean Cordey. *Inventaire des biens de Madame de Pompadour rédigé après son décès.* Paris, 1939.

COUPIN 1827: P. A. Coupin. *Essai sur J. L. David, peintre d'histoire, ancien membre de l'Institut, officier de la Légion d'honneur.* Paris, 1827.

COURAJOD 1874: Louis Courajod. *Histoire de l'École des Beaux-Arts au XVIIIe siècle. L'École royale des Élèves protégés.* Paris and London, 1874.

COURT DE GÉBELIN 1773–82: A. Court de Gébelin. *Monde primitif analysé et comparé avec le monde moderne.* 9 vols. Paris, 1773–82.

COWLEY 1983: Robert L. S. Cowley. *Hogarth's "Marriage A-la-Mode."* Ithaca, 1983.

COYPEL 1732: Charles-Antoine Coypel. "Dialogue sur la connoissance de la peinture." Originally published with "Discours sur la nécessité de recevoir des avis." Paris, 1732. Reprinted in *Oeuvres.* Paris, 1971.

COYPEL 1751: Charles-Antoine Coypel. "Dialogue de M. Coypel sur l'exposition des tableaux dans le Sallon du Louvre." Originally published in *Mercure de France* (November 1751). Reprinted in *Oeuvres.* Paris, 1971.

CRÉBILLON 1990: Claude-Prosper Jolyot de Crébillon. *Lettres de la marquise de M*** au comte de R***.* Ed. Desjonquères. Paris, 1990.

CROW 1985: Thomas E. Crow. *Painters and Public Life in Eighteenth-Century Paris.* New Haven and London, 1985.

CROW 1986: Thomas E. Crow. "La Critique des lumières dans l'art du dix-huitième siècle." *Revue de l'Art,* no. 73 (1986), 9–16.

CROW 1989 (A): Thomas E. Crow. "Fêtes Galantes." In *A New History of French Literature,* 402–09. Cambridge, Mass., and London 1989.

CROW 1989 (B): Thomas E. Crow. "Une Manière de travailler: In the Studio of David." *Parachute,* no. 56 (October–December 1989), 47–51.

CUZIN 1986: Jean-Pierre Cuzin. "Fragonard dans les musées français: Quelques tableaux reconsidérés ou discutés." *La Revue du Louvre et des Musées de France,* 1986, no. 1, 58–66.

CUZIN 1987: Jean-Pierre Cuzin. *Jean-Honoré Fragonard: Vie et oeuvre, catalogue complet des peintures.* Fribourg and Paris, 1987. English ed. New York, 1988.

D

DACIER 1715: A. L. Dacier. *Des causes de la corruption du goût.* 2d ed. Amsterdam, 1715.

DACIER 1909–21: Émile Dacier. *Catalogues de ventes et livrets de Salons illustrés par Gabriel de Saint-Aubin.* 13 pts. Paris, 1909–21.

DACIER 1912: Émile Dacier. "Gabriel de Saint-Aubin." *Revue de l'Art Ancien et Moderne* XXXI/17 (10 January 1912), 13–15.

DACIER 1923: Émile Dacier. "Ce que racontent les oeuvres d'art: Devant la prétendue *Antiope* de Watteau." *Le Figaro Artistique* (22 November 1923), 4–6.

DACIER 1929–31: Émile Dacier. *Gabriel de Saint-Aubin: Peintre, dessinateur, et graveur, 1724–1780.* 2 vols. Paris, 1929–31.

DACIER 1932: Émile Dacier. "La Curiosité au XVIIIe siècle: La Vente Charles Coypel d'après les notes manuscrites de P.-J. Mariette." *La Revue de l'Art Ancien et Moderne* 61 (February 1932), 61–72, 131–44.

DACIER, HÉROLD, AND VUAFLART 1921–29: Emile Dacier, J. Hérold, and A. Vuaflart. *Jean de Jullienne et les graveurs de Watteau au XVIIIe siècle.* Paris, 1921–29.

 HÉROLD AND VUAFLART. *Notices et documents biographiques.* Vol. 1. 1929.

 DACIER AND VUAFLART. *Historique.* Vol. 2. 1922.

 DACIER AND VUAFLART. *Catalogue.* Vol. 3. 1922.

 DACIER AND VUAFLART. *Planches.* Vol. 4. 1921.

DACOSTA KAUFMANN 1988: Thomas DaCosta Kaufmann. *The School of Prague: Painting at the Court of Rudolf II.* Chicago and London, 1988.

DAINVILLE 1978: François de Dainville. *L'Éducation des Jésuites, 16e–18e siècles.* Paris, 1978.

DAMISCH 1983: Hubert Damisch. *Die Französische Malerei.* Freiburg im Breisgau, 1983.

DANCHET 1751: Antoine Danchet. *Diane, divertissement pour le Roi* (1721). In *Théâtre de M. Danchet de l'Académie Française…*, vols. 3–4, 353–58. Paris, 1751.

DANDRÉ-BARDON 1765 (A): Michel-François Dandré-Bardon. *Traité de peinture, suivi d'un essai sur la sculpture.* 2 vols. Paris, 1765. Reprint. Geneva, 1972.

DANDRÉ-BARDON 1765 (B): Michel-François Dandré-Bardon. *Vie de Carle Vanloo.* Paris, 1765. Reprint. Geneva, 1973.

DANGEAU 1854–60: Philippe de Courcillon, marquis de Dangeau. *Journal du marquis de Dangeau.* Ed. E. Soulié, L. Dussieux, et al. 19 vols. Paris, 1854–60.

DANIELS 1976: Jeffrey Daniels. *Sebastiano Ricci.* Hove, 1976.

DARCEL 1872: Alfred Darcel. "Exposition rétrospective et monuments du vendomois." *Gazette des Beaux-Arts* 6 (1872), 177–194.

DARGENTY 1891: G. Dargenty. *Antoine Watteau.* Paris, 1891.

DARNTON 1991: Robert Darnton. *Edition et sédition: L'Univers de la littérature clandestine au XVIIIe siècle.* Paris, 1991.

DAVID 1880: J. David. *Le Peintre Louis David, 1748–1825.* Vol. 1, *Souvenirs et documents inédits.* Paris, 1880.

DAVIES 1946: Martin Davies. *National Gallery Catalogues: French School.* London, 1946.

DAVIES 1957: Martin Davies. *National Gallery Catalogues: French School.* 2d ed. London, 1957.

DEBRIE 1982: Christine Debrie. *Musée Antoine Lécuyer.* Saint-Quentin, 1982.

DEBRIE 1983: Christine Debrie. *Le Musée Antoine Lécuyer, Saint-Quentin.* Saint-Quentin, 1983.

DELÉCLUZE 1855: Étienne-Jean Delécluze. *Louis David, son école, et son temps: Souvenirs.* Paris, 1855. Reprint. Paris, 1983.

DELESTRE 1845: J.-B. Delestre. *Gros et ses ouvrages.* Paris [1845].

DELESTRE 1867: J.-B. Delestre. *Gros: Sa vie et ses ouvrages.* Paris, 1867.

DELIGNIÈRES 1867: E. Delignières. "Catalogue raisonné de l'oeuvre gravé de Jean Charles Levasseur d'Abbeville." *Mémoires de la Société Imperiale d'Émulation d'Abbeville, 1861–1866.* 1867.

DELLANEVA 1988: Joann Dellaneva. "*Mutare/Mutatus:* Pernette Du Guillet's Actaeon Myth and the Silencing of the Poetic Voice." In *Women in French Literature*, 47–55. Saratoga, Calif., 1988.

DÉMORIS 1978: René Démoris. "Le Corps royal et l'imaginaire au XVIIe siècle: *Le Portrait du roy* par Félibien." *Revue des Sciences Humaines* 172 (December 1978), 9–30.

DÉMORIS 1987: René Démoris. "Watteau: Le Paysage et ses figures." In *Antoine Watteau (1684–1721): Le Peintre, son temps, et sa légende,* ed. François Moreau and Margaret Morgan Grasselli. Paris and Geneva, 1987.

DEMOUSTIER 1804: Charles-Albert Demoustier. *Lettres à Émilie sur la mythologie.* Vol 1. Paris, 1804. First published in 1786.

DESCHEEMAEKER 1969: Jacques Descheemaeker. *La Maison d'Arenberg d'après les archives françaises.* Neuilly, 1969.

DESCOURTIEUX 1977–78: Patrick Descourtieux. *Les Théoriciens de l'art au XVIIIe siècle: La Font de Saint-Yenne.* Mémoire de Maîtrise. Université de Paris-Sorbonne, 1977–78.

DESMARETS DE SAINT-SORLIN 1657: J. Desmarets de Saint-Sorlin. *Clovis, ou la France chrétienne.* Paris, 1657. Reprint. Ed. R. Freudmann and H. G. Hall. Paris, 1972.

DETIENNE 1981: Marcel Detienne. *L'Invention de la mythologie.* Paris, 1981.

DÉZALLIER D'ARGENVILLE 1752: Antoine-Joseph Dézallier d'Argenville. *Voyage pittoresque des environs de Paris, ou description des maisons royales, châteaux, et autres lieux de plaisance, situés à quinze lieues aux environs de cette ville.* Paris, 1752.

DÉZALLIER D'ARGENVILLE 1762: Antoine-Joseph Dézallier d'Argenville. *Abrégé de la vie des plus fameux peintres.* 2d ed. 4 vols. Paris 1762.

DÉZALLIER D'ARGENVILLE 1772: Antoine-Joseph Dézallier d'Argenville. *Voyage pittoresque des environs de Paris, ou description des maisons royales, châteaux, et autres lieux de plaisance, situés à quinze lieues aux environs de cette ville.* 4th ed. Paris, 1772.

DÉZALLIER D'ARGENVILLE 1765: Antoine-Nicolas Dézallier d'Argenville. *Voyage pittoresque de Paris, ou indication de tout ce qu'il y a de beau dans cette grande ville en peinture, sculpture, et architecture.* 4th ed. Paris, 1765.

DÉZALLIER D'ARGENVILLE 1787: Antoine-Nicolas Dézallier d'Argenville. *Vies des fameux architectes depuis la renaissance des arts, avec la description de leurs ouvrages.* 2 vols. Paris, 1787. Reprint. Geneva, 1972.

DIDEROT 1875: Denis Diderot. "Plan d'une Université pour le gouvernement de Russie ou d'une éducation publique dans toutes les sciences." (1775) In *Oeuvres complètes.* Vol. 3. Paris, 1875.

DIDEROT 1955–70: Denis Diderot. *Correspondance.* Ed. Georges Roth and J. Varloot. 16 vols. Paris, 1955–70.

DIDEROT 1975–[1983]: Denis Diderot. *Salons.* Ed. Jean Seznec and Jean Adhémar. 2d ed. 3 vols. Oxford, 1975–[1983]. 1st ed. 4 vols. Oxford, 1957–67.

DIJON 1818: Musée de Dijon. *Notice des tableaux.* Dijon, 1818.

DIJON 1883: Musée de Dijon. *Catalogue historique et descriptif du Musée de Dijon.* Dijon, 1883.

DILKE 1899 (A): Emilia Dilke. *French Painters of the XVIIIth Century.* London, 1899.

DILKE 1899 (B): Emilia Dilke. "Jean Francois de Troy et sa rivalité avec François Le Moine." *Gazette des Beaux-Arts* 21 (1899), 279–90.

DIMIER 1928–30: Louis Dimier. *Les Peintres français du XVIIIe siècle: Histoire des vies et catalogue des oeuvres.* 2 vols. Paris and Brussels, 1928–30.

DOHME 1883: R. Dohme. *Die Ausstellung von Gemälde Älterer Meister in Berliner Privatbesitz: Die Französische Schule des XVIII. Jahrhunderts.* Berlin, 1883. Also in *Jahrbuch der Königlich Preussischen Kunstsammlunger* 4 (1883), 217–56.

DORIVAL 1942: Bernard Dorival. *La Peinture française.* 2 vols. Paris, 1942.

DOWLEY 1968: Francis H. Dowley. "French Baroque Representations of the 'Sacrifice of Iphigenia.'" In *Festschrift Ulrich Middeldorf*, vol. 1, 466–75. Berlin, 1968.

DOWLEY 1973: Francis H. Dowley. "The Iconography of Poussin's Painting Representing Diana and Endymion." *Journal of the Warburg and Courtauld Institutes* 36 (1973), 305–18.

DOWLEY 1988: Francis H. Dowley. "An Exchange on Jacques-Louis David's *Paris and Helen*." *Art Bulletin* LXX/3 (September 1988), 504–12.

DRAPER 1989: James Draper. "Arms for Aeneas: A Group Reattributed to Jean Cornu." *Metropolitan Museum Journal* 24 (1989), 223–37.

DUBE 1969: Wolf-Dieter Dube. *Alte Pinakothek München*. Paris, 1969.

DUBOIS DE SAINT-GELAIS 1727: Louis-François Dubois de Saint-Gelais. *Description des tableaux du Palais-Royal; avec la vie des peintres à la tête de leurs ouvrages*. Paris, 1727. Reprint. Geneva, 1972.

DUBOIS DE SAINT-GELAIS 1885: Louis-François Dubois de Saint-Gelais. *Histoire journalière de Paris par Dubois de Saint-Gelais (1716–1717)*. Paris, 1885.

DUBOS 1755: Abbé Jean-Baptiste Dubos. *Réflexions critiques sur la poésie et la peinture*. 3 vols. Paris, 1755.

DUBOS 1770: Abbé Jean-Baptiste Dubos. *Réflexions critiques sur la poésie et la peinture*. Paris, 1770. Reprint. Geneva, 1982.

DUCLAUX 1975: Lise Duclaux. *Musée du Louvre, Cabinet des Dessins: Inventaire général des dessins, école française*. Vol. XII, *Nadar-Ozanne*. Paris, 1975.

DUCLOS 1965: C. Pinot Duclos. "Confessions du comte de ***." In *Romanciers du XVIIIe siècle*, vol. 2, 195–301. Bibliothèque de la Pléiade, vol. 179. Paris, 1965.

DUFORT DE CHEVERNY 1886: J.-N. Dufort de Cheverny. *Mémoires sur les règnes de Louis XV et Louis XVI et sur la Révolution*. 2 vols. Paris, 1886.

DUGUET 1739: J.-J. Duguet. *Instruction d'un prince ou traité des qualités, des vertus et des devoirs d'un souverain, soit par rapport au gouvernement temporel de ses états, ou comme chef d'une société chrétienne qui est nécessairement liée avec la religion*. London, 1739.

DUMONT AND LAVIGNE 1877: A. Dumont and H. Lavigne. "Documents nouveaux sur les Coypel et les Boullogne, peintres, et sur les Dumont, sculpteurs, 1712–1788." *Nouvelles Archives de l'Art Français*, 1877, 219–73.

DUNAND 1980: Louis Dunand. "La Figuration, dans les estampes de Diane surprise au bain par Actéon: A propos d'une gravure de Jean-Théodore de Bry au Musée des Beaux-Arts." *Bulletin des Musées et Monuments Lyonnais* VI/4 (1980), 385–411.

DU PLAISIR 1683: Du Plaisir. *Sentiments sur les lettres et sur l'histoire avec scrupules sur le style*. Paris, 1683. Reprint. Geneva, 1975.

DUPUIS 1795: Charles-F. Dupuis. *Origine de tous les cultes, ou Religion universelle*. 4 vols. Paris, an III (1795).

DU RYER 1677: Pierre Du Ryer. *Les Métamorphoses d'Ovide en latin et françois divisées en XV livres avec de nouvelles explications historiques, morales, et politiques sur toutes les fables, chacune selon son sujet*. Brussels, 1677. 1st ed., 1660; reissued 1666, 1676, 1693, 1704, 1728, 1744.

DU RYER 1702: Pierre Du Ryer. *Les Métamorphoses d'Ovide*. Amsterdam, 1702.

DUSSIEUX 1856: L. Dussieux. *Les Artistes français à l'étranger*. Paris, 1856.

DUSSIEUX ET AL. 1854: L. Dussieux et al. *Mémoires inédits sur la vie et les ouvrages des membres de l'Académie Royale de Peinture et de Sculpture*. 2 vols. Paris, 1854.

DUSSLER 1971: Luitpold Dussler. *Raphael: A Critical Catalogue of His Pictures, Wall-Paintings, and Tapestries*. London and New York, 1971.

DUVIVIER 1852–53: M. Duvivier. "Sujets des morceaux de réception des membres de l'ancienne académie de peinture, sculpture, et gravure, 1648–1793." *Archives de l'Art Français*, 1852–53, 353–91.

E

EIDELBERG 1977: Martin Eidelberg. *Watteau's Drawings: Their Use and Significance*. New York and London, 1977.

EIDELBERG 1986: Martin Eidelberg. "The *Jullienne Spring* by Antoine Watteau." *Apollo* (August 1986), 98–103.

EISENSTADT 1930: Mussia Eisenstadt. *Watteau's Fêtes Galantes und ihre Ursprünge*. Berlin, 1930.

ELIADE 1957: M. Eliade. *Le Sacré et le profane*. Paris, 1957.

ELIAS 1983: N. Elias. *The Civilizing Process: The History of Manners*. Oxford, 1983.

ELLIS 1988: H. A. Ellis. *Boulainvilliers and the French Monarchy: Aristocratic Politics in Early Eighteenth-Century France*. Ithaca, 1988.

ENCYCLOPÉDIE 1751–65: *Encyclopédie, ou dictionnaire raisonné des sciences, des arts, et des métiers*. Ed. Denis Diderot and Jean Le Rond d'Alembert. 17 vols. Paris, 1751–65.

ENGERAND 1895: Fernand Engerand. "Les Commandes officielles de tableaux au XVIIIe siècle (1): Natoire." *La Chronique des Arts et de la Curiosité* 28 (24 August 1895), 276–77.

ENGERAND 1896: Fernand Engerand. "Les Commandes officielles de tableaux au XVIIIe siècle: Charles Coypel." *La Chronique des Arts et de la Curiosité*, no. 31 (3 October 1896), 300–301; no. 35 (14 November 1896), 344–46.

ENGERAND 1899: Fernand Engerand. *Inventaire des tableaux du roy, rédigé en 1709 et 1710 par Nicolas Bailly*. Paris, 1899.

ENGERAND 1901: Fernand Engerand. *Inventaire des tableaux commandés et achetés par la direction des Bâtiments du roi*. Paris, 1901.

ERICKSEN 1974: Svend Ericksen. *Early Neoclassicism in France: The Creation of the Louis Seize Style in Architectural Decoration, Furniture and Ormolu, Gold and Silver, and Sèvres Porcelein in the Mid-Eighteenth Century*. London, 1974.

ERICKSEN AND WATSON 1963: Svend Ericksen and F. J. B. Watson. "The 'Athénienne' and the Revival of the Classical Tripod." *Burlington Magazine* CV/720 (March 1963), 108–12.

ERNST 1928: Serge Ernst. "L'Exposition de la peinture française des XVIIe et XVIIIe siècles au Musée de l'Ermitage à Petrograd, 1922–25." *Gazette des Beaux-Arts* 17 (March 1928), 163–82.

ERNST 1935: Serge Ernst. "Notes sur des tableaux français de l'Ermitage." *Revue de l'Art Ancien et Moderne* 68 (June–December 1935), 135–44.

ESTOURNET 1905: O. Estournet. "La Famille des Hallé." *Réunion des Sociétés des Beaux-Arts des Départements* (1905), 71–236. Reprint. Paris, 1905.

EURIPIDES 1966: Euripides. *Iphigenia at Aulis; Rhesus Hecuba; The Daughters of Troy*. Vol. 1. Trans. Arthur S. Way. Cambridge, Mass., and London, 1966.

F

FABRE 1890: A.-V.-D.-P. Fabre. *Etudes littéraires sur le XVII siècle. Chapelain et nos deux premières académies*. Paris, 1890.

FABRE 1987: Jacqueline Fabre. "Le Théâtre de la foire ou la naissance d'une nouvelle mythologie." In *L'Antiquité gréco-romaine vue par le siècle des Lumières*. Actes du colloque. Tours, 1987.

FACK 1977: James Fack. "The Apotheosis of Aeneas: A Lost Royal Boucher Rediscovered." *Burlington Magazine*, CXIX/897 (December 1977), 829–33.

FARET 1925: N. Faret. *L'Honnête Homme ou l'art de plaire à la cour*. Ed. M. Magendie. Paris, 1925.

FAVART 1763: Charles-Simon Favart. *Les Nymphes de Diane* (1755). In *Théâtre de M. et Mme. Favart*. Vol. 4. Paris, 1763. Reprint. Geneva, 1971.

FAVIER 1970: Suzanne Favier. "A propos de la restauration par Barthélemy Prieur de la *Diane à la biche*." *La Revue du Louvre et des Musées de France*, 1970, no. 2, 71–77.

FELDMAN AND RICHARDSON 1972: Burton Feldman and Robert D. Richardson. *The Rise of Modern Mythology, 1680–1860*. Bloomington and London, 1972.

FÉLIBIEN 1725: André Félibien. *Entretiens sur les vies et sur les ouvrages des plus excellens peintres anciens et modernes; avec la vie des architects*. Trévoux, 1725. Reprint. Farnborough, 1967.

FENAILLE 1903–23: Maurice Fenaille. *État général des tapisseries de la manufacture des Gobelins.* 5 vols. Paris, 1903–23.

FENAILLE 1925: Maurice Fenaille. *François Boucher.* Paris, 1925.

FÉNELON 1843: F. de Salignac de la Mothe Fénelon. "Fragment d'un mémoire sur les affaires du jansénisme et sur quelques autres affaires du temps." (1710) In *Oeuvres de Fénelon.* Vol 4. Lyons-Paris, 1843.

FÉNELON 1927: F. de Salignac de la Mothe Fénelon. *Les Avantures de Télémaque,* book 17. In *Les Grands Écrivains de la France.* Paris, 1927.

FÉNELON 1968: F. de Salignac de la Mothe Fénelon. *Télémaque.* 2 vols. Paris, 1968.

FERRÉ 1972: J. Ferré. *Watteau.* Madrid, 1972.
 J. FERRÉ, G. Mathie, J. Saint-Paulien, M. Watteau, I. Torrecilla, and R. Brié. *Critiques.* Vol. 1; *Planches.* Vol. 2.
 J. FERRÉ and R. Brié. *Catalogue.* Vol. 3.
 J. FERRÉ, R. Brié, and C. Lugo. *Tables.* Vol. 4.

FERRIER-CAVERIVIÈRE 1985: N. Ferrier-Caverivière. *Le Grand Roi à l'aube des lumières, 1715–1751.* Paris, 1985.

FINCH AND JOLIAT 1971: Robert Finch and Eugene Joliat, eds. *French Individualist Poetry, 1686–1760: An Anthology.* Toronto and Buffalo, 1971.

FLAMMERMONT 1888–98: J. Flammermont. *Les Rémonstrances du Parlement de Paris au XVIIIe siècle.* 3 vols. Paris, 1888–98.

FLEURY 1686: C. Fleury. *Traité du choix et de la méthode des études.* Paris, 1686.

FLORISOONE 1948: Michel Florisoone. *La Peinture française, le dix-huitième siècle.* Paris, 1948.

FOHR 1982: Robert Fohr. *Tours, Musée des Beaux-Arts; Richelieu, Musée Municipal; Azay-le-Ferron, Château. Tableaux français et italiens du XVIIe siècle.* Paris, 1982.

FONTAINE 1910 (A): André Fontaine. *Les Collections de l'Académie Royal de Peinture et de Sculpture.* Paris, 1910. 2d ed. Paris, 1930.

FONTAINE 1910 (B): André Fontaine. *Comte de Caylus, vies d'artistes du XVIIIe siècle. Discours sur la peinture et la sculpture, Salons de 1751 et de 1753—lettre à Lagrenée.* Paris, 1910.

FONTAINE-MALHERBE 1767: Fontaine-Malherbe. "Éloge de monsieur Carle Vanloo." In *La Nécrologe des hommes célèbres de France,* 173–208. Paris, 1767.

FONTENAY 1776: Louis-Abel Fontenay. *Dictionnaire des artistes.* Paris, 1776. Reprint. Geneva, 1972.

FONTENROSE 1981: Joseph Fontenrose. "The Myth of Aktaion." In *Orion: The Myth of the Hunter and the Huntress,* 33–47. Berkeley, Los Angeles, and London, 1981.

FORMIGNY DE LA LONDE 1863: M. de Formigny de La Londe. "Jean Restout et son essai sur les principes de la peinture." *Bulletin de la Société des Beaux-Arts de Caen* 3, pt. 1 (1863), 45–81.

FOUCART 1985: Jacques Foucart. "Les Retrouvailles d'un grand Rubens du Louvre." *La Revue du Louvre et des Musées de France,* 1985, nos. 5–6, 387–96.

FOUCART-WALTER 1982: Elisabeth Foucart-Walter. *Le Mans, Musée de Tessé: Peintures françaises du XVIIe siècle.* Paris, 1982.

FOUCAULT 1966: Michel Foucault. *Les Mots et les choses.* Paris, 1966. 2d ed., 1976.

FOUCAULT 1982: M. Foucault. *The Order of Things: An Archeology of the Human Sciences.* London, 1982.

FOURCAUD 1901: L. de Fourcaud. "Antoine Watteau. V. L'Existence de Watteau (fin)." *Revue de l'Art Ancien et Moderne* LV/10 (10 October 1901), 241–58.

FRANKFURTER 1933: Alfred M. Frankfurter. "The Paintings in the William Rockhill Nelson Gallery of Art." *The Art News* XXXII/10 (9 December 1933), 29–52.

FRANKL 1961: Paul Frankl. "Boucher's Girl on the Couch." In *De Artibus Opuscula XL: Essays in Honor of Erwin Panofsky,* ed. Millard Meiss. Vol. 1, 138–52. Princeton, 1961.

FREDERICKSEN 1985: Burton B. Fredericksen. "Recent Acquisitions of Paintings: The J. Paul Getty Museum." *Burlington Magazine* CXXVII/985 (April 1985), 261–68.

FREDERICKSEN 1988–90: Burton B. Fredericksen, ed. *The Index of Paintings Sold in the British Isles During the 19th Century.* 2 vols. Santa Barbara and Oxford. 1988–90.

FRÉRON 1759: E.-C. Fréron. "Exposition des peintures, sculptures, et gravures." *L'Année Littéraire* 5 (2 September 1759), 217–31.

FRÉRON 1765: E.-C. Fréron. "Exposition des tableaux." *L'Année Littéraire* 6, letter 7 (4 October 1765), 145–75.

FRIMMEL 1906: Th. von Frimmel. "Bilder von J.B.M. Pierre in Hermannstadt und in Arras." *Blätter für Gemäldekunde,* no. 3 (1906), 23–24.

FRIZZONI 1913: Gustave Frizzoni. "Tribune des arts, sur les toiles agrandies à la Galerie du Louvre." *Les Arts,* 1913, no. 12, 31.

FUMAROLI 1975: M. Fumaroli. "Réflexions sur quelques frontispieces gravés d'ouvrages de rhétorique et d'éloquence (1594–1641)." *Bulletin de la Société de l'Histoire de l'Art Français,* 1975, 19–34.

FURCY-RAYNAUD 1903: Marc Furcy-Raynaud. "Correspondance de M. Marigny avec Coypel, Lépicié, et Cochin (première partie)." *Nouvelles Archives de l'Art Français* 19 (1903), 1–384.

FURCY-RAYNAUD 1904: Marc Furcy-Raynaud. "Correspondance de M. de Marigny avec Coypel, Lépicié, et Cochin (deuxième partie)." *Nouvelles Archives de l'Art Français* 20 (1904), 1–302.

FURCY-RAYNAUD 1905: Marc Furcy-Raynaud. "Correspondance de M. d'Angiviller avec Pierre (première partie)." *Nouvelles Archives de l'Art Français* 21 (1905), 1–368.

FURCY-RAYNAUD 1906, Marc Furcy-Raynaud. "Correspondance de M. d'Angiviller avec Pierre (deuxième partie)." *Nouvelles Archives de l'Art Français* 22 (1906), 1–374.

FURET 1984: F. Furet. *In the Workshop of History.* Trans. J. Mandelbaum. Chicago, 1984.

FURETIÈRE 1659: Antoine Furetière. *Poésies diverses.* Paris, 1659.

FURETIÈRE 1727: Antoine Furetière. *Dictionnaire universel.* The Hague, 1727. Reprint. Hildesheim, 1972.

FUZELIER 1734: Louis Fuzelier. *Les Amours des dieux* (1727). In *Recueil général des opéra représentez par l'Académie Royale de Musique depuis son établissement.* Vol. 3, 308–11. Paris, 1734. Reprint. Geneva, 1971.

G

GACHARD 1866: Gachard. "Arenberg (Léopold-Philippe-Charles-Joseph, duc D')." *Biographie nationale publiée par l'Académie Royale des Sciences, des Lettres, et des Beaux-Arts de Belgique.* Vol. 1. Brussels, 1866.

GAEHTGENS 1983: Thomas W. Gaehtgens. "Jean Restout, *Die Grossmut des Scipio.*" *Jahrbuch Preussischer Kulturbesitz* 20 (1983), 179–91.

GAEHTGENS AND LUGAND 1988: Thomas W. Gaehtgens and Jacques Lugand. *Joseph-Marie Vien, 1716–1809.* Paris, 1988.

GALERIE FRANÇOISE 1771: *Galerie françoise, ou portraits des hommes et des femmes célèbres qui ont paru en France.* Paris, 1771.

GALINSKY 1972: G. Karl Galinsky. *The Herakles Theme: The Adaptations of the Hero in Literature from Homer to the Twentieth Century.* Totowa, N.J., 1972.

GALLET 1972: Michel Gallet. *Paris Domestic Architecture.* London, 1972.

GALLET 1973: Michel Gallet. "L'Architecte Pierre de Vigny, 1690–1772: Ses constructions, son esthétique." *Gazette des Beaux-Arts* 82 (November 1973), 263–86.

GALLET 1976–77: Michel Gallet. "Trois décorateurs parisiens du XVIIIe siècle: Michel II Lange, J.B. Boistou, Joseph Métivier." *Bulletin de la Société de l'Histoire de Paris et de l'Ile de France,* 1976–77, 76–87.

GALLET AND BOTTINEAU 1982: Michel Gallet and Yves Bottineau. *Les Gabriel.* Paris, 1982.

GANZ 1924: Paul Ganz. *Meisterwerke der Offentlichen Kunstsammlung in Basel.* Munich, 1924.

GARNIER 1980–82: Nicole Garnier. "Antoine Coypel (1661–1722) et l'Italie." In *Colloqui del sodalizio: Sodalizio tra studiosi dell'arte* 7–8, 2nd ser. 1980–82 and 1982–84, 123–40.

GARNIER 1989: Nicole Garnier. *Antoine Coypel (1661–1722).* Paris, 1989.

GASTON-DREYFUS 1922: Philippe Gaston-Dreyfus. "Catalogue raisonné de l'oeuvre de Nicolas-Bernard Lépicié." *Bulletin de la Société de l'Histoire de l'Art Français* (1922), 134–283. Reprint. Paris, 1923.

GAUFFIN 1953: Axel Gauffin. "Watteau pa Nationalmuseum." In *Antoine Watteau och andra franska sjuttonhundratalsmästare i Nationalmuseum*, ed. Carl Nordenfalk, 9–12. Stockholm, 1953.

GAULT DE SAINT-GERMAIN 1808: P.-M. Gault de Saint-Germain. *Les Trois siècles de la peinture en France*. Paris, 1808.

GAUTHIER 1902: Jules Gauthier. "Donat Nonnotte: Vie du peintre François Lemoyne." *Réunion des Sociétés des Beaux-Arts des Départements* 26 (1902), 510–40.

GAUTHIER 1959: Maximilien Gauthier. *Watteau*. Paris, 1959.

GAUTRUCHE 1671: Pierre Gautruche. *Histoire poétique pour l'intelligence des poètes et des auteurs anciens*. Caen, 1671.

GENDRE 1983: Catherine Gendre. "Versailles, Musée Lambinet: Esquisses de Collin de Vermont et de J. M. Vien." *La Revue du Louvre et des Musées de France*, 1983, nos. 5–6, 399–403.

GENEVA 1954: Musée d'Art et d'Histoire, Geneva. *Guides illustrés 2: Peinture et sculpture*. Geneva, 1954.

GENEVA 1968: Musée d'Art et d'Histoire, Geneva. *Musée d'Art et d'Histoire. Guides illustrés 2: Beaux-Arts, salles 1–15*. Geneva, 1968.

GENEVA 1878: Musée Rath, Geneva. *Catalogue du Musée Rath à Genève*. Geneva, 1878.

GENEVA 1882: Musée Rath, Geneva. *Catalogue du Musée Rath à Genève*. Geneva, 1882.

GEORGI 1794: J. G. Georgi. *The Description of the Russian Imperial Capital City of St. Petersburg and Places of Interest in its Environs*. Pts. 1–3. St. Petersburg, 1794 [in Russian].

GIELLY 1928: L. Gielly. *Geneva, Musée d'Art et d'Histoire, section des beaux-arts: Catalogue des peintures et sculptures*. Geneva, 1928.

GILLET 1929: Louis Gillet. *La Peinture au Musée du Louvre: École française, XVIIIe siècle*. Paris, 1929.

GILLET 1935: Louis Gillet. *La Peinture de Poussin à David*. Paris, 1935.

GLIKSOHN 1985: Jean-Michel Gliksohn. *Iphigénie de la Grèce antique à l'Europe des Lumières*. Paris, 1985.

GODEAU 1650: Antoine Godeau. *Catéchisme royal*. Paris, 1650

GOLDMANN 1964: L. Goldmann. *The Hidden God: A Study of the Tragic Vision in the "Pensées" of Pascal and the Tragedies of Racine*. London, 1964.

GOLDSCHMIDT 1930: Ernst Goldschmidt. *Frankrigs malerkunst dens farve: Dens historie*. Vol. 3, *Det attende aarhundrede*. Copenhagen, 1930.

GONCOURT 1875: Edmond de Goncourt. *Catalogue raisonné de l'oeuvre peint, dessiné, et gravé d'Antoine Watteau*. Paris, 1875.

GONCOURT 1881: Edmond de Goncourt. *La Maison d'un artiste*. Paris, 1881. 2d ed. Paris, 1898.

GONCOURT 1877: Edmond and Jules de Goncourt. "Livre de raison de Louis Lagrenée." *L'Art* 4 (1877), 25–26, 136–41, 255–60. Reprinted in *Portraits intimes du XVIIIe siècle: Études nouvelles d'après les lettres autographes et les documents inédits*, 323–62. Paris, 1878.

GONCOURT 1880–82: Edmond and Jules de Goncourt. *L'Art du dix-huitième siècle*. 2 vols. Paris, 1880–82.

GONCOURT 1981: Edmond and Jules de Goncourt. *French Painters of the Eighteenth Century*. Trans. Robin Ironside. 2d ed. Oxford, 1981.

GONCOURT 1989: Edmond and Jules de Goncourt. *Journal: Mémoires de la vie litteraire*. Ed. Robert Riccatte. 3 vols. Paris, 1989.

GONSE 1900: Louis Gonse. *Les Chefs-d'Oeuvre des musées de France*. Paris, 1900.

GOODMAN-SOELLNER 1987: Elise Goodman-Soellner. "Boucher's *Madame de Pompadour at Her Toilette*." *Simiolus* 17 (1987), 41–58.

GORCZYCA 1987: Anna Gorczyca. *Les Amours de Pâris et Hélène*. Mémoire inédit de D. E. A. de l'université de Paris IV. Paris, 1987.

GORDON 1968: Katherine K. Gordon. "Madame de Pompadour, Pigalle, and the Iconography of Friendship." *Art Bulletin* L/3 (September 1968), 249–62.

GÖTHE 1887: Georg Göthe. *Nationalmusei tafvelsamling*. Stockholm, 1887.

GÖTHE 1900: Georg Göthe. *Notice descriptive des tableaux du Musée National de Stockholm*. Stockholm, 1900.

GOTTFRIED KELLER-STIFTUNG 1901: Gottfried Keller-Stiftung. *Bericht an das Tit. Departement des Innern der Schweiz. Eidgenossenschaft über die Thätigkeit der Eidg. Kommission der Gottfried Keller-Stiftung im Jahre 1900, Erstattet vom Präsidenten der Kommission*. Zurich, 1901.

GOUGENOT 1748: Louis Gougenot. *Lettre sur la peinture, sculpture et architecture à M*** par une société d'amateurs*. Paris, 1748.

GOULD 1959: Cecil Gould. *National Gallery Catalogues: The Sixteenth-Century Venetian School*. London, 1959.

GOWING 1987: Lawrence Gowing. *Paintings in the Louvre*. New York, 1987.

GRANBERG 1930–31: O. Granberg. *Svenska konstsamlingarnas historia. Fran Gustav vasa till vara dagar*. Vols. 2 and 3. Stockholm, 1930–31.

GRANDMAISON 1879: Charles de Grandmaison. "Inventaire des tableaux et objets d'art des châteaux d'Amboise et de Chanteloup (29 Ventôse an II—19 Mars 1794)." *Nouvelles Archives de l'Art Français*, 1879, 186–92.

GRANDMAISON 1897: Charles de Grandmaison. "Origines du Musée de Tours. Provenances des tableaux." In *Réunion des Sociétés des Beaux-Arts des Départements*, 1897, 559–86.

GRANDMAISON 1904: Charles de Grandmaison. "Essai d'armorial des artistes français." *Réunion des Sociétés des Beaux-Arts des Départements*, 1904, 589–687.

GRAPPE 1946: Georges Grappe. *Fragonard: La Vie et l'oeuvre*. Monaco, 1946.

GRAPPE, HUYGHE, AND BOUCHER 1935: Georges Grappe, René Huyghe, and François Boucher. "L'Art français du XVIIIe siècle. Exposition de Copenhague." *L'Amour de l'Art*, July 1935, 227–62.

GRASSELLI 1987: Margaret Morgan Grasselli. "The Drawings of Antoine Watteau: Stylistic Development and Problems of Chronology." 2 vols. Ph.D. diss., Harvard University, 1987.

GRASSELLI 1988: Margaret Morgan Grasselli. "A Drawing by Jean-Baptiste Nattier." *Master Drawings* XXVI/4 (Winter 1988), 356–57.

GRATE 1987: Pontus Grate. "Boucher in Stockholm." In *Florilegium in Honorem Carl Nordenfalk Octogenarii Contextum*, 69–80. Stockholm, 1987.

GRAVELOT AND COCHIN 1791: Hubert-François-Bourguignon Gravelot and Charles-Nicolas Cochin. *Iconologie par figures; ou, traité complet des allégories, emblèmes, etc*. Paris, 1791. Reprint. Geneva, 1972.

GRAVES 1955: Robert Graves. *The Greek Myths*. New York, 1955.

GREENBERG 1981: Mitchell Greenberg. "D'Aubigné's Sacrifice: *L'Hécatombe à Diane* and the Textuality of Desire." *Stanford French Review* V/1 (1981), 51–64.

GROUCHY 1893: Comte de Grouchy. "Meudon, Bellevue, et Chaville." *Mémoires de la Société de l'Histoire de Paris et de l'Ile de France* 20 (1893), 51–206.

GRUYER 1898: F.-A. Gruyer. *La Peinture au château de Chantilly*. Paris, 1898.

GUIFFREY 1873 (A): J. J. Guiffrey. *Table général des artistes ayant exposé aux Salons du XVIIIe siècle*. Paris, 1873

GUIFFREY 1873 (B): J. J. Guiffrey. *Lettres de noblesses et décorations de l'ordre de Saint-Michel conférées aux artistes au XVIIe et XVIIIe siècles*. Paris, 1873.

GUIFFREY 1877: J. J. Guiffrey. "Avis de parents. Procès-Verbal de suicide et inventaire des biens de François Le Moyne, premier peintre du roi (12 août 1693–4 juin et 9 août 1737)." *Nouvelles Archives de l'Art Français*, 1877, 184–218.

GUIFFREY 1881–1901: Jules Guiffrey. *Comptes des Bâtiments du roi sous le règne de Louis XIV*. 5 vols. Paris, 1881–1901.

GUIFFREY 1883: Jules Guiffrey. "Procès-Verbal d'apposition de scellés après le décès de Noël-Nicolas Coypel, peintre ordinaire du Roi." *Nouvelles Archives de l'Art Français*, 1883, 308–17.

GUIFFREY 1892: Jules Guiffrey. "Peintures commandées sous Louis XIV pour Trianon-sous-Bois." *Nouvelles Archives de l'Art Français*, 1892, 77–89.

GUIFFREY 1897: Jules Guiffrey. "Les Modèles des Gobelins devant le jury des arts en septembre 1794." *Nouvelles Archives de l'Art Française*, 1897, 349–425.

GUIFFREY AND MARCEL 1907–33: Jean Guiffrey and Pierre Marcel. *Inventaire général des dessins du Musée du Louvre et du Musée de Versailles: École français*. 11 vols. Paris, 1907–33.

GUILLAUMOT 1865: A. A. Guillaumot. *Le Château de Marly-le-Roi*. Paris, 1865.

H

HAGSTRUM 1980: J. H. Hagstrum. *Sex and Sensibility: Ideal and Erotic Love from Milton to Mozart*. Chicago, 1980.

HALBOUT 1970: M. Halbout. *J.-B.-M. Pierre, vie et oeuvre: Essai de catalogue des peintures et des dessins*. Mémoire dactylographie de l'École du Louvre, 1970.

HALBOUT AND ROSENBERG 1975: M. Halbout and P. Rosenberg. "A propos de Jean-Baptiste-Marie Pierre." *The Stanford Museum*, 1975, nos. 4–5, 14.

HALL 1990: H. G. Hall. *Richelieu's Desmarets and the Century of Louis XIV*. Oxford, 1990.

HALLAYS, ANDRÉ, AND ENGERAND 1928: A. Hallays, R. E. André, and R. Engerand. *Chanteloup, le château, la pagode*. Tours, 1928.

[HALLÉ] 1782: [Jean-Noël Hallé]. "Éloge de M. Hallé." In *Le Nécrologe des hommes célèbres de France*, 183–206. Paris, 1782.

HAMDORF 1986: Friedrich Wilhelm Hamdorf. *Dionysus/Bacchus: Kult und Wandlungen des Weingottes*. Munich, 1986.

HANFMANN 1951: George Hanfmann. *The Season Sarcophagus in Dumbarton Oaks*. 2 vols. Cambridge, Mass., 1951.

HANNOVER 1889: Emil Hannover. *Antoine Watteau aus dem Dänischen Übersetzt von Alice Hannover*. Berlin, 1889.

HARTAU 1985: J. Hartau. "Don Quixote in Broadsheets of the Seventeenth and Eighteenth Centuries." *Journal of the Warburg and Courtauld Institutes* 48 (1985), 234–38.

HARTH 1983: E. Harth. *Ideology and Culture in Seventeenth-Century France*. Cornell, 1983.

HASKELL 1980: Francis Haskell. *Patrons and Painters: A Study in the Relations Between Italian Art and Society in the Age of the Baroque*. 2d ed. New Haven and London, 1980.

HASKELL AND PENNY 1981: Francis Haskell and Nicolas Penny. *Taste and the Antique: The Lure of Classical Sculpture, 1500–1900*. New Haven, 1981.

HATIN 1865: E. Hatin. *Les Gazette de Hollande*. Paris, 1865.

HAUTECOEUR 1927: Louis Hautecoeur. *Histoire des châteaux du Louvre et des Tuileries tels qu'ils firent nouvellement construits, amplifiés, embellis, sous le règne de Louis XIV*. Paris, 1927.

HAUTECOEUR 1943–57: Louis Hautecoeur. *Histoire de l'architecture classique en France*. 7 vols. Paris, 1943–57.

HAUTECOEUR 1948: Louis Hautecoeur. *Ville de Genève, Musée d'Art et d'Histoire. Catalogue de la galerie des beaux-arts*. Geneva, 1948.

HAUTECOEUR 1959: Louis Hautecoeur. *Histoire de l'art*. Vol. 2, *De la réalité à la beauté*. Paris, 1959.

HAWKINS 1892: A. Hawkins. *Creole Art Gallery Catalogue*. New Orleans, 1892.

HEARTZ 1985: Daniel Heartz. "Opéra-Comique and the Théâtre Italien from Watteau to Fragonard." In *Music in the Classic Period: Essays in Honor of Barry S. Brook*, 69–84. New York, 1985.

HÉBERT 1756: Hébert. *Dictionnaire pittoresque et historique*. Paris, 1756. Reprint. Geneva, 1972.

HÉDOUIN 1845: P. Hédouin. "Watteau." *L'Artiste*, 16 November 1845, 45–48; 23 November 1845, 59–61; 30 November 1845, 78–80. Reprinted in *Mosaïques*. Paris, 1856.

HEIDNER 1982: Jan Heidner, ed. "Carl Fredrik Scheffer: Lettres particulières à Carl Gustaf Tessin." Ph.D. diss., University of Stockholm, 1982.

HEIM, BÉRAUD, AND HEIM 1989: François Heim, Claire Béraud, and Philippe Heim. *Les Salons de peinture de la Révolution française, 1789–1799*. Paris, 1989.

HEINECKEN 1778–90: Karl Heinrich von Heinecken. *Dictionnaire des artistes, dont nous avons des estampes, avec une notice detaillée de leurs ouvrages gravés*. 4 vols. Leipzig, 1778–90.

HELD 1961: Julius Held. "Flora, Goddess and Courtesan." In *De Artibus Opuscula XL: Essays in Honor of Erwin Panofsky*, ed. Millard Meiss. Vol. 1, 201–18. New York, 1961.

HELD 1980: Julius Held. *The Oil Sketches of Peter Paul Rubens: A Critical Catalogue*. 2 vols. Princeton, 1980.

HENRIET 1922: M. Henriet. "Un Amateur d'art au XVIIIe siècle: L'Académicien Watelet." *Gazette des Beaux-Arts* (September–October 1922), 173–94.

HERBERT 1972: R. L. Herbert. *David, Voltaire, Brutus, and the French Revolution: An Essay in Art and Politics*. London, 1972.

HERBET 1937: Felix Herbet. *Le Château de Fontainebleau: Les Appartements, les cours, le parc, les jardins*. Paris, 1937.

HERCENBERG 1975: Bernard Hercenberg. *Nicolas Vleughels, peintre et directeur de l'Académie de France à Rome, 1668–1737*. Paris, 1975.

HERDER 1784–91: Johann Gottfried von Herder. *Ideen zur Philosophie der Geschichte der Menschheit*. 4 vols. Riga and Leipzig, 1784–91.

HIESINGER 1976: Kathryn B. Hiesinger. "The Sources of François Boucher's *Psyche* Tapestries." *Philadelphia Museum of Art Bulletin*, November 1976, 7–23.

HOLLSTEIN 1969: *Hollstein's Dutch and Flemish Etchings, Engravings, and Woodcuts: Rembrandt van Rijn*. Vol. 18. Amsterdam, 1969.

HOLMA 1940: K. Holma. *David: Son évolution et son style*. Paris, 1940.

HOMER 1953: Homer. *The Odyssey*. 2 vols. Trans. A.T. Murray. Cambridge, Mass., and London, 1953.

HOMER 1978–85: Homer. *The Iliad*. 2 vols. Trans. A.T. Murray. Cambridge, Mass., and London, 1978–85.

HOPPE 1953: Ragnar Hoppe. "Franska 1700-talsmästare i Nationalmuseum." In *Antoine Watteau och andra franska sjuttonhundratalsmästare i Nationalmuseum*, ed. Carl Nordenfalk, 13–60. Stockholm, 1953.

HOURTICQ 1927: L. Hourticq. *La Vie des images*. Paris, 1927.

HOURTICQ 1939: Louis Hourticq. *La Peinture française XVIIIe siècle*. Paris, 1939.

HUEMER 1979: Frances Huemer. "A Dionysiac Connection in an Early Rubens." *Art Bulletin* LXI/4 (December 1979), 562–74.

HUIN [1980s]: Bernard Huin. *La Peinture ancienne au Musée Départemental des Vosges Épinal*. Épinal [1980s].

HUPPERT 1970: G. Huppert. *The Idea of Perfect History*. Urbana, 1970.

HUSSMAN 1977: G. C. Hussman. "Boucher's *Psyche* at the Basketmakers: A Closer Look." *J. Paul Getty Museum Journal* 4 (1977), 45–50.

HYGINUS 1960: Hyginus. "The Myths of Hyginus [Fabulae]." Trans. and ed. Mary Grant. *Humanistic Studies* 34 (1960), 1–244.

I

INGAMELLS 1982: John Ingamells. "*Perseus and Andromeda*: The Provenance." *Burlington Magazine* CXXIV/952 (July 1982), 396–400.

INGAMELLS 1989: John Ingamells. *The Wallace Collection Catalogue of Pictures*. Vol. 3, *French before 1815*. London, 1989.

INGERSOLL-SMOUSE 1920: Florence Ingersoll-Smouse. "Charles-Antoine Coypel (1694–1752)." *La Revue de l'Art Ancien et Moderne* 38 (January–May 1920), 143–54, 285–92.

INGERSOLL-SMOUSE 1923: Florence Ingersoll-Smouse. "Nicolas-Bernard Lépicié." *La Revue de l'Art Ancien et Moderne* 43 (1923), 39–43, 129–36, 365–78.

INGERSOLL-SMOUSE 1924: Florence Ingersoll-Smouse. "Nicolas-Bernard Lépicié." *La Revue de l'Art Ancien et Moderne* 46 (1924), 122–30, 217–28.

J

JACOBY 1987: Beverly Schreiber Jacoby. "François Boucher's Stylistic Development as a Draftsman: The Evolution of His Autonomous Drawings." In *Drawings Defined*, ed. Walter Strauss and Tracie Felker, 259–79. New York, 1987.

JACQUOT 1887: Albert Jacquot. "Le Peintre lorrain Charles-Louis Chéron et sa famille." *Réunion des Sociétés des Beaux-Arts des Départements*, 1887, 338–58.

JAMIESON 1930: I. Jamieson. *Charles-Antoine Coypel: Premier peintre de Louis XV et auteur dramatique (1694–1752)*. Paris, 1930.

JAMMES 1965: A. Jammes. "Louis XIV: Sa bibliothèque et le cabinet du Roi." *The Library* 20 (1965), 1–12.

JAQUET AND CHAPUIS 1945: Eugène Jaquet and Alfred Chapuis. *Histoire et technique de la montre suisse et ses origines à nos jours*. Basel and Ulten, 1945.

JEAN-RICHARD 1978: Pierrette Jean-Richard. *Musée du Louvre, Cabinet des Dessins, collection Edmond de Rothschild: Inventaire général des gravures. École française*. Vol. 1, *L'Oeuvre gravé de François Boucher dans la collection Edmond de Rothschild*. Paris, 1978.

JEROMACK 1987: Paul Jeromack. "Believing in the 18th Century: French Old Master Paintings, Now and Then." *Art and Auction* IX/7 (February 1987), 72–77.

JESTAZ 1969: Bertrand Jestaz. "Le Trianon de Marbre ou Louis XIV architecte." *Gazette des Beaux-Arts* 74 (November 1969), 259–86.

JEUNE 1987: Marie Jeune. *Sequence No. 1: La Renaissance*. Rouen, 1987.

JOHNSON 1978: N. R. Johnson. "Louis XIV and the Enlightenment." *Studies on Voltaire and the Eighteenth Century* 162 (1978).

JOHNSON 1968: W. McAllister Johnson. "From Favereau's *Tableaux des vertus et des vices* to Marolles' *Tableaux du temple des muses*: A Conflict Between the Franco-Flemish Schools in the Second Quarter of the Seventeenth Century." *Gazette des Beaux-Arts* 72 (October 1968), 171–90.

JOIN-LAMBERT 1986: S. Join-Lambert. "Sébastien Le Clerc le jeune (Paris 1676–1763), *Venus apportant le nectar et l'ambroisie pour deifier Énée, purifie dans les eaux du fleuve Numie*." In *La Mythologie: Clef de lecture du monde classique. Hommage à R. Chevallier*, ed. P. M. Martin and Ch. M. Ternes, 419–22. Tours, 1986.

JONES 1979: M. Jones. *Medals of the Sun King*. London, 1979.

JONES 1982: M. Jones. "The Medal as an Instrument of Propaganda in Late Seventeenth- and Early Eighteenth-Century Europe, Part I." *Numismatic Chronicle* 142 (1982), 117–26.

JONES 1983: M. Jones. "The Medal as an Instrument of Propaganda in Late Seventeenth- and Early Eighteenth-Century Europe, Part II." *Numismatic Chronicle* 143 (1983), 202–13.

JORDAN 1984: George E. Jordan. "Robb and Clay: Politicians and Scholars." *The New Orleans Art Review* III/1 (January–February 1984), 6–7.

JOSZ 1901: Virgile Josz. *Fragonard: Moeurs du XVIII siècle*. Paris, 1901.

JOSZ 1903: Virgile Josz. *Watteau: Moeurs du XVIIIe siècle*. Paris, 1903.

JOSZ 1904: Virgile Josz. *Antoine Watteau*. 2 vols. Paris, 1904.

JOUBIN 1924: André Joubin. "Études sur le Musée de Montpellier. Cent ans de peinture académique (1665–1759): Morceaux de réception à l'Académie Royale." *Gazette des Beaux-Arts* 9 (1924), 205–14.

JOUBIN 1926: André Joubin. *Catalogue des peintures et sculptures exposées dans les galeries du Musée Fabre de la ville Montpellier*. Paris, 1926.

JOUIN 1883: Henry Jouin. *Conférences de l'Académie Royale de Peinture et de Sculpture*. Paris, 1883.

JOUIN 1887 (A): Henry Jouin. "Contrat de mariage de Jean Ranc (1715)." *Nouvelles Archives de l'Art Français*, 1887, 140–43.

JOUIN 1887 (B): Henry Jouin. *Musée d'Angers, peintures, sculptures*. Angers, 1887.

JOUIN 1889 (A): Henry Jouin. *Charles Le Brun et les arts sous Louis XIV*. Paris, 1889.

JOUIN 1889 (B): Henry Jouin. "Charles Natoire et la peinture historique (1747)." *Nouvelles Archives de l'Art Français*, 1889, 139–49.

JOUVENCY 1705: Père Joseph de Jouvency. Publii Ovidii Nasonis Metamorphoseon libri XV, expurgati et explanati, cum Appendici de diis et heroibus poeticis, auctore Josepho Juvencio. Rouen, 1705.

JOUVENCY 1892: Père Joseph de Jouvency. *De ratione discendi et docendi*. Paris, 1892. 1st ed., 1692.

JUDSON 1966: J. Richard Judson. "Allegory of Dawn and Night." *Wadsworth Atheneum Bulletin*, Fall 1966, 1–11.

K

KAHN 1904: Gustave Kahn. *François Boucher*. Berlin [1904].

KAHN 1905: Gustave Kahn. *Boucher*. Paris, 1905.

KAHN 1907: Gustave Kahn. *François Boucher*. Paris [1907].

KALNEIN AND LEVEY 1972: Ward Kalnein and Michael Levey. *Art and Architecture of the Eighteenth Century in France*. Harmondsworth, 1972.

KANSAS CITY 1933: William Rockhill Nelson Gallery of Art, Kansas City. *Handbook of the William Rockhill Nelson Gallery of Art*. Kansas City, 1933.

KANSAS CITY 1949: Nelson-Atkins Museum of Art, Kansas City. *The William Rockhill Nelson Collection, Housed in the William Rockhill Nelson Gallery of Art and Mary Atkins Museum of Fine Arts*. Kansas City, 1949.

KANSAS CITY 1959: Nelson-Atkins Museum of Art, Kansas City. *Handbook of the Collections in the William Rockhill Nelson Gallery of Art and Mary Atkins Museum of Fine Arts, Kansas City, Missouri*. Kansas City, 1959.

KELLEY 1970: D. R. Kelley. *Foundations of Modern Historical Scholarship*. New York, 1970.

KELLY 1980: G. A. Kelly. "The History of the New Hero: Eulogy and its Sources in Eighteenth-Century France." *The Eighteenth Century* XXI/1 (1980), 3–24.

KEMP 1968: Martin Kemp. "Some Reflections on Watery Metaphors in Winckelmann, David, and Ingres." *Burlington Magazine* CX/782 (May 1968), 266–70.

KEOHANE 1980: N. Keohane. *Philosophy and the State in France: The Renaissance to the Enlightenment*. Princeton, 1980.

KIMBALL 1936: Fiske Kimball. "The Development of the 'cheminées à la royale.'" *Metropolitan Museum of Art Studies* 5 (1936), 259–80.

KIMBALL 1943: Fiske Kimball. *The Creation of the Rococo*. Philadelphia, 1943. French ed. Paris, 1949. Reprint. New York, 1980.

KINTZLER 1988: Catherine Kintzler. *Jean-Philippe Rameau: Splendeur et naufrage de l'esthétique du plaisir à l'âge classique*. 2d ed. Paris, 1988.

KLAITS 1976: J. Klaits. *Printed Propaganda Under Louis XIV: Absolute Monarchy and Public Opinion*. Princeton, 1976.

KLOSSOWSKI 1956: Pierre Klossowski. *Le Bain de Diane*. Paris, 1956. 2d ed., 1972.

KNAUER 1969: Elfriede Knauer. "Leda." *Jahrbuch der Berliner Museen* 11 (1969), 5–35.

KNOX 1985: George Knox. "Sebastiano Ricci at Burlington House: A Venetian Decoration 'alla Romana.'" *Burlington Magazine* CXXVII/990 (September 1985), 601–9.

KOCKS 1979: Dirk Kocks. "Sine Cerere et Libero Friget Venus." *Jahrbuch der Hamburger Kunstsammlungen* 24 (1979), 113–32.

KORSHAK 1987: Y. Korshak. "*Paris and Helen* by Jacques-Louis David: Choice and Judgment on the Eve of the French Revolution." *Art Bulletin* LXIX/1 (March 1987), 102–16.

KROHN 1922: Mario Krohn. *Frankrigs og Danmarks Kunstneriske Forbindelse i det 18. Aarhundrede*. 2 vols. Copenhagen, 1922.

KUZNETSOVA AND GEORGIEVSKAYA 1979: Irina Kuznetsova and Eugenia Georgievskaya. *French Painting from the Pushkin Museum, 17th to 20th Century*. New York and Leningrad, 1979.

L

[LABENSKY] 1838: [F. Labensky]. *Livret de la Galerie Impériale de l'Hermitage de Saint-Pétersbourg.* St. Petersburg, 1838.

LACAMBRE 1976: Geneviève Lacambre. "Les Paysages de Pierre-Henri de Valenciennes, 1750–1819." *Le Petit Journal des grandes expositions.* Musée du Louvre, dossier du département des peintures, no. 11, 1976.

LACAMBRE 1978: Geneviève Lacambre. "Pierre-Henri de Valenciennes en Italie: Un Journal de voyage inédit." *Bulletin de la Société de l'Histoire de l'Art Français,* 1978, 139–72.

LACAN 1964: Jacques Lacan. *Le Séminaire de Jacques Lacan, livre XI: Les Quatre concepts fondamentaux de la psychanalyse* (1964). Paris, 1973. Translated as *The Four Fundamental Concepts of Psycho-Analysis.* New York, 1978.

LACOMBE 1752: Jacques Lacombe. *Dictionnaire portatif des beaux-arts.* Paris, 1752. 2d ed. Paris, 1755.

LA CRESPILIÈRE 1666: Dufour La Crespilière. *L'Art d'aimer d'Ovide . . . nouvellement traduits en vers.* Paris, 1666.

LACROIX 1857: Paul Lacroix. "Jugements de Bachaumont sur les meilleurs artistes de son temps." *Revue Universelle des Arts* 5 (1857), 418–27.

LACROIX 1861: P. Lacroix. "Catalogue des tableaux qui se trouvent dans les galeries et les cabinets du Palais Impérial à Saint-Petersbourg, selon un Catalogue de 1774." *Revue Universelle des Arts* 14 (1861), 212–25.

LAFENESTRE [1920s]: Georges Lafenestre. *Le Louvre: Le Musée et les chefs-d'oeuvre de la peinture.* Paris [1920s].

LAFENESTRE AND MICHEL 1878: Georges Lafenestre and Ernest Michel. "Musée de Montpellier (Musée Fabre)." In *Inventaire général des richesses d'art de la France. Province,* ed. Ministère de l'Instruction Publique et des Beaux-Arts. Vol. 1, 191–367. Paris, 1878.

LAFENESTRE AND RICHTENBERGER 1893: Georges Lafenestre and Eugéne Richtenberger. *Le Musée National du Louvre.* Paris, 1893.

LA FEUILLE 1705: Daniel de La Feuille. *Symbola et emblemata.* Amsterdam, 1705.

LA FONTAINE 1965: Jean de La Fontaine. *Oeuvres complètes.* Ed. Pierre Clarac and Jean Marmier. Paris, 1965.

LA FONT DE SAINT-YENNE 1747: Étienne La Font de Saint-Yenne. *Réflexions sur quelques causes de l'état présent de la peinture en France avec un examen des principaux ouvrages exposés au Louvre le mois d'août 1746.* The Hague, 1747. Reprint. Geneva, 1970.

LA FONT DE SAINT-YENNE 1754: Étienne La Font de Saint-Yenne. *Sentimens sur quelques ouvrages de la peinture, sculpture, et gravure écrits à un particulier en province.* Paris, 1754.

LA FOSSE 1706: A. de La Fosse. *Traduction nouvelle des Odes d'Anacréon, avec des remarques par M. de La Fosse, sur le second édition faite à Paris en 1706.* Paris, 1706.

LA FOSSE 1747: A. de La Fosse. *Oeuvres.* 2 vols. Paris, 1747.

LAGRANGE-CHANCEL 1858: F. J. de Lagrange-Chancel. *Les Philippiques.* Paris, 1858.

LAINÉ 1828–50: P.-L. Lainé. *Archives généalogiques et historiques de la noblesse de France, ou recueil de preuves, mémoires, et notices généalogiques.* 11 vols. Paris, 1828–50.

LAING 1986: Alastair Laing. "Boucher et la pastorale peinte." *Revue de l'Art* 73 (1986), 55–64.

LAJARTE 1878: Théodore de Lajarte. *Bibliothèque musicale du théâtre de l'opéra.* Vol. 1. Paris, 1878. Reprint. Hildesheim, 1969.

LA LIVE DE JULLY 1764: Ange-Laurent de La Live de Jully. *Catalogue historique du cabinet de peinture et sculpture françoise de M. de Lalive.* Paris, 1764. Reprint. New York, 1988.

LALOIRE 1922: E. Laloire. "Une Quittance signée de Watteau." *Revue Belge de Philologie et d'Histoire* 1 (1922), 116–118.

LALOIRE 1940: E. Laloire. *Généalogie de la maison princière d'Arenberg (1547–1940).* Brussels, 1940.

LA MOTTE 1714: A. Houdar de La Motte. *L'Iliade poëme avec un discours sur Homère.* Paris, 1714.

LAMY-LASSALE 1979: C. Lamy-Lassale. "La Galerie de l'hôtel de Villars: Essai de mise au point." *Bulletin de la Société de l'Histoire de l'Art Français,* 1979, 141–48.

LANCRENON 1844: J.-F. Lancrenon. *Catalogue des peintures, et dessins du Musée de Besançon.* Besançon, 1844.

LANCRENON 1850: J.-F. Lancrenon. *Catalogue du Musée de Besançon.* Besançon, 1850.

LANCRENON 1853: J.-F. Lancrenon. *Catalogue des peintures. dessins, et sculptures du Musée de Besançon.* Besançon, 1853.

LANCRENON 1858: J.-F. Lancrenon. *Catalogue des peintures, dessins, et sculptures du Musée de Besançon.* Besançon, 1858.

LANCRENON 1865: J.-F. Lancrenon. *Catalogue des peintures, dessins, et sculptures du Musée de Besançon.* Besançon, 1865.

LANCRENON AND CASTAN 1879: J.-F. Lancrenon and A. Castan. *Catalogue des peintures, dessins, et sculptures du Musée de Besançon.* Besançon, 1879.

LANGLOIS 1922: C.V. Langlois. *Les Hôtels de Clisson, de Guise, et de Rohan-Soubise au Marais.* Paris, 1922.

LA ROQUE 1877: L. de La Roque. *Biographie montpelliérenne: peintres, sculpteurs, et architectes.* Montpellier, 1877.

LAROUSSE 1865–90: Pierre Larousse. *Grand Dictionnaire universelle.* 17 vols. Paris, 1865–90.

LARREY 1722: Isaac de Larrey. *Histoire de France sous le règne de Louis XIV.* 3 vols. Rotterdam, 1722.

LARROUMET 1895: G. Larroumet. *Etudes de littérature et d'art.* Paris, 1895.

LARSEN 1988: Erik Larsen. *The Paintings of Anthony Van Dyck.* 2 vols. Freren, 1988.

LASSERTEY 1793: Lassertey. "Rapport du citoyen Lassertey relatif à la visite par lui faite chez quelques émigrés." *Procès-Verbal des séances de l'assemblée administrative du département de l'Aube, tenues à Troyes dans les mois de decembre 1792, janvier et fevrier 1793,* 74–92. Troyes, 1793.

LAVALLÉE 1928: Pierre Lavallée. *Dessins français du XVIIIe siècle à la bibliothèque de l'École Nationale des Beaux-Arts.* Paris and Brussels, 1928.

LAVEDAN, CHARAGEAT, AND CATHEU 1947: Pierre Lavedan, Marguerite Charageat, and Françoise de Catheu. "Hôtels du faubourg Saint-Germain: Biron, Bauffremont, Beauharnais, Salm." *Congrès Archéologique de France,* 1947, 64–102.

LAVIN 1954: Irving Lavin. "Cephalus and Procris." *Journal of the Warburg and Courtauld Institutes* 17 (July–December 1954), 260–87.

LEACH 1981: Eleanor Winsor Leach. "Metamorphoses of the Acteon Myth in Campanian Painting." *Mitteilungen des Deutschen Archaeologischen Instituts. Roemische Abteilung* 88 (1981), 307–27.

LEBLANC 1747: Abbé Jean-Bernard Leblanc. *Lettre sur l'exposition des ouvrages de peinture, sculpture de l'année 1747 à Monsieur R. D. R.* Paris, 1747. Reprint. Geneva, 1970.

LEBLANC 1932: Marie-Louise Leblanc. *Le Musée de Lille: Peintures.* Paris, 1932.

LEBRUN 1776: Abbé J.-B. Lebrun. *Almanach historique et raisonné des architects, peintres, sculpteurs, graveurs, et ciseleurs.* Paris, 1776. Reprint. Geneva, 1972.

LEBRUN 1777: Abbé J.-B. Lebrun. *Almanach historique et raisonné des architects, peintres, sculpteurs, graveurs, et ciseleurs.* Paris, 1777. Reprint. Geneva, 1972.

LE COMTE 1604: Noël Le Comte. *Mythologie, c'est à dire explication des fables, contenant les généalogies des dieux . . . extraite du latin de Noël Le Comte.* 2 vols. Lyon, 1604.

LEFFLER 1976: P. K. Leffler. "The 'Histoire Raisonnée' 1660–1720: A Pre-Enlightenment Genre." *Journal of the History of Ideas* XXXVII/2 (April-June 1976), 219–40.

LEFFLER 1985: P. K. Leffler. "French Historians and the Challenge to Louis XIV's Absolutism." *French Historical Studies* XIV/1 (1985), 1–22.

LEFRANÇOIS 1981: Thierry Lefrançois. *Nicolas Bertin (1668–1736).* Neuilly-sur-Seine, 1981.

LEFRANÇOIS 1983: Thierry Lefrançois. "Charles Coypel, peintre du roi (1694–1752)." Ph.D. diss., Université de Paris-Sorbonne, 1983.

LEGRAN AND WRANGEL 1912: W. Legran and F. U. Wrangel. *Tessinska palatset*. Stockholm, 1912.

LEGRAND 1902: L. Legrand. *Louis Lacaze, discours prononcé le 15 janvier 1902*. Paris, 1902.

LEJEUNE 1864: Théodore Lejeune. *Guide théorique et pratique de l'amateur de tableaux*. Vol. 1. Paris, 1864.

LE MOËL AND ROSENBERG 1969: Michel Le Moël and Pierre Rosenberg. "La Collection des tableaux de Saint-Aignan et le catalogue de sa vente illustré par Gabriel de Saint-Aubin." *Revue de l'Art* 6 (1969), 51–67.

LE MOYNE 1670: Pierre Le Moyne. *De l'histoire*. Paris, 1670.

LE MOYNE 1695: Pierre Le Moyne. *On the Art Both of Writing and Judging History*. London, 1695.

LENINGRAD 1797: The Hermitage, Leningrad. *Catalogue of Paintings in the Imperial Gallery of the Hermitage, and in the Tauride and Marble Palaces, Compiled on the Order of His Imperial Majesty by Akimov, Gordeyev, and Kozlovsky with the Participation of F. I. Labensky, Keeper of the Hermitage Paintings in 1797*. Archives of the State Hermitage, f. 1, inv. VI-a, no. 87 [in Russian].

LENINGRAD 1859: The Hermitage, Leningrad. *Inventory of Pictures and Ceiling Paintings Belonging to Department 2 of the Imperial Hermitage, 1859*. Archives of the State Hermitage, f. 1, inv. XI-b, no. 1 [in Russian].

LENINGRAD 1976: The Hermitage, Leningrad. *The State Hermitage: Western European Painting, Catalogue*. Vol. 1. Leningrad, 1976 [in Russian].

LENOTRE 1930: G. Lenotre. *Le Château de Rambouillet: Six siècles d'histoire*. Paris, 1930.

[LE PAON] 1765: [Le Paon]. *Critique des peintures et sculptures de messieurs de l'Académie Royal, l'an 1765: Lettre à un amateur de la peinture*. Paris, 1765.

LE PAYS 1665: René Le Pays. *Amitiez, amours, et amourettes*. Paris, 1665. 1st ed., 1664.

LÉPICIÉ 1752: François Bernard Lépicié. *Vies des premiers-peintres du roi depuis M. Le Brun, jusqu'à présent*. 2 vols. in 1. Paris, 1752.

L(E) R(OUGE) 1719: L(e) R(ouge). *Les Curiositez de Paris*. Paris, 1719.

L(E) R(OUGE) 1733: L(e) R(ouge). *Les Curiositez de Paris, de Versailles, de Marly, de Vincennes, de S. Cloud, et des environs*. Paris, 1733.

L(E) R(OUGE) 1778: L(e) R(ouge). *Les Curiositez de Paris, de Versailles, de Marly, de Vincennes, de S. Cloud, et des environs*. Paris, 1778.

LE ROY 1859: E. Le Roy. *Quelques notes sur la collection de tableaux de monsieur Théodore Patureau, 9 May 1859*. Paris, 1859.

LEROY 1860: F.-N. Leroy. *Histoire de Jouvenet*. Paris and Rouen, 1860.

LE SAGE 1737: Alain-René Le Sage. *Le Foire de Guibray* (1714). In *Le Théâtre de la Foire, ou l'opéra-comique, contenant les meilleures pièces qui ont été représentées aux Foires de Saint-Germain et de Saint-Laurent*. Vol. 1, 32–39, 127–28. Amsterdam, 1737. Reprint. Geneva, 1968.

LE SAGE, FUZELIER, AND D'ORNEVAL 1737: Alain-René Le Sage, Louis Fuzelier, and d'Orneval. *Arlequin Endimion* (1721). In *Le Théâtre de la Foire, ou l'opéra-comique, contenant les meilleures pièces qui ont été représentées aux Foires de Saint-Germain et de Saint-Laurent*. Vol. 1, 456–67. Amsterdam, 1737. Reprint. Geneva, 1968.

LESCURE 1863–68: Mathurin-François-Adolphe de Lescure. *Journal et mémoires de Mathieu Marais, avocat au parlement de Paris sur la régence et le règne de Louis XV (1715–1737)*. 4 vols. Paris, 1863–68. Reprint. Geneva, 1967.

LESPINASSE 1971: Julie de Lespinasse. *Lettres*. Geneva, 1971.

LESPINASSE 1911: Pierre Lespinasse. "Notes et Documents. L'Art français et la suède de 1688–1713." *Bulletin de la Société de l'Histoire de l'Art Français*, 1911, 54–133.

LESPINASSE 1912: Pierre Lespinasse. "L'Art français et la suède de 1688 à 1816, appendice V: Catalogue général des tableaux de la reine Louise-Ulrique réunis au château de Drottningholm (1760)." *Bulletin de la Société de l'Histoire de l'Art Français*, 1912, 207–45.

LEVASSOR 1700–11: Michel Levassor. *Histoire du règne de Louis XIII, roi de France et de Navarre*. 10 vols. Amsterdam, 1700–11.

LEVEY 1964: Michael Levey. "A Watteau Rediscovered: *Le Printems* for Crozat." *Burlington Magazine* CVI/731 (February 1964), 53–58.

LEVEY 1982: Michael Levey. "A Boucher Mythological Painting Interpreted." *Burlington Magazine* CXXIV/952 (July 1982), 442–46.

LEVEY 1987: Michael Levey. "Exhibition Review: Paris, Grand Palais, Boucher." *Burlington Magazine* CXXIX/1008 (March 1987), 199–201.

LILLE 1875: Palais des Beaux Arts, Musée de Peinture, Lille. *Catalogue des tableaux, bas-reliefs, et statues exposés dans les galeries du musée des tableaux de la ville de Lille*. Lille, 1875.

LILLE 1893: Musée de Lille. *Catalogue des tableaux du Musée de Lille*. Lille, 1893.

LILLE 1970: Musée de Lille. *Cent chefs-d'oeuvres du Musée de Lille*. Lille, 1970.

LIMIERS 1718: H. P. de Limiers. *Histoire du règne de Louis XIV*. 10 vols. Amsterdam, 1718.

LIMIERS 1721: H. P. de Limiers. *Atlas historique*. 7 vols. Amsterdam, 1721.

LIPTON 1990: Eunice Lipton. "Women, Pleasure, and Painting (e.g. Boucher)." *Genders* 7 (1990), 69–86.

LISTER 1698: Martin Lister. *A Journey to Paris in the Year 1698*. London, 1698. Reprint. Urbana, 1967.

LLEWELLYN 1988: Nigel Llewellyn. "Illustrating Ovid." In *Ovid Renewed*, ed. Charles Martindale, 151–66. Cambridge, 1988.

LLOYD 1975: Christopher Lloyd. "Camille Pissarro and Hans Holbein." *Burlington Magazine* CXVII/872 (November 1975), 722–26.

LOCHE 1980: René Loche. *Jean-Étienne Liotard, peintre et collectionneur-marchand. A propos de quelques documents inédits*. Geneva, 1980.

LOCQUIN 1909: Jean Locquin. "Bernard Lépicié à l'École royale des Élèves protégés." *Bulletin de la Société de l'Histoire de l'Art français*, 1909, 93–97.

LOCQUIN 1912: Jean Locquin. *La Peinture d'histoire en France de 1747 à 1785*. Paris, 1912.

LOCQUIN 1922: Jean Locquin. "Le Retour à l'antique dans l'école anglaise et dans l'école française avant David." *La Renaissance de l'Art Français et des Industries de Luxe* 5 (1922), 473–81.

LOMAX 1982: David Lomax. "Noël-Nicolas Coypel (1690–1734)." *Revue de l'Art* 57 (1982), 29–48.

LOMAX 1983: David Lomax. "The Early Career of Noël Hallé." *Apollo*, February 1983, 106–09.

LONDON 1882: The National Gallery, London. *The Abridged Catalogue of the Pictures in the National Gallery with Short Biographical Notices of the Painters: Foreign Schools*. London, 1882 (with subsequent editions in 1885, 1888, 1898).

LONDON 1889: The National Gallery, London. *Descriptive and Historical Catalogue of the Pictures in the National Gallery: Foreign Schools*. London, 1889.

LONDON 1901: The National Gallery, London. *Descriptive and Historical Catalogue of the Pictures in the National Gallery with Biographical Notices of the Painters: Foreign Schools*. London, 1901.

LONDON 1913: The National Gallery, London. *Descriptive and Historical Catalogue of the Pictures in the National Gallery: Foreign Schools*. London, 1913.

LONDON 1921: The National Gallery, London. *Catalogue of the Pictures*. London, 1921.

LONDON 1929: The National Gallery, London. *Catalogue*. London, 1929.

LONDON 1986: The National Gallery, London. *National Gallery: Illustrated General Catalogue*. London, 1986.

LONGNON 1919: H. Longnon. *Le Château de Rambouillet*. Paris, 1919.

LONGUS 1955: Longus. *Daphnis and Chloe*. Trans. George Thornley and rev. J. M. Edmonds. Cambridge, Mass., and London, 1955. In the same volume: *The Love Romances of Parthenius and other Fragments*.

LORIN 1903: F. Lorin. *La Société des amis des monuments à Rambouillet: Notice sur Rambouillet, la ville, et le château*. Versailles, 1903.

LOSSKY 1962: Boris Lossky. *Tours, Musée des Beaux-Arts: Peintures du XVIIIe siècle*. Paris, 1962.

LOUIS XIV 1803: *Mémoires historiques et politiques de Louis XIV composés pour le Dauphin son fils* [1662]. Paris, 1803.

LUCIAN 1928: Lucian. "Dionysus." In *Works*. Vol. 1. Trans. A. M. Harmon. London and New York, 1928.

LUCIAN 1960: Lucian. "The Judgment of the Goddesses." In *Works*. Vol. 3. Trans. A. M. Harmon. Cambridge, Mass., and London, 1960.

LUCIAN 1961: Lucian. "Dialogues of the Gods." In *Works*. Vol. 7. Trans. M. P. Macleod. London and Cambridge, Mass., 1961.

LUCRETIUS 1959: Lucretius. *De rerum natura*. Trans. W. H. D. Rouse. London and Cambridge, Mass., 1959.

LUDMANN 1979: Jean-Daniel Ludmann. "Strasbourg, Musée des Beaux-Arts: Acquisitions de peintures et de dessins." *La Revue du Louvre et des Musées de France*, 1979, nos. 5–6, 450–52.

LUDMANN AND PONS 1979: Jean-Daniel Ludmann and Bruno Pons. "Documents inédits sur la galerie de l'hôtel de Toulouse." *Bulletin de la Société de l'Histoire de l'Art Français*, 1979, 116–28.

LUNA 1975: Juan José Luna. "Un Centenario olvidado: Jean Ranc." *Goya* 127 (July–August 1975), 22–26.

LUNA 1978: Juan José Luna. "Jean Ranc, pintor de camára de Felipe V. Aspectos ineditos." In *Actas del XXII Congreso Internacional de Historia del Arte España entre el Mediterraneo y el Atlantico, Granada 1973*. Vol. 3, 129–39. Granada, 1978.

LUNA 1980: Juan José Luna. "Jean Ranc: Ideas artísticas y métodos de trabajo, a través de pinturas y documentos." *Archivo Español de Arte* 53 (1980), 449–65.

LUNA 1987: Juan José Luna. "Influencias francesas en el mundo Goyesco." In *Goya, Nuevas Visiones: Homenaje a Enrique Lafuente Ferrari*, ed. Isabel García de la Rasilla and Francisco Calvo Serraller, 227–39. Madrid, 1987.

LUNDBERG 1931–32: M. Gunnar W. Lundberg. "Le Graveur suédois Pierre-Gustave Floding à Paris et sa correspondance." *Archives de l'Art Français* 17 (1931–32), 251–359.

LUYNES 1861: Duc de Luynes. *Mémoires du Duc de Luynes sur la cour de Louis XIV (1735–58)*. Ed. L. Dussieux and E. Soulié. 17 vols. Paris, 1861.

LYNCHE 1599: Richard Lynche. *The Fountaine of Ancient Fiction*. London, 1599. Reprint. New York and London, 1976.

M

MACFALL 1908: Haldane Macfall. *Boucher: The Man, His Times, His Art, and His Significance, 1703–1770*. London, 1908.

MACLEAN 1977: I. Maclean. *Woman Triumphant*. Baltimore, 1977.

MAGNE 1932: Émile Magne. *Le Château de Saint-Cloud, d'après documents inédits*. Paris, 1932.

MAGNE 1934: Émile Magne. *Le Château de Marly*. Paris, 1934.

MAGNIEN 1908: Maurice Magnien. "Le Trianon de Marbre pendant le règne de Louis XIV." *Revue de l'Histoire de Versailles et Seine-et-Oise*, 1908, 1–30.

MAGNIN 1914: J. Magnin. *La Peinture au Musée de Dijon*. Dijon, 1914.

MAGNIN 1919: J. Magnin. *La Peinture et le dessin au Musée de Besançon*. Dijon, 1919.

MAGNIN 1929: J. Magnin. *La Peinture au Musée de Dijon*. Besançon, 1929.

MAGNIN 1933: J. Magnin. *La Peinture au Musée de Dijon*. Besançon, 1933.

MAIHOWS 1881: Dr. Maihows. *Paris artistique et monumental en 1750, lettres du Dr. Maihows, traduites en l'anglais par Philippe-Florent de Puisieux, réimprimées pour la première fois avec préface, sommaires, et notes par Hippolyte Bonnardot*. Paris, 1881.

MAJWESKA-MASZKOWSKA 1976: B. Majewska-Maszkowska. *Mecenat artystyczny Izabelli z Czartoryskich Lubomirskiej (1736–1816)*. Wroclaw and Kracow, 1976.

MALASSIS 1878: A. P. Malassis, ed. *Correspondance de Mme. de Pompadour avec son père, M. Poisson et son frère, M. de Vandières*. Paris, 1878.

MALITSKAYA AND ANTONOVA 1965: K. M. Malitskaya and I. Antonova. *Great Paintings from the Pushkin Museum*. New York, [1965].

MALLETT 1979: Donald Mallett. *The Greatest Collector: Lord Hertford and the Founding of the Wallace Collection*. London, 1979.

MANNLICH 1805–10: Johann Christian von Mannlich. *Beschreibung der Churpfalzbaierischen Gemälde-Sammlung zu München und zu Schleissheim*. 3 vols. Munich, 1805–10.

MANNLICH 1989: Johann Christian von Mannlich. *Histoire de ma vie*. Ed. Karl-Heinz Bender and Hermann Kleber. Trier, 1989.

MANTZ 1859: Paul Mantz. "L'École française sous la régence, Antoine Watteau." *Revue Française* 16 (February–April 1859), 263–72, 345–53.

MANTZ 1870: Paul Mantz. "La Collection La Caze au Musée du Louvre." *Gazette des Beaux-Arts*, July 1870, 5–25.

MANTZ 1880: Paul Mantz. *François Boucher, Lemoyne, et Natoire*. Paris, 1880.

MANTZ 1890: Paul Mantz. "Watteau (sixième et dernier article)." *Gazette des Beaux-Arts* 3 (1890), 222–38.

MANTZ 1892: Paul Mantz. *Cent dessins de Watteau gravés par Boucher*. Paris, 1892.

MANUEL 1959: Frank Manuel. *The Eighteenth Century Confronts the Gods*. Cambridge, Mass., 1959.

MARAIS 1863–68: M. Marais. *Journal et mémoires de la régence et le règne de Louis XV (1715–1737)*. Ed. M. de Lescure. 4 vols. Paris, 1863–68. Reprint. Geneva, 1967.

MARCEL 1906: Pierre Marcel. *La Peinture française au début du dix-huitième siècle, 1690–1721*. Paris, 1906.

MARIE 1968: Alfred Marie. *Naissance de Versailles: Le Château, les jardins*. Vol. 2. Paris, 1968.

MARIE AND MARIE 1947: Jeanne Marie and Alfred Marie. *Marly*. Paris, 1947.

MARIETTE 1851–60: P. J. Mariette. "Abecedario." Ed. Ph. de Chennevières and A. de Montaiglon. 6 vols. Paris, 1851–60.

MARIVAUX 1716: Pierre Carlet de Chamblain de Marivaux. *L'Homère travesti; ou L'Iliade en vers burlesques*. Paris, 1716.

MARIVAUX 1781: Pierre Carlet de Chamblain de Marivaux. *Le Dénouement imprévu* (1724). In *Oeuvres*. Vol. 1. Paris, 1781. Reprint. Geneva and Paris, 1972.

MARMONTEL 1972: J.-F. Marmontel. *Mémoires de Marmontel*. Ed. John Renwick. 2 vols. Clermont-Ferrand, 1972.

MAROLLES 1655: Michel de Marolles. *Tableaux du Temple des Muses*. Paris, 1655. Reprint. New York and London, 1976.

MAROLLES 1660: Michel de Marolles. *Les Livres d'Ovide et de l'art d'aimer*. Paris, 1660.

MARSY 1746: François Marie de Marsy. *Dictionaire abrégé de peinture et d'architecture*. 2 vols. Paris, 1746.

MARTIGNAC 1697: Étienne Algay de Martignac. *Trad. Ovide. Les Oeuvres*. Lyon, 1697.

MARTIN 1970–72: Gregory Martin. *London, National Gallery: The Flemish School, circa 1600–circa 1900*. London, 1970–72.

MARTIN 1965: John Rupert Martin. *The Farnese Gallery*. Princeton, 1965.

MARTINDALE 1988: Charles Martindale, ed. *Ovid Renewed*. Cambridge, 1988.

MARZIO 1989: Peter C. Marzio. *A Permanent Legacy: 150 Works from the Collection of the Museum of Fine Arts, Houston*. New York, 1989.

MASSILLON 1865: J. B. Massillon. *Oeuvres complètes*. 2 vols. Paris, 1865.

MATHEY 1959: J. Mathey. *Antoine Watteau: Peintures réapparues, inconnues, ou negligées par les historiens*. Paris, 1959.

MATHIEU 1987: N. Mathieu. "Autour de trois représentations de Diane dans les musées de Tours et du Mans." In *L'Antiquité Gréco-Romaine vue par le siècle des Lumières. Actes du colloque*, 351–78. Tours, 1987.

MATHIEU-CASTELLANI 1978: Gisèle Mathieu-Castellani. "La Figure mythique de Diane dans L'Hécatombe d'Aubigné." *Revue d'Histoire Littéraire de la France* 78 (1978), 3–18.

MATHIEU-CASTELLANI 1979: Gisèle Mathieu-Castellani. *Éros baroque: Anthologie de la poésie amoureuse baroque, 1570–1620*. Paris, 1979.

MATHIEU-CASTELLANI 1981: Gisèle Mathieu-Castellani. "Actéon ou la beauté surprise." In *Mythes de l'éros baroque*, 51–100. Paris, 1981.

MATHIEU-CASTELLANI 1982: Gisèle Mathieu-Castellani. "Actéon ou la rhétorique du mythe dans la poésie baroque." In *La Mythologie au XVIIe siècle*, 33–41. Marseille, 1982.

MATHIEU-CASTELLANI 1984: Gisèle Mathieu-Castellani. "Lune, femme: L'Image de Diane chez Théophile et Tristan." In *Onze nouvelles études sur l'image de la femme dans la littérature française du dix-septième siècle*. Tubingen and Paris, 1984.

MATHON DE LA COUR 1765: Ch.-J. Mathon de La Cour. *Lettres à monsieur ***: Sur les peintures, les sculptures, et les gravures exposées au Sallon du Louvre en 1765. Première lettre*. Paris, 8 September 1765. *Collection Deloynes*, VIII, no. 108.

MAUCLAIR 1906: Camille Mauclair. *Jean-Baptiste Greuze*. Paris, 1906. Catalogue raisonné by J. Martin and Ch. Masson.

MAUGRAS 1903: Gaston Maugras. *La Disgrace du duc et la duchesse de Choiseul: La Vie à Chanteloup, le retour à Paris, la mort*. Paris, 1903.

MÉNARD 1874: René Ménard. "Pan et les satyres." *Gazette des Beaux-Arts*, 1874, 84–92.

MÉRÉ 1930: A. G. Méré. *Oeuvres complètes*. Ed. C. H. Bouhours. 3 vols. Paris, 1930.

MÉROT 1982: Alain Mérot. "La Place des sujets mythologiques et leur signification dans le décor peint, à Paris, dans la première moitié du XVIIe siècle." In *La Mythologie au XVIIe siècle*, 219–24. Marseille, 1982.

MÉROT 1987: Alain Mérot. *Eustache Le Sueur (1616–1655)*. Paris, 1987.

MERSON 1887: Olivier Merson. "Musée de Nantes." In *Inventaire général des richesses d'art de la France. Province. Monuments civils*. Vol. 2. Paris, 1887.

MESSELET 1935–36: Jean Messelet. "Jean Restout (1692–1768)." *Archives de l'Art Français* 19 (1935–36), 99–188.

METRA 1787–90: François Metra. *Correspondance secrète, politique, et littéraire: Mémoires pour servir à l'histoire des cours des sociétés et de la littérature en France, depuis la mort de Louis XV*. London, 1787–90. Reprint. Geneva, 1967.

MICHAUD AND MICHAUD 1854–65: Joseph François Michaud and Louis Gabriel Michaud. *Biographie universelle ancienne et moderne*. 2d ed. 45 vols. Paris, 1854–65.

MICHEL 1886: André Michel. *F. Boucher*. Vol. 10 of *Les Artistes célèbres*. Paris, 1886.

MICHEL 1906: André Michel. *François Boucher*. Paris, 1906. Catalogue compiled by L. Soullié and C. Masson.

MICHEL 1925: André Michel. *Histoire de l'art: Depuis les premiers temps chrétiens jusqu'à nos jours*. Vol. 7, *L'Art en Europe au XVIIIe siècle*. Paris, 1925.

MICHEL 1986: Christian Michel. "Lettres adressées par Charles-Nicolas Cochin fils à Jean-Baptiste Descamps (1757–1790)." *Archives de l'Art Français* 28 (1986), 9–98.

MICHEL 1879: Ernst Michel. *Catalogue des peintures et sculptures exposées dans les galeries du Musée Fabre de Montpellier*. Montpellier, 1879.

MICHEL 1890: Ernst Michel. *Catalogue des peintures et sculptures exposées dans les galeries du Musée Fabre de la ville de Montpellier*. Montpellier, 1890.

MIREUR 1901–12: H. Mireur. *Dictionnaire des ventes d'art faites en France et à l'étranger pendant les XVIIIme et XIXme siècles*. 7 vols. Paris, 1901–12.

MIRIMONDE 1961: A.-P. de Mirimonde. "Les Sujets musicaux chez Watteau." *Gazette des Beaux-Arts* 58 (November 1961), 249–88.

MIRIMONDE 1962: A.-P. de Mirimonde. "Statues et emblèmes dans l'oeuvre de Watteau." *La Revue du Louvre et des Musées de France*, 1962, no. 1, 11–20.

MIRIMONDE 1968: A.-P. de Mirimonde. "Psyche et le papillon." *L'Oeil* 160 (December 1968), 2–11.

MIRIMONDE 1977: A.-P. de Mirimonde. *L'Iconographie musicale sous les rois Bourbons: La Musique dans les arts plastiques, XVII–XVIII siècles*. 2 vols. Paris, 1977.

MIRIMONDE 1980: A.-P. de Mirimonde. "La Prétendue *Antiope* d'Antonio Allegri, dit *Le Corrège*, ou les enseignements d'une erreur de deux siècles et demi." *Gazette des Beaux-Arts* 95 (March 1980), 107–20.

MOLLETT 1883: John W. Mollett. *Watteau*. London, 1883.

MONTAGU 1968: Jennifer Montagu. "The Painted Enigma and French Seventeenth-Century Art." *Journal of the Warburg and Courtauld Institutes* 31 (1968), 307–35.

MONTAGU 1969: Jennifer Montagu. "Au temps du roi soleil. Les Peintres de Louis XIV." *Revue de l'Art* 3 (1969), 97–98.

MONTAIGLON 1875–92: Anatole de Montaiglon. *Procès-Verbaux de l'Académie Royal de Peinture et de Sculpture, 1648–1793*. 10 vols. Paris, 1875–92.

MONTAIGLON AND GUIFFREY 1887–1912: Anatole de Montaiglon and Jules Guiffrey. *Correspondance des directeurs de l'Académie de France à Rome, avec les surintendants des Bâtiments*. 18 vols. Paris, 1887–1912.

MONTESQUIEU 1758: Charles-Louis de Montesquieu. *Le Temple de Gnide*. In *Oeuvres de M. de Montesquieu, nouvelle édition revue, corrigée et considérablement augmentée par l'auteur*. 3 vols. Paris, 1758.

MONTFAUCON 1719: Bernard de Montfaucon. *L'Antiquité expliquée et représentée en figures*. 5 vols. Paris, 1719.

MONTFAUCON 1721–22: Bernard de Montfaucon. *Antiquity Explained and Represented in Sculpture*. 5 vols. Trans. David Humphreys. London, 1721–22. Reprint. New York, 1976. Supplement, 1724.

MONTPELLIER 1850: Musée Fabre, Montpellier. *Notice des tableaux et objets d'art exposées au Musée Fabre de la ville de Montpellier*. Montpellier, 1850.

MONTPELLIER 1859: Musée Fabre, Montpellier. *Notice des tableaux et objets d'art exposées au Musée Fabre de la ville Montpellier*. Montpellier, 1859.

MONTPELLIER 1904: Musée Fabre, Montpellier. *Catalogue des peintures et sculptures exposées dans les galeries du Musée Fabre de la ville de Montpellier*. Montpellier, 1904.

MONTPELLIER 1910: Musée Fabre, Montpellier. *Catalogue des peintures et sculptures exposées dans les galeries du Musée Fabre*. Montpellier, 1910.

MONTPELLIER 1914: Musée Fabre, Montpellier. *Catalogue des peintures et sculptures exposées dans les galeries du Musée Fabre*. Montpellier, 1914.

MONVILLE 1731: Abbé Mazière de Monville. *La Vie de Pierre Mignard, premier peintre du roy*. Amsterdam, 1731.

MORANT 1953: Henry de Morant. *Musée d'Angers: Guide des peintures*. Angers, 1953.

MORANT 1968: Henry de Morant. *La Peinture au Musée d'Angers*. Angers, 1968.

MOREL-PAYEN 1929 (A): Lucien Morel-Payen. *Le Musée de Troyes et la Bibliothèque*. Paris, 1929.

MOREL-PAYEN 1929 (B): Lucien Morel-Payen. *Troyes et l'Aube*. Troyes, 1929.

MORÉRI 1731–32: Louis Moréri. *Le Grand Dictionnaire historique*. 6 vols. Basel, 1731–32. 1st ed. 1674. Revised and reissued 1681, 1683, 1687, 1688, 1691, 1694, 1698, 1702, 1704, 1707, 1712, 1718, 1725, 1733, 1740, 1759.

MOSCHUS 1950: Moschus. "Europa." Pt. 2 of *The Poems of Moschus*. In *The Greek Bucolic Poets*. Trans. J. M. Edmonds. Cambridge, Mass., and London, 1950.

MOSELIUS 1939: Carl David Moselius. "Gustav III och konsten med en inledning om Tessin och Louisa Ulrika." *Nationalmusei Arsbok*, 1939, 82–154.

MOSKOWITZ AND MONGAN 1962: Ira Moskowitz and Agnes Mongan. *Great Drawings of All Time*. Vol. 3, *French, Thirteenth Century to 1919*. New York, 1962.

MOSS 1982: Ann Moss. *Ovid in Renaissance France: A Study of the Latin Editions of Ovid and Commentaries Printed in France Before 1600*. London, 1982.

MOSSER 1983: M. Mosser. "Le Souper grec de Mme Vigée-Lebrun." *Dix-Huitième Siècle* 15 (1983), 155–67.

MOUREAU AND GRASSELLI 1987: François Moureau and Margaret Morgan Grasselli, eds. *Antoine Watteau (1684–1721): Le Peintre, son temps, et sa légende*. Paris and Geneva, 1987.

MUNICH 1818: Munich. *Notice des tableaux de la Galerie Royale de Munich*. Munich, 1818.

MUNICH 1822: Munich. *Notice des tableaux de la Galerie Royale de Munich*. Munich, 1822.

Munich 1825: Munich. *Verzeichnis der Gemälde der Königlichen Bildergallerie in München*. Munich, 1825.

MUNICH 1850: Munich. *Verzeichnis der Gemälde in der Königlichen Gallerie zu Schleischeim*. Munich, 1850.

MUNICH 1870: Munich. *Katalog der Königlichen Gemälde-Galerie in Schleisheim*. Munich, 1870.

MUNICH 1928: Alte Pinakothek, Munich. *Illustrated Catalogue, Old Pinakothek*. Munich, 1928.

MUNICH 1936: Alte Pinakothek, Munich. *Katalog der Älteren Pinakothek*. Munich, 1936.

MUNICH 1983: Alte Pinakothek, Munich. *Bayerische Staatsgemäldesammlungen, Alte Pinakothek München, Erläuterungen zu den Ausgestellten Gemälden*. Munich, 1983. English ed., 1986.

[MUNICH] 1774: [E. Munich]. *Catalogue des tableaux qui se trouvent dans les galeries et dans les cabinets de Palais Impérial de Saint-Pétersbourg*. St. Petersburg, 1774.

N

NANCY 1854: Musée de Nancy. *Notice des tableaux exposés au Musée de Nancy*. Nancy, 1854.

NANCY 1866: Musée de Nancy. *Notice des tableaux, dessins, gravures, statues, et bas-reliefs exposés au Musée de Nancy*. Nancy, 1866.

NANCY 1883: Musée de Nancy. *Tableaux, dessins, statues, et bas-reliefs*. Nancy, 1883.

NANCY 1897: Musée de Nancy. *Tableaux, dessins, statues, et bas-reliefs: Catalogue*. Nancy, 1897.

NANCY 1909: Musée de Nancy. *Tableaux, dessins, statues, et objets d'art: Catalogue descriptif et annoté*. Nancy, 1909.

NANTES 1833: Musée de Nantes. *Catalogue des tableaux et statues du musée de la ville de Nantes*. Nantes, 1833.

NANTES 1834: Musée de Nantes. *Catalogue des tableaux et statues du musée de la ville de Nantes*. Nantes, 1834.

NANTES 1846: Musée de Nantes. *Catalogue des tableaux et statues du Musée de Nantes*. Nantes, 1846.

NANTES 1854: Musée de Nantes. *Catalogue des tableaux et statues du Musée de Nantes*. Nantes, 1854.

NANTES 1859: Musée de Nantes. *Catalogue des tableaux et statues du Musée de Nantes*. Nantes, 1859.

NANTES 1876: Musée de Nantes. *Catalogue des objets composant le Musée Municipal des Beaux-Arts*. Nantes, 1876.

NANTES 1903: Musée de Nantes. *Ville de Nantes, Musée des Beaux-Arts: Catalogue des peintures, sculptures, pastels, aquarelles, dessins, et objets d'art*. Paris, 1903.

NEMEITZ 1727: J. C. Nemeitz. *Séjour de Paris*. Leyden, 1727.

NEMILOVA 1964: I. S. Nemilova. "Essais sur l'oeuvre de Jean-Antoine Watteau: I—La Détermination de la date d'exécution du tableau *Le Savoyard*, conservé au Musée de l'Ermitage et le problème de la périodisation de la peinture de genre de Watteau." *Troudy gosoudarstvennogo Ermitaja* 8 (1964), 85–98.

NEMILOVA 1973: I. S. Nemilova. *Enigmas of Old Paintings*. Moscow, 1973 [in Russian].

NEMILOVA 1975: I. S. Nemilova. "Contemporary French Art in Eighteenth-Century Russia." *Apollo*, June 1975, 428–42.

NEMILOVA 1982: I. S. Nemilova. *French Painting of the Eighteenth Century in the Hermitage Collection. Catalogue raisonné*. Leningrad, 1982 [in Russian].

NEMILOVA 1986: I. S. Nemilova. *The Hermitage Catalogue of Western European Painting: French Painting, Eighteenth Century*. Trans. Valery A. Fateyev, Vladimir G. Ivanov, and Ruslan S. Smirnov. Moscow and Florence, 1986.

NÉRAUDAU 1986: Jean-Pierre Néraudau. *L'Olympe du Roi-Soleil: Mythologie et idéologie royale au Grand Siècle*. Paris, 1986.

NEW ORLEANS 1914: Isaac Delgado Museum of Art, New Orleans. *Catalogue*. New Orleans, 1914.

NEW ORLEANS 1932: Isaac Delgado Museum of Art, New Orleans. *Catalogue of Paintings, Sculpture, and Other Objects of Art in the Isaac Delgado Museum of Art*. New Orleans, 1932.

NICHOLS 1990: Lawrence W. Nichols. "*Putti Playing with the Accoutrements of Hercules*, c. 1721–24, François Le Moyne, and *Venus and Adonis*, c. 1740, Charles-Joseph Natoire." *Philadelphia Museum of Art Bulletin* LXXXVI/365–66 (Spring 1990), 3–7.

NICOLE 1668: Claude Nicole. *L'Art d'aimer d'Ovide traduit en vers françois*. Paris, 1668.

NICOLLE 1931: Marcel Nicolle. "Chefs-d'Oeuvre des musées de province: École française XVIIe et XVIIIe siècles." *Gazette des Beaux-Arts* 6 (August 1931), 98–127.

NICOLLE AND DACIER 1913: Marcel Nicolle and Emile Dacier. *Ville de Nantes, Musée Municipal des Beaux-Arts: Catalogue*. Nantes, 1913.

NOCQ AND DREYFUS 1930: Henry Nocq and Carle Dreyfus. *Tabatières, boites, et étuis; Orfèvreries de Paris XVIIIe siècle et début du XIXe des collections du Musée du Louvre*. Paris, 1930.

NOLHAC 1907: Pierre de Nolhac. *François Boucher, premier peintre du roi, 1703–1770*. Paris, 1907.

NOLHAC 1918: Pierre de Nolhac. *Fragonard, 1732–1806*. Paris, 1918.

NOLHAC 1925: Pierre de Nolhac. *Boucher, premier peintre du roi*. Paris, 1925.

NOLHAC 1931: Pierre de Nolhac. *Fragonard, 1732–1806*. Paris, 1931.

NONNOS 1956: Nonnos. *Dionysiaca*. Trans. W. H. D. Rouse. Cambridge, Mass., and London, 1956.

NORDENFALK 1953 (A): Carl Nordenfalk. "Kärlekslektionen av Watteau." In *Antoine Watteau och andra franska sjuttonhundratalsmästare i Nationalmuseum*, ed. Carl Nordenfalk, 61–145. Stockholm, 1953.

NORDENFALK 1953 (B): Carl Nordenfalk. "Tavelgalleriet pa Stockholms slott under senare hälften av 1700-talet." *Ur Nationalmusei handteckningssamling VI. Svenska kungaslott i skisser och ritningar*. Malmö, 1953.

NORDENFALK 1979: Carl Nordenfalk. "The Stockholm Watteaus and Their Secret." *Nationalmuseum Bulletin*, 1979, no. 3, 105–39. Reprinted in *Thought and Form Studies in 18th-Century Art to Bengt Dahlbäck*. Stockholm, 1980.

O

O'NEILL 1981: Mary O'Neill. *Musée des Beaux-Arts d'Orléans. Catalogue critique: Les Peintures de l'école française des XVIIe et XVIIIe siècles*. 2 vols. Orléans, 1981.

ORLANDI 1731: Pellagrino Antonio Orlandi. *L'Abcedario pittorico dall'autore ristampato, corretto, ed accresciuto di molti professori, e di altre notizie spettanti alla pittura*. Venice, 1731.

ORLIAC 1930: J. d'Orliac. *La Vie merveilleuse d'un beau domaine français: Chanteloup du XIIIe siècle au XXe siècle*. Paris and Tours, 1930.

OURSEL 1984: Hervé Oursel. *Le Musée des Beaux-Arts de Lille*. Paris, 1984.

OVID 1924: Ovid. *Tristia, Ex Ponto*. Trans. Arthur Leslie Wheeler. Cambridge, Mass., and London, 1924.

OVID 1951: Ovid. *Fasti*. Trans. Sir James George Frazer. Cambridge, Mass., and London, 1951.

OVID 1984: Ovid. *Metamorphoses*. 2 vols. Trans. Frank Justus Miller. Cambridge, Mass., and London, 1984.

OVID 1985: Ovid. *The Art of Love and Other Poems*. Trans. J. H. Mozley, rev. G. P. Goold. Cambridge, Mass., and London, 1985.

OVID 1986: Ovid. *Heroides and Amores*. Trans. Grant Showerman. Cambridge, Mass., and London, 1986.

OWENS 1986: Iris Owens. "The Boucher Dream." *Art and Antiques*, April 1986, 76–78, 88, ill.

OXFORD ENGLISH DICTIONARY 1933: *The Oxford English Dictionary*. 13 vols. Oxford, 1933.

OZANAM 1977: Denise Ozanam. "Jean Orry (1652–1719), seigneur de la Chapelle Godefroy." *La Vie en Champagne* 263 (February 1977), 2–4.

P

PAHIN DE LA BLANCHERIE 1783: Pahin de La Blancherie. *Essai d'un tableau historique des peintres de l'école française depuis Jean Cousin en 1500, jusqu'en 1783 inclusivement.* Paris, 1783. Reprint. Geneva, 1972.

PANARD 1747: Ch.-A. Panard. *Les Tableaux, comedie en un acte et en vers: Représentée par les comediens italiens ordinaires du roy, pour la première fois, le 18 Septembre 1747. Par monsieur Panard.* Paris, 1747 [Bibl. Nat. Impr., YF 7665].

PANOFSKY 1949: Dora Panofsky. "Narcissus and Echo: Notes on Poussin's *Birth of Bacchus* in the Fogg Museum of Art." *Art Bulletin* XXXI/2 (June 1949), 112–20.

PANOFSKY, 1960: Erwin Panofsky. *A Mythological Painting by Poussin.* Stockholm, 1960.

PANOFSKY 1972: Erwin Panofsky. *Studies in Iconology: Humanistic Themes in the Art of the Renaissance.* New York, 1972.

PAPILLON DE LA FERTÉ 1776: D.-P.-J. Papillon de La Ferté. *Extrait des différens ouvrages publiés sur la vie des peintres.* 2 vols. Paris, 1776. Reprint. Geneva, 1972.

PAPILLON DE LA FERTÉ 1887: D.-P.-J. Papillon de La Ferté. *L'Administration des menus. Journal de Papillon de La Ferté, intendant et contrôleur de l'argenterie, menus plaisirs, et affaires de la chambre du roi (1756–80).* Ed. E. Boysse. Paris, 1887.

PARIS 1867: Musée du Louvre, Paris. *Guide Through the Galleries of Paintings of the Imperial Museum of the Louvre.* Paris, 1867.

PARKER 1969: J. Parker. "The Hôtel de Varengeville Room and the Room from the Palais de Paar: A Magnificent Donation." *Metropolitan Museum of Art Bulletin* XXVIII/3 (November 1969), 129–46.

PARKER 1931: K. T. Parker. *The Drawings of Antoine Watteau.* London, 1931.

PARKER AND MATHEY 1957: K. T. Parker and J. Mathey. *Antoine Watteau: Catalogue complet de son oeuvre dessiné.* 2 vols. Paris, 1957.

PARNY 1799: Evariste Parny. *La Guerre des dieux anciens et modernes.* Paris, 1799.

PARTHEY 1863: G. Parthey. *Deutscher Bildersaal.* Vol. 1. Berlin, 1863.

PATTE 1765: P. Patte. *Monuments érigé à la gloire de Louis XV.* Paris, 1765.

PAULSON 1965: Ronald Paulson. *Hogarth's Graphic Works: First Complete Edition.* 2 vols. New Haven and London, 1965.

PAUSANIAS 1926: Pausanias. *Description of Greece.* 6 vols. Trans. W. H. S. Jones and H. A. Ormerod. London and New York, 1926.

PERKINS AND GAVIN 1980: Robert F. Perkins, Jr., and William J. Gavin III. *The Boston Athenaeum Art Exhibition Index, 1827–1874.* Boston, 1980.

PERNETY 1757: Antoine-Joseph Pernety. *Dictionnaire portatif de peinture, sculpture, et gravure.* Paris, 1757.

PÉROUSE DE MONTCLOS 1989: Jean-Marie Pérouse de Montclos. *Histoire de l'architecture française: De la Renaissance à la Révolution.* Paris, 1989.

PERRAULT 1692–97: Ch. Perrault. *Parralèle des anciens et des modernes.* 4 vols. Paris, 1692–97.

PERRAULT 1843: Cl. Perrault. *Mémoires, contes, et autres oeuvres.* Ed. P. L. Jacob. Paris, 1843.

PÉTRY 1989: Claude Pétry. *Le Musée des Beaux-Arts de Nancy.* Nancy, 1989.

PHILADELPHIA 1950–51: Philadelphia Museum of Art. *The Philadelphia Museum of Art Bulletin: Masterpieces from Philadelphia Private Collections, Part II.* Philadelphia, 1950–51.

PHILIPPE 1929: André Philippe. *Musée Départemental des Vosges. Catalogue de la section des beaux-arts: Peintures, dessins, sculptures.* Épinal, 1929.

PHILLIPS 1895: Claude Phillips. "Antoine Watteau." *The Portfolio,* June 1895, 1–92.

PHILLIPS 1968: Kyle M. Phillips, Jr. "Perseus and Andromeda." *American Journal of Archaeology* 72 (1968), 1–23.

PHILOSTRATUS 1931: Flavius Philostratus. *Philostratus, Imagines; Callistratus, Descriptions.* Trans. Arthur Fairbanks. London and New York, 1931.

PICARD 1952: Charles Picard. "L'Influence des antiques sur le classicism de David, Ingres, et de Delacroix." *Revue Archeologique* 40 (July–December 1952), 105–7.

PICON 1989: A. Picon. *Claude Perrault ou la curiosité d'un classique.* Paris, 1989.

PIGANIOL DE LA FORCE 1701: Jean-Aymar Piganiol de La Force. *Nouvelle description de châteaux et parcs de Versailles et de Marly.* Paris, 1701.

PIGANIOL DE LA FORCE 1742: Jean-Aymar Piganiol de La Force. *Description de Paris, de Versailles, de Marly, de S. Cloud, de Fontainebleau, et de toutes les autres belles maisons et châteaux des environs de Paris.* 8 vols. Paris, 1742.

PIGANIOL DE LA FORCE 1765: Jean-Aymar Piganiol de La Force. *Description de la ville de Paris et de ses environs.* 10 vols. Paris, 1765.

PIGLER 1956: A. Pigler. *Barockthemen.* 3 vols. Budapest, 1956. 2d ed., 1974.

PIGNATTI 1969: Terisio Pignatti. "Entre baroque et rococo." *L'Oeil* 174–75 (June–July 1969), 3–9.

PILES 1681: Roger de Piles. *Dissertation sur les ouvrages des plus fameux peintres: Le Cabinet de monseigneur le duc de Richelieu.* Paris, 1681. Reprint. Geneva, 1973.

PILES 1708: Roger de Piles. *Cours de peinture par principes.* Paris, 1708.

PILON 1912: E. Pilon. *Watteau et son école.* Paris, 1912. 2d ed., 1924.

PINETTE 1983: Matthieu Pinette. "Autun, Musée Rolin: *La Terre ou Cérès nourrissant Triptolème* par Natoire." *La Revue du Louvre et des Musées de France,* 1983, nos. 5–6, 397–98.

PITON 1904: Camille Piton. *Marly-le-Roi: Son histoire (1697–1904).* Paris, 1904.

PITOU 1983: Spire Pitou. *The Paris Opera: An Encyclopedia of Operas, Ballets, Composers, and Performers.* Vol. 1, *Genesis and Glory, 1671–1715.* Westport and London, 1983.

PITOU 1985: Spire Pitou. *The Paris Opera: An Encyclopedia of Operas, Ballets, Composers, and Performers.* Vol. 2, *Rococo and Romantic, 1715–1815.* Westport and London, 1985.

PLUCHE 1739: Abbé Noël-Antoine Pluche. *Histoire du ciel.* 2 vols. Paris, 1739.

POINSINET DE SIVRY ET AL. 1767–82: Louis Poinsinet de Sivry et al. *Le Nécrologe des hommes célèbres de France.* 17 vols. Paris, 1767–82.

POLAK 1948–49: B. H. Polak. "De invloed van enige monumenten der oudheid op het classicisme van David, Ingres, en Delacroix." *Nederlandsch Kunsthistorisch Jaarboek* 2 (1948–49), 287–315.

POLLEY ET AL. 1967: Robert L. Polley et al. *Great Art Treasures in America's Smaller Museums.* New York, 1967.

POLLOCK 1990: Griselda Pollock. "Review of Mary D. Garrard, *Artemisia Gentileschi: The Image of the Female Hero in Italian Baroque Art.*" *Art Bulletin* LXXII/3 (September 1990), 499–505.

POMMIER 1986: Edouard Pommier. "Versailles, l'image du souverain." In *Les Lieux de mémoire.* Vol. 2, *La Nation.* Ed. Pierre Nora. Paris, 1986.

PONS 1986: Bruno Pons. *De Paris à Versailles, 1699–1736: Les Sculpteurs ornemanistes parisiens et l'art décoratif des Bâtiments du Roi.* Strasbourg, 1986.

PONS 1987: Bruno Pons. "Les Cadres français du XVIIIe siècle et leurs ornements." *Revue de l'Art* 76 (1987), 41–50.

PONSONAILHE 1887: Charles Ponsonailhe. "Les Deux Ranc." *Réunion des Sociétés des Beaux-Arts des Départements à la Sorbonne* 11 (1887), 173–208.

POPULUS 1930: B. Populus. *Claude Gillot (1673–1722): Catalogue de l'oeuvre gravée.* Paris, 1930.

PORTALIS AND BÉRALDI 1880–82: Roger Portalis and Henri Béraldi. *Les Graveurs du dix-huitième siècle.* 3 vols. Paris, 1880–82. Reprint. New York, 1970.

POSNER 1971: Donald Posner. *Annibale Carracci: A Study in the Reform of Italian Painting around 1590.* 2 vols. London and New York, 1971.

POSNER 1973: Donald Posner. *Watteau: A Lady at Her Toilet.* London, 1973.

POSNER 1984: Donald Posner. *Antoine Watteau.* Ithaca, 1984.

POSNER 1988: Donald Posner. "The Source and Sense of Boucher's *Diana* in the Louvre." *Source* VIII/1 (Fall 1988), 23–27.

POSNER 1990: Donald Posner. "Mme de Pompadour as a Patron of the Visual Arts." *Art Bulletin* LXXII/1 (March 1990), 74–105.

POZZI 1932: H. L. S. Pozzi. *The French Journals of Mrs. Thrale and Doctor Johnson.* Ed. M. Tyson and H. Guppy. Manchester, 1932.

PRAGUE 1984: National Gallery, Prague. *Nǎrdon galerie v Praze.* Prague, 1984.

PROSCHWITZ 1983: Gunnar von Proschwitz. *Tableaux de Paris et de la cour de France, 1739–1742: Lettres inédites de Carl Gustaf, comte de Tessin.* Göteborg and Paris, 1983.

PUGLISI 1983: Catherine Puglisi. "A Study of the Roman-Bolognese Painter Francesco Albani." 2 vols. Ph.D. diss, New York University, 1983.

PUTTFARKEN 1985: Thomas Puttfarken. *Roger de Piles' Theory of Art.* New Haven, 1985.

Q

QUARRÉ AND GEIGER 1968: Pierre Quarré and Monique Geiger. *Musée des Beaux-Arts de Dijon: Catalogue des peintures françaises.* Dijon, 1968.

QUIMPER 1873: Musée de Quimper. *Catalogue des tableaux exposés dans les galeries du musée de la ville de Quimper dit Musée de Silguy.* Brest, 1873.

QUINAULT 1703: Philippe Quinault. *Le Triomphe de l'amour* (1681). In *Recueil général des opéra representez par l'Académie Royale de Musique depuis son établissement.* Vol. 1, 197–98. Paris, 1703. Reprint. Geneva, 1971.

QUINIOU 1976: P. Quiniou. *Musée des Beaux-Arts, Quimper.* Quimper, 1976.

R

RACINE 1950: Jean-Baptiste Racine. "Iphigénie." In *Oeuvres complètes.* Vol. 1. Paris, 1950.

RAMBAUD 1964–71: Mireille Rambaud. *Documents du minutier central concernant l'histoire de l'art (1700–1750).* 2 vols. Paris, 1964–71.

RAND 1990: Erica Rand. "Depoliticizing Women: Female Agency, the French Revolution, and the Art of Boucher and David." *Genders* 7 (1990), 46–68.

RANUM 1980: O. Ranum. *Artisans of Glory.* Chapel Hill, 1980.

RAPIN 1725: R. Rapin. *Oeuvres.* 3 vols. Paris, 1725.

RATOUIS DE LIMAY 1907: P. de Ratouis de Limay. *Un Amateur orléanais au XVIIIe siècle: Aignan-Thomas Desfriches (1715–1800).* Paris, 1907.

RAUNIÉ 1879: M.-A.-A.-E. Raunié. *Chausonnier historique du XVIIIe siècle.* 10 vols. Paris, 1879.

RAY 1990: William Ray. *Story and History: Narrative Authority and Social Identity in the Eighteenth-Century French and English Novel.* Cambridge, Mass., and Oxford, 1990.

RÉAU 1920: Louis Réau. "Le Tombeau de Mme La Live de Jully à St. Roch." *Bulletin de la Société de l'Histoire de l'Art Français,* 1920, 223–34.

RÉAU 1922: Louis Réau. "Lettres de Greuze au prince Nicolas Borisovitch Iousoupov." *Bulletin de la Société de l'Histoire de l'Art Français,* 1922, 395–99.

RÉAU 1925: Louis Réau. *Histoire de la peinture française au XVIIIe siècle.* 2 vols. Paris and Brussels, 1925.

RÉAU 1929: Louis Réau. *Catalogue de l'art français dans les musées russes.* Paris, 1929.

RÉAU 1935–36: Louis Réau. "Carle Vanloo (1705–1765)." *Archives de l'Art Français* 19 (1935–36), 7–96.

RÉAU 1956: Louis Réau. *Fragonard: Sa vie et son oeuvre.* Brussels, 1956.

RECUEIL GÉNÉRAL 1703: *Recueil général des opéra representez par l'Academie Royale de Musique.* 2 vols. Paris, 1703.

REFF 1964: Theodore Reff. "Copyists in the Louvre, 1850–1870." *Art Bulletin* XLVI/4 (December 1964), 552–59.

REINHOLD 1971: Meyer Reinhold. "The Naming of Pygmalion's Animated Statue." *The Classical Journal* LXVI/4 (April–May 1971), 316–19.

REY 1904: Auguste Rey. *Le Château de la Chevrette et Madame d'Épinay.* Paris, 1904.

REYNOLDS 1980: Graham Reynolds. *Wallace Collection Catalogue of Miniatures.* London, 1980.

RICCOBONI 1730–31: Luigi Riccoboni. *Histoire du théâtre italien, depuis la décadence de la comédie latine . . . avec des figures qui représentent leurs différens habillemens.* 2 vols. Paris, 1730–31.

RICCOBONI 1733: Luigi Riccoboni. *Diane et Endimion, ou l'amour vengé* (1721). In *Le Nouveau Théâtre italien, ou recueil général des comédies représentées par les comédiens italiens ordinaires du roi.* Vol. 1, 155–65. Paris, 1733.

RICHER 1665: L. Richer. *L'Ovide bouffon, ou les Métamorphoses travesties en vers burlesques.* Paris, 1665. 1st ed., 1649.

RIOPELLE 1990: Christopher Riopelle. "Renoir, The Great Bathers." *Philadelphia Museum of Art Bulletin,* Fall 1990, 1–41.

ROBB 1859: *Catalogue of the Collection of Paintings and Other Works of Art Belonging to James Robb, Esq.* New Orleans, 1859.

ROBERT-DUMESNIL 1835–71: Alexandre-Pierre-François Robert-Dumesnil. *Le Peintre-Graveur français.* 11 vols. Paris, 1835–71.

ROBIQUET 1938: Jean Robiquet. *La Femme dans la peinture française XVe–XXe siècle.* Paris, 1938.

ROLAND-MICHEL 1982: Marianne Roland-Michel. *Tout Watteau.* Paris, 1982 (Ullstein, 1980 and Milan, 1981).

ROLAND-MICHEL 1984 (A): Marianne Roland-Michel. *Lajoüe et l'art rocaille.* Paris, 1984.

ROLAND-MICHEL 1984 (B): Marianne Roland-Michel. *Watteau: Un Artiste au XVIIIe siècle.* Paris and London, 1984. English ed. New York, 1984.

ROLI 1977: Renato Roli. *Pittura bolognese, 1650–1800.* Bologna, 1977.

ROLLIN 1730: Charles Rollin. *De la manière d'enseigner et d'étudier les belles lettres par rapport à l'esprit et au coeur.* 4 vols. Paris, 1730.

ROLLIN 1819: Charles Rollin. *Traité des études.* (1726–28) In *Oeuvres complètes.* Vol. 17. Paris, 1819.

ROOSES 1977: Max Rooses. *L'Oeuvre de P.P. Reubens: Histoire et description de ses tableaux et dessins.* 5 vols. Soest, 1977.

ROSASCO 1975: Betsy Rosasco. "New Documents and Drawings Concerning Lost Statues from the Château of Marly." *Metropolitan Museum Journal* 10 (1975), 79–96.

ROSASCO 1986 (A): Betsy Rosasco. *The Sculpture of the Château of Marly During the Reign of Louis XIV.* New York, 1986.

ROSASCO 1986 (B): Betsy Rosasco. "A Terracotta *Aeneas and Anchises* Attributed to Laurent Guiard." *Record of the Art Museum, Princeton University* XLV/2 (1986), 3–15.

ROSENBERG 1896: A. Rosenberg. *Watteau.* Bielefeld and Leipzig, 1896.

ROSENBERG 1966: Pierre Rosenberg. *Inventaire des collections publiques françaises, 14. Rouen, Musée des Beaux-Arts: Tableaux français du XVIIème siècle et italiens des XVIIème siècles.* Paris, 1966.

ROSENBERG 1971: Pierre Rosenberg. "Note sur le cabinet de l'Amour de l'hôtel Lambert." *La Revue du Louvre et des Musées de France,* 1971, no. 3, 157–64.

ROSENBERG 1971–73: Pierre Rosenberg. "On Lemoine." *Minneapolis Institute of Arts Bulletin* 60 (1971–73), 54–59.

ROSENBERG 1972: Pierre Rosenberg. "Dessins français du XVIIe et du XVIIIe siècles dans les collections américains." *L'Oeil,* nos. 212–13 (August–September 1972) 11–15.

ROSENBERG 1977: Pierre Rosenberg. "Le Concours de peinture de 1727." *Revue de l'Art* 37 (1977), 29–42.

ROSENBERG 1984 (A): Pierre Rosenberg. *Vies anciennes de Watteau.* Paris, 1984.

ROSENBERG 1984 (B): Pierre Rosenberg. "Une Correspondance de Julien de Parme (1736–1799)." *Archives de l'Art Français* 26 (1984), 197–245.

ROSENBERG 1985: Pierre Rosenberg. "Un Pierre retrouvé." *Paragone* XXXVI/419–23 (January–May 1985), 269–73.

ROSENBERG 1989: Pierre Rosenberg. *Tout l'oeuvre peint de Fragonard.* Paris, 1989.

ROSENBERG AND JULIA 1986: Pierre Rosenberg and Isabelle Julia. "Drawings by Cazes." *Master Drawings* XXIII–XXIV/3 (Autumn 1986), 352–62.

ROSENBERG, REYNAUD, AND COMPIN 1974: Pierre Rosenberg, Nicole Reynaud, and Isabelle Compin. *Musée du Louvre, catalogue illustré des peintures: Écoles française XVII et XVIIIe siècles.* 2 vols. Paris, 1974.

ROSENBERG AND SCHNAPPER 1982–83: Pierre Rosenberg and Antoine Schnapper. "Paintings by Restout on Mythological and Historical Themes: Acquisition by the National Gallery of Canada of *Venus Presenting Arms to Aeneas.*" *National Gallery of Canada Annual Bulletin* 6 (1982–83), 42–54.

ROSENBERG AND STEWART 1987: Pierre Rosenberg and Marion C. Stewart. *French Paintings, 1500–1825, the Fine Arts Museums of San Francisco.* San Francisco, 1987.

ROSENBLUM 1967: Robert Rosenblum. *Transformations in Late Eighteenth-Century Art.* Princeton, 1967.

ROSENTHAL 1913: Léon Rosenthal. "L'Exposition de David et ses élèves au Petit Palais." *La Revue de l'Art Ancien et Moderne* 33 (January–June 1913), 337–50.

ROSS-ORRY 1977: Margaret Brudenell Ross-Orry. "Philibert Orry (1689–1747), mécène de Natoire." *La Vie en Champagne* 263 (February 1977), 5–8.

ROTH 1951: G. Roth. *Les Pseudo-Mémoires de Madame d'Épinay: Histoire de Madame de Montbrillant.* 3 vols. Paris, 1951.

ROTHKRUG 1965: L. Rothkrug. *Opposition to Louis XIV: The Political and Social Origins of the French Revolution.* Princeton, 1965.

RÖTHLISBERGER 1961: Marcel Röthlisberger. *Claude Lorrain: The Paintings.* 2 vols. New Haven, 1961.

ROUJON N.D.: Henry Roujoun. *François Boucher.* Paris, n.d.

ROUSSEAU 1753 (A): Jean-Baptiste Rousseau. *Oeuvres.* 5 vols. London, 1753.

ROUSSEAU 1753 (B): Jean-Jacques Rousseau. *Narcisse, ou l'amant de lui même.* Paris, 1753.

ROUSSEAU 1762: Jean-Jacques Rousseau. *Émile ou De l'Éducation.* Paris, 1762. *Classiques Garnier.* Paris, 1961.

ROY 1980: Alain Roy. *Les Envois de l'état au Musée de Dijon (1830–1815).* Paris, 1980.

ROY 1929: Maurice Roy. *Artistes et monuments de la renaissance en France: Recherches nouvelles et documents inédits.* Paris, 1929.

RUBIN 1978: James Henry Rubin. "Endymion's Dream as a Myth of Romantic Inspiration." *Art Quarterly,* Spring 1978, no. 1, 47–84.

RUCH 1964: John E. Ruch. "An Album of Early Drawings by François Boucher." *Burlington Magazine* CVI/740 (November 1964), 496–99.

RUIZ 1983: Jean-Claude Ruiz. "Meaux. Musée Bossuet: Enrichissements du XVIIIe siècle." *La Revue du Louvre et des Musées de France,* 1983, nos. 5–6, 392–94.

RUTLEDGE 1955: Anna Wells Rutledge. *Cumulative Record of Exhibition Catalogues: The Pennsylvania Academy of the Fine Arts 1807–1870; The Society of Artists, 1800–1814; The Artists' Fund Society, 1835–1845.* Philadelphia, 1955.

RYSZKIEWICZ 1967: Andrzej Ryszkiewicz. *Francusko-Polskie zwiazki artystyczne w kregu J. L. Davida.* Warsaw, 1967.

S

SABA 1988: Guido Saba. "L'Epître d'Actéon à Diane de Théophile de Viau: Lettre héroique et/ou nouvelle psychologique à la première personne." In *Ouverture et dialogue: Mélanges offerts à Wolfgang Leiner à l'occasion de son soixantième anniversaire.* Tubingen, 1988.

SAHUT 1973: Marie-Catherine Sahut. *Le Peintre Louis Galloche (1670–1761).* Mémoire de maîtrise, Université de Paris-Sorbonne, 1973.

SAINT-AMANT 1971: Marc Antoine-Gérard de Saint-Amant. *Oeuvres.* Vol. 1. Paris, 1971.

SAINT-ÉTIENNE 1981: Musée d'Art et d'Industrie de Saint-Étienne. *Catalogue raisonné du Musée d'Art et d'Industrie de Saint-Étienne.* Saint-Étienne, 1981.

SAINT-GEORGES 1858: Henri de Saint-Georges. *Notice historique sur le musée de peinture de Nantes d'après des documents officiels et inédits.* Nantes and Paris, 1858.

SAINT-GROUX 1907: André de Saint-Groux. "La Collection Ch. Sedelmeyer." *Les Arts* 64 (April 1907), 33–40.

SAINT-QUENTIN 1856: Musée de Saint-Quentin. *Notice historique et biographique sur Maurice Quentin Delatour suivie du catalogue du musée et du programme de la fête.* Saint-Quentin, 1856.

SAINT-SIMON 1879–1930: L. de Rouvroy, duc de Saint-Simon. *Mémoires de M. le duc de Saint-Simon.* Ed. J. L. Giraud Soulavie. 8 vols. Paris, 1879–1930.

SAINTE-BEUVE 1953–55: Charles-Augustin Sainte-Beuve. *Port-Royal.* 3 vols. Paris, 1953–55.

SAINTE-FARE-GARNOT 1988: Pierre-Nicolas Sainte-Fare-Garnot. *Le Décor des Tuileries sous le règne de Louis XIV.* Paris, 1988.

SAINTE-MARIE 1977: Jean-Pierre Sainte-Marie. "Charles-Joseph Natoire et la Chapelle-Godefroy." *La Vie en Champagne* 263 (February 1977), 14–20.

SAISSELIN 1979: R. G. Saisselin. "Painting and Writing: From the Poetry of Painting to the Writing of the *dessin idéal.*" *Eighteenth-Century Studies* XX/2 (Spring 1979), 121–47.

SAISSELIN 1981: R. G. Saisselin. "Neo-Classicism: Images of Public Virtue and Realities of Private Luxury." *Art History* IV/1 (March 1981), 14–36.

SALONS 1673–1881: *Catalogues of the Paris Salon, 1673 to 1881.* Ed. H.W. Janson. 60 vols. New York and London, 1977–78.

SAMOYAULT-VERLET 1975: Colombe Samoyault-Verlet. "Précisions iconographiques sur trois décors de la seconde école de Fontainebleau." In *Actes du colloque internationale sur l'art de Fontainebleau,* 241–47. Paris, 1975.

SANDER 1872: Fredrik Sander. *Nationalmuseum bidrag till taflegalleriets historia.* Vol. 1, *Riksrädet grefve Carl Gustaf Tessins, konung Adolf Fredriks och Drottning Louisa Ulrikas taflesamlingar.* Stockholm, 1872.

SANDOZ 1961: Marc Sandoz. "Louis-Jean-François Lagrenée, dit l'ainé (1725–1805), peintre d'histoire." *Bulletin de la Société de l'Histoire de l'Art Français,* 1961, 115–36.

SANDOZ 1963: Marc Sandoz. "The Drawings of Louis-Jean-François Lagrenée: Notes for a Tentative Catalogue Raisonne." *The Art Quarterly,* Spring 1963, 47–70.

SANDOZ 1967: Marc Sandoz. "Tableaux retrouvés de Jean-Baptiste Deshays, Gabriel Doyen et Louis Lagrenée (l'ainé)." *Bulletin de la Société de l'Histoire de l'Art Français,* 1967, 109–22.

SANDOZ 1975: Marc Sandoz. *Gabriel-François Doyen (1726–1806).* Paris, 1975.

SANDOZ 1983: Marc Sandoz. *Les Lagrenée.* Vol. 1, *Louis (Jean, François) Lagrenée, 1725–1805.* Paris, 1983.

SANI 1985: Bernardina Sani. *Rosalba Carriera: Lettere, diari, frammenti.* 2 vols. Florence, 1985.

SANS 1983–84: Jérôme Sans. "Jean-Michel Alberola." *Flash Art France* 2 (Winter 1983–84), 60–62.

SARTRE 1943: Jean-Paul Sartre. *L'Etre et le néant.* Paris, 1943.

SASLOW 1986: James M. Saslow. *Ganymede in the Renaissance: Homosexuality in Art and Society.* New Haven and London, 1986.

SAUNIER 1913: Charles Saunier. "David et son école au Palais des Beaux-Arts de la ville de Paris (Petit Palais)." *Gazette des Beaux-Arts* 9 (1913), 271–90.

SCHLAM 1984: Carl Schlam. "Diana and Actaeon: Metamorphoses of a Myth." *Classical Antiquity* 3 (April 1984), 82–110.

SCHNAPPER 1962: Antoine Schnapper. "De Nicolas Loir à Jean Jouvenet." *La Revue du Louvre et des Musées de France,* 1962, no. 3, 115–22.

SCHNAPPER 1967: Antoine Schnapper. *Tableaux pour le Trianon de Marbre, 1688–1714.* Paris, Mouton, and The Hague, 1967.

SCHNAPPER 1968 (A): Antoine Schnapper. "Le Grand Dauphin et les tableaux de Meudon." *Revue de l'Art* 1–2 (1968), 57–64.

SCHNAPPER 1968 (B): Antoine Schnapper. "The Age of Louis XIV: A New Look." *Apollo,* November 1968, 341–45.

SCHNAPPER 1968 (C): Antoine Schnapper. "Musées de Lille et de Brest, a propos de deux nouvelles acquisitions: *Le Chef-d'Oeuvre d'un muet* ou la tentative de Charles Coypel." *La Revue du Louvre et des Musées de France*, 1968, nos. 4–5, 253–64.

SCHNAPPER 1969: Antoine Schnapper. "Antoine Coypel: La Galerie d'Énée au Palais-Royal." *Revue de l'Art* 5 (1969), 33–42.

SCHNAPPER 1972: Antoine Schnapper. "Musée de Saint-Étienne, a propos d'un tableau de N. Bertin." *La Revue du Louvre et des Musées de France*, 1972, nos. 4–5, 357–60.

SCHNAPPER 1974: Antoine Schnapper. *Jean Jouvenet, 1644–1712 et la peinture d'histoire à Paris*. Paris, 1974.

SCHNAPPER 1975: Antoine Schnapper. "Louis Lagrenée and the Theme of Pygmalion." *Bulletin of the Detroit Institute of Arts* LIII/3–4 (1975), 112–17.

SCHNAPPER 1978: Antoine Schnapper. "Plaidoyer pour un absent: Bon Boullogne (1649–1717)." *Revue de l'Art* 40–41 (1978), 121–40.

SCHNAPPER 1979–80: Antoine Schnapper. "The Moses of Antoine Coypel." *Allen Memorial Art Museum Bulletin* XXXVII/2 (1979–80), 59–70.

SCHNAPPER 1980: Antoine Schnapper. *David témoin de son temps*. Fribourg, 1980. English ed., New York.

SCHNAPPER 1991: Antoine Schnapper. "Après l'exposition David: La Psyché retrouvée." *Revue de l'Art* 91 (1991), 60–67.

SCHNAPPER AND GUICHARNAUD 1986: Antoine Schnapper and Hélène Guicharnaud. *Louis de Boullogne, 1654–1733*. Paris, 1986.

SCHNEIDER 1987: Mechthild Schneider. "Pygmalion-Mythos des Schöpferischen Künstlers." *Pantheon* 45 (1987), 111–23.

SCHNEIDER 1912: René Schneider. "Le Mythe de Psyché dans l'art français depuis la révolution." *Revue de l'Art Ancien et Moderne* 32 (1912), 241–54, 363–78.

SCHNEIDER 1926: René Schneider. *L'Art français: Dix-huitième siècle*. Paris, 1926.

SCHÖNBERGER AND SOEHNER 1960: Arno Schönberger and Halldor Soehner. *The Rococo Age: Art and Civilization of the 18th Century*. Trans. Daphne Woodward. New York, 1960.

SCHOTTKY 1833: Julius Max Schottky. *Münchens Öffentliche Kunstschätze im Gebiete der Malerei*. Munich, 1833.

SCOTT 1988: Rachael Katherine Hannah Scott. "Decoration and Cultural Distinction in Paris, c. 1680–c. 1750." Ph.D. diss., University of London, 1988.

SCUDÉRY 1983: Georges de Scudéry. *Poésies diverses*. Vol. 1. Fasano di Puglia and Paris, 1983.

SÉAILLES 1927: Gabriel Séailles. *Watteau*, Paris, 1927.

SEDELMEYER 1906: Sedelmeyer Gallery. *Illustrated Catalogue of the Tenth Series of 100 Paintings by Old Masters*. Paris, 1906.

SEDELMEYER 1914: Sedelmeyer Gallery. *Illustrated Catalogue of the Eighteenth Series of 100 Paintings by Old Masters*. Paris, 1914.

SEELIG 1972: Lorenz Seelig. "L'Inventaire après-décès de Martin van den Bogaert dit Desjardins, sculpteur ordinaire du Roi (7 août 1694)." *Bulletin de la Société de l'Histoire de l'Art Français*, 1972, 161–82.

SEGRAIS 1700: Jean Regnault de Segrais. *Traduction de L'Énéide de Virgile*. 2d ed. Amsterdam, 1700.

SELIGMAN 1961: Germain Seligman. *Merchants of Art, 1880–1960: Eighty Years of Professional Collecting*. New York, 1961.

SENNETT 1974: R. Sennett. *The Fall of Public Man*. Cambridge, 1974.

SENSIER 1865: Alfred Sensier, ed. *Journal de Rosalba Carriera*. Paris, 1865.

SERRÉ DES RIEUX 1734: Jean de Serré des Rieux. "Diane, ou les loix de la chasse du cerf." In *Les Dons des enfants de Latone*. Paris, 1734.

SERRE AND LEEGENHOEK 1988: Jean-Claude Serre and Jacques Leegenhoek. *Jean-Claude Serre et Jacques Leegenhoek proposent exposition de tableaux des XVIIe et XVIIIe siècles du 21 septembre au 20 décembre 1988*. Paris, 1988.

SEZNEC 1953: Jean J. Seznec. *The Survival of the Pagan Gods: The Mythological Tradition and its Place in Renaissance Humanism and Art*. Trans. B. F. Sessions. New York, 1953.

SEZNEC 1955: Jean J. Seznec. "Diderot et les plagiats de Monsieur Pierre." *La Revue des Arts*, June 1955, 67–74.

SHERIFF 1990: Mary D. Sheriff. *Fragonard: Art and Eroticism*. Chicago, 1990.

SHOOLMAN AND SLATKIN 1950: Regina Shoolman and Charles E. Slatkin. *Six Centuries of French Master Drawings in America*. New York, 1950.

SIEFERT 1988: Helge Siefert. *Themen aus Homers Ilias in der Französischen Kunst (1750–1831)*. Munich, 1988.

SLUIJTER 1980–81: Eric J. Sluijter. "Depiction of Mythological Themes." In exh. Washington, Detroit, and Amsterdam, 1980–81, 55–64.

SLUIJTER 1985: Eric J. Sluijter. "Some Observations on the Choice of Narrative Mythological Subjects in Late Mannerist Painting in the Northern Netherlands." In *Netherlandish Mannerism*. Stockholm, 1985.

SMITH 1979: Anthony D. Smith. "The 'Historical Revival' in Late 18th-Century England and France." *Art History* II/2 (June 1979), 156–78.

SNOEP 1969: D.P. Snoep. "Honselaersdijk: Restauraties op papier." *Oud Holland* 84 (1969), 270–94.

SNYDERS 1965: G. Snyders. *La Pédagogie en France au XVIIe et XVIIIe siècles*. Paris, 1965.

SOUBEYRAN AND VILAIN 1975: Françoise Soubeyran and Jacques Vilain. "Gabriel Bouquier: Critique du Salon de 1775." Includes publication of Bouquier's *Observations critiques sur le Salon de 1775*. *La Revue de Louvre et des Musées de France*, 1975, no. 2, 95–104.

SOUCHAL 1969: François Souchal. "Jean Aubert, architecte des Bourbon-Condé." *Revue de l'Art* 6 (1969), 29–38.

SOUCHAL 1977–87: François Souchal. *French Sculptors of the 17th and 18th Centuries*. 3 vols. Trans. Elsie and George Hill. Oxford, 1977–87.

SOULIÉ 1852: E. Soulié. *Notice des peintures et sculptures placées dans les appartements et dans les jardins des Palais de Trianon*. Versailles, 1852.

SPEAR 1982: Richard Spear. *Domenichino*. 2 vols. New Haven and London, 1982.

SPENSER 1938: Edmund Spenser. *The Faerie Queen*. Vol. 6. Baltimore, 1938.

STALEY 1902: Edgcumbe Staley. *Watteau and His School*. London, 1902.

STANDEN 1964: Edith Standen. "The *Sujet de la fable* Gobelins Tapestries." *Art Bulletin* XLVI/2 (June 1964), 143–57.

STANDEN 1975 (A): Edith Standen. "The Memorable Judgment of Sancho Panza: A Gobelins Tapestry in the Metropolitan Museum." *Metropolitan Museum Journal* 10 (1975), 97–106.

STANDEN 1975 (B): Edith Standen. "The Tapestries of Diane de Poitiers." In *Actes du colloque internationale sur l'art de Fontainebleau*, 87–98. Paris, 1975.

STANDEN 1984–85: Edith Standen. "The *Amours des dieux*: A Series of Beauvais Tapestries after Boucher." *Metropolitan Museum Journal* 19–20 (1984–85), 63–84.

STANDEN 1988: Edith Standen. "Ovid's Metamorphoses: A Gobelins Tapestry Series." *Metropolitan Museum Journal* 23 (1988), 149–91.

STANTON 1980: D. C. Stanton. *The Aristocrat as Art: A Study of the "honnête homme" and the Dandy in Seventeenth- and Nineteenth-Century French Literature*. New York, 1980.

STAROBINSKI 1964: Jean Starobinski. "Psychanalyse et connaissance littéraire" (1964). In *L'Oeil vivant 2: La Relation critique*, 257–85. Paris, 1970.

STAROBINSKI 1977: Jean Starobinski. "Le Mythe au XVIIIe siècle." *Critique*, no. 366 (November 1977), 975–997.

STAROBINSKI 1981: Jean Starobinski. "Fable et mythologie, aux XVIIe et XVIIIe siècles: Dans la littérature et la réflexion theorique." In *Dictionnaire des mythologies et des religions des sociétés traditionnelles et du monde antique*. Vol. 1. Paris, 1981, 390–400.

STAROBINSKI 1989: Jean Starobinski. *Le remède dans le mal: Critique et legitimation de l'artifice à l'âge des lumières*. Paris, 1989.

STEADMAN 1963: John M. Steadman. "Falstaff as Actaeon: A Dramatic Emblem." *Shakespeare Quarterly* 14 (1963), 231–44.

STEIN 1913: Henri Stein. "La Société des Beaux-Arts de Montpellier (1779–1787)." In *Mélanges offerts à M. Henry Lemonnier*. Special edition of *Archives de l'Art Français*, no. 7 (1913).

STEPHENS 1978: F. G. Stephens. *Catalogue of Political and Personal Satires Preserved in the Department of Prints and Drawings in the British Museum*. Vol. 2 (1689–1733). London, 1978.

STERLING 1958: Charles Sterling. *Great French Paintings in the Hermitage*. Trans. Christopher Ligota. New York, 1958.

STEWART 1990: Andrew Stewart. *Greek Sculpture: An Exploration*. 2 vols. New Haven and London, 1990.

STOCKHOLM 1867: Nationalmuseum, Stockholm. *Förteckning öfver oljefärgstaflor . . . i National-Museum*. Stockholm, 1867.

STOCKHOLM 1920: Nationalmuseum, Stockholm. *Utställning av fransk sjuttonhundratalskonst, ur Nationalmusei samlingar vid kulturmässan i Östersund*. Stockholm, 1920.

STOCKHOLM 1928: Nationalmuseum, Stockholm. *Catalogue descriptif des collections de peintures du Musée National: Maîtres étrangers (à l'exclusion des Scandinaves)*. Stockholm, 1928.

STOCKHOLM 1948: Nationalmuseum, Stockholm. *Nationalmusei franska samling*. Stockholm, 1948.

STOCKHOLM 1958: Nationalmuseum, Stockholm. *Äldre utländska malningar och skulptures*. Stockholm, 1958.

STOCKHOLM 1990: Nationalmuseum, Stockholm. *Nationalmuseum Stockholm: Illustrerad katalog över äldre utländskt maleri*. Västervik, 1990.

STRÖMBOM 1951: Sixten Strömbom. *Masterpieces of the Swedish National Museum*. Trans. William Cameron. Stockholm, 1951.

STRYIENSKI 1903: Casimir Stryienski. "Le Salon de 1761 d'après le catalogue illustré par Gabriel de Saint-Aubin." *Gazette des Beaux-Arts*, 1903, 280–98.

STRYIENSKI 1912: Casimir Stryienski. "Le Musée d'Art et d'Histoire de Genève." *Les Arts* 131 (November 1912), 1–32.

STUFFMANN 1964: Margret Stuffmann. "Charles de La Fosse et sa position dans la peinture française à la fin de XVIIe siècle." *Gazette des Beaux-Arts* 64 (July–August 1964), 1–121.

STUFFMANN 1968: Margret Stuffmann. "Les Tableaux de la collection de Pierre Crozat, historique et destinée d'un ensemble célèbre, établis en partant d'un inventaire après décès inédit (1740)." *Gazette des Beaux-Arts* 72 (July–September 1968), 11–144.

SUMOWKSI 1983: Werner Sumowski. *Gemälde der Rembrandt-Schüler*. 5 vols. Landau, 1983.

T

TABARANT 1947: Adolphe Tabarant. *Manet et ses oeuvres*. Paris, 1947.

TALBOT 1974: William Talbot. "Jean-François de Troy: *Pan and Syrinx*." *Bulletin of The Cleveland Museum of Art* 61 (1974), 250–59.

TALLEMANT DES RÉAUX 1961: Gédéon Tallemant des Réaux. *Historiettes*. Vol 2. Paris, 1961.

TANNER 1974: Marie Tanner. "Chance and Coincidence in Titian's *Diana and Actaeon*." *Art Bulletin* LVI/4 (December 1974), 535–50.

TEICHLEIN 1875: A. Teichlein. *Gemälde-Verzeichnis der Königl. Bayer. Staats-Galerie in Schleissheim*. Munich, 1875.

TELLIER 1987: N. L. Tellier. *Face aux Colbert. Les Le Tellier, Vauban, Turgot . . . et l'avènement du libéralisme*. Quebec, 1987.

TERVARENT 1967: Guy de Tervarent. *Présence de Virgile dans l'art*. Vol. 12. Académie Royale de Belgique, Classe des Beaux-Arts, *Mémoires*. Brussels, 1967.

TESTELIN 1696: Henri Testelin. *Sentimens des plus habiles peintres sur la pratique de la peinture et sculpture mis en tables de preceptes, avec plusieurs discours academiques*. Paris, 1696.

TEYSSÈDRE 1963: Bernard Teyssèdre. "Une Collection française de Rubens au XVIIe siècle: Le Cabinet du duc de Richelieu, décrit par Roger de Piles (1676–1681)." *Gazette des Beaux-Arts* 62 (November 1963), 241–300.

THIEME AND BECKER 1907–50: Ulrich Thieme and Felix Becker. *Allgemeines Lexikon der Bildenden Künstler von der Antike bis zur Gegenwart*. 37 vols. Leipzig, 1907–50.

THIENESONN 1825: Carl Thienesonn. *Die Königliche Gemälde-Galerie in München*. Munich, 1825.

THIÉRY 1784: Luc Vincent Thiéry. *Almanach du voyageur à Paris, contenant une description exacte and interessante de tous les monumens, chefs-d'oeuvre des arts, etablissemens utiles, et autres objets de curiosité que renferme cette capitale*. Paris, 1784.

THIÉRY 1787: Luc Vincent Thiéry. *Guide des amateurs et des étrangers voyageurs à Paris, ou description raisonnée de cette ville, de sa banlieue, et de tout ce qu'elles contiennent de remarquable*. 2 vols. 1787.

THIÉRY 1788: Luc Vincent Thiéry. *Guide des amateurs et des étrangers voyageurs dans les maisons royales, châteaux, lieux de plaisance, établissemens publics, villages, et sejours les plus renommés. Aux environs de Paris*. Paris, 1788.

THIRION 1905: Henri Thirion. *Madame de Prie (1698–1727)*. Paris, 1905.

THIRY 1979: Anne Thiry. "L'Hôtel Peirenc de Moras, puis de Boullongne, 23, place Vendôme, architecture et décoration intérieure." *Bulletin de la Société de l'Histoire de Paris*, 1979, 52–84.

THOMASSIN 1681: Père Louis Thomassin. *Méthode d'étudier et d'enseigner chrétiennement et solidement les lettres humaines par rapport aux lettres divines et aux écritures*. Paris, 1681.

THOMÉ 1826: M.-A. Thomé. *Vie de David*. Paris, 1826.

THOMPSON 1956: Graves H. Thompson. "The Literary Sources of Titian's *Bacchus and Ariadne*." *The Classical Journal* LI/6 (March 1956), 259–64.

THOMPSON AND BRIGSTOCKE 1970: Colin Thompson and Hugh Brigstocke. *National Gallery of Scotland: Shorter Catalogue*. Edinburgh, 1970.

THUILLIER 1988: Jacques Thuillier. "L'Influence des Carrache en France: Pour un premier bilan." In *Les Carrache et les décors profanes*. Actes du colloque, organisé par l'École Française de Rome, 421–55. Rome, 1988.

THUILLIER AND CHÂTELET 1964: Jacques Thuillier and Albert Châtelet. *French Painting from Le Nain to Fragonard*. Trans. James Emmons. Geneva, 1964.

TOBIN 1981: Ronald W. Tobin. "Le Mythe d'Hercule au XVIIe siècle." In *La Mythologie au XVIIe siècle*, ed. Calude Faisant, 83–90. 11th Colloque, Centre Méridional de Rencontres sur le XVIIe siècle, 1981.

TOLEDANO AND FULTON 1968: Roulhac B. Toledano and W. Joseph Fulton. "Portrait Painting in Colonial and Ante-Bellum New Orleans." *Antiques*, June 1968, 788–95.

TOMLINSON 1989: Janis A. Tomlinson. *Francisco Goya: The Tapestry Cartoons and Early Career at the Court of Madrid*. Cambridge, 1989.

TOMLINSON 1981: R. Tomlinson. *La Fête galante: Watteau et Marivaux*. Geneva, 1981.

TOMOBE 1981: Naoshi Tomobe. *Shinwa Diana to bishintachi* (Mythologie: Déesses et trois Graces). Vol. 2 of *Bijutsu no naka no rafu* (Nu féminin dans l'art). Tokyo, 1981.

TOURNEUX 1877–82: Maurice Tourneux. *Correspondance littéraire, philosophique, et critique par Grimm, Diderot, Raynal, Meister, etc*. 16 vols. Paris, 1877–82.

TRESSIDER 1988: Warren Tressider. "The Stag's Skull and the Iconography of Titian's *Diana and Actaeon*." *Revue d'Art Canadienne* XV/2 (1988), 145–47.

TRINQUET 1968: Roger Trinquet. "Le Bain de Diane du Musée de Rouen." *Gazette des Beaux-Arts* 71 (January 1968), 1–16.

TRIPIER LE FRANC 1880: J. Tripier Le Franc. *Histoire de la vie et de la mort du Baron Gros*. Paris, 1880.

TRISTAN L'HERMITE 1925: François Tristan l'Hermite. *Les Amours*. Paris, 1925.

TROYES 1850: Musée de Troyes. *Notice sur les collections dont se compose le Musée de Troyes*. Troyes, 1850.

TROYES 1864: Musée de Troyes. *Notice sur les collections dont se compose le Musée de Troyes.* Troyes, 1864.

TROYES 1879: Musée de Troyes. *Catalogue du Musée de Troyes.* Troyes, 1879. 2d ed., 1882.

TROYES 1886: Musée de Troyes. *Catalogue du Musée de Troyes.* Troyes, 1886. 2d ed., 1894.

TROYES 1897: Musée de Troyes. *Catalogue du Musée de Troyes.* Troyes, 1897.

TROYES 1907: Musée de Troyes. *Catalogue des tableaux exposés au Musée de Troyes.* Troyes, 1907.

TROYES 1911: Musée de Troyes. *Catalogue des tableaux exposés au Musée de Troyes.* Troyes, 1911.

TUETEY 1901: L. Tuetey. "Procès-Verbaux de la commission des monuments (8 Novembre 1790–27 Aout 1793)." *Nouvelles Archives de l'Art Français* 17 (1901), 1–374.

TUETEY 1902: L. Tuetey. "Procès-Verbaux de la commission des monuments: Tome II. 1er Septembre 1793–16 Mars 1794." *Nouvelles Archives de l'Art Français* 18 (1902), 1–387.

TUETEY AND GUIFFREY 1909: Alexandre Tuetey and Jean Guiffrey. "La Commission du museum et la création du Musée du Louvre (1792–1793)." *Archives de l'Art Français* 3 (1909), 1–481.

TULARD 1989: Jean Tulard, ed. *Dictionnaire Napoléon.* Paris, 1989.

TYVAERT 1974: M. Tyvaert. "L'Image du roi: Légitimité et moralité royale dans les histoires de France au XVIIe siècle." *Revue d'Histoire Moderne et Contemporaine* 21 (October–December 1974), 521–47.

V

VACQUIER 1909: J. Vacquier. *Ancien hôtel du Maine et de Biron en dernier lieu établissement des dames du Sacré-Coeur.* Paris, 1909.

VALENCIENNES 1800: Pierre-Henri de Valenciennes. *Éléments de perspective pratique à l'usage des artistes suivis de réflexions et conseils à un élève sur la peinture et particulièrement sur le genre du paysage.* Paris, 1800. 2d ed. Paris, 1820. Reprint. Geneva, 1973.

VALENTINER 1956: W. R. Valentiner. *North Carolina Museum of Art: Catalogue of Paintings Including Three Sets of Tapestries.* Raleigh, 1956.

VALLERY-RADOT 1953: Jean Vallery-Radot. *Le Dessin français au XVIIe siècle.* Lausanne, 1953.

VAN DER KEMP 1967: G. Van der Kemp. "Musée de Versailles et des Trianons: La Restauration du Grand Trianon." *La Revue du Louvre et des Musées de France,* 1967, no. 1, 177–88.

VAN OERTZEN 1924: A. Van Oertzen. "Einrichtung der Münchner Gemälde Galerien durch Mannlich und Dillis." *Museumskunde* 17 (1924).

VAN WICQUEFORT 1673: Abraham Van Wicquefort. *Advis fidelle aux véritables hollandois touchant ce qui s'est passé dans les villages de Bodegrave et Swammerdam, et les cruautés inouïes que les françois y ont exercées, avec un mémoire de la dernière marche de l'armée du roy de France en Brabant et en Flandre.* The Hague, 1673.

VERGNET-RUIZ AND LACLOTTE 1965: Jean Vergnet-Ruiz and Michel Laclotte. *Great French Paintings from the Regional Museums of France.* Trans. Norbert Guterman. New York, 1965.

VIAU 1987: Théophile de Viau. *Oeuvres complètes.* Vol. 4. Paris and Rome, 1987.

VICKERS 1981: Nancy J. Vickers. "Diana Described: Scattered Woman and Scattered Rhyme." *Critical Inquiry* 8 (1981), 265–79.

VICKERS 1985: Nancy J. Vickers. "The Mistress in the Masterpiece." In *The Poetics of Gender.* New York, 1985, 19–41.

VIELCASTEL 1853–55: Horace de Vielcastel. "Travaux à Meudon en 1700." *Archives de l'Art Français,* 1853–55, 46–48.

VILAIN 1972: Jacques Vilain. "Peintures de l'école française du XVIIIe siècle." *La Revue du Louvre et des Musées de France,* 1972, nos. 4–5, 349–54.

VILAIN 1980: Jacques Vilain. "A propos de quelques dessins français de la période néoclassique." In *La Donation Suzanne et Henri Baderou au Musée de Rouen: Peintures et dessins de l'école française. Études de La Revue du Louvre et des Musées de France,* 1980, no. 1, 113–18.

VILAIN 1983: Jacques Vilain. "Tableaux de dessins du XVIIIe siècle français: Pour une politique d'acquisition." *La Revue du Louvre et des Musées de France,* 1983, nos. 5–6, 383–88.

VILLOT 1857: Frédéric Villot. *Notice des tableaux exposés dans les galeries du Musée Impérial du Louvre.* Paris, 1857. 9th ed., 1878.

VINGE 1967: Louise Vinge. *The Narcissus Theme in Western European Literature up to the Early 19th Century.* Lund, 1967.

VIRGIL 1913: Virgil. "The Eclogues." In *The Idylls of Theocritus and the Eclogues of Virgil.* Trans. C. S. Calverley. London, 1913.

VIRGIL 1954: Virgil. *The Aeneid.* Trans. H. Rushton Fairclough. Cambridge, Mass., and London, 1954.

VITRY 1911: Paul Vitry. *Catalogue du Musée de Tours.* Paris, 1911.

VITZTHUM 1966: Walter Vitzthum. "La Galerie de l'hôtel La Vrillière." *L'Oeil* 144 (December 1966), 24–32.

VOITURE 1971: Vincent Voiture. *Poésies.* Vol. 1. Paris, 1971.

VOLLEN 1982: Gene E. Vollen. *The French Cantata: A Survey and Thematic Catalogue.* Ann Arbor, 1982.

VOLTAIRE 1877–85: François-Marie Arouet de Voltaire. *Oeuvres complètes.* 52 vols. Paris, 1877–85.

VOLTAIRE 1963: François-Marie Arouet de Voltaire. *Correspondance.* Vol. 1. Paris, 1963.

VOSS 1953: Hermann Voss. "François Boucher's Early Development." *Burlington Magazine* XCV/600 (March 1953), 81–93.

VOSS 1954: Hermann Voss. "Boucher's Early Development—Addenda." *Burlington Magazine* XCVI/616 (July 1954) 206–10.

W

WALL 1988: Kathleen Wall. *The Callisto Myth from Ovid to Atwood: Initiation and Rape in Literature.* Kingston and Montreal, 1988.

WALLACE COLLECTION 1968: Wallace Collection. *Wallace Collection Catalogues: Pictures and Drawings.* London, 1968.

WALTON 1986: Guy Walton. *Louis XIV's Versailles.* Chicago, 1986.

WARD 1983: Roger Ward. "A Drawing for Boucher's *Jupiter and Callisto* at Kansas City." *Burlington Magazine* CXXV/969 (December 1983), 753.

WASHINGTON 1965: National Gallery of Art, Washington. *Summary Catalogue of European Paintings and Sculpture.* Washington, 1965.

WASHINGTON 1968: National Gallery of Art, Washington. *European Paintings and Sculpture.* Washington, 1968.

WASHINGTON 1975: National Gallery of Art, Washington. *European Paintings: An Illustrated Summary Catalogue.* Washington, 1975.

WATELET AND LÉVESQUE 1792: Claude-Henri Watelet and Pierre-Charles Lévesque. *Dictionnaire des arts de peinture, sculpture, et gravure.* 5 vols. Paris, 1792. Reprint. Geneva, 1972.

WATSON 1950: F. J. B. Watson. "A Note on Some Missing Works by de Troy." *Burlington Magazine* XCII/563 (February 1950), 50–53.

WATSON 1979: Paul F. Watson. *The Garden of Love in Tuscan Art of the Early Renaissance.* Philadelphia and London, 1979.

WEIGERT 1932: Roger-Armand Weigert. "Notes de Nicodème Tessin le jeune, relatives à son séjour a Paris en 1687." *Bulletin de la Société de l'Histoire de l'Art Français,* 1932, 220–89.

WEIGERT AND HERNMARCK 1964: Roger-Armand Weigert and Carl Hernmarck, eds. *Les Relations artistiques entre la France et la Suède, 1693–1718: Nicodème Tessin le jeune et Daniel Cronström correspondance (extraits).* Stockholm, 1964.

WETHEY 1969–75: Harold E. Wethey. *The Paintings of Titian.* 3 vols. London, 1969–75.

WILDENSTEIN 1964: Daniel Wildenstein. "L'Oeuvre gravé des Coypel." *Gazette des Beaux-Arts* 63 (May–June 1964), 261–74; 64 (September 1964), 140–52.

WILDENSTEIN 1973: Daniel and Georges Wildenstein. *Documents complémentaires au catalogue de l'oeuvre de Louis David.* Paris, 1973.

WILDENSTEIN AND MANDEL 1972: Daniel Wildenstein and G. Mandel. *L'Opera completa di Fragonard.* Milan, 1972.

WILDENSTEIN 1921: Georges Wildenstein. "L'Exposition Fragonard au pavillon de Marsen." *Renaissance de l'Art Français* 7 (July 1921), 357.

WILDENSTEIN 1923: Georges Wildenstein. "Deux tableaux de Fragonard au Musée d'Angers." *Beaux-Arts* (1 May 1923), 120–22.

WILDENSTEIN 1924 (A): Georges Wildenstein. *Lancret.* Paris, 1924.

WILDENSTEIN 1924 (B): Georges Wildenstein. *Le Salon de 1725.* Paris, 1924.

WILDENSTEIN 1960: Georges Wildenstein. *The Paintings of Fragonard.* Trans. C. W. Chilton and A. L. Kitson. Garden City, 1960.

WILLK-BROCARD 1983: N. Willk-Brocard. "Bacchanale ou *Les Dangers du vin,* par Noël Hallé (1711–1781)." *La Revue du Louvre et des Musées de France,* 1983, nos. 5–6, 390–92.

WILSON 1939: Elkin Calhoun Wilson. *England's Eliza.* Cambridge, Mass., 1939.

WINTER 1983: John F. Winter. "Les Horaces chez Corneille et les Horaces chez David: Un Aspect de l'évolution des idées du XVIIe au XVIIIe siècle." In *Iconographie et littérature d'un art à l'autre,* 121–32. Paris, 1983.

WITTKOWER 1981: Rudolph Wittkower. *Gian Lorenzo Bernini: The Sculptor of the Roman Baroque.* 3rd ed. Oxford, 1981.

Y

YARDENI 1973: M. Yardeni. "Journalisme et histoire contemporaine à l'époque de Bayle." *History and Theory* 12 (1973), 208–29.

YARNALL AND GERDTS 1986: James L. Yarnall and William H. Gerdts. *The National Museum of American Art's Index to American Art Exhibition Catalogues from the Beginning through the 1876 Centennial Year.* 6 vols. Boston, 1986.

Z

ZAFRAN 1980: Eric M. Zafran. "Charles Antoine Coypel's *Painting Ejecting Thalia.*" *Apollo,* April 1980, 280–87.

ZERNER 1969: Henri Zerner. *The School of Fontainebleau, Etchings and Engravings.* Trans. Stanley Brown. London, 1969.

ZIMMERMANN 1912: E. H. Zimmermann. *Watteau.* Stuttgart and Leipzig, 1912, (Paris, 1912 and New York, 1913).

ZOLTOWSKA 1974: Maria-Evelina Zoltowska. "La Première critique d'art écrite par un polonais: *Lettre d'un étranger sur le Salon de 1787* de Stanislas Kostka Potocki." *Dix-Huitième Siècle* 6 (1974), 325–41.

EXHIBITIONS

ATLANTA 1983
The Rococo Age. High Museum of Art. Catalogue by Eric M. Zafran.

BERLIN 1988
Die Verführung der Europa. Staatliche Museen Preussicher Kulturbesitz Kunstgewerbemuseum.

BERN 1942
50 Jahre, Gottfried Keller-Stiftung. Kunstmuseum.

BERN 1959
Das 17 Jahrhundert in der Französischen Malerei. Kunstmuseum.

BORDEAUX 1958
Paris et les ateliers provinciaux au XVIII siècle. Musée des Beaux-Arts. Catalogue by Gilberte Martin-Méry.

BORDEAUX 1980
Les Arts du théâtre: De Watteau à Fragonard. Galerie des Beaux-Arts. Catalogue by Gilberte Martin-Méry.

BORDEAUX, PARIS, AND MADRID 1979–80
L'Art européen à la cour d'Espagne au XVIIIe siècle. Galerie des Beaux-Arts; Galeries Nationales du Grand Palais; Museo del Prado.

BOSTON 1845
Paintings on Exhibition at Armory Hall. Boston Athenaeum.

BRAUNSCHWEIG 1983–84
Französische Malerei von Watteau bis Renoir. Herzog Anton Ulrich-Museum.

BRUSSELS 1947
De David à Cézanne. Palais des Beaux-Arts.

BRUSSELS 1953
La Femme dans l'art français. Palais des Beaux-Arts.

BRUSSELS 1975
De Watteau à David: Peintures et dessins des musées de province français. Palais des Beaux-Arts. Catalogue by Béatrix Saule, Jacques Vilain, and Nathalie Volle.

CHOLET 1973
Pierre-Charles Trémolières, 1703–1739. Musée Municipal.

CHOLET 1980–81
La Peinture mythologique au XVIIIe siècle en France. Musée Municipal.

CLERMONT-FERRAND 1984
Greuze et Diderot: Vie familiale et éducation dans la seconde moitié du XVIIIème siècle. Conservation des Musées d'Art de la Ville de Clermont-Ferrand.

COLUMBUS 1986–87
Choice by Choice: Celebrating Notable Acquisitions, 1976–1986. Columbus Museum of Art.

COMPIEGNE AND AIX-EN-PROVENCE 1977
Don Quichotte vu par un peintre du XVIIIe siècle: Natoire. Musée National du Château de Compiègne; Musée des Tapisseries d'Aix-en-Provence. Catalogue by Odile Picard Sébastiani and Marie-Henriette Krotoff.

COPENHAGEN 1935
Exposition de l'art français au XVIIIe siècle. Palais de Charlottenborg.

DUBLIN 1985
Le Classicisme français: Masterpieces of Seventeenth-Century Painting. National Gallery of Ireland. Catalogue by Sylvain Laveissière.

DUISBERG 1989
Skulptur aus dem Louvre: 89 Werke des Französischen Klassizismus, 1770–1830. Wilhelm Lehmbruck Museum der Stadt Duisberg.

EDINBURGH 1981
Poussin, Sacraments and Bacchanals: Paintings and Drawings on Sacred and Profane Themes by Nicolas Poussin, 1594–1665. National Gallery of Scotland.

FRANKFURT 1982
Jean-Antoine Watteau: Einschiffung nach Cythera, l'Ile de Cythère. Städtische Galerie im Stadelschen Kunstinstitut.

FRANKFURT 1988–89
Guido Reni und Europa. Schirn Kunsthalle. Catalogue by Sybille Ebert-Schifferer, Andrea Emiliani, and Erich Schleier.

FUKUOKA 1989
La Tradition et l'innovation dans l'art français par les peintres de Salons. Fukuoka Museum.

GENEVA 1949
Trois siècles de peinture française, XVIe–XVIIIe siècles. Musée Rath.

GRENOBLE, RENNES, AND BORDEAUX 1989–90
Laurent de La Hyre, 1606–1656: L'Homme et l'oeuvre. Musée de Grenoble; Musée de Rennes; Musée de Bordeaux. Catalogue by Pierre Rosenberg and Jacques Thuillier.

HARTFORD, SAN FRANCISCO, AND DIJON 1976–77
Jean-Baptiste Greuze, 1725–1805. Wadsworth Atheneum; California Palace of the Legion of Honor; Musée des Beaux-Arts.

INDIANAPOLIS 1965
The Romantic Era: Birth and Flowering, 1750–1850. Herron Museum of Art.

LAWRENCE, CHAPEL HILL, AND WELLESLEY 1981–82
The Engravings of Marcantonio Raimondi. Spencer Museum of Art, University of Kansas; Ackland Art Museum, University of North Carolina; Wellesley College Art Museum. Catalogue by Innis H. Shoemaker.

LENINGRAD 1972
The State Hermitage. Watteau and His Time: Painting, Graphic Art, Sculpture, Applied Art. The Hermitage.

LILLE 1968
Au temps du Roi soleil: Les Peintres de Louis XIV (1660–1715). Palais des Beaux-Arts. Catalogue by Antoine Schnapper et al.

LILLE 1985
Au temps de Watteau, Fragonard, et Chardin: Les Pays-Bas et les peintres français du XVIIIe siècle. Musée des Beaux-Arts. Catalogue by Hervé Oursel, Catherine Louboutin, and Annie Scottez.

LITTLE ROCK 1983
Les Temps elégants: The Times of Louis XIII to Louis XVI. Arkansas Art Center.

LONDON 1932
Exhibition of French Art, 1200–1900. Royal Academy of Arts.

LONDON 1954–55
European Masters of the Eighteenth Century. Royal Academy of Arts.

LONDON 1958
The Age of Louis XIV. Royal Academy of Arts.

LONDON 1968
France in the Eighteenth Century. Royal Academy of Arts.

LONDON 1972
The Age of Neoclassicism. Royal Academy of Arts and the Victoria and Albert Museum.

LONDON 1977
Aspects of French Academic Art, 1680–1780. Heim Gallery.

LONDON 1980
Watteau: Drawings in the British Museum. British Museum.

LONDON 1981
Art as Decoration. Heim Gallery.

LONDON 1986 (A)
Baroque III, 1620–1700. Matthiesen Fine Art Ltd.

LONDON 1986 (B)
French and Spanish Paintings. Colnaghi.

MANCHESTER 1984
François Boucher: Paintings, Drawings, and Prints from the Nationalmuseum Stockholm. City Art Gallery.

MAUBEUGE 1917
Ausstellung der aus St. Quentin und Umgebung Geretteten Kunstwerke. Museum au Pauvre Diable zu Maubeuge. Catalogue by D. Frh. v. Hadeln.

MIAMI 1984
In Quest of Excellence: Civic Pride, Patronage, Connoisseurship. Center for the Fine Arts. Catalogue by Jan van der Marck.

MONTPELLIER 1779
Exposition de la Société des Beaux-Arts de Montpellier.

MONTPELLIER 1965
Exposition des oeuvres recemment acquises par le Musée Fabre. Musée Fabre.

MOSCOW AND LENINGRAD 1978
De Watteau à David: Tableaux français du XVIIIe siècle des musées français. The Pushkin Museum; The Hermitage Museum (cat. in Russian).

MUNICH 1958
The Age of Rococo: Art and Culture of the Eighteenth Century. Munich, The Residenz.

NANCY 1955
Art français au temps de Stanislas. Musée des Beaux-Arts.

NANTES 1975
60 peintures, 1250–1884. Musée des Beaux-Arts.

NANTES 1983
Peintures monumentals. Vol. 1. Musée des Beaux-Arts.

NEW ORLEANS 1953–54
Masterpieces of French Painting through Five Centuries, 1400–1900. Isaac Delgado Museum of Art.

NEW ORLEANS AND WASHINGTON 1984–85
The Sun King: Louis XIV and the New World. Louisiana State Museum; Corcoran Gallery of Art.

NEW YORK 1935–36
French Painting and Sculpture of the Eighteenth Century. The Metropolitan Museum of Art.

NEW YORK 1939
Pollaiuolo to Picasso: Classics of the Nude. M. Knoedler and Company.

NEW YORK 1977
Paris–New York: A Continuing Romance. Wildenstein.

NEW YORK 1980
François Boucher. Wildenstein.

NEW YORK 1983
French Paintings of the Eighteenth Century. Didier Aaron.

NEW YORK 1987
François Boucher: His Circle and Influence. Stair Sainty Matthiesen.

NEW YORK 1988
Versailles: The View from Sweden. Cooper-Hewitt Museum.

NEW YORK 1989
1789: French Art During the Revolution. Colnaghi. Catalogue by Alan Wintermute.

NEW YORK 1990
Claude to Corot: The Development of Landscape Painting in France. Colnaghi.

NEW YORK AND CHICAGO 1990
From Poussin to Matisse: The Russian Taste for French Painting. The Metropolitan Museum of Art; The Art Institute of Chicago.

NEW YORK, DETROIT, AND PARIS 1986–87
François Boucher, 1703–1770. The Metropolitan Museum of Art; The Detroit Institute of Arts; Galeries Nationales du Grand Palais. Catalogue by Alastair Laing.

NEW YORK ET AL. 1984–85
The Grand Prix de Rome: Paintings from the École des Beaux-Arts, 1797–1863. National Academy of Design, et al. Catalogue by Philippe Grunchec.

NEW YORK, NEW ORLEANS, AND COLUMBUS 1985–86
The First Painters of the King: French Royal Taste from Louis XIV to the Revolution. Stair Sainty Matthiesen; New Orleans Museum of Art; Columbus Museum of Art. Catalogue by Colin B. Bailey.

NEW YORK AND PHILADELPHIA 1991
Paul Georges. Anne Plumb Gallery; More Gallery.

NICE, CLERMONT-FERRAND, AND NANCY 1977
Carle Vanloo, premier peintre du Roi (Nice, 1705– Paris, 1765). Musée Chéret; Musée Bargoin; Musée des Beaux-Arts. Catalogue by Marie-Catherine Sahut.

ORLÉANS 1984
Peintures françaises du Museum of Art de la Nouvelle Orléans. Musée des Beaux-Arts d'Orléans.

ÖSTERSUND 1920
Fransk sjuttonhundratalskonst ur Nationalmusei. Museum der Stadt Östersund.

PARIS 1727
Explication des tableaux exposez dans la Galerie d'Apollon. Palais du Louvre.

PARIS 1883–84
L'Art du XVIIIe siècle. Galerie Georges Petit.

PARIS 1913
David et ses élèves. Petit Palais.

PARIS 1921
Exposition d'oeuvres de J.-H. Fragonard. Musée des Arts Décoratifs; Pavillon de Marsan; Palais du Louvre.

PARIS 1936
Gros et ses amis. Petit Palais.

PARIS 1937
Chefs-d'Oeuvre de l'art français. Palais National des Arts.

PARIS 1948
David: Exposition en l'honneur du deuxième centenaire de sa naissance. Musée de l'Orangerie.

PARIS 1950
Chefs-d'Oeuvre des collections parisiennes. Musée Carnavalet.

PARIS 1954
Gros, Géricault, Delacroix. Bernheim jeune et Cie.

PARIS 1956
De Watteau à Prud'hon. Gazette des Beaux-Arts.

PARIS 1957
Besançon: Le plus ancien musée de France. Musée des Arts Décoratifs.

PARIS 1958
Le XVIIe siècle français. Petit Palais.

PARIS 1960
Exposition de 700 tableaux de toutes les écoles antérieurs à 1800 tirés des réserves du département des peintures. Musée du Louvre.

PARIS 1971
François Boucher: Gravures et dessins provenant du cabinet des dessins et de la collection Edmond de Rothschild au Musée du Louvre. Musée du Louvre. Catalogue by Pierrette Jean-Michel.

PARIS 1972–73
L'École de Fontainebleau. Galeries Nationales du Grand Palais.

PARIS 1973
Equivoques, peintures françaises du XIXème siècle. Musée des Arts Décoratifs.

PARIS 1974
Nouvelles acquisitions. Heim-Gairac Gallery.

PARIS 1974–75
Dessins du Musée Atger, conservés à la Bibliothèque de la Faculté de Médecine de Montpellier. Musée du Louvre.

PARIS 1976–77
Dessins français de l'Art Institute de Chicago de Watteau à Picasso. Musée du Louvre.

PARIS 1977–78
Le Siècle de Rubens dans les collections publiques françaises. Galeries Nationales du Grand Palais.

PARIS 1979 (A)
Chardin, 1699–1779. Galeries Nationales du Grand Palais. Catalogue by Pierre Rosenberg.

PARIS 1979 (B)
La Rue de Grenelle. Musée-Galerie de la Seita.

PARIS 1980–81
Cinq années d'enrichissement du patrimoine national, 1975–1980. Galeries Nationales du Grand Palais.

PARIS 1981
La Rue de Varenne. Musée Rodin.

PARIS 1982
Les Morceaux de réception des graveurs à l'Académie Royale des Beaux-Arts (1655–1789). Musée-Galérie de la Seita.

PARIS 1982–83
J. B. Oudry, 1686–1755. Galeries Nationales du Grand Palais.

PARIS 1983 (A)
Les Collections du comte d'Orsay: Dessins du Musée du Louvre. Musée du Louvre.

PARIS 1983 (B)
La Rue de Lille. Institut Néerlandais.

PARIS 1983–84
Hommage à Raphael: Raphael et l'art français. Galeries Nationales du Grand Palais. Catalogue by Jean-Paul Boulanger and Geneviève Renisio.

PARIS 1984 (A)
Catalogue de la donation Othon Kaufmann et François Schlageter au département des peintures. Musée du Louvre. Catalogue by Pierre Rosenberg.

PARIS 1984 (B)
La Rue Saint-Dominique. Musée Rodin.

PARIS 1984–85 (A)
Antoine Watteau, 1684–1721. National Gallery of Art, Washington; Galeries Nationales du Grand Palais, Paris; Schloss Charlottenburg, Berlin. Catalogue by Margaret Morgan Grasselli and Pierre Rosenberg.

PARIS 1984–85 (B)
Diderot et l'art de Boucher à David. Hôtel de la Monnaie.

PARIS 1985–86
Le Brun à Versailles. Musée du Louvre.

PARIS 1987
Dessins français du XVIIIe siècle de Watteau à Lemoyne. Musée du Louvre. Catalogue by Roseline Bacou et al.

PARIS 1988
Le Palais-Royal. Musée Carnavalet.

PARIS 1989
Le Beau Idéal, ou l'art du concept. Musée du Louvre. Catalogue by Régis Michel.

PARIS 1990
Le Peintre, le roi, le héros: "L'Andromède de Pierre Mignard." Musée du Louvre. Catalogue by Jean-Claude Boyer.

PARIS 1990–91
Vouet. Galeries Nationales du Grand Palais. Catalogue by Jacques Thuillier.

PARIS, DETROIT, AND NEW YORK 1974–75
French Painting, 1774–1830: The Age of Revolution. Galeries Nationales du Grand Palais; The Detroit Institute of Arts; The Metropolitan Museum of Art.

PARIS AND LUNÉVILLE 1986
Germain Boffrand, 1667–1754: L'Aventure d'un architecte indépendant. Délégation à l'action artistique de la ville de Paris; Château-Musée de Lunéville.

PARIS, MALIBU, AND HAMBURG 1981–82
De Michel-Ange à Gericault: Dessins de la donation Armand-Valton. École Nationale Supérieure des Beaux-Arts; J. Paul Getty Museum; Hamburger Kunsthalle.

PARIS AND MILAN 1988–89
Seicento: Le Siècle de Caravage dans les collections françaises. Galeries Nationales du Grand Palais; Palazzo Reale.

PARIS AND NEW YORK 1987–88
Fragonard. Galeries Nationales du Grand Palais; The Metropolitan Museum of Art. Catalogue by Pierre Rosenberg.

PARIS, NEW YORK, AND CHICAGO 1982
France in the Golden Age: Seventeenth-Century French Painting in American Collections. Galeries Nationales du Grand Palais; The Metropolitan Museum of Art; The Art Institute of Chicago.

PARIS AND ROME 1987
Subleyras. Musée du Luxembourg; Accademia di Francia a Roma, Villa Medici.

PARIS AND VERSAILLES 1989–90
Jacques-Louis David, 1748–1825. Musée du Louvre; Musée National du Château de Versailles. Catalogue by Antoine Schnapper.

PETROGRAD 1922–25
L'Exposition de peinture française des XVIIe et XVIIIe siècles. The Hermitage Museum.

PHILADELPHIA 1950
Masterpieces from Philadelphia Private Collections, Part II. Philadelphia Museum of Art.

PHILADELPHIA AND CAMBRIDGE 1988–89
Pietro Testa, 1612–1650: Prints and Drawings. Philadelphia Museum of Art; Arthur M. Sackler Museum. Catalogue by Elizabeth Cropper.

PITTSBURGH 1951
French Painting, 1100–1900. Carnegie Institute of Arts.

PRINCETON 1977
Eighteenth-Century French Life-Drawing: Selections from the Collection of Mathias Polakovits. Princeton University Art Museum. Catalogue by James Henry Rubin.

RENNES 1964
Peintures françaises du XVIIIe siècle du Musée du Louvre. Musée des Beaux-Arts.

RENNES 1985
Jean-Germain Drouais, 1763–1788. Musée des Beaux-Arts.

ROME 1973
Il Cavalier d'Arpino. Palazzo Venezia.

ROME 1981–82
David e Roma. Accademia di Francia a Roma, Villa Medici.

ROME 1990–91
J.H. Fragonard e H. Robert a Roma. Accademia di Francia a Roma, Villa Medici. Catalogue by Jean-Pierre Cuzin and Pierre Rosenberg.

ROME, UNIVERSITY PARK, AND NEW YORK 1990
Prize-Winning Drawings from the Roman Academy, 1682–1754. Accademia Nazionali di S. Luca; Palmer Museum of Art, Pennsylvania State University; National Academy of Design.

ROUEN 1966
Jean Jouvenet, 1644–1717. Musée des Beaux-Arts. Catalogue by Antoine Schnapper.

ROUEN 1970 (A)
Jean Restout (1692–1768). Musée des Beaux-Arts. Catalogue by Pierre Rosenberg and Antoine Schnapper.

ROUEN 1970 (B)
Choix de dessins anciens. Bibliothèque Municipal. Catalogue by Pierre Rosenberg and Antoine Schnapper.

ST. PETERSBURG 1982–83
Fragonard and His Friends: Changing Ideals in Eighteenth-Century Art. Museum of Fine Arts. Catalogue by Marion Lou Grayson.

SAINT-PRIEST, LE HAVRE, AND FONTEVRAUD 1984–85
Jean-Michel Alberola: Les Images peintes. Galerie Municipale; Musée des Beaux-Arts; Abbaye de Fontevraud.

SAN FRANCISCO 1920
Loan Exhibition of Paintings by Old Masters in the Palace of Fine Arts. San Francisco Museum of Art. Catalogue by J. Nilsen Laurvik.

SAN FRANCISCO 1939
Masterworks of Five Centuries. Golden Gate International Exposition.

SAN FRANCISCO 1939–40
Seven Centuries of Painting. California Palace of the Legion of Honor.

SAN FRANCISCO 1964
Man: Glory, Jest, and Riddle. California Palace of the Legion of Honor.

SPOLETO 1988
François-Xavier Fabre, 1766–1837. Palazzo Racani-Arroni.

STOCKHOLM 1945
Utställning av mästerverk ur Nationalmusei samlingar. Nationalmuseum.

STOCKHOLM 1979–80
1700-tal. Tanke och form i rokokon. Nationalmuseum.

STOCKHOLM 1983
Myter. Nationalmuseum.

STRAUBING 1952
Ausstellung Europaische Meisterwerke der Münchner Pinakothek.

STUTTGART 1984
Zeichnungen des 15. bis 18. Jahrhunderts. Graphische Sammlung, Staatsgalerie Stuttgart.

TOKYO AND KYOTO 1980
Fragonard. The National Museum of Western Art; Kyoto Municipal Museum.

TOKYO, UMEDA-OSAKA, HOKKAIDO-HAKODATE, AND YOKOHAMA 1990
Three Masters of French Rococo: Boucher, Fragonard, Lancret. Odakyu Grand Gallery; Daimaru Museum; Hokkaido-Hakodate Museum of Art; Sogo Museum of Art.

TOKYO, YAMAGUCHI, NAGOYA, AND KAMAKURA 1986–87
L'Exposition de la peinture française du rococo à l'impressionnisme. Musée Isetan; Musée Yamaguchi; Musée d'Aïchi; Musée d'Art Moderne.

TOLEDO, CHICAGO, AND OTTAWA 1975–76
The Age of Louis XV: French Painting, 1710–1774. Toledo Museum of Art; The Art Institute of Chicago; National Gallery of Canada. Catalogue by Pierre Rosenberg.

TORONTO, OTTAWA, SAN FRANCISCO, AND NEW YORK 1972–73
French Master Drawings of the 17th and 18th Centuries in North American Collections. Art Gallery of Ontario; National Gallery of Canada; California Palace of the Legion of Honor; New York Cultural Center. Catalogue by Pierre Rosenberg.

TOULON 1985
La Peinture en Provence dans les collections du Musée de Toulon du XVIIe au début du XXe siècle. Musée de Toulon.

TOULOUSE 1956–57
Pierre-Henri de Valenciennes. Musée Paul-Dupuy.

TOULOUSE 1987
Le Portrait toulousain de 1550 à 1800. Musée des Augustins.

TROYES, NIMES, AND ROME 1977
Charles-Joseph Natoire (Nîmes, 1700–Castel Gandolfo, 1777). Musée des Beaux-Arts; Musée des Beaux-Arts; Accademia di Francia a Roma, Villa Medici.

TURIN 1987
Lo Specchio e il doppio, dallo stagno di Narciso allo schermo televiso. Mole Antonelliana.

UDINE 1989
Sebastiano Ricci. Villa Manin di Passarrano. Catalogue by Giuseppe Bergamini.

VALENCIENNES 1918
Kunstwerke aus dem Besetzten Nordfrankreich. Musée de Valenciennes.

VERSAILLES 1963
Charles Le Brun, 1619–1690. Musée National du Château de Versailles. Catalogue by Jennifer Montagu and Jacques Thuillier.

VIENNA 1966
Kunst und Geist Frankreichs im 18. Jahrhundert. Oberes Belvedere.

WASHINGTON 1982
Eighteenth-Century Drawings from the Collection of Mrs. Gertrude Laughlin Chanler. National Gallery of Art. Catalogue by Margaret Morgan Grasselli.

WASHINGTON AND CHICAGO 1973–74
François Boucher in North American Collections: 100 Drawings. National Gallery of Art; The Art Institute of Chicago. Catalogue by Regina Shoolman Slatkin.

WASHINGTON, DETROIT, AND AMSTERDAM 1980–81
Gods, Saints, and Heroes: Dutch Painting in the Age of Rembrandt. National Gallery of Art; The Detroit Institute of Arts; Rijksmuseum.

WASHINGTON, TOLEDO, AND NEW YORK 1960–61
The Splendid Century: French Art, 1600–1715. National Gallery of Art; Toledo Museum of Art; The Metropolitan Museum of Art.

INDEX OF WORKS EXHIBITED BY ARTIST
All index references are to catalogue numbers

INDEX OF LENDERS
All index references are to catalogue numbers

PHOTOGRAPH CREDITS